ART HISTORY

Volume I Fifth Edition Fifth Edition

MARILYN STOKSTAD

Judith Harris Murphy Distinguished Professor of Art History Emerita The University of Kansas

MICHAEL W. COTHREN

Scheuer Family Professor of Humanities Department of Art, Swarthmore College

PEARSON

Boston Columbus Indianapolis New York San Francisco Upper Saddle River Amsterdam Cape Town Dubai London Madrid Milan Munich Paris Montréal Toronto Delhi Mexico City São Paulo Sydney Hong Kong Seoul Singapore Taipei Tokyo

Editorial Director: Craig Campanella Editor in Chief: Sarah Touborg Senior Sponsoring Editor: Helen Ronan Editorial Assistant: Victoria Engros Vice-President, Director of Marketing: Brandy Dawson Executive Marketing Manager: Kate Mitchell Marketing Assistant: Paige Patunas Managing Editor: Melissa Feimer Project Managers: Barbara Cappuccio and Marlene Gassler Senior Operations Supervisor: Mary Fischer **Operations Specialist:** Diane Peirano Media Director: Brian Hyland Senior Media Editor: David Alick Media Project Manager: Rich Barnes Pearson Imaging Center: Corin Skidds Printer/Binder: Courier / Kendallville Cover Printer: Lehigh-Phoenix Color / Hagerstown

This book was designed by Laurence King Publishing Ltd, London www.laurenceking.com

Editorial Manager: Kara Hattersley-Smith Senior Editor: Clare Double Production Manager: Simon Walsh Page Design: Nick Newton Cover Design: Jo Fernandes Picture Researcher: Evi Peroulaki Copy Editor: Jennifer Speake Indexer: Vicki Robinson

Cover image: Exekias (potter and painter), Ajax and Achilles Playing a Game, c. 540–530 BCE. Black-figure painting on a ceramic amphora, height of amphora 29" (61 cm). Photo: Vatican Museums.

Credits and acknowledgments borrowed from other sources and reproduced, with permission, in this textbook appear on the appropriate page within text or on the credit pages in the back of this book.

Copyright © 2014, 2011, 2008 by Pearson Education, Inc.

All rights reserved. Printed in the United States of America. This publication is protected by Copyright and permission should be obtained from the publisher prior to any prohibited reproduction, storage in a retrieval system, or transmission in any form or by any means, electronic, mechanical, photocopying, recording, or likewise. To obtain permission(s) to use material from this work, please submit a written request to Pearson Education, Inc., Permissions Department, One Lake Street, Upper Saddle River, New Jersey 07458 or you may fax your request to 201-236-3290.

Library of Congress Cataloging-in-Publication Data

Stokstad, Marilyn Art history / Marily

Art history / Marilyn Stokstad, Judith Harris Murphy Distinguished Professor of Art History Emerita, The University of Kansas, Michael W. Cothren, Scheuer Family Professor of Humanities, Department of Art, Swarthmore College. -- Fifth edition.

pages cm Includes bibliographical references and index. ISBN-13: 978-0-205-87347-0 (hardcover) ISBN-10: 0-205-87347-2 (hardcover) 1. Art--History--Textbooks. I. Cothren, Michael Watt. II. Title.

N5300.S923 2013 709--dc23

2012027450

10 9 8 7 6 5 4 3

Prentice Hall is an imprint of

www.pearsonhighered.com

ISBN 10: 0-205-87348-0 ISBN 13: 978-0-205-87348-7

Books à la carte ISBN 10: 0-205-93840-X ISBN 13: 978-0-205-93840-7

Brief Contents

Contents vii • Letter from the Author xiv • What's New xv • MyArtsLab xvi • Pearson Choices xviii • Acknowledgments and Gratitude xix • Use Notes xxi • Starter Kit xxii • Introduction xxvi

1	Prehistoric Art 1	11 Chinese and Korean Art before 1279 330
2	Art of the Ancient Near East 26	12 Japanese Art before 1333 360
3	Art of Ancient Egypt 48	13 Art of the Americas before 1300 382
4	Art of the Ancient Aegean 80	14 Early African Art 408
5	Art of Ancient Greece 100	15 Early Medieval Art in Europe 428
6	Etruscan and Roman art 156	16 Romanesque Art 458
7	Jewish and Early Christian Art 214	17 Gothic Art of the Twelfth and Thirteenth Centuries 494
8	Byzantine Art 232	18 Fourteenth-Century Art in Europe 530
9	Islamic Art 264	Map 562 • Glossary 563 • Bibliography 572 • Credits 584 • Index 586
10	Art of South and Southeast Asia before 1200 294	

Contents

Letter from the Author xiv • What's New xv • MyArtsLab xvi • Pearson Choices xviii • Acknowledgments and Gratitude xix • Use Notes xxi • Starter Kit xxii • Introduction xxvi

снартер

THE STONE AGE 2

THE PALEOLITHIC PERIOD 2

Shelter or Architecture? 4 Artifacts or Works of Art? 5 Cave Painting 8 Cave Sculptures 11

THE NEOLITHIC PERIOD12Architecture13Sculpture and Ceramics20

NEW METALLURGY, ENDURING STONE 23 The Bronze Age 23 Rock Carvings 24

BOXES

- ART AND ITS CONTEXTS The Power of Naming 6 Intentional House Burning 16
- A BROADER LOOK Prehistoric Woman and Man 22
- A CLOSER LOOK A House in Çatalhöyük 15
- ELEMENTS OF ARCHITECTURE Early Construction Methods 19
- TECHNIQUE
 Prehistoric Wall Painting 8
 Pottery and Ceramics 20
- RECOVERING THE PAST How Early Art is Dated 12

Art of the Ancient Near East 26

THE FERTILE CRESCENT AND MESOPOTAMIA 28

Sumer 28 Akkad 35 Ur and Lagash 37 Babylon 37

THE HITTITES OF ANATOLIA 37

ASSYRIA 38 Kalhu 38

Dur Sharrukin 41 Nineveh 42

NEO-BABYLONIA 44

PERSIA 44

BOXES

- ART AND ITS CONTEXTS Art as Spoils of War—Protection or Theft? 34 The Code of Hammurabi 39
- A BROADER LOOK A Lyre from a Royal Tomb in Ur 32
- A CLOSER LOOK
 Enemies Crossing the Euphrates to Escape Assyrian Archers 42

TECHNIQUE
 Cuneiform Writing 30

THE GIFT OF THE NILE 50

EARLY DYNASTIC EGYPT, c. 2950–2575 BCE 50 The God-Kings 50 Artistic Conventions 51 Funerary Architecture 53

THE OLD KINGDOM, c. 2575–2150 BCE 56 The Great Pyramids at Giza 56 Sculpture 58 Pictorial Relief in Tombs 61

THE MIDDLE KINGDOM, c. 1975–c. 1640 BCE 62 Portraits of Senusret III 62 Rock-Cut Tombs 62 Funerary Stelai 63 Town Planning 65

THE NEW KINGDOM, c. 1539–1075 BCE 65 The Great Temple Complexes 65 Hatshepsut 67 The Tomb of Ramose 69 Akhenaten and the Art of the Amarna Period 70 The Return to Tradition: Tutankhamun and Ramses II 73 The Books of the Dead 77

THE THIRD INTERMEDIATE PERIOD, c. 1075–715 bce 77

LATE EGYPTIAN ART, c. 715–332 BCE 78

BOXES

- ART AND ITS CONTEXTS Egyptian Symbols 51
- A BROADER LOOK The Temples of Ramses II at Abu Simbel 74
- A CLOSER LOOK The Palette of Narmer 52
- ELEMENTS OF ARCHITECTURE Mastaba to Pyramid 55
- TECHNIQUE
 Preserving the Dead 53
 Egyptian Pictorial Relief 64
 Glassmaking 76
- RECOVERING THE PAST How Early Art is Dated 79

THE BRONZE AGE IN THE AEGEAN82THE CYCLADIC ISLANDS82

THE MINOAN CIVILIZATION ON CRETE 84 The Old Palace Period, C. 1900–1700 BCE 84 The New Palace Period, C. 1700–1450 BCE 85 The Spread of Minoan Culture 90

THE MYCENAEAN (HELLADIC) CULTURE 92 Helladic Architecture 92 Mycenaean Tombs 97

Ceramic Arts 99

BOXES

A BROADER LOOK The Lion Gate 95

A CLOSER LOOK The "Flotilla Fresco" from Akrotiri 92

TECHNIQUE
 Aegean Metalwork 90

RECOVERING THE PAST Pioneers of Aegean Archaeology 85 The "Mask of Agamemnon" 97

Art of Ancient Greece 100

THE EMERGENCE OF GREEK CIVILIZATION 102 Historical Background 102 Religious Beliefs and Sacred Places 102 GREEK ART c. 900-c. 600 BCE 102 The Geometric Period 102 The Orientalizing Period 105 THE ARCHAIC PERIOD, c. 600-480 BCE 105 The Sanctuary at Delphi 107 Temples 108 Free-standing Sculpture 114 Painted Pots 117 THE EARLY CLASSICAL PERIOD, c. 480-450 BCE 120 Marble Sculpture 120 Bronze Sculpture 120 Ceramic Painting 126 THE HIGH CLASSICAL PERIOD, c. 450-400 BCE 127 The Akropolis 128 The Parthenon 129 The Propylaia and the Erechtheion 135 The Temple of Athena Nike 137 The Athenian Agora 137 City Plans 138 Stele Sculpture 139 Painting 140 THE LATE CLASSICAL PERIOD, c. 400-323 BCE 141 Sculpture 142 The Art of the Goldsmith 145

The Art of the Goldsmith 145 Painting and Mosaics 145

THE HELLENISTIC PERIOD, 323-31/30 BCE 147

The Corinthian Order in Hellenistic Architecture 147 Sculpture 149

BOXES

ART AND ITS CONTEXTS

Greek and Roman Deities 104 Classic and Classical 120 Who Owns the Art? The Elgin Marbles and the Euphronios Krater 133 Women at a Fountain House 139 Greek Theaters 148 The Celts 150

- A BROADER LOOK The Tomb of the Diver 124
- A CLOSER LOOK The Death of Sarpedon 119
- **ELEMENTS OF ARCHITECTURE** The Greek Orders 110
- TECHNIQUE
 Color in Greek Sculpture 113
 Black-Figure and Red-Figure 118
 "The Canon" of Polykleitos 134
- RECOVERING THE PAST
 The Riace Warriors 127

Etruscan and Roman Art 156

THE ETRUSCANS 158

Etruscan Architecture 158 Etruscan Temples 158 Tomb Chambers 160 Works in Bronze 164

THE ROMANS 166

THE REPUBLIC, 509–27 BCE166Portrait Sculpture167Roman Temples171

THE EARLY EMPIRE, 27 BCE-96 CE 171 Art in the Age of Augustus 172 The Julio-Claudians 172 Roman Cities and the Roman Home 176 Wall Painting 179 The Flavians 184

THE HIGH IMPERIAL ART OF TRAJAN AND
HADRIAN 190Imperial Architecture190Imperial Portraits200

THE LATE EMPIRE, THIRD AND FOURTH
CENTURIES CE 202The Severan Dynasty203The Soldier Emperors205Constantine the Great207Roman Art after Constantine211

BOXES

- ART AND ITS CONTEXTS
 Roman Writers on Art 167
 Roman Portraiture 168
 August Mau's Four Styles of Pompeian Painting 182
 A Painter at Work 183
- A BROADER LOOK The Ara Pacis Augustae 174
- A CLOSER LOOK Sarcophagus with the Indian Triumph of Dionysus 202
- ELEMENTS OF ARCHITECTURE
 Roman Architectural Orders 161
 The Roman Arch 170
 Roman Vaulting 187
 Concrete 194
- Roman Mosaics 199
- RECOVERING THE PAST
 The Capitoline She-Wolf 165
 The Mildenhall Treasure 212

Jewish and Early Christian Art 214

JEWS, CHRISTIANS, AND MUSLIMS 216

JUDAISM AND CHRISTIANITY IN THE LATE ROMAN WORLD 216

Early Jewish Art 216 Early Christian Art 220

IMPERIAL CHRISTIAN ARCHITECTURE AND ART 223 Rome 223 Ravenna and Thessaloniki 227

BOXES

- ART AND ITS CONTEXTS The Life of Jesus 230
- A BROADER LOOK The Oratory of Galla Placidia in Ravenna 228
- A CLOSER LOOK The Mosaic Floor of the Beth Alpha Synagogue 219
- ELEMENTS OF ARCHITECTURE Longitudinal-Plan and Central-Plan Churches 225
- RECOVERING THE PAST Dura-Europos 221

Byzantine Art 232

BYZANTIUM 234

EARLY BYZANTINE ART 235

The Golden Age of Justinian 235 Objects of Veneration and Devotion 244 Icons and Iconoclasm 246

MIDDLE BYZANTINE ART 248 Architecture and Wall Painting in Mosaic and Fresco 248 Precious Objects of Commemoration, Veneration, and Devotion 255

LATE BYZANTINE ART 258 Constantinople: The Chora Church 258 Icons 262

BOXES

ART AND ITS CONTEXTS

Naming Christian Churches: Designation + Dedication + Location 239 Scroll and Codex 245 Iconoclasm 247

A BROADER LOOK The Funerary Chapel of Theodore Metochites 260

A CLOSER LOOK Icon of St. Michael the Archangel 257

ELEMENTS OF ARCHITECTURE Pendentives and Squinches 238

Islamic Art 264

ISLAM AND EARLY ISLAMIC SOCIETY 266

THE EARLY PERIOD: NINTH THROUGH

TWELFTH CENTURIES268Architecture269Calligraphy275Lusterware276

THE LATER PERIOD: THIRTEENTH THROUGH

FIFTEENTH CENTURIES 277 Architecture 277 Luxury Arts 283 The Arts of the Book 284

ART AND ARCHITECTURE OF LATER EMPIRES 286 The Ottoman Empire 286 The Safavid Dynasty 289

THE MODERN ERA 291

BOXES

- ART AND ITS CONTEXTS The Five Pillars of Islam 271
- A BROADER LOOK The Great Mosque of Cordoba 272
- A CLOSER LOOK A Mamluk Glass Oil Lamp 279
- ELEMENTS OF ARCHITECTURE Arches 274

TECHNIQUE

Ornament 268 Carpet Making 292

Art of South and Southeast Asia before 1200 294

GEOGRAPHY 296

ART OF SOUTH ASIA 296

The Indus Civilization 296 The Vedic Period 299 The Maurya Period 299 The Period of the Shunga and Early Satavahana 301 The Kushan Period 306 The Gupta Period and its Successors 308 Other Developments, Fourth–Sixth Century 312 The Pallava Period 315 The Seventh Through Twelfth Centuries 317 The Chola Period 320

ART OF SOUTHEAST ASIA 321

Early Southeast Asia 321 Sixth to the Ninth Century 323 Tenth Through Twelfth Centuries 327

BOXES

ART AND ITS CONTEXTS

Buddhism 301 Mudras 308 Hinduism 309

A BROADER LOOK Shiva Nataraja of the Chola Dynasty 322

A CLOSER LOOK The Great Departure 304

ELEMENTS OF ARCHITECTURE Stupas and Temples 302

Chinese and Korean Art before 1279 330

THE MIDDLE KINGDOM 332

NEOLITHIC CULTURES 332 Painted Pottery Cultures 332 Liangzhu Culture 332

BRONZE AGE CHINA 334 Shang Dynasty 334 Zhou Dynasty 335

THE CHINESE EMPIRE: QIN DYNASTY 336

HAN DYNASTY 338 Philosophy and Art 338 Architecture 341

SIX DYNASTIES 341 Painting 341 Calligraphy 343 Buddhist Art and Architecture 344

SUI AND TANG DYNASTIES 345 Buddhist Art and Architecture 345 Figure Painting 347

SONG DYNASTY 348 Northern Song Painting 351 Southern Song Painting and Ceramics 354

THE ARTS OF KOREA 356

The Three Kingdoms Period 356 The Unified Silla Period 357 Goryeo Dynasty 358

BOXES

- ART AND ITS CONTEXTS
 Chinese Characters 337
 Daoism 338
 Confucius and Confucianism 342
- A BROADER LOOK The Silk Road during the Tang Period 349
- A CLOSER LOOK A Reception in the Palace 340
- ELEMENTS OF ARCHITECTURE Pagodas 351
- Piece-Mold Casting 335

Japanese Art before 1333 **360**

PREHISTORIC JAPAN 362 Jomon Period 362 Yayoi Period 362

Kofun Period 362

ASUKA PERIOD 364 Horyuji 365

NARA PERIOD 367

HEIAN PERIOD 369 Esoteric Buddhist Art 369 Pure Land Buddhist Art 371 Secular Painting and Calligraphy 373

KAMAKURA PERIOD376Pure Land Buddhist Art377Zen Buddhist Art381

BOXES

- ART AND ITS CONTEXTS Writing, Language, and Culture 365 Buddhist Symbols 368 Arms and Armor 377
- A BROADER LOOK Daruma, Founder of Zen 380
- A CLOSER LOOK The Tale of Genji 374
- TECHNIQUE Joined-Block Wood Sculpture 372
- RECOVERING THE PAST
 The Great Buddha Hall 370

Art of the Americas before 1300 382

THE NEW WORLD 384

MESOAMERICA 384

The Olmec 384 Teotihuacan 387 The Maya 390

CENTRAL AMERICA 396

SOUTH AMERICA: THE CENTRAL ANDES 397 Chavin de Huantar 398 The Paracas and Nazca Cultures 399 The Moche Culture 399

NORTH AMERICA 401

The East 401 The North American Southwest 404

BOXES

- ART AND ITS CONTEXTS Maya Writing 390 The Cosmic Ballgame 395
- A BROADER LOOK Rock Art 406
- A CLOSER LOOK
- Shield Jaguar and Lady Xok 394

Andean Textiles 397

Early African Art 408

THE LURE OF ANCIENT AFRICA 410 AFRICA—THE CRADLE OF ART AND

CIVILIZATION 410 AFRICAN ROCK ART 410

Saharan Rock Art 411 SUB-SAHARAN CIVILIZATIONS 412

Nok 412 Igbo-Ukwu 414 Ife 415 Benin 416

OTHER URBAN CENTERS 419 Jenné 422 Great Zimbabwe 423 Aksum and Lalibela 424 Kongo Kingdom 425

EXPORTING TO THE WEST 427

BOXES

- ART AND ITS CONTEXTS
 The Myth of "Primitive" Art 412
 Southern African Rock Art 414
- A BROADER LOOK A Warrior Chief Pledging Loyalty 420
- A CLOSER LOOK Roped Pot on a Stand 416

Lost-Wax Casting 418

CONTENTS XI

THE EARLY MIDDLE AGES 430

THE ART OF THE "BARBARIANS" IN EUROPE 431 The Merovingians 431 The Norse 433 The Celts and Anglo-Saxons in Britain 433

THE EARLY CHRISTIAN ART OF THE BRITISH ISLES 435 Illustrated Books 435

MOZARABIC ART IN SPAIN 439 Beatus Manuscripts 439

THE VIKING ERA 441 The Oseberg Ship 441 Picture Stones at Jelling 442 Timber Architecture 442

THE CAROLINGIAN EMPIRE 444 Carolingian Architecture 444 Illustrated Books 448 Carolingian Metalwork 450

OTTONIAN EUROPE 452

Ottonian Architecture 452 Ottonian Sculpture 454 Illustrated Books 456

BOXES

ART AND ITS CONTEXTS

Defining the Middle Ages 431 The Medieval Scriptorium 438

A BROADER LOOK The Lindisfame Gospels 436 A CLOSER LOOK

Psalm 23 in the Utrecht Psalter 450

RECOVERING THE PAST Sutton Hoo 434

Romanesque Art 458

EUROPE IN THE ROMANESQUE PERIOD 460

Political, Economic, and Social Life 460 The Church 460

ROMANESQUE ART 461

ARCHITECTURE 462 "First Romanesque" 463 Pilgrimage Churches 463 Cluny 465 The Cistercians 468 Regional Styles in Romanesque Architecture 469 Secular Architecture: Dover Castle, England 477

ARCHITECTURAL SCULPTURE 478

Wiligelmo at the Cathedral of Modena 478 The Priory Church of Saint-Pierre at Moissac 479 The Church of Saint-Lazare at Autun 482

SCULPTURE IN WOOD AND BRONZE 485

Christ on the Cross (Majestat Batlló) 485 Mary as the Throne of Wisdom 485 Tomb of Rudolf of Swabia 486 Renier of Huy 487

TEXTILES AND BOOKS 487

Chronicling History 487 Sacred Books 490

BOXES

ART AND ITS CONTEXTS The Pilgrim's Journey to Santiago 464 Relics and Reliquaries 467 St. Bernard and Theophilus: The Monastic Controversy over the Visual Arts 470 The Paintings of San Climent in Taull: Mozarabic Meets Byzantine 473 Hildegard of Bingen 492

A BROADER LOOK

The Bayeux Embroidery 488

- A CLOSER LOOK
- The Last Judgment Tympanum at Autun 483 ELEMENTS OF ARCHITECTURE

The Romanesque Church Portal 478

THE EMERGENCE OF THE GOTHIC STYLE496The Rise of Urban and Intellectual Life496The Age of Cathedrals497

GOTHIC ART IN FRANCE 497 The Birth of Gothic at the Abbey Church of Saint-Denis 498 Gothic Cathedrals 499 Art in the Age of St. Louis 514

GOTHIC ART IN ENGLAND 515 Manuscript Illumination 515 Architecture 518

GOTHIC ART IN GERMANY AND THE HOLY ROMAN EMPIRE 520 Architecture 521 Sculpture 523

GOTHIC ART IN ITALY525Sculpture: The Pisano Family525Painting527

BOXES

ART AND ITS CONTEXTS Abbot Suger on the Value of Art in Monasteries 497 Master Masons 504 Villard de Honnecourt 511

A BROADER LOOK The Sainte-Chapelle in Paris 512

A CLOSER LOOK Psalm 1 in the Windmill Psalter 516

ELEMENTS OF ARCHITECTURE Rib Vaulting 499 The Gothic Church 503

TECHNIQUE Stained-Glass Windows 501

Fourteenth-Century Art in Europe 530

FOURTEENTH-CENTURY EUROPE 532

ITALY 533 Florentine Architecture and Metalwork 533 Florentine Painting 536 Sienese Painting 542

FRANCE 548 Manuscript Illumination 549 Metalwork and Ivory 554

ENGLAND 554 Embroidery: Opus Anglicanum 554 Architecture 556

THE HOLY ROMAN EMPIRE557Mysticism and Suffering557The Supremacy of Prague559

BOXES

- ART AND ITS CONTEXTS A New Spirit in Fourteenth-Century Literature 533 The Black Death 550
- A BROADER LOOK An Ivory Chest with Scenes of Romance 552
- A CLOSER LOOK The Hours of Jeanne d'Évreux 551

TECHNIQUE Buon Fresco 539 Cennino Cennini on Panel Painting 546

Map 562 • Glossary 563 • Bibliography 572 • Credits 584 • Index 586

Letter from the Author

Dear Colleagues

Energized by an enthusiasm that was fueled by conviction, I taught my first introductory art history survey course in the late 1970s, soon after the dawn of a period of crisis and creativity in the discipline of art history that challenged the fundamental assumptions behind the survey and questioned the canon of works that had long served as its foundation. Some

professors and programs abandoned the survey altogether; others made it more expansive and inclusive. We all rethought what we were doing, and the soul searching this required made many of us better teachers—more honest and relevant, more passionate and convincing. It was for the subsequent generation of students and teachers, ready to reap the benefits of this refined notion of art history, that Marilyn Stokstad conceived and created her new survey textbook during the 1990s, tailored for students whose lives would unfold in the twenty-first century. It is a humbling honor to have become part of this historic project.

Reconsidering and refining what we do as professors and students of art history, however, did not cease at the turn of the century. The process continues. Like art, our teaching and learning changes as we and our culture change, responding to new expectations and new understandings. Opportunities for growth sometimes emerge in unexpected situations. Recently, while I was inching through sluggish suburban traffic with my daughter Emma-a gifted fifth-grade teacher-I confessed my disappointment in my survey students' dismal performance on the identification portion of their recent exam, lamenting their seeming inability to master basic information about the set of works I expected them to know. "Why," I asked rhetorically, "was it so difficult for them to learn these facts?" Emma's unexpected answer, rooted in her exploration of Grant Wiggins and Jay McTigue's Understanding by Design during a graduate course on curriculum development, shifted the question and reframed the discussion. "Dad," she said, "you are focusing on the wrong aspect of your teaching. What are you trying to accomplish by asking your students to learn those facts for identification on the exam? Question and explore your objectives first, then determine whether your assessment is actually the best way to encourage its accomplishment."

Emma's question, posed while I was planning this fifth edition of Art History, inspired me to pause and reflect more broadly on what it is that we seek to accomplish in art history survey courses. I initiated a series of conversations with professors across the country to take me beyond my own experience and into a national classroom. Many of you provided illuminating feedback, sharing goals and strategies, searching with me for a way of characterizing a shared set of learning outcomes that underlie the survey courses we teach as a way of introducing our students in the present to the study of art from the past. Talking with you helped me formulate language for the essential ideas we want our students to grasp, and characterize succinctly the kinds of knowledge and skills that are required to master them. From these conversations and your feedback, I developed a set of four fundamental outcomes envisioned for the book as a whole, outcomes that would be reflected within each chapter in four coordinated learning objectives at the beginning, and four assessment questions at the end. These overall learning outcomes aim to encompass the goals we share as we introduce the history of art to beginners. Thinking about them has already helped me refocus on what it is I am trying to accomplish in my own classroom. It certainly has alleviated the frustration I shared with Emma about my students' performance on slide IDs. I am now working on new ways to assess their engagement in relation to two fundamental goals-the "big ideas" that are embodied in these learning outcomes: building a knowledge base to anchor cultural understanding, and encouraging the extended examination of works of art, what I call "slow looking."

I hope these ideas, goals, and outcomes resonate as much with you as they have with me, that they will invite you to continue to think with me about the reasons why we believe the study of art history is meaningful and important for our students. After all, our discipline originated in dialogue, and it is rooted in the desire maybe even the need—to talk with each other about why works of art matter and why they affect us so deeply. I would love to hear from you—mcothre1@swarthmore.edu.

Warm regards,

pehan Colh

Michael Cothren

WHY USE THIS NEW EDITION?

Art history—what a wonderful, fascinating, and fluid discipline that evolves as the latest research becomes available for debate and consideration. The fifth edition of *Art History* has been revised to reflect these new discoveries, recent research and fresh interpretive perspectives, and also to address the changing needs of the audience—both students and educators. With these goals in mind, and by incorporating feedback from our many users and reviewers, we have sought to make this fifth edition an improvement over its earlier incarnations in sensitivity, readability, and accessibility without losing anything in comprehensiveness, in scholarly precision, or in its ability to engage readers.

To facilitate student learning and understanding of art history, the fifth edition is centered on four key Learning Outcomes. These overarching outcomes helped steer and shape this revision with their emphasis on the fundamental reasons we teach art history to undergraduates:

LEARNING OUTCOMES FOR ART HISTORY

Explore and understand the developing traditions and cultural exchanges represented by major monuments of world art by

- 1. Identifying the hallmarks of regional and period styles in relation to their technical, formal, and expressive character;
- 2. Understanding the principal themes, subjects, and symbols in the art of a variety of cultures, periods, and locations;
- 3. Probing the relationship of works of art to human history by exploring their cultural, economic, political, social, spiritual, moral, and intellectual contexts, and
- 4. Recognizing and applying the critical thinking, creative inquiry, and disciplined reasoning that stand behind art-historical interpretation, as well as the vocabulary and concepts used to describe and characterize works of art with clarity and power.

Each chapter opens with **Learn About It** objectives to help students focus on the upcoming chapter material and ends with corresponding **Think About It** assessment questions. These tools are rooted in the four learning outcomes stated above and help students think through, apply the chapter material, and synthesize their own viewpoints.

OTHER HIGHLIGHTS OF THE NEW EDITION INCLUDE THE FOLLOWING:

- The chapters are coordinated with significantly expanded MyArtsLab resources that enrich and reinforce student learning (see p. xvi).
- Crosscurrent Questions at the end of each chapter encourage students to compare works from different chapters and probe the relationship of recurrent themes across cultures, times, and places.
- Enriched **Recovering the Past** boxes document the discovery, re-evaluation, restoration, or conservation of works of art, such as the bronze She-Wolf that was once considered Etruscan and has recently been interpreted as medieval.
- **Closer Look** features appear in each chapter, guiding students in their exploration of details within a single work of art and helping students to understand issues of usage, iconography, and style. Each Closer Look is expanded and narrated within MyArtsLab to explore technique, style, subject matter, and cultural context.
- **Broader Look** boxes in each chapter offer an in-depth contextual treatment of a single work of art.
- Global coverage has been deepened with the addition of new works of art and revised discussions that incorporate new scholarship, especially in the area of South and Southeast Asia, whose chapters have been expanded.
- Throughout, **images have been updated** whenever new and improved images were available or works of art have been cleaned or restored.
- New works have been added to the discussion in many chapters to enhance and enrich what is said in the text. For example, the Disk of Enheduanna, Sphinx of Taharqo, garden mural from Livia's villa at Primaporta, and monastery of St. Catherine's on Mount Sinai. In addition, the following artists are now discussed through new, and more representative, works: Bihzad, Giovanni Pisano, Duccio, Verrocchio, Giambologna, Bronzino, Gentileschi, Hals, Steen, Rubens, Sharaku, Turner, Friedrich, Monet, Degas, Gauguin, Cézanne, and Warhol.
- New artists have been added, notably, Sultan Muhammad, Joan Mitchell, Diane Arbus, and Ed Ruscha.
- The **language used to characterize works of art**—especially those that attempt to capture the lifelike appearance of the natural world—has been **refined and clarified** to bring greater precision and nuance.
- In response to readers' requests, **discussion of many major monuments** has been revised and expanded.
- **Byzantine art** has been separated from the treatment of Jewish and Early Christian art for expanded treatment in a new chapter (8) of its own.

MyArtsLab lets your students experience and interact with art

This program will provide a better teaching and learning experience for you and your students. Here's how:

The new MyArtsLab delivers proven results in helping individual students succeed. Its automatically graded assessments, personalized study plan, and interactive eText provide engaging experiences that personalize, stimulate, and measure learning for each student.

- ► The Pearson eText lets students access their textbook anytime, anywhere, and any way they want—including downloading to an iPad or listening to chapter audio read by Michael Cothren and Brian Seymour. Includes a unique scale feature showing students the size of a work in relation to the human figure.
- Personalized study plan for each student promotes critical-thinking skills. Assessment tied to videos, applications, and chapters enables both instructors and students to track progress and get immediate feedback.

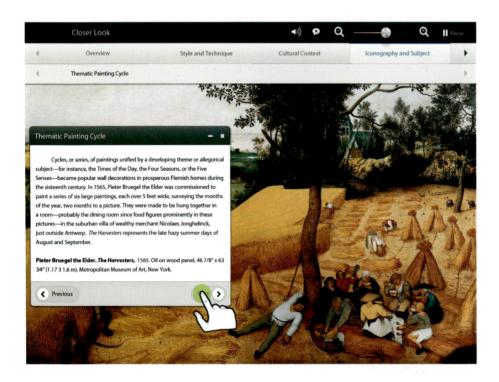

- New: Henry Sayre's *Writing About Art* 6th edition is now available online in its entirety as an eText within MyArtsLab.
- New and expanded: Closer Look tours—interactive walkthroughs featuring expert audio—offer in-depth looks at key works of art. Now optimized for mobile.
- New and expanded: Over 75 in total, 360-degree architectural panoramas and simulations of major monuments help students understand buildings—inside and out. *Now optimized for mobile.*

New: Students on Site videos—over 75 in total, produced and edited by students for students, these 2–3 minute videos provide "you are there" impressions of major monuments, reviewed and approved by art historians. To learn more about how your students can participate, please visit www.pearsonfreeagent.com

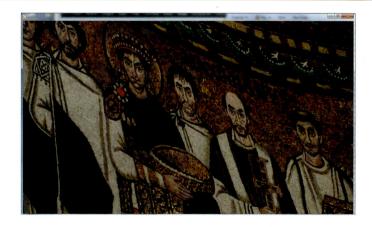

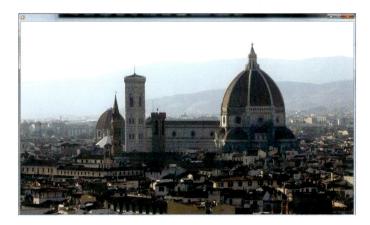

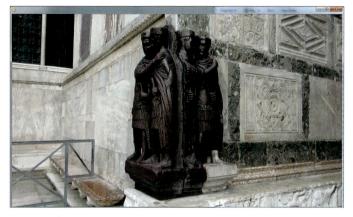

BREAK THROUGH TO A NEW WORLD OF LEARNING

MyArtsLab consistently and positively impacts the quality of learning in the classroom. When educators require and integrate MyArtsLab in their course, students and instructors experience success. Join our ever-growing community of 50,000 users across the country giving their students access to the high quality rich media and assessment on MyArtsLab.

"Students who use MyArtsLab perform better on their exams than students who do not."

-Cynthia Kristan-Graham, Auburn University

"MyArtsLab also makes students more active learners. They are more engaged with the material." —Maya Jiménez, Kingsborough Community College

"MyArtsLab keeps students connected in another way to the course material. A student could be immersed for hours!"

-Cindy B. Damschroder, University of Cincinnati

"I really enjoy using MyArtsLab. At the end of the quarter, I ask students to write a paragraph about their experience with MyArtsLab and 97% of them are positive."

-Rebecca Trittel, Savannah College of Art and Design

Join the conversation! www.facebook.com/stokstadcothren

ORDERING OPTIONS

Pearson arts titles are available in the following formats to give you and your students more choices—and more ways to save.

MyArtsLab with eText: the Pearson eText lets students access their textbook anytime, anywhere, and any way they want, including listening online or downloading to an iPad.

MyArtsLab with eText Combined: 0-205-88736-8 MyArtsLab with eText Volume I: 0-205-94839-1 MyArtsLab with eText Volume II: 0-205-94846-4

Build your own Pearson Custom e-course material. Pearson offers the first eBook-building platform that empowers educators with the freedom to search, choose, and seamlessly integrate multimedia. *Contact your Pearson representative to get started.*

The **Books à la Carte edition** offers a convenient, three-holepunched, loose-leaf version of the traditional text at a discounted price—allowing students to take only what they need to class. Books à la Carte editions are available both with and without access to MyArtsLab.

Books à la Carte edition Volume I: 0-205-93840-X Books à la Carte edition Volume I plus MyArtsLab: 0-205-93847-7 Books à la Carte edition Volume II: 0-205-93844-2 Books à la Carte edition Volume II plus MyArtsLab: 0-205-93846-9

The **CourseSmart eTextbook** offers the same content as the printed text in a convenient online format—with highlighting, online search, and printing capabilities. **www.coursesmart.com**

Art History **Portable edition** has all of the same content as the comprehensive text in six slim volumes. If your survey course is Western, the Portable Edition is available in value-package combinations to suit Western-focused courses (Books 1, 2, 4, and 6). Portable Edition volumes are also available individually for period or region specific courses.

- Book 1 Ancient Art (Chapters 1-6): 978-0-205-87376-0
- Book 2 Medieval Art (Chapters 7–9, 15–18): 978-0-205-87377-7
- Book 3 A View of the World, Part One (Chapters 9–14): 978-0-205-87378-4
- Book 4 Fourteenth to Seventeenth Century Art (Chapters 18–23): 978-0-205-87379-1
- Book 5 A View of the World, Part Two (Chapters 24–29): 978–0–205–87380–7
- Book 6 Eighteenth to Twenty-first Century Art (Chapters 30–33): 978-0-205-87756-0

INSTRUCTOR RESOURCES

All of our instructor resources are found on MyArtsLab and are available to faculty who adopt *Art History*. These resources include:

PowerPoints featuring nearly every image in the book, with captions and without captions.

Teaching with MyArtsLab PowerPoints help instructors make their lectures come alive. These slides allow instructors to display the very best rich media from MyArtsLab in the classroom—quickly and easily.

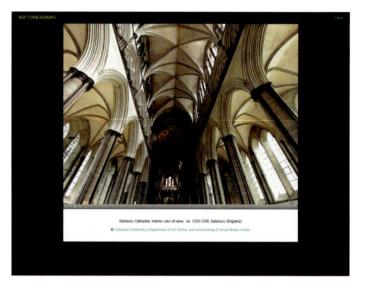

Instructor's Manual and Test Item File

This is an invaluable professional resource and reference for new and experienced faculty.

The Class Preparation Tool collects these and other presentation resources in one convenient online destination.

Art History, which was first published in 1995 by Harry N. Abrams, Inc. and Prentice Hall, Inc., continues to rely, each time it is revised, on the work of many colleagues and friends who contributed to the original texts and subsequent editions. Their work is reflected here, and we extend to them our enduring gratitude.

In preparing this fifth edition, we worked closely with two gifted and dedicated editors at Pearson/Prentice Hall, Sarah Touborg and Helen Ronan, whose almost daily support in so many ways was at the center of our work and created the foundation of what we have done. We are continually bolstered by the warm and dedicated support of Yolanda de Rooy, Pearson's President of the Social Sciences and the Arts, and Craig Campanella, Editorial Director. Also at Pearson, Barbara Cappuccio, Marlene Gassler, Melissa Feimer, Cory Skidds, Brian Mackey, David Nitti, and Carla Worner supported us in our work. At Laurence King Publishing, Clare Double, Kara Hattersley-Smith, Julia Ruxton, and Simon Walsh oversaw the production of this new edition. For layout design we thank Nick Newton and for photo research we thank Evi Peroulaki. Much appreciation also goes to Brandy Dawson, Director of Marketing, and Kate Stewart Mitchell, Marketing Manager extraordinaire, as well as the entire Social Sciences and Arts team at Pearson.

FROM MARILYN STOKSTAD: The fifth edition of *Art History* represents the cumulative efforts of a distinguished group of scholars and educators. Over four editions, the work done in the 1990s by Stephen Addiss, Chutsing Li, Marylin M. Rhie, and Christopher D. Roy for the original book has been updated and expanded by David Binkley and Patricia Darish (Africa); Claudia Brown and Robert Mowry (China and Korea); Patricia Graham (Japan); Rick Asher (South and Southeast Asia); D. Fairchild Ruggles (Islamic); Claudia Brittenham (Americas); Sara Orel and Carol Ivory (Pacific Cultures); and Bradford R. Collins, David Cateforis, Patrick Frank, and Joy Sperling (Modern). For this fifth edition, Robert DeCaroli reworked the chapters on South and Southeast Asia.

In addition, I want to thank University of Kansas colleagues Sally Cornelison, Susan Craig, Susan Earle, Charles Eldredge, Kris Ercums, Sherry Fowler, Stephen Goddard, Saralyn Reece Hardy, Marsha Haufler, Marni Kessler, Amy McNair, John Pulz, Linda Stone Ferrier, and John Younger for their help and advice. My thanks also to my friends Katherine Giele and Katherine Stannard, William Crowe, David Bergeron, and Geraldo de Sousa for their sympathy and encouragement. Of course, my very special thanks go to my sister, Karen Leider, and my niece, Anna Leider.

FROM MICHAEL COTHREN: Words are barely adequate to express my gratitude to Marilyn Stokstad for welcoming me with such trust, enthusiasm, and warmth into the collaborative adventure of revising this historic textbook, conceived and written for students in a new century. Working alongside her—and our extraordinary editors Sarah Touborg and Helen Ronan—has been delightful and rewarding, enriching, and challenging. I look forward to continuing the partnership.

My work was greatly facilitated by the research assistance and creative ideas of Moses Hanson-Harding, and I continued to draw on the work of Fletcher Coleman and Andrew Finegold, who helped with research on the previous edition. I also have been supported by a host of colleagues at Swarthmore College. Generations of students challenged me to hone my pedagogical skills and steady my focus on what is at stake in telling the history of art. My colleagues in the Art Department—especially Stacy Bomento, June Cianfrana, Randall Exon, Laura Holzman, Constance Cain Hungerford, Patricia Reilly, and Tomoko Sakomura—have answered all sorts of questions, shared innumerable insights on works in their areas of expertise, and offered unending encouragement and support. I am so lucky to work with them.

Many art historians have provided assistance, often at a moment's notice, and I am especially grateful to Betina Bergman, Claudia Brown, Elizabeth A.R. Brown, Brigitte Buettner, David Cateforis, Madeline Harrison Caviness, Sarah Costello, Cynthia Kristan-Graham, Joyce de Vries, Cheri Falkenstien-Doyle, Sharon Gerstel, Kevin Glowaki, Ed Gyllenhaal, Julie Hochstrasser, Vida J. Hull, Penny Jolly, Barbara Kellum, Alison Kettering, Benton Kidd, Ann Kuttner, Anne Leader, Steven A. LeBlanc, Cary Liu, Elizabeth Marlowe, Thomas Morton, Kathleen Nolan, David Shapiro, Mary Shepard, Larry Silver, David Simon, Donna Sadler, Jeffrey Chipps Smith, and Mark Tucker.

I was fortunate to have the support of many friends. John Brendler, David Eldridge, Stephen Lehmann, Mary Marissen, Denis Ott, and Bruce and Carolyn Stephens, patiently listened and truly relished my enjoyment of this work.

My preparation for this work runs deep. My parents, Mildred and Wat Cothren, believed in me from the day I was born and made significant sacrifices to support my education from pre-school through graduate school. From an early age, Sara Shymanski, my elementary school librarian, gave me courage through her example and loving encouragement to pursue unexpected passions for history, art, and the search to make them meaningful in both past and present. Françoise Celly, my painting professor during a semester abroad in Provence, by sending me to study the Romanesque sculpture of Autun, began my journey toward art history. At Vanderbilt, Ljubica Popovich fostered this new interest by teaching me about Byzantine art. My extraordinary daughters Emma and Nora remain a constant inspiration. I am so grateful for their delight in my passion for art's history, and for their dedication to keeping me from taking myself too seriously. My deepest gratitude is reserved for Susan Lowry, my wife and soul-mate, who brings joy to every facet of my life. She is not only patient and supportive during the long distractions of my work on this book; she has provided help in so very many ways. The greatest accomplishment of my life in art history occurred on the day I met her at Columbia in 1973.

If the arts are ultimately an expression of human faith and integrity as well as human thought and creativity, then writing and producing books that introduce new viewers to the wonders of art's history, and to the courage and visions of the artists and art historians that stand behind it—remains a noble undertaking. We feel honored to be a part of such a worthy project.

Marilyn Stokstad	Michael W. Cothren
Lawrence, KS	Swarthmore, PA
Spring 2012	

IN GRATITUDE: As its predecessors did, this fifth edition of Art History benefited from the reflections and assessments of a distinguished team of scholars and educators. The authors and Pearson are grateful to the following academic reviewers for their numerous insights and suggestions for improvement: Kirk Ambrose, University of Colorado, Boulder; Lisa Aronson, Skidmore College; Mary Brantl, St. Edward's University; Denise Budd, Bergen Community College; Anne Chapin, Brevard College; Sheila Dillon, Duke University; William Ganis, Wells College; Sharon Gerstel, University of California, Los Angeles; Kevin Glowacki, Texas A&M University; Amy Golahny, Lycoming College; Steve Goldberg, Hamilton College; Bertha Gutman, Delaware County Community College; Deborah Haynes, University of Colorado, Boulder; Eva Hoffman, Tufts University; Mary Jo Watson, University of Oklahoma; Kimberly Jones, University of Texas, Austin; Barbara Kellum, Smith College; Sarah Kielt Costello, University of Houston; Cynthia Kristan-Graham, Auburn University; Paul Lavy, University of Hawaii at Manoa; Henry Luttikhuizen, Calvin College; Elizabeth Mansfield, New York University; Michelle Moseley Christian, Virginia Tech; Eleanor Moseman, Colorado State University; Sheila Muller, University of Utah; Elizabeth Olton, University of Texas at San Antonio; David Parrish, Purdue University; Tomoko Sakomura, Swarthmore College; Erika Schneider, Framingham State University; David Shapiro; Richard Sundt, University of Oregon; Tilottama Tharoor, New York University; Sarah Thompson, Rochester Institute of Technology; Rebecca Turner, Savannah College of Art and Design; Linda Woodward, LSC Montgomery.

This edition has continued to benefit from the assistance and advice of scores of other teachers and scholars who generously answered questions, gave recommendations on organization and priorities, and provided specialized critiques during the course of work on previous editions.

We are grateful for the detailed critiques from the following readers across the country who were of invaluable assistance during work on the third and fourth editions: Craig Adcock, University of Iowa; Charles M. Adelman, University of Northern Iowa; Fred C. Albertson, University of Memphis; Kimberly Allen-Kattus, Northern Kentucky University; Frances Altvater, College of William and Mary; Michael Amy, Rochester Institute of Technology; Susan Jane Baker, University of Houston; Jennifer L. Ball, Brooklyn College, CUNY; Samantha Baskind, Cleveland State University; Tracey Boswell, Johnson County Community College; Jane H. Brown, University of Arkansas at Little Rock; Stephen Caffey, Texas A&M University; Charlotte Lowry Collins, Southeastern Louisiana University; Roger J. Crum, University of Dayton; Brian A. Curran, Penn State University; Cindy B. Damschroder, University of Cincinnati; Michael T. Davis, Mount Holyoke College; Juilee Decker, Georgetown College; Laurinda Dixon, Syracuse University; Rachael Z. DeLue, Princeton University; Anne Derbes, Hood College; Caroline Downing, State University of New York at Potsdam; Laura Dufresne, Winthrop University; Suzanne Eberle, Kendall College of Art & Design of Ferris State University; April Eisman, Iowa State University; Dan Ewing, Barry University; Allen Farber, State University of New York at Oneonta; Arne Flaten, Coastal Carolina University; John Garton, Cleveland Institute of Art; Richard Gay, University of North Carolina, Pembroke: Regina Gee, Montana State University: Rosi Gilday, University of Wisconsin, Oshkosh; Mimi Hellman, Skidmore College; Julie Hochstrasser, University of Iowa; Eunice D. Howe, University of Southern California; Phillip Jacks, George Washington University; Evelyn Kain, Ripon College; Nancy Kelker, Middle Tennessee State University; Patricia Kennedy, Ocean County College; Jennie Klein, Ohio University; Katie Kresser, Seattle Pacific University; Cynthia Kristan-Graham, Auburn University; Barbara Platten Lash, Northern Virginia Community College; William R. Levin, Centre College; Susan Libby, Rollins College; Henry Luttikhuizen, Calvin College; Lynn Mackenzie, College of DuPage; Elisa C. Mandell, California State University, Fullerton; Pamela Margerm, Kean University; Elizabeth Marlowe, Colgate University; Marguerite Mayhall, Kean University: Katherine A. McIver, University of Alabama at Birmingham; Dennis McNamara, Triton College; Gustav Medicus, Kent State University; Lynn Metcalf, St. Cloud State University; Janine Mileaf, Swarthmore College; Jo-Ann Morgan, Coastal Carolina University; Johanna D. Movassat, San Jose State University; Beth A. Mulvaney, Meredith College; Dorothy Munger, Delaware Community College; Jacqueline Marie Musacchio, Wellesley College; Bonnie Noble, University of North Carolina at Charlotte; Leisha O'Quinn, Oklahoma State University; Lynn Ostling, Santa Rosa Junior College; Willow Partington, Hudson Valley Community College; Martin Patrick, Illinois State University; Ariel Plotek, Clemson University; Patricia V. Podzorski, University of Memphis; Albert Reischuck, Kent State University; Margaret Richardson, George Mason University; James Rubin, Stony Brook University; Jeffrey Ruda, University of California, Davis; Donna Sandrock, Santa Ana College; Michael Schwartz, Augusta State University; Diane Scillia, Kent State University; Joshua A. Shannon, University of Maryland; Karen Shelby, Baruch College; Susan Sidlauskas, Rutgers University; Jeffrey Chipps Smith, University of Texas, Austin; Royce W. Smith, Wichita State University; Stephanie Smith, Youngstown State University; Stephen Smithers, Indiana State University; Janet Snyder, West Virginia University; Laurie Sylwester, Columbia College (Sonora); Carolyn Tate, Texas Tech University; Rita Tekippe, University of West Georgia; James Terry, Stephens College; Michael Tinkler, Hobart and William Smith Colleges; Amelia Trevelyan, University of North Carolina at Pembroke; Julie Tysver, Greenville Technical College; Jeryln Woodard, University of Houston; Reid Wood, Lorain County Community College. Our thanks also to additional expert readers including: Susan Cahan, Yale University; David Craven, University of New Mexico; Marian Feldman, University of California, Berkeley; Dorothy Johnson, University of Iowa; Genevra Kornbluth, University of Maryland; Patricia Mainardi, City University of New York; Clemente Marconi, Columbia University; Tod Marder, Rutgers University; Mary Miller, Yale University; Elizabeth Penton, Durham Technical Community College; Catherine B. Scallen, Case Western University; Kim Shelton, University of California, Berkeley.

Many people reviewed the original edition of Art History and have continued to assist with its revision. Every chapter was read by one or more specialists. For work on the original book and assistance with subsequent editions thanks goes to: Barbara Abou-el-Haj, SUNY Binghamton; Roger Aiken, Creighton University; Molly Aitken; Anthony Alofsin, University of Texas, Austin; Christiane Andersson, Bucknell University; Kathryn Arnold: Julie Aronson, Cincinnati Art Museum: Michael Auerbach, Vanderbilt University; Larry Beck; Evelyn Bell, San Jose State University; Janetta Rebold Benton, Pace University; Janet Berlo, University of Rochester; Sarah Blick, Kenyon College; Jonathan Bloom, Boston College; Suzaan Boettger; Judith Bookbinder, Boston College; Marta Braun, Ryerson University; Elizabeth Broun, Smithsonian American Art Museum; Glen R. Brown, Kansas State University; Maria Elena Buszek, Kansas City Art Institute; Robert G. Calkins; Annmarie Weyl Carr; April Clagget, Keene State College; William W. Clark, Queens College, CUNY; John Clarke, University of Texas, Austin; Jaqueline Clipsham; Ralph T. Coe; Robert Cohon, The Nelson-Atkins Museum of Art; Alessandra Comini; James D'Emilio, University of South Florida; Walter Denny, University of Massachusetts, Amherst; Jerrilyn Dodds, City College, CUNY; Lois Drewer, Index of Christian Art; Joseph Dye, Virginia Museum of Art; James Farmer, Virginia Commonwealth University; Grace Flam, Salt Lake City Community College; Mary D. Garrard; Paula Gerson, Florida State University; Walter S. Gibson; Dorothy Glass; Oleg Grabar; Randall Griffey, Amherst College; Cynthia Hahn, Florida State University; Sharon Hill, Virginia Commonwealth University; John Hoopes, University of Kansas; Reinhild Janzen, Washburn University; Wendy Kindred, University of Maine at Fort Kent; Alan T. Kohl, Minneapolis College of Art; Ruth Kolarik, Colorado College; Carol H. Krinsky, New York University; Aileen Laing, Sweet Briar College; Janet LeBlanc, Clemson University; Charles Little, The Metropolitan Museum of Art; Laureen Reu Liu, McHenry County College; Loretta Lorance; Brian Madigan, Wayne State University; Janice Mann, Bucknell University: Judith Mann, St. Louis Art Museum: Richard Mann, San Francisco State University; James Martin; Elizabeth Parker McLachlan; Tamara Mikailova, St. Petersburg, Russia, and Macalester College; Anta Montet-White; Anne E. Morganstern, Ohio State University; Winslow Myers, Bancroft School; Lawrence Nees, University of Delaware; Amy Ogata, Cleveland Institute of Art; Judith Oliver, Colgate University; Edward Olszewski, Case Western Reserve University; Sara Jane Pearman; John G. Pedley, University of Michigan; Michael Plante, Tulane University; Eloise Quiñones-Keber, Baruch College and the Graduate Center, CUNY; Virginia Raguin, College of the Holy Cross; Nancy H. Ramage, Ithaca College; Ann M. Roberts, Lake Forest College; Lisa Robertson, The Cleveland Museum of Art; Barry Rubin; Charles Sack, Parsons, Kansas; Ian Schall, The Nelson-Atkins Museum of Art: Tom Shaw, Kean College: Pamela Sheingorn, Baruch College, CUNY; Raechell Smith, Kansas City Art Institute; Lauren Soth; Anne R. Stanton, University of Missouri, Columbia; Michael Stoughton; Thomas Sullivan, OSB, Benedictine College (Conception Abbey); Pamela Trimpe, University of Iowa; Richard Turnbull, Fashion Institute of Technology; Elizabeth Valdez del Alamo, Montclair State College; Lisa Vergara; Monica Visoná, University of Kentucky; Roger Ward, Norton Museum of Art; Mark Weil, St. Louis; David Wilkins; Marcilene Wittmer, University of Miami.

Use Notes

The various features of this book reinforce each other, helping the reader to become comfortable with terminology and concepts that are specific to art history.

Starter Kit and Introduction The Starter Kit is a highly concise primer of basic concepts and tools. The Introduction explores the way they are used to come to an understanding of the history of art.

Captions There are two kinds of captions in this book: short and long. Short captions identify information specific to the work of art or architecture illustrated:

artist (when known)

title or descriptive name of work

date

original location (if moved to a museum or other site)

material or materials a work is made of

size (height before width) in feet and inches, with meters and centimeters in parentheses

present location

The order of these elements varies, depending on the type of work illustrated. Dimensions are not given for architecture, for most wall paintings, or for most architectural sculpture. Some captions have one or more lines of small print below the identification section of the caption that gives museum or collection information. This is rarely required reading; its inclusion is often a requirement for gaining permission to reproduce the work.

Longer, discursive captions contain information that complements the narrative of the main text.

Definitions of Terms You will encounter the basic terms of art history in three places:

In the Text, where words appearing in boldface type are defined, or glossed, at their first use.

In Boxed Features, on technique and other subjects, where labeled drawings and diagrams visually reinforce the use of terms.

In the Glossary, at the end of the volume (p. 563), which contains all the words in boldface type in the text and boxes.

Maps At the beginning of each chapter you will find a map with all the places mentioned in the chapter.

Boxes Special material that complements, enhances, explains, or extends the narrative text is set off in six types of tinted boxes.

Art and Its Contexts and A Broader Look boxes expand on selected works or issues related to the text. A Closer Look boxes use leader-line captions to focus attention on specific aspects of important works. Elements of Architecture boxes clarify specifically architectural features, often explaining engineering principles or building technology. Technique boxes outline the techniques and processes by which certain types of art are created. Recovering the Past boxes highlight the work of archaeologists who uncover and conservators who assure the preservation and clear presentation of art.

Bibliography The bibliography at the end of this book beginning on page 572 contains books in English, organized by general works and

by chapter, that are basic to the study of art history today, as well as works cited in the text.

Learn About It Placed at the beginning of each chapter, this feature captures in bulleted form the key learning objectives, or outcomes, of the chapter. They point to what will have been accomplished upon its completion.

Think About It These critical thinking questions appear at the end of each chapter and help students assess their mastery of the learning objectives (Learn About It) by asking them to think through and apply what they have learned.

MyArtsLab prompts These notations are found throughout the chapter and are keyed to MyArtsLab resources that enrich and reinforce student learning.

Dates, Abbreviations, and Other Conventions This book uses the designations BCE and CE, abbreviations for "Before the Common Era" and "Common Era," instead of BC ("Before Christ") and AD ("Anno Domini," "the year of our Lord"). The first century BCE is the period from 99 BCE to 1 BCE; the first century CE is from the year 1 CE to 99 CE. Similarly, the second century CE is the period from 199 BCE to 100 BCE; the second century CE extends from 100 CE to 199 CE.

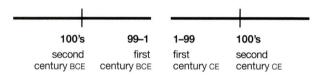

Circa ("about") is used with approximate dates, spelled out in the text and abbreviated to "c." in the captions. This indicates that an exact date is not yet verified.

An illustration is called a "figure," or "fig." Thus, figure 6–7 is the seventh numbered illustration in Chapter 6, and fig. Intro-3 is the third figure in the Introduction. There are two types of figures: photographs of artworks or of models, and line drawings. Drawings are used when a work cannot be photographed or when a diagram or simple drawing is the clearest way to illustrate an object or a place.

When introducing artists, we use the words *active* and *documented* with dates, in addition to "b." (for "born") and "d." (for "died"). "Active" means that an artist worked during the years given. "Documented" means that documents link the person to that date.

Accents are used for words in French, German, Italian, and Spanish only. With few exceptions, names of cultural institutions in Western European countries are given in the form used in that country.

Titles of Works of Art It was only over the last 500 years that paintings and works of sculpture created in Europe and North America were given formal titles, either by the artist or by critics and art historians. Such formal titles are printed in italics. In other traditions and cultures, a single title is not important or even recognized.

In this book we use formal descriptive titles of artworks where titles are not established. If a work is best known by its non-English title, such as Manet's *Le Déjeuner sur l'Herbe (The Luncheon on the Grass)*, the original language precedes the translation.

Starter Kit

Art history focuses on the visual arts—painting, drawing, sculpture, prints, photography, ceramics, metalwork, architecture, and more. This Starter Kit contains basic information and addresses concepts that underlie and support the study of art history. It provides a quick reference guide to the vocabulary used to classify and describe art objects. Understanding these terms is indispensable because you will encounter them again and again in reading, talking, and writing about art.

Let us begin with the basic properties of art. A work of art is a material object having both form and content. It is often described and categorized according to its *style* and *medium*.

FORM

Referring to purely visual aspects of art and architecture, the term *form* encompasses qualities of *line*, *shape*, *color*, *light*, *texture*, *space*, *mass*, *volume*, and *composition*. These qualities are known as *formal elements*. When art historians use the term *formal*, they mean "relating to form."

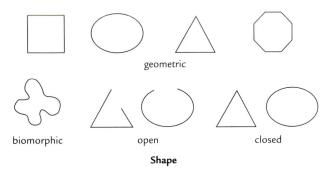

Line and shape are attributes of form. Line is an element—usually drawn or painted—the length of which is so much greater than the width that we perceive it as having only length. Line can be actual, as when the line is visible, or it can be implied, as when the movement of the viewer's eyes over the surface of a work follows a path determined by the artist. Shape, on the other hand, is the two-dimensional, or flat, area defined by the borders of an enclosing *outline* or *contour*. Shape can be *geometric, biomorphic* (suggesting living things; sometimes called *organic*), *closed*, or *open*. The *outline* or *contour* of a three-dimensional object can also be perceived as line.

Color has several attributes. These include *hue*, *value*, and *saturation*.

Hue is what we think of when we hear the word *color*, and the terms are interchangeable. We perceive hues as the result of differing wavelengths of electromagnetic energy. The visible spectrum, which can be seen in a rainbow, runs from red through violet. When the ends of the spectrum are connected through the hue red-violet, the result may be diagrammed as a color wheel. The primary hues (numbered 1) are red, yellow, and blue. They are known as primaries because all other colors are made by combining these hues. Orange, green, and violet result from the mixture of two primaries and are known as secondary hues (numbered 2). Intermediate hues, or tertiaries (numbered 3), result from the mixture of a primary and a secondary. Complementary colors are the two colors directly opposite one

another on the color wheel, such as red and green. Red, orange, and yellow are regarded as warm colors and appear to advance toward us. Blue, green, and violet, which seem to recede, are called cool colors. Black and white are not considered colors but neutrals; in terms of light, black is understood as the absence of color and white as the mixture of all colors.

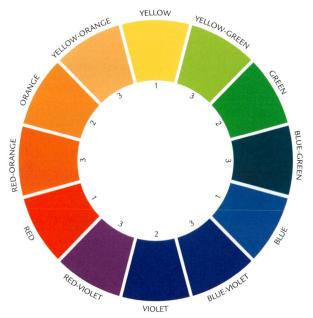

Value is the relative degree of lightness or darkness of a given color and is created by the amount of light reflected from an object's surface. A dark green has a deeper value than a light green, for example. In black-and-white reproductions of colored objects, you see only value, and some artworks—for example, a drawing made with black ink—possess only value, not hue or saturation.

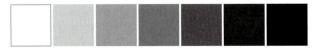

Value scale from white to black.

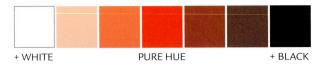

Value variation in red.

Saturation, also sometimes referred to as *intensity*, is a color's quality of brightness or dullness. A color described as highly saturated looks vivid and pure; a hue of low saturation may look a little muddy or grayed.

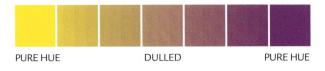

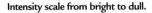

Texture, another attribute of form, is the tactile (or touch-perceived) quality of a surface. It is described by words such as smooth, polished, rough, prickly, grainy, or oily. Texture takes two forms: the texture of the actual surface of the work of art and the implied (illusionistically described) surface of objects represented in the work of art.

Space is what contains forms. It may be actual and threedimensional, as it is with sculpture and architecture, or it may be fictional, represented illusionistically in two dimensions, as when artists represent recession into the distance on a flat surface-such as a wall or a canvas-by using various systems of perspective.

Mass and volume are properties of three-dimensional things. Mass is solid matter-whether sculpture or architecture-that takes up space. Volume is enclosed or defined space, and may be either solid or hollow. Like space, mass and volume may be illusionistically represented on a two-dimensional surface, such as in a painting or a photograph.

Composition is the organization, or arrangement, of forms in a work of art. Shapes and colors may be repeated or varied, balanced symmetrically or asymmetrically; they may be stable or dynamic. The possibilities are nearly endless and artistic choice depends both on the time and place where the work was created as well as the objectives of individual artists. Pictorial depth (spatial recession) is a specialized aspect of composition in which the three-dimensional world is represented on a flat surface, or picture plane. The area "behind" the picture plane is called the picture space and conventionally contains three "zones": foreground, middle ground, and background.

Various techniques for conveying a sense of pictorial depth have been devised by artists in different cultures and at different times. A number of them are diagrammed here. In some European art, the use of various systems of perspective has sought to create highly convincing illusions of recession into space. At other times and in other cultures, indications of recession are actually suppressed or avoided to emphasize surface rather than space.

TECHNIQUE | Pictorial Devices for Depicting Recession in Space

overlapping

In overlapping, partially covered elements are meant to be seen as located behind those covering them.

diminution

In diminution of scale, successively smaller elements are perceived as being progressively farther away than the largest ones.

vertical perspective

Vertical perspective stacks elements, with the higher ones intended to be perceived as deeper in space.

atmospheric perspective

Through atmospheric perspective, objects in the far distance (often in bluish-gray hues) have less clarity than nearer objects. The sky becomes paler as it approaches the horizon.

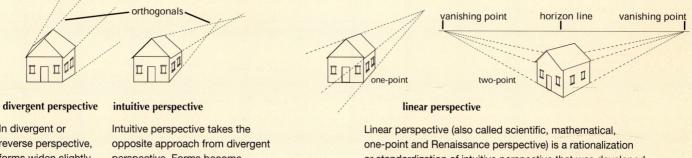

or standardization of intuitive perspective that was developed in fifteenth-century Italy. It uses mathematical formulas to construct images in which all elements are shaped by, or arranged along, orthogonals that converge in one or more vanishing points on a horizon line.

In divergent or reverse perspective, forms widen slightly and imaginary lines called orthogonals diverge as they recede in space.

perspective. Forms become narrower and orthogonals converge the farther they are from the viewer, approximating the optical experience of spatial recession.

STARTER KIT XXIII

CONTENT

Content includes *subject matter*, but not all works of art have subject matter. Many buildings, paintings, sculptures, and other art objects include no recognizable references to things in nature nor to any story or historical situation, focusing instead on lines, colors, masses, volumes, and other formal elements. However, all works of art—even those without recognizable subject matter—have content, or meaning, insofar as they seek to communicate ideas, convey feelings, or affirm the beliefs and values of their makers, their patrons, and usually the people who originally viewed or used them.

Content may derive from the social, political, religious, and economic *contexts* in which a work was created, the *intention* of the artist, and the *reception* of the work by beholders (the audience). Art historians, applying different methods of *interpretation*, often arrive at different conclusions regarding the content of a work of art, and single works of art can contain more than one meaning because they are occasionally directed at more than one audience.

The study of subject matter is called *iconography* (literally, "the writing of images") and includes the identification of *symbols* —images that take on meaning through association, resemblance, or convention.

STYLE

Expressed very broadly, *style* is the combination of form and composition that makes a work distinctive. *Stylistic analysis* is one of art history's most developed practices, because it is how art historians recognize the work of an individual artist or the characteristic manner of groups of artists working in a particular time or place. Some of the most commonly used terms to discuss *artistic styles* include *period style*, *regional style*, *regional style*, *abstract style*, *linear style*, and *painterly style*.

Period style refers to the common traits detectable in works of art and architecture from a particular historical era. It is good practice not to use the words "style" and "period" interchangeably. Style is the sum of many influences and characteristics, including the period of its creation. An example of proper usage is "an American house from the Colonial period built in the Georgian style."

Regional style refers to stylistic traits that persist in a geographic region. An art historian whose specialty is medieval art can recognize Spanish style through many successive medieval periods and can distinguish individual objects created in medieval Spain from other medieval objects that were created in, for example, Italy.

Representational styles are those that describe the appearance of recognizable subject matter in ways that make it seem lifelike.

Realism and **Naturalism** are terms that some people used interchangeably to characterize artists' attempts to represent the observable world in a manner that appears to describe its visual appearance accurately. When capitalized, Realism refers to a specific period style discussed in Chapter 31.

Idealization strives to create images of physical perfection according to the prevailing values or tastes of a culture. The artist may work in a representational style and idealize it to capture an underlying value or expressive effect. **Illusionism** refers to a highly detailed style that seeks to create a convincing illusion of physical reality by describing its visual appearance meticulously.

Abstract styles depart from mimicking lifelike appearance to capture the essence of a form. An abstract artist may work from nature or from a memory image of nature's forms and colors, which are simplified, stylized, perfected, distorted, elaborated, or otherwise transformed to achieve a desired expressive effect.

Nonrepresentational (or Nonobjective) Art is a term often used for works of art that do not aim to produce recognizable natural imagery.

Expressionism refers to styles in which the artist exaggerates aspects of form to draw out the beholder's subjective response or to project the artist's own subjective feelings.

Linear describes both styles and techniques. In linear styles artists use line as the primary means of definition. But linear paintings can also incorporate *modeling*—creating an illusion of three-dimensional substance through shading, usually executed so that brush-strokes nearly disappear.

Painterly describes a style of representation in which vigorous, evident brushstrokes dominate, and outlines, shadows, and highlights are brushed in freely.

MEDIUM AND TECHNIQUE

Medium (plural, *media*) refers to the material or materials from which a work of art is made. Today, literally anything can be used to make a work of art, including not only traditional materials like paint, ink, and stone, but also rubbish, food, and the earth itself.

Technique is the process that transforms media into a work of art. Various techniques are explained throughout this book in Technique boxes. Two-dimensional media and techniques include painting, drawing, prints, and photography. Three-dimensional media and techniques are sculpture (for example, using stone, wood, clay or cast metal), architecture, and many small-scale arts (such as jewelry, containers, or vessels) in media such as ceramics, metal, or wood.

Painting includes wall painting and fresco, illumination (the decoration of books with paintings), panel painting (painting on wood panels), painting on canvas, and handscroll and hanging scroll painting. The paint in these examples is pigment mixed with a liquid vehicle, or binder. Some art historians also consider pictorial media such as mosaic and stained glass—where the pigment is arranged in solid form—as a type of painting.

Graphic arts are those that involve the application of lines and strokes to a two-dimensional surface or support, most often paper. Drawing is a graphic art, as are the various forms of printmaking. Drawings may be sketches (quick visual notes, often made in preparation for larger drawings or paintings); studies (more carefully drawn analyses of details or entire compositions); cartoons (full-scale drawings made in preparation for work in another medium, such as fresco, stained glass, or tapestry); or complete artworks in themselves. Drawings can be made with ink, charcoal, crayon, or pencil. Prints, unlike drawings, are made in multiple copies. The various forms of printmaking include woodcut, the intaglio processes (engraving, etching, drypoint), and lithography.

Photography (literally, "light writing") is a medium that involves the rendering of optical images on light-sensitive surfaces. Photographic images are typically recorded by a camera.

Sculpture is three-dimensional art that is *carved*, *modeled*, *cast*, or *assembled*. Carved sculpture is subtractive in the sense that the image is created by taking away material. Wood, stone, and ivory are common materials used to create carved sculptures. Modeled sculpture is considered additive, meaning that the object is built up from a material, such as clay, that is soft enough to be molded and shaped. Metal sculpture is usually cast or is assembled by welding or a similar means of permanent joining.

Sculpture is either free-standing (that is, surrounded by space) or in pictorial relief. Relief sculpture projects from the background surface of the same piece of material. High-relief sculpture projects far from its background; low-relief sculpture is only slightly raised; and sunken relief, found mainly in ancient Egyptian art, is carved into the surface, with the highest part of the relief being the flat surface.

Ephemeral arts include processions, ceremonies, or ritual dances (often with décor, costumes, or masks); performance art; earthworks; cinema and video art; and some forms of digital or computer art. All impose a temporal limitation—the artwork is viewable for a finite period of time and then disappears forever, is in a constant state of change, or must be replayed to be experienced again.

Architecture creates enclosures for human activity or habitation. It is three-dimensional, highly spatial, functional, and closely bound with developments in technology and materials. Since it is difficult to capture in a photograph, several types of schematic drawings are commonly used to enable the visualization of a building:

Plans depict a structure's masses and voids, presenting a view from above of the building's footprint or as if it had been sliced horizontally at about waist height.

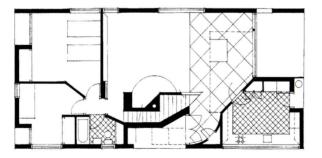

Plan: Philadelphia, Vanna Venturi House

Sections reveal the interior of a building as if it had been cut vertically from top to bottom.

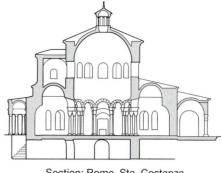

Section: Rome, Sta. Costanza

Isometric drawings show buildings from oblique angles either seen from above ("bird's-eye view") to reveal their basic threedimensional forms (often cut away so we can peek inside) or from below ("worm's-eye view") to represent the arrangement of interior spaces and the upward projection of structural elements.

Isometric cutaway from above: Ravenna, San Vitale

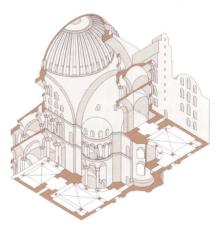

Isometric projection from below: Istanbul, Hagia Sophia

Introduction

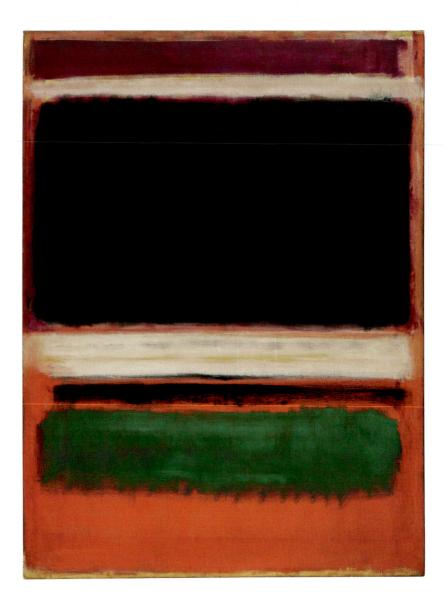

Intro-1 • Mark Rothko MAGENTA, BLACK, GREEN, ON ORANGE (NO. 3/NO. 13) 1949. Oil on canvas, $7'1\%'' \times 5'5''$ (2.165 \times 1.648 m). Museum of Modern Art, New York.

The title of this book seems clear. It defines a field of academic study and scholarly research that has achieved a secure place in college and university curricula across North America. But *Art History* couples two words—even two worlds—that are less well focused when separated. What is art? In what sense does it have a history? Students of art and its history should pause and engage, even if briefly, with these large questions before beginning the journey surveyed in the following chapters.

WHAT IS ART?

Artists, critics, art historians, and the general public all grapple with this thorny question. The *Random House Dictionary* defines "art" as "the quality, production, expression, or realm of what is beautiful, or of more than ordinary significance." Others have characterized "art" as something human-made that combines creative imagination and technical skill, and satisfies an innate desire for order and harmony—perhaps a human hunger for the beautiful. This seems

LEARN ABOUT IT

- 1.1 Explore the methods and objectives of visual analysis.
- **I.2** Assess the way art historians identify conventional subject matter and symbols in the process called iconography.
- **I.3** Survey the methods used by art historians to analyze works of art and interpret their meaning within their original cultural contexts.
- **I.4** Trace the process of art-historical interpretation in a case study.

relatively straightforward until we start to look at modern and contemporary art, where there has been a heated and extended debate concerning "What is Art?" The focus is often far from questions of transcendent beauty, ordered design, or technical skill, and centers instead on the conceptual meaning of a work for an elite target audience or the attempt to pose challenging questions or unsettle deep-seated cultural ideas.

The works of art discussed in this book represent a privileged subset of artifacts produced by past and present cultures. They were usually meant to be preserved, and they are currently considered worthy of conservation and display. The determination of which artifacts are exceptional-which are works of art-evolves through the actions, opinions, and selections of artists, patrons, governments, collectors, archaeologists, museums, art historians, and others. Labeling objects as art is usually meant to signal that they transcended or now transcend in some profound way their practical function, often embodying cherished cultural ideas or asserting foundational values. Sometimes it can also mean they are considered beautiful, well designed, and made with loving care, but this is not always the case. We will discover that at various times and places, the complex notion of what is art has little to do with standards of skill or beauty. Some critics and historians argue broadly that works of art are tendentious embodiments of power and privilege, hardly sublime expressions of beauty or truth. After all, art can be unsettling as well as soothing, challenging as well as reassuring, whether made in the present or surviving from the past.

Increasingly, we are realizing that our judgments about what constitutes art—as well as what constitutes beauty—are conditioned by our own education and experience. Whether acquired at home, in classrooms, in museums, at the movies, or on the Internet, our responses to art are learned behaviors, influenced by class, gender, race, geography, and economic status as well as education. Even art historians find that their definitions of what constitutes art—and what constitutes artistic quality—evolve with additional research and understanding. Exploring works by twentieth-century painter Mark Rothko and nineteenth-century quilt-makers Martha Knowles and Henrietta Thomas demonstrates how definitions of art and artistic value are subject to change over time.

Rothko's painting, MAGENTA, BLACK, GREEN, ON ORANGE (NO. 3/NO. 13) (FIG. Intro-1), is a well-known example of the sort of abstract painting that was considered the epitome of artistic sophistication by the mid-twentieth-century New York art establishment. It was created by an artist who meant it to be a work of art. It was acquired by the Museum of Modern Art in New York, and its position on the walls of that museum is a sure sign of its acceptance as art by a powerful cultural institution. However, beyond the context of the American artists, dealers, critics, and collectors who made up Rothko's art world, such paintings were often received with skepticism. They were seen by many as incomprehensible—lacking both technical skill and recognizable subject matter, two criteria that were part of the general public's definition of art at the time. Abstract paintings soon inspired a popular retort: "That's not art; my child could do it!" Interestingly enough, Rothko saw in the childlike character of his own paintings one of the qualities that made them works of art. Children, he said, "put forms, figures, and views into pictorial arrangements, employing out of necessity most of the rules of optical **perspective** and geometry but without the knowledge that they are employing them." He characterized his own art as childlike, as "an attempt to recapture the freshness and naiveté of childish vision." In part because they are carefully crafted by an established artist who provided these kinds of intellectual justifications for their character and appearance, Rothko's abstract paintings are broadly considered works of art and are treasured possessions of major museums across the globe.

Works of art, however, do not always have to be created by individuals who perceive themselves as artists. Nor are all works produced for an art market surrounded by critics and collectors ready to explain, exhibit, and disperse them, ideally to prestigious museums. Such is the case with this quilt (**FIG. Intro-2**), made by Martha Knowles and Henrietta Thomas a century before Rothko's painting. Their work is similarly composed of blocks of color, and like Rothko, they produced their visual effect by arranging these flat chromatic shapes carefully and regularly on a rectangular field. But this quilt was not meant to hang on the wall of an art museum. It is the social product of a friendship, intended as an intimate gift, presented to a loved one for use in her home. An inscription on the quilt itself makes this clear—"From M.A. Knowles to her

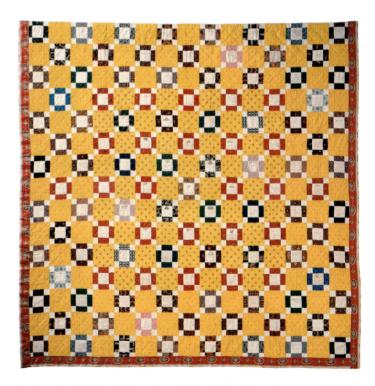

Intro-2 • Martha Knowles and Henrietta Thomas MY SWEET SISTER EMMA

1843. Cotton quilt, $8'11'' \times 9'1''$ (2.72 \times 2.77 m). International Quilt Studies Center, University of Nebraska, Lincoln, Nebraska.

ART AND ITS CONTEXTS | Art and Architecture

This book contains much more than paintings and textiles. Within these pages you will also encounter sculpture, vessels, books, jewelry, tombs, chairs, photographs, architecture, and more. But as with Rothko's *Magenta, Black, Green, on Orange (No. 3/No. 13)* (see Fig. Intro–1) and Knowles and Thomas's *My Sweet Sister Emma* (see Fig. Intro–2), criteria have been used to determine which works are selected for inclusion in a book titled *Art History*. Architecture presents an interesting case.

Buildings meet functional human needs by enclosing human habitation or activity. Many works of architecture, however, are considered "exceptional" because they transcend functional demands by manifesting distinguished architectural design or because they embody in important ways the values and goals of the culture that built them. Such buildings are usually produced by architects influenced, like painters, by great works and traditions from the past. In some cases they harmonize with, or react to, their natural or urban surroundings. For such reasons, they are discussed in books on the history of art.

Typical of such buildings is the church of Nôtre-Dame-du-Haut in Ronchamp, France, designed and constructed between 1950 and 1955

by Swiss architect Charles-Edouard Jeanneret, better known by his pseudonym, Le Corbusier. This building is the product of a significant historical moment, rich in international cultural meaning. A pilgrimage church on this site had been destroyed during World War II, and the creation here of a new church symbolized the end of a devastating war, embodying hopes for a brighter global future. Le Corbusier's design-drawing on sources that ranged from Algerian mosques to imperial Roman villas, from crab shells to airplane wings-is sculptural as well as architectural. It soars at the crest of a hill toward the sky but at the same time seems solidly anchored in the earth. And its coordination with the curves of the natural landscape complement the creation of an outdoor setting for religious ceremonies (to the right in the figure) to supplement the church interior that Le Corbusier characterized as a "container for intense concentration." In fact, this building is so renowned today as a monument of modern architecture, that the bus-loads of pilgrims who arrive at the site are mainly architects and devotees of architectural history.

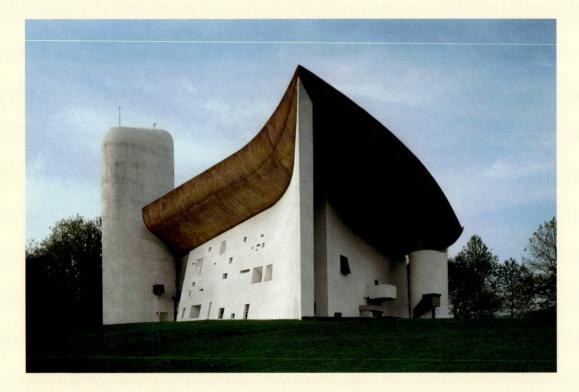

Intro-3 • Le Corbusier NÔTRE-DAME-DU-HAUT Ronchamp, France. 1950– 1955.

Sweet Sister Emma, 1843." Thousands of such friendship quilts were made by women during the middle years of the nineteenth century for use on beds, either to provide warmth or as a covering spread. Whereas quilts were sometimes displayed to a broad and enthusiastic audience of producers and admirers at competitions held at state and county fairs, they were not collected by art museums or revered by artists until relatively recently.

In 1971, at the Whitney Museum in New York—an establishment bastion of the art world in which Rothko moved and worked—art historians Jonathan Holstein and Gail van der Hoof mounted an exhibition entitled "Abstract Design in American Quilts," demonstrating the artistic affinity we have already noted in comparing the way Knowles and Thomas, like Rothko, create abstract patterns with fields of color. Quilts were later accepted or perhaps "**appropriated**"—as works of art and hung on the walls of a New York art museum because of their visual similarities with the avant-garde, abstract works of art created by establishment, New York artists.

Art historian Patricia Mainardi took the case for quilts one significant step further in a pioneering article of 1973 published in The Feminist Art Journal. Entitled, "Quilts: The Great American Art," her argument was rooted not only in the aesthetic affinity of quilts with the esteemed work of contemporary abstract painters, but also in a political conviction that the definition of art had to be broadened. What was at stake here was historical veracity. Mainardi began, "Women have always made art. But for most women, the arts highest valued by male society have been closed to them for just that reason. They have put their creativity instead into the needlework arts, which exist in fantastic variety wherever there are women, and which in fact are a universal female art, transcending race, class, and national borders." She argued for the inclusion of quilts within the history of art to give deserved attention to the work of women artists who had been excluded from discussion because they created textiles and because they worked outside the male-dominated professional structures of the art world-because they were women. Quilts now hang as works of art on the walls of museums and appear with regularity in books that survey the history of art.

As these two examples demonstrate, definitions of art are rooted in cultural systems of value that are subject to change. And as they change, the list of works considered by art historians is periodically revised. Determining what to study is a persistent part of the art historian's task.

WHAT IS ART HISTORY?

There are many ways to study or appreciate works of art. Art history represents one specific approach, with its own goals and its own methods of assessment and interpretation. Simply put, art historians seek to understand the meaning of art from the past within its original cultural contexts, both from the point of view of its producers—artists, architects, and patrons—as well as from the point of view of its consumers—those who formed its original audience. Coming to an understanding of the cultural meaning of a work of art requires detailed and patient investigation on many levels, especially with art that was produced long ago and in societies distinct from our own. This is a scholarly rather than an intuitive exercise. In art history, the work of art is seen as an embodiment of the values, goals, and aspirations of its time and place of origin. It is a part of culture.

Art historians use a variety of theoretical perspectives and a host of interpretive strategies to come to an understanding of works of art within their cultural contexts. But as a place to begin, the work of art historians can be divided into four types of investigation:

- 1. assessment of physical properties,
- 2. analysis of visual or formal structure,
- 3. identification of subject matter or conventional symbolism, and
- 4. integration within cultural context.

ASSESSING PHYSICAL PROPERTIES

Of the methods used by art historians to study works of art, this is the most objective, but it requires close access to the work itself. Physical properties include shape, size, materials, and technique. For instance, many pictures are rectangular (e.g., see FIG. Intro-1), but some are round (see page xxxi, FIG. C). Paintings as large as Rothko's require us to stand back if we want to take in the whole image, whereas some paintings (see page xxx, FIG. A) are so small that we are drawn up close to examine their detail. Rothko's painting and Knowles and Thomas's quilt are both rectangles of similar size, but they are distinguished by the materials from which they are made-oil paint on canvas versus cotton fabric joined by stitching. In art history books, most physical properties can only be understood from descriptions in captions, but when we are in the presence of the work of art itself, size and shape may be the first thing we notice. To fully understand medium and technique, however, it may be necessary to employ methods of scientific analysis or documentary research to elucidate the practices of artists at the time when and place where the work was created.

ANALYZING FORMAL STRUCTURE

Art historians explore the visual character that artists bring to their works—using the materials and the techniques chosen to create them—in a process called **formal analysis**. On the most basic level, it is divided into two parts:

- assessing the individual visual elements or formal vocabulary that constitute pictorial or sculptural communication, and
- discovering the overall arrangement, organization, or structure of an image, a design system that art historians often refer to as **composition**.

THE ELEMENTS OF VISUAL EXPRESSION Artists control and vary the visual character of works of art to give their subjects and ideas meaning and expression, vibrancy and persuasion, challenge or delight (see "A Closer Look," page xxx). For example, the motifs, objects, figures, and environments within paintings can be sharply defined by line (see FIGS. Intro-2, Intro-4), or they can be suggested by a sketchier definition (see FIGS. Intro-1, Intro-5). Painters can simulate the appearance of three-dimensional form through modeling or shading (see FIG. Intro-4 and page xxxi, FIG. C), that is, by describing the way light from a single source will highlight one side of a solid while leaving the other side in shadow. Alternatively, artists can avoid any strong sense of threedimensionality by emphasizing patterns on a surface rather than forms in space (see FIG. Intro-1 and page xxx, FIG. A). In addition to revealing the solid substance of forms through modeling, dramatic lighting can also guide viewers to specific areas of a picture (see page xxx, FIG. B), or it can be lavished on every aspect of a picture to reveal all its detail and highlight the vibrancy of its color (see page xxxi, FIG. D). Color itself can be muted or intensified, depending on the mood artists want to create or the tastes and expectations of their audiences.

A CLOSER LOOK | Visual Elements of Pictorial Expression: Line, Light, Form, and Color

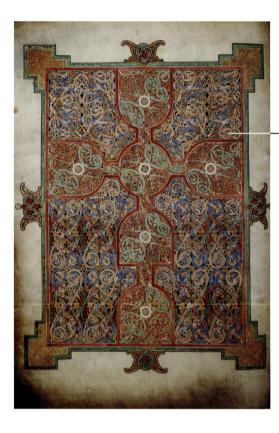

LINE

A. Carpet Page from the Lindisfarne Gospels From Lindisfarne, England. c. 715–720. Ink and tempera on vellum, $13\%'' \times 97/6''$ (34 \times 24 cm). British Library, London. Cotton MS Nero D.IV fol. 26v

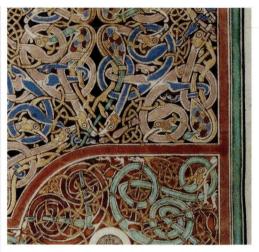

Every element in this complicated painting is sharply outlined by abrupt barriers between light and dark or between one color and another; there are no gradual or shaded transitions. Since the picture was created in part with pen and ink, the linearity is a logical extension of medium and technique. And although line itself is a "flattening" or two-dimensionalizing element in pictures, a complex and consistent system of overlapping gives the linear animal forms a sense of shallow but carefully worked-out three-dimensional relationships to one another.

LIGHT

B. Georges de la Tour The Education of the Virgin c. 1650. Oil on canvas, $33''\times 39^{1/2''}$ (83.8 \times 100.4 cm). The Frick Collection, New York.

The source of illumination is a candle depicted within the painting. The young girl's upraised right hand shields its flame, allowing the artist to demonstrate his virtuosity in painting the translucency of human flesh.

Since the candle's flame is partially concealed, its luminous intensity is not allowed to distract from those aspects of the painting most brilliantly illuminated by it—the face of the girl and the book she is reading.

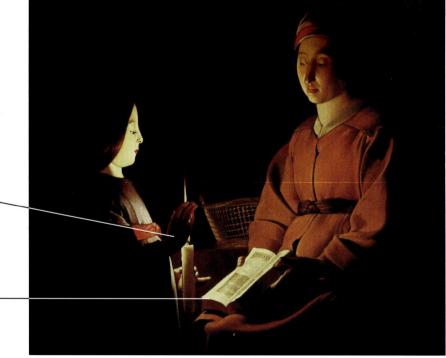

-**View** the Closer Look for visual elements of pictorial expression: line, light, form, and color on myartslab.com

FORM

C. Michelangelo The Holy Family (Doni Tondo) c. 1503. Oil and tempera on panel, diameter 3'11¹/4" (1.2 m). Galleria degli Uffizi, Florence.

The actual three-dimensional projection of the sculpted heads in medallions around the frame designed for this painting by Michelangelo himself—heightens the effect of fictive three-dimensionality in the figures painted on its flat surface. The complex overlapping of their highly three-dimensionalized bodies conveys the somewhat contorted spatial positioning and relationship of these three figures.

> Through the use of modeling or shading—a gradual transition from lights to darks—Michelangelo imitates the way solid forms are illuminated from a single light source—the side closest to the light source is bright while the other side is cast in shadow—and gives a sense of three-dimensional form to his figures.

In a technique called **foreshortening**, the carefully calculated angle of the Virgin's elbow makes it seem to project out toward the viewer.

Junayd chose to flood every aspect of his painting with light, as if everything in it were illuminated from all sides at once. As a result, the emphasis here is on jewel-like color. The vibrant tonalities and dazzling detail of the dreamy landscape are not only more important than the simulation of threedimensional forms distributed within a consistently described space; they actually upstage the human drama taking place against a patterned, tipped-up ground in the lower third of the picture.

COLOR

D. Junayd *Humay and Humayun*, from a manuscript of the *Divan* of Kwaju Kirmani

Made in Baghdad, Iraq. 1396. Color, ink, and gold on paper, $125\%'' \times 97/16'' (32 \times 24 \text{ cm})$. British Library, London. MS Add. 18113, fol. 31r

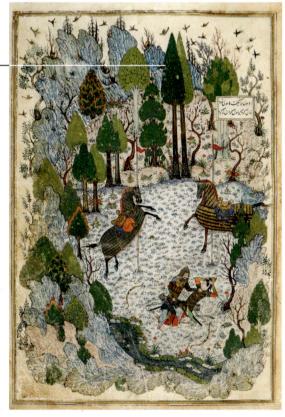

Thus, artists communicate with their viewers by making choices in the way they use and emphasize the elements of visual expression, and art-historical analysis seeks to reveal how artists' decisions bring meaning to a work of art. For example, in two paintings of women with children (see FIGS. Intro-4, Intro-5), Raphael and Renoir work with the same visual elements of line, form, light, and color in the creation of their images, but they employ these shared elements to differing expressive ends. Raphael concentrates on line to clearly differentiate each element of his picture as a separate form. Careful modeling describes these outlined forms as substantial solids surrounded by space. This gives his subjects a sense of clarity, stability, and grandeur. Renoir, on the other hand, foregrounds the flickering of light and the play of color as he downplays the sense of three-dimensionality in individual forms. This gives his image a more ephemeral, casual sense. Art historians pay close attention to such variations in the use of

visual elements—the building blocks of artistic expression—and use visual analysis to characterize the expressive effect of a particular work, a particular artist, or a general period defined by place and date.

COMPOSITION When art historians analyze composition, they focus not on the individual elements of visual expression but on the overall arrangement and organizing design or structure of a work of art. In Raphael's **MADONNA OF THE GOLDFINCH** (**FIG. Intro-4**), for example, the group of figures has been arranged in a triangular shape and placed at the center of the picture. Raphael emphasized this central weighting by opening the clouds to reveal a

Intro-4 • Raphael MADONNA OF THE GOLDFINCH (MADONNA DEL CARDELLINO)

1506. Oil on panel, $42'' \times 29^{1}\!\!/_{2}''$ (106.7 \times 74.9 cm). Galleria degli Uffizi, Florence.

The vibrant colors of this important work were revealed in the course of a careful, ten-year restoration, completed only in 2008. patch of blue in the middle of the sky, and by flanking the figural group with lacelike trees. Since the Madonna is at the center and since the two boys are divided between the two sides of the triangular shape, roughly-though not precisely-equidistant from the center of the painting, this is a bilaterally symmetrical composition: on either side of an implied vertical line at the center of the picture, there are equivalent forms on left and right, matched and balanced in a mirrored correspondence. Art historians refer to such an implied line—around which the elements of a picture are organized—as an axis. Raphael's painting has not only a vertical, but also a horizontal axis, indicated by a line of demarcation between light and dark-as well as between degrees of color saturation-in the terrain of the landscape. The belt of the Madonna's dress is aligned with this horizontal axis, and this correspondence, taken with the coordination of her head with the blue patch in the sky, relates her harmoniously to the natural world in which

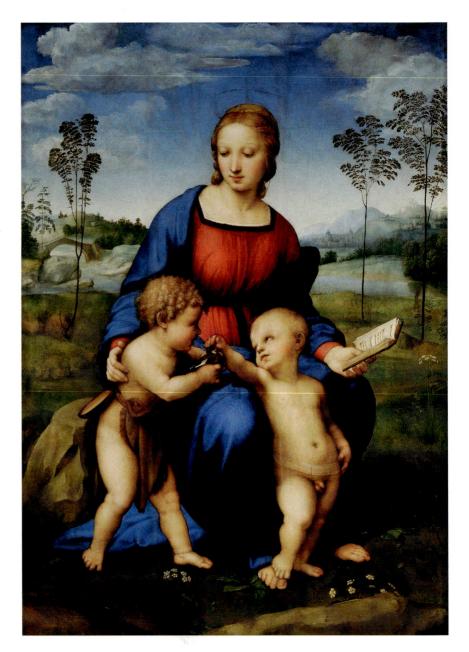

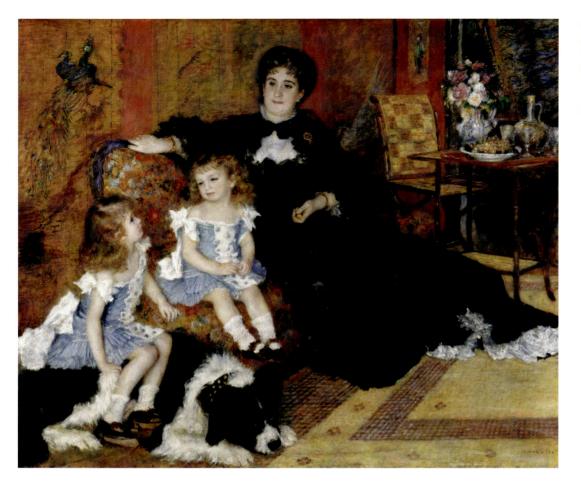

Intro-5 • Auguste Renoir MME. CHARPENTIER AND HER CHILDREN 1878. Oil on canvas, 601/2"

 \times 74⁷/₈" (153.7 \times 190.2 cm). Metropolitan Museum of Art, New York.

she sits, lending a sense of stability, order, and balance to the picture as a whole.

The main axis in Renoir's painting of MME. CHARPEN-TIER AND HER CHILDREN (FIG. Intro-5) is neither vertical, nor horizontal, but diagonal, running from the upper right to the lower left corner of the painting. All major elements of the composition are aligned along this axis-dog, children, mother, and the table and chair that represent the most complex and detailed aspect of the setting. The upper left and lower right corners of the painting balance each other on either side of the diagonal axis as relatively simple fields of neutral tone, setting off and framing the main subjects between them. The resulting arrangement is not bilaterally symmetrical, but blatantly asymmetrical, with the large figural mass pushed into the left side of the picture. And unlike Raphael's composition, where the spatial relationship of the figures and their environment is mapped by the measured placement of elements that become increasingly smaller in scale and fuzzier in definition as they recede into the background, the relationship of Renoir's figures to their spatial environment is less clearly defined as they recede into the background along the dramatic diagonal axis. Nothing distracts us from the bold informality of this family gathering.

Both Raphael and Renoir arrange their figures carefully and purposefully, but they follow distinctive compositional systems that communicate different notions of the way these figures interact with each other and the world around them. Art historians pay special attention to how pictures are arranged because composition is one of the principal ways artists charge their paintings with expressive meaning.

IDENTIFYING SUBJECT MATTER

Art historians have traditionally sought subject matter and meaning in works of art with a system of analysis that was outlined by Erwin Panofsky (1892–1968), an influential German scholar who was expelled from his academic position by the Nazis in 1933 and spent the rest of his career of research and teaching in the United States. Panofsky proposed that when we seek to understand the subject of a work of art, we derive meaning initially in two ways:

- First we perceive what he called "natural subject matter" by recognizing forms and situations that we know from our own experience.
- Then we use what he called "iconography" to identify the conventional meanings associated with forms and figures as bearers of narrative or symbolic content, often specific to a particular time and place.

Some paintings, like Rothko's abstractions and Knowles and Thomas's quilt, do not contain subjects drawn from the world around us, from stories, or from conventional symbolism, but Panofsky's scheme remains a standard method of investigating

A CLOSER LOOK | Iconography

The study and identification of conventional themes, motifs, and symbols to elucidate the subject matter of works of art.

These grapes sit on an imported, Italian silver tazza, a luxury object that may commemorate northern European prosperity and trade. This particular object recurs in several of Peeters's other still lifes.

An image of the artist herself appears on the reflective surface of this pewter tankard, one of the ways that she signed her paintings and promoted her career.

Luscious fruits and flowers celebrate the abundance of nature, but because these fruits of the earth will eventually fade, even rot, they could be moralizing references to the transience of earthly existence.

Detailed renderings of insects showcased Peeters's virtuosity as a painter, but they also may have symbolized the vulnerability of the worldly beauty of flowers and fruit to destruction and decay.

A. Clara Peeters Still Life with Fruit and Flowers c. 1612. Oil on copper, $25^{1}/_{5}$ " \times 35" (64 \times 89 cm). Ashmolean Museum, Oxford. These coins, including one minted in 1608-1609, help focus the dating of this painting. The highlighting of money within a still life could reference the wealth of the owner-or it could subtly allude to the value the artist has crafted here in paint.

This knife-which appears in several of Peeters's still lifes-is of a type that is associated with wedding gifts.

Quince is an unusual subject in Chinese painting, but the fruit seems to have carried personal significance for Zhu Da. One of his friends was known as the Daoist of Quince Mountain, a site in Hunan Province that was also the subject of a work by one of his favorite authors, Tang poet Li Bai.

B. Zhu Da (Bada Shanren) Quince (Mugua) 1690. Album leaf mounted as a hanging scroll; ink and colors on paper, $7\frac{7}{8}'' \times 5\frac{3}{4}''$ (20 \times 14.6 cm). Princeton University Art Museum.

The artist's signature reads "Bada Shanren painted this," using a familiar pseudonym in a formula and calligraphic style that the artist ceased using in 1695.

This red block is a seal with an inscription drawn from a Confucian text: "Teaching is half of learning." This was imprinted on the work by the artist as an aspect of his signature, a symbol of his identity within the picture, just as the reflection and inscribed knife identify Clara Peeters as the painter of her still life.

View the Closer Look for iconography on myartslab.com

meaning in works of art that present narrative subjects, portray specific people or places, or embody cultural values with iconic imagery or allegory.

NATURAL SUBJECT MATTER We recognize some things in works of visual art simply by virtue of living in a world similar to that represented by the artist. For example, in the two paintings by Raphael and Renoir just examined (see FIGS. Intro-4, Intro-5), we immediately recognize the principal human figures in both as a woman and two children, boys in the case of Raphael's painting, girls in Renoir's. We can also make a general identification of the animals: a bird in the hand of Raphael's boys, and a pet dog under one of Renoir's girls. And natural subject matter can extend from an identification of figures to an understanding of the expressive significance of their postures and facial features. We might see in the boy who snuggles between the knees of the woman in Raphael's painting, placing his own foot on top of hers, an anxious child seeking the security of physical contact with a trusted caretaker-perhaps his mother-in response to fear of the bird he reaches out to touch. Many of us have seen insecure children take this very pose in response to potentially unsettling encounters.

The closer the work of art is in both time and place to our own situation temporally and geographically, the easier it sometimes is to identify what is represented. But although Renoir painted his picture over 125 years ago in France, the furniture in the background still looks familiar, as does the book in the hand of Raphael's Madonna, painted five centuries before our time. But the object hanging from the belt of the scantily clad boy at the left in this painting will require identification for most of us. Iconographic investigation is necessary to understand the function of this form.

ICONOGRAPHY Some subjects are associated with conventional meanings established at a specific time or place; some of the human figures portrayed in works of art have specific identities; and some of the objects or forms have symbolic or allegorical meanings in addition to their natural subject matter. Discovering these conventional meanings of art's subject matter is called iconography. (See "A Closer Look," opposite.)

For example, the woman accompanied in the outdoors by two boys in Raphael's *Madonna of the Goldfinch* (see FIG. Intro-4) would have been immediately recognized by members of its intended early sixteenth-century Florentine audience as the Virgin Mary. Viewers would have identified the naked boy standing between her knees as her son Jesus, and the boy holding the bird as Jesus' cousin John the Baptist, sheathed in the animal skin garment that he would wear in the wilderness and equipped with a shallow cup attached to his belt, ready to be used in baptisms. Such attributes of clothing and equipment are often critical in making iconographic identifications. The goldfinch in the Baptist's hand was at this time and place a symbol of Christ's death on the cross, an allegorical implication that makes the Christ Child's retreat into secure contact with his mother—already noted on the level of natural subject matter—understandable in relation to a specific story. The comprehension of conventional meanings in this painting would have been almost automatic among those for whom it was painted, but for us, separated by time and place, some research is necessary to recover associations that are no longer part of our everyday world.

Although it may not initially seem as unfamiliar, the subject matter of Renoir's 1878 portrait of Mme. Charpentier and her Children (see FIG. Intro-5) is in fact even more obscure. There are those in twenty-first-century American culture for whom the figures and symbols in Raphael's painting are still recognizable and meaningful, but Marguérite-Louise Charpentier died in 1904, and no one living today would be able to identify her based on the likeness Renoir presumably gave to her face in this family portrait commissioned by her husband, the wealthy and influential publisher Georges Charpentier. We need the painting's title to make that identification. And Mme. Charpentier is outfitted here in a gown created by English designer Charles Frederick Worth, the dominant figure in late nineteenth-century Parisian high fashion. Her clothing was a clear attribute of her wealth for those who recognized its source; most of us need to investigate to uncover its meaning. But a greater surprise awaits the student who pursues further research on her children. Although they clearly seem to our eyes to represent two daughters, the child closest to Mme. Charpentier is actually her son Paul, who at age 3, following standard Parisian bourgeois practice, has not yet had his first haircut and still wears clothing comparable to that of his older sister Georgette, perched on the family dog. It is not unusual in art history to encounter situations where our initial conclusions on the level of natural subject matter will need to be revised after some iconographic research.

INTEGRATION WITHIN CULTURAL CONTEXT

Natural subject matter and iconography were only two of three steps proposed by Panofsky for coming to an understanding of the meaning of works of art. The third step he labeled "**iconology**," and its aim is to interpret the work of art as an embodiment of its cultural situation, to place it within broad social, political, religious, and intellectual contexts. Such integration into history requires more than identifying subject matter or conventional symbols; it requires a deep understanding of the beliefs and principles or goals and values that underlie a work of art's cultural situation as well as the position of an artist and patron within it.

In "A Closer Look" (opposite), the subject matter of two **still life** paintings (pictures of inanimate objects and fruits or flowers taken out of their natural contexts) is identified and elucidated, but to truly understand these two works as bearers of cultural meaning, more knowledge of the broader context and specific goals of artists and audiences is required. For example, the fact that Zhu Da (1626–1705) became a painter was rooted more in the political than the artistic history of China at the middle of the seventeenth century. As a member of the imperial family of the Ming dynasty,

his life of privilege was disrupted when the Ming were overthrown during the Manchu conquest of China in 1644. Fleeing for his life, he sought refuge in a Buddhist monastery, where he wrote poetry and painted. Almost 40 years later, in the aftermath of a nervous breakdown (that could have been staged to avoid retribution for his family background), Zhu Da abandoned his monastic life and developed a career as a professional painter, adopting a series of descriptive pseudonyms-most notably Bada Shanren ("mountain man of eight greatnesses") by which he is most often known today. His paintings are at times saturated with veiled political commentary; at times they seek to accommodate the expectations of collectors to assure their marketability; and in paintings like the one illustrated here (see page xxxiv, FIG. B), the artist seems to hark back to the contemplative, abstract, and spontaneous paintings associated with great Zen masters such as Muqi (c. 1201-after 1269), whose calligraphic pictures of isolated fruits seem almost like acts of devotion or detached contemplations on natural forms, rather than the works of a professional painter.

Clara Peeters's still life (see page xxxiv, FIG. A), on the other hand, fits into a developing Northern European painting tradition within which she was an established and successful professional, specializing in portrayals of food and flowers, fruit and reflective objects. Still-life paintings in this tradition could be jubilant celebrations of the abundance of the natural world and the wealth of luxury objects available in the prosperous mercantile society of the Netherlands. Or they could be moralizing "vanitas" paintings, warning of the ephemeral meaning of those worldly possessions, even of life itself. But this painting has also been interpreted in a more personal way. Because the type of knife that sits in the foreground near the edge of the table was a popular wedding gift, and since it is inscribed with the artist's own name, some have suggested that this still life could have celebrated Peeters's marriage. Or this could simply be a witty way to sign her picture. It certainly could be personal and at the same time participate in the broader cultural meaning of still-life paintings. Mixtures of private and public meanings have been proposed for Zhu Da's paintings as well. Some have seen the picture of quince illustrated here (see page xxxiv, FIG. B) as part of a series of allegorical "self-portraits" that extend across his career as a painter. Art historians frequently reveal multiple meanings when interpreting single works. Art often represents complex cultural and personal situations.

A CASE STUDY: ROGIER VAN DER WEYDEN'S PHILADELPHIA CRUCIFIXION

The basic, four-part method of art historical investigation and interpretation just outlined and explored may become clearer when its extended use is traced in relation to one specific work of art. A particularly revealing subject for such a case study is a

seminal and somewhat perplexing painting now in the Philadelphia Museum of Art-the CRUCIFIXION WITH THE VIRGIN AND ST. JOHN THE EVANGELIST (FIG. Intro-6) by Rogier van der Weyden (c. 1400-1464), a Flemish artist who will be featured in Chapter 19. Each of the four levels of art-historical inquiry reveals important information about this painting, information that has been used by art historians to reconstruct its relationship to its artist, its audience, and its broader cultural setting. The resulting interpretation is rich, but also complex. An investigation this extensive will not be possible for all the works of art in the following chapters, where the text will focus only on one or two facets of more expansive research. Because of the amount and complexity of information involved in a thorough art-historical interpretation, it is sometimes only in a second reading that we can follow the subtleties of its argument, after the first reading has provided a basic familiarity with the work of art, its conventional subjects, and its general context.

PHYSICAL PROPERTIES

Perhaps the most striking aspect of this painting's physical appearance is its division into two separate tall rectangular panels, joined by a frame to form a coherent, almost square composition. These are oak panels, prepared with chalk to form a smooth surface on which to paint with mineral pigments suspended in oil. A technical investigation of the painting in 1981 used infrared reflectography to reveal a very sketchy under-drawing beneath the surface of the paint, proving to the investigators that this painting is almost entirely the work of Rogier van der Weyden himself. Famous and prosperous artists of this time and place employed many assistants to work in large production workshops, and they would make detailed under-drawings to ensure that assistants replicated the style of the master. But in cases where the masters themselves intended to execute the work, only summary compositional outlines were needed. Modern technical investigation of Rogier's painting also used dendrochronology (the dating of wood based on the patterns of the growth rings) to date the oak panels and consequently the painting itself, now securely situated near the end of the artist's career, c. 1460.

The most recent restoration of the painting—during the early 1990s by Mark Tucker, Senior Conservator at the Philadelphia Museum of Art—returned it, as close as possible, to current views of its original fifteenth-century appearance (see "De-restoring and Restoring Rogier van der Weyden's *Crucifixion*," page xxviii). This project included extensive technical analysis of almost every aspect of the picture, during which a critical clue emerged, one that may lead to a sharper understanding of its original use. X-rays revealed dowel holes and plugs running in a horizontal line about onefourth of the way up from the bottom across the entire expanse of the two-panel painting. Tucker's convincing research suggests that the dowels would have attached these two panels to the backs of wooden boxes that contained sculptures in a complex work of art that hung over the altar in a fifteenth-century church.

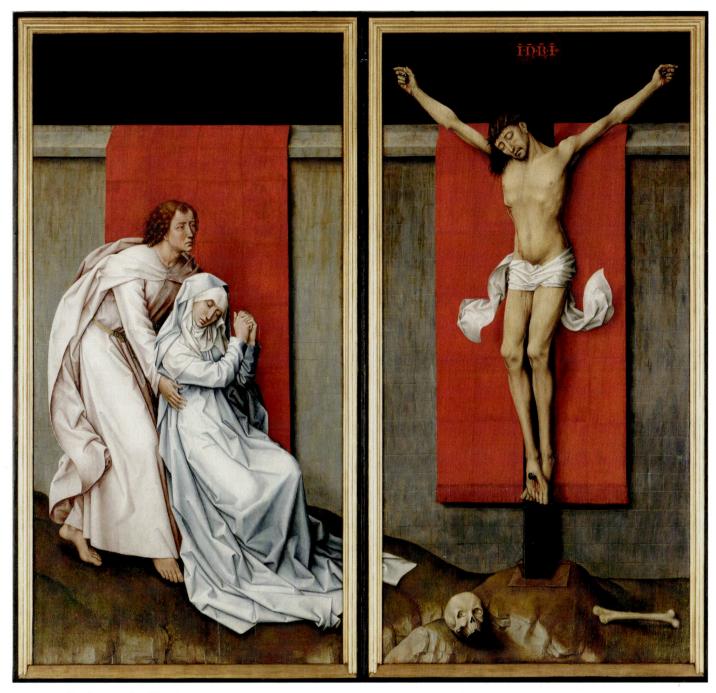

Intro-6 • Rogier van der Weyden CRUCIFIXION WITH THE VIRGIN AND ST. JOHN THE EVANGELIST c. 1460. Oil on oak panels, $71'' \times 73''$ (1.8 \times 1.85 m). John G. Johnson Collection, Philadelphia Museum of Art.

FORMAL STRUCTURE

The visual organization of this two-part painting emphasizes both connection and separation. It is at the same time one painting and two. Continuing across both panels is the strip of midnight blue sky and the stone wall that constricts space within the picture to a shallow corridor, pushing the figures into the foreground and close to the viewer. The shallow strip of mossy ground under the twofigure group in the left panel continues its sloping descent into the right panel, as does the hem of the Virgin's ice-blue garment. We look into this scene as if through a window with a mullion down the middle and assume that the world on the left continues behind this central strip of frame into the right side.

On the other hand, strong visual forces isolate the figures within their respective panels, setting up a system of "compare and contrast" that seems to be at the heart of the painting's design. The striking red cloths that hang over the wall are centered directly behind the figures on each side, forming internal frames that highlight them as separate groups and focus our attention back and forth between them rather than on the pictorial elements that unite their environments. As we begin to compare the two sides,

RECOVERING THE PAST | De-restoring and Restoring Rogier van der Weyden's *Crucifixion*

Ever since Rogier van der Weyden's strikingly asymmetrical, twopanel rendering of the Crucifixion (see FIG. Intro-6) was purchased by Philadelphia lawyer John G. Johnson in 1906 for his spectacular collection of European paintings, it has been recognized not only as one of the greatest works by this master of fifteenth-century Flemish painting, but as one of the most important European paintings in North America. Soon after the Johnson Collection became part of the Philadelphia Museum of Art in 1933, however, this painting's visual character was significantly transformed. In 1941, the museum employed freelance restorer David Rosen to work on the painting. Deciding that Rogier's work was seriously marred by later overpainting and disfigured by the discoloration of old varnish, he subjected the painting to a thorough cleaning. He also removed the strip of dark blue paint forming the sky above the wall at the top-identifying it as an eighteenth-century restoration-and replaced it with gold leaf to conform with remnants of gold in this area that he assessed as surviving fragments of the original background. Rosen's restoration of Rogier's painting was uncritically accepted for almost half a century, and the gold background became a major factor in the interpretations of art historians as distinguished as Erwin Panofsky and Meyer Schapiro.

In 1990, in preparation for a new installation of the work, Rogier's painting received a thorough technical analysis by Mark Tucker, the museum's Senior Conservator. There were two startling discoveries:

- The dark blue strip that had run across the top of the picture before Rosen's intervention was actually original to the painting. Remnants of paint left behind in 1941 proved to be the same azurite blue that also appears in the clothing of the Virgin, and in no instance did the traces of gold discovered in 1941 run under aspects of the original paint surface. Rosen had removed Rogier's original midnight blue sky.
- What Rosen had interpreted as disfiguring varnish streaking the wall and darkening the brilliant cloths of honor hanging over it were actually Rogier's careful painting of lichens and water stains on the stone and his overpainting on the fabric that had originally transformed a vermillion undercoat into deep crimson cloth.

In meticulous work during 1992–1993, Tucker cautiously restored the painting based on the evidence he had uncovered. Neither the lost lichens and water stains nor the toning crimson overpainting of the hangings were replaced, but a coat of blue-black paint was laid over Rosen's gold leaf at the top of the panels, taking care to apply the new layer in such a way that should a later generation decide to return to the gold leaf sky, the midnight tonalities could be easily removed. That seems an unlikely prospect. The painting as exhibited today comes as close as possible to the original appearance of Rogier's *Crucifixion*. At least we think so.

it becomes increasingly clear that the relationship between figures and environment is quite distinct on each side of the divide.

The dead figure of Christ on the cross, elevated to the very top of the picture, is strictly centered within his panel, as well as against the cloth that hangs directly behind him. The grid of masonry blocks and creases in the cloth emphasizes his rectilinear integration into a system of balanced, rigid regularity. His head is aligned with the cap of the wall, his flesh largely contained within the area defined by the cloth. His elbows mark the juncture of the wall with the edge of the hanging, and his feet extend just to the end of the cloth, where his toes substitute for the border of fringe they overlap. The environment is almost as balanced. The strip of dark sky at the top is equivalent in size to the strip of mossy earth at the bottom of the picture, and both are visually bisected by centered horizontals-the cross bar at the top and the alignment of bone and skull at the bottom. A few disruptions to this stable, rectilinear, symmetrical order draw the viewers' attention to the panel at the left: the downward fall of the head of Christ, the visual weight of the skull, the downturn of the fluttering loin cloth, and the tip of the Virgin's gown that transgresses over the barrier to move in from the other side.

John and Mary merge on the left into a single figural mass that could be inscribed into a half-circle. Although set against a rectilinear grid background comparable to that behind Jesus, they contrast with, rather than conform to, the regular sense of order. Their curving outlines offer unsettling unsteadiness, as if they are toppling to the ground, jutting into the other side of the frame. This instability is reinforced by their postures. The projection of Mary's knee in relation to the angle of her torso reveals that she is collapsing into a curve, and the crumpled mass of drapery circling underneath her only underlines her lack of support. John reaches out to catch her, but he has not yet made contact with her body. He strikes a stance of strident instability without even touching the ground, and he looks blankly out into space with an unfocused expression, distracted from, rather than concentrating on, the task at hand. Perhaps he will come to his senses and grab her. But will he be able to catch her in time, and even then support her, given his unstable posture? The moment is tense; the outcome is unclear. But we are moving into the realm of natural subject matter. The poignancy of this concentrated portrayal seems to demand it.

ICONOGRAPHY

The subject of this painting is among the most familiar themes in the history of European art. The dead Jesus has been crucified on the cross, and two of his closest associates—his mother and John, one of his disciples—mourn his loss. Although easily recognizable, the austere and asymmetrical presentation is unexpected. More usual is an earlier painting of this subject by the same artist, **CRUCIFIXION TRIPTYCH WITH DONORS AND SAINTS** (**FIG. Intro-7**), where he situates the crucified Christ at the center

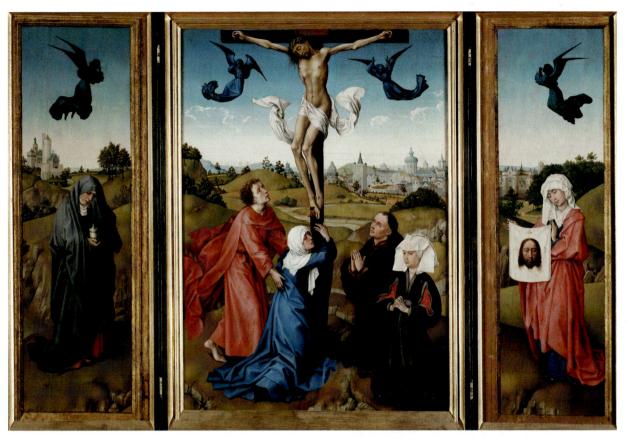

Intro-7 • Rogier van der Weyden CRUCIFIXION TRIPTYCH WITH DONORS AND SAINTS c. 1440. Oil on wooden panels, 39¾" × 55" (101 × 140 cm). Kunsthistorisches Museum, Vienna.

of a symmetrical arrangement, the undisputed axial focus of the composition. The scene unfolds here within an expansive landscape, populated with a wider cast of participants, each of whom takes a place with symmetrical decorum on either side of the cross. Because most crucifixions follow some variation on this pattern, Rogier's two-panel portrayal (see FIG. Intro-6) in which the cross is asymmetrically displaced to one side, with a spare cast of attendants relegated to a separately framed space, severely restricted by a stark stone wall, requires some explanation. As does the mysterious dark world beyond the wall, and the artificial backdrop of the textile hangings.

This scene is not only austere and subdued; it is sharply focused, and the focus relates it to the specific moment in the story that Rogier decided to represent. The Christian Bible contains four accounts of Jesus' crucifixion, one in each of the four Gospels. Rogier took two verses in John's account as his painting's text (John 19:26–27), cited here in the Douai-Reims literal English translation (1582, 1609) of the Latin Vulgate Bible that was used by Western European Christians during the fifteenth century:

When Jesus therefore had seen his mother and the disciple standing whom he loved, he saith to his mother: Woman, behold thy son. After that, he saith to the disciple: Behold thy mother. And from that hour, the disciple took her to his own. Even the textual source uses conventions that need explanation, specifically the way the disciple John is consistently referred to in this Gospel as "the disciple whom Jesus loved." Rogier's painting, therefore, seems to focus on Jesus' call for a newly expanded relationship between his mother and a beloved follower. More specifically, he has projected us slightly forward in time to the moment when John needs to respond to that call—Jesus has died; John is now in charge.

There are, however, other conventional iconographic associations with the crucifixion that Rogier has folded into this spare portrayal. Fifteenth-century viewers would have understood the skull and femur that lie on the mound at the base of the cross as the bones of Adam—the first man in the Hebrew Bible account of creation—on whose grave Jesus' crucifixion was believed to have taken place. This juxtaposition embodied the Christian belief that Christ's sacrifice on the cross redeemed believers from the death that Adam's original sin had brought to human existence.

Mary's swoon and presumed loss of consciousness would have evoked another theological idea, the *co-passio*, in which Mary's anguish while witnessing Jesus' suffering and death was seen as a parallel passion of mother with son, both critical for human salvation. Their connection in this painting is underlined visually by the similar bending of their knees, inclination of their heads, and closing of their eyes. They even seem to resemble each other in facial likeness, especially when compared to John.

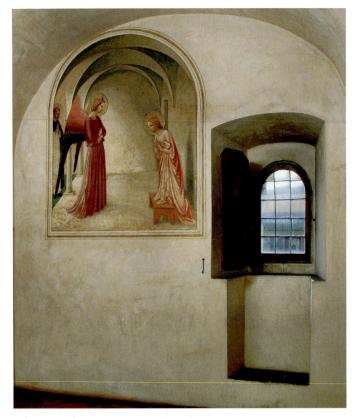

Intro-8 • VIEW OF A MONK'S CELL IN THE MONASTERY OF SAN MARCO, FLORENCE Including Fra Angelico's fresco of the *Annunciation*. c. 1438–1445.

CULTURAL CONTEXT

In 1981 art historian Penny Howell Jolly published an interpretation of Rogier's Philadelphia *Crucifixion* as the product of a broad personal and cultural context. In addition to building on the work of earlier art historians, she pursued two productive lines of investigation to explain the rationale for this unusually austere presentation:

- the prospect that Rogier was influenced by the work of another artist, and
- the possibility that the painting was produced for an institutional context that called for a special mode of visual presentation and a particular iconographic focus.

FRA ANGELICO AT SAN MARCO We know very little about the life of Rogier van der Weyden, but we do know that in 1450, when he was already established as one of the principal painters in northern Europe, he made a pilgrimage to Rome. Either on his way to Rome, or during his return journey home, he stopped off in Florence and saw the **altarpiece**, and presumably also the frescos, that Fra Angelico (c. 1400–1455) and his workshop had painted during the 1440s at the monastery of San Marco. The evidence of Rogier's contact with Fra Angelico's work is found in a work Rogier painted after he returned home, based on a panel of the San Marco altarpiece. For the Philadelphia *Crucifixion*,

however, it was Fra Angelico's devotional frescos on the walls of the monks' individual rooms (or cells) that seem to have had the greatest impact (**FIG. Intro-8**). Jolly compared the Philadelphia *Crucifixion* with a scene of the Mocking of Christ at San Marco to demonstrate the connection (**FIG. Intro-9**). Fra Angelico presented the sacred figures with a quiet austerity that recalls Rogier's unusual composition. More specific parallels are the use of an expansive stone wall to restrict narrative space to a shallow foreground corridor, the description of the world beyond that wall as a dark sky that contrasts with the brilliantly illuminated foreground, and the use of a draped cloth of honor to draw attention to a narrative vignette from the life of Jesus, to separate it out as an object of devotion.

THE CARTHUSIANS Having established a possible connection between Rogier's unusual late painting of the crucifixion and frescos by Fra Angelico that he likely saw during his pilgrimage to Rome in 1450, Jolly reconstructed a specific context of patronage and meaning within Rogier's own world in Flanders that could explain why the paintings of Fra Angelico would have had such an impact on him at this particular moment in his career.

During the years around 1450, Rogier developed a personal and professional relationship with the monastic order of

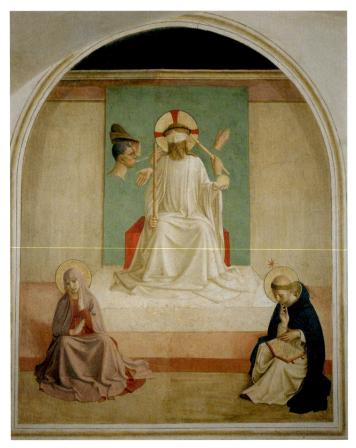

Intro-9 • Fra Angelico MOCKING OF CHRIST WITH THE VIRGIN MARY AND ST. DOMINIC Monastery of San Marco, Florence. c. 1441–1445.

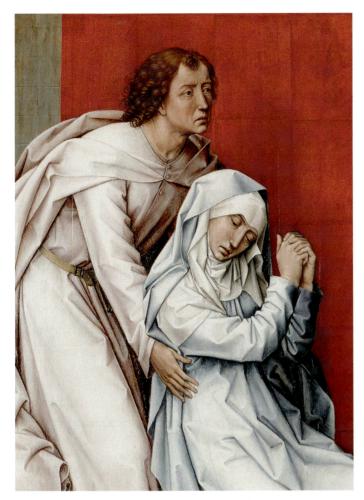

Intro-10 • DETAIL OF FIG. Intro-6 SHOWING PART OF THE LEFT WING

the Carthusians, and especially with the Belgian Charterhouse (or Carthusian monastery) of Hérrines, where his oldest son was invested as a monk in 1450. Rogier gave money to Hérrines, and texts document his donation of a painting to its chapel of St. Catherine. Jolly suggested that the Philadelphia *Crucifixion* could be that painting. Its subdued colors and narrative austerity are consistent with Carthusian aesthetic attitudes, and the walled setting of the scene recalls the enclosed gardens that were attached to the individual dormitory rooms of Carthusian monks. The reference in this painting to the *co-passio* of the Virgin provides supporting evidence since this theological idea was central to Carthusian thought and devotion. The *co-passio* was even reflected in the monks' own initiation rites, during which they re-enacted and sought identification with both Christ's sacrifice on the cross and the Virgin's parallel suffering.

In Jolly's interpretation, the religious framework of a Carthusian setting for the painting emerges as a personal framework for the artist himself, since this *Crucifixion* seems to be associated with important moments in his own life—his religious pilgrimage to Rome in 1450 and the initiation of his oldest son as a Carthusian monk at about the same time. Is it possible that the sense of loss and separation that Rogier evoked in his portrayal of a poignant moment in the life of St. John (**FIG. Intro-10**) could have been especially meaningful to the artist himself at the time this work was painted?

A CONTINUING PROJECT The final word has not been spoken in the interpretation of this painting. Mark Tucker's recent work on the physical evidence revealed by x-ray analysis points toward seeing these two panels as part of a large sculptured altarpiece. Even if this did preclude the prospect that it is the **panel painting** Rogier donated to the chapel of St. Catherine at Hérrines, it does not negate the relationship Jolly drew with Fra Angelico, nor the Carthusian context she outlined for the work's original situation. It simply reminds us that our historical understanding of works such as this will evolve when new evidence about them emerges.

As the history of art unfolds in the ensuing chapters of this book, it will be important to keep two things in mind as you read the characterizations of individual works of art and the larger story of their integration into the broader cultural contexts of those who made them and those for whom they were initially made. Arthistorical interpretations are built on extended research comparable to that we have just summarily surveyed for Rogier van der Weyden's Philadelphia *Crucifixion*. But the work of interpretation is never complete. Art history is a continuing project, a work perpetually in progress.

THINK ABOUT IT

- **I.1** Analyze the composition of one painting illustrated in this Introduction.
- **I.2** Characterize the difference between natural subject matter and iconography, focusing your discussion on a specific work of art.
- I.3 What are the four separate steps proposed here for characterizing the methods used by art historians to interpret works of art? Characterize the cultural analysis in step four by showing

the way it expands our understanding of one of the still lifes in the Closer Look.

- I.4 What aspect of the case study of Rogier van der Weyden's Philadelphia *Crucifixion* was especially interesting to you? Why? How did it broaden your understanding of what you will learn in this course?
- **Study** and review on myartslab.com

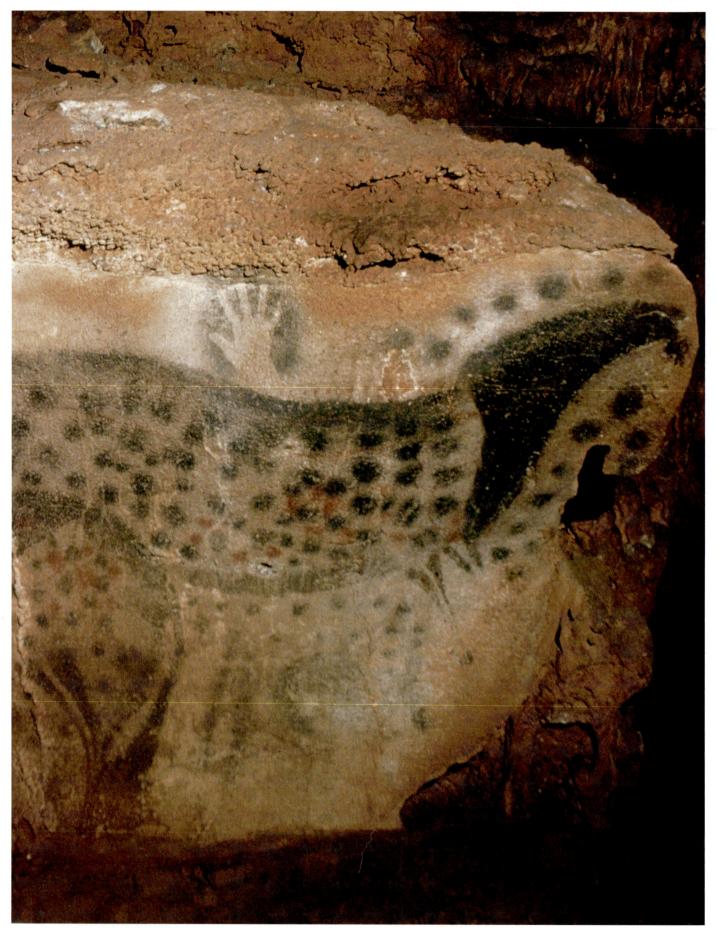

1-1 • SPOTTED HORSES AND HUMAN HANDS Pech-Merle Cave. Dordogne, France. Horses 25,000–24,000 BCE; hands c. 15,000 BCE. Paint on limestone, individual horses over 5' (1.5 m) in length.

Prehistoric Art

The detail shown at left features one of two horses, positioned back to back on the wall of a chamber within the Pech-Merle Cave, located in the Dordogne region of modern France (FIG. 1-1). The tapering head of this horse follows the natural shape of the rock. Black dots surround portions of its contours and fill most of its body, a striking feature that was once believed to be decorative, until DNA analysis of the remains of prehistoric horses, published in 2011, proved that one species flourishing at this time actually was spotted. In this instance, at least, prehistoric painters were painting what they saw. At a later date, a large fish (58 inches long and very difficult to see) was painted in red on top of the spots. Yet the painters left more than images of horses and fish; they left their own handprints in various places around the animals. These images, and many others hidden in chambers at the ends of long, narrow passages within the cave, connect us to an almost unimaginably ancient world of 25.000 BCE.

Prehistory includes all of human existence before the emergence of writing, and long before that people were carving objects, painting images, and creating shelters and other structures. Thirty thousand years ago our ancestors were not making "works of art" and there were no "artists" as we use the term today. They were flaking, chipping, and polishing flints into spear points, knives, and scrapers, not into sculptures, even if we find these artifacts pleasing to the eye and to the touch. And wall paintings must have seemed equally important as these tools to their prehistoric makers, in terms of everyday survival, not visual delight.

For art historians, archaeologists, and anthropologists, prehistoric "art" provides a significant clue—along with fossils, pollen, and other artifacts—to help us understand early human life and culture. Specialists continue to discover more about when and how these works were created. In 2012, for instance, an international team of scientists used a refined dating technology known as the uranium-thorium method (see "How Early Art is Dated," page 12) to prove that some paintings in a Spanish cave known as El Castillo are at least 40,000 years old—probably much older—raising the possibility that they could have been painted by Neanderthals rather than *Homo sapiens*.

We may never know exactly why these prehistoric paintings were made. In fact, there may be no single meaning or use for any one image on a cave wall; cave art probably meant different things to the different people who saw it, depending on their age, their experience, or their specific needs and desires. And the sculpture, paintings, and structures that survive are but a tiny fraction of what must have been created over a very long time span. The conclusions and interpretations we draw from them are only hypotheses, making prehistoric art one of the most speculative, but dynamic and exciting, areas of art history.

LEARN ABOUT IT

- 1.1 Explore the variety of styles, techniques, and traditions represented by what remains of prehistoric art and architecture, and probe its technical, formal, and expressive character.
- **1.2** Survey the principal themes, subjects, and symbols in prehistoric painting, sculpture, and objects.
- 1.3 Investigate how art historians and anthropologists have speculated on the cultural meanings of works for which there is no written record to provide historical context.
- **1.4** Grasp the concepts and vocabulary used to describe and characterize prehistoric art and architecture.

((• Listen to the chapter audio on myartslab.com

THE STONE AGE

How and when modern humans evolved is the subject of ongoing debate, but anthropologists now agree that the species called *Homo sapiens* appeared about 400,000 years ago, and that the subspecies to which we belong, *Homo sapiens sapiens* (usually referred to as modern humans), evolved as early as 120,000 years ago. Based on archaeological evidence, it is now clear that modern humans spread from Africa across Asia, into Europe, and finally to Australia and the Americas. This vast movement of people took place between 100,000 and 35,000 years ago.

Scholars began the systematic study of prehistory only about 200 years ago. Nineteenth-century archaeologists, struck by the wealth of stone tools, weapons, and figures found at ancient sites, named the whole period of early human development the Stone Age. Today, researchers divide the Stone Age into two parts: Paleolithic (from the Greek *paleo*-, "old," and *lithos*, "stone") and Neolithic (from the Greek *neo*-, "new"). They divide the Paleolithic period itself into three phases reflecting the relative position of objects found in the layers of excavation: Lower (the oldest), Middle, and Upper (the most recent). In some places archaeologists

1-2 • RAINBOW SERPENT ROCK

Western Arnhem Land, Australia.

Appearing in Australia as early as 6000 BCE, images of the Rainbow Serpent play a role in rituals and legends of the creation of human beings, the generation of rains, storms, and floods, and the reproductive power of nature and people. can identify a transitional, or Mesolithic (from the Greek *meso-*, "middle") period.

The dates for the transition from Paleolithic to Neolithic vary with geography and with local environmental and social circumstances. For some of the places discussed in this chapter, such as Western Europe, the Neolithic way of living did not emerge until 3000 BCE; in others, such as the Near East, it appeared as early as 8000 BCE. Archaeologists mark time in so many years ago, or BP ("before present"). However, to ensure consistent style throughout the book, which reflects the usage of art historians, this chapter uses BCE (before the Common Era) and CE (the Common Era) to mark time.

Much is yet to be discovered about prehistoric art. In Australia, some of the world's very oldest images have been dated to between 50,000 and 40,000 years ago, and the tradition of transient communities who marked the land in complex, yet stunningly beautiful ways continues into historical time. In western Arnhem Land (**FIG. 1-2**), rock art images of the Rainbow Serpent have their origins in prehistory, and were perhaps first created during times of substantial changes in the environment. Africa, as well, is home to ancient rock art in both its northern and southern regions. In all cases, archaeologists associate the arrival of modern humans in these regions with the advent of image making.

Indeed, it is the cognitive capability to create and recognize symbols and imagery that sets us as modern humans apart from all our predecessors and from all our contemporary animal relatives. We are defined as a species by our abilities to make and understand art. This chapter focuses primarily on the rich traditions of prehistoric European art from the Paleolithic and Neolithic periods and into the Bronze Age (MAP 1-1). Later chapters consider the prehistoric art of other continents and cultures, such as China (Chapter 11) and sub-Saharan Africa (Chapter 14).

THE PALEOLITHIC PERIOD

Human beings made tools long before they made what today we call "art." Art, in the sense of image making, is the hallmark of the Upper Paleolithic period and the emergence of our subspecies, Homo sapiens sapiens. Representational images appear in the archaeological record beginning about 38,000 BCE in Australia, Africa, and Europe. Before that time, during the Lower Paleolithic period in Africa, early humans made tools by flaking and chipping (knapping) flint pebbles into blades and scrapers with sharp edges. Dating to 2.5 million years ago, the earliest objects made by our human ancestors were simple stone tools, some with sharp edges, that were used to cut animal skin and meat and bash open bones to reveal the marrow, and also to cut wood and soft plant materials. These first tools have been found at sites such as Olduvai Gorge in Tanzania. Although not art, they document a critical development in our evolution: humans' ability to transform the world around them into specific tools and objects that could be used to complete a task.

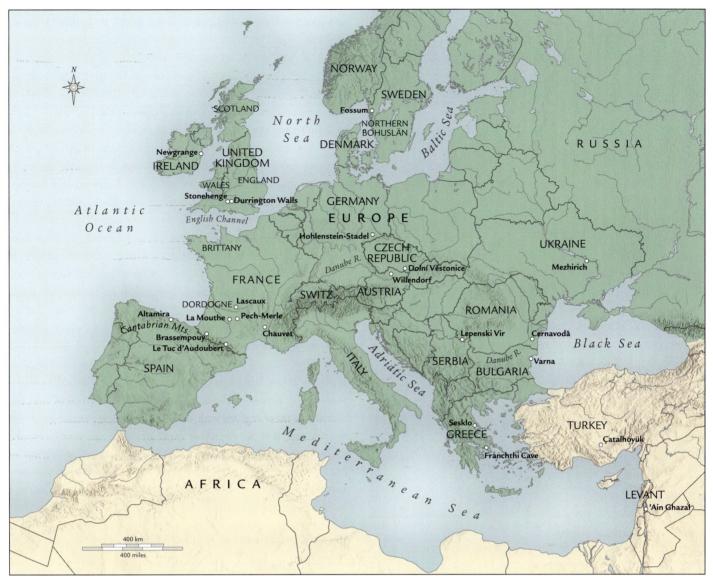

MAP 1-1 • PREHISTORIC EUROPE

As the Ice Age glaciers receded, Paleolithic, Neolithic, Bronze Age, and Iron Age settlements increased from south to north.

By 1.65 million years ago, significant changes in our ancestors' cognitive abilities and manual dexterity can be seen in sophisticated stone tools, such as the teardrop-shaped hand-axes (**FIG. 1-3**) that have been found at sites across Eurasia. These extraordinary objects, symmetrical in form and produced by a complex multistep process, were long thought of as nothing more than tools (or perhaps even as weapons), but the most recent analysis suggests that they had a social function as well. Some sites (as at Olorgesailie in Kenya) contain hundreds of hand-axes, far more than would have been needed in functional terms, suggesting that they served to announce an individual's skills, status, and standing in his or her community. Although these ancient hand-axes are clearly not art in the representational sense, it is important to see them in terms of performance and process. These concepts, so central to modern Western art, have deep prehistoric roots.

Evolutionary changes took place over time and by 400,000 years ago, during the late Middle Paleolithic period, a *Homo sapiens* subspecies called Neanderthal inhabited Europe. Its members used a wider range of stone tools and may have carefully buried their dead with funerary offerings. Neanderthals survived for thousands of years and overlapped with modern humans. *Homo sapiens sapiens*, which had evolved and spread out of Africa some 300,000 years after the Neanderthals, eventually replaced them, probably between 38,000 and 33,000 BCE.

Critical cognitive abilities set modern humans apart from all their predecessors; indeed *Homo sapiens sapiens*, as a species, outlasted Neanderthals precisely because they had the mental capacity to solve problems of human survival. The new cognitive abilities included improvements in recognizing and benefiting from variations in the natural environment, and in managing

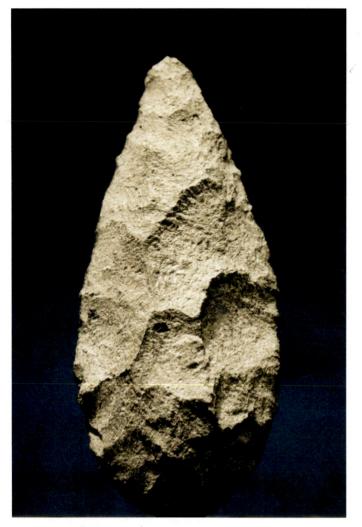

1-3 • PALEOLITHIC HAND-AXE From Isimila Korongo, Tanzania. 60,000 years ago. Stone, height 10" (25.4 cm).

social networking and alliance making—skills that enabled organized hunting. The most important new ability, however, was the capacity to think symbolically: to create representational analogies between one person, animal, or object, and another, and to recognize and remember those analogies. This cognitive development marks the evolutionary origin of what we call art.

The world's earliest examples of art come from South Africa: two 77,000-year-old, engraved blocks of red ocher (probably used as crayons) found in the Blombos Cave (FIG. 1-4). Both blocks are engraved in an identical way with cross-hatched lines on their sides. Archaeologists argue that the similarity of the engraved patterns means these two pieces were intentionally made and decorated following a common pattern. Thousands of fragments of ocher have been discovered at Blombos and there is little doubt that people were using it to draw patterns and images, the remains of which have long since disappeared. Although it is impossible to prove, it is highly likely that the ocher was used to decorate peoples' bodies as well as to color objects such as tools or shell ornaments. Indeed, in an earlier layer on the same site, archaeologists uncovered more than 36 shells, each of which had been perforated so that it could be hung from a string or thong, or attached to clothing or a person's hair; these shells would have been used to decorate the body. An ostrich eggshell bead came from the same site and would have served the same purpose. The Blombos finds are enormously important. Here our early ancestors, probably modern humans but possibly even their predecessors, used the earth's raw materials to decorate themselves with jewelry (made of shells) and body art (using the ocher).

SHELTER OR ARCHITECTURE?

"Architecture" usually refers to the enclosure of spaces with some aesthetic intent. People may object to its use in connection with

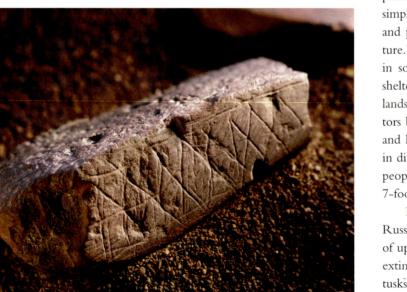

1-4 • DECORATED OCHER From Blombos Cave, southern Cape coast, South Africa. 75,000 years ago.

prehistoric improvisations, but building even a simple shelter requires a degree of imagination and planning deserving of the name "architecture." In the Upper Paleolithic period, humans in some regions used great ingenuity to build shelters that were far from simple. In woodlands, evidence of floors indicates that our ancestors built circular or oval huts of light branches and hides that measured as much as 15–20 feet in diameter. (Modern tents to accommodate six people vary from 10- by 11-foot ovals to 14- by 7-foot rooms.)

In the treeless grasslands of Upper Paleolithic Russia and Ukraine, builders created settlements of up to ten houses using the bones of the now extinct woolly mammoth, whose long, curving tusks made excellent roof supports and arched door openings (**FIG. 1–5**). This bone framework was probably covered with animal hides and turf. Most activities centered around the inside fire

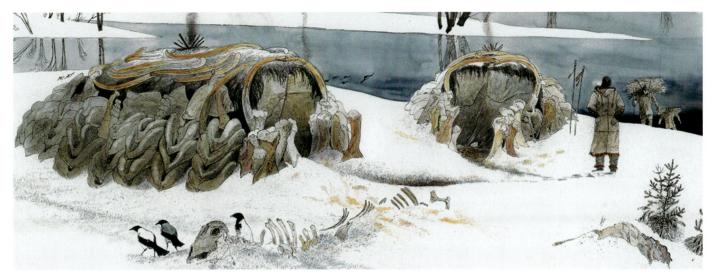

1-5 • RECONSTRUCTION DRAWING OF MAMMOTH-BONE HOUSES Ukraine. c. 16,000–10,000 BCE.

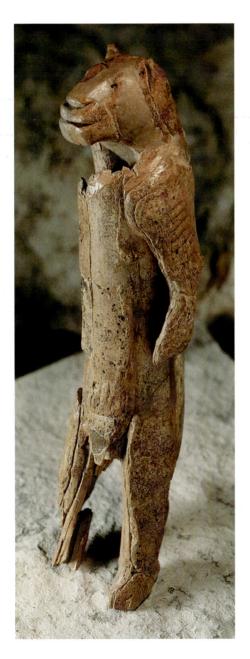

pit, or hearth, where food was prepared and tools were fashioned. Larger houses might have had more than one hearth, and spaces were set aside for specific uses—working stone, making clothing, sleeping, and dumping refuse. Inside the largest dwelling on a site in Mezhirich, Ukraine, archaeologists found 15 small hearths that still contained ashes and charred bones left by the last occupants. Some people also colored their floors with powdered ocher in shades that ranged from yellow to red to brown. These Upper Paleolithic structures are important because of their early date: The widespread appearance of durable architecture concentrated in village communities did not occur until the beginning of the Neolithic period in the Near East and southeastern Europe.

ARTIFACTS OR WORKS OF ART?

As early as 30,000 BCE small figures, or figurines, of people and animals made of bone, ivory, stone, and clay appeared in Europe and Asia. Today we interpret such self-contained, three-dimensional pieces as examples of **sculpture in the round**. Prehistoric carvers also produced relief sculpture in stone, bone, and ivory. In **relief sculpture**, the surrounding material is carved away to form a background that sets off the projecting figure.

THE LION-HUMAN An early and puzzling example of a sculpture in the round is a human figure probably male with a feline head (**FIG. 1-6**), made about 30,000–26,000 BCE. Archaeologists excavating at Hohlenstein-Stadel, Germany, found broken pieces of ivory (from a mammoth tusk) that they realized were parts of an entire figure. Nearly a foot tall, this remarkable statue surpasses most early figurines in size and complexity. Instead of copying

1-6 • LION-HUMAN

From Hohlenstein-Stadel, Germany. c. 30,000–26,000 BCE. Mammoth ivory, height 115%" (29.6 cm). Ulmer Museum, Ulm, Germany.

ART AND ITS CONTEXTS | The Power of Naming

Words are only symbols for ideas, and it is no coincidence that the origins of language and of art are often linked in human evolutionary development. But the very words we invent—or our ancestors invented—reveal a certain view of the world and can shape our thinking. Today, we exert the power of naming when we select a name for a baby or call a friend by a nickname. Our ideas about art can also be affected by names, even the ones used for captions in a book. Before the twentieth century, artists usually did not name, or title, their works. Names were eventually supplied by the works' owners or by art historians writing about them, and thus often express the cultural prejudices of the labelers or of the times in which they lived.

An excellent example of such distortion is the naming of the hundreds of small prehistoric statues of women that have been found. Earlier scholars called them by the Roman name Venus. For example, the sculpture in FIGURE 1–7 was once called the *Venus of Willendorf* after the place where it was found. Using the name of the Roman goddess of love and beauty sent a message that this figure was associated with religious belief, that it represented an ideal of womanhood, and that it was one of a long line of images of "classical" feminine beauty. In a short time, most similar works of sculpture from the Upper Paleolithic period came to be known as Venus figures. The name was repeated so often that even experts began to assume that the statues had to be fertility figures and Mother Goddesses, although there is no proof that this was so.

Our ability to understand and interpret works of art responsibly and creatively is easily compromised by distracting labels. Calling a prehistoric figure a woman instead of Venus encourages us to think about the sculpture in new and different ways.

what he or she saw in nature, the carver created a unique creature, part human and part beast. Was the figure intended to represent a person wearing a ritual lion mask? Or has the man taken on

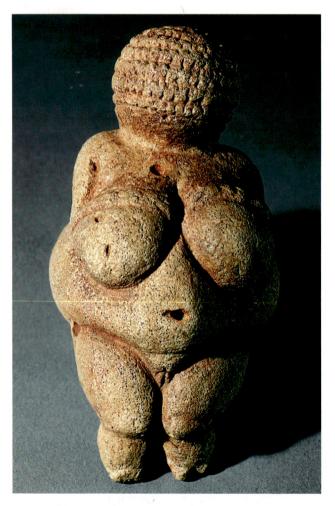

1-7 • WOMAN FROM WILLENDORF Austria. c. 24,000 BCE. Limestone, height 4%" (11 cm). Naturhistorisches Museum, Vienna.

the appearance of an animal? Archaeologists now think that the people who lived at this time held very different ideas (from our twenty-first-century ones) about what it meant to be a human and how humans were distinct from animals; it is quite possible that they thought of animals and humans as parts of one common group of beings who shared the world. What is absolutely clear is that the Lion-Human shows highly complex thinking and creative imagination: the uniquely human ability to conceive and represent a creature never seen in nature.

FEMALE FIGURES While a number of figurines representing men have been found recently, most human figures from the Upper Paleolithic period are female. The most famous of these, the **WOMAN FROM WILLENDORF** (FIG. 1-7), Austria, dates from about 24,000 BCE (see "The Power of Naming," above). Carved from limestone and originally colored with red ocher, the statuette's swelling, rounded forms make it seem much larger than its actual 4³/₈-inch height. The sculptor exaggerated the figure's female attributes by giving it pendulous breasts, a big belly with a deep navel (a natural indentation in the stone), wide hips, dimpled knees and buttocks, and solid thighs. By carving a woman with a well-nourished body, the artist may have been expressing health and fertility, which could ensure the ability to produce strong children, thus guaranteeing the survival of the clan.

The most recent analysis of the Paleolithic female sculptures, however, has replaced the traditional emphasis on fertility with more nuanced understandings of how and why the human figure is represented in this way, and who may have had these kinds of objects made. According to archaeologist Clive Gamble, these little sculptures were subtle forms of nonverbal communication among small isolated groups of Paleolithic people spread out across vast regions. Gamble noted the tremendous (and unusual) similarity in the shapes of figures, even those found in widely distant parts of Europe. He suggested that when groups of Paleolithic

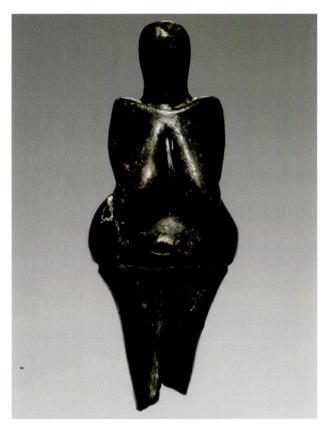

hunter-gatherers did occasionally meet up and interact, the female statues may have been among several signature objects that signaled whether a group was friendly and acceptable for interaction and, probably, for mating. As symbols, these figures would have provided reassurance of shared values about the body, and their size would have demanded engagement at a close personal level. It is not a coincidence, then, that the largest production of these types of Paleolithic figurine occurred during a period when climatic conditions were at their worst and the need for interaction and alliance building would have been at its greatest.

Another figure, found in the Czech Republic, the **WOMAN FROM DOLNÍ VĚSTONICE** (**FIG. 1-8**), takes our understanding of these objects further still. The site of Dolní Věstonice is important because it marks a very early date (23,000 BCE) for the use of fire to make durable objects out of mixtures of water and soil. What makes the figures from this site and those from other sites in the region (Pavlov and Prědmosti) unusual is their method of manufacture. By mixing the soil with water—to a very particular recipe—and then placing the wet figures in a hot kiln to bake, the makers were not intending to create durable, well-fired statues. On the contrary, the recipe used and the firing procedure followed indicate that the intention was to make the figures explode in the kilns before the firing process was complete, and before a "successful" figure could be produced. Indeed, the finds at these sites support this interpretation: There are very few complete figures, but numerous fragments that bear the traces of explosions at high temperatures. The Dolní Věstonice fragments are records of performance and process art in their rawest and earliest forms.

Another remarkable female image, discovered in the Grotte du Pape in Brassempouy, France, is the tiny ivory head known as the WOMAN FROM BRASSEMPOUY (FIG. 1-9). Though the finders did not record its archaeological context, recent studies prove it to be authentic and date it as early as 30,000 BCE. The carver captured the essence of a head, or what psychologists call the memory image-those generalized elements that reside in our standard memory of a human head. An egg shape rests on a long neck. A wide nose and strongly defined browline suggest deep-set eyes, and an engraved square patterning may be hair or a headdress. The image is an abstraction (what has come to be known as abstract art): the reduction of shapes and appearances to basic yet recognizable forms that are not intended to be exact replications of nature. The result in this case looks uncannily modern to contemporary viewers. Today, when such a piece is isolated in a museum case or as a book illustration we enjoy it as an aesthetic object, but we lose its original cultural context.

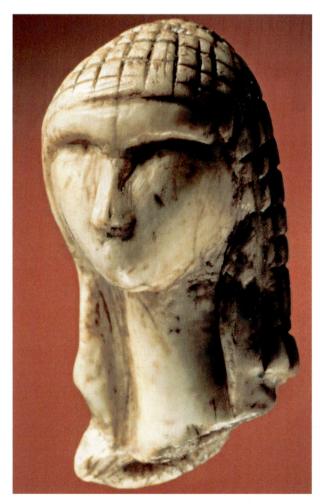

1-9 • WOMAN FROM BRASSEMPOUY Grotte du Pape, Brassempouy, Landes, France. Probably c. 30,000 BCE. Ivory, height 1¼″ (3.6 cm). Musée des Antiquités Nationales, Saint-Germain-en-Laye, France.

TECHNIQUE | Prehistoric Wall Painting

In a dark cave, working by the light of an animal-fat lamp, artists chew a piece of charcoal to dilute it with saliva and water. Then they blow out the mixture on the surface of a wall, using their hands as stencils. This drawing demonstrates how cave archaeologist Michel Lorblanchet and his assistant used the step-by-step process of the original makers of a cave painting at Pech-Merle (see FIG. 1–1) in France to create a complex design of spotted horses.

By turning himself into a human spray can, Lorblanchet produced clear lines on the rough stone surface much more easily than he could with a brush. To create the line of a horse's back, with its clean upper edge and blurry lower one, he blows pigment below his hand. To capture its angular rump, he places his hand vertically against the wall, holding it slightly curved. To produce the sharpest lines, such as those of the upper hind leg and tail, he places his hands side by side and blows between them. To create the forelegs and the hair on the horses' bellies, he fingerpaints. A hole punched in a piece of leather serves as a stencil for the horses' spots. It took Lorblanchet only 32 hours to reproduce the Pech-Merle painting of spotted horses, his speed suggesting that a single artist created the original (perhaps with the help of an assistant to mix pigments and tend the lamp). Homo sapiens sapiens artists used three painting techniques: the spraying demonstrated by Lorblanchet; drawing with fingers or blocks of ocher; and daubing with a paintbrush made of hair or moss. In some places in prehistoric caves three stages of image creation can be seen: engraved lines using flakes of flint, followed by a color wash of ocher and manganese, and a final engraving to emphasize shapes and details.

CAVE PAINTING

Art in Europe entered a rich and sophisticated phase well before 40,000 years ago, when images began to be painted on the walls of caves in central and southern France and northern Spain. No one knew of the existence of prehistoric cave paintings until one day in 1879, when a young girl, exploring with her father in Altamira in northern Spain, crawled through a small opening in the ground and found herself in a chamber whose ceiling was covered with painted animals (see FIG. 1-13). Her father, a lawyer and amateur archaeologist, searched the rest of the cave, told authorities about the remarkable find, and published his discovery the following year. Few people believed that these amazing works could have been made by "primitive" people, and the scientific community declared the paintings a hoax. They were accepted as authentic only in 1902, after many other cave paintings, drawings, and engravings had been discovered at other places in northern Spain and in France.

THE MEANING OF CAVE PAINTINGS What caused people to paint such dramatic imagery on the walls of caves? The idea that human beings have an inherent desire to decorate themselves and their surroundings—that an aesthetic sense is somehow innate to the human species—found ready acceptance in the nineteenth century. Many believed that people create art for the sheer love of beauty. Scientists now agree that human beings have an aesthetic impulse, but the effort required to accomplish the great cave paintings suggests their creators were motivated by more than simple visual pleasure (see "Prehistoric Wall Painting," above). Since the discovery at Altamira, anthropologists and art

historians have devised several hypotheses to explain the existence of cave art. Like the search for the meaning of prehistoric female figurines, these explanations depend on the cultural views of those who advance them.

In the early twentieth century, scholars believed that art has a social function and that aesthetics are culturally relative. They proposed that the cave paintings might be products both of rites to strengthen clan bonds and of ceremonies to enhance the fertility of animals used for food. In 1903, French archaeologist Salomon Reinach suggested that cave paintings were expressions of sympathetic magic: the idea, for instance, that a picture of a reclining bison would ensure that hunters found their prey asleep. Abbé Henri Breuil took these ideas further and concluded that caves were used as places of worship and were the settings for initiation rites. During the second half of the twentieth century, scholars rejected these ideas and rooted their interpretations in rigorous scientific methods and current social theory. André Leroi-Gourhan and Annette Laming-Emperaire, for example, dismissed the sympathetic magic theory because statistical analysis of debris from human settlements revealed that the animals used most frequently for food were not the ones traditionally portrayed in caves.

Researchers continue to discover new cave images and to correct earlier errors of fact or interpretation. A study of the Altamira Cave in the 1980s led anthropologist Leslie G. Freeman to conclude that the artists had faithfully represented a herd of bison during the mating season. Instead of being dead, asleep, or disabled—as earlier observers had thought—the animals were dust-wallowing, common behavior during the mating season. Similar thinking has led to a more recent interpretation of cave art by archaeologist Steve Mithen. In his detailed study of the motifs of the art and its placement within caves, Mithen argued that hoofprints, patterns of animal feces, and hide colorings were recorded and used as a "text" to teach novice hunters within a group about the seasonal appearance and behavior of the animals they hunted. The fact that so much cave art is hidden deep in almost inaccessible parts of caves—indeed, the fact that it is placed within caves at all—suggested to Mithen that this knowledge was intended for a privileged group and that certain individuals or groups were excluded from acquiring that knowledge.

South African rock-art expert David Lewis-Williams has suggested a different interpretation. Using a deep comparative knowledge of art made by hunter-gatherer communities that are still in existence, Lewis-Williams argued that Upper Paleolithic cave art is best understood in terms of shamanism: the belief that certain people (shamans) can travel outside of their bodies in order to mediate between the worlds of the living and the spirits. Traveling under the ground as a spirit, particularly within caves, or conceptually within the stone walls of the cave, Upper Paleolithic shamans would have participated in ceremonies that involved hallucinations. Images conceived during this trancelike state would likely combine recognizable (the animals) and abstract (the nonrepresentational) symbols. In addition, Lewis-Williams interprets the stenciled human handprints found on the cave walls (see FIG. 1-1) as traces of the nonshaman participants in the ritual reaching toward and connecting with the shaman spirits traveling within the rock.

Although the hypotheses that seek to explain cave art have changed and evolved over time, there has always been agreement that decorated caves must have had a special meaning because people returned to them time after time over many generations. in some cases over thousands of years. Perhaps Upper Paleolithic cave art was the product of rituals intended to gain the favor of the supernatural. Perhaps because much of the art was made deep inside the caves and nearly inaccessible, its significance may have had less to do with the finished painting than with the very act of creation. Artifacts and footprints (such as those found at Chauvet, below, and Le Tuc d'Audoubert, see FIG. 1-14) suggest that the subterranean galleries, which were far from living quarters, had a religious or magical function. Perhaps the experience of exploring the cave may have been significant to the image-makers. Musical instruments, such as bone flutes, have been found in the caves, implying that even acoustical properties may have had a role to play.

CHAUVET One of the earliest known sites of prehistoric cave paintings, discovered in December 1994, is the Chauvet Cave (called after one of the persons who found it) near Vallon-Pontd'Arc in southeastern France. It is a tantalizing trove of hundreds of paintings (**FIG. 1-10**). The most dramatic of the images depict grazing, running, or resting animals, including wild horses, bison, mammoths, bears, panthers, owls, deer, aurochs, woolly rhinoceroses, and wild goats (or ibex). Also included are occasional humans, both male and female, many handprints, and hundreds

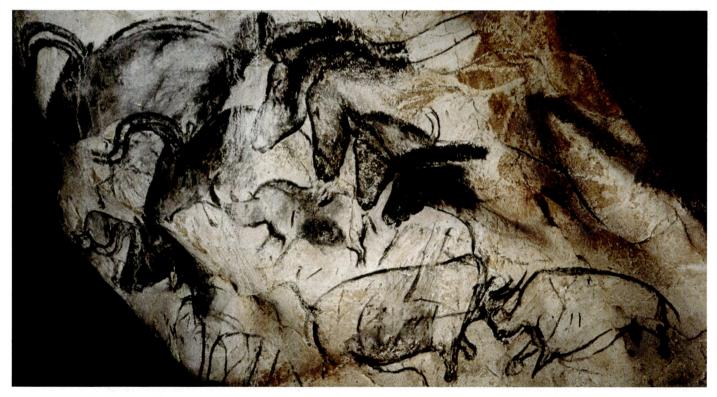

1-10 • WALL PAINTING WITH HORSES, RHINOCEROSES, AND AUROCHS Chauvet Cave. Vallon-Pont-d'Arc, Ardèche Gorge, France. c. 32,000–30,000 BCE. Paint on limestone.

Watch a video about cave painting on myartslab.com

Omega 2648

of geometric markings such as grids, circles, and dots. Footprints in the Chauvet Cave, left in soft clay by a child, go to a "room" containing bear skulls. The charcoal used to draw the rhinos has been radiocarbon-dated to 32,410 years old (+/- 720 years).

LASCAUX The best-known cave paintings are those found in 1940 at Lascaux, in the Dordogne region of southern France (see FIGS. 1-11, 1-12). They have been dated to about 15,000 BCE. Opened to the public after World War II, the prehistoric "museum" at Lascaux soon became one of the most popular tourist sites in France. Too popular, because the visitors brought heat, humidity, exhaled carbon dioxide, and other contaminants. The cave was closed to the public in 1963 so that conservators could battle an aggressive fungus. Eventually they won, but instead of reopening the site, the authorities created a facsimile of it. Visitors at what is called Lascaux II may now view copies of the paintings without harming the precious originals.

The scenes they view are truly remarkable. Lascaux has about 600 paintings and 1,500 engravings. In the HALL OF BULLS (Fig. 1-11), the Lascaux painters depicted cows, bulls, horses, and deer along the natural ledges of the rock, where the smooth white limestone of the ceiling and upper wall meets a rougher surface below. They also utilized the curving wall to suggest space. The animals appear singly, in rows, face to face, tail to tail, and even painted on top of one another. Their most characteristic features

have been emphasized. Horns, eyes, and hooves are shown as seen from the front, yet heads and bodies are rendered in profile in a system known as a **composite pose**. The animals are full of life and energy, and the accuracy in the drawing of their silhouettes, or outlines, is remarkable.

Painters worked not only in large caverns, but also far back in the smallest chambers and recesses, many of which are almost inaccessible today. Small stone lamps found in such caves—over 100 lamps have been found at Lascaux—indicate that the artists worked in flickering light obtained from burning animal fat. Although 1 pound of fat would burn for 24 hours and produce no soot, the light would not have been as strong as that created by a candle.

One scene at Lascaux was discovered in a remote setting on a wall at the bottom of a 16-foot shaft that contained a stone lamp and spears. The scene is unusual because it is the only painting in the cave complex that seems to tell a story (**FIG. 1-12**), and it is stylistically different from the other paintings at Lascaux. A figure who could be a hunter, greatly simplified in form but recognizably male and with the head of a bird or wearing a bird's-head mask, appears to be lying on the ground. A great bison looms above him. Below him lie a staff, or baton, and a spear-thrower (*atlatl*)—a device that allowed hunters to throw farther and with greater force—the outer end of which has been carved in the shape of a bird. The long, diagonal line slanting across the bison's hindquarters may be

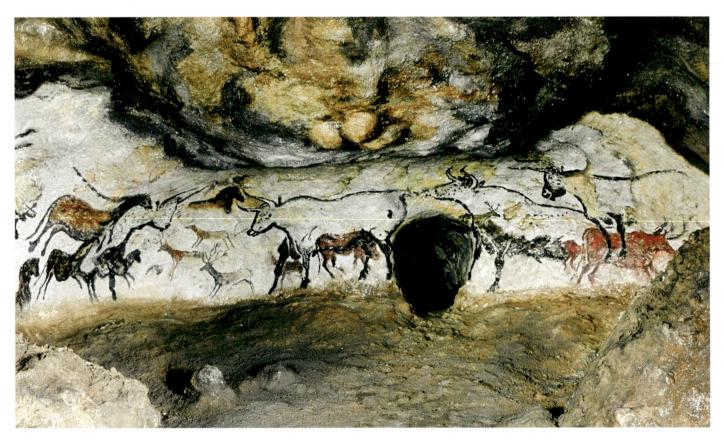

1-11 • HALL OF BULLS Lascaux Cave. Dordogne, France. c. 15,000 BCE. Paint on limestone, length of largest auroch (bull) 18' (5.50 m).

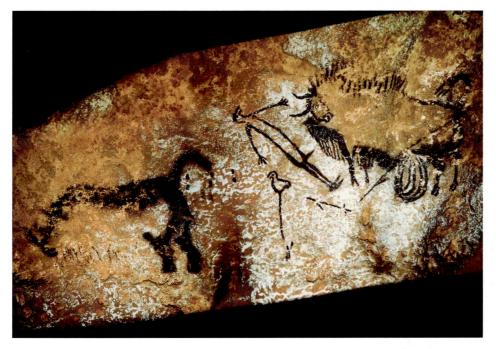

1-12 • BIRD-HEADED MAN WITH BISON Shaft scene in Lascaux Cave. c. 15,000 BCE. Paint on limestone, length approx. 9' (2.75 m).

CAVE SCULPTURES

Caves were sometimes adorned with relief sculpture as well as paintings. At Altamira, an artist simply heightened the resemblance of a natural projecting rock to a similar and familiar animal form. Other reliefs were created by modeling, or shaping, the damp clay of the cave's floor. An excellent example of such work in clay (dating to 13,000 BCE) is preserved at Le Tuc d'Audoubert, south of the Dordogne region of France. Here the sculptor created two bison leaning against a ridge of rock (FIG. 1-14). Although the beasts are modeled in very high relief (they extend well forward from the background), they display the same conventions as in earlier painted ones, with emphasis on the broad masses of the meat-bearing flanks and

a spear. The bison has been disemboweled and will soon die. To the left of the cleft in the wall a woolly rhinoceros seems to run off. Why did the artist portray the man as only a sticklike figure when the bison was rendered with such accurate detail? Does the painting illustrate a story or a myth regarding the death of a hero? Is it a record of an actual event? Or does it depict the vision of a shaman?

ALTAMIRA The cave paintings at Altamira, near Santander in the Cantabrian Mountains in Spain-the first to be discovered and attributed to the Upper Paleolithic periodhave been recently dated to about 12,500 BCE (see "How Early Art is Dated," page 12). The Altamira artists created sculptural effects by painting over and around natural irregularities in the cave walls and ceilings. To produce the herd of bison on the ceiling of the main cavern (FIG. 1-13), they used rich red and brown ocher to paint the large areas of the animals' shoulders, backs, and flanks, then sharpened the contours of the rocks and added the details of the legs, tails, heads, and horns in black and brown. They mixed yellow and brown from iron-based ocher to make the red tones, and they derived black from manganese or charcoal.

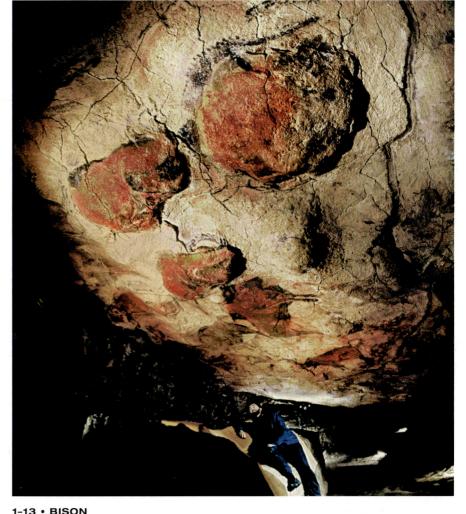

Ceiling of a cave at Altamira, Spain. c. 12,500 BCE. Paint on limestone, length approx. 8'3" (2.5 m).

RECOVERING THE PAST | How Early Art is Dated

Since the first discoveries at Altamira, archaeologists have developed increasingly sophisticated ways of dating cave paintings and other excavated objects. Today, they primarily use two approaches to determine an artifact's age. **Relative dating** relies on the chronological relationships among objects in a single excavation or among several sites. If archaeologists have determined, for example, that pottery types A, B, and C follow each other chronologically at one site, they can apply that knowledge to another site. Even if type B is the only pottery present, it can still be assigned a relative date. **Absolute dating**, on the other hand, aims to determine a precise span of calendar years in which an artifact was created.

The most accurate method of absolute dating is **radiometric dating**, which measures the degree to which radioactive materials have disintegrated over time. Used for dating organic (plant or animal) materials—including some pigments used in cave paintings—one radiometric method measures a carbon isotope called radiocarbon, or carbon-14, which is constantly replenished in a living organism. When an organism dies, it stops absorbing carbon-14 and starts to lose its store of the isotope at a predictable rate. Under the right circumstances, the amount of carbon-14 remaining in organic material can tell us how long ago an organism died.

This method has serious drawbacks for dating works of art. Using carbon-14 dating on a carved antler or wood sculpture shows only when

the animal died or when the tree was cut down, not when the artist created the work using those materials. Also, some part of the object must be destroyed in order to conduct this kind of test—something that is never desirable in relation to works of art. For this reason, researchers frequently test organic materials found in the same context as the work of art rather than sacrificing part of the work itself. Radiocarbon dating is most accurate for materials no more than 30,000 to 40,000 years old.

Potassium-argon dating, which measures the decay of a radioactive potassium isotope into a stable isotope of argon, an inert gas, is most reliable with materials over a million years old. Uranium-thorium dating measures the decay of uranium into thorium in the deposits of calcium carbonate that cover the surfaces of cave walls, to determine the minimum age of paintings under the crust. Thermo-luminescence dating measures the irradiation of the crystal structure of a material subjected to fire, such as pottery, and the soil in which it is found, determined by the luminescence produced when a sample is heated. Electron spin resonance techniques involve using a magnetic field and microwave irradiation to date a material such as tooth enamel and the soil around it.

Recent experiments have helped to date cave paintings with increasing precision. Radiocarbon analysis has determined, for example, that the animal images at Lascaux are 17,000 years old—to be more precise, 17,070 years, plus or minus 130 years.

shoulders. To make the animals even more lifelike, their creator engraved short parallel lines below their necks to represent their shaggy coats. Numerous small footprints found in the clay floor of this cave suggest that important group rites took place here.

THE NEOLITHIC PERIOD

Today, advances in technology, medicine, transportation, and electronic communication change human experience in a generation. Many thousands of years ago, change took place much more

> slowly. In the tenth millennium BCE the world had already entered the present interglacial period, and our modern climate was taking shape. The world was warming up, and this affected the distribution, density, and stability of plant and animal life as well as marine and aquatic resources. However, the Ice Age ended so gradually and unevenly among regions that people could not have known what was happening.

One of the fundamental changes that took place in our prehistoric past was in the relationship people had with their environment. After millennia of established interactions between people and wild plants and animals ranging from opportunistic foraging to well-scheduled gathering and collecting—people gradually started to exert increasing control over the land and its resources. Seen from the modern

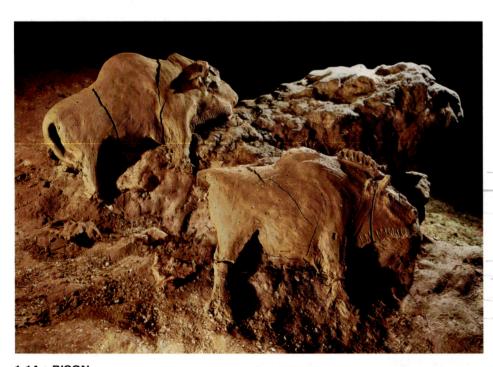

1-14 • BISON Le Tuc d'Audoubert, France. c. 13,000 BCE. Unbaked clay, length 25" (63.5 cm) and 24" (60.9 cm).

perspective, this change in economy (archaeologists use "economy" to refer to the ways people gathered or produced food) seems abrupt and complete. Different communities adopted and adapted new sets of technologies, skills, and plant and animal species that allowed them to produce food. This was the origin of plant and animal domestication. Wheat and barley were cultivated; sheep, goats, cattle, and pigs were bred. This new economy appeared at different rates and to varying degrees of completeness in different parts of the Near East and Europe, and no community relied exclusively on the cultivation of plants or on breeding animals. Instead they balanced hunting, gathering, farming, and animal breeding in order to maintain a steady food supply.

ARCHITECTURE

At the same time as these new food technologies and species appeared, people began to establish stronger, more lasting connections to particular places in the landscape. The beginnings of architecture in Europe are marked by the building of human social environments made up of simple but durable structures constructed of clay, mud, dung, and straw interwoven among wooden posts. While some of these buildings were simple huts, used for no more than a season at a time, others were much more substantial, with foundations made of stone, set into trenches, and supporting walls of large timbers. Some were constructed from simple bricks made of clay, mud, and straw, shaped in rectangular molds and then dried in the sun. Regardless of the technique used, the result was the same: people developed a new attachment to the land, and with settlement came a new kind of social life.

At the site of Lepenski Vir, on the Serbian bank of the Danube River, rows of trapezoidal buildings made of wooden posts, branches, mud, and clay—set on stone foundations and with stonefaced hearths—face the river from which the inhabitants took large fish (**FIG. 1-15**). Although this site dates to between 6300 and 5500 BCE, there is little evidence for the domestication of plants and animals that might be expected at this time in association with

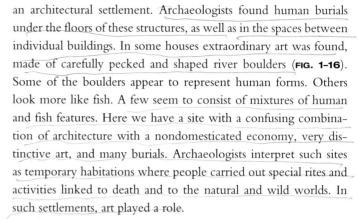

In some places early architecture was dramatic and longlasting, with the repeated building-sometimes over 1,000 years or more-of house upon house in successive architectural generations, resulting in the gradual rise of great mounds of villages referred to as tells or mound settlements. A particularly spectacular example is Çatalhöyük (Chatal Huyuk) in the Konya Plain in central Turkey where the first traces of a village date to 7400 BCE in the early Neolithic period. The oldest part of the site consists of many densely clustered houses separated by areas of rubbish. They were made of rectangular mud bricks held together with mortar; walls, floors, and ceilings were covered with plaster and lime-based paint and were frequently replastered and repainted (see "A Closer Look," page 15). The site was large and was home to as many as 3,000 people at any one time. Beyond the early date of the site and its size and population, the settlement at Çatalhöyük is important to the history of art for two reasons: the picture it provides of the use of early architecture and the sensational art that has been found within its buildings.

Archaeologists and anthropologists often assume that the decision to create buildings such as the houses at Neolithic sites came from a universal need for shelter from the elements. However, as suggested by the special nature of the activities at Lepenski Vir, recent work at Catalhöyük also shows clearly that while structures

did provide shelter, early houses had much more significant functions for the communities of people who lived in them. For the Neolithic people of Çatalhöyük, their houses were the key component of their worldview. Most importantly, they became an emblem of the spirit and history of a community. The building of house upon house created a historical continuity that outlasted any human lifetime; indeed, some house-rebuilding sequences lasted many hundreds of years. And the seasonal replastering and repainting of walls and floors only enhanced the sense of long-term continuity that made these buildings

1-15 • RECONSTRUCTION DRAWING OF LEPENSKI VIR HOUSE/SHRINE Serbia. 6000 BCE.

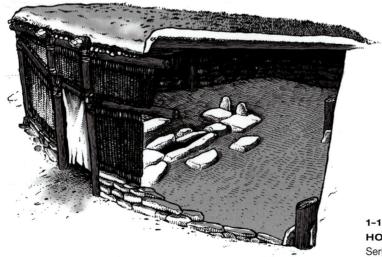

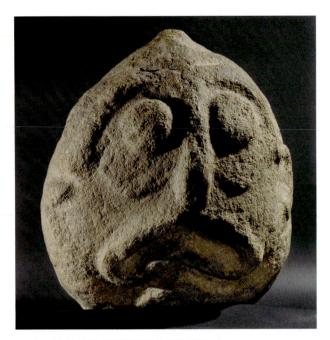

1-16 • HUMAN-FISH SCULPTURE From Lepenski Vir, Serbia. c. 6300-5500 BCE.

history-makers. In fact, Ian Hodder, the director of excavations at Çatalhöyük, and his colleagues call some of them "history houses" and have found no evidence to suggest that they were shrines or temples as earlier interpreters had mistakenly concluded.

As at Lepenski Vir, the dead were buried under the floors of many of the buildings at Çatalhöyük, so the site connected the community's past, present, and future. While there were no burials in some houses, a few contained between 30 and 60 bodies (the average is about six per house), and one had 62 burials, including people who had lived their lives in other parts of the village. Periodically, perhaps to mark special community events and ceremonies, people dug down into the floors of their houses and removed the heads of the long-deceased, then buried the skulls in new graves under the floors. Skulls were also placed in the foundations of new houses as they were built and rebuilt, and in other special deposits around the settlement. In one extraordinary burial, a deceased woman holds in her arms a man's skull that had been plastered and painted. Perhaps it, too, had been removed from an earlier underfloor grave.

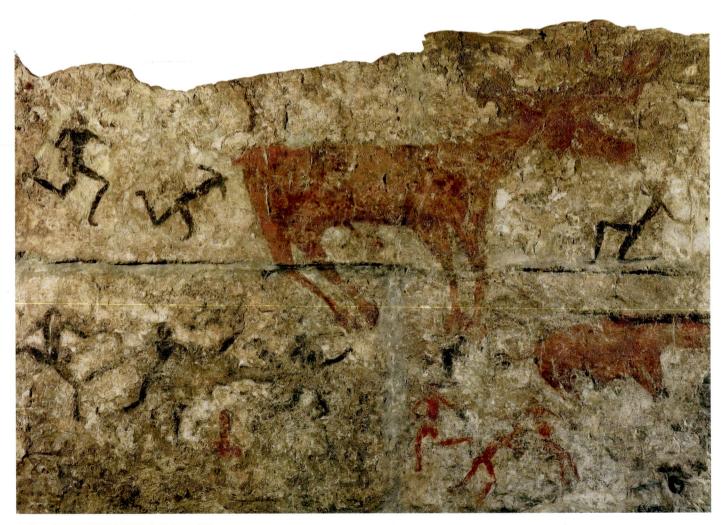

1-17 • MEN TAUNTING A DEER (?) Detail of a wall painting from Çatalhöyük, Turkey. c. 6000 BCE. Museum of Anatolian Civilization, Ankara, Turkey.

A CLOSER LOOK | A House in Çatalhöyük

Reconstruction drawing. Turkey. 7400-6200 BCE.

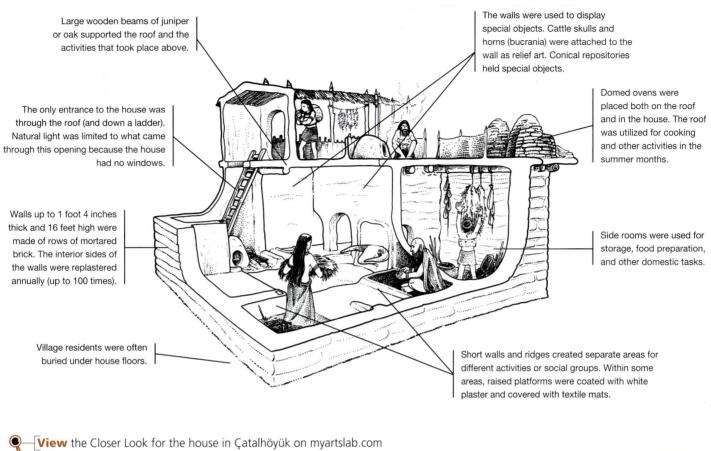

The houses of Çatalhöyük were powerful places not only because of the (literal) depths of their histories, but also because of the extraordinary art that decorated their interiors. Painted on the walls of some of the houses are violent and wild scenes. In some, humans are represented without heads as if they had been decapitated. Vultures or other birds of prey appear huge next to them, and narratives seem to highlight dangerous interactions between people and animals. In one painting (FIG. 1-17), a huge, horned wild animal (probably a deer) is surrounded by small humans who are jumping or running; one of them is pulling on something sticking out of the deer's mouth, perhaps its tongue. There is an emphasis on maleness: some of the human figures are bearded and the deer has an erect penis. Archaeologists have interpreted this scene as a dangerous game or ritual of baiting and taunting a wild animal. In other paintings, people hunt or tease boars or bulls. Conservation of the wall paintings is highly complex, and since many of the most dramatic examples were excavated before modern preservation techniques existed, we must rely on the archaeologist's narrative descriptions or quick field sketches.

Other representations of wild animals are modeled in relief on the interior walls, most frequently the heads and horns of bulls. In

some houses, people placed boar tusks, vulture skulls, and fox and weasel teeth under the floors; in at least one case, they dug into previous house generations to retrieve the plastered and painted heads of bulls.

Sites such as Lepenski Vir and Çatalhöyük have forced archaeologists to think in new ways about the role of architecture and art in prehistoric communities (see "Intentional House Burning," page 16). Critically, the mixture of shelter, architecture, art, spirit, ritual, and ceremony at these and many other Neolithic settlements makes us realize that we cannot easily distinguish between "domestic" and "sacred" architecture. This point re-emerges from the recent work at Stonehenge in England (see page 17). In addition, the clear and repeated emphasis on death, violence, wild animals, and male body parts at Çatalhöyük has challenged traditional interpretations of the Neolithic worldview that concentrated on representations of the female body, human fertility, and cults of the Mother Goddess.

Most Neolithic architectural sites were not as visually sensational as Çatalhöyük. At the site of Sesklo in northern Greece, dated to 6500 BCE, people built stone-based, long-lasting structures (FIG. 1-18) in one part of a village and less substantial mud, clay,

ART AND ITS CONTEXTS | Intentional House Burning

While much research has focused on the origins and construction technology of the earliest architecture—as at Çatalhöyük, Lepenski Vir, and other sites—some of the most exciting new work has come from studies of how Neolithic houses were destroyed. Excavations of settlements dating to the end of the Neolithic period in eastern and central Europe commonly reveal a level of ash and other evidence for great fires that burned down houses at these sites. The common interpretation had been that invaders, coming on horseback from Ukraine and Russia, had attacked these villages and burned the settlements.

In one of the most innovative recent studies, Mira Stevanović and Ruth Tringham employed the methods of modern forensic science and meticulously reconstructed the patterns of Neolithic house conflagrations. The results proved that the fires were not part of villagewide destructions, but were individual events, confined to particular houses. Most significantly, they showed that each fire had been deliberately set. In fact, in order to get the fires to consume the houses completely, buildings had been stuffed with combustibles before they were set alight. Repeated tests by experimental archaeologists have supported these conclusions. Each intentional, house-destroying fire was part of a ritual killing of the house and a rupture of the historical and social entity that the house had represented for the community. Critically, even in their destruction, prehistoric buildings played important and complex roles in relation to the ways that individuals and communities created (and destroyed) social identities and continuities.

and wood buildings in another part. The stone-based buildings may have had a special function within the community—whether ritual, crafts-based, or political is difficult to determine. Since they were rebuilt again and again over a long period of time, the part of the village where they were located "grew" vertically into a mound or tell. Some buildings had easily recognizable functions, such as a place for making ceramic vessels. The distinction between the area of the longer-lasting, often rebuilt buildings and the more temporary structures is clear in the style of architecture as well as in the quality of artifacts found. Finer, decorated pottery is more abundant in the former.

In different regions of Europe, people created architecture in different ways. The crowded buildings of Çatalhöyük differed from the structures at Sesklo, and these differed from the trapezoidal

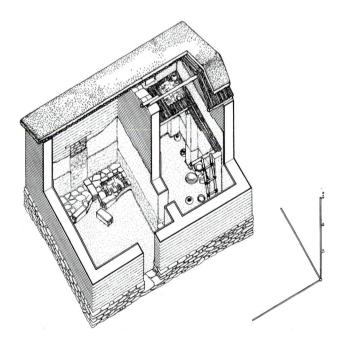

1-18 • SESKLO STONE-FOUNDATION HOUSE Sesklo, northern Greece. 6500 BCE.

huts at Lepenski Vir. To the northwest, in Germany and central Europe, Neolithic villages typically consisted of three or four long timber buildings, each up to 150 feet long, housing 45 to 50 people. The structures were rectangular, with a row of posts down the center supporting a ridgepole, a long horizontal beam against which the slanting roof poles were braced (see example 4 in "Early Construction Methods," page 19). The walls were probably made of wattle and daub (see example 5 in "Early Construction Methods") and roofed with thatch, plant material such as reeds or straw tied over a framework of poles. These houses also included large granaries, or storage spaces for the harvest; some buildings contain sections for animals and for people. Around 4000 BCE, Neolithic settlers began to locate their communities at defensible sites-near rivers, on plateaus, or in swamps. For additional protection, they also frequently surrounded their settlements with wooden walls, earth embankments, and ditches.

CEREMONIAL AND TOMB ARCHITECTURE In western and northern Europe, people erected huge stones to build ceremonial structures and tombs. In some cases, they had to transport these great stones over long distances. The monuments thus created are examples of what is known as **megalithic** architecture, the descriptive term derived from the Greek words for "large" (*mega-*) and "stone" (*lithos*).

Archaeologists disagree about the nature of the societies that created these monuments. Some believe they reflect complex, stratified societies in which powerful religious or political leaders dictated the design of these monuments and inspired (and coerced) large numbers of people to contribute their labor to such engineering projects. Skilled "engineers" would have devised the methods for shaping, transporting, and aligning the stones. Other interpreters argue that these massive monuments are clear evidence for shared collaboration within and between groups, with people working together on a common project, the successful completion of which fueled social cohesion in the absence of a powerful individual.

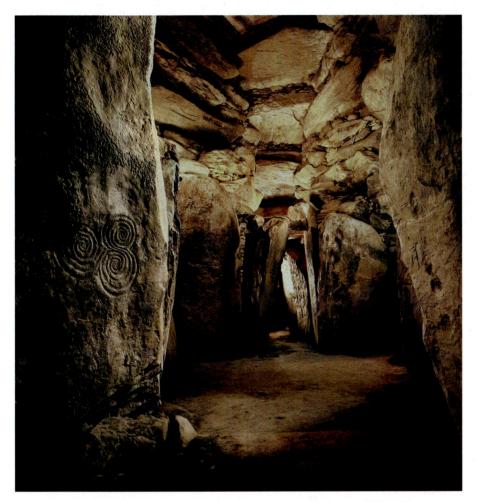

1-19 • TOMB INTERIOR WITH CORBELING AND ENGRAVED STONES Newgrange, Ireland. c. 3000–2500 BCE.

Many of these megalithic structures are associated with death. Most recent interpretations stress the role of death and burial as fundamental, public performances in which individual and group identity, cohesion, and dispute were played out. In this reasoning, death and its rituals are viewed as theater, with the deceased as well as grave goods perceived as props, the monument as a stage, the celebrants and mourners as actors, and the entire event proceeding in terms of an (unwritten) script with narrative and plot.

Elaborate megalithic tombs first appeared in the Neolithic period. Some were built for single burials; others consisted of multiple burial chambers. The simplest type was the **dolmen**, built on the post-and-lintel principle (see examples 1 and 2 in "Early Construction Methods," page 19). The tomb chamber was formed of huge upright stones supporting one or more tablelike rocks, or **capstones**. The structure was then mounded over with smaller rocks and dirt to form a **cairn** or artificial hill. A more imposing type of structure was the **passage grave**, in which narrow, stonelined passageways led into a large room at the center.

At Newgrange, in Ireland, the mound of an elaborate passage grave (**FIG. 1–19**) originally stood 44 feet high and measured about 280 feet in diameter. The mound was built of sod and river pebbles and was set off by a circle of engraved standing stones around its perimeter. Its passageway, 62 feet long and lined with standing stones, leads into a three-part chamber with a corbel vault (an arched structure that spans an interior space) rising to a height of 19 feet (see example 3 in "Early Construction Methods," page 19). Some of the stones are engraved with linear designs, mainly rings, spirals, and diamond shapes. These patterns may have been marked out using strings or compasses, then carved by picking at the rock surface with tools made of antlers. Recent detailed analysis of the art engraved on passage graves like Newgrange, but also at Knowth in Ireland, suggest that the images are entoptic (meaning that their significance and function relate to the particularities of perception by the eye), and that we should understand them in terms of the neuropsychological effect they would have had on people visiting the tomb. These effects may have included hallucinations. Archaeologists argue that key entoptic motifs were positioned at entrances and other important thresholds inside the tomb, and that they played important roles in ritual or political ceremonies that centered

around death, burial, and the commemoration and visitation of the deceased by the living.

STONEHENGE Of all the megalithic monuments in Europe, the one that has stirred the imagination of the public most strongly is **STONEHENGE**, on Salisbury Plain in southern England (**FIGS. 1-20, 1-21**). A **henge** is a circle of stones or posts, often surrounded by a ditch with built-up embankments. Laying out such circles with accuracy would have posed no particular problem. Architects likely relied on the human compass, a simple but effective surveying method that persisted well into modern times. All that is required is a length of cord either cut or knotted to mark the desired radius of the circle. A person holding one end of the cord is stationed in the center; a coworker, holding the other end and keeping the cord taut, steps off the circle's circumference. By the time of Stonehenge's construction, cords and ropes were readily available.

Stonehenge is not the largest such circle from the Neolithic period, but it is one of the most complex, with eight different phases of construction and activity starting in 3000 BCE during the Neolithic period, and stretching over a millennium and a half through the Bronze Age. The site started as a cemetery of cremation burials

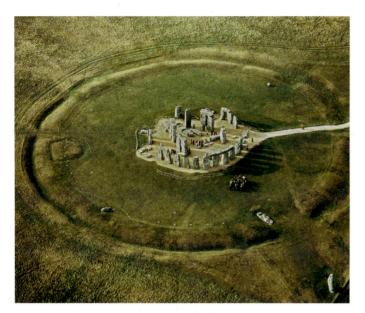

1-20 • STONEHENGE FROM THE AIR Salisbury Plain, Wiltshire, England. c. 2900–1500 BCE.

View the Closer Look for Stonehenge on myartslab.com

marked by a circle of bluestones. Through numerous sequences of alterations and rebuildings, it continued to function as a domain of the dead. Between 2900 and 2600 BCE, the bluestones were rearranged into an arc. Around 2500 BCE, a circle of sarsen stones was used to create the famous appearance of the site—sarsen is a gray sandstone—and the bluestones were rearranged within the sarsens. The center of the site was now dominated by a horseshoe-shaped

arrangement of five sandstone trilithons, or pairs of upright stones topped by **lintels**. The one at the middle stood considerably taller than the rest, rising to a height of 24 feet, and its lintel was more than 15 feet long and 3 feet thick. This group was surrounded by the so-called sarsen circle, a ring of sandstone uprights weighing up to 26 tons each and averaging 13 feet 6 inches tall. This circle, 106 feet in diameter, was capped by a continuous lintel. The uprights taper slightly toward the top, and the gently curved lintel sections were secured by **mortise-and-tenon** joints, that is, joints made by a conical projection at the top of each upright that fits like a peg into a hole in the lintel. Over the next thousand years people continued to alter the arrangement of the bluestones and cremation burials continued in pits at the site.

The differences in the types of stone used in the different phases of construction are significant. The use of bluestone in the early phases (and maintained and rearranged through the sequence) is particularly important. Unlike the sarsen stone, bluestone was not locally available and would have been transported over 150 miles from the west, where it had been quarried in the mountains of west Wales. The means of transporting the bluestones such distances remains a source of great debate. Some argue that they were floated around the coast on great barges; others hold that they traveled over land on wooden rollers. Regardless of the means of transport, the use of this distant material tells usthat the people who first transformed the Stonehenge landscape into a ceremonial site probably also had their ancestral origins in the west. By bringing the bluestones and using them in the early Stonehenge cemetery, these migrants made a powerful connection with their homelands.

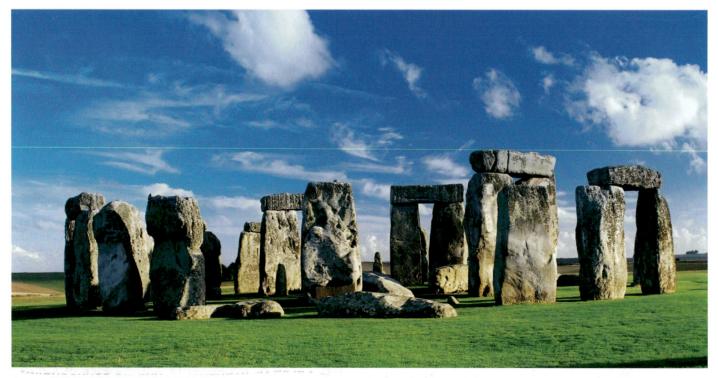

1-21 • STONEHENGE FROM THE GROUND

ELEMENTS OF ARCHITECTURE | Early Construction Methods

Of all the methods for spanning space, post-and-lintel construction is the simplest. At its most basic, two uprights (posts) support a horizontal element (lintel). There are countless variations, from the wood structures, dolmens, and other underground burial chambers of prehistory, to Egyptian and Greek stone construction, to medieval timber-frame buildings, and even to cast-iron and steel construction. Its limitation as a space spanner is the degree of tensile strength of the lintel material: the more flexible, the greater the span possible. Another early method for

creating openings in walls and covering space is corbeling, in which rows or layers of stone are laid with the end of each row projecting beyond the row beneath, progressing until opposing layers almost meet and can then be capped with a stone that rests across the tops of both layers. The walls of early buildings were often created by the stones or posts used to support the covering, but they could be made of what is known as wattle and daub-branches woven in a basketlike pattern, then covered with mud or clay.

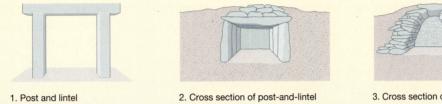

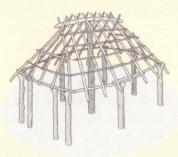

4. Wood-post framing of prehistoric structure

underground burial chamber

5. Neolithic wattle-and-daub walls, Thessaly, Greece, c. 6000 BCE

3. Cross section of corbeled underground burial chamber

6. Granite post-and-lintel construction, Valley Temple of Khafre, Giza, Egypt, c. 2500 BCE

• Watch an architectural simulation about post-and-lintel construction on myartslab.com

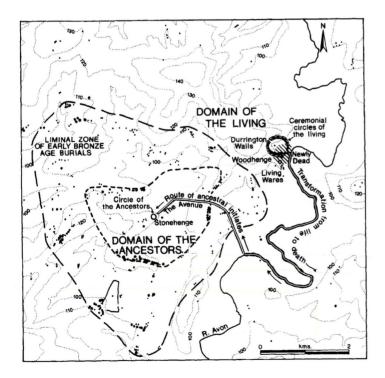

Through the ages, many theories have been advanced to explain Stonehenge. In the Middle Ages, people thought that Merlin, the legendary magician of King Arthur, had built it. Later, the site was erroneously associated with the rituals of the Celtic druids (priests). Because it is oriented in relation to the movement of the sun, some people have argued that it may have been an observatory or that it had special importance as a calendar for regulating early agricultural schedules. Today, none of these ideas is supported by archaeologists and the current evidence.

We now believe that Stonehenge was the site of ceremonies linked to death and burial. This theory has been constructed from evidence that looks not only at the stone circles but also at the nearby sites dating from the periods when Stonehenge was in use (FIG. 1-22). A new generation of archaeologists, led by Mike Parker Pearson, has pioneered this contextual approach to the puzzle of Stonehenge.

1-22 • PLAN OF STONEHENGE AND ITS SURROUNDING SETTLEMENTS

TECHNIQUE | Pottery and Ceramics

The terms pottery and ceramics may be used interchangeably and often are. Because it covers all baked-clay wares, **ceramics** is technically a more inclusive term than pottery. Pottery includes all baked-clay wares except **porcelain**, which is the most refined product of ceramic technology.

Pottery vessels can be formed in several ways. It is possible, though difficult, to raise up the sides from a ball of raw clay. Another method is to coil long rolls of soft, raw clay, stack them on top of each other to form a container, and then smooth them by hand. A third possibility is simply to press the clay over an existing form, a dried gourd for example. By about 4000 BCE, Egyptian potters had developed the potter's wheel, a round, spinning platform on which a lump of clay is placed and then formed with the fingers while rotating, making it relatively simple to produce a uniformly shaped vessel in a very short time. The potter's wheel appeared in the ancient Near East about 3250 BCE and in China about 3000 BCE.

After forming, a pot is allowed to dry completely before it is fired. Special ovens for firing pottery, called **kilns**, have been discovered at prehistoric sites in Europe dating from as early as 26,000 BCE (as at Dolní Věstonice). For proper firing, the temperature must be maintained at a relatively uniform level. Raw clay becomes porous pottery when heated to at least 500° Centigrade. It then holds its shape permanently and will not disintegrate in water. Fired at 800° Centigrade, pottery is technically known as **earthenware**. When subjected to temperatures between 1,200° and 1,400° Centigrade, certain stone elements in the clay vitrify, or become glassy, and the result is a stronger type of ceramic called **stoneware**.

Pottery is relatively fragile, and new vessels were constantly in demand to replace broken ones, so fragments of low-fired ceramics—fired at the hearth, rather than the higher-temperature kiln—are the most common artifacts found in excavations of prehistoric settlements. Pottery fragments, or **potsherds**, serve as a major key in dating sites and reconstructing human living and trading patterns.

The settlements built near Stonehenge follow circular layouts, connecting them in plan to the ceremonial site (**FIG. 1-23**). Unlike the more famous monument, however, these habitations were built of wood, in particular large posts and tree trunks. A mile from Stonehenge is Durrington Walls, which was a large inhabited settlement (almost 1,500 feet across) surrounded by a ditch. Inside are a number of circles—made not from stone but from wood—and

many circular houses constructed with wooden posts. The rubbish left behind at this and similar sites provides archaeologists with insights into the lives of the inhabitants. Chemical analysis of animal bone debris, for example, indicates that the animals consumed came from great distances before they were slaughtered, and therefore that the people who stayed here had come from regions far removed from the site.

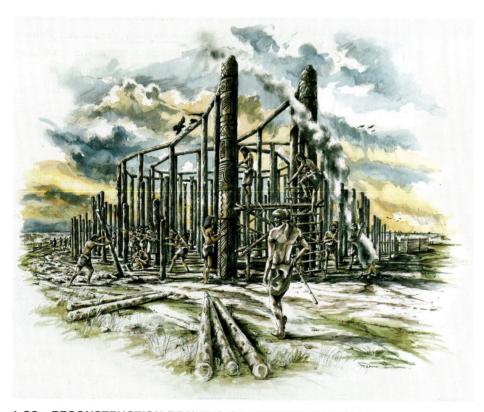

1-23 • RECONSTRUCTION DRAWING OF DURRINGTON WALLS The settlement at Durrington Walls, near Stonehenge, southern England. 2600 BCE.

Significantly, both Stonehenge and Durrington Walls are connected to the Avon River by banked avenues. These connected the worlds of the_ living (the wood settlement) with the domain of the dead (the stone circle). Neolithic people would have moved between these worlds as they walked the avenues, sometimes bringing the deceased to be buried or cremated, other times approaching the stone circle for ceremonies and rituals dedicated to the memories of the deceased and the very ancient ancestors. The meaning of Stonehenge therefore rests within an understanding of the larger landscape that contained not only other ritual sites but also sites of habitation.

SCULPTURE AND CERAMICS

In addition to domestic and ceremonial architecture and a food-producing economy, the other critical component of the Neolithic way of life was the ability to make ceramic vessels (see "Pottery and Ceramics," opposite). This "pot revolution" marked a shift from a complete reliance on skin, textile, and wooden containers to the use of pots made by firing clay. Pottery provided a new medium of extraordinary potential for shaping and decorating durable objects. Ceramic technology emerged independently, at different times, across the globe, with the earliest examples being produced by the Jomon culture of hunter-gatherers in Japan in 12,000 BCE (**FIG. 1-24**). It is extremely difficult to determine with certainty why pottery was first invented or why subsequent cultures adopted it. The idea that pottery would only emerge out of farming settlements is confounded by the example of the Jomon. Rather, it seems that there was no one set of social, economic, or environmental circumstances that led to the invention of ceramics.

It is likely that the technology for producing ceramics evolved in stages. Archaeologist Karen Vitelli's detailed studies of the early Neolithic site of Franchthi Cave in Greece have shown that pottery making at this site started with an experimental stage during which nonspecialist potters produced a small number of pots. These early pots were used in ceremonies, especially those where medicinal or narcotic plants were consumed (FIG. 1-25). Only later did specialist potters share manufacturing recipes to produce enough pots for standard activities such as cooking and eating. A similar pattern may have occurred in other early potting communities.

In addition to firing clay to make pots, cups, pitchers, and large storage containers, Neolithic people made thousands of miniature figures of humans. While it was once thought that these figurines

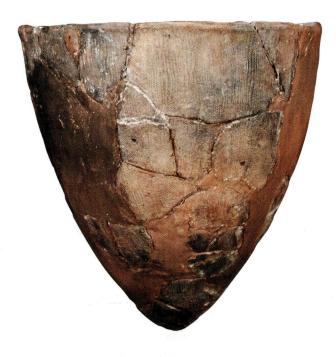

1-24 • EARLY POTTERY FROM JAPAN'S JOMON CULTURE 12,000 BCE.

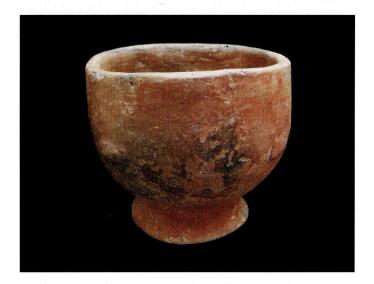

1-25 • EARLY POTTERY FROM THE FRANCHTHI CAVE, GREECE 6500 BCE.

refer to fertility cults and matriarchal societies, archaeologists now agree that they had many different functions—for example, as toys, portraits, votives. More importantly, specialists have shown that there are great degrees of similarity in figurine shape and decoration within distinct cultural regions. Such regional similarities, and the huge numbers of Neolithic figurines that would have been in circulation at any one place and time, have convinced experts that the critical significance of these objects is that they mark the emergence of the human body as the core location of human identity. Thus, the central role the body has played in the politics, philosophy, and art, of historical and modern times began over 8,000 years ago with Neolithic figurines.

Neolithic figures of humans were most numerous and diverse in central and eastern Europe (see "Prehistoric Woman and Man," page 22), but in the Near Eastern site of 'Ain Ghazal in modern Jordan, archaeologist Gary Rollefson found 32 extraordinary HUMAN FIGURES (FIG. 1-27). Dated to 6500 BCE and constructed by covering bundled-twig cores with layers of plaster, the statues were found in two pits. One contained 12 busts and 13 full figures, and in the other were two full figures, two fragmental busts, and three figures with two heads. These statues, each about 3 feet tall, are disturbing for many modern viewers, especially the startlingly stylized faces. The eyes-made with cowrie shells outlined with bitumen (a natural asphalt), also used to represent pupils-are wide open, giving the figures a lifelike appearance. Nostrils are also clearly defined, even exaggerated, but the mouths are discreet and tight-lipped. Clothes and other features were painted on the bodies. The powerful legs and feet are clearly modeled independently with plaster, but the strangely spindly arms and tiny, tapering hands cling closely to the body, as if inert. The impression is of living, breathing individuals who are unable (or unwilling) to gesture or speak.

A BROADER LOOK | Prehistoric Woman and Man

For all we know, the person who created these figurines at around 4500 BCE (**FIG. 1–26**) had nothing particular in mind—people had been modeling clay figures in southeastern Europe for a long time. Perhaps a woman who was making cooking and storage pots out of clay amused herself by fashioning images of the people she saw around her. But because these figures were found in the same grave in Cernavodă, Romania, they suggest to us an otherworldly message.

The woman, spread-hipped and big-bellied, sits directly on the ground, expressive of the mundane world. She exudes stability and fecundity. Her ample hips and thighs seem to ensure the continuity of her family. But in a lively, even elegant, gesture, she joins her hands coquettishly on one raised knee, curls up her toes, and tilts her head upward. Though earthbound, is she a spiritual figure communing with heaven? Her upwardly tilted head could suggest that she is watching the smoke rising from the hearth, or worrying about holes in the roof, or admiring hanging containers of laboriously gathered drying berries, or gazing adoringly at her partner. The man is rather slim, with massive legs and shoulders. He rests his head on his hands in a brooding, pensive pose, evoking thoughtfulness. Or is it weariness, boredom, or sorrow? We can interpret the Cernavodă woman and man in many ways, but we cannot know what they meant to their makers or owners. Depending on how they are displayed, we spin out different stories about them, broadening the potential fields of meaning. When they are set facing each other, or side by side as they are here, we tend to think of them as a couple—a woman and man in a relationship. In fact, we do not know whether the artist conceived of them in this way, or even made them at the same time. For all their visual eloquence, their secrets remain hidden from us, but it is difficult not to speculate.

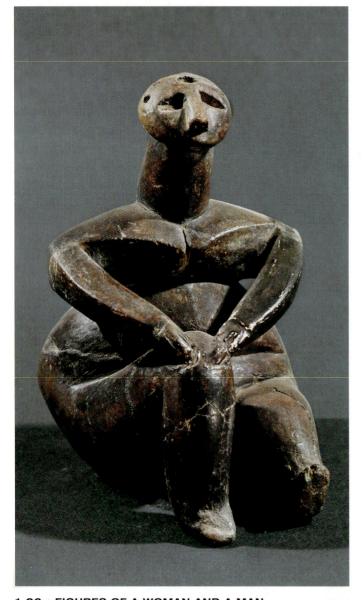

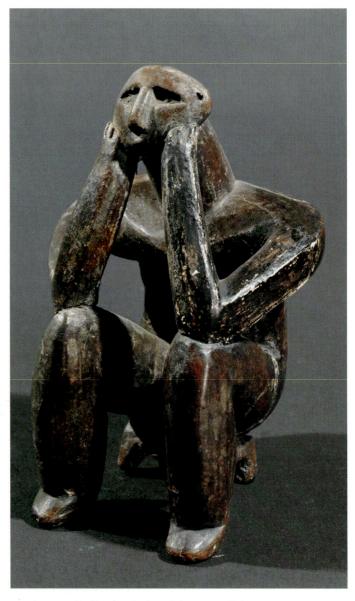

1-26 • FIGURES OF A WOMAN AND A MAN From Cernavodă, Romania. c. 4500 BCE. Ceramic, height 41/2" (11.5 cm). National History Museum, Bucharest.

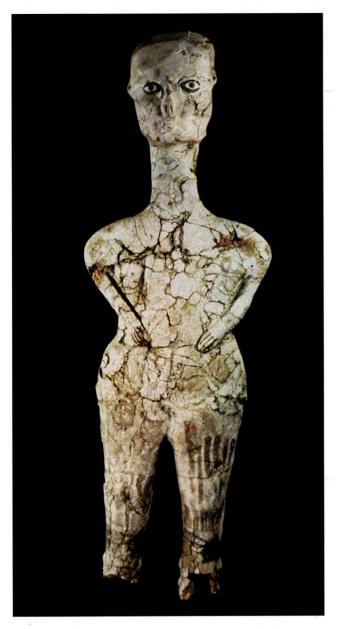

1-27 • HUMAN FIGURE From 'Ain Ghazal, Jordan. 6500 BCE. Fired lime plaster with cowrie shell, bitumen, and paint, height approx. 35" (90 cm). National Museum, Amman, Jordan.

Scholars have searched for clues about the function of these figures. The people who lived in 'Ain Ghazal built and rebuilt their houses, replastered walls, and buried their dead under house floors—they even dug down through the floors to retrieve the skulls of long-deceased relatives—just like the inhabitants of Çatalhöyük. They used the same plaster to coat the walls of their houses and to make the human figures. The site also contains buildings that may have served special, potentially ceremonial functions, and some suggest that the figures are linked to these rites. In addition to the figures' lifelike appearance, the similarity between the burial of bodies under house floors and the burial of the plaster figures in pits is striking. At the same time, however, there are significant differences: the statues are buried in groups while the human bodies are not; the statues are buried in pits, not in houses; and the eyes of the statues are open, as if they are alive and awake. In the current state of research, it is difficult to know with certainty how the figures of 'Ain Ghazal were used and what they meant to the people who made them.

NEW METALLURGY, ENDURING STONE

The technology of metallurgy is closely allied to that of ceramics. Although Neolithic culture persisted in northern Europe until about 2000 BCE (and indeed all of its key contributions to human evolution—farming, architecture, and pottery—continue through present times), the age of metals made its appearance in much of Europe about 3000 BCE. In central and southern Europe, and in the Aegean region, copper, gold, and tin had been mined, worked, and traded even earlier. Smelted and cast copper beads and ornaments dated to 4000 BCE have been discovered in Poland.

Metals were first used for ornamentation. Gold was one of the first metals to be used in prehistory, used to make jewelry (ear, lip, and nose rings) or to ornament clothing (appliqués sewn onto fabric). Toward the end of the Neolithic, people shaped simple beads by cold-hammering malachite, a green-colored, copper carbonate mineral that can be found on the surface of the ground in many regions.

Over time, the objects made from gold and copper became more complicated and technologies of extraction (the mining of copper in Bulgaria) and of metalworking (casting copper) improved. Ivan Ivanov discovered some of the most sensational (and earliest) prehistoric gold and copper objects in the late Neolithic cemetery at Varna on Bulgaria's Black Sea coast. While the cemetery consisted of several hundred graves of men, women, and children, a few special burials contained gold and copper artifacts (FIGS. 1-28, 1-29). Objects such as gold-covered scepters, bracelets, beads, arm rings, lip-plugs, and copper axes and chisels distinguish the graves of a small number of adult males, and in a very few of them, no skeleton was present. Instead, the body was represented by a clay mask richly decorated with gold adornments (see FIG. 1-28) and the grave contained extraordinary concentrations of metal and special marine-shell ornaments. As in other prehistoric contexts, death and its attendant ceremonies were the focus for large and visually expressive displays of status and authority.

THE BRONZE AGE

The period that followed the introduction of metalworking is commonly called the Bronze Age. Although copper is relatively abundant in central Europe and in Spain, objects fashioned from it are too soft to be functional and therefore usually have a ceremonial or representational use and value. However, bronze—an **alloy**, or mixture, of tin and copper—is a stronger, harder substance with a wide variety of uses.

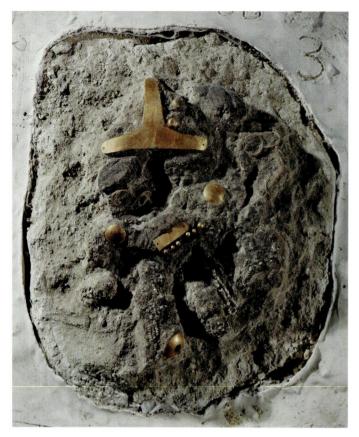

1-28 • GOLD-ADORNED FACE MASK From Tomb 3, Varna I, Bulgaria. Neolithic, 3800 BCE. Terra cotta and gold. Archaeological Museum, Plovdiv, Bulgaria.

The development of bronze, especially for weapons such as daggers and short swords, changed the peoples of Europe in fundamental ways. While copper ore was widely available across Europe, either as surface outcrops or easily mined, the tin that was required to make bronze had a much more limited natural distribution and often required extraction by mining. Power bases shifted within communities as the resources needed to make bronze were not widely available to all. Trade and intergroup contacts across the continent and into the Near East increased, and bronze objects circulated as prized goods.

ROCK CARVINGS

Bronze Age artistry is not limited to metalworking; indeed, some of the most exciting imagery of the period is found in the rock art of northern Europe. For a thousand years starting around 1500 BCE people created designs by scratching outlines and pecking and grinding the surface of exposed rock faces using stone hammers and sometimes grains of sand as an abrasive. The Swedish region of northern Bohuslän is especially rich in rock carvings dating to this period; archaeologists have recorded over 40,000 individual images from more than 1,500 sites. The range of motifs is wide, including boats, animals (bulls, elk, horses, a few snakes, birds, and fish), people (mostly sexless, some with horned helmets, but also men with erect penises), wheeled vehicles and ploughs (and unassociated disks, circles, and wheels), and weapons (swords, shields, and helmets). Within this range, however, the majority of images are boats (FIG. 1-30), not just in Sweden but across northern Europe. Interestingly, the boat images are unlike the boats that archaeologists have excavated. The rock-engraved images do not have masts, nor are they the dugouts or log boats that are known from this period. Instead they represent boats made from wooden planks or with animal skins.

What is the meaning of these boat images? Most agree that the location of the majority of the rock art near current or past shorelines is the critical clue to their meaning. Archaeologist Richard Bradley suggests that rock art connects sky, earth, and sea, perhaps visualizing the community's view of the three-part nature of the universe. Others suggest that the art is intentionally located

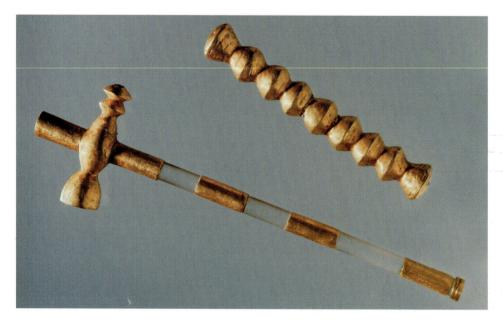

1-29 • GOLD SCEPTERS From Varna, Bulgaria. 3800 BCE. National Museum of History, Sofia, Bulgaria.

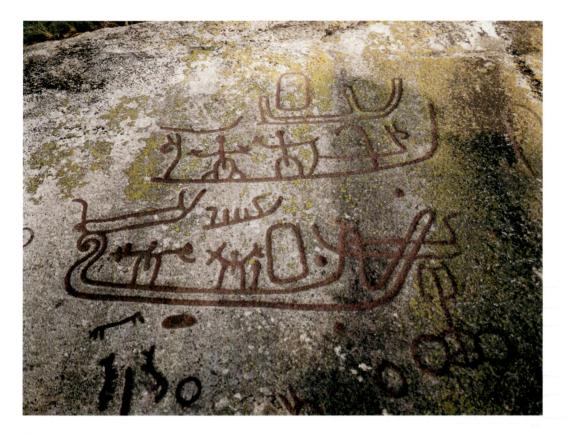

1-30 • ROCK ART: BOAT AND SEA BATTLE

Fossum, northern Bohuslän, Sweden. Bronze Age, c. 1500– 500 BCE.

between water and earth to mark a boundary between the world of the living and the world of spirits. In this view, the permanent character of the rock, grounded deep in the earth, provided a means of communication and connection between distant and distinct worlds.

For people of the prehistoric era, representational and abstract art had critical symbolic importance, justifying the labor required to paint in the deep recesses of caves, move enormous stones great distances, or create elaborately ornamented masks. Prehistoric art and architecture connected the earthly with the spiritual, established social power hierarchies, and perhaps helped people learn and remember information about the natural world that was critical for their survival. This art represents one of the fundamental elements of our development as a human species.

THINK ABOUT IT

- **1.1** Prehistoric artists created representations of human figures using a variety of media, styles, and techniques. Compare two examples drawn from different times and places by discussing the relationship between style or technique and expressive character.
- **1.2** What are the common motifs found in cave paintings such as those at Lascaux and Altamira? Summarize the current theories about their original meaning and purpose.
- **1.3** Many examples of prehistoric art and architecture express relationships between the living and the dead. Discuss how this theme is evoked in one work of architecture and one example of sculpture discussed in this chapter. Why do you think this theme was so important?
- **1.4** How did the emergence of ceramics and metallurgy transform art making in the Neolithic era? Select and analyze a work discussed in the chapter that was made in one of these new media and discuss the unique properties of the medium.

CROSSCURRENTS

FIG. 1–11

FIG. 1-21

Although we have limited information about the meanings prehistoric people associated with sacred spaces, art historians and archaeologists have linked these two famous sites with specific social practices and rituals. Discuss and compare current interpretations of Lascaux and Stonehenge, evidence as well as conclusions.

Study and review on myartslab.com

From Sippar; found at Susa (present-day Shush, Iran). Naram-Sin r. 2254–2218 BCE. Limestone, height 6'6" (1.98 m). Musée du Louvre, Paris.

Art of the Ancient Near East

In public works such as this stone stele (upright stone slab), the artists of Mesopotamia developed a suave and sophisticated symbolic visual language-a kind of conceptual art-that both celebrated and communicated the political stratification that gave order and security to their world. Akkadian ruler Naram-Sin (ruled 2254-2218 BCE) is pictured proudly here (FIG. 2-1). His preeminence is signaled directly by size: he is by far the largest person in this scene of military triumph, conforming to an artistic practice we call hierarchic scale, where relative size indicates relative importance. He is also elevated well above the other figures, boldly silhouetted against blank ground. Even the shape of the stone slab is an active part of the composition. Its tapering top perfectly accommodates the carved mountain within it, and Naram-Sin is posed to reflect the profile of both, increasing his own sense of grandeur by association. He clasps a veritable arsenal of weaponry-spear, battleaxe, bow and arrow-and the grand helmet that crowns his head sprouts horns, an attribute heretofore reserved for gods. By wearing it here, he is claiming divinity for himself. Art historian Irene Winter has gone even further, pointing to the eroticized pose and presentation of Naram-Sin, to the alluring display of a well-formed male body. In ancient Mesopotamian culture, male potency and vigor were directly related to mythical heroism and powerful kingship. Thus every aspect of the

representation of this ruler speaks to his sacred and political authority as leader of the state.

This stele is more than an emblem of Naram-Sin's divine right to rule, however. It also tells the story of one of his important military victories. The ruler stands above a crowded scene enacted by smaller figures. Those to the left, dressed and posed in a fashion similar to their ruler, represent his army, marching in diagonal bands up the hillside into battle. The artist has included identifiable native trees along the mountain pathway to heighten the sense that this portrays an actual event rather than a generic battle scene. Before Naram-Sin, both along the right side of the stele and smashed under his forward striding leg, are representations of the enemy, in this case the Lullubi people from eastern Mesopotamia (modern Iran). One diminutive adversary has taken a fatal spear to the neck, while companions behind and below him beg for mercy.

Taller than most people who stand in front of it, and carved of eye-catching pink stone, this sumptuous work of ancient art maintains the power to communicate with us forcefully and directly even across over four millennia of historical distance. We will discover in this chapter that powerful symbolism and dynamic story-telling are not unique to this one stele; they are signal characteristics of royal art in the ancient Near East.

LEARN ABOUT IT

- 2.1 Investigate a series of conventions for the portrayal of human figures through the history of the ancient Near East.
- 2.2 Explore the development of visual narrative to tell stories of gods, heroes, and rulers in sculpted reliefs.
- 2.3 Survey the various ways rulers in the ancient Near East expressed their power in portraits, historical narrative, and great palace complexes.
- 2.4 Evaluate the way modern archaeologists have laid the groundwork for the art-historical interpretation of the ancient cultures of the Near East.

((•- Listen to the chapter audio on myartslab.com

THE FERTILE CRESCENT AND MESOPOTAMIA

Well before farming communities appeared in Europe, people in Asia Minor and the ancient Near East were already domesticating grains in an area known today as the Fertile Crescent (MAP 2-1). In the sixth or fifth millennium BCE, agriculture developed in the alluvial plains between the Tigris and Euphrates rivers, which the Greeks called *Mesopotamia*, meaning the "land between the rivers," now in present-day Iraq. Because of problems with periodic flooding as well as drought, there was a need for large-scale systems to control the water supply. Meeting this need may have contributed to the development of the first cities.

Between 4000 and 3000 BCE, a major cultural shift seems to have taken place. Agricultural villages evolved into cities simultaneously and independently in both northern and southern Mesopotamia. These prosperous cities joined with their surrounding territories to create what are known as city-states, each with its own gods and government. Social hierarchies—rulers and workers—emerged with the development of specialized skills beyond those needed for agricultural work. To grain mills and ovens were added brick and pottery kilns and textile and metal workshops. With extra goods and even modest affluence came increased trade and contact with other cultures.

Organized religion played an important role, and the people who controlled rituals and the sacred sites eventually became full-time priests. The people of the ancient Near East worshiped numerous gods and goddesses. (The names of comparable deities varied over time and place—for example, Inanna, the Sumerian goddess of fertility, love, and war, was equivalent to the Babylonians' Ishtar.) Every city had its special protective deity, and the fate of the city was seen as dependent on the power of that deity. Large architectural complexes—clusters of religious, administrative, and service buildings—developed in each city as centers of ritual and worship and also of government.

Although the stone-free alluvial plain of southern Mesopotamia was prone to floods and droughts, it was a fertile bed for agriculture and successive, interlinked societies. But its wealth and agricultural resources, as well as its few natural defenses, made Mesopotamia vulnerable to political upheaval. Over the centuries, the balance of power shifted between north and south and between local powers and outside invaders. First the Sumerians controlled the south, filling their independent city-states with the fruits of new technology, developed literacy, and impressive art and architecture. Then they were eclipsed by the Akkadians, their neighbors to the north. When invaders from farther north in turn conquered the Akkadians, the Sumerians regained power locally. During this period the city-states of Ur and Lagash thrived under strong leaders. The Amorites were next to dominate the south. Under them and their king, Hammurabi, a new, unified society arose with its capital in the city of Babylon.

SUMER

The cities and city-states that developed along the rivers of southern Mesopotamia between about 3500 and 2340 BCE are known collectively as Sumer. The Sumerians are credited with important technological and cultural advances. They may have invented the wagon wheel and the plow. But perhaps their greatest contribution to later civilizations was the invention in 3400–3200 BCE of the first form of written script.

WRITING Sumerians pressed cuneiform ("wedge-shaped") symbols into clay tablets with a stylus, a pointed writing instrument, to keep business records (see "Cuneiform Writing," page 30). Thousands of surviving Sumerian tablets have allowed scholars to trace the gradual evolution of writing and arithmetic, another tool of commerce, as well as an organized system of justice. The world's first literary epic is Sumerian in origin, although the fullest surviving version of this tale is written in Akkadian, the language of Sumer's neighbors to the north. The Epic of Gilgamesh records the adventures of a legendary Sumerian king of Uruk and his companion Enkidu. When Enkidu dies, a despondent King Gilgamesh sets out to find the secret of eternal life from the only man and woman who had survived a great flood sent by the gods to destroy the world, because the gods had granted them immortality. Gilgamesh ultimately accepts his own mortality, abandons his quest, and returns to Uruk, recognizing the majestic city as his lasting accomplishment.

THE ZIGGURAT The Sumerians' most impressive surviving archaeological remains are **ziggurats**, huge stepped structures with a temple or shrine on top. The first ziggurats may have developed from the practice of repeated rebuilding at a sacred site, with rubble from one structure serving as the foundation for the next. Elevating the buildings also protected the shrines from flooding.

Whatever the origin of their design, ziggurats towering above the flat plain proclaimed the wealth, prestige, and stability of a city's rulers and glorified its gods. Ziggurats functioned symbolically too, as lofty bridges between the earth and the heavens—a meeting place for humans and their gods. They were given names such as "House of the Mountain" and "Bond between Heaven and Earth."

URUK Two large temple complexes in the 1,000-acre city at Uruk (present-day Warka, Iraq) mark the first independent Sumerian city-state. One was dedicated to Inanna, the goddess of love and war, while the other complex belonged to the sky god Anu. The temple platform of Anu, built up in stages over the centuries, ultimately rose to a height of about 40 feet. Around 3100 BCE, a whitewashed mud-brick temple that modern archaeologists refer to as the White Temple was erected on top of the platform (**FIG. 2-2**). This now-ruined structure was a simple rectangle with an off-center doorway that led into a

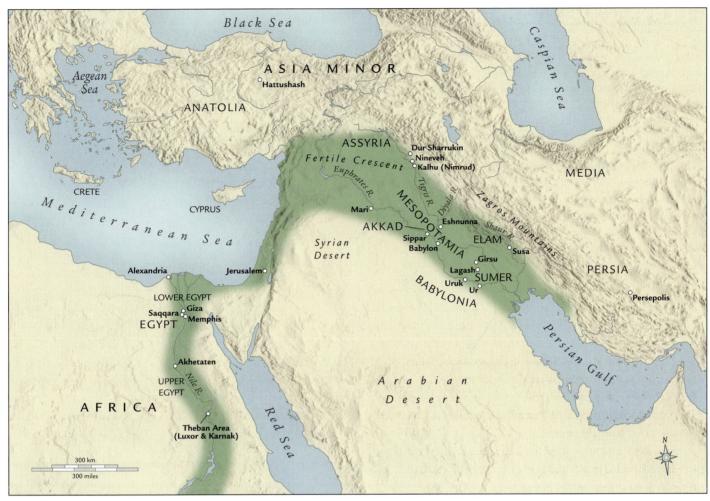

MAP 2-1 • THE ANCIENT NEAR EAST

The green areas represent fertile land that could support early agriculture, notably the area between the Tigris and Euphrates rivers and the strips of land on either side of the Nile in Egypt.

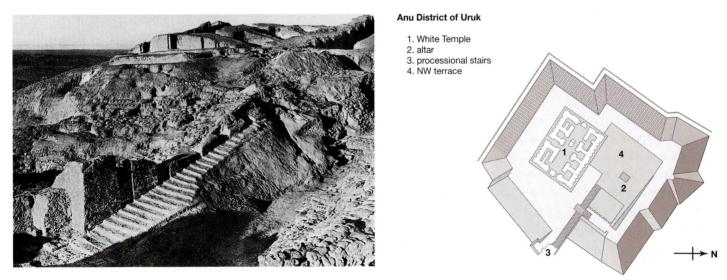

2-2 • RUINS AND PLAN OF THE ANU ZIGGURAT AND WHITE TEMPLE Uruk (present-day Warka, Iraq). c. 3400–3200 BCE.

Many ancient Near Eastern cities still lie undiscovered. In most cases an archaeological site in the region is signaled by a large mound—known locally as a *tell, tepe*, or *huyuk*—that represents the accumulated debris of generations of human habitation. When properly excavated, such mounds yield evidence about the people who inhabited the site.

TECHNIQUE | Cuneiform Writing

Sumerians invented writing around 3400–3200 BCE, apparently as an accounting system for goods traded at Uruk. The symbols were pictographs, simple pictures cut into moist clay slabs with a pointed tool. By the fourth millennium BCE, the symbols had begun to evolve from pictures into phonograms—representations of syllable sounds thus becoming a writing system as we know it. By 3000–2900, scribes adopted a stylus, or writing tool, with one triangular end and one pointed end that could be pressed easily and rapidly into a wet clay tablet to produce cuneiform writing.

These drawings demonstrate the shift from pictographs to cuneiform. The c. 3100 BCE drawing of a bowl (which means "bread" or "food") was reduced to a four-stroke sign by about 2400 BCE, and by about 700 BCE to a highly abstract arrangement of vertical marks. By combining the pictographs and, later, cuneiform signs, writers created composite signs; for example, a combination of the signs for "head" and "food" meant "to eat."

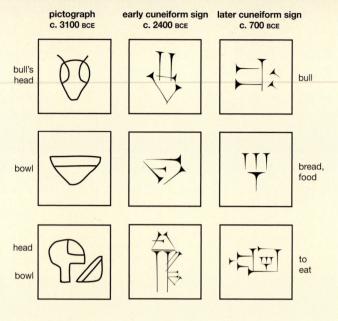

symbols

View the Closer Look for cuneiform writing in Sumeria on myartslab.com

large chamber containing an altar, and smaller spaces opened to each side.

Statues of gods and donors were placed in Sumerian temples. A striking life-size marble face from Uruk (**FIG. 2-3**) may represent a temple goddess. It could have been attached to a wooden head on a full-size wooden body. Now stripped of its original paint, wig, and the **inlay** set in for brows and eyes, it appears as a stark white mask. Shells may have been used for the whites of the eyes and lapis lazuli for the pupils, and the hair may have been gold.

A tall vessel of carved alabaster (a fine, white stone) found in the temple complex of Inanna at Uruk (FIG. 2-4) shows how early Mesopotamian sculptors told stories in stone with great clarity and verve. The visual narrative is organized into three registers, or horizontal bands, and the story condensed to its essential elements. The lowest register shows in a lower strip the sources of life in the natural world, beginning with water and plants (variously identified as date palm and barley, wheat and flax) and continuing in a superimposed upper strip, where alternating rams and ewes march single file along a solid ground-line. In the middle register naked men carry baskets of foodstuffs, and in the top register, the goddess Inanna accepts an offering from two standing figures. Inanna stands in front of the gate to her richly filled shrine and storehouse, identified by two reed door poles hung with banners. The two men who face her are thought to be first a naked priest or acolyte presenting an offering-filled basket, followed by a partially preserved, ceremonially dressed figure of the priest-king (not visible in FIGURE 2-4). The scene may represent a re-enactment of the ritual

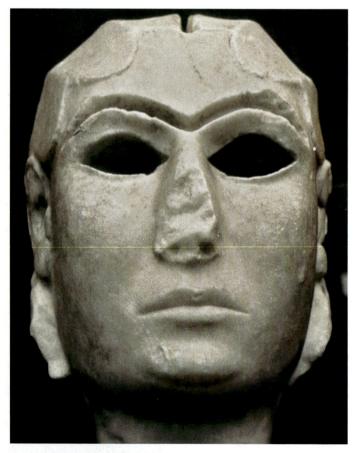

2-3 • HEAD OF A WOMAN From Uruk (present-day Warka, Iraq). c. 3300–3000 BCE. Marble, height approx. 8" (20.3 cm). Iraq Museum, Baghdad.

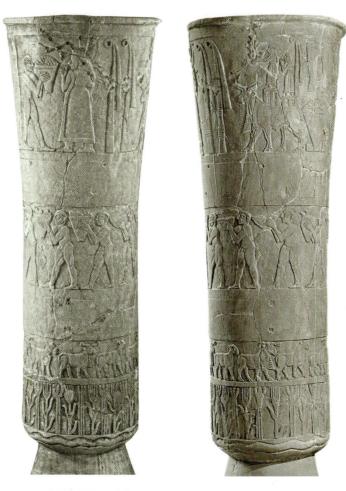

2-4 • CARVED VESSEL

From Uruk (present-day Warka, Iraq). c. 3300–3000 BCE. Alabaster, height 36" (91 cm). Iraq Museum, Baghdad.

marriage between the goddess and Dumuzi, her consort—a role taken by the priest-king—that took place during the New Year's festival to ensure the fertility of crops, animals, and people, and thus the continued survival of Uruk.

VOTIVE FIGURES Limestone statues dated to about 2900–2600 BCE from the Square Temple in Eshnunna (**FIG. 2-5**), excavated in 1932–1933, reveal another aspect of Sumerian religious art. These **votive figures** of men and women—images dedicated to the gods—are directly related to an ancient Near Eastern devotional practice in which individual worshipers could set up images of themselves in a shrine before a larger, more elaborate image of a god. A simple inscription might identify the figure as "One who offers prayers." Longer inscriptions might recount in detail all the things the donor had accomplished in the god's honor. Each sculpture served as a stand-in for the donor, locked in eye-contact with the god, caught perpetually in the act of worship.

The sculptors of these votive statues followed **conventions** (traditional ways of representing forms) that were important in Sumerian art. Figures have stylized faces and bodies, dressed in clothing that emphasizes pure cylindrical shapes. They stand solemnly, hands clasped in respect, perhaps a posture expected in devotional contexts. The bold, staring eyes may be related to statements in contemporary Sumerian texts that advise worshipers to approach their gods with an attentive gaze. As with the face of the woman from Uruk, arched brows were inlaid with dark shell, stone, or bitumen that once emphasized the huge, wide-open eyes.

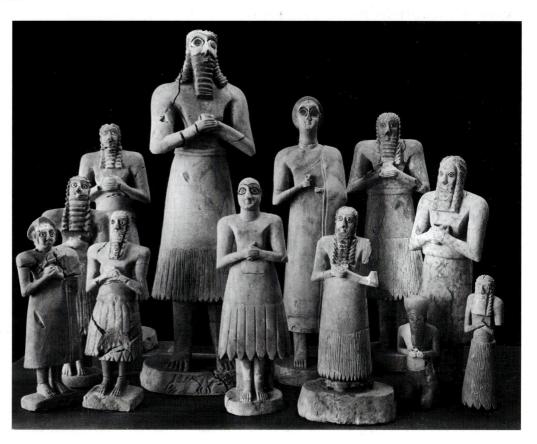

2-5 • TWELVE VOTIVE FIGURES

From the Square Temple, Eshnunna (present-day Tell Asmar, Iraq). c. 2900–2600 BCE. Limestone, alabaster, and gypsum, height of largest figure approx. 30" (76.3 cm). The Oriental Institute Museum, University of Chicago.

A BROADER LOOK | A Lyre from a Royal Tomb in Ur

Sir Leonard Woolley's excavations at Ur during the 1920s initially garnered international attention because of the association of this ancient Mesopotamian city with the biblical patriarch Abraham. It was not long, however, before the exciting discoveries themselves moved to center stage, especially 16 royal burials that yielded spectacular objects crafted of gold and lurid evidence of the human sacrifices associated with Sumerian royal burial practices, when retainers were seemingly buried with the rulers they served.

Woolley's work at Ur was a joint venture of the University of Pennsylvania Museum in Philadelphia and the British Museum in London, and in conformance with Iraq's Antiquities Law of 1922, the uncovered artifacts were divided between the sponsoring institutions and Iraq itself. Although Woolley worked with a large team of laborers and assistants during 12 seasons of digging at Ur, he and his wife Katherine reserved for themselves the painstakingly delicate process of uncovering the most important finds (FIG. 2-6). Woolley's own account of work within one tomb outlines the practice-"Most of the workmen were sent away ... so that the final work with knives and brushes could be done by my wife and myself in comparative peace. For ten days the two of us spent most of the time from sunrise to sunset lying on our tummies brushing and blowing and threading beads in their order as they lay You might suppose that to find three-score women all richly bedecked with jewelry could be a very thrilling experience, and so it is, in retrospect, but I'm afraid that at the moment one is much more conscious of the toil than of the thrill" (quoted in Zettler and Horne, p. 31).

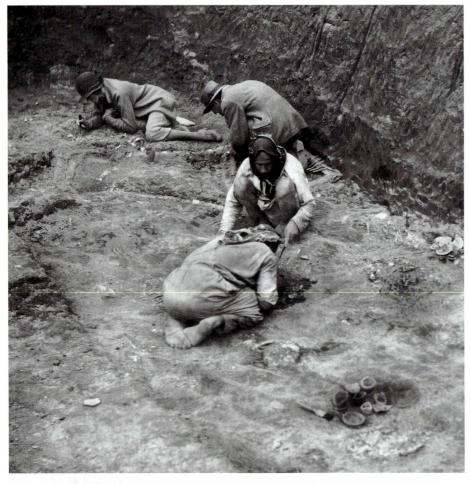

2-6 • KATHERINE AND LEONARD WOOLLEY (ABOVE) EXCAVATING AT UR IN 1937, BESIDE TWO ARCHAEOLOGICAL ASSISTANTS IN ONE OF THE ROYAL BURIALS

Archives of the University of Pennsylvania Museum, Philadelphia.

One of the most spectacular discoveries in the royal burials at Ur was an elaborate lyre, which rested over the body of the woman who had presumably played it during the funeral ceremony for the royal figure buried nearby (FIG. 2-7). Like nine other lyres Woolley found at Ur, the wooden sound box of this one had long since deteriorated and disappeared, but an exquisitely crafted bull's-head finial of gold and lapis lazuli survived, along with a plaque of carved shell inlaid with bitumen, depicting at the top a heroic image of a man interlocked with and in control of two bulls, and below them three scenes of animals mimicking the activities of humans (FIG. 2-8). On one register, a seated donkey plucks the strings of a bull lyre-similar to the instrument on which this set of images originally appearedstabilized by a standing bear, while a fox accompanies him with a rattle. On the register above, upright animals bring food and drink for a feast. A hyena to the left-assuming the role of a butcher with a knife in his belt-carries a table piled high with meat. A lion follows, toting a large jar and pouring vessel.

The top and bottom registers are particularly intriguing in relation to the Epic of Gilgamesh, a 3,000-line poem that is Sumer's great contribution to world literature. Rich in descriptions of heroic feats and fabulous creatures, Gilgamesh's story probes the guestion of immortality and expresses the heroic aim to understand hostile surroundings and to find meaning in human existence. Gilgamesh encounters scorpion-men, like the one pictured in the lowest register, and it is easy to see the hero himself in the commanding but unprotected bearded figure centered in the top register, naked except for a wide belt, masterfully controlling in his grasp the two powerfully rearing human-headed bulls that flank him. Because the poem was first written down 700 years after this lyre was created, this plaque may document a very long oral tradition.

On another level, because we know lyres were used in funeral rites, could this imagery depict a heroic image of the deceased in the top register, and a funeral banquet in the realm of the dead at the bottom? Cuneiform tablets preserve songs of mourning, perhaps chanted by priests accompanied by lyres at funerals. One begins, "Oh, lady, the harp of mourning is placed on the ground," a particularly poignant statement considering that the lyres of Ur may have been buried on top of the sacrificed bodies of the women who originally played them.

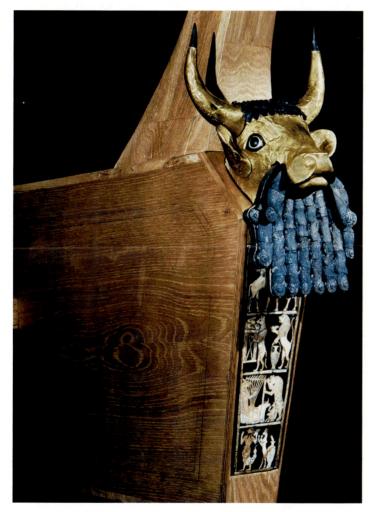

2-7 • **THE GREAT LYRE WITH BULL'S HEAD** From Royal Tomb (PG 789), Ur (present-day Muqaiyir, Iraq). c. 2600– 2500 BCE. Wood with gold, silver, lapis lazuli, bitumen, and shell, reassembled in modern wood support; height of head 14" (35.6 cm); height of front panel 13" (33 cm); maximum length of lyre 55½" (140 cm); height of upright back arm 46½" (117 cm). University of Pennsylvania Museum of Archaeology and Anthropology, Philadelphia.

2-8 • FRONT PANEL, THE SOUND BOX OF THE GREAT LYRE From Ur (present-day Muqaiyir, Iraq). Wood with shell inlaid in bitumen, height 13" \times 41/2" (33 \times 11 cm). University of Pennsylvania Museum of Archaeology and Anthropology, Philadelphia.

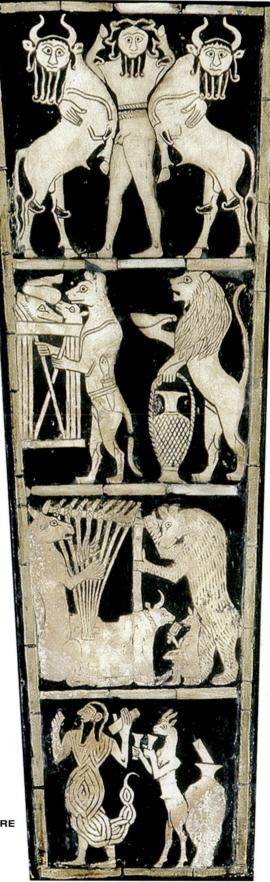

ART AND ITS CONTEXTS | Art as Spoils of War—Protection or Theft?

Art has always been a casualty in times of social unrest. One of the most recent examples is the looting of the unguarded Iraq National Museum after the fall of Baghdad to U.S.-led coalition forces in April 2003. Among the many thousands of treasures that were stolen is a precious marble head of a woman from Warka, over 5,000 years old (see Fig. 2–3). Fortunately it was later recovered. Also looted was a carved Sumerian vessel (see Fig. 2–4), eventually returned to the museum two months later, shattered into 14 pieces. The museum itself managed to reopen in 2009, but thousands of its antiquities are still missing.

Some of the most bitter resentment spawned by war has involved the taking by the victors of art objects that held great value for the conquered population. Two historically priceless objects unearthed in Elamite Susa, for example—the Akkadian stele of Naram-Sin (see Fig. 2–1) and the Babylonian stele of Hammurabi (see Fig. 2–15)—were not Elamite at all, but Mesopotamian. Both had been brought there as military booty by an Elamite king, who added an inscription to the stele of Naram-Sin claiming it for himself and his gods. Uncovered in Susa during excavations organized by French archaeologist Jacques de Morgan, both works were taken back to Paris at the turn of the twentieth century and are now displayed in the Louvre. Museums around the world contain such works, either snatched by invading armies or acquired as a result of conquest.

The Rosetta Stone, the key to deciphering Egyptian hieroglyphs, was discovered in Egypt by French troops in 1799, fell into British hands when they forced the French from Egypt, and ultimately ended up in the British Museum in London (see Fig. 3–38). In the early nineteenth century, the Briton Lord Elgin purchased and removed classical Greek sculpture from the Parthenon in Athens with the permission of the Ottoman authorities who governed Greece at the time (see "Who Owns the Art?" page 133). Although his actions may indeed have protected these treasures from neglect and damage in later wars, they have remained installed in the British Museum, despite continuing protests from Greece. Many German collections include works that were similarly "protected" at the end of World War II and are surfacing now. In the United States, Native Americans are increasingly vocal in their demands that artifacts and human remains collected by anthropologists and archaeologists be returned to them.

"To the victor," it is said, "belong the spoils." But passionate and continuous debate surrounds the question of whether this notion remains valid in our own time, especially in the case of revered cultural artifacts.

2-9 • FACE OF A WOMAN, KNOWN AS THE WARKA HEAD Displayed by Iraqi authorities on its recovery in 2003 by the Iraq Museum in Baghdad. The head is from Uruk (present-day Warka, Iraq). c. 3300– 3000 BCE. Marble, height approx. 8" (20.3 cm).

The male figures, bare-chested and dressed in what appear to be sheepskin skirts, are stocky and muscular, with heavy legs, large feet, big shoulders, and cylindrical bodies. The female figures are as massive as the men. Their long sheepskin skirts reveal sturdy legs and feet.

Sumerian artisans worked in various precious metals, and in bronze, often combining them with other materials. Many of these creations were decorated with—or were in the shape of—animals or composite animal-human-bird creatures. A superb example of their skill is a lyre—a kind of harp—from the city of Ur (presentday Muqaiyir, Iraq), to the south of Uruk. This combines wood, gold, lapis lazuli, and shell (see FIGS. 2-7, 2-8). Projecting from the base is a wood-sculpted head of a bearded bull overlaid with gold, intensely lifelike despite the decoratively patterned blue beard created from the semiprecious gemstone, lapis lazuli. Since lapis lazuli had to be imported from Afghanistan, the work documents widespread trade in the region at this time.

CYLINDER SEALS About the time written records appeared, Sumerians developed seals for identifying documents and establishing property ownership. By 3300–3100 BCE, record keepers redesigned the stamp seal as a cylinder. Rolled across documents on clay tablets or over the soft clay applied to a closure that needed sealing—a jar lid, the knot securing a bundle, or the door to a room—the cylinders left a raised mirror image of the design incised (cut) into their surface. Such sealing attested to the

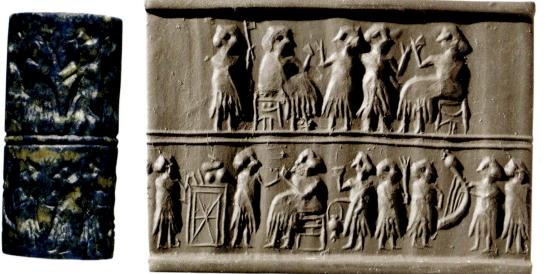

2-10 • CYLINDER SEAL AND ITS MODERN IMPRESSION

From the tomb of Queen Puabi (PG 800), Ur (present-day Muqaiyir, Iraq). c. 2600-2500 BCE. Lapis lazuli, height $1^{9}/_{16}$ " (4 cm), diameter $^{25}/_{32}$ " (2 cm). University of Pennsylvania Museum of Archaeology and Anthropology, Philadelphia.

authenticity or accuracy of a text or ensured that no unauthorized person could gain access to a room or container. Sumerian **cyl-inder seals**, usually less than 2 inches high, were generally made of a hard stone so that the tiny but intricate incised scenes would not wear away during repeated use. Individuals often acquired seals as signs of status or on appointment to a high administrative position, and the seals were buried with them, along with other important possessions.

The lapis lazuli **CYLINDER SEAL** in **FIGURE 2-10** is one of over 400 that were found in excavations of the royal burials at Ur. It comes from the tomb of a powerful royal woman known as Puabi, and was found leaning against the right arm of her body. The modern clay impression of its incised design shows two registers of a convivial banquet at which all the guests may be women, with fringed skirts and long hair gathered up in buns behind their necks. Two seated figures in the upper register raise their glasses, accompanied by standing servants, one of whom, at far left, holds a fan. The single seated figure in the lower register sits in front of a table piled with food, while a figure behind her offers a cup of drink, presumably drawn from the jar she carries in her other hand, reminiscent of the container held by the lion on the lyre plaque (see FIG. 2-8). Musical entertainment is provided by four women standing to the far right.

AKKAD

A people known as the Akkadians inhabited an area north of Uruk. During the Sumerian period, they adopted Sumerian culture, but unlike the Sumerians, the Akkadians spoke a Semitic language (the same family of languages that includes Arabic and Hebrew). Under the powerful military and political figure Sargon I (ruled c. 2332– 2279 BCE), they conquered most of Mesopotamia. For more than half a century, Sargon, "King of the Four Quarters of the World," ruled this empire from his capital at Akkad, the actual site of which is yet to be discovered. **DISK OF ENHEDUANNA** A partially preserved circular relief sculpture in alabaster, excavated at Ur in 1927 by British archaeologist Leonard Woolley (see "A Lyre from a Royal Tomb in Ur," page 32), is one of the most extraordinary surviving works of ancient Near Eastern art (**FIG. 2-11**). An inscription on the back identifies the centrally highlighted figure on the front—slightly larger than her companions and wearing a flounced, fleeced wool garment and the headgear of a high priestess—as Enheduanna,

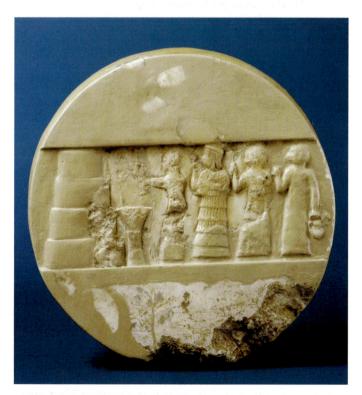

2-11 • DISK OF ENHEDUANNA From Ur (present-day Muqaiyir, Iraq). c. 2300–2275 BCE. Alabaster, diameter 10" (25.6 cm). University of Pennsylvania Museum of Archaeology and Anthropology, Philadelphia.

daughter of Sargon I and high priestess of the moon god Nanna at his temple in Ur. Enheduanna's name also appears in other surviving Akkadian inscriptions and most notably in association with a series of poems and hymns dedicated to the gods Nanna and Inanna. Hers is the earliest recorded name of an author in human history.

The procession portrayed on the front of the disk commemorates the dedication of Enheduanna's donation of a dais (raised platform) to the temple of Inanna in Ur. The naked man in front of her pours a ritual libation in front of a ziggurat, while Enheduanna and her two followers—probably female attendants—raise their right hands before their faces in a common gesture of pious greeting (e.g., see FIG. 2-14). Sargon's appointment of his daughter

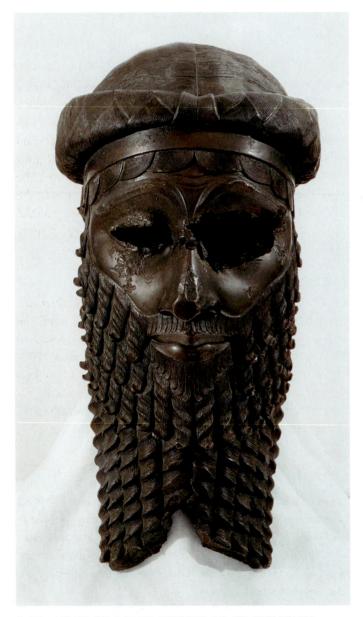

2-12 • HEAD OF A MAN (KNOWN AS AN AKKADIAN RULER)

From Nineveh (present-day Ninua, Iraq). c. 2300–2200 BCE. Copper alloy, height 14%" (36.5 cm). Iraq Museum, Baghdad.

to this important religious office followed an established tradition, but it may also have been the ruler's attempt to bolster his support and assert dynastic control in the southern part of his domain, largely populated by Sumerians.

HEAD OF A RULER A life-size bronze head (**FIG. 2-12**)—found in the northern city of Nineveh (present-day Ninua, Iraq) and thought to date from the time of Sargon—is the earliest known work of hollow-cast sculpture using the **lost-wax casting** process (see "Lost-Wax Casting," page 418). Its artistic and technical sophistication is nothing short of spectacular.

The facial features and hairstyle may reflect a generalized ideal more than the unique likeness of a specific individual, although the sculpture was once identified as Sargon himself. The enormous curling beard and elaborately braided hair (circling the head and ending in a knot at the back) indicate both royalty and ideal male appearance. The deliberate damage to the left side of the face and eye suggests that the head was symbolically mutilated at a later date to destroy its power. Specifically, the ears and the inlaid eyes appear to have been removed to deprive the head of its ability to hear and see.

THE STELE OF NARAM-SIN The concept of imperial authority was literally carved in stone by Sargon's grandson Naram-Sin (see FIG. 2-1). This 6½-foot-high stele (probably only ²/₃ its original height) memorializes one of his military victories, and is one of the first works of art created to celebrate a specific achievement of an individual ruler. The original inscription—framed in a rectangular box just above the ruler's head—states that the stele commemorates Naram-Sin's victory over the Lullubi people of the Zagros Mountains. Watched over by solar deities (symbolized by the rayed suns at the top of the stele) and wearing the horned helmet-crown heretofore associated only with gods, the hierarchically scaled king stands proudly above his soldiers and his fallen foes, boldly silhouetted against the sky next to the smooth surface of a mountain.

This expression of physical prowess and political power was erected by Naram-Sin in the courtyard of the temple of the sun god Shamash in Sippar, but it did not stay there permanently. During the twelfth century BCE—over a thousand years after the end of Akkadian rule—Elamite king Shutruk-Nahhunte conquered Sippar and transported the stele of Naram-Sin back to his own capital in Susa, where he rededicated it to an Elamite god. He also added a new explanatory inscription—in a diagonal band on the mountain in front of Naram-Sin—recounting his own victory and claiming this monument—which is identified specifically with Naram-Sin—as a statement of his own military and political prowess. The stele remained in Susa until the end of the nineteenth century, when it was excavated by a French archaeologist and traveled once more, this time appropriated for exhibition in Paris at the Louvre.

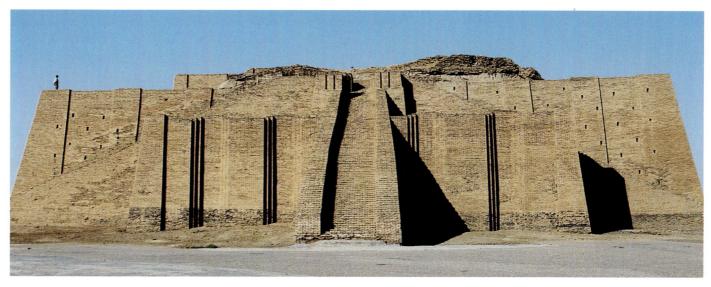

2-13 • NANNA ZIGGURAT Ur (present-day Muqaiyir, Iraq). c. 2100–2050 все.

UR AND LAGASH

The Akkadian Empire fell around 2180 BCE to the Guti, a mountain people from the northeast. For a brief time, the Guti controlled most of the Mesopotamian plain, but ultimately Sumerian people regained control of the region and expelled the Guti in 2112 BCE, under the leadership of King Urnammu of Ur. He sponsored magnificent building campaigns, notably a ziggurat dedicated to the moon god Nanna, also called Sin (FIG. 2-13). Although located on the site of an earlier temple, this imposing structure-mud-brick faced with kiln-dried brick set with bitumen-was not the accidental result of successive rebuilding. Its base is a rectangle 205 by 141 feet, with three sets of stairs converging at an imposing entrance gate atop the first of what were three platforms. Each platform's walls slope outward from top to base, probably to prevent rainwater from forming puddles and eroding the mud-brick pavement below. The first two levels of the ziggurat and their retaining walls are recent reconstructions.

One large Sumerian city-state remained independent throughout this period: Lagash, whose capital was Girsu (presentday Telloh, Iraq), on the Tigris River. Gudea, the ruler, built and restored many temples, and within them, following a venerable Mesopotamian tradition, he placed votive statues representing himself as governor and embodiment of just rule. The statues are made of diorite, a very hard stone, and the difficulty of carving it may have prompted sculptors to use compact, simplified forms for the portraits. Or perhaps it was the desire for powerful, stylized images that inspired the choice of this imported stone for this series of statues. Twenty of them survive, making Gudea a familiar figure in the study of ancient Near Eastern art.

Images of Gudea present him as a strong, peaceful, pious ruler worthy of divine favor (**FIG. 2-14**). Whether he is shown sitting or standing, he wears a long garment, which provides ample, smooth space for long cuneiform inscriptions. In this imposing statue, only $2\frac{1}{2}$ feet tall, his right shoulder is bare, and he wears a cap with a wide brim carved with a pattern to represent fleece. He holds a vessel in front of him, from which life-giving water flows in two streams, each filled with leaping fish. The text on his garment states that he dedicated himself, the statue, and its temple to the goddess Geshtinanna, the divine poet and interpreter of dreams. The sculptor has emphasized the power centers of the human body: the eyes, head, and smoothly muscled arms. Gudea's face is youthful and serene, and his eyes—oversized and wide open—perpetually confront the gaze of the deity with intense concentration.

BABYLON

For more than 300 years, periods of political turmoil alternated with periods of stable government in Mesopotamia, until the Amorites (a Semitic-speaking people from the Syrian desert, to the west) reunited the region under Hammurabi (ruled 1792–1750 BCE). Hammurabi's capital city was Babylon and his subjects were called Babylonians. Among Hammurabi's achievements was a written legal code that detailed the laws of his realm and the penalties for breaking them (see "The Code of Hammurabi," page 39).

THE HITTITES OF ANATOLIA

Outside Mesopotamia, other cultures developed and flourished in the ancient Near East. Anatolia (present-day Turkey) was home to several independent cultures that had resisted Mesopotamian domination, but the Hittites—whose founders had moved into the mountains and plateaus of central Anatolia from the east—were the most powerful among them.

The Hittites established their capital at Hattusha (near presentday Boghazkoy, Turkey) about 1600 BCE, and the city thrived until its destruction about 1200 BCE. Through trade and conquest, the Hittites created an empire that stretched along the coast of the

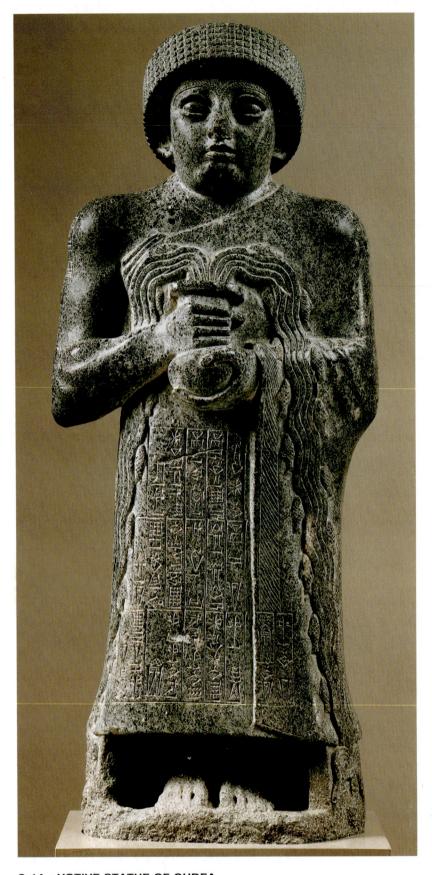

2-14 • VOTIVE STATUE OF GUDEA From Girsu (present-day Telloh, Iraq). c. 2090 BCE. Diorite, height 29" (73.7 cm). Musée du Louvre, Paris.

Read the document related to the statue of Gudea on myartslab.com Mediterranean Sea in the area of present-day Syria and Lebanon, bringing them into conflict with the Egyptian Empire, which was expanding into the same region (see Chapter 3). The Hittites also made incursions into Mesopotamia, and their influence was felt throughout the region.

The Hittites may have been the first people to work in iron, which they used for war-chariot fittings, weapons, chisels, and hammers. They are noted for the artistry of their fine metalwork and for their imposing palace citadels with double walls and fortified gateways, that survive today only in the ruins of archaeological sites. One of the most monumental of these sites consists of the foundations and base walls of the Hittite stronghold at Hattusha, which date to about 1400–1300 BCE. Local quarries supplied stone for the lower walls, and the upper walls, stairways, and walkways were finished in brick.

The blocks of stone used to frame doorways at Hattusha were decorated in high relief with a variety of guardian figures—some of them 7 feet tall. Some were half-human, half-animal creatures; others were more naturalistically rendered animals like the lions at the **LION GATE** (**FIG. 2-16**). Carved from the building stones and consistent with the colossal scale of the wall itself, the lions seem to emerge from the gigantic boulders that form the gate. Despite extreme weathering, the lions have endured over the millennia and maintain their sense of both vigor and permanence.

ASSYRIA

About 1400 BCE, a people called the Assyrians rose to dominance in northern Mesopotamia. After about 1000 BCE, they began to conquer neighboring regions. By the end of the ninth century BCE, the Assyrians controlled most of Mesopotamia, and by the early seventh century BCE they had extended their influence as far west as Egypt. Soon afterward they succumbed to internal weakness and external enemies, and by 600 BCE their empire had collapsed.

Assyrian rulers built huge palaces atop high platforms inside a series of fortified cities that served at one time or another as Assyrian capitals. They decorated these palaces with shallow stone reliefs of battle and hunting scenes, of Assyrian victories, of presentations of tribute to the king, and of religious imagery.

KALHU

During his reign (883–859 BCE), Assurnasirpal II established his capital at Kalhu (present-day Nimrud, Iraq), on the east bank of the Tigris River, and

ART AND ITS CONTEXTS | The Code of Hammurabi

Babylonian ruler Hammurabi's systematic codification of his people's rights, duties, and punishments for wrongdoing was engraved on a black basalt slab known as the **STELE OF HAMMURABI** (Fig. 2–15). This imposing artifact, therefore, is both a work of art that depicts a legendary event and a precious historical document that records a conversation about justice between god and man.

At the top of the stele, we see Hammurabi standing in an attitude of prayer before Shamash, the sun god and god of justice. Rays rise from Shamash's shoulders as he sits, crowned by a conical horned cap, on a backless throne, holding additional symbols of his power—the measuring rod and the rope circle. Shamash gives the law to the king, his intermediary, and the codes of justice flow forth underneath them in horizontal bands of exquisitely engraved cuneiform signs. The idea of god-given laws engraved on stone tablets will have a long tradition in the ancient Near East. About 500 years later, Moses, the lawgiver of Israel, received two stone tablets containing the Ten Commandments from God on Mount Sinai (Exodus 32:19).

A prologue on the front of the stele lists the temples Hammurabi has restored, and an epilogue on the back glorifies him as a peacemaker, but most of the stele "publishes" the laws themselves, guaranteeing uniform treatment of people throughout his kingdom. Within the inscription, Hammurabi declares that he intends "to cause justice to prevail in the land and to destroy the wicked and the evil, that the strong might not oppress the weak nor the weak the strong." Most of the 300 or so entries that follow deal with commercial and property matters. Only 68 relate to domestic problems, and a mere 20 deal with physical assault.

Punishments are based on the wealth, class, and gender of the parties—the rights of the wealthy are favored over the poor, citizens over slaves, men over women. Most famous are instances when punishments are specifically tailored to fit crimes—an eye for an eye, a tooth for a tooth, a broken bone for a broken bone. The death penalty is decreed for crimes such as stealing from a temple or palace, helping a slave to escape, or insubordination in the army. Trial by water and fire could also be imposed, as when an adulterous woman and her lover were to be thrown into the water; if they did not drown, they were deemed innocent. Although some of the punishments may seem excessive today, Hammurabi was breaking new ground by regulating laws and punishments rather than leaving them to the whims of rulers or officials.

2-15 • STELE OF HAMMURABI

Probably from Sippar; found at Susa (present-day Shush, Iran). c. 1792–1750 BCE. Basalt, height of stele approx. 7'4" (2.25 m); height of figural relief 28" (71.1 cm). Musée du Louvre, Paris.

Read the document related to the code of Hammurabi on myartslab.com

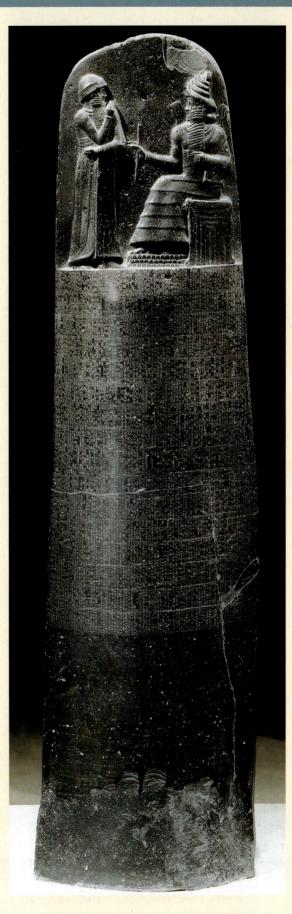

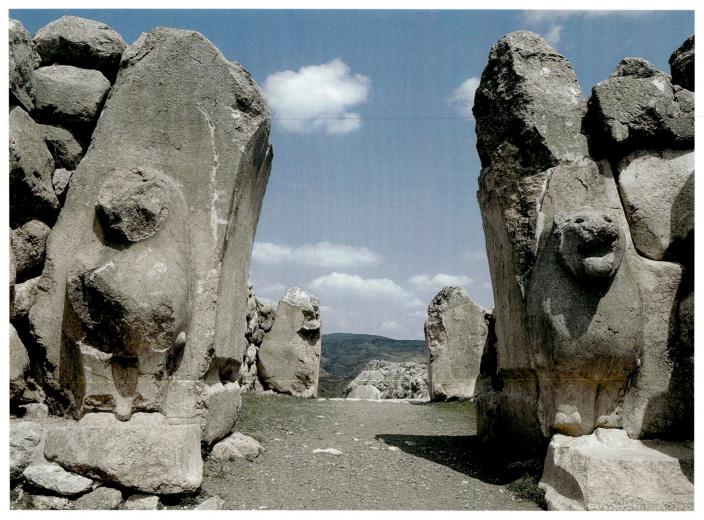

2-16 • LION GATE Hattusha (near present-day Boghazkoy, Turkey). c. 1400 BCE. Limestone.

undertook an ambitious building program. His architects fortified the city with mud-brick walls 5 miles long and 42 feet high, and his engineers constructed a canal that irrigated fields and provided water for the expanded population of the city. According to an inscription commemorating the event, Assurnasirpal gave a banquet for 69,574 people to celebrate the dedication of the new capital in 863 BCE.

Most of the buildings in Kalhu were made from mud bricks, but limestone and alabaster—more impressive and durable were used to veneer walls with architectural decoration. Colossal guardian figures flanked the major **portals** (grand entrances, often decorated), and panels covered the walls with scenes in **low relief** (sculpted relief with figures that project only slightly from a recessed background) of the king participating in religious rituals, war campaigns, and hunting expeditions.

THE LION HUNT In a vivid lion-hunting scene (**FIG. 2-17**), Assurnasirpal II stands in a chariot pulled by galloping horses and draws his bow against an attacking lion, advancing from the rear with arrows already protruding from its body. Another expiring beast collapses on the ground under the horses. This was probably a ceremonial hunt, in which the king, protected by men with swords and shields, rode back and forth killing animals as they were released one by one into an enclosed area. The immediacy of this image marks a shift in Mesopotamian art, away from a sense of timeless solemnity, and toward a more dramatic, even emotional, involvement with the event portrayed.

ENEMIES CROSSING THE EUPHRATES TO ESCAPE ASSYRIAN ARCHERS In another palace relief, the scene shifts from royal ceremony to the heat of battle, set within a detailed landscape (see "A Closer Look," page 42). Three of the Assyrians' energies—two using flotation devices made of inflated animal skins—swim across a raging river, retreating from a vanguard of Assyrian archers who kneel at its banks to launch their assault. The scene evokes a specific event from 878 BCE described in the annals of Assurnasirpal. As the Assyrian king overtook the army of an enemy leader named Kudurru near the modern town of Anu, both leader and soldiers escaped into the Euphrates River in an attempt to save their lives.

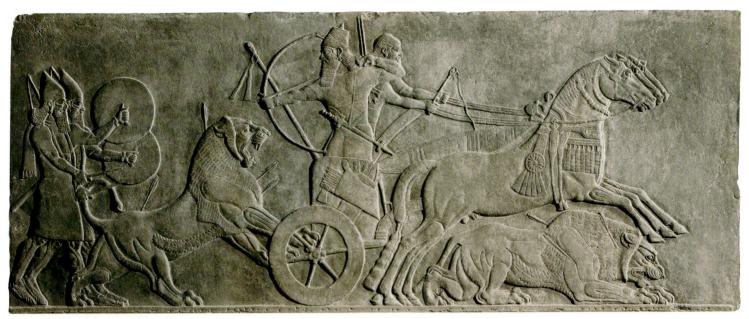

2-17 • ASSURNASIRPAL II KILLING LIONS From the palace complex of Assurnasirpal II, Kalhu (present-day Nimrud, Iraq). c. 875–860 BCE. Alabaster, height approx. 39" (99.1 cm). British Museum, London.

DUR SHARRUKIN

Sargon II (ruled 721–706 BCE) built a new Assyrian capital at Dur Sharrukin (present-day Khorsabad, Iraq). On the northwest side of the capital, a walled citadel, or fortress, straddled the city wall (**FIG. 2-18**). Within the citadel, Sargon's **palace complex** (the group of buildings where the ruler governed and resided) stood on a raised, fortified platform about 40 feet high—demonstrating the use of art as political propaganda.

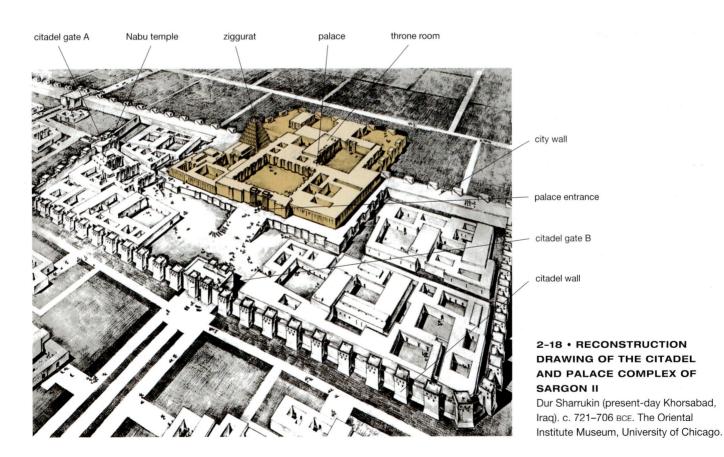

A CLOSER LOOK | Enemies Crossing the Euphrates to Escape Assyrian Archers

Palace complex of Assurnasirpal II, Kalhu (present-day Nimrud, Iraq). c. 875–860 BCE. Alabaster, height approx. 39" (99.1 cm). British Museum, London.

These Assyrian archers are outfitted in typical fashion, with protective boots, short "kilts," pointed helmets, and swords, as well as bows and quivers of arrows. Their smaller scale conveys a sense of depth and spatial positioning in this relief, reinforced by the size and placement of the trees. The detailed landscape setting documents the swirling water of the river, its rocky banks, and the airy environment of the trees, one of which is clearly described as a palm. The oblique line of the river bank and the overlapping of the swimmers convey a sense of depth receding from the picture plane into pictorial space. If this is the ruler of the enemy citadel, he seems shocked into powerlessness by the Assyrian invasion. Note the contrast between his lax weapon and those deployed by the archers of the Assyrian vanguard.

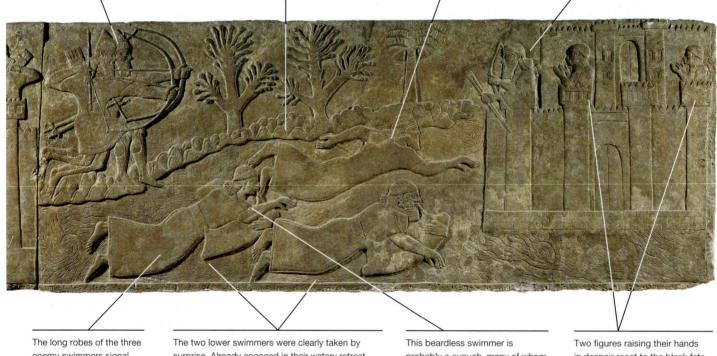

enemy swimmers signal their high status. They are not ordinary foot soldiers. The two lower swimmers were clearly taken by surprise. Already engaged in their watery retreat, they are still blowing through "tubes" to inflate their flotation devices, made from sewn animal skins. This beardless swimmer is probably a eunuch, many of whom served as high officials in ancient Near Eastern courts. Two figures raising their hands in despair react to the bleak fate of their arrow-riddled comrades attempting to swim to safety.

View the Closer Look for Enemies Crossing the Euphrates to Escape Assyrian Archers on myartslab.com

Guarded by two towers, the palace complex was accessible only by a wide ramp leading up from an open square, around which the residences of important government and religious officials were clustered. Beyond the ramp was the main courtyard, with service buildings on the right and temples on the left. The heart of the palace, protected by a reinforced wall with only two small, off-center doors, lay past the main courtyard. Within the inner compound was a second courtyard lined with narrative relief panels showing tribute bearers. Visitors would have waited to see the king in this courtyard that functioned as an open-air audience hall; once granted access to the royal throne room, they would have passed through a stone gate flanked, like the other gates of citadel and palace (**Fig. 2-19**), by awesome guardian figures. These colossal beings, known as **lamassus**, combined the bearded head of a man, the powerful body of a lion or bull, the wings of an eagle, and the horned headdress of a god.

In an open space between the palace complex and temple complex at Dur Sharrukin rose a ziggurat declaring the might of Assyria's kings and symbolizing their claim to empire. It probably had seven levels, each about 18 feet high and painted a different color (see FIG. 2-18). The four levels still remaining were once white, black, blue, and red. Instead of separate flights of stairs between the levels, a single, squared-off spiral ramp rose continuously around the exterior from the base.

NINEVEH

Assurbanipal (ruled 669-c. 627 BCE), king of the Assyrians three generations after Sargon II, maintained his capital at Nineveh.

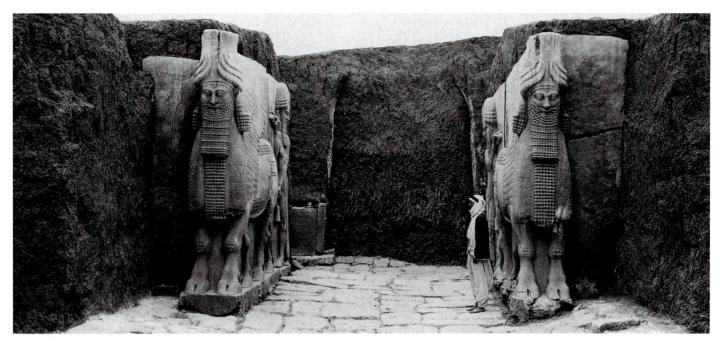

2-19 • GUARDIAN FIGURES AT GATE A OF THE CITADEL OF SARGON II DURING ITS EXCAVATION IN THE 1840S

Dur Sharrukin (present-day Khorsabad, Iraq). c. 721-706 BCE.

Like that of Assurnasirpal II two centuries earlier, his palace was decorated with alabaster panels carved with pictorial narratives in low relief. Most show Assurbanipal and his subjects in battle or hunting, but there are occasional scenes of palace life.

An unusually peaceful example shows the king and queen relaxing in a pleasure garden (**FIG. 2-20**). The king reclines on a couch, and the queen sits in a chair at his feet, while a musician at far left plays diverting music. Three servants arrive from the left with trays of food, while others wave whisks to protect the royal couple from insects. The king has taken off his rich necklace and hung it on his couch, and he has laid aside his weapons—sword, bow, and quiver of arrows—on the table behind him, but this apparently tranquil domestic scene is actually a victory celebration. A grisly trophy, the severed head of his vanquished enemy, hangs upside down from a tree at the far left.

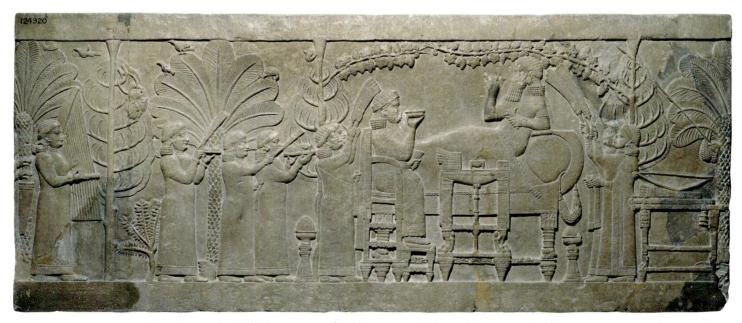

2-20 • ASSURBANIPAL AND HIS QUEEN IN THE GARDEN From the palace at Nineveh (present-day Ninua, Iraq). c. 647 BCE. Alabaster, height approx. 21" (53.3 cm). British Museum, London.

NEO-BABYLONIA

At the end of the seventh century BCE, Assyria was invaded by the Medes, a people from western Iran who were allied with the Babylonians and the Scythians, a nomadic people from northern Asia (present-day Russia and Ukraine). In 612 BCE, the Medes' army captured Nineveh. When the dust had settled, Assyria was no more and the Neo-Babylonians—so named because they recaptured the splendor that had marked Babylon 12 centuries earlier under Hammurabi—controlled a region that stretched from modern Turkey to northern Arabia and from Mesopotamia to the Mediterranean Sea.

The most famous Neo-Babylonian ruler was Nebuchadnezzar II (ruled 605–562 BCE), notorious today for his suppression of the Jews, as recorded in the book of Daniel in the Hebrew Bible, where he may have been confused with the final Neo-Babylonian ruler, Nabonidus. A great patron of architecture, Nebuchadnezzar II built temples dedicated to the Babylonian gods throughout his realm, and transformed Babylon—the cultural, political, and economic hub of his empire—into one of the most splendid cities of its day.

Babylon straddled the Euphrates River, its two sections joined by a bridge. The older, eastern sector was traversed by the Processional Way, the route taken by religious processions honoring the city's patron god, Marduk (FIG. 2-21). This street, paved with large stone slabs set in a bed of bitumen, was up to 66 feet wide at some points. It ran from the Euphrates bridge, through the temple district and palaces, and finally through the Ishtar Gate, the ceremonial entrance to the city. The Ishtar Gate's four crenellated towers (crenellations are notched walls for military defense) symbolized Babylonian power (FIG. 2-22). Beyond the Ishtar Gate, walls on either side of the route-like the gate itself-were faced with dark blue glazed bricks. The glazed bricks consisted of a film of colored glass adhering to the surface of the bricks after firing, a process used since about 1600 BCE. Against that blue background, specially molded turquoise, blue, and gold-colored bricks formed images of striding lions, mascots of the goddess Ishtar as well as the

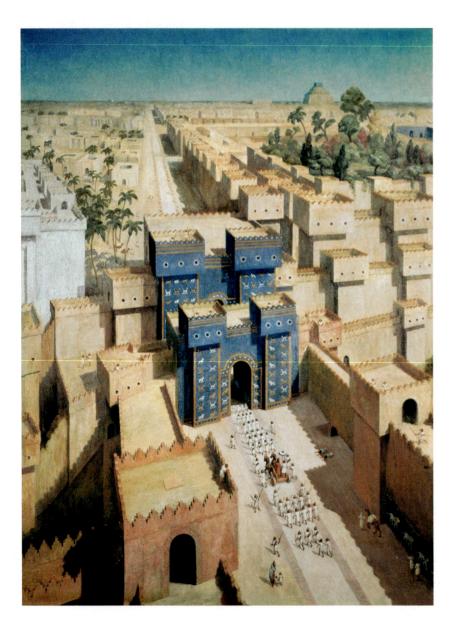

dragons that were associated with Marduk.

PERSIA

In the sixth century BCE, the Persians, a formerly nomadic, Indo-European-speaking people, began to seize power in Mesopotamia. From the region of Parsa, or Persis (present-day Fars, Iran), they established a vast empire. The rulers of this new empire traced their ancestry to a semilegendary Persian king named Achaemenes, and consequently they are known as the Achaemenids.

The dramatic expansion of the Achaemenids began in 559 BCE with the ascension of a remarkable leader, Cyrus II (Cyrus the Great, ruled 559–530 BCE). By the time of his death, the Persian Empire included Babylonia, Media (which stretched across present-day northern Iran through Anatolia), and some of the Aegean islands far to the west. Only the Greeks stood fast against them (see Chapter 5). When Darius I (ruled 521–486 BCE) took the throne, he could

2-21 • RECONSTRUCTION DRAWING OF BABYLON IN THE 6TH CENTURY BCE

The Oriental Institute Museum, University of Chicago.

The palace of Nebuchadnezzar II, with its famous Hanging Gardens, can be seen just behind and to the right of the Ishtar Gate, west of the Processional Way. The Marduk Ziggurat looms in the far distance on the east bank of the Euphrates.

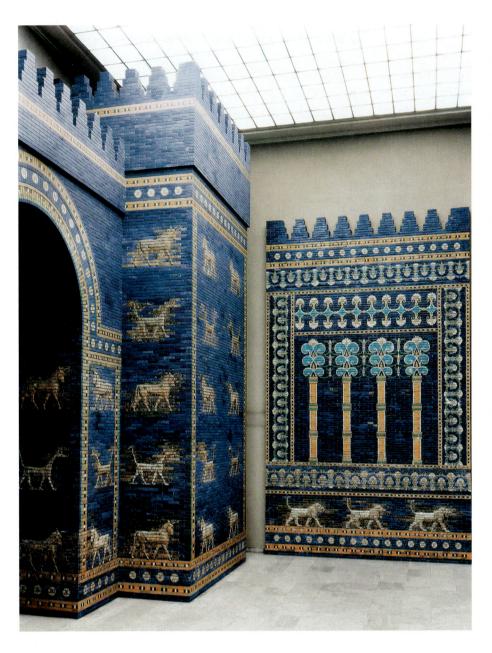

proclaim: "I am Darius, great King, King of Kings, King of countries, King of this earth."

An able administrator, Darius organized the Persian lands into 20 tribute-paying areas under Persian governors. He often left local rulers in place beneath the governors. This practice, along with a tolerance for diverse native customs and religions, won the Persians the loyalty of large numbers of their subjects. Like many powerful rulers, Darius created palaces and citadels as visible symbols of his authority. He made Susa his first capital and commissioned a 32-acre administrative compound to be built there.

In about 515 BCE, Darius began construction of Parsa, a new capital in the Persian homeland, today known by its Greek name: **PERSEPOLIS**. It is one of the best-preserved and most impressive ancient sites in the Near East (**FIG. 2-23**). Darius imported materials, workers, and artists from all over his empire. He even ordered work to be executed in Egypt and transported to his capital. The

2-22 • ISHTAR GATE AND THRONE ROOM WALL

Reconstruction; originally from Babylon (present-day Babil, Iraq). c. 575 BCE. Glazed brick, height of gate originally 40' (12.2 m) with towers rising 100' (30.5 m). Vorderasiatisches Museum, Staatliche Museen zu Berlin, Preussischer Kulturbesitz.

The Ishtar Gate is decorated with tiers of dragons (with the head and body of a snake, the forelegs of a lion, and the hind legs of a bird of prey) that were sacred to Marduk, with bulls associated with Adad, the storm god, and with lions associated with Ishtar. Now reconstructed in a Berlin museum, it is installed next to a panel from the throne room in Nebuchadnezzar's nearby palace, in which lions walk beneath stylized palm trees.

result was a new multicultural style of art that combined many different traditions— Persian, Median, Mesopotamian, Egyptian, and Greek.

In Assyrian fashion, the imperial complex at Persepolis was set on a raised platform, 40 feet high and measuring 1,500 by 900 feet, accessible only via a single approach made of wide, shallow steps that could be ascended on horseback. Like Egyptian and Greek cities, it was laid out on a rectangular grid. Darius lived to see the completion only of a treasury, the Apadana (audience hall), and a very small palace for himself. The **APADANA**, set above the rest of the complex on a second terrace (**FIG. 2-24**), had open porches on three sides and

a square hall large enough to hold several thousand people. Darius's son Xerxes I (ruled 485–465 BCE) added a sprawling palace complex for himself, enlarged the treasury building, and began a vast new public reception space, the Hall of 100 Columns.

The central stair of Darius's Apadana displays reliefs of animal combat, tiered ranks of royal guards (the "10,000 Immortals"), and delegations of tribute-bearers. Here, lions attack bulls on either side of the Persian generals. Such animal combats (a theme found throughout the Near East) emphasize the ferocity of the leaders and their men. Ranks of warriors cover the walls with repeated patterns and seem ready to defend the palace. The elegant drawing, balanced composition, and sleek modeling of figures reflect the Persians' knowledge of Greek art and perhaps the use of Greek artists. Other reliefs throughout Persepolis depict displays of allegiance or economic prosperity. In one example, once the centerpiece, Darius holds an audience while his son and heir, Xerxes,

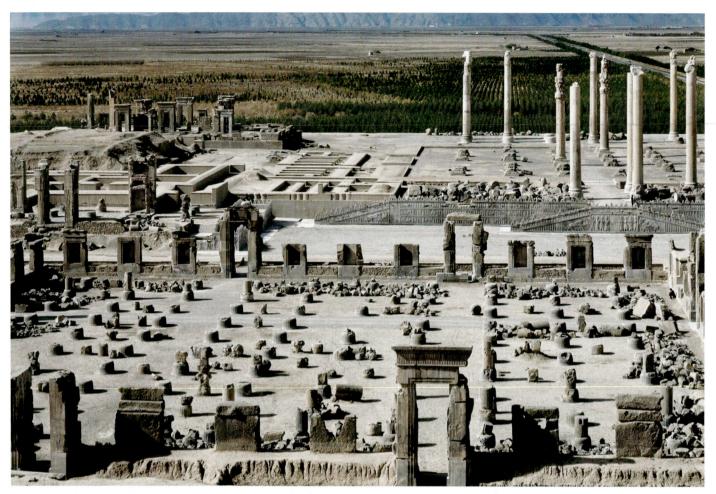

2-23 • AERIAL VIEW OF THE CEREMONIAL COMPLEX, PERSEPOLIS Iran. 518-c. 460 BCE.

• Watch a video about Persepolis on myartslab.com

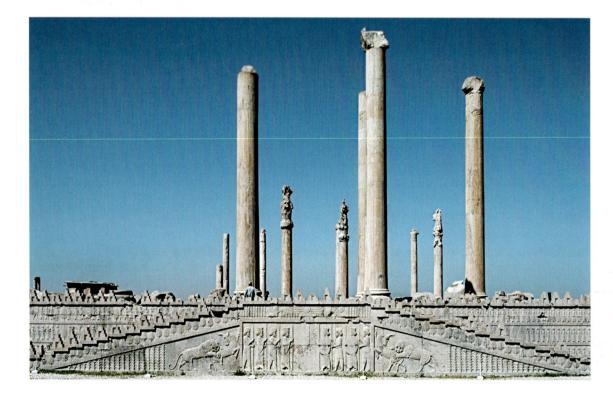

2-24 • APADANA (AUDIENCE HALL) OF DARIUS AND XERXES Ceremonial Complex, Persepolis, Iran. 518–c. 460 BCE.

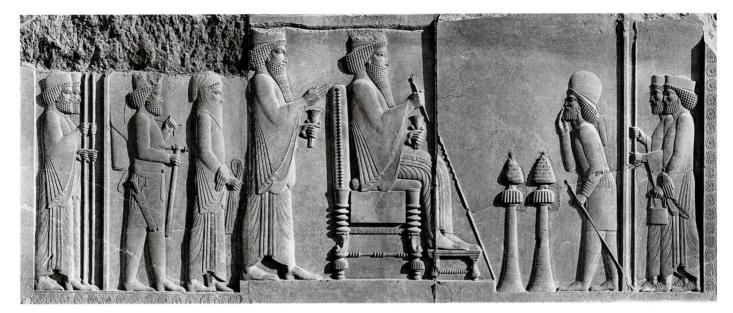

2-25 • DARIUS AND XERXES RECEIVING TRIBUTE Detail of a relief from the stairway leading to the Apadana, Persepolis, Iran. 491–486 BCE. Limestone, height 8'4" (2.54 m). Courtesy the Oriental Institute of the University of Chicago.

• Watch a video about the process of sculpting in relief on myartslab.com

listens from behind the throne (**FIG. 2-25**). Such panels would have looked quite different when they were freshly painted in bright colors, with metal objects such as Darius's crown and neck-lace covered in **gold leaf** (sheets of hammered gold).

At its height, the Persian Empire extended from Africa to India. From Persepolis, Darius in 490 BCE and Xerxes in 480 BCE sent their armies west to conquer Greece, but mainland Greeks successfully resisted the armies of the Achaemenids, preventing them from advancing into Europe. Indeed, it was a Greek who ultimately put an end to their empire. In 334 BCE, Alexander the Great of Macedonia (d. 323 BCE) crossed into Anatolia and swept through Mesopotamia, defeating Darius III and nearly destroying Persepolis in 330 BCE. Although the Achaemenid Empire was at an end, Persia eventually revived, and the Persian style in art continued to influence Greek artists (see Chapter 5) and ultimately became one of the foundations of Islamic art (see Chapter 9).

THINK ABOUT IT

- 2.1 Describe and characterize the way human figures are represented in the Sumerian votive figures of Eshnunna. What are the potential relationships between style and function?
- 2.2 Discuss the development of relief sculpture in the ancient Near East. Choose two specific examples, one from the Sumerian period and one from the Assyrian period, and explain how symbols and stories are combined to express ideas that were important to these two cultures.
- 2.3 Select two rulers discussed in this chapter and explain how each preserved his legacy through commissioned works of art and/or architecture.
- **2.4** How did the excavations of Sir Leonard Woolley contribute to our understanding of the art of the ancient Near East?

CROSSCURRENTS

FIG. 2–10

FIG. 2–20

Study and review on myartslab.com

Both of these works depict a social gathering involving food and drink, but they are vastly different in scale, materials, and physical context. How do the factors of scale and materials contribute to the visual appearance of the scenes? How does physical context and audience affect the meaning of what is portrayed?

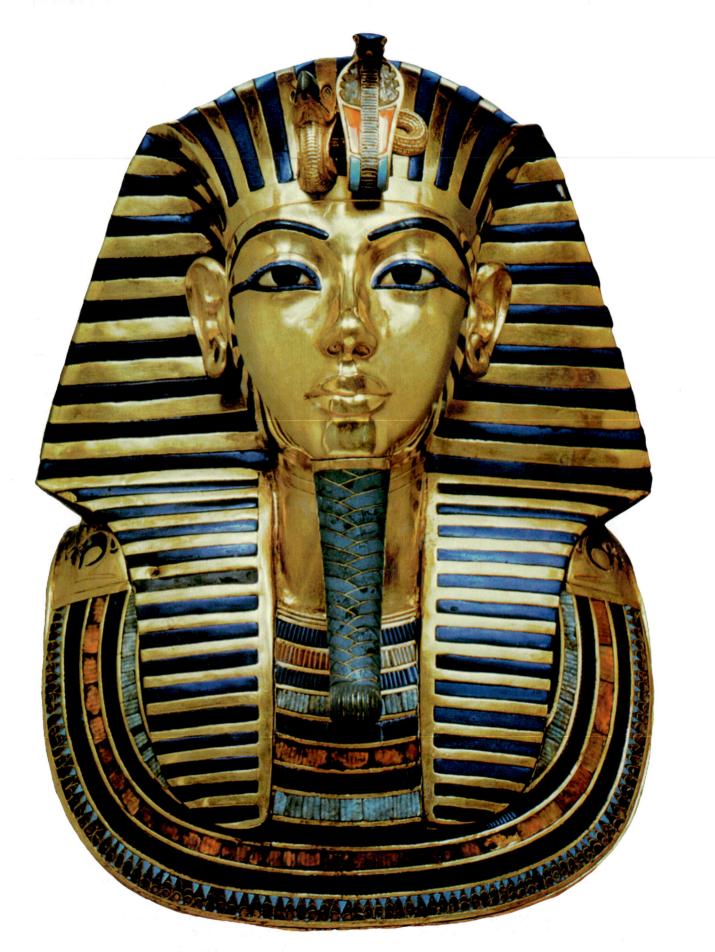

3-1 • FUNERARY MASK OF TUTANKHAMUN

From the tomb of Tutankhamun, Valley of the Kings. Eighteenth Dynasty (Tutankhamun, r. c. 1332–1322 BCE), c. 1327 BCE. Gold inlaid with glass and semiprecious stones, height 21¹/₄" (54.5 cm), weight 24 pounds (11 kg). Egyptian Museum, Cairo. (JE 60672)

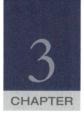

On February 16, 1923, The Times of London cabled the New York Times with dramatic news of a discovery: "This has been, perhaps, the most extraordinary day in the whole history of Egyptian excavation The entrance today was made into the sealed chamber of [Tutankhamun's] tomb ... and yet another door opened beyond that. No eyes have seen the King, but to practical certainty we know that he lies there close at hand in all his original state, undisturbed." And indeed he did. A collar of dried flowers and beads covered the chest, and a linen shroud was draped around the head. A gold FUNERARY MASK (FIG. 3-1) had been placed over the head and shoulders of his mummified body, which was enclosed in three nested coffins, the innermost made of gold (see FIG. 3-29, and page 73). The coffins were placed in a yellow quartzite sarcophagus (stone coffin) that was itself encased within gilt wooden shrines nested inside one another.

The discoverer of this treasure, the English archaeologist Howard Carter, had worked in Egypt for more than 20 years before he undertook a last expedition, sponsored by the wealthy British amateur Egyptologist Lord Carnarvon. Carter was convinced that the tomb of Tutankhamun, one of the last Eighteenth-Dynasty royal burial places still unidentified, lay hidden in the Valley of the Kings. After 15 years of

Art of Ancient Egypt

digging, on November 4, 1922, he unearthed the entrance to Tutankhamun's tomb and found unbelievable treasures in the antechamber: jewelry, textiles, gold-covered furniture, a carved and inlaid throne, four gold chariots. In February 1923, Carter pierced the wall separating the anteroom from the actual burial chamber and found the greatest treasure of all, Tutankhamun himself.

Since ancient times, tombs have tempted looters; more recently, they also have attracted archaeologists and historians. The first large-scale "archaeological" expedition in history landed in Egypt with the armies of Napoleon in 1798. The French commander must have realized that he would find great wonders there, for he took French scholars with him to study ancient sites. The military adventure ended in failure, but the scholars eventually published richly illustrated volumes of their findings, unleashing a craze for all things Egyptian that has not dimmed since. In 1976, the first blockbuster museum exhibition was born when treasures from the tomb of Tutankhamun began a tour of the United States and attracted over 8 million visitors. Most recently, in 2006, Otto Schaden excavated a tomb containing seven coffins in the Valley of the Kings, the first tomb to be found there since Tutankhamun's in 1922.

LEARN ABOUT IT

- 3.1 Explore the pictorial conventions for representing the human figure in ancient Egyptian art, established early on and maintained for millennia.
- **3.2** Analyze how religious beliefs were reflected in the funerary art and architecture of ancient Egypt.
- **3.3** Examine the relationship of royal ancient Egyptian art to the fortunes and aspirations of the rulers who commissioned it.
- **3.4** Understand and characterize the major transformation of ancient Egyptian art and convention under the revolutionary rule of Akhenaten.

((•• Listen to the chapter audio on myartslab.com

THE GIFT OF THE NILE

The Greek traveler and historian Herodotus, writing in the fifth century BCE, remarked, "Egypt is the gift of the Nile." This great river, the longest in the world, winds northward from equatorial Africa and flows through Egypt in a relatively straight line to the Mediterranean (MAP 3-1). There it forms a broad delta before emptying into the sea. Before it was dammed in 1970 by the Aswan High Dam, the lower (northern) Nile, swollen with the runoff of heavy seasonal rains in the south, overflowed its banks for several months each year. Every time the floodwaters receded, they left behind a new layer of rich silt, making the valley and delta a continually fertile and attractive habitat.

By about 8000 BCE, the valley's inhabitants had become relatively sedentary, living off the abundant fish, game, and wild plants. Not until about 5000 BCE did they adopt the agricultural village life associated with Neolithic culture (see Chapter 1). At that time, the climate of north Africa grew increasingly dry. To ensure adequate resources for agriculture, the farmers along the Nile began to manage flood waters in a system called basin irrigation.

The Predynastic period, from roughly 5000 to 2950 BCE, was a time of significant social and political transition that preceded the unification of Egypt under a single ruler. (After unification, Egypt was ruled by a series of family dynasties and is therefore characterized as "dynastic.") Rudimentary federations emerged and began conquering and absorbing weaker communities. By about 3500 BCE, there were several larger states, or chiefdoms, in the lower Nile Valley and a centralized form of leadership had emerged. Rulers were expected to protect their subjects, not only from outside aggression, but also from natural catastrophes such as droughts and insect plagues.

The surviving art of the Predynastic period consists chiefly of ceramic figurines, decorated pottery, and reliefs carved on stone plaques and pieces of ivory. A few examples of wall painting—lively scenes filled with small figures of people and animals—were found in a tomb at Hierakonpolis, in Upper Egypt, a Predynastic town of mud-brick houses that was once home to as many as 10,000 people.

EARLY DYNASTIC EGYPT, c. 2950–2575 BCE

Around 3000 BCE, Egypt became a consolidated state. According to legend, the country had previously evolved into two major kingdoms—the Two Lands—Upper Egypt in the south (upstream on the Nile) and Lower Egypt in the north (downstream). But a powerful ruler from Upper Egypt conquered Lower Egypt and unified the two kingdoms. In the art of the subsequent Early Dynastic period we see the development of fundamental and enduring ideas about kingship and the cosmic order. Since the works of art and architecture that survive from ancient Egypt come mainly from

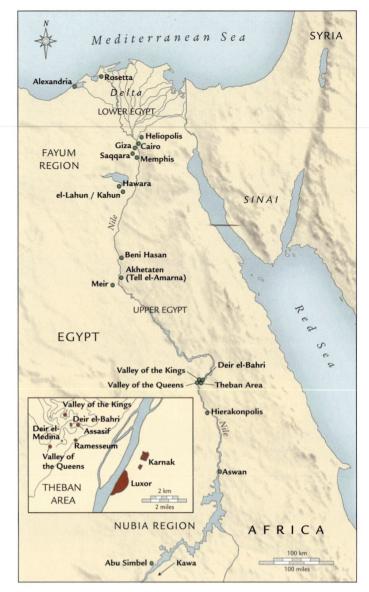

MAP 3-1 • ANCIENT EGYPT

Upper Egypt is below Lower Egypt on this map because the designations "upper" and "lower" refer to the directional flow of the Nile, not to our conventions for south and north in drawing maps. The two kingdoms were united c. 3000 BCE, just before the Early Dynastic period.

tombs and temples—the majority of which were located in secure places and built with the most durable materials—most of what we now know about the ancient art of Egypt is rooted in religious beliefs and practices.

THE GOD-KINGS

The Greek historian Herodotus thought the Egyptians were the most religious people he had ever encountered. In their worldview, the movements of heavenly bodies, the workings of gods, and the humblest of human activities were all believed to be part of a balanced and harmonious grand design. Death was to be feared only by those who lived in such a way as to disrupt that harmony. Upright souls could be confident that their spirits would live on eternally.

ART AND ITS CONTEXTS | Egyptian Symbols

Three crowns symbolize kingship in early Egyptian art: the tall, clublike white crown of Upper Egypt (sometimes adorned with two plumes); the flat or scooped red cap with projecting spiral of Lower Egypt; and the double crown representing unified Egypt.

A striped gold and blue linen head cloth, known as the **nemes headdress**, having a cobra and a vulture at the center front, was also commonly used as royal headgear. The upright form of the cobra, known as the *uraeus*, represents the goddess Wadjet of Lower Egypt and is often included in king's crowns as well (see FIG. 3–1). The queen's crown included the feathered skin of the vulture goddess Nekhbet of Upper Egypt.

The god Horus, king of the earth and a force for good, is represented as a falcon or falcon-headed man. His eyes symbolize the sun and moon; the solar eye is called the *wedjat*. The looped cross, called the **ankh**, is symbolic of everlasting life. The **scarab** beetle (*khepri*, meaning "he who created himself") was associated with creation, resurrection, and the rising sun.

By the Early Dynastic period, Egypt's kings were revered as gods in human form. A royal jubilee, the *heb sed* or *sed* festival, held in the thirtieth year of the living king's reign, renewed and reaffirmed his divine power, and when they died, kings rejoined their father, the sun god Ra, and rode with him in the solar boat as it made its daily journey across the sky.

In order to please the gods and ensure their continuing goodwill toward the state, kings built splendid temples and provided priests to maintain them. The priests saw to it that statues of the gods, placed deep in the innermost rooms of the temples, were never without fresh food and clothing. Egyptian gods and goddesses were depicted in various forms, some as human beings, others as animals, and still others as humans with animal heads. For example, Osiris, the overseer of the realm of the dead, regularly appears in human form wrapped in linen as a mummy. His son, the sky god Horus, is usually depicted as a falcon or falcon-headed man (see "Egyptian Symbols," above).

Over the course of ancient Egyptian history, Amun (chief god of Thebes, represented as blue and wearing a plumed crown), Ra (of Heliopolis), and Ptah (of Memphis) became the primary national gods. Other gods and their manifestations included Thoth (ibis), god of writing, science, and law; Ma'at (feather), goddess of truth, order, and justice; <u>Anubis (jackal)</u>, god of embalming and cemeteries; and Bastet (cat), daughter of Ra.

ARTISTIC CONVENTIONS

Conventions in art are established ways of representing things, widely accepted by artists and patrons at a particular time and place. Egyptian artists followed a set of fairly strict conventions, often based on conceptual principles rather than on the observation of the natural world with an eye to rendering it in lifelike fashion. Eventually a system of mathematical formulas was developed to determine design and proportions (see "Egyptian Pictorial Relief," page 64). The underlying conventions that govern ancient Egyptian art appear early, however, and are maintained, with subtle but significant variations, over almost three millennia of its history.

THE NARMER PALETTE This historically and artistically significant work of art (see "A Closer Look," page 52) dates from the Early Dynastic period and was found in the temple of Horus at Hierakonpolis. It is commonly interpreted as representing the unification of Egypt and the beginning of the country's growth as a powerful nation-state. It employs many of the

A CLOSER LOOK | The Palette of Narmer

From Hierakonpolis. Early Dynastic period, c. 2950 BCE. Green schist, height 25" (64 cm). Egyptian Museum, Cairo. (JE 32169 = CG 14716)

This figure, named by hieroglyphic inscription and standing on his own ground-line, holds the king's sandals. Narmer is barefoot because he is standing on sacred ground, performing sacred acts. The same sandal-bearer, likewise labeled, follows Narmer on the other side of the palette. Phonetic **hieroglyphs** centered at the top of each side of the palette name the king: a horizontal fish (*nar*) above a vertical chisel (*mer*). A depiction of the royal palace—seen simultaneously from above, as a groundplan, and frontally, as a **façade** (front wall of a building)—surrounds Narmer's name to signify that he is king.

Narmer here wears the red crown of Lower Egypt and is identified by the hieroglyph label next to his head, as well by as his larger size in relation to the other figures (hierarchic scale). The royal procession inspects two rows of decapitated enemies, their heads neatly tucked between their feet.

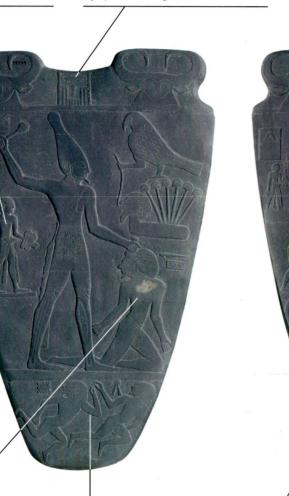

Narmer attacks a figure of comparable size, also identified by a hieroglyphic label, indicating that he is an enemy of real importance, likely the ruler of Lower Egypt.

Next to the heads of these two defeated enemies are, on the left, an aerial depiction of a fortified city, and on the right, a gazelle trap, perhaps emblems of Narmer's dominion over both city and countryside. A bull symbolizing the might of the king—he wears a bull's tail on both sides of the palette tramples another enemy in front of a fortified city. Palettes were tablets with circular depressions where eye makeup was ground and prepared. Although this example was undoubtedly ceremonial rather than functional, a mixing saucer is framed by the elongated, intertwined necks of lions, perhaps signifying the union of Upper and Lower Egypt.

Q—**[View** the Closer Look for the Palette of Narmer on myartslab.com

representational conventions that would dominate royal Egyptian art from this point on.

On the reverse side of the palette, as in the stele of Naram-Sin (see FIG. 2–1), hierarchic scale signals the importance of Narmer by

showing him overwhelmingly larger than the other human figures around him. He is also boldly silhouetted against a blank ground, just like Naram-Sin, distancing details of setting and story so they will not distract from his pre-eminence. He wears the white crown

TECHNIQUE | Preserving the Dead

Egyptians developed mummification techniques to ensure that the *ka*, soul or life force, could live on in the body in the afterlife. No recipes for preserving the dead have been found, but the basic process seems clear enough from images found in tombs, the descriptions of later Greek writers such as Herodotus and Plutarch, scientific analysis of mummies, and modern experiments.

By the time of the New Kingdom, the routine was roughly as follows: The body was taken to a mortuary, a special structure used exclusively for embalming. Under the supervision of a priest, workers removed the brains, generally through the nose, and emptied the body cavity—except for the heart—through an incision in the left side. They then covered the body with dry natron, a naturally occurring salt, and placed it on a sloping surface to allow liquids to drain. This preservative caused the skin to blacken, so workers often used paint or powdered makeup to restore some color, using red ocher for a man, yellow ocher for a woman. They then packed the body cavity with clean linen soaked in various herbs and ointments, provided by the family of the deceased. The major organs were wrapped in separate packets and stored in special containers called **canopic jars**, to be placed in the tomb chamber.

Workers next wound the trunk and each of the limbs separately with cloth strips, before wrapping the whole body in additional layers of cloth to produce the familiar mummy shape. The workers often inserted charms and other smaller objects among the wrappings.

of Upper Egypt while striking the enemy who kneels before him with a mace. Above this foe, the god Horus—depicted as a falcon with a human hand—holds a rope tied around the neck of a man whose head is attached to a block sprouting stylized papyrus, a plant that grew in profusion along the Nile and symbolized Lower Egypt. This combination of symbols made the central message clear: Narmer, as ruler of Upper Egypt, is in firm control of Lower Egypt.

Many of the figures on the palette are shown in composite poses, so that each part of the body is portrayed from its most characteristic viewpoint. Heads are shown in profile, to capture most clearly the nose, forehead, and chin, while eyes are rendered frontally, from their most recognizable and expressive viewpoint. Hips, legs, and feet are drawn in profile, and the figure is usually striding, to reveal both legs. The torso, however, is fully frontal. This artistic convention for representing the human figure as a conceptualized composite of multiple viewpoints was to be followed for millennia in Egypt when depicting royalty and other dignitaries. Persons of lesser social rank engaged in active tasks (compare the figure of Narmer with those of his standard-bearers) tend to be represented in ways that seem to us more lifelike.

FUNERARY ARCHITECTURE

Ancient Egyptians believed that an essential part of every human personality is its life force, or soul, called the *ka*, which lived on after the death of the body, forever engaged in the activities it had enjoyed in its former existence. But the *ka* needed a body to live in, either the mummified body of the deceased or, as a substitute, a sculpted likeness in the form of a statue. The Egyptians developed elaborate funerary practices to ensure that their deceased moved safely and effectively into the afterlife.

It was especially important to provide a comfortable home for the ka of a departed king, so that even in the afterlife he would continue to ensure the well-being of Egypt. Egyptians preserved the bodies of the royal dead with care and placed them in burial chambers filled with sculpted body substitutes and all the supplies and furnishings the *ka* might require throughout eternity (see "Preserving the Dead," above).

MASTABA AND NECROPOLIS In Early Dynastic Egypt, the most common tomb structure—used by the upper level of society, the king's family and relatives—was the **mastaba**, a flat-topped, one-story building with slanted walls erected above an underground burial chamber (see "Mastaba to Pyramid," page 55). Mastabas were at first constructed of mud brick, but toward the end of the Third Dynasty (c. 2650–2575 BCE), many incorporated cut stone, at least as an exterior facing.

In its simplest form, the mastaba contained a **serdab**, a small, sealed room housing the *ka* statue of the deceased, and a chapel designed to receive mourning relatives and offerings. A vertical shaft dropped from the top of the mastaba down to the actual burial chamber, where the remains of the deceased reposed in a coffin—at times placed within a larger stone sarcophagus—surrounded by appropriate grave goods. This chamber was sealed off after interment. Mastabas might have numerous underground burial chambers to accommodate whole families, and mastaba burial remained the standard for Egyptian elites for centuries.

Mastabas tended to be grouped together in a **necropolis** literally, a "city of the dead"—at the edge of the desert on the west bank of the Nile, for the land of the dead was believed to be in the direction of the setting sun. Two of the most extensive of these early necropolises are at Saqqara and Giza, just outside modern Cairo.

DJOSER'S COMPLEX AT SAQQARA For his tomb complex at Saqqara, the Third-Dynasty King Djoser (c. 2650–2631 BCE) commissioned the earliest-known monumental architecture in Egypt (**FIG. 3-2**). The designer of the complex was Imhotep, who served as Djoser's prime minister. Imhotep is the first architect in history to be identified; his name is inscribed together with Djoser's on the base of a statue of the king found near the Step Pyramid.

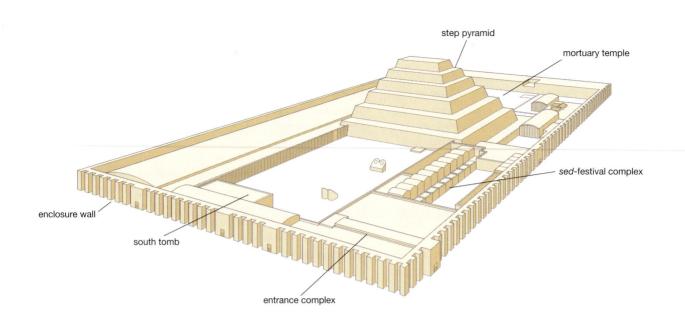

3-2 • RECONSTRUCTION DRAWING OF DJOSER'S FUNERARY COMPLEX, SAQQARA

Third Dynasty, c. 2630–2575 BCE. Situated on a level terrace, this huge commemorative complex—some 1,800′ (544 m) long by 900′ (277 m) wide—was designed as a replica in stone of the wood, brick, and reed buildings used in rituals associated with kingship. Inside the wall, the step pyramid dominated the complex.

It appears that Imhotep first planned Djoser's tomb as a singlestory mastaba, only later deciding to enlarge upon the concept. The final structure is a step pyramid formed by six mastaba-like elements of decreasing size stacked on top of each other (**FIG. 3-3**). Although the step pyramid resembles the ziggurats of Mesopotamia, it differs in both meaning (signifying a stairway to the sun god

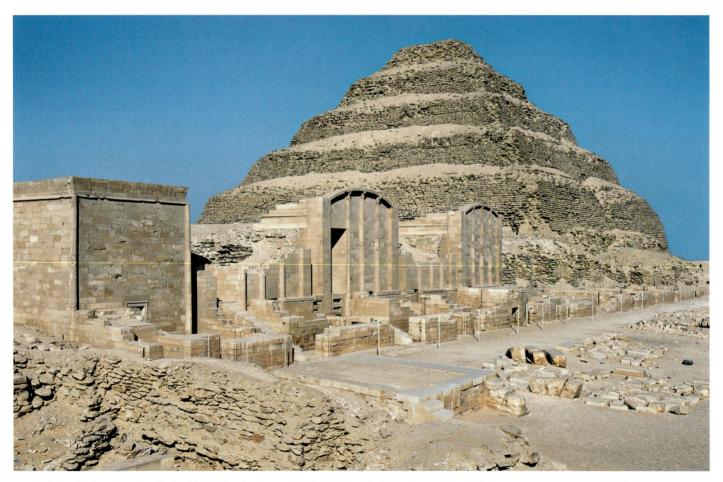

3-3 • THE STEP PYRAMID AND SHAM BUILDINGS, FUNERARY COMPLEX OF DJOSER Limestone, height of pyramid 204′ (62 m).

ELEMENTS OF ARCHITECTURE | Mastaba to Pyramid

As the gateway to the afterlife for Egyptian kings and members of the royal court, the Egyptian burial structure began as a low, solid, rectangular mastaba with an external niche that served as the focus of offerings. Later mastabas had either an internal *serdab* (the room where the *ka* statue was placed) and chapel (as in the drawing) or an attached chapel and *serdab* (not shown). Eventually, mastaba forms of decreasing

size were stacked over an underground burial chamber to form the step pyramid. The culmination of this development is the pyramid, in which the actual burial site may be within the pyramid—not below ground—with false chambers, false doors, and confusing passageways to foil potential tomb robbers.

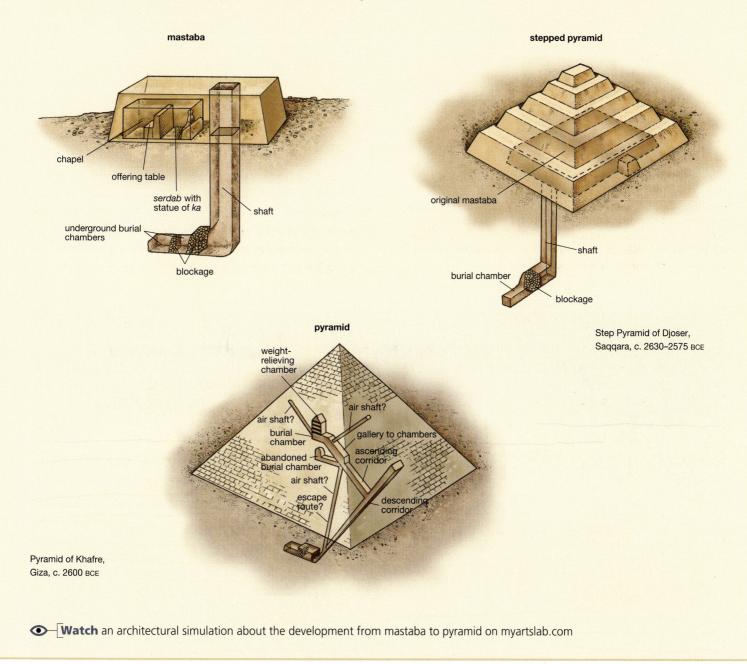

Ra) and purpose (protecting a tomb). A 92-foot shaft descended from the original mastaba enclosed within the pyramid. A descending corridor at the base of the step pyramid provided an entrance from outside to a granite-lined burial vault.

The adjacent funerary temple, where priests performed rituals before placing the king's mummified body in its tomb, was used for continuing worship of the dead king. In the form of his *ka* statue, Djoser intended to observe these devotions through two peepholes in the wall between the *serdab* and the funerary chapel. To the east of the pyramid, buildings filled with debris represent actual structures in which the spirit of the dead king could continue to observe the *sed* rituals that had ensured his long reign.

THE OLD KINGDOM, c. 2575–2150 BCE

The Old Kingdom was a time of social and political stability, despite increasingly common military excursions to defend the borders. The growing wealth of ruling families of the period is reflected in the enormous and elaborate tomb complexes they commissioned for themselves. Kings were not the only patrons of the arts, however. Upper-level government officials also could afford tombs decorated with elaborate carvings.

THE GREAT PYRAMIDS AT GIZA

The architectural form most closely identified with Egypt is the true pyramid with a square base and four sloping triangular faces, first erected in the Fourth Dynasty (2575–2450 BCE). The angled sides may have been meant to represent the slanting rays of the sun, for inscriptions on the walls of pyramid tombs built in the Fifth and Sixth Dynasties tell of deceased kings climbing up the rays to join the sun god Ra.

Although not the first pyramids, the most famous are the three great pyramid tombs at Giza (**FIGS. 3-4, 3-5**). These were built by three successive Fourth-Dynasty kings: Khufu (r. c. 2551–2528 BCE), Khafre (r. 2520–2494 BCE), and Menkaure (r. c. 2490–

2472 BCE). The oldest and largest pyramid at Giza is that of Khufu, which covers 13 acres at its base. It was originally finished with a thick veneer of polished limestone that lifted its apex to almost 481 feet, some 30 feet above the present summit. The pyramid of Khafre is slightly smaller than Khufu's, and Menkaure's is considerably smaller.

The site was carefully planned to follow the sun's east-west path. Next to each of the pyramids was a funerary temple connected by a causeway-an elevated and enclosed pathway or corridor—to a valley temple on the bank of the Nile (see FIG. 3-5). When a king died, his body was embalmed and ferried west across the Nile from the royal palace to his valley temple, where it was received with elaborate ceremonies. It was then carried up the causeway to his funerary temple and placed in its chapel, where family members presented offerings of food and drink, and priests performed rites in which the deceased's spirit consumed a meal. These rites were to be performed at the chapel in perpetuity. Finally, the body was entombed in a vault deep within the pyramid, at the end of a long, narrow, and steeply rising passageway. This tomb chamber was sealed off after the burial with a 50-ton stone block. To further protect the king from intruders, three false passageways obscured the location of the tomb.

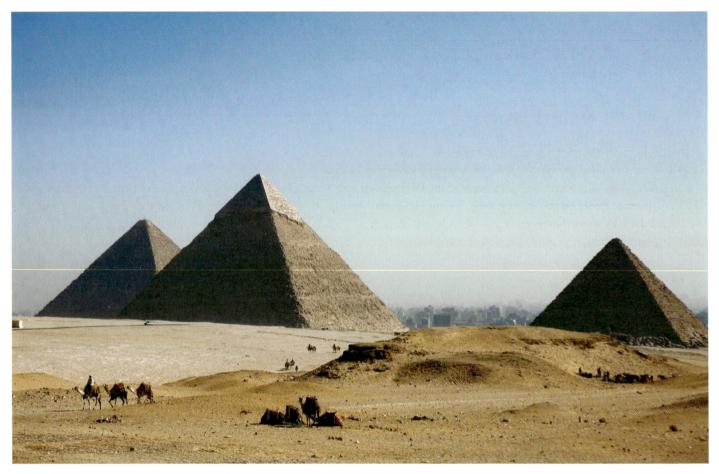

3-4 • GREAT PYRAMIDS, GIZA

Fourth Dynasty, c. 2575–2450 BCE. Erected by (from the left) Menkaure, Khafre, and Khufu. Limestone and granite, height of pyramid of Khufu, 450' (137 m).

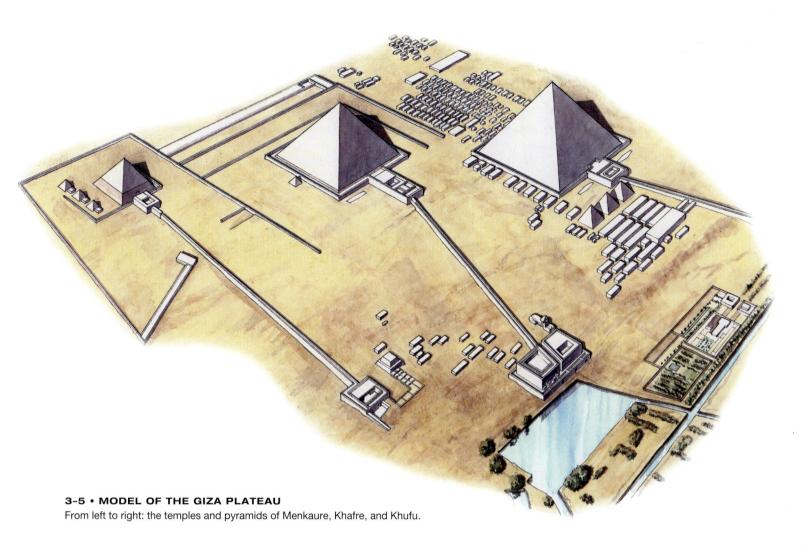

CONSTRUCTING THE PYRAMIDS Building a pyramid was a formidable undertaking. A large workers' burial ground discovered at Giza attests to the huge labor force that had to be assembled, housed, and fed. Most of the cut stone blocks—each weighing an average of 2.5 tons—used in building the Giza complex were quarried either on the site or nearby. Teams of workers transported them by sheer muscle power, employing small logs as rollers or pouring water on mud to create a slippery surface over which they could drag the blocks on sleds.

Scholars and engineers have various theories about how the pyramids were raised. Some ideas have been tested in computerized projections and a few models on a small but representative scale have been constructed. The most efficient means of getting the stones into position might have been to build a temporary, gently sloping ramp around the body of the pyramid as it grew higher. The ramp could then be dismantled as the stones were smoothed out or slabs of veneer were laid.

The designers who oversaw the building of such massive structures were capable of the most sophisticated mathematical calculations. They oriented the pyramids to the points of the compass and may have incorporated other symbolic astronomical calculations as well. There was no room for trial and error. The huge foundation layer had to be absolutely level and the angle of each of the slanting sides had to remain constant so that the stones would meet precisely in the center at the top.

KHAFRE'S COMPLEX Khafre's funerary complex is the best preserved. Its pyramid is the only one of the three to have maintained some of its veneer facing at the top. But the complex is most famous for the **GREAT SPHINX** that sits just behind Khafre's valley temple. This colossal portrait of the king—65 feet tall—combines his head with the long body of a crouching lion, seemingly merging notions of human intelligence with animal strength (**FIG. 3-6**).

In the adjacent **VALLEY TEMPLE**, massive blocks of red granite form walls and piers supporting a flat roof (**FIG. 3-7**). (See "Early Construction Methods," page 19.) A **clerestory** (a row of tall, narrow windows in the upper walls, not visible in the figure), lets in light that reflects off the polished Egyptian alabaster floor. Within the temple were a series of over-life-size statues, portraying **KHAFRE** as an enthroned king (**FIG. 3-8**). The falcon god Horus perches on the back of the throne, protectively enfolding the king's head with his wings. Lions—symbols of regal authority—form the throne's legs, and the intertwined lotus and papyrus plants beneath the seat symbolize the king's power over Upper (lotus) and Lower (papyrus) Egypt.

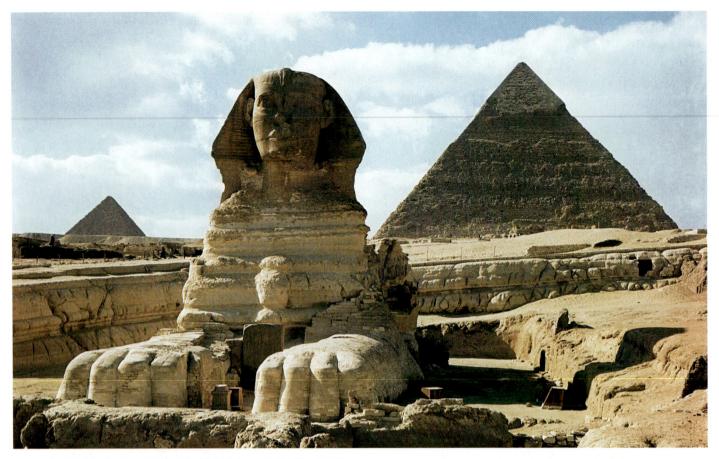

3-6 • GREAT SPHINX, FUNERARY COMPLEX OF KHAFRE Giza. Old Kingdom, c. 2520–2494 BCE. Limestone, height approx. 65' (19.8 m).

Khafre wears the traditional royal costume—a short, pleated kilt, a linen headdress, and a false beard symbolic of royalty. He exudes a strong sense of dignity, calm, and above all permanence. In his right hand, he holds a cylinder, probably a rolled piece of cloth. His arms are pressed tightly within the contours of his body, which is firmly anchored in the confines of the stone block from which it was carved. The statue was created from an unusual stone, a type of gneiss (related to diorite), imported from Nubia, that produces a rare optical effect. When illuminated by sunlight entering through the temple's clerestory, it glows a deep blue, the celestial color of Horus, filling the space with a blue radiance.

SCULPTURE

As the surviving statues of Khafre's valley temple demonstrate, Egyptian sculptors were adept at creating lifelike three-dimensional figures that also express a feeling of strength and permanence consistent with the unusually hard stones from which they were carved.

3-7 • VALLEY TEMPLE OF KHAFRE Giza. Old Kingdom, c. 2520–2494 BCE. Limestone and red granite. **3-8 • KHAFRE** Giza, valley temple of Khafre. Fourth Dynasty, c. 2520–2494 BCE. Diorite-gabbro gneiss, height 5'6¹/₈" (1.68 m). Egyptian Museum, Cairo. (JE 10062 = CG 14)

emerge, forming a single unit. They are further united by the queen's symbolic gesture of embrace. Her right hand comes from behind to clasp his torso, and her left hand rests gently, if stiffly, over his upper arm.

The king—depicted in accordance with Egyptian ideals as an athletic, youthful figure, nude to the waist and wearing the royal kilt and headcloth—stands in a conventional, balanced pose, striding with the left foot forward, his arms straight at his sides, and his fists clenched over cylindrical objects. His equally youthful queen, taking a smaller step forward, echoes his striding pose. Her sheer, close-fitting garment reveals the soft curves of her gently swelling body, a foil for the tight muscularity of the king. The time-consuming task of polishing this double statue was never completed, suggesting that the work may have been undertaken only a few years before Menkaure's death in about 2472 BCE. Traces of red paint remain on the king's face, ears, and neck (male figures were traditionally painted red), as do traces of black on the queen's hair.

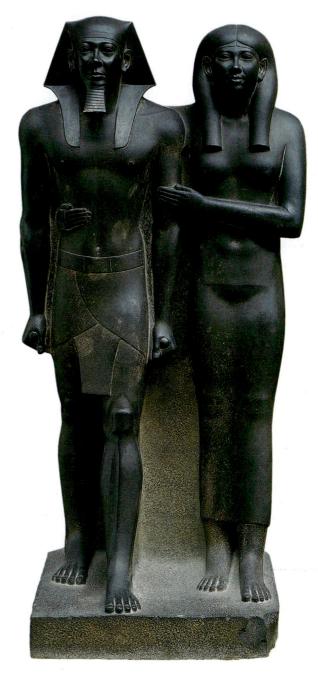

3-9 • MENKAURE AND A QUEEN, PROBABLY KHAMERERNEBTY II

From Giza. Fourth Dynasty, 2490–2472 BCE. Graywacke with traces of red and black paint, height 541/2" (142.3 cm). Museum of Fine Arts, Boston. Harvard University—Museum of Fine Arts Expedition. (11.1738)

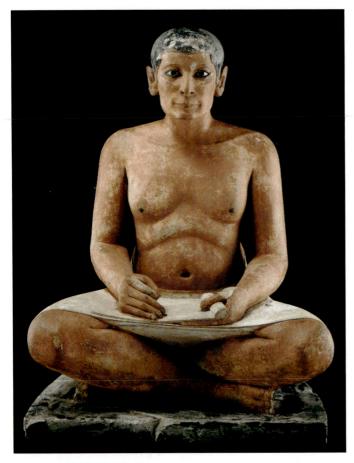

3-10 • SEATED SCRIBE

Found near the tomb of Kai, Saqqara. Fifth Dynasty, c. 2450–2325 BCE. Painted limestone with inlaid eyes of rock crystal, calcite, and magnesite mounted in copper, height 21" (53 cm). Musée du Louvre, Paris. (N 2290 = E 3023)

High-ranking scribes could hope to be appointed to one of several "houses of life," where they would copy, compile, study, and repair valuable sacred and scientific texts.

SEATED SCRIBE Old Kingdom sculptors also produced statues of less prominent people, rendered in a more relaxed, life-like fashion. A more lively and less formal mode is employed in the statue of a **SEATED SCRIBE** from early in the Fifth Dynasty (**FIG. 3-10**)—with round head, alert expression, and cap of close-cropped hair—that was discovered near the tomb of a government official named Kai. It could be a portrait of Kai himself. The irregular contours of his engaging face project a sense of individual likeness and human presence.

The scribe's sedentary vocation has made his sagging body slightly flabby, his condition advertising a life free from hard physical labor. As an ancient Egyptian inscription advises—"Become a scribe so that your limbs remain smooth and your hands soft and you can wear white and walk like a man of standing whom [even] courtiers will greet" (cited in Strouhal, p. 216). This scribe sits holding a papyrus scroll partially unrolled on his lap, his right hand clasping a now-lost reed brush used in writing. The alert expression on his face reveals more than a lively intelligence. Because the

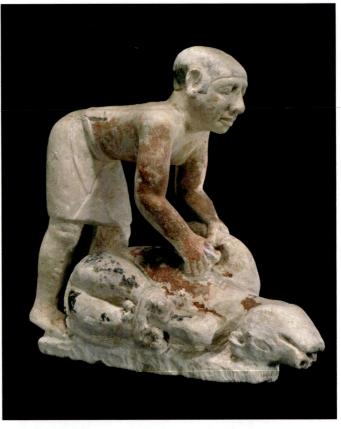

3-11 • BUTCHER

Perhaps from the tomb of the official Ni-kau-inpu and his wife Hemet-re, Giza? Fifth Dynasty, c. 2450–2325 BCE. Painted limestone (knife restored), height 145%" (37 cm). The Oriental Institute Museum, University of Chicago. (10626)

Although statues such as this have been assumed to represent the deceased's servants, it has recently been proposed that instead they depict relatives and friends of the deceased in the role of servants, allowing these loved ones to accompany the deceased into the next life.

pupils are slightly off-center in the irises, the eyes give the illusion of being in motion, as if they were seeking contact, and the reflective quality of the polished crystal inlay reproduces with eerie fidelity the contrast between the moist surface of eyes and the surrounding soft flesh in a living human face.

STATUETTES OF SERVANTS Even more lifelike than the scribe were smaller figures of servants at work that were made for inclusion in Old Kingdom tombs so that the deceased could be provided for in the next world. Poses are neither formal nor reflective, but rooted directly in the labor these figures were expected to perform throughout eternity. A painted limestone statuette from the Fifth Dynasty (FIG. 3-11) captures a butcher, raised up on the balls of his feet to bend down and lean forward, poised, knife in hand, over the throat of an ox that he has just slaughtered. Having accomplished his work, he looks up to acknowledge us, an action that only enhances his sense of lifelike presence. The emphasis on involved poses and engagement with

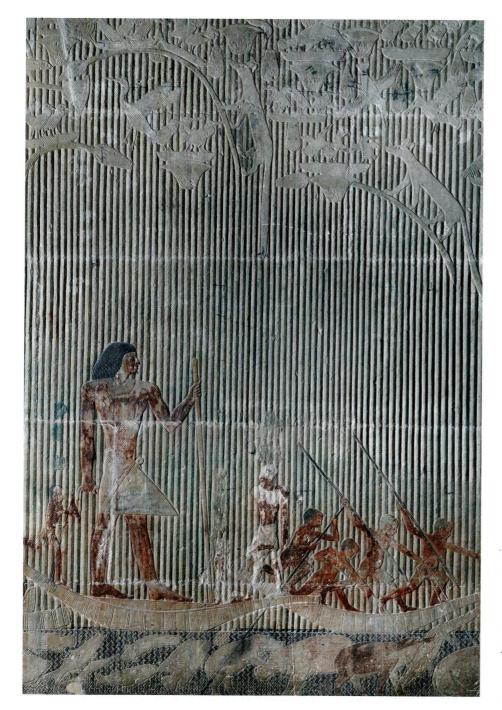

the viewer may have been an attempt to underscore the ability of such figures to perform their assigned tasks, or perhaps it was meant to indicate their lower social status by showing them involved in physical labor. Both may be signified here. The contrast between the detached stylization of upper-class figures and the engaging lifelikeness of laborers can be seen in Old Kingdom pictorial relief works as well.

PICTORIAL RELIEF IN TOMBS

To provide the *ka* with the most pleasant possible living quarters for eternity, wealthy families often had the interior walls and ceilings of their tombs decorated with paintings and reliefs. This

3-12 • TI WATCHING A HIPPOPOTAMUS HUNT

Tomb of Ti, Saqqara. Fifth Dynasty, c. 2450–2325 BCE. Painted limestone relief, height approx. 45" (114.3 cm).

decoration carried religious meaning, but it could also evoke the deceased's everyday life or depict ceremonial events that proclaimed the deceased's importance. Tombs therefore provide a wealth of information about ancient Egyptian culture.

THE TOMB OF TI On the walls of the large mastaba of a wealthy Fifth-Dynasty government official named Ti, a painted relief shows him watching a hippopotamus hunt—an official duty of royal courtiers (FIG. 3-12). It was believed that Seth, the god of chaos, disguised himself as a hippo. Hippos were also destructive since they wandered into fields, damaging crops. Tomb depictions of such hunts therefore proclaimed the valor of the deceased and the triumph of good over evil, or at least order over destructiveness.

The artists who created this picture in painted limestone relief used a number of established Egyptian representational conventions. The river is conceived as if seen from above, rendered as a band of parallel wavy lines below the boats. The creatures in this river, however—fish, a crocodile, and hippopotamuses—are shown in profile for easy identification. The shallow boats carrying Ti and his men by skimming along the surface of the water are shown straight on in relation to the viewers' vantage point, and the papyrus stalks that

choke the marshy edges of the river are disciplined into a regular pattern of projecting, linear, parallel, vertical forms that highlight the contrastingly crisp and smooth contour of Ti's stylized body. At the top of the papyrus grove, however, this patterning relaxes while enthusiastic animals of prey—perhaps foxes—stalk birds among the leaves and flowers. The hierarchically scaled and sleekly stylized figure of Ti, rendered in the conventional composite pose, looms over all. In a separate boat ahead of him, the actual hunters, being of lesser rank and engaged in more strenuous activities, are rendered in a more lifelike and lively fashion than their master. They are captured at the charged moment of closing in on the hunted prey, spears positioned at the ready, legs extended for the critical lunge forward.

THE MIDDLE KINGDOM, c. 1975–c. 1640 BCE

The collapse of the Old Kingdom, with its long succession of powerful kings, was followed by roughly 150 years of political turmoil, fragmentation, and warfare, traditionally referred to as the First Intermediate period (c. 2125–1975 BCE). About 2010 BCE, a series of kings named Mentuhotep (Eleventh Dynasty, c. 2010–c. 1938 BCE) gained power in Thebes, and the country was reunited under Nebhepetre Mentuhotep, who reasserted royal power and founded the Middle Kingdom,

The Middle Kingdom was another high point in Egyptian history. Arts and writing flourished in the Twelfth Dynasty (1938–1756 BCE), while reflecting a burgeoning awareness of the political upheaval from which the country had just emerged. Using a strengthened military, Middle Kingdom rulers expanded and patrolled the borders, especially in lower Nubia, south of present-day Aswan (see MAP 3-1, page 50). By the Thirteenth Dynasty (c. 1755–1630 BCE), however, central control by the government was weakened by a series of short-lived kings and an influx of foreigners, especially in the delta.

PORTRAITS OF SENUSRET III

Some royal portraits from the Middle Kingdom appear to express an unexpected awareness of the hardship and fragility of human existence. Statues of Senusret III, a king of the Twelfth Dynasty, who ruled from c. 1836 to 1818 BCE, reflects this new sensibility. Old Kingdom rulers such as Khafre (see FIG. 3–8) gaze into eternity confident and serene, toned and unflinching, whereas the portrait of **SENUSRET III** seems to capture a monarch preoccupied and emotionally drained (**FIG. 3–13**). Creases line his sagging cheeks, his eyes are sunken, his eyelids droop, his forehead is flexed, and his jaw is sternly set—a bold image of a resolute ruler, tested but unbowed.

Senusret was a dynamic king and successful general who led four military expeditions into Nubia, overhauled the Egyptian central administration, and was effective in regaining control over the country's increasingly independent nobles. To modern viewers, his portrait raises questions of interpretation. Are we looking at the face of a man wise in the ways of the world but lonely, saddened, and burdened by the weight of his responsibilities? Or are we looking at a reassuring statement that in spite of troubled times—that have clearly left their mark on the face of the ruler himself—royal rule endures in Egypt? Given what we know about Egyptian history at this time, it is difficult to be sure.

ROCK-CUT TOMBS

During the Eleventh and Twelfth Dynasties, members of the nobility and high-level officials commissioned tombs hollowed out of the face of a cliff. A typical rock-cut tomb included an entrance **portico** (projecting porch), a main hall, and a shrine with a burial chamber under the offering chapel. The chambers of these tombs,

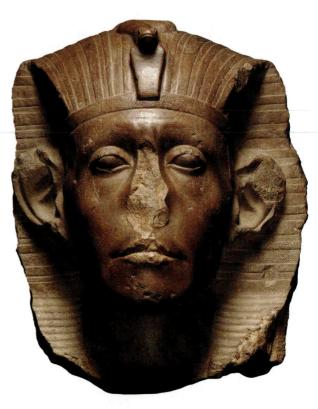

3-13 • HEAD OF SENUSRET III

Twelfth Dynasty, c. 1836–1818 _{BCE}. Yellow quartzite, height $173/4'' \times 131/2'' \times 17''$ (45.1 × 34.3 × 43.2 cm). The Nelson-Atkins Museum of Art, Kansas City, Missouri. Purchase: William Rockhill Nelson Trust (62-11)

as well as their ornamental columns, lintels, false doors, and niches, were all carved into the solid rock. An impressive necropolis was created in the cliffs at **BENI HASAN** on the east bank of the Nile (**FIG. 3-14**). Painted scenes cover the interior walls of many tombs. Among the best preserved are those in the Twelfth-Dynasty tomb

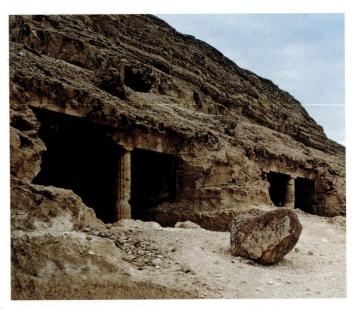

3-14 • **ROCK-CUT TOMBS, BENI HASAN** Twelfth Dynasty, 1938–1756 BCE. At the left is the entrance to the tomb of a provincial governor and the commander-in-chief Amenemhat.

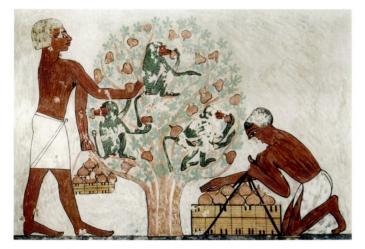

3-15 • PICKING FIGS Wall painting from the tomb of Khnumhotep, Beni Hasan. Twelfth Dynasty, c. 1890 BCE. Tempera facsimile by Nina de Garis.

of local noble Khnumhotep, some of which portray vivid vignettes of farm work on his estates. In one painting two men harvest figs, rushing to compete with three baboons who relish the ripe fruit from their perches within the trees (**FIG. 3–15**). One man reaches for a fig to add to the ordered stack in his basket, while his companion carefully arranges the harvest in a larger box for transport. Like the energetic hunters on the much earlier painted relief in the tomb of Ti (see FIG. 3-12), the upper torsos of these farm workers take a more lifelike profile posture, deviating from the strict frontality of the royal composite pose.

FUNERARY STELAI

Only the wealthiest and noblest of ancient Egyptians could afford elaborately decorated mastabas or rock-cut tombs. Prosperous people, however, could still commission funerary stelai depicting themselves, their family, and offerings of food. These personal monuments—meant to preserve the memory of the deceased and inspire the living to make offerings to them—contain compelling works of ancient Egyptian pictorial art. An unfinished stele made for the tomb of the **SCULPTOR USERWER** (FIG. **3-16**) presents three levels of decoration: one large upper block with five bands of hieroglyphs, beneath which are two registers with figures, each identified by inscription.

The text is addressed to the living, imploring them to make offerings to Userwer: "O living ones who are on the earth who pass by this tomb, as your deities love and favor you, may you say:

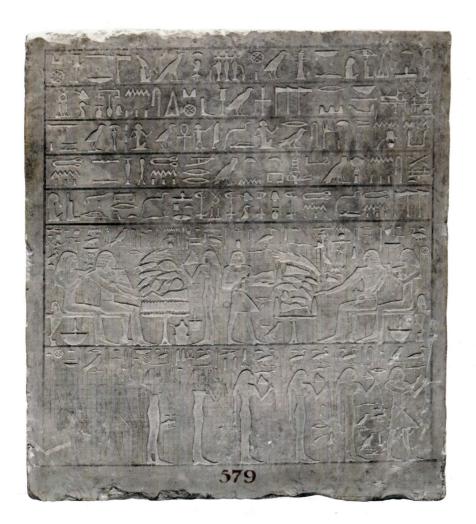

^{3-16 •} STELE OF THE SCULPTOR USERWER

Twelfth Dynasty, c. 1850 $_{BCE.}$ Limestone, red and black ink, $20^{1}\!\!/_{\!\!2}''\times19''$ (52 \times 48 cm). British Museum London. (EA 579)

TECHNIQUE | Egyptian Pictorial Relief

Painting usually relies on color and line for its effect, while relief sculpture usually depends on the play of light and shadow alone, but in Egypt, relief sculpture was also painted (see FIG. 3–17). The walls and closely spaced columns of Egyptian tombs and temples were almost completely covered with colorful scenes and hieroglyphic texts. Until the Eighteenth Dynasty (c. 1539–1292 BCE), the only colors used were black, white, red, yellow, blue, and green. Modeling might be indicated by overpainting lines in a contrasting color, although the sense of three-dimensionality was conveyed primarily by the carved forms and incised inscriptions underneath the paint. The crisp outlines created by such carving assured the primacy of line in Egyptian pictorial relief.

With very few exceptions, figures, scenes, and texts were composed in bands, or registers. The scenes were first laid out with inked lines, using a squared grid to guide the designer in proportioning the human figures. The sculptor who executed the carving followed these drawings, and it may have been another person who smoothed the carved surfaces of the relief and eventually covered them with paint.

The lower left corner of the unfinished Twelfth-Dynasty stele of Userwer shown here still maintains its preliminary underdrawings. In some figures there are also the tentative beginnings of the relief carving. The figures are delineated with black ink and the grid lines are rendered in red. Every body part had its designated place on the grid. For example, figures are designed 18 squares tall, measuring from the soles of their feet to their hairline; the tops of their knees conform with the sixth square up from the ground-line. Their shoulders align with the top of square 16 and are six squares wide. Slight deviations exist within this structured design format, but this **canon of proportions** represents an ideal system that was standard in pictorial relief throughout the Middle Kingdom.

DETAIL OF THE STELE OF THE SCULPTOR USERWER IN FIG. 3-16

'A thousand of bread and beer, a thousand of cattle and birds, a thousand of alabaster [vessels] and clothes, a thousand of offerings and provisions that go forth before Osiris''' (Robins, p. 103).

At left, on the register immediately below this inscription, Userwer sits before a table piled with offerings of food. Behind him is his wife Satdepetnetjer, and facing him on the other side of the offering table is Satameni, a standing woman also identified as his wife. Userwer could have had more than one wife, but one of these women might also be the sculptor's deceased first wife. At the other side of the stele on this same register but facing in the opposite direction sits another couple before another table heaped with food. They are identified as Userwer's parents, and the figure on the other side of their offering table is his son, Sneferuweser. In the lowest register are representations of other family members (probably Userwer's children) and his grandparents.

One of the most striking features of the lowest register of this stele is its unfinished state. The two leftmost figures were left uncarved, but the stone surface still maintains the preparatory ink drawing meant to guide the sculptor, preserving striking evidence of a system of canonical figure proportions that was established in the Middle Kingdom (see "Egyptian Pictorial Relief," above). The unfinished state of this stele has led to the suggestion that Userwer might have been in the process of carving it for himself when his sudden death left it incomplete.

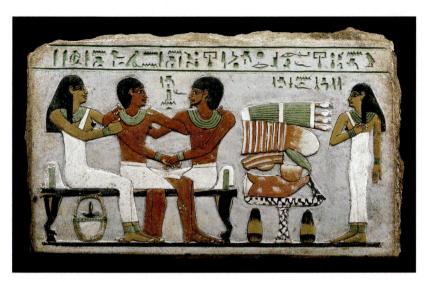

3-17 • STELE OF AMENEMHAT From Assasif. Late Eleventh Dynasty, c. 2000 BCE. Painted limestone, $11'' \times 15''$ (30 × 50 cm). Egyptian Museum, Cairo. (JE 45626)

A more modest stele for a man named **AMENEMHAT** was brought to completion as a vibrantly painted relief (**FIG. 3-17**). Underneath an inscription inviting food offerings for the deceased Amenemhat is a portrait of his family. Amenemhat sits on a lionlegged bench between his wife Iyi and their son Antef, embraced by both. Next to the trio is an offering table, heaped with meat, topped with onions, and sheltering two loaves of bread standing under the table on the floor. On the far right is Amenemhat and Iyi's daughter, Hapy, completing this touching tableau of family unity, presumably projected into their life after death. The painter of this relief follows an established Egyptian convention of differentiating gender by skin tonality: dark red-brown for men and lighter yellow-ocher for women.

TOWN PLANNING

Although Egyptians used durable materials in the construction of tombs, they built their own dwellings with simple mud bricks, which have either disintegrated over time or been carried away for fertilizer by farmers. Only the foundations of these dwellings now remain.

Archaeologists have unearthed the remains of Kahun, a town built by Senusret II (ruled c. 1842–1837 BCE) for the many officials, priests, and workers who built and maintained his pyramid complex. Parallel streets were laid out on a **grid**, forming rectangular blocks divided into lots for homes and other buildings. The houses of priests, court officials, and their families were large and comfortable, with private living quarters and public rooms grouped around central courtyards. The largest had as many as 70 rooms spread out over half an acre. Workers and their families made do with small, five-room row-houses built back to back along narrow streets.

A New Kingdom workers' village, discovered at Deir el-Medina on the west bank of the Nile near the Valley of the Kings, has provided us with detailed information about the lives of the people who created the royal tombs. Workers lived together here under the rule of the king's chief minister. During a ten-day week, they worked for eight days and had two days off, and also participated in many religious festivals. They lived a good life with their families, were given clothing, sandals, grain, and firewood by the king, and had permission to raise livestock and birds as well as tend a garden. The residents had a council, and the many written records that survive suggest a literate and litigious society that required many scribes. Because the men were away for most of the week working on the tombs, women had a prominent role in the town.

THE NEW KINGDOM, c. 1539–1075 BCE

During the Second Intermediate period (1630– 1520 BCE)—another turbulent interruption in the succession of dynasties ruling a unified Egypt—an eastern Mediterranean people called the Hyksos invaded Egypt's northernmost regions. Finally, the kings of the Eighteenth Dynasty (c. 1539–1292 BCE) regained control of the entire Nile region, extending from Nubia in the south to the Mediterranean Sea in the north, and restored political and economic strength. Roughly a century later, one of the same dynasty's most dynamic kings, Thutmose III (r. 1479–1425 BCE), extended Egypt's influence along the eastern Mediterranean coast as far as the region of present-day Syria. His accomplishment was the result of 15 or more military campaigns and his own skill at diplomacy. The heartland of ancient Egypt was now surrounded by a buffer of empire.

Thutmose III was the first ruler to refer to himself as "pharaoh," a term that literally meant "great house." Egyptians used it in the same way that Americans say "the White House" to mean the current U.S. president and his staff. The successors of Thutmose III continued to call themselves pharaohs, and the term ultimately found its way into the Hebrew Bible—and modern usage—as the title for the kings of Egypt.

THE GREAT TEMPLE COMPLEXES

At the height of the New Kingdom, rulers undertook extensive building programs along the entire length of the Nile. Their palaces, forts, and administrative centers disappeared long ago, but remnants of temples and tombs of this great age have endured. Thebes was Egypt's religious center throughout most of the New Kingdom, and worship of the Theban triad of deities—Amun, his wife Mut, and their son Khons—had spread throughout the country. Temples to these and other gods were a major focus of royal patronage, as were tombs and temples erected to glorify the kings themselves.

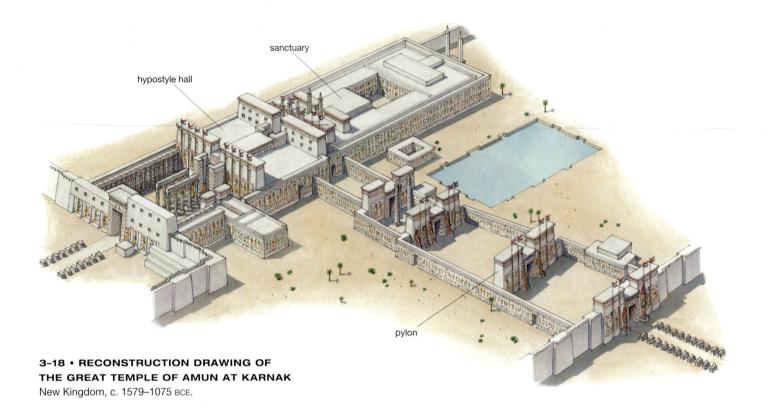

THE NEW KINGDOM TEMPLE PLAN As the home of the god, an Egyptian temple originally took the form of a house—a simple, rectangular, flat-roofed building preceded by a courtyard and gateway. The builders of the New Kingdom enlarged and multiplied these elements. The gateway became a massive **pylon** with tapering walls; the semipublic courtyard was surrounded by columns (a **peristyle** court); the temple itself included an outer **hypostyle hall** (a vast hall filled with columns) and an inner offering hall and sanctuary. The design was symmetrical and axial—that is, all its separate elements are symmetrically arranged along a dominant center line, creating a processional path from the outside straight into the sanctuary. The rooms became smaller, darker, and more exclusive as they neared the sanctuary, where the cult image of the god was housed. Only the pharaoh and the priests entered these inner rooms.

Two temple districts consecrated primarily to the worship of Amun, Mut, and Khons arose within the area of Thebes—a huge complex at Karnak to the north and, joined to it by an avenue of sphinxes, a more compact temple at Luxor to the south.

KARNAK Karnak was a long-standing sacred site, where temples were built and rebuilt for over 1,500 years. During the nearly 500 years of the New Kingdom, successive kings renovated and expanded the complex of the **GREAT TEMPLE OF AMUN** until it covered about 60 acres, an area as large as a dozen football fields (**FIG. 3–18**).

Access to the heart of the temple, a sanctuary containing the statue of Amun, was from the west (on the left side of the

reconstruction drawing) through a principal courtyard, a hypostyle hall, and a number of smaller halls and courts. Pylons set off each of these separate elements. Between the reigns of Thutmose I (Eighteenth Dynasty, r. c. 1493-1482 BCE), and Ramses II (Nineteenth Dynasty, r. c. 1279–1213 BCE), this area of the complex underwent a great deal of construction and renewal. The greater part of the pylons leading to the sanctuary and the halls and courts behind them were renovated or newly built and embellished with colorful pictorial wall reliefs. A sacred lake was also added to the south of the complex, where the king and priests might undergo ritual purification before entering the temple. Thutmose III erected a court and festival temple to his own glory behind the sanctuary of Amun. His great-grandson Amenhotep III (r. 1390–1353 BCE) placed a large stone statue of the god Khepri, the scarab (beetle) symbolic of the rising sun, rebirth, and everlasting life, next to the sacred lake.

In the sanctuary of Amun, priests washed the god's statue every morning and clothed it in a new garment. Because the god was thought to derive nourishment from the spirit of food, his statue was provided with tempting meals twice a day, which the priests then removed and ate themselves. Ordinary people entered the temple precinct only as far as the forecourts of the hypostyle halls, where they found themselves surrounded by inscriptions and images of kings and the god on columns and walls. During religious festivals, they lined the waterways, along which statues of the gods were carried in ceremonial boats, and were permitted to submit petitions to the priests for requests they wished the gods to grant.

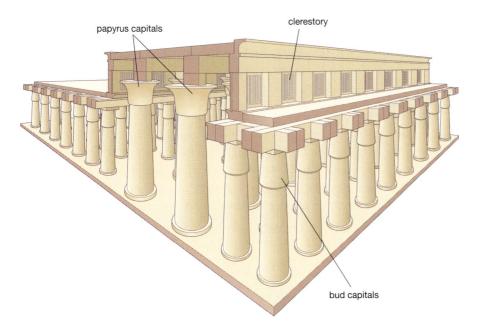

3-19 • RECONSTRUCTION DRAWING OF THE HYPOSTYLE HALL, GREAT TEMPLE OF AMUN AT KARNAK Nineteenth Dynasty, c. 1292–1190 BCE.

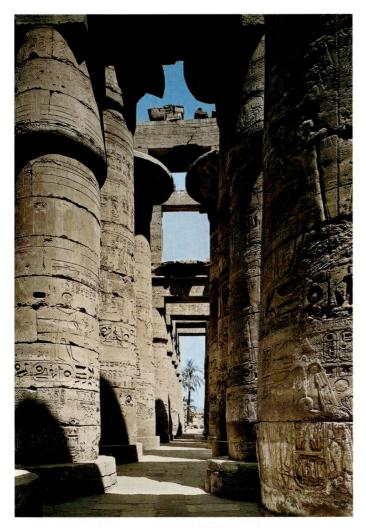

3-20 • COLUMNS WITH PAPYRIFORM AND BUD CAPITALS, HYPOSTYLE HALL, GREAT TEMPLE OF AMUN AT KARNAK

THE GREAT HALL AT KARNAK One of the most prominent features of the complex at Karnak is the enormous hypostyle hall set between two pylons at the end of the main forecourt. Erected in the reigns of the Nineteenth-Dynasty rulers Sety I (r. c. 1290-1279 BCE) and his son Ramses II (r. c. 1279–1213 BCE), and called the "Temple of the Spirit of Sety, Beloved of Ptah in the House of Amun," it may have been used for royal coronation ceremonies. Ramses II referred to it as "the place where the common people extol the name of his majesty." The hall was 340 feet wide and 170 feet long. Its 134 closely spaced columns supported a roof of flat stones, the center section of which rose some 30 feet higher than the broad sides (FIGS. 3-19, 3-20). The columns supporting this higher part of the roof are 69 feet tall and 12 feet in diameter, with massive papyrus capitals. On each side, smaller columns with bud capitals seem to march off forever into the darkness. In each of the side walls of the higher center sec-

tion, a long row of window openings created a clerestory. These openings were filled with stone grillwork, so they cannot have provided much light, but they did permit a cooling flow of air through the hall. Despite the dimness of the interior, artists covered nearly every inch of the columns, walls, and cross-beams with painted pictorial reliefs and inscriptions.

HATSHEPSUT

Across the Nile from Karnak and Luxor lay Deir el-Bahri and the Valleys of the Kings and Queens. These valleys on the west bank of the Nile held the royal necropolis, including the tomb of the pharaoh Hatshepsut. The dynamic Hatshepsut (Eighteenth Dynasty, r. c. 1473–1458 BCE) is a notable figure in a period otherwise dominated by male warrior-kings. Besides Hatshepsut, very few women ruled Egypt—they included the little-known Sobekneferu and Tausret, and much later, the well-known Cleopatra VII.

The daughter of Thutmose I, Hatshepsut married her halfbrother, who then reigned for 14 years as Thutmose II. When he died in c. 1473, she became regent for his underage son— Thutmose III—born to one of his concubines. Within a few years, Hatshepsut had herself declared "king" by the priests of Amun, a maneuver that made her co-ruler with Thutmose III for 20 years.

There was no artistic formula for a female pharaoh in Egyptian art, yet Hatshepsut had to be portrayed in her new role. What happened reveals something fundamentally important about the art of ancient Egypt. She was represented as a male king (**FIG. 3-21**), wearing a kilt and linen headdress, occasionally even a king's false beard. The formula for portraying kings was not adapted to suit one individual; she was adapted to conform to convention. There

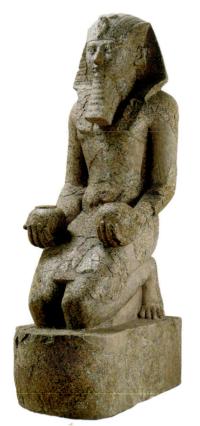

3-21 • HATSHEPSUT KNEELING

From Deir el-Bahri. Eighteenth Dynasty, c. 1473–1458 BCE. Red granite, height 8'6" (2.59 m). Metropolitan Museum of Art, New York.

could hardly be a more powerful manifestation of the premium on tradition in Egyptian royal art.

At the height of the New Kingdom, rulers undertook extensive personal building programs, and Hatshepsut is responsible for one of the most spectacular: her **FUNERARY TEMPLE** located at Deir el-Bahri, about a mile away from her actual tomb in the Valley of the Kings (**FIG. 3-22**). This imposing complex was designed for funeral rites and commemorative ceremonies and is much larger and more prominent than the tomb itself, reversing the scale relationship we saw in the Old Kingdom pyramid complexes.

3-22 • FUNERARY TEMPLE OF HATSHEPSUT, DEIR EL-BAHRI

View the Closer Look for the funerary temple of Hatshepsut

Eighteenth Dynasty, c. 1473–1458 BCE. (At the far left, ramp and base of the funerary temple of Mentuhotep III. Eleventh Dynasty, r. c. 2009–1997 BCE.)

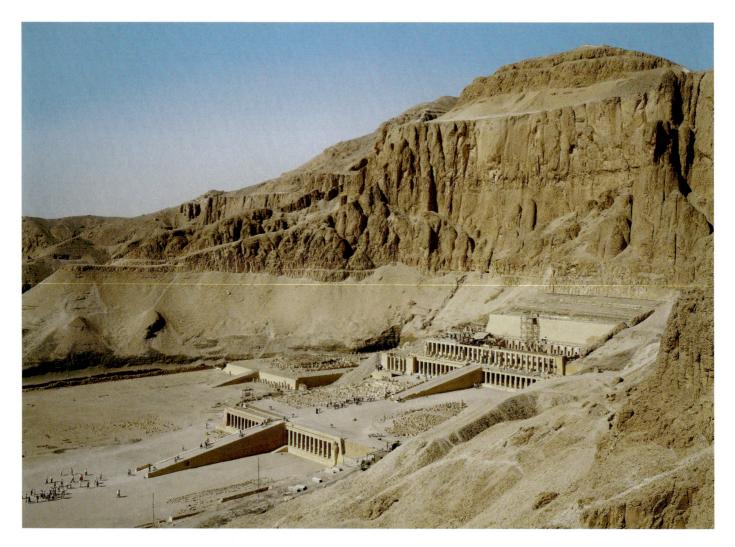

on myartslab.com

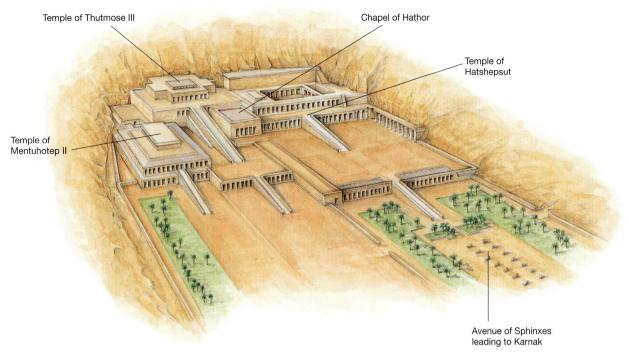

3-23 • SCHEMATIC DRAWING OF THE FUNERARY TEMPLE OF HATSHEPSUT Deir el-Bahri.

Magnificently sited and sensitively reflecting the natural threepart layering in the rise of the landscape-from flat desert, through a sloping hillside, to the crescendo of sheer stone cliffs-Hatshepsut's temple was constructed on an axial plan (FIG. 3-23). A causeway lined with sphinxes once ran from a valley temple on the Nile to the huge open space of the first court, where rare myrrh trees were planted in the temple's garden terraces. From there, visitors ascended a long, straight ramp to a second court where shrines to Anubis and Hathor occupy the ends of the columned porticos. On the temple's uppermost court, colossal royal statues fronted another colonnade (a row of columns supporting a lintel or a series of arches), and behind this lay a large hypostyle hall with chapels dedicated to Hatshepsut, her father, and the gods Amun and Ra-Horakhty-a powerful form of the sun god Ra combined with Horus. Centered in the hall's back wall was the entrance to the innermost sanctuary, a small chamber cut deep into the cliff.

THE TOMB OF RAMOSE

The traditional art of pictorial relief, employing a representational system that had dominated Egyptian figural art since the time of Narmer, reached a high degree of aesthetic refinement and technical sophistication during the reign of Amenhotep III (Eighteenth Dynasty, r. c. 1390–1353 BCE), especially in the reliefs carved for the unfinished tomb of Ramose near Thebes (**FIG. 3-24**).

As mayor of Thebes and vizier (principal royal advisor or minister) to both Amenhotep III and Amenhotep IV (r. 1353– c. 1336 BCE), Ramose was second only to the pharaoh in power and prestige. Soon after his ascent to political prominence, he began construction of an elaborate Theban tomb comprised of four rooms, including an imposing hypostyle hall 82 feet wide. Walls were covered with paintings or with shallow pictorial relief carvings, celebrating the accomplishments, affiliations, and lineage of Ramose and his wife Merytptah, or visualizing the funeral rites that would take place after their death. But the tomb was not used by Ramose. Work on it ceased in the fourth year of Amenhotep IV's reign, when, renamed Akhenaten, he relocated the court from Thebes to the new city of Akhetaten. Presumably Ramose moved with the court to the new capital, but neither his name nor a new tomb has been discovered there.

The tomb was abandoned in various stages of completion. The reliefs were never painted, and some walls preserve only the preliminary sketches that would have guided sculptors. But the works that were executed are among the most sophisticated relief carvings in the history of art. On one wall, Ramose and his wife Merytptah appear, hosting a banquet for their family. All are portrayed at the same moment of youthful perfection, even though they represent two successive generations. Sophisticated carvers lavished their considerable technical virtuosity on the portrayal of these untroubled and majestic couples, creating clear textural differentiation of skin, hair, clothes, and jewelry. The easy elegance of linear fluidity is not easy to obtain in this medium, and the convincing sense of three-dimensionality in forms and their placement is managed within an extraordinarily shallow depth of relief. In the detail of Ramose's brother May and sister-in-law Werener in FIG. 3-24, the traditional ancient Egyptian marital embrace (see FIGS. 3-9, 3-17) takes on a new tenderness, recalling-especially within

the eternal stillness of a tomb—the words of a New Kingdom love poem:

While unhurried days come and go, Let us turn to each other in quiet affection, Walk in peace to the edge of old age. And I shall be with you each unhurried day, A woman given her one wish: to see For a lifetime the face of her lord.

(Love Songs of the New Kingdom, trans. Foster, p. 18)

The conceptual conventions of Egyptian royal art are rendered in these carvings with such warmth and refinement that they become almost believable. Our rational awareness of their artificiality is momentarily eclipsed by their sheer beauty. But within this refined world of stable convention, something very jarring took place during the reign of Amenhotep III's successor, Amenhotep IV.

AKHENATEN AND THE ART OF THE AMARNA PERIOD

Amenhotep IV was surely the most unusual ruler in the history of ancient Egypt. During his 17-year reign (c. 1353–1336 BCE), he radically transformed the political, spiritual, and cultural life of the country. He founded a new religion honoring a single supreme god, the life-giving sun deity Aten (represented by the sun's disk), and changed his own name in about 1348 BCE to Akhenaten ("One Who Is Effective on Behalf of the Aten"). Abandoning Thebes, the capital of Egypt since the beginning of his dynasty and a city firmly in the grip of the priests of Amun, Akhenaten built a new capital much farther north, calling it Akhetaten ("Horizon of

3-24 • RAMOSE'S BROTHER MAY AND HIS WIFE WERENER Tomb of Ramose, Thebes. Eighteenth Dynasty, c. 1375–1365 BCE.

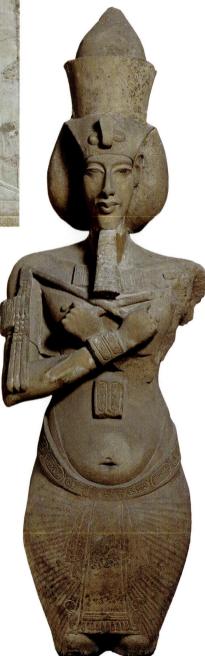

3-25 • COLOSSAL FIGURE OF AKHENATEN From the temple known as the Gempaaten, built early in Akhenaten's

reign just southeast of the Temple of Karnak. Sandstone with traces of polychromy, height of remaining portion about 13' (4 m). Egyptian Museum, Cairo. (JE 49528)

Read the document related to Akhenaten on myartslab.com

the Aten"). Using the modern name for this site, Tell el-Amarna, historians refer to Akhenaten's reign as the Amarna period.

THE NEW AMARNA STYLE Akhenaten's reign not only saw the creation of a new capital and the rise of a new religious focus; it also led to radical changes in royal artistic conventions. In portraits of the king, artists subjected his representation to startling stylizations, even physical distortions. This new royal figure style can be seen in a colossal statue of Akhenaten, about 16 feet tall, created for a new temple to the Aten that he built near the temple complex of Karnak, openly challenging the state gods (**FIG. 3-25**). This portrait was placed in one of the porticos of a huge courtyard (c. 426 by 394 feet), oriented to the movement of the sun.

The sculpture's strange, softly swelling forms suggest androgyny to modern viewers. The sagging stomach and inflated thighs contrast with spindly arms, protruding clavicles, and an attenuated neck, on which sits a strikingly stylized head. Facial features are exaggerated, often distorted. Slit-like eyes turn slightly downward, and the bulbous, sensuous lips are flanked by dimples that evoke the expression of ephemeral human emotion. Such stark deviations from convention are disquieting, especially since Akhenaten holds the flail and shepherd's crook, traditional symbols of the pharoah's super-human sovereignty.

The new Amarna style characterizes not only official royal portraits, but also pictorial relief sculpture portraying the family life of Akhenaten and Queen Nefertiti. In one panel the king and queen sit on cushioned stools playing with their nude daughters (**FIG. 3-26**), whose elongated shaved heads conform to the newly minted figure type. The royal couple receive the blessings of the Aten, whose rays end in hands that penetrate the open pavilion to offer ankhs before their nostrils, giving them the "breath of life." The king holds one child and lovingly pats her head, while she

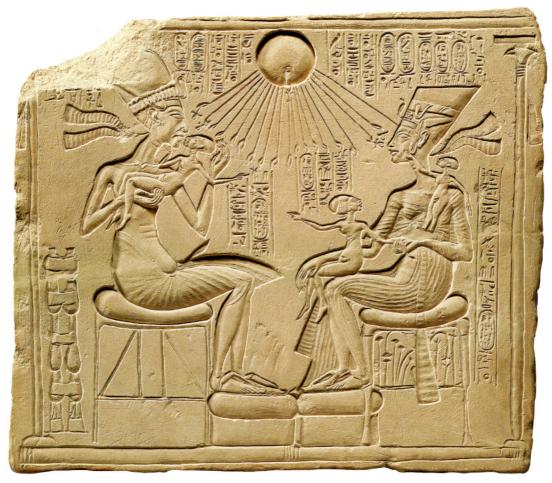

3-26 • AKHENATEN AND HIS FAMILY

From Akhetaten (present-day Tell el-Amarna). Eighteenth Dynasty, c. 1353–1336 BCE. Painted limestone relief, $12^{1}/4'' \times 15^{1}/4''$ (31.1 × 38.7 cm). Staatliche Museen zu Berlin, Preussischer Kulturbesitz, Ägyptisches Museum. (14145)

Egyptian relief sculptors often employed the **sunken relief** technique seen here. In ordinary reliefs, the background is carved back so that the figures project out from the finished surface. In sunken relief, the original flat surface of the stone is reserved as background, and the outlines of the figures are deeply incised, permitting the development of three-dimensional forms within them.

View the Closer Look for Akhenaten and his Family on myartslab.com

pulls herself forward to kiss him. The youngest of the three perches on Nefertiti's shoulder, trying to attract her mother's attention by stroking her cheek, while the oldest sits on the queen's lap, tugging at her mother's hand and pointing to her father. What a striking contrast with the relief from Ramose's tomb! Rather than composed serenity, this artist has conveyed the fidgety behavior of children and the loving involvement of their parents in a manner not even hinted at in earlier royal portraiture.

THE PORTRAIT OF TIY Akhenaten's goals were actively supported not only by Nefertiti but also by his mother, **QUEEN TIY** (**FIG. 3-27**). She had been the chief wife of the king's father, Amenhotep III, and had played a significant role in affairs of state during his reign. Queen Tiy's personality seems to emerge from a miniature portrait head that reveals the exquisite bone structure of her dark-skinned face, with its arched brows, uptilted eyes, and full lips. Originally, this portrait included a funerary silver headdress covered with gold cobras and gold jewelry. But after her son came to power and established his new religion, the portrait was altered. A brown cap covered with blue glass beads was placed over the original headdress.

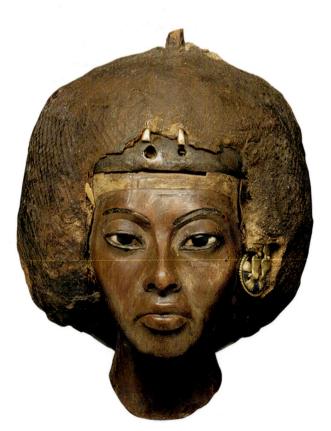

3-27 • QUEEN TIY

From Kom Medinet el-Ghurab (near el-Lahun). Eighteenth Dynasty, c. 1352 BCE. Wood (perhaps yew and acacia), ebony, glass, silver, gold, lapis lazuli, cloth, clay, and wax, height 3³/₄" (9.4 cm). Staatliche Museen zu Berlin, Preussischer Kulturbesitz, Ägyptisches Museum. (21834)

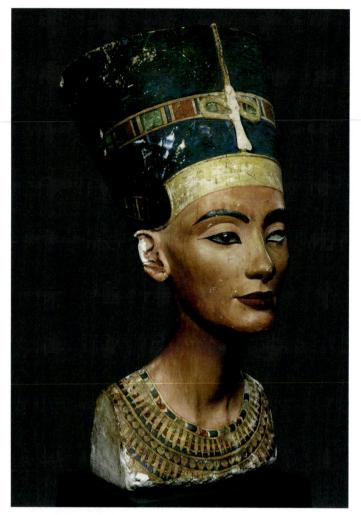

3-28 • NEFERTITI From Akhetaten (modern Tell el-Amarna). Eighteenth Dynasty, c. 1353– 1336 BCE. Painted limestone, height 20" (51 cm). Staatliche Museen zu Berlin, Preussischer Kulturbesitz, Ägyptisches Museum. (21300)

THE HEAD OF NEFERTITI The famous head of NEFERTITI

(FIG. 3-28) was discovered in 1912, along with drawings and other items related to commissions for the royal family, in the Akhetaten studio of the sculptor Thutmose. It may have served as a model for full-length sculptures or paintings of the queen. In 2007, analysis of this famous work using a CT scan revealed the existence of a delicately carved limestone sculpture underneath the modeled **stucco** that forms its outer surface. The faces of the queen in the two likenesses differs slightly. The sculptor seems to have smoothed out in stucco some of the facial irregularities in the underlying limestone carving—including a bump in Nefertiti's nose and creases around her mouth—and increased the prominence of her cheekbones, probably to bring the queen's face into conformity with contemporary notions of beauty, much in the way we would retouch a photographic image.

The proportions of Nefertiti's refined, regular features, long neck, and heavy-lidded eyes appear almost too ideal to be human, but are eerily consistent with standards of beauty in our own culture. Part of the appeal of this portrait bust, aside from its stunning beauty, may be the artist's dramatic use of color. The hues of the blue headdress and its striped band are repeated in the rich red, blue, green, and gold of the jeweled necklace. The queen's brows, eyelids, cheeks, and lips are heightened with color, as they no doubt were heightened with cosmetics in real life.

GLASS Glassmaking could only be practiced by artists working for the king, and Akhenaten's new capital had its own glassmaking workshops (see "Glassmaking," page 76). A bottle produced there and meant to hold scented oil was fashioned in the shape of a fish that has been identified as a bolti, a species that carries its eggs in its mouth and spits out its offspring when they hatch (see FIG. 3–33). The bolti was a common symbol for birth and regeneration, complementing the self-generation that Akhenaten attributed to the sun disk Aten.

THE RETURN TO TRADITION: TUTANKHAMUN AND RAMSES II

Akhenaten's new religion and revolutionary reconception of pharaonic art outlived him by only a few years. The priesthood of Amun quickly regained its former power, and his young son Tutankhaten (Eighteenth Dynasty, r. c. 1332–1322 BCE) returned to traditional religious beliefs, changing his name to Tutankhamun—"Living Image of Amun"—and moving the court back to Thebes. He died at age 19, and was buried in the Valley of the Kings.

Although some had doubted the royal lineage of the young Tutankhaten, recent DNA testing of a series of royal mummies from this period confirmed that he was the son of Akhenaten and one of his sisters. And his death at such a young age seems not to have been the result of royal intrigue and assassination, but poor health and serious injury. The DNA analysis documented his struggles with malaria, and CT scans revealed a badly broken and seriously infected leg, as well as a series of birth defects that have been ascribed to royal inbreeding.

TUTANKHAMUN'S TOMB The sealed inner chamber of Tutankhamun's tomb was never plundered, and when it was found in 1922 its incredible riches were just as they had been left since his interment. His mummified body, crowned with a spectacular mask preserving his royal likeness (see FIG. 3-1), lay inside three nested coffins that identified him with Osiris, the god of the dead. The innermost coffin, in the shape of a mummy, is the richest of the three (FIG. 3-29). Made of over 240 pounds (110.4 kg) of gold, its surface is decorated with colored glass and semiprecious gemstones, as well as finely incised linear designs and hieroglyphic inscriptions. The king holds a crook and a flail, symbols that were associated with Osiris and had become a traditional part of the royal regalia. A nemes headcloth with projecting cobra and vulture covers his head, and a blue braided beard is attached to his chin. Nekhbet and Wadjet, vulture and cobra goddesses of Upper and Lower Egypt, spread their wings across his body. The king's features as reproduced on the coffin and masks are those of a very young man, and the unusually full lips, thin-bridged nose, and pierced earlobes suggest the continuing vitality of some Amarna stylizations.

RAMSES II AND ABU SIMBEL By Egyptian standards Tutankhamun was a rather minor king. Ramses II, on the other hand, was both powerful and long-lived. Under Ramses II (Nineteenth Dynasty, r. c. 1279–1213 BCE), Egypt was a mighty empire. He was a bold leader and an effective political strategist. Although he did not win every battle, he was an effective master of royal propaganda, able to turn military defeats into glorious victories. He also triumphed diplomatically by securing a peace

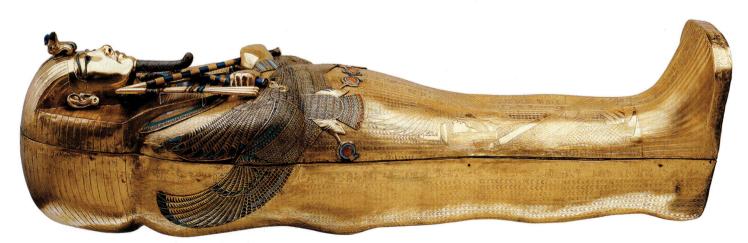

3-29 • **INNER COFFIN FROM TUTANKHAMUN'S SARCOPHAGUS** From the tomb of Tutankhamun, Valley of the Kings. Eighteenth Dynasty, c. 1332–1322 BCE. Gold inlaid with glass and semiprecious stones, height 6'7%" (1.85 m), weight nearly 243 pounds (110.4 kg). Egyptian Museum, Cairo. (JE 60671) Many art objects are subtle, captivating us through their enduring beauty or mysterious complexity. Monuments such as Ramses II's temples at Abu Simbel, however, engage us forcefully across the ages with a sense of raw power born of sheer scale. This king-god of Egypt, ruler of a vast empire, a virile wonder who fathered nearly a hundred children, is selfdescribed in an inscription he had carved into an obelisk (now standing in the heart of Paris): "Son of Ra: Ramses-Meryamun ['Beloved of Amun']. As long as the skies exist, your monuments shall exist, your name shall exist, firm as the skies." So far, this is true.

Abu Simbel was an auspicious site for Ramses II's great temples. It is north of the second cataract of the Nile, in Nubia, the ancient land of Kush, which Ramses ruled and which was the source of his gold, ivory, and exotic animal skins. The monuments were carved directly into the living rock of the sacred hills. The larger temple is dedicated to Ramses and the Egyptian gods Amun, Ra-Horakhty, and Ptah (**Fig. 3-30**). A row of four colossal seated statues of the king himself, 65 feet high, dominate the monument, flanked by relatively small statues of family members, including his principal wife Nefertari. Inside the temple, eight 23-foot statues of the god Osiris with the face of the god-king Ramses further proclaim his divinity. The corridor they form leads to seated figures of Ptah, Amun, Ramses II, and Ra. The corridor was oriented so that twice a year the first rays of the rising sun shot through it to illuminate statues of the king and the three gods placed against the back wall (**Fig. 3-31**).

About 500 feet away, Ramses ordered a smaller temple to be carved into a mountain sacred to Hathor, goddess of fertility, love, joy, and music, and to be dedicated to Hathor and to Nefertari. The two temples were oriented so that their axes crossed in the middle of the Nile, suggesting that they may have been associated with the annual life-giving flood.

Ironically, rising water nearly destroyed them both. Half-buried in the sand over the ages, the temples were only rediscovered early in the nineteenth century. But in the 1960s, construction of the Aswan High Dam flooded the Abu Simbel site. An international team of experts mobilized to find a way to safeguard Ramses II's temples, deciding in 1963 to cut them out of the rock in blocks (FIG. 3-32) and re-erect them on higher ground, secure from the rising waters of Lake Nasser. The projected cost of \$32 million was financed by UNESCO, with Egypt and the United States each pledging \$12 million. Work began in 1964 and was completed in 1968. Because of this international cooperation and a combination of modern technology and hard labor, Ramses II's temples were saved so they can continue to engage future generations.

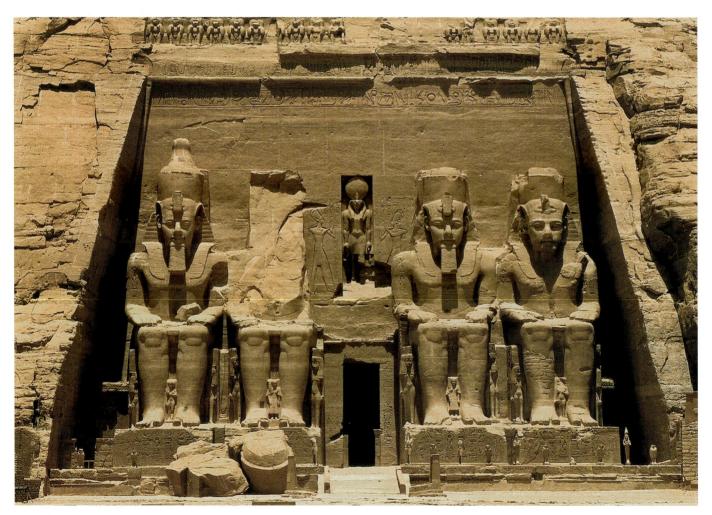

3-30 • TEMPLE OF RAMSES II Abu Simbel. Nineteenth Dynasty, c. 1279–1213 BCE.

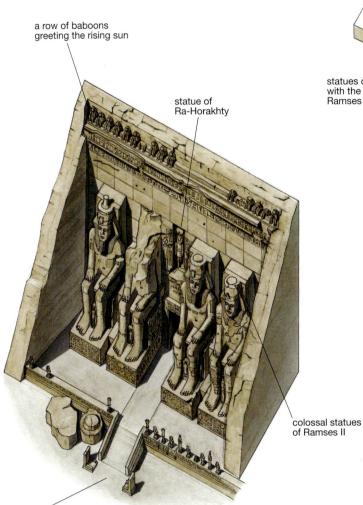

entrance to temple

EXTERIOR

3-31 • SCHEMATIC DRAWING OF THE TEMPLE OF RAMSES II Abu Simbel.

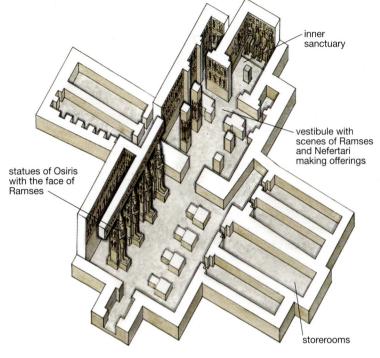

INTERIOR

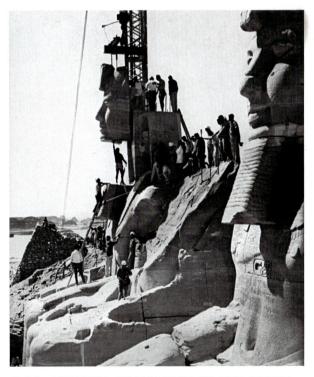

3-32 • REMOVAL OF THE FACE OF ONE OF THE COLOSSAL SCULPTURES OF RAMSES II AT ABU SIMBEL IN THE MID 1960S

TECHNIQUE | Glassmaking

No one knows precisely when or where the technique of glassmaking first developed, but the basics of the process are quite clear. Heating a mixture of sand, lime, and sodium carbonate or sodium sulfate to a very high temperature produces glass. The addition of other minerals can make the glass transparent, translucent, or opaque, as well as create a vast range of colors.

The first objects to be made entirely of glass in Egypt were produced with the technique known as core-formed glass. A lump of sandy clay molded into the desired shape was wrapped in strips of cloth, then skewered on a fireproof rod. It was then briefly dipped into a pot of molten glass. When the resulting coating of glass had cooled, the clay core was removed through the opening left by the skewer. To decorate the vessel, glassmakers frequently heated thin rods of colored glass and fused them on and flattened them against the surface in strips. The fish-shaped bottle (**FIG. 3-33**)—is an example of core-formed glass from the New Kingdom's Amarna period: The body was created from glass tinted with cobalt, and the surface was then decorated with small rods of white and orange glass, achieving the wavy pattern that resembles fish scales by dragging a pointed tool along the surface. Then two slices of a rod of spiraled black and white glass were fused to the surface to create its eyes.

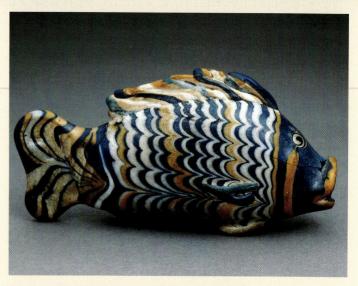

3-33 • FISH-SHAPED PERFUME BOTTLE

From Akhetaten (present-day Tell el-Amarna). Eighteenth Dynasty, reign of Akhenaten, c. 1353–1336 BCE. Core-formed glass, length 5³/₄" (14.5 cm). British Museum, London. (EA 55193)

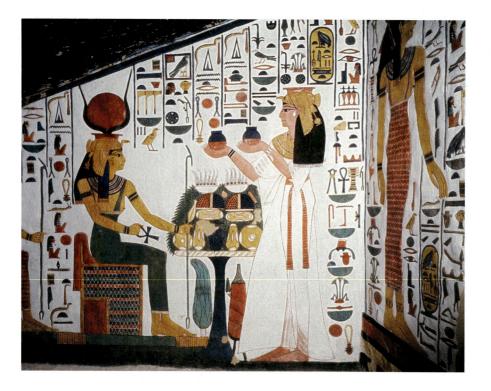

3-34 • QUEEN NEFERTARI MAKING AN OFFERING TO ISIS

Wall painting in the tomb of Nefertari, Valley of the Queens. Nineteenth Dynasty, 1290–1224 BCE.

agreement with the Hittites, a rival power centered in Anatolia (see Chapter 2) that had tried to expand to the west and south at Egypt's expense. Ramses twice reaffirmed that agreement by marrying Hittite princesses.

In the course of a long and prosperous reign, Ramses II initiated building projects on a scale rivaling the Old Kingdom

pyramids at Giza. Today, the most awe-inspiring of his many architectural monuments are found at Karnak and Luxor, and at Abu Simbel in Egypt's southernmost region (see "The Temples of Ramses II at Abu Simbel," page 74). At Abu Simbel, Ramses ordered two large temples to be carved into natural rock, one for himself and the other for his principal wife, Nefertari. The temples at Abu Simbel were not funerary monuments. Ramses' and Nefertari's tombs are in the Valleys of the Kings and Queens. The walls of Nefertari's tomb are covered with exquisite paintings. In one mural, Nefertari offers jars of perfumed ointment to the goddess Isis (**FIG. 3-34**). The queen wears the vulture-skin headdress and jeweled collar indicating her royal position, and a long, semitransparent white linen gown. Isis, seated on her throne behind a table heaped with offerings, holds a long scepter in her left hand, the ankh in her right. She wears a headdress surmounted by the horns of Hathor framing a sun disk, clear indications of her divinity.

The artists responsible for decorating the tomb diverged very subtly but distinctively from earlier stylistic conventions. The outline drawing and use of pure colors within the lines reflect traditional practices, but quite new is the slight modeling of the body forms by small changes of **hue** to enhance the appearance of threedimensionality. The skin color of these women is much darker than that conventionally used for females in earlier periods, and lightly brushed-in shading emphasizes their eyes and lips.

THE BOOKS OF THE DEAD

By the time of the New Kingdom, the Egyptians had come to believe that only a person free from wrongdoing could enjoy an afterlife. The dead were thought to undergo a last judgment consisting of two tests presided over by Osiris, the god of the underworld, and supervised by the jackal-headed god of embalming and cemeteries, Anubis. After the deceased were questioned about their behavior in life, their hearts—which the Egyptians believed to be the seat of the soul—were weighed on a scale against an ostrich feather, the symbol of Ma'at, goddess of truth, order, and justice. Family members commissioned papyrus scrolls containing magical texts or spells, which the embalmers sometimes placed among the wrappings of the mummified bodies. Early collectors of Egyptian artifacts referred to such scrolls, often beautifully illustrated, as "Books of the Dead." A scene in one that was created for a man named Hunefer (Nineteenth Dynasty) shows three successive stages in his induction into the afterlife (FIG. 3-35). At the left, Anubis leads him by the hand to the spot where he will weigh his heart against the "feather of Truth." Ma'at herself appears atop the balancing arm of the scales wearing the feather as a headdress. To the right of the scales, Ammit, the dreaded "Eater of the Dead"— part crocodile, part lion, and part hippopotamus—watches eagerly for a sign from the ibis-headed god Thoth, who prepares to record the result of the weighing.

But the "Eater" goes hungry. Hunefer passes the test, and Horus, on the right, presents him to the enthroned Osiris, who floats on a lake of natron (see "Preserving the Dead," page 53). Behind the throne, the goddesses Nephthys and Isis support the god's left arm, while in front of him Horus's four sons, each entrusted with the care of one of the deceased's vital organs, stand atop a huge lotus blossom rising up out of the lake. In the top register, Hunefer, finally accepted into the afterlife, kneels before 14 gods of the underworld.

THE THIRD INTERMEDIATE PERIOD, c. 1075–715 BCE

After the end of the New Kingdom, Egypt was ruled by a series of new dynasties, whose leaders continued the traditional patterns of royal patronage and pushed figural conventions in new

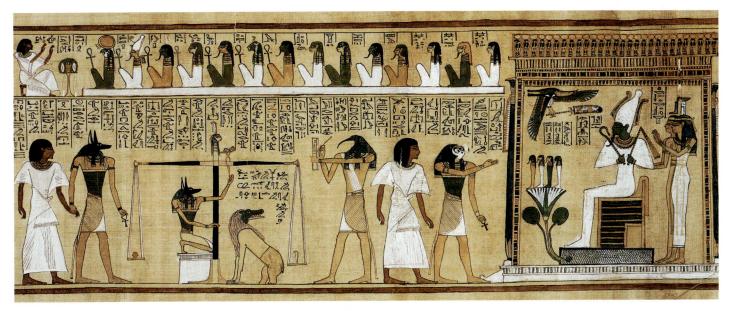

3-35 • JUDGMENT OF HUNEFER BEFORE OSIRIS

Illustration from a Book of the Dead. Nineteenth Dynasty, c. 1285 BCE. Painted papyrus, height 155%" (39.8 cm). British Museum, London. (EA 9901)

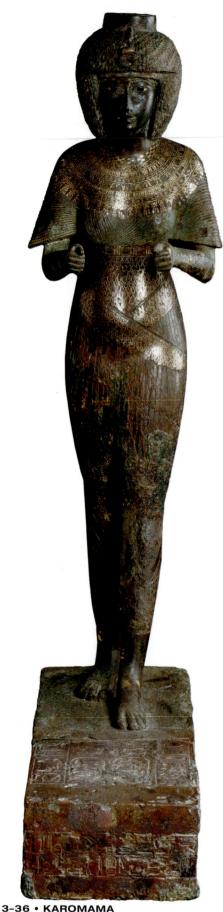

Third Intermediate period, Twenty-Second Dynasty, c. 945– 715 BCE. Bronze inlaid with gold, silver, electrum, glass, and copper, height 23¹/₂" (59.5 cm). Musée du Louvre, Paris.

and interesting directions. One of the most extraordinary, and certainly one of the largest, surviving examples of ancient Egyptian bronze sculpture dates from this period (**FIG. 3-36**). An inscription on the base identifies the subject as Karomama, divine consort of Amun and member of a community of virgin priestesses selected from the pharaoh's family or retinue who were dedicated to him. Karomama herself was the granddaughter of king Osorkan I (Twenty-First Dynasty, r. c. 985–978 BCE). These priestesses amassed great power, held property, and maintained their own court, often passing on their position to one of their nieces. The *sistra* (ritual rattles) that Karomama once carried in her hands would have immediately identified her as a priestess rather than a princess.

The main body of this statue was cast in bronze and subsequently covered with a thin sheathing of bronze, which was then exquisitely engraved with patterns inlaid with gold, silver, and electrum (a natural alloy of gold and silver). Much of the inlay has disappeared, but we can still make out the elaborately incised drawing of the bird wings that surround Karomama and accentuate the fullness of her figure, conceived to embody a new female ideal. Her slender limbs, ample hips, and more prominent breasts contrast with the uniformly slender female figures of the late New Kingdom (see FIG. 3–34).

LATE EGYPTIAN ART, c. 715–332 BCE

The Late period in Egypt saw the country and its art in the hands and service of foreigners. Nubians, Persians, Macedonians, Greeks, and Romans were all attracted to Egypt's riches and seduced by its art. In the eighth century, Nubians from the powerful kingdom of Kush—ancient Egypt's neighbor to the south—conquered Egypt, establishing capitals at Memphis and Thebes (712–657 BCE) and adopting Egyptian religious practices, artistic conventions, and architectural forms. The sphinx of the Nubian king Taharqo (r. c. 690–664 BCE) expresses royal power in a tradition dating back to the Old Kingdom (see FIG. 3–6), the two cobras on his forehead perhaps representing Taharqo's two kingdoms—Kush and Egypt (**FIG. 3–37**). The facial features,

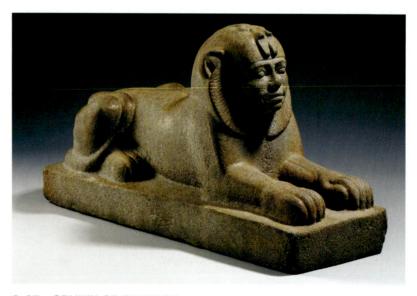

3-37 • SPHINX OF TAHARQO

From Temple T, Kawa, Nubia (modern Sudan). Twenty-Fifth Dynasty, c. 680 BCE. Granite, height 16" (40.6 cm); length 28¾" (73 cm). British Museum, London.

RECOVERING THE PAST | How Early Art is Dated

After centuries of foreign rule, beginning with the arrival of the Greeks in 332 BCE, the ancient Egyptian language gradually died out. Modern scholars were only able to recover this long-forgotten language through a fragment of a stone stele, dated 196 BCE (**FIG. 3-38**). Known today as the Rosetta Stone—for the area of the delta where one of Napoleon's officers discovered it in 1799—it contains a decree issued by the priests at Memphis honoring Ptolemy V (r. c. 205–180 BCE) carved in hieroglyphs, demotic (a simplified, cursive form of hieroglyphs), and Greek.

Even with the juxtaposed Greek translation, the two Egyptian texts remained incomprehensible until 1818, when Thomas Young, an English physician interested in ancient Egypt, linked some of the hieroglyphs to specific names in the Greek version. A short time later, French scholar Jean-François Champollion located the names Ptolemy and Cleopatra in both of the Egyptian scripts. With the phonetic symbols for P, T, O, and L in demotic, he was able to build up an "alphabet" of hieroglyphs, and by 1822 he had deciphered the two Egyptian texts.

3-38 • ROSETTA STONE 196 BCE. British Museum, London.

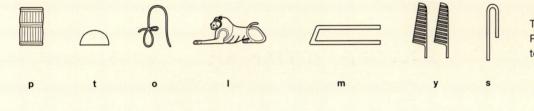

The hieroglyphic signs for the letters P, T, O, and L were Champollion's clues to deciphering the Rosetta Stone.

however, clearly identify him as African, and his specific identity is secured by an inscription engraved into his chest.

In 332 BCE, Macedonian Greeks led by Alexander the Great conquered Egypt, and after Alexander's death in 323 BCE, his

generals divided up his empire. Ptolemy, a Greek, took Egypt, declaring himself king in 305 BCE. The Ptolemaic dynasty ended with the death of Cleopatra VII (r. 51–30 BCE), when the Romans succeeded as Egypt's rulers and made it the breadbasket of Rome.

THINK ABOUT IT

- **3.1** Explain the traditional pictorial conventions for representing the human figure in ancient Egypt using the Palette of Narmer ("A Closer Look," page 52) as an example.
- **3.2** Summarize the religious beliefs of ancient Egypt with regard to the afterlife, and explain how their beliefs inspired traditions in art and architecture, citing specific examples both early and late.
- **3.3** How do depictions of royalty differ from those of more ordinary people in ancient Egyptian art? Focus your answer on one specific representation of each.
- **3.4** Characterize the stylistic transformation that took place during the rule of Akhenaten by comparing FIGURES 3–24 and 3–26. Why would there be such a drastic change?

CROSSCURRENTS

FIG. 2–17

FIG. 3–12

Study and review on myartslab.com

What do these two ancient scenes of hunting express about the wealthy and powerful people who commissioned them? How do the artists make their messages clear? How is location related to meaning?

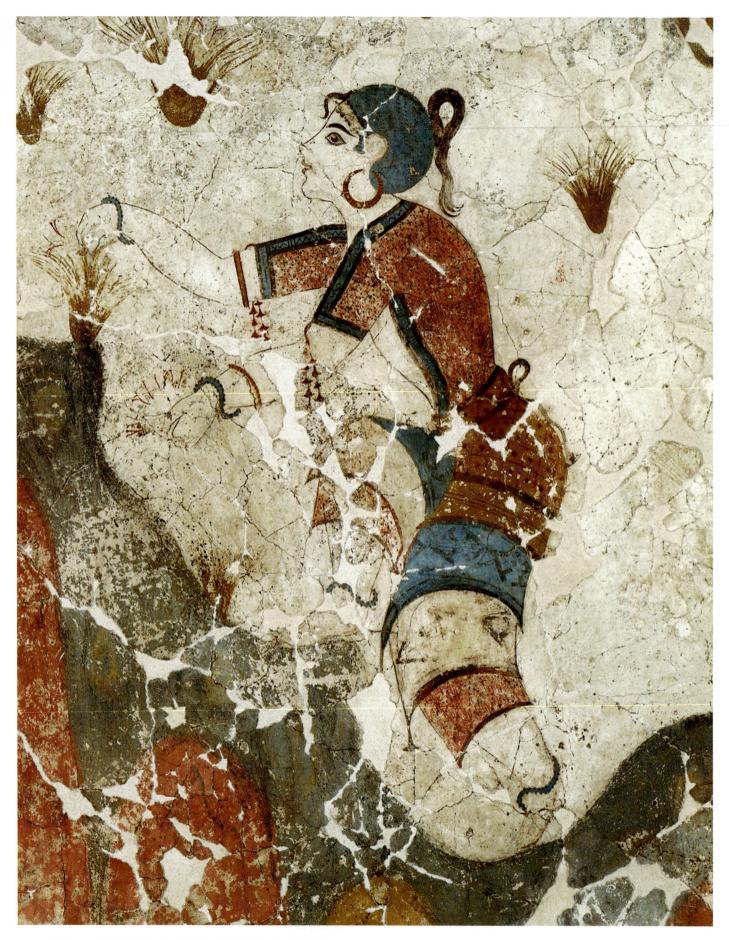

4-1 • GIRL GATHERING SAFFRON CROCUS FLOWERS Detail of wall painting, Room 3 of House Xeste 3, Akrotiri, Thera, Cyclades. Before 1630 BCE. Thera Foundation, Petros M. Nomikos, Greece.

Art of the Ancient Aegean

This elegantly posed and sharply silhouetted girl, reaching to pluck the crocus flowers blooming on the hillside in front of her (FIG. 4-1), offers us a window into life in the ancient Aegean world. The image is from a fresco of c. 1650 BCE found in a house in Akrotiri, a town on the Aegean island of Thera that seems to have been famous for the saffron harvested from its crocuses. Saffron was valued in the Bronze Age Aegean mainly as a yellow dye in textile production, but it also had medicinal properties and was used to alleviate menstrual cramps. The latter use may be referenced in this image, since the fresco was part of the elaborate painted decoration of a room that some scholars believe housed the coming-of-age ceremonies of young women at the onset of menses. The crocus gatherer's shaved head and looped long ponytail are attributes of childhood, but the light blue color of her scalp indicates that her hair is beginning to grow out, suggesting that she is entering adolescence.

The house that contained this painting disappeared suddenly more than 3,600 years ago, when the volcano that formed the island of Thera erupted, spewing pumice that filled and sealed every crevice of Akrotiri—fortunately, after the residents had fled. The rediscovery of the lost town in 1967 was among the most significant archaeological events of the second half of the twentieth century, and excavation of the city is still under way. The opportunity that Thera affords archaeologists to study works of art and architecture in context has allowed for a deeper understanding of the Bronze Age cultures of the Aegean. As the image of the girl gathering crocuses illustrates, wall paintings may reflect the ritual uses of a room or building, and the meanings of artifacts are better understood by considering both where they are found and how they are grouped with one another.

Before 3000 BCE until about 1100 BCE, several Bronze Age cultures flourished simultaneously across the Aegean: on a cluster of small islands (including Thera) called the Cyclades, on Crete and other islands in the eastern Mediterranean, and on mainland Greece (MAP 4-1). To learn about these cultures, archaeologists have studied shipwrecks, homes, and grave sites, as well as the ruins of architectural complexes. Archaeology-uncovering and interpreting material culture to reconstruct its original context-is our principal means of understanding the Bronze Age culture of the Aegean, since only one of its three written languages has been decoded. In recent years, archaeologists and art historians have collaborated with researchers in such areas of study as the history of trade and the history of climate change to provide an ever-clearer picture of ancient Aegean society. But many sites await excavation, or even discovery. The history of the Aegean Bronze Age is still being written.

LEARN ABOUT IT

- **4.1** Compare and contrast the art and architectural styles developed by three Aegean Bronze Age cultures.
- **4.2** Evaluate how archaeology has recovered, reconstructed, and interpreted ancient Aegean material culture despite the limitations of written documents.
- **4.3** Investigate the relationship between art and social rituals or communal practices in the ancient Aegean cultures.
- **4.4** Assess differences in the designs and use of the large architectural complexes created by the Minoans and the Mycenaeans.

((• Listen to the chapter audio on myartslab.com

THE BRONZE AGE IN THE AEGEAN

Using metal ores imported from Europe, Arabia, and Anatolia, Aegean peoples created exquisite objects of bronze that were prized for export. This early period when the manufacture of bronze tools and weapons became widespread is known as the Aegean Bronze Age. (See Chapter 1 for the Bronze Age in northern Europe.)

For the ancient Aegean peoples, the sea provided an important link not only between the mainland and the islands, but also to the world beyond. In contrast to the landlocked civilizations of the Near East, and to the Egyptians, who used river transportation, the peoples of the Aegean were seafarers, and their ports welcomed ships from other cultures around the Mediterranean. For this reason shipwrecks offer a rich source of information about the material culture of these ancient societies. For example, the wreck of a trading vessel (probably from the Levant, the Mediterranean coast of the Near East) thought to have sunk in or soon after 1306 BCE and discovered in the vicinity of Ulu Burun, off the southern coast of modern Turkey, carried an extremely varied cargo: metal ingots, bronze weapons and tools, aromatic resins, fruits and spices, jewelry and beads, African ebony, ivory tusks, ostrich eggs, disks of blue glass ready to be melted down for reuse, and ceramics from the Near East, mainland Greece, and Cyprus. Among the gold objects was a scarab associated with Nefertiti, wife of the Egyptian pharaoh Akhenaten. The cargo suggests that this vessel cruised from port to port along the Aegean and eastern Mediterranean seas, loading and unloading goods as it went. It also suggests that the peoples of Egypt and the ancient Near East were important trading partners.

Probably the thorniest problem in Aegean archaeology is that of dating the finds. In the case of the Ulu Burun wreck, the dating of a piece of freshly cut firewood on the ship to 1306 BCEusing a technique called dendrochronology that analyzes the spaces between growth rings-allowed unusual precision in pinpointing the moment this ship sunk. But archaeologists are not always able to find such easily datable materials. They usually rely on a relative dating system for the Aegean Bronze Age, based largely on pottery, but assigning specific dates to sites and objects with this system is complicated and controversial. One cataclysmic event has helped: A huge volcanic explosion on the Cycladic island of Thera, as we have seen, devastated Minoan civilization there and on Crete, only 70 miles to the south. Evidence from tree rings from Ireland and California and traces of volcanic ash in ice cores from Greenland put the date of the eruption about 1650-1625 BCE. Sometimes in this book you will find periods cited without attached dates and in other books you may encounter different dates from those given for objects shown here. You should expect dating to change in the future as our knowledge grows and new techniques of dating emerge.

THE CYCLADIC ISLANDS

On the Cycladic islands, late Neolithic and early Bronze Age people developed a thriving culture. They engaged in agriculture, herding, crafts, and trade, using local stone to build fortified towns and hillside burial chambers. Because they left no written records, their artifacts are our principal source of information about them. From about 6000 BCE, Cycladic artists used a coarse, poor-quality local clay to make a variety of ceramic objects, including engaging ceramic figurines of humans and animals, as well as domestic and ceremonial wares. Some 3,000 years later, they began to produce marble sculptures.

The Cyclades, especially the islands of Naxos and Paros, had ample supplies of a fine and durable white marble. Sculptors used this stone to create sleek, abstracted representations of human figures, ranging from a few inches to almost 5 feet tall. They were shaped—perhaps by women—with scrapers made of obsidian and smoothed by polishing stones of emery, both materials easily available on the Cyclades.

These sculptures have been found almost exclusively in graves, and, although there are a few surviving male figures, the

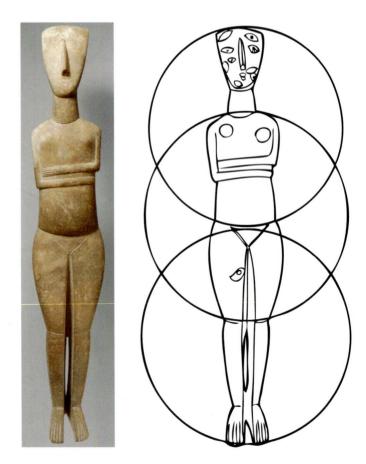

4-2 • FIGURE OF A WOMAN WITH A DRAWING SHOWING EVIDENCE OF ORIGINAL PAINTING AND OUTLINING DESIGN SCHEME

Cyclades. c. 2600–2400 BCE. Marble, height 24³/4" (62.8 cm). Figure: Metropolitan Museum of Art, New York. Gift of Christos G. Bastis (68.148). Drawing: Elizabeth Hendrix.

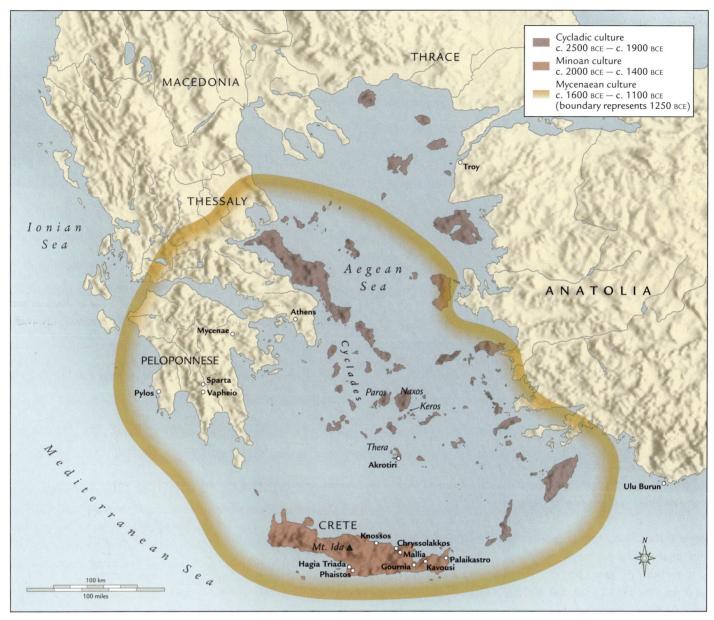

MAP 4-1 • THE ANCIENT AEGEAN WORLD

The three main cultures in the ancient Aegean were the Cycladic, in the Cyclades; the Minoan, on Thera and Crete; and the Helladic, including the Mycenaean, on mainland Greece but also encompassing the regions that had been the center of the two earlier cultures.

overwhelming majority represent nude women and conform to a consistent representational convention (**FIG. 4-2**). They are presented in extended poses of strict symmetry, with arms folded just under gently protruding breasts, as if they were clutching their abdomens. Necks are long, heads tilted back, and faces are featureless except for a prominent, elongated nose. All body parts are pared down to essentials, and some joints and junctures are indicated with incised lines. The sculptors carefully designed these figures, laying them out with a compass in conformity to three evenly spaced and equally sized circles—the first delineated by the upper arch of the head and the waist, the second by the sloping shoulders and the line of the knees, and the third beginning with the curving limit of the paired feet and meeting the bottom of the upper circle at the waist.

For us, these elegant, pure stylizations recall the modern work of sculptors like Brancusi (see FIGS. 32–27, 32–28), but originally their smooth marble surfaces were enlivened by painted motifs in blue, red, and more rarely green paint, emphasizing their surfaces rather than their three-dimensional shapes. Today, evidence of such painting is extremely faint, but many patterns have been recovered using controlled lighting and microscopic investigation. Unlike the forms themselves, the painted features are often asymmetrical in organization. In the example illustrated here, wide-open eyes appear on forehead, cheeks, and thigh, as well as on either side of the nose.

Art historians have proposed a variety of explanations for the meaning of these painted motifs. The angled lines on some figures' bodies could bear witness to the way Cycladic peoples decorated their own bodies—whether permanently with tattoos or scarification, or temporarily with body paint, applied either during their lifetimes or to prepare their bodies for burial. The staring eyes, which seem to demand the viewer's return gaze, may have been a way of connecting these sculpted images to those who owned or used them. And eyes on locations other than faces may aim to draw viewers' attention—perhaps even healing powers—to a particular area of the body. Some have associated eyes on bellies with pregnancy.

Art historian Gail Hoffman has argued that patterns of vertical red lines painted on the faces of some figures (**FIG. 4–3**) were related to Cycladic rituals of mourning their dead. Perhaps these sculptures were used in relation to a succession of key moments throughout their owners' lifetimes—such as puberty, marriage, and death—and were continually repainted with motifs associated with each ritual, before finally following their owners into their graves at death. Since there is no written evidence from Cycladic culture, and since our knowledge is hindered by the absence of any information on the archaeological contexts of many works, it is difficult to be certain, but these sculptures were clearly important to Bronze Age Cycladic peoples and seem to have taken on meaning in relationship to their use.

Although some Cycladic islands retained their distinctive artistic traditions, by the Middle and Later Bronze Age, the art and culture of the Cyclades as a whole was subsumed by Minoan and, later, Mycenaean culture.

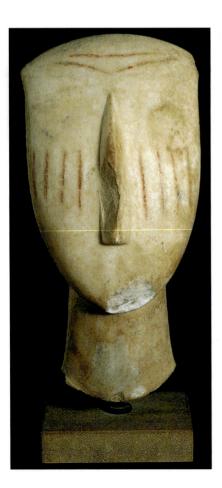

4-3 • HEAD WITH REMAINS OF PAINTED DECORATION Cyclades. c. 2500– 2200 BCE. Marble and

red pigment, height 9¹¹/₁₆" (24.6 cm). National Museum, Copenhagen. (4697)

THE MINOAN CIVILIZATION ON CRETE

As early as the Neolithic period, there was large-scale migration to and permanent settlement on Crete, the largest of the Aegean islands (155 miles long and 36 miles wide). By the Bronze Age, Crete was economically self-sufficient, producing its own grains, olives and other fruits, cattle, and sheep. With many safe harbors and a convenient location, Crete became a wealthy sea power, trading with mainland Greece, Egypt, the Near East, and Anatolia, thus acquiring the ores necessary for producing bronze.

Between about 1900 BCE and 1375 BCE, a distinctive culture flourished on Crete. The British archaeologist Sir Arthur Evans (see "Pioneers of Aegean Archaeology," opposite) named it Minoan after the legend of Minos, a king who had ruled from the capital, Knossos. According to this legend, a half-man, half-bull monster called the Minotaur—son of the wife of King Minos and a bull belonging to the sea god Poseidon—lived at Knossos in a maze called the Labyrinth. To satisfy the Minotaur's appetite for human flesh, King Minos ordered the mainland kingdom of Athens to send a yearly tribute of 14 young men and women, a practice that ended when the Athenian hero Theseus killed the beast.

Minoan chronology is divided into two main periods, the "Old Palace" period, from about 1900 to 1700 BCE, and the "New Palace" period, from around 1700 to 1450 BCE.

THE OLD PALACE PERIOD, c. 1900-1700 BCE

Minoan civilization remained very much a mystery until 1900 CE, when Sir Arthur Evans began uncovering the buried ruins of the architectural complex at Knossos, on Crete's north coast, that had been occupied in the Neolithic period, then built over with a succession of Bronze Age structures.

ARCHITECTURAL COMPLEXES Like nineteenth-century excavators before him, Evans called these great architectural complexes "palaces." He believed they were occupied by a succession of kings. While some scholars continue to believe that Evans's "palaces" actually were the residences and administrative centers of hereditary rulers, the evidence has suggested to others that Minoan society was not ruled by kings drawn from a royal family, but by a confederation of aristocrats or aristocratic families who established a fluid and evolving power hierarchy. In this light, some scholars interpret these elaborate complexes not primarily as residences, but as sites of periodic religious ceremony or ritual, perhaps enacted by a community that gathered within the court-yards that are their core architectural feature.

The walls of early Minoan buildings were made of rubble and mud bricks faced with cut and finished local stone, our first evidence of **dressed stone** used as a building material in the Aegean. Columns and other interior elements were made of wood. Both in large complexes and in the surrounding towns, timber appears to have been used for framing and bracing walls. Its strength and

RECOVERING THE PAST | Pioneers of Aegean Archaeology

Some see Heinrich Schliemann (1822–1890) as the founder of the modern study of Aegean civilization. Schliemann was the son of an impoverished German minister and a largely self-educated polyglot. He worked hard, grew rich, and retired in 1863 to pursue his lifelong dream of becoming an archaeologist, inspired by the Greek poet Homer's epic tales, the Iliad and the Odyssey. In 1869, he began conducting fieldwork in Greece and Turkey. Scholars of that time considered Homer's stories pure fiction, but by studying the descriptions of geography in the Iliad, Schliemann located a multilayered site at Hissarlik, in present-day Turkey, whose sixth level up from the bedrock is now generally accepted as the closest chronological approximation of Homer's Troy. After his success in Anatolia, Schliemann pursued his hunch that the grave sites of Homer's Greek royal family would be found inside the citadel at Mycenae. But the graves he found were too early to contain the bodies of Atreus, Agamemnon, and their relatives-a fact only established through recent scholarship, after Schliemann's death.

The uncovering of what Schliemann had considered the palace of the legendary King Minos fell to a British archaeologist, Sir Arthur Evans (1851–1941), who led the excavation at Knossos between 1900 and 1905. Evans gave the name Minoan—after legendary King Minos—to Bronze Age culture on Crete. He also made a first attempt to establish an absolute chronology for Minoan art, basing his conjectures on datable Egyptian artifacts found in the ruins on Crete and on Minoan artifacts found in Egypt. Later scholars have revised and refined both his dating and his interpretations of what he found at Knossos.

Evans was not the only pioneering archaeologist drawn to excavate on Crete. Boston-born Harriet Boyd Hawes (1871–1945), after graduating from Smith College in 1892 with a major in Classics and after a subsequent year of post-graduate study in Athens, traveled to Crete to find a site where she could begin a career in archaeology. She was in Knossos in 1900 to observe Evans's early work and was soon supervising her own excavations, first at Kavousi, and then at Gournia, where she directed work from 1901 until 1904. She is famous for the timely and thorough publication of her findings, accomplished while she was not only supervising these Bronze Age digs, but also pursuing her career as a beloved teacher of the liberal arts, first at Smith and later at Wellesley College.

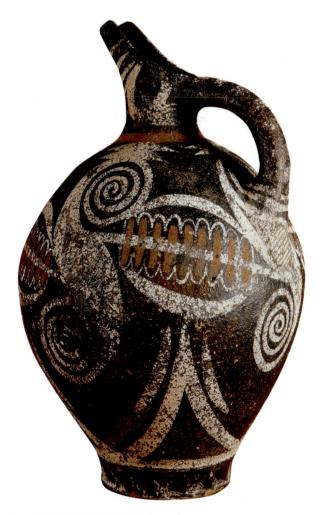

4-4 • KAMARES WARE JUG

From Phaistos, Crete. Old Palace period, c. 2000–1900 BCE. Ceramic, height 105%" (27 cm). Archaeological Museum, Iraklion, Crete.

flexibility would have minimized damage from the earthquakes common to the area. Nevertheless, an earthquake in c. 1700 BCE severely damaged buildings at several sites, including Knossos and Phaistos.

CERAMIC ARTS During the Old Palace period, Minoans developed elegant new types of ceramics, spurred in part by the introduction of the potter's wheel early in the second millennium BCE. One type is called Kamares ware, after the cave on Mount Ida overlooking the architectural complex at Phaistos, in southern Crete, where it was first discovered. The hallmarks of this select ceramic ware—so sought-after that it was exported as far away as Egypt and Syria—were its extreme thinness, its use of color, and its graceful, stylized, painted decoration. An example from about 2000–1900 BCE has a globular body and a "beaked" pouring spout (**FIG. 4–4**). Created from brown, red, and creamy white pigments on a black body, the bold, curving forms—derived from plant life—that decorate this jug seem to swell with its bulging contours.

THE NEW PALACE PERIOD, c. 1700-1450 BCE

The early architectural complex at Knossos, erected about 1900 BCE, formed the core of an elaborate new one built after a terrible earthquake shook Crete in c. 1700 BCE. This rebuilding, at Knossos and elsewhere, belonged to the period termed "New Palace" by scholars, many of whom consider it the highest point of Minoan civilization. In its heyday, the Knossos complex covered six acres (**FIG. 4-5**).

Damaged structures were repaired and enlarged, and the resulting new complexes shared a number of features. Multistoried,

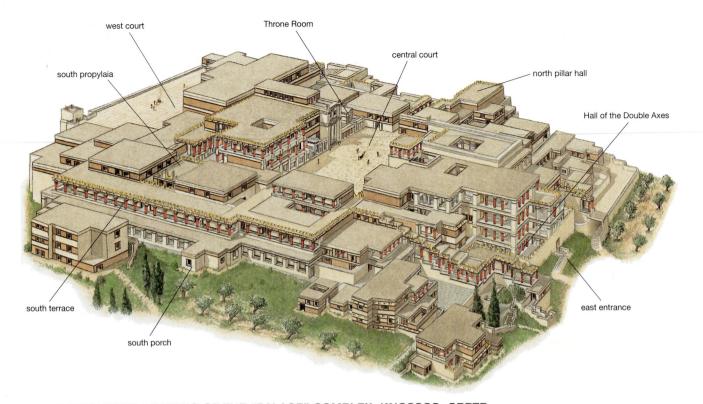

4-5 • **RECONSTRUCTION DRAWING OF THE "PALACE" COMPLEX, KNOSSOS, CRETE** As it would have appeared during the New Palace period. Site occupied since the Neolithic period; the Minoan complex of the Old Palace period (c. 1900–1700 все) was rebuilt during New Palace period (c. 1700–1450 все) after earthquakes and fires; final destruction c. 1375 все.

flat-roofed, and with many columns, they were designed to maximize light and air, as well as to define access and circulation patterns. Daylight and fresh air entered through staggered levels, open stairwells, and strategically placed air shafts and light-wells (**FIG. 4–6**).

Large, central courtyards—not audience halls or temples were the most prominent components of these rectangular complexes. Suites of rooms were arranged around them. Corridors and staircases led from the central and subsidiary courtyards, through apartments, ritual areas, and storerooms. Walls were coated with plaster, and some were painted with murals. Floors were plaster, or plaster mixed with pebbles, stone, wood, or beaten earth. The residential quarters had many luxuries: sunlit courtyards or lightwells, richly colored murals, and sophisticated plumbing systems.

Workshops clustered around the complexes formed commercial centers. Storeroom walls were lined with enormous clay jars for oil and wine, and in their floors stone-lined pits from earlier structures had been designed for the storage of grain. The huge scale of the centralized management of foodstuffs became apparent when excavators at Knossos found in a single (although more recent) storeroom enough ceramic jars to hold 20,000 gallons of olive oil.

THE LABYRINTH AT KNOSSOS Because double-axe motifs were used in its architectural decoration, the Knossos "palace" was referred to in later Greek legends as the Labyrinth, meaning the "House of the Double Axes" (Greek *labrys*, "double axe"). The organization of the complex seemed so complicated that the word labyrinth eventually came to mean "maze" and became part of the Minotaur legend.

This complicated layout provided the complex with its own internal security system: a baffling array of doors leading to unfamiliar rooms, stairs, yet more corridors, or even dead ends. Admittance could be denied by blocking corridors, and some rooms were accessible only from upper terraces. Close analysis, however, shows that the builders had laid out a square grid following predetermined principles, and that the apparently confusing layout may partially be the result of earthquake destruction and rebuilding over the centuries.

In typical Minoan fashion, the rebuilt Knossos complex was organized around a large central courtyard (see FIG. 4–5). A few steps led from the central courtyard down into the so-called Throne Room to the west, and a great staircase on the east side descended to the Hall of the Double Axes, an unusually grand example of a Minoan hall. (Evans gave the rooms their misleading but romantic names.) This hall and others were supported by the uniquely Minoan-type wooden columns that became standard in Aegean palace architecture (see FIG. 4–6). The tree trunks from which the columns were made were inverted so that they tapered toward the bottom. The top, supporting massive roof beams and a broad flattened capital, was wider than the bottom.

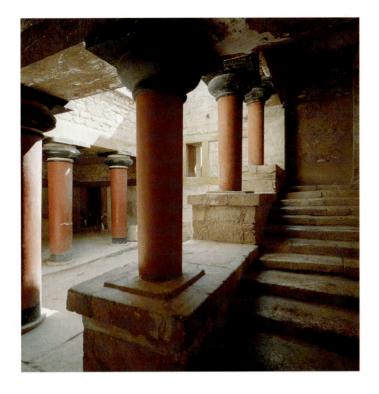

4-6 • EAST WING STAIRWELL "Palace" complex, Knossos, Crete. New Palace period, c. 1700–1450 BCE.

Rooms, following earlier tradition, were arranged around a central space rather than along an axis, as we have seen in Egypt and will see in mainland Greece. During the New Palace period, suites functioned as archives, business centers, and residences. Some must also have had a religious function, though the temples, shrines, and elaborate tombs seen in Egypt are not found in Minoan architecture.

BULL LEAPING AT KNOSSOS Minoan painters worked on a large scale, covering entire walls of rooms with geometric borders, views of nature, and scenes of human activity. Murals can be painted on a still-wet plaster surface (**buon fresco**) or a dry one (**fresco secco**). The wet technique binds pigments to the wall, but forces the painter to work very quickly. On a dry wall, the painter need not hurry, but the pigments tend to flake off over time. Minoans used both techniques.

Minoan wall painting displays elegant drawing, and, like Egyptian painters, Minoan painters filled these linear contours with bright and unshaded fields of pure color. They preferred profile or full-faced views, and they turned natural forms into decorative patterns through stylization. One of the most famous paintings of Knossos depicts one of the most prominent subjects in Minoan art: **BULL LEAPING** (**FIG. 4-7**). The panel—restored from excavated fragments—is one of a group of paintings with bulls as subjects

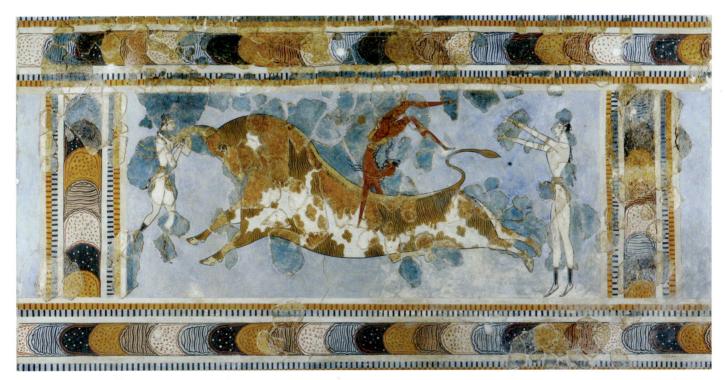

4-7 • BULL LEAPING

Wall painting with areas of modern reconstruction, from the palace complex, Knossos, Crete. Late Minoan period, c. 1450–1375 BCE. Height approx. 241/2" (62.3 cm). Archaeological Museum, Iraklion, Crete.

Careful sifting during excavation preserved many fragments of the paintings that once covered the walls at Knossos. The pieces were painstakingly sorted and cleaned by restorers and reassembled into puzzle pictures; more pieces were missing than found. Areas of color have been used in this reconstruction to fill the gaps, making it obvious which bits are the restored portions, but allowing us to have a sense of the original image.

from a room in the east wing of the complex. The action—perhaps representing an initiation or fertility ritual—shows three scantily clad youths around a gigantic dappled bull, which is charging in the **"flying-gallop"** pose. The pale-skinned person at the right her paleness probably identifying her as a woman—is prepared to catch the dark-skinned man in the midst of his leap, and the paleskinned woman at the left grasps the bull by its horns, perhaps to help steady it, or perhaps preparing to begin her own vault. Framing the action are strips of overlapping shapes, filled with ornament set within striped bands.

STATUETTE OF A MALE FIGURE FROM PALAIKASTRO

Surviving Minoan sculpture consists mainly of small, finely executed work in wood, ivory, precious metals, stone, and ceramic. **Faience** (colorfully glazed fine ceramic) female figurines holding serpents are among the most characteristic images and may have been associated with water, regenerative power, and protection of the home. But among the most impressive works is an unusually large male figure that has been reconstructed from hundreds of fragments excavated in eastern Crete at Palaikastro between 1987 and 1990 (**FIG. 4–8**). The blackened state of the remains bears witness to damage in a fire that must have destroyed the building where it was kept since fire damage pervades the archaeological layer in which these fragments were found. The cause or meaning of this fire is a mystery.

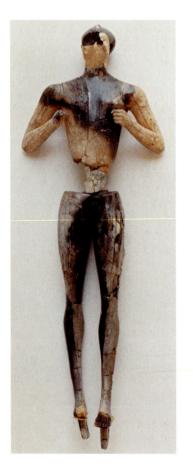

This statuette is a multimedia work assembled from a variety of mostly precious materials. The majority of the body was carved in exquisite anatomical detail-including renderings of subcutaneous veins, tendons, and bones-from the ivory of two hippopotamus teeth, with a gap in the lower torso for a wooden insert to which was attached a kilt made of gold foil. Miniature gold sandals slipped onto the small, tapering feet. The head was carved of gray serpentine with inset eyes of rock crystal, just as inlaid wooden nipples detail the figure's torso. The ivory and gold may have been imported-perhaps from Egypt-but the style is characteristically Minoan (compare FIG. 4-7). We know very little about the context and virtually nothing about the meaning or use of this figure but the nature of the materials and the large size suggest that it was important. Some have interpreted this as the cult statue of a young god; others have proposed it was a votive effigy for a religious ceremony; but these remain speculations.

STONE RHYTONS Almost certainly of ritual significance are a series of stone **rhytons**—vessels used for pouring liquids—that Minoans carved from steatite (a greenish or brown soapstone) and

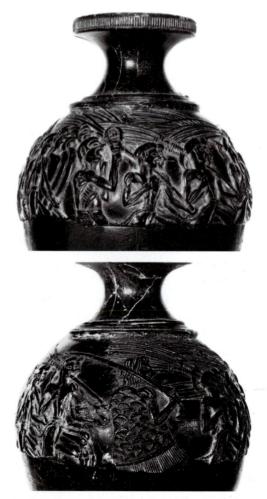

4-9 • TWO VIEWS OF THE HARVESTER RHYTON From Hagia Triada, Crete. New Palace period, c. 1650–1450 BCE. Steatite, greatest diameter 4½" (11.3 cm). Archaeological Museum, Iraklion, Crete.

4-8 • STATUETTE OF A MALE FIGURE From Palaikastro, Crete. c. 1500–1475 BCE. Ivory, gold,

serpentine, rock crystal, and wood, height $19\frac{1}{2}$ " (50 cm).

Archaeological Museum,

Siteia, Crete.

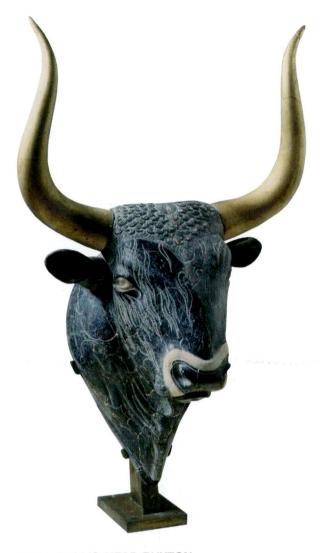

4–10 • BULL'S-HEAD RHYTON From Knossos, Crete. New Palace period, c. 1550–1450 BCE. Serpentine with shell, rock crystal, and red jasper; the gilt-wood horns are restorations, height 12" (30.5 cm). Archaeological Museum, Iraklion, Crete.

serpentine (usually dull green in color). These have been found in fragments and reconstructed by archaeologists. **THE HAR-VESTER RHYTON** was a cone-shaped vessel (only the upper part is preserved) barely 4½ inches in diameter (**FIG. 4-9**). It may have been covered with gold leaf, sheets of hammered gold (see "Aegean Metalwork," page 90).

A rowdy procession of 27 men has been crowded onto its curving surface. The piece is exceptional for the freedom with which the figures occupy three-dimensional space, overlapping and jostling one another instead of marching in orderly, patterned single file across the surface in the manner of some Near Eastern or Egyptian art. The exuberance of this scene is especially notable in the emotions expressed on the men's faces. They march and chant to the beat of a *sistrum*—a rattlelike percussion instrument elevated in the hands of a man whose wide-open mouth seems to signal singing at the top of his lungs. The men have large, bold features and sinewy bodies so trim we can see their ribs. One man stands out from the crowd because of his long hair, scale-covered ceremonial cloak, and commanding staff. Is he the leader of this enthusiastic band, or is he following along behind them? Archaeologists have proposed a variety of interpretations for the scene a spring planting or fall harvest festival, a religious procession, a dance, a crowd of warriors, or a gang of forced laborers.

As we have seen, bulls are a recurrent theme in Minoan art, and rhytons were also made in the form of a bull's head (**FIG. 4-10**). The sculptor carved this one from a block of greenish-black serpentine to create an image that approaches animal portraiture. Lightly engraved lines, filled with white powder to make them visible, enliven the animal's coat: short, curly hair on top of the head; longer, shaggy strands on the sides; and circular patterns along the neck suggest its dappled coloring. White bands of shell outline the nostrils, and painted rock crystal and red jasper form the eyes. The horns (here restored) were made of wood covered with gold leaf. This rhyton was filled with liquid through a hole in the bull's neck, and during ritual libations, fluid flowed out from its mouth.

CERAMIC ARTS The ceramic arts, so splendidly realized early on in Kamares ware, continued throughout the New Palace period. Some of the most striking ceramics are characterized as "Marine style," because of the depictions of sea life on their surfaces. In a stoppered bottle of this type known as the **OCTOPUS FLASK**, made about 1500–1450 BCE (**FIG. 4–11**), the painter created a dynamic arrangement of marine life, in

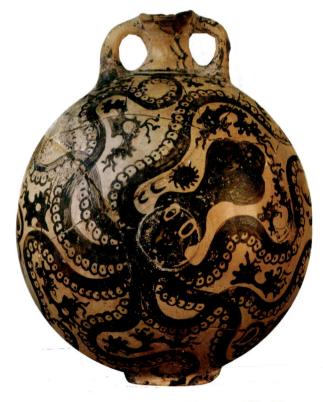

4-11 • OCTOPUS FLASK

From Palaikastro, Crete. New Palace period, c. 1500–1450 BCE. Marine-style ceramic, height 11" (28 cm). Archaeological Museum, Iraklion, Crete.

TECHNIQUE | Aegean Metalwork

Aegean artists created exquisite luxury goods from imported gold. Their techniques included lost-wax casting (see "Lost-Wax Casting," page 418), inlay, filigree, granulation, repoussé, niello, and gilding.

The early Minoan pendant with a pair of gold bees shown here (**FIG. 4–12**) exemplifies early sophistication in **filigree** (delicate decoration with fine wires) and **granulation** (minute granules or balls of precious metal fused to underlying forms), the latter used to enliven the surfaces and to outline or even create three-dimensional shapes.

The Vapheio Cup (see Fig. 4–13) and the funerary mask (see Fig. 4–20) are examples of **repoussé**, in which artists gently pushed up relief forms (perhaps by hammering) from the back of a thin sheet of gold. Experienced goldsmiths may have formed simple designs freehand, or used standard wood forms or punches. For more elaborate decorations they would first have sculpted the entire design in wood or clay and then used this form as a mold for the gold sheet.

The artists who created the Mycenaean dagger blade (see Fig. 4–21) not only inlaid one metal into another, but also employed a special technique called **niello**, still a common method of metal decoration. Powdered nigellum—a black alloy of lead, silver, and copper with sulfur—was rubbed into very fine engraved lines in a silver or gold surface, then fused to the surrounding metal with heat. The resulting lines appear as black drawings.

Gilding—the application of gold to an object made of some other material—was a technically demanding process by which paper-thin sheets of hammered gold called gold leaf (or, if very thin, gold foil) were meticulously affixed to the surface to be gilded. Gold sheets may once have covered the now-bare stone surface of the Harvester Rhyton (see FIG. 4–9) as well as the lost wooden horns of the Bull's-head Rhyton (see FIG. 4–10).

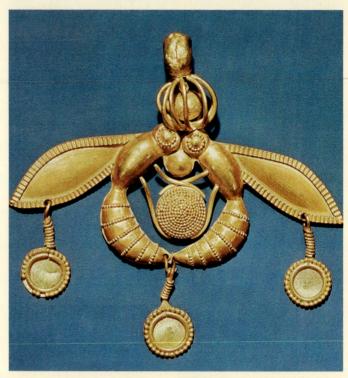

4-12 • PENDANT OF GOLD BEES From Chryssolakkos, near Mallia, Crete. Old Palace period, c. 1700–1550 BCE. Gold, height approx. 1¹³/₁₆" (4.6 cm). Archaeological Museum, Iraklion, Crete.

Watch a video about the process of lost-wax casting on myartslab.com

seeming celebration of Minoan maritime prowess. Like microscopic life teeming in a drop of pond water, sea creatures float around an octopus's tangled tentacles. The decoration on the Kamares ware jug (see FIG. 4–4) had reinforced the solidity of its surface, but here the pottery surface seems to dissolve. The painter captured the grace and energy of natural forms while presenting them as a stylized design in calculated harmony with the vessel's bulging shape.

METALWORK By about 1700 BCE, Aegean metalworkers were producing objects that rivaled those of Near Eastern and Egyptian jewelers, whose techniques they may have learned and adopted. For a pendant in gold found at Chryssolakkos (see "Aegean Metalwork," above), the artist arched a pair of easily recognizable but geometrically stylized bees (or perhaps wasps) around a honeycomb of gold granules, providing their sleek bodies with a single pair of outspread wings. The pendant hangs from a spider-like filigree form, with what appear to be long legs encircling a tiny gold ball. Small disks dangle from the ends of the wings and the point where the insects' bodies meet.

THE SPREAD OF MINOAN CULTURE

About 1450 BCE, a conquering people from mainland Greece, known as Mycenaeans, arrived in Crete. They occupied the buildings at Knossos and elsewhere until a final catastrophe and the destruction of Knossos about 1375 BCE caused them to abandon the site. But by 1400 BCE, the center of political and cultural power in the Aegean had shifted to mainland Greece.

The skills of Minoan artists, particularly metalsmiths, had made them highly sought after on the mainland. A pair of magnificent gold cups found in a large tomb at Vapheio, on the Greek mainland south of Sparta, were made sometime between 1650 and 1450 BCE, either by Minoan artists or by locals trained in Minoan style and techniques. One side of one cup is shown here (**FIG. 4-13**). The relief designs were executed in repoussé—the technique of pushing up the metal from the back of the sheet. The handles were attached with rivets, and the cup was then lined with sheet gold. In the scenes circling the cups, men are depicted trying to capture bulls in various ways. Here, a scantily clad man has roped a bull's hind leg. The figures dominate the landscape and bulge from the surface with a muscular vitality that belies the cup's

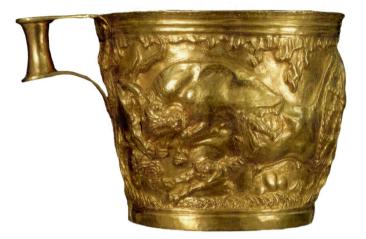

4-13 • VAPHEIO CUP

One of two cups found near Sparta, Greece. c. 1650–1450 $_{BCE.}$ Gold, height $4^{1}\!/_{2}^{\prime\prime}$ (11.3 cm). National Archaeological Museum, Athens.

small size—it is only 4½ inches tall. The depiction of olive trees could indicate that the scene is set in a sacred grove. Could the cups illustrate exploits in some long-lost heroic tale, or are they commonplace herding scenes?

WALL PAINTING AT AKROTIRI ON THERA Minoan cultural influences seem to have spread to the Cyclades as well as mainland Greece. Thera, for example, was so heavily under Crete's influence in the New Palace period that it was a veritable outpost of Minoan culture. A girl picking crocuses in a fresco in a house at Akrotiri (see FIG. 4–1) wears the typically colorful Minoan flounced skirt with a short-sleeved, open-breasted bodice, large earrings, and bracelets. This wall painting demonstrates the sophisticated decorative sense found in Minoan art, both in color selection and in surface detail. The room in which this painting appears seems to have been dedicated to young women's coming-of-age ceremonies, and its frescos provide the visual context for ritual activity, just like the courtyard of the architectural complexes in Crete.

In another Akrotiri house, an artist has created an imaginative landscape of hills, rocks, and flowers (**FIG. 4-14**), the first pure landscape painting we have encountered in ancient art. A viewer standing in the center of the room is surrounded by orange, rose, and blue rocky hillocks sprouting oversized deep-red lilies. Swallows, sketched by a few deft lines, swoop above and around the flowers. The artist unifies the rhythmic flow of the undulating landscape, the stylized patterning imposed on the natural forms, and the decorative use of bright colors alternating with darker, neutral tones, which were perhaps meant to represent areas of

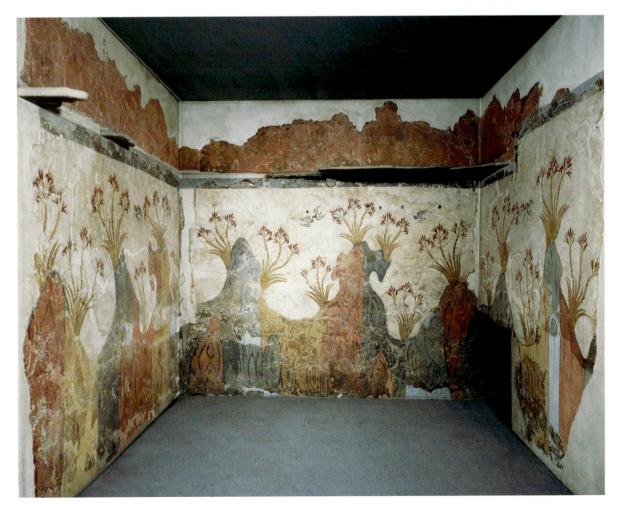

4-14 • LANDSCAPE ("SPRING FRESCO") Wall painting with areas of modern reconstruction, from Akrotiri,

A CLOSER LOOK | The "Flotilla Fresco" from Akrotiri

Detail of the left part of a mural from Room 5 of West House, Akrotiri, Thera. New Palace period, c. 1650 BCE. Height 145/16" (44 cm). National Archaeological Museum, Athens.

The depiction of lions chasing deer, perhaps signifying heroism or political power, has a long history in Aegean art. This block of land at the left seems to represent one of two spits of land in Thera that separate the sea from an enclosed area of water within a volcanic caldera at the center of the island. Both the volcanic quality of the painted rocks as well as their division into horizontal registers as bands of color reproduce the actual geological appearance of this terrain. The arrangement of ships and leaping dolphins in the central part of the mural uses vertical perspective (see Starter Kit, p. xxiii) to indicate recession into depth. In this system, higher placement is given to things that are in the distance, while those placed lower are closer to the viewer.

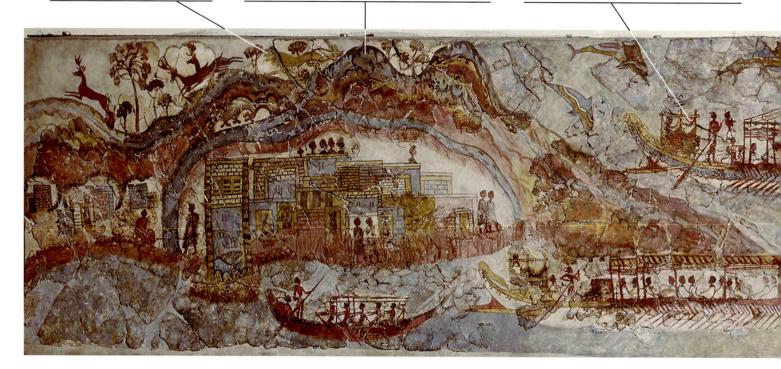

-View the Closer Look for the "Flotilla Fresco" from Akrotiri on myartslab.com

shadow. The colors may seem fanciful to us, but sailors today who know the area well attest to their accuracy, suggesting that these artists recorded the actual colors of Thera's wet rocks in the sunshine, a zestful celebration of the natural world. How different this is from the cool, stable elegance of Egyptian wall painting!

Direct references to the geology of Thera also appear in a long strip of wall painting known as the "Flotilla Fresco" (see "A Closer Look," above) running along the tops of the walls in the room of a house in Akrotiri, a domestic context comparable to that of the fresco of the girl gathering crocuses. This expansive tableau was for years interpreted as a long-distance voyage with a martial flavor, but recently art historian Thomas Strasser has argued convincingly that this is a specific seascape viewed from the eastern interior of the island of Thera itself, looking toward the western opening between two peninsular mountainous landmasses created by a volcanic caldera and at the open sea, populated by festive local ships and the dolphins that leap around them. Rather than serving as the setting for a military expedition, the land and sea of Thera itself may be the principal subject of this painting.

THE MYCENAEAN (HELLADIC) CULTURE

Archaeologists use the term *Helladic* (from *Hellas*, the Greek name for Greece) to designate the Aegean Bronze Age on mainland Greece. The Helladic period extends from about 3000 to 1000 BCE, concurrent with Cycladic and Minoan cultures. In the early part of the Aegean Bronze Age, Greek-speaking peoples, probably from the northwest, moved into the area. They brought with them advanced techniques for metalworking, ceramics, and architectural design, and they displaced the local Neolithic culture. Later in the Aegean Bronze Age, the people of the mainland city of Mycenae rose to power and extended their influence into the Aegean islands as well.

HELLADIC ARCHITECTURE

Mycenaean architecture developed in distinct ways from that of the Minoans. Mycenaeans built fortified strongholds called citadels to protect the palaces of their rulers. These palaces contained a Each of the seven vessels of the fleet on this fresco (only four can be seen in this partial view) is unique, differing in size, decoration (this one has lions painted on its side), and rigging. It has been suggested that this tableau represents a single moment from a nautical festival, perhaps a spring ceremony to kick off a new season of sailing.

Note the difference between the surviving fragments of the original fresco and the modern infill in this restored presentation of a dolphin swimming alongside the ships.

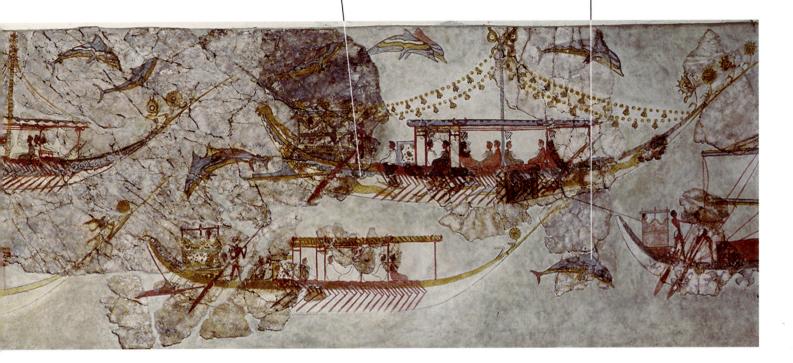

characteristic architectural unit called a **megaron** that was axial in plan, consisting of a large room, entered through a porch with columns, and sometimes a vestibule. The Mycenaeans also buried their dead in magnificent vaulted tombs, round in floor plan and crafted of cut stone.

MYCENAE Later Greek writers called the walled complex of Mycenae (**FIGS. 4-15, 4-16**) the home of Agamemnon, legendary Greek king and leader of the Greek army that conquered the great city of Troy, as described in Homer's epic poem, the *Iliad*. The site was occupied from the Neolithic period to around 1050 BCE. Even today, the monumental gateway to the citadel at Mycenae is an impressive reminder of the importance of the city. The walls were rebuilt three times—c. 1340 BCE, c. 1250 BCE, and c. 1200 BCE—each time stronger than the last and enclosing more space. The second wall, of c. 1250 BCE, enclosed an earlier grave circle and was pierced by two gates, the monumental "Lion Gate" (see FIG. 4-17) on the west and a smaller secondary, rear gate on the northeast side. The final walls were extended about 1200 BCE to protect the water supply, an underground cistern. These walls were about 25 feet thick and nearly 30 feet high. Their drywall masonry, using largely unworked boulders, is known as **cyclopean**, because it was believed that only the enormous Cyclops (legendary one-eyed giants) could have moved such massive stones.

As in Near Eastern citadels, the Lion Gate was provided with guardian figures, which stand above the door rather than to the sides in the door jambs. From this gate, the Great Ramp led up the hillside, past the grave circle, to the courtyard for the building occupying the highest point in the center of the city, which may have been the residence of a ruler. From the courtyard one entered a porch, a vestibule, and finally the megaron, which seems to be the intended destination, in contrast to Minoan complexes where the courtyard itself seems to be the destination. The great room of a typical megaron had a central hearth surrounded by four large columns that supported the ceiling. The roof above the hearth was probably raised to admit light and air and permit smoke to escape (see FIGS. 4-18, 4-19). Some architectural historians think that the megaron eventually came to be associated with royalty. The later

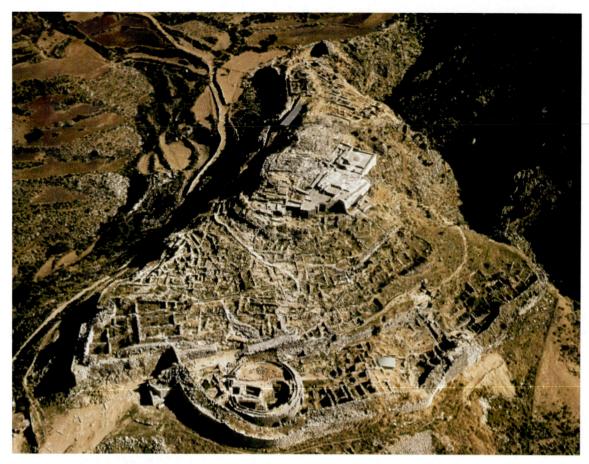

4-15 • CITADEL AT MYCENAE

Peloponnese, Greece. Aerial view. Site occupied c. 1600–1200 BCE; walls built c. 1340, 1250, 1200 BCE, creating a progressively larger enclosure.

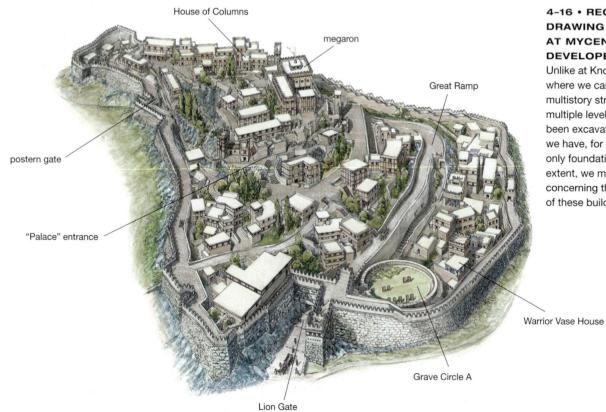

4-16 • RECONSTRUCTION DRAWING OF THE CITADEL AT MYCENAE AT ITS MOST DEVELOPED STATE

Unlike at Knossos and Akrotiri, where we can understand multistory structures because multiple levels survived and have been excavated, at Mycenae we have, for the most part, only foundations. To a certain extent, we must conjecture concerning the upper portions of these buildings.

A BROADER LOOK | The Lion Gate

One of the most imposing survivals from the Helladic Age is the gate to the city of Mycenae. The gate is today a simple opening, but its importance is indicated by the very material of the flanking walls, a conglomerate stone that can be polished to glistening multicolors. A corbeled relieving **arch** above the lintel forms a triangle filled with a limestone panel bearing a grand heraldic composition—guardian beasts flanking a single Minoan column that swells upward to a large, bulbous capital.

The archival photograph (**FIG. 4–17**) shows a group posing jauntily outside the gate. Visible is Heinrich Schliemann (standing at the left of the gate) and his wife and partner in archaeology, Sophia (sitting at the right). Schliemann had already "discovered" Troy, and when he turned his attention to Mycenae in 1876, he unearthed graves containing rich treasures, including gold masks. The grave circle he excavated lay just inside the Lion Gate (see FIG. 4–16).

The Lion Gate has been the subject of much speculation in recent years. What are the animals? What does the architectural feature mean? How is the imagery to be interpreted? The beasts supporting and defending the column are magnificent, supple creatures rearing up on hind legs. Their faces must once have been turned toward the visitor, but today only the attachment holes indicate the presence of their heads.

What were they—lions or lionesses? One scholar points out that since the beasts have

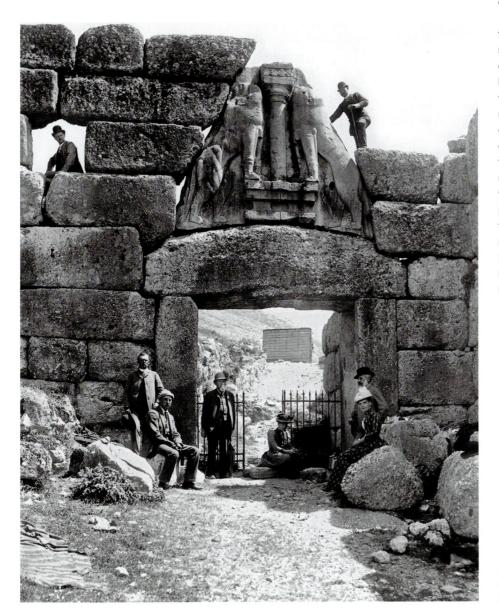

neither teats nor penises, it is impossible to say. The beasts do not even have to be felines. They could have had eagle heads, which would make them griffins, in which case should they not also have wings? They could have had human heads, and that would turn them into sphinxes. Pausanias, a Greek traveler who visited Mycenae in the second century CE, described a gate guarded by lions. Did he see the now-missing heads? And since mixedmedia sculpture-ivory and gold, marble and wood-was common in the ancient Aegean, one could imagine heads created from other materials-perhaps gold. Such heads would have gleamed and glowered out at the visitor. And if the stone sculpture was painted, as most was, the gold would not have seemed out of place.

A metaphor for power, the lions rest their feet on Minoan-style altars. Between them stands the mysterious Minoan column, also on the altar base. Clearly the Mycenaeans are borrowing symbolic vocabulary from Crete. But what does this composition mean? Scholars do not agree. Is it a temple? A palace? The entire city? Or the god of the place? The column and capital support a lintel or architrave, which in turn supports the butt ends of logs forming rafters of the horizontal roof, so the most likely theory is that the structure is the symbol of a palace or a temple. But some scholars suggest that by extension it becomes the symbol of a king or a deity. If so, the imagery of the Lion Gate, with its combination of guardian beasts and divine or royal palace, signifies the legitimate power of the ruler of Mycenae.

4-17 • LION GATE, MYCENAE c. 1250 BCE. Historic photo showing Heinrich and Sophia Schliemann.

Greeks adapted its form when building temples, which they saw as earthly palaces for their gods.

PYLOS The rulers of Mycenae fortified their city, but the people of Pylos, in the extreme southwest of the Peloponnese, perhaps felt that their more remote and defensible location made them less vulnerable to attack. This seems not to have been the case, for within a century of its construction in c. 1340 BCE, the palace at Pylos was destroyed by fires, apparently set during the violent upheavals that brought about the collapse of Mycenae itself.

The architectural complex at Pylos was built on a raised site

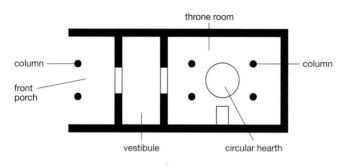

4-18 • PLAN OF THE MEGARON OF THE PYLOS PALACE c. 1300–1200 BCE.

without fortifications, and it was organized around a special area that included an archive, storerooms, workshops, and a megaron (FIG. 4-18) with a formal throne room that may also have been used to host feasting rituals involving elite members of the community. Including a porch and vestibule facing the courtyard, the Pylos megaron was a magnificent display of architectural and decorative skill. The reconstruction in FIGURE 4-19 shows how it might have looked. Every inch was painted-floors, ceilings, beams, and door frames with brightly colored abstract designs, and walls with paintings of large mythical animals and highly stylized plant and landscape forms. Flanking the throne (on the back wall of the reconstruction) are monumental paintings of lions and griffins. A circular hearth sits in the middle, set into a floor finished with plaster painted with imitations of stone and tile patterns. There was a spot in the megaron where priests and priestesses poured libations to a deity from a ceremonial rhyton, fostering communication between the people of Pylos and their god(s).

Clay tablets found in the ruins of the palace include an inventory of its elegant furnishings. The listing on one tablet reads: "One ebony chair with golden back decorated with birds; and a footstool decorated with ivory pomegranates. One ebony chair with ivory back carved with a pair of finials and with a man's figure and heifers; one footstool, ebony inlaid with ivory and pomegranates."

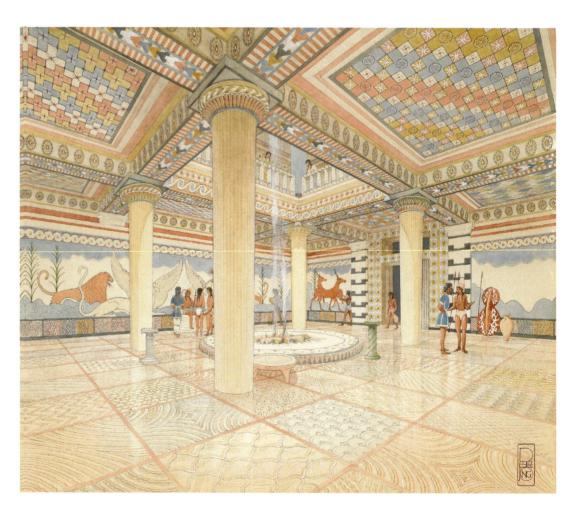

4-19 • RECONSTRUCTION DRAWING OF THE MEGARON (GREAT ROOM) OF THE PYLOS PALACE

c. 1300–1200 BCE. Watercolor by Piet de Jong.

English artist Piet de Jong (1887-1967) began his career as an architect, but his service in the post-World War I reconstruction of Greece inspired him to focus his talents on recording and reconstructing Greek archaeological excavations. In 1922, Arthur Evans called him to work on the reconstructions at Knossos, and Piet de Jong spent the rest of his life creating fanciful but archaeologically informed visions of the original appearance of some of the greatest twentiethcentury discoveries of ancient Greece and the Aegean during a long association with the British School of Archaeology in Athens.

RECOVERING THE PAST | The "Mask of Agamemnon"

One of Heinrich Schliemann's most amazing and famous discoveries in the shaft graves in Mycenae was a solid gold mask placed over the face of a body he claimed was the legendary Agamemnon, uncovered on November 30, 1876. But Schliemann's identification of the mask with this king of Homeric legend has been disproven, and even the authenticity of the mask itself has been called into question over the last 30 years.

Doubts are rooted in a series of stylistic features that separate this mask (FIG. 4-20) from the other four excavated by Schliemann in Grave Circle A—the treatment of the eyes and eyebrows, the cut-out separation of the ears from the flap of gold around the face, and most strikingly the beard and handlebar mustache that have suspicious parallels with nineteenth-century fashion in facial hair. Suspicions founded on such anomalies are reinforced by Schliemann's own history of deceit and embellishment when characterizing his life and discoveries, not to mention his freewheeling excavation practices, when judged against current archaeological standards.

Some specialists have claimed a middle ground between genuine or fake for the mask, suggesting that the artifact itself may be authentic, but that Schliemann quickly subjected it to an overzealous restoration to make the face of "Agamemnon" seem more heroic and noble—at least to viewers in his own day—than the faces of the four other Mycenaean funerary masks. But another scholar has argued that, in fact, this particular mask is not the one Schliemann associated with Agamemnon, undercutting some of the principal arguments for questioning its authenticity in the first place.

The resolution of these questions awaits a full scientific study to determine the nature of the alloy (gold was regularly mixed with small amounts of other metals to make it stronger) from which this mask was made, as well as a microscopic analysis of its technique and the appearance of its surface.

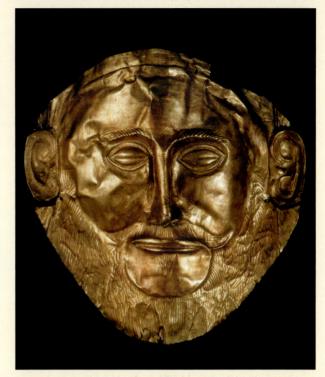

4-20 • "MASK OF AGAMEMNON" Funerary mask, from Shaft Grave v, Grave Circle A, Mycenae, Greece. c. 1600–1550 BCE. Gold, height approx. 12" (35 cm). National Archaeological Museum, Athens.

MYCENAEAN TOMBS

SHAFT GRAVES Tombs were given much greater prominence in the Helladic culture of the mainland than they were by the Minoans, and ultimately they became the most architecturally sophisticated monuments of the entire Aegean Bronze Age. The earliest burials were in **shaft graves**, vertical pits 20 to 25 feet deep. In Mycenae, the graves of important people were enclosed in a circle of standing stone slabs. In these graves, the ruling families laid out their dead in opulent dress and jewelry and surrounded them with ceremonial weapons (see FIG. 4–21), gold and silver wares, and other articles indicative of their status, wealth, and power. Among the 30 pounds of gold objects archaeologist Heinrich Schliemann found in the shaft graves of Mycenae were five funerary masks, and he identified one of these golden treasures as the face of Agamemnon, commander-in-chief of the Greek forces in Homer's account of the Trojan War (see "The Mask of Agamemnon," above). We now know these masks have nothing to do with the heroes of the Trojan War since the Mycenae graves are about 300 years older than Schliemann believed, and the burial practices they display were different from those described by Homer.

Also found in these shaft graves were bronze **DAGGER BLADES** (FIG. 4-21) decorated with inlaid scenes, further attesting to the wealth of the bellicose Mycenaean ruling elite. To form the

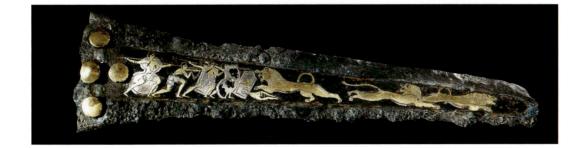

4-21 • DAGGER BLADE WITH LION HUNT

From Shaft Grave iv, Grave Circle A, Mycenae, Greece. c. 1550–1500 BCE. Bronze inlaid with gold, silver, and niello, length 9%" (23.8 cm). National Archaeological Museum, Athens. decoration of daggers like this, Mycenaean artists cut shapes out of different-colored metals (copper, silver, and gold), inlaid them in the bronze blade, and then added fine details in niello (see "Aegean Metalwork," page 90). In Homer's *Iliad*, the poet describes similar decoration on Agamemnon's armor and Achilles' shield. The blade shown here depicts four lunging hunters—Minoan in style attacking a charging lion who has already downed one of their companions who lies under the lion's front legs. Two other lions retreat in full flight. Like the bull in the Minoan fresco (see FIG. 4–7), these fleeing animals stretch out in the "flying-gallop" pose to indicate speed and energy.

THOLOS TOMBS By about 1600 BCE, members of the elite class on the mainland had begun building large above-ground burial places commonly referred to as **tholos** tombs (popularly known as **beehive tombs** because of their rounded, conical shape). More than 100 such tombs have been found, nine of them in the vicinity of Mycenae. Possibly the most impressive is the so-called **TREASURY OF ATREUS** (**FIGS. 4-22, 4-23**), which dates from about 1300 to 1200 BCE.

A walled passageway through the earthen mound covering the tomb, about 114 feet long and 20 feet wide and open to the sky, led to the entrance, which was 34 feet high, with a door

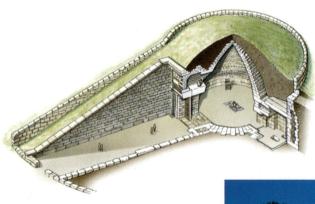

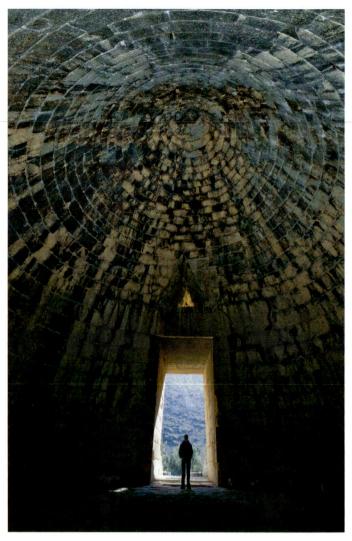

4-24 • CORBEL VAULT, INTERIOR OF THOLOS, THE SO-CALLED TREASURY OF ATREUS Limestone vault, height approx. 43' (13 m), diameter 47'6" (14.48 m).

 Watch an architectural simulation of the corbel vault on myartslab.com

4-22 • CUTAWAY DRAWING OF THOLOS, THE SO-CALLED TREASURY OF ATREUS

4-23 • EXTERIOR VIEW OF THOLOS, THE SO-CALLED TREASURY OF ATREUS Mycenae, Greece. c. 1300–1200 BCE.

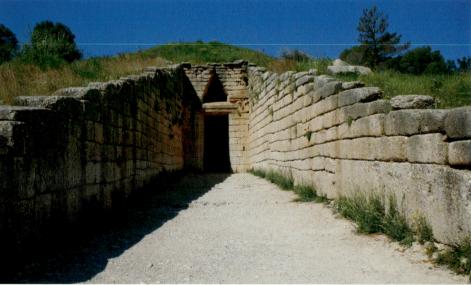

16¹/₂ feet high, faced with bronze plaques. On either side of the entrance were columns created from a green stone found near Sparta, and carved with decoration. The section above the lintel had smaller engaged columns on each side, and the relieving triangle was disguised behind a red-and-green engraved marble panel. The main tomb chamber (**FIG. 4–24**) is a circular room 47¹/₂ feet in diameter and 43 feet high. It is roofed with a **corbeled vault** built up in regular **courses**, or layers, of **ashlar**—precisely cut blocks of stone—smoothly leaning inward and carefully calculated to meet in a single capstone (topmost stone that joins sides and completes structure) at the peak. Covered with earth, the tomb became a conical hill. It was a remarkable engineering feat.

CERAMIC ARTS

In the final phase of the Helladic Bronze Age, Mycenaean potters created highly refined ceramics. A large **krater**—a bowl for mixing water and wine, used both in feasts and as grave markers—is an example of the technically sophisticated wares being produced on the Greek mainland between 1300 and 1100 BCE. Decorations could be highly stylized, like the scene of marching men on the **WARRIOR KRATER** (FIG. 4-25). On the side shown here, a woman at the far left bids farewell to a group of helmeted men marching off to the right, with lances and large shields. The vibrant energy of the Harvester Rhyton or the Vapheio Cup has changed to the regular rhythm inspired by the tramping feet of disciplined warriors. The only indication of the woman's emotions is the gesture of an arm raised to her head, a symbol of mourning. The men are seemingly interchangeable parts in a rigidly disciplined war machine.

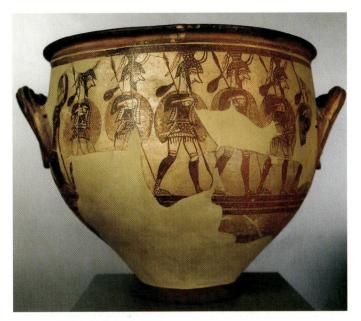

4-25 • WARRIOR KRATER From Mycenae, Greece. c. 1300–1100 BCE. Ceramic, height 16" (41 cm). National Archaeological Museum, Athens.

The succeeding centuries, between about 1100 and 900 BCE, were a time of transformation in the Aegean, marked by less political, economic, and artistic complexity and control. A new culture was forming, one that looked back upon the exploits of the Helladic warrior-kings as the glories of a heroic age, while setting the stage for a new Greek civilization.

THINK ABOUT IT

- 4.1 Choose a picture or sculpture of a human figure from two of the ancient Aegean cultures examined in this chapter. Characterize how the artist represents the human form and how that representation could be related to the cultural significance of the works in their original context.
- **4.2** Assess the methods of two archaeologists whose work is discussed in this chapter. How have they recovered, reconstructed, and interpreted the material culture of the Aegean Bronze Age?
- **4.3** What explanations have art historians proposed for the use and cultural significance of the elegant figures of women that have been excavated in the Cyclades?
- **4.4** Compare the plans of the architectural complexes at Knossos and Mycenae. How have the arrangements of the buildings aided archaeologists in speculating on the way in which these complexes were related to their cultural context and ritual or political use?

CROSSCURRENTS

FIG. 3-34

Discuss the differences in style between these two works of ancient painting. Attend to the distinct modes of representing human figures as well as to the ways those figures are related to their surroundings. Is there a possible relationship between the architectural context and the style of presentation?

Study and review on myartslab.com

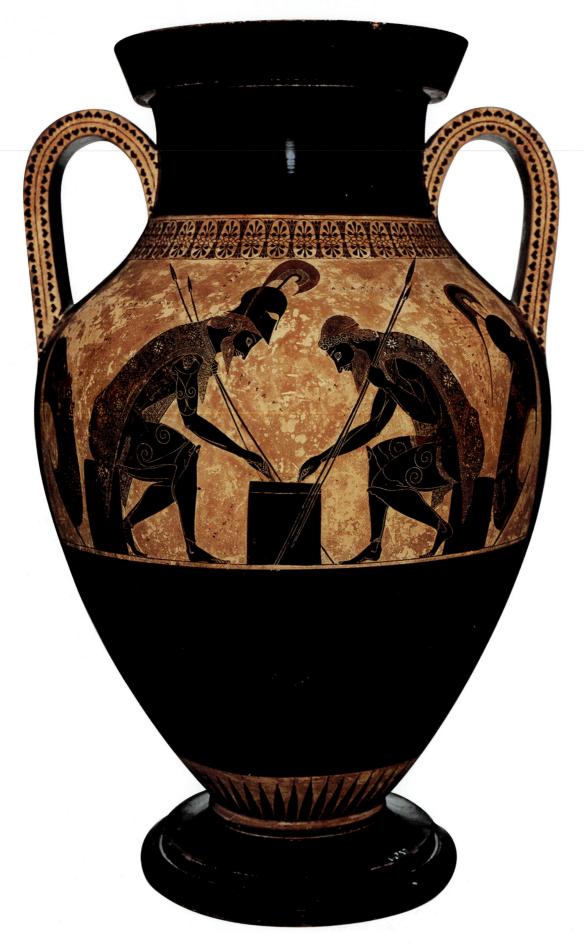

5-1 • Exekias (potter and painter) AJAX AND ACHILLES PLAYING A GAME c. 540–530 BCE. Black-figure painting on a ceramic amphora, height of amphora 2' (61 cm). Vatican Museums, Rome.

Art of Ancient Greece

This elegantly contoured amphora was conceived and created to be more than the all-purpose storage jar signaled by its shape, substance, and size (FIG. 5-1). A strip around the belly of its bulging form was reserved by Exekias-the midsixth-century BCE Athenian artist who signed it proudly as both potter and painter-for the presentation of a narrative episode from the Trojan War, one of the signal stories of the ancient Greeks' mythical conception of their past. Two heroic warriors, Achilles and Ajax, sit across from each other, supporting themselves on their spears as they lean in toward the block between them that serves as a makeshift board for their game of dice. Ajax, to the right, calls out "three"the spoken word written out diagonally on the pot's surface as if issuing from his mouth. Achilles counters with "four," the winning number, his victory presaged by the visual prominence of the boldly silhouetted helmet perched on his head. (Ajax's headgear has been set casually aside on his shield, leaning behind him.) Ancient Greek viewers, however, would have perceived the tragic irony of Achilles' victory. When these two warriors returned from this playful diversion into the serious contest of battle, Achilles would be killed. Soon afterwards, the grieving Ajax would take his own life in despair.

The poignant narrative encounter portrayed on this amphora is also a masterful compositional design. Crisscrossing diagonals and compressed overlapping of spears, bodies, and table describe spatial complexity as well as surface pattern. The varying textures of hair, armor, and clothing are dazzlingly evoked by the alternation between expanses of unarticulated surface and the finely incised lines of dense pattern. Careful contours convey a sense of three-dimensional human form. And the arrangement coordinates with the very shape of the vessel itself, its curving outline matched by the warriors' bending backs, the line of its handles continued in the tilt of the leaning shields.

There is no hint here of gods or kings. Focus rests on the private diversions of heroic warriors as well as on the identity and personal style of the artist who portrayed them. Supremely self-aware and self-confident, the ancient Greeks developed a concept of human supremacy and responsibility that required a new visual expression. Their art was centered in the material world, but it also conformed to strict ideals of beauty and mathematical concepts of design, paralleling the Greek philosophers' search for the human values of truth, virtue, and harmony, qualities that imbue both subject and style in this celebrated work.

LEARN ABOUT IT

- 5.1 Trace the emergence of a distinctive Classical style and approach to art and architecture during the early centuries of Greek civilization and assess the ways Hellenistic sculptors departed from its norms.
- **5.2** Explore the principal themes and subject matter of ancient Greek art, rooted in the lives—both heroic and ordinary—of the people who lived in this time and place as well as the mythological tales that were significant to them.
- **5.3** Explore the nature and meaning of the High Classical style in relation to the historical and cultural situation in Greece during the fifth century BCE.
- **5.4** Understand the differences between and assess the uses of the three orders used in temple architecture.

((•- Listen to the chapter audio on myartslab.com

THE EMERGENCE OF GREEK CIVILIZATION

Ancient Greece was a mountainous land of spectacular natural beauty. Olive trees and grapevines grew on the steep hillsides, producing oil and wine, but there was little good farmland. In towns, skilled artisans produced metal and ceramic wares to trade abroad for grain and raw materials. Greek merchant ships carried pots, olive oil, and bronzes from Athens, Corinth, and Aegina around the Mediterranean Sea, extending the Greek cultural orbit from mainland Greece south to the Peloponnese, north to Macedonia, and east to the Aegean islands and the coast of Asia Minor (MAP 5-1). Greek colonies in Italy, Sicily, and Asia Minor rapidly became powerful independent commercial and cultural centers themselves, but they remained tied to the homeland by common language, heritage, religion, and art.

Within a remarkably brief time, Greek artists developed focused and distinctive ideals of human beauty and architectural design that continue to exert a profound influence today. From about 900 BCE until about 100 BCE, they concentrated on a new, rather narrow range of subjects and produced an impressive body of work with focused stylistic aspirations in a variety of media. Greek artists were restless. They continually sought to change and improve existing artistic trends and fashions, effecting striking stylistic evolution over the course of a few centuries. This is in stark contrast to the situation we discovered in ancient Egypt, where a desire for permanence and continuity maintained stable artistic conventions for nearly 3,000 years.

HISTORICAL BACKGROUND

In the ninth and eighth centuries BCE, long after Mycenaean dominance in the Aegean had come to an end, the Greeks began to form independently governed city-states. Each city-state was an autonomous region with a city—Athens, Corinth, Sparta—as its political, economic, religious, and cultural center. Each had its own form of government and economy, and each managed its own domestic and foreign affairs. The power of these city-states initially depended at least as much on their manufacturing and commercial skills as on their military might.

Among the emerging city-states, Corinth, located on major land and sea trade routes, was one of the oldest and most powerful. By the sixth century BCE, Athens rose to commercial and cultural preeminence. Soon it had also established a representative government in which every community had its own assembly and magistrates. All citizens participated in the assembly and all had an equal right to own private property, to exercise freedom of speech, to vote and hold public office, and to serve in the army or navy. Citizenship, however, was open only to Athenian men. The census of 309 BCE in Athens listed 21,000 citizens, 10,000 foreign residents, and 400,000 others—that is, women, children, and slaves.

RELIGIOUS BELIEFS AND SACRED PLACES

According to ancient Greek legend, the creation of the world involved a battle between the earth gods, called Titans, and the sky gods. The victors were the sky gods, whose home was believed to be atop Mount Olympos in the northeast corner of the Greek mainland. The Greeks saw their gods as immortal and endowed with supernatural powers, but more than peoples of the ancient Near East and the Egyptians, they also visualized them in human form and attributed to them human weaknesses and emotions. Among the most important deities were the supreme god and goddess, Zeus and Hera, and their offspring (see "Greek and Roman Deities," page 104).

Many sites throughout Greece, called **sanctuaries**, were thought to be sacred to one or more gods. The earliest sanctuaries included outdoor altars or shrines and a sacred natural element such as a tree, a rock, or a spring. As more buildings were added, a sanctuary might become a palatial home for the gods, with one or more temples, several treasuries for storing valuable offerings, various monuments and statues, housing for priests and visitors, an outdoor dancefloor or permanent theater for ritual performances and literary competitions, and a stadium for athletic events. The Sanctuary of Zeus near Olympia, in the western Peloponnese, housed an extensive athletic facility with training rooms and arenas for track-and-field events. It was here that athletic competitions, prototypes of today's Olympic Games, were held.

Greek sanctuaries (see FIGS. 5–5, 5–6) are quite different from the religious complexes of the ancient Egyptians (see, for example, the Temple of Amun at Karnak, FIG. 3–18). Egyptian builders dramatized the power of gods or god-rulers by organizing their temples along straight, processional ways. The Greeks, in contrast, treated each building and monument as an independent element to be integrated with the natural features of the site, in an irregular arrangement that emphasized the exterior of each building as a discrete sculptural form on display.

GREEK ART c. 900-c. 600 BCE

Around the mid eleventh century BCE, a new culture began to form on the Greek mainland. Athens began to develop as a major center of ceramic production, creating both sculpture and vessels decorated with organized abstract designs. In this Geometric period, the Greeks, as we now call them, were beginning to create their own architectural forms and were trading actively with their neighbors to the east. By c. 700 BCE, in a phase called the Orientalizing period, they began to incorporate exotic foreign motifs into their native art.

THE GEOMETRIC PERIOD

What we call the Geometric period flourished in Greece between 900 and 700 BCE, especially in the decoration of ceramic vessels with linear motifs, such as spirals, diamonds, and cross-hatching. This abstract vocabulary is strikingly different from the stylized

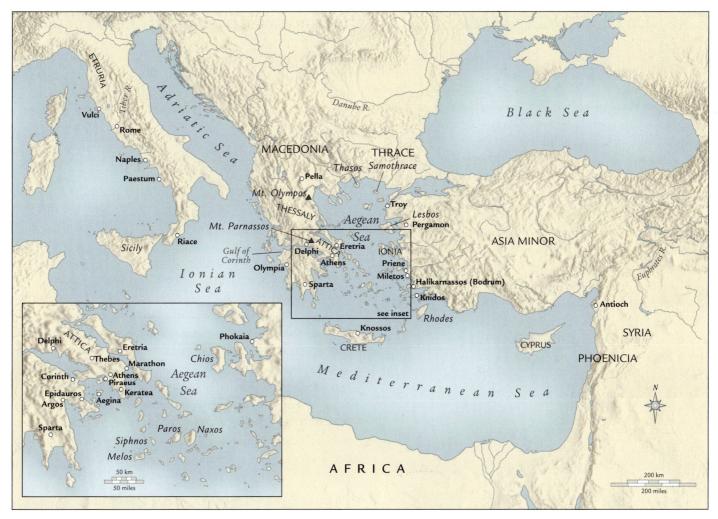

MAP 5-1 • ANCIENT GREECE

The cultural heartland of ancient Greece consisted of the Greek mainland, the islands of the Aegean, and the west coast of Asia Minor, but colonies on the Italic peninsula and the island of Sicily extended Greek cultural influence farther west into the Mediterranean.

plants, birds, and sea creatures that had characterized Minoan pots (see FIGS. 4-4, 4-11).

Large funerary vessels were developed at this time for use as grave markers, many of which have been uncovered at the ancient cemetery of Athens just outside the Dipylon Gate, once the main western entrance into the city. The krater illustrated here (**FIG. 5-2**) seems to provide a detailed pictorial record of funerary rituals associated with the important person whose death is commemorated by this work. On the top register, the body of the deceased

5-2 • Attributed to the Hirschfeld Workshop FUNERARY KRATER From the Dipylon Cemetery, Athens. c. 750–735 BCE. Ceramic, height 42⁵/₈" (108 cm). Metropolitan Museum of Art, New York. Rogers Fund, 1914. (14.130.14)

View the Closer Look for the funerary krater on myartslab.com

ART AND ITS CONTEXTS | Greek and Roman Deities

(The Roman form of the name is given after the Greek name.) The Five Children of Earth and Sky

Zeus (Jupiter), supreme Olympian deity. Mature, bearded man, often holding scepter or lightning bolt; sometimes represented as an eagle. **Hera** (Juno), goddess of marriage. Sister/wife of Zeus. Mature woman; cow and peacock are sacred to her.

Hestia (Vesta), goddess of the hearth. Sister of Zeus. Her sacred flame burned in communal hearths.

Poseidon (Neptune), god of the sea. Holds a three-pronged spear (trident). **Hades** (Pluto), god of the underworld, the dead, and wealth.

The Seven Sky Gods, Offspring of the First Five

Ares (Mars), god of war. Son of Zeus and Hera.

Hephaistos (Vulcan), god of the forge, fire, and metal handcrafts. Son of Hera (in some myths, also of Zeus); husband of Aphrodite.

Apollo (Phoebus), god of the sun, light, truth, music, archery, and healing. Sometimes identified with Helios (the Sun), who rides a chariot across the daytime sky. Son of Zeus and Leto (a descendant of Earth); brother of Artemis.

Artemis (Diana), goddess of the hunt, wild animals, and the moon. Sometimes identified with Selene (the Moon), who rides a chariot or oxcart across the night sky. Daughter of Zeus and Leto; sister of Apollo. Carries bow and arrows and is accompanied by hunting dogs. Athena (Minerva), goddess of wisdom, war, victory, and the city. Also goddess of handcrafts and other artistic skills. Daughter of Zeus; sprang fully grown from his head. Wears helmet and carries shield and spear. Aphrodite (Venus), goddess of love. Daughter of Zeus and the water nymph Dione; alternatively, born of sea foam; wife of Hephaistos. Hermes (Mercury), messenger of the gods, god of fertility and luck, guide of the dead to the underworld, and god of thieves and commerce. Son of Zeus and Maia, the daughter of Atlas, a Titan who supports the sky on his shoulders. Wears winged sandals and hat; carries caduceus, a wand with two snakes entwined around it.

Other Important Deities

Demeter (Ceres), goddess of grain and agriculture. Daughter of Kronos and Rhea, sister of Zeus and Hera.

Persephone (Proserpina), goddess of fertility and queen of the underworld. Wife of Hades; daughter of Demeter.

Dionysos (Bacchus), god of wine, the grape harvest, and inspiration. His female followers are called **maenads** (Bacchantes).

Eros (Cupid), god of love. In some myths, the son of Aphrodite. Shown as an infant or young boy, sometimes winged, carrying bow and arrows.Pan (Faunus), protector of shepherds, god of the wilderness and of music. Half-man, half-goat, he carries panpipes.

Nike (Victory), goddess of victory. Often shown winged and flying.

is depicted laying on its side atop a funeral bier, perhaps awaiting the relatively new Greek practice of cremation. Male and female figures stand on each side of the body, their arms raised and both hands placed on top of their heads in a gesture of anguish, as if these mourners were literally tearing their hair out with grief. In the register underneath, horse-drawn chariots and footsoldiers, who look like walking shields with tiny antlike heads and muscular legs, move in solemn procession.

The geometric shapes used to represent human figures on this pot—triangles for torsos; more triangles for the heads in profile; round dots for eyes; long, thin rectangles for arms; tiny waists; and long legs with bulging thigh and calf muscles—are what has given the Geometric style its name. Figures are shown in either full-frontal or full-profile views that emphasize flat patterns and crisp outlines. Any sense of the illusion of three-dimensional forms occupying real space has been avoided. But the artist has captured a deep sense of human loss by exploiting the stylized solemnity and strong rhythmic accents of the carefully arranged elements.

5-3 • MAN AND CENTAUR

Perhaps from Olympia. c. 750 BCE. Bronze, height 45%6" (11.1 cm). Metropolitan Museum of Art, New York. Gift of J. Pierpont Morgan, 1917. (17.190.2072)

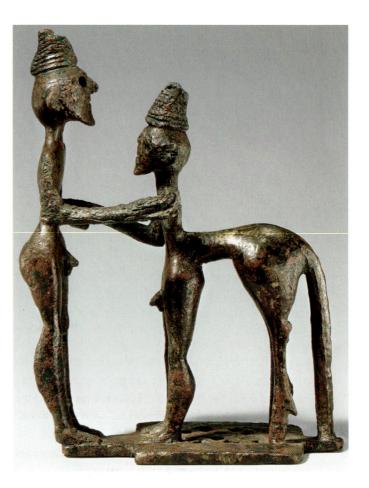

Egyptian funerary art reflected the strong belief that the dead, in the afterworld, could continue to engage in activities they enjoyed while alive. For the Greeks, the deceased entered a place of mystery and obscurity that living humans could not define precisely, and their funerary art, in contrast, focused on the emotional reactions of the survivors. The scene of human mourning on this pot contains no supernatural beings, nor any identifiable reference to an afterlife, only poignant evocations of the sentiments and rituals of those left behind on earth.

Greek artists of the Geometric period also produced figurines of wood, ivory, clay, and cast bronze. These small statues of humans and animals are similar in appearance to those painted on pots. A tiny bronze of this type, depicting a MAN AND CENTAUR-a mythical creature, part man and part horse (FIG. 5-3)—dates to about the same time as the funerary krater. Although there were wise and good centaurs in Greek lore, this work takes up the theme of battling man and centaur, prominent throughout the history of Greek art (see FIG. 5-38). The two figures confront each other after the man-perhaps Herakles-has stabbed the centaur; the spearhead is visible on the centaur's left side. Like the painter of the contemporary funerary krater, the sculptor has distilled the body parts of these figures to elemental geometric shapes, arranging them in a composition of solid forms and open, or negative, spaces that makes the piece interesting from multiple viewpoints. Most such sculptures have been found in sanctuaries, suggesting that they may have served as votive offerings to the gods.

THE ORIENTALIZING PERIOD

By the seventh century BCE, painters in major pottery centers in Greece had moved away from the dense linear decoration of the Geometric style, preferring more open compositions built around large motifs—real and imaginary animals, abstract plant forms, and human figures. The source of these motifs can be traced to the arts of the Near East, Asia Minor, and Egypt. Greek painters did not simply copy the work of Eastern artists, however. Instead, they drew on work in a variety of media—including sculpture, metalwork, and textiles—to invent an entirely new approach to painting vessels.

The Orientalizing style (c. 700–600 BCE) began in Corinth, a port city where luxury wares from the Near East and Egypt inspired artists. The new style is evident in a Corinthian **olpe**, or wide-mouthed pitcher, dating to about 650–625 BCE (**FIG. 5-4**). Silhouetted creatures—lions, panthers, goats, deer, bulls, boars, and swans—stride in horizontal bands against a light background with stylized flower forms called **rosettes** filling the spaces around them. An early example of the **black-figure** technique (see "Black-Figure and Red-Figure," page 118), dark shapes define the silhouettes of the animals against a background of very pale buff, the natural color of the Corinthian clay. The artist incised fine details inside the silhouetted shapes with a sharp tool and added touches of white and red slip to enliven the design.

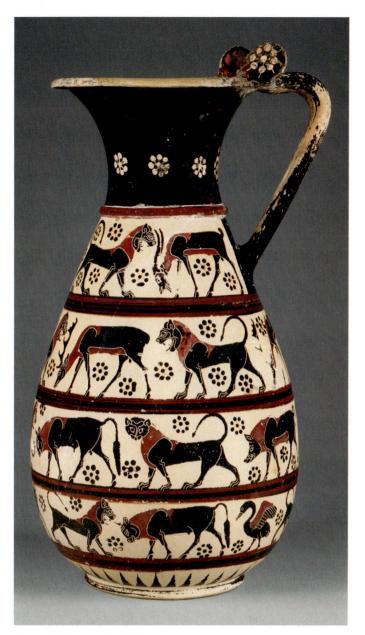

5-4 • OLPE (PITCHER) Corinth. c. 650–625 BCE. Ceramic with black-figure decoration, height 12%" (32.8 cm). J. Paul Getty Museum, Malibu.

THE ARCHAIC PERIOD, c. 600–480 BCE

The Archaic period does not deserve its name. "Archaic" means "antiquated" or "old-fashioned," even "primitive," and the term was chosen by art historians who wanted to stress what they perceived as a contrast between the undeveloped art of this time and the subsequent Classical period, once thought to be the most admirable and highly developed phase of Greek art. But the Archaic period was a time of great new achievement in Greece. In literature, Sappho wrote her inspired poetry on the island of Lesbos, while on another island the legendary storyteller, Aesop, crafted his animal fables. Artists and architects shared in the growing prosperity

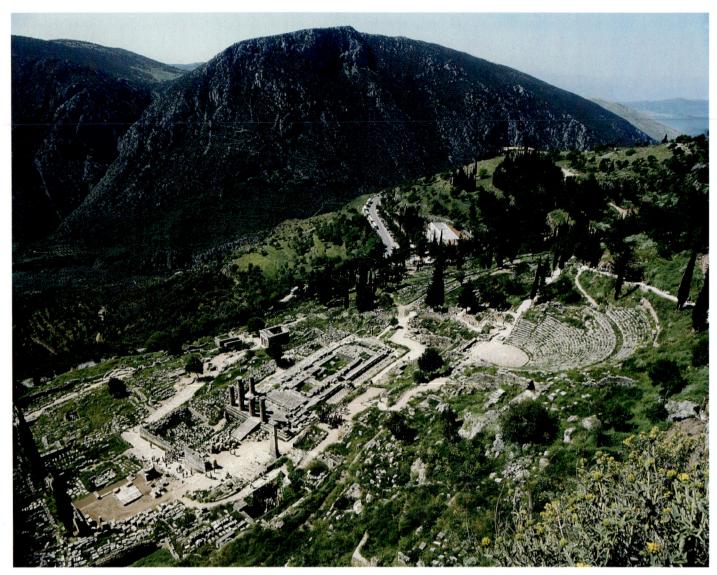

5-5 • AERIAL VIEW OF THE SANCTUARY OF APOLLO, DELPHI

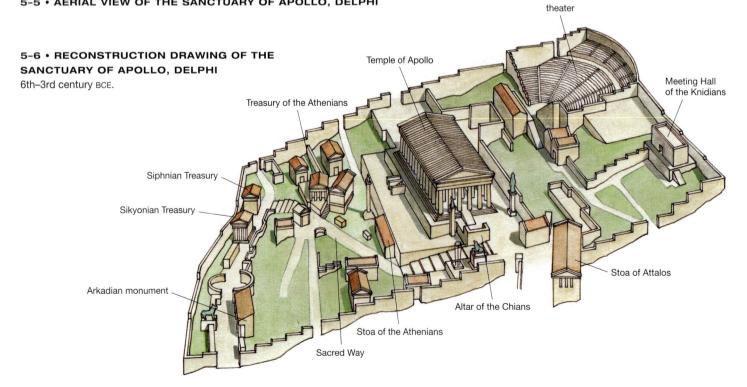

as city councils and wealthy individuals sponsored the creation of extraordinary sculpture and fine ceramics and commissioned elaborate civic and religious buildings in cities and sanctuaries.

THE SANCTUARY AT DELPHI

According to Greek myth, Zeus was said to have released two eagles from opposite ends of the earth and they met exactly at the rugged mountain site of Apollo's sanctuary (**FIG. 5–5**). From very early times, the sanctuary at Delphi was renowned as an oracle, a place where the god Apollo was believed to communicate with humans by means of cryptic messages delivered through a human intermediary, or medium (the Pythia). The Greeks and their leaders routinely sought advice at oracles, and attributed many twists of fate to misinterpretations of the Pythia's statements. Even foreign rulers journeyed to request help at Delphi.

Delphi was the site of the Pythian Games which, like the Olympian Games, attracted participants from all over Greece. The principal events were the athletic contests and the music, dance, and poetry competitions in honor of Apollo. As at Olympia, hundreds of statues dedicated to the victors of the competitions, as well as mythological figures, filled the sanctuary grounds. The sanctuary of Apollo was significantly developed during the Archaic period and included the main temple, performance and athletic areas, treasuries, and other buildings and monuments, which made full use of limited space on the hillside (**FIG. 5-6**).

After visitors had climbed the steep path up the lower slopes of Mount Parnassos, they entered the sanctuary by a ceremonial gate in the southeast corner. From there they zigzagged up the Sacred Way, so named because it was the route of religious processions during festivals. Moving past the numerous treasuries and memorials built by the city-states, they arrived at the long colonnade of the Temple of Apollo, rebuilt in c. 530 BCE on the site of an earlier temple. Below the temple was a **stoa**, a columned pavilion open on three sides, built by the people of Athens. There visitors rested, talked, or watched ceremonial dancing. At the top of the sanctuary hill was a stadium area for athletic contests.

TREASURY OF THE SIPHNIANS Sanctuaries also included treasuries built by the citizens of Greek city-states to house and protect their offerings. The small but luxurious **TREASURY OF THE SIPHNIANS** (**FIG. 5-7**) was built in the sanctuary of Apollo at Delphi by the residents of the island of Siphnos in the Cyclades, between about 530 and 525 BCE. It survives today only in fragments housed in the museum at Delphi. Instead of columns, the builders used two stately **caryatids**—columns carved in the form of clothed women in finely pleated, flowing garments, raised on **pedestals** and balancing elaborately carved capitals on their heads. The capitals support a tall **entablature** conforming to the **Ionic order**, which features a plain, or three-panel, **architrave** and a continuous carved **frieze**, set off by richly carved moldings (see "The Greek Orders," page 110).

Both the continuous frieze and the **pediments** of the Siphnian Treasury were originally filled with relief sculpture. A surviving section of the frieze from the building's north side, which shows a scene from the legendary **BATTLE BETWEEN THE GODS AND THE GIANTS**, is notable for its complex representation of space (**FIG. 5–8**). To give a sense of three-dimensional recession, the sculptors overlapped the figures—sometimes three deep—varying

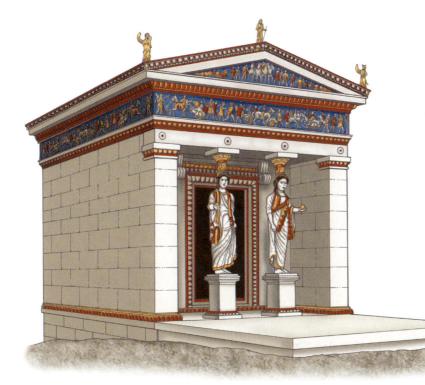

5-7 • RECONSTRUCTION DRAWING OF THE TREASURY OF THE SIPHNIANS

Sanctuary of Apollo, Delphi. c. 530-525 BCE.

This small treasury building at Delphi was originally elegant and richly ornamented. The figure sculpture and decorative moldings were once painted in strong colors, mainly dark blue, bright red, and white, with touches of yellow to resemble gold.

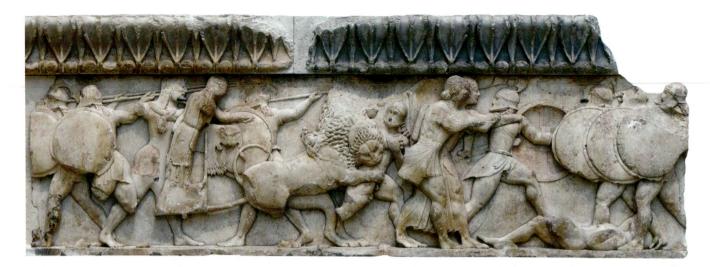

5-8 • BATTLE BETWEEN THE GODS AND THE GIANTS Fragments of the north frieze of the Treasury of the Siphnians, Sanctuary of Apollo, Delphi. c. 530–525 BCE. Marble, height 26" (66 cm). Archaeological Museum, Delphi.

the depth of the relief to allow viewers to grasp their placement within space. Originally such sculptures were painted with bright color to enhance the lifelike effect.

TEMPLES

For centuries ancient Greeks had worshiped at sanctuaries where an outdoor altar stood within an enclosed sacred area called a **temenos** reserved for worship. Sometimes temples sheltering a statue of a god were incorporated into these sanctuaries, often later additions to an established sanctuary. A number of standardized temple plans evolved, ranging from simple, one-room structures with columned **porches** (covered, open space in front of an entrance) to buildings with double porches (front and back), surrounded entirely by columns. Builders also experimented with the design of temple **elevations**—the arrangement, proportions, and appearance of the columns and the lintels, which now grew into elaborate entablatures. Two elevation designs emerged during the Archaic period: the **Doric order** and the Ionic order. The **Corinthian order**, a variant of the Ionic order, would develop later (see "The Greek Orders," page 110).

A particularly well-preserved Archaic Doric temple, built around 550 BCE, still stands at the former Greek colony of Poseidonia (Roman Paestum) about 50 miles south of the modern city of Naples, Italy (**FIG. 5-9**). Dedicated to Hera, the wife of Zeus, it is known today as Hera I to distinguish it from a second, adjacent temple to Hera built about a century later. A row of columns called the peristyle surrounded the main room, the **cella**. The columns of Hera I are especially robust—only about four times as high as their maximum diameter—and topped with a widely flaring capital and a broad, blocky **abacus**, creating an impression of great stability and permanence. As the column shafts rise, they swell in the middle and contract again toward the top, a refinement known as **entasis**, giving them a sense of energy and lift. Hera I has an uneven number of columns—nine—across the short ends of the peristyle, with a column instead of a space at the center of the two ends. The entrance to the **pronaos** (enclosed vestibule) has three columns in antis (between flanking wall piers), and a row of columns runs down the center of the wide cella to help support the ceiling and roof. The unusual two-aisle, two-door arrangement leading to the small room at the end of the cella proper suggests that the temple had two presiding deities: either Hera and Poseidon (patron of the city), or Hera and Zeus, or perhaps Hera in her two manifestations (as warrior and protector of the city and as mother and protector of children).

THE TEMPLE OF APHAIA ON AEGINA A fully developed and somewhat sleeker Doric temple-part of a sanctuary dedicated to a local goddess named Aphaia-was built on the island of Aegina during the first quarter of the fifth century BCE (FIG. 5-10). Spectacularly sited on a hill overlooking the sea, the temple is reasonably well preserved, in spite of the loss of pediments, roof, and sections of its colonnade. Enough evidence remains to form a reliable reconstruction of its original appearance (FIG. 5-11). The plan combines six columns on the facades with 12 on the sides, and the cella-whose roof was supported by superimposed colonnades-could be entered from porches on both short sides. The slight swelling of the columns (entasis) seen at Poseidonia is evident here as well, and the outside triglyphs are pushed to the ends of frieze, out of alignment with the column underneath them, to avoid the awkwardness of half a metope (rectangular panel with a relief or painting) at the corner.

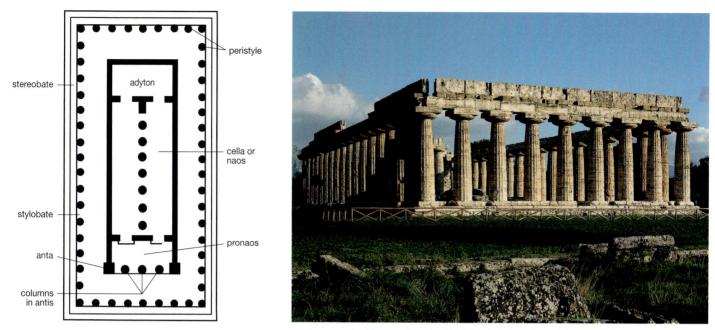

5-9 • PLAN (A) AND EXTERIOR VIEW (B) OF THE TEMPLE OF HERA I, POSEIDONIA (ROMAN PAESTUM) Southern Italy. c. 550–540 BCE.

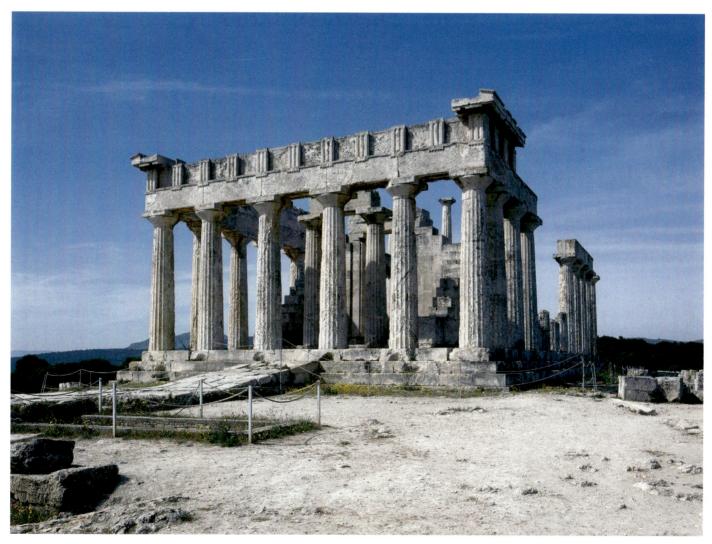

5-10 • TEMPLE OF APHAIA, AEGINA View from the east. c. 500 or c. 475 BCE. Column height about 17' (5.18 m).

ELEMENTS OF ARCHITECTURE | The Greek Orders

Each of the three Classical Greek architectural **orders**—Doric, lonic, and Corinthian—constitutes a system of interdependent parts whose proportions are based on mathematical ratios. No element of an order could be changed without producing a corresponding change in other elements.

The basic components are the **column** and the entablature, which function as post and lintel in the structural system. All three types of columns have a **shaft** and a **capital**; lonic and Corinthian also have a base. The shafts are formed of stacked round sections, or **drums**, which are joined inside by metal pegs. In Greek temple architecture, columns stand on the **stylobate**, the "floor" of the temple, which rests on top of a set of steps that form the temple's base, known as the **stereobate**.

In the Doric order, shafts sit directly on the stylobate, without a base. They are **fluted**, or channeled, with sharp edges. The height of the substantial columns ranges from five-and-a-half to seven times the diameter of the base. A necking at the top of the shaft provides a

transition to the capital itself, composed of the rounded **echinus**, and the tabletlike abacus. The entablature includes the architrave, the distinctive frieze of alternating **triglyphs** and **metopes**, and the **cornice**, the topmost, projecting horizontal element. The roofline may have decorative waterspouts and terminal decorative elements called **acroteria**.

The lonic order has more elongated proportions than the Doric, the height of a column being about nine times the diameter of its base. The flutes on the columns are deeper and are separated by flat surfaces called **fillets**. The capital has a distinctive spiral scrolled **volute**; the entablature has a three-panel architrave, continuous sculptured or decorated frieze, and richer decorative moldings.

The Corinthian order, a variant of the lonic order originally developed by the Greeks for use in interiors, was eventually used on temple exteriors as well. Its elaborate capitals are sheathed with stylized **acanthus** leaves that rise from a convex band called the **astragal**.

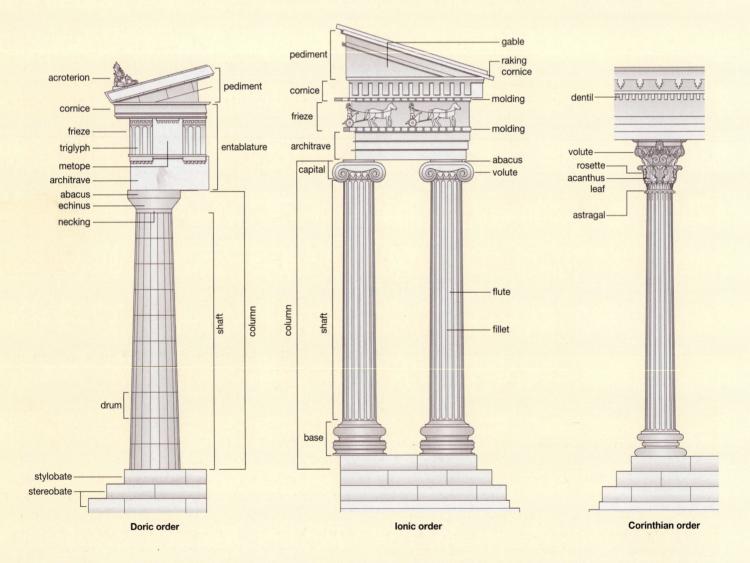

Watch an architectural simulation about the Greek orders on myartslab.com

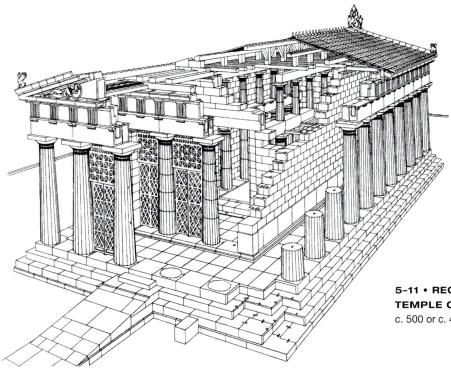

5-11 • RECONSTRUCTION DRAWING OF THE TEMPLE OF APHAIA, AEGINA c. 500 or c. 475 BCE.

Like most Greek temples, this building was neither isolated nor situated in open space, but set in relation to an outside altar where religious ceremonies were focused. By enclosing the temple within a walled precinct or temenos, the designer could control the viewer's initial experience of the temple. As the viewer entered the sacred space through a gatehouse—the propylon—the temple would be seen at an oblique angle (**FIG. 5-12**). Unlike ancient Egyptian temples, where long processional approaches led visitors directly to the flat entrance façade of a building (see **FIGS. 3-18**, **3-22**), the Greek architect revealed from the outset the full shape of a closed, compact, sculptural mass, inviting viewers not to enter seeking something within, but rather to walk around the exterior, exploring the rich sculptural embellishment on pediments and frieze. Cult ceremonies, after all, took place outside the temples.

Modern viewers, however, will not find exterior sculpture at Aegina. Nothing remains from the metopes, and substantial surviving portions of the two pediments were purchased in the early nineteenth century by the future Ludwig I of Bavaria and are now exhibited in Munich. The triangular pediments in Greek temples created challenging compositional problems for sculptors intent on fitting figures into the tapering spaces at the outside corners, since the scale of figures could not change, only their poses. The west pediment from Aegina (FIG. 5-13)—traditionally dated about 500-490 BCE, before its eastern counterpart-represents a creative solution that became a design standard, appearing with variations throughout the fifth century BCE. The subject of the pediment, rendered in fully three-dimensional figures, is the participation of local warriors in the military expedition against Troy. Fallen warriors fill the angles at both ends of the pediment base, while others crouch and lunge, rising in height toward an image of Athena as warrior goddess-who can fill the elevated pointed space at the center

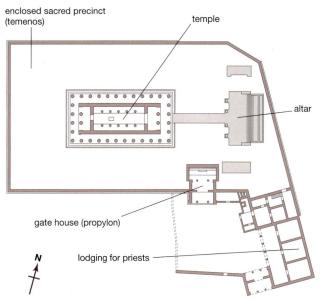

5-12 • PLAN OF COMPLEX OF THE TEMPLE OF APHAIA, AEGINA

c. 500 or c. 475 BCE.

peak since she is allowed to be represented larger (hierarchic scale) than the humans who flank her.

Among the best-preserved fragments from the west pediment is the **DYING WARRIOR** from the far right corner (**FIG. 5–14**). This tragic but noble figure struggles to rise up, supported on bent leg and elbow, in order to extract an arrow from his chest, even though his death seems certain. This figure originally would have been painted and fitted with authentic bronze accessories, heightening the sense of reality (see "Color in Greek Sculpture," page 113).

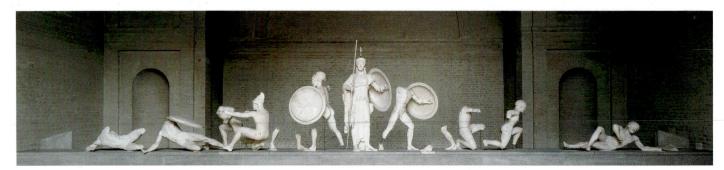

5-13 • WEST PEDIMENT OF THE TEMPLE OF APHAIA, AEGINA

c. 500–490 or 470s _{BCE}. Width about 49' (15 m). Surviving fragments as assembled in the Staatliche Antikensammlungen und Glyptothek, Munich (early restorations removed).

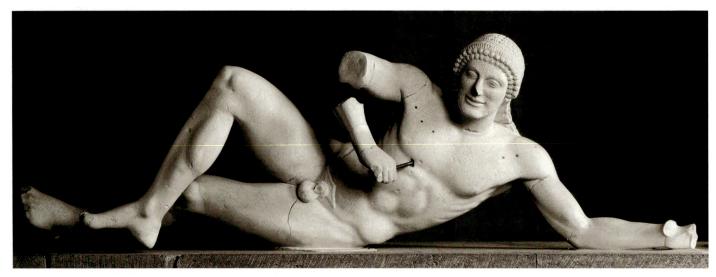

5-14 • DYING WARRIOR

From the right corner of the west pediment of the Temple of Aphaia, Aegina. c. 500–490 or 470s BCE. Marble, length 5'6" (1.68 m). Staatliche Antikensammlungen und Glyptothek, Munich.

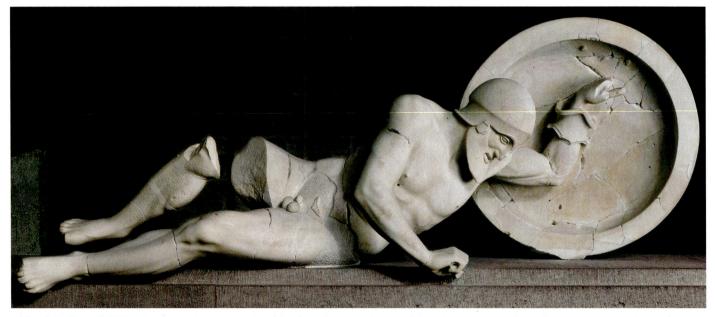

5-15 • DYING WARRIOR

From the left corner of the east pediment of the Temple of Aphaia, Aegina. c. 490–480 or 470s BCE. Marble, length 6' (1.83 m). Staatliche Antikensammlungen und Glyptothek, Munich.

TECHNIQUE | Color in Greek Sculpture

For many modern viewers, it comes as a real surprise, even a shock, that the stone sculptures of ancient Greece did not always have stark white, pure marble surfaces, comparable in appearance to-and consistent in taste with-the more recent, but still classicizing sculptures of Michelangelo or Canova (see FIGS. 21-10 and 30-14). But they were originally painted with brilliant colors. A close examination of Greek sculpture and architecture has long revealed evidence of polychromy, even to the unaided eye, but our understanding of the original appearance of these works has been greatly enhanced recently. Since the 1980s, German scholar Vinzenz Brinkmann has used extensive visual and scientific analysis to evaluate the traces of painting that remain on ancient Greek sculpture, employing tools such as ultraviolet and x-ray fluorescence, microscopy, and pigment analysis. Based on this research, he and his colleague Ulrike Koch-Brinkmann have fashioned reconstructions that allow us to imagine the exuberant effect these works would have had when they were new.

5-16 • Vinzenz Brinkmann and Ulrike Koch-Brinkmann RECONSTRUCTION OF ARCHER From the west pediment of the Temple of Aphaia, Aegina. 2004 CE. Staatliche Antikensammlungen und Glyptothek, Munich.

Illustrated here is their painted reconstruction of a kneeling archer from about 500 (or during the 470s) BCE that once formed part of the west pediment of the Temple of Aphaia at Aegina (FIGS. 5-16, 5-17). To begin with they have replaced features of the sculpture-ringlet hair extensions, a bow, a quiver, and arrows-probably made of bronze or lead and attached to the stone after it was carved, using the holes still evident in the current state of the figure's hip and head. Most stunning, however, is the diamond-shaped patterns that were painted on his leggings and sleeves, using pigments derived from malachite, azurite, arsenic, cinnabar and charcoal. And the surfaces of such figures were not simply colored in. Artists created a sophisticated integration of three-dimensional form, color, and design. The patterning applied to this archer's leggings actually changes in size and shape in relation to the body beneath it, stretching out on expansive thighs and constricting on tapering ankles. Ancient authors indicate that sculpture was painted to make figures more lifelike, and these recent reconstructions certainly back them up.

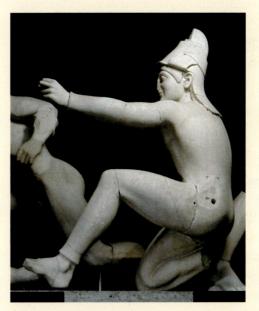

5-17 • ARCHER ("PARIS") From the west pediment of the Temple of Aphaia, Aegina. c. 500–490 or 470s BCE. Marble. Staatliche Antikensammlungen und Glyptothek, Munich.

A similar figure appeared on the east pediment (**FIG. 5-15**), traditionally seen as postdating the west pediment by a decade or so. The sculptor of this dying warrior also exploited the difficult framework of the pediment corner, only here, instead of an uplifted frontal form in profile, we see a twisted body capable of turning in space. The figure is more precariously balanced on his shield, clearly about to collapse. There is an increased sense of softness in the portrayal of human flesh and a greater sophistication in tailoring bodily posture not only to the tapering shape of the pediment, but also to the expression of the warrior's own emotional

involvement in the agony and vulnerability of his predicament, which in turn inspires a sense of pathos or empathy in the viewer.

For decades, art historians have taught that over the course of a decade, two successive sets of sculptures on Aegina allow us to trace the transition from Archaic toward Early Classical art. Very recently, however, Andrew Stewart has reviewed the archaeological evidence on the Athenian Akropolis and Aegina and reached a very different conclusion. He questions the traditional dating of key works from the transition between Archaic and Early Classical art—notably the Aegina pediment sculpture and the Kritios Boy (see FIG. 5–26)—placing them after the Persian invasion of 580– 579 BCE, and raising the question of whether Greek victory over this outside enemy might have been a factor in the stylistic change. In the case of the Aegina temple, this re-dating becomes especially interesting. Instead of assuming that the difference in style between the western and eastern pediments represents a time gap separating their production, Stewart proposes that both ensembles were produced concurrently during the 470s by two workshops, one conservative and one progressive.

FREE-STANDING SCULPTURE

In addition to statues designed for temple exteriors, sculptors of the Archaic period created a new type of large, free-standing statue made of wood, **terra cotta** (clay fired over low heat, sometimes unglazed), limestone, or white marble from the islands of Paros and Naxos. These free-standing figures were brightly painted and sometimes bore inscriptions indicating that individual men or women had commissioned them for a commemorative purpose. They have been found marking graves and in sanctuaries, where they lined the sacred way from the entrance to the main temple.

A female statue of this type is called a **kore** (plural, *koraî*), Greek for "young woman," and a male statue is called a **kouros** (plural, *kouroî*), Greek for "young man." Archaic *korai*, always clothed, probably represented deities, priestesses, and nymphs (young female immortals who served as attendants to gods). *Kouroi*, nearly always nude, have been variously identified as gods, warriors, and victorious athletes. Because the Greeks associated young, athletic males with fertility and family continuity, the *kouroi* figures may have symbolized ancestors.

METROPOLITAN KOUROS A kouros dated about 600 BCE (FIG. 5-18) recalls the pose and proportions of Egyptian sculpture. As with Egyptian figures such as the statue of Menkaure (see FIG. 3-9), this young Greek stands rigidly upright, arms at his sides, fists clenched, and one leg slightly in front of the other. However, the Greek artist has cut away all stone from around the body to make the human form free-standing. Archaic kouroi are also much less lifelike than their Egyptian forebears. Anatomy is delineated with linear ridges and grooves that form regular, symmetrical patterns. The head is ovoid and schematized, and the wiglike hair evenly knotted into tufts and tied back with a narrow ribbon. The eyes are relatively large and wide open, and the mouth forms a conventional closed-lip expression known as the Archaic smile. In Egyptian sculpture, male figures usually wore clothing associated with their status, such as the headdresses, necklaces, and kilts that identified them as kings. The total nudity of the Greek kouroi is unusual in ancient Mediterranean cultures, but it is acceptableeven valued-in the case of young men. Not so with women.

5-18 • METROPOLITAN KOUROS

Attica, Greece. c. 600–590 BCE. Marble, height 6'45%" (1.95 m). Metropolitan Museum of Art, New York. Fletcher Fund, 1932. (32.11.1)

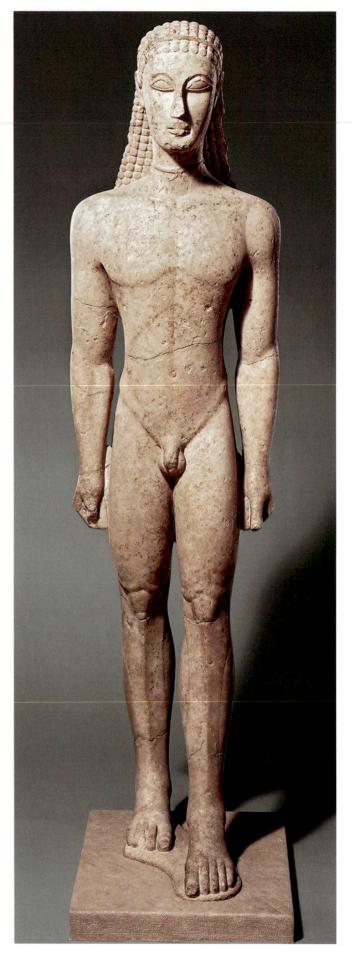

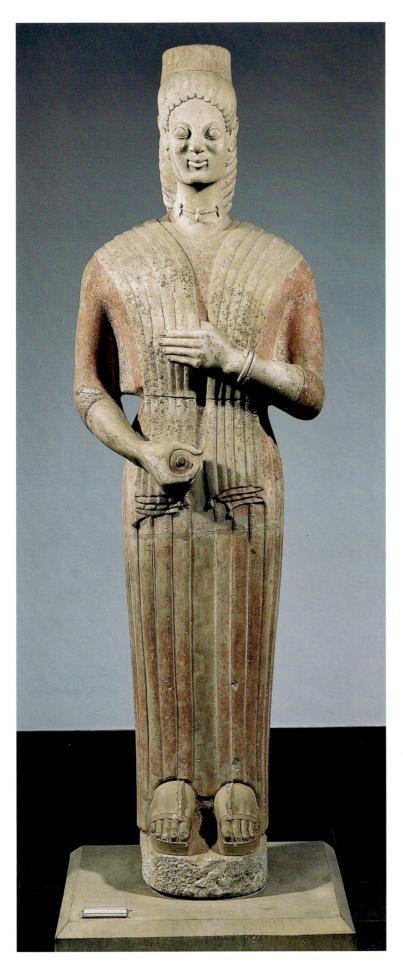

BERLIN KORE Early Archaic *korai* are as severe and stylized as the male figures. The **BERLIN KORE**, a funerary statue found in a cemetery at Keratea and dated about 570– 560 BCE, stands more than 6 feet tall (**FIG. 5–19**). The erect, full-bodied figure takes an immobile pose—accentuated by a bulky crown and thick-soled clogs. The thick robe and tasseled cloak over her shoulders fall in regularly spaced, symmetrically disposed, parallel folds like the fluting on a Greek column. This drapery masks her body but mimics its curving contours. Traces of red—perhaps the red clay used to make thin sheets of gold adhere—indicate that the robe was once painted or gilded. The figure holds a pomegranate in her right hand, a symbol of Persephone, who was abducted by Hades, the god of the underworld, and whose annual return brought the springtime.

ANAVYSOS KOUROS The powerful, rounded, athletic body of a *kouros* from Anavysos, dated about 530 BCE, documents the increasing interest of artists and their patrons in a more lifelike rendering of the human figure (**FIG. 5-20**). The pose, wiglike hair, and Archaic smile echo the earlier style, but the massive torso and limbs have carefully rendered, bulging muscularity, suggesting heroic strength. The statue, a grave monument to a fallen war hero, has been associated with a base inscribed: "Stop and grieve at the tomb of the dead Kroisos, slain by wild Ares [god of war] in the front rank of battle." However, there is no evidence that the figure was meant to preserve the likeness of Kroisos or anyone else. He is a symbolic type, not a specific individual.

"PEPLOS" KORE The kore in **FIGURE 5-21** is dated about the same time as the Anavysos Kouros, though she is a votive rather than a funerary statue. Like the *kouros*, she has rounded body forms, but unlike him, she is clothed. She has the same motionless, vertical pose of the Berlin Kore (see FIG. 5-19), but her bare arms and head convey a sense of soft flesh covering a real bone structure, and her smile and hair are considerably less stylized. The original painted colors on both body and clothing must have made her seem even more lifelike, and she also once wore a metal crown and jewelry.

The name we use for this figure is based on an assessment of her clothing as a young girl's peplos—a draped rectangle of cloth pinned at the shoulders and belted to give a bloused effect—but it has recently been argued that this *kore* is actually not wearing a peplos but a sheathlike garment,

5-19 • BERLIN KORE

From the cemetery at Keratea, near Athens. c. 570–560 BCE. Marble with remnants of red paint, height 6'3" (1.9 m). Staatliche Museen zu Berlin, Antikensammlung, Preussischer Kulturbesitz, Berlin.

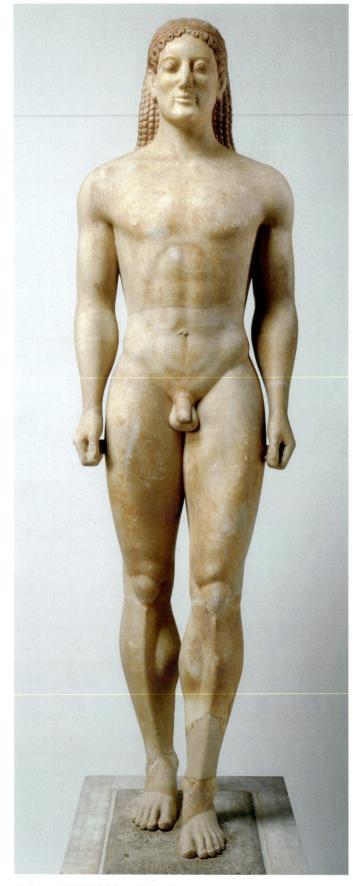

5-20 • ANAVYSOS KOUROS From the cemetery at Anavysos, near Athens. c. 530 BCE. Marble with remnants of paint, height 6'4" (1.93 m). National Archaeological Museum, Athens.

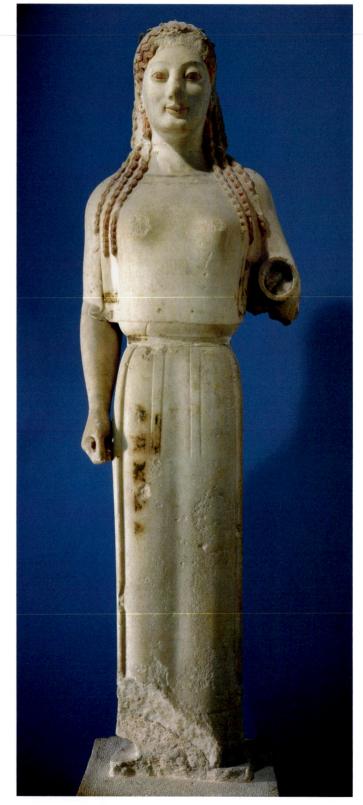

5-21 • "PEPLOS" KORE From the Akropolis, Athens. c. 530 BCE. Marble, height 4' (1.21 m). Akropolis Museum, Athens.

originally painted with a frieze of animals, identifying her not as a young girl but a goddess, perhaps Athena or Artemis. Her missing left forearm—which was made of a separate piece of marble fitted into the still-visible socket—would have extended forward horizontally, and may have held an attribute that provided the key to her identity.

PAINTED POTS

Greek potters created beautiful vessels whose standardized shapes were tailored to specific utilitarian functions (**FIG. 5-22**). Occasionally, these potters actually signed their work, as did the artists who painted scenes on the pots. Greek ceramic painters became highly accomplished at accommodating their pictures to the often awkward fields on utilitarian shapes, and they usually showcased not isolated figures but scenes of human interaction evoking a story.

BLACK-FIGURE VESSELS During the Archaic period, Athens became the dominant center for pottery manufacture and trade in Greece, and Athenian painters adopted Corinthian black-figure techniques (see FIG. 5–4), which became the principal mode of decoration throughout Greece in the sixth century BCE. At first, Athenian vase painters retained the horizontal banded composition that was characteristic of the Geometric period. Over time, however, they decreased the number of bands and increased the size of figures until a single narrative scene dominates each side of the vessel.

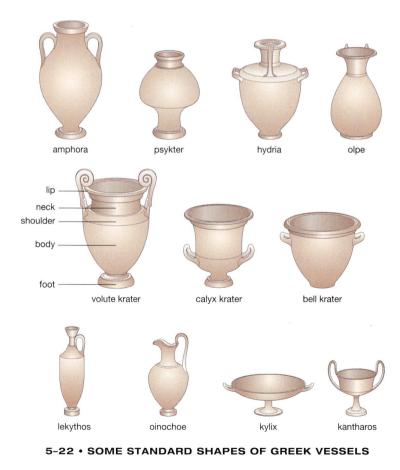

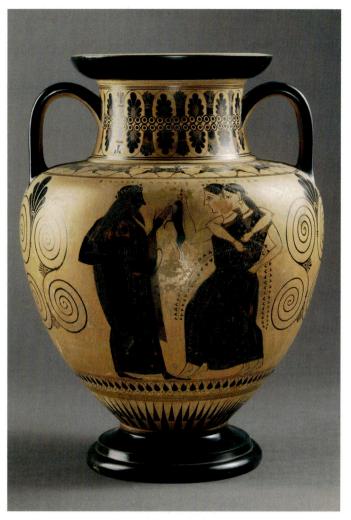

5-23 • Amasis Painter **DIONYSOS WITH MAENADS** c. 540 BCE. Black-figure decoration on an amphora. Ceramic, height of amphora 13" (33.3 cm). Bibliothèque Nationale, Paris.

THE AMASIS PAINTER A mid-sixth-century BCE amphora—a large, all-purpose storage jar—with bands of decoration above and below a central figural composition illustrates this development (**FIG. 5-23**). The painting on this amphora has been attributed to an artist we call the Amasis Painter, since this distinctive style was first recognized on vessels signed by a prolific potter named Amasis.

Two maenads (female worshipers of the wine god Dionysos), intertwined with arms around each other's shoulders, skip forward to present their offerings—a long-eared rabbit and a small deer—to the god. (Amasis signed his work just above the rabbit.) The maenad holding the deer wears the skin of a spotted panther (or leopard), its head still attached, draped over her shoulders and secured with a belt at her waist. The god, an imposing, richly dressed figure, clasps a large **kantharos** (wine cup). This encounter between humans and a god appears to be a joyful, celebratory occasion rather than one of reverence or fear. The Amasis Painter favored strong shapes and patterns over conventions for making figures appear to occupy real space. He emphasized fine details, such as the large, delicate petal and spiral designs below

TECHNIQUE | Black-Figure and Red-Figure

The two predominant techniques for painting on Greek ceramic vessels were black-figure (**Fig. 5–24**) and red-figure (**Fig. 5–25**). Both involved applying **slip** (a mixture of clay and water) to the surface of a pot and carefully manipulating the firing process in a kiln (a closed oven) to control the amount of oxygen reaching the ceramics. This firing process involved three stages. In the first stage, oxygen was allowed into the kiln, which "fixed" the whole vessel in one overall shade of red depending on the composition of the clay. Then, in the second (reduction) stage, the oxygen in the kiln was cut back (reduced) to a minimum, turning the vessel black, and the temperature was raised to the point at which the slip partially vitrified (became glasslike). Finally, in the third stage, oxygen was allowed back into the kiln, turning the unslipped areas back to a shade of red. The areas where slip had been applied, however, were sealed against the oxygen and remained black.

In the black-figure technique, artists silhouetted the forms—figures, objects, or abstract motifs—with slip against the unpainted clay of the background. Then, using a sharp tool (a stylus), they cut through the slip to the body of the vessel, **incising** linear details within the silhouetted

shape by revealing the unpainted clay underneath. The characteristic color contrast only appeared in firing. Sometimes touches of white and reddish-purple gloss—made of metallic pigments mixed with slip—enhanced the decorative effect.

In the red-figure technique, the approach was reversed. Artists painted not the shapes of the forms themselves but the background around forms (negative space), reserving unpainted areas for silhouetted forms. Instead of engraving details, painters drew on the reserved areas with a fine brush dipped in liquid slip. The result was a lustrous black vessel with light-colored figures delineated in fluid black lines.

The contrasting effects obtained by these two techniques are illustrated here in details of two sides of a single amphora of about 525 BCE, both portraying the same figural composition, one painted by an artist using black-figure, and the other painted by an innovative proponent of red-figure technique. The sharp precision and flattened decorative richness characterizing black-figure contrasts strikingly here with the increased fluidity and greater sense of three-dimensionality facilitated by the development of the red-figure technique.

5-24 • Lysippides Painter HERAKLES DRIVING A BULL TO SACRIFICE

c. 525–520 BCE. Black-figure decoration on an amphora. Ceramic, height of amphora $20^{15}/_{16}$ " (53.2 cm). Museum of Fine Arts, Boston. Henry Lillie Pierce Fund (99.538)

5-25 • Andokides Painter HERAKLES DRIVING A BULL TO SACRIFICE

c. 525–520 BCE. Red-figure decoration on an amphora. Ceramic, height of amphora 20¹⁵/₁₆" (53.2 cm). Museum of Fine Arts, Boston. Henry Lillie Pierce Fund (99.538)

each handle, the figures' meticulously arranged hair, and the bold patterns on their clothing.

EXEKIAS Perhaps the most famous of all Athenian black-figure painters, Exekias, signed many of his vessels as both potter and painter. He took his subjects from Greek mythology, which he and his patrons probably considered to be history. On the body of

an amphora we have already seen at the beginning of this chapter, he portrayed Trojan War heroes Ajax and Achilles in a rare moment of relaxation playing dice (see FIG. 5–1). This is an episode not included in any literary source, but for Greeks familiar with the story, this anecdotal portrayal of friendly play would have been a poignant reminder that before the end of the war, the heroes would be parted by death, Achilles in battle and Ajax by suicide.

A CLOSER LOOK | The Death of Sarpedon

by Euphronios (painter) and Euxitheos (potter). c. 515 BCE. Red-figure decoration on a calyx krater. Ceramic, height of krater 18" (45.7 cm). Museo Nazionale di Villa Giulia, Rome.

Hypnos (Sleep) and Thanatos (Death), identified by inscriptions that The painting's field is framed seem to emerge from their mouths, face each other on either side of by dense bands of detailed the fallen body of Sarpedon, gently raising the slain warrior. ornament, placed to highlight the contours of the krater. The god Hermes is identified not only by Sarpedon's body twists up to face inscription, but also by the viewer, allowing Euphronios to his caduceus (staff with outline every muscle and ligament coiled snakes) and winged of the torso, showing off both headgear. The attention his knowledge of anatomy and to contours, distribution his virtuosity in using the newly of drapery folds, and developed red-figure technique. overlapping of forms give the twisting figure threedimensionality. Blood continues illogically to pour from the wounds in Sarpedon's corpse, not out of ignorance on the part of the artist but because Euphronios makes it appear as if Sarpedon's of his determination to heighten the dramatic effect of the scene. left leg is projecting into the viewer's space through the technique of foreshortening.

View the Closer Look for the krater showing the death of Sarpedon on myartslab.com

Knowing the story was critical to engaging with such paintings, and artists often included identifying labels beside the characters to guide viewers to the narrative source so they could delight in the painters' rich renderings of familiar narrative situations.

RED-FIGURE VESSELS In the last third of the sixth century BCE, while many painters were still creating handsome blackfigure wares, some turned away from this meticulous process to a new, more fluid technique called **red-figure** (see "Black-Figure and Red-Figure," opposite). In this mode of decoration, red figures stand out against a black background, the opposite of blackfigure painting. The greater freedom and flexibility that resulted from painting rather than engraving details led ceramic painters to adopt the red-figure technique widely in a relatively short time. It allowed them to create livelier human figures with a more developed sense of bodily form—qualities that were increasingly demanded of Greek artists in several media. **EUPHRONIOS** One of the best-known red-figure artists was Euphronios. His rendering of the death of Sarpedon, about 515 BCE (see "A Closer Look," above), is painted on a krater called a **calyx krater** because its handles curve up like a flower's calyx. Such a vessel was used as a punchbowl during a **symposium**, a social gathering of rich and powerful men. According to Homer's *Iliad*, Sarpedon, a son of Zeus and a mortal woman, was killed by the Greek warrior Patroclus while fighting for the Trojans. Euphronios captures the scene in which the warrior is being carried off to the underworld, the land of the dead.

Euphronios has created a balanced composition of verticals and horizontals that take the shape of the vessel into account. The bands of decoration above and below the scene echo the long horizontal of the dead fighter's body, which seems to levitate in the gentle grasp of its bearers, and the inward-curving lines of the handles mirror the arching backs and extended wings of Hypnos (Sleep) and Thanatos (Death). The upright figures of the

ART AND ITS CONTEXTS | Classic and Classical

Our words "classic" and "classical" come from the Latin word *classis*, referring to the division of people into classes based on wealth. "Classic" has come to mean "first class" or "the standard of excellence." Greek artists in the fifth century BCE sought to create ideal images based on strict mathematical proportions, which we call "Classical." Since Roman artists were inspired by the Greeks, "Classical" often refers to the

cultures of ancient Greece and Rome. By extension, the word may also mean "in the style of ancient Greece and Rome," whenever or wherever that style is used. In the most general usage, a "classic" is something perhaps a literary work, an automobile, a film, even a soft drink—thought to be of lasting quality and universal esteem.

lance-bearers on each side and Hermes in the center counterbalance the horizontal and diagonal elements of the composition. While conveying a sense of the mass and energy of human subjects, Euphronios also portrayed the elaborate details of their clothing, musculature, and facial features with the fine tip of a brush. And he created the impression of real space around the figures by gently foreshortening Sarpedon's left leg that appears to be coming toward the viewer's own space. Such formal features, as well as a palpable sense of pathos in the face of Sarpedon's fate, seem to connect Euphronios' work with the dying warriors of the pediments from Aegina (see FIGS. 5–14, 5–15).

THE EARLY CLASSICAL PERIOD, c. 480–450 BCE

Over the brief span of 160 years, between c. 480 and 323 BCE, the Greeks established an ideal of beauty that has endured in the Western world to this day. Scholars have associated Greek Classical art with three general concepts: humanism, rationalism, and idealism (see "Classic and Classical," above). The ancient Greeks believed the words of their philosophers and followed these injunctions in their art: "Man is the measure of all things," that is, seek an ideal based on the human form; "Know thyself," seek the inner significance of forms; and "Nothing in excess," reproduce only essential forms. In their embrace of humanism, the Greeks even imagined their gods as perfect human beings. But the Greeks valued human reason over human emotion. They saw all aspects of life, including the arts, as having meaning and pattern. Nothing happens by accident. It is not surprising that great Greek artists and architects were not only practitioners but theoreticians as well. In the fifth century BCE, the sculptor Polykleitos (see "'The Canon' of Polykleitos," page 134) and the architect Iktinos both wrote books on the theory underlying their practice.

Art historians usually divide the Classical into three phases, based on the formal qualities of the art: the Early Classical period (c. 480–450 BCE); the High Classical period (c. 450–400 BCE); and the Late Classical period (c. 400–323 BCE). The Early Classical period begins with the defeat of the Persians in 480–479 BCE by an alliance of city-states led by Athens and Sparta. The expanding Persian Empire had posed a formidable threat to the independence

of the city-states, and the two sides had been locked in battle for decades until the Greek alliance was able to repulse a Persian invasion and score a decisive victory. Some scholars have argued that their success against the Persians gave the Greeks a self-confidence that accelerated artistic development, inspiring artists to seek new and more effective ways to express their cities' accomplishments. In any case, the period that followed the Persian Wars, extending to about 450 BCE, saw the emergence of a new stylistic direction, away from elegant stylizations and toward a sense of greater faithfulness to the natural appearance of human beings and their world.

MARBLE SCULPTURE

In the remarkably short time of only a few generations, Greek sculptors had moved far from the stiff bearing and rigid frontality of the Archaic kouroi to more relaxed poses in lifelike figures such as the so-called **KRITIOS BOY** of about 480 BCE (FIG. 5-26). The softly rounded body forms, broad facial features, and calm expression give the figure an air of self-confident seriousness. His weight rests on his left, engaged leg, while his right, relaxed leg bends slightly at the knee, and a noticeable curve in his spine counters the slight shifting of his hips and a subtle drop of one of his shoulders. We see here the beginnings of contrapposto, the convention (later developed in full by High Classical sculptors such as Polykleitos) of presenting standing figures with opposing alternations of tension and relaxation around a central axis that will dominate Classical art. The slight turn of the head invites the spectator to follow his gaze and move around the figure, admiring the small marble statue from every angle.

BRONZE SCULPTURE

The development of the technique of hollow-casting bronze in the lost-wax process gave Greek sculptors the potential to create more complex action poses with outstretched arms and legs. These were very difficult to create in marble, since unbalanced figures might topple over and extended appendages might break off due to their pendulous weight. Bronze figures were easier to balance, and the metal's greater tensile strength made complicated poses and gestures technically possible.

The painted underside of an Athenian **kylix** (broad, flat drinking cup) portrays work in a late Archaic foundry for casting life-size

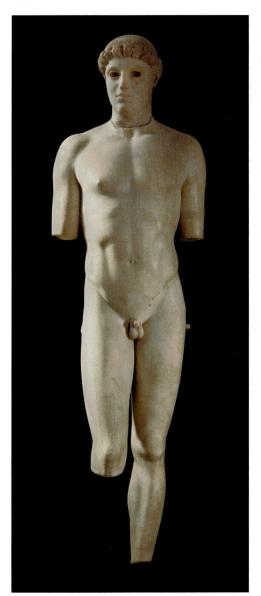

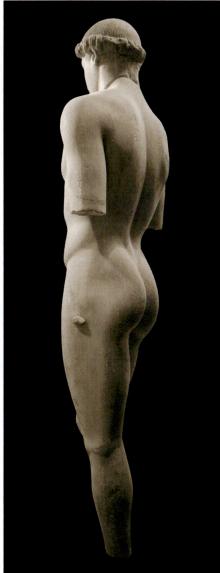

5-26 • KRITIOS BOY

From the Akropolis, Athens. c. 475 $_{\rm BCE.}$ Marble, height 3'10" (1.17 m). Akropolis Museum, Athens.

The damaged figure, excavated from the debris on the Athenian Akropolis, was thought by its finders to be by the Greek sculptor Kritios, whose work they knew only from Roman copies.

figures (FIG. 5-27), providing clear evidence that the Greeks were creating large bronze statues in active poses as early as the first decades of the fifth century BCE. The walls of the workshop are filled with hanging tools and other foundry paraphernalia including several sketches-a horse, human heads, and human figures in different poses. One worker, wearing what looks like a modern-day construction helmet, squats to tend the furnace on the left, perhaps aided by an assistant who peeks from behind. The man in the center, possibly the supervisor, leans on a staff, while a third worker assembles a leaping figure that is braced against a molded support. The unattached head lies between his feet.

5-27 • Foundry Painter **A BRONZE FOUNDRY** 490–480 BCE. Red-figure decoration on a kylix from Vulci, Italy. Ceramic, diameter of kylix 12" (31 cm). Staatliche Museen zu Berlin, Preussischer Kulturbesitz, Antikensammlung.

The Foundry Painter has masterfully organized this workshop scene within the flaring space that extends upward from the foot of the vessel and along its curving underside to the lip, thereby using a circle as the groundline for his composition.

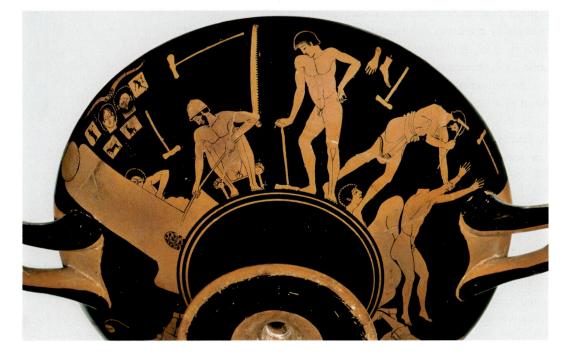

THE CHARIOTEER A spectacular and rare life-size bronze, the **CHARIOTEER** (**FIG. 5-28**), cast about 470 BCE, documents the skills of Early Classical bronze-casters. It was found in the sanctuary of Apollo at Delphi, together with fragments of a bronze chariot and horses, all buried during an earthquake in 373 BCE that may have saved them from the fate of most ancient bronzes, which were melted down so the material could be recycled and made into a new work. According to its inscription, the sculptural group commemorated a victory in the Pythian Games of 478 or 474 BCE, though it was the team of horses and the owner—not the charioteer—who were being celebrated.

The face of this handsome youth is highly idealized, but there is a lifelike quality to the way his head turns slightly to one side, and the glittering, onyx eyes and fine copper eyelashes enhance his intense, focused expression. He stands at attention, sheathed in a long robe with folds falling naturally under their own weight, varying in width and depth, yet seemingly capable of swaying and rippling with the charioteer's movement. The feet, with their closely observed toes, toenails, and swelling veins over the instep, are so realistic that they seem to have been cast from molds made from the feet of a living person.

THE RIACE WARRIORS Shipwreck as well as earthquake has protected ancient bronzes from recycling. As recently as 1972, divers recovered a pair of heavily corroded, larger-than-life-size bronze figures of warriors from the seabed off the coast of Riace, Italy, dating from about 460–450 BCE (see "The Riace Warriors," page 127).

The **WARRIOR** in **FIG. 5-29** reveals a striking balance between the idealized smoothness of "perfected" anatomy conforming to Early Classical standards and the reproduction of details observed from nature, such as the swelling veins in the backs of the hands. Contrapposto is further developed here than in the Kritios Boy, with a more pronounced counterbalance between tension (right leg and left arm) and relaxation (left leg and right arm), raising the prospect of a shift and

5-28 • CHARIOTEER

From the Sanctuary of Apollo, Delphi. c. 470 BCE. Bronze, copper (lips and lashes), silver (hand), onyx (eyes), height 5'11" (1.8 m). Archaeological Museum, Delphi.

The setting of a work of art affects the impression it makes. Today, the *Charioteer* is exhibited on a low base in the peaceful surroundings of a museum, isolated from other works and spotlighted for close examination. Its effect would have been very different in its original outdoor location, standing in a horse-drawn chariot atop a tall monument. Viewers in ancient times, tired from the steep climb to the sanctuary and jostled by crowds of fellow pilgrims, could have absorbed only its overall effect, not the fine details of the face, robe, and body visible to today's viewers.

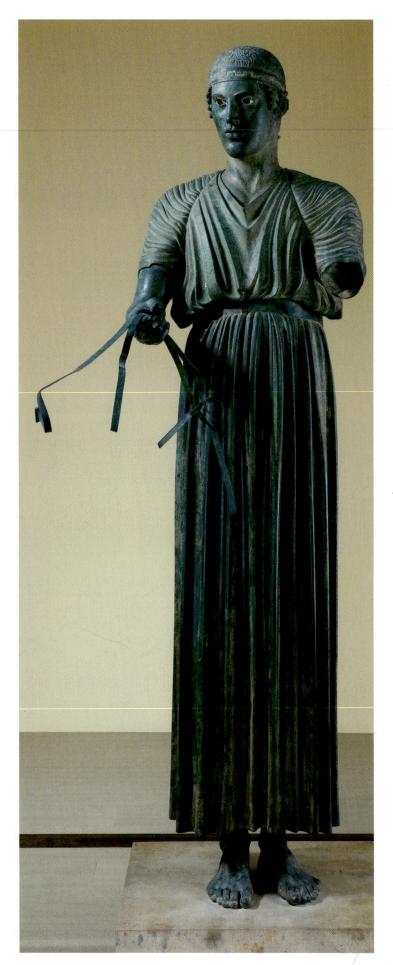

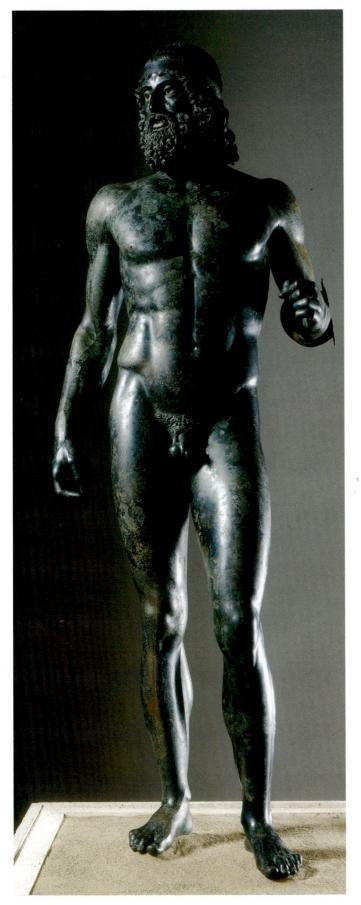

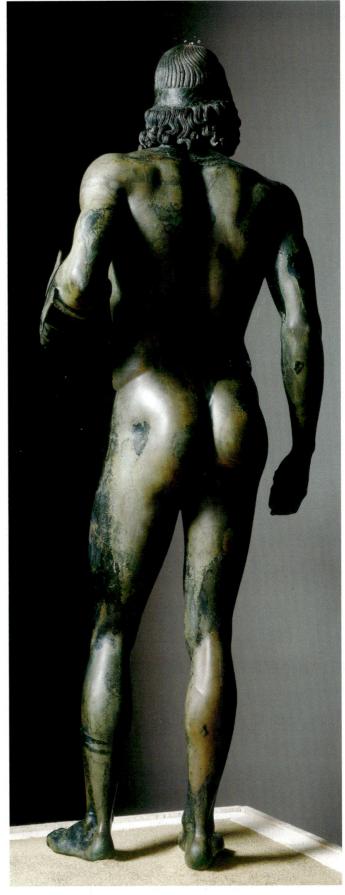

5-29 • WARRIOR

Found in the sea off Riace, Italy. c. 460–450 BCE. Bronze with bone and glass eyes, silver teeth, and copper lips and nipples, height 6'9" (2.05 m). National Archeological Museum, Reggio Calabria, Italy.

Although ancient Greek commentators describe elaborate monumental wall paintings and discuss the output and careers of illustrious painters from the fifth and fourth centuries BCE, almost nothing of this art has survived. We rely heavily on ceramics to fill gaps in our knowledge of Greek painting, assuming that the decoration of these more modest utilitarian vessels reflects the glorious painting tradition documented in texts. There are also tantalizing survivals in provincial Greek sites. Principal among them are the well-preserved Early Classical wall paintings of c. 480-470 BCE in the Tomb of the Diver, discovered in 1968 just south of the Greek colony of Poseidonia (Roman Paestum) in southern Italy.

The paintings cover travertine slabs that formed the four walls and roof of a tomb submerged into the natural rock (**FIG. 5–30**), approximately 7 feet long, 3½ feet wide, and 2½ feet deep. Painted in buon fresco (waterbased pigments applied to wet plaster) on a white ground in earthy browns, yellows, and blacks, with accents of blue, the scenes on the walls surrounded the occupant of this tomb with a group of reclining men, assembled for a symposium—lively, elite male gatherings that focused on wine, music, games, and love making. Many of the most distinguished of surviving Greek ceramic vessels were made for use in these playfully competitive drinking parties, and they are highlighted in the tomb paintings. On one short side (visible in the reconstruction drawing), a striding nude youth has filled the oinochoe (wine jug) in his right hand with the mixture of wine and water that was served from large kraters (punch bowls, like that portrayed on the table behind him) as the featured beverage of the symposium. He extends his arm toward a group of revelers reclining along one of the long walls (FIG. 5-31), each of whom has a kylix (wide, shallow, footed drinking cup). waiting to be filled. The man at the left reclines alone, raising his kylix to salute a couple just arriving-or perhaps toasting their departureon the other short side. Behind him, the two couples on the long frieze-in each case a bearded, mature man paired with a youthful companion-are already engaged in the party. The young man in the middle pairing is slinging his upraised kylix, presumably to propel the dregs of his wine toward a target, a popular symposium game. His partner turns in the opposite direction to ogle at the amorous pair at the right, who have abandoned their cups on the table in front of them and turned to embrace, gazing into each other's eyes as the erotic action heats up.

The significance of these paintings in relationship to a young man's tomb is not absolutely clear. Perhaps they are indicative of the deceased's elevated social status, since only wealthy aristocrats participated in such gatherings. The symposium could also represent funerary feasting or a vision of the pleasures that awaits the deceased in a world beyond death.

The transition between this world and the next certainly seems to be the theme of the spare but energetic painting on the roof of the tomb, where a naked boy is caught in mid dive, poised to plunge into the water portrayed as a blue mound underneath him (FIG. 5-32). Whereas the scene of the symposium accords with an ancient Greek pictorial tradition. especially prominent on ceramic vessels made for use by its male participants, this diver finds his closest parallels in Etruscan tomb painting (see FIG. 6-6), flourishing at this time farther north in Italy. Since the scene was located directly over the body of the man entombed here, it is likely that it mirrors his own plunge from life into death. And since it combines Greek and Etruscan traditions, perhaps this tomb was made for an Etruscan citizen of Poseidonia, whose tomb was commissioned from a Greek artist working in this flourishing provincial center.

5-30 • RECONSTRUCTION DRAWING OF THE TOMB OF THE DIVER, POSEIDONIA (ROMAN PAESTUM) c. 480 BCE.

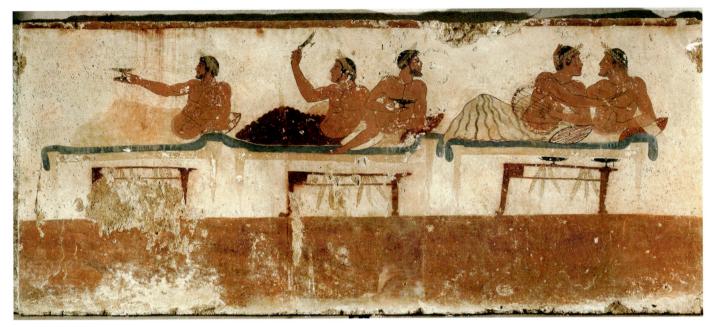

5-31 • A SYMPOSIUM SCENE

From the Tomb of the Diver, Poseidonia (Roman Paestum). c. 480 BCE. Fresco on travertine slab, height 31" (78 cm). Paestum Museum.

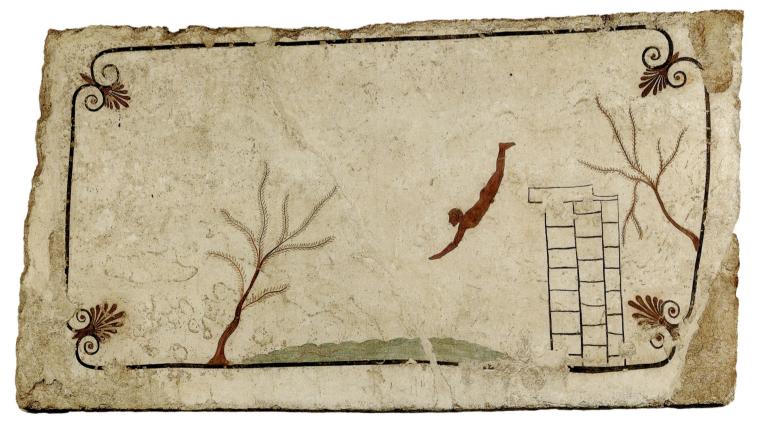

5-32 • A DIVER From the Tomb of the Diver, Poseidonia (Roman Paestum). c. 480 BCE. Fresco on travertine slab, height 3'4" (1.02 m). Paestum Museum. with it the possibility of movement and life. The lifelike quality of this bronze is further heightened by inserted eyeballs of bone and colored glass, copper inlays on lips and nipples, silver plating on the teeth that peek between parted lips, and attached eyelashes and eyebrows of separately cast strands of bronze. This accommodation of the intense study of the human figure to an idealism that belies the irregularity of nature will be continued by artists in the High Classical period.

CERAMIC PAINTING

Greek potters and painters continued to work with the red-figure technique throughout the fifth century BCE, refining their ability to create supple, rounded figures, posed in ever more complicated and dynamic compositions. One of the most prolific Early Classical artists was Douris, whose signature appears on over 40

surviving pots decorated with scenes from everyday life as well as mythological subjects. His conspicuous skill in composing complex figural scenes that respond to the complicated and irregular pictorial fields of a variety of vessel types is evident in a frieze of frisky satyrs that he painted c. 480 BCE around the perimeter of a **psykter** (**FIG. 5-33**). This strangely shaped pot was a wine cooler, made to float in a krater (see "A Closer Look," page 119) filled with chilled water, its extended bottom serving as a keel to keep it from tipping over.

Like the krater, the psykter was a vessel meant for use in exclusive male drinking parties know as symposia, and the decoration was chosen with this context in mind. The acrobatic virtuosity of the satyrs is matched by the artist's own virtuosity in composing them as an interlocking set of diagonal gestures that alternately challenge and correspond with the bulging form around which they are painted. The playful interaction of satyrs with their kylixes must have amused the tipsy revelers, especially when this pot was gently bobbing within the krater, making the satyrs seem to be walking around in circles on top of the wine. One satyr cups his kylix to his buttocks, juxtaposing convex and concave shapes. Another, balanced in a precarious handstand, seems to be observing his own reflection within the wine of his kylix.

But Douris was also capable of more lyrical compositions, as seen in the painting he placed within a kylix (**FIG. 5-34**), similar in shape to those used as props by the satyrs on the psykter. This **tondo** (circular painting) was an intimate picture. It became visible only to the user of the cup when he tilted up the kylix to drink from it; otherwise, sitting on a table, the painting would have been obscured by the dark wine pool within it. A languidly posed and elegantly draped youth stands behind an altar pouring wine from an **oinochoe** (wine jug) into the kylix of a more dignified, bearded older man. Euphronios' tentative essay in foreshortening Sarpedon's bent leg on his krater (see "A Closer Look," page 119) blossoms in the work of Douris to become full-scale formal projection as the graceful youth on this kylix bends his arm from the background to project his frontal oinochoe over the laterally held kylix of his seated companion.

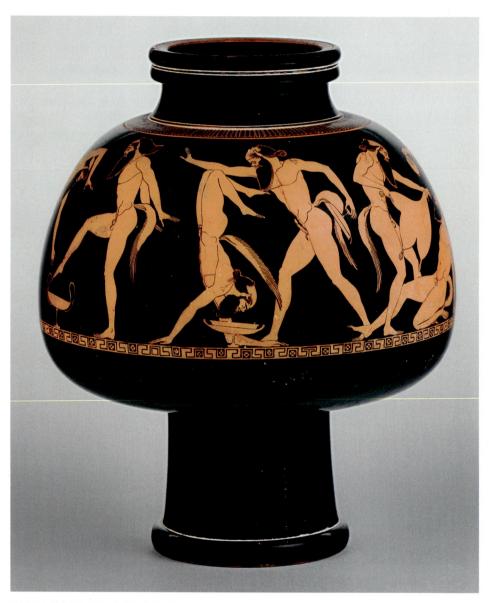

5-33 • Douris **FROLICKING SATYRS** c. 480 BCE. Red-figure decoration on a psykter. Ceramic, height 11⁵/₁₆" (28.7 cm). British Museum, London.

RECOVERING THE PAST | The Riace Warriors

In 1972, a scuba diver in the Ionian Sea near the beach resort of Riace, Italy, found what appeared to be a human elbow and upper arm protruding from sand about 25 feet beneath the sea. Taking a closer look, he discovered that the arm was made of metal, not flesh, and was part of a large statue. He quickly uncovered a second statue nearby, and underwater salvagers soon raised the statues: bronze warriors more than 6 feet tall, complete in every respect, except for swords, shields, and one helmet.

After centuries underwater, however, the bronze *Warriors* were corroded and covered with accretions. The clay cores from the casting

process were still inside, adding to the deterioration by absorbing lime and sea salts. Conservators first removed all the exterior corrosion and lime encrustations using surgeon's scalpels, pneumatic drills, and high-technology equipment such as sonar (sound-wave) probes and micro-sanders. Then they painstakingly removed the clay core through existing holes in the heads and feet using hooks, scoops, jets of distilled water, and concentrated solutions of peroxide. Finally, they cleaned the figures thoroughly by soaking them in solvents, and they sealed them with a fixative specially designed for use on metals before exhibiting them in 1980.

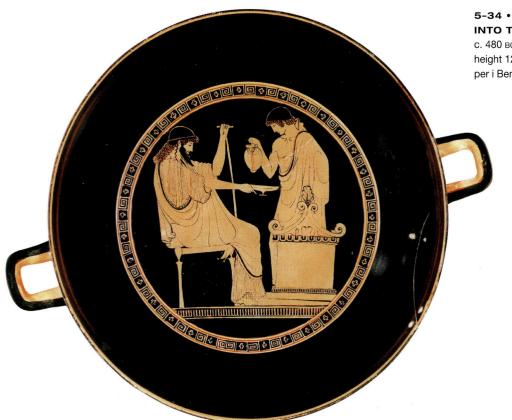

5-34 • Douris A YOUTH POURING WINE INTO THE KYLIX OF A COMPANION

c. 480 BCE. Red-figure decoration on a kylix. Ceramic, height 12¾" (32.4 cm). The Soprintendenza Speciale per i Beni Archeologici di Napoli e Pompei.

For the well-educated reveler using this cup at a symposium, there were several possible readings for the scene he was observing. This could be the legendary Athenian king Kekrops, who appears, identified by inscription, in the scene Douris painted on the underside of the kylix. Also on the bottom of the cup are Zeus and the young Trojan prince Ganymede, whom the supreme god abducted to Olympus to serve as his cup-bearer. Or, since the symposia themselves were the site of amorous interactions between older and younger men, the user of this cup might have found his own situation mirrored in what he was observing while he drank.

THE HIGH CLASSICAL PERIOD, c. 450–400 BCE

The High Classical period of Greek art lasted only a half-century, 450–400 BCE. The use of the word "high" to qualify the art of this time reflects the value judgments of art historians who have considered this period a pinnacle of artistic refinement, producing works that set a standard of unsurpassed excellence. Some have even referred to this half-century as Greece's "Golden Age," although these decades were also marked by turmoil and destruction. Without a common enemy, Sparta and Athens turned on each other in a series of conflicts known as the Peloponnesian War. Sparta dominated the Peloponnese peninsula and much of the rest of

mainland Greece, while Athens controlled the Aegean and became the wealthy and influential center of a maritime empire. Today we remember Athens more for its cultural and intellectual brilliance and its experiments with democratic government, which reached its zenith in the fifth century BCE under the charismatic leader Perikles (c. 495–429 BCE), than for the imperialistic tendencies of its considerable commercial power.

Except for a few brief interludes, Perikles dominated Athenian politics and culture from 462 BCE until his death in 429 BCE. Although comedy writers of the time sometimes mocked him, calling him "Zeus" and "The Olympian" because of his haughty personality, he was a dynamic, charismatic political and military leader. He was also a great patron of the arts, supporting the use of Athenian wealth for the adornment of the city, and encouraging artists to promote a public image of peace, prosperity, and power. Perikles said of his city and its accomplishments: "Future generations will marvel at us, as the present age marvels at us now." It was a prophecy he himself helped fulfill.

THE AKROPOLIS

Athens originated as a Neolithic **akropolis**, or "city on top of a hill" (*akro* means "high" and *polis* means "city"), that later served as a fortress and sanctuary. As the city grew, the Akropolis became

the religious and ceremonial center devoted primarily to the goddess Athena, the city's patron and protector.

After Persian troops destroyed the Akropolis in 480 BCE, the Athenians vowed to keep it in ruins as a memorial, but Perikles convinced them to rebuild it, arguing that this project honored the gods, especially Athena, who had helped the Greeks defeat the Persians. Perikles intended to create a visual expression of Athenian values and civic pride that would bolster the city's status as the capital of the empire he was instrumental in building. He chose his close friend Pheidias, a renowned sculptor, to supervise the rebuilding and assembled under him the most talented artists in Athens.

The cost and labor involved in this undertaking were staggering. Large quantities of gold, ivory, and exotic woods had to be imported. Some 22,000 tons of marble were transported 10 miles from mountain quarries to city workshops. Perikles was severely criticized by his political opponents for this extravagance, but it never cost him popular support. In fact, many working-class Athenians—laborers, carpenters, masons, sculptors, and the farmers and merchants who kept them supplied and fed—benefited from his expenditures.

Work on the **AKROPOLIS** continued throughout the fifth century BCE (**FIG. 5-35**). Visitors in 400 BCE would have climbed

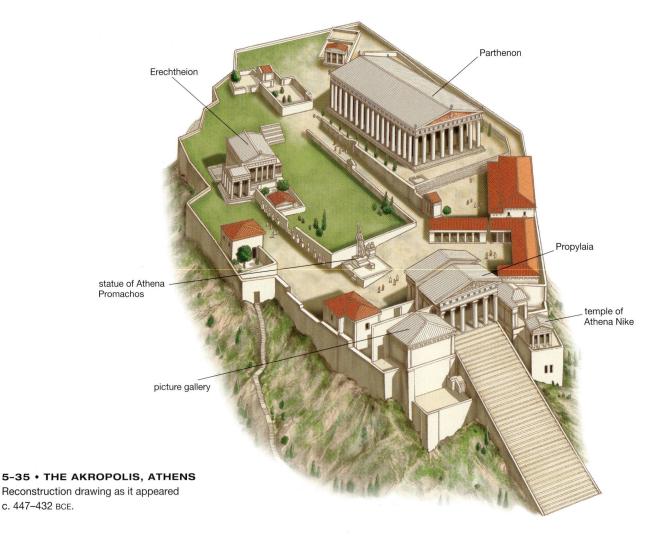

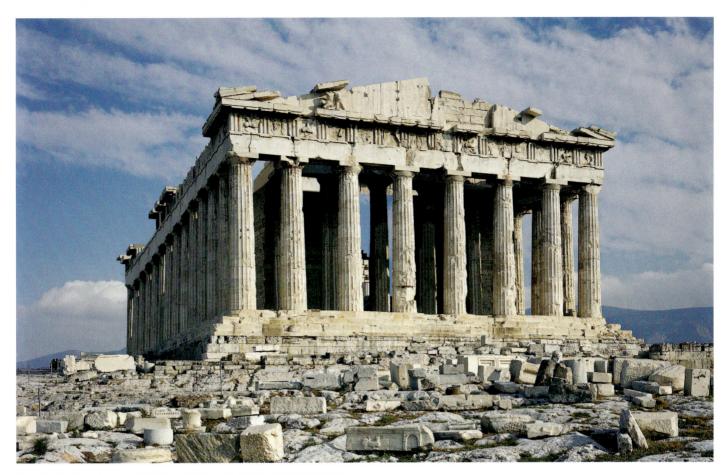

5-36 • Kallikrates and Iktinos VIEW (A) AND PLAN (B) OF THE PARTHENON

Akropolis, Athens. 447–432 BCE. Pentelic marble. Photograph: view from the northwest.

Explore the architectural panoramas of the Parthenon on myartslab.com

a steep ramp on the west side of the hill (in the foreground of FIGURE 5-35) to the sanctuary entrance, perhaps pausing to admire the small temple dedicated to Athena Nike (Athena as goddess of victory in war), poised on a projection of rock above the ramp. After passing through an impressive porticoed gatehouse called the Propylaia, they would have seen a huge bronze figure of Athena Promachos (the Defender), designed and executed by Pheidias between about 465 and 455 BCE. Sailors entering the Athenian port of Piraeus, about 10 miles away, could see the sun reflected off her helmet and spear tip. Behind this statue was a walled precinct that enclosed the Erechtheion, a temple dedicated to several deities, and to its right was the largest building on the Akropolis-the Parthenon, a temple dedicated to Athena Parthenos (the Virgin). Visitors approached the temple from its northwest corner, instantly grasping the imposing width and depth of this building, isolated like a work of sculpture elevated on a pedestal.

THE PARTHENON

Sometime around 490 BCE, Athenians had begun work on a temple to Athena Parthenos that was still unfinished when the Persians sacked the Akropolis a decade later. In 447 BCE Perikles

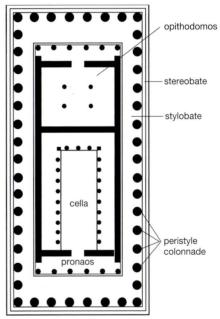

commissioned the architects Kallikrates and Iktinos to design a larger temple using the existing foundation and stone elements. The finest white marble was used throughout—even on the roof, in place of the more usual terra-cotta tiles (**FIG. 5-36**). The planning and execution of the Parthenon (dedicated in 438 BCE) required extraordinary mathematical and mechanical skills and would have been impossible without a large contingent of distinguished architects and builders, as well as talented sculptors and painters. The

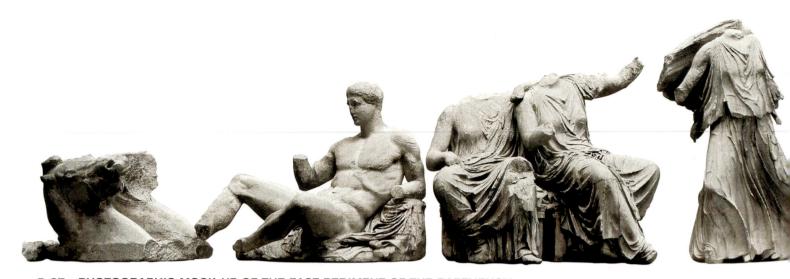

5-37 • PHOTOGRAPHIC MOCK-UP OF THE EAST PEDIMENT OF THE PARTHENON (USING PHOTOGRAPHS OF THE EXTANT MARBLE SCULPTURE) c. 447-432 BCE. The gap in the center represents the space that would have been occupied by the missing sculpture. The pediment is over 90 feet (27.45 m) long; the central space of about 40 feet (12.2 m) is missing.

result is as much a testament to Pheidias' administrative skills as his artistic vision, since he supervised the entire project.

One key to the Parthenon's sense of harmony and balance is an attention to proportions-especially the ratio of 4:9, expressing the relationship of breadth to length and the relationship of column diameter to space between columns. Also important are subtle refinements of design, deviations from absolute regularity to create a harmonious effect when the building was actually viewed. For example, since long, straight horizontal lines seem to sag when seen from a distance, base and entablature curve slightly upward to correct this optical distortion. The columns have a gentle swelling (entasis) and tilt inward slightly from bottom to top; the corners are strengthened visually by reducing the space between columns at those points. These subtle refinements in the arrangement of seemingly regular elements give the Parthenon a buoyant organic appearance and assure that it will not look like a heavy, lifeless stone box. The significance of their achievement was clear to its builders-Iktinos even wrote a book on the proportions of this masterpiece.

The sculptural decoration of the Parthenon reflects Pheidias' unifying aesthetic vision, but it also conveys a number of political and ideological themes: the triumph of the democratic Greek city-states over imperial Persia, the preeminence of Athens thanks to the favor of Athena, and the triumph of an enlightened Greek civilization over despotism and barbarism.

THE PEDIMENTS As with most temples, sculpture in the round filled both pediments of the Parthenon, set on the deep shelf of the cornice and secured to the wall with metal pins. Unfortunately, much has been damaged or lost over the centuries (also see "Who Owns the Art?" page 133). Using the locations of the pinholes and weathering marks on the cornice, and also drawings

made by French artist Jacques Carrey (1649–1726) on a visit to Athens in 1674, scholars have been able to determine the placement of surviving statues and infer the poses of missing ones. We know the subjects from the descriptions of the second century CE Greek writer Pausanias. The west pediment sculpture, facing the entrance to the Akropolis, presented the contest Athena won over the sea god Poseidon for rule over the Athenians. The east pediment figures, above the entrance to the cella, portrayed the birth of Athena, fully grown and clad in armor, from the brow of her father, Zeus.

The statues from the east pediment are the best preserved of the two groups (**FIG. 5-37**). Flanking the missing central figures probably Zeus seated on a throne with the newborn adult Athena standing at his side—were groups of goddesses and a single male figure. In the left corner was the sun god Helios in his horse-drawn chariot rising from the sea, while at the right the moon goddess Selene descends in her chariot to the sea, the head of her tired horse hanging over the cornice. The reclining male nude, whose relaxed pose fits so easily into the left pediment, has been identified as either Herakles with his lion's skin or Dionysos (god of wine) lying on a panther skin. The two seated women may be the earth and grain goddesses Demeter and Persephone. The running female figure just to the left of center is Iris, messenger of the gods, already spreading the news of Athena's birth.

The three interlocked female figures on the right side who seem to be awakening from a deep sleep, two sitting upright and one reclining, are probably Hestia (a sister of Zeus and the goddess of the hearth), Dione (one of Zeus's many consorts), and her daughter, Aphrodite. The sculptor, whether Pheidias or a follower, expertly rendered the female form beneath the fall of draperies, which both cover and reveal their bodies while uniting the three figures into a single mass.

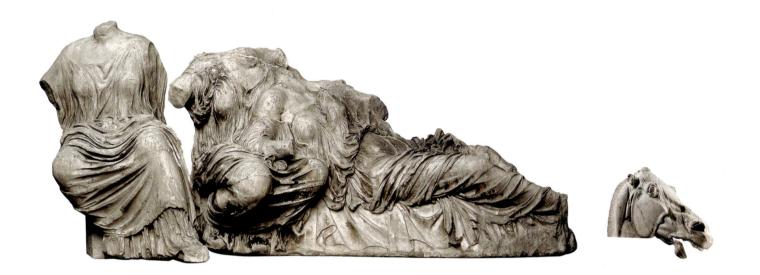

THE DORIC FRIEZE The all-marble Parthenon had two sculptured friezes, one above the outer peristyle and another atop the cella wall inside. The Doric frieze on the exterior had 92 metope reliefs depicting legendary battles, symbolized by combat between two representative figures: a centaur against a Lapith (a legendary people of pre-Hellenic times); a god against a Titan; a Greek against a Trojan; a Greek against an Amazon (one of the mythical tribe of female warriors sometimes said to be the daughters of the war god Ares). Each of these mythic struggles represented for the Greeks the triumph of reason over unbridled animal passion.

Among the best-preserved metope reliefs are several depicting the battle between Lapiths and centaurs from the south side of the

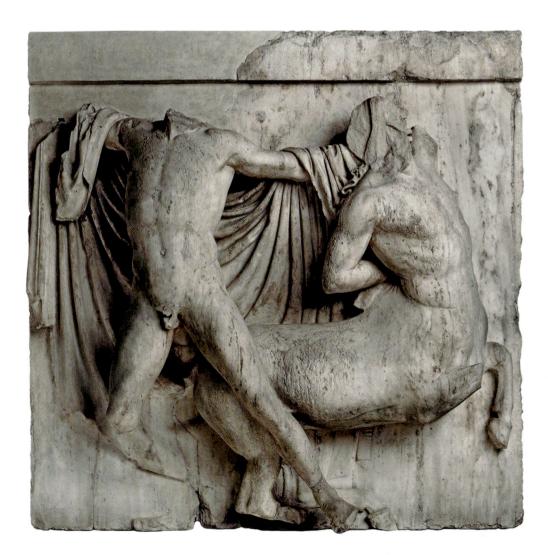

(FIG. 5-38) presents a pause within the fluid struggle, a timeless image standing for an extended historical episode. Forms are reduced to their most characteristic essentials, and so dramatic is the chiasmic (X-shaped) composition that we easily accept its visual contradictions. The Lapith is caught at an instant of total equilibrium. What could be a grueling tug-of-war between a man and a man-beast has been transformed into an athletic ballet, choreographed to show off the Lapith warrior's flexed muscles and graceful movements against the implausible backdrop of his carefully draped cloak.

Parthenon. The panel shown here

5-38 • LAPITH FIGHTING A CENTAUR

Metope relief from the Doric frieze on the south side of the Parthenon. c. 447–432 BCE. Marble, height 56" (1.42 m). British Museum, London.

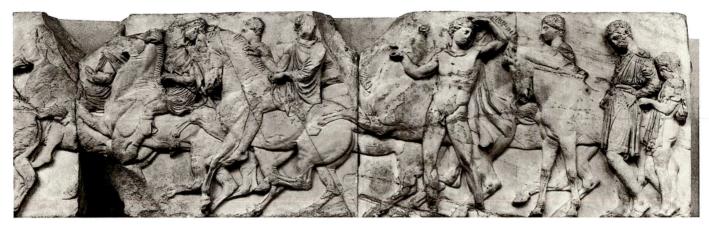

5-39 • HORSEMEN

Detail of the Procession, from the Ionic frieze on the north side of the Parthenon. c. 447–432 BCE. Marble, height 41¾" (106 cm). British Museum, London.

THE PROCESSIONAL FRIEZE Enclosed within the Parthenon's Doric peristyle, a continuous, 525-foot-long Ionic frieze ran along the exterior wall of the cella. Since the eighteenth century, its subject has been seen as a procession celebrating the festival that took place in Athens every four years, when the women of the city wove a new wool peplos and carried it to the Akropolis to clothe an ancient wooden cult statue of Athena. Both the skilled riders in the procession (**FIG. 5-39**), and the graceful but physically sturdy young walkers (**FIG. 5-40**), are representative types, ideal inhabitants of a successful city-state. The underlying message of

the frieze as a whole is that the Athenians are a healthy, vigorous people, united in a democratic civic body looked upon with favor by the gods. The people are inseparable from and symbolic of the city itself.

A more recent interpretation by art historian Joan Connelly, however, has challenged the traditional reading of the frieze as an ideal rendering of a contemporary event. She argues that—consistent with what we know of temple decoration elsewhere—what is portrayed is not contemporary but mythological history—the legendary Athenian king Erechtheus, who, following the advice

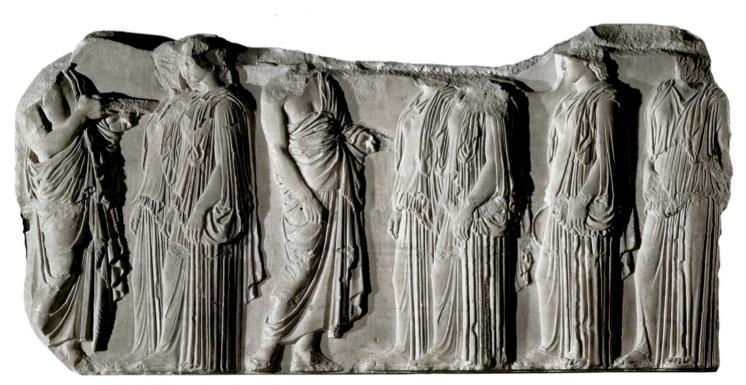

5-40 • YOUNG WOMEN AND MEN

Detail of the Procession, from the Ionic frieze on the east side of the Parthenon. c. 447–432 BCE. Marble, height 3'6" (1.08 m). Musée du Louvre, Paris.

At the beginning of the nineteenth century, Thomas Bruce, the British Earl of Elgin and ambassador to Constantinople, acquired much of the surviving sculpture from the Parthenon, which was at that time being used for military purposes. He shipped it back to London in 1801 to decorate a lavish mansion for himself and his wife; but by the time he returned to England, his wife had left him and the ancient treasures were at the center of a financial dispute and had to be sold. Referred to as the Elgin Marbles, most of the sculpture is now in the British Museum, including all the elements seen in FIGURE 5–37. The Greek government has tried unsuccessfully to have the Elgin Marbles returned.

Recently, another Greek treasure has been in the news. In 1972, a krater, painted by Euphronios and depicting the death of the

warrior Sarpedon during the Trojan War, had been purchased by the Metropolitan Museum of Art in New York (see "A Closer Look," page 119). Museum officials were told that it had come from a private collection, and it became the centerpiece of the museum's galleries of Greek vessels. But in 1995, Italian and Swiss investigators raided a warehouse in Geneva, Switzerland, where they found documents showing that the krater had been stolen from an Etruscan tomb near Rome. The Italian government demanded its return. The controversy was only resolved in 2006. The krater, along with other objects known to have been stolen from other Italian sites, were returned, and the Metropolitan Museum will display pieces "of equal beauty" under longterm loan agreements with Italy.

of the oracle at Delphi, sacrificed one of his own daughters to save the city of Athens from an external enemy. This theme, also incorporating a procession, would have had obvious resonance with the recent Athenian victory over the Persians.

As with the metope relief of a Lapith fighting a centaur (see FIG. 5–38), viewers of the processional frieze easily accept its disproportions, spatial compression and incongruities, and such implausible compositional features as men and women standing as tall as rearing horses. Carefully planned rhythmic variations contribute to the effectiveness of the frieze. Horses plunge ahead at full gallop; women proceed with a slow, stately step, while men pause to look back at the progress of those behind them.

In executing the frieze, the sculptors took into account the spectators' low viewpoint and the dim lighting inside the peristyle. They carved the top of the frieze band in higher relief than the lower part, thus tilting the figures out to catch the reflected light from the pavement, permitting a clearer reading of the action. The subtleties in the sculpture may not have been as evident to Athenians in the fifth century BCE as they are now: the frieze, seen at the top of a high wall and between columns, was originally completely painted. Figures in red and ocher, accented with glittering gold and real metal details, were set against a contrasting background of dark blue.

STATUE OF ATHENA PARTHENOS After having explored the considerable richness of sculpture on the exterior of the Parthenon, with permission, viewers could have climbed the east steps to look into the cella, where they would have seen Pheidias' colossal gold and ivory statue of Athena—outfitted in armor and holding a shield in one hand and a winged Nike (Victory) in the other—which was installed in the temple and dedicated 438 BCE (**FIG. 5-41**). The original has completely vanished, but descriptions and later copies allow us a clear sense of its appearance and its imposing size, looming nearly 40 feet tall.

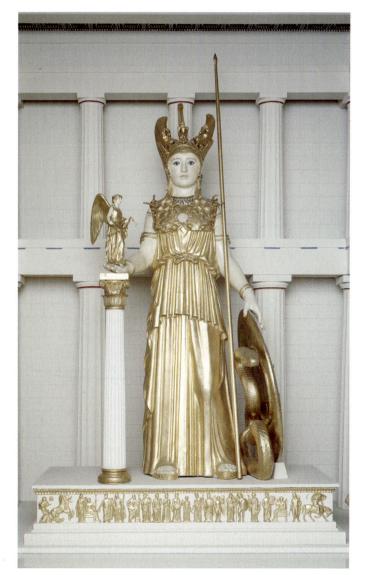

5-41 • RE-CREATION OF PHEIDIAS' HUGE GOLD AND IVORY FIGURE OF ATHENA Royal Ontario Museum, Toronto.

TECHNIQUE | "The Canon" of Polykleitos

Just as Greek architects defined and followed a set of standards for ideal temple design, Greek sculptors sought an ideal for representing the human body. Studying actual human beings closely and selecting those human attributes they considered most desirable—such as regular facial features, smooth skin, and particular body proportions—sculptors combined them into a single ideal of physical perfection.

The best-known theorist of the High Classical period was the sculptor Polykleitos of Argos. About 450 BCE, balancing careful observation with generalizing **idealization**, he developed a set of rules for constructing what he considered the ideal human figure, which he set down in a treatise called "The Canon" (*kanon* is Greek for "measure," "rule," or "law"). To illustrate his theory, Polykleitos created a bronze statue of a standing man carrying a spear—perhaps the hero Achilles. Neither the treatise nor the original statue has survived, but both were widely discussed in the writings of his contemporaries, and later Roman artists made marble copies of the *Spear Bearer (Doryphoros)*. By studying these copies, scholars have tried to determine the set of measurements that defined ideal human proportions in Polykleitos' canon.

The canon included a system of ratios between a basic unit and the length of various body parts. Some studies suggest that this basic unit may have been the length of the figure's index finger or the width of its hand across the knuckles; others suggest that it was the height of the head from chin to hairline. The canon also included guidelines for symmetria ("commensurability"), by which Polykleitos meant the relationship of body parts to one another. In the Spear Bearer, he explored not only proportions, but also the diagonally counterbalanced relationships between weight-bearing and relaxed legs and arms around a central axis, referred to as contrapposto.

The Roman marble copy of the **SPEAR BEARER** (FIG. 5–42) shows a male athlete, perfectly balanced, with the whole weight of the upper body supported over the straight (engaged) right leg. The left leg is bent at the knee, with the left foot poised on the ball of the foot, suggesting the weight shift of preceding and succeeding movement. The pattern of tension and relaxation is reversed in the arrangement of the arms, with the right relaxed on the engaged side, and the left bent to support the weight of the (missing) spear. The pronounced tilt of the *Spear Bearer*'s hipline accommodates the raising of the left foot onto its ball, and the head is turned toward the same side as the engaged leg. Hints of this dynamically balanced body pose—characteristic of High Classical standing figure sculpture—had already appeared in the Kritios Boy (see FIG. 5–26) and it was developed further in the Riace *Warrior* (see FIG. 5–29).

5-42 • Polykleitos **SPEAR BEARER (DORYPHOROS)** Roman copy after the original bronze of c. 450–440 BCE. Marble, height 6'11" (2.12 m); tree trunk and brace strut are Roman additions. National Archaeological Museum, Naples.

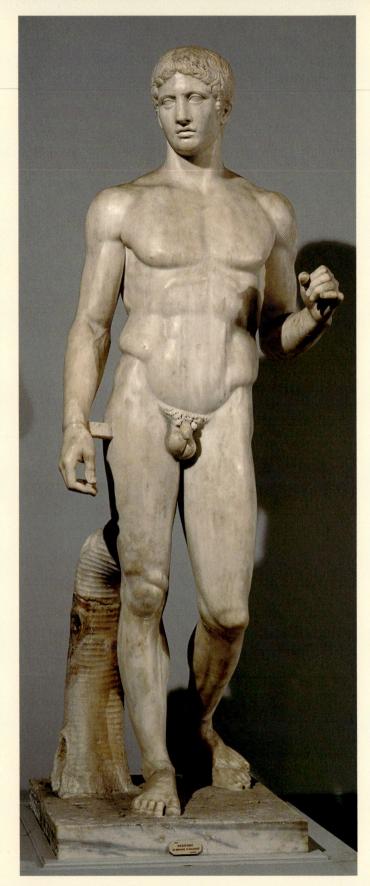

THE PROPYLAIA AND THE ERECHTHEION

Upon completion of the Parthenon, work began in 437 on the monumental gatehouse, the Propylaia (**FIG. 5-43**), that had been part of the original design of the Akropolis complex. The Propylaia had no sculptural decoration, but its north wing was originally a dining hall that later became the earliest known museum (meaning "home of the Muses"), a gallery built specifically to house a collection of paintings for public view.

Construction of the **ERECHTHEION** (**FIG. 5-44**), the second important temple erected on the Akropolis under Perikles' building program, began in the 430s BCE and ended in 406 BCE, just before the fall of Athens to Sparta. The asymmetrical plan reflects the building's multiple functions in housing several shrines, and also conformed to the sharply sloping terrain on which it is located. The Erechtheion stands on the site of the mythical contest between the sea god Poseidon and Athena for patronage over Athens. During this contest, Poseidon struck a rock with his trident (three-pronged harpoon), bringing forth a spout of water, but Athena gave an olive tree to Athens and won the contest. The Athenians enclosed what they believed to be this sacred rock, bearing the marks of the trident, in the Erechtheion's north porch. The Erechtheion also housed the venerable wooden cult statue of Athena that was the center of the Panathenaic festival.

The north and east porches of the Erechtheion have come to epitomize the Ionic order, serving as an important model for European architects since the eighteenth century. Taller and more

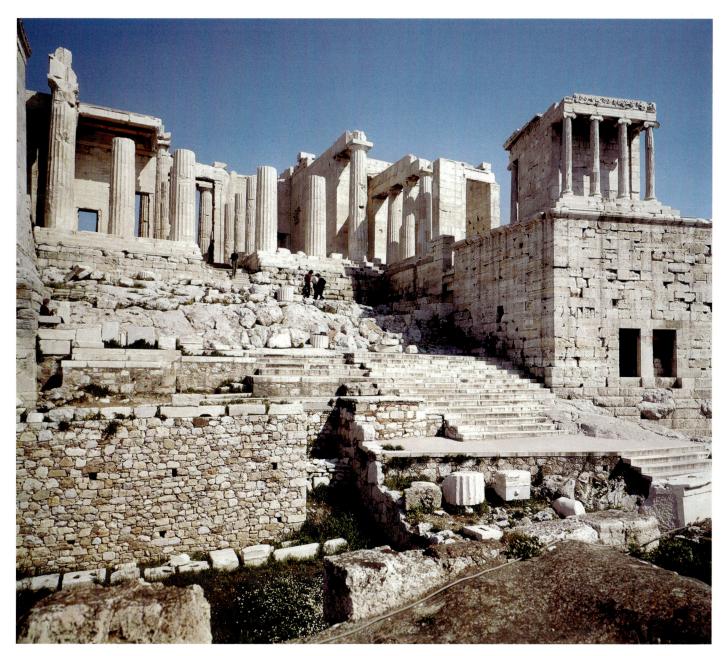

5-43 • THE MONUMENTAL ENTRANCE TO THE AKROPOLIS, ATHENS The Propylaia (Mnesikles) with the Temple of Athena Nike (Kallikrates) on the bastion at the right. c. 437–423 BCE.

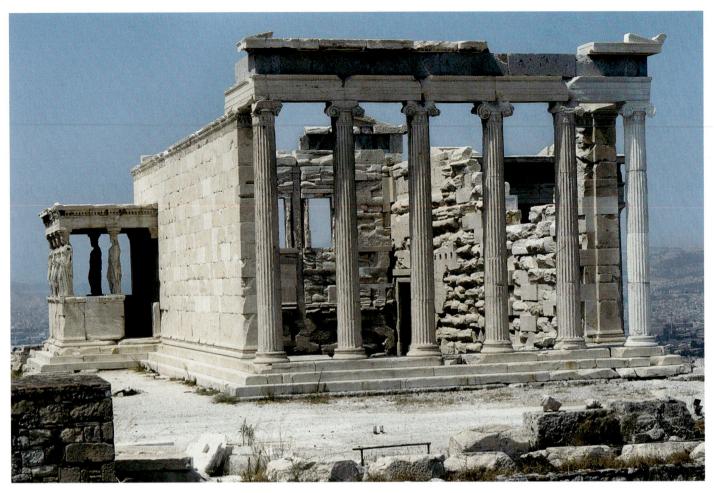

5-44 • **ERECHTHEION** Akropolis, Athens. 430s–406 BCE. View from the east. Porch of the Maidens at left; the north porch can be seen through the columns of the east wall.

slender in proportion that the Doric, the Ionic order also has richer and more elaborately carved decoration (see "The Greek Orders," page 110). The columns rise from molded bases and end in volute (spiral) capitals; the frieze is continuous.

The **PORCH OF THE MAIDENS** (**FIG. 5–45**), on the south side facing the Parthenon, is even more famous. Raised on a high base, its six stately caryatids support an Ionic entablature made up of bands of carved molding. In a pose characteristic of Classical figures, each caryatid's weight is supported on one engaged leg, while the free leg, bent at the knee, rests on the ball of the foot. The three caryatids on the left have their right legs engaged, and the three on the right have their left legs engaged, creating a sense of closure, symmetry, and rhythm.

5-45 • PORCH OF THE MAIDENS (SOUTH PORCH), ERECHTHEION

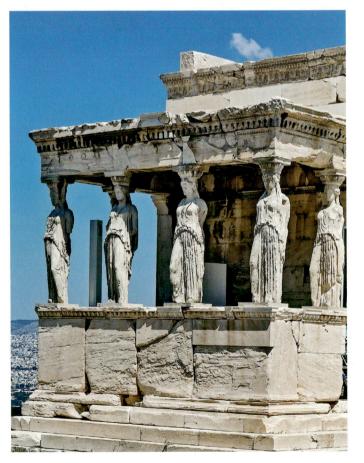

Akropolis, Athens. Porch c. 420–410 BCE.

5-46 • NIKE (VICTORY) ADJUSTING HER SANDAL

Fragment of relief decoration from the parapet (now destroyed), Temple of Athena Nike, Akropolis, Athens. Last quarter of the 5th century (perhaps 410–405) BCE. Marble, height 3'6" (1.06 m). Akropolis Museum, Athens.

THE TEMPLE OF ATHENA NIKE

The Ionic Temple of Athena Nike (victory in war), located south of the Propylaia, was designed and built about 425 BCE, probably by Kallikrates (see FIG. 5–43). Reduced to rubble during the Turkish occupation of Greece in the seventeenth century CE, the temple has since been rebuilt. Its diminutive size about 27 by 19 feet—and refined Ionic decoration are in marked contrast to the weightier Doric Propylaia adjacent to it.

Between 410 and 405 BCE, this temple was surrounded by a parapet or low wall faced with sculptured panels depicting Athena presiding over the preparation of a celebration by winged Nikes (victory figures). The parapet no longer exists, but some panels have survived, including the celebrated NIKE (VICTORY) ADJUSTING HER SANDAL (FIG. 5-46). The figure bends forward gracefully, allowing her chiton (tunic) to slip off one shoulder. Her large overlapping wings effectively balance her unstable pose. Unlike the decorative swirls of heavy fabric covering the Parthenon goddesses, or the weighty, pleated robes of the Erechtheion caryatids, the textile covering this Nike appears delicate and light, clinging to her body like wet silk, one of the most discreetly erotic images in ancient art.

THE ATHENIAN AGORA

In Athens, as in most cities of ancient Greece, commercial, civic, and social life revolved around the marketplace, or agora. The Athenian Agora, at the foot of the Akropolis, began as an open space where farmers and artisans displayed their wares. Over time, public and private structures were erected on both sides of the Panathenaic Way, a ceremonial road used during an important festival in honor of Athena (FIG. 5-47). A stone drainage system was installed to prevent flooding, and a large fountain house was built to provide water for surrounding homes, administrative buildings, and shops (see "Women at a Fountain House," page 139). By 400 BCE, the Agora contained several religious and administrative structures and even a small racetrack. The Agora also had the city mint, its military headquarters, and two buildings devoted to court business.

In design, the stoa, a distinctively Greek structure found nearly everywhere people gathered, ranged from a simple roof held up by columns to a substantial, sometimes architecturally impressive, building with two stories and shops along one side.

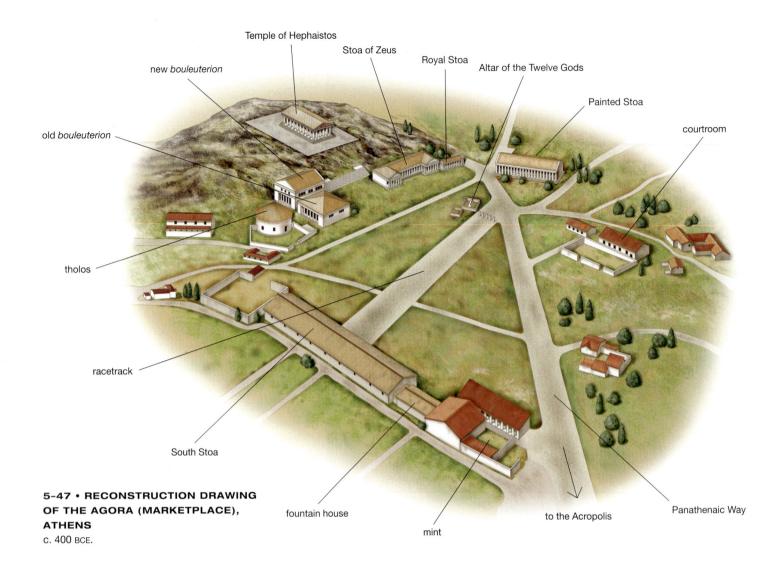

Stoas offered protection from the sun and rain, and provided a place for strolling and talking business, politics, or philosophy. While city business could be, and often was, conducted in the stoas, agora districts also came to include buildings with specific administrative functions.

In the Athenian Agora, the 500-member *boule*, or council, met in a building called the *bouleuterion*. This structure, built before 450 BCE but probably after the Persian destruction of Athens in 480 BCE, has a simple rectangular plan with a vestibule and large meeting room. Near the end of the fifth century BCE, a new *bouleuterion* was constructed to the west of the old one. This too had a rectangular plan. The interior, however, may have had permanent tiered seating arranged in an ascending semicircle around a ground-level **podium**, or raised platform.

Nearby was a small, round building with six columns supporting a conical roof, a type of structure known as a tholos. Built about 465 BCE, this tholos was the meeting place of the 50-member executive committee of the boule. The committee members dined there at the city's expense, and a few of them always spent the night there in order to be available for any pressing business that might arise. Private houses surrounded the Agora. Compared with the often grand public buildings, houses of the fifth century BCE in Athens were rarely more than simple rectangular structures of stucco-faced mud brick with wooden posts and lintels supporting roofs of terra-cotta tiles. Rooms were small and included a day-room in which women could sew, weave, and do other chores, a dining room with couches for reclining around a table, a kitchen, bedrooms, and occasionally an indoor bathroom. Where space was not at a premium, houses sometimes opened onto small courtyards or porches.

CITY PLANS

In older Greek cities such as Athens, buildings and streets developed in conformance to the needs of their inhabitants and the requirements of the terrain. As early as the eighth century BCE, however, builders in some western Greek settlements began to use a mathematical concept of urban development based on the **orthogonal** (or grid) plan. New cities or rebuilt sections of old cities were laid out on straight, evenly spaced parallel streets that intersected at right angles to create rectangular blocks. These blocks were then subdivided into identical building plots.

ART AND ITS CONTEXTS | Women at a Fountain House

Since most women in ancient Greece were confined to their homes, their daily trip to the communal well or fountain house in the agora was an important event. The Archaic ceramic artist known as the Priam Painter has recorded a vignette from this aspect of Greek city life on a black-figure **hydria** (water jug) (**FIG. 5–48**). In the shade of a Doriccolumned porch, three women fill hydriae just like the one on which they are painted. A fourth balances her empty jug on her head as she waits, while a fifth woman, without a jug, seems to be waving a greeting to someone. The building is designed like a stoa, open on one side, but having animal-head spigots on three walls. The Doric columns support a Doric entablature with an architrave above the colonnade and a colorful frieze—here black-and-white blocks replace carved metopes.

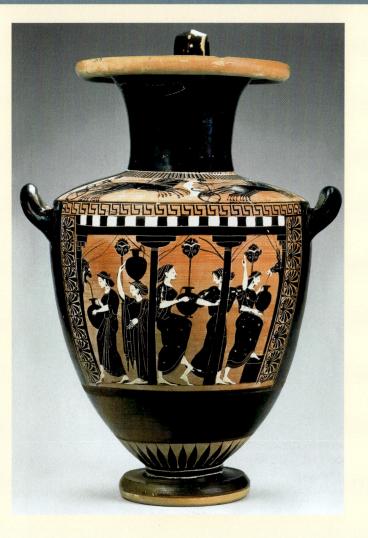

5-48 • Priam Painter **WOMEN AT A FOUNTAIN HOUSE** 520–510 BCE. Black-figure decoration on a hydria. Ceramic, height of hydria 20⁷/₈" (53 cm). Museum of Fine Arts, Boston. William Francis Warden Fund. (61.195)

During the Classical period, Hippodamos of Miletos, a major urban planner of the fifth century BCE, held views on the reasoned perfectibility of urban design akin to those of the Athenian philosophers (such as Socrates) and artists (such as Polykleitos). He believed the ideal city should be limited to 10,000 citizens divided into three classes—artists, farmers, and soldiers—and three zones sacred, public, and private. The basic Hippodamian plot was a square 600 feet on each side, divided into quarters. Each quarter was subdivided into six rectangular building plots measuring 100 by 150 feet, a scheme still widely used in American and European cities and suburbs.

STELE SCULPTURE

Upright stone slabs called stelai (singular, stele) were used in Greek cemeteries as gravestones, carved in low relief with an image (actual or allegorical) of the person(s) to be remembered. Instead of the proud warriors or athletes used in the Archaic period, however, Classical stelae place figures in personal or domestic contexts that often feature women and children. A touching mid-fifthcentury BCE example found on the island of Paros portrays a young girl, seemingly bidding farewell to her pet birds, one of which she kisses on the beak (**FIG. 5-49**). She wears a loose peplos, which parts at the side to disclose the tender flesh underneath and clings elsewhere over her body to reveal its three-dimensional form. The extraordinary carving recalls the contemporary reliefs of the Parthenon frieze, and like them, this stele would have been painted with color to provide details such as the straps of the girl's sandals or the feathers on her beloved birds.

Another, somewhat later, stele commemorates the relationship between a couple, identified by name across an upper frieze resting on two Doric pilasters (**FIG. 5-50**). The husband Ktesilaos stands casually with crossed legs and joined hands, gazing at his wife Theano, who sits before him on a bench, pulling at her gauzy wrap with her right hand in a gesture that is often associated with Greek brides. Presumably this was a tombstone for a joint grave, since both names are inscribed on it, but we do not know which of the two might have died first, leaving behind a mate to mourn and memorialize by commissioning this stele. The air of introspective melancholy here, as well as the softness and delicacy of both flesh and fabric, seem to point forward out of the High Classical period and into the increased sense of narrative and delicacy that was to characterize the fourth century BCE.

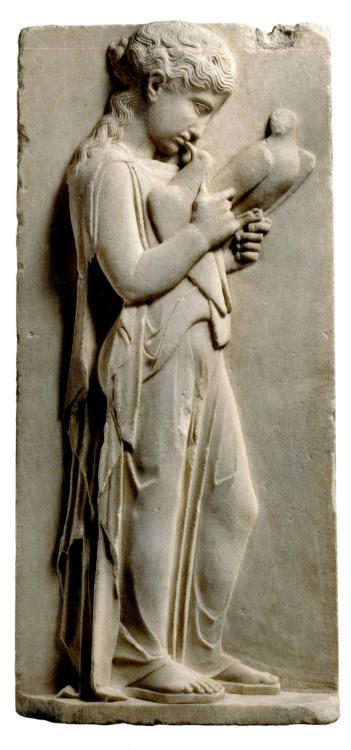

5-49 • GRAVE STELE OF A LITTLE GIRL c. 450–440 BCE. Marble, height 31¹/₂" (80 cm). Metropolitan Museum of Art, New York.

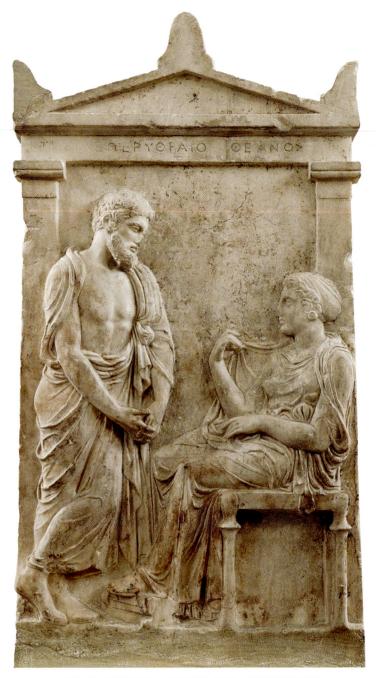

5-50 • GRAVE STELE OF KTESILAOS AND THEANO c. 400 BCE. Marble, height 365%" (93 cm). National Archaeological Museum, Athens.

PAINTING

The Painted Stoa built on the north side of the Athenian Agora (see FIG. 5-47) about 460 BCE is known to have been decorated with paintings (hence its name) by the most famous artists of the time, including Polygnotos of Thasos (active c. 475–450 BCE). His contemporaries praised his talent for creating the illusion of spatial recession in landscapes, rendering female figures clothed in transparent draperies, and conveying through facial expressions the full range of human emotions. Ancient writers described his painting, as well as other famous works, enthusiastically, but nothing survives for us to see.

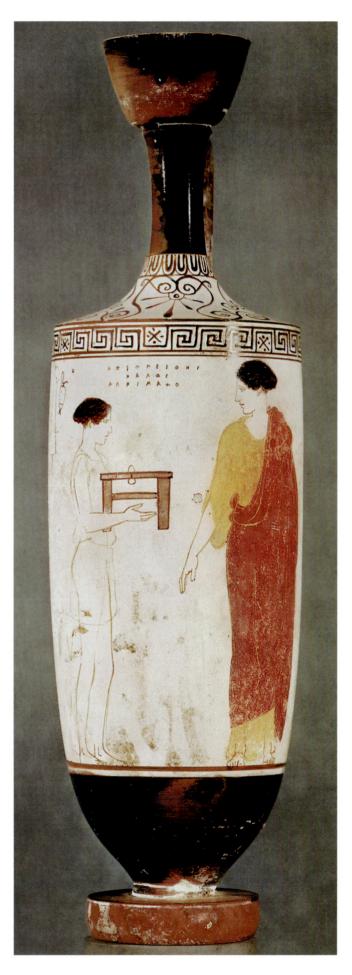

5–51 • Style of the Achilles Painter **WOMAN AND MAID** c. 450–440 BCE. White-ground lekythos. Ceramic, with additional painting in tempera, height 15¹/₈" (38.4 cm). Museum of Fine Arts, Boston. Francis Bartlett Donation of 1912. (13.201)

White-ground ceramic painting, however, may echo the style of lost contemporary wall and panel painting. In this technique, painters first applied refined white slip as the ground on which they painted designs with liquid slip. High Classical whiteground painting became a specialty of Athenian potters. Artists enhanced the fired vessel with a full range of colors using paints made by mixing tints with white clay, and also using **tempera**, an opaque, water-based medium mixed with glue or egg white. This fragile decoration deteriorated easily, and for that reason seems to have been favored for funerary, votive, and other nonutilitarian vessels.

Tall, slender, one-handled white-ground **lekythoi** were used to pour libations during religious rituals. Some convey grief and loss, with scenes of departing figures bidding farewell. Others depict grave stelai draped with garlands. Still others envision the deceased returned to the prime of life and engaged in a seemingly everyday activity. A white-ground lekythos, dated about 450–440 BCE, shows a young servant girl carrying a stool for a small chest of valuables to a well-dressed woman of regal bearing, the dead person whom the vessel memorializes (**FIG. 5–51**). As on the stele of Ktesilaos and Theano (see **FIG. 5–50**), the scene portrayed here contains no overt signs of grief, but a quiet sadness pervades it. The two figures seem to inhabit different worlds, their glances somehow failing to meet.

THE LATE CLASSICAL PERIOD, c. 400–323 BCE

After the Spartans defeated Athens in 404 BCE, they set up a pro-Spartan government so oppressive that within a year the Athenians rebelled against it, killed its leader, Kritias, and restored democracy. Athens recovered its independence and its economy revived, but it never regained its dominant political and military status. It did, however, retain its reputation as a center of artistic and intellectual life. In 387 BCE, the great philosopher-teacher Plato founded a school just outside Athens, as his student Aristotle did later. Among Aristotle's students was young Alexander of Macedon, known to history as Alexander the Great.

In 359 BCE, a crafty and energetic warrior, Philip II, had come to the throne of Macedon. In 338, he defeated Athens and rapidly conquered the other Greek cities. When he was assassinated two years later, his kingdom passed to his 20-year-old son, Alexander, who consolidated his power and led a united Greece in a war of revenge and conquest against the Persians. In 334 BCE, he crushed the Persian army and conquered Syria and Phoenicia. By 331, he had occupied Egypt and founded the seaport he named Alexandria. The Egyptian priests of Amun recognized him as the son

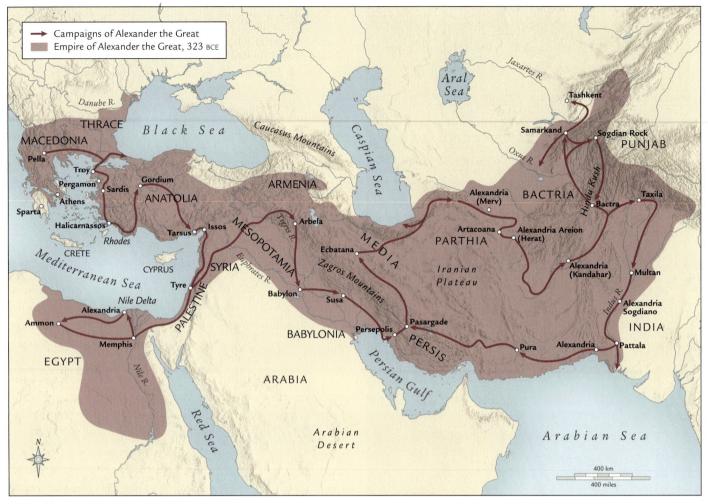

MAP 5-2 • HELLENISTIC GREECE

Alexander the Great created a Greek empire that extended from the Greek mainland and Egypt across Asia Minor and as far east as India.

of a god, an idea he readily adopted. That same year, he reached the Persian capital of Persepolis and continued east until reaching present-day Pakistan in 326 BCE; his troops then refused to go any farther (MAP 5-2). On the way home in 323 BCE, Alexander died of a fever. He was only 33 years old.

Changing political conditions never seriously dampened the Greeks' artistic creativity. Indeed, artists experimented widely with new subjects and styles. Although they maintained a Classical approach to composition and form, they relaxed its conventions, supported by a sophisticated new group of patrons drawn from the courts of Philip and Alexander, wealthy aristocrats in Asia Minor, and foreign aristocrats eager to import Greek works and, sometimes, Greek artists.

SCULPTURE

Throughout the fifth century BCE, sculptors had accepted and worked within standards for the ideal proportions and forms of the human figure, as established by Pheidias and Polykleitos at mid century. But fourth-century BCE artists began to challenge and modify those standards. On mainland Greece, in particular, a new canon of proportions associated with the sculptor Lysippos emerged for male figures—now eight or more "heads" tall rather than the six-and-a-half or seven-head height of earlier works. The calm, noble detachment characteristic of High Classical figures gave way to more sensitively rendered expressions of wistful introspection, dreaminess, even fleeting anxiety or lightheartedness.

PRAXITELES According to the Greek traveler Pausanias, writing in the second century CE, the Late Classical sculptor Praxiteles (active in Athens from about 370 to 335 BCE or later) carved a "Hermes of stone who carries the infant Dionysos" for the Temple of Hera at Olympia. In 1875, just such a statue depicting the messenger god Hermes teasing the baby Dionysos with a bunch of grapes was discovered in the ruins of this temple (**FIG. 5-52**). Initially accepted as an original work of Praxiteles because of its high quality, recent studies hold that it is probably an excellent Roman or Hellenistic copy.

The sculpture highlights the differences between the fourth- and fifth-century BCE Classical styles. Hermes has a smaller head and a more sensual and sinuous body than Polykleitos' *Spear*

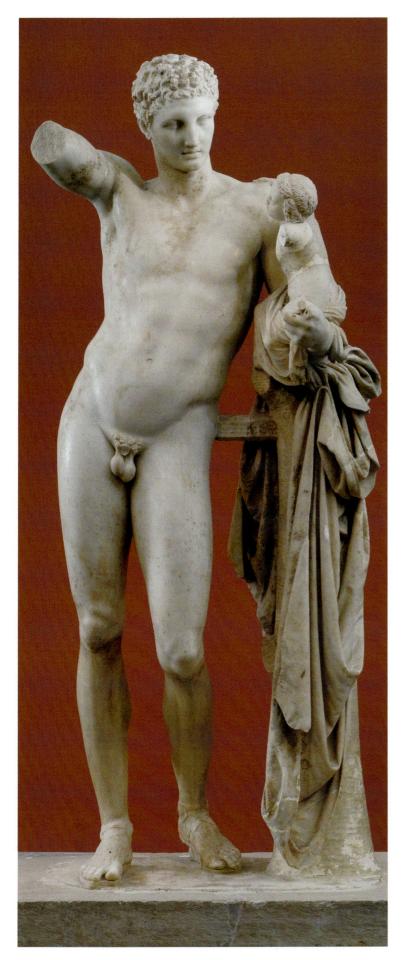

Bearer (see "'The Canon' of Polykleitos," page 134). His offbalance, S-curving pose, requires him to lean on a post a clear contrast with the balanced posture of Polykleitos' work. Praxiteles also created a sensuous play of contrasting textures over the figure's surface, juxtaposing the gleam of smooth flesh with crumpled draperies and rough locks of hair. Praxiteles humanizes his subject with a hint of narrative—two gods, one a loving adult and the other a playful child, caught in a moment of absorbed companionship.

Around 350 BCE, Praxiteles created a daring statue of Aphrodite for the city of Knidos in Asia Minor. Although artists of the fifth century BCE had begun to hint boldly at the naked female body beneath tissue-thin drapery as in the panel showing a Nike adjusting her sandal (see FIG. 5-46) this Aphrodite was apparently the first statue by a well-known Greek sculptor to depict a fully nude woman, and it set a new standard (FIG. 5-53). Although nudity among athletic young men was admired in Greek society, nudity among women was seen as a sign of low character. The acceptance of nudity in statues of Aphrodite may be related to the gradual merging of the Greeks' concept of this goddess with some of the characteristics of the Phoenician goddess Astarte (the Babylonian Ishtar), who was nearly always shown nude in Near Eastern art.

In the version of Praxiteles' statue seen here (actually a composite of two Roman copies), the goddess is preparing to take a bath, with a water jug and her discarded clothing at her side. Her hand is caught in a gesture of modesty that only calls attention to her nudity. Her strong and well-toned body leans forward slightly, with one projecting knee in a seductive pose that emphasizes the swelling forms of her thighs and abdomen. According to an old legend, the sculpture was so realistic that Aphrodite herself journeyed to Knidos to see it and cried out in shock, "Where did Praxiteles see me naked?" The Knidians were so proud of their Aphrodite that they placed it in an open shrine where people could view it from every side. Hellenistic and Roman copies probably numbered in the hundreds, and nearly 50 survive in various collections today.

5-52 • Praxiteles or his followers HERMES AND THE INFANT DIONYSOS

Probably a Hellenistic or Roman copy after a Late Classical 4th– century BCE original. Marble, with remnants of red paint on the lips and hair, height 7'1" (2.15 m). Archaeological Museum, Olympia.

Discovered in the rubble of the ruined Temple of Hera at Olympia in 1875, this statue is now widely accepted as an outstanding Roman or Hellenistic copy. Support for this conclusion comes from certain elements typical of Roman sculpture: Hermes' sandals, which recent studies suggest are not accurate for a fourth-century BCE date; the supporting element of crumpled fabric covering a tree stump; and the use of a reinforcing strut, or brace, between Hermes' hip and the tree stump.

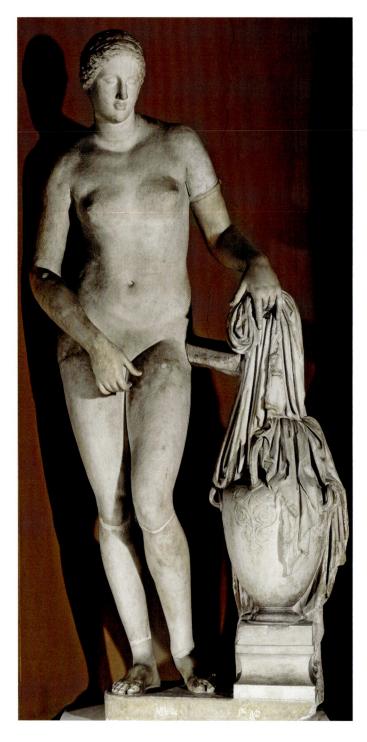

5-53 • Praxiteles APHRODITE OF KNIDOS

Composite of two similar Roman copies after the original marble of c. 350 BCE. Marble, height 6'8" (2.04 m). Vatican Museums, Museo Pio Clementino, Gabinetto delle Maschere, Rome.

The head of this figure is from one Roman copy, the body from another. Seventeenth- and eighteenth-century CE restorers added the nose, the neck, the right forearm and hand, most of the left arm, and the feet and parts of the legs. This kind of restoration would rarely be undertaken today, but it was frequently done and considered quite acceptable in the past, when archaeologists were trying to put together a body of work documenting the appearance of lost Greek statues.

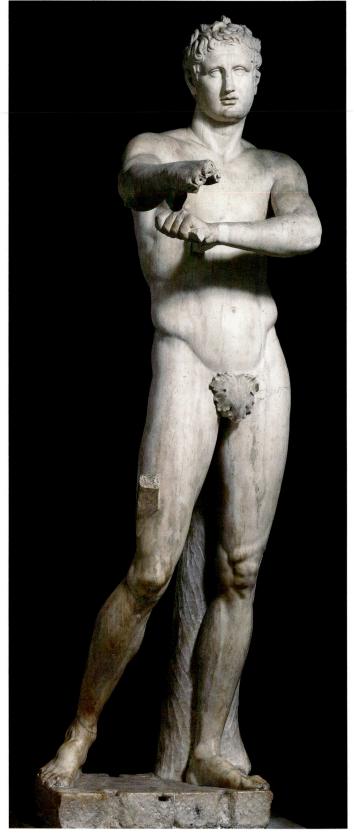

5-54 • Lysippos MAN SCRAPING HIMSELF (APOXYOMENOS)

Roman copy after the original bronze of c. 350–325 BCE. Marble, height 6'9" (2.06 m). Vatican Museums, Museo Pio Clementino, Gabinetto dell'Apoxyomenos, Rome.

LYSIPPOS Compared to Praxiteles, more details of Lysippos' life are known, and, although none of his original works has survived, there are many copies of the sculpture he produced between c. 350 and 310 BCE. He claimed to be entirely self-taught and asserted that "nature" was his only model, but he must have received some technical training in the vicinity of his home, near Corinth. He expressed great admiration for Polykleitos, but his own figures reflect a different ideal and different proportions. For his famous portrayal of a MAN SCRAPING HIMSELF (APOXYOMENOS), known today only from Roman copies (FIG. 5-54), he chose a typical Classical subject-a nude male athlete. But instead of a figure actively engaged in his sport, striding, or standing at ease, Lysippos depicted a young man after his workout, methodically removing oil and dirt from his body with a scraping tool called a strigil.

This tall and slender figure with a relatively small head, makes a telling comparison with Polykleitos' *Spear Bearer* (see "The Canon' of Polykleitos," page 134). Not only does it reflect a different canon of proportions, but the legs are in a wider stance to counterbalance the outstretched arms, and there is a pronounced curve to the posture. The *Spear Bearer* is contained within fairly simple, compact contours and oriented toward a center-front viewer. In contrast, the arms of the *Man Scraping Himself* break free into the surrounding space, inviting the viewer to move around the statue to absorb its full aspect. Roman authors, who may have been describing the bronze original rather than a marble copy, remarked on the subtle modeling

When Lysippos was summoned to create a portrait of Alexander the Great, he portrayed Alexander as a full-length standing figure with an upraised arm holding a scepter, the same way he posed Zeus. Based on description and later copies, we know Lysippos idealized the ruler as a ruggedly handsome, heavy-featured young man with a large Adam's apple and short, tousled hair. According to the Roman historian Plutarch, Lysippos presented Alexander in a meditative pose, perhaps contemplating grave decisions, waiting to receive divine advice.

of the statue's elongated body and the spatial extension of its pose.

THE ART OF THE GOLDSMITH

The detailed, small-scale work of Greek goldsmiths followed the same stylistic trends and achieved the same high standards of technique and execution characterizing other arts. A specialty of Greek goldsmiths was the design of earrings in the form of tiny works of sculpture. They were often placed on the ears of marble statues of goddesses, but they adorned the ears of living women as well. **EARRINGS** dated about 330–300 BCE depict the abducted youth Ganymede caught in the grasp of an eagle (Zeus) (**FIG. 5–55**), a technical *tour-de-force*. Slightly more than 2 inches high, they were hollow-cast using the lost-wax process, no doubt to make them light on the ear. Despite their small size, they capture the drama of their subject, evoking swift movement through space.

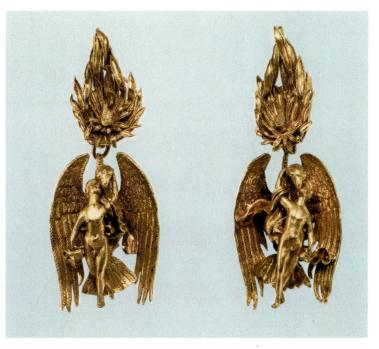

5-55 • EARRINGS c. 330–300 BCE. Hollow-cast gold, height 2³/₈" (6 cm). Metropolitan Museum of Art, New York. Harris Brisbane Dick Fund, 1937. (37.11.9–10)

PAINTING AND MOSAICS

Roman observers such as Pliny the Elder praised Greek painters for their skill in capturing the appearance of the real world. Roman patrons also admired Greek murals, and they commissioned copies, in fresco or **mosaic**, to decorate their homes. (Mosaics—created from **tesserae**, small cubes of colored stone or marble—provide a permanent waterproof surface that the Romans used for floors in important rooms.) A first-century CE Roman mosaic, **ALEXAN-DER THE GREAT CONFRONTS DARIUS III AT THE BATTLE OF ISSOS (FIG. 5–56)**, for example, replicates a Greek painting of about 310 BCE. Pliny the Elder mentions a painting of this subject by Philoxenos of Eretria, but a new theory claims the original as a work of Helen of Egypt.

Such copies document a growing taste for dramatic narrative subjects in late fourth-century BCE Greek painting. Certainly the scene here is one of violent action, where diagonal disruption and radical foreshortening draw the viewer in and elicit an emotional response. Astride a rearing horse at the left, his hair blowing free and his neck bare, Alexander challenges the helmeted and armored Persian leader, who stretches out his arm in a gesture of defeat and apprehension as his charioteer whisks him back toward safety within the Persian ranks. The mosaicist has created an illusion of solid figures through modeling, mimicking the play of light on three-dimensional surfaces by highlights and shading.

The interest of fourth-century BCE artists in creating believable illusions of the real world was the subject of anecdotes repeated by later writers. One popular legend involved a floral designer named Glykera—widely praised for her artistry in weaving blossoms and greenery into wreaths, swags, and garlands for religious processions

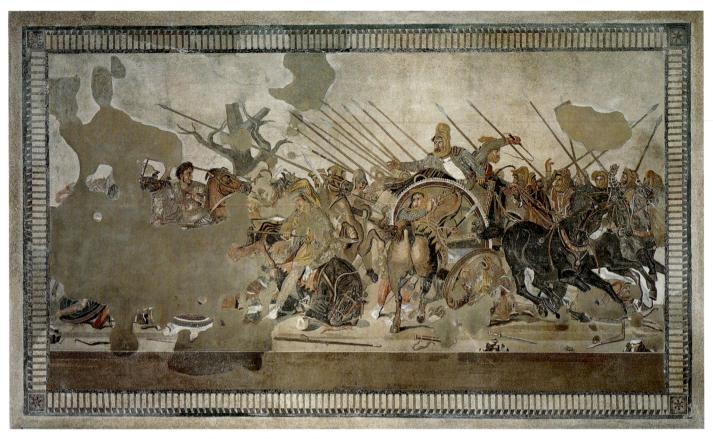

5-56 • ALEXANDER THE GREAT CONFRONTS DARIUS III AT THE BATTLE OF ISSOS

Floor mosaic, Pompeii, Italy. 1st-century BCE Roman copy of a Greek wall painting of c. 310 BCE, perhaps by Philoxenos of Eretria or Helen of Egypt. Entire panel 8'10" \times 17' (2.7 \times 5.2 m). Museo Archeologico Nazionale, Naples.

and festivals—and Pausias—the foremost painter of his day. Pausias challenged Glykera to a contest, claiming that he could paint a picture of one of her complex works that would appear as lifelike to the spectator as her real one. According to the legend, he succeeded. It is not surprising, although perhaps unfair, that the opulent floral borders so popular in later Greek painting and mosaics are described as "Pausian" rather than "Glykeran."

A Pausian design frames a mosaic floor from a palace at Pella (Macedonia), dated about 300 BCE (FIG. 5-57). The floor features a series of hunting scenes, such as the *Stag Hunt* seen here, prominently signed by an artist named Gnosis. The blossoms, leaves, spiraling tendrils, and twisting, undulating stems that frame this scene, echo the linear patterns formed by the

5-57 • Gnosis STAG HUNT

Detail of mosaic floor decoration from Pella, Macedonia (in presentday Greece). 300 BCE. Pebbles, central panel $10'7'_{2''} \times 10'5''$ (3.24 \times 3.17 m). Signed at top: "Gnosis made it." Archaeological Museum, Pella.

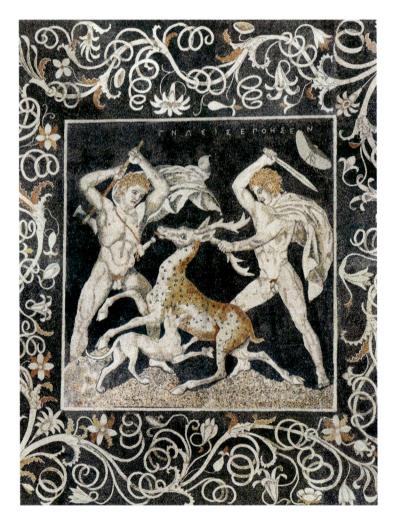

hunters, the dog, and the struggling stag. The human and animal figures are modeled in light and shade, and the dog's front legs are expertly foreshortened to create the illusion that the animal is turning at a sharp angle into the picture. The work is all the more impressive because it was not made with uniformly cut marble in different colors, but with a carefully selected assortment of natural pebbles.

THE HELLENISTIC PERIOD, 323–31/30 BCE

When Alexander died unexpectedly at age 33 in 323 BCE, he left a vast empire with no administrative structure and no accepted successor. Almost immediately his generals turned against one another, local leaders fought to regain their lost autonomy, and the empire began to break apart. By the early third century BCE, three of Alexander's generals—Antigonus, Ptolemy, and Seleucus—had carved out kingdoms. The Antigonids controlled Macedonia and mainland Greece; the Ptolemies ruled Egypt; and the Seleucids controlled Asia Minor, Mesopotamia, and Persia.

Over the course of the second and first centuries BCE, these kingdoms succumbed to the growing empire centered in Rome. Ptolemaic Egypt endured the longest, and its capital Alexandria, flourished as a prosperous seaport and great center of learning and the arts. Its library is estimated to have contained 700,000 papyrus and parchment scrolls. The Battle of Actium in 31 BCE and the death in 30 BCE of Egypt's last Ptolemaic ruler, the remarkable Cleopatra, marks the end of the Hellenistic period.

Alexander's lasting legacy was the spread of Greek culture far beyond its original borders, but artists of the Hellenistic period developed visions discernibly distinct from those of their Classical Greek predecessors. Where earlier artists sought to codify a generalized artistic ideal, Hellenistic artists shifted focus to the individual and the specific. They turned increasingly away from the heroic to the everyday, from gods to mortals, from aloof serenity to individual emotion, and from decorous drama to emotional melodrama. Their works appeal to the senses through luscious or lustrous surface treatments and to our hearts as well as our intellects through expressive subjects and poses. Although such tendencies are already evident during the fourth century BCE, they become more pronounced in Hellenistic art.

THE CORINTHIAN ORDER IN HELLENISTIC ARCHITECTURE

In the architecture of the Hellenistic period, a variant of the Ionic order that had previously been reserved for interiors—called Corinthian by the Romans and featuring elaborate foliate capitals—challenged the dominant Doric and Ionic orders (see "The Greek Orders," page 110). In Corinthian capitals, curly acanthus leaves and coiled flower spikes surround a basket-shaped core. Above the capitals, the Corinthian entablature, like the Ionic, has a stepped-out architrave and a continuous frieze, but it includes additional bands of carved moldings.

The Corinthian **TEMPLE OF OLYMPIAN ZEUS**, located in the lower city of Athens at the foot of the Akropolis, was designed by the Roman architect Cossutius in the second century BCE (**FIG. 5-58**) on the foundations of an earlier Doric temple, but it was not completed until three centuries later, under the patronage of the Roman emperor Hadrian. Viewed through these huge columns—55 feet 5 inches tall—the Parthenon seems modest in comparison. But the new temple followed long-established

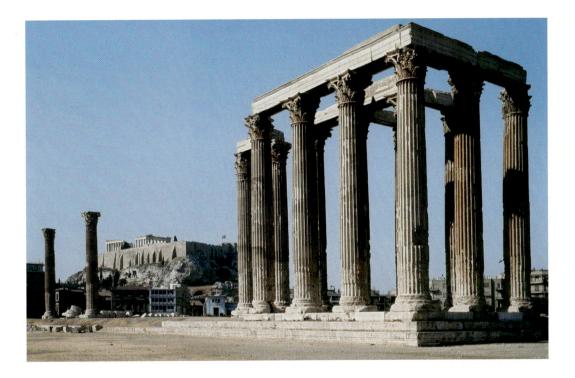

5-58 • TEMPLE OF OLYMPIAN ZEUS, ATHENS

View from the southeast with the Akropolis in the distance. Building and rebuilding phases: foundation c. 520– 510 BCE, using the Doric order; temple designed by Cossutius begun 175 BCE; left unfinished 164 BC; completed 132 CE using Cossutius' design. Height of columns 55'5" (16.89 m).

ART AND ITS CONTEXTS | Greek Theaters

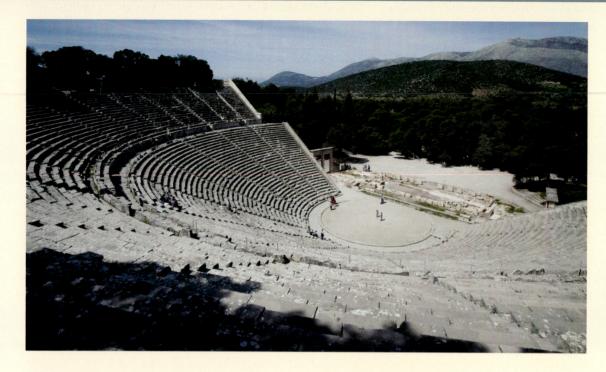

In ancient Greece, the theater was more than mere entertainment: It was a vehicle for the communal expression of religious beliefs through music, poetry, and dance. In very early times, theater performances took place on the hard-packed dirt or stone-surfaced pavement of an outdoor threshing floor-the same type of floor later incorporated into religious sanctuaries. Whenever feasible, dramas were also presented facing a steep hill that served as elevated seating for the audience. Eventually such sites were made into permanent open-air auditoriums. At first, tiers of seats were simply cut into the side of the hill. Later, builders improved them with stone.

During the fifth century BCE, the plays were usually tragedies in verse based on popular myths, and were performed at festivals dedicated to Dionysos; the three great Greek tragedians-Aeschylus, Sophocles, and Euripides-created works that would define tragedy for centuries. Because they were used continuously and frequently modified over many centuries, early theaters have not survived in their original form.

The theater at Epidauros (FIG. 5-59), built in the second half of the fourth century BCE, is characteristic. A semicircle of tiered seats built into the hillside overlooked the circular performance area, called the orchestra, at the center of which was an altar to Dionysos. Rising behind the orchestra was a two-tiered stage structure made up of the vertical skene (scene)-an architectural backdrop for performances that also screened the backstage area from view-and the proskenion (proscenium), a raised platform in front of the skene that was

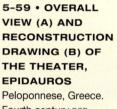

Fourth century BCE and later.

gangway

increasingly used over time as an extension of the orchestra. Ramps connecting the proskenion with lateral passageways provided access for performers. Steps gave the audience access to the 55 rows of seats and divided the seating area into uniform wedge-shaped sections. The tiers of seats above the wide corridor, or gangway, were added at a much later date. This design provided uninterrupted sight lines and good acoustics, and allowed for the efficient entrance and exit of the 12,000 spectators. No better design has ever been created.

conventions. It was an enclosed rectangular building surrounded by a screen of columns standing on a three-stepped base. It is, quite simply, a Greek temple grown very large.

SCULPTURE

Hellenistic sculptors produced an enormous variety of work in a wide range of materials, techniques, and styles. The period was marked by two broad and conflicting trends. One trend emulated earlier Classical models; sculptors selected aspects of favored works of the fourth century BCE and incorporated them into their own work. The other (sometimes called anti-Classical or Baroque) abandoned Classical strictures and experimented freely with new forms and subjects. This style was especially strong in Pergamon and other eastern centers of Greek culture.

PERGAMON Pergamon—capital of a breakaway state within the Seleucid realm established in the early third century BCE—quickly became a leading center of the arts and the hub of an experimental sculptural style that had far-reaching influence throughout the Hellenistic period. This radical style characterizes a monument com-

memorating the victory in 230 BCE of Attalos I (ruled 241–197 BCE) over the Gauls, a Celtic people (see "The Celts," page 150). The monument extols the dignity and heroism of the defeated enemies and, by extension, the power and virtue of the Pergamenes.

The bronze figures of Gauls mounted on the pedestal of this monument are known today only from Roman copies in marble. One captures the slow demise of a wounded Celtic soldiertrumpeter (**FIG. 5-60**), whose lime-spiked hair, mustache, and twisted neck ring or **torc** (reputedly the only thing the Gauls wore into battle) identify him as a **barbarian** (a label the ancient Greeks used for all foreigners, whom they considered uncivilized). But the sculpture also depicts his dignity and heroism in defeat, inspiring in viewers both admiration and pity for this fallen warrior. Fatally injured, he struggles to rise, but the slight bowing of his supporting right arm and his unseeing, downcast gaze indicate that he is on the point of death. This kind of deliberate attempt to elicit a specific emotional response in the viewer is known as **expressionism**, and it was to become a characteristic of Hellenistic art.

The sculptural style and approach seen in the monument to the defeated Gauls became more pronounced and dramatic in later

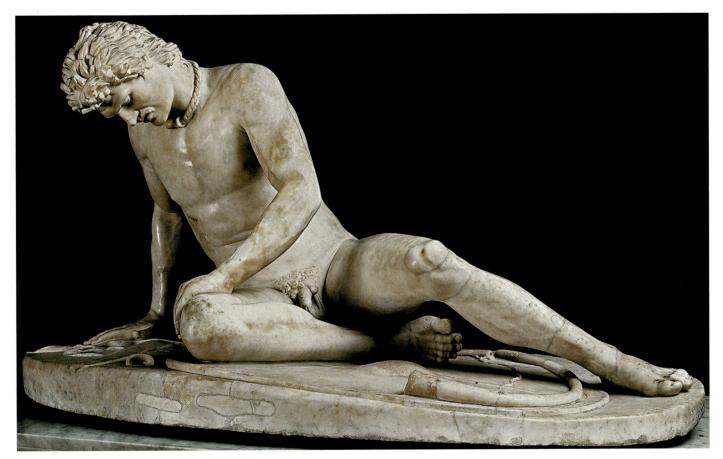

5-60 • EPIGONOS (?) DYING GALLIC TRUMPETER

Roman copy (found in Julius Caesar's garden in Rome) after the original bronze of c. 220 BCE. Marble, height 361/2" (93 cm). Museo Capitolino, Rome.

Pliny the Elder described a work like the *Dying Gallic Trumpeter*, attributing it to an artist named Epigonos. Recent research indicates that Epigonos probably knew the early fifth-century BCE sculpture of the Temple of Aphaia on Aegina, which included the *Dying Warriors* (see FIGS. 5–14, 5–15), and could have had it in mind when he created his own works.

ART AND ITS CONTEXTS | The Celts

During the first millennium BCE, Celtic peoples inhabited most of central and western Europe. The Celtic Gauls portrayed in the Hellenistic Pergamene victory monument (see FIG. 5–60) moved into Asia Minor from Thrace during the third century BCE. The ancient Greeks referred to these neighbors, like all outsiders, as barbarians. Pushed out by migrating people, attacked and defeated by challenged kingdoms like that at Pergamon, and then by the Roman armies of Julius Caesar, the Celts were pushed into the northwesternmost parts of the continent— Ireland, Cornwall, and Brittany. Their wooden sculpture and dwellings and their colorful woven textiles have disintegrated, but spectacular funerary goods such as jewelry, weapons, and tableware survive.

This golden **TORC**, dating sometime between the third and first centuries BCE (**FIG. 5–61**), was excavated in 1866 from a Celtic tomb in

northern France, but it is strikingly similar to the neck ring worn by the dying trumpeter illustrated in FIGURE 5–60. Torcs were worn by noblemen and were sometimes awarded to warriors for heroic performance in combat. Like all Celtic jewelry, the decorative design of this work consists not of natural forms but of completely abstract ornament, in this case created by the careful twisting and wrapping of strands of pure gold, resolved securely by the definitive bulges of two knobs. In Celtic hands, pattern becomes an integral part of the object itself, not an applied decoration. In stark contrast to the culture of the ancient Greeks, where the human figure was at the heart of all artistic development, here it is abstract, nonrepresentational form and its continual refinement that is the central artistic preoccupation.

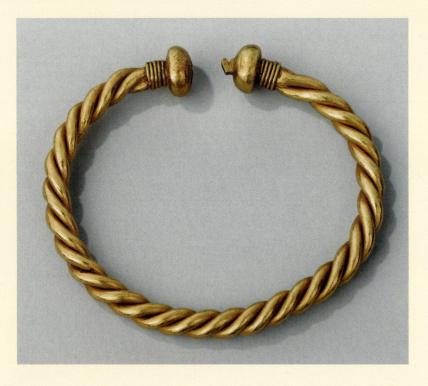

5–61 • TORC Found at Soucy, France. Celtic Gaul, 3rd–1st century BCE. Gold, height $5'' \times \text{length } 5\%''$ (12.7 × 14.5 cm). Musée Nationale du Moyen-Âge, Paris.

works, culminating in the sculptured frieze wrapped around the base of a Great Altar on a mountainside at Pergamon (**FIG. 5-62**). Now reconstructed inside a Berlin museum, the original altar was enclosed within a single-story Ionic colonnade raised on a high podium reached by a monumental staircase 68 feet wide and nearly 30 feet deep. The sculptural frieze, over 7 feet in height, probably executed during the reign of Eumenes II (197–159 BCE), depicts the battle between the gods and the giants, a mythical struggle that the Greeks saw as a metaphor for their conflicts with outsiders, all of whom they labeled barbarians. In this case it evokes the Pergamenes' victory over the Gauls.

The Greek gods fight here not only with giants, but also with monsters with snakes for legs emerging from the bowels of the earth. In this detail (**FIG. 5-63**), the goddess Athena at the left has grabbed the hair of a winged male monster and forced him to his knees. Inscriptions along the base of the sculpture identify him as Alkyoneos, a son of the earth goddess Ge. Ge rises from the ground on the right in fear as she reaches toward Athena, pleading for her son's life. At the far right, a winged Nike rushes to crown Athena with a victor's wreath.

The figures in the Pergamon frieze not only fill the space along the base of the altar, they also break out of their architectural boundaries and invade the spectators' space, crawling out onto the steps that visitors climbed on their way to the altar. Many consider this theatrical and complex interaction of space and form to be a benchmark of the Hellenistic style, just as they consider the balanced restraint of the Parthenon sculpture to be the epitome of the High Classical style. Where fifth-century BCE artists sought

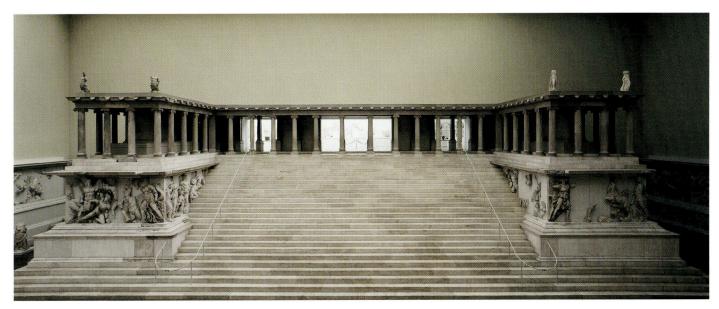

5-62 • RECONSTRUCTED WEST FRONT OF THE ALTAR FROM PERGAMON (IN MODERN TURKEY)

c. 175–150 BCE. Marble, height of figure 7'7" (2.3 m). Staatliche Museen, Berlin.

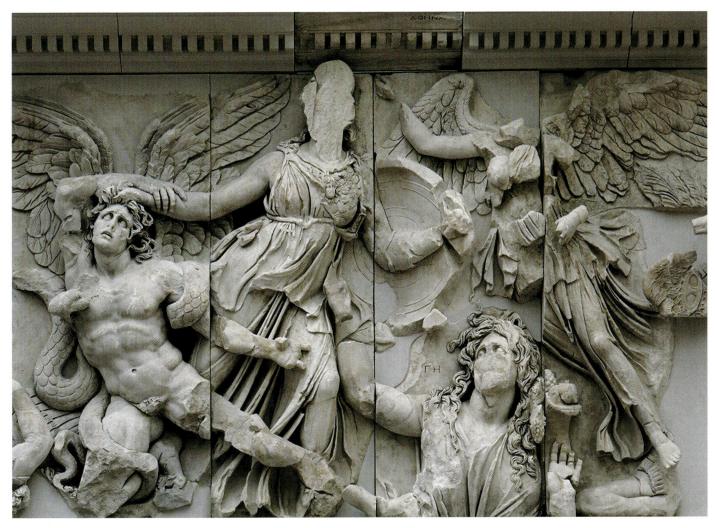

5-63 • ATHENA ATTACKING THE GIANTS Detail of the frieze from the east front of the altar from Pergamon. c. 175–150 BCE. Marble, frieze height 7'7" (2.3 m). Staatliche Museen, Berlin. horizontal and vertical equilibrium and control, the Pergamene artists sought to balance opposing forces in three-dimensional space along dynamic diagonals. Classical preference for smooth, evenly illuminated surfaces has been replaced by dramatic contrasts of light and shade playing over complex forms carved with deeply undercut high relief. The composure and stability admired in the Classical style have given way to extreme expressions of pain, stress, wild anger, fear, and despair. Whereas the Classical artist asked only for an intellectual commitment, the Hellenistic artist demanded that the viewer also empathize.

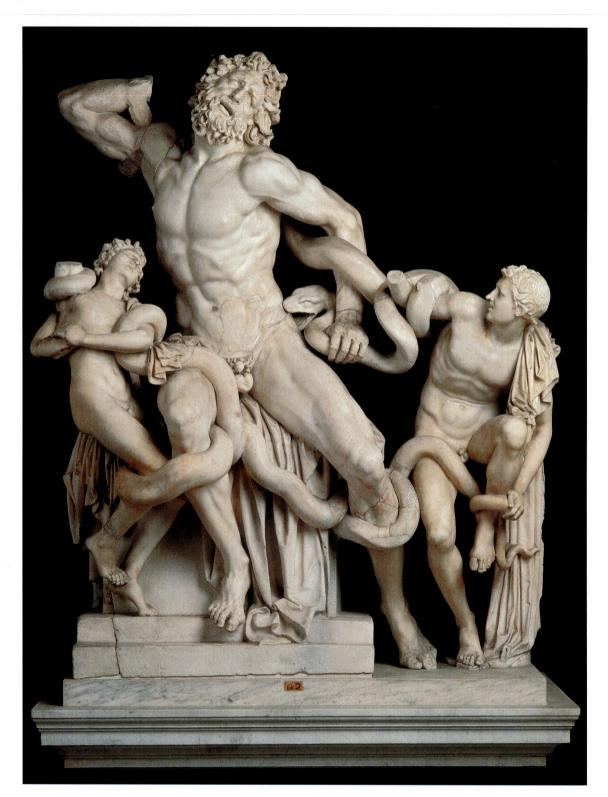

5-64 • Hagesandros, Polydoros, and Athenodoros of Rhodes LAOCOÖN AND HIS SONS Original of 1st century BCE, or a Roman copy, adaptation, or original of the 1st century CE. Marble, height 8' (2.44 m). Musei Vaticani, Museo Pio Clementino, Cortile Ottagono, Rome.

THE LAOCOÖN Pergamene artists may have inspired the work of Hagesandros, Polydoros, and Athenodoros, three sculptors on the island of Rhodes named by Pliny the Elder as the creators of the famed **LAOCOÖN AND HIS SONS** (**FIG. 5-64**). This work has been assumed by many art historians to be a Hellenistic original from the first century BCE, although others argue that it is a brilliant copy, a creative adaptation, or a Hellenistic-style invention, commissioned by an admiring Roman patron in the first century CE.

This complex sculptural composition illustrates an episode from the Trojan War when the priest Laocoön warned the Trojans not to bring within their walls the giant wooden horse left behind by the Greeks. The gods who supported the Greeks retaliated by sending serpents from the sea to destroy Laocoön and his sons as they walked along the shore. The struggling figures, anguished faces, intricate diagonal movements, and skillful unification of diverse forces in a complex composition all suggest a strong relationship between Rhodian and Pergamene sculptors. Although sculpted in the round, the Laocoön was composed to be seen frontally and from close range, and the three figures resemble the relief sculpture on the altar from Pergamon.

THE NIKE OF SAMOTHRACE This winged figure of Victory (**FIG. 5-65**) is even more theatrical than the Laocoön. In its original setting—in a hillside niche high above the theater in the Sanctuary of the Great Gods at Samothrace, perhaps drenched with spray from a fountain—this huge goddess must have reminded visitors of the god in Greek plays who descends from heaven to determine the outcome of the drama. The forward momentum of the

5-65 • NIKE (VICTORY) OF SAMOTHRACE Sanctuary of the Great Gods, Samothrace. c. 180 BCE (?). Marble, height 8'1" (2.45 m). Musée du Louvre, Paris.

The wind-whipped costume and raised wings of this Nike indicate that she has just alighted on the prow of the stone ship that formed the original base of the statue. The work probably commemorated an important naval victory, perhaps the Rhodian triumph over the Seleucid king Antiochus III in 190 BCE. The Nike (lacking its head and arms) and a fragment of its stone ship base were discovered in the ruins of the Sanctuary of the Great Gods by a French explorer in 1863 (additional fragments were discovered later). Soon after, the sculpture entered the collection of the Louvre Museum in Paris.

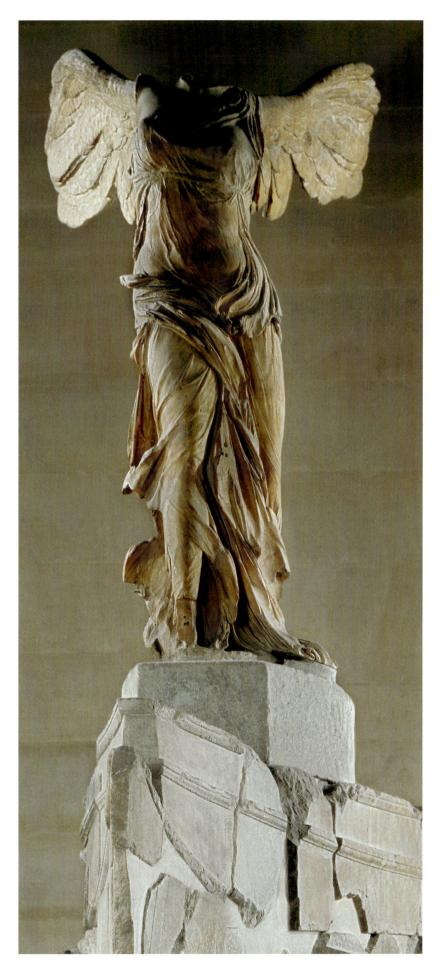

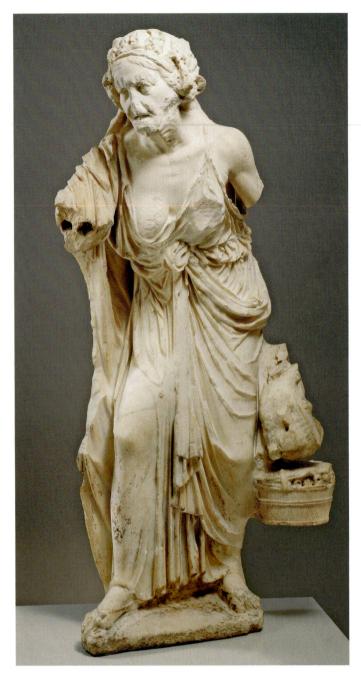

5-66 • OLD WOMAN Roman 1st century CE copy of a Greek work of the 2nd century BCE. Marble, height 491/2" (1.25 m).

Metropolitan Museum of Art, New York. Rogers Fund, 1909. (09.39)

5-67 • Alexandros from Antioch-on-the-Orontes APHRODITE OF MELOS (ALSO CALLED VENUS DE MILO)

c. 150-100 BCE. Marble, height 6'8" (2.04 m). Musée du Louvre, Paris.

The original appearance of this famous statue's missing arms has been much debated. When it was dug up in a field on the Cycladean island of Milos in 1820, some broken pieces (now lost) found with it indicated that the figure was holding out an apple in its right hand. Many judged these fragments to be part of a later restoration, not part of the original statue. Another theory is that Aphrodite was admiring herself in the highly polished shield of the war god Ares, an image that was popular in the second century BCE. This theoretical "restoration" would explain the pronounced S-curve of the pose and the otherwise unnatural forward projection of the knee.

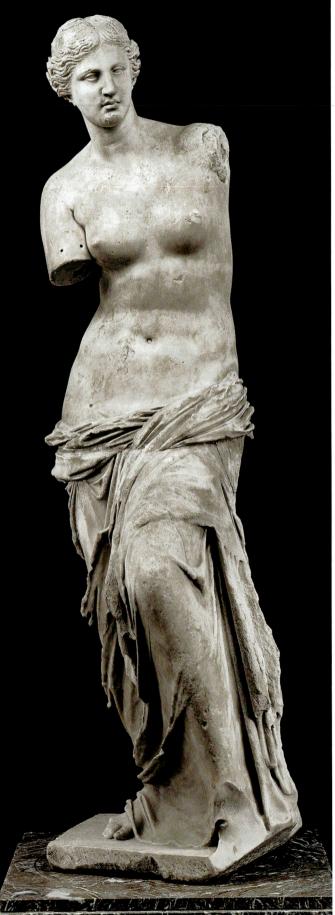

Nike's heavy body is balanced by the powerful backward thrust of her enormous wings. The large, open movements of the figure, the strong contrasts of light and dark on the deeply sculpted forms, and the contrasting textures of feathers, fabric, and skin typify the finest Hellenistic art.

OLD WOMAN The Hellenistic world was varied and multicultural, and some artists turned from generalizing idealism to an attempt to portray the world as they saw it, including representations of people from every level of society, unusual types as well as ordinary individuals. Traditionally, this figure of an aged woman (FIG. 5-66) has been seen as a seller on her way to the agora, carrying three chickens and a basket of produce. Despite the bunched and untidy disposition of her dress, however, it is elegant in design and made of fine fabric, and her hair is not in total disarray. These characteristics, along with the woman's sagging lower jaw, unfocused stare, and lack of concern for her exposed breasts, have led to a more recent interpretation that sees her as an aging, dissolute follower of Dionysos on her way to a religious festival, carrying offerings and wearing on her head the ivy wreath associated with the cult of this god of wine. Either way, she is the antithesis of the Nike of Samothrace. Yet in formal terms, both sculptures stretch out assertively into the space around them, both demand an emotional response from the viewer, and both display technical virtuosity in the rendering of forms and textures.

APHRODITE OF MELOS Not all Hellenistic artists followed the descriptive and expressionist tendencies of the artists of Pergamon and Rhodes. Some turned to the past, creating an eclectic style by reexamining and borrowing elements from earlier Classical styles and combining them in new ways. Many looked back to Praxiteles and Lysippos for their models. This was the case with Alexandros son of Menides, the sculptor of an Aphrodite (better known as the VENUS DE MILO) (FIG. 5-67) found on the island of Melos by French excavators in the early nineteenth century. The dreamy gaze recalls Praxiteles' work (see FIG. 5-53), and the figure has the heavier proportions of High Classical sculpture, but the twisting stance and the strong projection of the knee are typical of Hellenistic art, as is the rich three-dimensionality of the drapery. The juxtaposition of soft flesh and crisp drapery, seemingly in the process of slipping off the figure, adds a note of erotic tension.

By the end of the first century BCE, the influence of Greek painting, sculpture, and architecture had spread to the artistic communities of the emerging Roman Empire. Roman patrons and artists maintained their enthusiasm for Greek art into Early Christian and Byzantine times. Indeed, so strong was the urge to emulate the work of great Greek artists that, as we have seen throughout this chapter, much of our knowledge of Greek achievements comes from Roman replicas of Greek artworks and descriptions of Greek art by Roman writers.

THINK ABOUT IT

- **5.1** Discuss the development of a characteristically Greek approach to the representation of the male nude by comparing the Anavysos Kouros (FIG. 5-20), the Kritios Boy (FIG. 5-26), the Spear Bearer (FIG. 5-42), and Hermes and the Infant Dionysos (FIG. 5-52). What changes and what remains constant?
- 5.2 Choose a work from this chapter that illustrates a scene from a Greek myth or a scene from daily life in ancient Greece. Discuss the nature of the story or event, the particular aspect chosen for illustration by the artist, and the potential meaning of the episode in relation to its cultural context.
- 5.3 What ideals are embodied in the term "High Classicism" and what are the value judgments that underlie this art-historical category? Select one sculpture and one building discussed in the chapter, and explain why these works are regarded as High Classical.
- 5.4 Distinguish the attributes of the Doric and Ionic orders, focusing your discussion on a specific building representing each.

CROSSCURRENTS

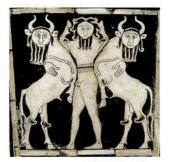

What is the common theme found in the heroic subjects depicted on these two very different works? What does the specific function and location of each indicate about the importance of that theme in each culture?

FIG. 2-8

Study and review on myartslab.com

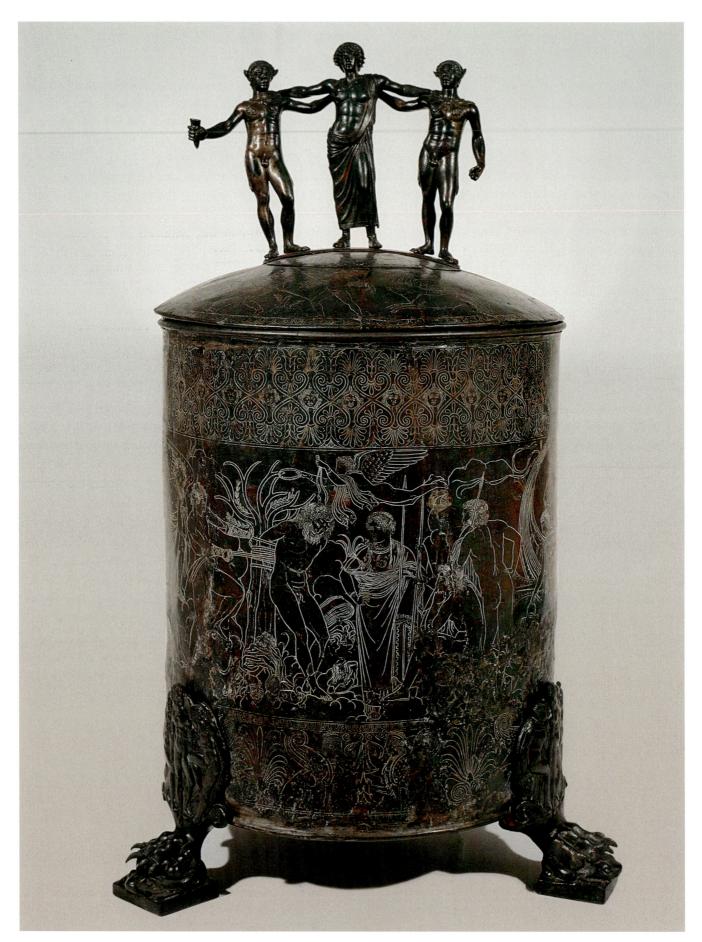

Etruscan and Roman Art

Long before the Romans ruled the entire Italic peninsula as the center of an expanding empire, the Etruscans created a thriving culture in northern and central Italy. Etruscan artists were known throughout the Mediterranean world for their special sophistication in casting and engraving on bronze. Some of their most extraordinary works were created for domestic use, including a group of surviving **cistae**—cylindrical containers used by wealthy women as cases for toiletry articles such as mirrors, cosmetics, and perfume.

This exquisitely wrought and richly decorated example—**THE FICORONI CISTA.** named after an eighteenthcentury owner—was made in the second half of the fourth century BCE and excavated in Palestrina (FIG. 6-1). It was commissioned by an Etruscan woman named Dindia Macolnia as a gift for her daughter, perhaps on the occasion of her marriage. The artist Novios Plautios signed the precisely engraved drawings around the cylinder, accomplished while the hammered bronze sheet from which it was constructed was still flat. First he incised lines within the metal and then filled them with a white substance to make them stand out. The cista's legs and handle—created by the figural group of Dionysus between two satyrs—were cast as separate pieces, attached during the assembly process.

The natural poses and individualization of these figures-both incised and cast-recalls the relaxed but lively naturalism of Etruscan wall paintings, but the Classicizing idealization of bodies and poses seems to come directly from contemporary Greek art. Furthermore, the use of broad foliate and ornamental bands to frame the frieze of figural narrative running around the cylinder matches the practice of famous Greek ceramic painters like Euphronios (see "A Closer Look," page 119). As with Greek pots, the most popular subjects for cistae were Greek myths. Here Novios has engraved sequential scenes drawn from an episode in the story of the Argonauts' quest for the Golden Fleece. The sailors sought water in the land of King Amykos, but the hostile king would only give them water from his spring if they beat him in a boxing match. After the immortal Pollux defeated Amykos, the Argonauts tied the king to a tree, the episode highlighted on the side of the cista seen here.

Novios Plautios probably based this scene on a monumental, mid-fourth-century BCE Greek painting of the Argonauts by Kydias that seems to have been in Rome at this time—perhaps explaining why the artist tells us in his incised signature that he executed this work in Rome. The combination of cultural components coming together in the creation of this cista—Greek stylistic sources in the work of an Etruscan artist living in Rome—will continue as Roman art develops out of the native heritage of Etruria and the emulation of the imported Classical heritage of the Greeks.

LEARN ABOUT IT

- 6.1 Explore the various ways Romans embellished the walls and floors of their houses with illusionistic painting in fresco and mosaic.
- **6.2** Trace the development and use of portraiture as a major artistic theme for the ancient Romans.
- **6.3** Examine the ways that Etruscan funerary art celebrates the vitality of human existence.
- **6.4** Investigate how knowledge of Roman advances in structural technology furthers our understanding of Roman civic architecture.

((•• Listen to the chapter audio on myartslab.com

THE ETRUSCANS

At the end of the Bronze Age (about 1000 BCE), a central European people known as the Villanovans occupied the northern and western regions of the boot-shaped Italian peninsula, while the central area was home to people who spoke a closely related group of Italic languages, Latin among them. Beginning in the eighth century BCE, Greeks established colonies on the Italian mainland and in Sicily. From the seventh century BCE, people known as Etruscans, probably related to the Villanovans, gained control of the north and much of today's central Italy, an area known as Etruria. They reached the height of their power in the sixth century BCE, when they expanded into the Po River valley to the north and the Campania region to the south (MAP 6-1).

Etruscan wealth came from fertile soil and an abundance of metal ore. Besides being farmers and metalworkers, the Etruscans were also sailors and merchants, and they exploited their resources in trade with the Greeks and with other people of the eastern Mediterranean. Etruscan artists knew and drew inspiration from Greek and Near Eastern art, assimilating such influences to create a distinctive Etruscan style.

ETRUSCAN ARCHITECTURE

In architecture, the Etruscans established patterns of building that would be adopted later by the Romans. Cities were laid out on grid plans, like cities in Egypt and Greece, but more regularly. Two main streets—one usually running north—south and the other east—west—divided the city into quarters, with the town's business district centered at their intersection. We know something about Etruscan domestic architecture within these quarters, because they created house–shaped funerary urns and also decorated the interiors of tombs to resemble houses. Dwellings were designed around a central courtyard (or **atrium**) that was open to the sky, with a pool or cistern fed by rainwater.

Walls with protective gates and towers surrounded Etruscan cities. The third- to second-century BCE city gate of Perugia, called the **PORTA AUGUSTA**, is one of the few surviving examples of Etruscan monumental architecture (**FIG. 6-2**). A tunnellike passageway between two huge towers, this gate is significant for anticipating the Roman use of the round arch, which is here extended to create a semicircular barrel vault over the passageway (see "The Roman Arch," page 170, and "Roman Vaulting," page 187). A square frame surmounted by a horizontal decorative element resembling an entablature sets off the entrance arch, which is accentuated by a molding. The decorative section is filled with a row of circular panels, or **roundels**, alternating with rectangular, columnlike upright strips called **pilasters** in an effect reminiscent of the Greek Doric frieze.

ETRUSCAN TEMPLES

The Etruscans incorporated Greek deities and heroes into their pantheon and, like the ancient Mesopotamians, used divination

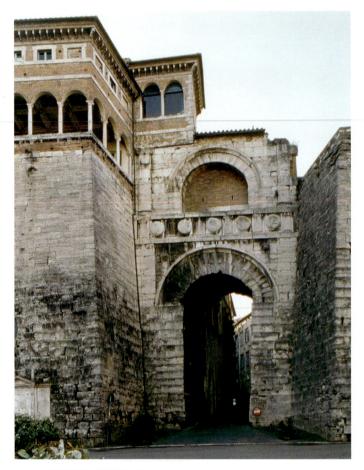

6-2 • PORTA AUGUSTA Perugia, Italy. 3rd–2nd century BCE.

to predict future events. Beyond this and their burial practices (as revealed by the findings in their tombs), we know little about their religious beliefs. Our knowledge of the appearance of Etruscan temples comes from a few excavated foundations, from ceramic votive models, and from the later writings of the Roman architect Vitruvius, who compiled, sometime between 33 and 23 BCE, descriptions of the nature of Etruscan architecture (see "Roman Writers on Art," page 167).

Etruscans built their temples with mud-brick walls; columns and entablatures were made of wood or a quarried volcanic rock (tufo) that hardens upon exposure to air. Vitruvius indicates that like the Greeks, Etruscan builders also used the post-and-lintel structure and gable roofs, with bases, column shafts, and capitals recalling the Doric or Ionic order, and entablatures resembling a Doric frieze (**FIG. 6-3**). Vitruvius used the term "**Tuscan order**" to describe the characteristic Etruscan variation of Doric, with an unfluted shaft and simplified base, capital, and entablature (see "Roman Architectural Orders," page 161).

Like the Greeks, the Etruscans built rectangular temples on a high platform, but often imbedded them within urban settings. Rather than surrounding temples uniformly on all sides with a stepped stereobate and peristyle colonnade, as was the practice in

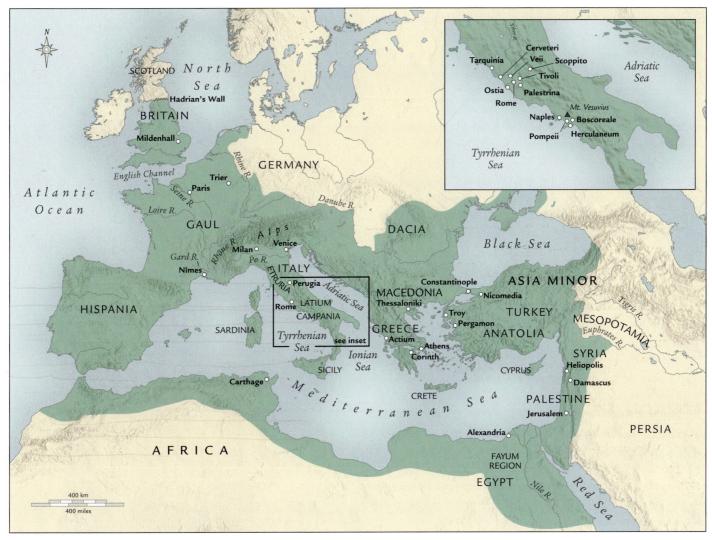

MAP 6-1 • THE ANCIENT ROMAN WORLD

This map shows the Roman Empire at its greatest extent, which was reached in 106 cE under the emperor Trajan.

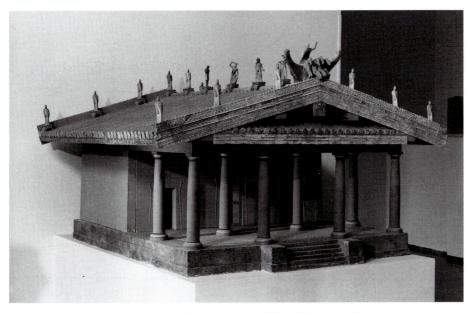

6-3 • **MODEL (A) AND PLAN (B) OF AN ETRUSCAN TEMPLE** Based on descriptions by Vitruvius.

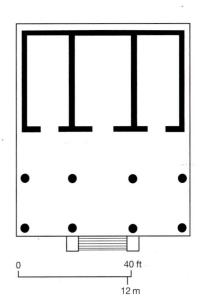

Greece (see FIGS. 5–10, 5–36), Etruscans built a single flight of stairs leading to a columned porch on one short side. An approach to siting and orientation also constitutes an important difference from Greek temples, which were built toward the center of an enclosed sacred precinct (see FIGS. 5–12, 5–36), rather than on the edge of a courtyard or public square. Also, there was an almost even division in Etruscan temples between porch and interior space, which was often divided into three rooms, presumably for cult statues (see FIG. 6–3B).

Although Etruscan temples were simple in form, they were embellished with dazzling displays of painting and terra-cotta sculpture. The temple roof, rather than the pediment, served as a base for large statue groups. Etruscan artists excelled at the imposing technical challenge of making huge terra-cotta figures for placement on temples. A splendid example is a life-size figure of **APOLLO** (FIG. 6-4). To make such large clay sculptures, artists had to know how to construct figures so that they did not collapse under their own weight while the raw clay was still wet. They also had to regulate the kiln temperature during the long firing process. The names of some Etruscan terra-cotta artists have come down to us, including that of a sculptor from Veii (near Rome) called Vulca, in whose workshop this figure of Apollo may have been created.

Dating from about 510–500 BCE and originally part of a fourfigure scene depicting one of the labors of Hercules, this boldly striding Apollo comes from the temple dedicated to Minerva and other gods in the sanctuary of Portonaccio at Veii. Four figures on the temple's ridgepole (horizontal beam at the peak of the roof) depicted Apollo and Hercules fighting for possession of a deer sacred to Diana, while she and Mercury looked on.

Apollo's well-developed body and his "Archaic smile" clearly demonstrate that Etruscan sculptors were familiar with the *kouroi* of their Archaic Greek counterparts. But a comparison of the Apollo and a figure such as the Greek Anavysos Kouros (see FIG. 5-20) reveals telling differences. Unlike the Greek *kouros*, the body of the Etruscan Apollo is partially concealed by a rippling robe that cascades in knife-edged pleats to his knees. The forward-moving pose of the Etruscan statue also has a dynamic vigor that is avoided in the balanced, rigid stance of the Greek figure. This sense of energy expressed in purposeful movement is a defining characteristic of Etruscan sculpture and painting.

TOMB CHAMBERS

Like the Egyptians, the Etruscans seem to have conceived tombs as homes for the dead. The Etruscan cemetery of La Banditaccia at Cerveteri, in fact, was laid out as a small town, with "streets" running between the grave mounds. The tomb chambers were partially or entirely excavated below the ground, and some were hewn out of bedrock. They were roofed over, sometimes with corbel vaulting, and covered with dirt and stones.

Etruscan painters had a remarkable ability to envision their subjects inhabiting a bright, tangible world just beyond the tomb. Vividly colored scenes of playing, feasting, dancing, hunting,

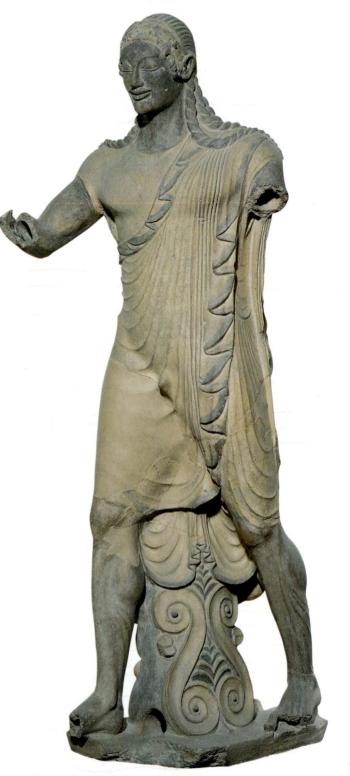

6-4 • Master Sculptor Vulca (?) **APOLLO** From the temple of Minerva, Portonaccio, Veii. c. 510–500 BCE. Painted terra cotta, height 5'10" (1.8 m). Museo Nazionale di Villa Giulia, Rome.

fishing, and other leisure activities decorated the walls. In a late sixth-century BCE tomb from Tarquinia, wall paintings show two boys spending a day in the country, surrounded by the graceful flights of brightly colored birds (**FIG. 6-6**). The boy to the left is climbing a hillside to the promontory of a cliff, soon to put aside

ELEMENTS OF ARCHITECTURE | Roman Architectural Orders

The Etruscans and Romans adapted Greek architectural orders (see "The Greek Orders," page 110) to their own tastes, often using them as applied decoration on walls. The Etruscans developed the Tuscan order by modifying the Doric order, adding a base under the shaft, which was often left unfluted. This system was subsequently adopted by the Romans. Later, the Romans created the **Composite order (Fig. 6–5)** by combining the volutes of Greek Ionic capitals with the acanthus leaves from the Corinthian order. In this diagram, the two Roman orders are shown on pedestals, which consist of a **plinth**, a **dado**, and a cornice.

6-5 • FAÇADE OF LIBRARY OF CELSUS, EPHESUS Modern Turkey. Detail showing capital, architrave, frieze, and cornice, conforming to the Composite order. 135 cE. Marble.

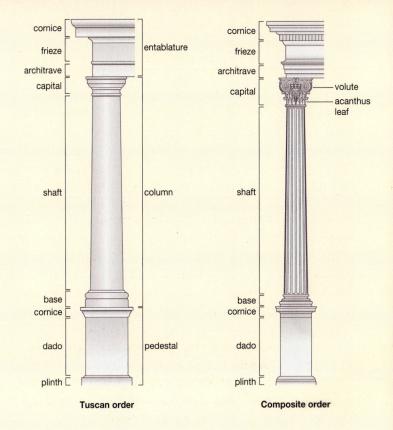

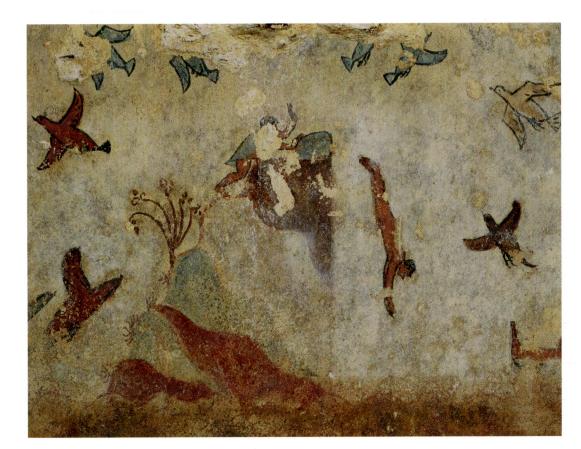

6-6 • BOYS CLIMBING ROCKS AND DIVING, TOMB OF HUNTING AND FISHING Tarquinia, Italy. Late 6th century BCE.

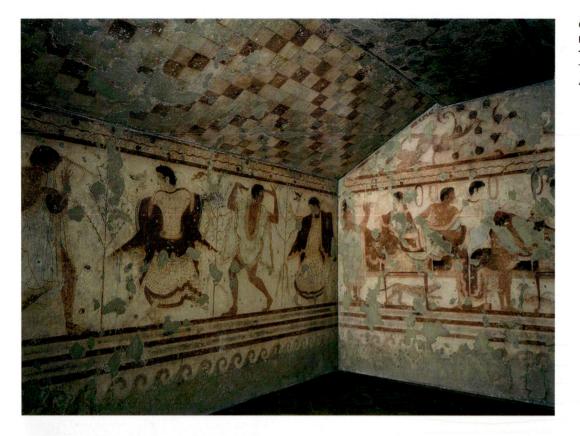

6-7 • DANCERS AND DINERS, TOMB OF THE TRICLINIUM Tarquinia, Italy. c. 480– 470 BCE.

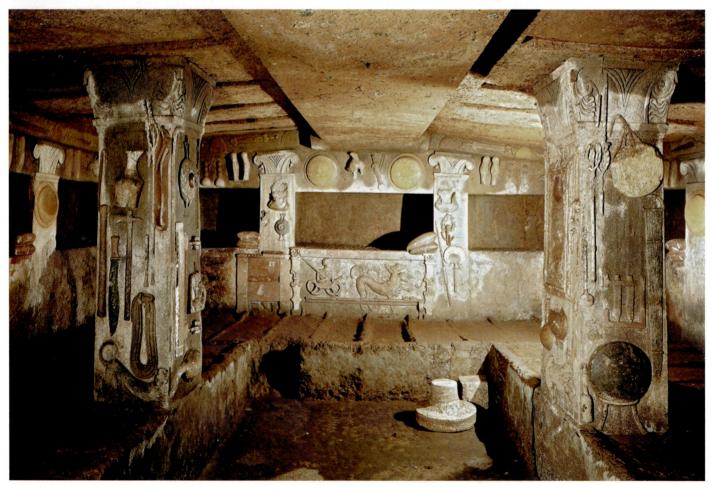

6-8 • BURIAL CHAMBER, TOMB OF THE RELIEFS Cerveteri, Italy. 3rd century BCE.

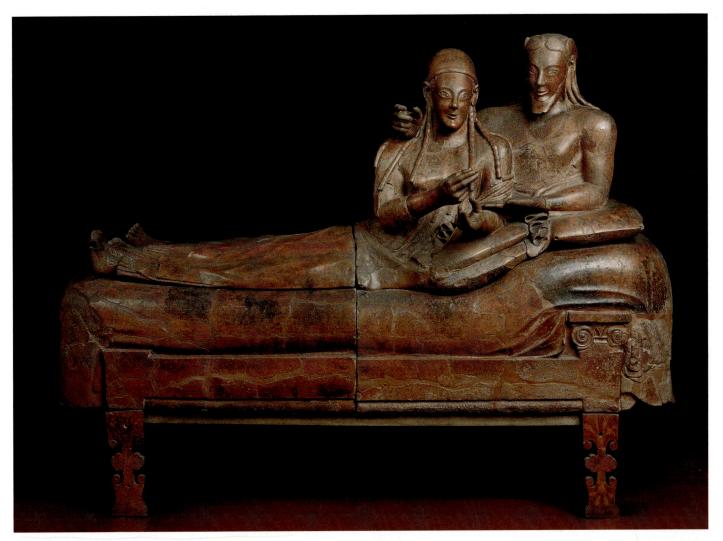

6-9 • RECLINING COUPLE ON A SARCOPHAGUS FROM CERVETERI c. 520 BCE. Terra cotta, length 6'7" (2.06 m). Museo Nazionale di Villa Giulia, Rome.

Portrait sarcophagi like this one evolved from earlier terra-cotta cinerary urns with sculpted heads of the deceased whose ashes they held.

his clothes and follow his naked companion, caught by the artist in mid-dive, plunging toward the water below. Such charming scenes of carefree diversions, removed from the routine demands of daily life, seem to promise a pleasurable post-mortem existence to the occupant of this tomb. But this diver could also symbolize the deceased's own plunge from life into death (see "The Tomb of the Diver," page 124).

In a painted frieze in the **TOMB OF THE TRICLINIUM**, somewhat later but also from Tarquinia, the diversions are more mature in focus as young men and women frolic to the music of the lyre and double flute within a room whose ceiling is enlivened with colorful geometric decoration (**FIG. 6-7**). These dancers line the side walls, composed within a carefully arranged setting of stylized trees and birds, while at the end of the room couples recline on couches enjoying a banquet as cats prowl underneath the table looking for scraps. The immediacy of this wall painting is striking. Dancers and diners—women as well as men—are engaging in the joyful customs and diversions of human life as we know it.

Some tombs were carved out of the rock to resemble rooms in a house. The **TOMB OF THE RELIEFS**, for example, seems to have a flat ceiling supported by square stone posts (**FIG. 6-8**). Its walls were plastered and painted, and it was fully furnished. Couches were carved from stone, and other fittings were formed of stuceo, a slow-drying type of plaster that can be easily molded and carved. Simulated pots, jugs, robes, axes, and other items were molded and carved to look like real objects hanging on hooks. Could the animal rendered in low relief at the bottom of the post just left of center be the family pet?

The remains of the deceased were placed in urns or sarcophagi (coffins) made of clay or stone. On the terra-cotta **SARCOPHA-GUS FROM CERVETERI**, dating from about 520 BCE (**FIG. 6-9**), a husband and wife are shown reclining comfortably on a dining

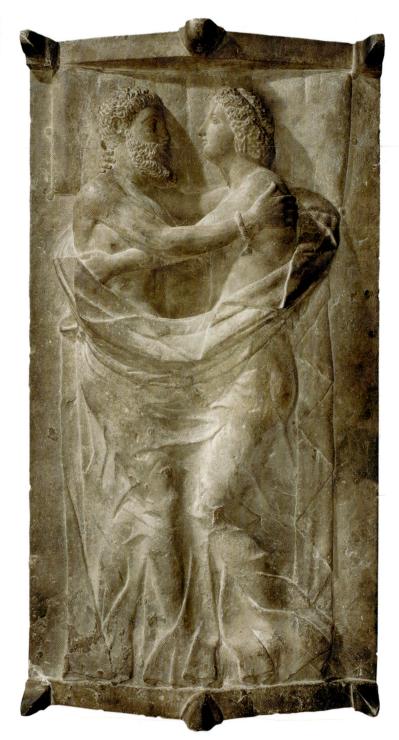

6-10 • MARRIED COUPLE (LARTH TETNIES AND THANCHVIL TARNAI) EMBRACING

Lid of a sarcophagus. c. 350–300 BCE. Marble, length 7' (2.13 m). Museum of Fine Arts, Boston. Museum purchase with funds donated by contribution and the Benjamin Pierce Cheney Fund (86.145a-b)

couch. The smooth, lifelike forms of their upper bodies are vertical and square-shouldered, but their hips and extended legs seem to sink into the softness of the couch. Rather than a somber memorial to the dead, we encounter two lively individuals with alert eyes and warm smiles. The man once raised a drinking vessel, addressing the viewer with the lively and engaging gesture of a genial host, perhaps offering an invitation to dine with them for eternity or to join them in the sort of convivial festivities recorded in the paintings on the walls of Etruscan tombs.

The lid of another Etruscan sarcophagus—slightly later in date and carved of marble rather than molded in clay—also portrays a reclining Etruscan couple, but during a more private moment (**FIG. 6-10**). Dressed only in their jewelry and just partially sheathed by the light covering that clings to the forms of their bodies, this loving pair has been caught for eternity in a tender embrace, absorbed with each other rather than looking out to engage the viewer. The sculptor of this relief was clearly influenced by Greek Classicism in the rendering of human forms, but the human intimacy that is captured here is far removed from the cool, idealized detachment characterizing Greek funerary stelai (see FIG. 5–50).

WORKS IN BRONZE

The Etruscans developed special sophistication in casting and engraving on bronze. Some of the most extraordinary works were created for domestic use, including a group of surviving cistae—cylindrical containers used by wealthy women as cases for toiletry articles such as mirrors. The richly decorated Ficoroni Cista, dated to the second half of the fourth century BCE and found in Palestrina (see FIG. 6-1), was made by Novios Plautios for a woman named Dindia Macolnia, who gave it to her daughter.

Since Etruscan bronze artists went to work for Roman patrons after Etruscan lands became part of the Roman Republic, distinguishing between Etruscan and early Roman art is often difficult. A head that was once part of a bronze statue of a man may be an example of an important Roman commission from an Etruscan artist (FIG. 6-12). Since it is over life size, this head may have been part of a commemorative work honoring a great man, and the downturned tilt of the head, as well as the flexing of the neck, have led many to propose that it was part of an equestrian figure. Traditionally dated to about 300 BCE, this rendering of a strong, broad face with heavy brows, hawk nose, firmly set lips, and clear-eyed expression is scrupulously detailed. The commanding, deep-set eyes are created with ivory inlay, within which float irises created of glass paste within a ring of bronze. The lifelike effect is further enhanced by added eyelashes of separately cut pieces of bronze. This work is often associated with a set of male virtues that would continue to be revered by the Romans: stern seriousness, strength of character, the age-worn appearance of a life well lived, and the wisdom and sense of purpose it confers.

Etruscan art and architectural forms left an indelible stamp on the art and architecture of early Rome that was rivaled only by the influence of Greece. By 88 BCE, when the Etruscans were granted Roman citizenship, their art had already been absorbed into that of Rome.

RECOVERING THE PAST | The Capitoline She-Wolf

This ferocious she-wolf has been considered an outstanding example of Etruscan bronze sculpture (**Fig. 6–11**), lauded for its technical sophistication and expressive intensity and traditionally dated to c. 500–470 BCE. She confronts us with a vicious snarl, her tense body, thin flanks, and protruding ribs, contrasting with her pendulous, milk-filled teats. Since she currently suckles two chubby human boys—Renaissance additions of the fifteenth century—the ensemble evokes the story of the twins Romulus and Remus, legendary founders of Rome, who were nursed back to health by a she-wolf after having been left to die on the banks of the Tiber. But is this famous animal actually Etruscan in origin?

Now in Rome's Museo Capitolino, the bronze she-wolf was restored and cleaned during 1997–2000, under the supervision of archaeologist Anna Maria Carruba, who has mounted a serious challenge to its Etruscan pedigree. She argues, in fact, that it dates not from antiquity, but from the Middle Ages. Technical as well as stylistic evidence supports her conclusions, specifically the fact that this unusual work, created by the lost-wax process, was formed in the medieval technique of single-pour casting, whereas all surviving Etruscan and Roman bronzes were assembled from separate pieces soldered together. Carruba's proposal of a date of c. 800 cE for the she-wolf has certainly caught the attention of specialists in ancient art, many of whom have revised their assessment of the work. Others are waiting for the full publication of the scientific evidence before removing the Capitoline She-Wolf from the Etruscan canon.

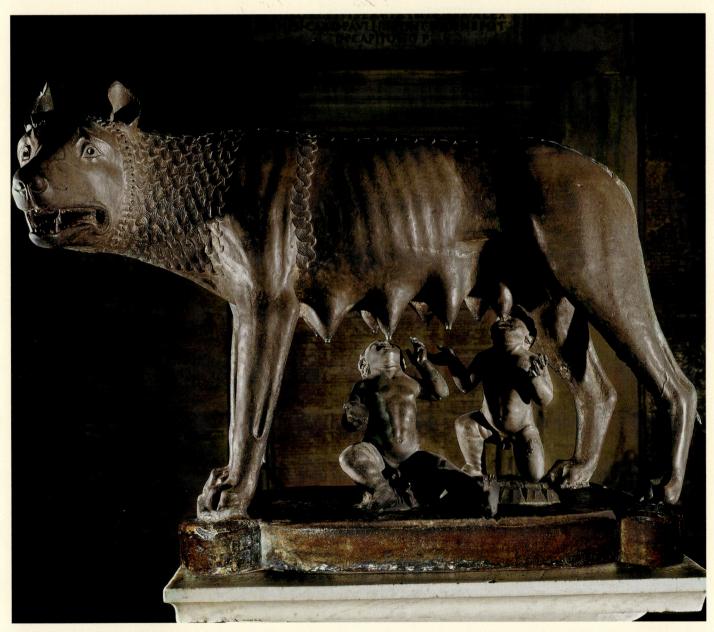

6-11 • CAPITOLINE SHE-WOLF c. 500 BCE or c. 800 CE? (Boys underneath, 15th century CE). Bronze, height 331/2" (85 cm). Museo Capitolino, Rome.

6-12 • HEAD OF A MAN (TRADITIONALLY KNOWN AS "BRUTUS")

c. 300 BCE. Bronze, eyes of painted ivory, height $12\frac{1}{2}$ " (31.8 cm). Palazzo dei Conservatori, Rome.

THE ROMANS

At the same time that the Etruscan civilization was flourishing, the Latin-speaking inhabitants of Rome began to develop into a formidable power. For a time, kings of Etruscan lineage ruled them, but in 509 BCE the Romans overthrew them and formed a republic centered in Rome. The Etruscans themselves were absorbed by the Roman Republic at the end of the third century BCE, by which time Rome had steadily expanded its territory in many directions. The Romans unified what is now Italy and, after defeating their rival, the North African city-state of Carthage, they established an empire that encompassed the entire Mediterranean region (see MAP 6-1).

At its greatest extent, in the early second century CE, the Roman Empire reached from the Euphrates River, in southwest Asia, to Scotland. It ringed the Mediterranean Sea—*mare nostrum*, or "our sea," the Romans called it. Those who were conquered by the Romans gradually assimilated Roman legal, administrative, and cultural structures that endured for some five centuries—and in the eastern Mediterranean until the fifteenth century CE—and left a lasting mark on the civilizations that emerged in Europe.

The Romans themselves assimilated Greek gods, myths, and religious beliefs and practices into their state religion. During the imperial period, they also deified some of their emperors posthumously. Worship of ancient gods mingled with homage to past rulers; oaths of allegiance to the living ruler made the official religion a political duty. Religious worship became increasingly ritualized, perfunctory, and distant from the everyday life of most people.

Many Romans adopted the so-called mystery religions of the people they had conquered. Worship of Isis and Osiris from Egypt, Cybele (the Great Mother) from Anatolia, the hero-god Mithras from Persia, and the single, all-powerful God of Judaism and Christianity from Palestine challenged the Roman establishment. These unauthorized religions flourished alongside the state religion, with its Olympian deities and deified emperors, despite occasional government efforts to suppress them.

THE REPUBLIC, 509–27 BCE

Early Rome was governed by kings and an advisory body of leading citizens called the Senate. The population was divided into two classes: a wealthy and powerful upper class, the patricians, and a lower class, the plebeians. In 509 BCE, Romans overthrew the last Etruscan king and established the Roman Republic as an oligarchy, a government by aristocrats, that would last about 450 years.

ART AND ITS CONTEXTS | Roman Writers on Art

Only one book devoted specifically to the arts survives from antiquity. All our other written sources consist of digressions and insertions in works on other subjects. That one book, the *Ten Books on Architecture* by Vitruvius (c. 80–c. 15 BCE), however, is invaluable. Written for Augustus in the first century BCE, it is a practical handbook for builders that discusses such things as laying out cities, siting buildings, and using the Greek architecture, and he also made significant contributions to art theory, including studies on proportion.

Pliny the Elder (c. 23–79 cE) wrote a vast encyclopedia of "facts, histories, and observations" known as *Naturalis Historia* (*The Natural History*) that often included discussions of art and architecture. Pliny occasionally used works of art to make his points—for example, citing

sculpture within his essays on stone and metals. Pliny's scientific turn of mind led to his death, for he was overcome while observing the eruption of Mount Vesuvius that buried Pompeii. His nephew, Pliny the Younger (c. 61–113 cE), a voluminous letter writer, added to our knowledge of Roman domestic architecture with his meticulous descriptions of villas and gardens.

Valuable bits of information can also be found in books by travelers and historians. Pausanias, a second-century cE Greek traveler, wrote descriptions that are basic sources on Greek art and artists. Flavius Josephus (c. 37–100 cE), a historian of the Flavians, wrote in his *Jewish Wars* a description of the triumph of Titus that includes the treasures looted from the Temple in Jerusalem (see FIG. 6–37).

As a result of its stable form of government, and especially of its encouragement of military conquest, by 275 BCE Rome controlled the entire Italian peninsula. By 146 BCE, Rome had defeated its great rival, Carthage, on the north coast of Africa, and taken control of the western Mediterranean. By the mid second century BCE, Rome had taken Macedonia and Greece, and by 44 BCE, it had conquered most of Gaul (present-day France) as well as the eastern Mediterranean (see MAP 6-1). Egypt remained independent until Octavian defeated Mark Antony and Cleopatra at the Battle of Actium in 31 BCE.

During the Republic, Roman art was rooted in its Etruscan heritage, but territorial expansion brought wider exposure to the arts of other cultures. Like the Etruscans, the Romans admired Greek art. As Horace wrote (*Epistulae* ii, 1): "Captive Greece conquered her savage conquerors and brought the arts to rustic Latium." The Romans used Greek designs and Greek orders in their architecture, imported Greek art, and employed Greek artists. In 146 BCE, for example, they stripped the Greek city of Corinth of its art treasures and shipped them back to Rome.

PORTRAIT SCULPTURE

Portrait sculptors of the Republican period sought to create lifelike images based on careful observation of their subjects, objectives that were related to the Romans' veneration of their ancestors and the making and public displaying of death masks of deceased relatives (see "Roman Portraiture," page 168).

Perhaps growing out of this early tradition of maintaining images of ancestors as death masks, a new Roman artistic ideal emerged during the Republican period in relation to portrait sculpture, an ideal quite different from the one we encountered in Greek Classicism. Instead of generalizing a human face, smoothed of its imperfections and caught in a moment of detached abstraction, this new Roman idealization emphasized—rather than suppressed—the hallmarks of advanced age and the distinguishing aspects of individual likenesses. This mode is most prominent in portraits of Roman patricians (**FIG. 6-13**), whose time-worn faces

6-13 • PORTRAIT HEAD OF AN ELDER FROM SCOPPITO 1st century BCE. Marble, height 11" (28 cm). Museo Nazionale, Chieti.

ART AND ITS CONTEXTS | Roman Portraiture

The strong emphasis on portraiture in Roman art may stem from the early practice of creating likenesses—in some cases actual wax death masks—of revered figures and distinguished ancestors for display on public occasions, most notably funerals. Contemporary historians have left colorful evocations of this distinctively Roman custom. Polybius, a Greek exiled to Rome in the middle of the second century BCE, wrote home with the following description:

... after the interment [of the illustrious man] and the performance of the usual ceremonies, they place the image of the departed in the most conspicuous position in the house, enclosed in a wooden shrine. This image is a mask reproducing with remarkable fidelity both the features and the complexion of the deceased. On the occasion of public sacrifices, they display these images, and decorate them with much care, and when any distinguished member of the family dies they take them to the funeral, putting them on men who seem to bear the closest resemblance to the original in stature and carriage.... There could not easily be a more ennobling spectacle for a young man who aspires to fame and virtue. For who would not be inspired by the sight of the images of men renowned for their excellence, all together and as if alive and breathing?... By this means, by the constant renewal of the good report of brave men, the celebrity of those who performed noble deeds is rendered immortal, while at the same time the fame of those who did good services to their country becomes known to the people and a heritage for future generations. (The Histories, 7.53, 54, trans. W.R. Paton, Loeb Library ed.)

Growing out of this heritage, Roman Republican portraiture is frequently associated with the notion of **verism**—an interest in the faithful reproduction of the immediate visual and tactile appearance of subjects. Since we find in these portrait busts the same sorts of individualizing physiognomic features that allow us to differentiate among the people we know in our own world, it is easy to assume that they are exact likenesses of their subjects as they appeared during their lifetime. Of course, this is impossible to verify, but our strong desire to believe it must realize the intentions of the artists who made these portraits and the patrons for whom they were made.

A life-size marble statue of a Roman **PATRICIAN** (**FIG. 6-14**), dating from the period of the Emperor Augustus, reflects the practices documented much earlier by Polybius and links the man portrayed with a revered tradition and its laudatory associations. The large marble format emulates a Greek notion of sculpture, and its use here signals not only this man's wealth but also his sophisticated artistic tastes, characteristics he shared with the emperor himself. His toga, however, is not Greek but indigenous and signifies his respectability as a Roman citizen of some standing. The busts of ancestors that he holds in his hands document his distinguished lineage in the privileged upper class (laws regulated which members of society could own such collections) and the statue as a whole proclaims his adherence to the family tradition by having his own portrait created.

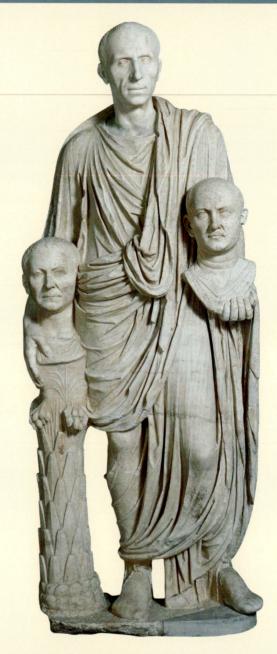

6-14 • PATRICIAN CARRYING PORTRAIT BUSTS OF TWO ANCESTORS (KNOWN AS THE BARBERINI TOGATUS) End of 1st century BCE or beginning of 1st century CE. Marble, height 5'5" (1.65 m). Palazzo de Conservatori, Rome.

The head of this standing figure, though ancient Roman in origin, is a later replacement and not original to this statue. The separation of head and body in this work is understandable since in many instances the bodies of full-length portraits were produced in advance, waiting in the sculptor's workshop for a patron to commission a head with his or her own likeness that could be attached to it. Presumably the busts carried by this patrician were likewise only blocked out until they could be carved with the faces of the commissioner's ancestors. These faces share a striking family resemblance, and the stylistic difference reproduced in the two distinct bust formats reveals that these men lived in successive generations. They could be the father and grandfather of the man who carries them.

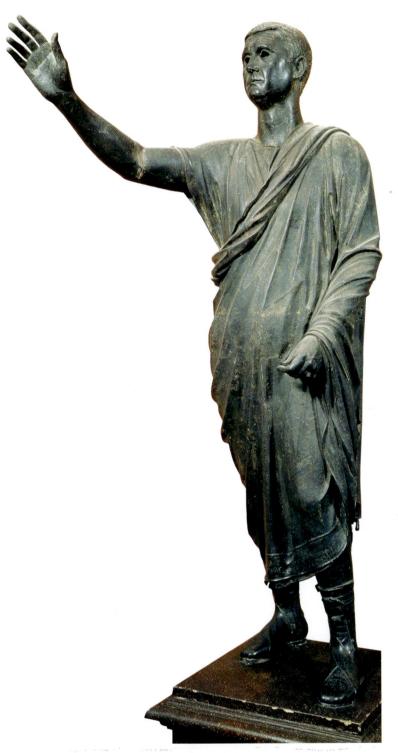

6-15 • AULUS METELLUS (THE ORATOR) Found near Perugia. c. 80 все. Bronze, height 5'11" (1.8 m). Museo Archeologico Nazionale, Florence.

embody the wisdom and experience that come with old age. Frequently we take these portraits of wrinkled elders at face value, as highly realistic and faithful descriptions of actual human beings contrasting Roman realism with Greek idealism—but there is good reason to think that these portraits actually conform to a particularly Roman type of idealization that underscores the effects of aging on the human face.

THE ORATOR The life-size bronze portrait of **AULUS METELLUS**—the Roman official's name is inscribed on the hem of his garment in Etruscan letters (**FIG. 6-15**)—dates to about 80 BCE. The statue, known from early times as *The Orator*, depicts a man addressing a gathering, his arm outstretched and slightly raised, a pose expressive of rhetorical persuasiveness. The orator wears sturdy laced leather boots and a folded and draped toga, the characteristic garment of a Roman senator. Perhaps the statue was mounted on an inscribed base in a public space by officials grateful for Aulus' benefactions on behalf of their city.

THE DENARIUS OF JULIUS CAESAR The propaganda value of portraits was not lost on Roman leaders. In 44 BCE, Julius Caesar issued a **DENARIUS** (a widely circulated coin) bearing his portrait (**FIG. 6–16**) conforming to the Roman ideal of advanced age. He was the first Roman leader to place his own image on a coin, initiating a practice that would be adopted by his successors, but at the time when this coin was minted, it smacked of the sort of megalomaniacal behavior that would ultimately lead to his assassination. Perhaps it is for this reason that Caesar underscores his age, and thus his old-fashioned respectability, in this portrait, which reads as a mark of his traditionalism as a senator. But the inscription placed around his head—CAESAR DICT PERPETUO, or "Caesar, dictator forever"—certainly contradicts the ideal embodied in the portrait.

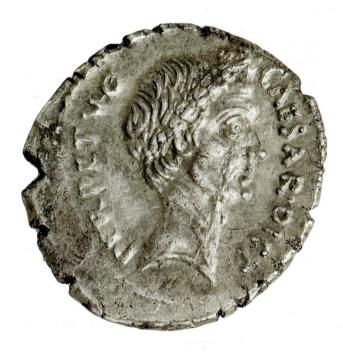

6-16 • DENARIUS WITH PORTRAIT OF JULIUS CAESAR 44 BCE. Silver, diameter approximately ³/₄" (1.9 cm). American Numismatic Society, New York.

ELEMENTS OF ARCHITECTURE | The Roman Arch

The round arch was not an Etruscan or Roman invention, but the Etruscans and Romans were the first to make widespread use of it (see Fig. 6–2)—both as an effective structural idea and an elegant design motif.

Round arches displace most of their weight, or downward **thrust** (see arrows on diagram), along their curving sides, transmitting that weight to adjacent supporting uprights (door or window jambs, columns, or piers). From there, the thrust goes to, and is supported by, the ground. To create an arch, brick or cut stones are formed into a curve by fitting together wedge-shaped pieces, called **voussoirs**, until they meet and are locked together at the top center by the final piece, called the **keystone**. These voussoirs exert an outward as well as a downward thrust, so arches may require added support, called **buttressing**, from adjacent masonry elements.

Until the keystone is in place and the mortar between the bricks or stones dries, an arch is held in place by wooden scaffolding called **centering**. The points from which the curves of the arch rise are called **springings**, and their support is often reinforced by **impost blocks**. The wall areas adjacent to the curves of the arch are **spandrels**. In a succession of arches, called an **arcade**, the space encompassed by each arch and its supports is called a **bay**. A stunning example of the early Roman use of the round arch is a bridge known as the **PONT DU GARD** (Fig. 6–17), part of an aqueduct located near Nîmes, in southern France. An ample water supply was essential for a city, and the Roman invention to supply this water was the aqueduct, built with arcades—a linear series of arches. This aqueduct brought water from springs 30 miles to the north using a simple gravity flow, and it provided 100 gallons a day for every person in Nîmes. Each arch buttresses its neighbors and the huge arcade ends solidly in the hillsides. The structure conveys the balance, proportions, and rhythmic harmony of a great work of art, and although it harmonizes with its natural setting, it also makes a powerful statement about Rome's ability to control nature in order to provide for its cities. Both structure and function are marks of Roman civilization.

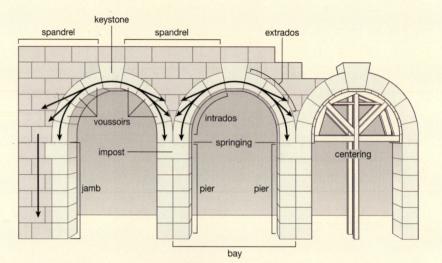

6-17 • PONT DU GARD

Nîmes, France. Late 1st century BCE. Height above river 160' (49 m), width of road bed on lower arcade 20' (6 m).

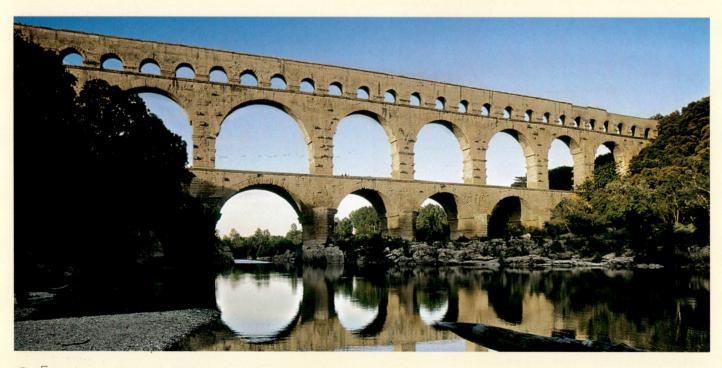

• Watch an architectural simulation about the arch on myartslab.com

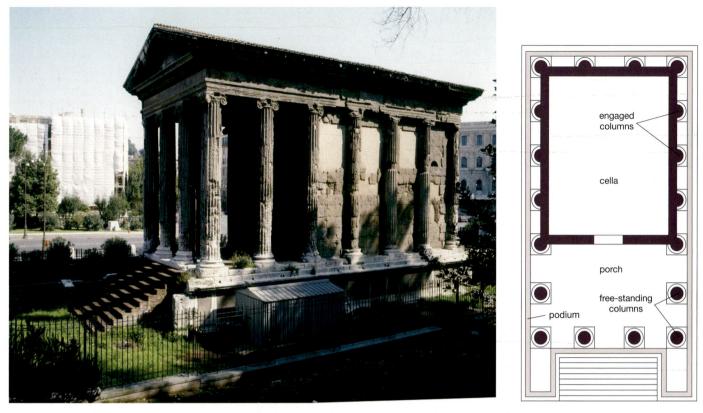

6-18 • EXTERIOR VIEW (A) AND PLAN (B) OF A TEMPLE, PERHAPS DEDICATED TO PORTUNUS Forum Boarium (Cattle Market), Rome. Late 2nd century BCE.

ROMAN TEMPLES

Architecture during the Roman Republic reflected both Etruscan and Greek practices. Like the Etruscans, the Romans built urban temples in commercial centers as well as in special sanctuaries. An early example is a small rectangular temple standing on a raised platform, or podium, beside the Tiber River in Rome (FIG. 6-18), probably from the second century BCE and perhaps dedicated to Portunus, the god of harbors and ports. This temple uses the Etruscan system of a rectangular cella and a front porch at one end reached by a broad, inviting flight of steps, but the Roman architects have adopted the Greek Ionic order, with full columns on the porch and half-columns engaged (set into the wall) around the exterior walls of the cella (see FIG. 6-18B) and a continuous frieze in the entablature. The overall effect resembles a Greek temple, but there are two major differences. First, Roman architects liberated the form of the column from its post-and-lintel structural roots and engaged it onto the surface of the wall as a decorative feature. Second, while a Greek temple encourages viewers to walk around the building and explore its uniformly articulated sculptural mass, Roman temples are defined in relation to interior spaces, which visitors are invited to enter through one opening along the longitudinal axis of a symmetrical plan.

By the first century BCE, nearly a million people lived in Rome, which had evolved into the capital of a formidable commercial and political power with a growing overseas empire. As long as Republican Rome was essentially a large city-state, its form of government—an oligarchy under the control of a Senate—remained feasible. But as the empire around it grew larger and larger, a government of competing senators and military commanders could not enforce taxation and maintain order in what was becoming a vast and complicated territorial expanse. As governance of the Republic began to fail, power became concentrated in fewer and fewer leaders, until it was ruled by one man, an emperor, rather than by the Senate.

THE EARLY EMPIRE, 27 BCE-96 CE

The first Roman emperor was born Octavian in 63 BCE. When he was only 18 years old, his brilliant great-uncle, Julius Caesar, adopted him as son and heir, recognizing in him qualities that would make him a worthy successor. Shortly after Julius Caesar refused the Senate's offer of the imperial crown, early in 44 BCE, he was murdered by a group of conspirators, and the 19-year-old Octavian stepped up. Over the next 17 spectacular years, as general, politician, statesman, and public-relations genius, Octavian vanquished warring internal factions and brought peace to fractious provinces. By 27 BCE, the Senate had conferred on him the title of Augustus (meaning "exalted," "sacred"). Assisted by his astute and pragmatic second wife, Livia, Augustus led the state and the empire for 45 years. He established efficient rule and laid the foundation for an extended period of stability, domestic peace, and economic prosperity known as the *Pax Romana* ("Roman Peace"), which lasted over 200 years (27 BCE to 180 CE). In 12 BCE he was given the title Pontifex Maximus ("High Priest"), becoming the empire's highest religious official as well as its political leader.

Conquering and maintaining a vast empire required not only the inspired leadership and tactics of Augustus, but also careful planning, massive logistical support, and great administrative skill. Some of Rome's most enduring contributions to Western civilization reflect these qualities—its system of law, its governmental and administrative structures, and its sophisticated civil engineering and architecture.

To facilitate the development and administration of the empire, as well as to make city life comfortable and attractive to its citizens, the Roman state undertook building programs of unprecedented scale and complexity, mandating the construction of central administrative and legal centers (forums and basilicas), recreational facilities (racetracks, stadiums), temples, markets, theaters, public baths, aqueducts, middle-class housing, and even entire new towns. To accomplish these tasks without sacrificing beauty, efficiency, and human well-being, Roman builders and architects developed rational plans using easily worked but durable materials and highly sophisticated engineering methods.

To move their armies about efficiently, to speed communications between Rome and the farthest reaches of the empire, and to promote commerce, the Romans built a vast and complex network of roads and bridges. Many modern European highways still follow the lines laid down by Roman engineers, some Roman bridges are still in use, and Roman-era foundations underlie the streets of many cities.

ART IN THE AGE OF AUGUSTUS

Roman artists of the Augustan age created a new style—a new Roman form of idealism that, though still grounded in the appearance of the everyday world, is heavily influenced by a revival of Greek Classical ideals. They enriched the art of portraiture in both official images and representations of private individuals, they recorded contemporary historical events on public monuments, and they contributed unabashedly to Roman imperial propaganda.

AUGUSTUS OF PRIMAPORTA In the sculpture known as AUGUSTUS OF PRIMAPORTA (FIG. 6-19)—because it was discovered in Livia's villa at Primaporta, near Rome (see FIG. 6-32) we see the emperor as he wanted to be seen and remembered. This work demonstrates the creative combination of earlier sculptural traditions that is a hallmark of Augustan art. In its idealization of a specific ruler and his prowess, the sculpture also illustrates the way Roman emperors would continue to use portraiture for propaganda that not only expressed their authority directly, but rooted it in powerfully traditional stories and styles.

The sculptor of this larger-than-life marble statue adapted the standard pose of a Roman orator (see FIG. 6-15) by melding it with the contrapposto and canonical proportions developed by the Greek High Classical sculptor Polykleitos, as exemplified by his *Spear Bearer* (see "'The Canon' of Polykleitos," page 134), Like the heroic Greek figure, Augustus' portrait captures him in the physical prime of youth, far removed from the image of advanced age idealized in the coin portrait of Julius Caesar. Although Augustus lived almost to age 76, in his portraits he is always a vigorous ruler, eternally young. But like Caesar, and unlike the *Spear Bearer*, Augustus' face is rendered with the kind of details that make this portrait an easily recognizable likeness.

To this combination of Greek and Roman traditions, the sculptor of the Augustus of Primaporta added mythological and historical imagery that exalts Augustus' family and celebrates his accomplishments. Cupid, son of the goddess Venus, rides a dolphin next to the emperor's right leg, a reference to the claim of the emperor's family, the Julians, to descent from the goddess Venus through her human son Aeneas. Augustus' anatomically conceived cuirass (torso armor) is also covered with figural imagery. Midtorso is a scene representing Augustus' 20 BCE diplomatic victory over the Parthians; a Parthian (on the right) returns a Roman military standard to a figure variously identified as a Roman soldier or the goddess Roma. Looming above this scene at the top of the cuirass is a celestial deity who holds an arched canopy, implying that the peace signified by the scene below has cosmic implications. The personification of the earth at the bottom of the cuirass holds an overflowing cornucopia, representing the prosperity brought by Augustan peace.

Another Augustan monument that synthesizes Roman traditions and Greek Classical influence to express the peace and prosperity that Augustus brought to Rome is the Ara Pacis Augustae (see "The Ara Pacis Augustae," page 174). The processional friezes on the exterior sides of the enclosure wall clearly reflect Classical Greek works like the Ionic frieze of the Parthenon (see FIG. 5–40), with their three-dimensional figures wrapped in revealing draperies that also create rhythmic patterns of rippling folds. But unlike the Greek sculptors of the Parthenon, the Roman sculptors of the Ara Pacis depicted actual individuals participating in a specific event at a known time. The Classical style may evoke the general notion of a Golden Age, but the historical references and identifiable figures in the Ara Pacis procession associate that Golden Age specifically with Augustus and his dynasty.

THE JULIO-CLAUDIANS

After his death in 14 CE, Augustus was deified by decree of the Roman Senate and succeeded by his stepson Tiberius (r. 14–37 CE). In acknowledgment of the lineage of both—Augustus from Julius Caesar and Tiberius from his father, Tiberius Claudius Nero, Livia's first husband—the dynasty is known as the Julio-Claudian (14–68 CE). It ended with the death of Nero in 68 CE.

An exquisite large onyx **cameo** (a gemstone carved in low relief) known as the **GEMMA AUGUSTEA** glorifies Augustus as triumphant over barbarians (a label for foreigners that the Romans

Early 1st century CE. Perhaps a copy of a bronze statue of c. 20 BCE. Marble, originally colored, height 6'8" (2.03 m). Musei Vaticani, Braccio Nuovo, Rome.

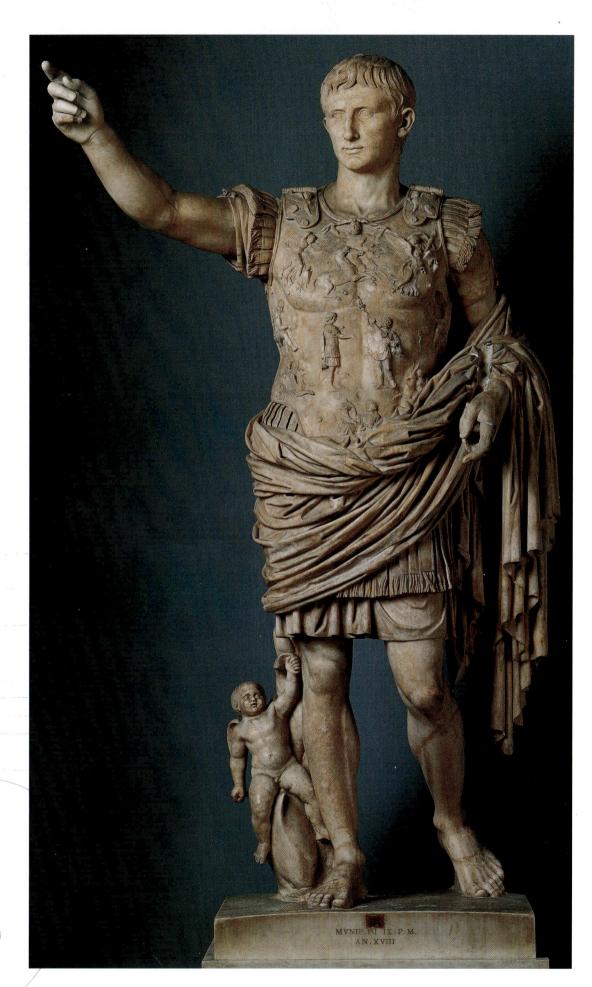

A BROADER LOOK | The Ara Pacis Augustae

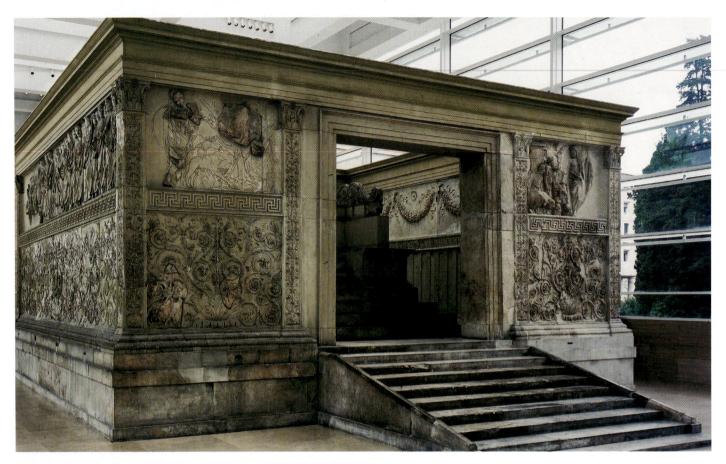

6-20 • ARA PACIS AUGUSTAE (ALTAR OF AUGUSTAN PEACE) Rome. 13–9 BCE. View of west side. Marble, approx. 34'5" × 38' (10.5 × 11.6 m).

This monument was begun when Augustus was 50 (in 13 BCE) and was dedicated on Livia's 50th birthday (9 BCE).

One of the most extraordinary surviving Roman monuments from the time of Augustus is the **ARA PACIS AUGUSTAE**, or Altar of Augustan Peace (**FIG. 6–20**), begun in 13 BCE and dedicated in 9 BCE, on the occasion of Augustus' triumphal return to the capital after three years spent establishing Roman rule in Gaul and Hispania. In its original location in the Campus Martius (Plain of Mars), the Ara Pacis was aligned with a giant sundial, marked out on the pavement with lines and bronze inscriptions, using as its pointer an Egyptian obelisk that Augustus had earlier brought from Heliopolis to signify Roman dominion over this ancient land.

The Ara Pacis itself consists of a walled rectangular enclosure surrounding an openair altar, emulating Greek custom (**FIG. 6–21**). Made entirely of marble panels carved with elaborate sculpture, the monument presented powerful propaganda, uniting portraiture and allegory, religion and politics, the private and the public. On the inner walls, foliate garlands are suspended in swags from ox skulls. The skulls symbolize sacrificial offerings at the altar during annual commemorations, and the garlands—including fruits and flowers from every season—signify the continuing peace and prosperity that Augustus brought to the Roman world.

On the exterior, this theme of natural prosperity continues in lower reliefs of lavish, scrolling acanthus populated by animals. Above them, decorative allegory gives way to figural tableaux. On the front and back are framed allegorical scenes evoking the mythical history of Rome and the divine ancestry of Augustus. The longer sides portray two continuous processions, seemingly representing actual historical events rather than myth or allegory. Perhaps they document Augustus' triumphal return, or they could memorialize the dedication and first sacrifice performed by Augustus on the completed altar itself. In any event, the arrangement of the participants is emblematic of the fundamental dualism characterizing Roman rule under Augustus. On one side march members of the Senate, a stately line of male elders. But on the other is Augustus' imperial family (FIG. 6-22)men, women, and notably, children, who stand in the foreground as Augustus' hopes for dynastic succession. Whereas most of the adults maintain their focus on the ceremonial event, the imperial children are allowed to fidget, look at their cousins, or reach up to find comfort in holding the hands or tugging at the garments of the adults around them, one of whom puts her finger to her mouth in a shushing gesture, perhaps seeking to mitigate their distracting behavior. The lifelike aura brought by such anecdotal details underlines the earthborn reality of the ideology embodied here. Rome is now subject to the imperial rule of the family of Augustus, and this stable system will bring continuing peace and prosperity since his successors have already been born.

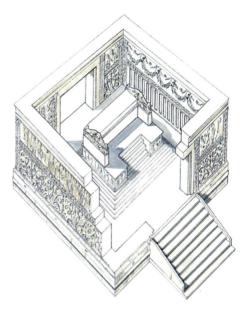

The Ara Pacis did not survive from antiquity in the form we see today. The monument eventually fell into disuse, ultimately into ruin. Remains were first discovered in 1568, but complete excavation took place only in 1937– 1938, under the supervision of archaeologist Giuseppe Moretti, sponsored by dictator Benito Mussolini, who was fueled by his own ideological objectives. Once the monument had been unearthed, Mussolini had it reconstructed and commissioned a special building to house it, close to the **Mausoleum** (monumental tomb) of Augustus, all in preparation for celebrating the 2,000th anniversary of Augustus' birth and associating

6-21 • RECONSTRUCTION DRAWING OF THE ARA PACIS AUGUSTAE

the Roman imperial past with Mussolini's fascist state. The dictator even planned his own burial within Augustus' mausoleum.

More recently, the City of Rome commissioned American architect Richard Meier to design a new setting for the Ara Pacis, this time within a sleek, white box with huge walls of glass that allow natural light to flood the exhibition space (seen in FIG. 6–20). Many Italian critics decried the Modernist design of Meier's building—completed in 2006—but this recent urban renewal project focused on the Ara Pacis has certainly revived interest in one of the most precious remains of Augustan Rome.

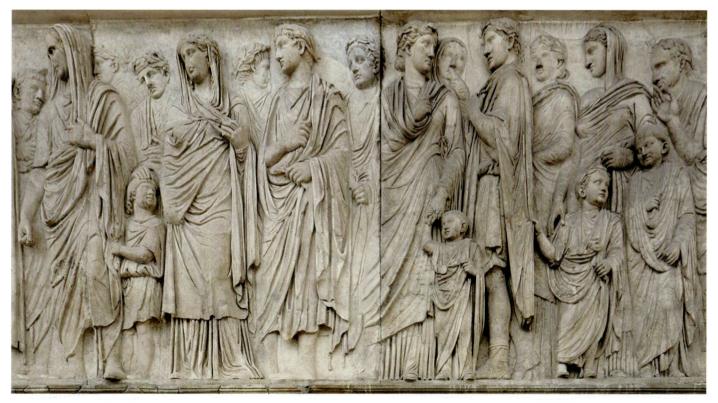

6-22 • IMPERIAL PROCESSION

Detail of a relief on the south side of the Ara Pacis. Height 5'2" (1.6 m).

The figures in this frieze represent members of Augustus' extended family, and scholars have proposed some specific, if tentative, identifications. The middle-aged man with the shrouded head at the far left is generally accepted to be a posthumous portrait of Marcus Agrippa, who would have been Augustus' successor had he not predeceased him in 12 BCE. The bored but well-behaved youngster pulling at Agrippa's robe—and being restrained gently by the hand of the man behind him—is probably Agrippa's son Gaius Caesar. The heavily swathed woman next to Agrippa on the right may be Augustus' wife, Livia, followed perhaps by Tiberius, who would become the next emperor. Behind Tiberius could be Antonia, the niece of Augustus, looking back at her husband, Drusus, Livia's younger son. She may grasp the hand of Germanicus, one of her younger children. The depiction of children and real women in an official relief was new to the Augustan period and reflects Augustus' desire to promote private family life as well as to emphasize his potential heirs and thus the continuity of his dynasty.

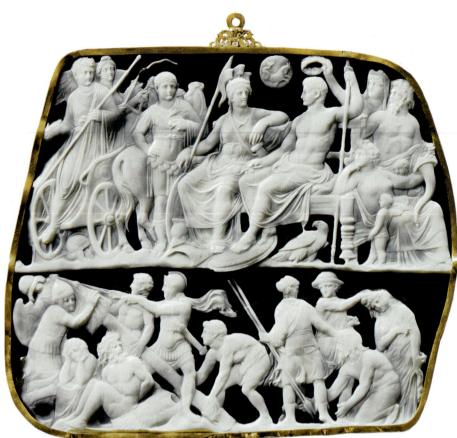

6-23 · GEMMA AUGUSTEA Early 1st century ce. Onyx, $7\frac{1}{2}'' \times 9''$ (19 × 23 cm). Kunsthistorisches Museum, Vienna.

adopted from the Greeks) and as the deified emperor (**FIG. 6-23**). The emperor, crowned with a victor's wreath, sits at the center right of the upper register. He has assumed the pose and identity of Jupiter, the king of the gods; an eagle, sacred to Jupiter, stands at his feet. Sitting next to him is a personification of Rome that seems to have Livia's features. The sea goat in the roundel between them may represent Capricorn, the emperor's zodiac sign.

Tiberius, as the adopted son of Augustus, steps out of a chariot at far left, returning victorious from the German front, prepared to assume the imperial throne as Augustus' chosen heir. Below this realm of godlike rulers, Roman soldiers are raising a post or standard on which armor captured from the defeated enemy is displayed as a trophy. The cowering, shackled barbarians on the bottom right wait to be tied to it. The artist of the Gemma Augustea brilliantly combines idealized, heroic figures based on Classical Greek art with recognizable Roman portraits, the dramatic action of Hellenistic art with Roman attention to descriptive detail and historical specificity.

ROMAN CITIES AND THE ROMAN HOME

In good times and bad, individual Romans—like people everywhere at any time—tried to live a decent or even comfortable life with adequate shelter, food, and clothing. The Romans loved to have contact with the natural world. The middle classes enjoyed their gardens, wealthy city dwellers maintained rural estates, and Roman emperors had country villas that were both functioning farms and places of recreation. Wealthy Romans even brought nature indoors by commissioning artists to paint landscapes on the interior walls of their homes. Through the efforts of the modern archaeologists who have excavated them, Roman cities and towns, houses, apartments, and country villas still evoke for us the ancient Roman way of life with amazing clarity.

ROMAN CITIES Roman architects who designed new cities or who expanded and rebuilt existing ones based the urban plan on the layout of Roman army camps. Like Etruscan towns, they were designed as a grid with two bisecting main streets crossing at right angles to divide the layout into quarters. The **forum** and other public buildings were generally located at this intersection, where the commander's headquarters was placed in a military camp.

Much of the housing in a Roman city consisted of brick apartment blocks called *insulae*. These apartment buildings had internal courtyards, multiple floors joined by narrow staircases, and occasionally overhanging balconies. City dwellers—then as now—were social creatures who spent much of their lives in public markets, squares, theaters, baths, and neighborhood bars. The city dweller returned to the *insulae* to sleep, perhaps to eat. Even women enjoyed a public life outside the home—a marked contrast to the circumscribed lives of Greek women.

The affluent southern Italian city of Pompeii, a thriving center of between 10,000 and 20,000 inhabitants, gives a vivid picture of Roman city life. In 79 CE Mount Vesuvius erupted, burying the city under more than 20 feet of volcanic ash and preserving it until its rediscovery and excavation, beginning in the eighteenth century (**FIGS. 6-24, 6-25**). Temples and government buildings surrounded a main square, or forum; shops and houses lined mostly straight, paved streets; and a protective wall enclosed the heart of the city. The forum was the center of civic life in Roman cities, as the agora was in Greek cities. Business was conducted in its basilicas and porticos, religious duties performed in its temples, and speeches delivered in its open square. For recreation, people went to the nearby baths or to events in the theater or amphitheater.

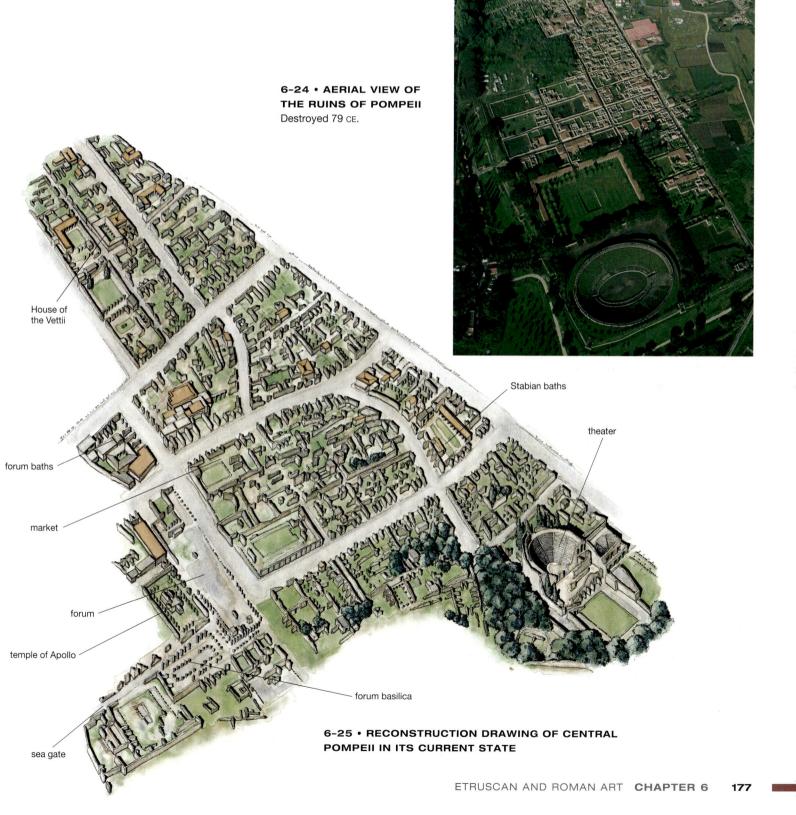

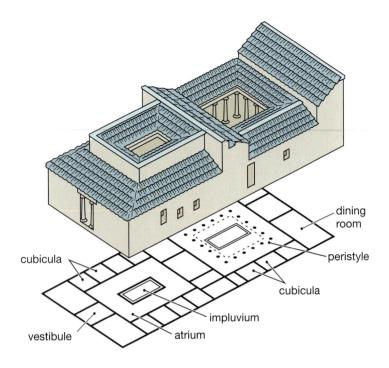

6-26 • PLAN AND RECONSTRUCTION DRAWING OF THE HOUSE OF THE SILVER WEDDING Pompeii. 1st century ce.

ROMAN HOUSES Wealthy city dwellers lived in private houses with enclosed gardens and were often fronted by shops facing the street. The Romans emphasized the interior rather than the exterior in such gracious domestic architecture.

A Roman house usually consisted of small rooms laid out around one or two open courts, the atrium and the peristyle (FIG. 6-26). People entered the house from the street through a vestibule and stepped into the atrium, a large space with an impluvium (pool for catching rainwater). The peristyle was a planted courtyard, farther into the house, enclosed by columns. Off the peristyle was the formal reception room or office called the tablinum, and here the head of the household conferred with clients. Portrait busts of the family's ancestors might be displayed in the tablinum or in the atrium. The private areas-such as the family dining and sitting rooms, as well as bedrooms (cubicula)-and service areas-such as the kitchen and servants' quarters-could be arranged around the peristyle or the atrium. In Pompeii, where the mild southern climate permitted gardens to flourish year-round, the peristyle was often turned into an outdoor living room with painted walls, fountains, and sculpture, as in the mid first-century CE remodeling of the second-century BCE HOUSE OF THE VETTI (FIG. 6-27). Since Roman houses were designed in relation to a

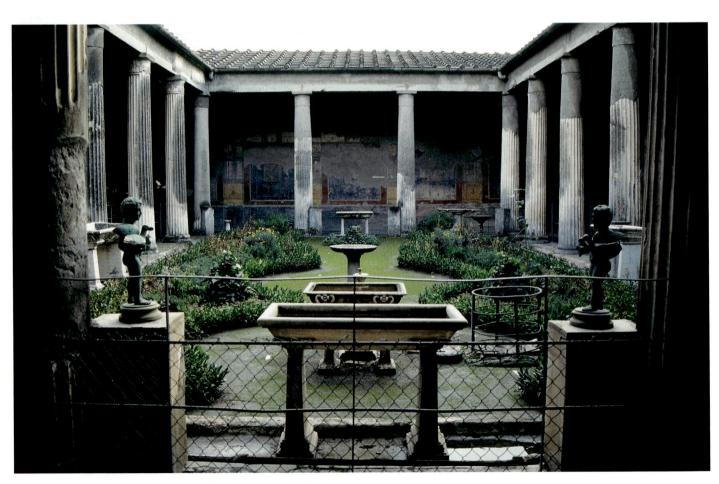

6-27 • PERISTYLE GARDEN, HOUSE OF THE VETTII Pompeii. Rebuilt 62–79 ce.

long axis that runs from the entrance straight through the atrium and into the peristyle, visitors were greeted at the door of the house with a deep vista, showcasing the lavish residence of their host and its beautifully designed and planted gardens extending into the distance.

Little was known about these gardens until archaeologist Wilhelmina Jashemski (1910–2007) excavated the peristyle in the House of G. Polybius in Pompeii, beginning in 1973. Earlier archaeologists had usually ignored, or unwittingly destroyed, evidence of gardens, but Jashemski developed a new way to find and analyze the layout and the plants cultivated in them. Workers first removed layers of debris and volcanic material to expose the level of the soil as it was before the eruption in 79 CE. They then collected samples of pollen, seeds, and other organic material and carefully injected plaster into underground root cavities. When the surrounding earth was removed, the roots, now in plaster, enabled botanists to identify the types of plants and trees cultivated in the garden and to estimate their size.

The garden in the house of Polybius was surrounded on three sides by a portico, which protected a large cistern on one side that

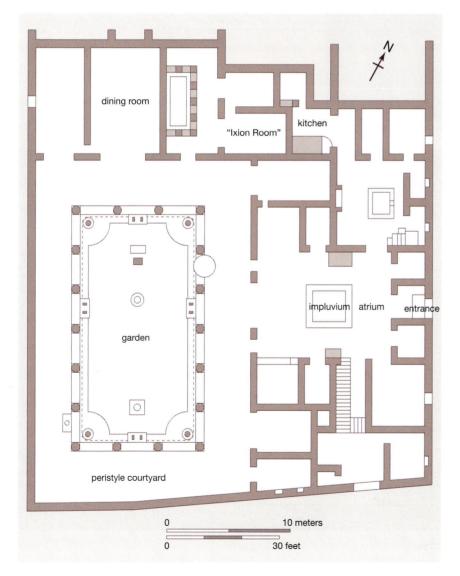

supplied the house and garden with water. Young lemon trees in pots lined the fourth side of the garden, and nail holes in the wall above the pots indicated that the trees had been espaliered pruned and trained to grow flat against a support—a practice still in use today. Fig, cherry, and pear trees filled the garden space, and traces of a fruit-picking ladder, wide at the bottom and narrow at the top to fit among the branches, was found on the site.

An aqueduct built during the reign of Augustus eliminated Pompeii's dependence on wells and rainwater basins and allowed residents to add pools, fountains, and flowering plants that needed heavy watering to their gardens. In contrast to earlier, unordered plantings, formal gardens with low, clipped borders and plantings of ivy, ornamental boxwood, laurel, myrtle, acanthus, and rosemary—all mentioned by writers of the time—became fashionable. There is also evidence of topiary work, the clipping of shrubs and hedges into fanciful shapes, sculpture, and fountains. The peristyle garden of the House of the Vettii, for example, had more than a dozen fountain statues jetting water into marble basins (see FIG. 6–27). In the most elegant peristyles, mosaic decorations covered the floors, walls, and fountains.

WALL PAINTING

The interior walls of Roman houses were plain, smooth plaster surfaces with few architectural moldings or projections. On these invitingly blank fields, artists painted decorations. Some used mosaic, but most employed pigment suspended in a water-based solution of lime and soap, sometimes with a little wax. After such paintings were finished, they were polished with a special metal, glass, or stone burnisher and then buffed with a cloth. Many fine wall paintings in a series of developing styles (see, "August Mau's Four Styles of Pompeian Painting," page 182) have come to light through excavations, first in Pompeii and other communities surrounding Mount Vesuvius, near Naples, and more recently in and around Rome.

HOUSE OF THE VETTII Some of the finest surviving Roman wall paintings are found in the Pompeian House of the Vettii, whose peristyle garden we have already explored (see FIG. 6–27). The house was built in conformity to the axial house plan—with entrance leading through atrium to peristyle garden (**FIG. 6–28**)—by two

6-28 • PLAN OF THE HOUSE OF THE VETTII Pompeii. Rebuilt 62–79 cc.

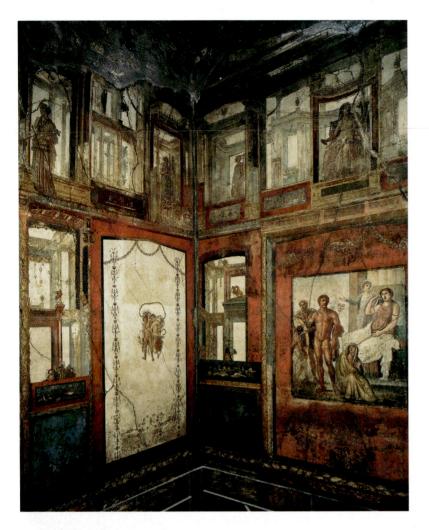

6-29 • WALL PAINTING IN THE "IXION ROOM," HOUSE OF THE VETTII Pompeii, Rebuilt 62-79 cc.

brothers, wealthy freed slaves A. Vettius Conviva and A. Vettius Restitutus. Between its damage during an earthquake in 62 CE and the eruption of Vesuvius in 79 CE, the walls of the house were repainted, and this spectacular Fourth-Style decoration was uncovered in a splendid state of preservation during excavations at the end of the nineteenth century.

A complex combination of painted fantasies fills the walls of a reception room off the peristyle garden (**FIG. 6-29**). At the base of the walls is a lavish frieze of simulated colored-marble revetment, imitating the actual stone veneers that are found in some Roman residences. Above this "marble" dado are broad areas of pure red or white, onto which are painted pictures resembling framed panel paintings, swags of floral garlands, or unframed figural vignettes. The framed picture here illustrates a Greek mythological scene from the story of Ixion, who was bound by Zeus to a spinning wheel in punishment for attempting to seduce Hera. Between these pictorial fields, and along a long strip above them that runs around the entire room, are fantastic architectural vistas with multicolored columns and undulating

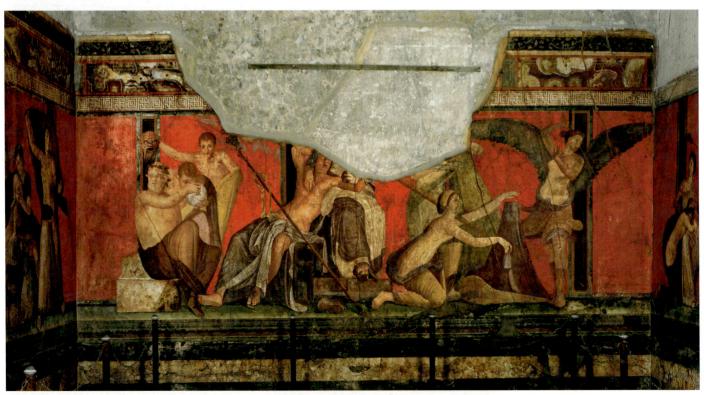

6-30 • INITIATION RITES OF THE CULT OF BACCHUS (?), VILLA OF THE MYSTERIES Pompeii. Wall painting. c. 60–50 BCE.

entablatures that recede into fictive space through the use of fanciful linear perspective. The fact that this fictive architecture is occupied here and there by volumetric figures only enhances the sense of three-dimensional spatial definition.

VILLAS Villas were the country houses of wealthy Romans, and their plans, though resembling town houses, were often more expansive and irregular. The eruption of Vesuvius in 79 CE preserved not only the houses along the city streets within Pompeii, but also the so-called VILLA OF THE MYSTERIES just outside the city walls. Here a series of elaborate figural murals from the mid first century BCE (FIG. 6–30) seem to portray the initiation rites of a mystery religion, probably the cult of Bacchus, which were often performed in private homes as well as in special buildings or temples. Perhaps this room in this villa was a shrine or meeting place for such a cult to this god of vegetation, fertility, and wine. Bacchus (or Dionysus) was one of the most important deities in Pompeii.

The entirely painted architectural setting consists of a simulated marble dado (similar to that which we saw in the House of the Vettii) and, around the top of the wall, an elegant frieze supported by painted pilaster strips. The figural scenes take place on a shallow "stage" along the top of the dado, with a background of a brilliant, deep red—now known as Pompeian red—that, as we have already seen, was very popular with Roman painters. The tableau unfolds around the entire room, perhaps depicting a succession of events that culminate in the acceptance of an initiate into the cult.

The walls of a room from another villa, this one at Boscoreale, farther removed from Pompeii and dating slightly later, open onto a fantastic urban panorama (**FIG. 6-31**). Surfaces seem to dissolve behind an inner frame of columns and lintels, opening onto a maze

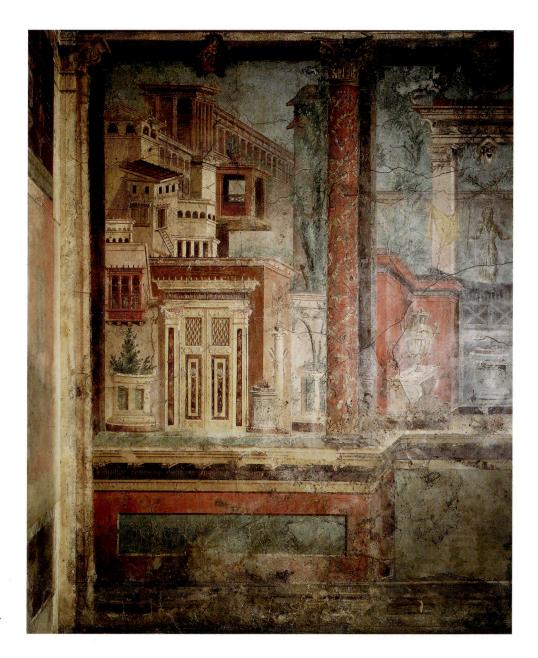

6-31 • CITYSCAPE, HOUSE OF PUBLIUS FANNIUS SYNISTOR Boscoreale. Detail of a wall painting from a bedroom. c. 50–30 BCE. Metropolitan Museum of Art, New York.

Rogers Fund, 1903. (03.14.13)

ART AND ITS CONTEXTS | August Mau's Four Styles of Pompeian Painting

In the 1870s, German art historian August Mau (1840–1909), in an early analysis of Pompeian wall painting proposed a schematic organizing system that is still used by many today to categorize its stylistic development. In the earliest wall paintings from Pompeii, artists covered the walls with illusionistic paintings of thin slabs of colored marble and projecting architectural moldings. Mau referred to this as First-Style wall painting (c. 300–100 все). By about 100 все, painters began to extend the space of a room visually with scenes of figures on a shallow platform or with landscapes or cityscapes (see FIGS. 6–30, 6–31)—Mau's Second Style (c. 100–20 все). Starting in

the late first century BCE, Third-Style wall painting replaced vistas with solid planes of color, decorated with slender, whimsical architectural and floral details and small, delicate vignettes (c. 20 BCE–C. 50 CE). In the final phase of Pompeian wall painting, the Fourth Style (c. 50–79 CE) united all three earlier styles into compositions of enormous complexity (see FIG. 6–29), where some wall surfaces seem to recede or even disappear behind a maze of floating architectural forms, while other flat areas of color become the support for simulated paintings of narrative scenes or still lifes (compositions of inanimate objects) (e.g., see FIG. 6–32).

of complicated architectural forms, like the painted scenic backdrops of a stage. Indeed, the theater may have inspired this kind of decoration, as the theatrical masks hanging from the lintels seem to suggest. By using a kind of **intuitive perspective**, the artists have created a general impression of real space beyond the wall. In intuitive perspective, the architectural details follow diagonal lines that the eye interprets as parallel lines receding into the distance, and objects meant to be perceived as far away from the surface plane of the wall are shown gradually smaller and smaller than those intended to appear in the foreground.

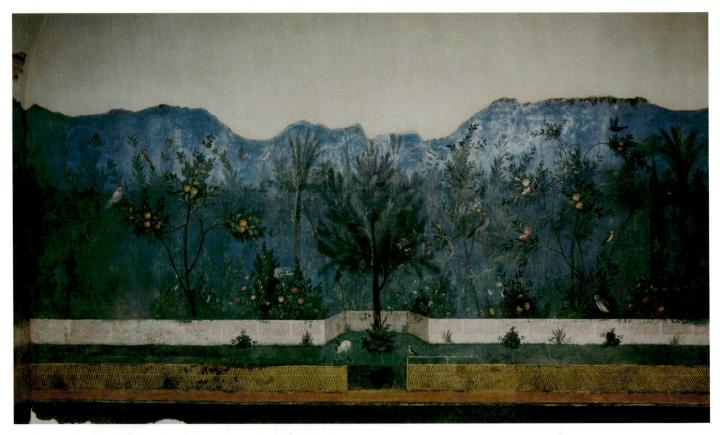

6-32 • GARDEN VISTA, VILLA OF LIVIA AT PRIMAPORTA Near Rome. Late 1st century BCE. Museo Nazionale Romano, Rome.

Like the garlands and curling vine scrolls on the Ara Pacis Augustae (see Fig. 6–20), the lush fertility of nature seems to celebrate the vitality and prosperity of Rome under Augustan peace.

ART AND ITS CONTEXTS | A Painter at Work

This fresco—portraying a painter absorbed in her art—once decorated the walls of a house in Pompeii (**FIG. 6–33**). Like women in Egypt and Crete, Roman women were far freer and more worldly than their Greek counterparts. Many received a formal education and became physicians, writers, shopkeepers, even overseers in such male-dominated businesses as shipbuilding. But we have little information about the role women played in the visual arts, making the testimony of this picture all the more precious.

The painter sits within a room that opens behind her to the outdoors, holding her palette in her left hand, a sign of her profession. She is dressed in a long robe, covered by an ample mantle, and her hair is pulled back by a gold headband; but lighting and composition highlight two other aspects of her body: her centralized face, which focuses intently on the subject of her painting-a sculptured rendering of the bearded fertility god Priapus appearing in the shadows of the right background-and her right arm, which extends downward so she can dip her brush into a paintbox that rests precariously on a rounded column drum next to her folding stool. A small child steadies the panel on which she paints, and two elegantly posed and richly dressed women-perhaps her patrons-stand next to a pier behind her. The art she is practicing reflects well on her social position. Pliny the Elder claimed that "Among artists, glory is given only to those who paint panel paintings" (Natural History 35.118). Wall paintings, he claimed, are of lesser value because they cannot be removed in case of fire. In this fresco, however, fixed positioning facilitated survival. When Mount Vesuvius erupted in 79 CE, it was wall paintings like this one that were preserved for rediscovery by eighteenth-century archaeologists.

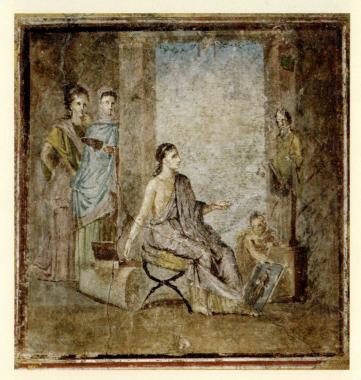

6-33 • A PAINTER AT WORK

From the House of the Surgeon, Pompeii. 1st century $_{BCE-1}$ st century cc. Fresco, $17^7\!\!/_8''\times17^3\!\!/_8''$ (45.5 \times 45.3 cm). Museo Archeologico Nazionale, Naples.

This painting of a female artist at work was conceived as a simulated panel painting, positioned on the yellow wall of a small room (compare the red wall in FIG. 6–29). It was revered so highly by the archaeologists who discovered it in 1771 that it was cut out of the wall to be exhibited as a framed picture in a museum, a practice that would be anathema today but was far from unusual in the eighteenth century.

Close to Rome, the late first-century BCE paintings on the dining-room walls of Livia's villa at Primaporta, exemplify yet another approach to creating a sense of expanded space with murals (**FIG. 6-32**). Instead of rendering a stage set or opening onto an expansive architectural vista, the artists here "dissolved" wall surfaces by creating the illusion of being on a porch or pavilion looking out over a low wall into an orchard of flowering shrubs and heavily laden fruit trees populated by a variety of wonderfully observed birds—an idealized view of the carefully cultivated natural world. Here the painters used **atmospheric perspective**, where the world becomes progressively less distinct as it recedes into the distance.

ROMAN REALISM IN DETAILS: STILL LIFES AND POR-

TRAITS In addition to cityscapes, landscapes and figural tableaux, other subjects that appeared in Roman art included exquisitely rendered genre scenes (see "A Painter at Work," above), still lifes,

and portraits. A still-life panel from Herculaneum, a community in the vicinity of Mount Vesuvius near Pompeii, depicts everyday domestic objects—still-green peaches just picked from the tree and a glass jar half-filled with water (**FIG. 6-34**). The items have been carefully arranged on two stepped shelves to give the composition clarity and balance. A strong, clear light floods the picture from left to right, casting shadows, picking up highlights, and enhancing the illusion of solid objects in real space.

Few Pompeian paintings are more arresting than a double portrait of a young husband and wife (**FIG. 6–35**), who look out from their simulated spatial world beyond the wall into the viewers' space within the room. The swarthy, wispy-bearded man addresses us with a direct stare, holding a scroll in his left hand, a conventional attribute of educational achievement seen frequently in Roman portraits. Though his wife overlaps him to stake her claim to the foreground, her gaze out at us is less direct. She also holds fashionable attributes of literacy—the stylus she elevates in front of

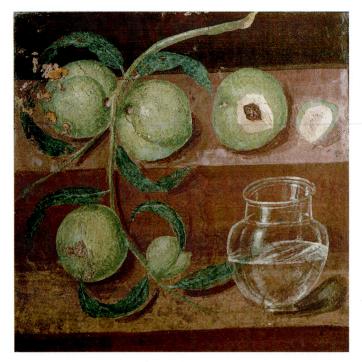

6-34 • STILL LIFE, HOUSE OF THE STAGS (CERVI)

Herculaneum. Detail of a wall painting. Before 79 CE. Approx. $1'2'' \times 1'\frac{1}{2}''$ (35.5 \times 31.7 cm). Museo Archeologico Nazionale, Naples.

her chin and the folding writing tablet on which she would have used the stylus to inscribe words into a wax infill. This picture is comparable to a modern studio portrait photograph—perhaps a wedding picture—with its careful lighting and retouching, conventional poses and accoutrements. But the attention to physiognomic detail—note the differences in the spacing of their eyes and the shapes of their noses, ears, and lips—makes it quite clear that we are in the presence of actual human likenesses.

THE FLAVIANS

The Julio-Claudian dynasty ended with the suicide of Nero in 68 CE, which led to a brief period of civil war. Eventually an astute general, Vespasian, seized control of the government in 69 CE, founding a new dynasty known as the Flavian—practical military men who inspired confidence and ruled for the rest of the first century, restoring the imperial finances and stabilizing the frontiers. They replaced the Julio-Claudian fashion for classicizing imperial portraiture with a return to the ideal of time-worn faces, enhancing the effects of old age.

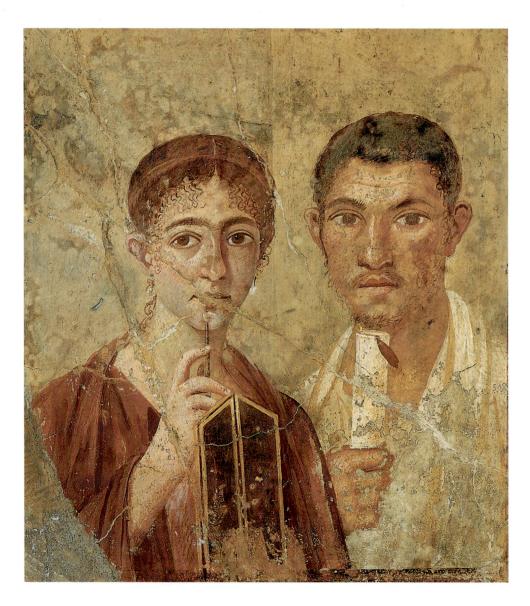

6-35 • PORTRAIT OF A MARRIED COUPLE Wall painting from Pompeii. Mid 1st century cE. Height 25¹/₂" (64.8 cm). Museo Archeologico Nazionale, Naples. THE ARCH OF TITUS When Domitian assumed the throne in 81 CE, he immediately commissioned a triumphal arch to honor the capture of Jerusalem in 70 CE by his brother and deified predecessor, Titus. Part architecture, part sculpture, and distinctly Roman, free-standing triumphal archs commemorate a triumph, or formal victory celebration, during which a victorious general or emperor paraded through Rome with his troops, captives, and booty. Constructed of concrete and faced with marble, **THE ARCH OF TITUS (FIG. 6-36)** is essentially a free-standing gateway whose passage is covered by a barrel vault and which served as a giant base, 50 feet tall, for a lost bronze statue of the emperor in a four-horse chariot, a typical triumphal symbol. Applied to the faces of the arch are columns in the Composite order supporting an entablature. The inscription on the uppermost, or attic, story declares that the Senate and the Roman people erected the monument to honor Titus.

Titus' capture of Jerusalem ended a fierce campaign to crush a revolt of the Jews in Palestine. The Romans sacked and destroyed

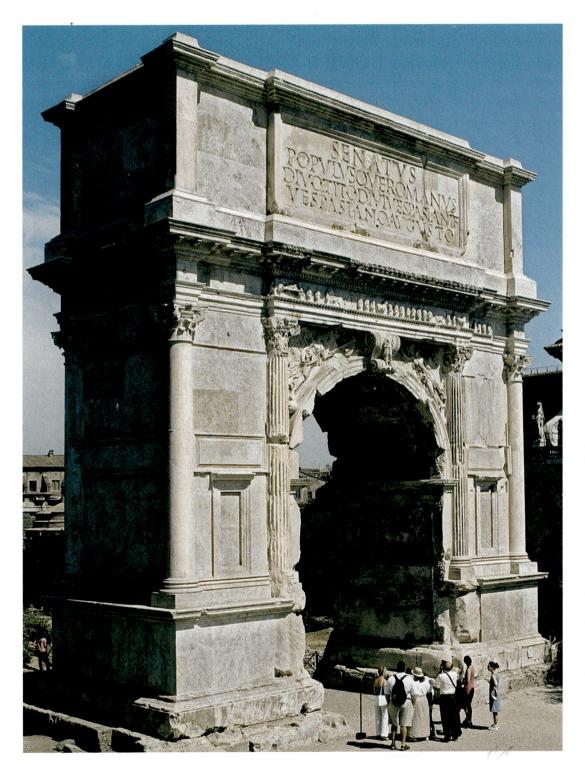

6-36 • THE ARCH OF TITUS

Rome. c. 81 cE (restored 1822–1824). Concrete and white marble, height 50' (15 m).

The dedication inscribed across the tall attic story above the arch opening reads: "The Senate and the Roman people to the Deified Titus Vespasian Augustus, son of the Deified Vespasian." The perfectly sized and spaced Roman capital letters meant to be read from a distance and cut with sharp terminals (serifs) to catch the light established a standard that calligraphers and font designers still follow.

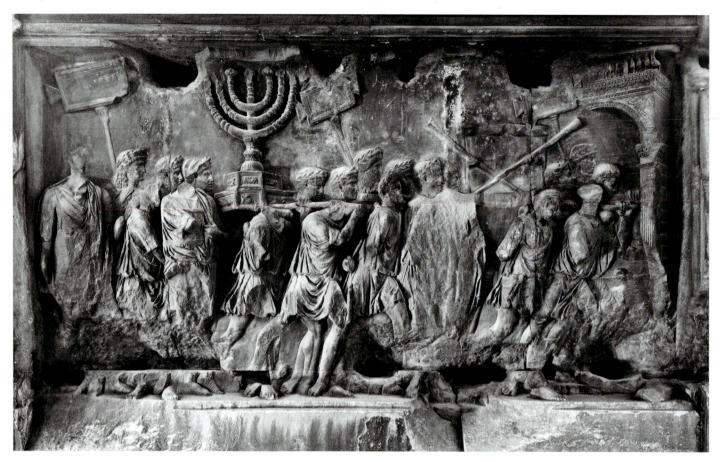

6-37 • **SPOILS FROM THE TEMPLE IN JERUSALEM** Relief in the passageway of the Arch of Titus. Marble, height 6'8" (2.03 m).

the Temple in Jerusalem, carried off its sacred treasures, then displayed them in a triumphal procession in Rome (**FIG. 6-37**). A relief on the inside walls of the arch, capturing the drama of the occasion, depicts Titus' soldiers flaunting this booty as they carry it through the streets of Rome. The soldiers are headed toward the right and through an arch, turned obliquely to project into the viewers' own space, thus allowing living spectators a sense of the press of a boisterous, disorderly crowd. They might expect at any moment to hear soldiers and onlookers shouting and chanting.

The mood of the procession depicted in this relief contrasts with the relaxed but formal solemnity of the procession portrayed on the Ara Pacis (see FIG. 6-22), but like the sculptors of the Ara Pacis, the sculptors of the Arch of Titus showed the spatial relationships among figures by varying the depth of the relief to render nearer elements in higher relief than those more distant. A **menorah** (seven-branched lampholder) from the Temple in Jerusalem dominates the scene, rendered as if seen from the low point of view of a spectator at the event.

THE FLAVIAN AMPHITHEATER Romans were huge sports fans, and the Flavian emperors catered to their tastes by building splendid facilities. Construction of the FLAVIAN AMPHITHE-ATER, Rome's greatest arena (FIGS. 6-38, 6-39), began under Vespasian in 70 CE and was completed under Titus, who dedicated it in 80 CE. The Flavian Amphitheater came to be known as the "Colosseum," because a gigantic statue of Nero called the *Colossus* stood next to it. "Colosseum" is a most appropriate description of this enormous entertainment center. Its outer wall stands 159 feet high. It is an oval, measuring 615 by 510 feet, with a floor 280 by 175 feet. This floor was laid over a foundation of service rooms and tunnels that provided an area for the athletes, performers, animals, and equipment. The floor was covered by sand, *arena* in Latin, hence the English term "arena" for a building of this type.

Roman audiences watched a variety of athletic events, blood sports, and spectacles, including animal hunts, fights to the death between gladiators or between gladiators and wild animals, performances of trained animals and acrobats, and even mock sea battles, for which the arena would be flooded. The opening performances in 80 CE lasted 100 days, during which time it was claimed that 9,000 wild animals and 2,000 gladiators died for the amusement of the spectators.

The amphitheater is such a remarkable piece of planning with easy access, perfect sight lines, and effective crowd control—that stadiums today still use this efficient plan. Some 50,000 spectators could move easily through the 76 entrance doors to the

ELEMENTS OF ARCHITECTURE | Roman Vaulting

The Romans became experts in devising methods of covering large, open architectural spaces with concrete and masonry, using barrel vaults, groin vaults, or domes.

A **barrel vault** is constructed in the same manner as the round arch (see "The Roman Arch," page 170). In a sense, it is a series of connected arches extended in sequence along a line. The outward pressure exerted by the curving sides of the barrel vault requires buttressing within or outside the supporting walls. A third type of vault brought to technical perfection by the Romans is the **dome**. The rim of the dome is supported on a circular wall, as in the Pantheon (see FIGS. 6–49, 6–50, 6–52). This wall is called a drum when it is raised on top of a main structure. Sometimes a circular opening, called an **oculus**, is left at the top.

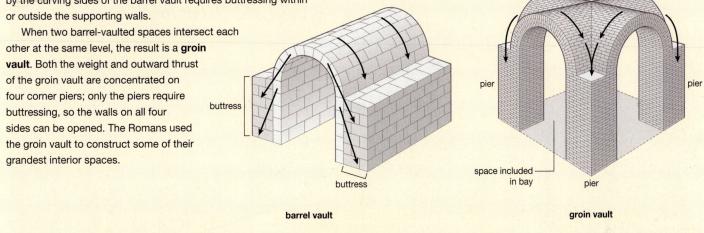

• Watch an architectural simulation about the groin vault on myartslab.com

three levels of seats—laid over barrel-vaulted access corridors and entrance tunnels—and the standing area at the top. Each spectator had an uninterrupted view of the events below, and the walls on the top level supported a huge awning that could shade the seats. Sailors, who had experience in handling ropes, pulleys, and large expanses of canvas, worked the apparatus that extended the awning.

The curving, outer wall of the Colosseum consists of three levels of arcades surmounted by a wall-like attic (top) story. Each

arch is framed by engaged columns. Entablature-like friezes mark the divisions between levels. Each level also uses a different architectural order, increasing in complexity from bottom to top: the plain Tusean order on the ground level, Ionic on the second level, Corinthian on the third, and Corinthian pilasters on the fourth. The attic story is broken by small, square windows, which originally alternated with gilded-bronze shield-shaped ornaments called **cartouches**, supported on brackets that are still in place.

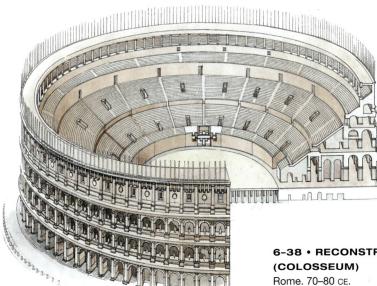

6-38 • RECONSTRUCTION DRAWING OF THE FLAVIAN AMPHITHEATER (COLOSSEUM)

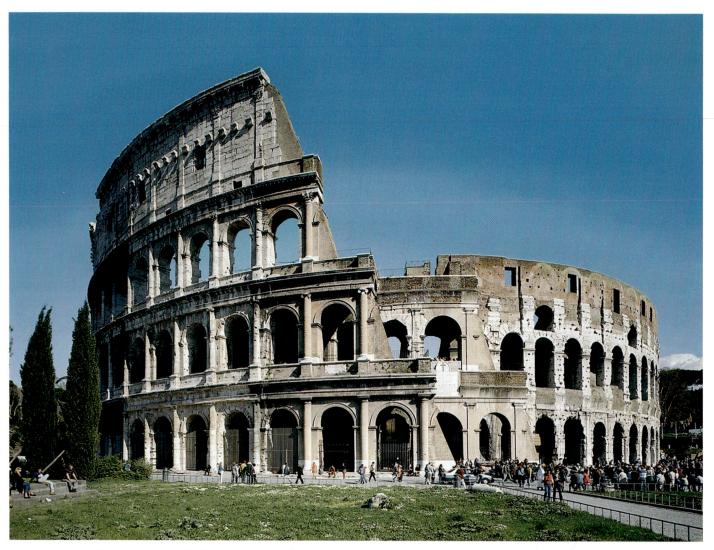

6-39 • OUTER WALL OF THE FLAVIAN AMPHITHEATER Rome. 70–80 CE.

All these elements are purely decorative. As we saw in the Etruscan Porta Augusta (see FIG. 6-2), the addition of post-and-lintel decoration to arched structures was an Etruscan innovation. The systematic use of the orders in a logical succession from sturdy Tuscan to lighter Ionic to decorative Corinthian follows a tradition inherited from Hellenistic architecture. This orderly, dignified, and visually satisfying way of organizing the façades of large buildings is still popular. Unfortunately, much of the Colosseum was dismantled in the Middle Ages as a source of marble, metal fittings, and materials for buildings such as churches.

PORTRAIT SCULPTURE Roman patrons continued to expect recognizable likenesses in their portraits, but this did not preclude idealization. A portrait sculpture of a **YOUNG FLAVIAN WOMAN** (**FIG. 6-40**) is idealized in a manner similar to the *Augustus of Primaporta* (see FIG. 6-19). Her well-observed, recognizable features—a strong nose and jaw, heavy brows, deep-set eyes, and a long neck—contrast with the smoothly rendered flesh and soft, sensual lips.

Her hair is piled high in an extraordinary mass of ringlets following the latest court fashion. Executing the head required skillful chiseling and **drillwork**, a technique for rapidly cutting deep grooves with straight sides, used here to render the holes in the center of the curls. The overall effect, especially from a distance, is quite lifelike, as the play of natural light over the subtly sculpted marble surfaces simulates the textures of real skin and hair.

A contemporary bust of an older woman (**FIG. 6-41**) presents a strikingly different image of its subject. Although she also wears her hair in the latest fashion, it is less elaborate and less painstakingly confected and carved than that of her younger counterpart. The work emphasizes not the fresh sheen of an unblemished face, but a visage clearly marked by the passage of time during a life well lived. We may regard this portrait as less idealized and more naturalistic, but for a Roman viewer, it conformed to an ideal of age and accomplishment by showcasing signs of aging facial features, cherished since the Republican period as reflections of virtue and venerability.

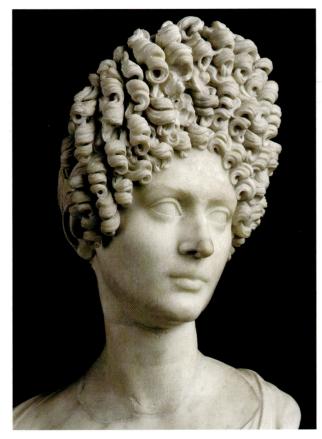

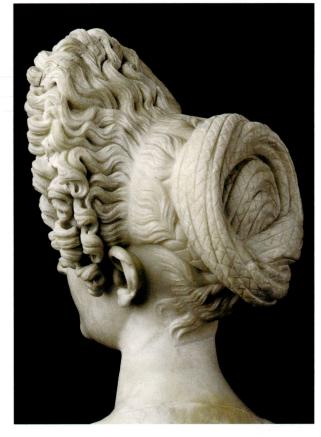

6-40 • YOUNG FLAVIAN WOMAN c. 90 cE. Marble, height 25" (65.5 cm). Museo Capitolino, Rome.

6-41 • MIDDLE-AGED FLAVIAN WOMAN Late 1st century cE. Marble, height 91/2" (24.1 cm). Musei Vaticani, Museo Gregoriano Profano, ex-Lateranese, Rome.

THE HIGH IMPERIAL ART OF TRAJAN AND HADRIAN

Domitian, the last Flavian emperor, was assassinated in 96 CE and succeeded by a senator, Nerva (r. 96–98 CE), who designated as his successor Trajan, a general born in Spain who had commanded Roman troops in Germany. For nearly a century, the empire was under the control of brilliant administrators. Instead of depending on the vagaries of fate (or genetics) to produce intelligent heirs, the emperors Nerva (r. 96–98 CE), Trajan (r. 98–117 CE), Hadrian (r. 117–138 CE), and Antoninus Pius (r. 138–161 CE)—but not his successor, Marcus Aurelius (r. 161–180 CE)—each selected an able administrator to follow him, thus "adopting" his successor. Italy and the provinces flourished, and official and private patronage of the arts increased.

Under Trajan, the empire reached its greatest territorial expanse. By 106 CE, he had conquered Dacia, roughly present-day Romania (see MAP 6-1), and his successor, Hadrian, consolidated the empire's borders and imposed far-reaching social, governmental, and military reforms. Hadrian was well educated and widely traveled, and his admiration for Greek culture spurred new building programs and classicizing works of art throughout the empire. Unfortunately, Marcus Aurelius broke the tradition of adoption and left his son, Commodus, to inherit the throne. Within 12 years, Commodus (r. 180–192 CE) had destroyed the stable government his predecessors had so carefully built.

IMPERIAL ARCHITECTURE

The Romans believed their rule extended to the ends of the Western world, but the city of Rome remained the nerve center of the empire. During his long and peaceful reign, Augustus had paved the city's old Republican Forum, restored its temples and basilicas, and followed Julius Caesar's example by building an Imperial Forum. These projects marked the beginning of a continuing effort to transform the capital into a magnificent monument to imperial rule. Such grand structures as the Imperial Forums, the Colosseum, the Circus Maximus (a track for chariot races), the Pantheon, and aqueducts stood amid the temples, baths, warehouses, and homes

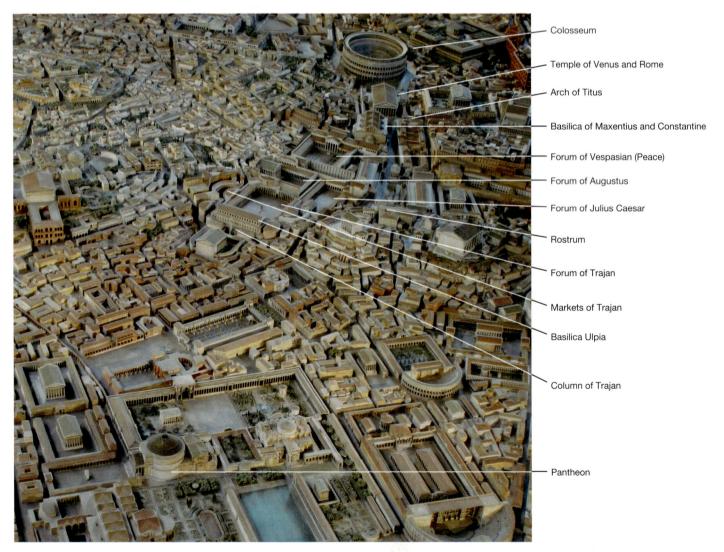

6-42 • MODEL OF IMPERIAL ROME IN c. 324 CE

in the city center as expressions of successive emperors' beneficence and their desire to leave their mark on, and preserve their memory in, the capital. A model of Rome's city center makes apparent the dense building plan (**FIG. 6-42**).

THE FORUM OF TRAJAN The last and largest Imperial Forum was built by Trajan about 110–113 CE and finished under Hadrian about 117 CE on a large piece of property next to the earlier forums of Augustus and Julius Caesar (**FIG. 6-43**). For this major undertaking, Trajan chose a Greek architect, Apollodorus of Damascus, who was experienced as a military engineer. A straight, central axis leads from the Forum of Augustus through a triple-arched gate surmounted by a bronze chariot group into a large, colonnaded square with a statue of Trajan on horseback at its center. Closing off the courtyard at the north end was the **BASILICA ULPIA** (**FIG. 6-44**), dedicated in c. 112 CE, and named for the family to which Trajan belonged.

A **basilica** was a large, rectangular building with an extensive interior space, adaptable for a variety of administrative governmental functions. The Basilica Ulpia was a court of law, but other basilicas served as imperial audience chambers, army drill halls, and schools. The Basilica Ulpia was a particularly grand interior space, 385 feet long (not including the apses) and 182 feet wide. A large central area (the **nave**) was flanked by double colonnaded aisles surmounted by open galleries or by a clerestory, an upper nave wall with windows. The timber truss roof

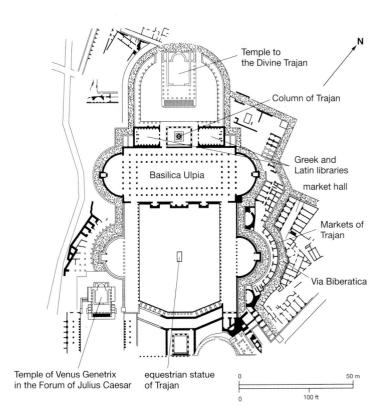

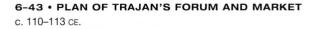

6-44 • Gilbert Gorski RESTORED PERSPECTIVE VIEW OF THE CENTRAL HALL, BASILICA ULPIA

Rome. As it was c. 112 CE.

Trajan's architect was Apollodorus of Damascus. The building may have had clerestory windows instead of the gallery shown in this drawing. The Column of Trajan can be seen through the upper colonnade at right.

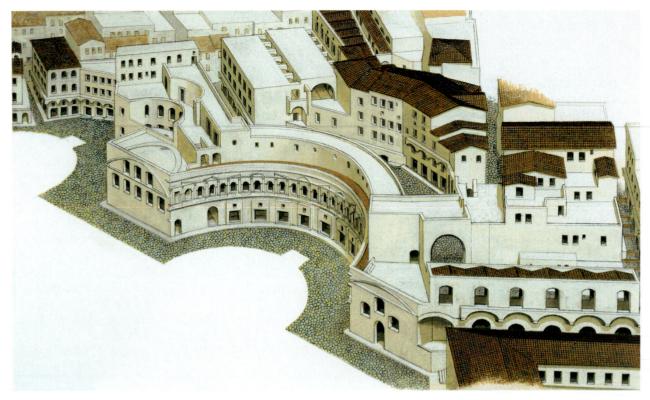

6-45 • RECONSTRUCTION DRAWING OF TRAJAN'S MARKET Rome. As it was 100–112 ce.

had a span of about 80 feet. The two **apses**, rounded extensions at each end of the building, provided imposing settings for judges when the court was in session.

During the site preparation for Trajan's forum, part of a commercial district had to be razed and excavated. To make up for the loss, Trajan ordered the construction of a handsome public market (**FIGS. 6-45, 6-46**). The market, comparable in size to a large modern shopping mall, had more than 150 individual shops

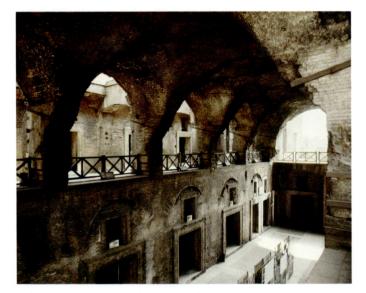

6-46 • MAIN HALL, TRAJAN'S MARKET Rome. 100–112 CE.

on several levels and included a large groin-vaulted main hall. In compliance with a building code that was put into effect after a disastrous fire in 64 CE, the market, like most Roman buildings of the time, was constructed of concrete (see "Concrete," page 194) faced with brick, with only occasional detailing in stone and wood.

Behind the Basilica Ulpia stood twin libraries built to house the emperor's collections of Latin and Greek manuscripts. These buildings flanked an open court, the location of the great spiral column that became Trajan's tomb when Hadrian placed a golden urn containing his predecessor's ashes in its base. The column commemorated Trajan's victory over the Dacians and was erected either c. 113 CE, at about the same time as the Basilica Ulpia, or by Hadrian after Trajan's death in 117 CE.

THE COLUMN OF TRAJAN The relief decoration on the **COLUMN OF TRAJAN** spirals upward in a band that would stretch almost 625 feet if laid out straight. Like a giant, unfurled version of the scrolls housed in the libraries next to it, the column presents a continuous pictorial narrative of the Dacian campaigns of 102–103 and 105–106 CE (**FIG. 6-47**). The remarkable sculpture includes more than 2,500 individual figures linked by land-scape and architecture, and punctuated by the recurring figure of Trajan. The narrative band slowly expands from about 3 feet in height at the bottom, near the viewer, to 4 feet at the top of the column, where it is farther from view. The natural and architectural elements in the scenes have been kept small so the important figures can occupy as much space as possible.

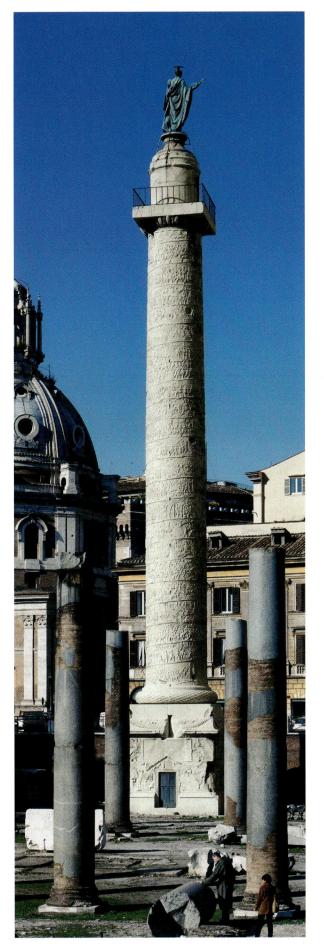

6-47 • COLUMN OF TRAJAN

Rome. 113–116 cE, or after 117 cE. Marble, overall height with base 125' (38 m); column alone 97'8'' (29.77 m); length of relief 625' (190.5 m).

The height of the column may have recorded the depth of the excavation required to build the Forum of Trajan. The gilded bronze statue of Trajan that once stood on the top was replaced in 1588 CE with the statue of St. Peter seen today.

View the Closer Look for the Column of Trajan on myartslab.com

The scene at the beginning of the spiral, at the bottom of the column, shows Trajan's army crossing the Danube River on a pontoon bridge to launch the first Dacian campaign of 101 CE (**FIG. 6–48**). Soldiers construct battlefield headquarters in Dacia from which the men on the frontiers will receive orders, food, and weapons. In this spectacular piece of imperial ideology or propaganda, Trajan is portrayed as a strong, stable, and efficient commander of a well-run army, and his barbarian enemies are shown as worthy opponents of Rome.

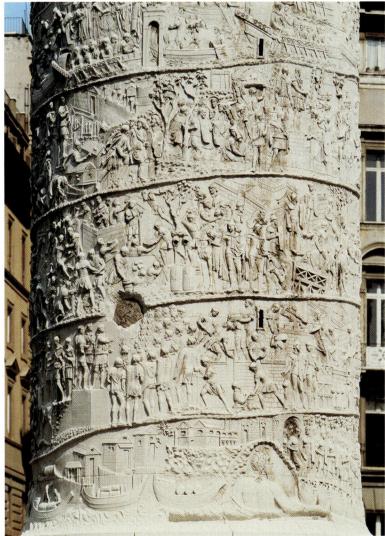

6-48 • ROMANS CROSSING THE DANUBE AND BUILDING A FORT

Detail of the lowest part of the Column of Trajan. 113–116 cE, or after 117 cE. Marble, height of the spiral band approx. 36'' (91 cm).

ELEMENTS OF ARCHITECTURE | Concrete

The Romans were pragmatic builders, and their practicality extended from recognizing and exploiting undeveloped potential in construction methods and physical materials to organizing large-scale building works. Their exploitation of the arch and the vault is typical of their adapt-and-improve approach (see "The Roman Arch," page 170, and "Roman Vaulting," page 187). But their innovative use of concrete, beginning in the first century BCE, was a technological breakthrough of the greatest importance in the history of architecture.

In contrast to stone—which was expensive and difficult to quarry and transport—the components of concrete were cheap, relatively light, and easily transported. Building stone structures required highly skilled masons, but a large, semiskilled workforce directed by a few experienced supervisors could construct brick-faced concrete buildings.

Roman concrete consisted of powdered lime, a volcanic sand called *pozzolana*, and various types of rubble, such as small rocks and broken pottery. Mixing these materials in water caused a chemical reaction that blended them, and they hardened as they dried into a strong, solid mass. At first, concrete was used mainly for poured foundations, but with technical advances it became indispensable for the construction of walls, arches, and vaults for ever-larger buildings, such as the Flavian

Amphitheater (see FIG. 6–38) and the Markets of Trajan (see FIG. 6–46). In the earliest concrete wall construction, workers filled a framework of rough stones with concrete. Soon they developed a technique known as *opus reticulatum*, in which the framework is a diagonal web of smallish bricks set in a cross pattern. Concrete-based construction freed the Romans from the limits of right-angle forms and comparatively short spans. With this new freedom, Roman builders pushed the established limits of architecture, creating some very large and highly original spaces by pouring concrete over wooden frameworks to mold it into complex curving shapes.

Concrete's one weakness was that it absorbed moisture and would eventually deteriorate if unprotected, so builders covered exposed surfaces with a veneer, or facing, of finer materials—such as marble, stone, stucco, or painted plaster—to protect it. An essential difference between Greek and Roman architecture is that Greek builders reveal the building material itself and accept the design limitations of post-andlintel construction, whereas Roman buildings expose only an externally applied surface covering. The sophisticated structural underpinnings that allow huge spaces molded by three-dimensional curves are set behind them, hidden from view.

Watch an architectural simulation about the Roman use of concrete on myartslab.com

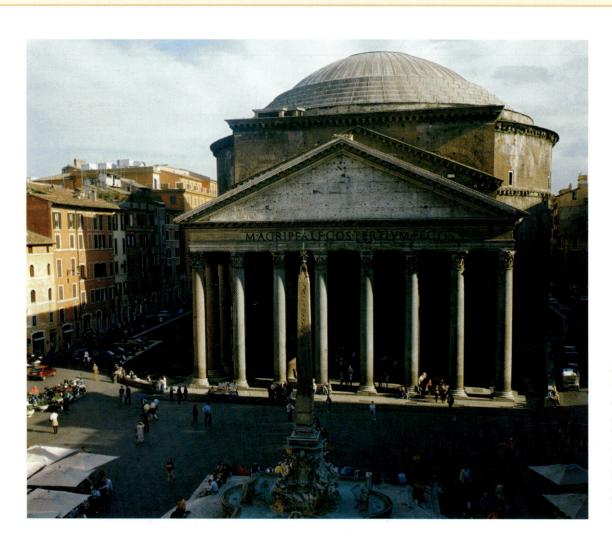

6-49 • PANTHEON Rome. c. 110–128 ce.

Today a huge fountain dominates the square in front of the Pantheon. Built in 1578 by Giacomo della Porta, it now supports an Egyptian obelisk placed there in 1711 by Pope Clement XI.

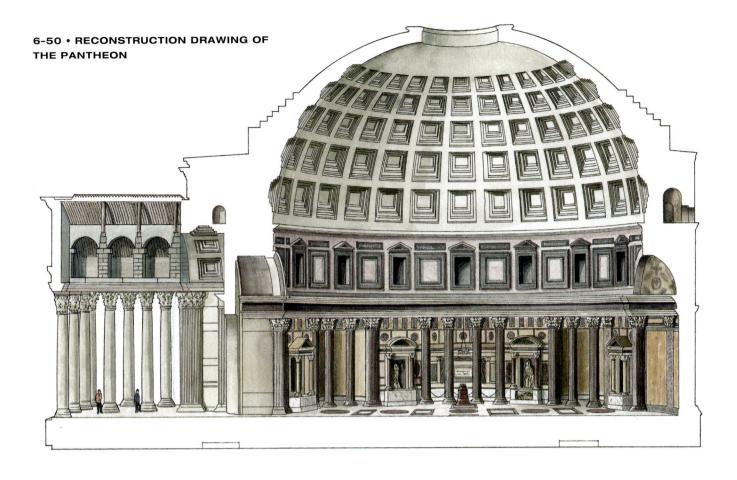

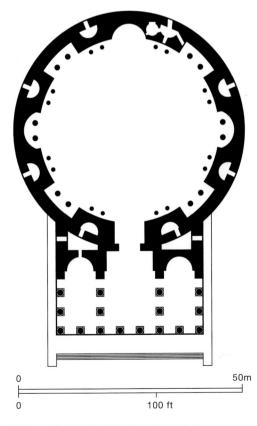

6-51 • PLAN OF THE PANTHEON

THE PANTHEON Perhaps the most remarkable ancient building surviving in Rome—and one of the marvels of world architecture in any age—is a temple to Mars, Venus, and the divine Julius Caesar known as the **PANTHEON** (**FIG. 6-49**). Although this magnificent monument was designed and constructed during the reigns of emperors Trajan and Hadrian, the long inscription on the architrave states that it was built by "Marcus Agrippa, son of Lucius, who was consul three times." Agrippa, the son-in-law and valued advisor of Augustus, sponsored a building on this site in 27–25 BCE. After a fire in 80 CE, Domitian either restored the Pantheon or built a new temple, which burned again after being struck by lightning in 110 CE. Although there has been a strong scholarly consensus that it was Hadrian who reconstructed the building in its current state in 118–128 CE, a recent study of the brick stamps has argued convincingly that the Pantheon was begun soon after 110 under Trajan, but only completed during the reign of his successor, Hadrian. This spectacular and influential design may represent another work of Apollodorus of Damascus.

The current setting of the temple gives little suggestion of its original appearance. Centuries of dirt and street construction hide its podium and stairs. Attachment holes in the pediment indicate the placement of bronze sculpture, perhaps an eagle within a wreath, the imperial Jupiter. Today we can see the sides of the rotunda flanking the entrance porch, but when the Pantheon was constructed, the façade of this porch resembling the façades of typical, rectangular temples—was literally all viewers could see of the building. Since their approach was controlled by an enclosed courtyard (see FIG. 6-42), the actual circular shape of the Pantheon was concealed. Viewers were therefore surprised to pass through the rectilinear and restricted aisles of the portico and the huge main door to encounter the gaping space of the giant **rotunda** (circular room) surmounted by a vast, bowl-shaped dome, 143 feet in diameter and 143 feet from the floor at its summit (**FIGS. 6-50, 6-51**). Even without the controlled

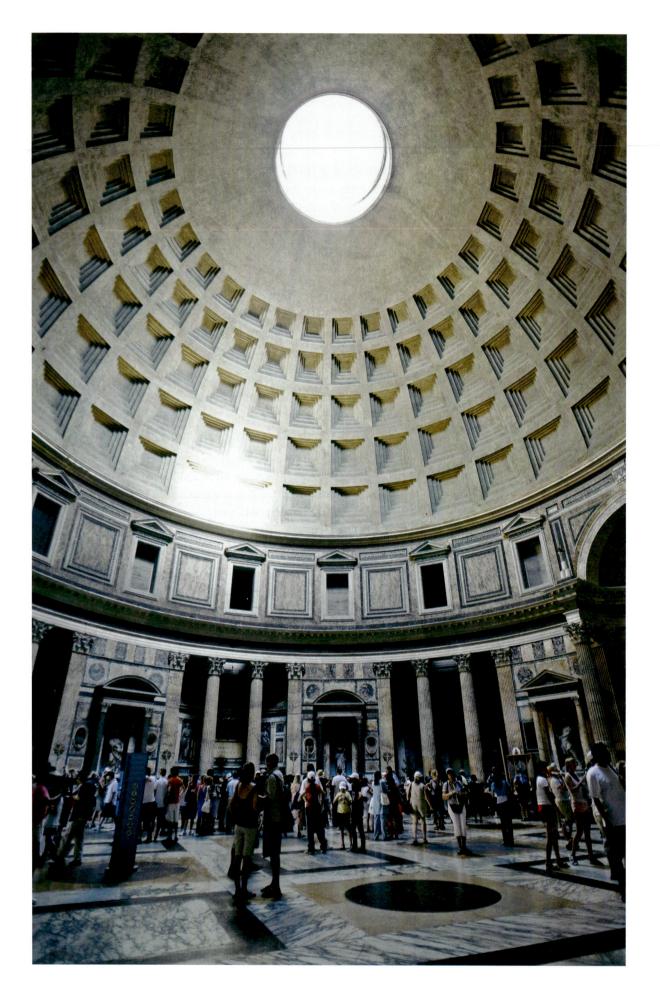

6-52 • DOME OF THE PANTHEON

With light from the oculus on its coffered ceiling. c. 110–128 cE. Brick, concrete, marble veneer, diameter of dome 143' (43.5 m).

*

Explore the architectural panoramas of the Pantheon on myartslab.com

courtyard approach, encountering this glorious space today is still an overwhelming experience—for many of us, one that is repeated on successive visits to the rotunda.

Standing at the center of this hemispherical temple (**FIG. 6–52**), the visitor feels isolated from the outside world and intensely aware of the shape and tangibility of the luminous space itself. Our eyes are drawn upward over the patterns made by the sunken panels, or **coffers**, in the dome's ceiling to the light entering the 29-footwide oculus, or round central opening, which illuminates a brilliant circle against the surface of the dome. This disk of light moves around this microcosm throughout the day like a sun. Clouds can be seen traveling across the opening on some days; on others, rain falls in and then drains off through conduits on the floor planned by the original engineer. Occasionally a bird flies in.

The simple shape of the Pantheon's dome belies its sophisticated design and engineering (see FIG. 6-52). Marble veneer and two tiers of richly colored architectural detail conceal the internal brick arches and concrete structure of the 20-foot-thick walls of the rotunda. More than half of the original decoration-a wealth of columns, pilasters, and entablatures-survives. The simple repetition of square against circle, established on a large scale by juxtaposing the rectilinear portico against the circular rotunda, is found throughout the building's ornamentation. The wall is punctuated by seven exedrae (niches)-rectangular alternating with semicircular-that originally held statues of gods. The square, boxlike coffers inside the dome, which help lighten the weight of the masonry, may once have contained gilded bronze rosettes or stars suggesting the heavens. In 609 CE, Pope Boniface IV rededicated the Pantheon as the Christian church of St. Mary of the Martyrs, thus ensuring its survival through the Middle Ages and down to our day.

HADRIAN'S VILLA AT TIVOLI To imagine imperial Roman life at its most luxurious, one must go to Tivoli, a little more than 20 miles from Rome. HADRIAN'S VILLA, or country residence, was not a single building but an architectural complex of many buildings, lakes, and gardens spread over half a square mile (FIG. 6-53). Each section had its own inner logic, and each took advantage of natural land formations and attractive views. Hadrian

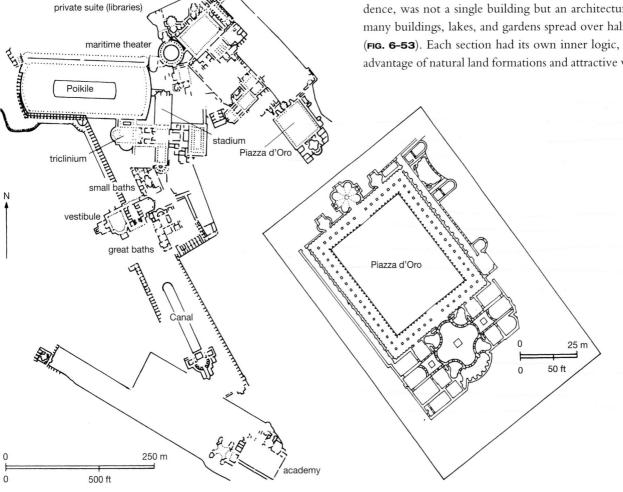

6-53 • PLAN OF HADRIAN'S VILLA Tivoli. c. 125-135 ce.

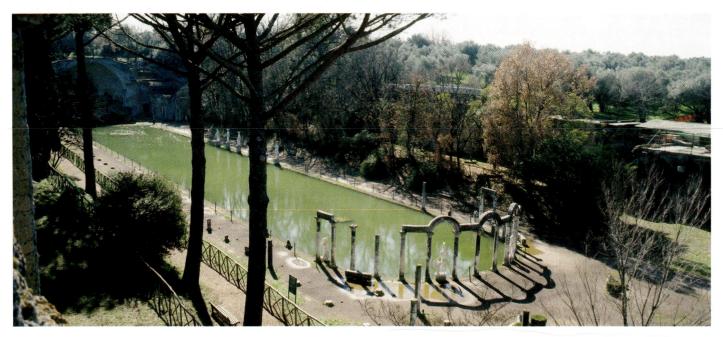

6-54 • THE CANAL (REFLECTING POOL), HADRIAN'S VILLA Tivoli. c. 125–135 ce.

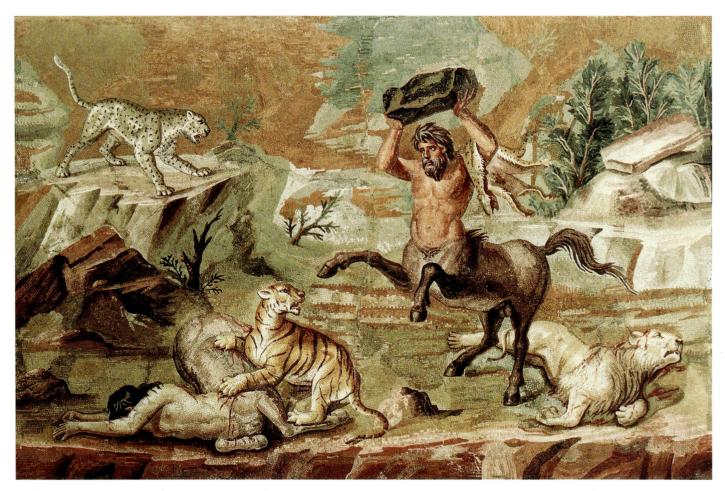

6-55 • BATTLE OF CENTAURS AND WILD BEASTS From Hadrian's Villa, Tivoli. c. 125 cc. Mosaic, $23'' \times 36''$ (58.4 × 91.4 cm). Staatliche Museen zu Berlin, Preussischer Kulturbesitz, Antikensammlung, Berlin.

This floor mosaic may be a copy of a much-admired scene of a fight between centaurs and wild animals painted by the late fifth-century BCE Greek artist Zeuxis.

TECHNIQUE | Roman Mosaics

Mosaics were used widely in Hellenistic times and became enormously popular for decorating homes in the Roman period. Mosaic designs were created with pebbles (see FIG. 5–57), or with small, regularly shaped pieces of colored stone and marble, called *tesserae*. The stones were pressed into a kind of soft cement called grout. When the stones were firmly set, the spaces between them were also filled with grout. After the surface dried, it was cleaned and polished. Since the natural stones produced only a narrow range of colors, glass *tesserae* were also used to extend the palette as early as the third century BCE.

Mosaic production was made more efficient by the use of emblemata (the plural of *emblema*, "central design"). These small, intricate mosaic compositions were created in the artist's workshop in square or rectangular trays. They could be made in advance, carried to a work site, and inserted into a floor decorated with an easily produced geometric pattern. Some skilled mosaicists even copied well-known paintings, often by famous Greek artists. Employing a technique in which very small tesserae, in a wide range of colors, were laid down in irregular, curving lines, they effectively imitated painted brushstrokes. One example is *The Unswept Floor* (**FIG. 6–56**). Herakleitos, a second-century cE Greek mosaicist living in Rome, made this copy of an original work by the renowned second-century BCE artist Sosos. Pliny the Elder, in his *Natural History*, mentions a mosaic of an unswept floor and another of doves that Sosos made in Pergamon. (For another Roman mosaic copy of a Greek painting, see FIG. 5–56.)

A dining room would be a logical location for a floor mosaic of this theme, with table scraps re-created in meticulous detail, even to the shadows they cast, and a mouse foraging among them. Guests reclining on their banquet couches would certainly have been amused by the pictures on the floor, but they could also have shown off their knowledge of the notable Greek precedents for the mosaic beneath their feet.

6-56 • THE UNSWEPT FLOOR Mosaic variant of a 2nd-century BCE painting by Sosos of Pergamon. 2nd century CE. Signed by Herakleitos. Musei Vaticani, Museo Gregoriano Profano, Rome.

instructed his architects to re-create his favorite places throughout the empire so he could pretend to enjoy the Athenian Grove of Academe, the Painted Stoa from the Athenian Agora, and buildings of the Ptolemaic capital of Alexandria in Egypt.

Landscapes with pools, fountains, and gardens turned the villa into a place of sensuous delight. An area with a long reflecting pool, called **THE CANAL**, was framed by a colonnade with alternating semicircular and straight entablatures (**FIG. 6-54**). Copies of famous Greek statues—sometimes even originals—filled the spaces between columns. So great was Hadrian's love of Greek sculpture that he even had the caryatids of the Erechtheion (see FIG. 5-45) replicated for his pleasure palace.

The individual buildings were not large, but they were extremely complex and imaginatively designed, exploiting fully the flexibility offered by concrete vaulted construction. Walls and floors had veneers of marble and travertine or of exquisite mosaics and paintings. A panel from one of the floor mosaics (**FIG. 6-55**) demonstrates the extraordinary artistry of Hadrian's mosaicists (see "Roman Mosaics," page 199). In a rocky landscape with only a few bits of greenery, a desperate male centaur raises a large boulder over his head to crush a tiger that has attacked and severely wounded a female centaur. Two other felines apparently took part in the attack—the white leopard on the rocks to the left and the dead lion at the feet of the male centaur. The artist rendered the figures with three-dimensional shading, foreshortening, and a great sensitivity to a range of figure types, including human torsos and powerful animals in a variety of poses.

IMPERIAL PORTRAITS

Imperial portraits were objects of propaganda, proclaiming the accomplishments and pretensions of emperors. Marcus Aurelius, like Hadrian, was a successful military commander who was equally proud of his intellectual attainments. In a lucky error—or twist of fortune—a gilded-bronze equestrian statue of the emperor, dressed as a military commander in a tunic and short, heavy cloak (**FIG. 6–57**), came mistakenly to be revered during the Middle Ages as a statue of Constantine, the first Christian emperor, and

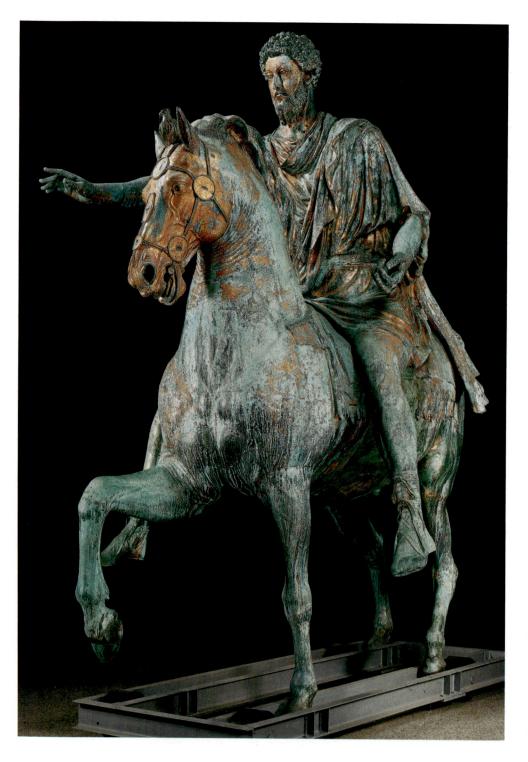

6-57 • EQUESTRIAN STATUE OF MARCUS AURELIUS

c. 176 cE. Bronze, originally gilded, height of statue 11'6" (3.5 m). Museo Capitolino, Rome.

Between 1187 and 1538, this statue stood in the piazza fronting the palace and church of St. John Lateran in Rome. In January 1538, Pope Paul III had it moved to the Capitoline Hill, and Michelangelo made it the centerpiece of his newly redesigned Capitoline Piazza. After being removed from its base for cleaning and restoration during the 1980s, it was taken inside the Capitoline Museum to protect it from air pollution, and a copy has replaced it in the piazza.

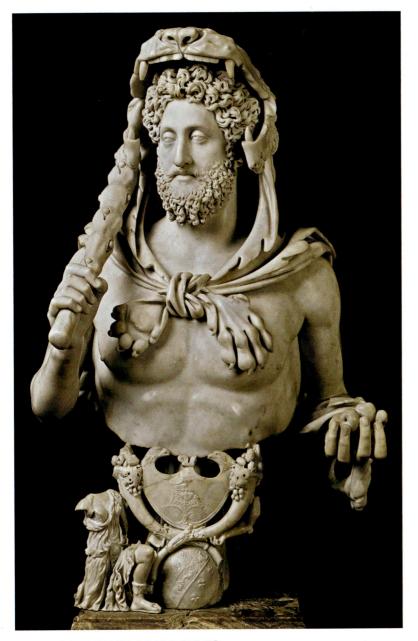

6-58 • COMMODUS AS HERCULES From the Esquiline Hill, Rome. c. 191–192 ce. Marble, height 46¹/₂" (118 cm). Palazzo dei Conservatori, Rome.

consequently the sculpture escaped being melted down. The raised foreleg of his horse once trampled a crouching barbarian.

Marcus Aurelius' head, with its thick, curly hair and full beard (a fashion initiated by Hadrian), resembles traditional "philosopher" portraits from the Greek world. The emperor wears no armor and carries no weapons; like Egyptian kings, he conquers effortlessly by divine will. And like his illustrious predecessor Augustus, he reaches out to those around him in a rhetorical gesture of address. It is difficult to create an equestrian portrait in which the rider stands out as the dominant figure without making the horse look too small. The sculptor of this statue found a balance acceptable to viewers of the time and, in doing so, created a model for later artists.

Marcus Aurelius was succeeded as emperor by his son Commodus, a man without political skill, administrative competence, or intellectual distinction. During his unfortunate reign (180-192 CE), he devoted himself to luxury and frivolous pursuits, claiming at various times to be the reincarnation of Hercules and the incarnation of the god Jupiter. When he proposed to assume the consulship dressed and armed as a gladiator, his associates, including his mistress, arranged to have him strangled in his bath by a wrestling partner. In a spectacular marble bust, the emperor poses as HERCU-LES (FIG. 6-58), adorned with references to the hero's legendary labors: Hercules' club, the skin and head of the Nemean lion, and the golden apples from the Garden of the Hesperides. Commodus' likeness emphasizes his family resemblance to his more illustrious and powerful father (see FIG. 6-57), but it also captures his vanity, through the grand pretensions of his costume and the Classical associations of his body type. The sculptor's sensitive modeling and expert drillwork exploit the play of light and shadow on the figure to bring out the textures of the hair, beard, facial features, and drapery, and to capture the illusion of life and movement.

FUNERARY SCULPTURE During the second and third centuries, a shift from cremation to inhumation created a growing demand for sarcophagi in which to bury the bodies of the deceased. Wealthy Romans commissioned thousands of massive and elaborate marble sarcophagi, encrusted with sculptural relief, created in large production workshops throughout the Roman Empire.

In 1885, nine particularly impressive sarcophagi were discovered in private underground burial chambers built for use by a powerful, aristocratic Roman family the Calpurnii Pisones. One of these sarcophagi, from c. 190 CE, portrays the *Indian Triumph of Dionysus* (see "A Closer Look," page 202). This is a popular theme in late second-century CE sarcophagi, but here the carved relief

is of especially high quality—complex but highly legible at the same time. The mythological composition owes a debt to imperial. ceremony: Dionysus, at far left in a chariot, receives from a personification of Victory standing behind him a laurel crown, identical to the headdress worn by Roman emperors during triumphal processions. Also derived from state ceremony is the display of booty and captives carried by the elephants at the center of the composition. But religion, rather than statecraft, is the real theme here. The set of sarcophagi to which this belongs proclaims the family's adherence to a mystery cult of Dionysus that focused on themes of decay and renewal, death and rebirth. The triumph of the deceased over death is the central message here, not one particular episode in the life of Dionysus himself.

A CLOSER LOOK | Sarcophagus with the Indian Triumph of **Dionysus**

c. 190 ce. Marble, $471_{2}^{\prime\prime} \times 921_{2}^{\prime\prime} \times 351_{16}^{\prime\prime}$ (120.7 \times 234.9 \times 90.96 cm). Walters Art Museum, Baltimore.

Semele, mortal mother of the god Dionysus, gives birth As part of their worship, followers of Dionysiac mystery religions prematurely and then dies. Once grown, Dionysus These hooked sticks are re-created the triumphant return of the god from India by would travel to the underworld and bring his mother identical to the ankusha still parading in the streets after dark. A dancing maenad beats her to paradise. Semele's death therefore suggests the used by mahouts (elephant tambourine here, suggesting the sounds and movements that promise of eternal life through her son. drivers) in India today. would accompany such ritual re-enactments. The presence of exotic animals Snakes were not only used in the rites of Dionysiac The aged god Silenus leans on a thyrsos staff, mystery religions; they were powerful symbols of rebirth composed of a giant fennel wound with ivy and

such as elephants, a lion, a giraffe, and panthers, identifies this scene as Dionysus' triumphant return from India.

and phallic fertility, making them especially appropriate in the context of a sarcophagus. Three snakes appear along the ground-line of the sculptural frieze.

topped with a pinecone, symbolizing fertility. Dionysus, with whom such staffs were associated. also carries one here as his triumphal scepter.

View the Closer Look for the sarcophagus with the Indian Triumph of Dionysus on myartslab.com

THE LATE EMPIRE, THIRD AND FOURTH CENTURIES CE

The comfortable life suggested by the wall paintings in Roman houses and villas was, within a century, to be challenged by hard times. The reign of Commodus marked the beginning of a period of political and economic decline. Barbarian groups had already begun moving into the empire in the time of Marcus Aurelius. Now they pressed on Rome's frontiers. Many crossed the borders and settled within them, disrupting provincial governments. As perceived threats spread throughout the empire, imperial rule became increasingly authoritarian. Eventually the army controlled the government, and the Imperial Guards set up and deposed rulers almost at will, often selecting candidates from among poorly educated, power-hungry provincial leaders in their own ranks.

THE SEVERAN DYNASTY

Despite the pressures brought by political and economic change, the arts continued to flourish under the Severan emperors (193– 235 CE) who succeeded Commodus. Septimius Severus (r. 193– 211 CE), who was born in Africa, and his Syrian wife, Julia Domna, restored public buildings, commissioned official portraits, and revitalized the old cattle market in Rome into a well-planned center of bustling commerce. Their sons, Geta and Caracalla, succeeded Septimius Severus as co-emperors in 211 CE, but Caracalla murdered Geta in 212 CE and then ruled alone until he in turn was murdered in 217 CE.

PORTRAITS OF CARACALLA The Emperor Caracalla appears in his portraits as a fierce and courageous ruler, capable of confronting Rome's enemies and safeguarding the security of the Roman Empire. In the example shown here (**FIG. 6-59**), the sculptor has enhanced the intensity of the emperor's expression by producing strong contrasts of light and dark with careful chiseling and drillwork. Even the marble eyes have been drilled and

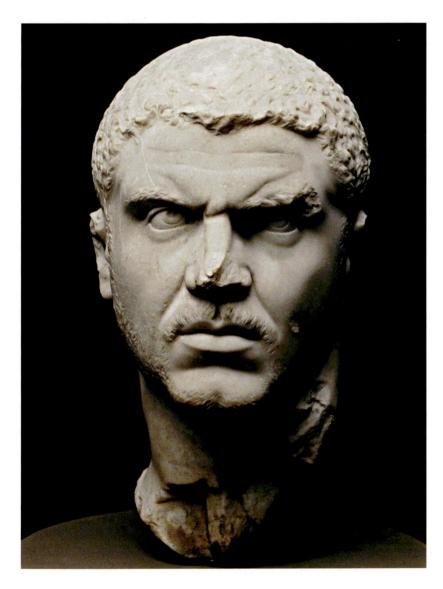

engraved to catch the light in a way that makes them dominate his expression. The contrast between this style and that of the portraits of Augustus is a telling reflection of the changing character of imperial rule. Augustus envisioned himself as the suave initiator of a Golden Age of peace and prosperity; Caracalla presents himself as a no-nonsense ruler of iron-fisted determination, with a militaristic, close-cropped haircut and a glare of fierce intensity.

THE BATHS OF CARACALLA The year before his death in 211 CE, Septimius Severus had begun a popular public-works project: the construction of magnificent new public baths on the southeast side of Rome as a new recreational and educational center. Caracalla completed and inaugurated the baths today known by his name, in 216–217 CE. The impressive brick and concrete structure was hidden under a sheath of colorful marble and mosaic. The builders used soaring groin and barrel vaults, which allow the maximum space with the fewest possible supports. The groin vaults also made possible large windows in every

bay. Windows were important, since the baths depended on natural light and could only be open during daylight hours.

The **BATHS OF CARACALLA** (**FIG. 6-60**) were laid out on a strictly symmetrical plan. The bathing facilities were grouped in the center of the main building to make efficient use of the below-ground furnaces that heated them and to allow bathers to move comfortably from hot to cold pools and then finish with a swim. Many other facilities—exercise rooms, shops, latrines, and dressing rooms—were housed on each side of the bathing block. The bath buildings alone covered 5 acres. The entire complex, which included gardens, a stadium, libraries, a painting gallery, auditoriums, and huge water reservoirs, covered an area of 50 acres.

6-59 • CARACALLA Early 3rd century ce. Marble, height 14½" (36.2 cm). Metropolitan Museum of Art, New York. Samuel D. Lee Fund, 1940. (40.11.1A)

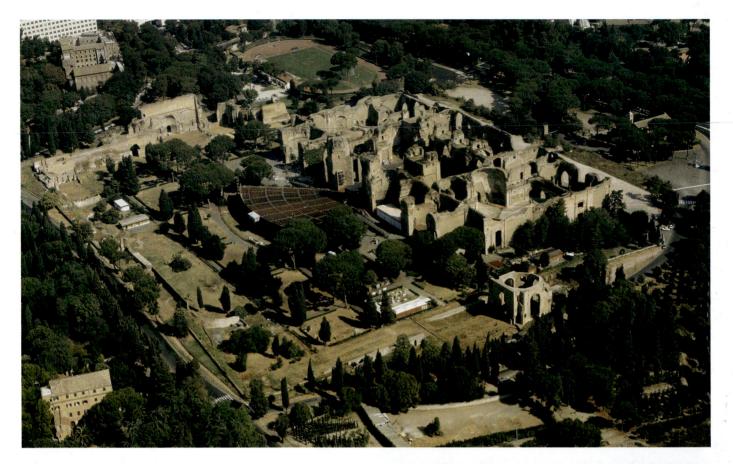

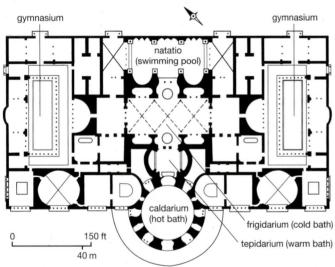

6-60 • AERIAL VIEW (A) AND PLAN (B) OF THE BATHS OF CARACALLA

Rome. c. 211-217 CE.

Explore the architectural panoramas of the Baths of Caracalla on myartslab.com

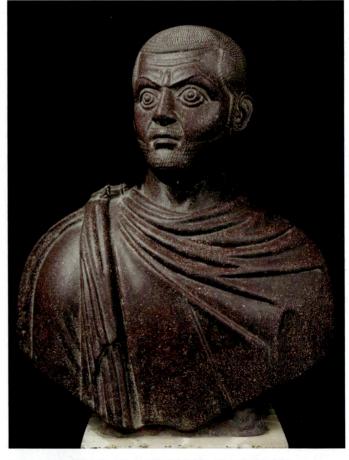

6-61 • PORTRAIT OF A TETRARCH (GALERIUS?) Early 4th century ce. Porphyry, 2'51/2" (65 cm). Egyptian Museum, Cairo.

THE SOLDIER EMPERORS

Following the assassination of the last Severan emperor by one of his military commanders in 235 CE, Rome was plunged into a period of anarchy that lasted for 50 years. A series of soldier emperors attempted to rule the empire, but real order was only restored by Diocletian (r. 284–305 CE), also a military commander. This brilliant politician and general reversed the empire's declining fortunes, but he also initiated an increasingly autocratic form of rule, and the social structure of the empire became increasingly rigid.

To divide up the task of defending and administering the Roman world and to assure an orderly succession, in 286 CE Diocletian divided the empire in two parts. According to his plan, he would rule in the East with the title of "Augustus," while another Augustus, Maximian, would rule in the West. Then, in 293 CE, he devised a form of government called a tetrarchy, or "rule of four," in which each Augustus designated a subordinate and heir, who held the title of "Caesar." And the Roman Empire, now divided into four quadrants, would be ruled by four individuals.

TETRARCHIC PORTRAITURE Diocletian's political restructuring is paralleled by the introduction of a radically new, hard style of geometricized abstraction, especially notable in portraits of the tetrarchs themselves. A powerful bust of a tetrarch, startlingly alert with searing eyes (FIG. 6-61), embodies this stylistic shift toward the antithesis of the suave Classicism seen in the portrait of Commodus as Hercules (see FIG. 6-58). There is no clear sense of likeness. Who this individual is seems to be less significant than the powerful position he holds. Some art historians have interpreted this change in style as a conscious embodiment of Diocletian's new concept of government, while others have pointed to parallels with the provincial art of Diocletian's Dalmatian homeland or with the Neoplatonic aesthetics of idealized abstrac-

6-62 • THE TETRARCHS

c. 300 cE. Porphyry, height of figures 51'' (129 cm). Installed at the corner of the façade of the Cathedral of St. Mark, Venice.

This particular sculpture may have been made in Egypt and moved to Constantinople after 330 CE. Christian crusaders who looted Constantinople in 1204 CE took the statue to Venice and installed it at the Cathedral of St. Mark, where it is today.

tion promoted by Plotinus, a third-century CE philosopher who was widely read in the late Roman world. In any event, these riveting works represent not a degeneration of the Classical tradition but its conscious replacement by a different aesthetic viewpoint—militaristic, severe, and abstract rather than suave, slick, and classicizing.

This new mode is famously represented by an actual sculptural group of **THE TETRARCHS** (**FIG. 6-62**). The four figures are nearly identical, except that the senior Augusti have beards while

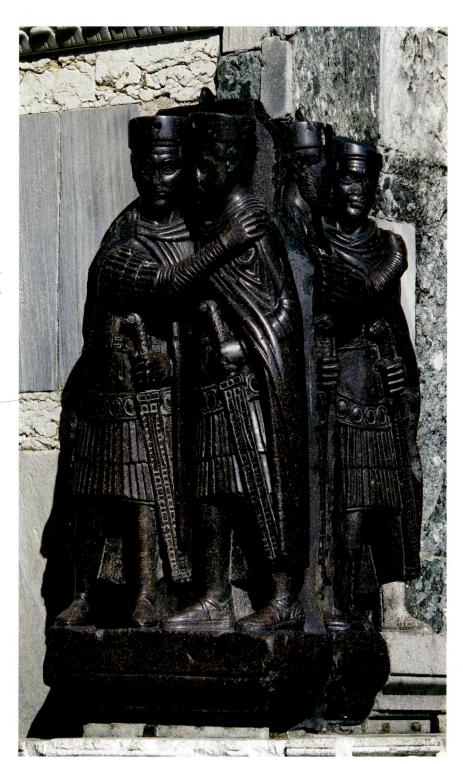

their juniors, the Caesars, are clean-shaven. Dressed in military garb and clasping swords at their sides, they embrace each other in a show of imperial unity, proclaiming an alliance rooted in strength and vigilance. The sculpture is made of porphyry, an extremely hard, purple stone from Egypt that was reserved for imperial use (see FIG. 6-61).

THE BASILICA AT TRIER The tetrarchs ruled the empire from administrative headquarters in Milan (Italy), Trier (Germany), Thessaloniki (Greece), and Nicomedia (Turkey). Imposing architecture was created to house the government in these new capital cities. In Trier, for example, Constantius Chlorus (Caesar, 293–

305; Augustus, 305–306 CE) and his son Constantine fortified the city with walls and a monumental gate that still stand. They built public amenities, such as baths, and a palace with a huge **AUDI-ENCE HALL**, later used as a Christian church (**FIGS. 6-63, 6-64**). This early fourth-century basilica's large size and simple plan and structure exemplify the architecture of the tetrarchs: no-nonsense, imposing buildings that would impress their subjects. The audience hall is a large rectangular building, 190 by 95 feet, with a strong directional focus given by a single apse opposite the door. Brick walls, originally stuccoed on the outside and covered with marble veneer inside, are pierced by two rows of arched windows. A flat roof, nearly 100 feet above the floor, covers both

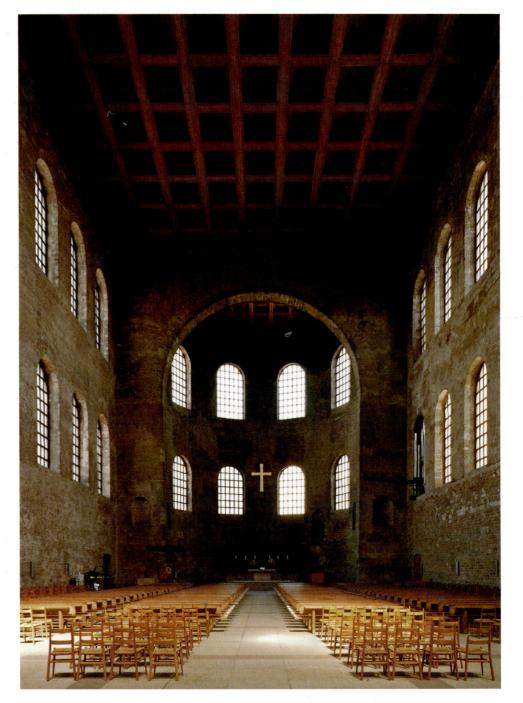

6-63 • AUDIENCE HALL OF CONSTANTIUS CHLORUS (NOW KNOWN AS THE BASILICA)

Trier, Germany. View of the nave. Early 4th century ce. Height of room 100' (30.5 m).

Only the left wall and apse survive from the original Roman building. The hall became part of the bishop's palace during the medieval period.

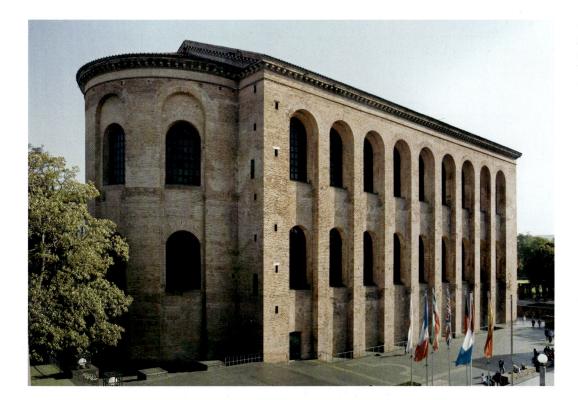

6-64 • EXTERIOR OF AUDIENCE HALL OF CONSTANTIUS CHLORUS Trier, Germany. Early 4th century ce.

the nave and the apse. In a concession to the northern climate, the building was centrally heated with hot air flowing under the floor, a technique also used in Roman baths. The windows of the apse create an interesting optical effect. Slightly smaller than the windows in straight side walls, they create the illusion of greater distance, so that the tetrarch enthroned in the apse would appear larger than life and the hall would seem longer than it actually is.

CONSTANTINE THE GREAT

In 305 CE, Diocletian abdicated and forced his fellow Augustus, Maximian, to do so too. The orderly succession he had planned for failed to occur, and a struggle for position and advantage followed almost immediately. Two main contenders appeared in the Western Empire: Maximian's son Maxentius, and Constantine, son of Tetrarch Constantius Chlorus. Constantine emerged victorious in 312, defeating Maxentius at the Battle of the Milvian Bridge at the entrance to Rome.

According to Christian tradition, Constantine had a vision the night before the battle in which he saw a flaming cross in the sky and heard these words: "In this sign you shall conquer." The next morning he ordered that his army's shields and standards be inscribed with the monogram XP (the Greek letters *chi* and *rho*, standing for *Christos*). The victorious Constantine then showed his gratitude by ending the persecution of Christians and recognizing Christianity as a lawful religion. He may have been influenced in that decision by his mother, Helena, a devout Christian—later canonized. Whatever his motivation, in 313 CE, together with Licinius, who ruled the Eastern Empire, Constantine issued the Edict of Milan, a model of religious toleration. The Edict granted freedom to all religious groups, not just Christians. Constantine, however, remained the Pontifex Maximus of Rome's state religion and also reaffirmed his devotion to the military's favorite god, Mithras, and to the Invincible Sun, Sol Invictus, a manifestation of Helios Apollo, the sun god. In 324 CE, Constantine defeated Licinius, his last rival, and ruled as sole emperor until his death in 337. He made the port city of Byzantium the new capital of the Roman Empire after his last visit to Rome in 325, and renamed the city after himself—Constantinople (present-day Istanbul, in Turkey). Rome, which had already ceased to be the seat of government in the West, further declined in importance.

THE ARCH OF CONSTANTINE In Rome, next to the Colosseum, the Senate erected a triumphal arch to commemorate Constantine's victory over Maxentius (FIG. 6-65), a huge, triple arch that dwarfs the nearby Arch of Titus (see FIG. 6-36). Its three barrel-vaulted passageways are flanked by columns on high pedestals and surmounted by a large attic story with elaborate sculptural decoration and a laudatory inscription: "To the Emperor Constantine from the Senate and the Roman People. Since through divine inspiration and great wisdom he has delivered the state from the tyrant and his party by his army and noble arms, [we] dedicate this arch, decorated with triumphal insignia." The "triumphal insignia" were in part appropriated from earlier monuments made for Constantine's illustrious predecessors-Trajan, Hadrian, and Marcus Aurelius. The reused items visually transferred the old Roman virtues of strength, courage, and piety associated with these earlier exemplary emperors to Constantine

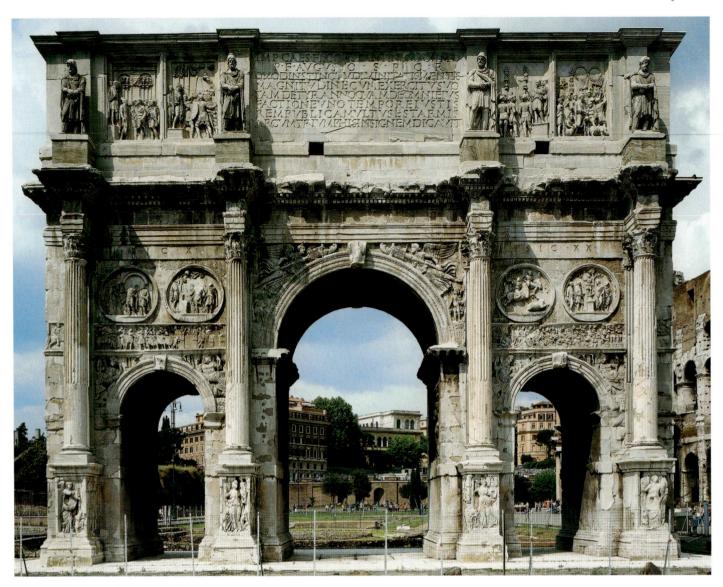

6-65 • ARCH OF CONSTANTINE

Rome. 312–315 CE (dedicated July 25, 315). $69' \times 85'$ (21 \times 26 m).

This massive, triple-arched monument to Emperor Constantine's victory over Maxentius in 312 cE is a wonder of recycled sculpture. On the attic story, flanking the inscription over the central arch, are relief panels taken from a monument celebrating the victory of Marcus Aurelius over the Germans in 174 cE. On the attached piers framing these panels are large statues of prisoners made to celebrate Trajan's victory over the Dacians in the early second century cE. On the inner walls of the central arch and on the attic of the short sides (neither seen here) are reliefs also commemorating Trajan's conquest of Dacia. Over each of the side arches is a pair of large tondi (circular compositions) taken from a monument to Hadrian (see FIG. 6–66). The rest of the decoration is early fourth century cE, contemporary with the arch.

himself. New reliefs were made for the arch to recount the story of Constantine's victory and to symbolize his own power and generosity. They run in strips underneath the reused Hadrianic tondi (a tondo is a circular composition) (**FIG. 6–66**).

Although the new Constantinian reliefs reflect the longstanding Roman predilection for depicting important events with recognizable detail, they nevertheless represent a significant change in style, approach, and subject matter (see lower figural frieze in FIG. 6–65). In this scene of Constantine addressing the Roman people in the Roman Forum, the Constantinian reliefs are easily distinguished from the reused Hadrianic tondi mounted just above them because of the faithfulness of the new reliefs to the avant-garde tetrarchic style we have already encountered in portraiture. The forceful, blocky, mostly frontal figures are compressed into the foreground plane. The participants to the sides, below the enthroned Constantine (his head is missing), almost congeal into a uniformly patterned mass that isolates the new emperor and connects him visually with the seated statues of his illustrious predecessors flanking him on the dais. This two-dimensional, hierarchical approach with its emphasis on authority and power

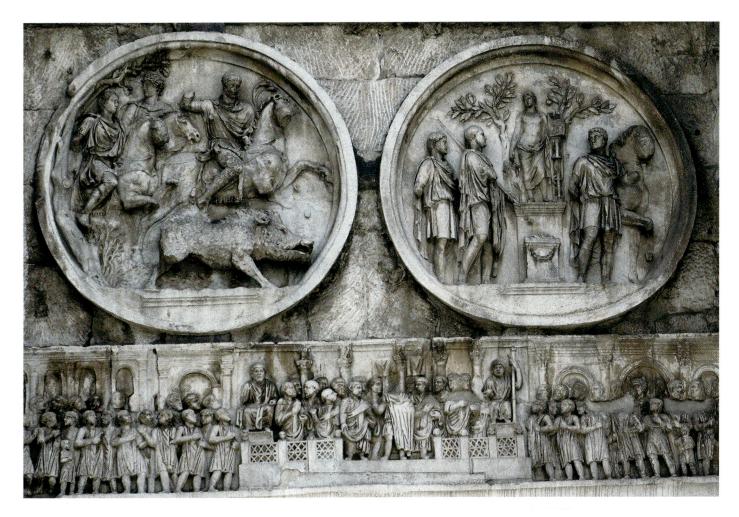

6-66 • HADRIAN/CONSTANTINE HUNTING BOAR AND SACRIFICING TO APOLLO; CONSTANTINE ADDRESSING THE ROMAN PEOPLE IN THE ROMAN FORUM

Tondi made for a monument to Hadrian and reused on the Arch of Constantine. c. 130–138 ce. Marble, diameter 6'6" (2 m). Frieze by Constantinian sculptors 312–315 ce. Marble, height 3'4" (1 m).

The two tondi were originally part of a lost monument erected by the emperor Hadrian (r. 117–138 cE). The boar hunt demonstrates his courage and physical prowess, and his sacrificial offering to Apollo shows his piety and gratitude to the gods for their support. The classicizing heads, form-enhancing drapery, and graceful poses of the figures betray a debt to the style of Late Classical Greek art. In the fourth century cE, Constantine appropriated these tondi, had Hadrian's head recarved with his own or his father's features, and incorporated them into his own triumphal arch (see FIG. 6–65) so that the power and piety of this predecessor could reflect on him and his reign. In a strip of relief underneath the tondi, sculptors from his own time portrayed a ceremony performed by Constantine during his celebration of the victory over his rival, Maxentius, at the Battle of the Milvian Bridge (312 cE). Rather than the Hellenizing mode popular during Hadrian's reign, the Constantinian sculptors employ the blocky and abstract stylizations that became fashionable during the Tetrarchy.

rather than on individualized outward form is far removed from the classicizing illusionism of earlier imperial reliefs. It is one of the Roman styles that will be adopted by the emerging Christian Church.

THE BASILICA NOVA Constantine's rival Maxentius, who controlled Rome throughout his short reign (r. 306–312), ordered the repair of older buildings there and had new ones built. His most impressive undertaking was a huge new basilica, just southeast of the Imperial Forums, called the **BASILICA NOVA**, or New Basilica (**FIG. 6-67**). Now known as the Basilica of Maxentius and Constantine, this was the last important imperial government building erected in Rome. Like all basilicas, it functioned as an administrative center and provided a magnificent setting for the emperor when he appeared as supreme judge.

Earlier basilicas, such as Trajan's Basilica Ulpia (see FIG. 6–44), had been columnar halls, but Maxentius ordered his engineers to create the kind of large, unbroken, vaulted space found in public baths. The central hall was covered with groin vaults, and the side aisles were covered with lower barrel vaults that acted as buttresses, or projecting supports, for the central vault and allowed generous window openings in the clerestory areas over the side walls.

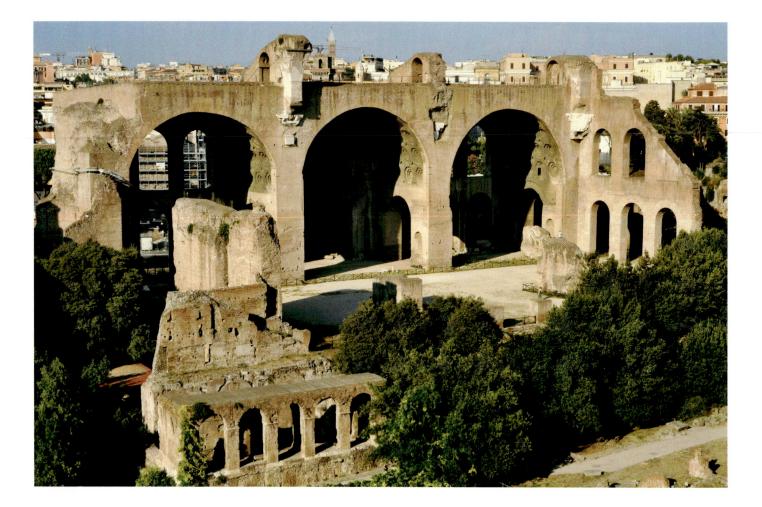

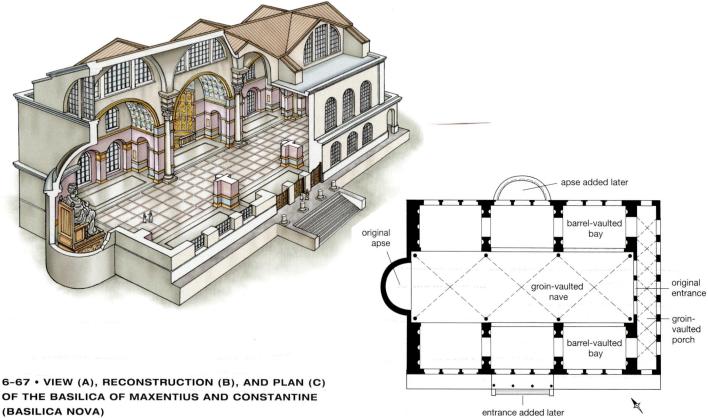

Rome. 306–313 CE.

6-68 • CONSTANTINE THE GREAT

From the Basilica of Maxentius and Constantine, Rome. 325–326 CE.

Marble, height of head 8'6" (2.6 m). Palazzo dei Conservatori, Rome.

Three of these brick-and-concrete barrel vaults still loom over the streets of present-day Rome (see FIG. 6–67A). The basilica originally measured 300 by 215 feet and the vaults of the central nave rose to a height of 114 feet. A groin-vaulted porch extended across the short side and sheltered a triple entrance to the central hall. At the opposite end of the long axis of the hall was an apse of the same width, which acted as a focal point for the building (see FIGS. 6–67B, 6–67C). Such directional focus along a central axis from entrance to apse was adopted by Christians for use in basilican churches.

Constantine, seeking to impress the people of Rome with visible symbols of his authority, put his own stamp on projects Maxentius had started, including this one. He may have changed the orientation of the Basilica Nova by adding an imposing new entrance in the center of the long side facing the Via Sacra and a giant apse facing it across the three aisles. He also commissioned a colossal, 30-foot statue of himself to be placed inside within an apse (FIG. 6-68). Sculptors used white marble for the head, chest, arms, and legs, and sheets of bronze for the drapery, all supported on a wooden frame. This statue became a permanent stand-in for the emperor, representing him whenever the conduct of business legally required his presence. The head combines features of traditional Roman portraiture with some of the abstract qualities evident in images of the tetrarchs (see FIG. 6-61). The defining characteristics of Constantine's face-his heavy jaw, hooked nose, and jutting chin-have been incorporated into a stylized, symmetrical pattern in which other features, such as his eyes, eyebrows, and hair, have been simplified into repeated geometric arcs. The result is a work that projects imperial power and dignity with no hint of human frailty or imperfection.

ROMAN ART AFTER CONSTANTINE

Although Constantine was baptized only on his deathbed in 337, Christianity had become the official religion of _ the empire by the end of the fourth century, and non-Christians had become targets of persecution. This religious shift, however, did not diminish Roman interest in the artistic traditions of their pagan Classical past. A large silver **PLATTER** dating from the mid fourth century CE (**FIG. 6-69**) proves that artists working for Christian patrons continued to use pagan themes, allowing them the opportunity to create elaborate figural compositions

displaying the nude or lightly draped human body in complex,

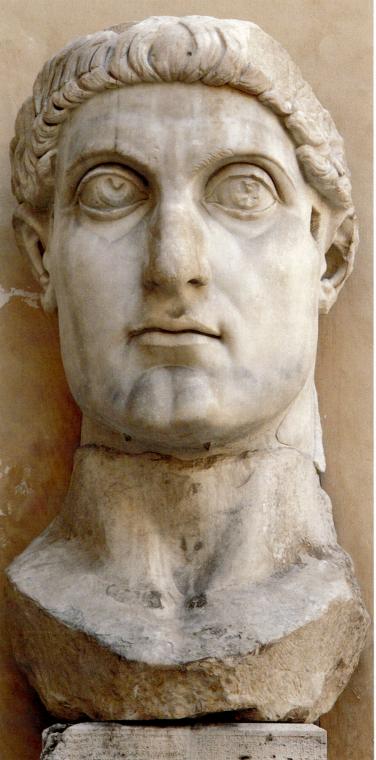

dynamic poses. The platter was found in a cache of silver tableware near Mildenhall, England, including spoons engraved with Christian symbols. The original owner of the hoard was likely to have been a wealthy Roman Christian, living in the provinces. Such opulent items were often hidden or buried to protect them from theft and looting, a sign of the breakdown of the Roman peace, especially in provincial areas (see "The Mildenhall Treasure," page 212).

RECOVERING THE PAST | The Mildenhall Treasure

In 1942, a farmer plowing a field outside the town of Mildenhall in Suffolk, England, located near the site of an ancient Roman villa, accidentally made one of the greatest archaeological finds of the twentieth century. In total he unearthed 34 pieces of Roman silver dating from the fourth century cE. The find was not made public until four years later, since the farmer and his associates claimed they were unaware of how valuable it was, both materially and historically. When word of the discovery leaked out, however, the silver was confiscated by the government to determine if it was a "Treasure Trove"—gold or silver objects that have been intentionally hidden (rather than, for example, included in a burial) and that by law belong not to the finder, but to the Crown. The silver found at Mildenhall was deemed a "Treasure Trove" and is now one of the great glories of the British Museum in London.

This is the official story of the discovery at Mildenhall. But there are

those who do not believe it. None of the silver in the hoard showed any sign of having been dented by a plow, and some believe that the quality and style of the objects are inconsistent with a provincial Roman context, especially so far in the hinterlands in England. Could the treasure have been looted from Italy during World War II, brought back to England (Mildenhall is not far from an American airfield), and buried to set up a staged discovery? The farmer who discovered the hoard and his associates, some argue, changed their story several times over the course of its history. Most scholars do believe the official story—that the silver was buried quickly for safekeeping by wealthy provincial Romans in Britain who felt threatened by a possible invasion or attack, and was forgotten (perhaps its owners were killed in the expected turmoil) until its accidental discovery in 1942. But when the history of art is founded on undocumented archaeological finds, there is usually room for doubt.

50000

View the Closer Look for a platter from the Mildenhall Treasure on myartslab.com

The Bacchic revelers on this platter whirl, leap, and sway in a dance to the piping of satyrs around a circular central medallion. In the centerpiece, the head of the sea god Oceanus is ringed by nude females frolicking in the waves with fantastic sea creatures. In the outer circle, the figure of Bacchus is the one stable element. With a bunch of grapes in his right hand, a krater at his feet, and one foot on the haunches of his panther, he listens to a male follower begging for another drink. Only a few figures away, the pitifully drunken hero Hercules has lost his lionskin mantle and collapsed in a stupor into the supporting arms of two satyrs. The detail, clarity, and liveliness of this platter reflect the work of a virtuoso artist. Deeply engraved lines emphasize the contours of the subtly modeled bodies, echoing the technique of undercutting used to add depth to figures in stone and marble reliefs and suggesting a connection between silverworking and relief sculpture.

Not all Romans, however, converted to Christianity. Among the champions of paganism were the Roman patricians Quintus Aurelius Symmachus and Virius Nicomachus Flavianus. A famous ivory diptych (**FIG. 6-70**) attests to the close relationship between their families, perhaps through marriage, as well as to their firmly held beliefs. A **diptych** was a pair of panels attached with hinges, not unlike the modest object held by the woman in FIG. 6-35, but in this case made of a very precious material and

CHAPTER 6 ETRUSCAN AND ROMAN ART

212

object held by the woman in Fig.From Mildenhall, England. Mid 4th century cE. Silver, diameter approx. 24" (61 cm).ade of a very precious material andBritish Museum, London.

6-69 • PLATTER

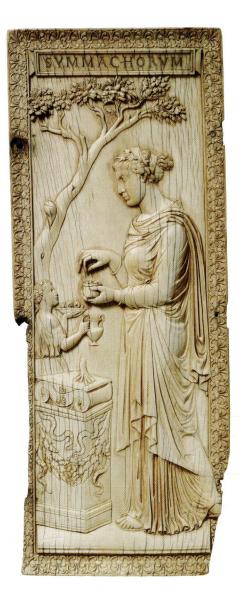

6-70 • PRIESTESS OF BACCHUS (?)

Right panel of the diptych of Symmachus and Nicomachus. c. 390–401 ce. lvory, $1134'' \times 434''$ (29.9 \times 12 cm). Victoria & Albert Museum, London.

carved with reliefs on the exterior sides. On the interior of a diptych there were shallow, traylike recessions filled with wax, into which messages could be written with a stylus and sent with a servant as a letter to a friend or acquaintance, who could then smooth out the wax surface, incise a reply with his or her own stylus, and send the diptych back to its owner with the servant. Here one family's name is inscribed at the top of each panel. On the panel inscribed "Symmachorum" (illustrated here), a stately, elegantly attired priestess burns incense at a beautifully decorated altar. On her head is a wreath of ivy, sacred to Bacchus. She is assisted by a small child, and the event takes place out of doors under an oak tree, sacred to Jupiter. Like the silversmiths, Roman ivory carvers of the fourth century CE were highly skillful, and their work was widely admired. For conservative patrons like the Nicomachus and Symmachus families, they imitated the Augustan style effortlessly. The exquisite rendering of the drapery and foliage recalls the reliefs of the Ara Pacis (see FIG. 6–22).

Classical subject matter remained attractive to artists and patrons throughout the late Roman period. Even such great Christian thinkers as the fourth-century CE bishop Gregory of Nazianzus spoke out in support of the right of the people to appreciate and enjoy their Classical heritage, so long as they were not seduced by it to return to pagan practices. As a result, stories of the ancient gods and heroes entered the secular realm as lively, visually delightful, even erotic decorative elements. As Roman authority gave way to local rule by powerful "barbarian" tribes in much of the West, many people continued to appreciate Classical learning and to treasure Greek and Roman art. In the East, Classical traditions and styles were cultivated to become an enduring element of Byzantine art.

THINK ABOUT IT

- 6.1 Characterize the salient stylistic features of the murals that survive from Roman houses in Pompeii, discussing specific examples from this chapter.
- **6.2** Explain how the Roman interest in portraits grew out of early funeral rituals and developed into a powerful aspect of imperial self-fashioning.
- 6.3 Describe and evaluate the subjects used in Etruscan tomb paintings and sarcophagi. How do Etruscan practices relate to what we have discovered about tombs in other ancient cultures?
- 6.4 Identify two key structural advances made by Roman builders and discuss their use in one large civic building. Why do you think the ancient Romans built on such a large scale?

CROSSCURRENTS

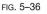

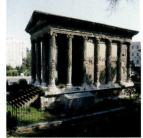

FIG. 6–18A

Greek and Roman temples have features in common, but they are fundamentally different in important respects. Evaluate the significant similarities and dissimilarities by comparing these two buildings.

Study and review on myartslab.com

7-1 • CUBICULUM OF LEONIS, CATACOMB OF COMMODILLA Near Rome. Late 4th century.

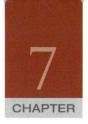

Jewish and Early Christian Art

In this painting in a Roman **catacomb** (underground cemetery) (**FIG. 7-1**), St. Peter, like Moses before him, strikes a rock and water flows from it (scene at left). Imprisoned in Rome at the end of his missionary journeys, Peter was said to have converted his fellow prisoners and jailers to Christianity, but he needed water with which to baptize them. Miraculously, a spring gushed forth at the touch of his staff. In spite of his all too human frailty, Peter became the rock (Greek *petros*) on which Jesus founded the Church. He was considered the first bishop of Rome, predecessor of today's pope. By including this episode from the life of Peter in the chamber's decoration, the early Christians, who dug this catacomb as a place to bury their dead, may have sought to emphasize the importance of their own city in Christian history.

In the star-studded heavens painted on the vault of this chamber, floats the face of Christ, flanked by the first and last letters of the Greek alphabet, alpha and omega. Here Christ takes on the guise not of the youthful teacher or miracle worker seen so often in Early Christian art, but of a more mature Greek philosopher, with long beard and hair. The **halo** (circle) of light around his head indicates his importance and his divinity, a symbol appropriated from the conventions of late Roman imperial art, where haloes often appeared around the heads of emperors.

These two catacomb paintings represent two major directions of early Christian art-the narrative and the iconic—that will continue to be important as this visual tradition develops. The **narrative image** recounts an event drawn from St. Peter's life—striking the rock for water which in turn evokes the establishment of the Church as well as the essential Christian rite of baptism. The **iconic image**—Christ's face flanked by alpha and omega—offers a tangible expression of an intangible concept. The letters signify the beginning and end of time, and, combined with the image of Christ, symbolically represent not a story, but an idea—the everlasting dominion of the heavenly Christ.

Throughout the long and continuing history of Christian art these two tendencies will be apparent—the narrative urge to tell a good story, whose moral or theological implications often have instructional value, and the desire to create iconic images that symbolize the core concepts and values of the developing religious tradition. In both cases, the works of art take on meaning only in relation to viewers' stored knowledge of Christian stories and beliefs. This art was made not to teach non-readers new stories or concepts, as is so often claimed, but rather to remind faithful viewers of stories they had already heard—perhaps to draw specific lessons in their retelling—or to highlight ideas that were central to religious belief and would guide the religious devotional practice it inspired.

LEARN ABOUT IT

- **7.1** Investigate of the ways in which late antique Jewish and Christian art developed from the artistic traditions of the ancient Roman world.
- **7.2** Interpret how late antique Jewish and Christian artists used narrative and iconic imagery to convey the foundations of the Christian faith for those already initiated into the life of the Church.
- **7.3** Understand the relationship between the art and architecture of Jewish and Christian communities and their cultural and political situation within the late Roman Empire.
- **7.4** Analyze the connection between form and function in buildings created for worship.

((• Listen to the chapter audio on myartslab.com

JEWS, CHRISTIANS, AND MUSLIMS

Three religions that arose in the Near East still dominate the spiritual life of the Western world today: Judaism, Christianity, and Islam. All three are monotheistic-believing that the same God of Abraham created and rules the universe, and hears the prayers of the faithful. Jews believe that God made a covenant, or pact, with their ancestors, the Hebrews, and that they are God's chosen people. They await the coming of a savior, the Messiah, "the anointed one." Christians believe that Jesus of Nazareth was that Messiah (the name Christ is derived from the Greek term meaning "Messiah"). They believe that in Jesus, God took human form, preached among men and women, suffered execution, then rose from the dead and ascended to heaven after establishing the Christian Church under the leadership of the apostles (his closest disciples). Muslims, while accepting the Hebrew prophets and Jesus as divinely inspired, believe Muhammad to be the last and greatest prophet of God (Allah), the Messenger of God through whom Islam was revealed some six centuries after Jesus' lifetime.

All three are "religions of the book," that is, they have written records of God's will and words: the Hebrew Bible; the Christian Bible, which includes the Hebrew Bible as its Old Testament as well as the Christian New Testament; and the Muslim Qur'an, believed to be the Word of God as revealed in Arabic directly to Muhammad through the archangel Gabriel.

JUDAISM AND CHRISTIANITY IN THE LATE ROMAN WORLD

Both Judaism and Christianity existed within the Roman Empire, along with various other religions devoted to the worship of many gods. The variety of religious buildings excavated in present-day Syria at the abandoned Roman outpost of Dura-Europos (see "Dura-Europos," page 221) represents the cosmopolitan religious character of Roman society in the second and third centuries. The settlement destroyed in 256 CE—included a Jewish house-synagogue, a Christian house-church, shrines to the Persian cults of Mithras and Zoroaster, and temples to Greek and Roman gods, including Zeus and Artemis.

EARLY JEWISH ART

Although we concentrate here on the art and architecture of the late Roman world, Jewish art has a much longer history. The Jewish people trace their origin to a Semitic people called the Hebrews, who lived in the land of Canaan. Canaan, known from the second century CE by the Roman name Palestine, was located along the eastern edge of the Mediterranean Sea (MAP 7-1). According to the Torah—the first five books of the Hebrew Bible—God promised the patriarch Abraham that Canaan would be a homeland for the Jewish people (Genesis 17:8), a belief that remains important for some Jews to this day.

Jewish settlement of Canaan probably began sometime in the second millennium BCE. According to Exodus, the second book of

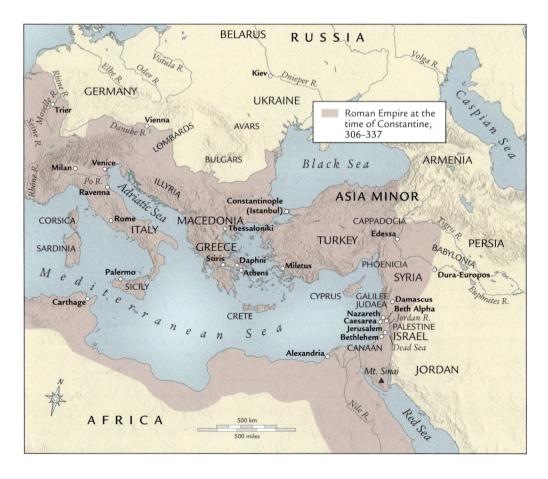

MAP 7-1 • THE LATE ROMAN AND BYZANTINE WORLD

During the period that saw the early spread of Christianity and ultimately its legalization by Constantine, the Roman Empire still extended completely around the shores of the Mediterranean Sea.

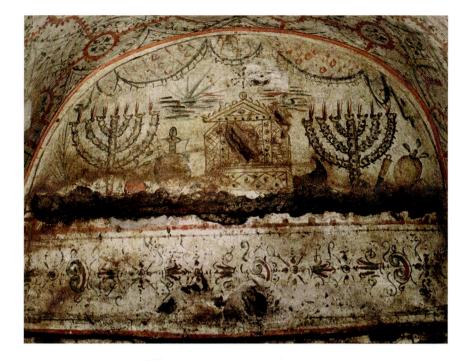

7-2 • ARK OF THE COVENANT AND MENORAHS

Wall painting in a Jewish catacomb, Villa Torlonia, Rome. 3rd century. $3'11'' \times 5'9''$ (1.19 \times 1.8 m).

The menorah form probably derives from the ancient Near Eastern Tree of Life, symbolizing for the Jewish people both the end of exile and the paradise to come.

the Torah, the prophet Moses led the Hebrews out of slavery in Egypt to the promised land of Canaan. At one crucial point during the journey, Moses climbed alone to the top of Mount Sinai, where God gave him the Ten Commandments, the cornerstone of Jewish law. The commandments, inscribed on tablets, were kept in a gold-covered wooden box, the Ark of the Covenant.

Jewish law forbade the worship of idols, a prohibition that often made the representational arts—especially sculpture in the round—suspect. Nevertheless, artists working for Jewish patrons depicted both symbolic and narrative Jewish subjects, and they drew from the traditions of both Near Eastern and Classical Greek and Roman art.

THE FIRST TEMPLE IN JERUSALEM In the tenth century BCE, the Jewish king Solomon built a temple in Jerusalem to house the Ark of the Covenant. According to the Hebrew Bible (2 Chronicles 2–7), he sent to nearby Phoenicia for cedar, cypress, and sandalwood, and for a superb construction supervisor. Later known as the First Temple, this building was the spiritual center of Jewish life. Biblical texts describe courtyards, two bronze pillars (large, free-standing architectural forms), an entrance hall, a main hall, and the Holy of Holies, the innermost chamber that housed the Ark and its guardian cherubim, or attendant angels.

In 586 BCE, the Babylonians, under King Nebuchadnezzar II, conquered Jerusalem. They destroyed the Temple, exiled the Jews, and carried off the Ark of the Covenant. When Cyrus the Great of Persia conquered Babylonia in 539 BCE, he permitted the Jews to return to their homeland (Ezra 1:1–4) and rebuild the Temple, which became known as the Second Temple. When Canaan became part of the Roman Empire, Herod the Great (king of Judaea, 37–34 BCE) restored the Second Temple. In 70 CE, Roman forces led by the general and future emperor Titus destroyed and

looted the Second Temple and all of Jerusalem, a campaign the Romans commemorated on the Arch of Titus (see FIG. 6–37). The site of the Second Temple, the Temple Mount, is also an Islamic holy site, the Haram al-Sharif, and is now occupied by the shrine called the Dome of the Rock (see FIGs. 9–3, 9–4).

JEWISH CATACOMB ART IN ROME Most of the earliest surviving examples of Jewish art date from the Hellenistic and Roman periods. Six Jewish catacombs, discovered on the outskirts of Rome and in use from the first to fourth centuries CE, display wall paintings with Jewish themes. In one example, from the third century CE, two menorahs flank the long-lost **ARK OF THE COVENANT** (**FIG. 7-2**). The continuing representation of the menorah, one of the precious objects looted from the Second Temple, kept the memory of the lost Jewish treasures alive.

SYNAGOGUES Judaism has long emphasized religious learning. Jews gather in synagogues for study of the Torah—considered a form of worship. A synagogue can be any large room where the Torah scrolls are kept and read; it was also the site of communal social gatherings. Some synagogues were located in private homes or in buildings originally constructed like homes. The first Dura-Europos synagogue consisted of an assembly hall, a separate alcove for women, and a courtyard. After a remodeling of the building, completed in 244–245 CE, men and women shared the hall, and residential rooms were added. Two architectural features distinguished the assembly hall: a bench along its walls and a niche for the Torah scrolls (**FIG. 7-3**).

Scenes from Jewish history and the story of Moses, as recorded in Exodus, unfold in a continuous visual narrative around the room, employing the Roman tradition of epic historical presentation (see FIG. 6–48). In the scene of **THE CROSSING OF THE RED**

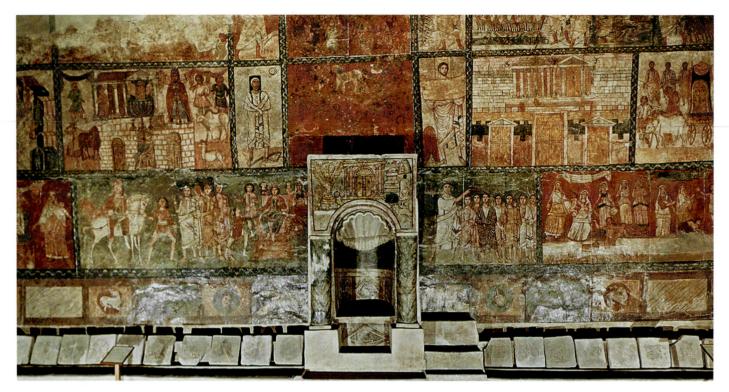

7-3 • WALL WITH TORAH NICHE From a house-synagogue, Dura-Europos, Syria. 244–245 ce. Tempera on plaster, section approx. 40' (12.19 m) long. Reconstructed in the National Museum, Damascus, Syria.

SEA (**FIG. 7-4**), Moses appears twice to signal sequential moments in the dramatic narrative. To the left he leans toward the army of Pharaoh, which is marching along the path that had been created for the Hebrews by God's miraculous parting of the waters, but at the right, wielding his authoritative staff, Moses returns the waters over the Egyptian soldiers to prevent their pursuit. Over each scene hovers a large hand, representing God's presence in both miracles—the parting and the unparting—using a symbol that will also be frequent in Christian art. Hierarchic scale makes it clear who is the hero in this two-part narrative, but the clue to his identity is provided only by the context of the story, which observers would have already known.

In addition to house-synagogues, Jews built meeting places designed on the model of the ancient Roman basilica. A typical

7-4 • THE CROSSING OF THE RED SEA Detail of a wall painting from a house-synagogue, Dura-Europos, Syria. 244– 245 ce. National Museum,

Damascus, Syria.

A CLOSER LOOK | The Mosaic Floor of the Beth Alpha Synagogue

by Marianos and Hanina. Ritual Objects, Celestial Diagram, and Sacrifice of Isaac. Galilee, Israel. 6th century CE.

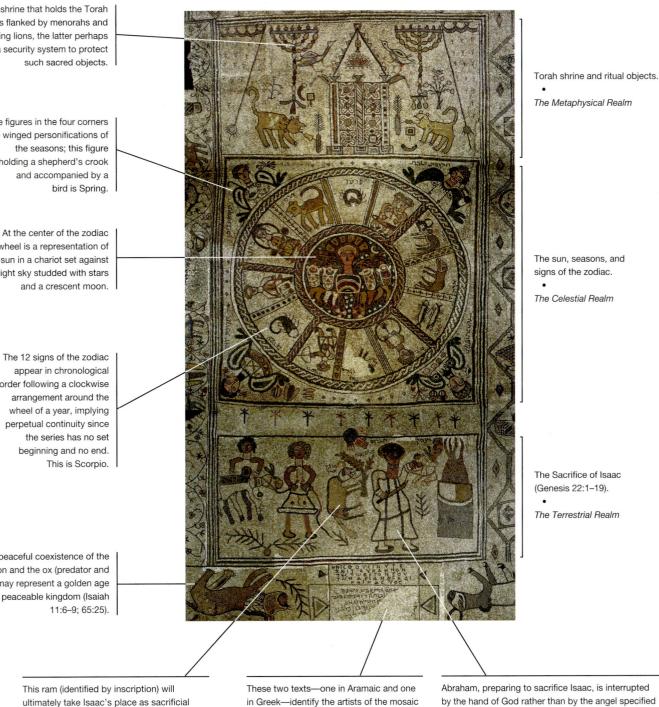

The shrine that holds the Torah is flanked by menorahs and growling lions, the latter perhaps as a security system to protect such sacred objects.

The figures in the four corners are winged personifications of the seasons; this figure holding a shepherd's crook and accompanied by a

wheel is a representation of the sun in a chariot set against a night sky studded with stars and a crescent moon.

The 12 signs of the zodiac appear in chronological order following a clockwise arrangement around the wheel of a year, implying perpetual continuity since the series has no set beginning and no end.

The peaceful coexistence of the lion and the ox (predator and prey) may represent a golden age or peaceable kingdom (Isaiah

beings frontally.

are shown consistently in profile, human

offering. Throughout the mosaic, animals as Marianos and his son Hanina, and date their work to the reign of either Emperor Justin I (518-527) or Justin II (565-578).

by the hand of God rather than by the angel specified in the Bible. Both Abraham and Isaac are identified by inscription, but Abraham's advanced age is signaled pictorially by the streaks of gray in his beard.

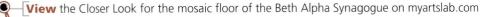

basilica synagogue had a central nave; an aisle on both sides, separated from the nave by a line of columns; a semicircular apse with Torah shrine in the wall facing Jerusalem; and perhaps an atrium and porch, or **narthex** (vestibule). The small fifth-century CE synagogue at Beth Alpha-discovered between the Gilboa mountains and the River Jordan by farmers in 1928-fits well into this pattern, with a three-nave interior, vestibule, and courtyard. Like some other very grand synagogues, it also has a mosaic floor, in this case a later addition from the sixth century. Most of the floor decoration is geometric in design, but in the central nave there are three complex panels full of figural compositions and symbols (see "A Closer Look," page 219) created using 21 separate colors of stone and glass tesserae. The images of ritual objects, a celestial diagram of the zodiac, and a scene of Abraham's near-sacrifice of Isaac, bordered by strips of foliate and geometric ornament, draw on both Classical and Near Eastern pictorial traditions.

EARLY CHRISTIAN ART

At age 30, a Palestinian Jew named Jesus gathered a group of followers, male and female. He performed miracles of healing and preached love of God and neighbor, the sanctity of social justice, the forgiveness of sins, and the promise of life after death. Christian belief holds that, after his ministry on Earth, Jesus was executed by crucifixion, and after three days rose from the dead.

THE CHRISTIAN BIBLE The Christian Bible is divided into two parts: the Old Testament (the Hebrew Bible) and the New Testament. The life and teachings of Jesus of Nazareth were recorded between about 70 and 100 CE in New Testament Gospels attributed to the four evangelists (from the Greek *evangelion*, meaning "good news"): Matthew, Mark, Luke, and John. The order was set by St. Jerome, an early Church scholar who translated the Christian scriptures from Greek into Latin.

In addition to the four Gospels, the New Testament includes the Acts of the Apostles and the Epistles, 21 letters of advice and encouragement written to Christian communities in Greece, Asia Minor, and other parts of the Roman Empire. The final book is Revelation (Apocalypse), a series of enigmatic visions and prophecies concerning the eventual triumph of God at the end of the world, written about 95 CE.

THE EARLY CHURCH Jesus limited his ministry primarily to Jews; it was his apostles, as well as later followers such as Paul, who took his teachings to gentiles (non-Jews). Despite sporadic persecutions, Christianity persisted and spread throughout the Roman Empire. The government formally recognized the religion in 313, and Christianity grew rapidly during the fourth century. As well-educated, upper-class Romans joined the Christian Church, they established an increasingly elaborate organizational structure, ever-more complicated rituals and doctrine, and ambitious and elaborate works of art and architecture.

Christian communities became organized by geographic units, called dioceses, along the lines of Roman provincial governments. Senior church officials called bishops served as governors of dioceses made up of smaller units, known as parishes, headed by priests. A bishop's church is a **cathedral**, a word derived from the Latin *cathedra*, which means "chair" but took on the meaning of "bishop's throne."

Communal Christian worship focused on the central "mystery," or miracle, of the Incarnation of God in Jesus Christ and the promise of salvation. At its core was the ritual consumption of bread and wine, identified as the Body and Blood of Christ, which Jesus had inaugurated at the Last Supper, a Passover seder meal with his disciples just before his crucifixion. Around these acts developed an elaborate religious ceremony, or liturgy, called the **Eucharist** (also known as Holy Communion or the Mass).

The earliest Christians gathered to worship in private apartments or houses, or in buildings constructed after domestic models such as the third-century church-house excavated at Dura-Europos (see "Dura-Europos," opposite). As their worship became more ritualized and complicated, however, Christians developed special buildings-churches and baptisteries-as well as specialized ritual equipment. They also began to use art to visualize their most important stories and ideas (see FIG. 7-1). The earliest surviving Christian art dates to the early third century and derives its styles and its imagery from Jewish and Roman visual traditions. In this process, known as syncretism, artists assimilate images from other traditions-either unconsciously or deliberately-and give them new meanings. For example, orant figures-worshipers with arms outstretched in prayer-can be pagan, Jewish, or Christian, depending on the context in which they occur. Perhaps the best-known syncretic image is the Good Shepherd. In pagan art, he was Apollo, or Hermes the shepherd, or Orpheus among the animals, or a personification of philanthropy. For Early Christians, he became the Good Shepherd of the Psalms (Psalm 23) and the Gospels (Matthew 18:12-14, John 10:11-16). Such images, therefore, do not have a stable meaning, but are associated with the meaning(s) that a particular viewer brings to them. They remind rather than instruct.

CATACOMB PAINTINGS Christians, like Jews, used catacombs for burials and funeral ceremonies, not as places of worship. In the Christian Catacomb of Commodilla, dating from the fourth century, long rectangular niches in the walls, called *loculi*, each held two or three bodies. Affluent families created small rooms, or **cubicula** (singular, *cubiculum*), off the main passages to house sarcophagi (see FIG. 7–1). The *cubicula* were hewn out of tufo, a soft volcanic rock, then plastered and painted with imagery related to their owners' religious beliefs. The finest Early Christian catacomb paintings resemble murals in houses such as those preserved at Rome and Pompeii.

One fourth-century Roman catacomb contained remains, or relics, of SS. Peter and Marcellinus, two third-century Christians

RECOVERING THE PAST | Dura-Europos

Our understanding of buildings used for worship by third-century Jews and Christians was greatly enhanced-even revolutionized-by the spectacular discoveries made in the 1930s while excavating the Roman military garrison and border town of Dura-Europos (in modern Syria). In 256, threatened by the Parthians attacking from the east, residents of Dura built a huge earthwork mound around their town in an attempt to protect themselves from the invading armies. In the process-since they were located on the city's margins right against its defensive stone wallthe houses used by Jews and Christians as places of worship were buried under the earthwork perimeter. In spite of this enhanced fortification, the Parthians conquered Dura-Europos. But since the victors never unearthed the submerged margins of the city, an intact Jewish house-synagogue and Christian house-church remained underground awaiting the explorations of modern archaeologists.

We have already seen the extensive strip narratives flanking the Torah shrine in the house-synagogue (see FIG. 7-3). The discovery of this expansive pictorial decoration contradicted a long-held scholarly belief that Jews of this period avoided figural decoration of any sort, in conformity with Mosaic law (Exodus 20:4). And a few blocks down the street that ran along the city wall, a typical Roman house built around a central courtyard held another surprise. Only a discreet red cross above the door distinguished it from the other houses on its block, but the arrangement of the interior clearly documents its use as a Christian place of worship. A large assembly hall that could seat 60-70 people lies on one side of the courtyard, and across from it is a smaller but extensively decorated room with a water tank set aside for baptism, the central rite of Christian initiation (FIG. 7-5). Along the walls were scenes from Christ's miracles and a monumental portrayal of women visiting his tomb about to discover his resurrection (below). Above the baptismal basin is a lunette (semicircular wall section) featuring the Good Shepherd with his flock, but also including at lower left diminutive figures of Adam and Eve covering themselves in shame after their sinful disobedience (FIG. 7-6). Even this early in Christian art, sacred spaces were decorated with pictures proclaiming the theological meaning of the rituals they housed. In this painting, Adam and Eve's fall from grace is juxtaposed with a larger image of the Good Shepherd (representing Jesus) who came to Earth to care for and guide his sheep (Christian believers) toward redemption and eternal life-a message that was especially appropriate juxtaposed with the rite of Christian baptism, which signaled the converts' passage from sin to salvation.

7-5 • RECONSTRUCTION OF BAPTISTERY, WITH FRAGMENTS OF ORIGINAL FRESCO From Christian house-church, Dura-Europos, Syria. Before 256. Yale University Art Gallery, New Haven, Connecticut.

7-6 • THE GOOD SHEPHERD WITH ADAM AND EVE AFTER THE FALL Detail of lunette fresco in FIG. 7–5.

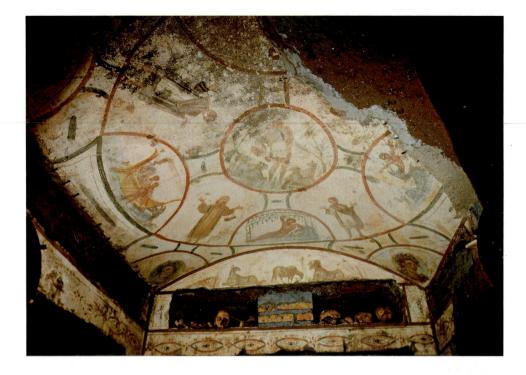

7-7 • THE GOOD SHEPHERD, ORANTS, AND THE STORY OF JONAH

Painted ceiling of the Catacomb of SS. Peter and Marcellinus, Rome. Late 3rd– early 4th century.

martyred for their faith. Here, the ceiling of a *cubiculum* is partitioned by a central **medallion**, or round compartment, and four semicircular lunettes, framed by arches (**FIG. 7-7**). At the center is a Good Shepherd, whose pose has roots in Classical sculpture. In its new context, the image was a reminder of Jesus' promise "I am the good shepherd. A good shepherd lays down his life for the sheep" (John 10:11).

The semicircular compartments surrounding the Good Shepherd tell the story of Jonah and the sea monster from the Hebrew Bible (Jonah 1–2), in which God caused Jonah to be thrown overboard, swallowed by the monster, and released, repentant and unscathed, three days later. Christians reinterpreted this story as a parable of Christ's death and resurrection—and hence of the everlasting life awaiting true believers—and it was a popular subject in Christian catacombs. On the left, Jonah is thrown from the boat; on the right, the monster spits him up; and below, between these two scenes, Jonah reclines in the shade of a vine, a symbol of paradise. Orant figures stand between the lunettes, presumably images of the faithful Christians who were buried here.

SCULPTURE Early Christian sculpture before the fourth century is rarer than painting. What survives is mainly sarcophagi and small statues and reliefs. A remarkable set of small marble figures, discovered in the 1960s and probably made in third-century Asia Minor, features a gracious **GOOD SHEPHERD** (**FIG. 7-8**). Because it was found withsculptures depicting Jonah—as we have already seen, a popular Early Christian theme—it is probably from a Christian context.

7-8 • THE GOOD SHEPHERD

Eastern Mediterranean, probably Anatolia (Turkey). Second half of the 3rd century. Marble, height 19³/₄" (50.2 cm), width 6" (15.9 cm). Cleveland Museum of Art. John L. Severance Fund (1965.241)

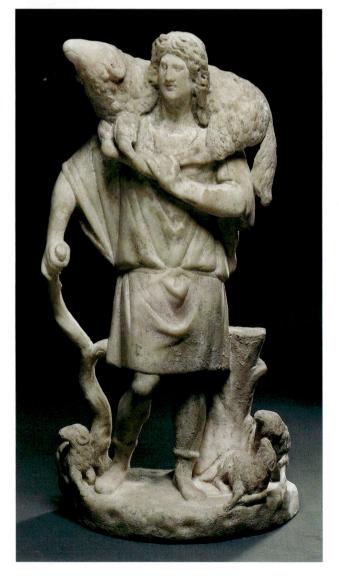

IMPERIAL CHRISTIAN ARCHITECTURE AND ART

When Constantine issued the Edict of Milan in 313, granting all people in the Roman Empire freedom to worship whatever god they wished, Christianity and Christian art and architecture entered a new phase. Sophisticated philosophical and ethical systems developed, incorporating many ideas from Greek and Roman pagan thought. Church scholars edited and commented on the Bible, and the papal secretary who would become St. Jerome (c. 347–420) undertook a new translation from Hebrew and Greek versions into Latin, the language of the Western Church. The socalled Vulgate (from the same root as the word "vulgar," the Latin *vulgaris*, meaning "common" or "popular") became the official version of the Bible.

ROME

The developing Christian community had special architectural needs. Greek temples had served as the house and treasury of the gods, forming a backdrop for ceremonies that took place at altars in the open air, but with Christianity, an entire community needed to gather inside a building to worship. Christians also needed locations for special activities such as the initiation of new members, private devotion, and burials. Beginning with the age of Constantine, pagan basilicas provided the model for congregational churches, and tombs provided a model for baptisteries and martyrs' shrines (see "Longitudinal-Plan and Central-Plan Churches," page 225).

OLD ST. PETER'S Constantine ordered the construction of a large new basilican church to mark the place where Christians believed St. Peter was buried (**FIGS. 7-9, 7-13**). Our knowledge of what is now called Old St. Peter's (it was destroyed and replaced by a new building in the sixteenth century) is based on written descriptions, drawings made before and while it was being dismantled, the study of other churches inspired by it, and modern archaeological excavations at the site.

Old St. Peter's included architectural elements in an arrangement that has characterized Christian basilican churches ever since. An atrium, or courtyard, in front of the basilica and a narthex across its width in the entrance end provided a place for people who had not yet been baptized. Five doorways—a large, central portal into the nave and two portals on each side—gave access to the church. Columns supporting an entablature lined the nave, forming what is called a nave colonnade. Running parallel to the nave colonnade on each side was another row of columns that created double side aisles; these columns supported round arches rather than an entablature. The roofs of both nave and aisles were supported by wooden rafters. Sarcophagi and tombs lined the side aisles and graves were dug under the floor. At the apse end of the nave, Constantine's architects added an innovative transept—a perpendicular hall crossing in front of the apse. This area provided additional

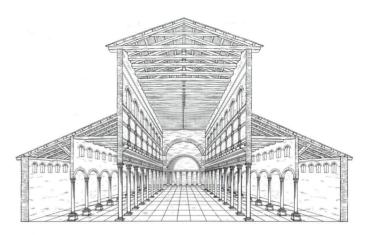

7-9 • RECONSTRUCTION DRAWING OF THE INTERIOR OF OLD ST. PETER'S, ROME c. 320-327.

Read the document related to Old St. Peter's on myartslab.com

space for the large number of clergy serving the church, and it also accommodated pilgrims visiting the tomb of St. Peter. Old St. Peter's could hold at least 14,000 worshipers, and it remained the largest church in Christendom until the eleventh century.

SANTA SABINA Old St. Peter's is gone, but the church of Santa Sabina in Rome, constructed by Bishop Peter of Illyria (a region in the Balkan peninsula) a century later, between about 422 and 432, appears much as it did in the fifth century (**FIGS. 7-10, 7-11**). The basic elements of the Early Christian basilica are clearly visible here, inside and out: a nave lit by clerestory windows, flanked by single side aisles, and ending in a rounded apse.

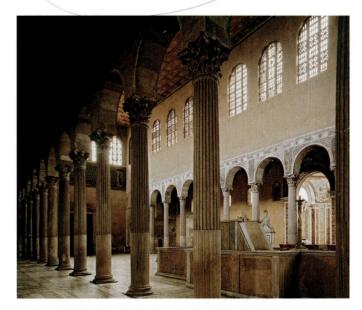

7-10 • INTERIOR, CHURCH OF SANTA SABINA View from the south aisle near the sanctuary toward the entrance. c. 422–432.

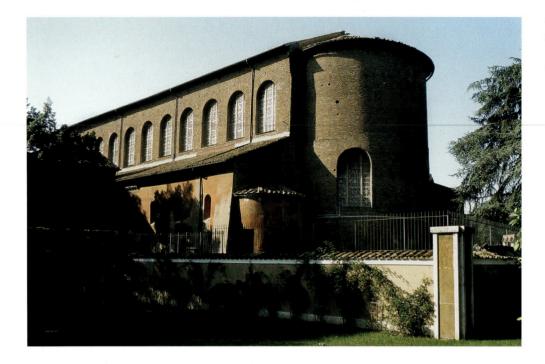

7-11 • CHURCH OF SANTA SABINA, ROME Exterior view from the southeast. c. 422–432.

Santa Sabina's exterior is simple brickwork. In contrast, the church's interior displays a wealth of marble veneer and 24 fluted marble columns with Corinthian capitals reused from a second-century pagan building. (Material reused from earlier buildings is known as *spolia*, Latin for "spoils.") The columns support round arches, creating a nave arcade, in contrast to the straight rather than arching nave colonnade in Old St. Peter's. The spandrels between the arches are faced with marble veneer that portrays chalices (wine cups) and paten (bread plates), essential equipment for the Eucharistic rite that took place at the altar. In such basilicas, the expanse of wall between the arcade and the clerestory typically had paintings or mosaics with biblical scenes, but here the decoration of the upper walls is lost.

SANTA COSTANZA Central-plan Roman buildings, with vertical (rather than longitudinal) axes, served as models for Christian tombs, martyrs' churches, and baptisteries (see "Longitudinal-Plan and Central-Plan Churches," opposite). One of the earliest surviving central-plan Christian buildings is the mausoleum of Constantina, daughter of Constantine. Her tomb was built outside the walls of Rome just before 350 (FIGS. 7-14, 7-15), and it was consecrated as a church in 1256, dedicated to Santa Costanza (the Italian form of Constantina, who was sanctified after her death). The building is a tall rotunda with an encircling barrelvaulted passageway called an **ambulatory**. Paired columns with Composite capitals and richly molded entablature blocks support the arcade and dome. Originally, the interior was entirely sheathed in mosaics and veneers of fine marble.

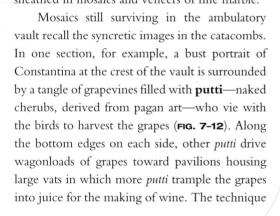

7-12 • HARVESTING OF GRAPES Ambulatory vault, church of Santa Costanza, Rome. c. 350. Mosaic.

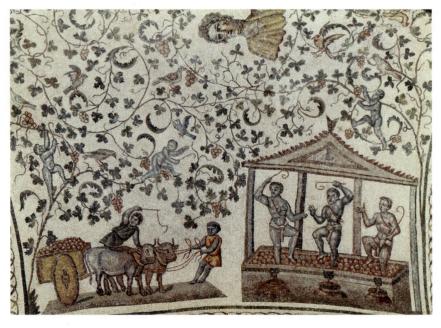

ELEMENTS OF ARCHITECTURE | Longitudinal-Plan and Central-Plan Churches

The forms of Early Christian buildings were based on two Roman prototypes: rectangular basilicas (see FIGS. 6-44, 6-63, 6-67) and circular or squared structures-including rotundas like the Pantheon (see FIGS. 6-50, 6-51). As in the basilica of Old St. Peter's in Rome (FIG. 7-13), longitudinal-plan churches are characterized by a forecourt, the atrium, leading to an entrance porch, the narthex, which spans one of the building's short ends. Doorways-known collectively as the church's portals-lead from the narthex into a long, congregational area called a nave. Rows of columns separate the high-ceilinged nave from one or two lower aisles on either side. The nave can be lit by windows along its upper level just under the ceiling, called a clerestory, that rises above the side aisles' roofs. At the opposite end of the nave from the narthex is a semicircular projection, the apse. The apse functions as the building's focal point where the altar, raised on a platform, is located. Sometimes there is also a transept, a wing that crosses the nave in front of the apse, making the building T-shape. When additional space (a liturgical choir) comes between the transept and the apse, the plan is known as a Latin cross.

Central-plan buildings were first used by Christians, like their pagan Roman forebears, as tombs. Central planning was also employed for

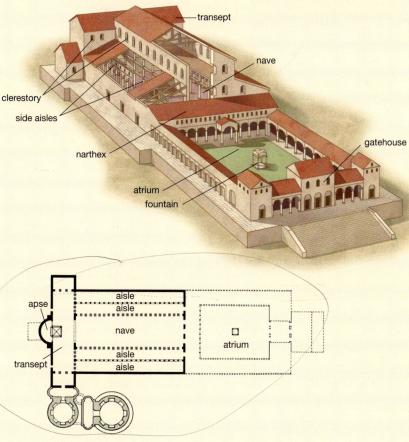

7-13 • PLAN (A) AND RECONSTRUCTION DRAWING (B) OF OLD ST. PETER'S

c. 320–327; atrium added in later 4th century. Approx. 394' (120 m) long and 210' (64 m) wide.

baptisteries (where Christians "died"—giving up their old life—and were reborn as believers), and churches dedicated to martyrs (e.g. San Vitale, see FiG. 8–5), often built directly over their tombs. Like basilicas, centralplan churches can have an atrium, a narthex, and an apse. But instead of the longitudinal axis of basilican churches, which draws worshipers forward along a line from the entrance toward the apse, central-plan buildings, such as the Mausoleum of Constantina—rededicated in 1256 as the church of Santa Costanza (**Fig. 7–14**)—have a more vertical axis, from the center up through the dome, which may have functioned as a symbolic "vault of heaven."

7-14 • PLAN (A) AND SECTION (B) OF THE CHURCH OF SANTA COSTANZA, ROME c. 350.

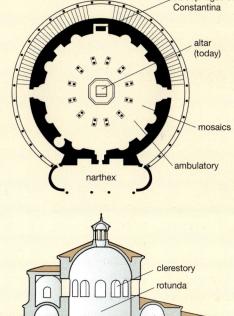

sarcophagus of

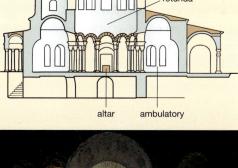

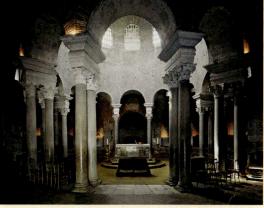

7-15 • CHURCH OF SANTA COSTANZA, ROME c. 350. View from ambulatory into rotunda.

and style are Roman; the subject is traditional, associated with Bacchus and his cult; but the meaning here is new. In a Christian context, the wine refers to the Eucharist and the trampling of grapes for the making of wine becomes an image of death and resurrection. Constantina's pagan husband, however, may have appreciated the parallel, pagan allusion.

Within her mausoleum, Constantina (d. 354) was buried within a spectacularly huge porphyry sarcophagus (**FIG. 7-16**) that was installed across from the entrance on the other side of the ambulatory in a rectangular niche (visible on the plan in **FIG. 7-14**; an in-place replica peeks over the altar in **FIG. 7-15**). The motifs are already familiar—the same theme of *putti* making wine that we saw highlighted in the mosaics of the ambulatory vaults. Here the scenes are framed by a huge, undulating grapevine, whose subsidiary shoots curl above and below to fill the flat sides of the box. Striding along its base, peacocks symbolize eternal life in paradise, while a lone sheep could represent a member of Jesus' flock, presumably Constantina herself.

THE SARCOPHAGUS OF JUNIUS BASSUS Carved about the same time, but made of marble, the SARCOPHAGUS OF JUNIUS BASSUS (FIG. 7-17) is packed with elaborate figural scenes like the second-century CE Dionysiac sarcophagus (see "A Closer Look," page 202), only here they are separated into two registers, where columns, entablatures, and gables divide the space into fields

7-16 • SARCOPHAGUS OF CONSTANTINA c. 350. Porphyry, height 7'5" (2.26 m). Musei Vaticani, Vatican, Rome.

for individual scenes. Junius Bassus was a Roman official who, as the inscription here tells us, was "newly baptized" and died on August 25, 359, at age 42.

In the center of both registers is a triumphant Christ. Above, he appears as a Roman emperor, distributing legal authority in the form of scrolls to flanking figures of SS. Peter and Paul, and resting his feet on the head of Coelus, the pagan god of the heavens, here representing the cosmos to identify Christ as Cosmocrator (ruler of the cosmos). In the bottom register,

the earthly Jesus makes his triumphal entry into Jerusalem, like a Roman emperor entering a conquered city. Jesus, however, rides on a humble ass rather than a powerful steed.

Even in the earliest Christian art, such as that in catacomb paintings and here on the sarcophagus of Junius Bassus, artists employed episodes from the Hebrew Bible allegorically since Christians saw them as prefigurations of important events in the New Testament. At the top left, Abraham passes the test of faith and need not sacrifice his son Isaac. Christians saw in this story an allegory that foreshadowed God's sacrifice of his own son, Jesus, which culminates not in Jesus' death, but in his resurrection. Under the triangular gable, second from the end at bottom right, the Hebrew Bible story of Daniel saved by God from the lions prefigures Christ's emergence alive from his tomb. At bottom far left, God tests the faith of Job, who provides a model for the sufferings of Christian martyrs. Next to Job, Adam and Eve have sinned to set in motion the entire Christian redemption story. Lured by the serpent, they have eaten the forbidden fruit and, conscious of their nakedness, are trying to hide their genitals with leaves.

On the upper right side, spread over two compartments, Jesus appears before Pontius Pilate, who is about to wash his hands, symbolizing his denial of responsibility for Jesus' death. Jesus' position here, held captive between two soldiers, recalls (and perhaps could also be read as) his arrest in Gethsemane, especially since the composition of this panel is reflected in the arrests of the

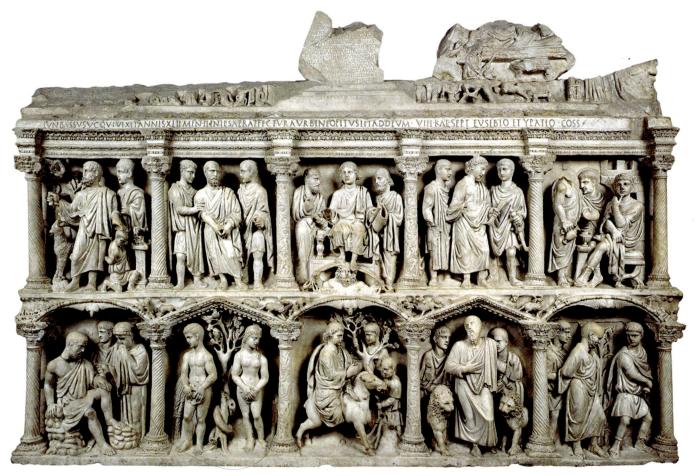

7-17 • SARCOPHAGUS OF JUNIUS BASSUS Grottoes of St. Peter, Vatican, Rome. c. 359. Marble, $4' \times 8'$ (1.2 × 2.4 m).

apostles Peter (top, second frame from the left) and Paul (bottom, far right).

RAVENNA AND THESSALONIKI

As the city of Rome's political importance dwindled, that of other imperial cities grew. In 395, Emperor Theodosius I split the Roman Empire into Eastern and Western divisions, each ruled by one of his sons. Heading the West, Honorius (r. 395–423) first established his capital at Milan, but in 402, to escape the siege by Germanic settlers, he moved his government to Ravenna, on the east coast of Italy. Its naval base, Classis (present-day Classe), had been important since the early days of the empire. In addition to military security, Ravenna offered direct access by sea to Constantinople. When Italy fell in 476 to the Ostrogoths, Ravenna became one of their headquarters, but the beauty and richness of Early Christian buildings can still be experienced there in a remarkable group of especially well-preserved fifth- and sixth-century churches, baptisteries, and oratories, encrusted with mosaics (see "The Oratory of Galla Placidia in Ravenna," page 228).

The history of Thessaloniki (now in modern Greece) as an imperial capital dates back even earlier, to the reorganization of Roman imperial government under Diocletian (see pages 205–207). Galerius—at first Diocletian's Caesar at the creation of the

Tetrarchy in 293 and then emperor of the East from Diocletian's retirement in 305 to his own death in 311—made Thessaloniki his capital, initiating an ambitious building program that included a hippodrome, a palace, and a triumphal arch. After Constantine eliminated his rivals and became sole emperor of the Roman world in 324, Thessaloniki decreased in importance, though it remained a provincial capital and the seat of a powerful bishop. The local Christian community dates to the first century CE. St. Paul's letters written to the church in Thessaloniki during the 50s became part of the New Testament.

THE ROTUNDA CHURCH OF ST. GEORGE IN THESSA-

LONIKI Galerius constructed within his palace complex a grand rotunda that may have been intended for his tomb. During the fifth century, this imperial building was converted into a church through the addition of an apse on the east side, an entrance on the west, and an ambulatory encircling the entire rotunda. The interior surface of the huge dome—almost 100 feet in diameter was covered with lavish golden mosaics, perhaps created by artists who were called here from Constantinople, which was developing into one of the great artistic centers of the Christian Roman world (**FIG. 7-21**). Forming a circle around and above worshipers within the building, 16 standing figures of saints dressed in One of the earliest surviving Christian structures in Ravenna is a magnificent **oratory** (small chapel) that was attached c. 425–426 to the narthex of the palace church of Santa Croce (**FIG. 7–18**). This building was dedicated to St. Lawrence, but today it bears the name of the remarkable Galla Placidia—daughter of Roman emperor Theodosius I, wife of a Gothic king, sister of emperors Honorius and Arcadius, and mother of Emperor Valentinian III. As regent for her son after 425, she ruled the Western Empire until about 440. The oratory came to be called the Mausoleum of Galla Placidia because she and her family were once believed to be buried there.

This small building is **cruciform**, or crossshape. A barrel vault covers each of its arms, and a pendentive dome—a dome continuous with its pendentives—covers the square space at the center (see "Pendentives and Squinches," page 238). The interior of the chapel contrasts markedly with the unadorned exterior, a transition seemingly designed to simulate the passage from the real world into the supernatural realm (**Fig. 7–19**). The worshiper looking from the western entrance across to the eastern bay of the chapel sees brilliant mosaics in the vaults and panels of veined marble sheathing the walls below. Bands of luxuriant floral designs and geometric patterns cover the arches and barrel vaults, and figures of standing apostles, gesturing like orators, fill the upper walls of the central space. Doves flanking a small fountain between the apostles symbolize eternal life in heaven.

In the lunette at the end of the barrel vault opposite the entrance, a mosaic depicts the third-century St. Lawrence, to whom the building was dedicated. The triumphant martyr carries a cross over his shoulder like a trophy and gestures toward the fire-engulfed metal grill on which he was literally roasted at his martyrdom. At the left stands a tall cabinet containing the Gospels, signifying the faith for which he gave his life. Opposite St. Lawrence, in a lunette over the entrance portal, is a mosaic of **THE GOOD SHEPHERD** (**FIG. 7–20**). A comparison with third- and fourthcentury renderings of the same subject (see FIGS. 7–6, 7–7) reveals significant changes in content and design.

Jesus is no longer a boy in a simple tunic, but an adult emperor wearing purple and gold royal robes, his imperial majesty signaled by the golden halo surrounding his head and by a long golden staff that ends in a cross instead of a shepherd's crook. By the time this mosaic was made, Christianity had been the official state religion for 45 years, and nearly a century had passed since the last state persecution of Christians. The artists and patrons of this mosaic chose to assert the glory of Jesus in mosaic, the richest medium of wall decoration, in an imperial image still imbued with pagan spirit but now claiming the triumph of a new faith.

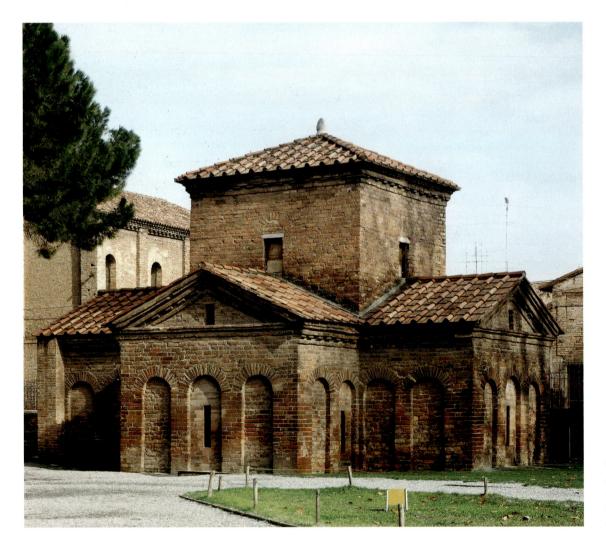

7-18 • ORATORY OF GALLA PLACIDIA, RAVENNA c. 425-426.

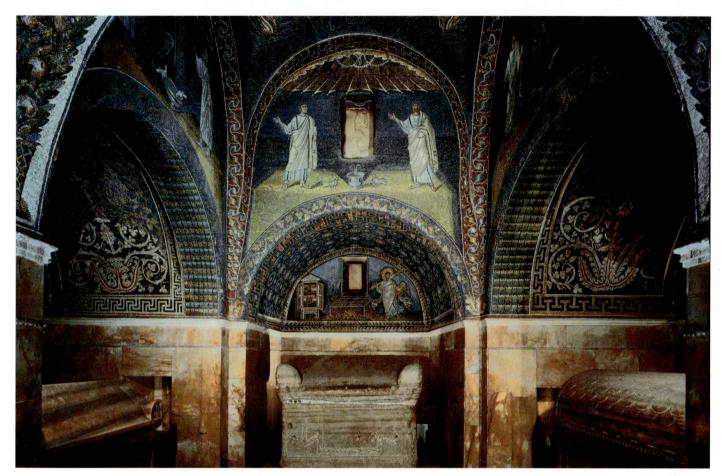

7-19 • ORATORY OF GALLA PLACIDIA

View from entrance, barrel-vaulted arms housing sarchophagi, lunette mosaic of the martyrdom of St. Lawrence. c. 425-426.

Explore the architectural panoramas of the oratory of Galla Placidia on myartslab.com

Lunette over the entrance, Oratory of Galla Placidia. c. 425–426. Mosaic.

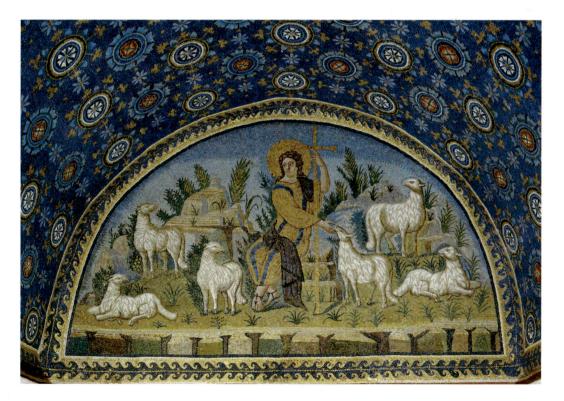

ART AND ITS CONTEXTS | The Life of Jesus

Episodes from the life of Jesus as recounted in the Gospels form the principal subject matter of Christian visual art. What follows is a list of main events in his life with parenthetical references citing their location in the Gospel texts.

Incarnation and Childhood of Jesus

Annunciation: The archangel Gabriel informs the Virgin Mary that God has chosen her to bear his Son. A dove often represents the **Incarnation**, her miraculous conception of Jesus through the Holy Spirit. (Lk 1:26–28)

Visitation: The pregnant Mary visits her older cousin Elizabeth, pregnant with the future St. John the Baptist. (Lk 1:29–45)

Nativity: Jesus is born in Bethlehem. The Holy Family—Jesus, Mary, and her husband, Joseph—is usually portrayed in a stable, or, in Byzantine art, a cave. (Lk 2:4–7)

Annunciation to and Adoration of the Shepherds: Angels announce Jesus' birth to shepherds, who hurry to Bethlehem to honor him. (Lk 2:8–20)

Adoration of the Magi: Wise men from the east follow a bright star to Bethlehem to honor Jesus as king of the Jews, presenting him with precious gifts. Eventually these Magi became identified as three kings, often differentiated through facial type as young, middle-aged, and old. (Mat 2:1–12)

Presentation in the Temple: Mary and Joseph bring the infant Jesus to the Temple in Jerusalem, where he is presented to the high priest. (Lk 2:25–35)

Massacre of the Innocents and Flight into Egypt: An angel warns Joseph that King Herod—to eliminate the threat of a newborn rival king—plans to murder all male babies in Bethlehem. The Holy Family flees to Egypt. (Mat 2:13–16)

Jesus' Ministry

Baptism: At age 30, Jesus is baptized by John the Baptist in the River Jordan. The Holy Spirit appears in the form of a dove and a heavenly voice proclaims Jesus as God's Son. (Mat 3:13–17, Mk 1:9–11, Lk 3:21–22)

Marriage at Cana: At his mother's request Jesus turns water into wine at a wedding feast, his first public miracle. (Jn 2:1–10)

Miracles of Healing: Throughout the Gospels, Jesus performs miracles of healing the blind, possessed (mentally ill), paralytic, and lepers; he also resurrects the dead.

Calling of Levi/Matthew: Jesus calls to Levi, a tax collector, "Follow me." Levi complies, becoming the disciple Matthew. (Mat 9:9, Mk 2:14)

Raising of Lazarus: Jesus brings his friend Lazarus back to life four days after his death. (Jn 11:1–44)

Transfiguration: Jesus reveals his divinity in a dazzling vision on Mount Tabor as his closest disciples—Peter, James, and John—look on. (Mat 17:1–5, Mk 9:2–6, Lk 9:28–35)

Tribute Money: Challenged to pay the temple tax, Jesus sends Peter to catch a fish, which turns out to have the required coin in its mouth. (Mat 17:24–27, Lk 20:20–25)

Jesus' Passion, Death, and Resurrection

Entry into Jerusalem: Jesus, riding an ass and accompanied by his disciples, enters Jerusalem, while crowds honor him, spreading clothes and palm fronds in his path. (Mat 21:1–11, Mk 11:1–11, Lk 19:30–44, Jn 12:12–15)

Last Supper: During the Jewish Passover seder, Jesus reveals his impending death to his disciples. Instructing them to drink wine (his blood) and eat bread (his body) in remembrance of him, he lays the foundation for the Christian Eucharist (Mass). (Mat 26:26–30, Mk 14:22–25, Lk 22:14–20)

Washing the Disciples' Feet: At the Last Supper, Jesus washes the disciples' feet, modeling humility. (Jn 13: 4–12)

Agony in the Garden: In the Garden of Gethsemane on the Mount of Olives, Jesus struggles between his human fear of pain and death and his divine strength to overcome them. The apostles sleep nearby, oblivious. (Lk 22:40–45)

Betraya/Arrest: Judas Iscariot (a disciple) has accepted a bribe to indicate Jesus to an armed band of his enemies by kissing him. (Mat 26:46–49, Mk 14:43–46, Lk 22:47–48, Jn 18:3–5)

Jesus before Pilate: Jesus is taken to Pontius Pilate, Roman governor of Judaea, and charged with treason for calling himself king of the Jews. Pilate proposes freeing Jesus but is shouted down by the mob, which demands Jesus be crucified. (Mat 27:11–25, Mk 15:4–14, Lk 23:1–24, Jn 18:28–40)

Crucifixion: Jesus is executed on a cross, often shown between two crucified criminals and accompanied by the Virgin Mary, John the Evangelist, Mary Magdalen, and other followers at the foot of the cross; Roman soldiers sometimes torment Jesus—one extending a sponge on a pole with vinegar instead of water for him to drink, another stabbing him in the side with a spear. A skull can identify the execution ground as Golgotha, "the place of the skull." (Mat 27:35–50, Mk 15:23–37, Lk 23:38–49, Jn 19:18–30)

Descent from the Cross (Deposition): Jesus' followers take his body down from the cross. (Mat 27:55–59, Mk 15:40–46, Lk 23:50–56, Jn 19:38–40)

Lamentation/Pietà and Entombment: Jesus' sorrowful followers gather around his body to mourn and then place his body in a tomb. An image of the grieving Virgin alone with Jesus across her lap is known as a **pietà** (from Latin *pietas*, "pity"). (Mat 27:60–61, Jn 19:41–42)

Resurrection/Holy Women at the Tomb: Three days after his entombment, Christ rises from the dead, and his female followers usually including Mary Magdalen—discover his empty tomb. An angel announces Christ's resurrection. (Mat 28, Mk 16, Lk 24:1–35, Jn 20)

Descent into Limbo/Harrowing of Hell (Anastasis): The resurrected Jesus descends into limbo, or hell, to free deserving predecessors, among them Adam, Eve, David, and Moses. (Apocryphal Gospel of Nicodemus, not in the New Testament)

Noli Me Tangere ("Do Not Touch Me"): Christ appears to Mary Magdalen as she weeps at his tomb. When she reaches out to him, he warns her not to touch him. (Lk 24:34–53, Jn 20:11–31)

Ascension: Christ ascends to heaven from the Mount of Olives, disappearing in a cloud, while his mother and apostles watch. (Acts 1)

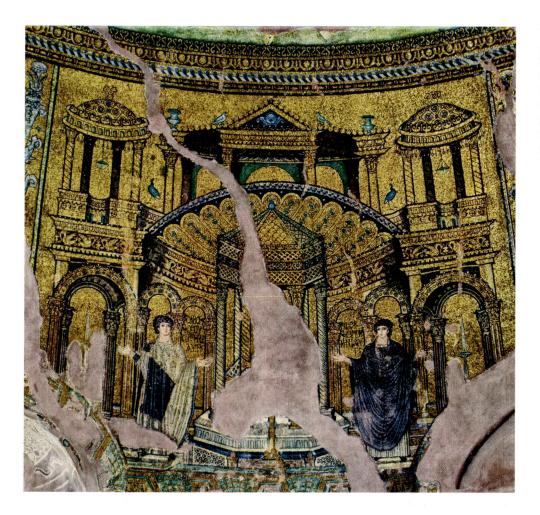

liturgical vestments make orant gestures of prayer, as if celebrating the liturgy in paradise concurrent with the services held here on earth. Behind them is a backdrop of elaborate architectural fantasies composed of Classical forms, decorated with gems, and inhabited by peacocks. The figures are equally Classical, with

their careful modeling, lavish drapery, and most notably their air of grace, eloquence, and composure. Classicizing features such as these will continue to develop as the Early Christian art of the Eastern Roman Empire blossoms into Byzantine art, which will flourish until the fifteenth century, centered in Constantinople.

THINK ABOUT IT

- 7.1 Discuss the Roman foundations of Early Christian sculpture, focusing your answer on the sarcophagus of Junius Bassus (FIG. 7-17). Look back to Chapter 6 to help form your ideas.
- 7.2 Distinguish the "iconic" from the "narrative" in two works of late antique Jewish or Christian art discussed in this chapter. How were these two traditions used by the communities that created these works?
- 7.3 How does the situation of the Jewish and Christian buildings in Dura-Europos on the outskirts of the Roman Empire affect their design and decoration?
- 7.4 Identify the distinctive features of basilicas and central-plan churches, and discuss how the forms of these early churches were geared toward specific types of Christian worship and devotional practice.

CROSSCURRENTS

Both Etruscans and Early Christians often painted the interior walls of their tombs. Discuss the themes chosen for the murals in these two examples. Are the images related to life, to death, or to life after death? How are the styles and subjects related to these two cultures?

Study and review on myartslab.com

7-21 • SS. ONESIPHOROS AND PORPHYRIOS STANDING **BEFORE AN ARCHITECTURAL** BACKDROP

Mosaics on the interior of the dome of the church of St. George (formerly the mausoleum of Galerius). Thessaloniki, northern Greece. Rotunda 4th century; mosaics 5th century.

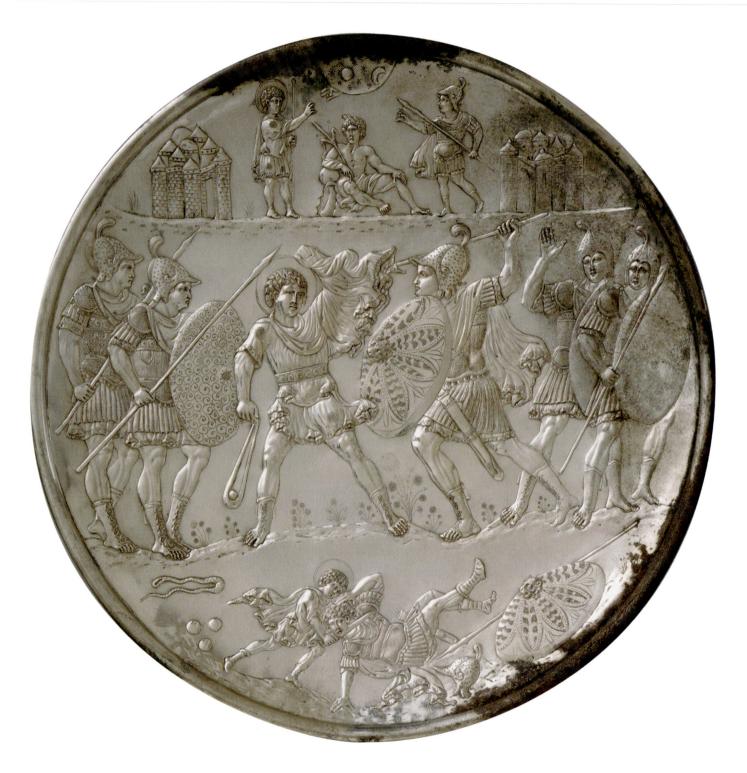

8-1 • DAVID BATTLING GOLIATH One of the "David Plates," made in Constantinople. 629–630 CE. Silver, diameter 19⁷/₈" (49.4 cm). Metropolitan Museum of Art, New York.

Byzantine Art

The robust figures on this huge silver plate (FIG. 8-1) enact three signature episodes in the youthful hero David's combat with the Philistine giant Goliath (1 Samuel 17:41–51). In the upper register, David-easily identified not only by his youth but also by the prominent halo as the "good guy" in all three scenes-and Goliath challenge each other on either side of a seated Classical personification of the stream that will be the source of the stones David is about to use in the ensuing battle. The confrontation itself appears in the middle, in a broad figural frieze whose size signals its primary importance. Goliath is most notable here for his superior armamentshelmet, spear, sword, and an enormous protective shield. At the bottom, David, stones and slingshot flung behind him, consummates his victory by severing the head of his defeated foe, whose imposing weapons and armor are scattered uselessly behind him.

Some may be surprised to see a Judeo-Christian subject portrayed in a style that was developed for the exploits of Classical heroes, but this mixture of traditions is typical of the eclecticism characterizing the visual arts as the Christianized Roman world became the Byzantine Empire. Patrons saw no conflict between the artistic principles of the pagan past and the Christian teaching undergirding their imperial present. To them, this Jewish subject, created for a Christian patron in a pagan style, would have attracted notice only because of its sumptuousness and its artistic virtuosity.

This was one of nine "David Plates" unearthed in Cyprus in 1902. Control stamps—guaranteeing the purity of the material, much like the stamps of "sterling" that appear on silver today—date them to the reign of the Byzantine emperor Heraclius (r. 613–641 CE). Displayed in the home of their owners, they were visual proclamations of wealth, but also of education and refined taste, just like collections of art and antiques in homes today. A constellation of iconographic and historical factors, however, allows us to uncover a subtler message. For the original owners, the single combat of David and Goliath might have recalled a situation involving their own emperor and enemies.

The reign of Heraclius was marked by war with the Sasanian Persians. A decisive moment in the final campaign of 628–629 CE occurred when Heraclius himself stepped forward for single combat with the Persian general Razatis, and the emperor prevailed, presaging Byzantine victory. Some contemporaries referred to Heraclius as a new David. Is it possible that the set of David Plates was produced for the emperor to offer as a diplomatic gift to one of his aristocratic allies, who subsequently took them to Cyprus? Perhaps the owners later buried them for safekeeping—like the early silver platter from Mildenhall (see FIG. 6–68)—where they awaited discovery at the beginning of the twentieth century.

LEARN ABOUT IT

- 8.1 Survey the variety of stylistic sources and developments that characterize the long history of Byzantine art.
- 8.2 Understand the principal themes and subjects secular as well as sacred—used by Byzantine artists.
- 8.3 Assess the central role of images in the devotional practices of the Byzantine world and explore the reasons for and impact of the brief interlude of iconoclasm.
- 8.4 Trace the growing Byzantine interest in conveying human emotions and representing human situations when visualizing sacred stories.

((•• Listen to the chapter audio on myartslab.com

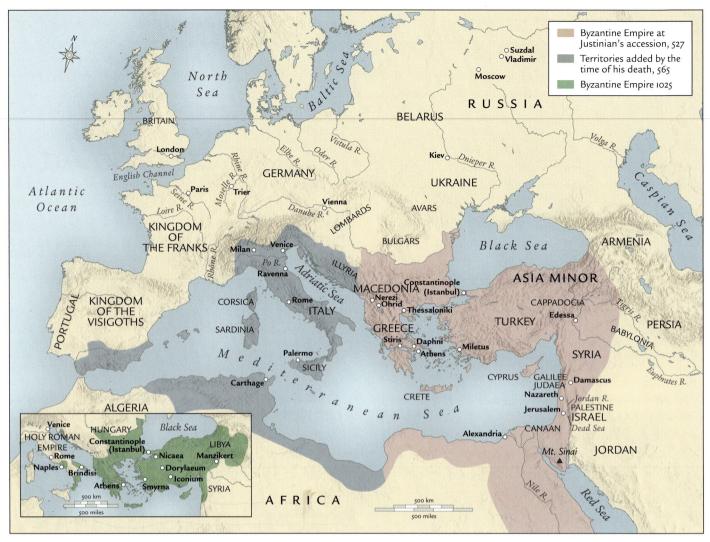

MAP 8-1 • THE LATE ROMAN AND BYZANTINE WORLD

The eastern shores of the Mediterranean, birthplace of Judaism and Christianity, were the focal point of the Byzantine Empire. The empire expanded further west under Emperor Justinian, though by 1025 cE it had contracted again to the east.

BYZANTIUM

Art historians apply the term "Byzantine" broadly to the art and architecture of Constantinople—whose ancient name, before Constantine renamed the revitalized city after himself, was Byzantium—and of the regions under its influence. Constantine had chosen well in selecting the site of his new capital city—his "New Rome." Constantinople lay at the crossroads of the overland trade routes between Asia and Europe and the sea route connecting the Black Sea and the Mediterranean. Even as the territories controlled by Byzantine rulers diminished in size and significance from century to century leading up to the fall of Constantinople in 1453, Byzantine emperors continued to conceive themselves as successors to the rulers of ancient Rome, their domain as an extension of the Roman Empire, and their capital city as an enduring manifestation of the glory that was ancient Rome.

conceive themselves as succes-
neir domain as an extension of
l city as an enduring manifes-
Rome.point Russia succeeded Constantinople as the "Third Rome" and
the center of the Eastern Orthodox Church. Late Byzantine art
continued to flourish into the eighteenth century in Ukraine, Rus-
sia, and much of southeastern Europe.

In this chapter, we will focus on what has been considered the

three "golden ages" of Byzantine art. The Early Byzantine period,

most closely associated with the reign of Emperor Justinian I (r.

527–565), began in the fifth century and ended in 726, at the onset

of the iconoclast controversy that led to the destruction of reli-

gious images. The Middle Byzantine period began in 843, when

Empress Theodora (c. 810-867) reinstated the veneration of icons,

and continued until 1204, when Christian crusaders from west-

ern Europe occupied Constantinople. The Late Byzantine period

began with the restoration of Byzantine rule in 1261 and ended

with the empire's fall to the Ottoman Turks in 1453, at which

EARLY BYZANTINE ART

THE GOLDEN AGE OF JUSTINIAN

During the fifth and sixth centuries, while invasions and religious controversy racked the Italian peninsula, the Eastern Roman Empire prospered. In fact, during the sixth century under Emperor Justinian I and his wife, Empress Theodora (d. 548), Byzantine political power, wealth, and culture were at their peak. Imperial forces held northern Africa, Sicily, much of Italy, and part of Spain. Ravenna became the Eastern Empire's administrative capital in the west, and Rome remained under nominal Byzantine control until the eighth century.

HAGIA SOPHIA IN CONSTANTINOPLE In Constantinople, Justinian and Theodora embarked on a spectacular campaign of building and renovation, but little now remains of their architectural projects or of the old imperial capital itself. The church of Hagia Sophia, meaning "Holy Wisdom" (referring to the dedication of this church to Christ as the embodiment of divine wisdom) is a spectacular exception (FIG. 8-2). It replaced a fourth-century church destroyed when crowds, spurred on by Justinian's foes during the devastating urban Nika Revolt in 532, set the old church on fire and cornered the emperor within his palace. Theodora, a brilliant and politically shrewd woman, is said to have shamed Justinian, who was plotting to escape, into not fleeing the city, saying "Purple makes a fine shroud"—a reference to purple as the imperial color. Theodora meant that she would rather remain and die an empress than flee and preserve her life. Taking up her words as a battle cry, Justinian led the imperial forces in crushing the rebels and restoring order, reputedly slaughtering 30,000 of his subjects in the process.

To design a new church that embodied imperial power and Christian glory, Justinian chose two scholar-theoreticians, Anthemius of Tralles and Isidorus of Miletus. Anthemius was a specialist in geometry and optics, and Isidorus a specialist in physics who had also studied vaulting. They developed an audacious and awe-inspiring design, executed by builders who had refined their masonry techniques by building the towers and domed rooms that were part of the city's defenses. So when Justinian ordered the construction of domed churches, and especially Hagia Sophia, master masons with a trained and experienced workforce stood ready to give permanent form to his architects' dreams.

The new Hagia Sophia was not constructed by the miraculous intervention of angels, as was rumored, but by mortal builders in only five years (532–537). Procopius of Caesarea, who chronicled Justinian's reign, claimed poetically that Hagia Sophia's gigantic

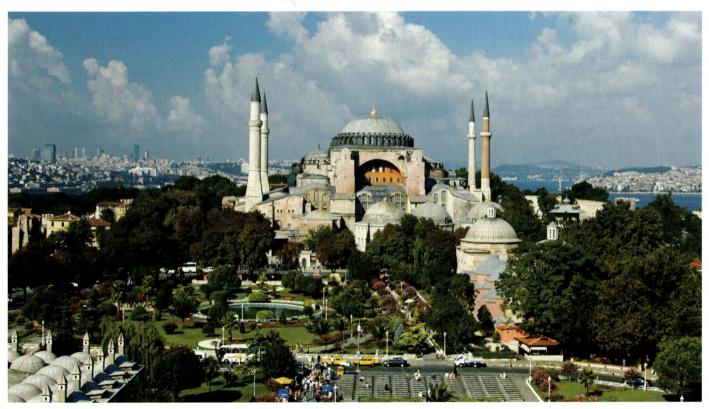

8-2 • Anthemius of Tralles and Isidorus of Miletus CHURCH OF HAGIA SOPHIA, CONSTANTINOPLE

Modern Istanbul. 532–537. View from the southwest.

The body of the original church is now surrounded by later additions, including the minarets built after 1453 by the Ottoman Turks. Today the building is a museum.

dome seemed to hang suspended on a "golden chain from heaven." Legend has it that Justinian himself, aware that architecture can be a potent symbol of earthly power, compared his accomplishment with that of the legendary builder of the First Temple in Jerusalem, saying "Solomon, I have outdone you."

Hagia Sophia is an innovative hybrid of longitudinal and central architectural planning (**FIG. 8-3**). The building is clearly dominated by the hovering form of its gigantic dome (**FIG. 8-4**). But flanking **conches**—halfdomes—extend the central space into a longitudinal nave that expands outward from the central dome to connect with the narthex on one end and the halfdome of the sanctuary apse on the other. This processional core, called the **naos** in Byzantine architecture, is flanked by side aisles and **galleries** above them overlooking the naos.

Since its idiosyncratic mixture of basilica and rotunda precludes a ring of masonry underneath the dome to provide support around its circumference (as in the Pantheon, see FIGS. 6-50, 6-51), the main dome of Hagia Sophia rests instead on four pendentives (triangular curving vault sections) that connect the base of the dome with the huge supporting piers at the four corners of the square area beneath it (see "Pendentives and Squinches," page 238). And since these piers are essentially submerged back into the darkness of the aisles, rather than expressed within the main space itself (see FIG. 8-3), the dome seems to float mysteriously over a void. The miraculous, weightless effect was reinforced by the light-reflecting gold mosaic that covered the surfaces of dome and pendentives alike, as well as by the band of 40 windows that perforate the base of the dome right where it meets its support. This daring move challenges architectural logic by seeming to weaken the integrity of the masonry at the very place where it needs to be strong, but the windows created the circle of light that helps the dome appear to hover, and a reinforcement of buttressing on the exterior made the solution sound as well as shimmering. The origin of the dome on pendentives is obscure, but its large-scale use at Hagia Sophia was totally unprecedented and represents one

of the boldest experiments in the history of architecture. It was to become the preferred method of supporting domes in Byzantine architecture.

The architects and builders of Hagia Sophia clearly stretched building materials to their physical limits, denying the physicality of the building in order to emphasize its spirituality. In fact, when the first dome fell in 558, it did so because a pier and pendentive shifted and because the dome was too shallow and exerted too much outward force at its base, not because the windows weakened the support. Confident of their revised technical methods, the architects designed a steeper dome that raised the summit 20 feet higher. They also added exterior buttressing. Although repairs had to be made in 869, 989, and 1346, the church has since withstood numerous earthquakes.

The liturgy used in Hagia Sophia in the sixth century has been lost, but it presumably resembled the rites described in detail for the church in the Middle Byzantine period. The celebration of the Eucharist took place behind a screen that separated the sanctuary from the nave. The emperor was the only layperson permitted to enter the sanctuary. Other men and women stood in the aisles or in the galleries, where they witnessed the processions of clergy, moving in a circular path from the sanctuary into the nave and back five or six times during the ritual.

Hagia Sophia was thus a gigantic theater for public, imperial worship of God—whose presence was assumed within the building—created by a culture within which Church and state were inextricably intertwined. Justinian had the sanctuary embellished with 40,000 pounds of silver that he donated himself. This precious material was crafted into sumptuous decorations on the altar, a ciborium (canopy sheltering the altar), ambo (pulpit), and screen. Since there was no figural decoration on the walls of the building in Justinian's time to focus the attention of viewers in any one place, worshipers standing on the church floor must have surveyed the whole expanse of the interior, shifting their attention from one shimmering vista to the next.

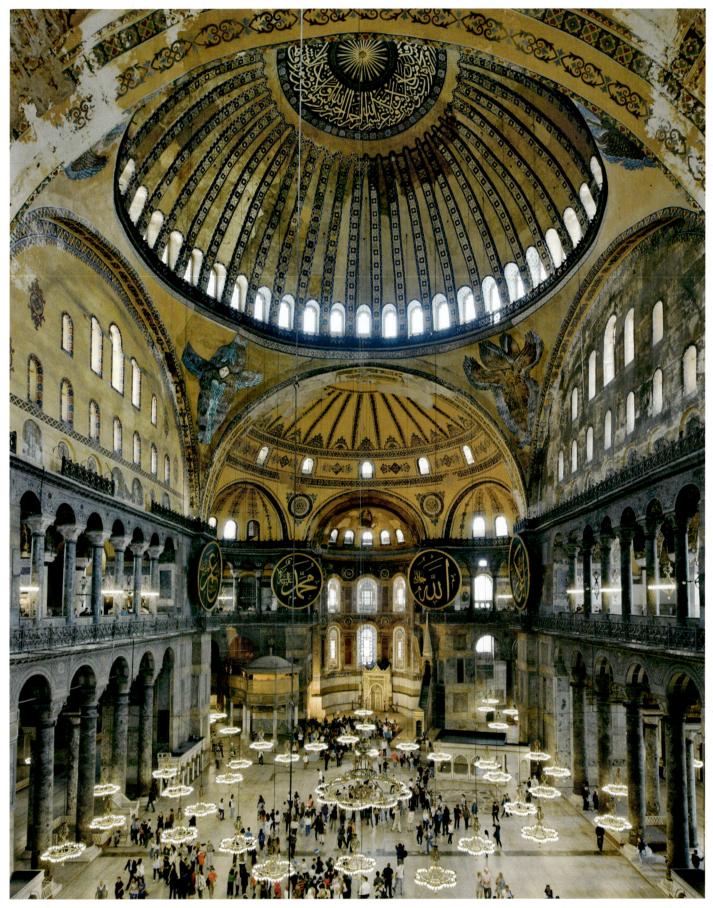

8-4 • INTERIOR OF THE CHURCH OF HAGIA SOPHIA

Read the document related to the church of Hagia Sophia on myartslab.com

ELEMENTS OF ARCHITECTURE | Pendentives and Squinches

Pendentives and squinches are two methods of supporting a round dome or its drum over a square space. Pendentives are concave, triangular forms between the arches under a dome. They rise upward and inward to form a circular base of support on which the dome rests. Squinches are diagonal lintels placed across the upper corner of the wall and supported by an arch or a series of corbeled arches that give it a nichelike shape. Because squinches create an octagon, which is close in shape to a circle, they provide a solid base around the perimeter of a dome, usually elevated on a drum (a circular wall), whereas pendentives project the dome slightly inside the square space it covers, making it seem to float. Byzantine builders preferred pendentives (as at Hagia Sophia, see FIG. 8-4), but elaborate, squinch-supported domes became a hallmark of Islamic architecture.

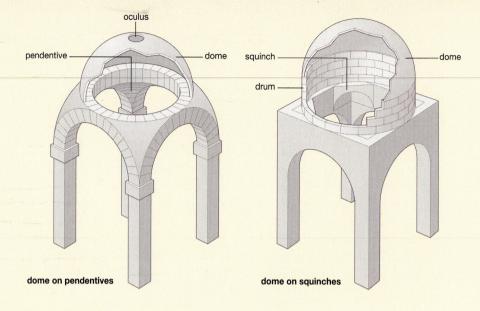

• Watch an architectural simulation about pendentives and squinches on myartslab.com

SAN VITALE IN RAVENNA In 540, Byzantine forces captured Ravenna from the Arian Christian Ostrogoths who had themselves taken it from the Romans in 476. Much of our knowledge of the art of this turbulent period comes from the well-preserved monuments at Ravenna. In 526, Ecclesius, bishop of Ravenna,

commissioned two new churches, one for the city and one for its port, Classis. In the 520s, construction began on a centralplan church, a **martyrium** (church built over the grave of a martyr) dedicated to the fourth-century Roman martyr St. Vitalis (Vitale in Italian), but it was not finished until after Justinian had

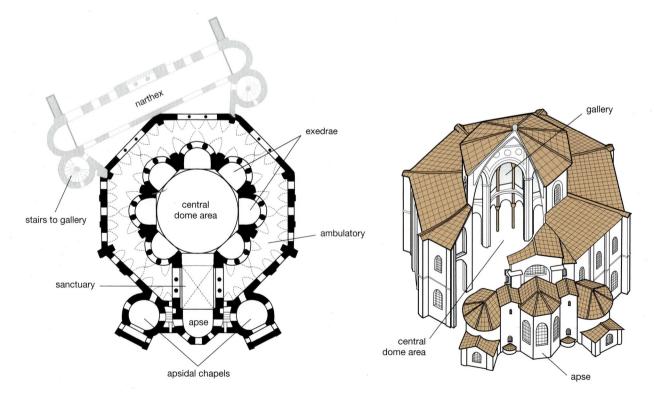

8-5 • PLAN (A) AND CUTAWAY DRAWING (B) OF THE CHURCH OF SAN VITALE, RAVENNA Under construction from c. 520; consecrated 547.

Christian churches are identified by a three-part descriptive title combining (1) designation (or type), with (2) dedication (often to a saint), and finally (3) geographic location, cited in that order.

Designation: There are various types of churches, fulfilling a variety of liturgical and administrative objectives, and the identification of a specific church often begins with an indication of its function within the system. For example, an **abbey church** or monastery church is the place of worship within a monastery or convent; a **pilgrimage church** is a site that attracts visitors wishing to venerate **relics** (material remains or objects associated with a saint) as well as attend services. A cathedral is a bishop's primary church (the word derives from the Latin *cathedra*, meaning chair, since the chair or throne of a bishop is contained within his cathedral). A bishop's domain is called a diocese, and there can be only one church in the diocese designated as its bishop's cathedral, but a diocese has numerous parish churches where local residents attend regular services.

Dedication: Christian churches are always dedicated to Christ, the Virgin Mary, a saint, or a sacred concept or event, for example St. Peter's Basilica or the church of Hagia Sophia (Christ as the embodiment of Holy Wisdom). In short-hand identification, when we omit the church designation at the beginning, we always add an apostrophe and an *s* to a saint's name, as when using "St. Peter's" to refer to the Vatican Basilica of St. Peter in Rome.

Location: The final piece of information that clearly pinpoints the specific church indicated in a title is its geographic location, as in the church of San Vitale in Ravenna or the Cathedral of Notre-Dame (French for "Our Lady," referring to the Virgin Mary) in Paris. "Notre-Dame" alone usually refers to this Parisian cathedral, in spite of the fact that many contemporary cathedrals elsewhere (e.g. at Chartres and Reims) were also dedicated to "Notre-Dame." Similarly, "St. Peter's" usually means the Vatican church of the pope in Rome.

conquered Ravenna and established it as the administrative capital of Byzantine Italy (**FIG. 8–5**).

San Vitale was designed as a central-domed octagon surrounded by eight radiating exedrae (wall niches), surrounded in turn by an ambulatory and gallery, all covered by vaults. A rectangular sanctuary and semicircular apse project from one of the sides of the octagon, and circular rooms flank the apse. A separate oval narthex, set off-axis, joined church and palace and also led to cylindrical stair towers that gave access to the second-floor gallery.

The floor plan of San Vitale only hints at the effect of the complex, interpenetrating interior spaces of the church, an effect that was enhanced by the offset narthex, with its double sets of doors leading into the church. People entering from the right saw only arched openings, whereas those entering from the left approached on an axis with the sanctuary, which they saw straight ahead of them. The dome rests on eight large piers that frame the exedrae and the sanctuary. The undulating, two-story exedrae open through superimposed arcades into the outer aisles on the ground floor and into galleries on the second floor. They push out the circular central space and create an airy, floating sensation, reinforced by the liberal use of veined marble veneer and colored glass and gold mosaics in the surface decoration. As in Hagia Sophia, structure seems to dissolve into shimmering light and color, only here an elaborate program of figural mosaics focuses the worshiper's attention within the sanctuary (FIG. 8-6).

In the halfdome of the sanctuary apse (FIG. 8-7), St. Vitalis and Bishop Ecclesius flank an image of Christ enthroned. The other sanctuary images relate to its use for the celebration of the Eucharist. The lunette on the north wall shows an altar table set for the meal that Abraham offers to three disguised angels (Genesis 18:1–15), and next to it a portrayal of his near-sacrifice of Isaac. In the spandrels and other framed wall spaces appear prophets and evangelists, and the program is bristling with symbolic references to Jesus, but the focus of the sanctuary program is the courtly tableau in the halfdome of the apse.

A youthful, classicizing Christ appears on axis, dressed in imperial purple and enthroned on a cosmic orb in paradise, the setting indicated by the four rivers that flow from the ground underneath him. Two winged angels flank him, like imperial bodyguards or attendants. In his left hand Christ holds a scroll with seven seals that he will open at his Second Coming at the end of time, proclaiming his authority not only over this age, but over the age to come. He extends his right hand to offer a crown of martyrdom to a figure on his right (our left) labeled as St. Vitalis, the saint to whom this church is dedicated. On the other side is the only un-nimbed figure in the tableau, labeled as Bishop Ecclesius, the founder of San Vitale, who holds forward a model of the church itself, offering it to Christ. The artist has imagined a scene of courtly protocol in paradise, where Christ, as emperor, gives a gift to, and receives a gift from, members of the celestial entourage.

In separate, flanking rectangular compositions, along the curving wall of the apse underneath the scene in the halfdome appear Justinian and Theodora and their retinues (Justinian can be seen in FIG. 8–6). The royal couple did not attend the dedication ceremonies for the church of San Vitale, conducted by Archbishop Maximianus in 547. There is no evidence that they actually set foot in Ravenna, but these two large mosaic panels that face each other across its sanctuary picture their presence here in perpetuity.

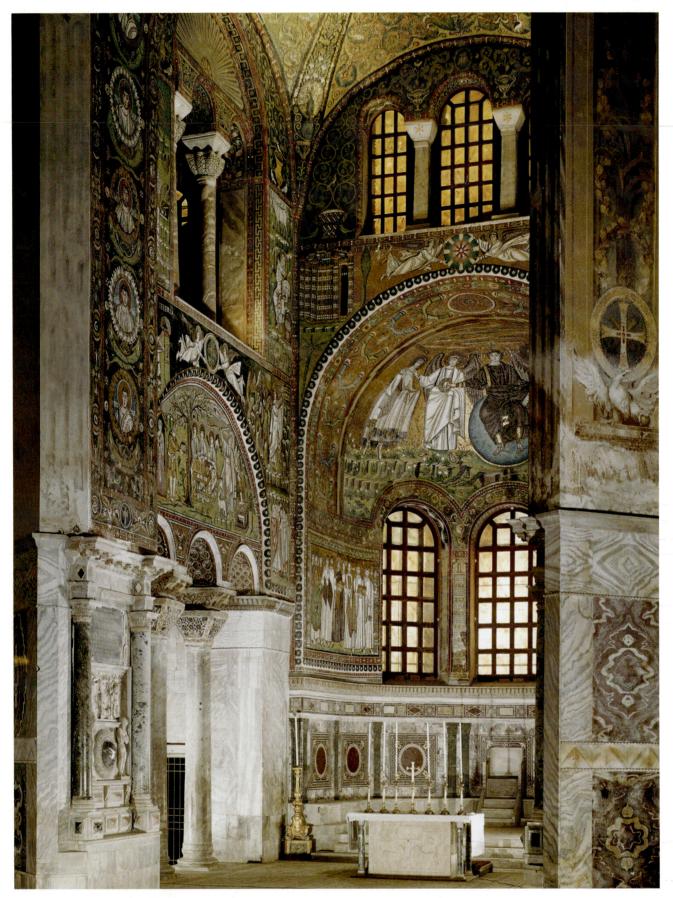

8-6 • CHURCH OF SAN VITALE View into the sanctuary toward the northeast. c. 547.

Explore the architectural panoramas of the church of San Vitale on myartslab.com

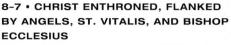

Church of San Vitale, Ravenna. c. 547. Mosaic.

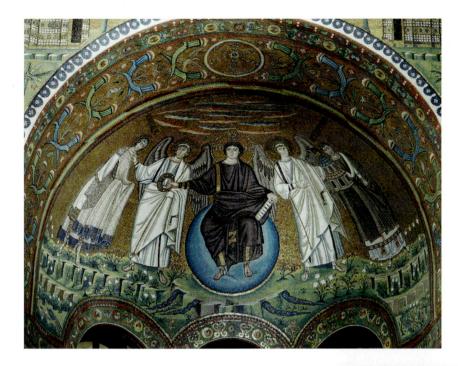

8-8 • EMPEROR JUSTINIAN AND HIS ATTENDANTS, NORTH WALL OF THE APSE Church of San Vitale, Ravenna. Consecrated 547.

Mosaic, $8'8'' \times 12'$ (2.64 \times 3.65 m).

As head of state, the haloed Justinian wears a huge jeweled crown and a purple cloak; he carries a large golden paten that he is donating to San Vitale for the celebration of the Eucharist. Bishop Maximianus at his left holds a jeweled cross and another churchman holds a jewel-covered book. Government officials stand at Justinian's right, followed by barbarian mercenary soldiers, one of whom wears a neck torc, another a Classical cameo cloak clasp.

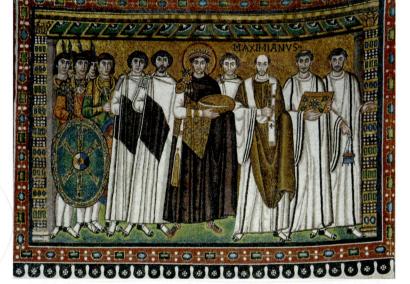

8-9 • EMPRESS THEODORA AND HER ATTENDANTS, SOUTH WALL OF THE APSE Church of San Vitale, Ravenna. c. 547. Mosaic 8'8" × 12' (2.64 × 3.65 m).

Like Justinian, Theodora has a halo, wears imperial purple, and carries in her hands a liturgical vessel—the chalice that held the Eucharistic wine—that she will donate to the church. Her elaborate jewelry includes a wide collar of embroidered and jeweled cloth. A crown, hung with long strands of pearls (thought to protect the wearer from disease), frames her face. Her attendants also wear the rich textiles and jewelry of the Byzantine court.

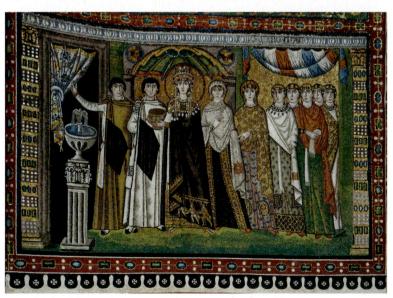

Justinian (**FIG. 8–8**), on the north wall, carries a large golden paten that will be used to hold the Eucharistic bread and stands next to Maximianus, who holds a golden, jewel-encrusted cross. The priestly celebrants at the right carry the Gospels, encased in a golden, jeweled book cover, symbolizing the coming of Christ as the Word, and a censer containing burning incense to purify the altar prior to the Eucharist.

On the south wall, Theodora, standing beneath a fluted shell canopy and singled out by a golden halo and elaborate crown, carries a huge golden chalice studded with jewels (**FIG. 8-9**). The rulers present these gifts as precious offerings to Christ—emulating most immediately Bishop Ecclesius, who offers a model of the church to Christ in the halfdome of the apse, but also the three Magi who brought valuable gifts to the infant Jesus, depicted in "embroidery" at the bottom of Theodora's purple cloak. In fact, the paten and chalice offered by the royal couple will be used by this church to offer Eucharistic bread and wine to the local Christian community during the liturgy. In this way the entire program of mosaic decoration revolves around themes of offering, extended into the theme of the Eucharist itself.

Theodora's group stands beside a fountain, presumably in a courtyard leading to the entrance to the church. The open doorway and curtain are Classical space-creating devices, but here the mosaicists have deliberately avoided allowing their illusionistic power to overwhelm their ability also to create flat surface patterns. Notice, too, that the figures cast no shadows, and, though modeled, their outlines as silhouetted shapes are more prominent than their sense of three-dimensionality. Still, especially in Justinian's panel, a complex and carefully controlled system of overlapping allows us to see these figures clearly and logically situated within a shallow space, moving in a stately procession from left to right toward the entrance to the church and the beginning of the liturgy. So the scenes portrayed in these mosaic paintings are both flattened and three-dimensional, abstract and representational, patterned and individualized. Like Justinian and Theodora, their images are both there and not there at the same time.

THE MONASTERY OF ST. CATHERINE ON MOUNT SINAI Justinian's imperial architectural projects extended across the breadth of the Byzantine Empire, emulating the example of the great emperors of ancient Rome. Soon after the dedication of San Vitale, he sponsored the reconstruction of the monastery of St. Catherine at Mount Sinai in Egypt (FIG. 8–10). This pilgrimage destination and spiritual retreat had been founded much earlier, during the fourth century, at the place where Moses had encountered God in the burning bush (Exodus 4 and 5) and in the shadow of the peak on which he had met God to receive the Ten Commandments (Exodus 19 and 20). Justinian's reconstruction focused on two aspects of the complex. In conjunction with the installation of a frontier garrison to protect both monks and pilgrims from Bedouin attacks on this remote border outpost, Justinian had the walls of the monastery fortified. He also commissioned a new church, dedicated to the Virgin Mary and—according to inscriptions carved into the wooden beams that support its roof built in memory of Theodora, who died in 548.

Procopius' description of this project focuses on characterizing the lives of the monks who lived there:

On this Mount Sinai whose life is a kind of careful rehearsal of death, and they enjoy without fear the solitude which is very precious to them. Since these monks have nothing to desire, for they are superior to all human wishes and they have no interest in owning anything or in caring for their bodies, nor do they seek pleasure in any other thing whatever, therefore the emperor Justinian built them a church which he dedicated to the Mother of God, so that they might be enabled to pass their lives within it, praying and holding services. (*Buildings*, V, viii, translated by H.B. Dewing, Loeb Library ed.)

The origins of monasticism in the eastern Christian world can be traced back to the third century, when some devout Christians began to retire into the desert to become hermits, living a secluded life of physical austerity and devoted to continual meditation and prayer. By the fourth century, groups of men and women began assembling around these hermits, ultimately forming independent secluded communities devoted to prayer and work. These monks and nuns practiced celibacy, poverty, and obedience to a spiritual leader, and they aspired to self-sufficiency so as to minimize contact with the outside world. The monastic movement grew rapidly; by 536 there were about 70 monasteries in Constantinople alone. Although they continued to function as retreats from the secular world-places where pious men and women could devote themselves almost exclusively to the contemplative life and safe havens for orphans, the poor, and the elderly-the monasteries, being taxexempt, also amassed enormous wealth from the donations and bequests of the rich.

A local architect designed the new basilica church that Justinian commissioned for the monks and pilgrims of Mount Sinai. The building was constructed of local materials, but the sumptuous decoration of the sanctuary derives from more cosmopolitan artistic centers. The marble revetment that faces the lower walls of the apse was imported from an island quarry near Constantinople, and the artists who covered the halfdome of the apse and the end wall of the nave above it with powerful scenes in sumptuous mosaics were probably called in from Jerusalem, or even Constantinople. As at San Vitale, mosaic decoration is concentrated in the sanctuary, where the apse would have glistened with vivid color and divine light—a spotlighted destination at the end of the longitudinal axis of the processional nave (**FIG. 8–11**).

The mosaics integrate a series of stories and themes into a coherent program around the notion of theophany—the appearance of God to human beings. Two rectangular scenes on the end wall of the nave, above the apse (only partially visible in FIG. 8–11), picture two local theophanies—Moses before the burning bush

8-10 • THE MONASTERY OF ST. CATHERINE, SINAI

Mount Sinai, Egypt. Fortifications and church constructed under the patronage of Emperor Justinian, c. 548–566.

Founded in the fourth century, this monastery was initially associated with the burning bush, since it was built on the site where Moses was believed to have encountered this startling theophany, but in the tenth or eleventh century it was rededicated to St. Catherine of Alexandria after acquiring her relics.

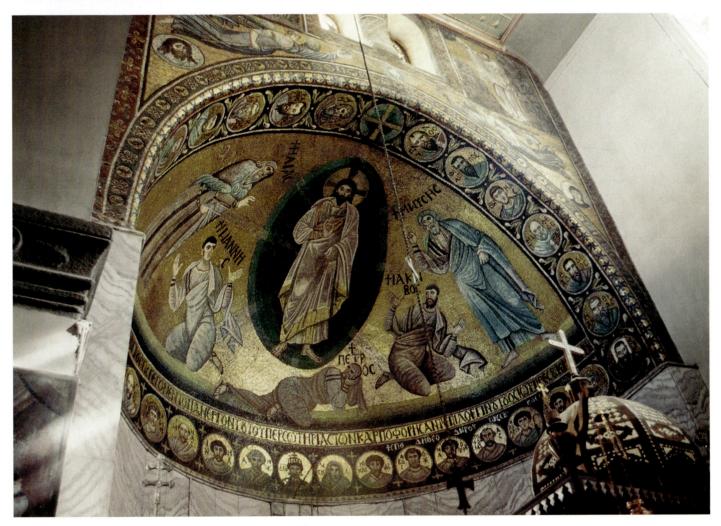

8-11 • THE TRANSFIGURATION OF CHRIST

Apse mosaic in the church of the Virgin, monastery of St. Catherine, Mount Sinai, Egypt. c. 565.

Framing the scene of the Transfiguration are medallion portraits of the 12 apostles, 2 monastic saints, and the 17 major and minor prophets. Sixth-century viewers would probably have associated David—in the medallion directly under Jesus and dressed in the robes and crown of a Byzantine emperor—with the patron, Emperor Justinian, and an inscription running above the lower row of medallions to the right identifies the monastic leaders at the time the mosaic was made and dates them to 565/6, near the time of Justinian's death.

and Moses receiving the law. The halfdome of the apse highlights the Transfiguration, an episode from the life of Jesus during which he was transformed "on a high mountain" from human to divine and set between apparitions of Moses and Elijah before the eyes of Peter, James, and John, three of his disciples (Matthew 17:1-6). The central figure of Jesus fits the description in the gospel text-"his face shone like the sun, and his clothes became dazzling white." The artists have flattened Jesus' form and set him against a contrasting deep blue mandorla (body halo), through which pass rays of light emanating from him and touching the figures around him. Unlike Jesus, the three apostles below him-who "fell to the ground and were overcome by fear"-are active rather than static, aggressively three-dimensional rather than brilliantly flattened, in a visual contrast between celestial apparition and earthly form. The entire tableau takes place against a background of golden light, with no indication of a landscape setting other than the banded lines of color at the bottom of the scene.

OBJECTS OF VENERATION AND DEVOTION

The court workshops of Constantinople excelled in the production of luxurious small-scale works in gold, ivory, and textiles. The Byzantine elite also sponsored vital **scriptoria** (writing centers for scribes—professional document writers) for the production of **manuscripts** (handwritten books), often located within monasteries.

THE ARCHANGEL MICHAEL DIPTYCH Commemorative ivory diptychs—two carved panels hinged together—originated with ancient Roman politicians elected to the post of consul. New consuls would send notices of their election to friends and colleagues by inscribing them in wax that filled a recessed rectangular area on the inner sides of a pair of ivory panels carved with elaborate decoration on the reverse. Christians adapted the practice for religious use, inscribing a diptych with the names of people to be remembered with prayers during the liturgy.

This large panel depicting the **ARCHANGEL MICHAEL**—the largest surviving Byzantine ivory—was half of such a diptych (**FIG. 8–12**). In his classicizing serenity, imposing physical presence, and elegant architectural setting, the archangel is comparable to the (supposed) priestess of Bacchus in the fourth-century pagan Symmachus diptych panel (see FIG. 6–70) and reminiscent of the standing saints in the dome mosaics of St. George in Thessaloniki (see FIG. 7–21). His relationship to the architectural space and the frame around him, however, is more complex. His heels rest on the top step of a stair that clearly lies behind the columns and pedestals, but the rest of his body projects in front of them—since it overlaps the architectural setting—creating a striking tension between this celestial figure and his terrestrial backdrop.

The angel is outfitted here as a divine messenger, holding a staff of authority in his left hand and a sphere symbolizing worldly power in his right. Within the arch is a similar cross-topped orb, framed by a wreath bound by a ribbon with long, rippling extensions,

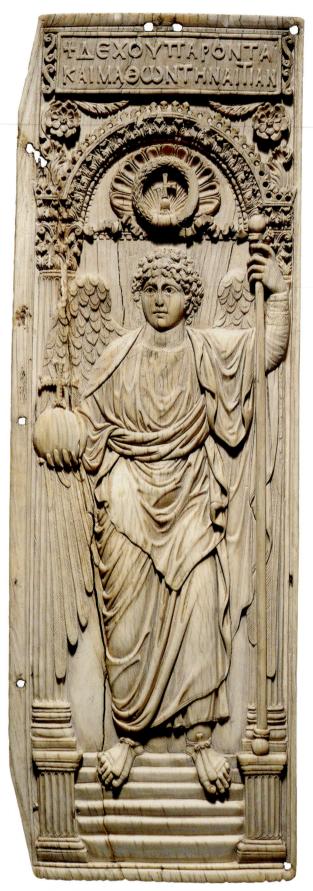

8-12 • ARCHANGEL MICHAEL Panel of a diptych, probably from the court workshop at Constantinople. Early 6th century. Ivory, $17'' \times 5\frac{1}{2}''$ (43.3 × 14 cm). British Museum, London.

ART AND ITS CONTEXTS | Scroll and Codex

Since people began to write some 5,000 years ago, they have kept records on a variety of materials, including clay or wax tablets, pieces of broken pottery, papyrus, animal skins, and paper. Books have taken two forms: scroll and codex.

Scribes made scrolls from sheets of papyrus glued end to end or from thin sheets of cleaned, scraped, and trimmed sheepskin or calfskin, a material known as **parchment** or, when softer and lighter, vellum. Each end of the scroll was attached to a rod; readers slowly unfurled the scroll from one rod to the other as they read. Scrolls could be written to be read either horizontally or vertically.

At the end of the first century CE, the more practical and manageable **codex** (plural, codices)—sheets bound together like the modern book—

replaced the scroll as the primary form of recording texts. The basic unit of the codex was the eight-leaf quire, made by folding a large sheet of parchment twice, cutting the edges free, then sewing the sheets together up the center. Heavy covers kept the sheets of a codex flat. The thickness and weight of parchment and vellum made it impractical to produce a very large manuscript, such as an entire Bible, in a single volume. As a result, individual sections were made into separate books.

Until the invention of printing in the fifteenth century, all books were manuscripts—that is, they were written by hand. Manuscripts often included illustrations, called **miniatures** (from *minium*, the Latin word for a reddish lead pigment). Manuscripts decorated with gold and colors were said to be illuminated.

that is set against the background of a scallop shell. The lost half of this diptych would have completed the Greek inscription across the top, which reads: "Receive these gifts, and having learned the cause...." Perhaps the other panel contained a portrait of the emperor—many think he would be Justinian—or of another high official who presented the panels as a gift to an important colleague, acquaintance, or family member. Nonetheless, the emphasis here is on the powerfully classicized celestial messenger, who does not need to obey the laws of earthly scale or human perspective.

THE VIENNA GENESIS Byzantine manuscripts were often made with very costly materials. For example, sheets of purpledyed **vellum** (a fine writing surface made from calfskin) and gold and silver inks were used to produce a codex now known as the Vienna Genesis. It was probably made in Syria or Palestine, and the purple vellum indicates that it may have been created for an imperial patron, since costly purple dye, made from the secretions of murex mollusks, was usually restricted to imperial use. The Vienna Genesis is written in Greek and illustrated with pictures that appear below the text at the bottom of the pages.

The story of **REBECCA AT THE WELL** (FIG. 8–13) (Genesis 24) appears here in a single composition, but the painter—clinging to the **continuous narrative** tradition that had characterized the illustration of scrolls—combines events that take place at different times in the story within a single narrative space. Rebecca, the heroine, appears at the left walking away from the walled city of Nahor with a large jug on her shoulder, going to fetch water. A colonnaded road leads toward a spring, personified by a reclining pagan water nymph who holds a flowing jar. In the foreground, Rebecca appears again, clearly identifiable by continuity of costume. Her jug now full, she encounters a thirsty camel driver and offers him water to drink. Since he is Abraham's servant, Eliezer, in search of a bride for Abraham's son Isaac, Rebecca's generosity results in her marriage to Isaac. The lifelike poses and rounded, full-bodied figures of this narrative scene conform to the conventions of traditional

Roman painting. The sumptuous purple of the background and the glittering metallic letters of the text situate the book within the world of the privileged and powerful in Byzantine society.

8-13 • **REBECCA AT THE WELL** Page from a codex featuring the book of Genesis (known as the Vienna Genesis). Made in Syria or Palestine. Early 6th century. Tempera, gold, and silver paint on purple-dyed vellum, $131/_{2}^{"} \times 97/_{8}^{"}$ (33.7 × 25 cm). Österreichische Nationalbibliothek, Vienna.

LUXURY WORKS IN SILVER The imperial court at Constantinople had a monopoly on the production of some luxury goods, especially those made of precious metals. A seventh-century court workshop seems to have been the origin of a spectacular set of nine silver plates portraying events in the early life of the biblical King David, including the plate that we examined at the beginning of the chapter (see FIG. 8–1).

The plates would have been made by hammering a large silver ingot (the plate in FIG. 8-1 weighs 12 pounds 10 ounces) into a round shape and raising on it the rough semblance of the human figures and their environment. With finer chisels, silversmiths

then refined these shapes, and at the end of their work, they punched ornamental motifs and incised fine details. The careful modeling, lifelike postures, and intricate engraving document the highly refined artistry and stunning technical virtuosity of these cosmopolitan artists at the imperial court who still practiced a classicizing art that had characterized some works of Christian art for centuries (see FIGS. 7–8, 7–21, 8–12).

ICONS AND ICONOCLASM

Christians in the Byzantine world prayed to Christ, Mary, and the saints while gazing at images of them on independent panels known as icons. Church doctrine toward the veneration of icons was ambivalent. Christianity inherited from Judaism an uneasiness with the power of religious images, rooted in the Mosaic prohibition of "graven images" (Exodus 20:4). The lingering effects of the early persecution of Christians because of their refusal to venerate images of Roman emperors only intensified this anxiety. But key figures of the Eastern Church, such as Basil the Great of Cappadocia (c. 329-379) and John of Damascus (c. 675-749), distinguished between idolatry-the worship of images-and

8-14 • VIRGIN AND CHILD WITH SAINTS AND ANGELS

Icon. Second half of the 6th century. **Encaustic** on wood, $27'' \times 18\%''$ (69 \times 48 cm). Monastery of St. Catherine, Mount Sinai, Egypt.

Read the document related to painting icons on myartslab.com

the veneration of an idea or holy person depicted in a work of art. Icons were thus accepted as aids to meditation and prayer, as intermediaries between worshipers and the holy personages they depicted. Honor showed to the image was believed to transfer directly to its spiritual prototype.

Surviving early icons are rare. A few precious examples exist at the monastery of St. Catherine on Mount Sinai, among them **VIRGIN AND CHILD WITH SAINTS AND ANGELS (FIG. 8-14)**. As Theotokos (Greek for "bearer of God"), Jesus' earthly mother was viewed as a powerful, ever-forgiving intercessor, who could be counted on to appeal to her divine son for mercy on behalf of devout

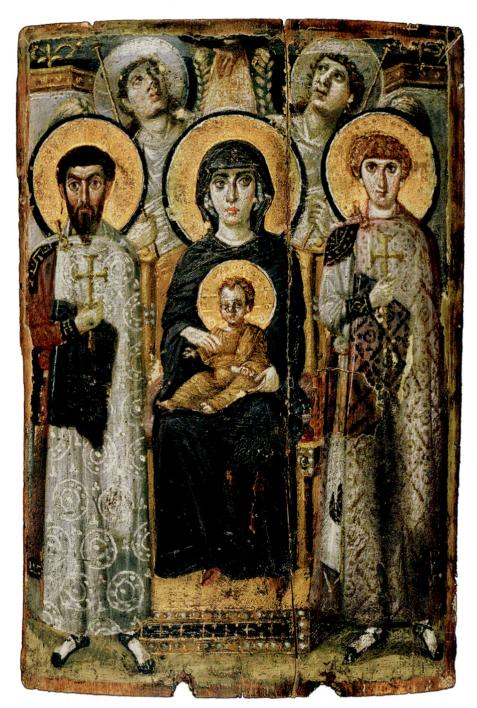

ART AND ITS CONTEXTS | Iconoclasm

Iconoclasm (literally "image breaking," from the Greek words *eikon* "image" and *klao* meaning "break" or "destroy") is the prohibition and destruction of works of visual art, usually because they are considered inappropriate in religious contexts.

During the eighth century, mounting discomfort with the place of icons in Christian devotion grew into a major controversy in the Byzantine world, and between 726 and 730, Emperor Leo III (r. 717–741) imposed iconoclasm, initiating the systematic destruction of images of saints and sacred stories on icons and in churches, as well as the persecution of those who made them and defended their use. His successor, Constantine V (r. 741–775), enforced these policies and practices with even greater fervor, but at the end of the reign of Leo IV (r. 775–780), his widow, Empress Irene, who ruled as regent for their son Constantine IV (r. 780–797), put an end to iconoclasm in 787 through a church council held in Nicea. Leo V (r. 813–820) instituted a second phase of iconoclasm in 813, and it remained imperial policy until March 11, 843, when the widowed Empress Theodora reversed her husband Theophilus' policy and reinstated the central place of images in Byzantine devotional practice.

A number of explanations have been proposed for these two interludes of Byzantine iconoclasm. Some Church leaders feared that the use of images in worship could lead to idolatry or at least distract worshipers from their spiritual exercises. Specifically, there were questions surrounding the relationship between images and the Eucharist, the latter considered by iconoclasts as sufficient representation of the presence of Christ in the church. But there was also anxiety in Byzantium about the weakening state of the empire, especially in relation to the advances of Arab armies into Byzantine territory. It was easy to pin these hard times on God's displeasure with the idolatrous use of images. Coincidentally, Leo III's success fighting the Arabs could be interpreted as divine sanction of his iconoclastic position, and its very adoption might appease the iconoclastic Islamic enemy itself. Finally, since the production and promotion of icons was centered in monasteries-at that time rivaling the state in strength and wealth-attacking the use of images might check their growing power. Perhaps all these factors played a part, but at the triumph of the iconophiles (literally "lovers of images") in 843, the place of images in worship was again secure: Icons proclaimed Christ as God incarnate and facilitated Christian worship by acting as intermediaries between humans and saints. Those who had suppressed icons became heretics (FIG. 8-15).

But iconoclasm is not restricted to Byzantine history. It reappears from time to time throughout the history of art. Protestant reformers in

sixteenth-century Europe adopted what they saw as the iconoclastic position of the Hebrew Bible (Exodus 20:4), and many works of Catholic art were destroyed by zealous reformers and their followers. Even more recently, in 2001, the Taliban rulers of Afghanistan dynamited two gigantic fifth-century CE statues of the Buddha carved into the rock cliffs of the Bamiyan Valley, specifically because they believed such "idols" violated Islamic law.

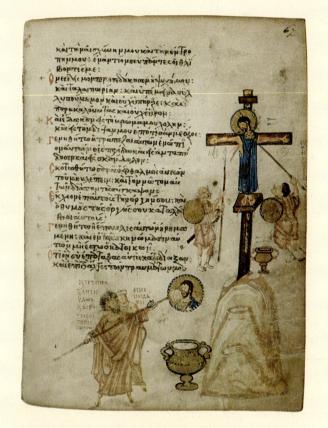

8-15 • CRUCIFIXION AND ICONOCLASTS

From the Chludov Psalter. Mid 9th century. Tempera on vellum, $73\!\!\!/''\times6''$ (19.5 \times 15 cm). State Historical Museum, Moscow. MS. D. 29, fol. 67v

This page and its illustration of Psalm 69:21—made soon after the end of the iconoclastic controversy in 843—records the iconophiles' harsh judgment of the iconoclasts. Painted in the margin at the right, a scene of the Crucifixion shows a soldier tormenting Christ with a vinegar-soaked sponge. In a striking visual parallel, two named iconoclasts—identified by inscription—in the adjacent picture along the bottom margin employ a whitewash-soaked sponge to obliterate an icon portrait of Christ, thus linking them by their actions with those who had crucified him.

and repentant worshipers. The Virgin and Child are flanked here by Christian warrior-saints Theodore (left) and George (right)—both legendary figures said to have slain dragons, representing the triumph of the Church over the "evil serpent" of paganism. Angels behind them twist their heads to look heavenward. The artist has painted the Christ Child, the Virgin, and especially the angels, with an illusionism that renders them lifelike and three-dimensional in appearance. But the warrior-saints—who look out to meet directly the worshipful gaze of viewers—are more stylized. Here the artist barely hints at bodily form beneath the richly patterned textiles of their cloaks, and their tense faces are frozen in frontal stares of gripping intensity.

In the eighth century, the veneration of icons sparked a major controversy in the Eastern Church, and in 726 Emperor Leo III launched a campaign of **iconoclasm** ("image breaking"), banning the use of icons in Christian worship and ordering the destruction of devotional pictures (see "Iconoclasm," page 247). Only a few early icons survived in isolated places like Mount Sinai, which was no longer a part of the Byzantine Empire at this time. But iconoclasm did not last. In 787 iconoclasm was revoked at the instigation of Empress Irene, only to be reinstated in 813. Again it was an empress—Theodora, widow of Theophilus, last of the iconoclastic emperors—who reversed her husband's policy in 843, and from this moment onward icons would play an increasingly important role as the history of Byzantine art developed.

MIDDLE BYZANTINE ART

With the turmoil and destruction of iconoclasm behind them, Byzantine patrons and artists turned during the second half of the ninth century to ambitious projects of restoration and renewal, redecorating church interiors with figural images and producing new icons in a variety of media for the devotional practices of the faithful. This period also saw a renewal and expansion of the power and presence of monasteries in the Byzantine world. A new Macedonian dynasty of rulers-founded in 866 by Emperor Basil I (r. 866-886) and continuing until 1056-increased Byzantine military might, leading to an expansion of imperial territory, only checked in the mid eleventh century by the growing power of the Turks who dealt the Byzantine army a series of military setbacks that would continue to erode the empire until the fifteenth century. But after the empire stabilized under the Komnenian dynasty (1081-1185), it was not the Turks who instigated the end of the Middle Byzantine period. It ended abruptly when Christian crusaders from the west, setting out on a holy war against Islam, diverted their efforts to conquering the wealthy Christian Byzantine Empire, taking Constantinople in 1204. The crusaders looted the capital and set up a Latin dynasty of rulers to replace the Byzantine emperors, who fled into exile.

The patronage of the Macedonian dynasty stimulated a new golden age of Byzantine art, often referred to as the "Macedonian Renaissance," since it was marked by an intensified interest in the styles and themes of classical art, as well as by a general revitalization of intellectual life, including the study and emulation of the classics. As the Middle Byzantine period developed, the geography of Byzantine art changed significantly. As we have seen, early Byzantine civilization had been centered in lands along the rim of the Mediterranean Sea that had been within the Roman Empire. During the Middle Byzantine period, Constantinople's scope was reduced to present-day Turkey and other areas by the Black Sea, as well as the Balkan peninsula, including Greece, and southern Italy. The influence of Byzantine culture also extended into Russia and Ukraine, and to Venice, Constantinople's trading partner in northeastern Italy, at the head of the Adriatic Sea.

ARCHITECTURE AND WALL PAINTING IN MOSAIC AND FRESCO

Although the restitution of images within Byzantine religious life led to the creation of new mosaics in the major churches of the capital, comparatively few Middle Byzantine churches in Constantinople have survived intact. Better-preserved examples of the central-plan domed churches that were popular in the Byzantine world survive in Greece to the southwest and Ukraine to the northeast, and are reflected in Venice within the western medieval world. These structures document the Byzantine taste for a multiplicity of geometric forms, for verticality, and for rich decorative effects both inside and out.

APSE MOSAIC OF HAGIA SOPHIA The upper parts of Justinian's church of Hagia Sophia was originally encrusted with broad expanses of gold mosaic framed by strips of vegetal and geometric ornament, but figural mosaics highlighting sacred individuals or

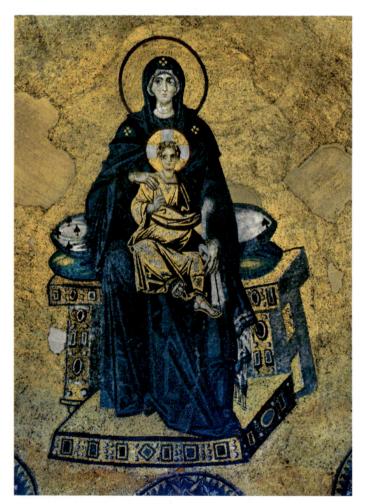

8-16 • VIRGIN AND CHILD IN THE APSE OF HAGIA SOPHIA Constantinople (Istanbul). Dedicated in 867. Mosaic.

sacred stories seem not to have been part of the original design. With the restitution of images at the end of iconoclasm, however, there was an urgency to assert the significance of images within Byzantine churches, and the great imperial church of the capital was an important location to proclaim the orthodoxy of icons. By 867, mosaicists had inserted an iconic rendering of the Incarnation in the form of an image of the Virgin Mary holding the child Jesus in her lap (FIG. 8-16), flanked by angels, and accompanied by an inscription claiming that "the images which the imposters [the iconoclast emperors] had cast down here, pious emperors have set up again." The design of Hagia Sophia-especially the disposition of the sanctuary apse perforated from top to bottom with bands of windows-provided no obvious areas to highlight a figural mosaic, and working at the extreme height of the halfdome-where the mosaic is located-required the erection of immense wooden scaffolding to accommodate the artists at work (see FIG. 8-4, where the Virgin and Child appear at the top of the central lower apse, floating above the middle of the five windows at the bottom of the halfdome). Adding this mosaic was an expensive project.

Floating on an expansive sweep of gold mosaic with neither natural nor architectural setting—like a monumental icon presented for the perpetual veneration of the faithful—the Virgin and Child in Hagia Sophia recalls the pre-iconoclastic rendering on a surviving icon from Mount Sinai (see FIG. 8-14), but their gracefully modeled faces, their elegantly attenuated bodily proportions, and the jewel-studded bench that serves as their throne, proclaim the singular importance of their placement in Constantinople's principal imperial church. Co-emperors Michael III and Basil I were present in Hagia Sophia on March 29, 867, when the patriarch Photios preached the sermon at the dedication of the apse mosaics, laying claim to the historic moment this represented and challenging the rulers to maintain the orthodoxy it represented.

MONASTERY OF HOSIOS LOUKAS Although an outpost, Greece was part of the Byzantine Empire, and the eleventhcentury Katholikon (main church) of the monastery of Hosios Loukas, built a few miles from the village of Stiris in central Greece, is an excellent example of Middle Byzantine architecture (**FIG. 8-17**). It stands next to the earlier church of the Theotokos (Virgin Mary) within the courtyard of the walled enclosure that contained the life of the monks (**FIG. 8-18**). They slept in individual rooms—called "cells"—incorporated into the walls around the periphery of the complex, and they ate their meals together in a long rectangular hall, parallel to the main church.

The Katholikon has a compact central plan with a dome, supported on squinches, rising over an octagonal core (see "Pendentives and Squinches," page 238). On the exterior, the rising forms of apses, walls, and roofs disguise the vaulting roofs of the interior. The Greek builders created a polychromed decorative effect on the exterior, alternating stones with bricks set both vertically and horizontally and using diagonally set bricks to form saw-toothed moldings. Inside the churches, the high central space carries the eyes of worshipers upward into the main dome, which soars above a ring of tall arched openings.

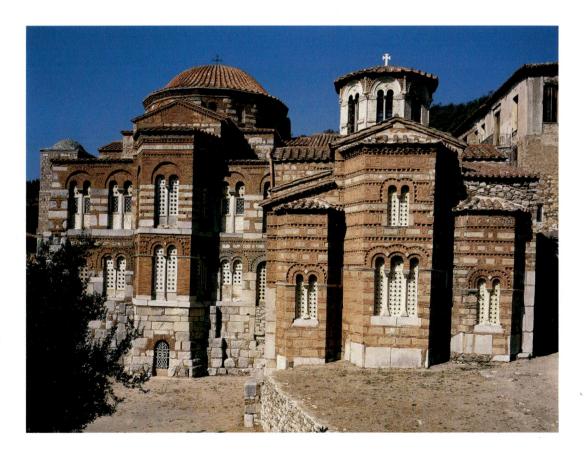

8-17 • MONASTERY CHURCHES AT HOSIOS LOUKAS, STIRIS

Central Greece. Katholikon (left), early 11th century, and church of the Theotokos, late 10th century. View from the east.

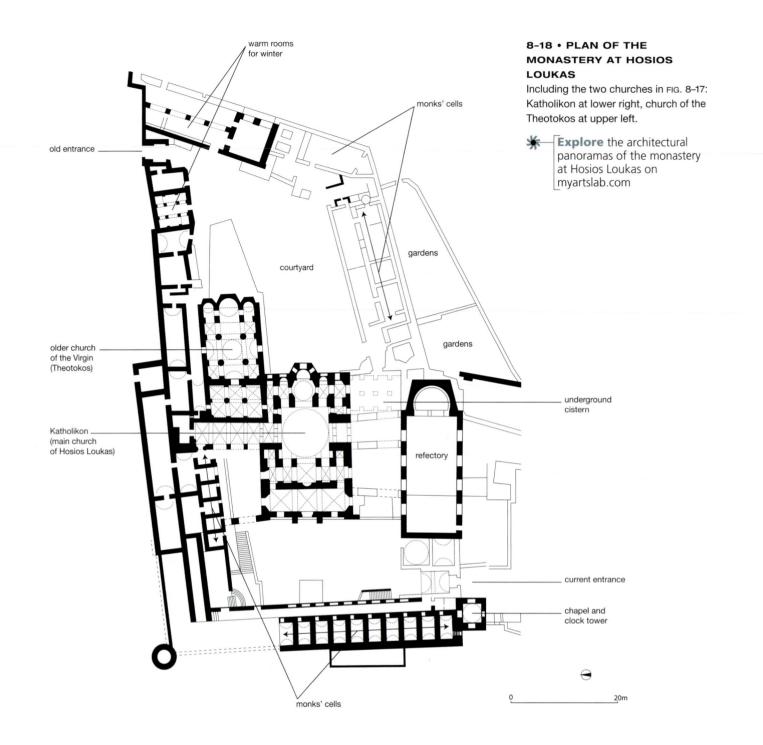

Unlike Hagia Sophia, with its clear, sweeping geometric forms, the Katholikon has a complex variety of architectural shapes and spaces, including domes, groin vaults, barrel vaults, pendentives, and squinches, all built on a relatively small scale (**FIG. 8-19**). The barrel vaults and tall sanctuary apse with flanking rooms further complicate the spatial composition. Single, double, and triple windows create intricate and unusual patterns of light that illuminated a mosaic of Christ Pantokrator (now lost) looming at the center of the main dome. A mosaic of the Lamb of God surrounded by the Twelve Apostles at Pentecost fills the secondary, sanctuary dome, and the apse halfdome presents a rendering of the Virgin and Child Enthroned, reminiscent of the ninth-century mosaic in the apse halfdome of Hagia Sophia (see **FIG. 8-16**). Scenes of Christ's life on earth (the Nativity appears on the squinch visible in FIG. 8–19) and figures of saints fill the upper surfaces of the interior with brilliant color and dramatic images. As at Hagia Sophia, the lower walls are faced with a multicolored stone veneer. A screen with icons separates the congregation from the sanctuary.

CATHEDRAL OF SANTA SOPHIA IN KIEV During the ninth century, the rulers of Kievan Rus—Ukraine, Belarus, and Russia—adopted Orthodox Christianity and Byzantine culture. These lands had been settled by eastern Slavs in the fifth and sixth centuries, but later were ruled by Scandinavian Vikings who had sailed down the rivers from the Baltic to the Black Sea. In Constantinople, the Byzantine emperor hired the Vikings as his

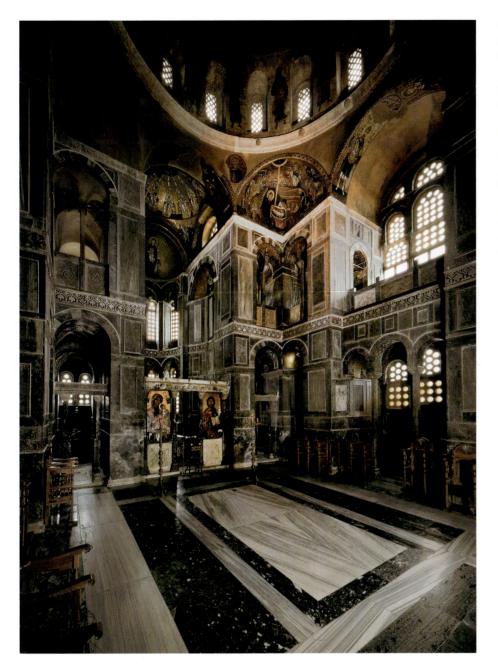

8-19 • CENTRAL DOMED SPACE AND APSE (THE NAOS), KATHOLIKON Monastery of Hosios Loukas. Early 11th

century and later.

The subjects of the mosaics in Middle Byzantine churches such as the Katholikon at Hosios Loukas were organized into three levels according to meaning. Heavenly subjects like Christ Pantokrator, the Virgin Mary, Pentecost (Acts 2:1–3), or angels, appear on the tops of domes or in apse halfdomes. Below them, in a middle register are scenes from Christ's life on earth—here the Nativity in a squinch. Below, at the lowest level of mosaics are iconic representations of saints, closer to the viewer and thus more available for individual prayerful veneration.

personal bodyguards, and Viking traders established a headquarters in the upper Volga region and in the city of Kiev, which became the capital of the area under their control.

The first Christian member of the Kievan ruling family was Princess Olga (c. 890–969), who was baptized in Constantinople by the patriarch himself, with the Byzantine emperor as her godfather. Her grandson Grand Prince Vladimir (r. 980–1015) established Orthodox Christianity as the state religion in 988 and cemented his relations with the Byzantines by accepting baptism and marrying Anna, the sister of the powerful Emperor Basil II (r. 976–1025).

Vladimir's son Grand Prince Yaroslav (r. 1036–1054) founded the **CATHEDRAL OF SANTA SOPHIA** in Kiev (**FIG. 8-20**). The church—originally designed as a typical Byzantine multipledomed cross—was expanded with double side aisles, leading to five apses, and incorporating a large central dome surrounded by 12 smaller domes, all of which creates a complicated and compartmentalized interior. The central domed space of the crossing, however, focuses attention on the nave and the main apse, where the walls glow with lavish decoration, including the mosaics of the central dome, the apse, and the arches of the crossing. The remaining surfaces are frescoed with scenes from the lives of Christ, the Virgin, the apostles Peter and Paul, and the archangels.

The Kievan mosaics established a standard iconographic system used in Russian Orthodox churches. A Christ Pantokrator fills the curving surface at the crest of the main dome (not visible above the window-pierced drum in FIG. 8–20). At a lower level, the apostles stand between the windows of the drum, with the four evangelists occupying the pendentives. An orant figure of the Virgin Mary seems to float in a golden heaven on the halfdome

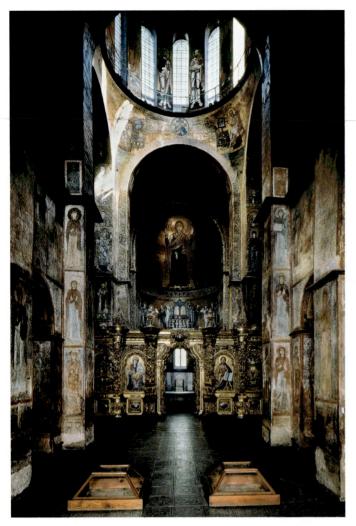

8-20 • INTERIOR, CATHEDRAL OF SANTA SOPHIA, KIEV 1037–1046. Apse mosaics: Orant Virgin and Communion of the Apostles.

and upper wall of the apse, and on the wall below her is the Communion of the Apostles. Christ appears not once, but twice, in this scene, offering the Eucharistic bread and wine to the apostles, six on each side of the altar. With such extravagant use of costly mosaic, Prince Yaroslav made a powerful political declaration of his own power and wealth—and that of the Kievan Church as well.

MONASTERY CHURCH OF THE DORMITION AT DAPHNI

The refined mosaicists who worked c. 1100 at the monastery church of the Dormition at Daphni, near Athens, seem to have conceived their compositions in relation to an intellectual ideal. They eliminated all "unnecessary" detail to focus on the essential elements of a narrative scene, conveying its mood and message in a moving but elegant style. The main dome of this church has retained its riveting image of the Pantokrator, centered at the crest of the dome like a seal of divine sanction and surveillance (**FIG. 8-21**). This imposing figure manages to be elegant and awesome at the same time. Christ blesses or addresses the assembled congregation with one hand, while the slender, attenuated fingers of the other spread to clutch a massive book securely. In the squinches of the corner piers are four signal episodes from his life: Annunciation, Nativity, Baptism, and Transfiguration.

A mosaic of the **CRUCIFIXION** from the lower part of the church (**FIG. 8-22**) exemplifies the focus on emotional appeal to individuals that appears in late eleventh-century Byzantine art. The figures inhabit an otherworldly space, a golden universe anchored to the material world by a few flowers, which suggest the promise of new life. A nearly nude Jesus is shown with bowed head and gently sagging body, his eyes closed in death. The witnesses have been reduced to two isolated mourning figures, Mary and the young apostle John, to whom Jesus had just entrusted the care of his mother. The elegant cut of the contours and the eloquent restraint of the gestures only intensify the emotional power of the image. The nobility and suffering of these figures was meant to move monks and visiting worshipers toward a deeper involvement with their own meditations.

This depiction of the Crucifixion has symbolic as well as emotional power. The mound of rocks and the skull at the bottom of the cross represent Golgotha, the "place of the skull," the hill outside ancient Jerusalem where Adam was thought to be buried and where the Crucifixion was said to have taken place. The faithful saw Jesus Christ as the new Adam, whose sacrifice on the cross saved humanity from the sins brought into the world by Adam and

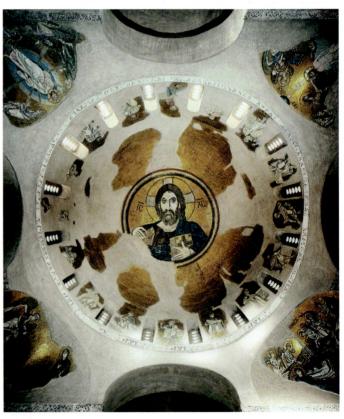

8-21 • CHRIST PANTOKRATOR WITH SCENES FROM THE LIFE OF CHRIST

Central dome and squinches, Church of the Dormition, Daphni, Greece. c. 1100. Mosaic.

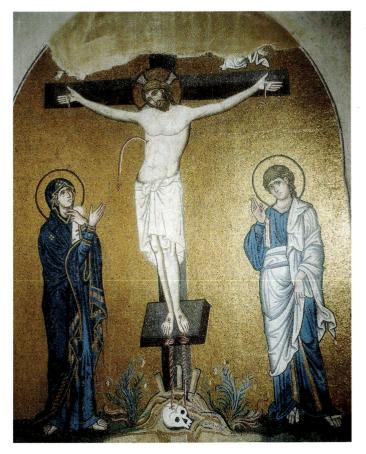

8-22 • CRUCIFIXION Church of the Dormition, Daphni, Greece. c. 1100. Mosaic.

Eve. The arc of blood and water springing from Jesus' side refers to Eucharistic and baptismal rites. As Paul wrote in his First Letter to the Corinthians: "For just as in Adam all die, so too in Christ shall all be brought to life" (1 Corinthians 15:22). The timelessness and simplicity of this image were meant to aid the Christian worshiper seeking to achieve a mystical union with the divine through prayer and meditation, both intellectually and emotionally.

MONASTERY CHURCH OF ST. PANTELEIMON AT NEREZI Dedicated in 1164, the church of St. Panteleimonthe Katholikon of the small monastery at Nerezi in Macedoniawas built under the patronage of Alexios Komnenos, nephew of Emperor John II (r. 1118-1143). Here the wall paintings were created in fresco rather than mosaic, with a stylistic delicacy and painterly spontaneity characteristic of Byzantine art under the Komnenians. It represents well the growing emphasis in capturing the emotionalism of sacred narrative, already noted at Daphni. In the upper part of one wall, the scene of the **LAMENTATION** over the dead body of Christ (FIG. 8-23)—a non-biblical episode that seems to have been developed during the twelfth centuryforges a direct link with viewers' emotions, while standing in the register below, a group of monastic saints model the unswerving postures of spiritual stability. The narrative emphasis is on the Virgin's anguish as she cradles the lifeless body of her son in the broad extension of her lap, pulling his head toward her, cheek to cheek, in a desperate final embrace. Behind her, St. John bends

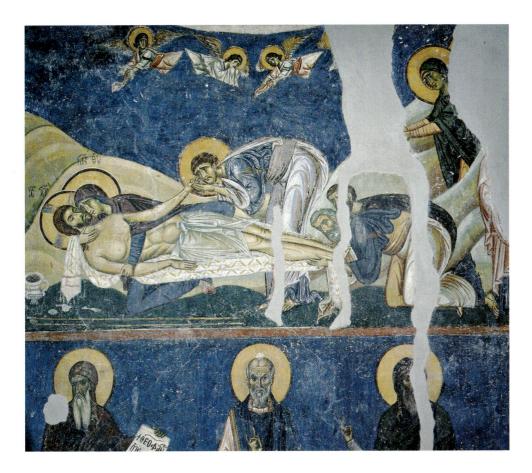

8-23 • LAMENTATION WITH STANDING MONASTIC SAINTS BELOW

North wall of the church of the monastery of St. Panteleimon, Nerezi (near Skopje), Macedonia. 1164. Fresco.

to lift Jesus' hand to his cheek, conforming to a progressively descending diagonal arrangement of mourners that tumbles from the mountainous backdrop toward resolution in the limp torso of the savior. Such emotional expressions of human grief in human terms will be taken up again in Italy by Giotto over a century later (see FIG. 18–8).

THE CATHEDRAL OF ST. MARK IN VENICE The northeastern Italian city of Venice, set on the Adriatic at the crossroads of Europe and Asia Minor, was in certain ways an outpost of Byzantine art in Italy. Venice had been subject to Byzantine rule in the sixth and seventh centuries, and up to the tenth century, the city's ruler, the doge ("duke" in Venetian dialect), had to be ratified by the Byzantine emperor. At the end of the tenth century, Constantinople granted Venice a special trade status that allowed its merchants to control much of the commerce between east and west, and the city grew enormously wealthy.

Venetian architects looked to Byzantine domed churches for inspiration in 1063, when the doge commissioned a church to replace the palace chapel that had housed the relics of St. Mark the apostle since they had been brought to Venice from Alexandria in 828/29 (FIG. 8-24). The Cathedral of St. Mark is designed as a Greek cross, with arms of equal length. A dome covers each square unit-five great domes in all, separated by barrel vaults and supported by pendentives. Unlike Hagia Sophia in Constantinople, where the space seems to flow from the narthex up into the dome and through the nave to the apse, St. Mark's domed compartments produce a complex space in which each dome maintains its own separate vertical axis. As we have seen elsewhere, marble veneer covers the lower walls, and golden mosaics glimmer above on the vaults, pendentives, and domes. A view of the exterior of St. Mark's as it would have appeared in early modern times can be seen in a painting by the fifteenth-century Venetian artist Gentile Bellini (see FIG. 20-42).

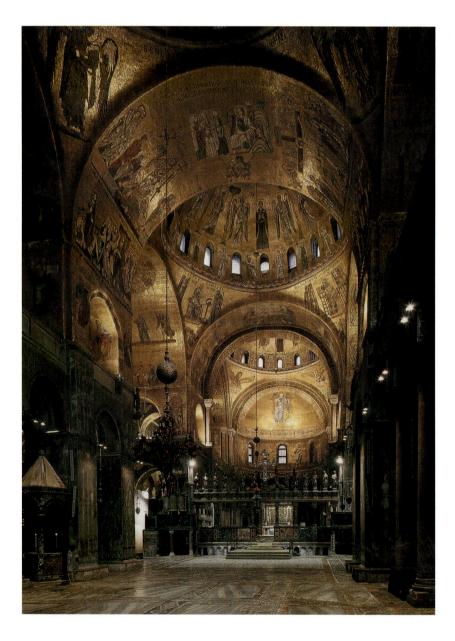

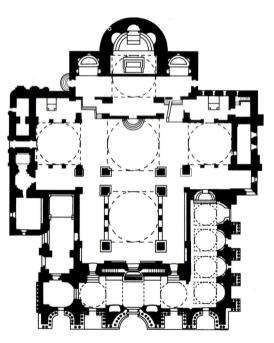

8-24 • INTERIOR (A) AND PLAN (B) OF THE CATHEDRAL OF ST. MARK Venice. Begun 1063. View looking toward apse.

This church is the third one built on the site. It was both the palace chapel of the doge and the burial place for the bones of the patron of Venice, St. Mark. The church was consecrated as a cathedral in 1807. The mosaics have been reworked continually to the present day.

1000000

PRECIOUS OBJECTS OF COMMEMORATION, VENERATION, AND DEVOTION

As in the Early Byzantine period, tenth-, eleventh-, and twelfth-century artists produced small, often portable, luxury items for wealthy members of the imperial court as well as for Church dignitaries. These patrons often commissioned such precious objects as official gifts for one another. They had to be portable, sturdy, and refined, representing the latest trends in style and subject. These works frequently combined exceptional beauty and technical virtuosity with religious meaning; many were icons or devotional objects. Ivory carving, gold and **enamel** work, fine books, and intricate panel paintings were especially prized.

IVORIES Standing slightly over 9 inches tall, the small ivory ensemble known as the HARBAVILLE TRIP-TYCH (named after a nineteenth-century owner) was made as a portable devotional object with two hinged wings that could be folded shut for travel. Its privileged owner used this work as the focus for private prayer; as a luxury object it also signaled high status and wealth. When opened (FIG. 8-25A), the triptych features across the top of the central panel a tableau with an enthroned Christ flanked by Mary and St. John the Baptist. This is a composition known as the "Deësis" (meaning "entreaty" in Greek), which shows Mary and John interceding with Christ, presumably pleading for forgiveness and salvation for the owner of this work. St. Peter stands directly under Christ, gesturing upward toward him, and flanked by four other apostles-SS. James, John, Paul, and Andrew, all identified by inscriptions. The figures in the outer panels (both back and front) are military saints, bishop saints, and martyrs.

These holy figures stand in undefined spatial settings, given definition only by the small bases under their feet, effectively removing their gently modeled forms from the physical world. As a whole, they represent a celestial court of saints attending the enthroned Christ in paradise, categorized into thematic groups in an organization that recalls the ordered distribution of subjects in a Middle Byzantine church (see FIGS. 8–19, 8–20). On the back of the central panel (FIG. 8–25B) is a symbolic evocation of paradise itself in the form of a

large stable cross surrounded by luxurious vegetation inhabited by animals, presumably an evocation of the longed-for destination of the original owner, a reminder to focus attention on devotional practice and enlist the aid of the congregation of saints to assure the attainment of salvation. An abbreviated inscription above the cross—IC XC NIKA—backs up the pictorial reminder with words— "Jesus Christ is victorious."

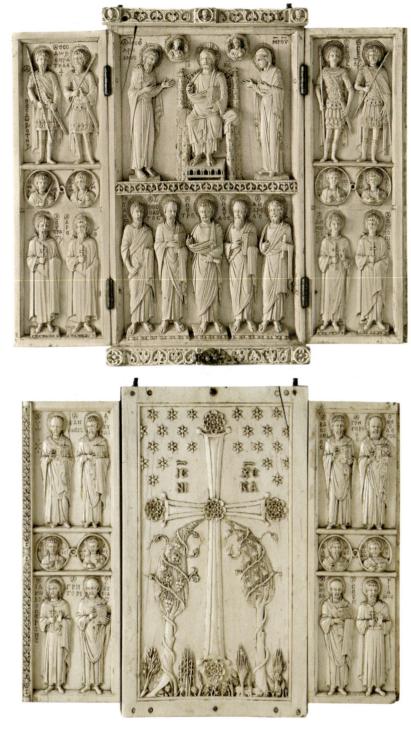

8-25 • FRONT (A) AND BACK (B) OF THE HARBAVILLE TRIPTYCH From Constantinople. Mid 10th century. Ivory, closed $9\frac{1}{2}$ " \times 55%" (24.2 \times 14.3 cm); open $9\frac{1}{2}$ " \times 11" (24.2 \times 28 cm). Musée du Louvre, Paris.

Related to the Harbaville Triptych in both figure style and compositional format is an independent ivory panel portraying an emperor and empress gesturing toward and standing between an elevated figure of Christ, who reaches out to touch the crowns they wear on their heads (**FIG. 8–26**). The imperial figures are identified by inscription as Romanos and Eudokia—most likely Emperor Romanos II, son and co-emperor of Constantine VII

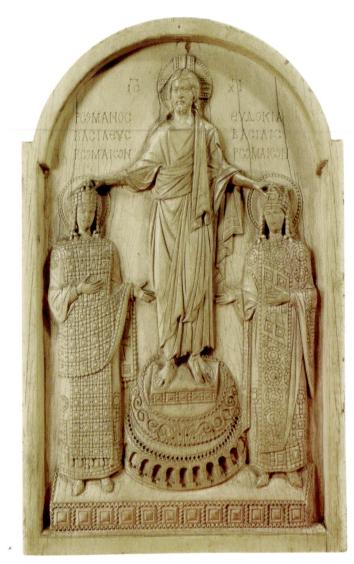

8-26 • CHRIST CROWNING EMPEROR ROMANOS II AND EMPRESS EUDOKIA

From Constantinople. 945–949. lvory, $73\%'' \times 334''$ (18.6 \times 9.5 cm). Cabinet des Médailles, Bibliothèque Nationale de France, Paris.

Porphyrogenitos (r. 945–959), and Romanos's first wife Eudokia, the daughter of Hugo of Provence, King of Rome, whom Romanos married in 944 when she was only 4 years old, and who died in 949. This is not a scene of coronation but an emblem—Eudokia, for instance, is represented as an adult rather than as a child—of the fusion of imperial authority with the religious faith that sanctioned and supported it. The carefully modeled figure of Christ, whose drapery is arranged to give three-dimensionality to his bodily form, offers a striking contrast to the stiff and flattened figures of the imperial couple, all but consumed by the elaborate decoration of their royal robes.

MANUSCRIPTS Painted books were some of the most impressive products of the Middle Byzantine period, and of the Macedonian Renaissance in particular. The luxurious Paris **Psalter** (named after its current library location) is a noteworthy example.

This personal devotional book—meant to guide the prayer life of its aristocratic owner—includes the complete text of the Psalms and a series of odes or canticles drawn from the Bible that were a standard part of Byzantine psalters. The annotation of the biblical texts with passages from interpretive commentaries gives this book a scholarly dimension consistent with a revival of learning that took place under the Macedonians emperors. Indeed it seems to have been commissioned in Constantinople by the intellectual Emperor Constantine VII Porphyrogenitos as a gift for his son Romanos II, whom we have already encountered (see FIG. 8–26).

This book is best known, however, neither for its learned texts nor for its imperial patron or owner, but for its set of 14 full-page miniatures. The fresh spontaneity of these paintings and the complicated abstraction underlying their compositional structure—salient stylistic features of the Macedonian Renaissance—make this book one of the true glories of Byzantine art. Eight of these framed miniatures portray episodes from the life of Israel's King David, who as a boy had saved the people of God by killing the giant Goliath

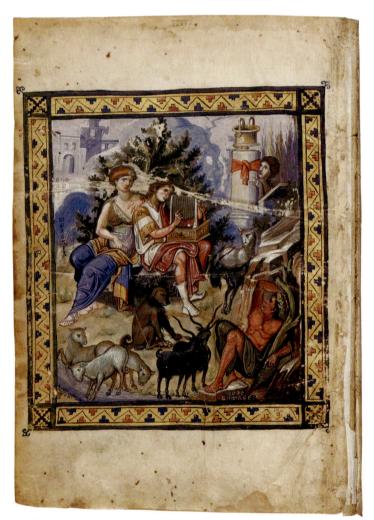

8-27 • DAVID COMPOSING THE PSALMS Page from the Paris Psalter. Constantinople. c. 950. Paint and gold on vellum, sheet size $141/2'' \times 101/2''$ (37 × 26.5 cm). Bibliothèque Nationale de France, Paris.

A CLOSER LOOK | Icon of St. Michael the Archangel

Made in Constantinople. 12th century. Silver-gilt on wood, cloisonné enamels, gemstones. $18\frac{1}{8}'' \times 13\frac{3}{4}''$ (46 \times 35 cm).

Treasury of the Cathedral of St. Mark, Venice.

This bust portrait of Christ, created with cloisonné enamel, appears directly over the head of St. Michael, sanctioning his power with a gesture of blessing or recognition. The medallions on the upper corners portray SS. Peter and Menas, but the enamels once filling comparable medallions on the lower strip of the frame are lost.

Heavily abbreviated inscriptions flanking or surmounting the saints identify them by name.

In 1834, restorers replaced the wings of St. Michael, which are now probably disproportionately large in relation to the originals. In the same restoration, the precious gemstones once set into the frame were replaced with colored alass.

Four pairs of military saints in oval compartments flank St. Michael on the lateral strips of the frame. This entourage emphasizes the military character of St. Michael himself. who is dressed and equipped for battle as the leader of a heavenly army.

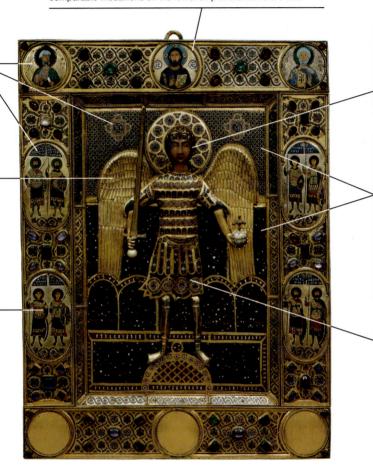

Luminous enamel (glass heated to the melting point at which it bonds to the underlying or surrounding metal) completely covers the face of St. Michael to give it the appearance of human flesh.

Lavish and intricate patterns created from enamel fill the background around St. Michael. Byzantine artists were virtuosos in the cloisonné technique. in which aold strips or wires are soldered to the underlying metal surface to separate the different colors of enamel from each other, forming a network of delicate gold lines that delineate the decorative forms and enliven the surface with reflected light.

A series of separately fabricated forms-nimbed head, torso, legs, arms, wings, sword, and fully three-dimensional orb and sword-have been assembled to create the projecting figure of St. Michael.

View the Closer Look for the icon of St. Michael the Archangel on myartslab.com

(see FIG. 8-1) and who was traditionally considered the author of the Psalms. The first of these depicts David seated outdoors against a background of lush foliage while he composes the Psalms to the accompaniment of his harp (FIG. 8-27). Groups of animals surround him in the foreground, while his native city of Bethlehem looms through the atmospheric mist in the background.

The Macedonian Renaissance emphasis on a Classical revival is evident here in the personification of abstract ideas and landscape features: Melody, a languorous female figure, leans casually on David's shoulder to inspire his compositions, while another woman, perhaps Echo, peeks from behind a column in the right background. The swarthy reclining youth in the lower foreground is a personification of Mount Bethlehem, as we learn from his inscription. The motif of the dog watching over the sheep and goats while his master strums the harp invokes the Classical subject of Orpheus charming wild animals with music. The strongly modeled three-dimensionality of the forms, the integration of the figures into a three-dimensional space, and the use of atmospheric perspective all enhance the Classical flavor of the painting, in yet another example of the enduring vitality of pagan artistic traditions at the Christian court in Constantinople.

ICONS In the centuries after the end of iconoclasm, one of the major preoccupations of Byzantine artists was the creation of independent devotional images in a variety of media. The revered twelfth-century icon of Mary and Jesus known as the VIRGIN

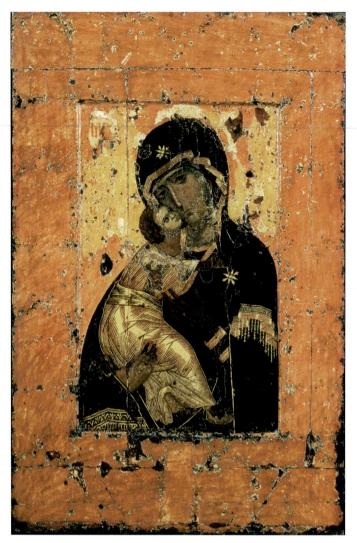

8-28 • VIRGIN OF VLADIMIR Probably from Constantinople. Faces, 12th century; the figures have been retouched. Tempera on panel, height approx. 31" (78 cm). Tretyakov Gallery, Moscow.

OF VLADIMIR (**FIG. 8-28**) was probably painted in Constantinople but brought to Kiev. This distinctively humanized image is another example of the growing desire for a more immediate and personal religion that we have already seen in the Crucifixion mosaic at Daphni, dating slightly earlier. Here the artist used an established iconographic type, known as the "Virgin of Compassion," showing Mary and the Christ Child pressing their cheeks together and gazing at each other with tender affection, that is found as early as the tenth century and was believed to have been first painted by St. Luke, reproducing what he had seen in a vision. The *Virgin of Vladimir* was thought to protect the people of the city where it resided. It arrived in Kiev sometime in the 1130s, was subsequently taken to the city of Suzdal, and finally to Vladimir in 1155. In 1480, it was moved to the Cathedral of the Dormition in the Moscow Kremlin.

Also from the twelfth century, but made from more precious materials and presenting a saintly image more hieratic than intimate, is a representation of the archangel Michael in silver-gilt and enamel (see "A Closer Look," page 257), whose technical virtuosity and sumptuous media suggest it may have been an imperial commission for use within the palace complex itself. St. Michael is dressed here as a confrontational military commander in the heavenly forces, a real contrast with the calmly classicizing angelic form he takes in the large ivory panel we examined from the Early Byzantine period (see FIG. 8–12). This later St. Michael did not remain in Constantinople. It is now in the treasury of the Cathedral of St. Mark in Venice, one of many precious objects taken as booty by Latin crusaders in 1204 at the fall of Constantinople during the ill-conceived Fourth Crusade. This devastating event brought an abrupt end to the Middle Byzantine period.

LATE BYZANTINE ART

A third great age of Byzantine art began in 1261, after the Byzantines expelled the Christian crusaders who had occupied Constantinople for nearly 60 years. Although the empire had been weakened and its domain decreased to small areas of the Balkans and Greece, the arts underwent a resurgence known as the Palaeologue Renaissance after the new dynasty of emperors who regained Constantinople. The patronage of emperors, wealthy courtiers, and the Church stimulated renewed church building as well as the production of icons, books, and precious objects.

CONSTANTINOPLE: THE CHORA CHURCH

In Constantinople, many existing churches were renovated, redecorated, and expanded during the Palaeologue Renaissance. Among these is the church of the monastery of Christ in Chora. The expansion of this church was one of several projects that Theodore Metochites (1270-1332), a humanist poet and scientist, and the administrator of the imperial treasury at Constantinople, sponsored between c. 1315 and 1321. He added a two-story annex on the north side, two narthexes on the west, and a parekklesion (side chapel) used as a funerary chapel on the south (FIG. 8-29). These structures contain the most impressive interior decorations remaining in Constantinople from the Late Byzantine period, rivaling in splendor and technical sophistication the works of the age of Justinian, but on a more intimate scale. The walls and vaults of the parekklesion are covered with frescos (see "The Funerary Chapel of Theodore Metochites," page 260), and the narthex vaults are encrusted with mosaics.

In the new narthexes of the Chora church, above an expanse of traditional marble revetment on the lower walls, mosaics cover every surface—the domical groin vaults, the wall lunettes, even the undersides of arches—with narrative scenes and their ornamental framework (**FIG. 8–30**). The small-scale figures of these mosaics seem to dance with relentless enthusiasm through the narrative episodes they enact from the lives of Christ and his mother. Unlike the stripped-down narrative scenes of Daphni (see **FIG. 8–22**), here the artists have lavished special attention on the

8-29 • PLAN OF THE MONASTERY CHURCH OF CHRIST IN CHORA, CONSTANTINOPLE Modern Istanbul. (Present-day Kariye Müzesi.) Original construction 1077–1081; expanded and refurbished c. 1315–1321.

Explore the architectural panoramas of the church of Christ in Chora on myartslab.com

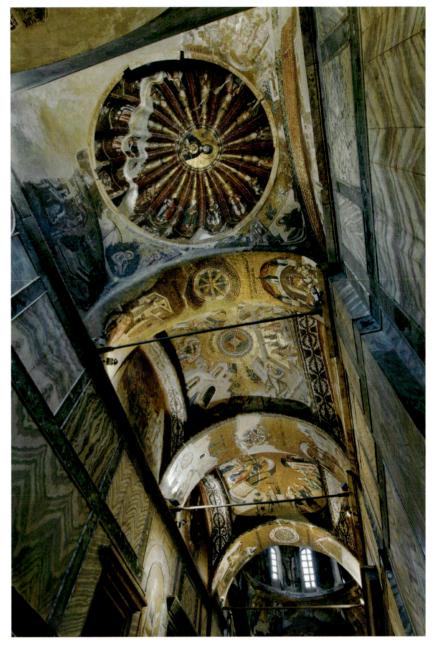

8-30 • MOSAICS IN THE VAULTING OF THE INNER NARTHEX Church of Christ in Chora. (Present-day Kariye Müzesi.)

c. 1315–1321.

settings, composing their stories against backdrops of architectural fantasies and stylized plants. The architecture of the background is presented in an innovative system of perspective, charting its three-dimensionality not in relation to a point of convergence in the background—as will be the case in the linear, **one-point perspective** of fifteenth-century Florentine art (see "Renaissance Perspective," page 610)—but projecting forward in relationship to a point in the foreground, thereby drawing attention to the figural scenes themselves.

The Chora mosaics build on the growing Byzantine interest in the expression of emotions within religious narrative, but they broach a level of human tenderness that surpasses anything we have seen in Byzantine art thus far. The artists invite viewers to see the participants in these venerable sacred stories as human beings just like themselves, only wealthier and holier. For example, an entire narrative field in one vault is devoted to a scene where the infant Mary is cuddled between her adoring parents, Joachim and Anna (**FIG. 8–33**; part of the scene is visible in FIG. 8–30). Servants on either side of the family look on with gestures and expressions of admiration and approval, perhaps modeling the response that is expected from viewers within the narthex itself. The human interaction even extends to details, such as the nuzzling of Mary's head into the beard of her father as she leans back to look into his eyes, and her tentative reach toward her mother's face at the same time. In another scene, the young Jesus rides on the shoulders of Joseph, in a pose still familiar to fathers and children in our own time. The informality and believability that these anecdotal details bring to sacred narrative recalls developments as far away as Italy, where at this same time Giotto and Duccio were using similar devices to bring their stories to life (see Chapter 18).

Theodore Metochites (1270-1332) was one of the most fascinating personalities of the Late Byzantine world. Son of a disgraced intellectual cleric-condemned and exiled for championing the union of the Roman and Byzantine Churches-Metochites became a powerful intellectual figure in Constantinople. As a poet, philosopher, and astronomer who wrote scores of complicated commentaries in an intentionally cultivated, arcane, and mannered literary style, he ridiculed a rival for his prose style of "excess clarity." In 1290, Emperor Andronicus II Palaeologus (r. 1282-1328) called Metochites to court service, where the prolific young scholar became an influential senior statesman, ascending to the highest levels of the government and amassing power and wealth second only to that of the emperor himself. Metochites' political and financial status plummeted when the emperor was overthrown by his grandson in 1328. Stripped of his wealth and sent into exile, Metochites was allowed to return to the capital two years later, retiring to house arrest at the Chora monastery, where he died and was buried in 1332.

It is his association with this monastery that has become Theodore Metochites' greatest claim to enduring fame. Beginning in about 1315, at the peak of his power and wealth, he funded an expansion and restoration of the church of Christ in Chora (meaning "in the country"), part of an influential monastery on the outskirts of Constantinople. The mosaic decoration he commissioned for the church's expansive narthexes (see FIGS. 8–30, 8–33) may be the most sumptuous product of his beneficence, but the project probably revolved around a **FUNERARY CHAPEL** (or parekklesion) that he built adjacent to the main church (**FIG. 8–32**), with the intention of creating a location for his own funeral and tomb.

The extensive and highly integrative program of frescos covering every square inch of the walls and vaults of this jewel-box space focuses on funerary themes and expectations of salvation and its rewards. Above a dado of imitation marble stand a frieze of 34 military saints ready to fulfill their roles as protectors of those buried in the chapel. Above them, on the side walls of the main space, are stories from the Hebrew Bible interpreted as prefigurations of the Virgin Mary's intercessory powers. A portrayal of Jacob's ladder (Genesis 28:11-19), for example, evokes her position between heaven and earth as a bridge from death to life. In the pendentives of the dome over the main space (two of which are seen in the foreground) sit famous Byzantine hymn writers, with quotations from their work. These carefully chosen passages highlight texts associated with funerals, including one that refers to the story of Jacob's ladder.

The climax of the decorative program, however, is the powerful rendering of the

ANASTASIS that occupies the halfdome of the apse (FIG. 8-31). In this popular Byzantine representation of the Resurrection-drawn not from the Bible but from the apocryphal Gospel of Nicodemus—Jesus demonstrates his powers of salvation by descending into limbo after his death on the cross to save his righteous Hebrew forebears from Satan's grasp. Here a boldly striding Christ-brilliantly outfitted in a pure white that makes him shine to prominence within the fresco programlunges to rescue Adam and Eve from their tombs, pulling them upward with such force that they seem to float airborne under the spell of his power. Satan lies tied into a helpless bundle at his feet, and patriarchs, kings, and prophets to either side look on in admiration, perhaps waiting for their own turn to be rescued. During a funeral in this chapel, the head of the deceased would have been directed toward this engrossing tableau, closed eyes facing upward toward a painting of the Last Judgment, strategically positioned on the vault over the bier. In 1332, this was the location of Metochites' own dead body since this parekklesion was indeed the site of his funeral. He may have been buried in one of the niche tombs cut into the walls of the chapel, or even within a tomb that was placed under the floor of the sanctuary itself, directly under the painted image of the archangel Michael, guardian of souls.

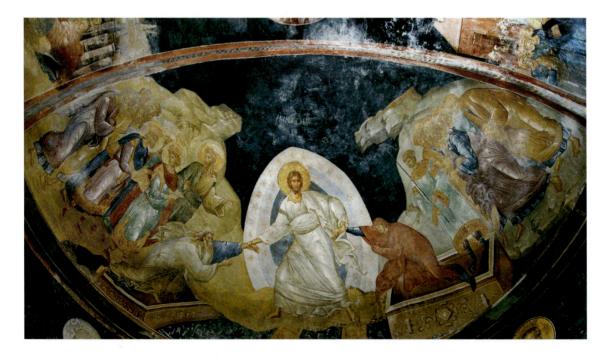

8-31 • ANASTASIS Apse of the funerary chapel, church of the monastery of Christ in Chora. c. 1321. Fresco.

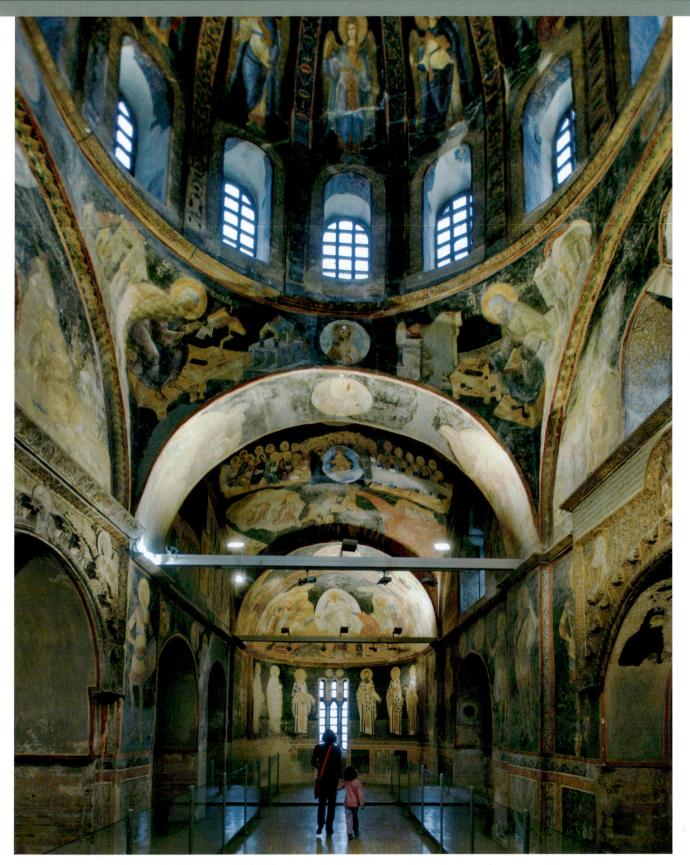

8-32 • FUNERARY CHAPEL (PAREKKLESION) Church of the monastery of Christ in Chora. (Present-day Kariye Müzesi.) c. 1315–1321.

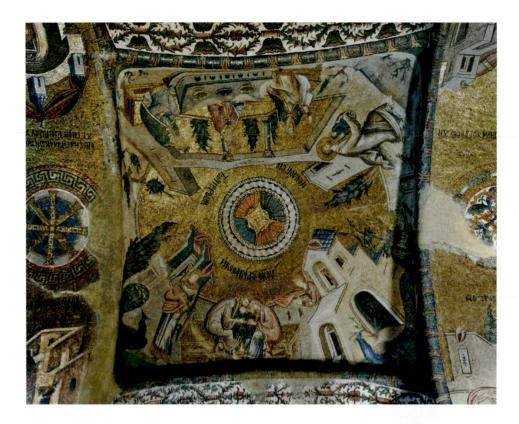

8-33 • THE INFANT VIRGIN MARY CARESSED BY HER PARENTS JOACHIM AND ANNA

Inner narthex, church of Christ in Chora. (Present-day Kariye Müzesi.) c. 1315–1321. Mosaic.

The Greek inscription placed over the family group identifies this scene as the fondling of the Theotokos (bearer of God).

ICONS

Late Byzantine artists of Constantinople created icons as well as painting murals and making mosaics on walls. Among the most dynamic and engaging is a representation of the Annunciation on one side of an early fourteenth-century double-sided icon (FIG. 8-34)-the other side has an image of the Virgin and Childroughly contemporary with the redecoration of the Chora church. This icon was made in the capital, perhaps under imperial patronage, and sent from there to the archbishop of Ohrid. Over three feet tall, it was probably mounted on a pole and carried in processions, where both sides would be visible. Characteristic of Constantinopolitan art under the Palaeologues are the small heads of the figures, their inflated bodies, and the light-shot silk of their clothing; the forward projecting perspective of the architecture of background and throne, similar in concept to what we have seen in the Chora mosaics (see FIG. 8-33); as well as the fanciful caryatids perched on the tops of the columns.

The practice of venerating icons intensified in Russia during this period; regional schools of icon painting flourished, fostering the work of remarkable artists. One of these was the renowned artistmonk Andrey Rublyov who created a magnificent icon of **THE HOSPITALITY OF ABRAHAM** sometime between about 1410 and 1425 (**FIG. 8–35**). It was commissioned in honor of Abbot Sergius of the Trinity-Sergius Monastery, near Moscow. The theme is the Trinity, represented here by three identical angels. Rublyov's source for this idea was a story in the Hebrew Bible of the patriarch Abraham and his wife Sarah, who entertained three strangers who were in fact God represented by three divine beings in human form (Genesis 18). Tiny images of Abraham and Sarah's home and

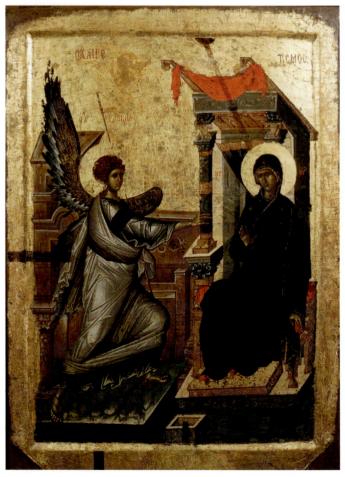

8-34 • **ANNUNCIATION TO THE VIRGIN** Sent from Constantinople to the church of the Virgin Peribleptos, Ohrid, Macedonia. Early 14th century. Tempera on panel, 36%" $\times 26\%$ " (93 \times 68 cm). Icon Gallery, Ohrid, Macedonia.

the oak of Mamre can be seen above the angels. The food the couple offered to the strangers becomes a chalice on an altarlike table.

Rublyov's icon clearly illustrates how Late Byzantine artists—like the artists of ancient Greece—relied on mathematical conventions to create ideal figures, giving their works remarkable consistency. But unlike the Greeks, who based their formulas on close observation of nature, Byzantine artists invented an ideal geometry to evoke a spiritual realm and conformed their representations of human forms and features to it. Here the circle forms the basic underlying structure for the composition. Despite this formulaic approach, talented artists like Rublyov worked within it to create a personal, expressive style. Rublyov relied on typical Late Byzantine conventions—salient contours, small heads and long bodies, and a focus on a limited number of figures—to capture the sense of the spiritual in his work, yet he distinguished his art by imbuing it with a sweet, poetic ambience.

The Byzantine tradition continued for centuries in the art of the Eastern Orthodox Church and is carried on to this day in Greek and Russian icon painting. But in Constantinople, Byzantine art—like the empire itself—came to an end in 1453. When the forces of the Ottoman sultan Mehmed II overran the capital, the Eastern Empire became part of the Islamic world. The Turkish conquerors were so impressed with the splendor of the Byzantine art and architecture in the capital, however, that they adopted its traditions and melded them with their own rich aesthetic heritage into a new, and now Islamic, artistic efflorescence.

8-35 • Andrey Rublyov THE HOSPITALITY OF ABRAHAM lcon. c. 1410–1425. Tempera on panel, $55\frac{1}{2}^{"} \times 44\frac{1}{2}^{"}$ (141 × 113 cm). Tretyakov State Gallery, Moscow.

THINK ABOUT IT

- 8.1 Characterize the role of the Classical tradition, already notable in the Early Christian period, in the developing history of Byzantine art. When was it used? In what sorts of contexts? Develop your discussion in relation to two specific examples from two different periods of Byzantine art.
- 8.2 Compare the portrayals of the Byzantine rulers in the mosaics of San Vitale in Ravenna (see FIGS. 8–8, 8–9) and those on a tenth-century ivory plaque (see FIG. 8–26). Attend to the subjects of the scenes themselves as well as the way the emperor and empress are incorporated within them.
- **8.3** How were images used in Byzantine worship? Why were images suppressed during iconoclasm?
- 8.4 How do the mosaics of the Chora church in Constantinople emphasize the human dimensions of sacred stories? Consider, in particular, how the figures are represented, what kinds of stories are told, and in what way.

CROSSCURRENTS

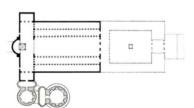

Both of these grand churches were built under the patronage of powerful rulers and were meant to glorify them as well as serve the Christian community. What features do they share? In what ways are they fundamentally different? What functions did they serve in both Church and state?

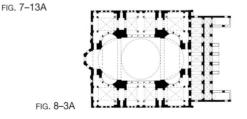

Study and review on myartslab.com

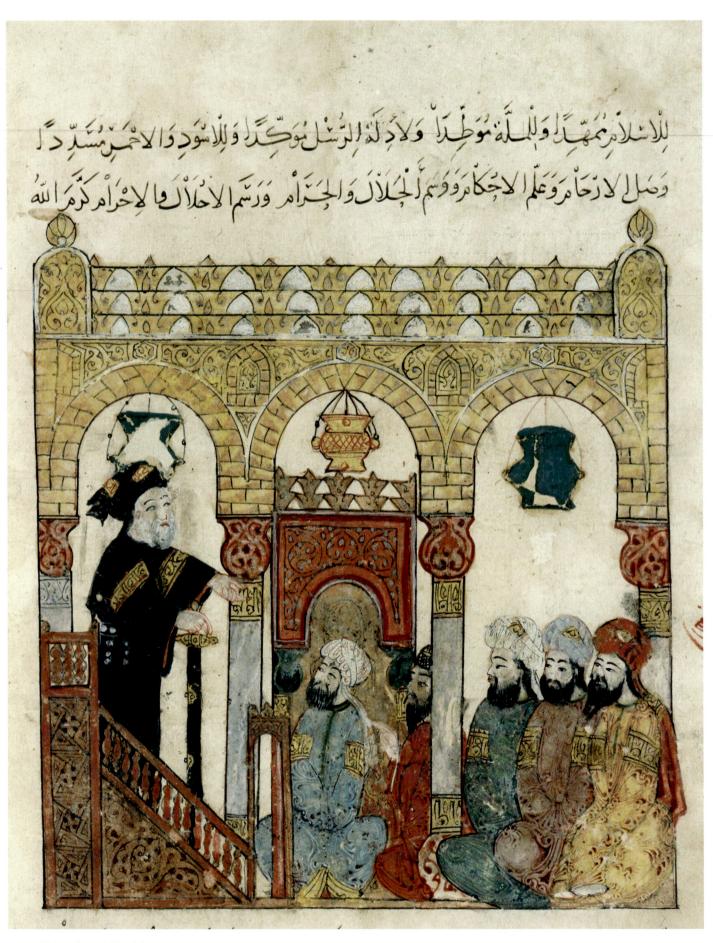

9-1 • Yahya Ibn al-Wasiti THE MAQAMAT OF AL-HARIRI From Baghdad, Iraq. 1237. Ink, pigments, and gold on paper, 13³/₄" × 10¹/₄" (35 × 25 cm). Bibliothèque Nationale, Paris. Arabic MS. 5847, fol. 18v

Islamic Art

The Magamat ("Assemblies"), by al-Hariri (1054-1122), belongs to a popular Islamic literary genre of cautionary tales. Al-Hariri's stories revolve around a silver-tongued scoundrel named Abu Zayd, whose cunning inevitably triumphs over other people's naivety. His exploits take place in a world of colorful settings-desert camps, ships, pilgrim caravans, apothecary shops, mosques, gardens, libraries, cemeteries, and courts of law. In such settings, these comic stories of trickery and theft would seem perfectly suited for illustration, and that is the case in this engaging manuscript, made in Baghdad during the thirteenth century. Human activity permeates the compositions-pointing fingers, arguing with adversaries, riding horses, stirring pots, and strumming musical instruments. And these vivid visualizations of Abu Zayd's adventures provide us with rare windows into ordinary Muslim life, here prayer in the congregational mosque (FIG. 9-1), a religious and social institution at the center of Islamic culture.

The congregation has gathered to hear a sermon preached by the deceitful Abu Zayd, who plans to make off with the alms collection. The men sit directly on the ground, as is customary not only in mosques, but in traditional dwellings. The listener in the front row tilts his chin upward to focus his gaze directly upon the speaker. He is framed and centered by the arch of the **mihrab** (the niche indicating the direction of Mecca) on the rear wall; his white turban contrasts noticeably with the darker gold background. Perhaps he stands in for the manuscript's reader who, perusing the illustrations of these captivating stories, pauses to project him- or herself into the scene.

The columns of the mosque's arcades have ornamental capitals from which spring half-round arches. Glass mosque lamps hang from the center of each arch. Figures wear turbans and flowing, loose-sleeved robes with epigraphic borders (tiraz) embroidered in gold. Abu Zayd delivers his sermon from the steps of a minbar (pulpit) with an arched gateway opening at the lowest level. This minbar and the arcades that form the backdrop of the scene are reduced in scale so the painter can describe the entire setting and still make the figures the main focus of the composition. Likewise, although in an actual mosque the minbar would share the same wall as the mihrab, here they have been separated, perhaps to keep the minbar from hiding the mihrab, and to rivet our attention on what is most important-the rapt attention Abu Zayd commands from his captive audience, a group we ourselves join as we relish the anecdotal and pictorial delights of this splendid example of Islamic visual narrative.

LEARN ABOUT IT

- Explore the stylistic variety of art and architecture created in the disparate areas of the Islamic world.
- **9.2** Explore the use of ornament and inscription in Islamic art.
- **9.3** Interpret Islamic art as a reflection of both religion and secular society.
- **9.4** Recognize the role of political transformation in the creation of Islamic artistic eclecticism as well as its unification around a shared cultural and religious viewpoint.

((•- Listen to the chapter audio on myartslab.com

ISLAM AND EARLY ISLAMIC SOCIETY

Islam arose in seventh-century Arabia, a land of desert oases with no cities of great size and sparsely inhabited by tribal nomads. Yet, under the leadership of its founder, the Prophet Muhammad (c. 570–632 CE), and his successors, Islam spread rapidly throughout northern Africa, southern and eastern Europe, and into Asia, gaining territory and converts with astonishing speed. Because Islam encompassed geographical areas with a variety of long-established cultural traditions, and because it admitted diverse peoples among its converts, it absorbed and combined many different techniques and ideas about art and architecture. The result was a remarkably sophisticated artistic eclecticism.

Muslims ("those who have submitted to God") believe that in the desert outside of Mecca in 610, Muhammad received revelations that led him to found the religion called Islam ("submission to God's will"). Many powerful Meccans were hostile to the message preached by the young visionary, and in 622 he and his companions fled to Medina. There Muhammad built a house that became a gathering place for the converted and thus the first mosque. Muslims date their history as beginning with this *hijira* ("emigration").

In 630, Muhammad returned to Mecca with an army of 10,000, routed his enemies, and established the city as the spiritual capital of Islam. After his triumph, he went to the **KAABA** (**FIG. 9-2**), a cubelike, textile-draped shrine said to have been built for God by Ibrahim (Abraham) and Isma⁵il (Ishmael) and long the focus of pilgrimage and polytheistic worship. He emptied the shrine, repudiating its accumulated pagan idols, while preserving the enigmatic structure itself and dedicating it to God.

The Kaaba is the symbolic center of the Islamic world, the place to which all Muslim prayer is directed and the ultimate destination of Islam's obligatory pilgrimage, the *hajj*. Each year, huge numbers of Muslims from all over the world travel to Mecca to circumambulate the Kaaba during the month of pilgrimage. The exchange of ideas that occurs during the intermingling of these diverse groups of pilgrims has contributed to Islam's cultural eclecticism.

Muhammad's act of emptying the Kaaba of its pagan idols instituted the fundamental practice of avoiding figural imagery in Islamic religious architecture. This did not, however, lead to a ban

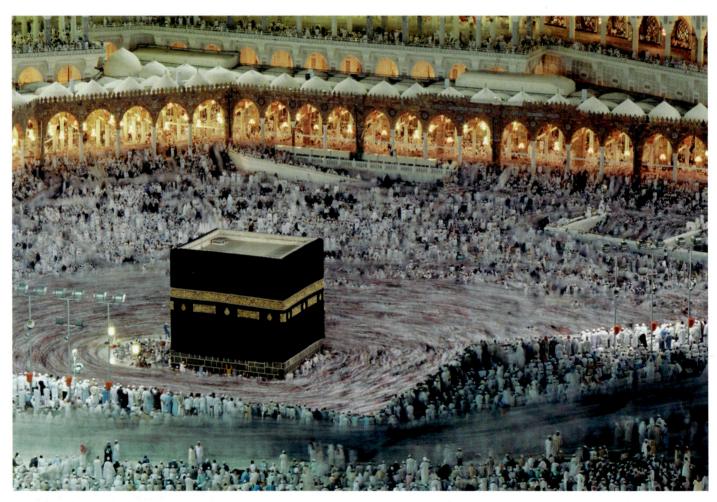

9-2 • THE KAABA, MECCA

The Kaaba represents the center of the Islamic world. Its cubelike form is draped with a black textile that is embroidered with a few Qur'anic verses in gold.

MAP 9-1 • THE ISLAMIC WORLD

Within 200 years after 622 CE, the Islamic world expanded from Mecca to India in the east, and to Morocco and Spain in the west.

on art. Figural imagery is frequent in palaces and illustrated manuscripts, and Islamic artists elaborated a rich vocabulary of nonfigural ornament, including complex geometric designs and scrolling foliate vines (that Europeans labeled **arabesques**), which were appropriate in all contexts. Islamic art revels in surface decoration, in manipulating line, color, and especially pattern, often highlighting the interplay of pure abstraction, organic form, and script.

According to tradition, the Qur'an assumed its final form during the time of the third caliph (successor to the Prophet), Uthman (r. 644–56). As the language of the Qur'an, Arabic and its script have been a powerful unifying force within Islam. From the eighth through the eleventh centuries, it was the universal language among scholars in the Islamic world and in some Christian lands as well. Inscriptions frequently ornament works of art, sometimes written clearly to provide a readable message, but in other cases written as complex patterns also to delight the eye.

The Prophet was succeeded by a series of caliphs. The accession of Ali as the fourth caliph (r. 656–61) provoked a power struggle that led to his assassination and resulted in enduring divisions within Islam. Followers of Ali, known as Shi'ites (referring to the party or *shi'a* of Ali), regard him alone as the Prophet's

rightful successor. Sunni Muslims, in contrast, recognize all of the first four caliphs as "rightly guided." Ali was succeeded by his rival Muawiya (r. 661–80), a close relative of Uthman and the founder of the first Muslim dynasty, the Umayyad (661–750).

Islam expanded dramatically. Within two decades, seemingly unstoppable Muslim armies conquered the Sasanian Persian Empire, Egypt, and the Byzantine provinces of Syria and Palestine. By the early eighth century, the Umayyads had reached India, conquered northern Africa and Spain, and penetrated France before being turned back (MAP 9-1). In these newly conquered lands, the treatment of Christians and Jews who did not convert to Islam was not consistent, but in general, as "People of the Book"—followers of a monotheistic religion based on a revealed scripture—they enjoyed a protected status, though they were subject to a special tax and restrictions on dress and employment.

Muslims participate in congregational worship at a mosque (*masjid*, "place of prostration"). The Prophet Muhammad himself lived simply and instructed his followers in prayer at his house, now known as the Mosque of the Prophet, where he resided in Medina. This was a square enclosure that framed a large courtyard with rooms along the east wall where he and his family lived. Along

TECHNIQUE | Ornament

Islamic art delights in complex ornament that sheathes surfaces, distracting the eye from the underlying structure or physical form.

ablaq masonry (*Madrasa*-Mausoleum-Mosque of Sultan Hasan, Cairo; see FIG. 9–14) juxtaposes stone of contrasting colors. The ornamental effect is enhanced here by the interlocking jigsaw shape of the blocks, called joggled voussoirs.

cut tile (Shah-i Zinda, Samarkand; see FiG. 9–18), made up of dozens of individually cut ceramic tile pieces fitted precisely together, emphasizes the clarity of the colored shapes.

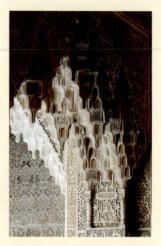

muqarna (Palace of the Lions, Alhambra, Granada; see FIG. 9–16) consist of small nichelike components, usually stacked in multiples as successive, nonload-bearing units in arches, cornices, and domes, hiding the transition from the vertical to the horizontal plane.

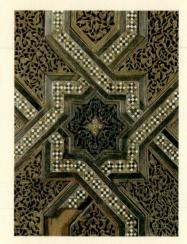

wooden strapwork (Kutubiya minbar, Marrakesh; see FIG. 9–9) assembles finely cut wooden pieces to create the appearance of geometrically interlacing ribbons, often framing smaller panels of carved wood and inlaid ivory or mother-of-pearl (shell).

mosaic (Dome of the Rock, Jerusalem; see FIG. 9–4) is comprised of thousands of small glass or glazed ceramic *tesserae* set on a plaster ground. Here the luminous white circular shapes are mother-of-pearl.

water (Court of the Myrtles, Alhambra, Granada) as a fluid architectural element reflects surrounding architecture, adds visual dynamism and sound, and, running in channels between areas to unite disparate spaces.

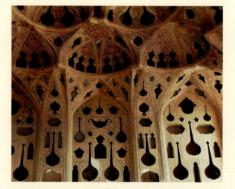

chini khana (Ali Qapu Pavilion, Isfahan) literally "china cabinet"—is a panel of niches, sometimes providing actual shelving, but used here for its contrast of material and void which reverses the typical figureground relationship.

the south wall, a thatched portico supported by palm-tree trunks sheltered both the faithful as they prayed and Muhammad as he spoke from a low platform. This simple arrangement inspired the design of later mosques. Without the architectural focus provided by chancels, altars, naves, or domes, the space of this prototypical hypostyle (multicolumned) mosque reflected the founding spirit of Islam in which the faithful pray as equals directly to God, led by an imam, but without the intermediary of a priesthood.

THE EARLY PERIOD: NINTH THROUGH TWELFTH CENTURIES

The caliphs of the Umayyad dynasty (661–750) ruled from Damascus in Syria, and throughout the Islamic empire they built mosques and palaces that projected the authority of the new rulers and reflected the growing acceptance of Islam. In 750 the Abbasid

clan replaced the Umayyads in a coup d'état, ruling as caliphs until 1258 from Baghdad, in Iraq. Their long and cosmopolitan reign saw achievements in medicine, mathematics, the natural sciences, philosophy, literature, music, and art. They were generally tolerant of the ethnically diverse populations in the territories they subjugated, and they admired the past achievements of Roman civilization as well as the living traditions of Byzantium, Persia, India, and China, freely borrowing artistic techniques and styles from all of them.

In the tenth century, the Islamic world split into separate kingdoms ruled by independent caliphs. In addition to the Abbasids of Iraq, there was a Fatimid Shi'ite caliph ruling Tunisia and Egypt, and a descendant of the Umayyads ruling Spain and Portugal (together then known as al-Andalus). The Islamic world did not reunite under the myriad dynasties who thereafter ruled from northern Africa to Asia, but loss in unity was gain to artistic diversity.

ARCHITECTURE

While Mecca and Medina remained the holiest Muslim cities, the political center under the Umayyads shifted to the Syrian city of Damascus in 656. In the eastern Mediterranean, inspired by Roman and Byzantine architecture, the early Muslims became enthusiastic builders of shrines, mosques, and palaces. Although tombs were officially discouraged in Islam, they proliferated from the eleventh century onward, in part due to funerary practices imported from the Turkic northeast, and in part due to the rise of Shi'ism with its emphasis on genealogy and particularly ancestry through Muhammad's daughter, Fatima. **THE DOME OF THE ROCK** In the center of Jerusalem rises the Haram al-Sharif ("Noble Sanctuary"), a rocky outcrop from which Muslims believe Muhammad ascended to the presence of God on the "Night Journey" described in the Qur'an, as well as the site of the First and Second Jewish Temples. Jews and Christians variously associate this place with Solomon, the site of the creation of Adam, and the place where the patriarch Abraham prepared to sacrifice his son Isaac at the command of God. In 691–92, a domed shrine was built over the rock (**FIG. 9–3**), employing artists

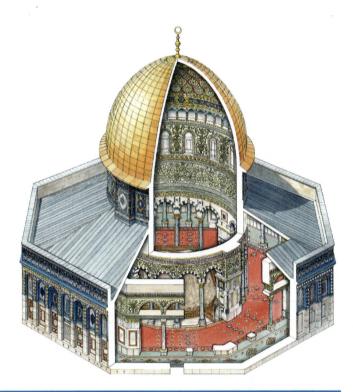

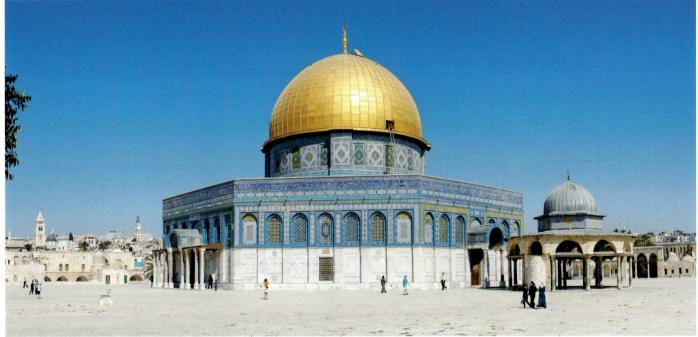

9-3 • EXTERIOR VIEW (A) AND CUTAWAY DRAWING (B) OF THE DOME OF THE ROCK, JERUSALEM Israel. Begun 691.

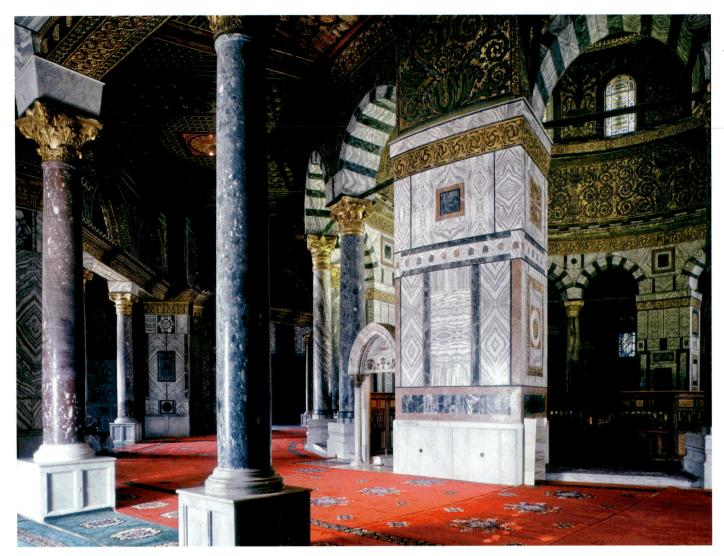

9-4 • INTERIOR, DOME OF THE ROCK Israel. Begun 691.

The arches of the inner and outer face of the central arcade are encrusted with golden mosaics, a Byzantine technique adapted for Islamic use to create ornament and inscriptions. The pilgrim must walk around the central space first clockwise and then counterclockwise to read the inscriptions. The carpets and ceilings are modern but probably reflect the original intent.

trained in the Byzantine tradition to create the first great monument of Islamic art. By assertively appropriating a site holy to Jews and Christians, the Dome of the Rock manifested Islam's view of itself as completing and superseding the prophecies of those faiths.

Structurally, the Dome of the Rock imitates the centrally planned form of Early Christian and Byzantine martyria (see FIGS. 7-15, 8-5). However, unlike the plain exteriors of its models, it is crowned by a golden dome that dominates the skyline. The ceramic tiles on the lower portion of the exterior were added later, but the opulent marble veneer and mosaics of the interior are original (see "Ornament," page 268). The dome, surmounting a circular drum pierced with windows and supported by arcades of alternating **piers** and columns, covers the central space containing the rock (**FIG. 9-4**), and concentric aisles (ambulatories) permit devout visitors to circumambulate it.

Inscriptions from the Qur'an interspersed with passages from other texts, including information about the building itself, form a frieze around the inner and outer arcades. As pilgrims walk around the central space to read the inscriptions in brilliant gold mosaic on turquoise green ground, the building communicates both as a text and as a dazzling visual display. These inscriptions are especially notable because they are the oldest surviving written verses from the Qur'an and the first use of Qur'anic inscriptions in architecture. Below, walls are faced with marble—the veining of which creates abstract symmetrical patterns—and the rotunda is surrounded by columns of gray marble with gilded capitals. Above the calligraphic frieze is another mosaic frieze depicting symmetrical vine scrolls and trees in turquoise, blue, and green, embellished with imitation jewels, over a gold ground. The mosaics are variously thought to represent the gardens of Paradise and trophies of

ART AND ITS CONTEXTS | The Five Pillars of Islam

Islam emphasizes a direct personal relationship with God. The Pillars of Islam, sometimes symbolized by an open hand with the five fingers extended, enumerate the duties required of Muslims by their faith.

- The first pillar (shahadah) is to proclaim that there is only one God and that Muhammad is his messenger. While monotheism is common to Judaism, Christianity, and Islam, and Muslims worship the God of Abraham, and also acknowledge Hebrew and Christian prophets such as Musa (Moses) and Isa (Jesus), Muslims deem the Christian Trinity polytheistic and assert that God was not born and did not give birth.
- The second pillar requires prayer (salat) to be performed by turning to face the Kaaba in Mecca five times daily: at dawn, noon, late afternoon, sunset, and nightfall. Prayer can occur almost anywhere, although the prayer on Fridays takes place in the congregational mosque. Because ritual ablutions are required for purity, mosque courtyards usually have fountains.
- The third pillar is the voluntary payment of annual tax or alms (zakah), equivalent to one-fortieth of one's assets. Zakah is used for charities such as feeding the poor, housing travelers, and paying the dowries of orphan girls. Among Shi'ites, an additional tithe is required to support the Shi'ite community specifically.

- The fourth pillar is the dawn-to-dusk fast (*sawm*) during Ramadan, the month when Muslims believe Muhammad received the revelations set down in the Qur'an. The fast of Ramadan is a communally shared sacrifice that imparts purification, self-control, and fellowship with others. The end of Ramadan is celebrated with the feast day 'Id al-Fitr (Festival of the Breaking of the Fast).
- For those physically and financially able to do so, the fifth pillar is the pilgrimage to Mecca (*hajj*), which ideally is undertaken at least once in the life of each Muslim. Among the extensive pilgrimage rites are donning simple garments to remove distinctions of class and culture; collective circumambulations of the Kaaba; kissing the Black Stone inside the Kaaba (probably a meteorite that fell in pre-Islamic times); and the sacrificing of an animal, usually a sheep, in memory of Abraham's readiness to sacrifice his son at God's command. The end of the *hajj* is celebrated by the festival 'Id al-Adha (Festival of Sacrifice).

The directness and simplicity of Islam have made the Muslim religion readily adaptable to numerous varied cultural contexts throughout history. The Five Pillars instill not only faith and a sense of belonging, but also a commitment to Islam in the form of actual practice.

Muslim victories offered to God. Though the decorative program is extraordinarily rich, the focus of the building is neither art nor architecture but the plain rock it shelters.

THE GREAT MOSQUE OF KAIROUAN Muslim congregations gather on Fridays for regular worship in a mosque. The earliest mosque type followed the model of the Prophet's own house. The **GREAT MOSQUE** of Kairouan, Tunisia (**FIG. 9–5**), built in the ninth century, reflects the early form of the mosque but is elaborated with later additions. The large rectangular space is divided between a courtyard and a flat-roofed hypostyle prayer hall oriented toward Mecca. The system of repeated bays and aisles can easily be extended as the congregation grows in size one of the hallmarks of the hypostyle plan. New is the large

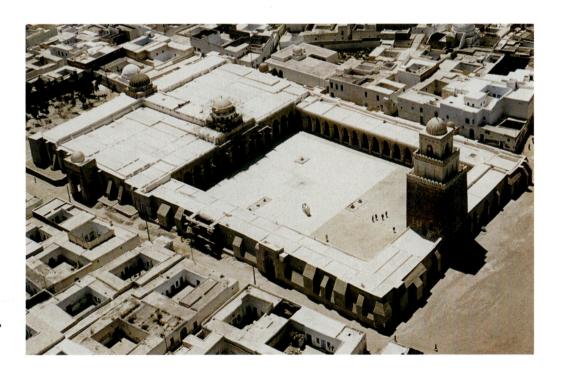

9-5 • THE GREAT MOSQUE, KAIROUAN Tunisia. 836–875. When the Umayyads were toppled in 750, a survivor of the dynasty, Abd al-Rahman I (r. 756–788), fled across north Africa into southern Spain (al-Andalus) where, with the support of Muslim settlers, he established himself as the provincial ruler, or emir. This newly transplanted Umayyad dynasty ruled in Spain from its capital in Cordoba (756–1031). The Hispano-Umayyads were noted patrons of the arts, and one of the finest surviving examples of Umayyad architecture is the Great Mosque of Cordoba (**FIGS. 9–6, 9–7**).

In 785, the Umayyad conquerors began building the Cordoba mosque on the site of a Christian church built by the Visigoths, the pre-Islamic rulers of Spain. The choice of site was both practical-for the Muslims had already been renting space within the church-and symbolic, an appropriation of place (similar to the Dome of the Rock) that affirmed their presence. Later rulers expanded the building three times, and today the walls enclose an area of about 620 by 460 feet, about a third of which is the courtyard. This patio was planted with fruit trees, beginning in the early ninth century; today orange trees seasonally fill the space with color and sweet scent. Inside, the proliferation of pattern in the repeated columns and double flying arches is both colorful and dramatic. The marble columns and capitals in the hypostyle prayer hall were recycled from the Christian church that had formerly occupied the site, as well as from classical buildings in the region, which had been a wealthy Roman province. The mosque's interior incorporates spolia (reused) columns of slightly varying heights. Two tiers of arches, one over the other, surmount these columns, the upper tier springing from rectangular

9-6 • PRAYER HALL, GREAT MOSQUE, CORDOBA Spain. Begun 785/786.

piers that rise from the columns. This doubletiered design dramatically increases the height of the interior space, inspiring a sense of monumentality and awe. The distinctively shaped **horseshoe arches**—a form known from Roman times and favored by the Visigoths—came to be closely associated with Islamic architecture in the West (see "Arches," page 274). Another distinctive feature of these arches, adopted from Roman and Byzantine precedents, is the alternation of white stone and red-brick voussoirs forming the curved arch. This mixture of materials may have helped the building withstand earthquakes.

In the final century of Umayyad rule, Cordoba emerged as a major commercial and intellectual hub and a flourishing center for the arts, surpassing Christian European cities in science, literature, and philosophy. As a sign of this new wealth, prestige, and power, Abd al-Rahman III (r. 912-961) boldly reclaimed the title of caliph in 929. He and his son al-Hakam II (r. 961–976) made the Great Mosque a focus of patronage, commissioning costly and luxurious renovations such as a new mihrab with three bays in front of it (FIG. 9-8). These capped the magsura, an enclosure in front of the mihrab reserved for the ruler and other dignitaries, which became a feature of congregational mosques after an assassination attempt on one of the Umayyad rulers. A minbar formerly stood by the mihrab as the place for the prayer leader and as a symbol of authority. The melon-shaped, ribbed dome

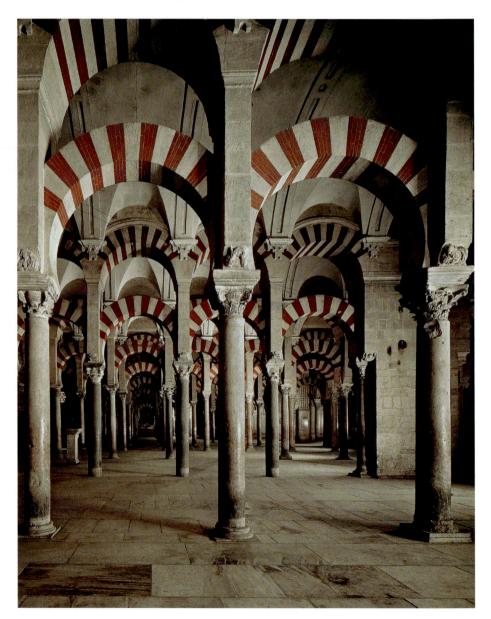

over the central bay may be a metaphor for the celestial canopy. It seems to float upon a web of crisscrossing arches, the complexity of the design reflecting the Islamic interest in mathematics and geometry, not purely as abstract concepts but as sources for artistic inspiration. Lushly patterned mosaics with inscriptions, geometric motifs, and stylized vegetation clothe both this dome and the mihrab below in brilliant color and gold. These were installed by a Byzantine master sent by the emperor in Constantinople, who brought with him boxes of small glazed ceramic and glass pieces (tesserae). Such artistic exchange is emblematic of the interconnectedness of the medieval Mediterranean-through trade, diplomacy, and competition.

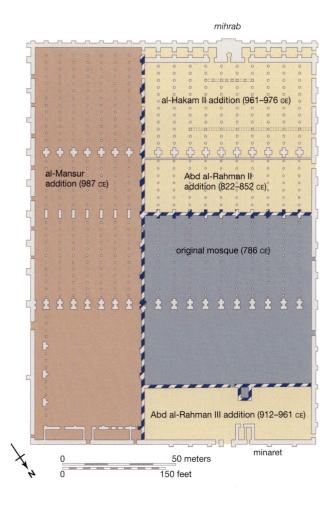

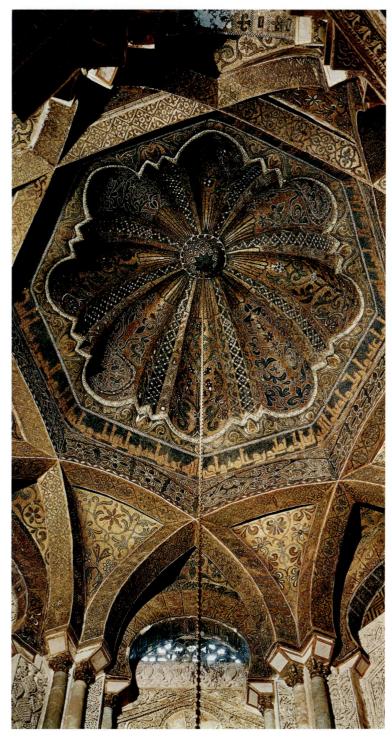

9-8 • DOME IN FRONT OF THE MIHRAB, GREAT MOSQUE 965.

9-7 • PLAN OF THE GREAT MOSQUE Begun 785/786.

ELEMENTS OF ARCHITECTURE | Arches

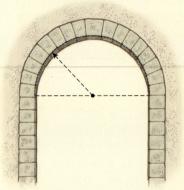

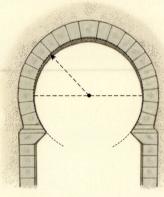

The simple **semicircular arch**, inherited from the Romans and Byzantines, has a single center point that is level with the points from which the arch springs. The **horseshoe arch** predates Islam but became the prevalent arch form in the Maghreb (see FIG. 9–6). The center point is above the level of the arch's springing point, so that it pinches inward above the capital. The pointed arch, introduced

after the beginning of Islam, has two (sometimes four) center points, the points generating different circles that overlap (see FIG. 9–28).

A **keel arch** has flat sides, and slopes where other arches are curved. It culminates at a pointed apex (see "Ornament," cut tile, page 268).

• Watch an architectural simulation about Islamic arches on myartslab.com

minaret (a tower from which the faithful are called to prayer) that rises from one end of the courtyard, standing as a powerful sign of Islam's presence in the city.

The **qibla** wall, marked by a centrally positioned *mihrab* niche, is the wall of the prayer hall that is closest to Mecca. Prayer is oriented toward this wall. In the Great Mosque of Kairouan, the *qibla* wall is given heightened importance by a raised roof, a dome over the *mihrab*, and a central aisle that marks the axis that extends from the minaret to the *mihrab* (for a fourteenth-century example of a *mihrab*, see FIG. 9-17). The *mihrab* belongs to the historical tradition of niches that signify a holy place—the Torah shrine in a synagogue, the frame for sculptures of gods or ancestors in Roman architecture, the apse in a church.

THE KUTUBIYA MOSQUE In the Kutubiya Mosque, the principal mosque of Marrakesh, Morocco, survives an exceptionally exquisite, twelfth-century wooden *minbar*—made originally for the Booksellers' Mosque in Marrakesh (**FIG. 9-9**). It consists of a staircase from which the weekly sermon was delivered to the congregation (see FIG. 9-1). The sides are paneled in wooden marquetry with strapwork in a geometric pattern of eight-pointed stars and

9-9 • MINBAR

From the Kutubiya Mosque, Marrakesh, Morocco. 1125–1130. Wood and ivory, 12'8" \times 11'4" \times 2'10" (3.86 \times 3.46 \times 0.87 m). Badi Palace Museum, Marrakesh.

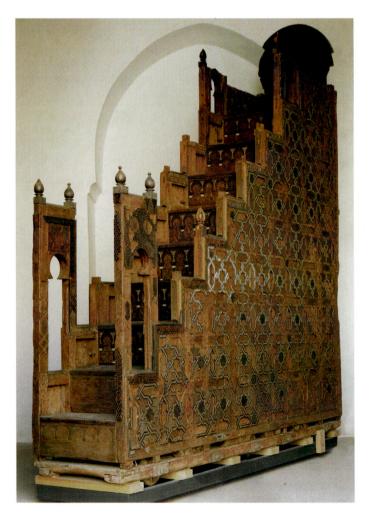

elongated hexagons inlaid with ivory (see "Ornament," page 268). The areas between the strapwork are filled with wood carved in swirling vines. Reflecting the arcades of its original architectural context, the risers of the stairs represent horseshoe arches (see "Arches," opposite) resting on columns with ivory capitals and bases. This minbar is much like others across the Islamic world, but those at the Kutubiya Mosque and the Great Mosque of Cordoba (see "the Great Mosque of Cordoba, page 272) were the finest, according to Ibn Marzuq (1311-1379), a distinguished preacher who had given sermons from 48 minbars.

CALLIGRAPHY

From the beginning, Arabic script was held in high esteem in Islamic society. Reverence for the Qur'an as the word of God extended-and continues to extend-by association to the act of writing itself, and **calligraphy** (the art of the finely written word) became one of the glories of Islamic art. Writing was not limited to books and documents but-as we have seen-was displayed on the walls of buildings and will appear on works in many media throughout the history of Islamic art. The written word played two roles: It could convey information about a building or object, describing its beauty or naming its patron, and it could delight the eye as a manifestation of beauty.

Arabic script is written from right to left, and a letter's form varies depending on its position in a word. With its rhythmic interplay between verticals and horizontals, Arabic lends itself to many variations. Calligraphers enjoyed the highest status of all

artists in Islamic society. Apprentice scribes had to learn secret formulas for inks and paints, and become skilled in the proper ways to sit, breathe, and manipulate their tools. They also had to absorb the complex literary traditions and number symbolism that had developed in Islamic culture. Their training was long and arduous, but unlike other artists who were generally anonymous in the early centuries of Islam, outstanding calligraphers received public recognition.

Formal Kufic script (after Kufa, a city in Iraq) is blocky and angular, with strong upright strokes and long horizontals. It may have developed first for carved or woven inscriptions where clarity and practicality of execution were important. Most early Qur'ans were horizontal in orientation and had large Kufic letters creating only three to five lines per page. Visual clarity was essential because one book was often shared simultaneously by multiple readers. A page from a ninth-century Syrian Qur'an exemplifies the style common from the eighth to the tenth century (FIG. 9-10). Red diacritical marks (pronunciation guides) accent the dark brown ink; the surah ("chapter") title is embedded in the burnished ornament at the bottom of the sheet. Instead of page numbers, the brilliant gold of the framed words and the knoblike projection in the left-hand margin mark chapter breaks.

By the tenth century, more than 20 cursive scripts had come into use. They were standardized by Ibn Mugla (d. 940), an Abbasid official who fixed the proportions of the letters in each script and devised a method for teaching calligraphy that is still in use today. The Qur'an was usually written on parchment (treated

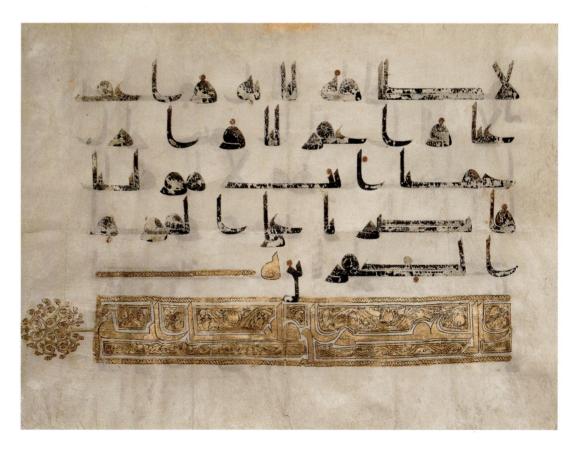

9-10 • PAGE FROM THE QUR'AN

Surah 2:286 and title of surah 3 in Kufic script. Syria. 9th century. Black ink, pigments, and gold on vellum, 83/8" \times 11¹/₈" (21.8 \times 29.2 cm). Metropolitan Museum of Art, New York. Rogers Fund, 1937. (37.99.2)

Read the document related to the Qur'an on myartslab.com

9-11 • PLATE WITH KUFIC BORDER

From Khurasan. 10th–12th century. Earthenware with white and black slip, and lead glaze, diameter $14\frac{1}{2}$ " (33.8 cm). Musée du Louvre, Paris.

animal skin) and vellum (calfskin or a fine parchment). Paper was first manufactured in Central Asia during the mid eighth century, having been introduced earlier by Buddhist monks. Muslims learned how to make high-quality, rag-based paper, and eventually established their own paper mills. By about 1000, paper had largely replaced the more costly parchment for everything but Qur'an manuscripts, which adopted the new medium much later. It was a change as momentous as that brought about by movable type or the Internet, affecting not only the appearance of books but also their content. The inexpensive new medium sparked a surge in book production and the proliferation of increasingly elaborate and decorative cursive scripts which had generally superseded Kufic by the thirteenth century.

Kufic script remained popular, however, in other media. It was the sole decoration on a type of white pottery made from the tenth century onward in and around the region of Nishapur (in Khurasan, in present-day Iran) and Samarkand (in present-day Uzbekistan) known as epigraphic ware. These elegant earthenware bowls and plates employ a clear lead glaze over a painted black inscription on a white slip ground (**FIG. 9-11**). Here the script's horizontals and verticals have been elongated to fill the plate's rim, stressing the letters' verticality in such a way that they seem to radiate from the bold spot at the center of the circle. The fine quality of the lettering indicates that a calligrapher furnished the model. The inscription translates: "Knowledge [or magnanimity]: the beginning of it is bitter to taste, but the end is sweeter than honey," an apt choice for tableware made to appeal to an educated patron. Inscriptions on Islamic ceramics provide a storehouse of such popular aphorisms.

LUSTERWARE

In the ninth century, Islamic potters developed a means of producing a lustrous metallic surface on their ceramics. They may have learned the technique from Islamic glassmakers in Syria and Egypt, who had produced luster-painted vessels a century earlier. First the potters applied a paint laced with silver, copper, or gold oxides to the surface of already fired and glazed tiles or vessels. In a second firing with relatively low heat and less oxygen, these oxides burned away to produce a reflective, metallic sheen. The finished **luster-ware** resembled precious metal. Lusterware tiles, dated 862/863, decorated the *mihrab* of the Great Mosque at Kairouan. At first a carefully guarded secret of Abbasid potters in Iraq, lusterware soon spread throughout the Islamic world, to North Africa, Egypt, Iran, Syria, and Spain.

Early potters covered the entire surface with luster, but soon they began to use luster to paint patterns using geometric design, foliate motifs, animals, and human figures, in brown, red, purple, and/or green. Most common was monochrome lusterware in shades of brown, as in this tenth-century jar from Iraq (FIG. 9-12). The form of the vessel is emphasized by the distribution of decorative motifs-the lip and neck are outlined with a framed horizontal band of scalloped motifs, the shoulder singled out with dots within circles (known as the "peacock's eye" motif), and the height emphasized by boldly ornamented vertical strips with undulating outlines moving up toward pointed tops and dividing the surface of the jar into quadrants. Emphasis, however, is placed on representations of enigmatic human figures dressed in dark, hooded garments. They stand in bended postures and hold beaded strands while looked directly out toward viewers, engaged in an activity whose meaning and significance remains a mystery.

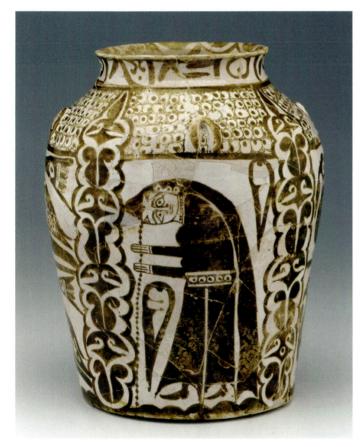

9-12 • LUSTERWARE JAR

Iraq. 10th century. Glazed earthenware with luster, $11'_{h''} \times 9'_{h''}$ (28.2 \times 23.2 cm). Freer Gallery of Art, Smithsonian Institution, Washington, DC.

THE LATER PERIOD: THIRTEENTH THROUGH FIFTEENTH CENTURIES

The Abbasid caliphate began a slow disintegration in the ninth century, and power in the Islamic world became distributed among more or less independent regional rulers. During the eleventh century, the Saljuqs, a Turkic people, swept from north of the Caspian Sea into Khurasan and took Baghdad in 1055, becoming the virtual rulers of the Abbasid lands. The Saljuqs united most of Iran and Iraq, establishing a dynasty that endured from 1037/38 to 1194. A branch of the dynasty, the Saljugs of Rum, ruled much of Anatolia (Turkey) from the late eleventh to the beginning of the fourteenth century. The central and eastern Islamic world suffered a dramatic rift in the early thirteenth century when the nomadic Mongols-non-Muslims led by Genghiz Khan (r. 1206-1227) and his successors-attacked northern China, Central Asia, and ultimately Iran. The Mongols captured Baghdad in 1258 and encountered weak resistance until they reached Egypt, where they were firmly defeated by the new ruler of the Mamluk dynasty (1250-1517). In Spain, the borders of Islamic territory were gradually pushed southward by Christian forces until the rule of the last Muslim dynasty there, the Nasrids (1230-1492), was ended. Morocco was ruled by the Berber Marinids (from the mid thirteenth century until 1465).

Although the religion of Islam remained a dominant and unifying force throughout these developments, the history of later Islamic society and culture reflects largely regional phenomena. Only a few works have been selected here and in Chapter 24 to characterize Islamic art, and they by no means provide a comprehensive history.

ARCHITECTURE

The new dynasties built on a grand scale, expanding their patronage from mosques and palaces to include new functional buildings, such as tombs, madrasas (colleges for religious and legal studies), public fountains, and urban hostels. To encourage long-distance trade, remote caravanserais (inns) were constructed for traveling merchants. A distinguishing characteristic of architecture in the later period is its complexity. Multiple building types were now combined in large and diverse complexes, supported by perpetual endowments (called *waqf*) that funded not only the building, but its administration and maintenance. Increasingly, these complexes included the patron's own tomb, thus giving visual prominence to the act of individual patronage and expressing personal identity through commemoration. A new plan emerged, organized around a central courtyard framed by four large iwans (large vaulted halls with rectangular plans and monumental arched openings); this four-iwan plan was used for schools, palaces, and especially mosques.

THE MAMLUKS IN EGYPT Beginning in the eleventh century, Muslim rulers and wealthy individuals endowed hundreds of charitable complexes that displayed pietý as well as personal

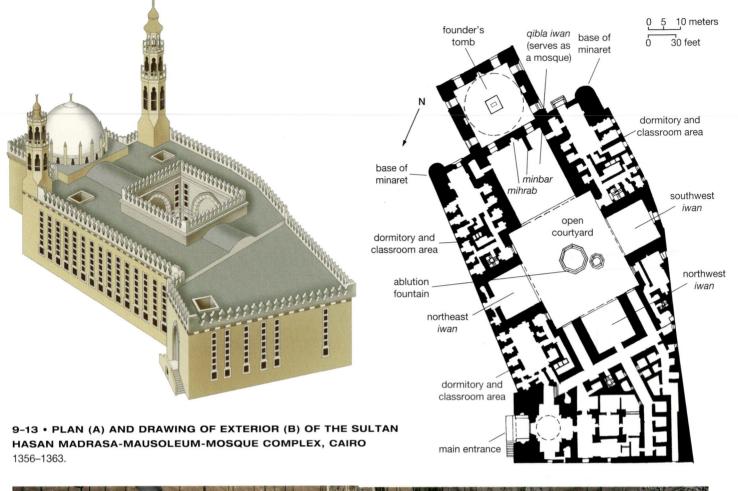

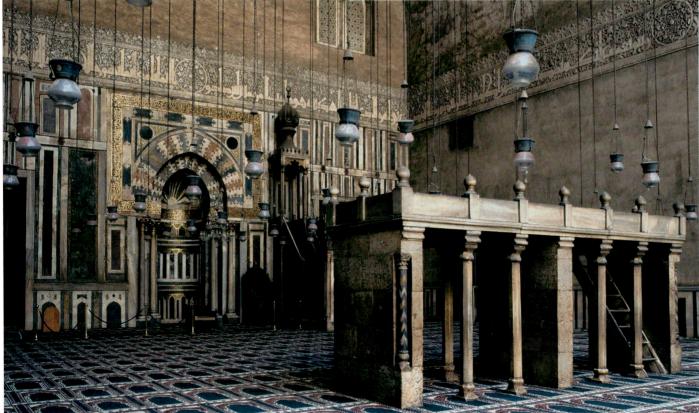

9-14 • QIBLA WALL WITH MIHRAB AND MINBAR Sultan Hasan Madrasa-Mausoleum-Mosque Complex, Cairo. 1356–1363.

A CLOSER LOOK | A Mamluk Glass Oil Lamp

by 'Ali ibn Muhammad al-Barmaki. Cairo, Egypt. c. 1329–1335. Blown glass, polychrome enamel, and gold. Diameter 9% (23.89 cm), height 14" (35.56 cm). Metropolitan Museum of Art, New York.

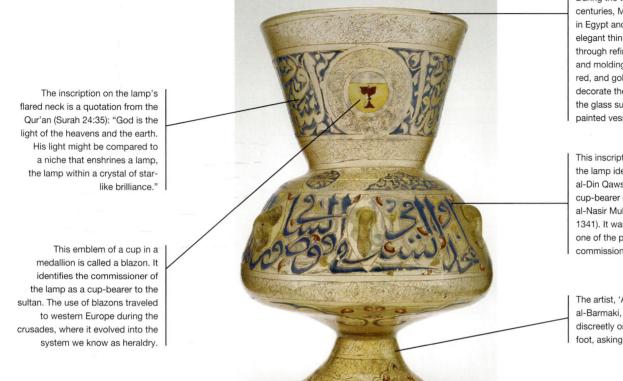

During the thirteenth and fourteenth centuries, Mamluk glassmakers in Egypt and Syria imparted an elegant thinness to their vessels through refined glass-blowing and molding techniques. The blue, red, and gold enamel used to decorate the lamp was affixed to the glass surface by reheating the painted vessel.

This inscription around the body of the lamp identifies the patron, Sayf al-Din Qawsun (d. 1342), emir and cup-bearer of the Mamluk Sultan al-Nasir Muhammad (r. 1293– 1341). It was probably intended for one of the patron's architectural commissions in Cairo.

The artist, 'Ali ibn Muhammad al-Barmaki, signed this work discreetly on the upper band of the foot, asking for God's protection.

Q—**View** the Closer Look for the Mamluk glass oil lamp on myartslab.com

wealth and status. The combined madrasa-mausoleum-mosque complex established in mid-fourteenth-century Cairo by the Mamluk Sultan Hasan (FIG. 9-13) is a splendid example. A deflected entrance-askew from the building's orientation-leads from the street, through a dark corridor, into a central, well-lit courtyard of majestic proportions. The complex has a classic four-iwan plan, each iwan serving as a classroom for students following a different branch of study, who are housed in a surrounding, multi-storied cluster of tiny rooms. The sumptuous qibla iwan served as the prayer hall for the complex (FIG. 9-14). Its walls are ornamented with typically Mamluk panels of sharply contrasting marbles (ablaq masonry, see "Ornament," page 268) that culminate in a doubly recessed mihrab framed by slightly pointed arches on columns. The marble blocks of the arches are ingeniously joined in interlocking pieces called joggled voussoirs. The paneling is surmounted by a wide band of Kufic script in stucco set against a background of scrolling vines, both the text and the abundant foliage referring to the paradise that is promised to the faithful. Next to the *mihrab*, an elaborate *minbar* stands behind a platform for reading the Qur'an. Just beyond the *qibla iwan* is the patron's monumental domed tomb, ostentatiously asserting his identity with the architectural complex. The Sultan Hasan complex is vast in scale and opulent in decoration, but money was not an object: The project was financed by the estates of victims of the bubonic plague that had raged in Cairo from 1348 to 1350.

Partly because the mosque in the Sultan Hasan complex and many smaller establishments—required hundreds of lamps, glassmaking was a booming industry in Egypt and Syria. Made of ordinary sand and ash, glass is the most ethereal of materials. The ancient Egyptians were producing glassware by the second millennium BCE (see "Glassmaking," page 76), and the tools and techniques for making it have changed little since then. Islamic artists also used glass for beakers and bottles, but lamps, lit from within by oil and wick, glowed with special brilliance (see "A Closer Look," above). THE NASRIDS IN SPAIN Muslim patrons also spent lavishly on luxurious palaces set in gardens. The Alhambra in Granada, in southeastern Spain, is an outstanding and sumptuous example. Built on the hilltop site of an early Islamic fortress, this palace complex was the seat of the Nasrids (1232-1492), the last Spanish Muslim dynasty, by which time Islamic territory had shrunk from covering most of the Iberian peninsula to the region around Granada. To the conquering Christians at the end of the fifteenth century, the Alhambra represented the epitome of luxury. Thereafter, they preserved the complex as much to commemorate the defeat of Islam as for its beauty. Essentially a small town extending for about half a mile along the crest of a high hill overlooking Granada, it included government buildings, royal residences, gates, mosques, baths, servants' quarters, barracks, stables, a mint, workshops, and gardens. Much of what one sees at the site today was built in the fourteenth century or by Christian patrons in later centuries.

The Alhambra offered dramatic views to the settled valley and snowcapped mountains around it, while enclosing gardens within its courtyards. One of these is the Court of the Lions, which stood at the heart of the so-called Palace of the Lions, the private retreat of Sultan Muhammad V (r. 1354–1359 and 1362–1391). The **COURT OF THE LIONS** is divided into quadrants by cross-axial walkways—a garden form called a *chahar bagh*. The walkways carry channels that meet at a central marble fountain held aloft on the backs of 12 stone lions (**FIG. 9–15**). Water animates the fountain, filling the courtyard with the sound of its life-giving abundance. In an adjacent courtyard, the Court of the Myrtles, a basin's round shape responds to the naturally concentric ripples of the water that spouts from a central jet (see "Ornament," page 268). Water has a practical role in the irrigation of gardens, but here it is raised to the level of an art form.

The Court of the Lions is encircled by an arcade of stucco arches embellished with **muqarnas** (nichelike components stacked in tiers, see "Ornament," page 268) and supported on single columns or clusters of two and three. Second-floor **miradors**—windows that frame intentional views—look over the courtyard, which was originally either gardened or more likely paved, with aromatic citrus confined to corner plantings. From these windows, protected by latticework screens, the women of the court, who did not appear in public, would watch the activities of the men below. At one end of the Palace of the Lions, a particularly magnificent *mirador* looks out onto a large, lower garden and the plain below. From here, the sultan literally oversaw the fertile valley that was his kingdom.

Pavilions used for dining and musical performances open off the Court of the Lions. One of these, the so-called Hall of the Abencerrajes, in addition to having excellent acoustics, is covered by a ceiling of dazzling geometrical complexity and exquisitely carved stucco (**FIG. 9-16**). The star-shaped vault is formed by a honeycomb of clustered *muqarnas* arches that alternate with corner squinches themselves filled with more *muqarnas*. The square room thus rises to an eight-pointed star, pierced by 16 windows, that culminates in a burst of *muqarnas* floating high overhead—a dematerialized architectural form, perceived and yet ultimately unknowable, like the heavens themselves.

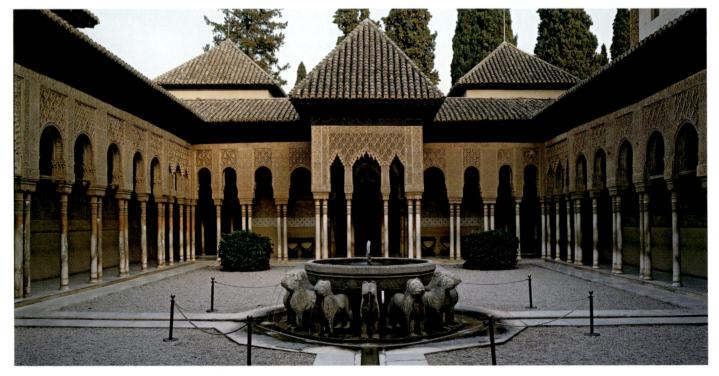

9-15 • COURT OF THE LIONS, ALHAMBRA Granada, Spain. 1354–1391.

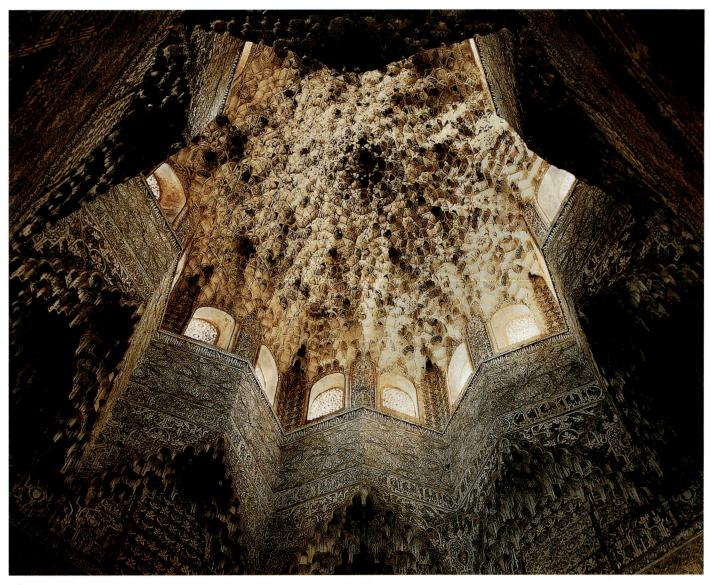

9-16 • MUQARNAS DOME, HALL OF THE ABENCERRAJES, PALACE OF THE LIONS, ALHAMBRA

Granada, Spain. 1354-1391.

The stucco *muqarnas* (stalactite) ornament does not support the dome but is actually suspended from it, composed of some 5,000 individual plaster pieces. Of mesmerizing complexity, the vault's effect can be perceived but its structure cannot be fully comprehended.

• Watch a video about the Alhambra on myartslab.com

THE TIMURIDS IN IRAN, UZBEKISTAN, AND AFGHANI-

STAN The Mongol invasions brought devastation and political instability but also renewal and artistic exchange that provided the foundation for successor dynasties with a decidedly eastern identity. One of the empires to emerge after the Mongols was the vast Timurid empire (1370–1506), which conquered Iran, Central Asia, and the northern part of South Asia. Its founder, Timur (known in the West as Tamerlane), was a Mongol descendant, a lineage strengthened through marriage to a descendant of Genghiz Khan. Timur made his capital at Samarkand (in present-day Uzbekistan), which he embellished by means of the forcible

relocation of expert artists from the areas he conquered. Because the empire's compass was vast, Timurid art could integrate Chinese, Persian, Turkic, and Mediterranean artistic ideas into a Mongol base. Its architecture is characterized by axial symmetry, tall double-shelled domes (an inner dome capped by an outer shell of much larger proportions), modular planning with rhythmically repeated elements, and brilliant cobalt blue, turquoise, and white glazed ceramics. Although the empire itself lasted only 100 years after the death of Timur, its legacy endured in the art of the later Safavid dynasty in Iran and the Mughals of South Asia.

9-17 • TILE MOSAIC MIHRAB

From the Madrasa Imami, Isfahan, Iran. Founded 1354. Glazed and cut tiles, $11'3'' \times 9'5^{11}/_{16''}$ (3.43 \times 2.89 m). Metropolitan Museum of Art, New York. Harris Brisbane Dick Fund. (39.20)

This *mihrab* has three inscriptions: the outer inscription, in cursive, contains Qur'anic verses (surah 9) that describe the duties of believers and the Five Pillars of Islam. Framing the niche's pointed arch, a Kufic inscription contains sayings of the Prophet. In the center, a panel with a line in Kufic and another in cursive states: "The mosque is the house of every pious person." Made during a period of uncertainty as Iran shifted from Mongol to Timurid rule, this *mihrab* (1354), originally from a *madrasa* in Isfahan, is one of the finest examples of architectural ceramic decoration from this era (**FIG. 9-17**). More than 11 feet tall, it was made by painstakingly cutting each individual piece of tile, including the pieces making up the letters on the curving surface of the keel-profiled niche. The color scheme—white against turquoise and cobalt blue with accents of dark yellow and green—was typical of this type of decoration, as were the harmonious, dense, contrasting patterns of organic and geometric forms. The cursive inscription of the outer frame is rendered in elegant white lettering on a blue ground, while the Kufic inscription bordering the pointed arch reverses these colors for a striking contrast.

Near Samarkand, the preexisting Shah-i Zinda ("Living King") **FUNER-ARY COMPLEX** was adopted for the tombs of Timurid family members, especially princesses, in the late fourteenth and fifteenth centuries (**FIG. 9-18**). The mausolea are arrayed along a central avenue that descends from the tomb

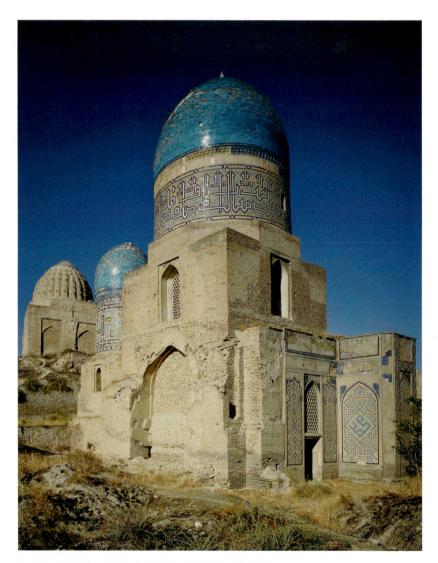

9-18 • SHAH-I ZINDA FUNERARY COMPLEX Samarkand, Uzbekistan. Late 14th–15th century.

Timurid princesses were buried here and built many of the tombs. The lively experimentation in varied artistic motifs indicates that women were well versed in the arts and empowered to exercise personal taste.

of Qutham b. Abbas (a cousin of the Prophet and a saint). The women sought burial in the vicinity of the holy man in order to gain *baraka* (blessing) from his presence. Like all Timurid architecture, the tombs reflect modular planning—noticeable in the repeated dome-on-square unit—and a preference for blue glazed tiles. The domes of the individual structures were double-shelled and, for exaggerated effect, stood on high drums inscribed with Qur'anic verses in interwoven Kufic calligraphy. The ornament adorning the exterior façades consists of an unusually exuberant array of patterns and techniques, from geometry to chinoiserie, and both painted and cut tiles (see "Ornament," page 268). The tombs reflect a range of individual taste and artistic experimentation that was possible precisely because they were private commissions that served the patrons themselves, rather than the city or state (as in a congregational mosque).

LUXURY ARTS

Islamic society was cosmopolitan, with pilgrimage, trade, and a well-defined road network fostering the circulation of marketable goods. In addition to the import and export of basic and practical commodities, luxury arts brought particular pleasure and status to wealthy owners and were visible signs of cultural refinement. On objects made of ceramics, ivory, glass (see "A Closer Look," page 279), metal, and textiles, calligraphy was prominently displayed. These precious art objects were eagerly exchanged and collected from one end of the Islamic world to the other, and despite their Arabic lettering—or perhaps precisely because of its exotic artistic cachet—they were sought by European patrons as well.

CERAMICS From the beginning, Islamic civilization in Iran was characterized by the production of exceptionally sophisticated and strikingly beautiful luxury ceramic ware. During the twelfth century, Persian potters developed a technique of multicolor ceramic overglaze painting known as *mina'i* ware, the Persian word for "enamel" (**FIG. 9-19**). The decoration of *mina'i* bowls, plates, and beakers often reference or portray stories and subjects popular with potential owners. The circular scene at the bottom of this bowl is drawn from the royal life of Bahram Gur (Sasanian king Bahram V, r. 420–438), legendary in the Islamic world for his prowess in love and hunting; this episode combines both. Bahram Gur rides proudly atop a large camel next to his favorite, the ill-fated lute player Azada, who has foolishly belittled his skills as

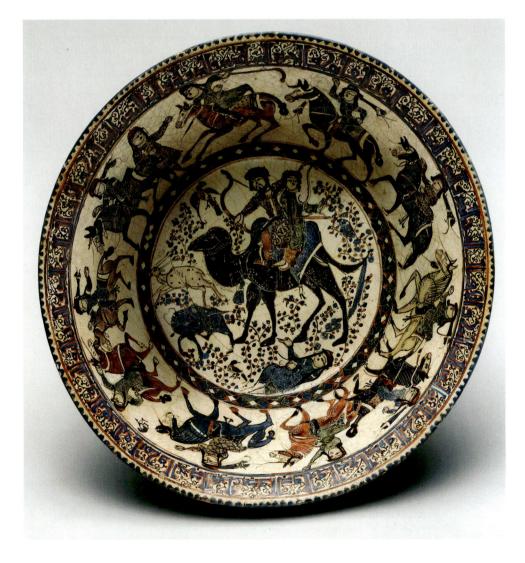

9–19 • MINA'I BOWL WITH BAHRAM GUR AND AZADA Iran. 12th–13th century. *Mina'i* ware (stoneware with polychrome in-glaze and overglaze), diameter 8¹/₂" (21.6 cm). Metropolitan Museum of Art, New York.

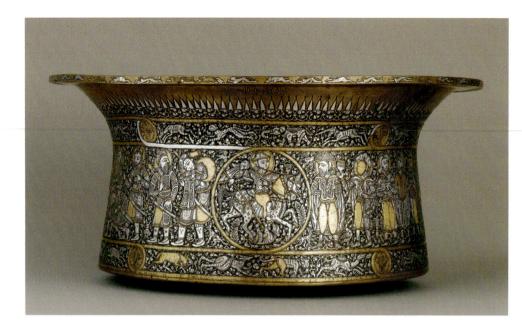

9-20 • Muhammad Ibn al-Zain BAPTISTERY OF ST. LOUIS

Syria or Egypt. c. 1300. Brass inlaid with silver and gold, $8^{3}_{4}'' \times 19^{3}_{4}''$ (22.2 × 50.2 cm). Musée du Louvre, Paris.

This beautifully crafted basin, with its princely themes of hunting and horsemanship, was made, judging by its emblems and coats of arms, for an unidentified, aristocratic Mamluk patron. However, it became known as the Baptistery of St. Louis, because it was acquired by the French sometime before the end of the fourteenth century (long after the era of St. Louis [king Louis IX, r. 1226–1270]) and used for royal baptisms.

a hunter. To prove his peerless marksmanship, the king pins with his arrow the hoof and ear of a gazelle who had lifted its hind leg to scratch an itch. In this continuous narrative (representing multiple scenes from the same story within a single composition), the subsequent action is also portrayed: Azada trampled to death under the camel after Bahram Gur had pushed her from her mount as punishment for mocking him.

METALWORK Islamic metalsmiths enlivened the surface of vessels with scrolls, interlacing designs, human and animal figures, and calligraphic inscriptions. A shortage of silver in the mid twelfth century prompted the development of inlaid brasswork that used the more precious metal sparingly, as in FIGURE 9-20. This basin, made in Mamluk Egypt in the late thirteenth or early fourteenth century by Muhammad Ibn al-Zain (who signed it in six places), is among the finest works of metal produced by a Muslim artist. The dynamic surface is crowded with overlapping figures in vigorous poses that nevertheless remain distinct by means of hatching, modeling, and framing. The exterior face is divided into three bands. The upper and lower depict running animals, and the center shows scenes of horsemen flanked by attendants, soldiers, and falcons-scenes of the princely arts of horsemanship and hunting. In later metalwork, such pictorial cycles were replaced by elegant large-scale inscriptions.

THE ARTS OF THE BOOK

The art of book production had flourished from the first century of Islam because an emphasis on the study of the Qur'an promoted a high level of literacy among both men and women. With the availability of paper, books on a wide range of religious as well as secular subjects became available, although since they were handcopied, books always remained fairly costly. (Muslims did not adopt the printing press until the eighteenth and nineteenth centuries.)

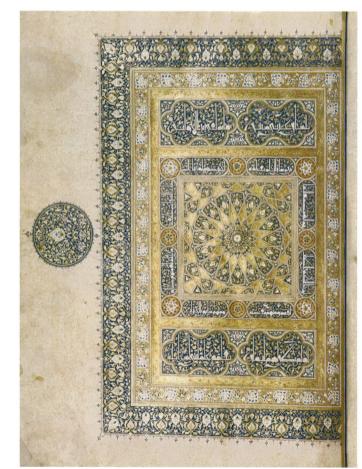

9-21 • QUR'AN FRONTISPIECE

Cairo. c. 1368. Ink, pigments, and gold on paper, $24''\times$ 18'' (61 \times 45.7 cm). National Library, Cairo. MS. 7

The Qur'an to which this page belonged was donated in 1369 by Sultan Shaban to the *madrasa* established by his mother. A close collaboration between illuminator and scribe can be seen here and throughout the manuscript. Libraries, often associated with *madrasas*, were endowed by members of the educated elite. Books made for royal patrons had luxurious bindings and highly embellished pages, the result of workshop collaboration between noted calligraphers and illustrators.

The manuscript illustrators of Mamluk Egypt (1250–1517) executed intricate nonfigural designs filled with sumptuous botanical ornamentation for Qur'ans. As in architectural decoration, the exuberant ornament adheres to a strict geometric organization. In an impressive frontispiece, the design radiates on each page from a 16-pointed starburst, filling the central square (**FIG. 9-21**). The surrounding frames contain interlacing foliage and stylized flowers that embellish the holy scripture. The page's resemblance to court carpets was not coincidental. Designers often worked in more than of the thirteenth-century Persian poet Sa'di's *Bustan* ("Orchard"), made for the royal library in 1488. Sa'di's narrative anthology in verse includes the story of Yusuf and Zulayhka—the biblical Joseph whose virtue was proven by resisting seduction by his master Potiphar's wife, named Zulayhka in the Islamic tradition (Genesis 39:6–12; Qur'an 12:23–25). Bihzad's vizualization of this event (**FIG. 9-22**) is one of the masterpieces of Persian narrative painting. The dazzling and elaborate architectural setting is inspired not by Sa'di's account, but visualizes Timurid poet Jami's more mystical version of the story (quoted in an architectural frame around the central *iwan* under the two figures), written only five years before Bihzad's painting. Jami sets his story in a seduction palace that Zulayhka had built specifically for this encounter, and into which

one medium, leaving the execution of their efforts to specialized artisans. In addition to religious works, scribes copied and recopied famous secular texts—scientific treatises, manuals of all kinds, stories, and especially poetry. Painters supplied illustrations for these books and also created individual smallscale paintings—miniatures—that were collected by the wealthy and placed in albums.

BIHZAD One of the great royal centers of Islamic miniature painting was at Herat in western Afghanistan, where a Persian school of painting and calligraphy was founded in the early fifteenth century under the highly cultured patronage of the Timurid dynasty (1370-1507). In the second half of the fifteenth century, the most famous painter of the Herat School was Kamal al-Din Bihzad (c. 1450-1536/37), who worked under the patronage of Sultan Husayn Bayqara (r. 1470-1506). When the Safavids supplanted the Timurids in 1506/07 and established their capital at Tabriz in northwestern Iran, Bihzad moved to Tabriz, where he headed the Safavid royal workshop.

Bihzad's key paintings, including his only signed works, appear in a manuscript

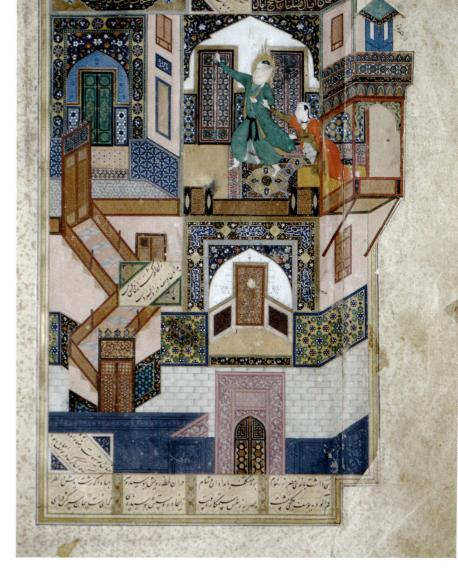

9-22 • Kamal al-Din Bihzad YUSUF FLEEING ZULAYHKA

From a copy of the *Bustan* of Sa'di. Herat, Afghanistan. 1488. Ink and pigments on paper, approx. $12'' \times 8\frac{1}{2}''$ (30.5 × 21.5 cm). Cairo, National Library. (MS Adab Farsi 908, f. 52v) she leads Joseph ever inward from room to room, with entrance doors locked as they pass from one room to the next. As the scarlet-garbed Zulayhka lunges to possess him, the fire-haloed Joseph flees her advances as the doors miraculously open in front of him.

The brilliant, jewel-like color of Bihzad's architectural forms, and the exquisite detail with which each is rendered are salient characteristics of his style, as is the dramatic lunge of Zulayhka and Yusuf's balletic escape. The asymmetrical composition depends on a delicately balanced placement of flat screens of colorful ornament and two emphatically three-dimensional architectural features—a projecting balcony to the right and a zigzagging staircase to the left. Bihzad signed this work in a calligraphic panel over a window at upper left.

ART AND ARCHITECTURE OF LATER EMPIRES

In the pre-modern era, three great powers emerged in the Islamic world. The introduction of gunpowder for use in cannons and guns caused a shift in military strategy; isolated lords in lone castles could not withstand gunpowder sieges. Power lay not in thick walls but in strong centralized governments that could invest in firepower and train armies in its use. To the west was the Ottoman Empire (1342-1918), which grew from a small principality in Asia Minor. In spite of setbacks inflicted by the Mongols, the Ottomans ultimately controlled Anatolia, western Iran, Iraq, Syria, Palestine, western Arabia (including Mecca and Medina), northern Africa (excepting Morocco), and part of eastern Europe. In 1453, their stunning capture of Constantinople (ultimately renamed Istanbul) brought the Byzantine Empire to an end. To the east of the Ottomans, Iran was ruled by the Safavid dynasty (1501-1732), distinguished for their Shi'ite branch of Islam. Their patronage of art and architecture brought a new refinement to artistic ideas and techniques drawn from the Timurid period. The other heirs to the Timurids were the Mughals of South Asia (1526-1858). The first Mughal emperor, Babur, invaded Hindustan (India and Pakistan) from Afghanistan, bringing with him a taste for Timurid gardens, architectural symmetry, and modular planning. The Mughals will be discussed in Chapter 24. Here we will focus on the Ottomans and the Safavids.

THE OTTOMAN EMPIRE

Imperial Ottoman mosques were strongly influenced by Byzantine church plans. Prayer-hall interiors are dominated by ever-larger domed spaces uninterrupted by structural supports. Worship is directed, as in other mosques, toward a *qibla* wall and *mihrab* opposite the entrance.

Upon conquering Constantinople, Ottoman rulers converted the great Byzantine church of Hagia Sophia into a mosque, framing it with two graceful Turkish-style minarets in the fifteenth century and two more in the sixteenth century (see FIG. 8–2). In conformance with Islamic practice, the church's figural mosaics were destroyed or whitewashed. Huge calligraphic disks with the names of God (Allah), Muhammad, and the early caliphs were added to the interior in the mid nineteenth century (see FIG. 8–4). At present, Hagia Sophia is neither a church nor a mosque but a state museum.

SINAN Ottoman architects had already developed the domed, centrally planned mosque, but the vast open interior and structural clarity of Hagia Sophia inspired them to strive for a more ambitious scale. For the architect Sinan (c. 1489-1588) the development of a monumental, centrally planned mosque was a personal quest. Sinan began his career in the army, serving as engineer in the Ottoman campaigns at Belgrade, Vienna, and Baghdad. He rose through the ranks to become, in 1528, chief architect for Suleyman "the Magnificent," the tenth Ottoman sultan (r. 1520-1566). Suleyman's reign marked the height of Ottoman power, and the sultan sponsored an ambitious building program on a scale not seen since the days of the Roman Empire. Serving Suleyman and his successor, Sinan is credited with more than 300 imperial commissions, including palaces, madrasas and Qur'an schools, tombs, public kitchens, hospitals, caravanserais, treasure houses, baths, bridges, viaducts, and 124 large and small mosques.

Sinan's crowning accomplishment, completed about 1579, when he was over 80, was a mosque he designed in the provincial capital of Edirne for Suleyman's son, Selim II (r. 1566-1574) (FIG. 9-23). The gigantic hemispheric dome that tops the Selimiye Mosque is more than 102 feet in diameter-larger than the dome of Hagia Sophia, as Sinan proudly pointed out. It crowns a building of extraordinary architectural coherence. The transition from square base to the central dome is accomplished by corner halfdomes that enhance the spatial plasticity and openness of the prayer hall's airy interior (FIG. 9-24). The eight massive piers that bear the dome's weight are visible both within and without-on the exterior they resolve in pointed towers that encircle the main domerevealing the structural logic of the building and clarifying its form. In the arches that support the dome and span from one pier to the next-indeed at every level-light pours through windows into the interior, a space at once soaring and serene.

The interior was clearly influenced by Hagia Sophia—an open expanse under a vast dome floating on a ring of light—but it rejects Hagia Sophia's longitudinal pull from entrance to sanctuary. The Selimiye Mosque is truly a centrally planned structure. In addition to the mosque, the complex housed a *madrasa* and other educational buildings, a cemetery, a hospital, and charity kitchens, as well as the income-producing covered market and baths. Framed by the vertical lines of four minarets and raised on a platform at the city's edge, the Selimiye Mosque dominates the skyline.

The Topkapi, the Ottomans' enormous palace in Istanbul, was a city unto itself. Built and inhabited from 1473 to 1853, it

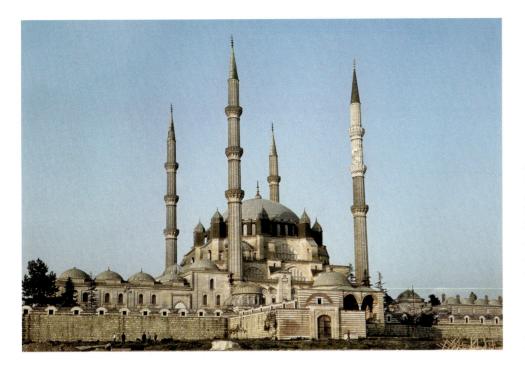

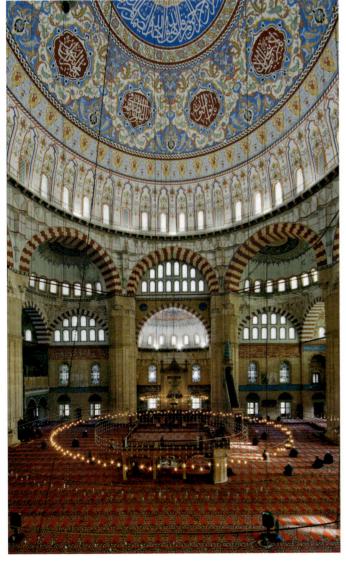

9-24 • INTERIOR, MOSQUE OF SULTAN SELIM

9-23 • PLAN (A) AND EXTERIOR VIEW (B) OF THE MOSQUE OF SULTAN SELIM, EDIRNE Western Turkey. 1568–1575.

The minarets that pierce the sky around the prayer hall of this mosque, their sleek, fluted walls and needle-nosed spires soaring to more than 295 feet, are only 12½ feet in diameter at the base, an impressive feat of engineering. Only royal Ottoman mosques were permitted multiple minarets, and having more than two was unusual.

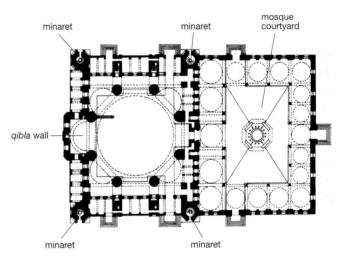

consisted of enclosures within walled enclosures, mirroring the immense political bureaucracy of the state. Inside, the sultan was removed from virtually all contact with the public. At the end of the inner palace, a free-standing pavilion, the Baghdad Kiosk (1638), provided him with a sumptuous retreat (FIG. 9-25). The kiosk consists of a low dome set above a cruciform hall with four alcoves. Each recess contains a low sofa (a Turkish word) laid with cushions and flanked by cabinets of wood inlaid with ivory and shell. Alternating with the cabinets are niches with ornate profiles: When stacked in profusion such niches-called chini khana-form decorative panels. On the walls, the blue and turquoise glazed tiles contain an inscription of the Throne Verse (Qur'an 2:255) which proclaims God's dominion "over the heavens and the earth," a reference to divine power that appears in many throne rooms and places associated with Muslim sovereigns. Sparkling light glows in the stained glass above.

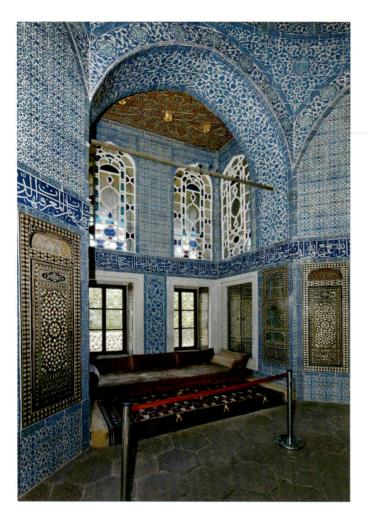

9-25 • BAGHDAD KIOSK ALCOVE Topkapi Palace, Istanbul. 1638.

TUGRAS Following a practice begun by the Saljuqs and Mamluks, the Ottomans put calligraphy to political use, developing the design of imperial ciphers—tugras—into a specialized art form. Ottoman *tugras* combined the ruler's name and title with the motto "Eternally Victorious" into a monogram denoting the authority of the sultan and of those select officials who were also granted an emblem. *Tugras* appeared on seals, coins, and buildings, as well as on official documents called *firmans*, imperial edicts supplementing Muslim law. Suleyman issued hundreds of edicts, and a high court official supervised specialist calligraphers and illuminators who produced the documents with fancy *tugras* (**FIG. 9-26**).

Tugras were drawn in black or blue with three long, vertical strokes to the right of two concentric horizontal teardrops. Decorative foliage patterns fill the area within the script. By the 1550s, this fill decoration became more naturalistic, and in later centuries it spilled outside the emblems' boundary lines. This rare, oversized *tugra* has a sweeping, fluid but controlled line, drawn to set proportions. The color scheme of delicate floral interlace enclosed in the body of the *tugra* may have been inspired by Chinese blue-and-white porcelain; similar designs appear on Ottoman ceramics and textiles.

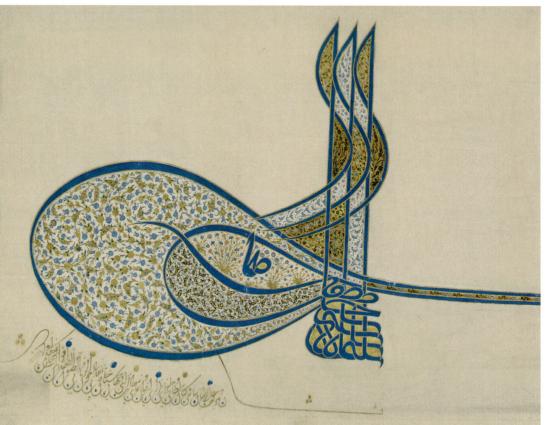

9-26 • ILLUMINATED TUGRA OF SULTAN SULEYMAN

From Istanbul, Turkey. c. 1555–1560. Ink, paint, and gold on paper, removed from a *firman* and trimmed to $20\frac{1}{2}$ " × $25\frac{3}{8}$ " (52 × 64.5 cm). Metropolitan Museum of Art, New York. Rogers Fund, 1938. (38.149.1)

The *tugra* shown here is from a document endowing an institution in Jerusalem that had been established by Suleyman's powerful wife, Hurrem.

THE SAFAVID DYNASTY

When Shah Isma'il (r. 1501–1524) solidified Safavid rule over the land of the Timurids in the early years of the sixteenth century, he called Bihzad, the most distinguished member of the Herat School, to the capital city of Tabriz to supervise the Safavid royal workshop that established a new golden age of book production by blending the Herat style with that of other regional Persian traditions. But it was Isma'il's son and successor Shah Tahmasp (r. 1524–1576) who emerged as the most important early patron.

SULTAN MUHAMMAD As a child, Tahmasp was trained in the art of calligraphy and drawing in Herat, where Shah Isma'il had dispatched him to serve as titular governor. Shortly after succeed-

first Shah, Gayumars, who ruled from a mountaintop over a people who were the first to make clothing from leopard skins and develop the skill of cooking. The elevated and central figure of the king is surrounded by the members of his family and court, each rendered with individual facial features and varying body proportions to add a sense of naturalism to the unleashed fantasy characterizing the surrounding world. The landscape sparkles with brilliant color, encompassing the detailed delineation of lavish plant life as well as melting renderings of pastel rock formations, into which are tucked the faces of the spirits and demons animating this primitive paradise. This is a painting meant to be savored slowly by an intimate, elite audience within the Safavid court. It is packed with surprises and unexpected delights.

ing his father, the youthful Tahmasp commissioned from the royal workshop in Tabriz a spectacular manuscript copy of the Shahnama ("Book of Kings"), Firdawsi's poetic history of Persian rulers written in the late tenth and early eleventh centuries. Tahmasp's monumental volume-with pages 181/2 inches tall, larger than any book produced during the Timurid period-consists of 742 folios whose margins are embellished with pure gold; 258 full-page pictures highlight the important kings and heroes of Persian royal history. The paintings were produced by a series of artists over an extended period during the 1520s and into the 1530s. This was the most important royal artistic project of the early Safavid period.

Among the most impressive paintings indeed, a work many consider the greatest of all Persian manuscript paintings—is a rendering of **THE "COURT OF GAYUMARS"** (**FIG. 9-27**) painted by Sultan Muhammad, the most renowned artist in the royal workshop. This assessment is not only modern. In 1544, Dust Muhammad—painter, chronicler, and **connoisseur**—cited this painting in particular when singling out Sultan Muhammad as the premier painter participating in the project, claiming that "although it has a thousand eyes, the celestial sphere has not seen his like" (Blair and Bloom, page 168). Sultan Muhammad portrayed the idyllic reign of the legendary

9-27 • Sultan Muhammad THE "COURT OF GAYUMARS"

From the Shahnama of Shah Tahmasp (fol. 20v). Tabriz, Iran. c. 1525–1535. Ink, pigments, and gold on paper, page size $18\frac{1}{2}'' \times 12\frac{1}{2}''$ (47 × 31.8 cm). Aga Khan Museum, Toronto. (AKM165)

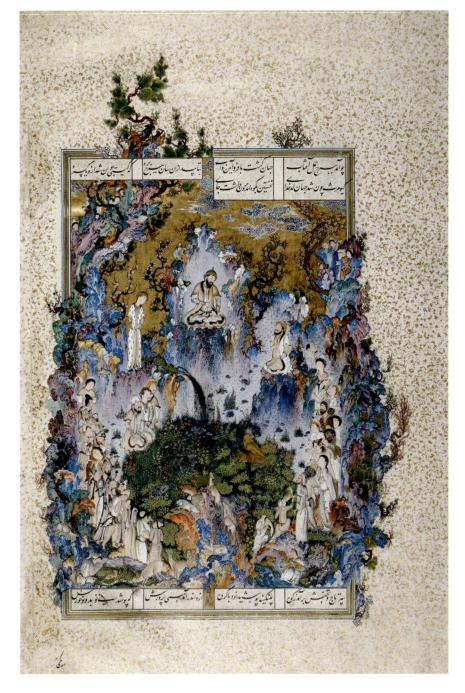

ARCHITECTURE Whereas the Ottomans took their inspiration from works of the Byzantine Empire, the Safavids looked to Timurid architecture with its tall, double-shell domes, sheathed in blue tiles. In the later Safavid capital of Isfahan, the typically Timurid taste for modular construction re-emerged on a grand scale that extended well beyond buildings to include avenues, bridges, public plazas, and gardens. To the preexisting city of Isfahan, Safavid Shah Abbas I (1588–1629) added an entirely new extension, planned around an immense central plaza (*maydan*) and a broad avenue, called the Chahar Bagh, that ran through a zone of imperial palace pavilions and gardens down to the river. The city's prosperity and beauty so amazed visitors who flocked from around the world to conduct trade and diplomacy that it led to the popular saying, "Isfahan is half the world."

With Isfahan's **MASJID-I SHAH** or Royal Mosque (1611– 1638), the four-*iwan* mosque plan reached its apogee (**FIG. 9-28**). Stately and huge, it anchors the south end of the city's *maydan*. Its 90-foot portal and the passageway through it aligns with the *maydan*, which is oriented astrologically, but the entrance corridor soon turns to conform to the prayer hall's orientation to

9-28 • PLAN (A) AND EXTERIOR VIEW (B) OF THE MASJID-I SHAH, ISFAHAN Iran. 1611–1638.

The tall bulbous dome behind the *qibla iwan* and the large *pishtaqs* with minarets are pronounced vertical elements that made royal patronage visible not only from the far end of the *maydan* but throughout the city and beyond.

Mecca. The portal's great *iwan* is framed by a *pishtaq* (a rectangular panel framing an *iwan*) that rises above the surrounding walls and is enhanced by the soaring verticality of its minarets. The *iwan*'s profile is reflected in the repeated, double-tiered *iwans* that parade across the façade of the mosque courtyard and around the *maydan* as a whole. Achieving unity through the regular replication of a single element—here the arch—is a hallmark of Safavid architecture, inherited from Timurid aesthetics, but achieved on an unprecedented scale and integrated within a well-planned urban setting.

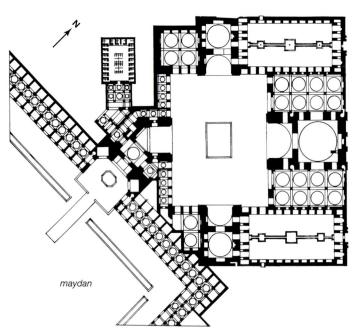

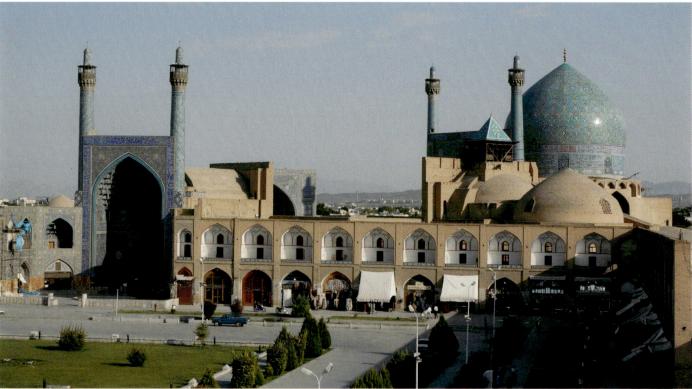

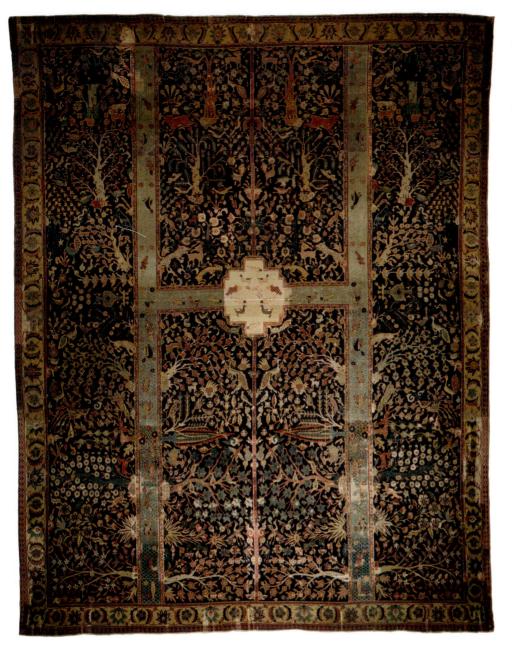

9-29 • GARDEN CARPET

The so-called Wagner Carpet. Iran. 17th century. Wool pile, cotton warp, cotton and wool weft, $17'5'' \times 13'11''$ (5.31 \times 4.25 m). Burrell Collection, Glasgow.

The carpet fascinates not only for the fact that so simple a technique as a knotted yarn can produce such complex, layered designs, but also for the combination of perspectives: From above, the carpet resembles a plan, but the trees are shown in profile, as if from ground level.

CARPETS The Safavid period was a golden age of carpet making (see "Carpet Making," page 292). Shah Abbas built workshops in Isfahan and Kashan that produced large, costly carpets that were often signed—indicating the weaver's growing prestige. Among the types produced were medallion carpets, centered around a sun or star, and garden carpets, representing Paradise as a shady garden with four rivers. The seventeenth-century **GARDEN CARPET** in **FIGURE 9-29** represents a dense field of trees (including cypresses) and flowers, populated with birds, animals, and even fish, and traversed by three large water channels that form an H with a central pool at the center. Laid out on the floor of an open-air hall, and perhaps set with bowls of ripe fruit and other delicacies, such carpets brought the beauty of nature indoors.

Rugs have long been used for Muslim prayer, which involves repeatedly kneeling and touching the forehead to the floor before God. While individuals often had their own small prayer rugs, with representations of mihrab niches to orient them in prayer, many mosques were furnished with wool-pile rugs received as pious donations. In Islamic houses, people sat and slept on cushions, carpets, and thick mats laid directly on the floor, so cushions took the place of the fixed furnishings of Western domestic environments. Historically, rugs from Iran, Turkey, and elsewhere were highly valued by Westerners, who often displayed them on tables rather than floors. They remain one of the predominant forms of Islamic art known in the West.

THE MODERN ERA

Islamic art is not restricted to the distant past. But with the dissolution of the great Islamic empires and the formation of smaller nation-states during the twentieth century, questions of identity and its expression in art changed significantly. Muslim artists and

TECHNIQUE | Carpet Making

Because textiles are made of organic materials that are destroyed through use, very few carpets from before the sixteenth century have survived. Carpets fall into two basic types: flat-weave carpets and pile, or knotted, carpets. Both can be made on either vertical or horizontal looms.

The best-known flat-weaves today are kilims, which are typically woven in wool with bold, geometric patterns and sometimes with brocaded details. Kilim weaving is done with a **tapestry** technique called slit tapestry (see A).

Knotted carpets are an ancient invention. The oldest known example, excavated in Siberia and dating to the fourth or fifth century BCE, has designs evocative of Achaemenid art, suggesting that the technique may have originated in Central Asia. In knotted carpets, the pile—the plush, thickly tufted surface—is made by tying colored strands of yarn, usually wool but occasionally silk for deluxe carpets, onto the vertical elements (the **warp**) of a yarn grid (see B and C). These knotted loops are later trimmed and sheared to form the plush pile surface of the carpet. The **weft** strands (crosswise threads) are shot horizontally, usually twice, after each row of knots is tied, to hold the knots in place and to form the horizontal element common to all woven structures. The weft is usually an undyed yarn and is hidden by the colored knots of the warp. Two common knot tying techniques are the asymmetrical knot, used in many carpets from Iran, Egypt, and Central Asia (formerly termed the Sehna knot), and the symmetrical knot (formerly called the Gördes knot) more commonly used in Anatolian Turkish carpet weaving. The greater the number of knots, the shorter the pile. The finest carpets can have as many as 2,400 knots per square inch, each one tied separately by hand.

Although royal workshops produced luxurious carpets (see FIG. 9–29), most knotted rugs have traditionally been made in tents and homes, woven, depending on local custom, either by women or by men.

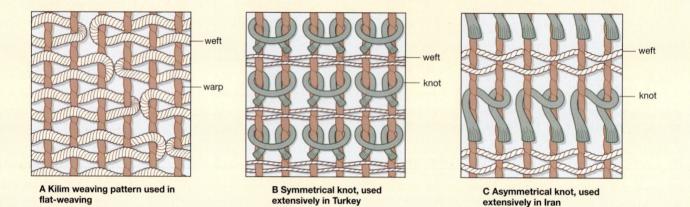

9-30 • Hasan Fathy MOSQUE AT NEW GOURNA

Luxor, Egypt. 1945– 1947. Gouache on paper, $221/2'' \times 177/8''$ (52.8 × 45.2 cm). Collection of the Aga Khan Award for Architecture, Geneva, Switzerland.

9-31 • Paolo Portoghesi, Vittorio Gigliotti, and Sami Mousawi **ISLAMIC MOSQUE AND CULTURAL CENTER, ROME** 1984–1992.

The prayer hall, $197' \times 131'$ (60 \times 40 m), which has an ablution area on the floor below, can accommodate a congregation of 2,500 on its main floor and balconies. The large central dome ($65\frac{1}{2}$ '; 20 m in diameter) is surrounded by 16 smaller domes, all similarly articulated with concrete ribs.

architects began to participate in international movements that swept away many of the visible signs that formerly expressed their cultural character and difference. When architects in Islamic countries were debating whether modernity promised opportunities for new expression or simply another form of Western domination, the Egyptian Hasan Fathy (1900–1989) questioned whether abstraction could serve the cause of social justice. He revived traditional, inexpensive, and locally obtainable materials such as mud brick and forms such as wind scoops (an inexpensive means of catching breezes to cool a building's interior) to build affordable housing for the poor. Fathy's New Gourna Village (designed 1945–1947) in Luxor, Egypt, became a model of environmental sustainability realized in pure geometric forms that resonated with references to Egypt's architectural past (**Fig. 9-30**). In their simplicity, his watercolor paintings are as beautiful as his buildings.

More recently, Islamic architects have sought to reconcile modernity with an Islamic cultural identity distinct from the West. In this spirit Iraqi architect Sami Mousawi and the Italian firm of Portoghesi-Gigliotti designed the **ISLAMIC CULTURAL CENTER** in Rome (completed 1992) with clean modern lines, exposing the structure while at the same time taking full advantage of opportunities for ornament (**FIG. 9–31**). The structural logic appears in the prayer hall's concrete columns that rise to meet abstract capitals in the form of plain rings, then spring upward to make a geometrically dazzling eight-pointed star supporting a dome of concentric circles. There are references here to the interlacing ribs of the *mihrab* dome in the Great Mosque of Cordoba, to the great domed spans of Sinan's prayer halls, and to the simple palm-tree trunks that supported the roof of the Mosque of the Prophet in Medina.

THINK ABOUT IT

- **9.1** Explain how the design of the mosque varies across the Islamic world with reference to three examples. Despite the differences, what features do mosques typically have in common?
- **9.2** Images of people are not allowed in Islamic religious contexts, but mosques and other religious buildings are lavishly decorated. What artistic motifs and techniques are used and why?
- **9.3** Compare the painted pages from sumptuous manuscripts in FIGURES 9–21 and 9–27. How does the comparison reveal the distinctive aspirations of religious and secular art in Islamic society? How are they different, and what features do they share?
- **9.4** Select an Islamic structure that is influenced by Roman or Byzantine architecture. Which forms are borrowed? Why and how, in their new Islamic context, are they transformed?

CROSSCURRENTS

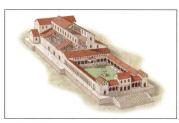

FIG. 7-13B

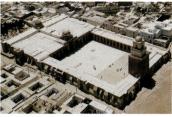

FIG. 9–5

Study and review on myartslab.com

These buildings were constructed for worship during the formative years of Christianity and Islam. Explain why they appear similar and discuss the ways in which their designs are consistent with the religious and cultural contexts.

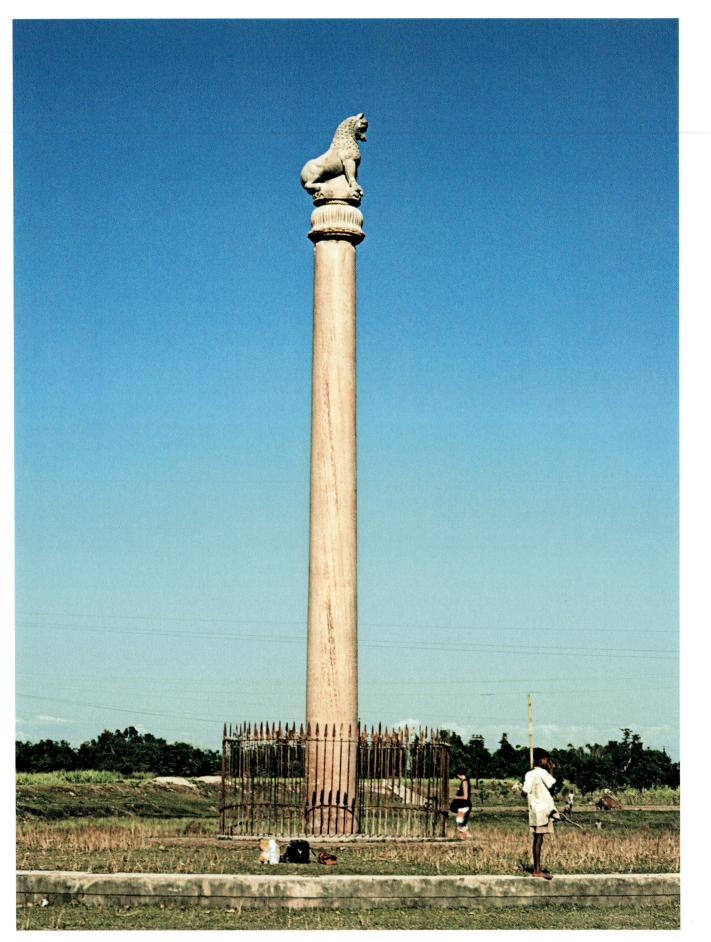

10-1 • ASHOKAN PILLAR Lauriya Nandangarh, Bihar, India. Maurya period, c. 246 BCE.

Art of South and Southeast Asia before 1200

In 1837, when examining inscriptions on a series of massive monolithic pillars (FIG. 10-1) in northern India, amateur scholar James Princep realized that the designation "Beloved of the Gods" was one of the great ruler Ashoka Maurya's personal epithets. This realization made clear that the pillars dated to the time of King Ashoka (273-232 BCE) and lifted some of the mystery surrounding this renowned figure. The heroic qualities of Ashoka are well recorded in the Indian cultural tradition. His accomplishments served as inspiration for later kings, like those of the Gupta dynasty, and Buddhist literary sources credit him with a wide range of miraculous deeds. But in spite of this fame, early historians had great difficulty distinguishing the historical man from the legend. Once properly identified, his name appeared in numerous Maurya-dynasty inscriptions and what they reveal about the humanity of this man is in many ways more captivating than the larger-than-life figure encountered in the legends.

Notably, in his Thirteenth Rock Edict, Ashoka presents himself as a man weary of battle and intensely remorseful for the death and suffering generated by his political ambitions. In it, he recalls a horrific battle in the region of Kalinga that took place eight years into his reign. By his estimation 100,000 died and many thousands more were dispossessed or left in despair from the conflict. In surveying this carnage, Ashoka admits to being deeply pained and resolves henceforth to seek conquest through moral teachings (*dharma*) rather than by the sword. His profound change of heart also proved to be a sound policy for establishing legal consistency over his vast empire, and this stability stimulated a rich period of artistic production.

As part of this conversion, Ashoka supported religious institutions and gave special attention to the nascent Buddhist community. He also widely distributed royal inscriptions by having them carved directly onto boulders and mountainsides. These rock edicts were far more plentiful than the inscribed columns, commonly called Ashokan pillars, which are few in number and appear to have been concentrated in the heart of the Maurya empire. The remains of about 19 such pillars exist, but not all bear inscriptions that can be attributed with certainty to Ashoka. Most were placed at the sites of Buddhist monasteries along a route leading from Punjab in the northwest to Ashoka's capital, Pataliputra, in the northeast.

Pillars and pillared halls had been used as emblems of kingship in the Persian Achaemenid empire (Chapter 2, pages 45–46) and it is possible that Ashoka was inspired by their precedent when he decided to display his words on columns detached from an architectural setting. Most of these edicts are inscribed in Prakrit, a language closely related to classical Sanskrit, but others were written in the languages spoken locally, like Greek and Aramaic. These observations are indicative of the size and reach of Ashoka's empire, which set the model for South Asian kingship over the centuries to come.

LEARN ABOUT IT

- 10.1 Recognize the stylistic differences in regional art and architecture from South and Southeast Asia.
- **10.2** Understand the significance of iconography and narrative in the religious art of South and Southeast Asia.
- **10.3** Explore the correlation between Hindu and Buddhist religious worldviews and architectural form.
- 10.4 Identify the ways in which patronage benefited royal donors such as Ashoka Maurya, Sembiyan Mahadevi, Kyanzittha, and Suryavarman II.

((• Listen to the chapter audio on myartslab.com

GEOGRAPHY

It is difficult to make inclusive claims about South and Southeast Asia because the two areas were and are home to a broad range of diverse ethnic communities, political units, language groups, and cultural traditions. One of the few things both regions share is a historical importance to trade networks and, consequently, an exposure to similar ideological and religious ideas, most notably Hinduism, Buddhism, and Islam. The same proximity to the sea that played a role in trade also ensured exposure to the monsoon rains which pull moisture from the oceans each summer and have traditionally enabled vigorous agricultural production. Due to their wealth and accessibility, both regions have historically been subject to periods of invasion, immigration, and colonization. This sporadic influx of new peoples has, at times, been a source of great hardship, but each wave added to the rich diversity of these regions and contributed new layers to their remarkable artistic heritage.

The South Asian subcontinent, or Indian subcontinent, as it is commonly called, is a peninsular region that includes the presentday countries of India, Afghanistan, Pakistan, Nepal, Bhutan, Bangladesh, and Sri Lanka (MAP 10-1). This land mass is slowly pressing into the rest of Asia and the collision has given rise to the Himalayas, the world's highest mountains, which form a protective barrier to the north. Southeast Asia, by contrast, is part of the Asian continental plate and can be divided into two geographic regions. The first part is its peninsular or mainland portion which emerges from the southern edge of Asia and includes Myanmar, Cambodia, Laos, Malaysia, Singapore, Thailand, and Vietnam. The second region is comprised of a vast archipelago of islands that spreads out into the Pacific and Indian oceans. This maritime region includes the states of Brunei, East Timor, Indonesia, and the Philippines.

ART OF SOUTH ASIA

The earliest civilization of South Asia was nurtured in the lower reaches of the Indus River, in present-day Pakistan and northwestern India. Known as the Indus or Harappan civilization (after Harappa, the first-discovered site), it flourished from approximately 2600 to 1900 BCE, or during roughly the same time as the Old Kingdom period of Egypt, the Minoan civilization of the Aegean, and the dynasties of Ur and Babylon in Mesopotamia. Indeed, it is considered, to be one of the world's earliest urban river-valley civilizations.

A chance late nineteenth-century discovery of some small **SEALS** (such as those whose impressions are shown in **FIGURE 10-2**), provided the first clue that an ancient civilization had existed in the Indus River Valley. This discovery prompted further excavations, beginning in the 1920s and continuing to the present, that subsequently uncovered a number of major urban areas at points along the lower Indus River, including Harappa, Mohenjo-Daro, and Chanhu-Daro.

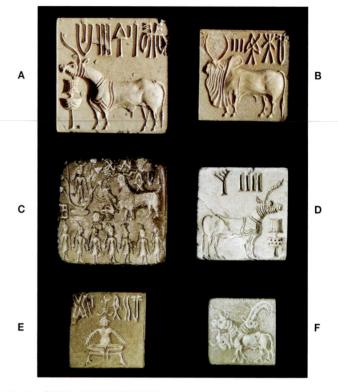

10-2 • SEAL IMPRESSIONS

A, D horned animal; B buffalo; C sacrificial rite to a goddess (?); E yogi; F three-headed animal. Indus Valley civilization, c. 2500–1500 BCE. Seals steatite, each approx. $1\frac{1}{4}$ " × $1\frac{1}{4}$ " (3.2 × 3.2 cm).

The more than 2,000 small seals and impressions that have been found offer an intriguing window on the Indus Valley civilization. Usually carved from steatite stone, the seals were coated with alkali and then fired to produce a lustrous, white surface. A perforated knob on the back of each may have been for suspending them. The most popular subjects are animals, most commonly a one-horned bovine standing before an altarlike object (A, D). The function of the seals may relate to trade but this remains uncertain since the script that is so prominent in the impressions has yet to be deciphered.

THE INDUS CIVILIZATION

MOHENJO-DARO The ancient cities of the Indus Valley resemble each other in design and construction, suggesting a coherent culture. At Mohenjo-Daro, the best preserved of the sites, archaeologists discovered an elevated citadel area about 50 feet high, surrounded by a wall. Among the citadel's buildings is a remarkable WATER TANK, a large watertight pool that may have been a public bath but could also have had a ritual use (FIG. 10-3). Stretching out below the elevated area was the city, arranged in a gridlike plan with wide avenues and narrow side streets. Its houses, often two stories high, were generally built around a central courtyard. Like other Indus Valley cities, Mohenjo-Daro was constructed of fired brick, in contrast to the less durable sun-dried brick used in other cultures of the time. The city included a network of covered drainage systems that channeled away waste and rainwater. Clearly the technical and engineering skills of this civilization were highly advanced. At its peak, about 2500 to 2000 BCE, Mohenjo-Daro

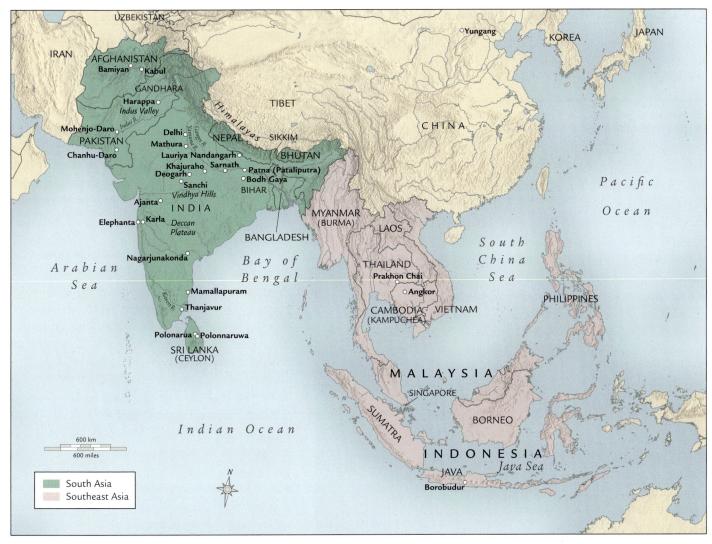

MAP 10-1 • SOUTH AND SOUTHEAST ASIA

As the deserts in western China heat during the summer months, the hot air rises and pulls cool air north off the oceans. As this water-laden air hits the Himalayas and the Tibetan plateau, it drops the torrential monsoon rains over much of South and Southeast Asia.

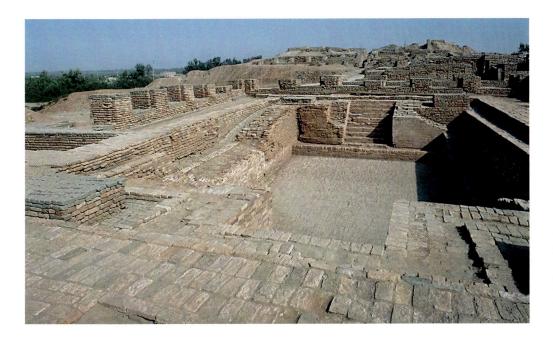

10-3 • LARGE WATER TANK, MOHENJO-DARO

Indus Valley (Harappan) civilization, c. 2600–1900 BCE.

Possibly a public or ritual bathing area.

was approximately 6–7 square miles in size and had a population of about 20,000–50,000. This uniformity suggests some form of central political control, but in the absence of any clear political or religious structures we can say very little about how these cities were governed.

INDUS VALLEY SEALS Although our knowledge of the Indus civilization is limited by the fact that we cannot read its writing, motifs on seals as well as the few discovered artworks strongly suggest continuities with later South Asian cultures. The seal in FIGURE 10-2E, for example, depicts a man in a meditative posture that resembles later forms of yoga, traditional physical and

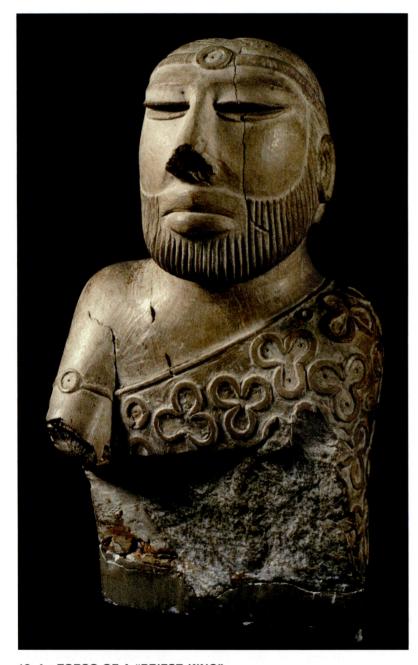

10-4 • TORSO OF A "PRIEST-KING" From Mohenjo-Daro. Indus Valley civilization, c. 2600–1900 BCE. Steatite, height 67/8" (17.5 cm). National Museum of Pakistan, Karachi.

mental exercises usually undertaken for spiritual purposes. In FIGURE 10-2C, people with elaborate headgear stand in a row or procession observing a figure standing in a tree—possibly a god-dess—and a kneeling worshiper. This scene may offer some insight into the religious or ritual customs of Indus people, whose deities may have been ancient prototypes of later Indian gods and goddesses.

Numerous terra-cotta figurines and a few stone and bronze statuettes have been found at Indus sites. They reveal a confident maturity of artistic conception and technique. Both the terra-cotta and the stone figures foreshadow the later Indian artistic tradition in their sensuous naturalism.

> "PRIEST-KING" FROM MOHENJO-DARO The male torso sometimes called the "priest-king" (FIG. **10-4**) suggests by this name a structure of society where priests functioned as kings-for which we have no evidence at all. Several features of this figure, including a low forehead, a broad nose, thick lips, and long slit eyes, are seen on other works from Mohenjo-Daro. The man's garment is patterned with a **trefoil** (three-lobed) motif. The depressions of the trefoil pattern were originally filled with red pigment, and the eyes were inlaid with colored shell or stone. Narrow bands with circular ornaments adorn the upper arm and the head. The headband falls in back into two long strands, and they may be an indication of rank. Certainly, with its formal pose and simplified, geometric form, the statue conveys a commanding human presence.

> **NUDE TORSO FROM HARAPPA** Although its date is disputed by some, a nude **MALE TORSO (FIG. 10–5**) found at Harappa is an example of a contrasting naturalistic style of ancient Indus origin. Less than 4 inches tall, it is one of the most extraordinary portrayals of the human form to survive from any early civilization. Its lifelike rendering emphasizes the soft texture of the human body and the subtle nuances of muscular form. With these characteristics the Harappa torso forecasts the essential aesthetic attributes of later Indian sculpture.

The reasons for the demise of this flourishing civilization are not yet understood. Recent research has suggested that between 2000 and 1750 there was a gradual breakdown of the architectural regularity characteristic of earlier periods. Many now think this was due to climate change and a dramatic shift in the course of local rivers. These changes made it impossible to practice the agriculture and river trade on which these cities depended. The cities of the Indus civilization declined, and predominantly rural and nomadic societies emerged.

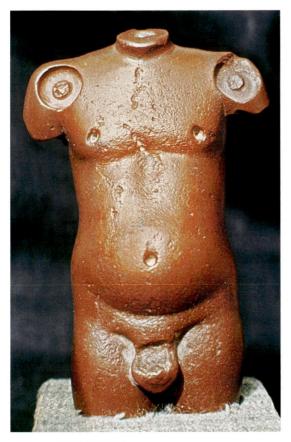

10-5 • MALE TORSO From Harappa. Indus Valley civilization, c. 2600–1900 BCE. Red sandstone, height 3³/₄" (9.5 cm). National Museum, New Delhi.

THE VEDIC PERIOD

About 2000 BCE nomadic herdsmen, the Aryans, entered India from Central Asia and the Russian steppes. Gradually they blended with the indigenous populations and introduced the horse and chariot, the Sanskrit language, a hierarchical social order, and religious practices that centered on the propitiation of gods through fire sacrifice. The earliest of their sacred writings, known as the Vedas, contain hymns to various gods including the divine king Indra. The importance of the fire sacrifice, overseen by a powerful priesthood—the Brahmins—and religiously sanctioned social classes, persisted through the Vedic period. At some point, the class structure became hereditary and immutable, with lasting consequences for Indian society.

During the latter part of this period, from about 800 BCE, the Upanishads were composed. These texts, written primarily by Brahmins, attempted to reform the Vedic ritual by emphasizing the unity between the individual and the divine. Some authors asserted that the material world is illusory and that only the universal divine (Brahman) is real and eternal. Others held that our existence is cyclical and that beings are caught in *samsara*, a relent-less cycle of birth, life, death, and rebirth. Believers aspire to attain liberation from *samsara* and to unite the individual soul with the eternal, universal Brahman.

The latter portion of the Vedic period also saw the flowering of India's epic literature, written in the melodious and complex Sanskrit language. By around 400 BCE, the *Mahabharata*, the longest epic in world literature, and the *Ramayana*, the most popular and enduring religious epic in India and Southeast Asia, were taking shape. These texts relate histories of gods and humans, bringing profound philosophical ideas to a more accessible and popular level. In this way, the Vedic tradition continued to evolve, emerging later as Hinduism, a loose term that encompasses the many religious forms that resulted from the mingling of Vedic culture with indigenous beliefs (see "Hinduism," page 309).

In this stimulating religious, philosophical, and literary climate, numerous religious communities arose, some of which did not accept the primacy of the Brahmins. Among these heterodox groups the Jains and the Buddhists were the most successful. The last of the 24 Jain spiritual pathfinders (tirthankara), Mahavira, is believed to have taught in the sixth century BCE. His were the earliest teachings ever to recognize non-violence as a central moral principle. The Buddha Shakyamuni is thought to have lived shortly thereafter in the fifth century BCE (see "Buddhism," page 301). Both traditions espoused some basic Upanishadic tenets, such as the cyclical nature of existence and the need for liberation from the material world. However, they rejected the authority of the Vedas, and with it the legitimacy of the fire sacrifice and the hereditary class structure of Vedic society, with its powerful, exclusive priesthood. In further contrast with the Brahmins, who often held important positions in society, both Jainism and Buddhism were renunciate (shramana) traditions, centered on communities of monks and nuns who chose to separate themselves from worldly concerns. Over time, however, even these communities began to play important social roles. Nevertheless, asceticism held, and continues to hold, an important place within most South Asian religious traditions.

THE MAURYA PERIOD

In about 700 BCE, hundreds of years after their decline along the Indus, cities began to reappear on the subcontinent, particularly in the north, where numerous kingdoms arose. For most of its subsequent history, India was a shifting mosaic of regional kingdoms. From time to time, however, a particularly powerful dynasty formed an empire. The first of these was the Maurya dynasty (c. 322–185 BCE), which extended its rule over all but the southernmost portion of the subcontinent.

During the reign of the third Maurya king, Ashoka (r. c. 273–232 BCE), Buddhism expanded from a religion largely localized in the Maurya heartland, a region known as Magadha, to one extending across the entire empire. Among the monuments he erected were monolithic pillars set up primarily at the sites of Buddhist monasteries. The fully developed Ashokan pillar—a slightly tapered sandstone shaft that usually rested on a stone foundation slab sunk more than 10 feet into the ground—rose to a height of around 50 feet (see FIG. 10-1). On it were often carved inscriptions relating to rules of *dharma*, the divinely ordained moral law believed to keep the universe from falling into chaos. Ideal kings were enjoined to uphold this law, and many later Buddhists interpreted the rules as also referring to Buddhist teachings. At the top were placed elaborate animal-shaped capitals carved from separate blocks of sandstone. Both shaft and capital were given the high polish characteristic of Maurya stonework. Scholars believe that the pillars, which served as royal standards, symbolized the **axis mundi** ("axis of the world"), joining earth with the cosmos and representing the vital link between the human and celestial realms.

LION CAPITAL FROM SARNATH This capital (FIG. 10-6) originally crowned the pillar erected at Sarnath, the site of the Buddha's first sermon. It represents four addorsed, or back-to-back, Asiatic lions with open mouths standing atop a circular platform depicting a bull, horse, lion, and elephant separated by large chariot wheels. The base is an inverted lotus blossom whose

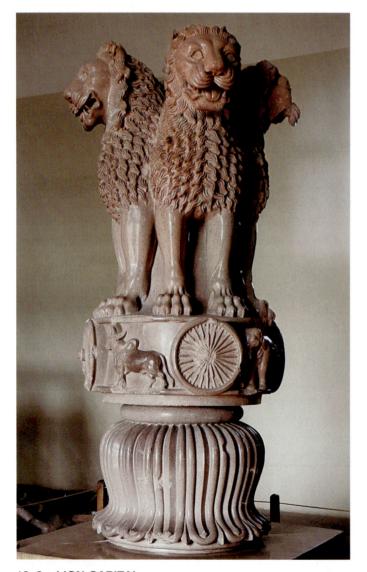

10-6 • LION CAPITAL From Ashokan pillar at Sarnath, Uttar Pradesh, India. Maurya period, c. 250 BCE. Polished sandstone, height 7' (2.13 m). Archaeological Museum, Sarnath.

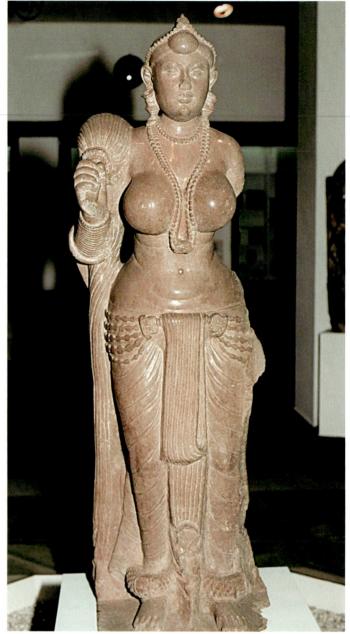

10-7 • FEMALE FIGURE HOLDING A FLY-WHISK From Didarganj, Patna, Bihar, India. Probably Maurya period, c. 250 BCE. Polished sandstone, height 5'4¹/4" (1.63 m). Patna Museum, Patna.

Commonly identified as a *yakshi*, this sculpture has become one of the most famous works of Indian art. Holding a fly-whisk in her raised right hand, the figure wears only a long shawl and a skirtlike cloth. The nubbled tubes about her ankles probably represent anklets made of beaten gold. Her hair is bound behind in a large bun, and a small bun sits on her forehead. This hairstyle appears again in Indian sculpture of the later Kushan period (c. second century CE).

bell-shape formed a transition to the column. The deeply cut carving promotes an active play of light and shadow and results in details that are readily visible even when this image was placed high atop its perch.

Some poetic references allude to the Buddha's sermon as the "Lion's Roar," whereas, others refer to it as the turning of the

ART AND ITS CONTEXTS | Buddhism

The Buddhist religion developed from the teachings of Shakyamuni Buddha, who lived during the fifth century BCE in the present-day regions of southern Nepal and northern India. At his birth, it is believed, seers foretold that the infant prince, named Siddhartha Gautama, would become either a *chakravartin* (world-conquering ruler) or a *buddha* (fully enlightened being). Hoping for a ruler like himself, Siddhartha's father tried to surround his son with pleasure and shield him from pain. Yet the prince was eventually exposed to the sufferings of old age, sickness, and death—the inevitable fate of all mortal beings. Deeply troubled by the human condition, Siddhartha at age 29 left the palace, his family, and his inheritance to live as an ascetic in the wilderness. After six years of meditation, he attained complete enlightenment at a site in India now called Bodh Gaya.

Following his enlightenment, the Buddha ("Awakened One") gave his first teaching in the Deer Park at Sarnath. Here he expounded the Four Noble Truths that are the foundation of Buddhism: (1) life is suffering; (2) this suffering has a cause, which is ignorance and desire; (3) this ignorance and desire can be overcome and extinguished; (4) the way to overcome them is by following the eightfold path of right view, right resolve, right speech, right action, right livelihood, right effort, right mindfulness, and right concentration. After the Buddha's death at age 80, his many disciples developed his teachings and established the world's oldest monastic institutions. A buddha is not a god but rather one who sees the ultimate nature of the world and is therefore no longer subject to *samsara*, the cycle of birth, death, and rebirth that otherwise holds us in its grip, whether we are born into the world of the gods, humans, animals, demons, tortured spirits, or hellish beings.

The early form of Buddhism, known as Theravada or Nikaya, stresses self-cultivation for the purpose of attaining nirvana, which is the extinction of samsara for oneself. Theravada Buddhism has continued mainly in Sri Lanka and Southeast Asia. Almost equally old is another form of Buddhism, known as Mahayana, which became popular mainly in northern India; it eventually flourished in China, Korea, Japan, and in Tibet (as Vajrayana). Compassion for all beings is the foundation of Mahayana Buddhism, whose goal is not only nirvana for oneself but buddhahood (enlightenment) for every being throughout the universe. Many schools of Buddhism recognize buddhas other than Shakyamuni from the past, present, and future. One such is Maitreya, the next buddha destined to appear on earth. Several Buddhist schools also accept the existence of bodhisattvas ("those whose essence is wisdom"), saintly beings who are on the brink of achieving buddhahood but have vowed to help others achieve buddhahood before crossing over themselves. In art, bodhisattvas and buddhas are most clearly distinguished by their clothing and adornments: bodhisattvas wear the princely garb of India, while buddhas wear monks' robes.

Read the document related to the Buddha on myartslab.com

"Wheel of the Law" (*dharmachakra*). This designation likens the Buddha's teachings to a chariot wheel and the sermon to the first push that set the wheel rolling across the world. The four lions and spoked wheels on the capital face the cardinal directions, thus referencing these descriptive titles.

However, the imagery works on two levels and also holds important political associations. The lion may have served as a metaphor for the Buddha's preaching but prior to that is was a symbol of kingship, and the elephant, horse, and bull were similarly potent as emblems of worldly and military power. When considered in conjunction with the wheel motifs, this imagery almost certainly also references the king as a *chakravartin*. This term refers to a universal king of such power that the wheels of his chariot pass everywhere unimpeded. The designation held great significance in South Asia, and Ashoka is here associating the worldly might of his empire with the moral authority of Buddhism. This relationship would have been further reinforced by the large wheel, now lost, that is believed to have rested atop the lions.

FEMALE FIGURE FROM DIDARGANJ Alongside the formal religious institutions of the Brahmins, Buddhists, and Jains, there existed a host of popular religious practices centered on local gods of villages and fields who were believed to oversee worldly matters such as health, wealth, and fertility. A spectacular **FEMALE**

FIGURE HOLDING A FLY-WHISK, or *chauri* (FIG. 10-7), found at Didarganj, near the Maurya capital of Pataliputra may represent one such deity. The statue, dated by most scholars to the Maurya period, probably represents a **yakshi**, a spirit associated with the productive and reproductive forces of nature. With its large breasts and pelvis, the figure embodies the association of female beauty with procreative abundance, bounty, and auspiciousness.

Sculpted from fine-grained sandstone, the statue conveys the *yakshi*'s authority through the frontal rigor of her pose, the massive volumes of her form, and the strong, linear patterning of her ornaments and dress. Alleviating and counterbalancing this hierarchical formality are her soft, youthful face, the precise definition of prominent features such as the stomach muscles, and the polished sheen of her exposed flesh. As noted above, this lustrous polish is a special feature of Maurya sculpture.

THE PERIOD OF THE SHUNGA AND EARLY SATAVAHANA

With the demise of the Maurya empire, India returned to rule by regional dynasties. Between the second century BCE and the early centuries CE, two of the most important of these dynasties were the Shunga dynasty (185–72 BCE) in central India and the Satavahana dynasty (third century BCE–third century CE), who initially ruled in central India and after the first century in the south. During this

ELEMENTS OF ARCHITECTURE | Stupas and Temples

Buddhist architecture in South Asia consists mainly of stupas and temples, often at monastic complexes containing *viharas* (monks' cells and common areas). These monuments may be either structural—built up from the ground—or rock-cut—hewn out of a mountainside. Stupas derive from burial mounds and contain relics beneath a solid, domeshaped core. A major stupa is surrounded by a railing that creates a sacred path for ritual circumambulation at ground level. This railing is punctuated by gateways, called **toranas** in Sanskrit, aligned with the cardinal points. The stupa sits on a round or square terrace; and stairs may lead to an upper circumambulatory path around the platform's edge. On top of the stupa a railing defines a square, from the center of which rises a mast supporting tiers of disk-shaped "umbrellas."

Hindu architecture in South Asia consists mainly of temples, either structural or rock-cut, executed in a number of styles and dedicated to diverse deities. The two general Hindu temple types are the northern and southern styles, prevalent in northern India and southern India respectively. Within these broad categories is great stylistic diversity, though all are raised on plinths and dominated by their superstructures. In north India, the term **shikhara** is used to refer to the entire towerlike superstructure which often curves inward, sloping more steeply near its peak. In the south, by contrast, the southern superstructure is comprised of angular, steplike terraces and the term *shikhara* refers only to the finial, that is, the uppermost member of the superstructure. North Indian *shikhara* are crowned by **amalakas**. Inside, a series of **mandapas** (halls) leads to an inner sanctuary, the **garbhagriha**, which contains a sacred image. An axis mundi is imagined to run vertically up from the Cosmic Waters below the earth, through the *garbhagriha*'s image, and out through the top of the tower.

Jain architecture consists mainly of structural and rock-cut monasteries and temples that have much in common with their Buddhist and Hindu counterparts.

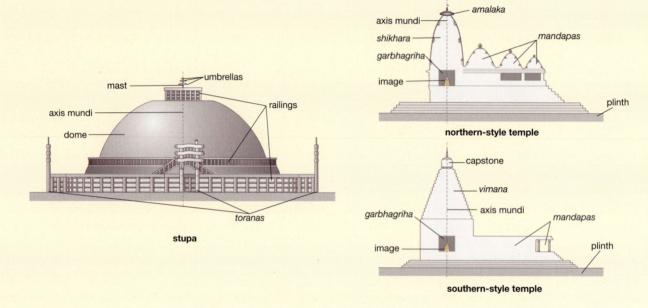

• Watch an architectural simulation about stupas and temples on myartslab.com

period, some of the most magnificent early Buddhist structures were created.

Religious monuments called **stupas**, solid mounds enclosing a relic, are fundamental to Buddhism (see "Stupas and Temples," above). In practice, the exact nature of the relic varies, but in ideal cases they are connected directly with the Buddha himself or to one of his important disciples. The form, size, and decoration of stupas differ from region to region, but their symbolic meaning remains virtually the same, and their plan is a carefully calculated **mandala**, or diagram of the cosmos as envisioned in Buddhism. Stupas are open to all for private worship.

The first stupas were constructed to house the Buddha's remains after his cremation. According to tradition, these relics

were divided into eight portions and given to important kings, who then further divided and encased the remains in burial mounds. Since the early stupas held actual remains of the Buddha, they were venerated as his body and, by extension, his enlightenment and attainment of *nirvana* (liberation from rebirth). The method of veneration was, and still is, to circumambulate, or walk around, the stupa in a clockwise direction.

THE GREAT STUPA AT SANCHI Probably no early Buddhist structure is more famous than the **GREAT STUPA** at Sanchi in central India (**FIG. 10-8**). Most likely dating to the time of Ashoka, the Great Stupa originally formed part of a large monastery complex crowning a hill. During the mid second century BCE, it was

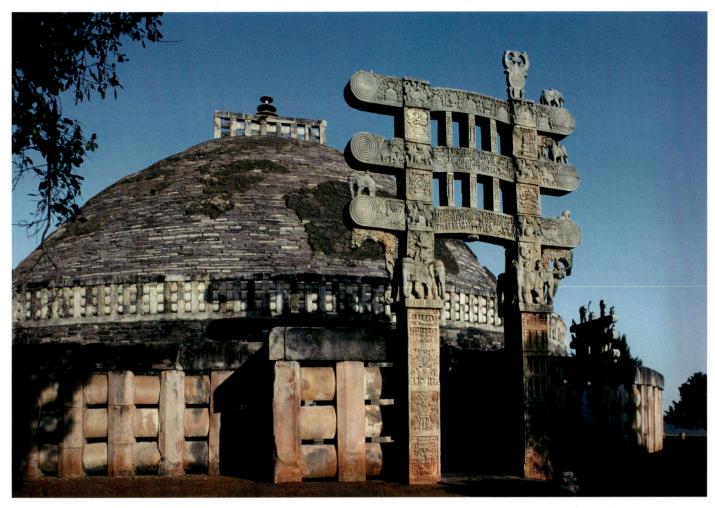

10-8 • STUPA 1 (THE GREAT STUPA) AT SANCHI Madhya Pradesh, India. Founded 3rd century BCE; enlarged c. 150–50 BCE.

View the Closer Look for Stupa 1 (The Great Stupa) at Sanchi on myartslab.com

enlarged to its present size, and the surrounding stone railing was constructed. About 100 years later, elaborately carved stone gate-ways were added to the railing.

Representative of the early central Indian stupa type, the solid, hemispherical mound of the Great Stupa at Sanchi was built up from rubble and dirt, faced with dressed stone, then covered with a shining white plaster made from lime and powdered seashells. A 10-foot-tall stone railing demarcates a circumambulatory path at ground level. Another walkway, approached by a staircase on the south side, creates a second raised level for circumambulation. On top of the mound a square enclosure, designated by another railing, contains the top of a mast bearing three stone disks, or "umbrellas," of decreasing size. Interpreted in various ways, these disks are probably an architectural form derived from the parasols used to shade kings and indicate people of importance. They may also correspond to the "Three Jewels of Buddhism"—the Buddha, the Law, and the Monastic Order.

As is often true in religious architecture, the railing provides a physical and symbolic boundary between an inner, sacred area and the outer, profane world. Carved with octagonal uprights and lens-shaped crossbars, it probably simulates the wooden railings of the time. Aligned with the four cardinal directions, four stone gateways, or *toranas*, punctuate the railing. An inscription on the south gateway indicates that it was provided by ivory carvers from the nearby town of Vidisha, while another inscription, also on the south *torana*, specifies a gift during the reign of King Satakarni of the Satavahana dynasty, providing the first-century BCE date for the gateways. The vast majority of the inscriptions at Sanchi, however, record modest donations by individual devotees from all walks of life. This collaborative patronage points to Buddhism's expanding popularity.

Rising to a height of 35 feet, the gateways are the only elements of the Great Stupa at Sanchi to be ornamented with sculpture.

The four gates support a three-tiered array of architraves in which posts and crossbars are elaborately carved with symbols and scenes drawn mostly from the Buddha's life and the **Jataka tales**, stories of the Buddha's past lives. These relief sculptures employ two distinctive features of early South Asian visual narrative. The first is that the Buddha himself is not shown in human form prior to the late first century BCE. Instead, he is represented by symbols East torana (exterior middle architrave) of Stupa 1 (The Great Stupa) at Sanchi. 1st century BCE. Sandstone.

Before he became the Buddha, Prince Siddhartha resolved to give up his royal comforts in order to pursue the life of an ascetic. Confiding only in his charioteer Channa, the prince slipped out of his palace in the dead of night, and, mounting his horse, headed for the gates. The local gods, vakshas, were eager for the prince to succeed on his spiritual quest and cupped their hands under the horse's hooves

so that no one would awaken from the noise. Indeed, in some versions, they carry the horse and its rider right over the palace walls. This story is depicted, using some distinctive forms of visual narrative, on the middle architrave of the east gate of the Great Stupa at Sanchi.

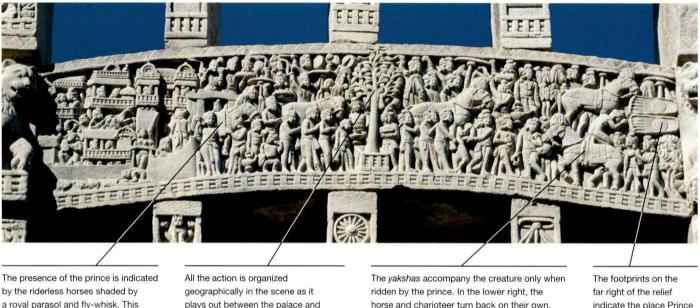

moments in the story. transition into the forest setting.

is the same horse shown at various

horse and charioteer turn back on their own, unaccompanied by the local gods and leaving Shakyamuni to begin his life as an ascetic.

indicate the place Prince Siddhartha dismounted

View the Closer Look for The Great Departure on myartslab.com

the forest. This tree indicates the

such as his footprints, an empty "enlightenment" seat, or a plank. The reasons for this absence are still widely debated but, since Vedic gods and Jinas are very rarely depicted in this period, it seems likely that this was the result of a wider cultural practice rather than a uniquely Buddhist prohibition. The second is that South Asian sculpture frequently employs continuous narrative. This means that several moments in time are represented in the same visual frame. For an example see "A Closer Look," above. The toranas are further decorated with free-standing sculptures depicting such subjects as yakshis and their male counterparts, yakshas, riders on real and mythical animals, and the Buddhist wheel.

Forming a bracket between each capital and the lowest crossbar on the east gate is a sculpture of a YAKSHI (FIG. 10-9). These yakshis are some of the finest female figures in Indian art, and they make an instructive comparison with the Didarganj image of the Maurya period (see FIG. 10-7). The earlier figure was distinguished by a formal, somewhat rigid pose, an emphasis on realistic details, and a clear distinction between clothed and nude parts of the body. In contrast, the Sanchi yakshi leans daringly into space with casual abandon, supported by one leg as the other charmingly crosses behind. Her thin, diaphanous garment is noticeable only by its hems, and so she appears almost nude, which emphasizes her form. The mango tree on which she hangs is heavy with fruit, reasserting the fecundity and bounty associated with these mercurial deities. This semidivine figure's presence on a Buddhist gateway implies her role as a guardian or devotee, which, in turn, speaks to Buddhism's inclusiveness. Even deities were understood to benefit from the Buddha's teachings.

THE CHAITYA HALL AT KARLE From ancient times, caves have been considered hallowed places in India, because they were frequently the abodes of holy men and ascetics. Around the second century BCE, cavelike sanctuaries were hewn out of the stone plateaus in the region of south-central India known as the Deccan. Made for the use of Jain and Buddhist monks, these sanctuaries were carved from top to bottom like great pieces of sculpture, with all details completely finished in stone. Entering these remarkable halls transports one to an otherworldly sacred

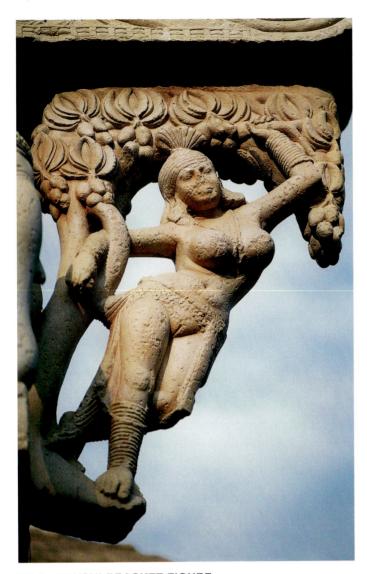

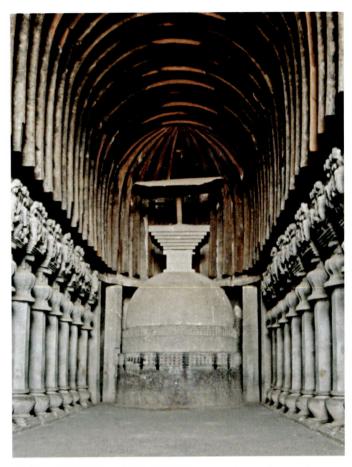

10-10 • CHAITYA HALL, KARLE Maharashtra. India. 1st century BCE-1st century CE.

10-9 • YAKSHI BRACKET FIGURE East *torana* of the Great Stupa at Sanchi. Sandstone, height approx. 60" (152.4 cm).

space. The atmosphere created by the cool, dark interior and the echo that magnifies the smallest sound combine to promote a state of heightened awareness.

The monastic community utilized two types of rock-cut halls. The **vihara** functioned as the monks' living quarters, and the **chaitya** ("sanctuary") usually enshrined a stupa. A **CHAITYA HALL** at Karle (**FIG. 10-10**), dating from the first century BCE to the first century CE, is one of the largest and most fully developed examples of these early Buddhist works. At the entrance, columns once supported a wooden façade, in front of which stands a pillar, inspired by Ashokan precedents. The walls of the vestibule are carved in relief with rows of small balcony railings and arched windows, simulating the appearance of a great multi-storied palace. At the base of the side walls, enormous statues of elephants seem to support the entire structure on their backs. Dominating the upper portion of the main façade is a large horseshoe-shaped opening, which provides the hall's main source of light. The window was originally fitted with a carved wooden screen, some of which remains, that filtered the light streaming inside.

Three entrances allow access to the interior. Flanking the doorways are sculpted panels of **mithuna** couples, amorous male and female figures that evoke the auspicious qualities of harmony and fertility in life. The interior hall, 123 feet long, has a 46-foot-high ceiling carved in the form of a barrel vault ornamented with arching wooden ribs. Both the interior and exterior of the hall were once brightly painted. Pillars demarcate a pathway for circumambulation around the stupa in the apse at the far end.

The side aisles are separated from the main aisle by closely spaced columns whose bases resemble a large pot set on a stepped pyramid of planks. The statues that comprise the upper capitals of these columns depict pairs of kneeling elephants, each bearing a *mithuna* couple. These figures, the only sculpture within this austere hall, may represent the nobility coming to pay homage at the temple. The pillars around the apse are plain, and the stupa is simple. A railing motif ornaments its base. The stupa was once topped with wooden umbrellas, only one of which remains. As with nearly everything in the cave, the stupa is carved from the rock of the cliff.

THE KUSHAN PERIOD

Around the first century CE, the regions of present-day Afghanistan, Pakistan, and north India came under the control of the Kushans, originally a nomadic people forced out of northwest China by the Han. Exact dates are uncertain, but they ruled from the first to the third century CE.

These heavily-bearded warrior kings made widespread use of royal portraiture on coins and in sculptural form. An image of **KING KANISHKA** (FIG. 10-11), whose reign is thought to have begun in 127 CE, represents one of the Kushan's most illustrious rulers. This boldly frontal work stands over 5 feet tall even with the head missing. The fact that his hands rest on his sword and massive club makes his martial authority clear even before reading the inscription which identifies him as "The great king, king of kings." Attired in a coat and heavy felt riding boots, he is ill-suited for the warm South Asian climate and his garments reflect his Central Asian heritage. The hundreds of pearls that line the hem of his outfit are indicative of his great wealth and were particularly rare in the inland territories from which the Kushan migrated.

10-11 • KING KANISHKA Uttar Pradesh, India. c. 2nd–3rd century ce. Sandstone, height 5'3" (1.6 m). Government Museum, Mathura.

These rulers were remarkably eclectic in their religious views and, judging from their coins, supported a wide range of religious institutions. In this tolerant climate, and perhaps spurred on by Kushan royal images, innovative figural art began to blossom in the Jain, Brahmanic, and Buddhist traditions.

Among these innovations are the first depictions of the Buddha himself in art. (Previously, as in the Great Stupa at Sanchi, the Buddha had been indicated solely by symbols.) Distinctive styles arose in the Gandhara region in the northwest (present-day Pakistan and Afghanistan) and in the important religious center of Mathura in central India. While the images from these Kushancontrolled regions are stylistically quite distinct, they shared a basic visual language, or iconography, in which the Buddha is readily recognized by specific characteristics. For instance, he wears a monk's robe, a long length of cloth draped over the left shoulder and around the body. The Buddha also is said to have had 32 major distinguishing marks, called lakshanas, some of which are reflected in the iconography (see "Buddhist Symbols," page 368). These include a golden-colored body, long arms that reached to his knees, the impression of a wheel (chakra) on the palms of his hands and the soles of his feet, and the urna-a mark between his eyebrows. A prince in his youth, he had worn the customary heavy earrings, and so his earlobes are usually shown elongated. The top of his head is said to have had a protuberance called an ushnisha, which in images often resembles a bun or topknot and symbolizes his enlightenment.

THE GANDHARA STYLE Combining elements of Hellenistic, Persian, and Indian styles, Gandhara sculptors typically portrayed the Buddha as an athletic figure, more powerful and heroic than an ordinary human. Carved from schist, a fine-grained dark stone, this over-life-size **STANDING BUDDHA** (FIG. 10-12) may date to the fully developed stage of the Gandhara style, possibly around the third century CE. The Buddha's body, revealed through the folds of the garment, is broad and massive, with heavy shoulders and limbs and a well-defined torso. His left knee bends gently, suggesting a slightly relaxed posture.

The treatment of the robe is especially characteristic of the Gandhara manner. Tight, naturalistic folds alternate with delicate creases, setting up a clear, rhythmic pattern of heavy and shallow lines. On the upper part of the figure, the folds break asymmetrically along the left arm; on the lower part, they drape in a symmetric U shape. The strong tension of the folds suggests life and power within the image. This complex fold pattern resembles the treatment of togas on certain Roman statues (see FIG. 6-22), and it exerted a strong influence on portrayals of the Buddha in Central and East Asia. The Gandhara region's relations with the Hellenistic world may have led to this strongly Western style in its art. Pockets of Hellenistic culture had thrived in neighboring Bactria (present-day northern Afghanistan and southern Uzbekistan) since the fourth century BCE, when the Greeks under Alexander the Great had reached the borders of India. Also, Gandhara's position

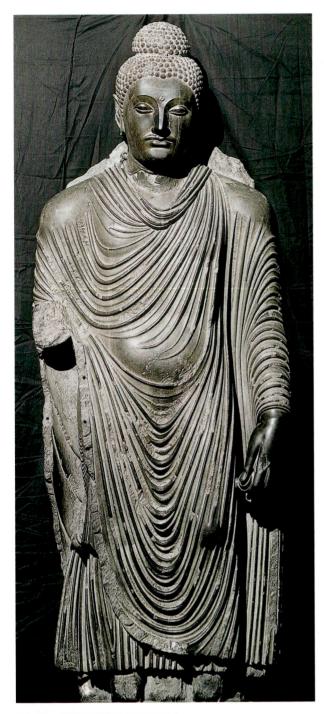

10-12 • STANDING BUDDHA From Gandhara, Pakistan. Kushan period, c. 2nd–3rd century ce. Schist, height 7'6" (2.28 m). Lahore Museum, Lahore.

near the east-west trade routes appears to have stimulated contact with Roman culture in the Near East during the early centuries of the first millennium CE.

THE MATHURA STYLE The second major style of Buddhist art in the Kushan period—that found at Mathura—was not allied with the Hellenistic-Roman tradition. Instead, the Mathura style evolved from representations of *yakshas*, the indigenous male nature deities. Early images of the Buddha produced at Mathura

draw on this sculptural tradition, often portraying him in a frontal stance with broad shoulders and wide eyes.

The stele in **FIGURE 10-13** is one of the finest of the early Mathura images. The sculptors worked in a distinctive red sandstone flecked with cream-colored spots. Carved in **high relief** (forms projecting strongly from the background), it depicts a seated Buddha with two attendants. His right hand is raised in a symbolic gesture meaning "have no fear." Images of the Buddha rely on a repertoire of such gestures, called **mudras**, to communicate certain ideas, such as teaching, meditation, or the attaining of enlightenment (see "Mudras," page 308). The Buddha's *urna*, his *ushnisha*, and the impressions of wheels on his palms and soles are all clearly visible in this figure. Behind his head is a large, circular halo; the scallop points of its border represent radiating light. Behind the halo are branches of the pipal tree, the tree under which the Buddha was seated when he achieved enlightenment. Two celestial beings hover above.

As in Gandhara sculptures, the Mathura work gives a powerful impression of the Buddha. The robe is pulled tightly over the body,

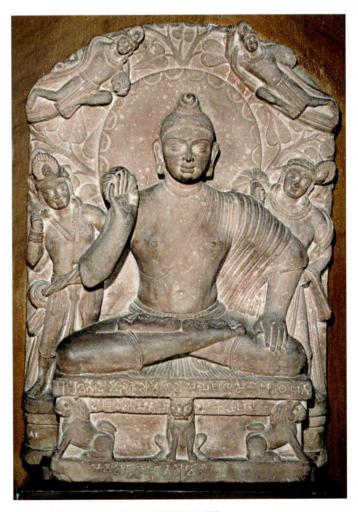

10-13 • BUDDHA AND ATTENDANTS From Katra Keshavdev, Mathura, Madhya Pradesh, India. Kushan period, c. late 1st–early 2nd century cE. Red sandstone, height 27¹/₄" (69.2 cm). Government Museum, Mathura.

ART AND ITS CONTEXTS | Mudras

Mudras (Sanskrit for "sign") are ancient symbolic hand gestures that first appeared in a manual on dance, but came to be regarded as physical expressions of a particular action or state of being. In Buddhist art, they function iconographically. *Mudras* are also used during meditation to invoke specific states of mind. The following are the most common *mudras* in Asian art.

Dharmachakra mudra

Appears as if the subject is counting on his fingers, The gesture of teaching, setting the *chakra* (wheel) of the *dharma* (law or doctrine) in motion. Hands are at chest level.

Dhyana mudra

A gesture of meditation and balance, symbolizing the path toward enlightenment. Hands are in the lap, the lower representing *maya*, the physical world of illusion, the upper representing *nirvana*, enlightenment and release from the world.

Vitarka mudra

This variant of *dharmachakra mudra* stands for intellectual debate. The right and/or left hand is held at shoulder level with thumb and forefinger touching. Resembles counting on the fingers with one hand.

Abhaya mudra

The gesture of reassurance, blessing, and protection, this *mudra* means "have no fear." The right hand is at shoulder level, palm outward.

Bhumisparsha mudra

This gesture calls upon the earth to witness Shakyamuni Buddha's enlightenment at Bodh Gaya. A seated figure's right hand reaches toward the ground, palm inward.

Varada mudra

The gesture of charity, symbolizing the fulfillment of all wishes. Alone, this *mudra* is made with the right hand; but when combined with *abhaya mudra* in standing Buddha figures (as is most common), the left hand is occasionally shown in *varada mudra*.

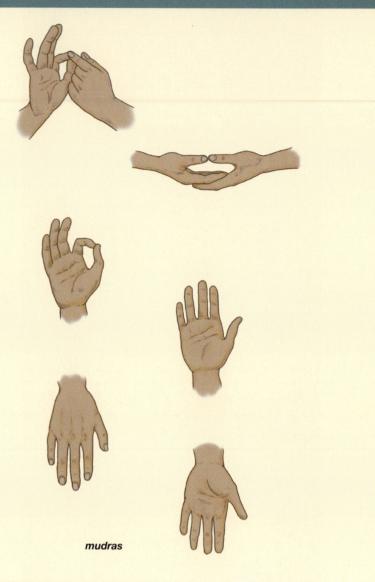

allowing the fleshy form to be seen as almost nude. Where the pleats of the robe appear, such as over the left arm and fanning out between the legs, they are depicted abstractly through compact parallel formations of ridges with an incised line in the center of each ridge. This characteristic Mathura tendency to abstraction also appears in the face, whose features take on geometric shapes, as in the rounded forms of the widely opened eyes. Nevertheless, the torso with its subtle and soft modeling is strongly naturalistic. This Buddha's riveting outward gaze and alert posture impart a more intense, concentrated energy that draws on imagery associated with nature deities and reveal a spiritual power contained in physical form.

THE GUPTA PERIOD AND ITS SUCCESSORS

The Guptas, who founded a dynasty in the eastern region of central India, expanded their territories during the fourth century CE to form an empire that encompassed northern and much of central India. Although Gupta rule was not long-lasting (ending in 550) or the most expansive, the influence of Gupta culture was tremendous and its impact was felt long after its decline. Renowned for their flourishing artistic, mathematical, and literary culture, the Guptas and their contemporaries brought forth some of India's most widely admired works of art. While Buddhism continued to be a major religion, the earliest surviving Hindu temples also date from this time.

By the fourth century the Vedic sacrifice, in which burnt offerings were ritually sent up to the gods, had given way to templebased practices that invoked the divine presence into a sanctified architectural setting. These practices, collectively termed Hinduism by later observers, were still presided over by Brahmin priests but often brought new deities into prominence.

ART AND ITS CONTEXTS | Hinduism

Hinduism is not one religion but many related beliefs and innumerable sects. It results from the mingling of Vedic beliefs with indigenous, local beliefs and practices. All three major Hindu sects draw upon the texts of the Vedas, which are believed to be sacred revelations set down about 1200–800 BCE. The gods lie outside the finite world, but they can appear in visible form to believers. Each Hindu sect takes its particular deity as supreme. By worshiping gods with rituals, meditation, and intense love, individuals may be reborn into increasingly higher positions until they escape the cycle of life, death, and rebirth, which is called *samsara*. The most popular deities are Vishnu, Shiva, and the Great Goddess, Devi. Deities are revealed and depicted in multiple aspects.

Vishnu: Vishnu is a benevolent god who works for the order and wellbeing of the world. He is often represented lying in a trance or asleep on the Cosmic Waters, where he dreams the world into existence. His attributes include the discus, conch shell, mace, and lotus. He usually has four arms and wears a crown and lavish jewelry. He rides a man-bird, Garuda. Vishnu appears in ten different incarnations (*avatara*), including Rama and Krishna, who have their own sects. Rama embodies virtue, and, assisted by the monkey king, he fights the demon Ravana. As Krishna, Vishnu is a supremely beautiful, blue-skinned youth who lives with the cowherds, loves the maiden Radha, and battles the demon Kansa.

Shiva: Shiva is both creative and destructive, light and dark, male and female, ascetic and family man. His symbol is the *linga*, an upright phallus represented as a low pillar, set in a low base, or *yoni*, which represents the feminine. As an expression of his power and creative energy, he is often represented as Lord of the Dance, dancing the

TEMPLE OF VISHNU AT DEOGARH One of the earliest northern-style temples, dedicated to the Hindu god Vishnu, is at Deogarh in north-central India and dates to 530 CE (**FIG. 10-14**). The entire temple site is patterned on a *mandala*, or sacred diagram. Much of the central tower, or *shikhara*, has crumbled away,

Cosmic Dance, the endless cycle of death and rebirth, destruction and creation (see "Shiva Nataraja of the Chola Dynasty," page 322). He dances within a ring of fire, his four hands holding fire, a drum, and gesturing to the worshipers. Shiva's animal vehicle is the bull. His consort is Parvati; their sons are the elephant-headed Ganesha, the remover of obstacles, and Karttikeya, often associated with war.

Devi: Devi, the Great Goddess, controls material riches and fertility. She has forms indicative of beauty, wealth, and auspiciousness, but also forms of wrath, pestilence, and power. As the embodiment of cosmic energy, she provides the vital force to all the male gods. Her symbol, the *yoni*, is an abstract depiction of female genitals often associated with the *linga* of Shiva. When armed and riding a lion (as the goddess Durga), she personifies righteous fury. As the goddess Lakshmi, she is the goddess of wealth and beauty. She is often represented by the basic geometric forms: squares, circles, triangles.

Brahma: Brahma, who once had his own cult, embodies spiritual wisdom. His four heads symbolize the four cosmic cycles, four earthly directions, and four classes of society: priests (brahmins), warriors, merchants, and laborers.

There are countless other deities, but central to Hindu practice are *puja* (forms of worship) and *darshan* (beholding a deity), generally performed to obtain a deity's favor and in the hope that this favor will lead to liberation from *samsara*. Because desire for the fruits of our actions traps us, the ideal is to consider all earthly endeavors as sacrificial offerings to a god. Pleased with our devotion, he or she may grant us an eternal state of pure being, pure consciousness, and pure bliss.

so we cannot determine its original shape with precision. Clearly a massive, solid structure built of large cut stones, it would have given the impression of a mountain, one of several metaphoric meanings of a Hindu temple. The temple has only one chamber, the *garbhagriha*, literally the womb chamber, which corresponds

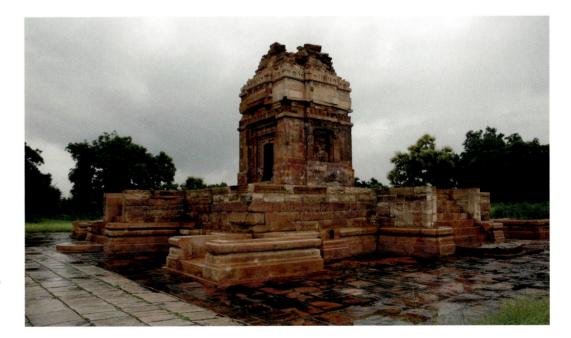

10-14 • VISHNU TEMPLE, DEOGARH Uttar Pradesh, India. Gupta dynasty, c. 530 cE. to the center of a *mandala*. As the deity's residence, the *garbhagriha* is likened to a sacred cavern within the "cosmic mountain" of the temple.

Large panels sculpted in relief with images of Vishnu appear as "windows" on the temple's exterior. These elaborately framed panels do not function literally to let light *into* the temple; they function symbolically to let the light of the deity *out* of the temple to be seen by those outside.

One panel depicts **VISHNU LYING ON THE COSMIC WATERS** at the beginning of creation (**FIG. 10-15**). He sleeps on the serpent of infinity, Ananta, whose body coils endlessly into space. Stirred by his female aspect (*shakti*, or female energy), personified here by the goddess Lakshmi, seen holding his foot,

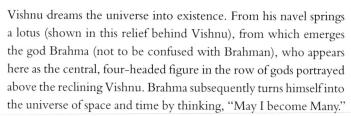

The sculptor has depicted Vishnu as a large, resplendent figure with four arms. His size and his multiple arms denote his omnipotence. He is lightly garbed but richly ornamented. The ideal of the Gupta style is evident in the smooth, perfected shape of the body and in the lavishly detailed jewelry, including Vishnu's characteristic cylindrical crown. The four figures on the right in the frieze below personify Vishnu's four attributes. They stand ready to

> fight the appearance of evil, represented at the left of the frieze by two demons who threaten to kill Brahma and jeopardize all creation.

> The birth of the universe and the appearance of evil are thus portrayed here in three clearly organized registers. Typical of Indian religious and artistic expression, these momentous events are set before our eyes not in terms of abstract symbols, but as a drama acted out by gods in superhuman form.

SEATED BUDDHA FROM SARNATH

Buddhism continued to thrive during the Gupta period. Although the Gandhara style eventually declined in influence, the Mathura style gave rise to the Buddhist visual forms found over much of north India, including at sites like Sarnath.

The seated Buddha in FIGURE 10-16 embodies the fully developed Sarnath Gupta style. Carved from fine-grained sandstone, the figure sits in a yogic posture making the teaching gesture indicative of the First Sermon. This event is further indicated by the presence of devotees/listeners represented on the pedestal along with a wheel whose outer tread faces toward the viewer. The devotees, who may also represent the donors of this image, are joined in their devotion by two divine beings flying in from above. The plain robe, portrayed with none of the creases and folds so prominent in the Kushan-period images, is distinctive of the Sarnath style. The body, clearly visible through the clinging robe, is graceful and slight, with broad shoulders and

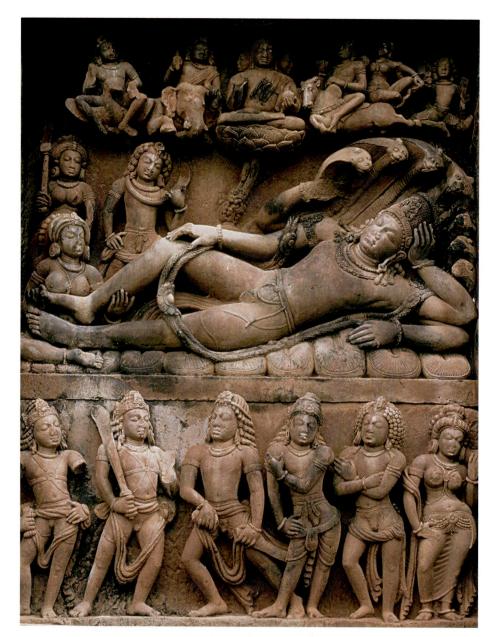

10-15 • VISHNU LYING ON THE COSMIC WATERS
 Relief panel in the Vishnu Temple, Deogarh. c. 530 ce. Sandstone, height approx. 5' (1.5 m).
 Watch a video about the process of relief carving on myartslab.com

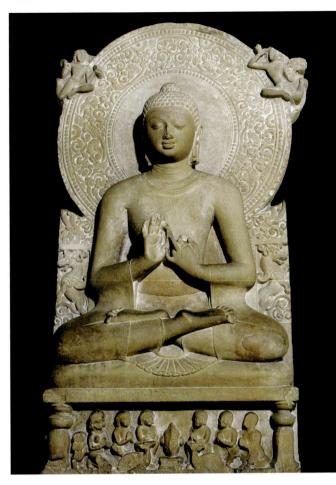

10-16 • BUDDHA PREACHING HIS FIRST SERMON From Sarnath, Uttar Pradesh, India. Gupta period, c. 465–485 CE. Sandstone, height 5'3" (1.6 m). Archaeological Museum, Sarnath.

a well-proportioned torso. Only a few lines of the garment at the neck, waist, and hems interrupt the purity of its subtly shaped surfaces; the face, smooth and ovoid, has the same refined elegance. The downcast eyes suggest otherworldly introspection, yet the gentle, open posture maintains a human quality. Behind the head is a large, circular halo. Carved in concentric circles of pearls and foliage, the ornate halo contrasts dramatically with the plain surfaces of the figure.

THE AJANTA CAVES Prior to the late fifth century, the Vakataka dynasty had been subject to Gupta rule. Shortly after winning regional control, people affiliated with their court began to sponsor a new phase of construction at the rock-cut monastery of Ajanta. Each of these large caves, over 20 in all, appears to have had its own major patron. Whether inspired by devotion or competition, these caves are among the finest rock-cut architecture found anywhere. Adding to the importance of these caves is the fact that they preserve examples of wall painting, giving us a rare glimpse of a refined art form that has almost entirely been lost to time. Of these examples, Cave I, a large *vihara* hall with monks' chambers around the sides and a Buddha shrine chamber in the back, houses some of the finest. Murals painted in mineral pigments on a prepared plaster surface cover the walls of the central court. Some depict episodes from the Buddha's past lives while two large bodhisattvas, one of which is seen in **FIGURE 10-17**, flank the entrance to the shrine chamber.

Bodhisattvas are enlightened beings who postpone *nirvana* and buddhahood to help others achieve enlightenment. They are distinguished from buddhas in art by their princely garments. Lavishly adorned with delicate ornaments, this bodhisattva wears a bejeweled crown, large earrings, a pearl necklace, armbands, and bracelets. A striped cloth covers his lower body. The graceful bending posture and serene gaze impart a sympathetic attitude. His possible identity as the compassionate bodhisattva Avalokiteshvara is indicated by the lotus flower he holds in his right hand.

The naturalistic style balances outline and softly graded color tones. Outline drawing, always a major ingredient of Indian painting, clearly defines shapes; tonal gradations impart the illusion of three-dimensional form, with lighter tones used for protruding parts

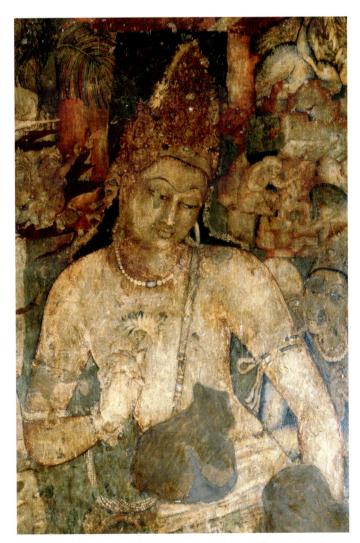

10-17 • BODHISATTVA Detail of a wall painting in Cave I, Ajanta, Maharashtra, India. Vakataka dynasty, c. 475 cE.

such as the nose, brows, shoulders, and chest muscles. Together with the details of the jewels, these highlighted areas resonate against the subdued tonality of the figure. Sophisticated, realistic detail is balanced by the languorous human form. This particular synthesis is evident also in the Sarnath statue (see FIG. 10–16), which shares much in common as well with the sculpture of Ajanta.

OTHER DEVELOPMENTS, FOURTH-SIXTH CENTURY

THE BAMIYAN BUDDHAS The Gupta and their feudatories were by no means the only kingdoms to flourish in fourth- to sixth-century South Asia. For example, at the site of Bamiyan, about 155 miles northwest of Kabul, Afghanistan, two enormous Buddhas were carved from the rock of a cliff, one some 115 feet in height (FIG. 10-18), the other about 165 feet. Located just west of one of the most treacherous portions of the Silk Road, this rich oasis town was a haven and crossroad on the lucrative trade routes that reached from China to the West. Buddhist travelers must have offered gifts of thanks or prayers for safety, depending on their destinations. Recorded by a Chinese pilgrim who came to Bamiyan in the fifth century, these Buddhas must date from before his visit. On the right side of the smaller figure, pilgrims could walk within the cliff up a staircase that ended at the Buddha's shoulder. There they could look into the vault of the niche and see a painted image of the sun god, suggesting a metaphoric pilgrimage to the heavens. They then could circumambulate the figure at the level of the head and return to ground level by a

staircase on the figure's left side. These huge figures likely served as the model for those at rock-cut sanctuaries in China, for example, at Yungang. Despite the historical and religious importance of these figures, and ignoring the pleas of world leaders, the Taliban demolished the Bamiyan Buddhas in 2001.

SIGIRIYA, SRI LANKA Far away from Afghanistan, in the south, the palace site of SIGIRIYA was built on a dramatic plateau that rises abruptly above the forest canopy in north-central Sri Lanka (FIG. 10-19). According to the royal chronicles, this structure was built by King Kassapa in the late 400s CE after usurping the throne from his father and driving off his brother. Visitors to the palace first passed through a broad moat and elaborate terraced gardens before beginning their ascent. At its base, the staircase passes through the chest of a massive sculptural lion, of which only the naturalistically rendered feet currently exist. As visitors climbed higher they were greeted by painted murals depicting elegant, HEAVENLY MAIDENS moving among clouds (FIG. 10-20), before emerging at the top of the plateau. Only the foundations of the palace buildings, cisterns, and a few sculptures remain, but they are sufficient to get a sense of the site's imposing splendor and spectacular elevation. Kassapa did not have long to enjoy his luxurious and well-fortified home, however, because within approximately 11 years the rightful heir, his brother Moggallana, returned with an army and took back the kingdom. After his victory, Moggallana gave Sigiriya to the Buddhists as a monastery.

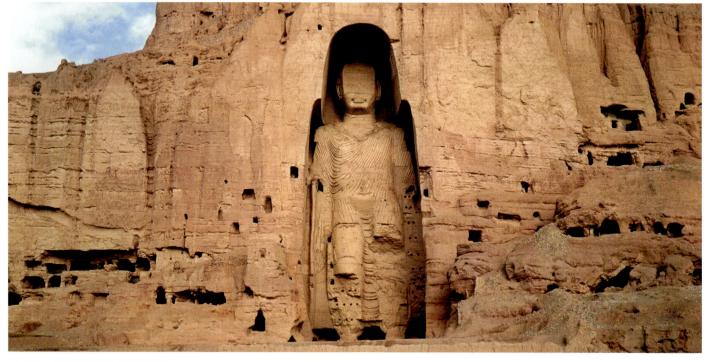

10-18 • STANDING BUDDHA Bamiyan, Afghanistan. c. 5th century CE. Sandstone coated in stucco, 175' (54 m).

This photograph pre-dates the destruction of the Buddhas in 2001. Currently their recesses stand empty.

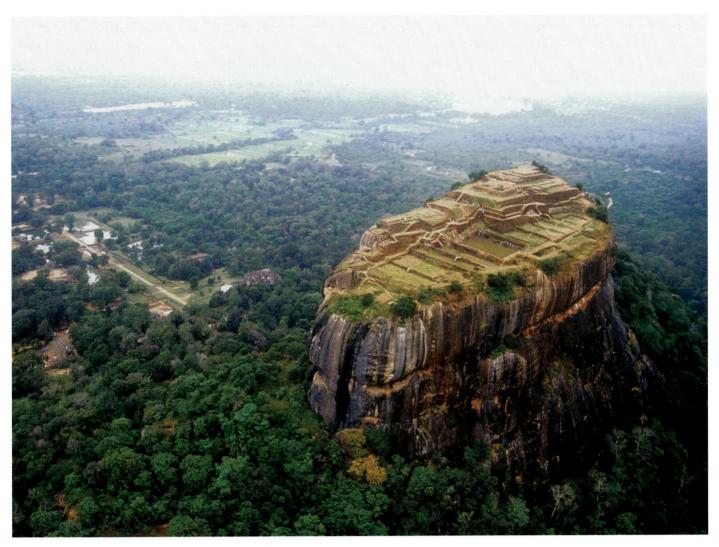

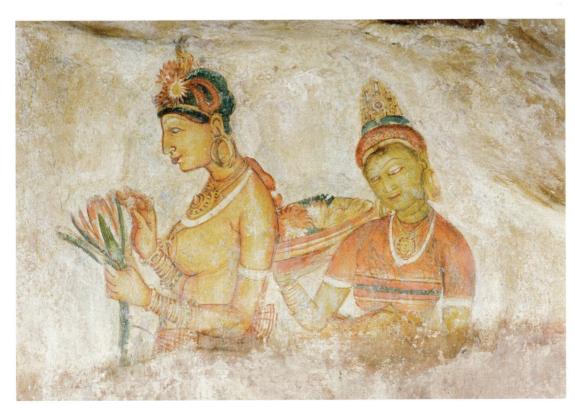

10-19 • SIGIRIYA Matale District, Central Province, Sri Lanka. 5th century cE. Aerial view.

10-20 • HEAVENLY MAIDENS Detail of wall painting, Sigiriya. 5th century cE.

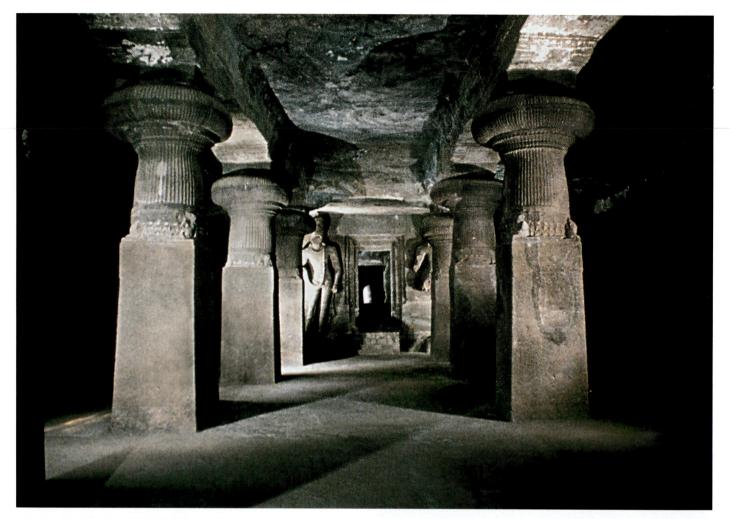

10-21 • CAVE-TEMPLE OF SHIVA, ELEPHANTA Maharashtra, India. Post-Gupta period, mid 6th century CE. View along the east–west axis to the *linga* shrine.

Watch a video about the Elephanta caves
 on myartslab.com

TEMPLE OF SHIVA AT ELEPHANTA The Hindu god Shiva exhibits a wide range of aspects or forms, both gentle and wild: He is the Great Yogi who dwells for vast periods of time in meditation in the Himalayas; he is also the husband par excellence who makes love to the goddess Parvati for eons at a time; he is the Slayer of Demons; and he is the Cosmic Dancer who dances the destruction and re-creation of the world. Many of these forms of Shiva appear in the monumental relief panels adorning a cavetemple carved in the mid sixth century on the island of Elephanta off the coast of Mumbai in western India. The cave-temple is complex in layout and conception and is a fine example of Hindu rock-cut architecture. While most temples have one entrance, this

10-22 • ETERNAL SHIVA Rock-cut relief in the cave-temple of Shiva, Elephanta. Mid 6th century ce. Height approx. 11' (3.4 m).

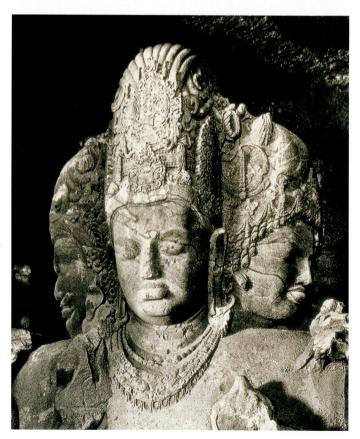

temple offers three—one facing north, one east, and one west. The interior, impressive in its size and grandeur, is designed along two main axes, one running north—south, the other east—west. The three entrances provide the only source of light, and the resulting cross- and back–lighting effects add to the sense of the cave as a place of mysterious, almost confusing complexity.

Along the east-west axis, large pillars cut from the rock appear to support the low ceiling and its beams, although, as with all architectural elements in a cave-temple, they are not structural (FIG. 10-21). The pillars form orderly rows, but the rows are hard to discern within the framework of the cave shape, which is neither square nor longitudinal, but formed of overlapping mandalas that create a symmetric yet irregular space. The pillars each have an unadorned, square base rising to nearly half its total height. Above is a circular column, which has a curved contour and a billowing "cushion" capital. Both column and capital are delicately fluted, adding a surprising refinement to these otherwise sturdy forms. The focus of the east-west axis is a square linga shrine (see FIG. 10-21, center). A pair of colossal standing guardian figures flank each of its four entrances. In the center of the shrine is the linga, the abstracted symbol of Shiva that represents his presence as the unmanifest Formless One, or Brahman. Synonymous with Shiva, the linga is seen in nearly every Shiva temple and shrine.

The focus of the north–south axis, in contrast, is a relief on the south wall with a huge bust of Shiva representing his Sadashiva, or **ETERNAL SHIVA**, aspect (**FIG. 10-22**). Three heads rest upon the broad shoulders of the upper body, but five heads are implied: the fourth behind and the fifth, never depicted, on top. The head in the front depicts Shiva deep in introspection. The massiveness of the broad head, the large eyes barely delineated, and the mouth with its heavy lower lip suggest the god's serious depths. Lordly and majestic, he easily supports his huge crown, intricately carved with designs and jewels, and the matted, piled–up hair of a yogi. On his left shoulder, his protector nature is depicted as female, with curled hair and a pearl-festooned crown. On his right shoulder, his wrathful, destroyer nature wears a fierce expression, and snakes encircle his neck.

THE PALLAVA PERIOD

Rising to power in the late sixth century, the Pallava dynasty spread from its heartland in southeastern India, drawing wealth from overseas trade. The kingdom grew to its peak during the reigns of King Mahendravarman I (c. 600–630 CE) and his successor Narasimhavarman I (c. 630–668 CE) who was also referred to by his nickname Mamalla (which alludes to his skill at wrestling). Both men sponsored rock-cut shrines and sculpture at the coastal city of Mamallapuram, near Chennai. Often religious in subject matter, the carving is at times infused with a whimsical humor. This good-natured irreverence emerges most clearly in the Pallava literary tradition. One well-known farcical drama, attributed to Mahendravarman himself, pokes fun at Tantric ascetics, Buddhist monks, and Brahmin priests. At Mamallapuram there are many large boulders and cliffs along the shore from which the Pallava-period stonecutters carved entire temples as well as reliefs. Among the most interesting of these rock-cut temples is a group known as the Five Rathas, which preserve diverse early architectural styles that probably reflect the forms of contemporary wood or brick structures.

DHARMARAJA RATHA AT MAMALLAPURAM One of this group, called today the DHARMARAJA RATHA (FIG. 10-23), epitomizes the early southern-style temple. Each story of the superstructure is articulated by a cornice and carries a row of miniature shrines. Both shrines and cornices are decorated with a window motif from which faces peer. The shrines not only demarcate each story, but also provide loftiness for this palace intended to enshrine a god. The temple, square in plan, remains unfinished, and the garbhagriha usually found inside was never hollowed out, suggesting that, like cave-temples, Dharmaraja Ratha was executed from the top downward. On the lower portion, only the columns and niches have been carved. The presence of a single deity in each niche forecasts the main trend in temple sculpture in the centuries ahead: The tradition of narrative reliefs declined, and the stories they told became concentrated in statues of individual deities, which conjure up entire mythological episodes

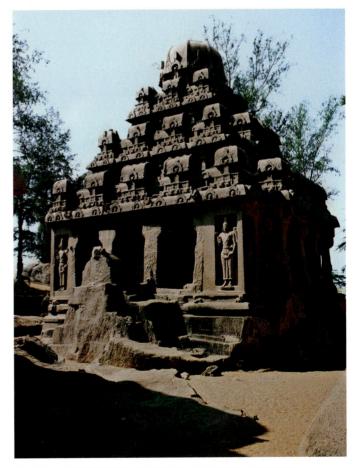

10-23 • DHARMARAJA RATHA, MAMALLAPURAM Tamil Nadu, India. Pallava period, c. mid 7th century CE.

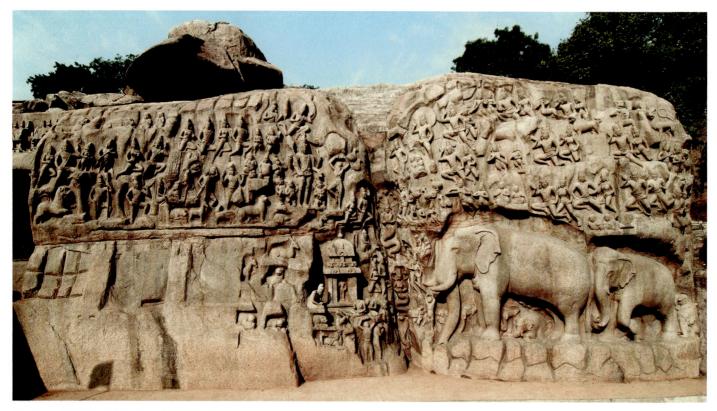

10-24 • DESCENT OF THE GANGES Rock-cut relief, Mamallapuram, Tamil Nadu, India. Mid 7th century ce. Granite, approx. 20' (6 m).

View the Closer Look for the Descent of the Ganges relief on myartslab.com

through characteristic poses and a few symbolic objects. On the south side of this ratha, among the images of deities, is an unusual two-armed image identified as a representation of King Mamalla who appears to be visually associating himself with Shiva. This practice of depicting royalty in the likeness of divinity became more common over time and was widely practiced in parts of Southeast Asia.

DESCENT OF THE GANGES RELIEF AT MAMALLAPURAM

An enormous relief at Mamallapuram (FIG. 10-24) depicts the penance of a king, Bhagiratha, who sought to purify the bones of his deceased relatives by subjecting himself to terrible austerities. In response to his penance, the god Shiva sent the sacred Ganges River, represented by the natural cleft in the rock, to earth, thereby allowing the holy man to ensure his relatives some peace in their next lives. Bhagiratha is shown staring directly at the sun through his parted fingers, standing for interminable periods on one foot, and in deep prayer before a temple. In the upper left part of the relief, Shiva, shown four-armed, appears before Bhagiratha to grant his wish. Elsewhere in the relief, animal families are depicted, generally in mutually protective roles. In a characteristically Pallava twist, this pious scene is mimicked by a cat who does his best to imitate Bhagiratha's pose (FIG. 10-25). The reference is to the story of an aging cat who pretends to be an ascetic (who has renounced meat) so as to lure the local mice into complacency, much to their misfortune. This cautionary tale about false ascetics serves as an apt and humorous foil to the upper scene of consummate penance and faith. Both tales are set on the banks of the Ganges.

This richly carved relief was executed under the Pallava dynasty, which continued to flourish in southeastern India until the ninth century CE. The relief must have been visible to anyone

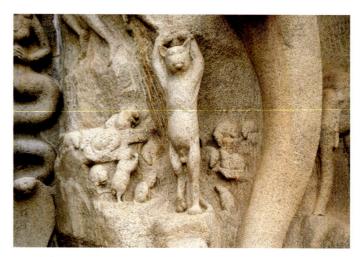

10-25 • CAT IN YOGIC POSTURE Detail from rock-cut relief, Mamallapuram, Tamil Nadu, India. Mid 7th century ce.

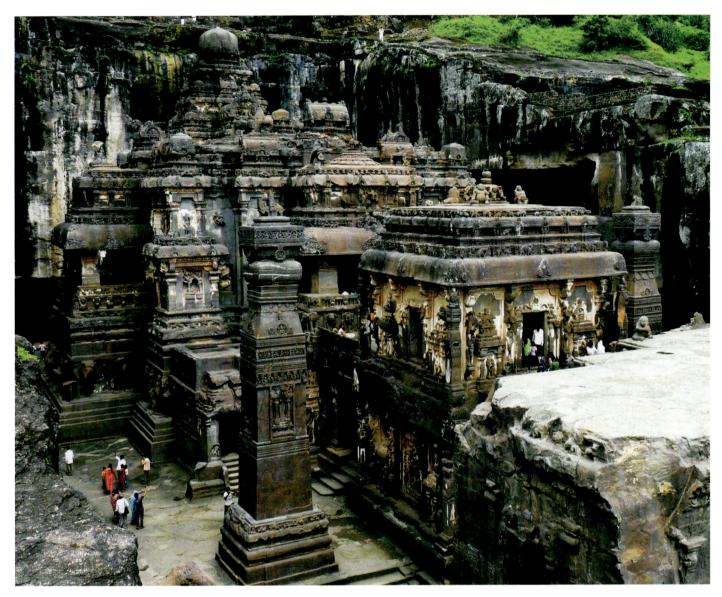

10-26 • KAILASHA TEMPLE, ELLORA Cave 16, Ellora, Aurangabad District, Maharashtra, India. Mid 8th century ce.

heading inland from the sea and likely served as an allegory for benevolent kingship. It was possibly even an attempt to invoke the presence of the sacred Ganges River right at the heart of the Pallavas' southern empire.

THE SEVENTH THROUGH TWELFTH CENTURIES

During the seventh through twelfth centuries, regional styles developed in ruling kingdoms that were generally smaller than those that had preceded them. Hindu gods Vishnu, Shiva, and the Great Goddess (mainly Durga) grew increasingly popular. Monarchs rivaled each other in the building of temples to their favored deity, and many complicated and subtle variations of the Hindu temple emerged with astounding rapidity in different regions. By around 1000 the Hindu temple reached unparalleled heights of grandeur and engineering. **KAILASHA TEMPLE, ELLORA** Occupied and expanded from the fifth to the tenth century, the rock-cut site of Ellora has 34 caves in all, variously dedicated to Buddhism, Jainism, and Hinduism. Among the most spectacular of these is "Cave" 16, the **KAILASHA TEMPLE** (FIG. 10-26), which was most likely started in the reign of the Rashtrakuta king Krishna I (r. 757–83 CE) and completed under his successors. In many ways, this structure marks the apex of the South Asian rock-cut tradition, as the skilled architects and artists managed successfully to sculpt an entire two-story, highly ornamented Shiva temple out of a single mass of stone. The structure is set back in the mountainside, which required cutting straight down 107 feet so that the rock would be high enough to accommodate the stepped, southern-style tower.

Passing the outer gateway, devotees can circumambulate at ground level and admire the narrative sculptural scenes and large elephants that adorn the lower plinth. Alternately, visitors can climb

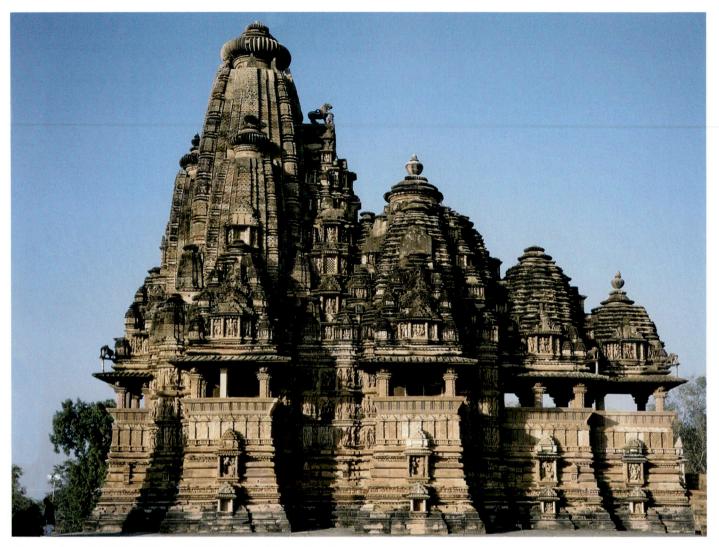

10–27 • KANDARIYA MAHADEVA TEMPLE, KHAJURAHO Madhya Pradesh, India. Chandella dynasty, c. 1000 ce.

an internal staircase to a second level where a relatively small shrine dedicated to Shiva's bull-mount, Nandi, faces the main temple across a bridge. The interior of the main temple hall (*mandapa*) was originally painted with additional narrative imagery. The *garbha-griha* can be circumambulated from the second story by passing out onto a balcony from which a number of subsidiary shrines radiate. The narrative sculpture throughout the site depict a wide range of deities and events from Hindu literature, many of which feature Shiva.

This site takes the metaphorical association between temples and mountains to an extreme as it is constructed, quite literally, from a mountain. Even the temple itself is named for Shiva's abode on Mount Kailasha in the Himalayas. Despite this association, remote mountainside locations better suited the needs of Buddhist and Jain monastic communities. Such locations proved to fit poorly with the public nature and ritual requirements of Hindu temples. The Kailasha Temple stands as the last of the great rock-cut Hindu temples. From this point on, architects and donors favored built structures placed in or near major urban centers. **KANDARIYA MAHADEVA TEMPLE, KHAJURAHO** In 950 CE, the Chandella court moved against the weakened Pratihara dynasty, to whom they were vassals. This rebellion proved successful, and the Chandella marked their new status by undertaking an ambitious project of temple building. The earliest of these structures housed an image of Vishnu taken directly from their previous overlords, but this temple was only the first among many. Khajuraho remained the capital and main temple site for the Chandellas, who constructed more than 80 temples there, about 25 of which are well preserved.

The **KANDARIYA MAHADEVA** (**FIG. 10-27**), a temple dedicated to Shiva at Khajuraho was probably built by a ruler of the Chandella dynasty in the late tenth or early eleventh century. In the northern style, a curvilinear *shikhara* rises over the *garbhagriha* of the temple. Extensively ornamented with additional halls on the front and porches to the sides and back, the temple rests on a stone terrace that sets off a sacred space from the mundane world. A steep flight of stairs at the front (to the right in the illustration) leads to a series of three *mandapas* (distinguished on the outside by

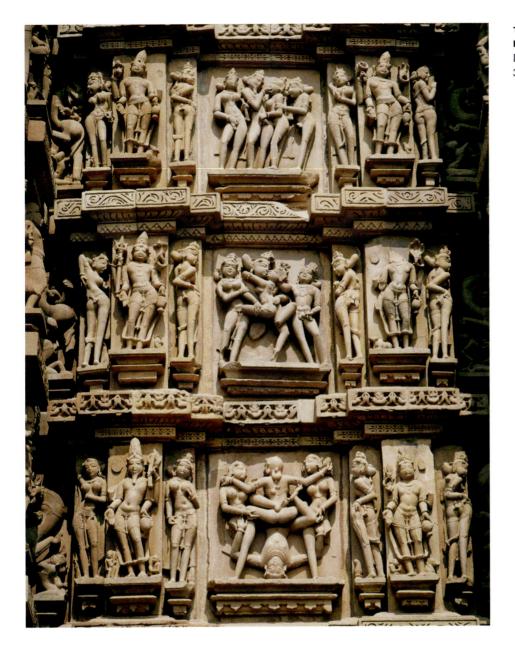

10-28 • EROTIC SCULPTURES, KANDARIYA MAHADEVA TEMPLE Detail of reliefs. Height of registers approx. 3'3" (1 m). Sandstone, c. 1000 ce.

pyramidal roofs), preceding the *garbhagriha*. The *mandapas* serve as spaces for ritual, such as dances performed for the deity, and for the presentation of offerings. The temple is built of stone blocks using only post-and-lintel construction. Despite this architectural challenge, the *shikhara* rises more than 100 feet over the *garbhagriha* and is crowned by a small *amalaka*, or bulbous ornament. The *shikhara* is bolstered by the many smaller subsidiary towers bundled around it. This decorative scheme adds a complex richness to the surface, but it also obscures the shape of the main *shikhara*, which is slender, with a swift and impetuous upward movement. The roofs of the *mandapas* contribute to the impression of rapid ascent by growing progressively taller as they near the *shikhara*.

Despite its apparent complexity, the temple has a clear structure and unified composition. Strong horizontal **moldings** (shaped or sculpted strips) and the open spaces over the *mandapas* and porches separate the towers of the superstructure from the

lower portion. Three rows of sculpture—some 600 figures—are integrated into the exterior walls. Approximately 3 feet tall and carved in high relief, the sculptures depict gods and goddesses, as well as figures in erotic postures.

The Khajuraho temples are especially well known for their **EROTIC SCULPTURES** (**FIG. 10–28**). These carvings are not placed haphazardly, but rather in a single vertical line at the juncture of the walls enclosing the *garbhagriha* and the last *mandapa*. Their significance is uncertain; perhaps they derive from the amorous couples (*mithuna*) found at the entrances of many temples and *chaityas*. It is also possible that they relate to two growing traditions within Hinduism: *tantra* and *bhakti*.

Throughout this period, two major religious movements were developing that affected Hindu practice and art: the tantric, or esoteric, and the *bhakti*, or devotional. Although both movements evolved throughout India, the influence of tantric sects appeared during this period primarily in the art of the north (see Chapter 24 for further discussion), while the *bhakti* movements found artistic expression across South Asia. *Bhakti* revolves around the ideal relationship between humans and deities. Rather than focusing on ritual and the performance of *dharma* according to the Vedas, *bhakti* stresses an intimate, personal, and loving relation with the god, and complete devotion and surrender to the deity. Tantrism, by contrast, is pursued under the guidance of a teacher and employs various techniques designed to help the devotee self-identify with the deity. Ultimately this leads to a profound understanding that there is no separation between oneself and the divine. Although not typical, both traditions have, at times, employed erotic or romantic imagery as a visual means of expressing ideas of devotion and unity.

GAL VIHARA, SRI LANKA During the twelfth century, when Buddhism had all but disappeared from India, it was still thriving in Sri Lanka. This island kingdom played a large role in exporting Buddhist ideas to parts of Southeast Asia, with which it had maintained close economic and cultural ties. Sri Lanka was central to strengthening and maintaining the conservative Theravada Buddhist traditions, especially by preserving scriptures and relics. Sri Lankan sculptors further refined Indian styles and iconography in colossal Buddhist sculptures but rarely initiated further elaboration on traditional Buddhist forms. Because the Buddha's image was believed to have been based on a portrait made during his lifetime, intentional variation was unnecessary and inaccurate.

The construction of the Gal Vihara is linked to an ambitious series of construction projects undertaken by King Parakramabahu in the mid twelfth century. The rock-cut **PARINIRVANA OF THE BUDDHA** at this monastic complex (**FIG. 10-29**) is one of three colossal Buddhas at the site. This serene and dignified image restates one of the early themes of Buddhist art, that of the Buddha's final death and transcendence, with a sophistication of modeling and proportion that updates and localizes the classical Buddhist tradition. Postholes in the rock face reveal that this sculpture was originally housed in a wooden superstructure, that has since decayed. Fortunately granite is more durable, and this fine example of Sri Lankan colossal sculpture has been preserved. This monastery, located north of the capital in Polonnaruwa, was occupied until the capital fell in the late 1200s.

THE CHOLA PERIOD

The Cholas, who succeeded the Pallavas in the mid ninth century, founded a dynasty that governed most of the far south of India well into the late thirteenth century. Its extensive trade networks and powerful navy also made it a potent cultural force in many parts of Southeast Asia over these centuries. The Chola dynasty reached its peak during the reign of Rajaraja I (r. 985-1014). As an expression of gratitude for his many victories in battle, Rajaraja built the Rajarajeshvara Temple to Shiva in his capital, Thanjavur (formerly known as Tanjore). The name Rajarajeshvara means the temple of Rajaraja's Lord, that is, Shiva, which also has the effect of linking the name of the king with that of Shiva. His patronage of the temple was in part a reflection of the fervent Shiva bhakti movement which had reached its peak by that time. Now, commonly called the Brihadeshvara (Temple of the Great Lord), this temple is a remarkable achievement of the southern style of Hindu architecture (FIG. 10-30). It stands within a huge, walled compound near the banks of the Kaveri River. Although smaller shrines dot the compound, the Rajarajeshvara dominates the area.

Rising to an astonishing height of 216 feet, this temple was probably the tallest structure in India in its time. Each story is decorated with miniature shrines, window motifs, and robust dwarf figures who seem to be holding up the next story. Like the

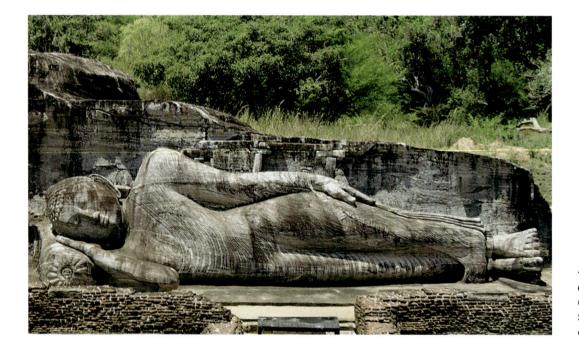

10-29 • PARINIRVANA OF THE BUDDHA Gal Vihara, near Polonnaruwa, Sri Lanka. 11th–12th century cE. Granite.

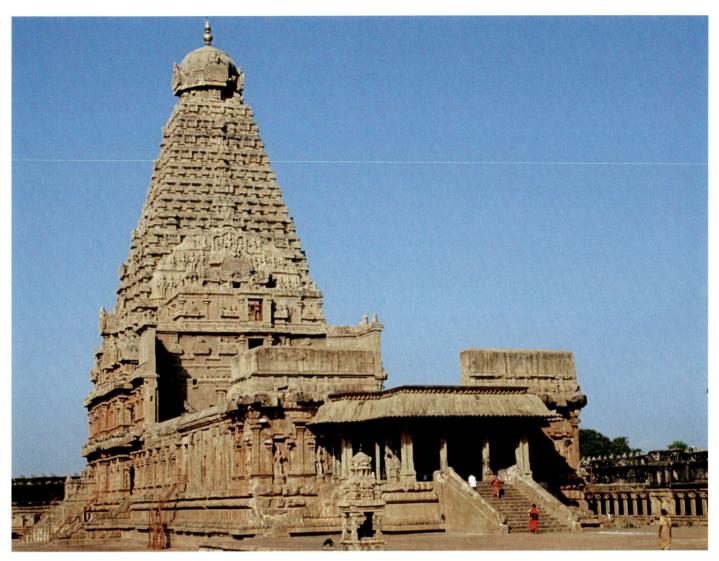

10-30 • RAJARAJESHVARA TEMPLE OF SHIVA, THANJAVUR Tamil Nadu, India. Chola dynasty, 1003–1010 CE.

contemporaneous Kandariya Mahadeva Temple at Khajuraho (see FIG. 10-27), the Rajarajeshvara has a longitudinal axis and greatly expanded dimensions, especially with regard to its superstructure, a four-sided, hollow pyramid. Typical of the southern style, the mandapa at the front of the Rajarajeshvara has a flat roof, as opposed to the pyramidal roofs of the northern style. The walls of the sanctum rise for two stories, with each story emphatically articulated by a large cornice. The interior was originally painted and portions of this decoration have recently been uncovered as sections of the over-painting were removed. The exterior walls are ornamented with niches, each of which holds a single statue, usually depicting a form of Shiva. Because the Rajarajeshvara's superstructure is not obscured by its decorative motifs, it forcefully ascends skyward and is topped by an octagonal dome-shaped capstone. This huge capstone is exactly the same size as the garbhagriha housed 13 stories directly below. It thus evokes the shrine a final time before the eye ascends to the point separating the worldly from the cosmic sphere above.

ART OF SOUTHEAST ASIA

With its high mountainous interior and dense vegetation, Southeast Asia's earliest human settlements naturally formed along the rivers and coastlines, facilitating both food production and trade. Additionally, the presence of rich mineral deposits allowed for the development of metallurgy. Bronze casting developed early in the region and the oldest bronze finds, located on the mainland, have been, with some disagreement, dated to 1500 BCE.

EARLY SOUTHEAST ASIA

Archaeological work at sites such as Ban Chiang in northeastern Thailand has uncovered a wide range of bronze tools and jewelry as well as finely decorated ceramics. Because its distinctive bronzework has been found as far afield as Java, the archaeological site of Dongson in northern Vietnam reveals evidence of short range ocean trade having developed shortly after 600 BCE. By the first century CE, these trade networks had expanded, and evidence Perhaps no sculpture is more representative of Hinduism than the statues of Shiva Nataraia, or Shiva as the Lord of Dance, a form perfected by sculptors under the royal patronage of the south Indian Chola dynasty during the late tenth to eleventh centuries. (For more Chola art, see FIG. 10-30.) The particularly striking Chola version of the Dancing Shiva was introduced and promoted primarily through the efforts of one woman, Queen Sembiyan Mahadevi. Donation records spanning over 60 years reveal that she was a major patron both of temple building and bronze casting and many of her projects involved increasing the prominence of Shiva Nataraja. It was not unusual for Hindu royal families to associate themselves with a particular aspect of a deity, and her efforts were instrumental in forging such a bond between Shiva Nataraja and the Chola state.

The dance of Shiva is a dance of cosmic proportions, signifying the universe's cycle of death and rebirth; it is also a dance for each individual, signifying the liberation of the believer through Shiva's compassion. In the iconography of the Nataraja, this sculpture shows Shiva with four arms dancing on the prostrate body of Apasmara, a dwarf figure who symbolizes "becoming" and whom Shiva controls (FIG. 10-31). Shiva's extended left hand holds a ball of fire; a circle of fire rings the god. The fire is emblematic of the destruction of samsara and the physical universe as well as the destruction of maya (illusion) and our ego-centered perceptions. Shiva's back right hand holds a drum; its beat represents the irrevocable rhythms of creation and destruction, birth and death. His front right arm shows the abhava "have no fear" mudra

(see "Mudras," page 308). The front left arm, gracefully stretched across his body with the hand pointing to his raised foot, signifies the promise of liberation.

The artist has rendered the complex pose with great clarity. The central axis, which aligns the nose, navel, and insole of the weightbearing foot, maintains the figure's equilibrium while the remaining limbs asymmetrically extend far to each side. Shiva wears a short loincloth, a ribbon tied above his waist, and delicately tooled ornaments. The scant clothing reveals his perfected form with its broad shoulders tapering to a supple waist. The jewelry is restrained and the detail does not detract from the beauty of the body. This work was made using the lost-wax method and is a testament to the extraordinary skill routinely exhibited by Chola artists.

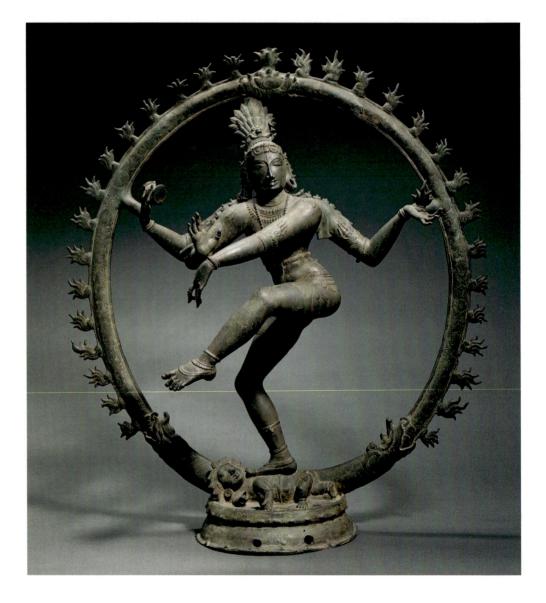

10-31 • SHIVA NATARAJA (SHIVA AS LORD OF THE DANCE)

South India. Chola dynasty, 11th century cE. Bronze, $437\!/\!s''\times40''$ (111.5 \times 101.65 cm). The Cleveland Museum of Art. Purchase from the J.H. Wade Fund (1930.331)

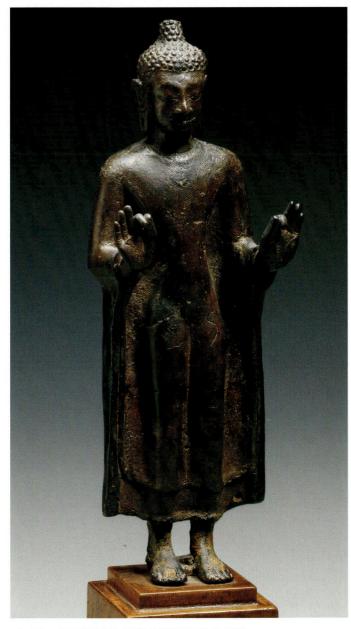

10-32 • STANDING DVARAVATI BUDDHA Mon Dvaravati style, from Thailand. 8th century CE. Bronze, 52" (1.3 m). The Nelson-Atkins Museum of Art, Kansas City, Missouri. Purchase: William Rockhill Nelson Trust (51-23)

for a kingdom, or collection of states, called Funan, in the southern reaches of the Southeast Asian peninsula is provided by thirdcentury CE Chinese sources. As long-distance trade increased, the Southeast Asians found themselves in a strategic and lucrative location for controlling and mediating exchanges between East Asia and points west. Having no shortage of locally produced and highly prized commodities, like hardwoods and spices, regional merchants were also active participants in this trade network. It was perhaps inevitable that over these centuries of trade, new ideas also arrived. By the sixth century CE there is ample evidence that Buddhism and Hinduism had taken firm root in the Mon kingdom of Dvaravati (modern-day Thailand and southern Myanmar) as well as in the Pre-Ankorian art of the Khmer (in modern Cambodia).

SIXTH TO THE NINTH CENTURY

As trade networks strengthened and expanded, Southeast Asian communities gained increased access to foreign goods and foreign ideas. The South Asian religions of Hinduism and Buddhism were of particular influence and gained popularity just as some of the earliest large-scale kingdoms were emerging. These religions supported and inspired emerging dynasties and became closely intertwined with early Southeast Asian concepts of kingship.

DVARAVATI-STYLE BUDDHA, THAILAND The Mon ethnic group was among the first in Southeast Asia to adopt Buddhism. Starting in the sixth century CE they organized into a kingdom whose name, Dvaravati, is preserved thanks to a cache of ritual coins unearthed from a stupa in Nakhon Pathom, Thailand. The archaeological remains from this kingdom are quite varied in form, media, and subject, which is not surprising, given that the Mon controlled this region until the Khmer gained influence in the tenth century.

Characteristic of the sculpture associated with early Mon sites are the standing Buddha images in bronze, such as this eighth century example (**FIG. 10-32**). Stylistically, this image exhibits the arched brows, outlined facial features, and curled hair reminiscent of the Mathura style; however, the double robe is flattened in a distinctive manner against the body with a capelike angularity at its base. The iconography is consistent with that seen in South Asia, but Dvaravati Buddhas almost invariably display the same *mudra* in both hands, in this case the *vitarka*. The reasons for this insistence on symmetry are not known, but it suggests a local preference. The typically small size of these images may indicate that they were inspired by portable icons carried along the trade routes.

HARIHARA, CAMBODIA Local preferences are exhibited clearly in a late seventh-century CE sculpture from Phnom Da, Cambodia. This pre-Angkorian Khmer work depicts a merged form of the Hindu gods Shiva and Vishnu, known as HARIHARA (FIG. 10-33). Such images are only rarely encountered in South Asia but in Southeast Asia, in the absence of a long history of sectarian differences between devotees of the two gods, this unified expression of Hindu divinity became extremely popular. Iconographically, the right side of the image depicts Shiva with his trident, matted hair, third eye and animal skins. The left half, correspondingly, represents Vishnu whose cylindrical crown, chakra (throwing disk), and fine garments indicate his identity. The artist has rendered this complex subject with great skill but in this early period the Khmer still did not fully trust the strength of the stone, so the sculptor cautiously linked the hands to the head with a supporting arch of stone.

BOROBUDUR, INDONESIA The mainland was not alone in transforming new ideas from abroad. The islands of Southeast Asia, and Java in particular, produced some of the earliest and grandest

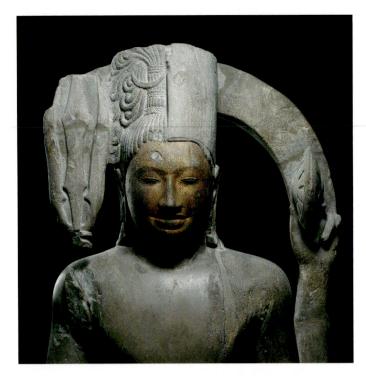

10-33 • HARIHARA

From Angkor Barei, Cambodia. Pre-Angkorian Khmer, 7th century CE. Sandstone, 68" (76 cm). Musée Guimet, Paris, France.

responses to imported Buddhist ideas. The remarkable structure of **BOROBUDUR** (**FIG. 10–34**) was built in its central Java location by the Shailendra dynasty about the year 800. It appears to have been the endpoint of a processional road that linked this site with the Buddhist sacred structures at Mendut and Pawon. Borobudur has characteristics typical of a stupa as well as those suggestive of a three dimensional *mandala*, or cosmic diagram, but many aspects of the structure's use are still poorly understood.

The monument itself rises more than 100 feet from ground level. This stepped pyramid of volcanic-stone blocks has five lower quadrilateral terraces that support three roughly circular terraces surmounted by a large bell-shaped stupa, itself ringed by 72 smaller openwork stupas. Each of the squared terraces is enclosed by a high wall bearing extensive relief sculpture and adorned with Buddha images in niches and small bell-shaped projections. The

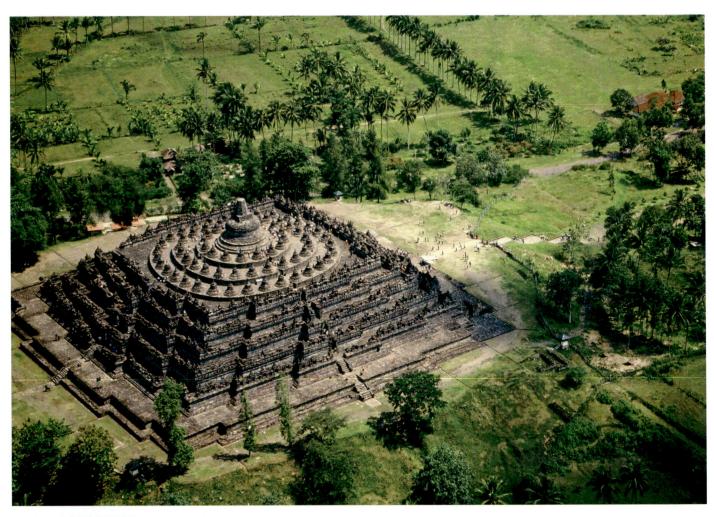

10-34 • BOROBUDUR Central Java, Magelang District, Indonesia. c. 800 cE. Aerial view. **Explore** the architectural panoramas of Borobudur on myartslab.com

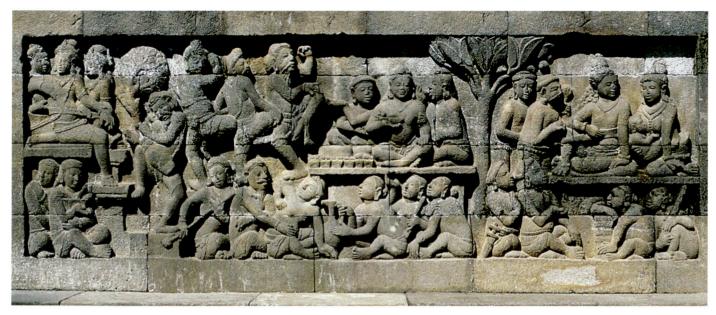

10-35 • SCENE OF DRUNKENNESS AND MODERATION Borobudur, east side. Central Java, Indonesia. 9th century CE.

This scene depicts a lesson from the Karmavibhanga on the rewards for moderation in food and drink. The figures on the upper right turn away from the scene of debauchery played out in front of them. In reward for this good judgment they are reborn as individuals with few diseases, indicated by the hearty couple surrounded by supplicants on the right side of the panel. The tree divides the cause from the effect.

decoration on the lowest level was hidden for centuries because, shortly after the monument was built, it was bolstered by a heavy architectural foot in order to stop the structure from spreading as the dirt in its core settled under the weight of the stone. These **bas-reliefs** were exposed and carefully photographed during the restoration of the monument begun in 1975. As with all sculpture at the site, the figures are elegant with full rounded bodies whose smooth forms are sporadically accentuated by delicately carved adornments.

The decorative program of these relief carvings displays a carefully calculated arrangement that moves from pragmatic moral lessons at the base up to more abstract religious ideas at the summit. The lowest gallery, which had been covered by the foot, depicts instructive scenes of karmic reward and punishment (FIG. 10-35). As one circumambulates to the next set of terraces, scenes of the Buddha's past lives and other moral tales share space with the life story of Shakyamuni Buddha. Moving upward, terraces four and five visually recount the story of Sudhana, an ordinary man who seeks personal enlightenment, eventually achieving it with the guidance of a bodhisattva. At this point visitors exit to the upper three circular terraces whose rows of stupas and wide vista may be a metaphor for the enlightened state. Each of these perforated stupas holds a seated Buddha except for the large, central stupa, whose surface is solid. The placement of Buddha images on the monument and their differing mudras corresponds to the arrangement found in some Buddhist mandalas and points to another layer of meaning in this exceptionally complex architectural plan.

LORO JONGGRANG, INDONESIA Slightly later than Borobudur, but clearly influenced by its example, is the extensive site of **LORO JONGGRANG** in Prambanan, Java (**FIG. 10-36**). Although not a stepped pyramid, this Hindu monument employs a concentric plan and shares Borobudur's repetition of bell-shaped forms. This temple complex was begun in the mid ninth century by the Sanjaya dynasty, regional rivals to the Shailendra, under the reign of Rakai Pikatan. It was further expanded by later kings.

The buildings in the complex are arranged around the central temple dedicated to Shiva. The central sacred area, housing the biggest temples, is enclosed in an outer wall, beyond which the remains of 224 shrines are arrayed in four concentric squares. Most of these shrines are now badly damaged and their function is not clear, but some have speculated that their locations may reflect the social status of their donors. The towering central structure stands almost 155 feet high and is flanked by two somewhat smaller structures dedicated to Vishnu and Brahma, each just over 108 feet in height. The primary image of Shiva is an anthropomorphic representation rather than a linga. Its east-facing chamber is surrounded by subsidiary shrines aligned to the other cardinal directions housing images of deities associated with Shiva. The flanking temples have only one chamber each, which contain beautifully carved images of Vishnu and Brahma respectively. A row of three smaller chambers is located just across from the entrances to the main temples. It is believed that these buildings were dedicated to the mounts (vahana) of the three gods, but only the image of Shiva's mount, the bull Nandi, has survived. All the temples are raised on high plinths decorated with narrative scenes in relief.

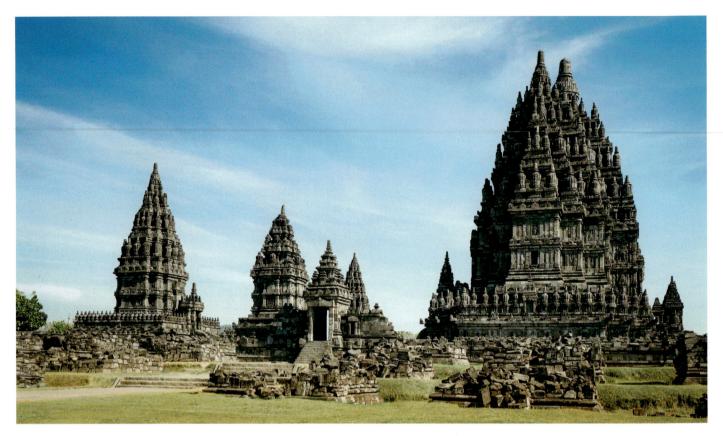

10-36 • LORO JONGGRANG Prambanan, Central Java, Indonesia. 9th century ce.

A portion of these reliefs depicts scenes from the *Ramayana*. This Hindu epic was known in Indonesia from an early date and aspects of the story were adjusted to better suit the needs and expectations of its Southeast Asian audience. Some of this local influence can be seen in a relief (**FIG. 10–37**) portraying the moment the wicked demon king Ravana (Rawana) abducts Sita, the wife of the hero Rama. Ravana, disguised as a Brahmin, seizes Sita in the midst of a Javanese village and in the process overturns a number of objects as the witnesses to the event react in horror and

surprise. The wildlife in this panel exploit the distraction, a dog in the foreground grabs at food fallen from an overturned pot, a rat can be seen sneaking into the storehouse, and a monkey reaches for food held by a seated man. The addition of these details, not mentioned in the text, reinforce the shamefully animalistic nature of Ravana's actions, which ultimately lead to his own destruction. Typical for the art of Java in this period the panel is full of activity as each event is accompanied by a host of attendants, onlookers, and references to the natural world.

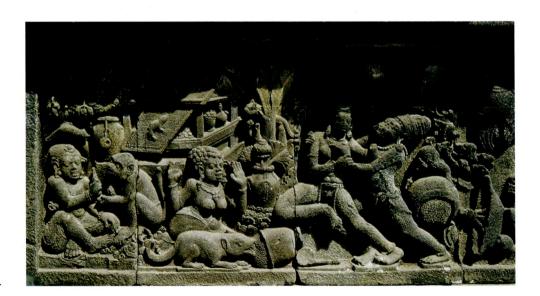

10-37 • **ABDUCTION OF SITA** Illustration of the *Ramayana*, relief 13, scene 2, Chandi Shiva, Prambanan, Central Java, Indonesia. 9th century ce.

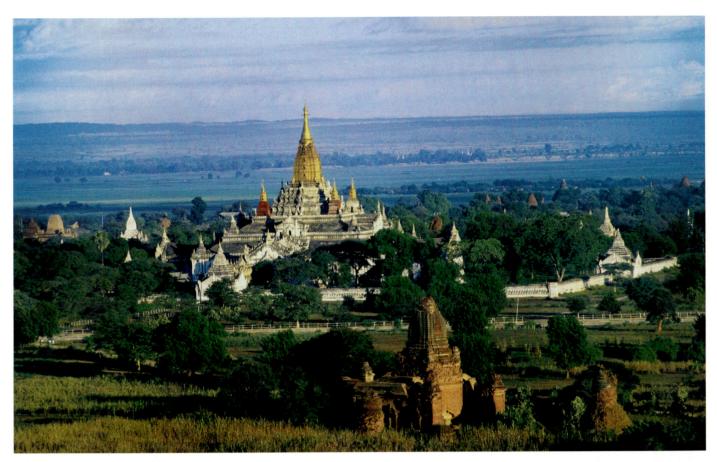

^{10-38 •} ANANDA TEMPLE Bagan, Mandalay Division, Myanmar. 11th century ce. Height c. 30" (76 cm).

TENTH THROUGH TWELFTH CENTURIES

By the tenth through twelfth centuries the powerful kingdoms in Angkor and Bagan were reaching their peak. Their great wealth and success found expression in innovative forms of architectural construction whose ambitious design and grand scale took earlier forms of Southeast Asian construction to new heights.

ANANDA TEMPLE, MYANMAR King Anawrahta came to power in 1044, uniting the disparate regional rulers in northern Myanmar under his rule and the local gods (*nats*) under Bud-dhism. Lavish temple-building projects were not just a means for the king to demonstrate his legitimacy and accrual of good *karma* (the concept that one's deeds, good or bad, eventually produce correspondingly positive or negative consequences), it was also seen as means of ensuring the welfare of state interests and public well-being. The focus of this fervent generosity was the Buddhist monastic order based near the capital in Bagan (also called Pagan). Over the course of generations of public and royal patronage this semiarid valley came to house several thousand spectacular Buddhist structures, large and small, in various states of repair.

Among these, one of the grandest is the **ANANDA TEM-PLE** (**FIG. 10-38**), built in 1105 by King Kyanzittha, Anawrahta's adopted son and eventual successor. According to the legends, the head monk at Bagan, Shin Arahan, introduced the king to eight monks from India who were seeking support abroad. The ensuing discussions inspired the king to undertake a major act of patronage, which culminated in the construction of the Ananda Temple. The unique architectural plan of this temple is rather complex but it can be envisioned as four temples placed up against the sides of a massive square-based stupa, which rises to almost 175 feet. The temples each face a cardinal direction and house large Buddha images covered in gold leaf, most of which have been renovated or replaced over the centuries. The walls of these temples have openings that make way for two covered circumambulation pathways. While most of the sculpture, in niches, along these pathways remain, almost none of the painting still exists. The exterior is embellished with rising spires and flamelike decoration over the windows and doors. The central roof rises to the main tower in five tiers. These are decorated with horizontal bands of inset glazed ceramic plaques, many of which display scenes from the Buddha's past lives.

Of particular note are two gilded lacquer images in postures of reverence flanking the Buddha image in the west-facing shrine. These images are believed to depict **KING KYANZITTHA** (**FIG. 10-39**), shown in elaborate attire, and his chief monk Shin Arahan, bald and in simple robes. The details of these figures have been somewhat effaced due to layers of gold leaf, but this accretion may also have protected the lacquer from decay.

10-39 • PORTRAIT OF KING KYANZITTHA West shrine, Ananda Temple, Bagan. 11th century cE. Gilded lacquer. Height 30" (76 cm).

The Ananda is just one grand temple among many in Bagan. Unfortunately, misguided attempts by the government in Myanmar to restore these structures has resulted in conjectural and inaccurate renovations that have hidden or destroyed much of the early material.

ANGKOR WAT, CAMBODIA In 802, the Khmer king Jayavarman II, newly returned from Java, climbed Mount Kulen in what is now northwestern Cambodia. He was accompanied on this trip by a Brahmin who performed a ritual on the mountaintop that marked a special relationship between Jayavarman II and the Hindu god Shiva.

Thereafter, Jayavarman II and subsequent rulers in his lineage claimed the title of "god-king" (*devaraja*). The special religious status indicated by this designation was further solidified through architectural projects that invoked divine symbolism on behalf of the ruler. While Jayavarman II had ascended an actual mountain, his descendants opted to construct elaborate temple mountains near the major urban centers of Roluos and Angkor. These immense structures recalled the sacred mountains on which the gods dwell and marked the political and religious center of the Khmer empire.

Among the grandest and most unusual of these structures is Suryavarman II's temple mountain, known today as **ANGKOR WAT (FIG. 10-40)**. Having come to power after a period of turmoil, Suryavarman II (r. 1113–1150), unlike most of his predecessors, chose to devote himself to the god Vishnu rather than to

10-40 • ANGKOR WAT Angkor, Cambodia. 12th century CE.

Explore the architectural panoramas of Angkor Wat on myartslab.com

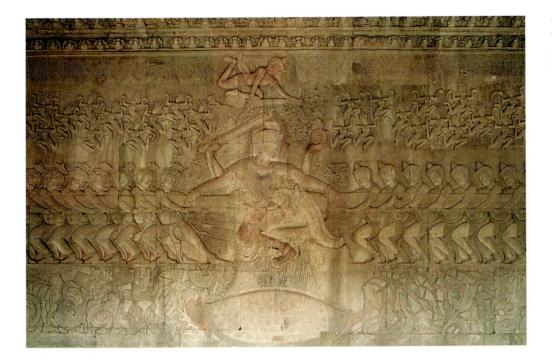

Shiva. He further broke with tradition by having his temple face west to the setting sun, a direction which had funerary associations.

The temple is a massive structure, comprised of three concentric galleries that frame a stepped pyramid crowned by five delicately tapered towers. This entire structure is surrounded by lakelike moats over 820 feet wide and crossed by walkways adorned with balustrades shaped like multi-headed serpents. The inner walls of the three outer galleries contain elaborate bas-relief sculptures, many of which depict scenes from the great Hindu epics or glorified depictions of the king.

One relief on the east side of the outer gallery portrays a Hindu story known as the Churning of the Ocean of Milk

(FIG. 10-41). In this tale, set in a time before the world was fully formed, Vishnu orchestrates the production of the elixir of immortality. He achieves this by wrapping the cosmic serpent around a great mountain emerging from the sea. Then by pulling on the serpent, the gods, working with their enemies, the asura, manage to churn up the elixir of immortality from the ocean's depths. This relief may hold a clue to understanding the monument as a whole. With its mountainlike towers, broad moat, and serpent balustrades, the entire complex at Angkor Wat parallels the setting of the legend and may speak to Suryavarman II's hopes for gaining a sort of immortality through his own special union with Vishnu.

THINK ABOUT IT

- 10.1 Consider the use of rock-cut architecture. What were the benefits and drawbacks to this architectural technique? How did it influence, and how was it influenced, by built architecture? Give examples.
- 10.2 Select one architectural work from the chapter and one work of sculpture. Explain how either Buddhist or Hindu ideas are expressed through their decoration, form, or iconography.
- **10.3** Describe the typical form of Indian temples, northern and southern. Contrast the stupa and the temple directly, paying attention to specific building features and how they are used.
- 10.4 How do sites like Mamallapuram, the Ananda Temple, and Angkor Wat help legitimize the authority of the ruler?

CROSSCURRENTS

FIG. 10-24

Water symbolism occurs frequently in the art of South and Southeast Asia. Consider the way practical concerns over climate and commerce may have shaped the way this imagery was understood. Why would such symbolism be appropriate for royally sponsored sculpture and what was its significance?

Study and review on myartslab.com

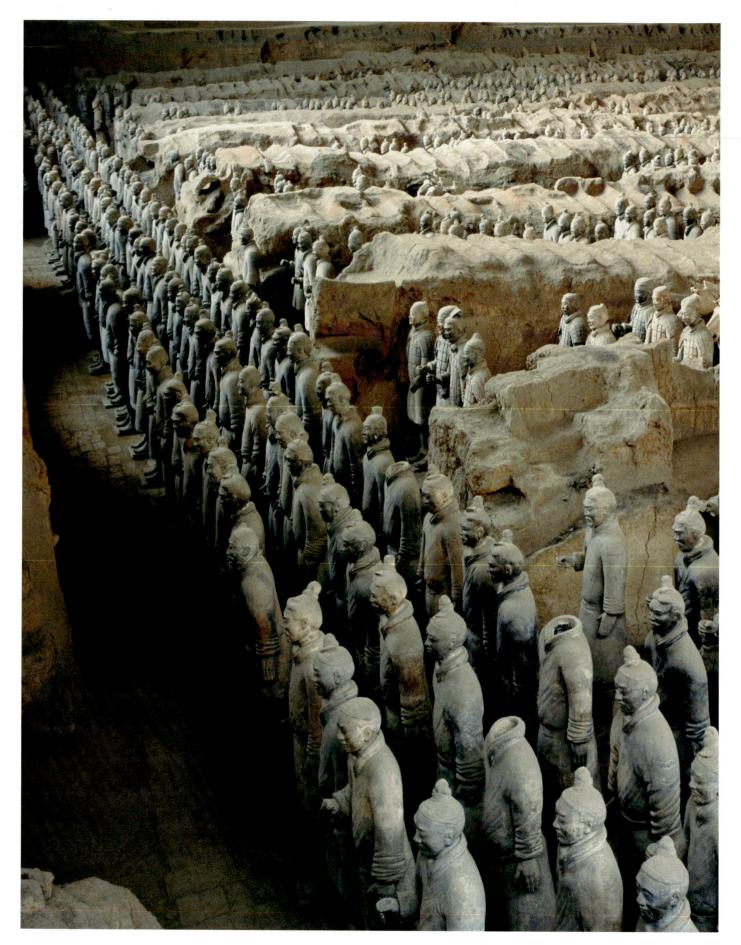

11-1 • CERAMIC SOLDIERS From the mausoleum of Emperor Shihuangdi, Lintong, Shaanxi. Qin dynasty, c. 210 BCE. Earthenware, life-size.

Chinese and Korean Art before 1279

As long as anyone could remember, the huge mound in Shaanxi Province in northern China had been part of the landscape. No one dreamed that an astonishing treasure lay beneath the surface until one day in 1974 peasants digging a well accidentally brought to light the first hint of riches. When archaeologists began to excavate, they were stunned by what they found: a vast underground army of some 8.000 life-size terra-cotta soldiers with 100 life-size ceramic horses standing in military formation, facing east, supplied with weapons, and ready for battle (FIG. 11-1). For more than 2,000 years, while the tumultuous history of China unfolded overhead, they had guarded the tomb of Emperor Shihuangdi, the ruthless ruler who first united the states of China into an empire, the Qin. In ongoing excavations at the site, additional bronze carriages and horses were found, further evidence of the technology and naturalism achieved by artisans during Qin Shihuangdi's reign. The tomb mound itself has not been excavated.

China has had a long-standing fascination with antiquity, but archaeology is a relatively young discipline there. Only since the 1920s have scholars methodically dug into the layers of history at thousands of sites across the country, yet so much has been unearthed that ancient Chinese history has been rewritten many times. The archaeological record shows that Chinese civilization arose several millennia ago, and was distinctive for its early advances in ceramics and metalwork, as well as for the elaborate working of jade. Early use of the potter's wheel, mastery of reduction firing, and the early invention of high-fired stoneware and porcelain distinguish the technological advancement of Chinese ceramics. Highly imaginative bronze castings and proficient techniques of mold making characterize early Chinese metalworking. Early attainments in jade reflect a technological competence with rotary tools and abrasion, as well as an aesthetic passion for the subtleties of shape, proportion, and surface texture.

Archaeology has supplemented our understanding of historically appreciated Chinese art forms. These explored human relationships and ethical ideals, exemplifying Confucian values and teaching the standards of conduct that underlie social order. Later, China also came to embrace the Buddhist tradition from India. In princely representations of Buddhist divinities and in sublime and powerful, but often meditative, figures of the Buddha, China's artists presented the divine potential of the human condition. Perhaps the most distinguished Chinese tradition is the presentation of philosophical ideals through the theme of landscape. Paintings simply in black ink, depictions of mountains and water, became the ultimate artistic medium for expressing the vastness, abundance, and endurance of nature.

Chinese civilization radiated its influence throughout East Asia. Chinese learning repeatedly stimulated the growth of culture in Korea, which in turn transmitted influence to Japan.

LEARN ABOUT IT

- **11.1** Trace the developing period and regional styles in the art of early China and Korea and assess the relationship between Chinese and Korean traditions.
- **11.2** Explore the principal themes and subjects of the diverse artistic production of China and Korea from the Neolithic period through the thirteenth century CE.
- **11.3** Probe the relationship between the history of art and the evolving Confucian, Daoist, and Buddhist traditions of China and Korea.
- **11.4** Discuss the development of traditional Chinese landscape painting and learn the vocabulary and principles that allow us to characterize, interpret, and discuss it.

((•• Listen to the chapter audio on myartslab.com

THE MIDDLE KINGDOM

Among the cultures of the world, China is distinguished by its long, uninterrupted development, now traced back some 8,000 years. From Qin (pronounced "chin") comes our name for the country that the Chinese call the Middle Kingdom, the country in the center of the world. Present-day China occupies a large landmass in the center of east Asia, covering an area slightly larger than the continental United States. Within its borders lives one-fifth of the human race.

The historical and cultural heart of China is the land watered by its three great rivers, the Yellow (Huang Ho), the Yangzi, and the Xi (MAP 11-1). The Qinling Mountains divide Inner China into north and south, regions with strikingly different climates, cultures, and historical fates. In the south, the Yangzi River flows through lush green hills to the fertile plains of the delta. Along the southern coastline, rich with natural harbors, arose China's port cities, the focus of a vast maritime trading network. The Yellow River, nicknamed "China's Sorrow" because of its disastrous floods, winds through the north. The north country is a dry land of steppe and desert, hot in the summer and lashed by cold winds in the winter. Over its vast and vulnerable frontier have come the nomadic invaders that are a recurring theme in Chinese history, but caravans and emissaries from Central Asia, India, Persia, and, eventually, Europe also crossed this border.

NEOLITHIC CULTURES

Early archaeological evidence had led scholars to believe that agriculture, the cornerstone technology of the Neolithic period, made its way to China from the ancient Near East. More recent findings, however, suggest that agriculture based on rice and millet arose independently in east Asia before 5000 BCE and that knowledge of Near Eastern grains followed some 2,000 years later. One of the clearest archaeological signs of Neolithic culture in China is evidence of the vigorous emergence of towns and cities. At Jiangzhai, near modern Xi'an, for example, the foundations of more than 100 dwellings have been discovered surrounding the remains of a communal center, a cemetery, and a kiln. Dated to about 4000 BCE, the ruins point to the existence of a highly developed early society. Elsewhere, the foundations of the earliest-known Chinese palace have been uncovered and dated to about 2000 BCE.

PAINTED POTTERY CULTURES

In China, as in other places, distinctive forms of Neolithic pottery identify different cultures. One of the most interesting objects thus far recovered is a shallow red **BOWL** with a turned-out rim (**FIG. 11-2**). Found in the village of Banpo near the Yellow River, it was crafted sometime between 5000 and 4000 BCE. The bowl is an artifact of the Yangshao culture, one of the most important of the so-called Painted Pottery cultures of Neolithic China. Although the potter's wheel had not yet been developed, the bowl is perfectly

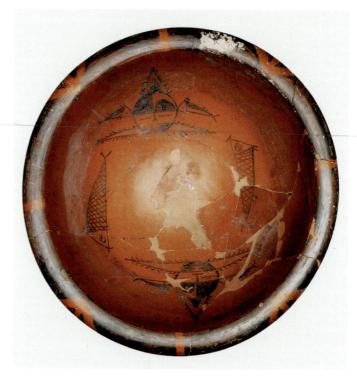

11–2 • BOWL From Banpo, near Xi'an, Shaanxi. Neolithic period, Yangshao culture, 5000–4000 BCE. Painted pottery, height 7" (17.8 cm). Banpo Museum.

round and its surfaces are highly polished, bearing witness to a distinctly advanced technology. The decorations are especially intriguing. There are markings on shards from this location that may be evidence of the beginnings of writing in China, which was fully developed by the time the first definitive examples appear during the second millennium BCE, in the later Bronze Age.

Inside the bowl, a pair of stylized fish suggests that fishing was an important activity for the villagers. The images between the two fish represent human faces flanked by fish, one on each side. Although there is no certain interpretation of the image, it may be a depiction of an ancestral figure who could assure an abundant catch, since the worship of ancestors and nature spirits was a fundamental element of later Chinese beliefs.

LIANGZHU CULTURE

Banpo lies near the great bend in the Yellow River, in the area traditionally regarded as the cradle of Chinese civilization, but archaeological finds have revealed that Neolithic cultures spread over a far broader geography. Recent excavations in sites more than 800 miles away, near Hangzhou Bay, in the southeastern coastal region, have uncovered human and animal images—often masks or faces—more than 5,000 years old from the Liangzhu culture (**FIG. 11-3**). Large, round eyes, a flat nose, and a rectangular mouth protrude slightly from the background pattern of wirelike lines. Above the forehead, a second, smaller face grimaces from under a huge headdress. The upper face may be human, perhaps riding the animal figure below. The drawing reproduces one of

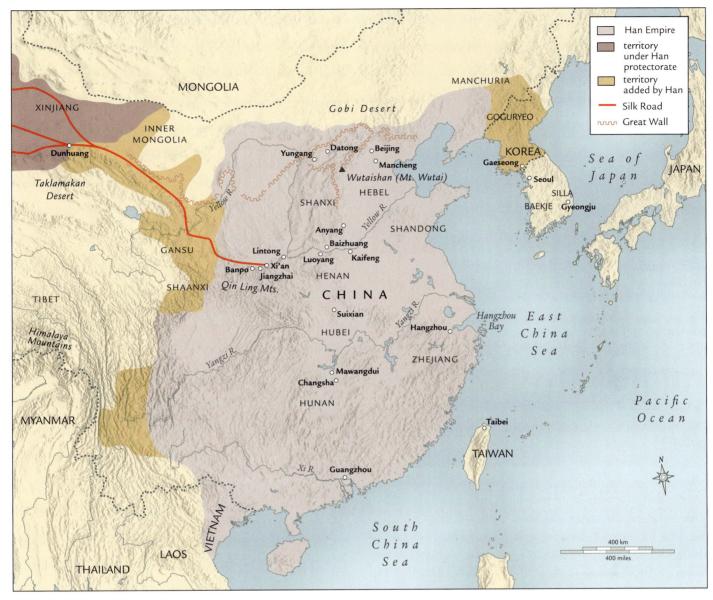

MAP 11-1 • CHINA AND KOREA

The map shows the borders of contemporary China and Korea. Bright-colored areas indicate the extent of China's Han dynasty (206 BCE-220 CE).

11-3 • DRAWING OF THE MASK DECORATION ON A JADE CONG Neolithic period, Liangzhu culture, 3200–2200 BCE.

11-4 • CONG

Neolithic period, Liangzhu culture, 3200–2200 BCE. Jade, height 1% × width 2%" (5 × 6.6 cm). Shanghai Museum.

The *cong* is one of the most prevalent and mysterious of early Chinese jade shapes. Originating in the Neolithic period, it continued to play a prominent role in burials through the Shang and Zhou dynasties. Many experts believe the *cong* was connected with the practice of contacting the spirit world.

eight masks that were carved in low relief on the outside of a large jade cong, an object resembling a cylindrical tube encased in a rectangular block. Another **CONG** (**FIG. 11-4**), also from Liangzhu, bears a lustrous, smooth finish and similar—if more stylized—mask motifs. Both *congs* were found near the remains of persons buried with what appear to be sets of numerous jade objects.

The intricacy of these carvings documents the technical sophistication of the jade-working Liangzhu culture, which seems to have emerged around 3300 BCE. Jade, a stone cherished by the Chinese throughout their history, is extremely hard and is difficult to carve. Liangzhu artists must have used sand as an abrasive to slowly grind the stone down; modern artisans marvel at the refinement and virtuosity of the work they produced.

The meaning of the masklike image in FIGURE 11-3 is open to interpretation. Its combination of human and animal features seems to show how the ancient Chinese imagined supernatural beings, either deities or dead ancestors. Similar masks later formed the primary decorative motif of Bronze Age ritual objects. Still later, Chinese historians began referring to the ancient mask motif as **taotie**, but the motif's original meaning had already been lost. The jade carving here seems to be a forerunner of this most central and mysterious image.

BRONZE AGE CHINA

China entered its Bronze Age in the second millennium BCE. As with agriculture, scholars at first theorized that the technology had been imported from the Near East. Archaeological evidence now makes clear, however, that bronze casting using the **piece-mold** **casting** technique arose independently in China, where it attained an extraordinary level of sophistication (see "Piece-Mold Casting," opposite).

SHANG DYNASTY

Traditional Chinese histories tell of three Bronze Age dynasties: the Xia, the Shang, and the Zhou. Experts at one time tended to dismiss the Xia and Shang as legendary, but twentieth-century archaeological discoveries fully established the historical existence of the Shang (c. 1700–1100 BCE) and point strongly to the historical existence of the Xia as well.

Shang kings ruled from a succession of capitals in the Yellow River Valley, where archaeologists have found walled cities, palaces, and vast royal tombs. The Shang were surrounded by many other states—some rivals, others clients—and their culture spread widely. Society seems to have been highly stratified, with a ruling group that had the bronze technology needed to make weapons and ritual vessels. They maintained their authority in part by claiming power as intermediaries between the supernatural and human realms. The chief Shang deity, Shangdi, may have been a sort of "Great Ancestor." It is thought that nature and fertility spirits were also honored, and that regular sacrifices were thought necessary to keep the spirits of dead ancestors vital so that they might help the living.

Shang priests communicated with the supernatural world through oracle bones. An animal bone or piece of tortoiseshell was inscribed with a question and heated until it cracked; the crack was then interpreted as an answer. Oracle bones, many of which have been recovered and deciphered, contain the earliest known form of Chinese writing, a script fully recognizable as the ancestor of the system still in use today (see "Chinese Characters," page 337).

RITUAL BRONZES Shang tombs reveal a warrior culture of great splendor and violence. Many humans and animals were sacrificed to accompany the deceased into death. In one tomb, for example, chariots were found with the skeletons of their horses and drivers; in another, dozens of human skeletons lined the approaches to the central burial chamber. The tombs contain hundreds of jade, ivory, and lacquer objects, gold and silver ornaments, and bronze vessels. The enormous scale of Shang burials illustrates the great wealth of the civilization and the power of a ruling class able to consign such great quantities of treasure to the earth. It also documents this culture's reverence for the dead.

Bronze vessels are the most admired and studied of Shang artifacts. Like oracle bones and jade objects, they were connected with ritual practices, serving as containers for offerings of food and wine. A basic repertoire of about 30 shapes evolved. Some shapes derive from earlier pottery forms, while others seem to reproduce wooden containers. Still others are highly sculptural and take the form of fantastic composite animals.

One functional shape, the **fang ding**, a rectangular vessel standing on four elongated legs, was used for food offerings. Early

TECHNIQUE | Piece-Mold Casting

The early piece-mold technique for bronze casting is different from the lost-wax process developed in the ancient Mediterranean and Near East. Although we do not know the exact steps ancient Chinese artists followed, we can deduce the general procedure for casting a vessel.

First, a model of the bronze-to-be was made of clay and dried. Then, to create a mold, damp clay was pressed onto the model; after the clay mold dried, it was cut away in pieces, which were keyed for later reassembly and then fired. The original model itself was shaved down to serve as the core for the mold. After this, the pieces of the mold were reassembled around the core and held in place by bronze spacers, which locked the core in position and ensured an even casting space around the core. The reassembled mold was then covered with another layer of clay, and a sprue, or pouring duct, was cut into the clay to receive the molten metal. A riser duct may also have been cut to allow the hot gases to escape. Molten bronze was then poured into the mold. When the metal cooled, the mold was broken apart to reveal a bronze copy of the original clay model. Finely cast relief decoration could be worked into the model or carved into the sectional molds, or both. Finally, the vessel could be burnished—a long process that involved scouring the surface with increasingly fine abrasives.

The vessel shown here is a *fang ding*. A *ding* is a ceremonial cooking vessel used in Shang rituals and buried in Shang tombs. The Zhou people also made, used, and buried *ding* vessels.

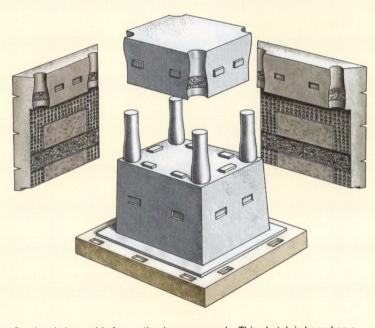

Sectional clay molds for casting bronze vessels. This sketch is based on a vessel in the Zhengzhou Institute of Cultural Relics and Archaeology.

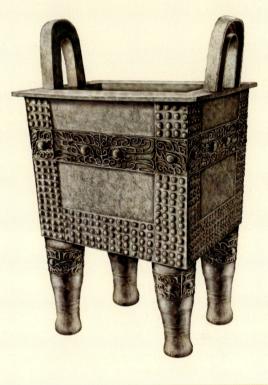

examples (see "Piece-Mold Casting," above) featured decoration of raised bosses and masklike (taotie) motifs in horizontal registers on the sides and the legs. This late Shang example, one of hundreds of vessels recovered from the royal tombs near Yin, the last of the Shang capitals (present-day Anyang), is extraordinary for its size. Weighing nearly 2,000 pounds, it is the largest Shang ding vessel thus far recovered. A ritual pouring vessel, called a GUANG (FIG. 11-5), shows a highly sculptural rendition of animal forms. The pouring spout and cover take the form of the head and body of a tiger, while the rear portion of the vessel and cover is conceived as an owl. Overall geometric decoration combines with suggestive zoomorphic forms. Such images seem to be related to the hunting life of the Shang, but their deeper significance is unknown. Sometimes strange, sometimes fearsome, Shang creatures seem always to have a sense of mystery, evoking the Shang attitude toward the supernatural world.

ZHOU DYNASTY

Around 1100 BCE, the Shang were conquered by the Zhou from western China. During the Zhou dynasty (1100–221 BCE) a feudal society developed, with nobles related to the king ruling over numerous small states. (Zhou nobility are customarily ranked in English by such titles as duke and marquis.) The supreme deity became known as Tian, or Heaven, and the king ruled as the Son of Heaven. Later Chinese ruling dynasties continued to follow the belief that imperial rule emanated from a mandate from Heaven.

The first 300 years of this longest-lasting Chinese dynasty were generally stable and peaceful. In 771 BCE, however, the Zhou suffered defeat in the west at the hands of a nomadic tribe. Although they quickly established a new capital to the east, their authority had been crippled, and the later Eastern Zhou period was a troubled one. States grew increasingly independent, giving only nominal allegiance to the Zhou kings. Smaller states were

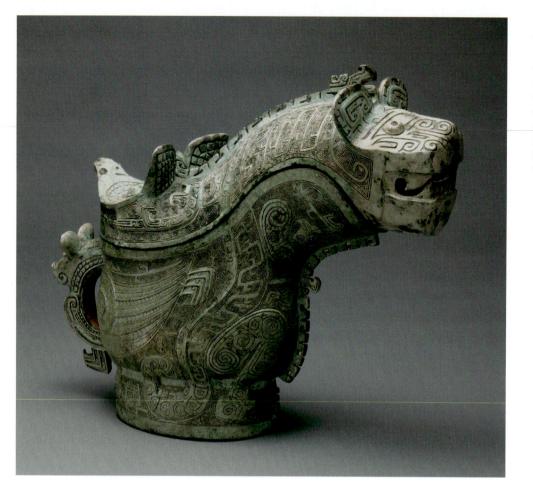

11-5 • COVERED RITUAL WINE-POURING VESSEL (GUANG) WITH TIGER AND OWL DÉCOR

Shang dynasty, 13th century BCE. Cast bronze, height with cover 9³/₄" (25 cm), width including handle 12³/₈" (31.5 cm). Arthur M. Sackler Museum, Harvard Art Museum, Cambridge, Massachusetts. Bequest of Grenville L. Winthrop (1943.52.103)

swallowed up by their larger neighbors. During the time historians call the Spring and Autumn period (722–481 BCE), 10 or 12 states, later reduced to seven, emerged as powers. The ensuing Warring States period (481–221 BCE) saw intrigue, treachery, and increasingly ruthless warfare.

Against this background of social turmoil, China's great philosophers arose—such thinkers as Confucius, Laozi, and Mozi. Traditional histories speak of China's "one hundred schools" of philosophy, indicating a shift of focus from the supernatural to the human world. Nevertheless, elaborate burials on an even larger scale than before reflected the continuation of traditional beliefs.

BRONZE BELLS Ritual bronze objects continued to play an important role during the Zhou dynasty, and new forms developed. One of the most spectacular recent discoveries is a carillon of 65 bronze components, mostly bells arranged in a formation 25 feet long (FIG. 11-6), found in the tomb of Marquis Yi of the state of Zeng. Each bell is precisely calibrated to sound two tones—one when struck at the center, another when struck at a corner. They are arranged in scale patterns in a variety of registers, and several musicians would have moved around the carillon, striking the bells in the appointed order.

Music may well have played a part in rituals for communicating with the supernatural, for the *taotie* typically appears on the front and back of each bell. The image is now much more intricate and stylized, a complexity made possible in part by the more refined lost-wax casting process (see "Lost-Wax Casting," page 418), which had replaced the older piece-mold technique. The marquis, who died in 433 BCE, must have considered music important, for among the more than 15,000 objects recovered from his tomb were many musical instruments. Zeng was one of the smallest and shortestlived states of the Eastern Zhou, but the contents of this tomb, in quantity and quality, attest to its high cultural level.

THE CHINESE EMPIRE: QIN DYNASTY

Toward the middle of the third century BCE, the state of Qin launched military campaigns that led to its triumph over the other states by 221 BCE. For the first time in its history, China was united under a single ruler. This first emperor of Qin, Shihuangdi, a man of exceptional ability, power, and ruthlessness, was fearful of both assassination and rebellion. Throughout his life, he sought ways to attain immortality. Even before uniting China, he began his own mausoleum at Lintong, in Shaanxi Province. This project continued throughout his life and after his death, until rebellion abruptly ended the dynasty in 206 BCE. Since that time, the mound over the mausoleum has always been visible, but not until an accidental discovery in 1974 was its army of terra-cotta soldiers and horses even imagined (see FIG. 11–1). Modeled from clay with individualized

ART AND ITS CONTEXTS | Chinese Characters

Each word in Chinese is represented by its own unique symbol, called a character. Some characters originated as **pictographs**, images that mean what they depict. Writing reforms over the centuries have often disguised the resemblance, but if we place modern characters next to their ancestors, the pictures come back into focus:

	water	horse	moon	child	tree	mountain
Ancient	12	S.	D	9	Ж	M
Modern	水	馬	月	千	木	e.h.
Other characters are ideographs, pictures that represent abstract						

Other characters are ideographs, pictures that represent abstrac concepts or ideas:

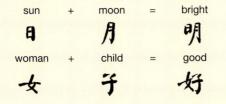

Most characters were formed by combining a radical, which gives the field of meaning, with a phonetic, which originally hinted at pronunciation. For example, words that have to do with water have the character for "water" \checkmark abbreviated to three strokes \checkmark as their radical. Thus "to bathe," \checkmark pronounced *mu*, consists of the water radical and the phonetic \bigstar , which by itself means "tree" and is also pronounced *mu*. Here are other "water" characters. Notice that the connection to water is not always literal.

These phonetic borrowings took place centuries ago. Many words have shifted in pronunciation, and for this and other reasons there is no way to tell how a character is pronounced or what it means just by looking at it. While at first this may seem like a disadvantage, in the case of Chinese it is advantageous. Spoken Chinese has many dialects. Some are so far apart in sound as to be virtually different languages. But while speakers of different dialects cannot understand each other, they can still communicate through writing, for no matter how they say a word, they write it with the same character. Writing has thus played an important role in maintaining the unity of Chinese civilization through the centuries.

faces and meticulously rendered uniforms and armor and then fired, the figures claim a prominent place in the great tradition of Chinese ceramic art. Literary sources suggest that the tomb itself, which has not yet been opened, reproduces the world as it was known to the Qin, with stars overhead and rivers and mountains below. Thus did the tomb's architects try literally to ensure that the underworld—the world of souls and spirits—would match the human world.

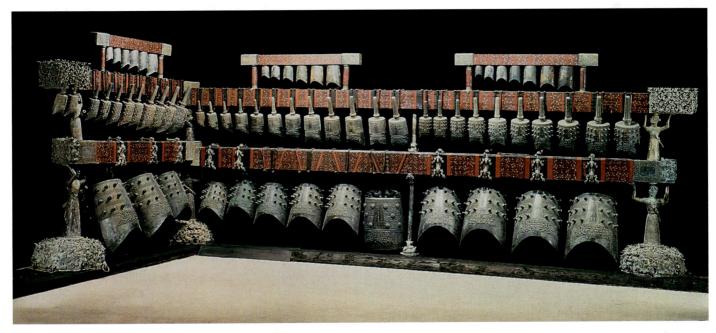

11-6 • SET OF BELLS

From the tomb of Marquis Yi of Zeng, Suixian, Hubei. Zhou dynasty, 433 BCE. Bronze, with bronze and timber frame, frame height 9' (2.74 m), length 25' (7.62 m). Hubei Provincial Museum, Wuhan.

ART AND ITS CONTEXTS | Daoism

Daoism is an outlook on life that brings together many ancient ideas regarding humankind and the universe. Its primary text, a slim volume called the *Daodejing (The Way and Its Power)*, is ascribed to the Chinese philosopher Laozi, who is said to have been a contemporary of Confucius (551–479 BCE). Later, a philosopher named Zhuangzi (369–286 BCE) explored many of the same ideas in a book that is known simply by his name: *Zhuangzi*. Together the two texts formed a body of ideas that crystallized into a school of thought during the Han period.

A *dao* is a way or path. The Dao is the Ultimate Way, the Way of the universe. The Way cannot be named or described, but it can be hinted at. It is like water. Nothing is more flexible and yielding, yet water can wear down the hardest stone. Water flows downward, seeking the lowest ground. Similarly, a Daoist sage seeks a quiet life, humble and hidden, unconcerned with worldly success. The Way is great precisely because it is small. The Way may be nothing, yet nothing turns out to be essential. To recover the Way, we must unlearn. We must return to a state of nature. To follow the Way, we must practice *wu wei* (nondoing). "Strive for nonstriving," advises the *Daodejing*.

All our attempts at asserting ourselves, at making things happen, are like swimming against a current and are thus ultimately futile, even harmful. If we let the current carry us, however, we will travel far. Similarly, a life that follows the Way will be a life of pure effectiveness, accomplishing much with little effort.

It is often said that the Chinese are Confucians in public and Daoists in private, and the two approaches do seem to balance each other. Confucianism is a rational political philosophy that emphasizes propriety, deference, duty, and self-discipline. Daoism is an intuitive philosophy that emphasizes individualism, nonconformity, and a return to nature. If a Confucian education molded scholars outwardly into responsible, ethical officials, Daoism provided some breathing room for the artist and poet inside.

Qin rule was harsh and repressive. Laws were based on a totalitarian philosophy called legalism, and all other philosophies were banned, their scholars executed, and their books burned. Yet the Qin also established the mechanisms of centralized bureaucracy that molded China both politically and culturally into a single entity. Under the Qin, the country was divided into provinces and prefectures, the writing system and coinage were standardized, roads were built to link different parts of the country with the capital, and battlements on the northern frontier were connected to form the Great Wall. To the present day, China's rulers have followed the administrative framework first laid down by the Qin.

HAN DYNASTY

The commander who overthrew the Qin became the next emperor and founded the Han dynasty (206 BCE–220 CE). During this period China enjoyed peace, prosperity, and stability. Borders were extended and secured, and Chinese control over strategic stretches of Central Asia led to the opening of the Silk Road, a land route that linked China by trade all the way to Rome. One of the precious goods traded, along with spices, was silk, which had been cultivated and woven in China since at least the third millennium BCE, and had been treasured in Greece and Rome since the third century BCE (see "The Silk Road during the Tang Period," page 349).

PAINTED BANNER FROM CHANGSHA The early Han dynasty marks the twilight of China's so-called mythocentric age, when people believed in a close relationship between the human and supernatural worlds. The most elaborate and best-preserved surviving painting from this time is a T-shaped silk **BANNER** that summarizes this early worldview (**FIG. 11-7**). Found in the tomb of a noblewoman on the outskirts of present-day Changsha, the

banner dates from the second century BCE and is painted with scenes representing three levels of the universe—heaven, earth, and underworld—and includes a portrait of the deceased.

The heavenly realm appears at the top, in the crossbar of the T. In the upper-right corner is the sun, inhabited by a mythical crow; in the upper left, a mythical toad stands on a crescent moon. Between them is an image of the Torch Dragon, a primordial deity shown as a man with a long serpent's tail. Dragons and other celestial creatures swarm underneath him.

A gate guarded by two seated figures stands where the horizontal of heaven meets the banner's long, vertical stem. Two intertwined dragons loop through a circular jade piece known as a bi, itself usually a symbol of heaven, dividing this vertical segment into two areas. The portion above the bi represents the first stage of the heavenly realm. Here, the deceased woman and three attendants stand on a platform while two kneeling attendants welcome her. The portion beneath the bi represents the earthly world and the underworld. Silk draperies and a stone chime hanging from the bi form a canopy for the platform below. Like the bronze bells we saw earlier, stone chimes were ceremonial instruments dating from Zhou times. On the platform, ritual bronze vessels contain food and wine for the deceased, just as they did in Shang tombs. The squat, muscular man holding up the platform stands on a pair of fish whose bodies form another bi. The fish and the other strange creatures in this section are inhabitants of the underworld.

PHILOSOPHY AND ART

The Han dynasty marked the beginning of a new age, when the philosophical ideals of Daoism and Confucianism, formulated during the troubled times of the Eastern Zhou, became central to Chinese thought. Since this period, their influence has been continuous and fundamental.

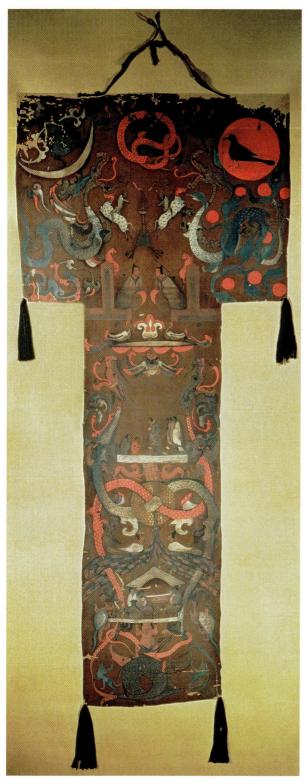

11-7 • PAINTED BANNER

From the tomb of the Marquess of Dai, Mawangdui, Changsha, Hunan. Han dynasty, c. 160 $_{\rm BCE}$. Colors on silk, height $6'81\!\!/_2''$ (2.05 m). Hunan Provincial Museum.

DAOISM AND NATURE Daoism emphasizes the close relationship between humans and nature. It is concerned with bringing the individual life into harmony with the Dao, or the Way, of the universe (see "Daoism," opposite). For some a secular, philosoph-

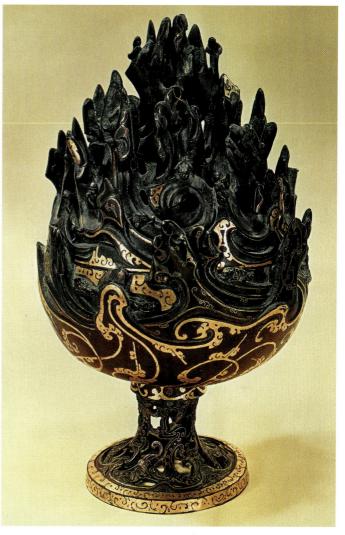

11-8 • INCENSE BURNER

From the tomb of Prince Liu Sheng, Mancheng, Hebei. Han dynasty, 113 $_{\rm BCE.}$ Bronze with gold inlay, height $10^{1}\!/_{2}''$ (26 cm). Hebei Provincial Museum, Shijiazhuang.

Technically, this exquisite work represents the ultimate development of the long and distinguished tradition of bronze casting in China.

ical path, Daoism on a popular level developed into an organized religion, absorbing many traditional folk practices and the search for immortality.

Immortality was as intriguing to Han rulers as it had been to the first emperor of Qin. Daoist adepts experimented with diet, physical exercise, and other techniques in the belief that immortal life could be achieved on earth. A popular Daoist legend, which tells of the Land of Immortals in the Eastern Sea, takes form in a bronze **INCENSE BURNER** from the tomb of Prince Liu Sheng, who died in 113 BCE (**FIG. 11–8**). Around the bowl, gold inlay outlines the stylized waves of the sea. Above them rises the mountainous island, crowded with birds, animals, and the immortals themselves, all cast in bronze with highlights of inlaid gold. This visionary world would have been shrouded in the shifting mist of incense when the burner was in use.

A CLOSER LOOK | A Reception in the Palace

Detail from a rubbing of a stone relief in the Wu family shrine (Wuliangci). Jiaxiang, Shandong. Han dynasty, 151 ce. $27\frac{1}{2}$ " \times 66¹/₂" (70 \times 169 cm).

Birds and small figures, possibly alluding to mythical creatures or immortals.

Women-and an empress?-receiving visitors on the upper floor.

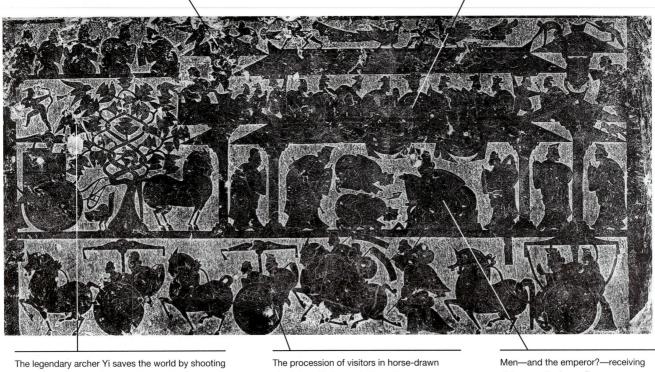

the extra sun-crows that were threatening it.

chariots on their way to the palace.

visitors on the lower floor.

View the Closer Look for A Reception in the Palace on myartslab.com

CONFUCIANISM AND THE STATE In contrast to the metaphysical focus of Daoism, Confucianism is concerned with the human world; its goal is the attainment of social harmony. To this end, it proposes a system of ethics based on reverence for ancestors and correct relationships among people. Beginning with selfdiscipline in the individual, Confucianism teaches how to rectify relationships within the family, and then, in ever-widening circles, with friends and others, all the way up to the level of the emperor and the state (see "Confucius and Confucianism," page 342).

Emphasis on social order and respect for authority made Confucianism especially attractive to Han rulers, who were eager to distance themselves from the disastrous legalism of the Qin. The Han emperor Wudi (r. 141-87 BCE) made Confucianism the official imperial philosophy, and it remained the state ideology of China for more than 2,000 years, until the end of imperial rule in the twentieth century. Once institutionalized, Confucianism took on so many rituals that it eventually assumed the form and force of a religion. Han philosophers contributed to this process by infusing Confucianism with traditional Chinese cosmology.

They emphasized the Zhou idea, taken up by Confucius, that the emperor ruled by the mandate of Heaven. Heaven itself was reconceived more abstractly as the moral force underlying the universe. Thus the moral system of Confucian society became a reflection of universal order.

Confucian subjects turn up frequently in Han art. Among the most famous examples are the reliefs from the Wu family shrines built in 151 CE in Jiaxiang. Carved and engraved in low relief on stone slabs, the scenes were meant to teach Confucian themes such as respect for the emperor, filial piety, and wifely devotion. Daoist motifs also appear, as do figures from traditional myths and legends in a synchronism characteristic of Han art (see "A Closer Look," above).

When compared with the Han-dynasty banner (see FIG. 11-7), this late Han relief clearly shows the change that took place in the Chinese worldview in the span of 300 years. The banner places equal emphasis on heaven, earth, and the underworld; human beings are dwarfed by a great swarm of supernatural creatures and divine beings. In the relief in the Wu shrine, the focus is clearly on the human realm and human behavior. The composition conveys the importance of the emperor as the holder of the mandate of Heaven and illustrates fundamental Confucian themes of social order and decorum.

ARCHITECTURE

Contemporary literary sources are eloquent on the wonders of the Han capital. Unfortunately, our only information about Han architecture is in the form of ceramic models of buildings found in tombs, where they were intended to house or support the dead in the afterlife. A particularly elaborate seven-story dwelling, connected by a third-story covered passageway to a tower (**FIG. 11–9**), was excavated in 1993 in a tomb near the village of Baizhuang in Henan Province. The entrance to the main house, flanked by towers, opens into an enclosed courtyard occupied here by a clay figure of the family dog. Pigs and oxen probably occupied the ground floor, with the second level reserved for storage. The family lived in the upper stories, where larger windows provided sufficient light and air.

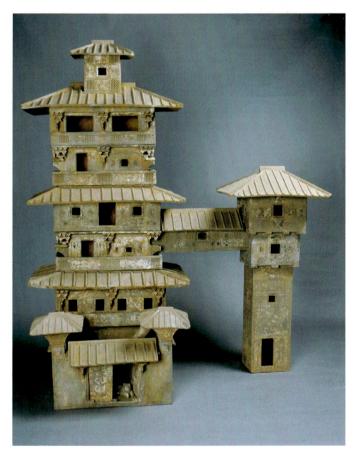

11-9 • TOMB MODEL OF A HOUSE AND TOWER From Tomb 6, Baizhuang, Henan Province. Eastern Han dynasty, 1st century cE. Painted earthenware, height of main house $6'3^{1}/_{2}''$ (1.92 m); height of tower $4'2^{1}/_{2}''$ (1.28 m). Henan Museum.

The main house in this ceramic model is assembled from a stack of 13 individual components. Hand-written inscriptions on several of them indicate their specific placement in the assembly process.

Aside from the multi-level construction, the most interesting feature of the house is the **bracketing** system (architectural elements projecting from the wall) that supports the rather broad eaves of its tiled roofs. Bracketing became a standard element of east Asian architecture, not only in private homes but more typically in palaces and temples (see FIG. 11-15). Another interesting aspect of the model is the elaborate painting on the exterior walls, much of it decorative but some of it illustrating structural features such as posts and lintels. Literary sources describe the walls of Han palaces as decorated with paint and lacquer, and also inlaid with precious metals and stones.

SIX DYNASTIES

With the fall of the Han in 220 CE, China splintered into three warring kingdoms. In 280 CE, the empire was briefly reunited, but invasions by nomadic peoples from central Asia, a source of disruption throughout Chinese history, soon forced the court to flee south. For the next three centuries, northern and southern China developed separately. In the north, 16 kingdoms carved out by invaders rose and fell before giving way to a succession of largely foreign dynasties. Warfare was commonplace. Tens of thousands of Chinese fled south, where six short-lived dynasties succeeded each other in an age of almost constant turmoil broadly known as the Six Dynasties period or the period of the Southern and Northern dynasties (265–589 CE).

In this chaotic context, the Confucian system lost influence. In the south especially, many intellectuals—the creators and custodians of China's high culture—turned to Daoism, which contained a strong escapist element. Educated to serve the government, they increasingly withdrew from public life. They wandered the landscape, drank, wrote poems, practiced calligraphy, and expressed their disdain for the social world through willfully eccentric behavior.

The rarefied intellectual escape route of Daoism was available only to the educated elite. Most people sought answers in the magic and superstitions of Daoism in its religious form. Though weak and disorganized, the southern courts remained centers of traditional Chinese culture, and Confucianism survived as official doctrine. Yet ultimately it was a newly arrived religion—Buddhism—that flourished in the troubled China of the Six Dynasties.

PAINTING

Although few paintings survive from the Six Dynasties, abundant literary sources describe the period as an important one for painting. Landscape, later a major theme of Chinese art, first appeared as an independent subject. Daoists wandered through China's countryside seeking spiritual refreshment, and both painters and scholars of the Six Dynasties found that wandering in the mind's eye through a painted landscape could serve the same purpose. This new emphasis on the spiritual value of painting contrasted Confucius was born in 551 BCE in the state of Lu, roughly present-day Shandong Province, into a declining aristocratic family. While still in his teens he set his heart on becoming a scholar; by his early twenties he had begun to teach.

By this time, wars for supremacy had begun among the various states of China, and the traditional social fabric seemed to be breaking down. Looking back to the early Zhou dynasty as a sort of golden age, Confucius thought about how a just and harmonious society could again emerge. For many years he sought a ruler who would put his ideas into effect, but to no avail. Frustrated, he spent his final years teaching. After his death in 479 BCE, his conversations with his students were collected by his disciples and their followers into a book known in English as the *Analects*, which is the only record of his teaching.

At the heart of Confucian thought is the concept of *ren* (human-heartedness). *Ren* emphasizes morality and empathy as the basic standards for all human interaction. The virtue of *ren* is most fully realized in the Confucian ideal of the *junzi* (gentleman). Originally indicating noble birth, the term was redefined to mean one who through education and self-cultivation had become a superior person, right-thinking and right-acting in all situations. A *junzi* is the opposite of a petty or small-minded person. His characteristics include moderation,

integrity, self-control, loyalty, reciprocity, and altruism. His primary concern is justice.

Together with human-heartedness and justice, Confucius emphasized *li* (etiquette). *Li* includes everyday manners as well as ritual, ceremony, and protocol—the formalities of all social conduct and interaction. Such forms, Confucius felt, choreographed life so that an entire society moved in harmony. *Ren* and *li* operate in the realm of the Five Constant Relationships that define Confucian society: parent and child, husband and wife, elder sibling and younger sibling, elder friend and younger friend, ruler and subject. Deference to age is clearly built into this view, as is the deference to authority that made Confucianism attractive to emperors. Yet responsibilities flow the other way as well: The duty of a ruler is to earn the loyalty of subjects, of a husband to earn the respect of his wife, of age to guide youth wisely.

During the early years of the People's Republic of China, and especially during the Great Proletarian Cultural Revolution (1966–1976), Confucius and Confucian thought were denigrated. Recently, however, Confucian temples in Beijing and elsewhere have been restored. Notably, the Chinese government has used the philosopher's name officially in establishing hundreds of Confucius Institutes in more than 80 countries, to promote the learning of the Chinese language abroad.

with the Confucian view, which had emphasized its moral and didactic usefulness.

Reflections on painting traditions also inspired the first works on theory and aesthetics. Some of the earliest and most succinct formulations of the ideals of Chinese painting are the six principles set out by the scholar Xie He (fl. c. 500–535 CE). The first two principles in particular offer valuable insight into the context in which China's painters worked. The first principle announces that "spirit consonance" imbues a painting with "life's movement." This "spirit" is the Daoist qi, the breath that animates all creation, the energy that flows through all things. When a painting has qi, it will be alive with inner essence, not merely outward resemblance. Artists must cultivate their own spirit so that this universal energy flows through them and infuses their work. The second principle recognizes that brushstrokes are the "bones" of a picture, its primary structural

11-10 • After Gu Kaizhi DETAIL OF ADMONITIONS OF THE IMPERIAL INSTRUCTRESS TO COURT LADIES

Six Dynasties period or later, 5th–8th century ce. Handscroll, ink and colors on silk, $93/4" \times 11'6"$ (24.8 \times 348.2 cm). British Museum, London.

element. Traditional Chinese judge a painting above all by the quality of its brushwork. Each brushstroke is a vehicle of expression; it is through the vitality of a painter's brushwork that "spirit consonance" makes itself felt.

We can sense this attitude already in the rapid, confident brushstrokes that outline the figures of the Han banner (see FIG. 11-7) and again in the more controlled, rhythmical lines of one of the most important works associated with the Six Dynasties period, a painted scroll known as **ADMONITIONS OF THE IMPERIAL INSTRUCTRESS TO COURT LADIES**. Attributed to the painter Gu Kaizhi (344–407 CE), it alternates illustrations and text to relate seven Confucian stories of wifely virtue from Chinese history. The first illustration depicts the courage of Lady Feng (**FIG. 11-10**). An escaped circus bear rushes toward her husband, a Han emperor, who is filled with fear. Behind his throne, two female servants have turned to run away. Before him, two male attendants, themselves on the verge of panic, try to fend off the bear with spears. Only Lady Feng is calm as she rushes forward to place herself between the beast and the emperor.

The figures are drawn with a brush in a thin, even-width line, and a few outlined areas are filled with color. Facial features, especially those of the men, are carefully delineated. Movement and emotion are shown through conventions—the scarves flowing from Lady Feng's dress, indicating that she is rushing forward, and the upturned strings on both sides of the emperor's head, suggesting his fear. There is no hint of a setting; the artist's careful placement of figures creates a sense of depth.

The painting is on silk, which was typically woven in bands about 12 inches wide and up to 20 or 30 feet long. Early Chinese painters thus developed the format used here, the **handscroll**—a long, narrow, horizontal composition, compact enough to be held in the hand when rolled up. Handscrolls are intimate works, meant to be viewed by only two or three people at a time. They were not displayed completely unrolled as we commonly see them today in museums. Rather, viewers would open a scroll and savor it slowly from right to left, displaying only an arm's length at a time.

CALLIGRAPHY

The emphasis on the expressive quality and structural importance of brushstrokes finds its purest embodiment in calligraphy. The same brushes are used for both painting and calligraphy, and a relationship between them was recognized as early as Han times. In his teachings, Confucius had extolled the importance of the pursuit of knowledge and the arts. Among the visual arts, painting was felt to reflect moral concerns, while calligraphy was believed to reveal the character of the writer.

Calligraphy is regarded as one of the highest forms of artistic expression in China. For more than 2,000 years, China's literati— Confucian scholars and literary men who also served the government as officials—have been connoisseurs and practitioners of this art. During the fourth century CE, calligraphy came to full maturity. The most important practitioner of the day was Wang Xizhi

11-11 • Wang Xizhi PORTION OF A LETTER FROM THE FENG JU ALBUM

Six Dynasties period, mid 4th century cE. Ink on paper, $934'' \times 181/2''$ (24.7 \times 46.8 cm). National Palace Museum, Taibei, Taiwan, Republic of China.

The stamped characters that appear on Chinese artworks are seals personal emblems. The use of seals dates from the Zhou dynasty, and to this day such seals traditionally employ the archaic characters, known appropriately as "seal script," of the Zhou or Qin. Cut in stone, a seal may state a formal, given name, or it may state any of the numerous personal names that China's painters and writers adopted throughout their lives. A treasured work of art often bears not only the seal of its maker, but also those of collectors and admirers through the centuries. In the Chinese view, these do not disfigure the work but add another layer of interest. This sample of Wang Xizhi's calligraphy, for example, bears the seals of two Song-dynasty emperors, a Song official, a famous collector of the sixteenth century, and two Qing-dynasty emperors of the eighteenth and nineteenth centuries.

(c. 307–365), whose works have served as models of excellence for subsequent generations. The example here comes from a letter, now somewhat damaged and mounted as part of an album, known as **FENG JU** (**FIG. 11–11**).

Feng Ju is an example of "running" or semicursive style, neither too formal nor too free but with a relaxed, easygoing manner. Brushstrokes vary in width and length, creating rhythmic vitality. Individual characters remain distinct, yet within each character the strokes are connected and simplified as the brush moves from one to the other without lifting off the page. The effect is fluid and graceful, yet strong and dynamic. Wang Xizhi's running style came to be officially accepted and learned along with other script styles by those who practiced this art.

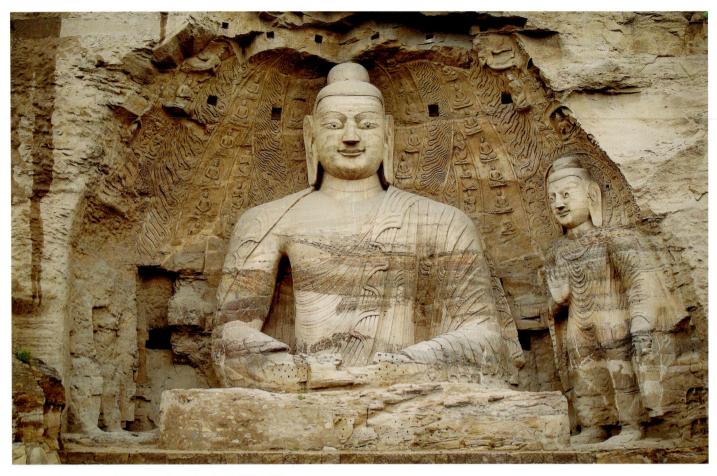

11-12 • SEATED BUDDHA, CAVE 20, YUNGANG Datong, Shanxi. Northern Wei dynasty, c. 460. Stone, height 45' (13.7 m).

View the Closer Look for the seated Buddha on myartslab.com

BUDDHIST ART AND ARCHITECTURE

Buddhism originated in India during the fifth century BCE (see Chapter 10), then gradually spread north into central Asia. With the opening of the Silk Road during the Han dynasty, its influence reached China. To the Chinese of the Six Dynasties, beset by constant warfare and social devastation, Buddhism offered consolation in life and the promise of salvation after death. The faith spread throughout the country across all social levels, first in the north, where many of the invaders promoted it as the official religion, then slightly later in the south, where it found its first great patron in the emperor Liang Wu Di (r. 502–549 CE). Thousands of temples and monasteries were built; many became monks and nuns.

Almost nothing remains in China of the Buddhist architecture of the Six Dynasties, but we can see what it must have looked like in the Japanese Horyuji Temple (see FIG. 12–4), which was based on Chinese models of this period.

ROCK-CUT CAVES OF THE SILK ROAD The most impressive works of Buddhist art surviving from the Six Dynasties are the hundreds of northern rock-cut caves along the trade routes between Xinjiang in Central Asia and the Yellow River Valley. Both the caves and the sculptures that fill them were carved from the solid rock of the cliffs. Small caves high above the ground were retreats for monks and pilgrims, while larger caves at the base of the cliffs were wayside shrines and temples.

The caves at Yungang, in Shanxi Province in central China, contain many examples of the earliest phase of Buddhist sculpture in China, including the monumental **SEATED BUDDHA** in Cave 20 (**FIG. 11-12**). The figure was carved in the latter part of the fifth century by the imperial decree of a ruler of the Northern Wei dynasty (386–534 CE), the longest-lived and most stable of the northern kingdoms. Most Wei rulers were avid patrons of Buddhism, and under their rule the religion made its greatest advances in the north.

The front part of the cave has crumbled away, and the 45-foot statue, now exposed to the open air, is clearly visible from a distance. The elongated ears, protuberance on the head (*ushnisha*), and monk's robe are traditional attributes of the Buddha. The masklike face, full torso, massive shoulders, and shallow, stylized drapery indicate strong Central Asian influence. The overall effect of this colossus is remote and austere, less human than the more sensuous expression of the early Buddhist traditions in India.

SUI AND TANG DYNASTIES

In 581 CE, a general from the last of the northern dynasties replaced a child emperor and established a dynasty of his own, the Sui. Defeating all opposition, he molded China into a centralized empire as it had been in Han times. The short-lived Sui dynasty fell in 618, but, in reunifying the empire, paved the way for one of the greatest dynasties in Chinese history: the Tang (618–907). Even today many Chinese living abroad still call themselves "Tang people." To them, Tang implies that part of the Chinese character that is strong and vigorous (especially in military power), noble and idealistic, but also realistic and pragmatic.

BUDDHIST ART AND ARCHITECTURE

The new Sui emperor was a devout Buddhist, and his reunification of China coincided with a fusion of the several styles of

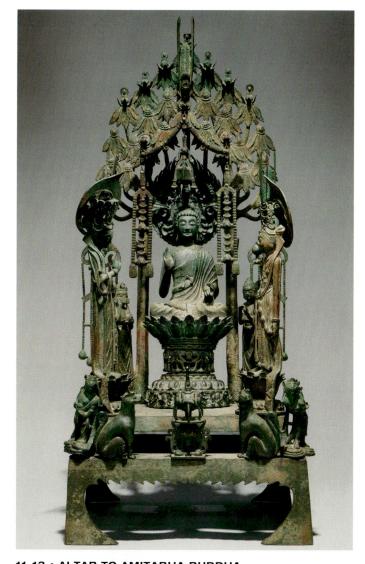

11-13 • ALTAR TO AMITABHA BUDDHA Sui dynasty, 593. Bronze, height 301//8" (76.5 cm). Museum of Fine Arts, Boston. Gift of Mrs. W. Scott Fitz (22.407) and Gift of Edward Holmes Jackson in memory of his mother, Mrs. W. Scott Fitz (47.1407–1412)

Buddhist sculpture that had developed. This new style is seen in a bronze **ALTAR TO AMITABHA BUDDHA** (**FIG. 11-13**), one of the many Buddhas of Mahayana Buddhism. Amitabha dwelled in the Western Pure Land, a paradise into which his faithful followers were promised rebirth. With its comparatively simple message of salvation, the Pure Land sect eventually became the most popular form of Buddhism in China and one of the most popular in Japan (see Chapter 12).

The altar depicts Amitabha in his paradise, seated on a lotus throne beneath a canopy of trees. Each leaf cluster is set with jewels. Seven celestial figures sit on the topmost clusters, and ropes of "pearls" hang from the tree trunks. Behind Amitabha's head is a halo of flames. To his left, the bodhisattva, a being close to enlightenment but who voluntarily remains on earth to help others achieve this goal, Guanyin holds a pomegranate; to his right, another bodhisattva clasps his hands in prayer. Behind are four disciples who first preached the teachings of the Buddha. On the lower level, an incense burner is flanked by seated lions and two smaller bodhisattvas. Focusing on Amitabha's benign expression and filled with objects symbolizing his power, the altar combines the sensuality of Indian styles, the schematic abstraction of central Asian art, and the Chinese emphasis on linear grace and rhythm into a harmonious new style.

Buddhism reached its greatest development in China during the subsequent Tang dynasty, which for nearly three centuries ruled China and controlled much of Central Asia. From emperors and empresses to common peasants, virtually the entire country adopted the Buddhist faith. A Tang vision of the most popular sect, Pure Land, was expressed in a wall painting from a cave in Dunhuang (FIG. 11-14). A major stop along the Silk Road, Dunhuang has nearly 500 caves carved into its sandy cliffs, all filled with painted clay sculpture and decorated with wall paintings from floor to ceiling. The site was worked on continuously from the fourth to the fourteenth century, a period of almost 1,000 years. In the detail shown here, a seated Amitabha Buddha appears at center, flanked by four bodhisattvas, his messengers to the world. Two other groups of bodhisattvas are clustered at right and left. Great halls and towers rise in the background, representing the Western Paradise in terms of the grandeur of Tang palaces. Indeed, the aura of opulence could just as easily be that of the imperial court. This worldly vision of paradise, recorded with great attention to detail in the architectural setting, provides our best indication of the splendor of Tang civilization at a time when Chang'an (present-day Xi'an) was probably the greatest city in the world.

The early Tang emperors proclaimed a policy of religious tolerance, but during the ninth century a conservative reaction developed. Confucianism was reasserted and Buddhism was briefly suppressed as a "foreign" religion. Thousands of temples, shrines, and monasteries were destroyed and innumerable bronze statues melted down. Fortunately, several Buddhist structures do survive from the Tang dynasty. One of them, the Nanchan Temple, is the earliest important surviving example of Chinese architecture.

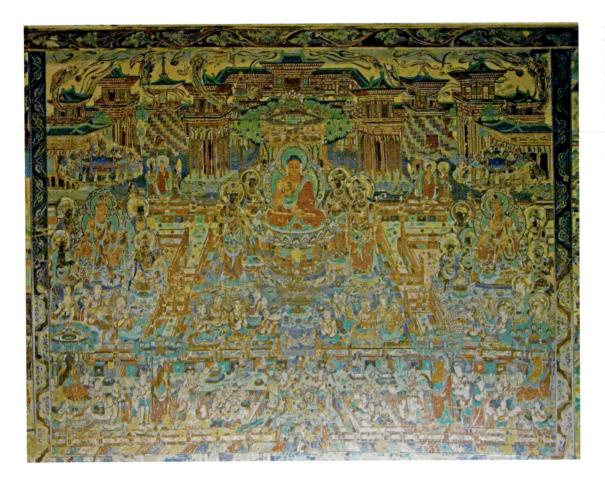

11-14 • THE WESTERN PARADISE OF AMITABHA BUDDHA

Detail of a wall painting in Cave 217, Dunhuang, Gansu. Tang dynasty, c. 750. $10'2'' \times 16'$ (3.1 × 4.86 m).

NANCHAN TEMPLE The Nanchan Temple shows characteristics of both temples and palaces of the Tang dynasty (**FIG. 11–15**). Located on Mount Wutai (Wutaishan) in the eastern part of Shanxi Province, this small hall was constructed in 782. The tiled roof, seen earlier in the Han tomb model (see FIG. 11–9), has taken on a curved silhouette. Quite subtle here, this curve became increasingly pronounced in later centuries. The very broad overhanging eaves are supported by a correspondingly elaborate bracketing system.

Also typical is the bay system of construction, in which a cubic unit of space, a bay, is formed by four posts and their lintels. The bay functioned in Chinese architecture as a **module**, a basic unit of construction. To create larger structures, an architect multiplied the number of bays. Thus, though modest in scope with only three

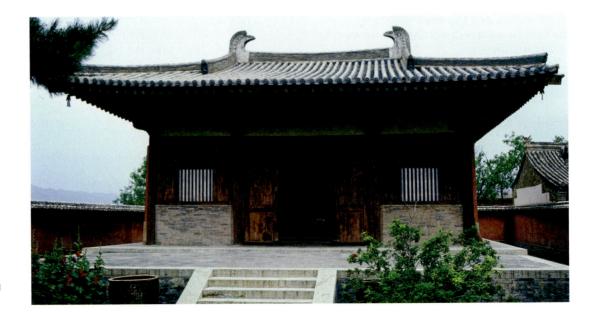

11-15 • NANCHAN TEMPLE, WUTAISHAN Shanxi. Tang dynasty, 782.

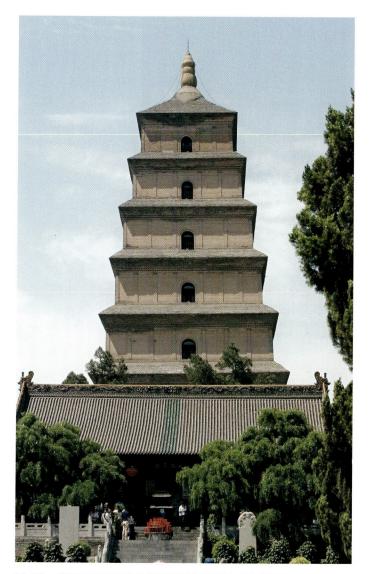

11-16 • GREAT WILD GOOSE PAGODA AT CI'EN TEMPLE, CHANG'AN

Shanxi. Tang dynasty, first erected 645; rebuilt mid 8th century CE.

bays, the Nanchan Temple still gives an idea of the vast, multi-storied palaces of the Tang depicted in such paintings as FIGURE 11–14.

GREAT WILD GOOSE PAGODA The Great Wild Goose Pagoda of the Ci'en Temple in the Tang capital of Chang'an also survives (**FIG. 11-16**). The temple, constructed in 645 for the famous monk Xuanzang (600–664) on his return from a 16-year pilgrimage to India, was where he taught and translated the Sanskrit Buddhist scriptures he had brought back with him.

Pagodas—towers associated with East Asian Buddhist temples—originated in the Indian Buddhist stupa, the elaborate burial mound that housed relics of the Buddha (see "Pagodas," page 351). In China this form blended with a traditional Han watchtower to produce the pagoda. Built entirely in brick, the Great Wild Goose Pagoda nevertheless imitates the wooden architecture of the time. The walls are decorated in low relief to resemble bays, and bracket systems are reproduced under the projecting roofs of each story. Although modified and repaired in later times (its seven stories were originally five, and a new finial has been added), the pagoda still preserves the essence of Tang architecture in its simplicity, symmetry, proportions, and grace.

FIGURE PAINTING

Later artists looking back on their heritage recognized the Tang dynasty as China's great age of figure painting. Unfortunately, very few Tang **scroll paintings** still exist. The wall paintings of Dunhuang (see FIG. 11-14) give us some idea of the character of Tang figure painting, and we can look at copies of lost Tang paintings made by later, Song-dynasty artists. **LADIES PREPAR-ING NEWLY WOVEN SILK** is an outstanding example of such copies, this one attributed to Huizong (r. 1101–1126 CE), the last emperor of the Northern Song dynasty (**FIG. 11-17**). An inscription on the scroll identifies the Tang original as a famous work by

11-17 • Attributed to Emperor Huizong DETAIL OF LADIES PREPARING NEWLY WOVEN SILK

Copy after a lost Tang-dynasty painting by Zhang Xuan. Northern Song dynasty, early 12th century cE. Handscroll with ink and colors on silk, $14\frac{1}{2}'' \times 57\frac{1}{2}''$ (36×145.3 cm). Museum of Fine Arts, Boston. Chinese and Japanese Special Fund (12.886)

Confucius said of himself, "I merely transmit, I do not create; I love and revere the ancients." In this spirit, Chinese painters regularly copied paintings of earlier masters. Painters made copies both to absorb the lessons of their great predecessors and to perpetuate the achievements of the past. In later centuries, they took up the practice of regularly executing a work "in the manner of" some particularly revered ancient master. This was at once an act of homage, a declaration of artistic allegiance, and a way of reinforcing a personal connection with the past.

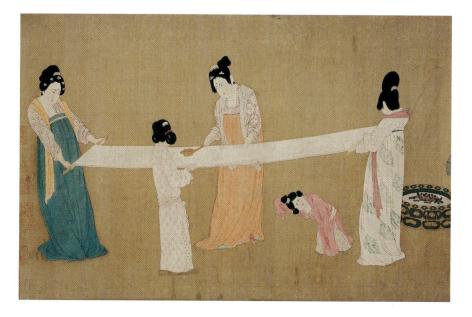

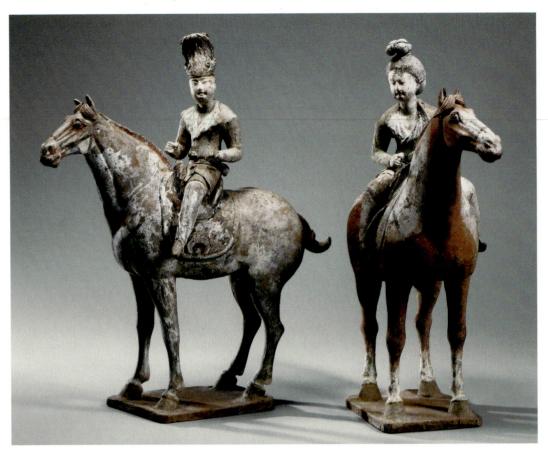

11-18 • TWO EQUESTRIAN FIGURES

Tang dynasty, first half of 8th century CE. Molded, reddish-buff earthenware with cold-painted pigments over white ground, height (male figure) 14¹/₂" (37 cm). Arthur M. Sackler Museum, Harvard Art Museum, Cambridge, Massachusetts. Gift of Anthony M. Solomon (2003.207.1-2)

This pair documents the lively participation of women as well as men in sport and riding. Both have pointed boots and are mounted on a standing saddled and bridled horse; their hands are positioned to hold the reins. The male figure wears a tall, elaborately embellished hat, and the female figure has her hair arranged in a topknot.

Zhang Xuan, an eighth-century painter known for his depictions of women at the Tang court. Since the original no longer exists, we cannot know how faithful the copy is, but its refined lines and bright colors seem to share the grace and dignity of Tang sculpture and architecture.

Two earthenware **EQUESTRIAN FIGURES** (FIG. 11-18), a man and a woman, made for use as tomb furnishings, reveal more directly the robust naturalism and exuberance of figural representation during the Tang period. Accurate in proportion and lively in demeanor, the statuettes are not glazed (as is the tomb figure in FIGURE 11-19) but are "cold-painted" using pigments after firing to render details of costume and facial features.

SONG DYNASTY

A brief period of disintegration followed the fall of the Tang, but eventually China was again united, this time under the Song dynasty (960–1279). A new capital was founded at Bianjing (present-day Kaifeng), near the Yellow River. In contrast to the outgoing confidence of the Tang, the mood during the Song was more introspective, a reflection of China's weakened military situation. In 1126, the Jurchen tribes of Manchuria invaded China, sacked the capital, and took possession of much of the northern part of the country. Song forces withdrew south and established a new capital at Hangzhou. From this point on, the dynasty is known as the Southern Song (1127–1179), with the first portion called in retrospect the Northern Song (960–1126).

Although China's territory had diminished, its wealth had increased because of advances in agriculture, commerce, and technology begun under the Tang. Patronage was plentiful, and the arts flourished. Song culture is noted for its refined taste and intellectual grandeur. Where the Tang had reveled in exoticism, eagerly absorbing influences from Persia, India, and Central Asia, Song culture was more self-consciously Chinese. Philosophy experienced its most creative era since the "one hundred schools" of the Zhou. Song scholarship was brilliant, especially in history, and its poetry is noted for its depth. Perhaps the finest expressions of the Song, however, are in art, especially painting and ceramics. Under a series of ambitious and forceful Tang emperors, Chinese control once again extended over Central Asia. Goods, ideas, and influence flowed along the Silk Road. In the South China Sea, Arab and Persian ships carried on a lively trade with coastal cities. Chinese cultural influence in east Asia was so important that Japan and Korea sent thousands of students to study Chinese civilization.

Cosmopolitan and tolerant, Tang China was confident and curious about the world. Many foreigners came to the splendid new capital Chang'an (present-day Xi'an), and they are often depicted in the art of the period. A ceramic statue of a camel carrying a troupe of musicians (FIG. 11-19) reflects the Tang fascination with the "exotic" Turkic cultures of Central Asia. The three bearded musicians (one with his back to us) are Central Asian, while the two smooth-shaven ones are Han Chinese. Bactrian, or two-humped, camels, themselves exotic Central Asian "visitors," were beasts of burden in the caravans that traversed the Silk Road. The stringed lute (which the Chinese called the pipa) came from Central Asia to become a lasting part of Chinese music.

Stylistically, the statue reveals a new interest in naturalism, an important trend in both painting and sculpture. Compared with the rigid, staring ceramic soldiers of the first emperor of Qin, this Tang band is alive with gesture and expression. The majestic camel throws its head back; the musicians are vividly captured in mid-performance. Ceramic figurines such as this, produced by the thousands for Tang tombs, offer glimpses into the gorgeous variety of Tang life. The statue's three-color glaze technique was a specialty of Tang ceramicists. The glazesusually chosen from a restricted palette of amber-yellow, green, and blue-were splashed freely and allowed to run over the surface during firing to convey a feeling of spontaneity. The technique is emblematic of Tang culture itself in its robust, colorful, and cosmopolitan expressiveness.

11-19 • CAMEL CARRYING A GROUP OF MUSICIANS

From a tomb near Xi'an, Shanxi. Tang dynasty, c. mid 8th century cE. Earthenware with three-color glazes, height 26¹/₈" (66.5 cm). National Museum, Beijing.

The Silk Road had first flourished in the second century CE. A 5,000-mile network of caravan routes from the Han capital (near present-day Luoyang, Henan, on the Yellow River) to Rome, it brought Chinese luxury goods to Western markets.

The journey began at the Jade Gate (Yumen) at the westernmost end of the Great Wall, where Chinese merchants turned their goods over to Central Asian traders. Goods would change hands many more times before reaching the Mediterranean. Caravans headed first for the nearby desert oasis of Dunhuang. Here northern and southern routes diverged to skirt the vast Taklamakan Desert. At Khotan, in western China, farther west than the area shown in MAP 11–1, travelers on the southern route could turn off toward a mountain pass into Kashmir, in northern India. Or they could continue on, meeting up with the northern route at Kashgar, on the western border of the Taklamakan, before proceeding over the Pamir Mountains into present-day Afghanistan. From there, travelers could head toward presentday Pakistan and India, or travel west through present-day Uzbekistan, Iran, and Iraq, arriving finally at Antioch, in Syria, on the coast of the Mediterranean. After that, land and sea routes led to Rome.

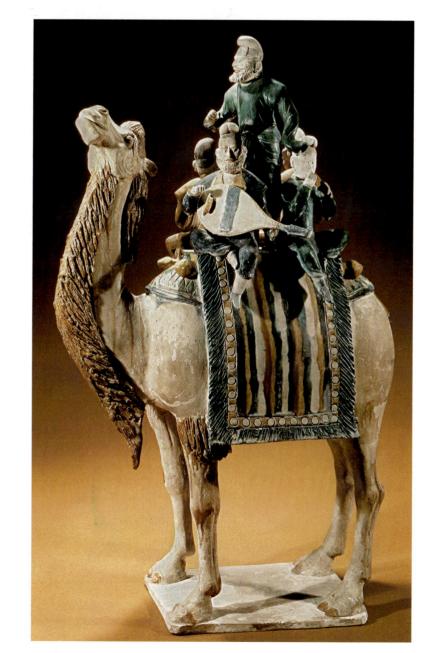

SEATED GUANYIN BODHISATTVA No hint of political disruption or religious questioning intrudes on the sublime grace and beauty of this **SEATED GUANYIN BODHISATTVA** (**FIG. 11-20**), carved from wood in the eleventh or twelfth century in a territory on the northern border of Song China, a region ruled by the Liao dynasty_(907–1125). Bodhisattvas are represented as young princes wearing royal garments and jewelry, their finery indicative of their worldly but virtuous lives. Guanyin is the Bodhisattva of Infinite Compassion, who appears in many guises, in this case as the Water and Moon Guanyin. He sits on rocks by the sea, in the position known as royal ease. His right arm rests on his raised and bent right knee and his left arm and foot hang down, the foot touching a lotus blossom.

PHILOSOPHY: NEO-CONFUCIANISM Song philosophers continued the process, begun during the Tang, of restoring Confucianism to dominance. In strengthening Confucian thought, they drew on Daoist and especially Buddhist ideas, even as they openly rejected Buddhism itself as foreign. These innovations provided Confucianism with a new metaphysical aspect, allowing it

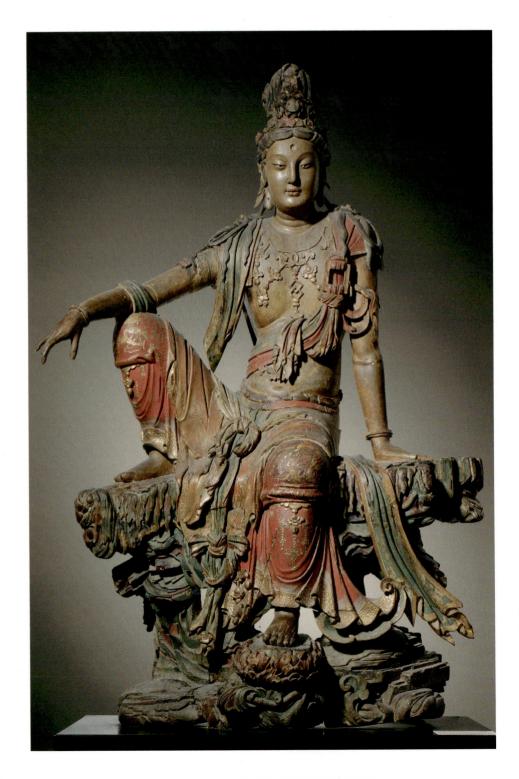

Liao dynasty, 11th–12th century CE (the painting and gilding were restored in the 16th century). Wood with paint and gold, $95'' \times 65''$ (241.3 × 165.1 cm). The Nelson-Atkins Museum of Art, Kansas City, Missouri. Purchase, William Rockhill Nelson Trust (34–10)

ELEMENTS OF ARCHITECTURE | Pagodas

Pagodas developed from Indian stupas as Buddhism spread northeast in along the Silk Road. Stupas merged with the watchtowers of Handynasty China in multi-storied stone or wood structures with projecting tiled roofs. This transformation culminated in wooden pagodas with upward-curving roofs supported by elaborate bracketing

in China, Korea, and Japan. Buddhist pagodas retain the axis mundi masts of stupas. Like their South Asian prototypes, early East Asian pagodas were symbolic rather than enclosing structures. Later examples often provided access to the ground floor and sometimes to upper levels.

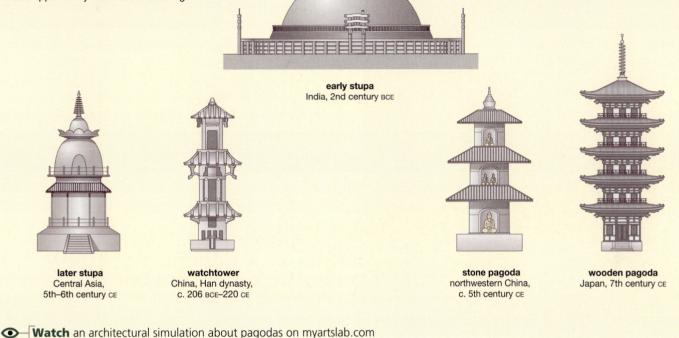

to propose a richer, all-embracing explanation of the universe. This new synthesis of China's three main paths of thought is called Neo-Confucianism.

Neo-Confucianism teaches that the universe consists of two interacting forces known as li (principle or idea) and qi (matter). All pine trees, for example, consist of an underlying li we might call "Pine Tree Idea" brought into the material world through qi. All the li of the universe, including humans, are but aspects of an eternal first principle known as the Great Ultimate (taiji), which is completely present in every object. Our task as human beings is to rid our qi of impurities through education and self-cultivation so that our li may realize its oneness with the Great Ultimate. This lifelong process resembles the striving to attain buddhahood, and, if we persist in our attempts, one day we will be enlightened—the term itself comes directly from Buddhism.

NORTHERN SONG PAINTING

Neo-Confucian ideas found visual expression in art, especially in landscape, which became the most highly esteemed subject for painting. Northern Song artists studied nature closely to master its many appearances: the way each species of tree grows; the distinctive character of each rock formation; the changes of the seasons; the myriad birds, blossoms, and insects. This passion for descriptive detail was the artist's form of self-cultivation; mastering outward forms showed an understanding of the principles behind them.

Yet despite the convincing accumulation of detail, Song landscape paintings do not record a specific site. The artist's goal was to paint the eternal essence of "mountain-ness," for example, not to reproduce the appearance of a particular mountain. Painting landscapes required artists to orchestrate their cumulative understanding of *li* in all its aspects—mountains and rocks, streams and waterfalls, trees and grasses, clouds and mist. A landscape painting thus expressed the desire for the spiritual communion with nature that was the key to enlightenment. As the tradition progressed, landscape also became a vehicle for conveying human emotions, even for speaking indirectly of one's own deepest feelings.

In the earliest times, art had reflected the mythocentric worldview of the ancient Chinese. Later, as religion came to dominate people's lives, the focus of art shifted, and religious images and human actions became important subjects. Subsequently, during the Song dynasty, artists developed landscape as the chief means of expression, preferring to avoid direct depiction of the human condition and to convey ideals in a symbolic manner. Chinese artistic expression thus moved from the mythical, through the religious and ethical, and finally to the philosophical and aesthetic.

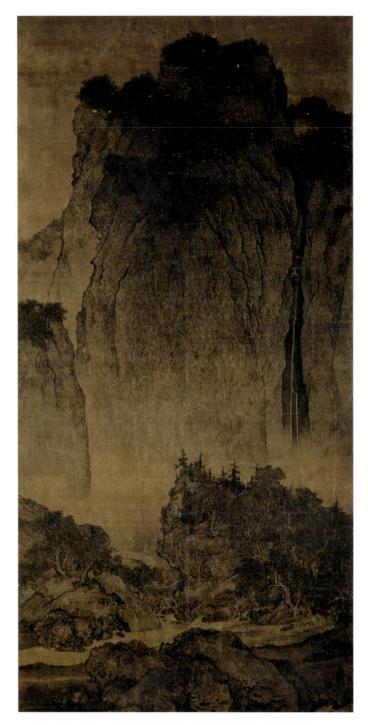

11-21 • Fan Kuan TRAVELERS AMONG MOUNTAINS AND STREAMS

Northern Song dynasty, early 11th century CE. Hanging scroll with ink and colors on silk, height 6'9¹/₂" (2.06 m). National Palace Museum, Taibei, Taiwan, Republic of China.

FAN KUAN One of the first great masters of Song landscape was the eleventh-century painter Fan Kuan (active c. 990–1030 CE), whose surviving major work, TRAVELERS AMONG MOUNTAINS AND STREAMS, is regarded as one of the great monuments of Chinese art (FIG. 11-21). The work is physically large—almost 7 feet high—but the sense of monumentality also

radiates from the composition itself, which makes its impression even when much reduced.

The composition unfolds in three stages, comparable to three acts of a drama. At the bottom a large, low-lying group of rocks, taking up about one-eighth of the picture surface, establishes the extreme foreground. The rest of the landscape pushes back from this point. In anticipating the shape and substance of the mountains to come, the rocks introduce the main theme of the work, much as the first act of a drama introduces the principal characters. In the middle ground, travelers and their mules are coming from the right. Their size confirms our human scale—how small we are, how vast is nature. This middle ground takes up twice as much picture surface as the foreground, and, like the second act of a play, shows variation and development. Instead of a solid mass, the rocks here are separated into two groups by a waterfall that is spanned by a bridge. In the hills to the right, the rooftops of a temple stand out above the trees.

Mist veils the transition to the background, with the result that the mountain looms suddenly. This background area, almost twice as large as the foreground and middle ground combined, is the climactic third act of the drama. As our eyes begin their ascent, the mountain solidifies. Its ponderous weight increases as it billows upward, finally bursting into the sprays of energetic brushstrokes that describe the scrubby growth on top. To the right, a slender waterfall plummets, not to balance the powerful upward thrust of the mountain but simply to enhance it by contrast. The whole painting, then, conveys the feeling of climbing a high mountain, leaving the human world behind to come face to face with the Great Ultimate in a spiritual communion.

All the elements are depicted with precise detail and in proper scale. Jagged brushstrokes describe the contours of rocks and trees and express their rugged character. Layers of short, staccato strokes (translated as "raindrop texture" from the Chinese) accurately mimic the texture of the rock surface. Spatial recession from foreground through middle ground to background is logically and convincingly handled.

Although it contains realistic details, the landscape represents no specific place. In its forms, the artist expresses the ideal forms behind appearances; in the rational, ordered composition, he expresses the intelligence of the universe. The arrangement of the mountains, with the central peak flanked by lesser peaks on each side, seems to reflect both the ancient Confucian notion of social hierarchy, with the emperor flanked by his ministers, and the Buddhist motif of the Buddha with bodhisattvas at his side. The landscape, a view of nature uncorrupted by human habitation, expresses a kind of Daoist ideal. Thus we find the three strains of Chinese thought united, much as they are in Neo-Confucianism itself.

The ability of Chinese landscape painters to take us out of ourselves and to let us wander freely through their sites is closely linked to the avoidance of perspective as it is understood in the West. Fifteenth-century European painters, searching for fidelity to

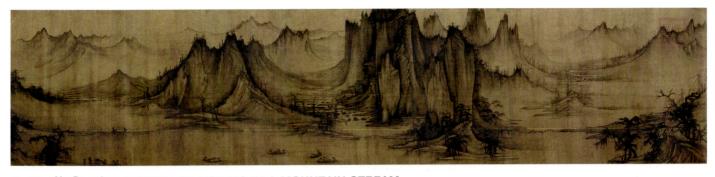

11–22 • Xu Daoning SECTION OF FISHING IN A MOUNTAIN STREAM Northern Song dynasty, mid 11th century cE. Handscroll with ink on silk, $19'' \times 6'10''$ (48.9 cm \times 2.09 m). The Nelson-Atkins Museum of Art, Kansas City, Missouri. Purchase, William Rockhill Nelson Trust (33–1559)

appearances, developed a scientific system for recording exactly the view that could be seen from a single, stable vantage point. The goal of Chinese painting is precisely to avoid such limits and show a totality beyond what we are normally given to see. If the ideal for centuries of Western painters was to render what can be seen from a fixed viewpoint, that of Chinese artists was to reveal nature through a distant, all-seeing, and mobile viewpoint.

XU DAONING This sense of shifting perspective is clearest in the handscroll, where our vantage point changes constantly as we move through the painting. One of the finest handscrolls to survive from the Northern Song is FISHING IN A MOUNTAIN STREAM (FIG. 11-22), a painting executed in the middle of the eleventh century by Xu Daoning (c. 970-c. 1052). Starting from a thatched hut in the right foreground, we follow a path that leads to a broad, open view of a deep vista dissolving into distant mists and mountain peaks. (Remember that viewers observed only a small section of the scroll at a time. To mimic this effect, use two pieces of paper to frame a small viewing area, then move them slowly leftward.) Crossing over a small footbridge, we are brought back to the foreground with the beginning of a central group of high mountains that show extraordinary shapes. Again our path winds back along the bank, and we have a spectacular view of the highest peaks from another small footbridge the artist has placed for us. At the far side of the bridge, we find ourselves looking up into a deep valley, where a stream lures our eyes far into the distance. We can imagine ourselves resting for a moment in the small pavilion halfway up the valley on the right. Or perhaps we may spend some time with the fishers in their boats as the valley gives way to a second, smaller group of mountains, serving both as an echo of the spectacular central group and as a transition to the painting's finale, a broad, open vista. As we cross the bridge here, we meet travelers coming toward us who will have our experience in reverse. Gazing out into the distance and reflecting on our journey, we again feel that sense of communion with nature that is the goal of Chinese artistic expression.

Such handscrolls have no counterpart in the Western visual arts and are often compared instead to the tradition of Western

music, especially symphonic compositions. Both are generated from opening motifs that are developed and varied, both are revealed over time, and in both our sense of the overall structure relies on memory, for we do not see the scroll or hear the composition all at once.

ZHANG ZEDUAN The Northern Song fascination with precision extended to details within landscape. The emperor Huizong, whose copy of *Ladies Preparing Newly Woven Silk* was seen in FIGURE 11-17, gathered around himself a group of court painters who shared his passion for quiet, exquisitely detailed, delicately colored paintings of birds and flowers. Other painters specialized in domestic and wild animals, still others in palaces and buildings. One of the most spectacular products of this passion for observation is **SPRING FESTIVAL ON THE RIVER**, a long handscroll painted in the late eleventh or early twelfth century by Zhang Zeduan, an artist connected to the court (**FIG. 11-23**). Beyond its considerable visual delights, the painting is also a valuable record of daily life in the Song capital.

The painting depicts a festival day when local inhabitants and visitors from the countryside thronged the streets. One high point is the scene reproduced here, which takes place at the Rainbow Bridge. The large boat to the right is probably bringing goods from the southern part of China up the Grand Canal that ran through the city at that time. The sailors are preparing to pass beneath the bridge by lowering the sail and taking down the mast. Excited figures on ship and shore gesture wildly, shouting orders and advice, while a noisy crowd gathers at the bridge railing to watch. Stalls on the bridge are selling food and other merchandise; wine shops and eating places line the banks of the canal. Everyone is on the move. Some people are busy carrying goods, some are shopping, some are simply enjoying themselves. Each figure is splendidly animated and full of purpose; the depiction of buildings and boats is highly detailed, almost encyclopedic.

Little is known about the painter Zhang Zeduan other than that he was a member of the scholar-official class, the highly educated elite of imperial China. His painting demonstrates skill in the fine-line architectural drawing called *jiehua* ("ruled-line") painting.

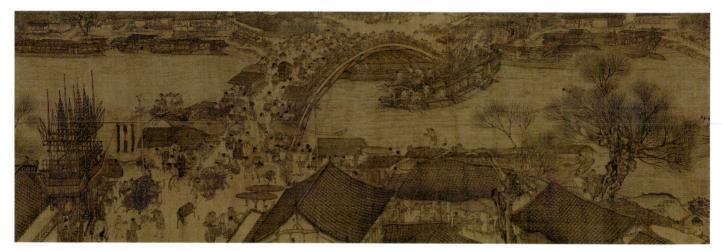

11-23 • Zhang Zeduan SECTION OF SPRING FESTIVAL ON THE RIVER Northern Song dynasty, late 11th–early 12th century ce. Handscroll with ink and colors on silk, $9^{1}/{2^{"}} \times 7'4"$ (24.8 cm \times 2.28 m). The Palace Museum, Beijing.

Interestingly, some of Zhang Zeduan's peers were already beginning to cultivate quite a different attitude toward painting as a form of artistic expression, one that placed overt display of technical skill at the lowest end of the scale of values. This emerging scholarly aesthetic, developed by China's literati, later came to dominate Chinese thinking about art.

SOUTHERN SONG PAINTING AND CERAMICS

Landscape painting took a very different course after the fall of the north to the Jurchen in 1127, and the removal of the court to its new southern capital in Hangzhou.

XIA GUI A new sensibility is reflected in the extant portion of **TWELVE VIEWS OF LANDSCAPE** (FIG. 11-24) by Xia Gui (fl. c. 1195–1235), a member of the newly established Academy of Painters. In general, academy members continued to favor such subjects as birds and flowers in the highly refined, elegantly colored court style patronized earlier by Huizong (see FIG. 11-17). Xia Gui, however, was interested in landscape and cultivated his own style. Only the last four of the 12 views that originally made up this long handscroll have survived, but they are enough to illustrate the unique quality of his approach.

In contrast to the majestic, austere landscapes of the Northern Song painters, Xia Gui presents an intimate and lyrical view of nature. Subtly modulated, carefully controlled ink washes evoke a landscape veiled in mist, while a few deft brushstrokes suffice to indicate the details showing through the mist—the grasses growing by the bank, the fishers at their work, the trees laden with moisture, the two bent-backed figures carrying their heavy loads along the path that skirts the hill. Simplified forms, stark contrasts of light and dark, asymmetrical composition, and great expanses of blank space suggest a fleeting world that can be captured only in glimpses. The intangible has more presence than the tangible. By limiting himself to a few essential details, the painter evokes a deep feeling for what lies beyond.

This development in Song painting from the rational and intellectual to the emotional and intuitive, from the tangible to the intangible, had a parallel in philosophy. During the late twelfth century, a new school of Neo-Confucianism called School of the Mind insisted that self-cultivation could be achieved through

11-24 • Xia Gui SECTION OF TWELVE VIEWS OF LANDSCAPE

Southern Song dynasty, early 13th century cE. Handscroll with ink on silk, height 11" (28 cm); length of extant portion 7'71/2" (2.31 m). The Nelson-Atkins Museum of Art, Kansas City, Missouri. Purchase, William Rockhill Nelson Trust (32–159/2)

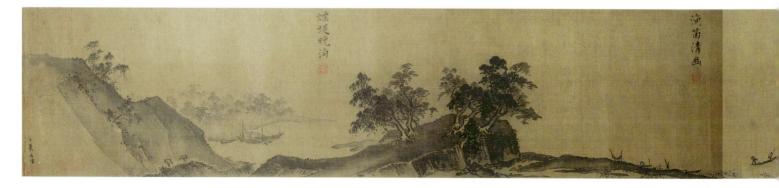

contemplation, which might lead to sudden enlightenment. The idea of sudden enlightenment may have come from Chan Buddhism, better known in the West by its Japanese name, Zen. Chan Buddhists rejected formal paths to enlightenment such as scripture, knowledge, and ritual, in favor of meditation and techniques designed to "short-circuit" the rational mind. Xia Gui's painting seems to suggest this intuitive approach.

The subtle and sophisticated paintings of the Song were created for a highly cultivated audience who were equally discerning in other arts such as ceramics. Building on the considerable accomplishments of the Tang, Song potters achieved a technical and aesthetic perfection that has made their wares models of excellence throughout the world. Like their painter contemporaries, Song potters turned away from the exuberance of Tang styles to create more quietly beautiful pieces.

GUAN WARE Among the most prized of the many types of Song ceramics is Guan ware, made mainly for imperial use (**FIG. 11-25**). The everted lip, high neck, and rounded body of this simple vessel show a strong sense of harmony. Enhanced by a lustrous grayish-blue glaze, the form flows without break from base to lip, evoking an introspective quality as eloquent as the blank spaces in Xia Gui's painting. The aesthetic of the Song is most evident in the crackle pattern on the glazed surface. The crackle technique was probably discovered accidentally, but came to be used deliberately in some of the most refined Song wares. In the play of irregular, spontaneous crackles over a perfectly regular, perfectly planned form we can sense the same spirit that hovers behind the self-effacing virtuosity and freely intuitive insights of Xia Gui's landscape.

In 1279 the Southern Song dynasty fell to the conquering forces of the Mongol leader Kublai Khan (1215–1294). China was subsumed into the vast Mongol empire. Mongol rulers founded the Yuan dynasty (1279–1368), setting up their capital in the northeast in what is now Beijing. Yet the cultural center of China remained in the south, in the cities that rose to prominence during the Song, especially Hangzhou. This separation of political and cultural centers, coupled with a lasting resentment toward "barbarian" rule, created the climate for later developments in Chinese art.

11-25 • GUAN WARE VESSEL

Southern Song dynasty, 13th century CE. Gray stoneware with crackled grayish-blue glaze, height 6⁵/₈" (16.8 cm). Percival David Foundation of Chinese Art, British Museum, London.

• Watch a video about the process of ceramic making on myartslab.com

THE ARTS OF KOREA

Set between China and Japan, Korea occupies a peninsula in northeast Asia. Inhabited for millennia, the peninsula gave rise to a distinctively Korean culture during the Three Kingdoms period.

THE THREE KINGDOMS PERIOD

Traditionally dated 57 BCE–668 CE, the Three Kingdoms period saw the establishment of three independent nation-states: Silla in the southeast, Baekje in the southwest, and Goguryeo in the north. Large tomb mounds built during the fifth and sixth centuries are enduring monuments of this period.

A GOLD HEADDRESS The most spectacular items recovered from these tombs are trappings of royal authority (FIG. 11-26). Made expressly for burial, this elaborate crown was assembled from cut pieces of thin gold sheet, held together by gold wire.

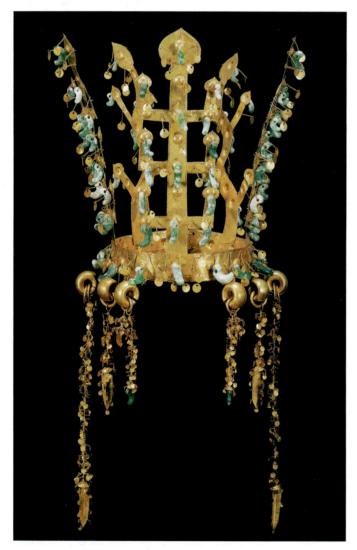

11-26 • CROWN

From the Gold Crown Tomb, Gyeongju, North Gyeongsang Province, Korea. Three Kingdoms period, Silla kingdom, probably 6th century cc. Gold with jadeite ornaments, height $17\frac{1}{2}$ " (44.5 cm). National Museum of Korea, Seoul, Republic of Korea.

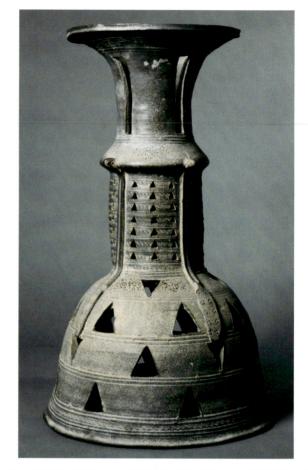

11-27 • CEREMONIAL STAND WITH SNAKE, ABSTRACT, AND OPENWORK DECORATION

Reportedly recovered in Andong, North Gyeongsang Province, Korea. Three Kingdoms period, Silla kingdom, 5th–6th century cE. Gray stoneware with combed, stamped, applied, and openwork decoration and with traces of natural ash glaze, height 231/8" (58.7 cm). Arthur M. Sackler Museum, Harvard University, Cambridge, Massachusetts. Partial gift of Maria C. Henderson and partial purchase through the Ernest B. and Helen Pratt Dane Fund for the Acquisition of Oriental Art (1991.501)

Spangles of gold embellish the crown, as do comma-shaped ornaments of green and white jadeite—a form of jade mineralogically distinct from the nephrite prized by the early Chinese. The tall, branching forms rising from the crown's periphery resemble trees and antlers. Within the crown is a conical cap woven of narrow strips of sheet gold and ornamented with appendages that suggest wings or feathers.

HIGH-FIRED CERAMICS The tombs have also yielded ceramics in abundance. Most are containers for offerings of food placed in the tomb to nourish the spirit of the deceased. These items generally are of unglazed stoneware, a high-fired ceramic that is impervious to liquids, even without glaze.

The most imposing ceramic shapes are tall **STANDS** (**FIG. 11-27**), typically designed as a long, cylindrical shaft set on a

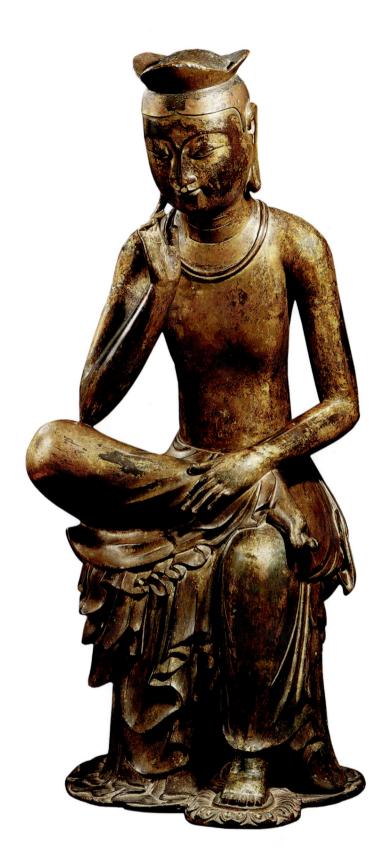

11-28 • BODHISATTVA SEATED IN MEDITATION

Korea. Three Kingdoms period, probably Silla kingdom, early 7th century CE. Gilt bronze, height 35%" (91 cm). National Museum of Korea, Seoul, Republic of Korea (formerly in the collection of the Toksu Palace Museum of Fine Arts, Seoul).

bulbous base and used to support round-bottomed jars. Cut into the moist clay before firing, their openwork apertures lighten what otherwise would be rather ponderous forms. Although few examples of Three Kingdoms ceramics exhibit surface ornamentation, other than an occasional combed wave pattern or an incised configuration of circles and **chevrons** (v-shapes), here snakes inch their way up the shaft of the stand.

A BODHISATTVA SEATED IN MEDITATION Buddhism was introduced into the Goguryeo kingdom from China in 372 CE and into Baekje by 384. Although it probably reached Silla in the second half of the fifth century, Buddhism gained recognition as the official religion of the Silla state only in 527.

At first, Buddhist art in Korea imitated Chinese examples. By the late sixth century, however, Korean sculptors had created a distinctive style, exemplified by a magnificent gilt-bronze image of a bodhisattva (probably the bodhisattva Maitreya) seated in meditation that likely dates to the early seventh century (**FIG. 11-28**). Although the pose derives from late sixth-century Chinese sculpture, the slender body, elliptical face, elegant drapery folds, and trilobed crown are distinctly Korean.

Buddhism was introduced to Japan from Korea—from the Baekje kingdom, according to literary accounts. In fact, historical sources indicate that numerous Korean sculptors were active in Japan in the sixth and seventh centuries; several early masterpieces of Buddhist art in Japan show pronounced Korean influence (see FIG. 12–6).

THE UNIFIED SILLA PERIOD

In 660, the Silla kingdom conquered Baekje, and, in 668, through an alliance with Tang-dynasty China, it vanquished Goguryeo, uniting the peninsula under the rule of the Unified Silla dynasty, which lasted until 935. Buddhism prospered under Unified Silla, and many large, important temples were erected in and around Gyeongju, the Silla capital.

SEOKGURAM The greatest monument of the Unified Silla period is Seokguram, an artificial cave-temple constructed under royal patronage atop Mount Toham, near Gyeongju. The temple is modeled after Chinese cave-temples of the fifth, sixth, and seventh centuries, which were in turn inspired by the Buddhist cave-temples of India.

Built in the mid eighth century of cut blocks of granite, Seokguram consists of a small rectangular antechamber joined by a narrow vestibule to a circular main hall with a domed ceiling. More than 11 feet in height, a huge seated Buddha dominates the main hall (**FIG. 11-29**). Seated on a lotus pedestal, the image represents the historical Buddha Shakyamuni at the moment of his enlightenment, as indicated by his earth-touching gesture, or *bhumisparsha mudra*. The full, taut forms, diaphanous drapery, and anatomical details of his chest relate this image to eighth-century Chinese sculptures. Exquisitely carved low-relief images of bodhisattvas

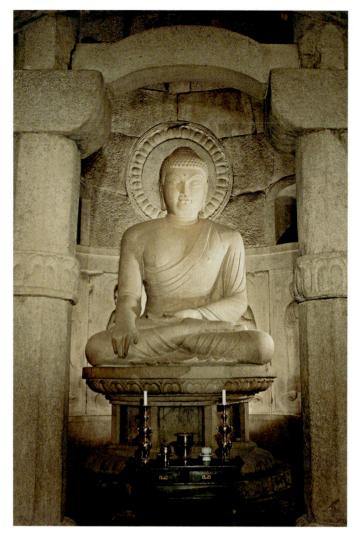

11-29 • SEATED SHAKYAMUNI BUDDHA Seokguram Grotto, near Gyeongju, North Gyeongsang Province, Korea. Unified Silla period, c. 751 cE. Granite, height of Buddha 11'2¹/₂" (3.42 m).

The Buddha's hands are in the *bhumisparsha mudra*, the earth-touching gesture symbolizing his enlightenment).

and lesser deities grace the walls of the antechamber, vestibule, and main hall.

GORYEO DYNASTY

Established in 918, the Goryeo dynasty eliminated the last vestiges of Unified Silla rule in 935; it would continue until 1392, ruling from its capital at Gaeseong—to the northwest of present-day Seoul and now in North Korea. A period of courtly refinement, the Goryeo dynasty is best known for its celadon-glazed ceramics.

CELADON-GLAZED CERAMICS The term **celadon** refers to a high-fired, transparent glaze of pale bluish-green hue, typically applied over a pale gray stoneware body. Chinese potters invented celadon glazes and had initiated the continuous production of celadon-glazed wares as early as the first century CE. Korean potters began to experiment with such glazes in the eighth and ninth centuries, and soon the finest Goryeo celadons rivaled the best Chinese court ceramics. Although these wares were used by people of various socioeconomic classes during the Goryeo dynasty, the finest examples went to the palace, to nobles, or to powerful Buddhist clergy.

Prized for their classic simplicity, eleventh-century Korean celadons often have little decoration, but during the twelfth century potters added incised, carved, or molded embellishments, either imitating those of contemporary Chinese ceramics or exploring new styles and techniques of ornamentation. Most notable among their inventions was inlaid decoration, in which black and white slips, or finely ground clays, were inlaid into the intaglio lines of decorative elements incised or stamped in the clay body, creating underglaze designs in contrasting colors, as seen in a bottle (**FIG. 11-30**) displaying three different pictorial scenes inlaid in black and

11-30 • MAEBYEONG BOTTLE WITH DECORATION OF BAMBOO AND BLOSSOMING PLUM TREE

Korea. Goryeo dynasty, late 12th–early 13th century CE. Inlaid celadon ware: light gray stoneware with decoration inlaid with black and white slips under celadon glaze, height 13¹/₄" (33.7 cm). Tokyo National Museum, Tokyo, Japan. (TG-2171)

11-31 • SEATED WILLOW-BRANCH GWANSE'EUM BOSAL (THE BODHISATTVA AVALOKITESHVARA)

Korea. Goryeo dynasty, late 14th century cE. Hanging scroll with ink, colors, and gold pigment on silk, height $62^{1}/_{2}^{\prime\prime}$ (159.6 cm). Arthur M. Sackler Museum, Harvard University, Cambridge, Massachusetts. Bequest of Grenville L. Winthrop (1943.57.12)

white slips. The scene shown here depicts a clump of bamboo growing at the edge of a lake, the stalks intertwined with the branches of a blossoming plum tree (which flowers in late winter, before sprouting leaves). Geese swim in the lake and butterflies flutter above, linking the several scenes around the bottle. Called *maebyeong* ("plum bottle"), such broadshouldered vessels were used as storage jars for wine, vinegar, and other liquids. A small, bell-shaped cover originally capped the bottle, protecting its contents and complementing its curves.

BUDDHIST PAINTING Buddhism, the state religion of Goryeo, enjoyed royal patronage, allowing many temples to commission the very finest architects, sculptors, and painters. The most sumptuous Buddhist works produced during the Goryeo period were paintings. Wrought in ink and colors on silk, a fourteenth-century hanging scroll (**FIG. 11-31**) depicts Gwanse'eum Bosal (whom the Chinese called Guanyin), the bodhisattva of compassion. The rich colors and gold pigment reflect the luxurious taste of the period. Numerous paintings of this type were exported to Japan, where they influenced the course of Buddhist painting.

THINK ABOUT IT

- **11.1** To what extent is naturalism—the artistic goal of reproducing the visual appearance of the natural world a motivating force in the developing history of early Chinese and Korean art?
- **11.2** Compare and contrast the Chinese seated Guanyin bodhisattva (FIG. 11–20) and the Korean bodhisattva seated in meditation (FIG. 11–28). Define the meaning of bodhisattva, and examine how the artists gave visual expression to the deity's attributes.
- **11.3** Summarize the main tenets of Confucianism. Then select a work from the chapter that gives visual form to Confucian philosophy and explain how it does so.
- **11.4** Select one of the Song-era Chinese landscape paintings included in the chapter. Describe it carefully and explain how it may embody philosophical or religious ideals.

CROSSCURRENTS

FIG. 3–3

FIG. 11-1

These two imposing complexes from Egypt and China are royal tombs. Explain how they represent the political stature of the entombed and the beliefs of their cultures.

Study and review on myartslab.com

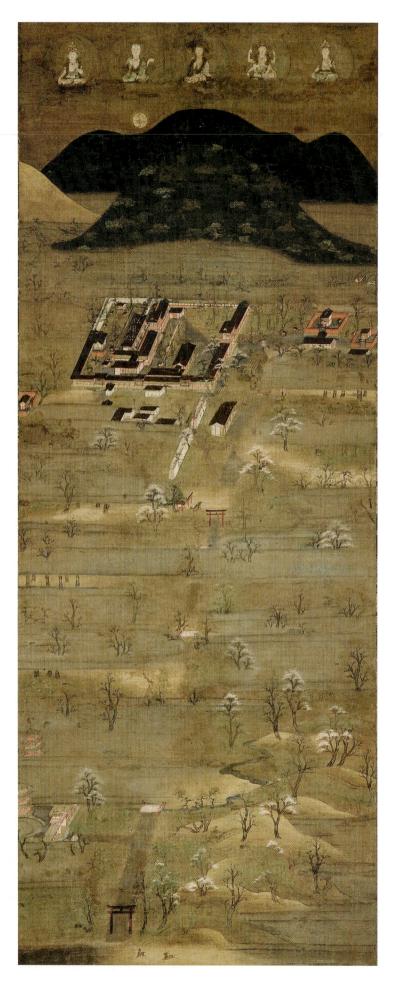

12-1 • KASUGA SHRINE MANDALA

Kamakura period, early 14th century cE. Hanging scroll with ink, color, and gold on silk, $39\frac{1}{2}$ " $\times 15\frac{5}{6}$ " (100.3 $\times 39.8$ cm). Mary and Jackson Burke Foundation.

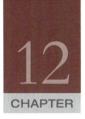

Japanese Art before 1333

A group of Buddhist deities hovers across the top of this painting (FIG. 12-1), poised in the sky above a vast vertical expanse of verdant hills and meadows filled with blossoming cherry and plum trees, and a diagrammatic, bird's-eye view of a religious compound. The sacred site depicted in idealized but recognizable form is the Kasuga Shrine in Nara, dedicated to deities, known as kami, of Japan's native Shinto religion. It served as the family shrine for the most powerful aristocratic clan in ancient Japan, the Fujiwara, who chose the site because of its proximity to their home as well as for its natural beauty. Life in Japan revolved around natural seasonal rhythms and the conceptions of kami, who give and protect life and embody the renewable, life-sustaining forces of nature. The kami were believed to have descended from mysterious heavens at supremely beautiful places such as majestic mountains, towering waterfalls, old and gnarled trees, or unusual rock formations, thus rendering such locations holy-places where one might seek communion with kami. The deer glimpsed scampering about the groundsprominently silhouetted at the very bottom of the paintingare considered sacred messengers of kami. They roam freely in this area even today.

That foreign deities associated with Buddhism preside over a native Shinto shrine presented no anomaly. By the Heian period (794–1185 CE), the interaction of Buddhist and Shinto doctrines in Japan resulted from the belief that *kami* were emanations of Buddhist deities who were their original forms. When Buddhism first entered Japan in the sixth century, efforts began to integrate the foreign faith with the indigenous Japanese religious belief system centered around *kami*, which only later came to be called Shinto. Until the government forcibly separated the two religions in the latter part of the nineteenth century, and elevated Shinto to bolster worship of the emperor, the two religions were intimately intertwined, evolving together as complementary systems. Shinto explains the origins of the Japanese people and its deities protect them, while Buddhism offers salvation after death.

This painting encapsulates various aspects of ancient and early medieval Japanese art and culture. Like all religious art from early Japan, it was created to embody religious teachings and beliefs, and was not considered a work of art in its own time. It represents how reverence for the natural world informed religious practice and visual vocabulary and shows how the foreign religion of Buddhism was integrated with indigenous belief systems, without sacrificing either. We will discover other examples of creative syntheses of disparate traditions as we survey the art of early Japan.

LEARN ABOUT IT

- **12.1** Recognize the native elements in early Japanese art and assess the influence of outside traditions in tracing its stylistic development.
- **12.2** Understand the themes and subjects associated with the developing history of Buddhism in Japan.
- **12.3** Explore the relationship of the history of early Japanese art and architecture to changing systems of government and patterns of religion.
- **12.4** Learn to characterize the significant distinctions between the art of the refined Heian court and the dynamic Kamakura shogunate.

((• Listen to the chapter audio on myartslab.com

PREHISTORIC JAPAN

Human habitation in Japan dates to around 30,000 years ago (MAP 12-1). Sometime after 15,000 years ago Paleolithic peoples gave way to Neolithic hunter-gatherers, who gradually developed the ability to make and use ceramics. Recent scientific dating methods have shown that some works of Japanese pottery date to earlier than 10,000 BCE, making them the oldest now known (see Chapter 1).

JOMON PERIOD

The early potters lived during the Jomon ("cord markings") period (c. 12,000–400 BCE), named for the patterns on much of the pottery they produced. They made functional earthenware vessels, probably originally imitating reed baskets, by building them up with coils of clay, then firing them in bonfires at relatively low temperatures (see FIG. 1–24). They also created small humanoid figures known as **dogu**, which were probably effigies that manifested a kind of sympathetic magic. Around 5000 BCE agriculture emerged with the planting and harvesting of beans and gourds.

YAYOI PERIOD

During the succeeding Yayoi era (c. 400 BCE–300 CE), the introduction of rice cultivation by immigrants from Korea helped transform Japan into an agricultural nation. As it did elsewhere in the world, this shift to agriculture brought larger permanent settlements, class structure with the division of labor into agricultural and nonagricultural tasks, and more hierarchical forms of social organization. Korean settlers also brought metal technology. Bronze was used to create weapons as well as ceremonial objects such as bells. Iron metallurgy developed later in this period, eventually replacing stone tools in everyday life.

KOFUN PERIOD

Centralized government developed during the ensuing Kofun ("old tombs") period (c. 300–552 CE), named for its large royal tombs. With the emergence of a more complex social order, the veneration of leaders grew into the beginnings of an imperial system. Still in existence today in Japan, this system eventually explained that the emperor (or, very rarely, empress) descended directly from Shinto deities. When an emperor died, chamber tombs were constructed following Korean examples. Various grave goods were placed inside the tomb chambers, including large amounts of pottery, presumably to pacify the spirits of the dead and to serve them in their next life. As part of a general cultural transfer from China through Korea, fifth-century potters in Japan gained knowledge of finishing techniques and improved kilns, and began to produce high-fired ceramic ware.

The Japanese government has never allowed the major sacred tombs to be excavated, but much is known about the mortuary practices of Kofun-era Japan. Some huge tombs of the fifth and

CHINA

sixth centuries were constructed in a shape resembling a large keyhole and surrounded by moats dug to protect the sacred precincts. Tomb sites might extend over more than 400 acres, with artificial hills built over the tombs themselves. On the top of the hills were placed ceramic sculptures called **haniwa**.

Hokkaido, Honshu, Shikoku, and Kyushu.

HANIWA The first *haniwa* were simple cylinders that may have held jars with ceremonial offerings. By the fifth century, these cylinders came to be made in the shapes of ceremonial objects, houses, and boats. Gradually, living creatures were added to the repertoire of *haniwa* subjects, including birds, deer, dogs, monkeys, cows, and horses. By the sixth century, **HANIWA** in human shapes were crafted, including males and females of various types, professions, and classes (**FIG. 12-2**).

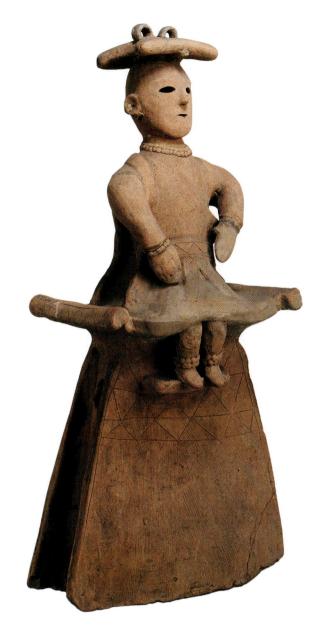

12-2 • HANIWA

Kyoto. Kofun period, 6th century CE. Earthenware, height 27" (68.5 cm). Collection of the Tokyo National Museum. Important Cultural Property.

There have been many theories on the function of *haniwa*. The figures seem to have served as some kind of link between the world of the dead, over which they were placed, and the world of the living, from which they could be viewed. This figure has been identified as a seated female shaman, wearing a robe, belt, and necklace and carrying a mirror at her waist. In early Japan, shamans acted as agents between the natural and the supernatural worlds, just as *haniwa* figures were links between the living and the dead.

Haniwa embody aesthetic characteristics that we will encounter again in Japanese art. Haniwa were left with their clay bodies unglazed; they do not show a preoccupation with technical virtuosity. Instead, their makers explored the expressive potentials of simple and bold forms. Haniwa are never perfectly symmetrical; their slightly off-center eye-slits, irregular cylindrical bodies, and unequal arms seem to impart the idiosyncrasy of life and individuality.

SHINTO As described at the beginning of this chapter, Shinto is Japan's indigenous religious belief system. It encompasses a variety of ritual practices that center around family, village, and devotion to *kami*. The term Shinto was not coined until after the arrival of Buddhism in the sixth century CE, and as *kami* worship was influenced by and incorporated into Buddhism it became more systematized, with shrines, a hierarchy of deities, and more strictly regulated ceremonies.

THE ISE SHRINE One of the great Shinto monuments is the Grand Shrine of Ise, on the coast southwest of Tokyo (FIG. 12-3), where the main deity worshiped is the sun goddess Amaterasuo-mi-kami, the legendary progenitor of Japan's imperial family. Japan's earliest written historical texts recorded by the imperial court in the eighth century claim that the Ise Shrine dates to the first century CE. Although we do not know for certain if this is true, it is known that it has been ritually rebuilt, alternately on two adjoining sites at 20-year intervals with few breaks since the year 690, a time when the imperial family was solidifying its hegemony. Its most recent rebuilding took place in 1993, by carpenters who train for the task from childhood. After the kami is ceremonially escorted to the freshly copied shrine, the old shrine is dismantled. Thus-like Japanese culture itself-this exquisite shrine is both ancient and constantly renewed. In this sense it embodies one of the most important characteristics of Shinto faith-ritual purification-derived from respect for the cycle of the seasons in

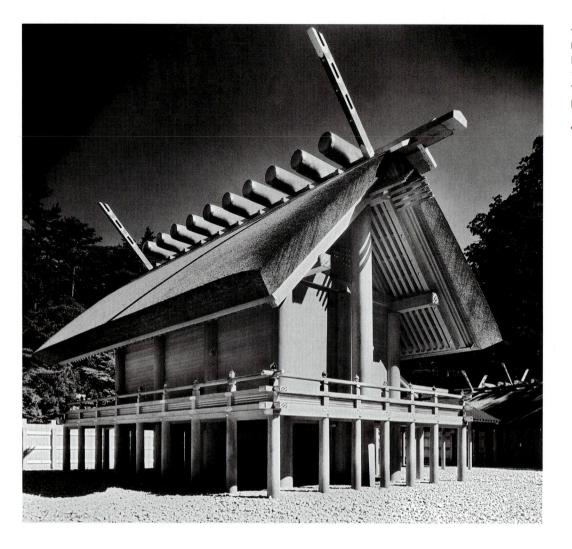

12-3 • MAIN HALL, INNER SHRINE, ISE

Mie Prefecture. Last rebuilt 1993. Photograph by Watanabe Yoshio (1907–2000), 1953. National Treasure.

Watch a video about the rebuilding of the Ise Shrine on myartslab.com

which pure new life emerges in springtime and gives way to death in winter, yet is reborn again in the following year.

Although Ise is visited by millions of pilgrims each year, only members of the imperial family and a few Shinto priests are allowed within the enclosure that surrounds its inner shrine. Detailed documents on its appearance date back to the tenth century, but shrine authorities denied photographers access to its inner compound until 1953, when the iconic photograph of it reproduced in FIGURE 12–3 was taken by a photographer officially engaged by a quasi-governmental cultural relations agency. The reluctance of shrine officials to permit photography even then may stem from beliefs that such intimate pictures would violate the privacy of the shrine's most sacred spaces.

Many aspects of the Ise Shrine are typical of Shinto architecture, including the wooden piles that elevate the building above the ground, a thatched roof held in place by horizontal logs, the use of unpainted cypress wood, and the overall feeling of natural simplicity rather than overwhelming size or elaborate decoration. The building's shape seems indebted to early raised granaries known from drawings on bronze artifacts of the Yayoi period. The sensitive use of unornamented natural materials in the Ise Shrine suggests an early origin for an aspect of Japanese taste that persists to the present day.

ASUKA PERIOD

During the single century of the Asuka period (552–645 CE), new forms of philosophy, medicine, music, food, clothing, agriculture, city planning, religion, visual art, and architecture entered Japan from Korea and China at an astonishing pace. Most significant among these were the Buddhist religion, a centralized governmental structure, and a system of writing. Each was adopted and gradually modified to suit local Japanese conditions, and each has had an enduring legacy.

Buddhism reached Japan in Mahayana form, with its many buddhas and bodhisattvas (see "Buddhism," page 301). After being accepted by the imperial family, it was soon adopted as a state religion. Buddhism represented not only different gods from Shinto but an entirely new concept of religion. Worship of Buddhist deities took place inside worship halls of temples situated in close proximity to imperial cities. The Chinese-influenced temples looked nothing like previous Japanese buildings. They housed

ART AND ITS CONTEXTS | Writing, Language, and Culture

Chinese culture enjoyed great prestige in east Asia. Written Chinese served as an international language of scholarship and cultivation, much as Latin did in medieval Europe. Educated Koreans, for example, wrote almost exclusively in Chinese until the fifteenth century. In Japan, Chinese continued to be used for certain kinds of writing, such as Buddhist *sutras*, philosophical and legal texts, and Chinese poetry (by Japanese writers), into the nineteenth century.

When it came to writing their own language, the Japanese initially borrowed Chinese characters, or *kanji*. Differences between the Chinese and Japanese languages made this system extremely unwieldy, so during the ninth century they developed two syllabaries, or *kana*, from simplified Chinese characters. (A syllabary is a system of lettering in which each symbol stands for a syllable.) *Katakana*, consisting of angular symbols, was developed to aid pronunciation of Chinese Buddhist texts and now is generally used for foreign words. *Hiragana*, comprised of graceful, cursive symbols, was the written language the Japanese first used to write native poetry and prose. Eventually it came to be used to represent only the grammatical portions of the written Japanese language in conjunction with Chinese characters that convey meaning. Japanese written in *hiragana* was once called "women's hand" because its rounded forms looked feminine. During the Heian period *hiragana* were used to create a large body of literature, written either by women or sometimes for women by men.

A charming poem originated in Heian times to teach the new writing system. In two stanzas of four lines each, it uses almost all of the syllable sounds of spoken Japanese and thus almost every *kana* symbol. It was memorized as we would recite our abcs. The first stanza translates as:

Although flowers glow with color They are quickly fallen, And who in this world of ours Is free from change? (Translation by Earl Miner)

Like Chinese, Japanese is written in columns from top to bottom and across the page from right to left. (Following this logic, Chinese and Japanese handscrolls also read from right to left.) Below is the stanza written three ways. At the right, it appears in *katakana* glossed with the original phonetic value of each symbol. In the center, the stanza appears in flowing *hiragana*. To the left is the mixture of *kanji* and *hiragana* that eventually became standard.

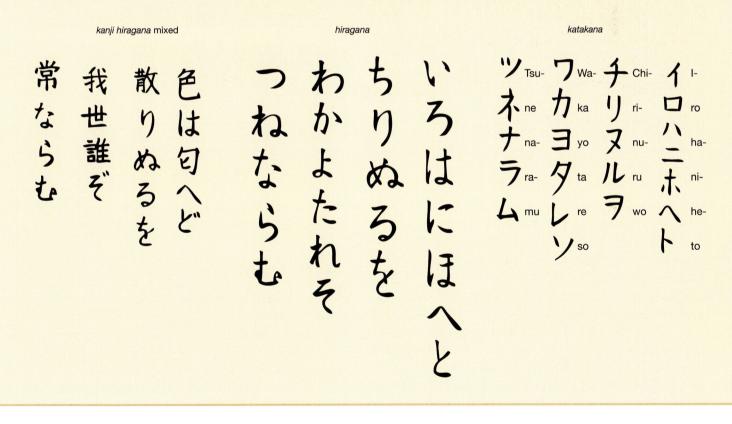

anthropomorphic and elaborately symbolic Buddhist icons (see "Buddhist Symbols," page 368) at a time when *kami* were not portrayed in human form. Yet Buddhism attracted followers because it offered a rich cosmology with profound teachings of meditation and enlightenment. The protective powers of its deities enabled the ruling elites to justify their own power, through association with Buddhism, and they called upon Buddhist deities to nurture and protect the populace over whom they ruled. Many highly developed aspects of continental Asian art traveled to Japan with the new religion, including new methods of painting and sculpture.

HORYUJI

The most significant surviving early Japanese temple is Horyuji, located on Japan's central plains not far from Nara. The temple was founded in 607 by Prince Shotoku (574–622), who ruled Japan as a regent and became the most influential early proponent

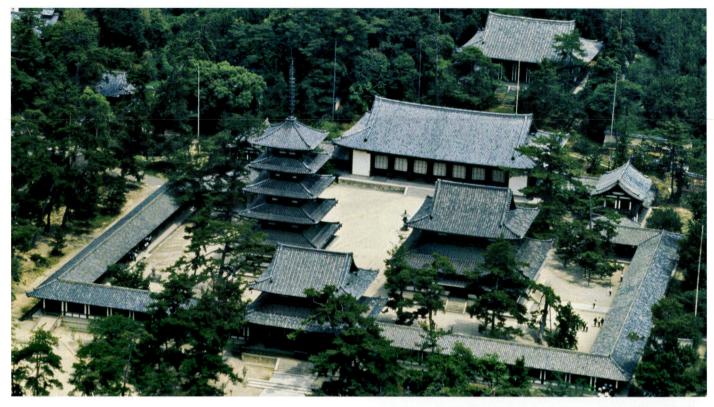

12-4 • **AERIAL VIEW OF HORYUJI COMPOUND** Pagoda to the west (left), golden hall (*kondo*) to the east (right). Nara Prefecture. Asuka period, 7th century ce. UNESCO World Heritage Site, National Treasure.

of Buddhism. Rebuilt after a fire in 670, Horyuji is the oldest wooden temple in the world. The just proportions and human scale of its buildings, together with the artistic treasures it houses, make Horyuji a beautiful as well as important monument to Buddhist faith in early Japan.

The main compound of Horyuji consists of a rectangular courtyard surrounded by covered corridors, one of which contains a gateway. Within the compound are two buildings: the **kondo** (golden hall) and a five-story pagoda. Within a simple asymmetrical layout, the large *kondo* balances the tall, slender pagoda (**FIG. 12-4**). The *kondo*, filled with Buddhist images, is used for worship and ceremonies, while the pagoda serves as a **reliquary** and is not entered. Other monastery buildings lie outside the main compound, including an outer gate, a lecture hall, a repository for sacred texts, a belfry, and dormitories for monks.

Among the many treasures still preserved in Horyuji is a portable shrine decorated with paintings in lacquer. It is known as the Tamamushi Shrine after the *tamamushi* beetle, whose iridescent

12-5 • HUNGRY TIGRESS JATAKA

Panel of the Tamamushi Shrine, Horyuji. Asuka period, c. 650 cE. Lacquer on wood, height of shrine 7'7½" (2.33 m). Horyuji Treasure House, Nara. National Treasure.

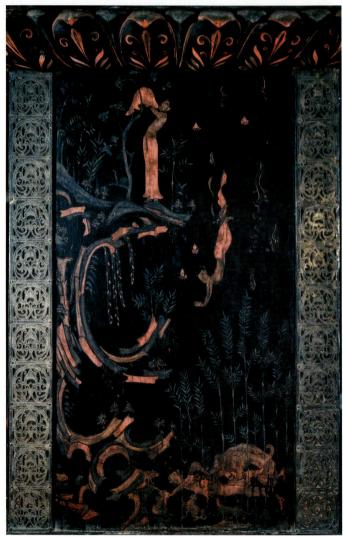

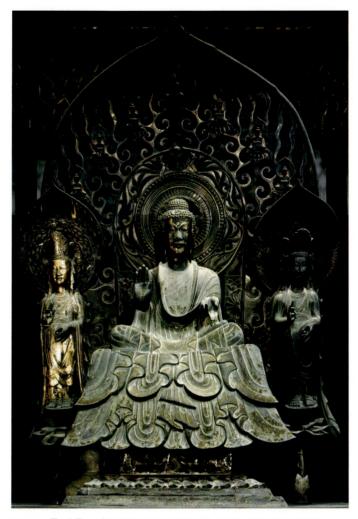

12-6 • Tori Busshi BUDDHA SHAKA AND ATTENDANT BODHISATTVAS IN THE HORYUJI KONDO Asuka period, c. 623 ce. Gilt bronze, height of seated figure $34\frac{1}{2}$ " (87.5 cm). Horyuji, Nara. National Treasure.

wings were originally affixed to the shrine to make it glitter, much like mother-of-pearl. Its architectural form replicates an ancient palace-form building type that pre-dates Horyuji itself.

HUNGRY TIGRESS JATAKA Paintings on the sides of the Tamamushi Shrine are among the few two-dimensional works of art to survive from the Asuka period. Most celebrated among them are two that illustrate Jataka tales, stories about former lives of the Buddha. One depicts the future Buddha nobly sacrificing his life in order to feed his body to a starving tigress and her cubs (FIG. 12-5). Since the tigers are at first too weak to eat him, he jumps off a cliff to break open his flesh. The painter has created a full narrative within a single frame. The graceful form of the Buddha appears three times in three sequential stages of the story, harmonized by the curves of the rocky cliff and tall wands of bamboo. First, he hangs his shirt on a tree, then he dives downward onto the rocks, and finally the starving animals devour his body. The elegantly slender renditions of the figure and the stylized treatment of the cliff, trees, and bamboo represent an international Buddhist style that was transmitted to Japan via China and Korea. Such illustrations of Jataka tales helped popularize Buddhism in Japan.

SHAKA TRIAD Another example of the international style of early Buddhist art at Horyuji is the sculpture called the Shaka Triad, traditionally attributed to sculptor Tori Busshi (**FIG. 12-6**). (Shaka is the Japanese name for Shakyamuni, the historical Buddha.) Tori Busshi (Busshi means Buddhist image-maker) may have been a descendant of Korean craftsmakers who emigrated to Japan as part of an influx of Buddhists and artisans from Korea. The Shaka Triad reflects the strong influence of Chinese art of the Northern Wei dynasty (see FIG. 11-12). The frontal pose, the outsized face and hands, and the linear treatment of the drapery all suggest that the maker of this statue was well aware of earlier continental models, while the fine bronze casting of the figures shows his advanced technical skill.

NARA PERIOD

The Nara period (645–794) is named for Japan's first permanent imperial capital, founded in 710. Previously, an emperor's death was thought to taint his entire capital city, so for reasons of purification (and perhaps also of politics), his successor usually selected a new site. As the government adopted ever more complex aspects of the Chinese political system, necessitating construction of huge administrative complexes, it abandoned this custom in the eighth century when Nara was founded. During this period, divisions of the imperial bureaucracy grew exponentially and hastened the swelling of the city's population to perhaps 200,000 people.

One result of the strong central authority was the construction in Nara of magnificent Buddhist temples and Shinto shrines that dwarfed those built previously. The expansive park in the center of Nara today is the site of the largest and most important of these, including the Shinto Kasuga Shrine depicted in FIGURE 12-1. The grandest of the Buddhist temples in Nara Park is Todaiji, which the deeply religious Emperor Shomu (r. 724–749) conceived as the headquarters of a vast network of branch temples throughout the nation. Todaiji served as both a state-supported central monastic training center and as the setting for public religious ceremonies. The most spectacular of these took place in 752 and celebrated the consecration of the main Buddhist statue of the temple in a traditional "eye-opening" ceremony, in its newly constructed Great Buddha Hall (Daibutsuden; see "The Great Buddha Hall," page 370). The statue, a giant gilt-bronze image of the Buddha Birushana (Vairochana in Sanskrit), was inspired by the Chinese tradition of erecting monumental stone Buddhist statues in cave-temples (see FIG. 11–12).

The ceremony, which took place in the vast courtyard in front of the Great Buddha Hall, was presided over by an illustrious Indian monk and included *sutra* chanting by over 10,000 Japanese Buddhist monks and sacred performances by 4,000 court musicians

ART AND ITS CONTEXTS | Buddhist Symbols

A few of the most important Buddhist symbols, which have myriad variations, are described here in their most generalized forms.

Lotus flower: Usually shown as a white waterlily, the lotus (Sanskrit, *padma*) symbolizes spiritual purity, the wholeness of creation, and cosmic harmony. The flower's stem is an *axis mundi* ("axis of the world").

Lotus throne: Buddhas are frequently shown seated on an open lotus, either single or double, a representation of *nirvana* (see FIG. 12–12).

Chakra: An ancient sun symbol, the *chakra* (wheel) symbolizes both the various states of existence (the Wheel of Life) and the Buddhist doctrine (the Wheel of the Law). A *chakra*'s exact meaning depends on how many spokes it has.

Marks of a buddha: A buddha is distinguished by 32 physical attributes (*lakshanas*). Among them are a bulge on top of the head (*ushnisha*), a tuft of hair between the eyebrows (*urna*), elongated earlobes, and 1,000-spoked *chakras* on the soles of the feet.

Mandala: Mandalas are diagrams of cosmic realms, representing order and meaning within the spiritual universe. They may be simple or complex, three- or two-dimensional, and in a wide array of forms—such as an Indian stupa (see FIG. 10–8) or a Womb World *mandala* (see FIG. 12–10), an early Japanese type.

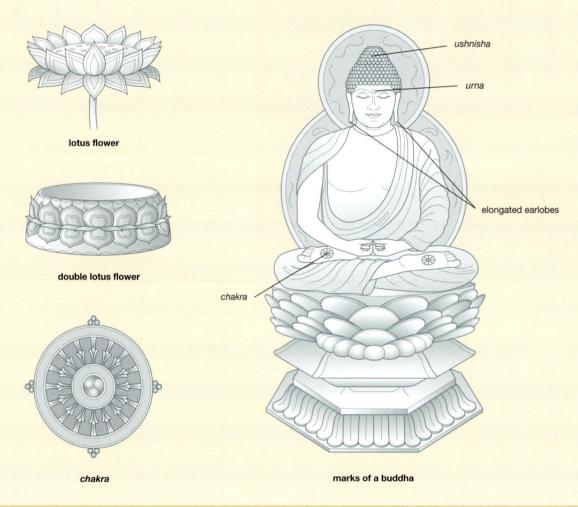

and dancers. Vast numbers of Japanese courtiers and emissaries from the Asian continent comprised the audience. Numerous ritual objects used in the ceremony came from exotic Asian and Near Eastern lands. The resulting cosmopolitan atmosphere reflected the position Nara then held as the eastern terminus of the Central Asian Silk Road.

Many of these treasures have been preserved in the Shosoin Imperial Repository at Todaiji, which today contains some 9,000 objects. The Shosoin came into being in the year 756, when Emperor Shomu died and his widow Empress Komyo, a devout Buddhist, donated some 600 of his possessions to the temple, including a number of objects used during the Great Buddha's consecration ceremony. Many years later, objects used in Buddhist rituals and previously stored elsewhere at Todaiji were incorporated into the collection. The objects formerly owned by Emperor Shomu consisted mainly of his personal possessions, such

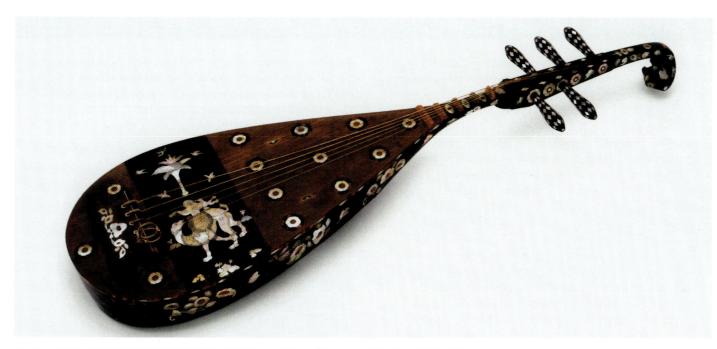

12-7 • FIVE-STRINGED LUTE (BIWA) WITH DESIGN OF A CENTRAL ASIAN MAN PLAYING A BIWA ATOP A CAMEL

Chinese. Tang dynasty, 8th century cE. Red sandalwood and chestnut inlaid with mother-of-pearl, amber, and tortoiseshell. Length $42^{1}/_{2}$ " (108.1 cm), width 12" (30.9 cm), depth $3^{1}/_{2}$ " (9 cm). Shosoin, Todaiji.

as documents, furniture, musical instruments, games, clothing, medicine, weapons, food and beverage vessels of metal, glass, and lacquer, and some Buddhist ritual objects. Some of these were made in Japan while others came from as far away as China, India, Iran, Greece, Rome, and Egypt. They reflect the vast international trade network that existed at this early date.

One of the items Empress Komyo donated in 756 is a magnificently crafted five-stringed lute (biwa) made of lacquered red sandalwood and chestnut, and inlaid with mother-of-pearl, amber, and tortoiseshell. Its plectrum guard features the portrayal of a central Asian musician (his ethnicity apparent from his clothing and physical features) sitting on a camel and playing a lute (FIG. 12-7). This is the only existing example of an ancient fivestringed lute, an instrument invented in India and transmitted to China and Japan via the Silk Road. The Shosoin piece is generally identified as Chinese, but, as with many of the objects preserved in the Shosoin, the location of its manufacture is not absolutely certain. While it was most likely crafted in China and imported to Japan for use in the consecration ceremony (researchers have recently conclusively determined that it was indeed played), it is also plausible that Chinese (or Japanese) craftsmakers made it in Japan using imported materials. Its meticulous workmanship is characteristic of the high level of craft production achieved by artists of this era.

Influenced by Emperor Shomu, the Buddhist faith permeated all aspects of Nara court society. Indeed, in 749 Shomu abdicated the throne to spend the remainder of his life as a monk. His daughter, also a devout Buddhist, succeeded him as empress but wanted to cede her throne to a Buddhist monk. This so dismayed her advisors that they moved the capital city away from Nara, where they felt Buddhist influence had become overpowering, and establish a new one in Kyoto, within whose bounds, at first, only a few Buddhist temples would be allowed. The move of the capital to Kyoto marked the end of the Nara period.

HEIAN PERIOD

During the Heian period (794–1185) the Japanese fully absorbed and transformed their cultural borrowings from China and Korea. Generally peaceful conditions contributed to a new air of selfreliance, and the imperial government severed ties to China in the ninth century, a time when the power of related aristocratic families increased. An efficient method of writing the Japanese language was developed, and the rise of vernacular literature generated such prose masterpieces as Lady Murasaki's *The Tale of Genji*. During these four centuries of splendor and refinement, two major streams of Buddhism emerged—esoteric sects and, later, those espousing salvation in the Pure Land Western Paradise of the Buddha Amida.

ESOTERIC BUDDHIST ART

With the removal of the capital to Kyoto, the older Nara temples lost their influence. Soon two new Esoteric sects of Buddhism, Tendai and Shingon, grew to dominate Japanese religious life. Strongly influenced by polytheistic religions such as Hinduism, Esoteric Buddhism (known as Tantric Buddhism in Nepal and

RECOVERING THE PAST | The Great Buddha Hall

The Great Buddha Hall (Daibutsuden) is distinguished today as the largest wooden structure in the world. Yet the present GREAT BUDDHA HALL (FIG. 12-8), dating to a reconstruction of 1707, is 30 percent smaller than the original, which towered nearly 90 feet in height. Since it was first erected in 752 CE, natural disasters and intentional destruction by foes of the imperial family have necessitated its reconstruction four times. It was first destroyed during civil wars in the twelfth century and rebuilt in 1203, then destroyed in yet another civil war in 1567. Reconstruction did not next occur until the late seventeenth century under the direction of a charismatic monk who solicited funds not from the government, which was then impoverished, but through popular subscription. This building, completed in 1707, is essentially the structure that stands on the site today. However, by the late nineteenth century its condition had deteriorated so profoundly that restoration finally undertaken between 1906 and 1913 entailed completely dismantling it and putting it back together, this time utilizing steel (imported from England) and concrete to provide invisible support to the roof, which had nearly collapsed. Architects adopted this nontraditional solution mainly because no trees of sufficiently large dimensions could be found, and no traditional carpenters then living possessed knowledge of ancient construction techniques. This project occurred only after laws were enacted in 1897 to preserve ancient architecture. Another major restoration of the building took place between 1973 and 1980.

Like the building, the Great Buddha (*Daibutsu*) statue has not survived intact. Its head was completely destroyed in the late sixteenth century and replaced as part of the hall's reconstruction in the late seventeenth century, when its torso and lotus petal throne also required extensive restoration. The present statue, though impressive in scale, appears stiff and rigid. Its more lyrical original appearance may have approximated engraved images of seated Buddhist deities found on a massive cast-bronze lotus petal from the original statue that has survived in fragmentary form (**FIG. 12–9**). The petal features a buddha with a narrow waist, broad shoulders, and elegantly flowing robes that characterize the style of contemporaneous buddha images of the Tang dynasty (see, for example, the central buddha in FIG. 11–14).

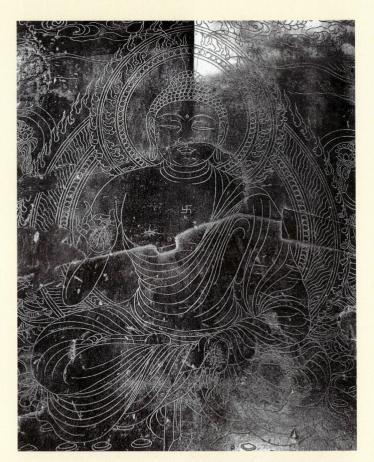

12-9 • THE BUDDHA SHAKA, DETAIL OF A PARADISE SCENE

Engraved bronze lotus petal from the original Great Buddha (*Daibutsu*) statue of the Buddha Birushana. 8th century ce. Height of petal 79" (200 cm). *Daibutsuden*, Todaiji. National Treasure.

12-8 • GREAT BUDDHA HALL (DAIBUTSUDEN), TODAIJI, NARA

Original structure completed in 752 cE; twice destroyed; rebuilt in 1707; extensively restored 1906– 1913, 1973–1980. UNESCO World Heritage Site, National Treasure.

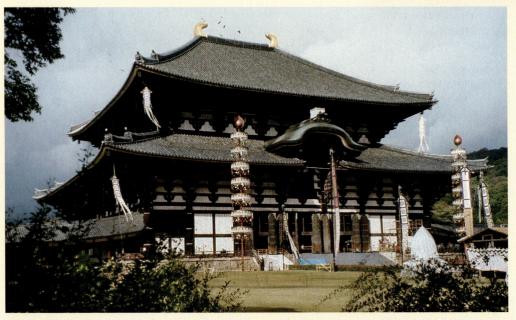

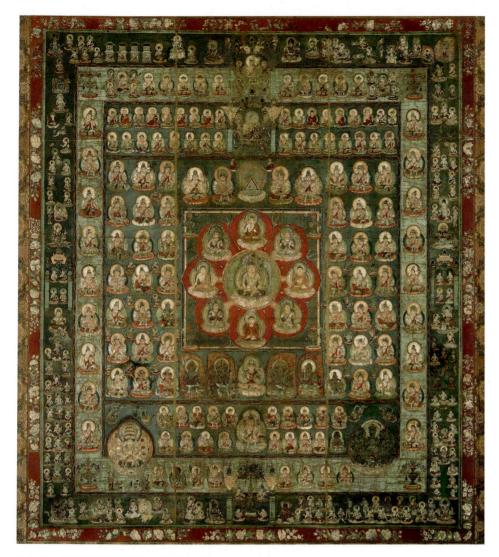

12-10 • WOMB WORLD MANDALA

Heian period, late 9th century ce. Hanging scroll with colors on silk, $6' \times 5'1^{1}\!/_{2}''$ (1.83 \times 1.54 m). Toji, Kyoto. National Treasure.

Mandalas are used not only in teaching, but also as vehicles for practice. A monk, initiated into secret teachings, may meditate upon and assume the gestures of each deity depicted in the *mandala*, gradually working out from the center, so that he absorbs some of each deity's powers. The monk may also recite magical phrases, called mantras, as an aid to meditation. The goal is to achieve enlightenment through the powers of the different forms of the Buddha. *Mandalas* are created in sculptural and architectural forms as well as in paintings (see FIG. 10–34). Their integration of the two most basic shapes, the circle and the square, is an expression of the principles of ancient geomancy (divining by means of lines and figures) as well as Buddhist cosmology.

Tibet) included a daunting number of deities, each with magical powers. The historical Buddha was no longer very important. Instead, most revered was the universal Buddha, called Dainichi ("Great Sun" in Japanese), who was believed to preside over the universe. He was accompanied by buddhas and bodhisattvas, as well as guardian deities who formed fierce counterparts to the more benign gods.

Esoteric Buddhism is hierarchical, and its deities have complex relationships to one another. Learning all the different gods and their interrelationships was assisted greatly by paintings, especially *mandalas*, cosmic diagrams of the universe that portray the deities in schematic order. The **WOMB WORLD MANDALA** from Toji, for example, is entirely filled with depictions of gods. Dainichi is at the center, surrounded by buddhas of the four directions (**Fig. 12-10**). Other deities, including some with multiple heads and limbs, branch out in diagrammatical order, each with a specific symbol of power and targeted to various levels of potential worshipers, some of whom needed to be frightened to awaken to Buddhist teaching. To believers, the *mandala* represents an ultimate reality beyond the visible world.

Perhaps the most striking attribute of many Esoteric Buddhist images is their sense of spiritual force and potency, especially in depictions of the wrathful deities, which are often surrounded by flames, like those visible in the Womb World *mandala* just below the main circle of Buddhas. Esoteric Buddhism, with its intricate theology and complex doctrines, was a religion for the educated aristocracy, not for the masses. Its elaborate network of deities, hierarchy, and ritual, found parallels in the elaborate social divisions of the Heian court.

PURE LAND BUDDHIST ART

Rising militarism, political turbulence, and the excesses of the imperial court marked the beginning of the eleventh century in Japan. To many, the unsettled times seemed to confirm the coming of *Mappo*, the Buddhist concept of a longprophesied dark age of spiritual degeneration. Japanese of all classes reacted by increasingly turning to the promise of salvation after death through simple faith in the existence of a Buddhist realm

known as the Western Paradise of the Pure Land, a resplendent place filled with divine flowers and music. Amida (Amithaba in Sanskrit) and his attendant bodhisattvas preside there as divine protectors who compassionately accept into their land of bliss all who submit wholeheartedly to their benevolent powers. Pure Land beliefs had spread to Japan from China by way of Korea, where they also enjoyed great popularity. They offered a more immediate and easy means to achieve salvation than the elaborate rituals of the Esoteric sects. Pure Land Buddhism held that merely by chanting *Namu Amida Butsu* ("Hail to Amida Buddha"), the faithful would be reborn into the Western Paradise.

TECHNIQUE | Joined-Block Wood Sculpture

Wood is a temperamental material because fluctuations in moisture content cause it to swell and shrink. Cut from a living, sap-filled tree, it takes many years to dry to a state of stability. While the outside of a piece of wood dries fairly rapidly, the inside yields its moisture only gradually, causing a difference in the rates of shrinkage between the inside and the outside, which induces the wood to crack. Consequently, a large statue carved from a single log must inevitably crack as it ages. Natural irregularities in wood, such as knots, further accentuate this problem. Thus, wood with a thinner cross section and fewer irregularities is less susceptible to cracking because it can dry more evenly. (This is the logic behind sawing logs into boards before drying.)

Japanese sculptors developed an ingenious and unique method, the joined-block technique, to reduce cracking in heavy wooden statues. This allowed them to create larger statues in wood than ever before, enabled standardization of body proportions, and encouraged division of labor among teams of carvers, some of whom became specialists in certain parts, such as hands or crossed legs or lotus thrones. To create large statues seated in the lotus pose, sculptors first put four blocks together vertically two by two in front and back, to form the main body, then added several blocks horizontally at what would become the front of the statue for the lap and knees. After carving each part, they assembled the figure and hollowed out the interior. This cooperative approach also had the added benefit of enabling workshops to produce large statues more quickly to meet a growing demand. Jocho is credited as the master sculptor who perfected this technique. The diagram shows how he assembled the Amida Buddha at the Byodoin (see FIG. 12–12).

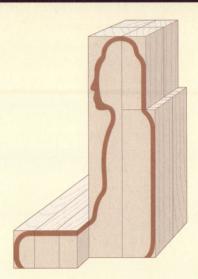

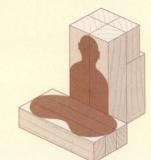

Diagram of the joined-block wood sculpture technique used on the Amida statue by Jocho.

• Watch an architectural simulation about the joined-block technique on myartslab.com

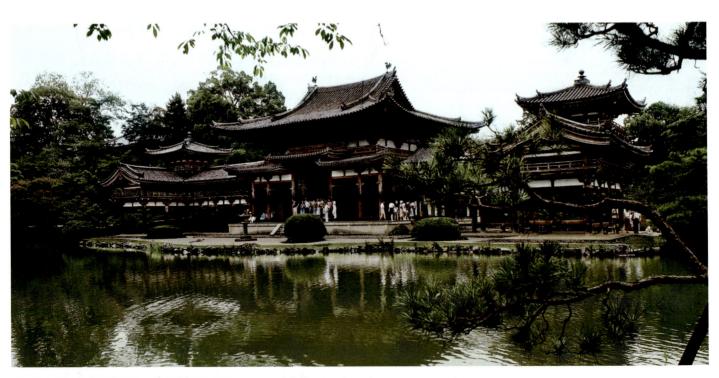

12-11 • PHOENIX HALL, BYODOIN, UJI Kyoto Prefecture. Heian period, c. 1053 cE. UNESCO World Heritage Site, National Treasure.

BYODOIN One of the most beautiful temples of Pure Land Buddhism is the Byodoin, located in the Uji Mountains not far from central Kyoto (FIG. 12-11). The temple itself was originally a secular villa whose form was intended to suggest the appearance of the palatial residence of Amida in his Western Paradise (see FIG. 11-14). It was built for a member of the powerful Fujiwara family who served as the leading counselor to the emperor. After the counselor's death in the year 1052, his descendants converted the palace into a memorial temple to honor his spirit. The Byodoin is often called the Phoenix Hall, not only for the pair of phoenix images on its roof, but also because the shape of the building itself suggests the mythical bird. Its thin columns give the Byodoin a sense of airiness, as though the entire temple could easily rise up through the sky to Amida's Western Paradise. The hall rests gently in front of an artificial pond created in the shape of the Sanskrit letter A, the sacred symbol for Amida.

The Byodoin's central image of Amida, carved by the master sculptor Jocho (d. 1057), exemplifies the serenity and compassion of this Buddha (**FIG. 12-12**). When reflected in the water of the pond before it, the Amida image seems to shimmer in its private mountain retreat. The figure was not carved from a single block of wood like earlier sculpture, but from several blocks in Jocho's new **joined-block** method of construction (see "Joined-Block Wood Sculpture," opposite). This technique allowed sculptors to create larger and lighter statuary. It also reflects the growing importance of wood as the medium of choice for Buddhist sculpture, reflecting a long-standing Japanese love for this natural material.

Surrounding the Amida on the walls of the Byodoin are smaller wooden figures of bodhisattvas and angels, some playing musical instruments. Everything

about the Byodoin was designed to simulate the appearance of the paradise that awaits the believer after death. Its remarkable state of preservation after more than 900 years allows visitors to experience the late Heian religious ideal at its most splendid.

SECULAR PAINTING AND CALLIGRAPHY

Parallel with the permeation of Buddhism during the Heian era (794–1185) was a refined secular culture that developed at court. Gradually, over the course of these four centuries, the pervasive influence of Chinese culture in aristocratic society gave rise to new, uniquely Japanese developments. Above all, Heian court culture greatly valued refinement; pity any man or woman at court who was not accomplished in several forms of art. A woman would be admired for the way she arranged the 12 layers of her robes by color, or a man for knowing which kind of incense was being burned. Concurrently, court life became preoccupied by the

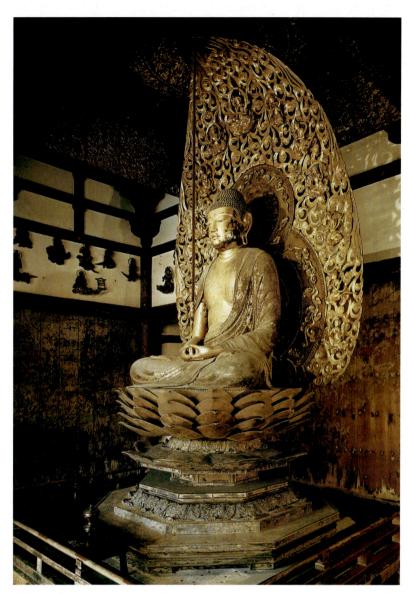

12-12 • Jocho **AMIDA BUDDHA** Phoenix Hall, Byodoin. Heian period, c. 1053 cE. Gold leaf and lacquer on wood, height 9'8" (2.95 m). National Treasure.

poetical expression of human love. In this climate, women became a vital force in Heian society. Although the status of women was to decline in later periods, they contributed greatly to art at the Heian court and became famous for their prose and poetry.

Although male courtiers continued to be required to read and write Chinese, both men and women of court society wrote prose and poetry in their native Japanese language using the newly devised *kana* script (see "Writing, Language, and Culture," page 365). They also used *kana* on text portions of new types of smallscale secular paintings—handscrolls or folding albums designed to be appreciated in private settings.

At the beginning of the eleventh century, the lady-in-waiting Lady Murasaki transposed the lifestyle of Heian aristocrats into fiction for the amusement of her fellow court ladies in *The Tale of Genji*, which some consider the world's first novel. Still today the Japanese admire this tale of 54 chapters as the pinnacle of Japanese

A CLOSER LOOK | The Tale of Genji

Scene from the Kashiwagi chapter.

Heian period, 12th century ce. Handscroll with ink and colors on paper, $85\%' \times 187\%''$ (21.9 \times 47.9 cm). Tokugawa Art Museum, Nagoya. National Treasure.

Only 19 illustrated scenes from this earliest known example of an illustrated handscroll of *The Tale of Genji*, created about 100 years after the novel was written, have been preserved. Scholars assume that it once contained illustrations from the entire novel of 54 chapters, approximately 100 pictures in all. Each scroll seems to have been produced by a team of artists. One was the calligrapher, most likely a

member of the nobility. Another was the master painter, who outlined two or three illustrations per chapter in fine brushstrokes and indicated the color scheme. Next, colorists went to work, applying layer after layer of color to build up patterns and textures. After they had finished, the master painter returned to reinforce outlines and apply the finishing touches, among them the details of the faces.

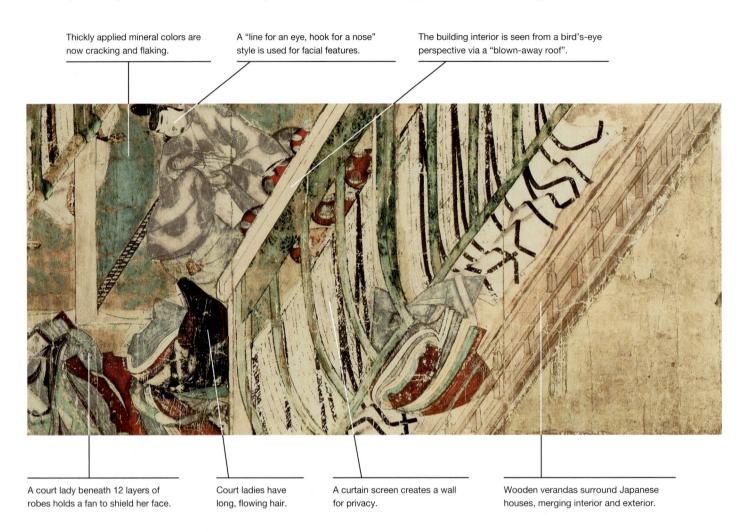

View the Closer Look for The Tale of Genji on myartslab.com

literary achievement (in 2009, the official 1,000-year anniversary of its completion, numerous exhibitions and celebrations took place throughout Japan). Underlying the story of the love affairs of Prince Genji and his companions is the Heian conception of fleeting pleasures and ultimate sadness in life, an echo of the Buddhist view of the vanity of earthly pleasures.

YAMATO-E HANDSCROLLS—THE TALE OF GENJI One of the earliest extant examples of secular painting from Japan in a new native style called **yamato-e** (native Japanese-style pictures; Yamato is the old Japanese word for Japan) is an illustrated handscroll depicting a series of scenes from *The Tale of Genji*, painted in the twelfth century. The handscroll alternates sections of text with illustrations of scenes from the story and features delicate lines, strong (but sometimes muted) mineral colors, and asymmetrical compositions. The *Genji* paintings have a refined, subtle emotional impact. They generally show court figures in architectural settings, with the frequent addition of natural elements, such as sections of gardens, that help to convey the mood of the scene. Thus a blossoming cherry tree appears in a scene of happiness, while unkempt weeds appear in a depiction of loneliness. Such correspondences between nature and human

emotion are an enduring theme of Japanese poetry and art. The figures in *The Tale of Genji* paintings do not show their emotions directly on their faces, which are rendered with a few simple lines. Instead, their feelings are conveyed by colors, poses, the fluttering of curtains, and the overall composition of the scenes.

One scene evokes the seemingly happy Prince Genji holding a baby boy borne by his wife, Nyosan. In fact, the baby was fathered by another court noble. Since Genji himself has not been faithful to Nyosan-whose appearance is only implied by the edge of her clothing seen to Genji's lefthe cannot complain; meanwhile the true father of the child has died, unable to acknowledge his only son (see "A Closer Look," opposite). Thus, what should be a joyful scene has undercurrents of irony and sorrow. The irony is even greater because Genji himself is the illegitimate son of an emperor.

Steeped in the Western tradition, we might expect a painting of such an emotional scene to focus on the people involved. Instead, the human participants are rendered here rather small in size, and the scene is dominated by a wall hung with curtains and blinds that effectively squeezes Genji and his wife into a corner, their space even further restricted at the top by the frame. It is the composition, not facial expression or bodily posture, that conveys how their positions in courtly society have forced them into this unfortunate situation.

12-13 • BOOK PAGE FROM THE ISHIYAMA-GIRE (DISPERSED VOLUMES, ONCE OWNED BY THE ISHIYAMA TEMPLE, OF THE ANTHOLOGY OF THE THIRTY-SIX IMMORTAL POETS)

Heian period, early 12th century cE. Ink with gold and silver on decorated and collaged paper, $8'' \times 6\%''$ (20.6 \times 16.1 cm). Freer Gallery of Art, Smithsonian Institution, Washington, DC. (F1969.4)

CALLIGRAPHY IN JAPANESE The text portions of the *The Tale of Genji* handscroll were written in *kana* script, which was also used to write poetry in Japanese. In the Heian period, the most significant form of native poetry was a 31-syllable format known as *waka*, which had first been composed earlier than the eighth century. During the Heian era, the finest *waka* by various writers were collected together and hand-copied in albums, the most popular of which featured writers collectively known as the Thirty-Six Immortal Poets, an anthology still appreciated by educated Japanese today. The earliest of many surviving examples of this iconic collection originally contained 39 volumes of

poems. Two volumes were taken apart and sold in 1929, and now survive in single-page sections (**FIG. 12-13**). Collectively these separated volumes are known as the *Ishiyama-gire* (Ishiyama fragments, named after Ishiyamadera, the temple that originally owned the volumes).

With its simple, flowing letters, characters, or syllables, interspersed occasionally with more complex Chinese characters, this style of writing gave a distinctive asymmetrical balance to the appearance of the written words. In these pages, the poems seem to float elegantly on fine dyed papers decorated with painting, block printing, scattered sheets and particles of gold and silver, and

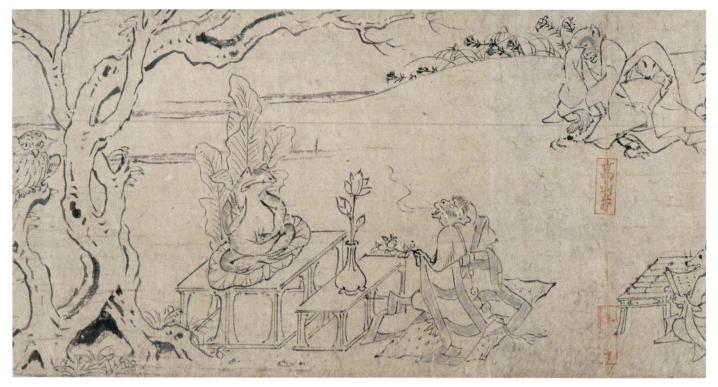

12-14 • Attributed to Toba Sojo SCENE FROM FROLICKING ANIMALS Heian period, 12th century ce. Handscroll with ink on paper, height 12" (30.5 cm). Kozanji, Kyoto. National Treasure.

sometimes paper collage. Often, as in FIGURE 12-13, the irregular pattern of torn paper edges adds a serendipitous element. The page shown here reproduces two verses by the eighth-century courtier Ki no Tsurayuki that express melancholy emotions. One reads:

Until yesterday I could meet her, But today she is gone— Like clouds over the mountain She has been wafted away.

The spiky, flowing calligraphy and the patterning of the papers, the rich use of gold, and the suggestions of natural imagery match the elegance of the poetry, epitomizing courtly Japanese taste.

YAMATO-E HANDSCROLLS-FROLICKING ANIMALS In

its sedate and sophisticated portrayal of courtly life, *The Tale of Genji* scroll represents one side of *yamato-e*. But another style of native painting emerged contemporaneously. Characterized by bold, confident strokes of the brush, and little if any use of color, it depicted subjects outside the court, in playful and irreverent activities. One of the early masterpieces of this style is a set of handscrolls known as *Frolicking Animals (Choju Giga)* that satirizes human behavior through animal antics. Freely executed entirely in black ink, the humorous parodies are attributed to Toba Sojo (1053–1140), abbot of a Buddhist monastery.

In one particularly amusing scene, a monkey—robed as a monk preoccupied with the passionate incantations that emerge from his gaping mouth like wisps of smoke—offers a peach branch on an altar, behind which is a frog, posed as a buddha enthroned on a lotus leaf (**FIG. 12-14**). Behind this monkey-monk is an assembly of animals—rabbits, monkey, foxes, and frog—representing monastic and secular worshipers, some bored and distracted, others focusing on their prayers, which are either read from texts or guided by the Buddhist prayer beads clutched in their hands. Although unlike the *Genji* scroll there is no accompanying text to *Frolicking Animals*, making it difficult to know exactly what was being satirized, the universality of the humorous antics portrayed has made it continually engaging to viewers everywhere.

KAMAKURA PERIOD

The courtiers of the Heian era seem to have become so engrossed in their own refinement that they neglected their responsibilities for governing the country. At the same time clans of warriors samurai—from outside the capital grew increasingly strong. Two of these, the Taira and Minamoto, were especially powerful and took opposing sides in the factional conflicts of the imperial court, in order to control the weakened emperor and take charge of the government.

The Kamakura era (1185–1333) began when the head of the Minamoto clan, Yoritomo (1147–1199), defeated the Taira family and ordered the emperor to appoint him as shogun (general-in-chief). To resist what he perceived as the softening effects of courtly life in Kyoto, he established his military capital in Kamakura, while

ART AND ITS CONTEXTS | Arms and Armor

Battles such as the one depicted in *Night Attack on the Sanjo Palace* (see FIG. 12–15) were fought largely by archers on horseback. Samurai archers charged the enemy at full gallop and loosed their arrows just before they wheeled away. The scroll clearly shows their distinctive bow, with its asymmetrically placed handgrip. The lower portion of the bow is shorter than the upper so it can clear the horse's neck. The samurai wear long, curved swords at their waists.

By the tenth century, Japanese swordsmiths had perfected techniques for crafting their legendarily sharp swords. Sword-makers face a fundamental difficulty: steel hard enough to hold a razor-sharp edge is brittle and breaks easily, but steel resilient enough to withstand rough use is too soft to hold a keen edge. The Japanese ingeniously forged a blade which laminated a hard cutting edge within less brittle support layers.

The earliest form of samurai armor, illustrated here, known as *yoroi*, was intended for use by warriors on horseback, as seen in FIGURE 12–15. It was made of overlapping iron and lacquered leather scales, punched with holes and laced together with leather thongs and brightly colored silk braids. The principal piece wrapped around the chest, left side, and back. Padded shoulder straps hooked it together back to front. A separate piece of armor was tied to the body to protect the right side. The upper legs were protected by a four-sided skirt that attached to the body armor, while two large rectangular panels tied on with cords guarded the arms. The helmet was made of iron plates riveted together. From it hung a neckguard flared sharply outward to protect the face from arrows shot at close range as the samurai wheeled away from an attack.

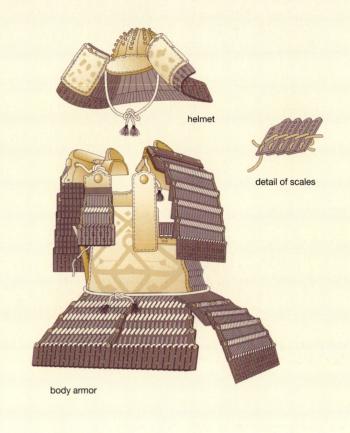

the emperor continued to reside in Kyoto. Although Yoritomo's newly invented title of shogun nominally respected the authority of the emperor, at the same time it assured him of supreme military and political power. The shogunate initiated by Yoritomo endured in various forms until 1868.

A BATTLE HANDSCROLL The battles for domination between the Minamoto and the Taira became famous not only in medieval Japanese history but also as subjects in literature and art. One of the great painted handscrolls depicting these battles is NIGHT ATTACK ON THE SANJO PALACE (FIG. 12-15). Though it was painted perhaps a century after the actual event, the artist conveyed the sense of eye-witness reporting even though imagining the scene from verbal-at best semifactual-descriptions. The style of the painting includes some of the brisk and lively linework of Frolicking Animals and also aspects of the more refined brushwork, use of color, and bird's-eye viewpoint of The Tale of Genji scroll. The relentless focus, however, is on the dynamic depiction of the savagery of warfare across expansive lateral compositions (see "Arms and Armor," above). Unlike the Genji scroll, Night Attack is full of action: flames engulf the palace, horses charge, warriors behead their enemies, court ladies try to hide. The sense of energy and violence is pervasive, conveyed with sweeping power. There

is no trace here of courtly poetic refinement and melancholy; the new world of the samurai is dominating the secular arts.

PURE LAND BUDDHIST ART

By the beginning of the Kamakura period, Pure Land Buddhist beliefs had swept throughout Japan, and several charismatic priests founded new sects to promote this ideology. They traveled throughout the country, spreading the new gospel in ways that appealed to people of all levels of education and sophistication. They were so successful that since the Kamakura period, Pure Land Buddhist sects have remained the most popular form of Buddhism in Japan.

A PORTRAIT SCULPTURE The itinerant monk Kuya (903– 972), famous for urging country folk to join him in singing chants in praise of the Buddha Amida, was one of the early proponents of Pure Land practices. Kamakura-period Pure Land Buddhist followers—who regarded this Heian-period monk as a founder of their religious tradition—would have immediately recognized Kuya in this thirteenth-century portrait statue by Kosho (**FIG. 12-16**). The traveling clothes, the small gong, the staff topped by deer horns (it was after slaying a deer that he was converted to Buddhism), are attributes that clearly identify the monk, whose

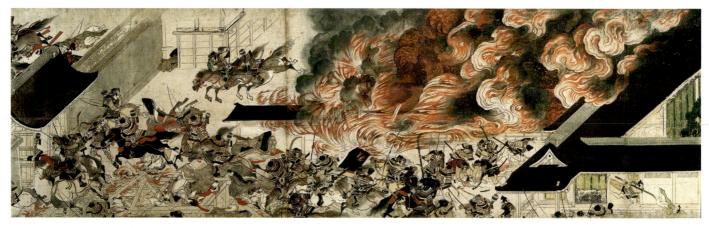

12-15 • SECTION OF NIGHT ATTACK ON THE SANJO PALACE

Kamakura period, late 13th century cE. Handscroll with ink and colors on paper, $16^{1}4'' \times 23'$ (41.3 cm \times 7 m). Museum of Fine Arts, Boston. Fenollosa-Weld Collection (11.4000)

The battles between the Minamoto and Taira clans were fought primarily by mounted and armored warriors, who used both bows and arrows, and the finest swords. In the year 1160, some 500 Minamoto rebels opposed to the retired emperor Go-Shirakawa carried out a daring raid on the Sanjo Palace. In a surprise attack in the middle of the night, they abducted the emperor. The scene was one of great carnage, much of it caused by the burning of the wooden palace. Despite the drama of the scene, this was not the decisive moment in the war. The Minamoto rebels would eventually lose more important battles to their Taira enemies. Yet the Minamoto heirs to those who carried out this raid would eventually prove victorious, destroying the Taira clan in 1185.

sweetly intense expression gives this sculpture a radiant sense of faith. As for Kuya's chant, Kosho's solution to the challenge of putting words into sculptural form was simple but brilliant: He carved six small buddhas emerging from Kuya's mouth, one for each of the six syllables of *Na-mu-A-mi-da-Bu(tsu)* (the final syllable *tsu* is not articulated). Believers would have understood that these six small buddhas embodied the Pure Land chant.

RAIGO PAINTINGS Pure Land Buddhism taught that even one sincere invocation of the sacred chant could lead the most wicked sinner to the Western Paradise. Popular paintings called **raigo** ("welcoming approach") depicted the Amida Buddha, accompanied by bodhisattvas, coming down to earth to welcome the soul of the dying believer. Golden cords were often attached to these paintings, which were taken to the homes of the dying. A person near death held onto these cords, hoping that Amida would escort the soul directly to paradise.

Raigo paintings differ significantly in style from the complex mandalas and fierce guardian deities of Esoteric Buddhism. The earliest-known example of this subject is found on the walls and doors of the Phoenix Hall, surrounding Jocho's sculpture of Amida (see FIG. 12–12). Like that statue, they radiate warmth and compassion. In the Kamakura period, *raigo* paintings were made in great numbers, reflecting the popularity of Pure Land Buddhism at

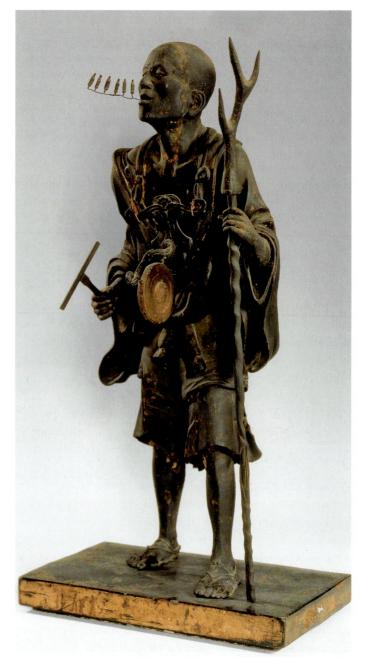

12–16 • Kosho **KUYA PREACHING** Kamakura period, before 1207 ce. Painted wood with inlaid eyes, height 46¹/₂" (117.5 cm). Rokuhara Mitsuji, Kyoto. Important Cultural Property.

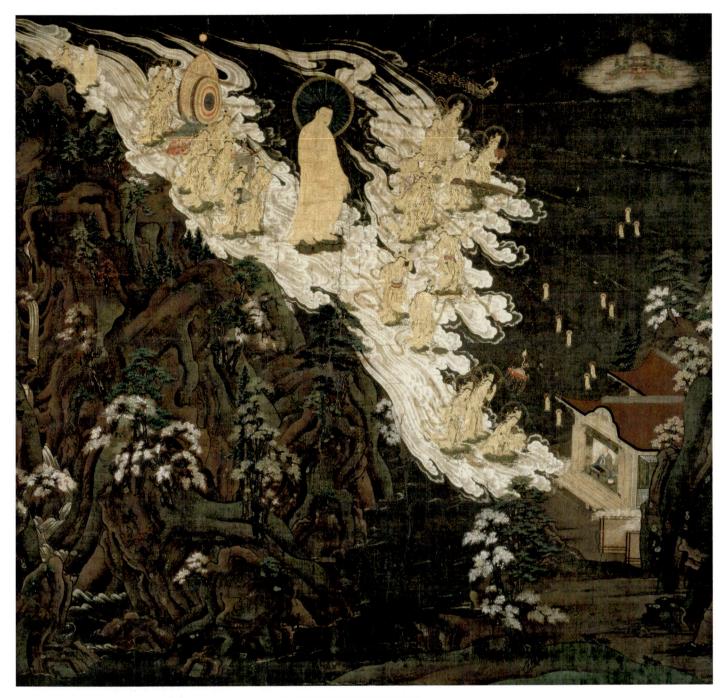

12–17 • DESCENT OF AMIDA AND THE TWENTY-FIVE BODHISATTVAS Kamakura period, 13th century CE. Hanging scroll with colors and gold on silk, $57\frac{1}{4}$ " × $61\frac{1}{2}$ " (145 × 155.5 cm). Chionin, Kyoto. National Treasure.

that time. One magnificent example portrays Amida Buddha and 25 bodhisattvas swiftly descending over mountains (**FIG. 12-17**). The artist used gold paint and thin slivers of gold leaf cut in elaborate patterning to suggest the divine radiance of the deities. This painstaking cut-gold leaf technique, known as *kirikane*, is one of the great achievements of early Japanese Buddhist artists. It originated in China, but Japanese artists refined and perfected it. In this painting, the darkened silk behind the figures heightens the sparkle of their golden aura. In the flickering light of oil lamps and torches,

raigo paintings would have appeared magical, whether in a temple or in a dying person's home.

One of the most remarkable aspects of this painting is its sensitive rendering of the landscape, full of rugged peaks and flowering trees. Perhaps this emphasis on the natural setting derives from a traditional Japanese appreciation for the beautiful land in which they dwelled, an appreciation that may stem from Shinto beliefs. In fact, Shinto pictures portraying the landscape of Japan as divine first appeared in the Kamakura period, just when Pure Land Chan (called Zen in Japan) monks modeled their behavior on that of the patriarch or founder of their lineage, the mythical Indian Buddhist sage Daruma (Bodhidharma in Sanskrit), who emigrated to China in the sixth century CE and famously transmitted his teachings to a Chinese disciple, who became the second Chan patriarch. This portrait of DARUMA (FIG. 12-18) is one of the earliest surviving examples of a Japanese Zen painting. Using fine ink outlines and a touch of color for the robe and the figure's sandals, the artist portrays the Chan master seated meditating atop a rock, with an unwavering, focused gaze that is intended to convey his inner strength and serenity. At the top of the scroll is an inscription in Chinese by Yishan Yining (1247-1317), one of several influential early Chinese Chan masters to emigrate to Japan. He had actually planned only to visit Japan in his role as head of an official diplomatic delegation from China in 1299, but he stayed for the remainder of his life. Although the Japanese were wary of him at first, his sincere intentions to teach Chan and his erudite abilities quickly

attracted influential supporters, to whom he taught Chinese religious practices and cultural traditions. Thus soon after arrival, Yishan was appointed as the tenth head abbot of the large Zen temple of Kenchoji in Kamakura, a post he held briefly before moving on to head several other Zen temples.

Kenchoji had been founded in 1253 by another emigrant Chan master, Lanxi Daolong (1213-1278). Lanxi had been the first Chan master to travel to Japan. There, he was warmly received by the fifth Minamoto shogun who helped him plan construction of Kenchoji where, for the first time, authentic Chinese Chan Buddhism was to be taught in Japan. Kenchoji remains one of the most important Zen monasteries in Japan today. The temple owns many formal portraits of its founder, including this one (FIG. 12-19), considered by many to be the best, in that it seems to capture Daolong's inner spirit as well as his outer form. This type of painting is peculiar to Chan and Zen sects and is known as chinso. These paintings were often gifts given by a master to disciples when they completed their

formal training and departed his presence to officiate at their own temples. They served as personal reminders of their master's teachings and tangible evidence (like a diploma) of their right to transmit Zen teachings to their own pupils. Lanxi Daolong dedicated the inscription of this painting to an important regent (samurai official), a confidant of the shogun, and not an ordained Zen monk. This shows that Zen, from its early days in Japan, also strove to attract followers from among those in power who could not abandon their secular life for the rigorous, cloistered existence required of Zen monks who lived in temples.

12-19 • PORTRAIT OF THE CHINESE CHAN MASTER LANXI DAOLONG Inscription by Lanxi Daolong. Kamakura period, dated 1271 cE. Hanging scroll with colors on silk, $41\frac{1}{3}$ " \times 18" (105 \times 46.1 cm). Kenchoji, Kamakura, National Treasure.

12-18 • DARUMA

Artist unknown, inscription by Chinese Chan (Zen) master Yishan Yining (1247–1317). Kamakura period, early 14th century cE. Hanging scroll with ink and colors on silk, $395\%'' \times 20''$ (100.8 \times 50.8 cm). Tokyo National Museum. Important Cultural Property. Buddhism grew in popularity. One of these paintings is the Kasuga Shrine *mandala* of FIGURE 12-1, demonstrating how Kamakura artists represented the merging of the two faiths of Buddhism and Shinto. The artist of this work made the shrine buildings resemble those of the palatial abode of Amida in his Western Paradise and rendered the landscape details with the radiant charm of Amida's heaven.

ZEN BUDDHIST ART

Toward the latter part of the Kamakura period, Zen Buddhism was introduced to Japan from China where it was already highly developed and known as Chan. Zen had been slow to reach Japan because of the interruption of relations between the two countries during the Heian period. But during the Kamakura era, both emigrant Chinese (see "Daruma, Founder of Zen," opposite) and Japanese monks—who went to China to study Buddhism and returned home enthused about the new teachings they learned there—brought Zen to Japan. The monk Kuya, represented in the statue by Kosho (see FIG. 12-16), epitomized the itinerant life of a Pure Land Buddhist monk who wandered the countryside and relied on the generosity of believers to support him. Zen monks lived very differently. They secluded themselves in monasteries, leading an austere life of simplicity and self-responsibility.

In some ways, Zen resembles the original teachings of the historical Buddha: it emphasizes individual enlightenment through meditation, without the help of deities or magical chants. It especially appealed to the self-disciplined spirit of samurai warriors, who were not satisfied with the older forms of Buddhism connected with the Japanese court. Zen was the last major form of Buddhism to reach Japan from the Asian mainland and it had a profound and lasting impact on Japanese arts and culture.

Just as the *Night Attack* (see FIG. 12–15) reveals a propensity for recording the consequences of political turbulence by representing gruesome and detailed battle scenes in vivid colors, Kamakuraera Buddhist sculpture and painting also emphasized realism. Various factors account for this new taste. Society was dominated by samurai warriors, who possessed a more pragmatic outlook on the world than the Heian-period courtiers, who had lived a dreamlike, insular existence at court. In addition, renewed contacts with China introduced new styles for Buddhist art that also emphasized lifelike portrayal. Finally, forging personal connections with heroic exploits and individuals—both past and present, political and religious—greatly concerned the people of the Kamakura period. Representing these figures in arresting pictorial and sculpted images helped reinforce legends and perpetuate their influence, which accounts for the predominance of these subjects at this time.

As the Kamakura era ended, the seeds of the future were planted both politically and culturally. The coming age witnessed the nation's continued dominance by the warrior class and the establishment of Zen as the religion of choice among those warriors who wielded power at the highest levels. As before, the later history of Japanese art continued to be marked by an intriguing interplay between native traditions and imported foreign tendencies.

THINK ABOUT IT

- 12.1 Discuss the influence of Chinese art on the early Japanese Buddhist complex at Horyuji, referring to Chapter 11 as necessary.
- **12.2** Compare the Heian-period Womb World *Mandala* (FIG. 12–10) with the Kamakura-period *Descent of Amida and the Twenty-Five Bodhisattvas* (FIG. 12–17). How do these pictures embody the specific type of Buddhism from which each emerged? How would they have been used by believers?
- **12.3** Discuss a work of art in this chapter that combines aspects of the foreign traditions of Buddhism with native Shinto traditions. How do the artists blend the disparate traditions? How would the blending affect the way the work functioned within a religious context?
- **12.4** Characterize and compare one representative secular work of art from Heian courtly culture with one from the warrior culture that replaced it during the Kamakura period. How do these works relate to the political climates of these two distinct eras in early Japanese history?

CROSSCURRENTS

These two works of art proclaim political power by documenting military conquest, but they chose vastly different media and contexts to accomplish this goal. How do the distinctions between these battle narratives relate to the cultural context that gave rise to each? Be sure to consider the viewing context when forming your answer.

FIG. 6-48

FIG. 12–15

Study and review on myartslab.com

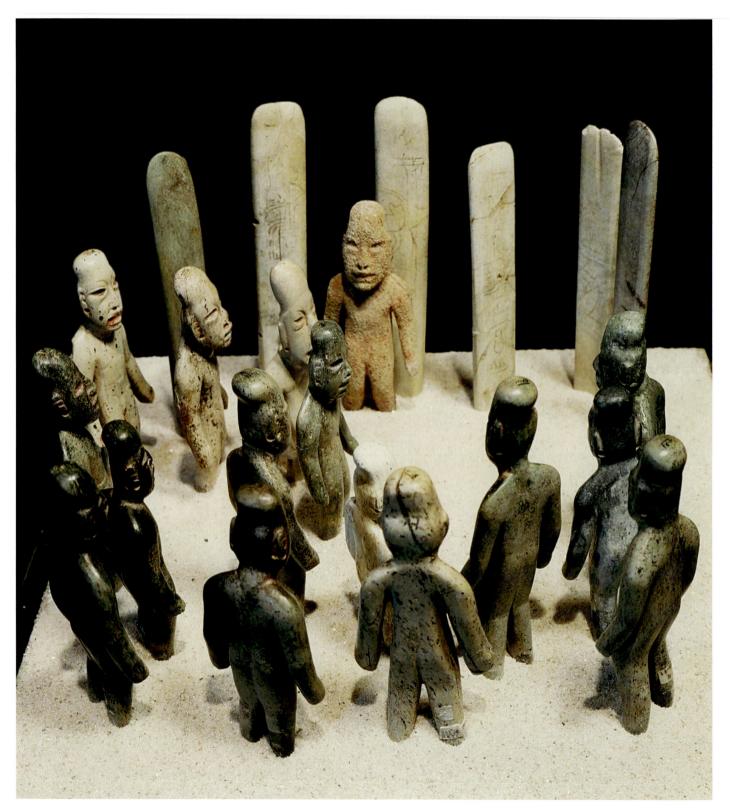

13-1 • OFFERING 4, LA VENTA Mexico. Olmec culture, c. 900–400 BCE. Jade, greenstone, granite, and sandstone, height of figures 6¹/₄"-7" (16–18 cm). Museo Nacional de Antropología, Mexico City.

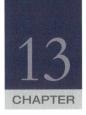

Art of the Americas before 1300

The scene hints at a story in progress (FIG. 13-1). Fifteen figures of precious greenstone converge on a single figure made of a baser, more porous stone. The tall oblong stones (celts) in the background evoke an architectural space, perhaps a location within the Olmec center of La Venta (Mexico), where this tableau was created sometime between 900 and 400 BCE. The figures have the slouching bodies, elongated heads, almond-shaped eyes, and downturned mouths characteristic of Olmec art. Holes for earrings and the simple lines of the bodies suggest that these sculptures may originally have been dressed and adorned with perishable materials. The poses of the figures, with their knees slightly bent and their arms flexed at their sides, lend a sense of arrested movement to this enigmatic scene. Is it a council? A trial? An initiation? Are the greenstone figures marching in front of the reddish granite figure as he reviews them, or moving to confront him? With no texts to explain the scene, the specific tale it narrates may never be known, but it is clear that this offering commemorates an important event.

And it was remembered. This tableau was set up in the earth and buried underneath a plaza at La Venta, one of a number of offerings of works of art and precious materials beneath the surface of the city. Colored sand and floors covered the offerings, each colored floor signifying a successive renovation of the plaza. Over a century after these sculptures were buried, a hole was dug directly over the offering and it was viewed once more. Pieces of the later floors fell into the hole, but the figures themselves were not disturbed. After this, the scene was buried once again. The precision of this later excavation suggests that the exact location of the tableau was remembered. The archaeological record assures us that this work of art, although hidden, still exerted tremendous power.

This extraordinary find demonstrates the importance of scientific archaeological excavations for understanding ancient art. Had these objects been torn out of the ground by looters and sold piecemeal on the black market, we might never have known how Olmec sculptures were used to create narrative installations or imagined that buried art could be remembered for so long. Instead, this discovery provides a context for isolated greenstone figures that have been found throughout Mesoamerica (modern Mexico, Guatemala, and Honduras). It provides evidence that all these sculptures were made by the Olmec, Mesoamerica's first great civilization, and suggests that these objects, scattered today, might have once been assembled in meaningful ways like the offering at La Venta.

LEARN ABOUT IT

- **13.1** Compare the various ways the ancient artists of the Americas represented the human figure.
- **13.2** Recognize themes and symbols specific to individual ancient American cultures as well as instances of commonalities across time and geography.
- **13.3** Explore how an understanding of the ritual use or practical function of an object is critical to evaluating its meaning in ancient American visual arts.
- **13.4** Recognize how differences in environmental conditions affected the urban planning and architectural design of Mesoamerican, South American, and North American communities.

((• Listen to the chapter audio on myartslab.com

THE NEW WORLD

In recent years the question of the original settlement of the Americas has become an area of debate. The traditional view has been that human beings arrived in North and South America from Asia during the last Ice Age, when glaciers trapped enough of the world's water to lower the level of the oceans and expose a land bridge across the Bering Strait. Although most of present-day Alaska and Canada was covered by glaciers at that time, an ice-free corridor along the Pacific coast would have provided access from Asia to the south and east. Thus, this theory holds that sometime before 12,000 years ago, perhaps as early as 20,000 to 30,000 years ago, Paleolithic hunter-gatherers emerged from this corridor and began to spread out into two vast, uninhabited continents. This view is now challenged by the early dates of some new archaeological finds and by evidence suggesting the possibility of early connections with Europe as well, perhaps along the Arctic coast of the North Atlantic. Recently, some have suggested that Pacific Islanders could have sailed to the coast of Chile and spread out from there. In any event, by between 10,000 and 12,000 years ago, bands of hunters roamed throughout the Americas, and after the ice had retreated, the peoples of the Western Hemisphere were essentially cut off from the rest of the world until they were overrun by European invaders, beginning at the end of the fifteenth century CE.

In this isolation, the peoples of the Americas experienced cultural transformations similar to those seen elsewhere around the world following the end of the Paleolithic era. In most regions they developed an agricultural way of life. A trio of native plants corn, beans, and squash—was especially important, but people also cultivated potatoes, tobacco, cacao, tomatoes, and avocados. New World peoples also domesticated many animals: dogs, turkeys, guinea pigs, llamas, and their camelid cousins—alpacas, guanacos, and vicuñas.

As elsewhere, the shift to agriculture in the Americas was accompanied by population growth and, in some places, the rise of hierarchical societies, the appearance of ceremonial centers and towns with monumental architecture, and the development of sculpture, ceramics, and other arts. The people of Mesoamericathe region that extends from central Mexico well into Central America-developed writing, astronomy, a complex and accurate calendar, and a sophisticated system of mathematics. Central and South American peoples had advanced metallurgy and produced exquisite gold, silver, and copper objects. The metalworkers of the Andes, the mountain range along the western coast of South America, began to produce metal jewelry, weapons, and agricultural implements in the first millennium CE, and people elsewhere in the Americas made tools, weapons, and art from other materials such as bone, ivory, stone, wood, and, where it was available, obsidian, a volcanic glass capable of a cutting edge 500 times finer than surgical steel. Basketry and weaving became major art forms. The inhabitants of the American Southwest built multi-storied,

apartmentlike village and cliff dwellings, as well as elaborate irrigation systems with canals. Evidence of weaving in the American Southwest dates to about 7400 BCE.

Extraordinary artistic traditions flourished in many regions in the Americas before 1300 CE. This chapter explores the accomplishments of selected cultures in five of those areas: Mesoamerica, Central America, the central Andes of South America, the Southeastern Woodlands and great river valleys of North America, and the North American Southwest.

MESOAMERICA

Ancient Mesoamerica encompasses the area from north of the Valley of Mexico (the location of Mexico City) to present-day Belize, Honduras, and western Nicaragua in Central America (MAP 13-1). The region is one of great contrasts, ranging from tropical rainforest to semiarid mountains. The civilizations that arose in Mesoamerica varied, but they were linked by cultural similarities and trade. Among their shared features were a ballgame with religious and political significance (see "The Cosmic Ballgame," page 395), aspects of monumental building construction, and a complex system of multiple calendars including a 260-day divinatory cycle and a 365-day ritual and agricultural cycle. Many Mesoamerican societies were sharply divided into elite and commoner classes.

The transition to farming began in Mesoamerica between 7000 and 6000 BCE, and by 3000 to 2000 BCE settled villages were widespread. Customarily the region's subsequent history is divided into three broad periods: Formative or Preclassic (1500 BCE–250 CE), Classic (250–900 CE), and Postclassic (900–1521 CE). This chronology derives primarily from the archaeology of the Maya—the people of Guatemala, southern Mexico, and the Yuca-tan Peninsula—with the Classic period bracketing the era during which the Maya erected dated stone monuments. As with the study of ancient Greek art, the term "Classic" reflects the view of early scholars that this period was a kind of golden age. Although this view is no longer current—and the periods are only roughly applicable to other cultures of Mesoamerica—the terminology has endured.

THE OLMEC

The first major Mesoamerican art style, that of the Olmec, emerged during the Formative/Preclassic period, beginning around 1500 BCE. Many of the key elements of Mesoamerican art, including monumental stone sculpture commemorating individual rulers, finely carved jades, elegant ceramics, and architectural elements such as pyramids, plazas, and ballcourts, were first developed by the Olmec. In the fertile, swampy coastal areas of the presentday Mexican states of Veracruz and Tabasco, the Olmec raised massive earth mounds on which they constructed ceremonial centers. These centers probably housed an elite group of rulers and priests supported by a larger population of farmers who lived in villages of pole-and-thatch houses. The presence at Olmec sites of goods

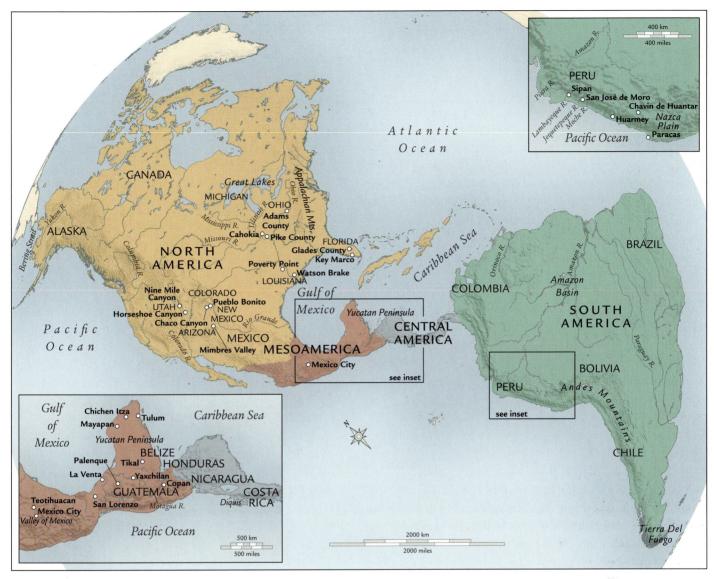

MAP 13-1 • THE AMERICAS BEFORE 1300

Human beings moved across North America, then southward through Central America until they eventually reached the Tierra del Fuego region of South America.

such as obsidian, iron ore, and jade that are not found in the Gulf of Mexico region but come from throughout Mesoamerica indicates that the Olmec participated in extensive long-distance trade. They went to especially great lengths to acquire jade, which was one of the most precious materials in ancient Mesoamerica.

The earliest Olmec ceremonial center (c. 1200–900 BCE), at San Lorenzo, was built atop a giant earthwork, nearly threequarters of a mile long, with an elaborate stone drainage system running throughout the mound. Other architectural features included a palace with basalt columns, a possible ballcourt, and a stone-carving workshop. Another center, at La Venta, thriving from about 900 to 400 BCE, was built on high ground between rivers. Its most prominent feature, an earth mound known as the **GREAT PYRAMID**, still rises to a height of over 100 feet (**FIG. 13-2**), and, like ancient pyramids in Egypt, those in Mesoamerica seem to have been envisioned as artificial sacred mountains, linked to creation stories and cultural cosmology. The La Venta pyramid stands at the south end of a large, open plaza arranged on a north-south axis and defined by long, low earth mounds. Many of the physical features of La Venta—including the symmetrical arrangement of earth mounds, platforms, and central open spaces along an axis that was probably determined by astronomical observations—are characteristic of later monumental and ceremonial architecture throughout Mesoamerica. What was buried beneath the surface of La Venta—massive stone mosaics, layers of colored clay, and greenstone figures like those in FIGURE 13-1, discussed at the beginning of the chapter—may have been as important as what was visible on the surface.

The Olmec produced an abundance of monumental basalt sculpture, including **COLOSSAL HEADS** (**FIG. 13-3**), altars, and seated figures. The huge basalt blocks for the large works of sculpture were quarried at distant sites and transported to San

13-2 • GREAT PYRAMID AND PLAZA, LA VENTA

Mexico. Olmec culture, c. 900– 400 BCE. Pyramid height approx. 100' (30 m).

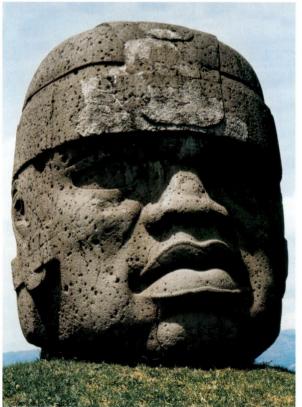

Lorenzo, La Venta, and other centers. Colossal heads ranged in height from 5 to 12 feet and weighed from 5 to more than 20 tons. The heads portray adult males wearing close-fitting caps with chin straps and large, round earspools (cylindrical earrings that pierce the earlobe). The fleshy faces have almond-shaped eyes, flat broad noses, thick protruding lips, and down-turned mouths. Since each face is different, they may represent specific individuals. Ten colossal heads were found at San Lorenzo, where many had been mutilated and buried by about 900 BCE, when the site went into decline. At La Venta, 102 basalt monuments have been found, including four more colossal heads, massive thrones or altars, tall stone stelae (upright slabs), and other kinds of figural sculpture. The colossal heads and the subjects depicted on other monumental sculpture suggest that the Olmec elite were interested in commemorating rulers and historic events.

In addition to these heavy basalt monuments, Olmec artists also made smaller, more portable jade and ceramic objects (see FIG. 13–1). Jade, available only from the Motagua River Valley in present-day Guatemala, was prized for its brilliant blue-green color and the smooth, shiny surfaces it could achieve with careful polishing. Its green hue and its natural appearance in

13-3 • COLOSSAL HEAD, SAN LORENZO Mexico. Olmec culture, c. 1200–900 BCE. Basalt, height 7'5" (2.26 m).

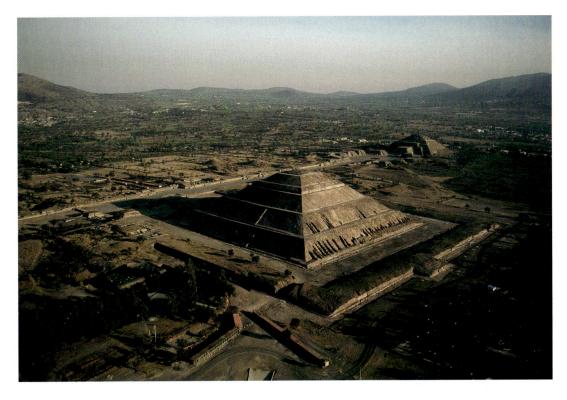

stream beds made it a symbol of fertility. Jade is one of the hardest materials in Mesoamerica, and, with only stone tools available, Olmec craftsmakers used jade tools and powdered jade dust as an abrasive to carve and polish these sculptures. Other figurines were made out of softer and more malleable greenstones, like serpentine, which occur in many parts of Mesoamerica. Olmec ceramics, including decorated vessels and remarkably lifelike clay babies, also appear to have been prized far beyond the Olmec heartland. Olmec greenstone and ceramic objects have been found throughout Mesoamerica, evidence of the extensive reach and influence of Olmec art and culture.

By 200 CE, forests and swamps had begun to reclaim Olmec sites, but since Olmec civilization had spread widely throughout Mesoamerica, it would have an enduring influence on its successors. As the Olmec centers of the Gulf Coast faded, the great Classic period centers in the Maya region and Teotihuacan area in the Valley of Mexico were beginning their ascendancy.

TEOTIHUACAN

Located some 30 miles northeast of present-day Mexico City, the city of Teotihuacan experienced a period of rapid growth early in the first millennium CE. By 200 CE, it had emerged as Mesoamerica's first truly urban settlement, a significant center of commerce and manufacturing. At its height, between 300 and 650, Teotihuacan covered nearly nine square miles and had a population of at least 125,000, making it the largest city in the Americas and one of the largest in the world at that time (**FIG. 13-4**). Its residents lived in walled "apartment compounds," and the entire city was organized on a grid (**FIG. 13-5**), its orientation chosen both for its calendrical significance and to respond to the surrounding landscape.

13-4 • CEREMONIAL CENTER OF THE CITY OF TEOTIHUACAN

Mexico. Teotihuacan culture, c. 100–650 cE. View from the southeast. The Pyramid of the Sun is in the foreground, and the Pyramid of the Moon is visible in the distance. The Avenue of the Dead, the north–south axis of the city, which connects the two pyramids, continues for over a mile.

 Watch an architectural simulation about the ceremonial center of Teotihuacan on myartslab.com

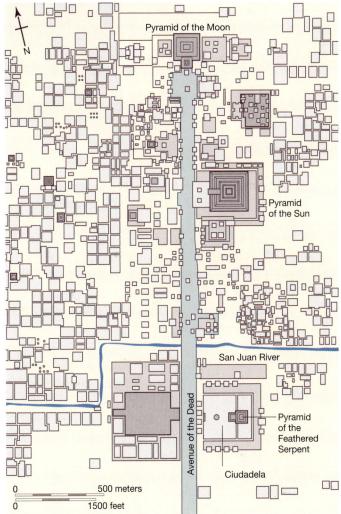

13-5 • PLAN OF THE CEREMONIAL CENTER OF TEOTIHUACAN

13-6 • PYRAMID OF THE FEATHERED SERPENT

The Ciudadela, Teotihuacan, Mexico. Teotihuacan culture, c. 200 ce.

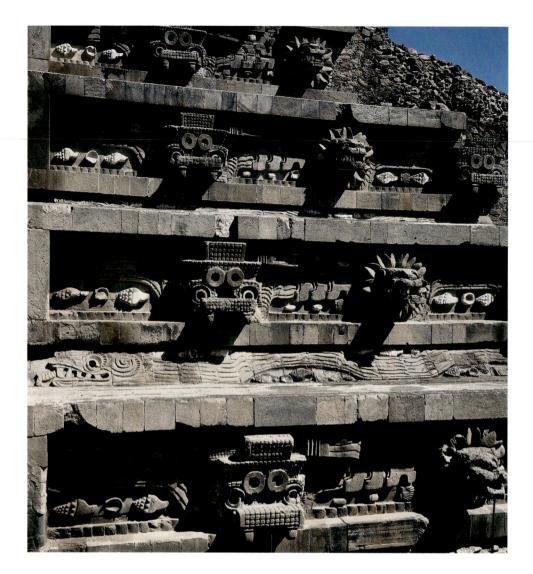

Although Teotihuacan declined in power after 650, it was never forgotten. Centuries later, it remained a legendary pilgrimage center. The much later Aztec people (c. 1300–1525) revered the site, believing it to be the place where the gods created the sun and the moon. In fact, Teotihuacan, a word indicating a place of divinity, is the Aztec name for the city. The names we use for its principal monuments are also Aztec names. We do not know what the original inhabitants of Teotihuacan called these buildings nor what they called their own city.

The center of the city is bisected by a broad processional thoroughfare laid out on a north–south axis, extending for more than a mile and in places as much as 150 feet wide, which the Aztecs called the Avenue of the Dead. At the center of the Teo-tihuacan grid, a series of canals forced the San Juan River to run perpendicular to the avenue. At the north end of this central axis stands the Pyramid of the Moon, facing a large plaza flanked by smaller, symmetrically placed platforms. It seems to echo the shape of the mountain behind it, and as one walks toward the pyramid of the Moon was enlarged several times, as were many Mesoamerican pyramids; each enlargement completely enclosed

the previous structure and was accompanied by rich sacrificial offerings.

The largest of Teotihuacan's architectural monuments, the Pyramid of the Sun, located just to the east of the Avenue of the Dead, is slightly over 200 feet high and measures about 720 feet on each side at its base, similar in size to, but not as tall as, the largest Egyptian pyramid at Giza. It is built over a multi-chambered cave with a spring that may have been the original focus of worship at the site and its source of prestige. The pyramid rises in a series of sloping steps to a flat platform, where a small temple once stood. A monumental stone stairway led from level to level up the side of the pyramid to the temple platform. The exterior was faced with stone, which was then stuccoed and painted.

At the southern end of the ceremonial center, and at the heart of the city, is the Ciudadela (Spanish for a fortified city center), a vast sunken plaza surrounded by temple platforms. One of the city's principal religious and political centers, the plaza could accommodate an assembly of more than 60,000 people. Early in Teotihuacan's history, its focal point was the **PYRAMID OF THE FEATHERED SERPENT** (**FIG. 13-6**). This seven-tiered structure exhibits the *talud-tablero* (slope-and-panel) construction that is a

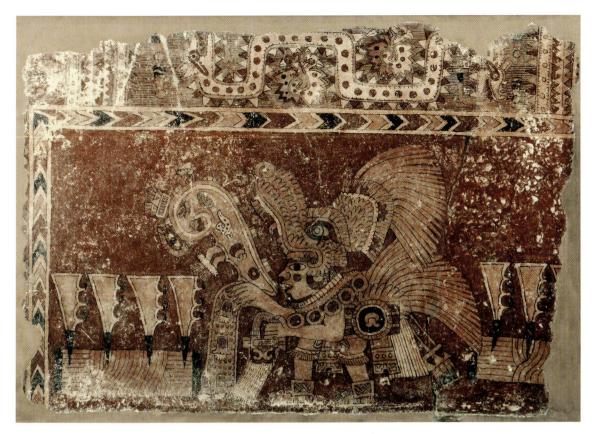

13-7 • BLOODLETTING RITUAL

Fragment of a fresco from Teotihuacan, Mexico. Teotihuacan culture, c. 550–650 cE. Pigment on lime plaster, $32^{1}/4'' \times 45^{1}/4''$ (82 × 116.1 cm). The Cleveland Museum of Art. Purchase from the J. H. Wade Fund (63.252)

The maguey (agave) plant supplied the people of Teotihuacan with food, with fiber for making clothing, rope, and paper, and with the precious drink pulque. As this painting indicates, priestly officials used its spikes in rituals to draw their own blood as a sacrifice.

hallmark of the Teotihuacan architectural style. The *talud* (sloping base) of each platform supports a *tablero* (entablature), that rises vertically and is surrounded by a frame.

Archaeological excavations of the temple's early phase have revealed reliefs portraying undulating feathered serpents floating in a watery space punctuated by aquatic shells. Their flat, angular, abstract style, typical of Teotihuacan art, is in marked contrast to the curvilinear, organic forms of Olmec art. While the bodies of the feathered serpents are rendered in low relief, in the vertical tablero sections three-dimensional sculptures of fanged serpent heads emerge from aureoles of stylized feathers. Each serpent carries on its body a squarish headdress with a protruding upper jaw, huge, round eves originally inlaid with obsidian, and a pair of round goggles on its forehead between the eyes. These mosaic headdresses seem to represent an aspect of the Teotihuacan Storm God associated with warfare-other works of art at Teotihuacan and elsewhere in Mesoamerica show armed warriors wearing the same headdress. Inside the pyramid, this militaristic message was reinforced by the burials of dozens of sacrificial victims, some of them wearing necklaces made of human jawbones (or shell imitations thereof), their arms tied behind their backs. In the fourth century, the elaborate sculptural façade of the Pyramid of the

Feathered Serpent was concealed behind a plainer *talud-tablero* structure tacked onto the front of the pyramid.

The residential sections of Teotihuacan fanned out from the city's center. The large and spacious palaces of the elite, with as many as 45 rooms and seven patios, stood nearest the ceremonial center. Artisans, foreign traders, and peasants lived farther away, in more crowded compounds, all aligned with the Teotihuacan grid. Palaces and more humble homes alike were rectangular one-story structures with high walls—plastered and covered with paintings— and suites of rooms arranged around open courtyards.

Teotihuacan's artists created wall paintings in a fresco technique, applying pigments directly on damp lime plaster. Once the paint was applied, the walls were polished to give a smooth, shiny, and durable surface. The style, like that of the sculpture, was flat, angular, and abstract, often featuring processions of similarly dressed figures, rows of mythological animals, or other kinds of repeating images. Teotihuacan painters worked in several different color schemes, including a bright polychrome and a more restricted palette emphasizing tones of red. A detached fragment of a wall painting, now in the Cleveland Museum of Art, depicts a **BLOODLETTING RITUAL** (**Fig. 13-7**) in which an elaborately dressed man enriches and revitalizes the earth with his own

ART AND ITS CONTEXTS | Maya Writing

Maya writing is logosyllabic-it consists of ideographs or logographs that represent entire words as well as a set of symbols that stand for the sound of each syllable in the Maya language. Thus, a word like balam (jaguar) could be written in many different ways: with the logograph "BALAM", a picture of the head of a jaguar (top right); with three syllables, "ba-la-ma," for the sounds of the word balam (bottom right); or a combination of the two systems-the logograph "BALAM" complemented with one or more phonetic syllables, to make it clear which logograph was represented (and avoid the possibility of confusing this logograph with the symbol for hix, another kind of feline, for example) (middle right). The combination of these two systems allowed Maya scribes extraordinary flexibility, and some calligraphers seem to have delighted in finding as many different ways as possible to write the same word. Many Maya logographs remained very pictorial, like the glyph for jaguar illustrated here, which meant that Maya writing was never too distant from other kinds of image making. In fact, the same word, ts'ib, signified both writing and painting in the Classic Maya language.

With major advances in the decipherment of Maya hieroglyphic writing—beginning in the 1950s and continuing to this day—it has become clear that the inscriptions on Maya architecture and stelae appear almost entirely devoted to a ceremonial recording of historical events. They document the dates of royal marriages, births of heirs,

alliances between cities, and great military victories, and they tie these events to astronomical events and propitious dates in the Maya calendar. We know that the Maya also wrote books, but only four of these fragile manuscripts—called codices—have survived, all of them from the Postclassic period.

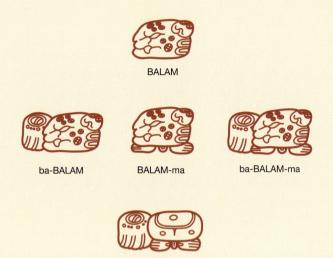

blood. The man's large canine headdress, decorated with precious feathers from the quetzal bird, indicates his high status. He stands between rectangular plots of earth or bundles of grass pierced with bloody maguey (*Agave americana*) spines (used in bloodletting), and he scatters seeds or drops of blood from his right hand, as indicated by the stream of conventionalized symbols for blood, seeds, and flowers cascading downward. The sound scroll emerging from his open mouth symbolizes his ritual chant. The visual weight accorded the headdress and the sound scroll suggests that the man's priestly office and chanted words were essential elements of the ceremony. Such bloodletting rituals were widespread in Mesoamerica.

Teotihuacan was a wealthy and cosmopolitan city, home to people from all over Mesoamerica. One reason for its wealth was its control of a source of high-quality obsidian. Goods made at Teotihuacan, including obsidian tools and pottery, were distributed widely throughout Mesoamerica in exchange for luxury items such as the brilliant green feathers of the quetzal bird. Yet not all interactions between Teotihuacan and other Mesoamerican centers were peaceful—the threat of Teotihuacan military force, so clearly expressed at the Pyramid of the Feathered Serpent, was always present.

Sometime in the early seventh century disaster struck Teotihuacan. The ceremonial center was sacked and burned, and the city went into a permanent decline. Nevertheless, its influence continued as other centers throughout Mesoamerica, as far south as the highlands of Guatemala, borrowed and transformed its imagery over the next several centuries.

ba-la-ma

THE MAYA

The ancient Maya are noted for a number of achievements. In densely populated cities they built imposing pyramids, temples, palaces, and administrative structures. They developed the most advanced hieroglyphic writing in Mesoamerica and perfected a sophisticated version of the Mesoamerican calendrical system (see "Maya Writing," above). Using these, they recorded the accomplishments of their rulers in sculpture, ceramic vessels, wall paintings, and books. They studied astronomy and the natural cycles of plants and animals, and used sophisticated mathematical concepts such as zero and place value.

An increasingly detailed picture of the Maya has been emerging from recent archaeological research and from advances in deciphering their writing. That picture shows a society divided into competing city-states in a near-constant state of war with each other. A hereditary ruler and an elite class of nobles and priests governed each city-state, supported by a large group of farmer-commoners. Rulers established their legitimacy, maintained links with their divine ancestors, commemorated important calendrical dates, and sustained the gods through elaborate rituals, including ballgames, bloodletting ceremonies, and human sacrifice. Rulers commemorated such events and their military exploits on carved stelae. A complex pantheon of deities presided over the Maya universe. Maya civilization emerged during the Late Preclassic period (400 BCE–250 CE), reached its peak in the southern lowlands of Mexico and Guatemala during the Classic period (250–900 CE), and shifted to the northern Yucatan Peninsula during the Postclassic period (900–1521 CE). Throughout this time, the Maya maintained strong ties with other regions of Mesoamerica: They inherited many ideas and technologies from the Olmec, had trade and military interactions with Teotihuacan, and, centuries later, were in contact with the Aztec Empire.

TIKAL The monumental buildings of Maya cities were masterly examples of the use of architecture for public display and as the backdrop for social and sacred ritual. Tikal (in present-day Guatemala) was one of the largest Maya cities, with a population of up to 70,000 at its height. Unlike Teotihuacan, with its grid plan, Maya cities, including Tikal, conformed to the uneven terrain of the rainforest. Plazas, pyramid-temples, ballcourts, and other structures stood on high ground connected by wide elevated roads, or causeways.

Tikal was settled in the Late Preclassic period, in the fourth century BCE, and continued to flourish through the Early Classic period. The kings of Tikal were buried in funerary pyramids in the **NORTH ACROPOLIS**, visible on the left in **FIGURE 13-8**,

which was separated by a wide plaza from the royal palace to the south. Tikal suffered a major upheaval in 378 CE, recorded in texts from the city and surrounding centers, when some scholars believe the arrival of strangers from Teotihuacan precipitated the death of Tikal's king and the installation of a new ruler with ties to Central Mexico. Art from this period shows strong Teotihuacan influence in ceramic and architectural forms, though both were soon adapted to suit local Maya aesthetics. The city enjoyed a period of wealth and regional dominance until a military defeat led to a century of decline.

In the eighth century CE, the city of Tikal again flourished during the reign of Jasaw Chan K'awiil (nicknamed Ruler A before his name could be fully read; r. 682–734), who initiated an ambitious construction program and commissioned many stelae decorated with his own portrait. His building program culminated in the construction of Temple I (see FIG. 13–8), a tall pyramid that faces a companion pyramid, Temple II, across a large central plaza. Containing Jasaw Chan K'awiil's tomb in the limestone bedrock below, Temple I rises above the forest canopy to a height of more than 140 feet. Its base has nine layers, probably reflecting the belief that the underworld had nine levels. Priests climbed the steep stone staircase on the exterior to the temple on top, which consists of two narrow, parallel rooms covered with a steep roof supported

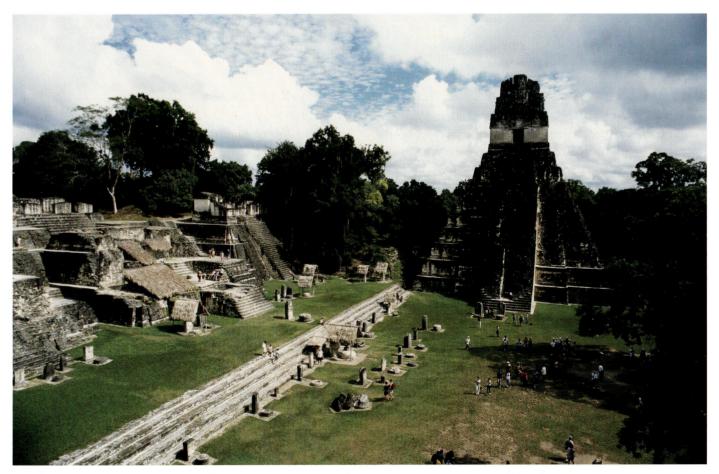

13-8 • BASE OF NORTH ACROPOLIS (LEFT) AND TEMPLE I, TIKAL Guatemala. Maya culture. North Acropolis, 4th century BCE–5th century CE; Temple I (Tomb of Jasaw Chan K'awiil), c. 734 CE.

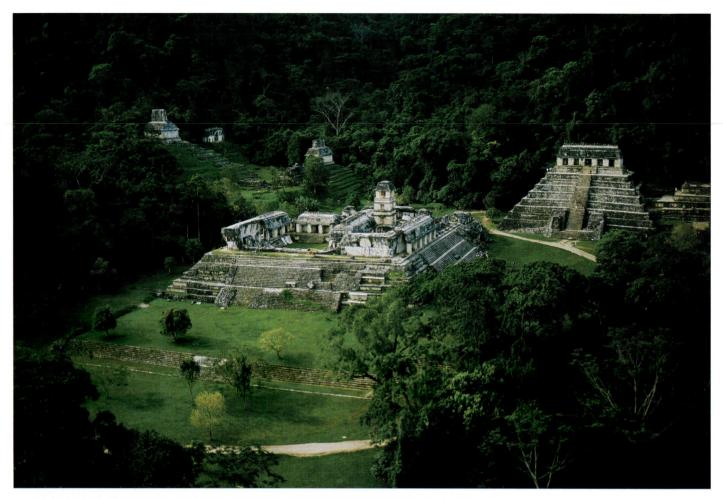

13-9 • PALACE (FOREGROUND) AND TEMPLE OF THE INSCRIPTIONS, PALENQUE Mexico. Maya culture. Palace, 5th–8th century ce; Temple of the Inscriptions (Tomb of Pakal the Great), c. 683 ce.

by corbel vaults. The crest that rises over the roof of the temple, known as a **roof comb**, was originally covered with brightly painted sculpture. Ritual performances on the narrow platform at the top of the pyramid would have been visible throughout the plaza. Inspired by Jasaw Chan K'awiil's's building program, later kings of Tikal also built tall funerary pyramids that still tower above the rainforest canopy.

PALENQUE The small city-state of Palenque (in the present-day Mexican state of Chiapas) rose to prominence later than Tikal, during the Classic period. Hieroglyphic inscriptions record the beginning of its royal dynasty in 431 CE, but the city had only limited regional importance until the ascension of a powerful ruler, K'inich Janahb Pakal (*pakal* is Maya for "shield"), who ruled from 615 to 683. Known as Pakal the Great, he and his sons, who succeeded him, commissioned most of the structures visible at Palenque today. As at Tikal, urban planning responds to the land-scape. Perched on a ridge over 300 feet above the swampy lowland plains, the buildings of Palenque are terraced into the mountains with a series of aqueducts channeling rivers through the urban core. The center of the city houses the palace, the Temple of

the Inscriptions, and other temples (**FIG. 13–9**). Still other temples, elite palaces, and a ballcourt surround this central group.

The palace was an administrative center as well as a royal residence. At its core was the throne room of Pakal the Great, a spacious structure whose stone roof imitated the thatched roofs of more humble dwellings. Over time, the palace grew into a complex series of buildings organized around four courtyards, where the private business of the court was transacted. From the outside, the palace presented an inviting façade of wide staircases and open colonnades decorated with stucco sculptures, but access to the interior spaces was tightly limited.

Next to the palace stands the Temple of the Inscriptions, Pakal the Great's funerary pyramid. Rising 75 feet above the plaza, it has nine levels like Temple I at Tikal (see FIG. 13–8). The shrine on the summit consists of a portico with five entrances and a vaulted inner chamber originally surmounted by a tall roof comb. Its façade still retains much of its stucco sculpture. The inscriptions that give the building its name consist of three large panels of text that line the back wall of the outer chamber at the top of the temple, linking Pakal's accomplishments to the mythical history of the city. A corbel-vaulted stairway beneath the summit shrine zigzags down

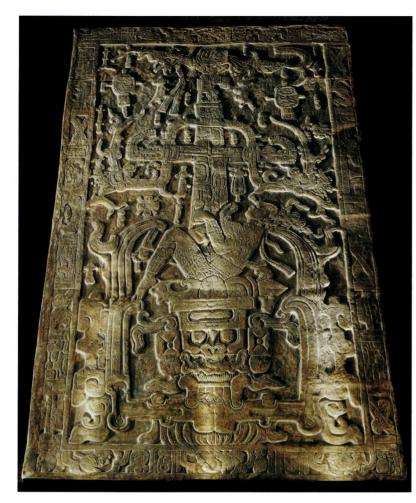

13-10 • LID OF THE SARCOPHAGUS OF PAKAL THE GREAT From Pakal's tomb, Temple of the Inscriptions, Palenque, Mexico. Maya culture, c. 683 cE. Limestone, $12'1'_{2''} \times 7'1'_{2''}$ (3.72 \times 2.17 m).

80 feet to a small subterranean chamber that contained the undisturbed tomb of Pakal, which was discovered in the 1950s.

Pakal the Great—dressed as the Maya maize god and covered with pale green jade and brilliant red cinnabar—lay in a monolithic, uterus-shaped sarcophagus that represented him balanced between the underworld and the earth. His ancestors, carved on the sides of the sarcophagus, emerge from cracks in the earth to witness his death and descent into the underworld, the subject of an elaborate relief sculpture on the lid (**FIG. 13–10**). The reclining king appears here poised in relaxed resignation at the very moment of his death, falling into the jaws of the underworld as if consumed by the earth itself. Above him rises the World Tree, an *axis mundi*, with a fantastical bird representing the celestial realm perched at the top. The branches of this tree are filled with references to the bloodletting rituals that sustain royal power and maintain the continuity of human life.

Underneath the sarcophagus, archaeologists found a stucco portrait of Pakal, in the guise of the Maize God, with a headband of maize flowers and upswept hair that recall the leaves of the plant (**FIG. 13-11**). His features—sloping forehead and elongated skull (babies' heads were bound to produce this shape), large curved nose (enhanced by an ornamental bridge), full lips, and open mouth—are characteristic of the Maya ideal of beauty, also associated with the youthful Maize God, who represented—among other things the cycle of death and rebirth, as in the constant cycle of planting and harvesting life-sustaining food. Pakal's long, narrow face and jaw, however, are individual characteristics that carry a sense of personal likeness into this symbolic portrait. Traces of pigment indicate that, like much Maya sculpture, this stucco head was once colorfully painted.

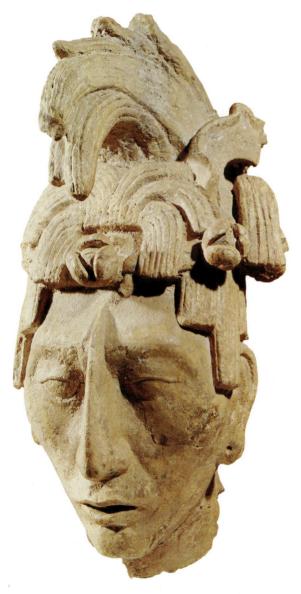

13-11 • PORTRAIT OF PAKAL THE GREAT From Pakal's tomb, Temple of the Inscriptions, Palenque, Mexico. Maya culture, mid 7th century cE. Stucco and red paint, height 167/8" (43 cm). Museo Nacional de Antropología, Mexico City.

A CLOSER LOOK | Shield Jaguar and Lady Xok

Lintel 24.

Yaxchilan, Mexico. Maya culture, 725 cE. Limestone, $43\frac{1}{2}'' \times 31\frac{3}{4}''$ (110.5 × 80.6 cm). British Museum, London.

Shield Jaguar's elaborate headgear includes the shrunken head of a sacrificial victim, proclaiming his past piety in another ritual pleasing to the gods.

The two inscriptions—almost acting as an internal frame for the standing figure—record the date and the nature of the ritual portrayed: bloodletting on October 28, 709. It also identifies the standing king as Shield Jaguar and the kneeling woman as Lady Xok.

The sharply outlined subjects, as well as the way they project forward from a deeply recessed, blank background, focus viewers' attention on the bodies of Lord Shield Jaguar and his kneeling wife, Lady Xok.

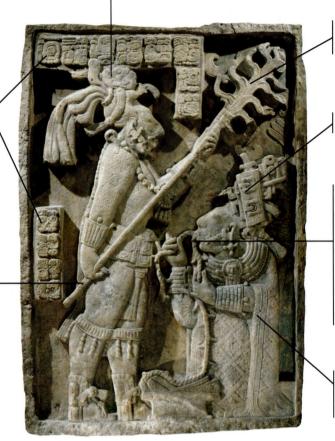

Shield Jaguar holds a huge torch, indicating that this ritual took place within a dark room or during the night.

Tasseled headdresses are associated with bloodletting rituals.

Lady Xok pulls a rope of thorns through her perforated tongue, while spiraling dotted lines show the blood she is sacrificing to the gods. The spiny rope falls to a basket with blood-spotted paper and a sting ray spine also sometimes used for bloodletting. This ritual of selfmutilation was required of royalty since it was believed to maintain royal rule and continuation of human life within the kingdom by gaining favor with the gods.

Lady Xok is lavishly dressed in a garment made of patterned fabric edged with a fringe. The mosaics on her cuffs and collar could be made of jade or shell.

Q—**[View** the Closer Look for Shield Jaguar and Lady Xok on myartslab.com

YAXCHILAN Elite men and women, rather than gods, were the usual subjects of Maya sculpture, and most works show rulers performing religious rituals in elaborate costumes and headdresses. The Maya favored low relief for carving commemorative stelae and decorating buildings. One of the most outstanding examples is one of a series of carved lintels from a temple in the city of Yaxchilan, dedicated in 726 by Lady Xok, the principal wife and queen of the ruler nicknamed "Shield Jaguar the Great." In this retrospective image of a rite conducted when Shield Jaguar (r. 681–742) became the ruler of Yaxchilan in 681, Lady Xok pulls a rope of thorns through her perforated tongue in a bloodletting ritual while her husband stands with a torch to illuminate the scene (see "A Closer Look," above). The relief is unusually

high, giving the sculptor ample opportunity to display a virtuoso carving technique, for example, in Lady Xok's garments and jewelry. The lintels were originally brightly painted as well. That the queen figures so prominently on the lintels of this temple is an indication of her importance at court, and of the status that elite Maya women could attain as important actors in the rituals that assured the power of Maya rulers and the survival of their subjects.

POSTCLASSIC PERIOD After warfare and environmental crisis led to the abandonment of the lowland Maya city-states around 800, the focus of Maya civilization shifted north to the Yucatan Peninsula. One of the principal cities of the Postclassic period was Chichen Itza, which means "at the mouth of the well of

ART AND ITS CONTEXTS | The Cosmic Ballgame

The ritual ballgame was one of the defining characteristics of Mesoamerican society. It was generally played on a long, rectangular court with a large, solid, heavy rubber ball. Using their elbows, knees, or hips—but not their hands—heavily padded players directed the ball toward a goal or marker. The rules, size and shape of the court, the number of players on a team, and the nature of the goal varied. The largest surviving ballcourt, at Chichen Itza, is bigger than a modern football field. Large stone rings set in the walls of this court about 25 feet above the field served as goals. The **BALLCOURT** in **FIGURE 13-12** was constructed at the heart of the ceremonial center in the southernmost Maya city of Copan.

The game was a common subject in Mesoamerican art. This scene, painted on a **CYLINDRICAL VESSEL** (Fig. 13–13), shows four lords playing the ballgame, the architectural space of the ballcourt suggested by a few horizontal lines. The men wear elaborate headdresses and padded gear to protect them from the heavy rubber ball. The painter has chosen a moment of arrested movement: One player kneels to hit the ball—or has just hit it—while the others gesture and lean toward him.

The ballgame may have had religious and political significance: It features in creation stories and was sometimes associated with warfare. Captive warriors might have been forced to play the game, and when the stakes were high the game may have culminated in human sacrifice.

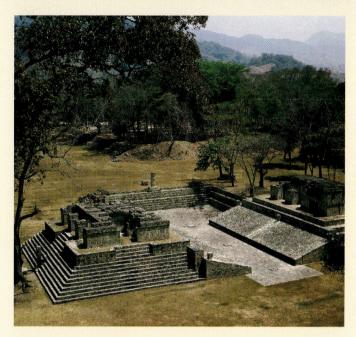

13-12 • BALLCOURT Copan, Honduras. Maya culture, c. 711–736 ce.

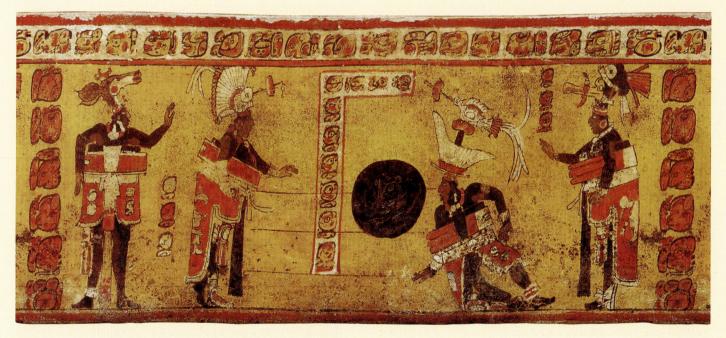

13-13 • CYLINDRICAL VESSEL WITH BALLGAME SCENE

Maya culture, 600–800 CE. Painted ceramic, diameter 6³/₈" (15.9 cm), height 8¹/₈" (20.5 cm). Dallas Museum of Art. Gift of Mr. and Mrs. Raymond Nasher 1983.148

This roll-out photograph shows the entire scene painted around the cylinder; a person holding the vessel would have to turn it to see what was happening. The text running around the rim is a standard dedicatory inscription, naming it as a vessel for drinking chocolate, and tests of residues inside such vessels have confirmed this use. Without sugar or milk, Maya chocolate was a very different drink from the one we are used to, a frothy and bitter beverage consumed on courtly and ritual occasions.

Read the document related to the Maya civilization on myartslab.com

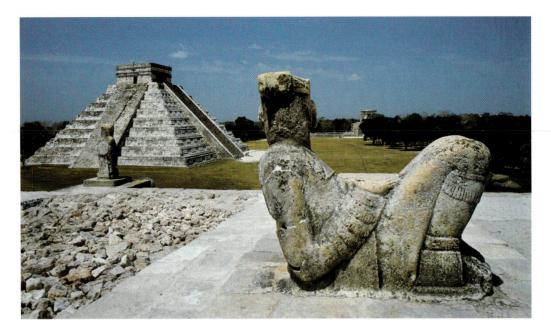

13-14 • PYRAMID ("EL CASTILLO") WITH CHACMOOL IN FOREGROUND

Chichen Itza, Yucatan, Mexico. Maya culture, 9th-12th century CE.

From the top of the Temple of the Warriors, where a reclining *chacmool* sculpture graces the platform, there is a clear view of the radial pyramid nicknamed "El Castillo."

• Watch a video about the Chichen Itza site on myartslab.com

the Itza," and may refer to the deep *cenote* (sinkhole) at the site that was sacred to the Maya. The city flourished from the ninth to the thirteenth century, and at its height covered about 6 square miles.

One of Chichen Itza's most conspicuous structures is a massive nine-level pyramid in the center of a large plaza, nicknamed EL CASTILLO ("the castle" in Spanish) (FIG. 13-14). A stairway on each side of the radial pyramid leads to a square temple on the summit. At the spring and fall equinoxes, the setting sun casts undulating shadows on the stairway, forming bodies for the serpent heads carved at the base of the north balustrades, pointing toward the Sacred Cenote. Many prominent features of Chichen Itza are markedly different from earlier Maya sites and recall complexes in central Mexico, including long, colonnaded halls and inventive columns in the form of inverted, descending serpents. Brilliantly colored relief sculpture and painting covered the buildings of Chichen Itza. Many of the surviving works show narrative scenes that emphasize military conquests. Sculpture at Chichen Itza, including the serpent columns and balustrades, and the halfreclining figures known as chacmools, has the sturdy forms, proportions, and angularity of architecture, rather than the curving complexity and subtle modeling of Classic Maya sculpture. The chaemools may represent fallen warriors and were used to receive sacrificial offerings.

After Chichen Itza's decline, Mayapan, in the middle of the Yucatan Peninsula, became the principal Maya center. But by the time the Spanish arrived in the early sixteenth century, Mayapan, too, had declined (destroyed in the mid fifteenth century), and smaller cities like Tulum, located on the Caribbean coast, were all that remained. The Maya people and much of their culture would survive the devastation of the conquest, adapting to the imposition of Hispanic customs and beliefs. Many Maya continue to speak their own languages, to venerate traditional sacred places, and to follow traditional ways.

CENTRAL AMERICA

Unlike their neighbors in Mesoamerica, who lived in complex hierarchical societies, the people of Central America lived in extended family groups, in towns led by chiefs. A notable example of these small chiefdoms was the Diquis culture (located in present-day Costa Rica), which lasted from about 700 to 1500 CE. The Diquis occupied fortified villages and seem to have engaged in constant warfare with one another. Although they did not produce monumental architecture or the large-scale sculpture found in other parts of Costa Rica, they created fine featherwork, ceramics, textiles, and objects of gold and jade.

Metallurgy and the use of gold and copper-gold alloys were widespread in Central America. The technique of lost-wax casting probably first appeared in present-day Colombia between 500 and 300 BCE. From there it spread north to the Diquis. A small, exquisite pendant (**FIG. 13-15**) illustrates the style and technique of Diquis goldwork. The pendant depicts a male figure wearing bracelets, anklets, and a belt with a snake-headed penis sheath. He plays a drum while holding the tail of a snake in his teeth and its head in his left hand. The wavy forms with serpent heads emerging from his scalp suggest an elaborate headdress, and the creatures emerging from his legs suggest some kind of reptile costume. The inverted triangles on the headdress probably represent birds' tails.

In Diquis mythology, serpents and crocodiles inhabited a lower world, humans and birds a higher one. Diquis art depicts animals and insects as fierce and dangerous. The man in the pendant is clearly a performer, and some have interpreted him as a shaman transforming himself into a composite serpent-bird or enacting a ritual snake dance surrounded by serpents or crocodiles. The scrolls on the sides of his head may represent a shaman's power to hear and understand the speech of animals. Whatever its specific meaning, the pendant evokes a ritual of mediation between earthly and cosmic powers involving music, dance, and costume.

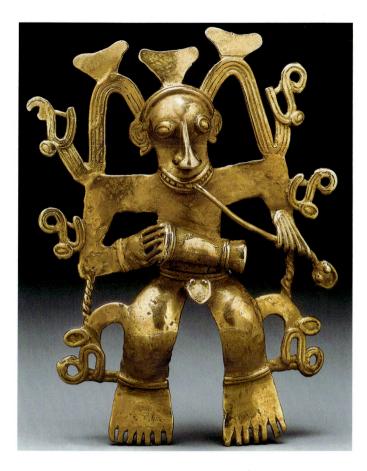

13-15 • SUPERNATURAL FIGURE WITH DRUM AND SNAKE

Whether gold figures of this kind were protective amulets or signs of high status, they were certainly more than personal adornment. Shamans and warriors wore gold to inspire fear, perhaps because gold was thought to capture the energy and power of the sun. This energy was also thought to allow shamans to leave their bodies and travel into cosmic realms.

SOUTH AMERICA: THE CENTRAL ANDES

Like Mesoamerica, the central Andes of South America—primarily present-day Peru and Bolivia—saw the development of complex hierarchical societies with rich and varied artistic traditions. The area is one of dramatic contrasts. The narrow coastal plain, bordered by the Pacific Ocean on the west and the abruptly soaring

TECHNIQUE | Andean Textiles

Textiles were one of the most important forms of art and technology in Andean society. Specialized fabrics were developed for everything from ritual burial shrouds and ceremonial costumes to rope bridges and knotted cords for record keeping. Clothing indicated ethnic group and social status and was customized for certain functions, the most rarefied being royal ceremonial garments made for specific occasions and worn only once. Andean textiles are among the most technically complex cloths ever made, and their creation consumed a major portion of societal resources.

Andean textile artists used two principal materials: cotton and camelid fiber. (Camelid fiber—Ilama, alpaca, guanaco, or vicuña hair—is the Andean equivalent of wool.) Cotton grows on the coast, while llamas, alpacas, and other camelids thrive in the highlands. The presence of cotton fibers in the highlands and camelid fibers on the coast documents trade between the two regions from very early times and suggests that the production of textiles was an important factor in the domestication of both plants (cotton) and animals (llamas).

The earliest Peruvian textiles were made by twining, knotting, wrapping, braiding, and looping fibers. Those techniques continued to be used even after the invention of weaving looms in the early second millennium BCE. Most Andean textiles were woven on a simple, portable backstrap loom in which the undyed cotton warp (the lengthwise threads) was looped and stretched between two bars. One bar was tied

to a stationary object and the other strapped to the waist of the weaver. The weaver controlled the tension of the warp threads by leaning back and forth while threading a shuttle from side to side to insert the weft (crosswise threads). Changing the arrangement of the warp threads between each passage of the weft created a stable interlace of warp and weft: a textile.

Andean artists used a variety of different techniques to decorate their textiles, creating special effects that were prized for their laborintensiveness and difficulty of manufacture as well as their beauty. In tapestry weaving, a technique especially suited to representational textiles, the weft does not run the full width of the fabric; each colored section is woven as an independent unit. **Embroidery** with needle and thread on an already woven textile allows even greater freedom from the rigid warp-and-weft structure of the loom, allowing the artist to create curvilinear forms with thousands of tiny stitches (see FIG. 13–17). As even more complex techniques developed, the production of a single textile might involve a dozen processes requiring highly skilled workers. Dyeing technology, too, was an advanced art form in the ancient Andes, with some textiles containing dozens of colors.

Because of their complexity, deciphering how these textiles were made can be a challenge, and investigators rely on contemporary Andean weavers—inheritors of this tradition—for guidance. Now, as then, fiber and textile arts are primarily in the hands of women. Andes Mountains on the east, is one of the driest deserts in the world. Life here depends on the rich marine resources of the Pacific Ocean and the rivers that descend from the Andes, forming a series of valley oases. The Andes themselves are a region of lofty snowcapped peaks, high grasslands, steep slopes, and deep, fertile river valleys. The high grasslands are home to the Andean camelids that have served for thousands of years as beasts of burden and a source of wool and meat. The lush eastern slopes of the Andes descend to the tropical rainforest of the Amazon basin.

In contrast to developments in other parts of the world, Andean peoples developed monumental architecture and textiles long before ceramics and intensive agriculture, usually the two hallmarks of early civilization. Thus, the earliest period of monumental architecture, beginning around 3000 BCE, is called the Preceramic period. On the coast, sites with ceremonial mounds and plazas were located near the sea, while in the highlands early centers consisted of multi-roomed stone-walled structures with sunken central fire pits for burning ritual offerings. In the second millennium BCE (the Initial Period), as agriculture became more important both in the highlands and on the coast, the scale and pace of construction increased dramatically. Communities in the coastal valleys built massive U-shaped ceremonial complexes, while highland religious centers focused on sunken circular courtyards. By adding to these constructions bit by bit over generations, and using older constructions as the nucleus of new buildings, relatively small communities could generate mountain-size pyramids.

CHAVIN DE HUANTAR

Located on a trade route between the coast and the Amazon basin, the highland site of Chavin de Huantar was an important religious center between 900 and 200 BCE, home to a style of art that spread through much of the Andes. In Andean chronology, this era is known as the Early Horizon, the first of three so-called Horizon periods. The period was one of artistic and technical innovation in ceramics, metallurgy, and textiles.

The architecture of Chavin synthesizes coastal and highland traditions, combining the U-shaped pyramid typical of the coast with a sunken circular plaza lined with carved reliefs, a form common in the highlands. The often fantastical animals that adorn Chavin sculpture have features of jaguars, hawks, caimans, and other tropical Amazonian beasts.

Within the U-shaped Old Temple at Chavin is a mazelike system of narrow galleries, at the very center of which lies a sculpture called the **LANZÓN** (**FIG. 13-16**). Wrapped around a 15-foot-tall blade-shaped stone with a narrow projection at the top—a form that may echo the shape of traditional Andean planting sticks this complex carving depicts a powerful creature with a humanoid body, clawed hands and feet, and enormous fangs. Its eyebrows and strands of hair terminate in snakes—a kind of composite and transformational imagery shared by many Chavin images. The creature is bilaterally symmetrical, except that it has one hand raised and the other lowered. Compact frontality, flat relief, curvilinear design,

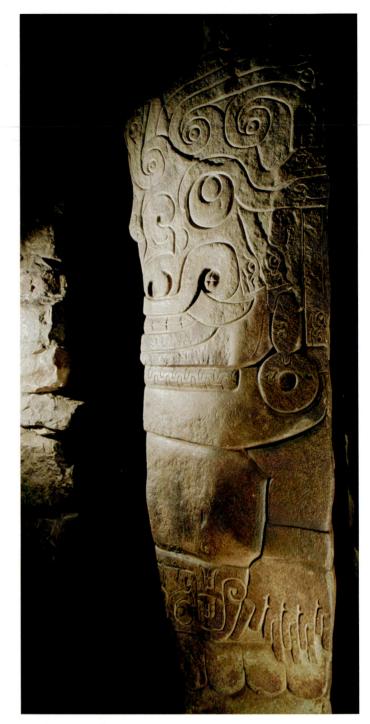

13-16 • LANZÓN, CHAVIN DE HUANTAR Peru. Chavin culture, c. 900 BCE. Granite, height 15' (4.5 m).

and the combination of human, animal, bird, and reptile parts characterize this early art.

It has been suggested that the Lanzón was an oracle (a chamber directly above the statue would allow priests' disembodied voices to filter into the chamber below), which would explain why people from all over the Andes made pilgrimages to Chavin, bringing exotic goods to the highland site and spreading the style of its art throughout the Andean region as they returned home.

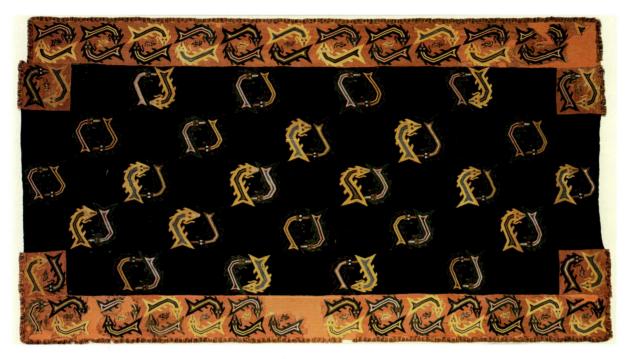

13-17 • MANTLE WITH DOUBLE FISH PATTERN Paracas Necropolis, Peru. Paracas culture, 1st century ce. Cotton and camelid fiber, plain weave with stem-stitch embroidery, $1181/4'' \times 633/4''$ (3 × 1.62 m). Brooklyn Museum. Alfred W. Jenkins Fund (34.1560)

THE PARACAS AND NAZCA CULTURES

While Chavin de Huantar was flourishing as a highland center whose art was enormously influential throughout the Andes, different valleys on the Pacific coast developed distinctive art styles and cultures.

PARACAS The Paracas culture of the Peruvian south coast flourished from about 600 BCE to 200 CE, overlapping the Chavin period. It is best known for its stunning textiles, which were found in cemeteries as wrappings, in many layers, around the bodies of the dead. Some bodies were wrapped in as many as 200 pieces of cloth.

Weaving is of great antiquity in the central Andes and continues to be among the most prized arts in the region (see "Andean Textiles," page 397). Fine textiles were a source of prestige and wealth. The designs on Paracas textiles include repeated embroidered figures of warriors, dancers, composite creatures, and animals (**FIG. 13-17**). Tiny overlapping stitches on this example create a colorful, curvilinear pattern of paired fish—probably sharks, based on the placement of the gills—striking against the dark blue field and red border. Paracas embroiderers sometimes used as many as 22 different colors within a single figure, but only one simple stitch.

NAZCA The Nazca culture, which dominated portions of the south coast of Peru during the first seven centuries CE, overlapped the Paracas culture to the north. Nazca artisans wove fine fabrics, and also produced multicolored pottery with painted and modeled images reminiscent of those on Paracas textiles.

The Nazca are best known for their colossal earthworks, or **geoglyphs**, which dwarf even the most ambitious twentiethcentury environmental sculpture. On great stretches of desert they literally drew in the earth. By removing dark, oxidized stones, they exposed the light underlying stones. In this way they created gigantic images—including a **HUMMINGBIRD** with a beak 120 feet long (**FIG. 13-18**), a killer whale, a monkey, a spider, a duck, and other birds—similar to those with which they decorated their pottery. They also made abstract patterns and groups of straight, parallel lines that extend for up to 12 miles. The purpose and meaning of the glyphs remain a mystery, but the "lines" of stone are wide enough to have been ceremonial pathways.

THE MOCHE CULTURE

The Moche culture dominated the north coast of Peru from the Piura Valley to the Huarmey Valley—a distance of some 370 miles—between about 100 and 700 CE. Moche lords ruled each valley in this region from a ceremonial-administrative center. The largest of these, in the Moche Valley (from which the culture takes its name), contained the so-called Huaca del Sol (Pyramid of the Sun) and Huaca de la Luna (Pyramid of the Moon), both built of **adobe** brick (sun-baked blocks of clay mixed with straw). The Huaca del Sol, one of the largest ancient structures in South America, was originally 1,100 feet long by 500 feet wide, rising in a series of terraces to a height of 59 feet. Much of this pyramid was destroyed in the seventeenth century, when a Spanish mining company diverted a river through it to wash out the gold contained in its many burials. Recent excavations at the Huaca de la

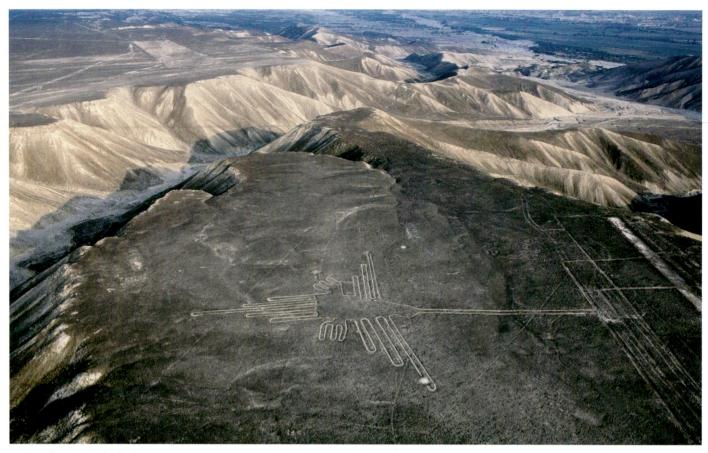

13-18 • EARTH DRAWING (GEOGLYPH) OF A HUMMINGBIRD, NAZCA PLAIN Southwest Peru. Nazca culture, c. 1–700 ce. Length approx. 450' (137 m); wingspan approx. 220' (60.9 m).

• Watch a video about the earth drawings on the Nazca Plain on myartslab.com

Luna have revealed brightly painted reliefs of deities, captives, and warriors, remade during successive renovations of the pyramid. This site had been thought to be the capital of the entire Moche realm, but the accumulating evidence indicates that the Moche maintained a decentralized social network.

The Moche were exceptional potters and metalsmiths. Vessels were made in the shapes of naturalistically modeled human beings, animals, and architectural structures, at times combined in complex figural scenes. They developed ceramic molds, which allowed them to mass-produce some forms. They also created **PORTRAIT VESSELS** that seem to preserve individual likenesses (**FIG. 13-19**) and recorded mythological narratives and ritual scenes in intricate fine-line painting. Similar scenes were painted on the walls of temples and administrative buildings. Moche metalsmiths, the most sophisticated in the central Andes, developed several innovative metal alloys.

13-19 • MOCHE PORTRAIT VESSEL

Peru. Moche culture, c. 100–700 ce. Clay, height 11" (28 cm). Ethnologisches Museum, Staatliche Museen zu Berlin.

This is one of several portrait vessels, made from the same mold, that seems to show a particular individual.

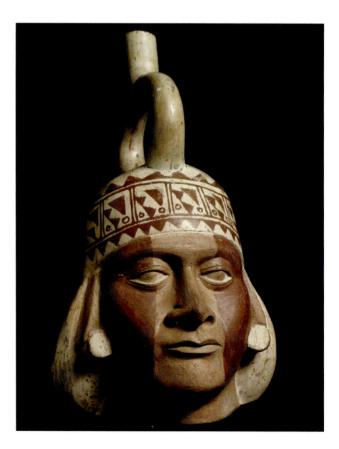

THE TOMB OF THE WARRIOR PRIEST A central theme in Moche iconography is a ceremony in which prisoners captured in battle are sacrificed and several elaborately dressed figures then drink their blood. Archaeologists have labeled the principal figure in this sacrifice ceremony as the Warrior Priest and other important figures as the Bird Priest and the Priestess. The recent discovery of a number of spectacularly rich Moche tombs indicates that the sacrifice ceremony was an actual Moche ritual and that Moche lords and ladies assumed the roles of the principal figures. The occupant of a tomb at Sipán, in the Lambayeque Valley on the northwest coast, was buried with the regalia of the Warrior Priest. In tombs at the site of San José de Moro, just south of Sipán, several women were buried with the regalia of the Priestess.

Among the riches accompanying the Warrior Priest at Sipán was a pair of exquisite gold-and-turquoise **EARSPOOLS**, each of which depicts three Moche warriors (**FIG. 13-20**). The central figure bursts into three dimensions, while his companions are shown in profile, in a flat inlay technique. All three are adorned with tiny gold-and-turquoise earspools, simpler versions of the object they themselves adorn. They wear gold-and-turquoise headdresses topped with delicate sheets of gold that resemble the crescent-shaped knives used in sacrifices. The central figure has a

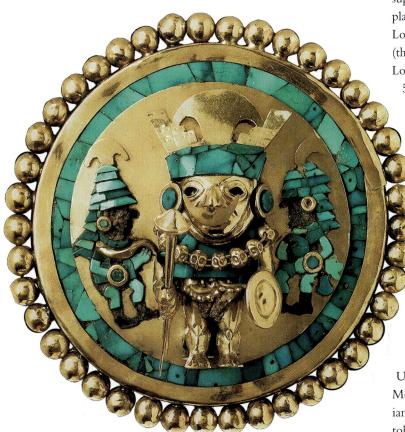

13-20 • EARSPOOL

From Sipán, Peru. Moche culture, c. 300 cE. Gold, turquoise, quartz, and shell, diameter approx. 3" (9.4 cm). Bruning Archaeological Museum, Lambayeque, Peru.

crescent-shaped nose ornament and carries a removable gold club and shield. A necklace of owl's-head beads strung with gold thread hangs around his shoulders; similar objects have been found in other tombs at Sipán. These earspools illustrate two of the most notable features of Moche art: its capacity for naturalism and its close attention to detail.

NORTH AMERICA

Compared to the densely inhabited agricultural regions of Mesoamerica and South America, most of North America remained sparsely populated. Early people lived primarily by hunting, fishing, and gathering edible plants. Agriculture was developed on a limited scale with the cultivation of squash, sunflowers, and other plants to supplement a diet comprised largely of game, fish, and berries.

THE EAST

We are only beginning to understand the early culture of eastern North America. Archaeologists have discovered that people lived in communities that included both burial and ceremonial earthworks—mounds of earth-formed platforms that probably supported a chief's house and served as the shrines of ancestors and places for a sacred fire, tended by special guardians. Poverty Point, Louisiana, is one of the largest of the earthwork ceremonial centers (though not the earliest—this distinction goes to Watson Brake, Louisiana, dating to 3400–3000 BCE). Dated between 1800 and 500 BCE—essentially contemporary with Stonehenge in England (see FIG. 1-20) and with Olmec constructions in Mexico (see FIG. 13-2)—Poverty Point consisted of huge, concentric earthen arcs three-quarters of a mile wide.

THE WOODLAND PERIOD The Woodland period (300 BCE-1000 CE) saw the creation of impressive earthworks along the great river valleys of the Ohio and Mississippi, where people built monumental mounds and buried individuals with valuable grave goods. Objects discovered in these burials indicate that the people of the Mississippi, Illinois, and Ohio river valleys traded widely with other regions of North and Central America. For example, the burial sites of the Adena (c. 1100 BCE-200 CE) and the Hopewell (c. 100 BCE-550 CE) cultures contained objects made with copper from present-day Michigan's Upper Peninsula, and cut sheets of mica from the Appalachian Mountains, turtle shells and sharks' teeth from Florida, and obsidian from Wyoming and Idaho. The pipes for the ritual smoking of tobacco that the Hopewell people created from fine-grained pipestone have been found from Lake Superior to the Gulf of Mexico.

The Hopewell carved their pipes with representations of forest animals and birds, sometimes with inlaid eyes and teeth of freshwater pearls and bone. Combining realism and elegant

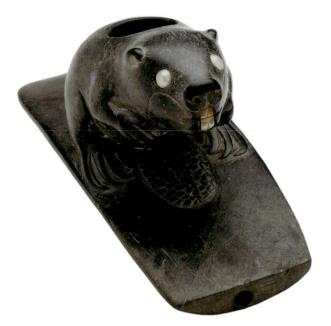

13–21 • BEAVER EFFIGY PLATFORM PIPE From Bedford Mound, Pike County, Illinois. Hopewell culture, c. 100– 400 CE. Pipestone, river pearls, and bone, $4\%_{16}'' \times 1\%'' \times 2''$. Gilcrease Museum, Tulsa, Oklahoma.

simplification, a beaver crouching on a platform forms the bowl of a pipe found in present-day Illinois (**FIG. 13-21**). As in a modern pipe, the bowl—a hole in the beaver's back—could be filled with tobacco or other dried leaves, the leaves lighted, and smoke drawn through the hole in the stem. Using the pipe in this way, the smoker would be face to face with the beaver, whose shining pearl eyes may suggest an association with the spirit world.

THE MISSISSIPPIAN PERIOD The Mississippian period (c. 700-1550 CE) is characterized by the widespread distribution of complex chiefdoms, both large and small, that proliferated throughout the region. The people of the Mississippian culture continued the mound-building tradition begun by the Adena, Hopewell, and others. From 1539 to 1543 Hernando de Soto encountered Mississippian societies while exploring the region, and this contact between native North American people and Europeans resulted in catastrophe. The Europeans introduced diseases, especially smallpox, to which native populations had had no previous exposure and hence no immunity. In short order, 80 percent of the native population perished, an extraordinary disruption of society, far worse than the Black Death in fourteenth-century Europe. By the time other Europeans reached the area, the great earthworks of the Mississippian culture had long been abandoned.

One of the most impressive Mississippian period earthworks is the **GREAT SERPENT MOUND** in present-day Adams County, Ohio (**FIG. 13-22**). Researchers using carbon-14 dating have recently proposed dating the mound to about 1070 CE. There have been many interpretations of the twisting snake form, especially the "head" at the highest point, a Y-shape and an oval enclosure that some see as the serpent opening its jaws to swallow a huge egg. Perhaps the people who built it were responding to the spectacular astronomical display of Halley's Comet in 1066.

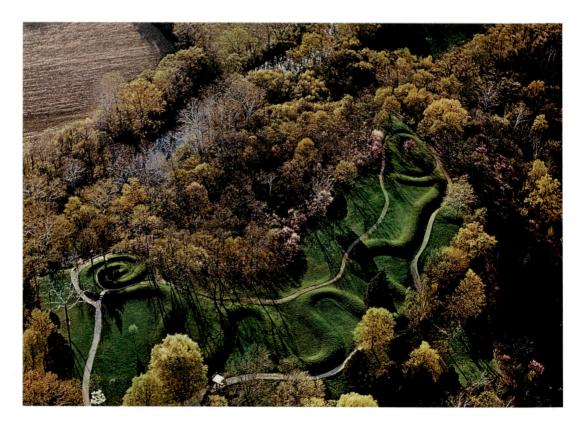

13-22 • GREAT SERPENT MOUND Adams County, Ohio. Mississippian culture, c. 1070 cE. Length approx. 1,254' (328.2 m).

13-23 • RECONSTRUCTION OF CENTRAL CAHOKIA, AS IT WOULD HAVE APPEARED ABOUT 1150 CE

East St. Louis, Illinois. Mississippian culture, c. 1000–1300 cE. East–west length approx. 3 miles (4.82 km), north–south length approx. $2^{1/4}$ miles (3.6 km); base of great mound, $1,037' \times 790'$ (316 \times 241 m), height approx. 100' (30 m). Monk's Mound is the large platform in the center of the image. Painting by William R. Iseminger. Courtesy of Cahokia Mounds Historic Site.

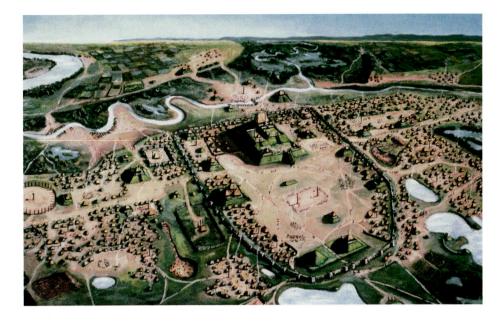

Mississippian peoples built a major urban center known as Cahokia, near the juncture of the Illinois, Missouri, and Mississippi rivers (now East St. Louis, Illinois). Although the site may have been inhabited as early as about 3000 BCE, most monumental construction at Cahokia took place between about 1000 and 1300 CE. At its height the city had a population of up to 15,000 people, with another 10,000 in the surrounding countryside (**FIG. 13-23**).

The most prominent feature of Cahokia—a feature also found at other Mississippian sites—is an enormous earth mound called Monk's Mound, covering 15 acres and originally 100 feet high. A small, rounded platform on its summit initially supported a wooden fence and a rectangular building. The mound is aligned with the sun at the equinox and may have had a special use during planting or harvest festivals. Smaller rectangular and rounded mounds in front of the principal mound surrounded a large, roughly rectangular plaza. The city's entire ceremonial center was protected by a stockade, or fence, of upright wooden posts. In all, the walled enclosure contained more than 100 mounds, platforms, wooden enclosures, and houses. The various earthworks functioned as tombs and bases for palaces and temples, and also served to make astronomical observations.

Postholes indicate that woodhenges (circles of wooden columns) were a significant feature of Cahokia. The largest (seen to the extreme left in FIGURE 13-23) had 48 posts forming a circle with a diameter of about 420 feet. Sight lines between a 49th post set east of the center of the enclosure and points on the perimeter enabled early astronomers to determine solstices and equinoxes.

FLORIDA GLADES CULTURE In 1895, excavators working in submerged mud and shell mounds off Key Marco on the west coast of Florida made a remarkable discovery: posts carved with birds and animals were preserved in the swamps. The large mound called Fort Center, in Glades Country, Florida, gives the Florida Glades culture its name. At Key Marco, painted wooden animal and bird heads, a human mask, and the figure of a kneeling cat-human were found in circumstances that suggested a ruined shrine. Recently, carbon-14 dating of these items has confirmed a date of about 1000 CE. Although the heads are spare in details, the artists show a remarkable power of observation in reproducing the creatures they saw around them, such as the **PELICAN** in **FIGURE 13-24**. The surviving head, neck, and breast of the pelican are made of carved

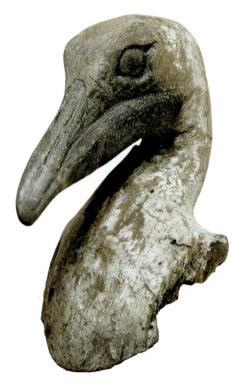

13-24 • **PELICAN FIGUREHEAD** Key Marco, Florida. Florida Glades culture, c. 1000 ce. Wood and paint, $4\%'' \times 2\%'' \times 3\%'' (11.2 \times 6 \times 8 \text{ cm})$. The University Museum of Archaeology and Anthropology, Philadelphia.

wood, painted black, white, and gray (other images also had traces of pink and blue paint). The bird's outstretched wings were found nearby, but the wood shrank and disintegrated as it dried. Carved wooden wolf and deer heads were also found. Archaeologists think the heads might have been attached to ceremonial furniture or posts. Some see evidence here of a bird and animal cult or perhaps the use of birds and animals as clan symbols.

THE NORTH AMERICAN SOUTHWEST

Farming cultures were slower to arise in the arid American Southwest, which became home to three major early cultures. The Hohokam culture, centered in the central and southern parts of present-day Arizona, emerged around 200 BCE and endured until sometime around 1300 CE. The Hohokam built large-scale irrigation systems, multi-story residences, and ballcourts that demonstrate ties with Mesoamerica. The Mimbres/Mogollon culture, located in the mountains of west-central New Mexico and east-central Arizona, flourished from about 200 to about 1150 CE. Potters made deep bowls painted with lively, imaginative, and sometimes complex scenes of humans and animals (FIG. 13-25). Much of our knowledge of this ceramic tradition is based on examples excavated in burials under the floors of Mimbres dwellings, where food bowls-most of them intentionally punctured before burial-were inverted and placed over the head of the deceased. Some experts believe these perforated bowls could have represented the dome of the sky and embodied ideas about the transport of the dead from the earth into the spirit world.

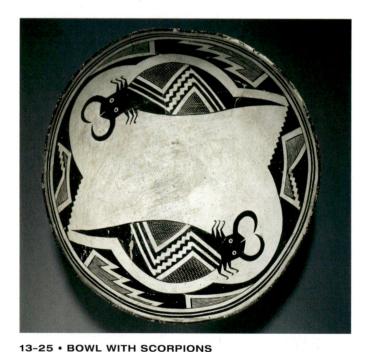

Swarts Ruin, Southwest New Mexico. Mimbres culture, c. 1000–1150 cE. Earthenware with white slip and black paint, height 4¾" (12 cm), diameter 115%" (29.5 cm). Courtesy of the Peabody Museum of Archaeology and Ethnology, Harvard University.

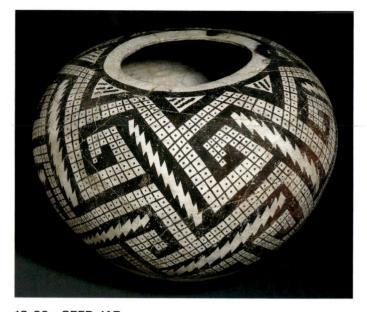

13-26 • SEED JAR Ancestral Puebloan culture, c. 1150 cE. Earthenware with black-andwhite pigment, diameter 14½" (36.9 cm). Saint Louis Art Museum. Funds given by the Children's Art Festival (175:1981)

The third southwestern culture, the Ancestral Puebloans (formerly called Anasazi), emerged around 500 CE in the Four Corners region, where present-day Colorado, Utah, Arizona, and New Mexico meet. The Puebloans adopted the irrigation technology of the Hohokam and began building elaborate, multi-storied, apartmentlike "great houses" with many rooms for specialized purposes, including communal food storage and ritual.

As in Mimbres culture, Ancestral Puebloan people found aesthetic expression in their pottery, an ancient craft refined over generations. Women were the potters in ancient Pueblo society. They developed a functional, aesthetically pleasing, coil-built earthenware, or low-fired ceramic, initiating a tradition of ceramic production that continues to be important today among the Pueblo peoples of the Southwest. One type of vessel, a wide-mouthed **SEED JAR** with a globular body and holes near the rim (**FIG. 13-26**), would have been suspended from roof poles by thongs attached to the jar's holes, out of reach of voracious rodents. The example shown here is decorated with black-and-white dotted squares and zigzag patterns. The patterns conform to the body of the jar, enhancing its curved shape by focusing the energy of the design around its bulging expansion.

CHACO CANYON Chaco Canyon, covering about 30 square miles in present-day New Mexico with nine great houses, or pueblos, was an important center of Ancestral Puebloan civilization. The largest-known "great house" is **PUEBLO BONITO** (**FIG. 13-27**), which was built in stages between the tenth and mid thirteenth centuries. Eventually it comprised over 800 rooms in four or five stories, arranged in a D shape. Within the crescent

part of the D, 32 **kivas** recall the round, semisubmerged pit houses of earlier Southwestern cultures. Here men performed religious rituals and instructed youths in their responsibilities. Interlocking pine logs formed a shallow, domelike roof with a hole in the center through which the men entered by climbing down a ladder. Based on what we know of later Pueblo beliefs, a small indentation in the floor of the kiva, directly under the entrance and behind the fire pit, may have symbolized the "navel of the earth"—the place where ancestors of the Ancestral Pueblo themselves had emerged to settle on the earth in mythic "first times." The top of the kivas formed the floor of the communal plaza.

Pueblo Bonito stood at the hub of a network of wide, straight roads—almost invisible today, but discovered through aerial photography—that radiated out to some 70 other communities. They make no detour to avoid topographic obstacles; when they encounter cliffs, they become stairs. Their undeviating course suggests that they were more than practical thoroughfares: They may have served as processional ways. Given its place at the intersection of this road system and the prominence of kivas in the design of great houses such as Pueblo Bonito, some have suggested that Chaco Canyon may have been a gathering place or pilgrimage site for people from the entire region at specific times of year.

Though no one knows for certain why Chaco Canyon was abandoned, the Ancestral Puebloan population declined during a severe drought in the twelfth century, and building at Pueblo Bonito ceased around 1250. Ancestral Puebloans may have moved to the Rio Grande and Mogollon River valleys, where they built new apartmentlike dwellings on ledges under sheltering cliffs

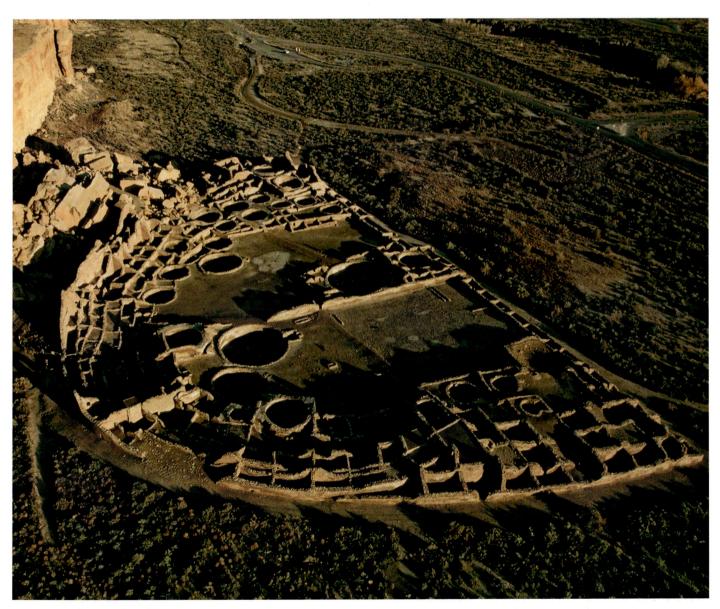

13-27 • PUEBLO BONITO Chaco Canyon, New Mexico. 830–1250 ce.

A BROADER LOOK | Rock Art

The rock art of the American Southwest consists of pictographs, which are painted, and petroglyphs, which are pecked or engraved. While occurring in numerous distinctive styles, rock art images include humans, animals, and geometric figures, represented singly and in multi-figured compositions. Petroglyphs are often found in places where the dark brown bacterial growths and staining known as "**desert varnish**" streak down canyon walls (see FIG. 13–29). To create an image, the artist scrapes or pecks through the layer of varnish, exposing the lighter sandstone beneath.

In the Great Gallery of Horseshoe Canyon, Utah, the painted human figures have long, decorated rectangular bodies and knoblike heads (**FIG. 13–28**). One large, wide-eyed figure (popularly known as the "Holy Ghost") is nearly 8 feet tall. Archaeologists have dated these paintings to as early as 1900 BCE and as recently as 300 CE; rock art is very difficult to date with any precision.

In the petroglyphs of Nine Mile Canyon in central Utah—attributed to the Fremont people (800–1300 cE), agriculturists as well as hunters—a large human hunter draws his bow and arrow on a flock of bighorn sheep (**FIG. 13–29**). Other hunters and a large, rectangular armless figure wearing a horned headdress mingle with the animals. The scene gives rise to the same questions and arguments we have noted with regard to the prehistoric art discussed in Chapter 1: Is this a record of a successful hunt or is it part of some ritual activity to ensure success?

13-29 • HUNTER'S MURAL Nine Mile Canyon, Utah. Fremont people, 800–1300 CE.

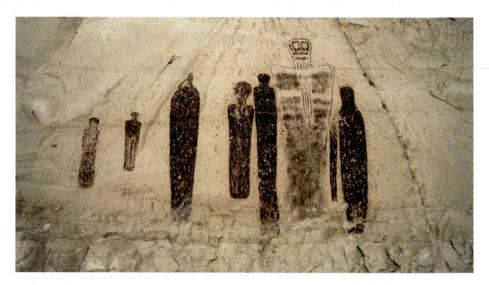

13-28 • ANTHROPOMORPHS, THE GREAT GALLERY, HORSESHOE (BARRIER) CANYON

Utah. c. 1900 BCE-300 CE. Largest figure about 8' (2.44 m) tall.

These may represent holy or priestly figures and are often associated with snakes, dogs, and other small energetic creatures. Big-eyed anthropomorphs may be rain gods. Painters used their fingers and yucca-fiber brushes to apply the reddish pigment made from hematite (iron oxide).

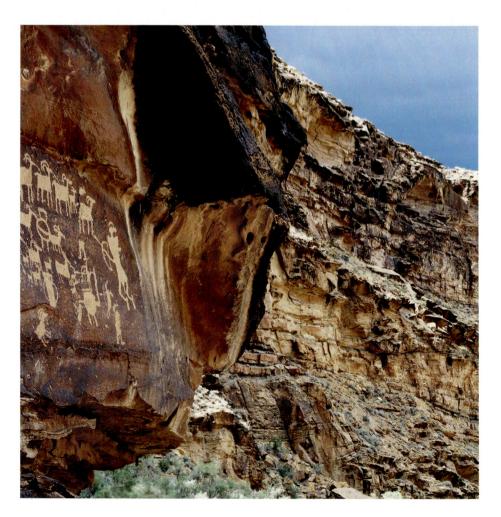

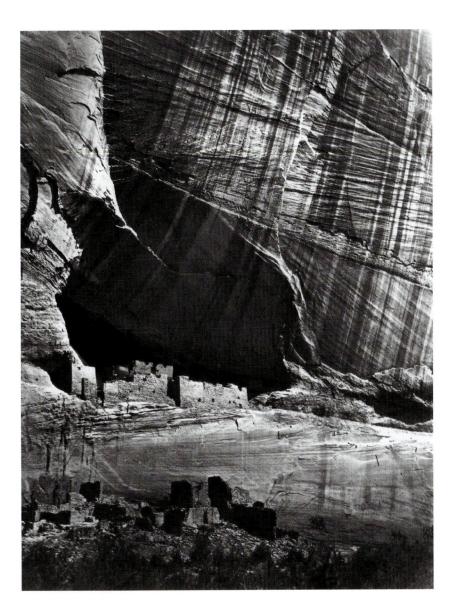

13-30 • Timothy O'Sullivan ANCIENT RUINS IN THE CANYON DE CHELLEY

Arizona. Albumen print. 1873. National Archives, Washington, DC.

While ostensibly a documentary photograph, Timothy O'Sullivan's picture of "The White House," built by twelfth-century Ancestral Puebloans, is both a valuable document for the study of architecture and an evocative art photograph, filled with the Romantic sense of sublime melancholy.

(FIG. 13-30). Difficult as it must have been to live high on canyon walls and commute to the farm the valley below, the cliff communities had the advantage of being relatively secure. The rock shelters in the cliffs also acted as insulation, protecting the dwellings from the extremes of heat and cold that characterize this part of the world. Like a modern apartment complex, the many rooms housed an entire community comfortably. Communal solidarity and responsibility became part of the heritage of the Pueblo peoples.

Throughout the Americas, for the next several hundred years, artistic traditions would continue to emerge, develop, and be transformed as the indigenous peoples of various regions interacted. But more than anything else, the sudden incursions of Europeans, beginning in the late fifteenth century, would have a dramatic and lasting impact on these civilizations and their art.

THINK ABOUT IT

- 13.1 Characterize and compare the differing figure styles of paintings from Teotihuacan and Maya culture as seen in FIGS. 13-7 and 13-13.
- **13.2** Discuss the significance of bloodletting as a recurring theme in early Mesoamerican art, focusing your answer on one specific work of art in this chapter.
- 13.3 Evaluate what we can learn about the broad cultural values of Olmec civilization from the figural group that was the subject of the opening discussion in this chapter.
- 13.4 Compare the architectural complexes of Teotihuacan and Chaco Canyon. Evaluate the arguments for understanding both of these early monuments of American art as ceremonial sites. What do we know of the rituals that would have been performed in each location?

CROSSCURRENTS

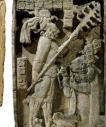

Ch. 13 Closer Look, page 394

Both of these works, representing activities and relationships critical to royal power, were created in pictorial relief sculpture. Compare the two very different techniques of carving and figural styles. How are style and technique related to the cultural traditions of the time when and place where they were made?

Study and review on myartslab.com

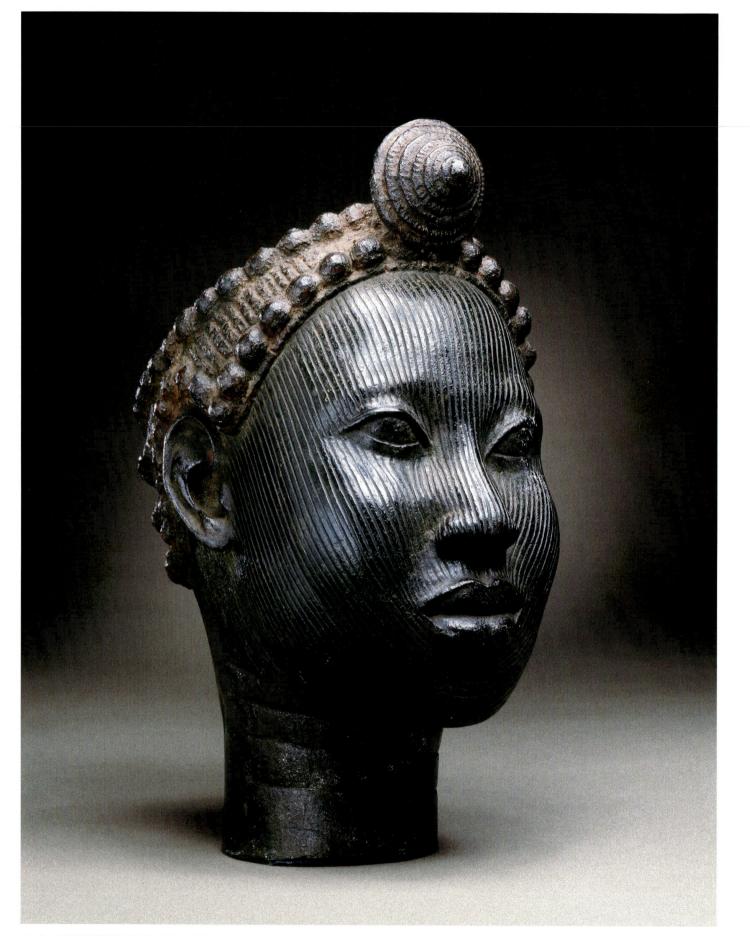

14-1 • CROWNED HEAD OF A YORUBA RULER From Ife, Nigeria. Yoruba, 12th–15th century ce. Zinc brass, height 97/16" (24 cm). Museum of Ife Antiquities, Ife, Nigeria.

The Yoruba people of southwestern Nigeria regard the city of Ife (also known as Ile-Ife) as the "navel of the world," the site of creation, the place where Ife's first ruler—the *oni* Oduduwa—came down from heaven to create Earth and then to populate it. By the eleventh century CE, Ife was a lively metropolis, and, even today, every Yoruba city claims "descent" from Ife. It was, and remains, the sacred city of the Yoruba people.

A sculptural tradition of casting lifelike human heads, using the lost-wax process, began in Ife about 1050 CE and flourished over four centuries. Although the ancestral line of the Ife oni (king) has continued unbroken, knowledge of the precise purpose of these arresting works has been lost. The cast-bronze head in **FIGURE 14-1** demonstrates the extraordinary artistry that produced them. The modeling of the flesh—covered with thin, parallel **scarification** patterns (decorations made by scarring)—is remarkably sensitive, especially the subtle transitions around the nose and mouth. The full, delicate lips and expressive eyes bulge organically in ways that are strikingly similar to the faces of some modern Yoruba, underlining the sense of an individual likeness.

This head was cast with a crown, and its size and delicate features suggest it may represent a female *oni*. Although its precise use is not known, similar life-size heads have large holes in the neck, suggesting they may have been attached

Early African Art

to wooden figures, and mannequins with naturalistic facial features have been documented at memorial services for deceased individuals among contemporary Yoruba peoples. The Ife mannequin could have been dressed in the *oni*'s robes. But the head could also have been used to display an actual crown during annual purification and renewal rites.

The question of whether the Ife heads are true portraits has been debated, and their attention to the distinctive contours and features that provide individuality to human faces gives an impression that they could be. They all, however, seem to represent individuals of the same age and embody a similar concept of physical perfection, suggesting they are idealized images representing both physical beauty and moral character. As we have seen in the portraits of other cultures, however, idealization does not preclude the possibility that the faces describe the distinguishing characteristics of a specific human being.

The superb naturalism of Ife sculpture contradicted everything Europeans thought they knew about African art. The German scholar, Leo Frobenius, who "discovered" Ife sculpture in 1910 suggested that it was created not by Africans but by survivors from the legendary lost island of Atlantis. Later, there was speculation that influence from ancient Greece or Renaissance Europe must have reached Ife. Scientific study, however, finally put such prejudiced ideas to rest.

LEARN ABOUT IT

- **14.1** Compare the variety of figure styles used by the early artists of Africa and explore the relationship of style to technique, especially bronze casting.
- **14.2** Understand how African arts mediate and support communication between the temporal and the supernatural worlds of various spirit forces.
- 14.3 Explore how the arts of early Africa are fully realized and understood in the context of ritual and ceremony.
- **14.4** Recognize how contact with other cultures has affected the development and also threatened the very survival of early African art.

((•• Listen to the chapter audio on myartslab.com

THE LURE OF ANCIENT AFRICA

"I descended [the Nile] with three hundred asses laden with incense, ebony, grain, panthers, ivory, and every good product." Thus the Egyptian envoy Harkhuf described his return from Nubia, the African land to the south of Egypt, in 2300 BCE. The riches of Africa attracted merchants and envoys in ancient times, and trade brought the continent in contact with the rest of the world. Egyptian relations with the rest of the African continent continued through the Hellenistic era and beyond. Phoenicians and Greeks founded dozens of settlements along the Mediterranean coast of North Africa between 1000 and 300 BCE to extend trade routes across the Sahara to the peoples of Lake Chad and the bend of the Niger River (MAP 14-1). When the Romans took control of North Africa, they continued this lucrative trans-Saharan trade. In the seventh and eighth centuries CE, the expanding empire of Islam swept across North Africa, and thereafter Islamic merchants were regular visitors to Bilad al-Sudan (the Land of the Blacks-sub-Saharan Africa). Islamic scholars chronicled the great West African empires of Ghana, Mali, and Songhay, and West African gold financed the flowering of Islamic culture.

East Africa, meanwhile, had been drawn since at least the beginning of the Common Era into the maritime trade that ringed the Indian Ocean and extended east to Indonesia and the South China Sea. Arab, Indian, and Persian ships plied the coastline. A new language, Swahili, evolved from centuries of contact between Arabic-speaking merchants and Bantu-speaking Africans, and great port cities such as Kilwa, Mombasa, and Mogadishu arose.

In the fifteenth century, Europeans ventured by ship into the Atlantic Ocean and down the coast of Africa. Finally encountering the continent firsthand, they were often astonished by what they found (see "The Myth of 'Primitive' Art," page 412). "Dear King My Brother," wrote a fifteenth-century Portuguese king to his new trading partner, the king of Benin in west Africa. The Portuguese king's respect was well founded—Benin was vastly more powerful and wealthier than the small European country that had just stumbled upon it.

As we saw in Chapter 3, Africa was home to one of the world's earliest great civilizations, that of ancient Egypt, and as we saw in Chapter 9, Egypt and the rest of North Africa contributed prominently to the development of Islamic art and culture. This chapter examines the artistic legacy elsewhere in ancient Africa.

AFRICA—THE CRADLE OF ART AND CIVILIZATION

During the twentieth century, the sculpture of traditional African societies—wood carvings of astonishing formal inventiveness and power—found admirers the world over. While avidly collected, these works were much misunderstood. For the past 75 years, art historians and cultural anthropologists have studied African art firsthand, which has added to our overall understanding

410

of art making in many African cultures. However, except for a few isolated examples (such as in Nigeria and Mali), the historical depth of our understanding is still limited by the continuing lack of systematic archaeological research. Our understanding of traditions that are more than 100 years old is especially hampered by the fact that most African art was made from wood, which decays rapidly in sub-Saharan Africa. Consequently, few examples of African masks and sculpture remain from before the nineteenth century, and for the most part it is necessary to rely on contemporary traditions and oral histories to help extrapolate backward in time to determine what may have been the types, styles, and meanings of art made in the past. Nevertheless, the few surviving ancient African artworks-in such durable materials as terra cotta, stone, and bronze, and an extensive record in rock art that has been preserved in sheltered places-bear eloquent witness to the skill of early African artists and the splendor of the civilizations in which they worked.

Twentieth-century archaeology has made it popular to speak of Africa as the cradle of human civilization. Certainly the earliest evidence for our human ancestors comes from southern Africa (see "Southern African Rock Art," page 414). Now evidence of the initial stirrings of artistic activity also comes from this region. Recently, quantities of ocher pigment thought to have been used for ceremonial or decorative purposes, and perforated shells thought to have been fashioned into beads and worn as personal adornment, have been found in Blombos Cave on the Indian Ocean coast of South Africa, dating to approximately 77,000 years ago. Also discovered together with these were two small, ocher blocks that had been smoothed and then decorated with geometric arrays of carved lines (see FIG. 1-4). These incised abstract patterns pre-date any other findings of ancient art by more than 30,000 years, and they suggest a far earlier development of modern human behavior than had been previously recognized.

The earliest-known figurative artworks from the African continent are animal figures dating to about 25,000 BCE, painted in red and black pigment on flat stones found in a cave designated as Apollo 11, located in the desert mountains of Namibia. These figures are comparable to the better-known European cave drawings such as those from the Chauvet Cave (c. 32,000–30,000 BCE) and Lascaux Cave (c. 15,000–13,000 BCE) discussed in Chapter 1.

AFRICAN ROCK ART

Like the Paleolithic inhabitants of Europe, early Africans painted and inscribed images on the walls of caves and rock shelters. Rock art is found throughout the African continent in places where the environment has been conducive to preservation—areas ranging from small, isolated shelters to great cavernous formations. Distinct geographic zones of rock art can be identified broadly, encompassing the northern, central, southern, and eastern regions of the continent. These rock paintings and engravings range in form from highly abstract geometric designs to abstract and naturalistic

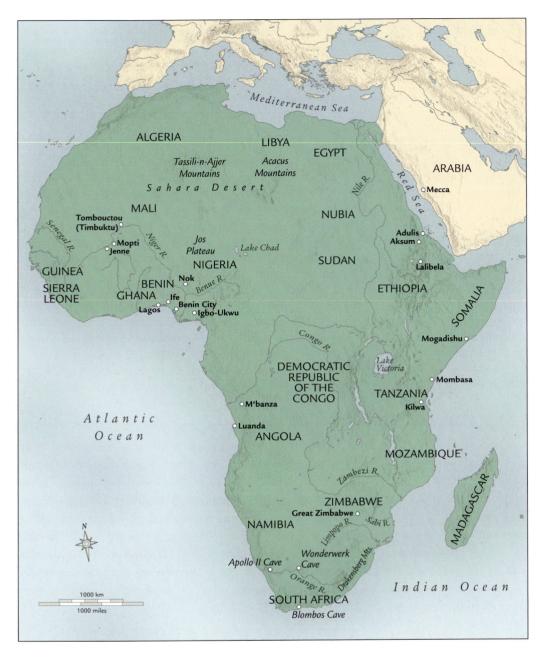

MAP 14-1 • ANCIENT AFRICA

Nearly 5,000 miles from north to south, Africa is the secondlargest continent and was the home of some of the earliest and most advanced cultures of the ancient world.

representations of human and animal forms, including hunting scenes, scenes of domestic life, and costumed figures that appear to be dancing. The long record of rock art, extending over thousands of years in numerous places, charts dramatic environmental and social change in the deserts of Africa. Images depicting human subjects are also important evidence that the African artistic traditions of body decoration, mask making and performance spring from ancient African roots.

SAHARAN ROCK ART

The mountains of the central Sahara—principally the Tassilin-Ajjer range in the south of present-day Algeria and the Acacus Mountains in present-day Libya—contain images that span a period of thousands of years. They record not only the artistic and cultural development of the peoples who lived in the region, but also the transformation of the Sahara from a fertile grassland to the vast desert we know today.

The earliest Saharan rock art is thought to date from at least 8000 BCE, during the transition into a geological period known as the Makalian Wet Phase. At that time the Sahara was a grassy plain, perhaps much like the game-park reserves of modern east Africa. Vivid images of hippopotamuses, elephants, giraffes, antelopes, and other animals incised on rock surfaces attest to the abundant wildlife that roamed the region.

A variety of scenes found on rock walls in both southern Algeria and Libya depict men and women dancing or performing various ceremonial activities. The artists who created these works paid close attention to details of clothing, body decoration, and headdresses; in some examples the figures are depicted wearing masks that cover their faces. It is suggested that they are engaged in

ART AND ITS CONTEXTS | The Myth of "Primitive" Art

The word "primitive" was once used by Western art historians to categorize the art of Africa, the art of the Pacific islands, and the indigenous art of the Americas. The term itself means "early" or "first of its kind," but its use was meant to imply that these cultures were crude, simple, backward, and stuck in an early stage of development.

This attitude was accepted by Christian missionaries and explorers, who often described the peoples among whom they worked as "heathen," "barbaric," "ignorant," "tribal," "primitive," and other terms rooted in racism and colonialism. Such usages were extended to these peoples' creations, and "primitive art" became the conventional label for their cultural products.

Criteria that have been used to label a people "primitive" include the use of so-called Stone Age technology, the absence of written histories, and the failure to build great cities. Even based on these criteria, however, the accomplishments of the peoples of Africa, to take just one example, contradict such prejudiced condescension: Africans south of the Sahara have smelted and forged iron since at least 500 BCE. Africans in many areas made and used high-quality steel for weapons and tools. Many African peoples have recorded their histories in Arabic since at least the tenth century CE. The first European visitors to Africa admired the style and sophistication of urban centers such as Benin and Luanda, to name only two of the continent's great cities. Clearly, neither the cultures of ancient Africa nor the artworks they produced were "primitive."

Until quite recently, Westerners tended to see Africa as a single country and not as an immense continent of vastly diverse cultures. Moreover, they perceived artists working in Africa as craftsmakers bound to styles and images dictated by village elders and producing art that was anonymous and interchangeable. Over the past several decades, however, these misconceptions, too, have crumbled. Art historians and anthropologists have now identified numerous African cultures and artists and compiled catalogs of their work. For example, the wellknown Yoruba artist Olowe of Ise (see Chapter 29) was commissioned by rulers throughout the Yoruba region in the early twentieth century to create prestige objects such as palace veranda posts and palace doors or tour-de-force carvings such as magnificent lidded bowls supported by kneeling figures. Certainly we will never know the names of the vast majority of African artists of the past, just as we do not know the names of the sculptors responsible for the portrait busts of ancient Rome or the monumental reliefs of the Hindu temples of South Asia. But, as elsewhere, the greatest artists in Africa were famous and sought after, while innumerable others labored honorably and not at all anonymously.

rituals intended to ensure adequate rainfall or success in hunting, or to honor their dead. Produced in a variety of styles, these images document the development of the complex ceremonial and ritual lives of the people who created them (**FIG. 14–2**).

By 4000 BCE the climate had become more arid, and hunting had given way to herding as the primary life-sustaining activity of the Sahara's inhabitants. Among the most beautiful and complex examples of Saharan rock art created in this period are scenes of sheep, goats, and cattle and of the daily lives of the people who tended them. Some scenes found at Tassili-n-Ajjer date from late in the herding period, about 5000–2000 BCE, and illustrate men and women gathered in front of round, thatched houses. As the men tend cattle, the women prepare a meal and care for children. Some scenes attempt to create a sense of depth and distance with overlapping forms, and the placement of near figures lower and distant figures higher in the picture plane.

By 2500–2000 BCE the Sahara was drying and the great game had disappeared, but other animals appear in the rock art. The horse was brought from Egypt by about 1500 BCE and is seen regularly in rock art over the ensuing millennia. The fifth-century BCE Greek historian Herodotus described a chariot-driving people called the Garamante, whose kingdom corresponds roughly to present-day Libya. Rock-art images of horse-drawn chariots bear out his account. Around 600 BCE the camel was introduced into the region from the east, and images of camels were painted on and incised into the rock.

The drying of the Sahara coincided with the rise of Egyptian civilization along the Nile Valley to the east. Similarities can be

noted between Egyptian and Saharan motifs, among them images of rams with what appear to be disks between their horns. These similarities have been interpreted as evidence of Egyptian influence on the less-developed regions of the Sahara. Yet in light of the great age of Saharan rock art, it seems just as plausible that the influence flowed the other way, carried by people who had migrated into the Nile Valley when the grasslands of the Sahara disappeared.

SUB-SAHARAN CIVILIZATIONS

Saharan peoples presumably migrated southward as well, into the Sudan, the broad belt of grassland that stretches across Africa south of the Sahara Desert. They brought with them knowledge of settled agriculture and animal husbandry. The earliest evidence of settled agriculture in the Sudan dates from about 3000 BCE. Toward the middle of the first millennium BCE, at the same time that iron technology was being developed elsewhere in Africa, knowledge of ironworking spread across the Sudan as well, enabling its inhabitants to create more effective weapons and farming tools. In the wake of these developments, larger and more complex societies emerged, especially in the fertile basins of Lake Chad in the central Sudan and the Niger and Senegal rivers to the west.

NOK

Some of the earliest evidence of iron technology in sub-Saharan Africa comes from the so-called Nok culture, which arose in the western Sudan, in present-day Nigeria, as early as 500 BCE. The

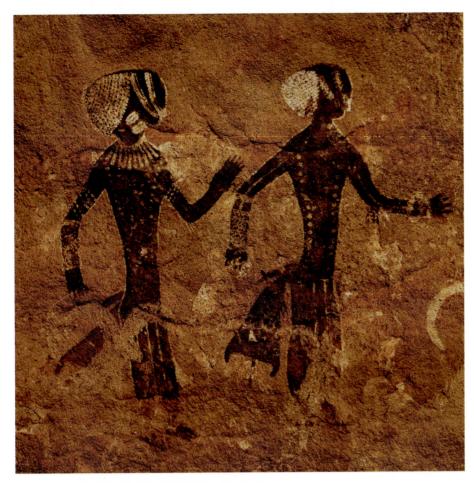

14-2 • DANCERS IN CEREMONIAL ATTIRE Section of rock-wall painting, Tassili-n-Ajjer, Algeria. c. 5000–2000 BCE.

Nok people were farmers who grew grain and oil-bearing seeds, but they were also smelters with the technology for refining ore. Slag and the remains of furnaces have been discovered, along with clay nozzles from the bellows used to fan the fires. The Nok people created the earliest-known sculpture of sub-Saharan Africa, producing accomplished terra-cotta figures of human and animal subjects between about 500 BCE and 200 CE.

Nok sculpture was discovered in modern times by tin miners digging in alluvial deposits on the Jos plateau north of the confluence of the Niger and Benue rivers. Presumably, floods from centuries past had removed the sculptures from their original contexts, dragged and rolled them along, and then deposited them, scratched and broken, often leaving only the heads from what must have been complete human figures. Following archaeological convention, the name of a nearby village, Nok, was given to the culture that created these works. Nok-style works of sculpture

14-3 • HEAD

From Nok, Nigeria. c. 500 $_{\rm BCE-200}$ ce. Terra cotta, height $14^{3}\!\!/_{16}{}''$ (36 cm). National Museum, Lagos, Nigeria.

have since been found in numerous sites over a wide area.

The Nok **HEAD** in FIGURE 14-3, slightly larger than life-size, probably formed part of a complete figure. The triangular or D-shaped eyes are characteristic of Nok style and appear also on sculptures of animals. Holes in the pupils, nostrils, and mouth allowed air to pass freely as the figure was fired. Each of the large buns of its elaborate hairstyle is pierced with a hole that may have held ornamental feathers. Other Nok figures were created displaying beaded necklaces, armlets, bracelets, anklets, and other prestige ornaments. Nok sculpture may represent ordinary people dressed for special occasions or it may portray people of high status, thus reflecting social stratification in this early farming culture. In either case, the sculpture provides evidence of considerable technical accomplishment, which has led to speculation that Nok culture was built on the achievements of an earlier culture still to be discovered.

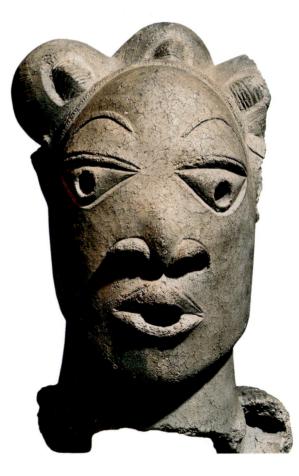

ART AND ITS CONTEXTS | Southern African Rock Art

Rock painting (pictographs) and engraving (petroglyphs) from sites in southern Africa differ in style and date from those discussed for the Sahara region. Some works of art pre-date those found in the Sahara, while others continued to be produced into the modern era. Early works include an engraved fragment found in datable debris in Wonderwerk Cave, South Africa, which is about 10,000 years old. Painted stone flakes found at a site in Zimbabwe suggest dates between 13,000 and 8000 BCE.

Numerous examples of rock painting are also found in eastern South Africa in the region of the Drakensberg Mountains. Almost 600 sites have been located in rock shelters and caves, with approximately 35,000 individual images catalogued. It is believed the paintings were produced, beginning approximately 2,400 years ago, by the predecessors of San peoples. Ethnographic research among the San and related peoples in southern Africa suggest possible interpretations for some of the paintings. For example, rock paintings depicting groups of dancing figures may relate to certain forms of San rituals that are still performed today to heal individuals or to cleanse communities. These may have been created by San ritual specialists or shamans to record their curing dances or trance experiences of the spirit world. San rock artists continued to create rock paintings into the late nineteenth century. These latter works depict the arrival of Afrikaner pioneers in the region as well as British soldiers brandishing guns used to hunt eland (FIG. 14–4).

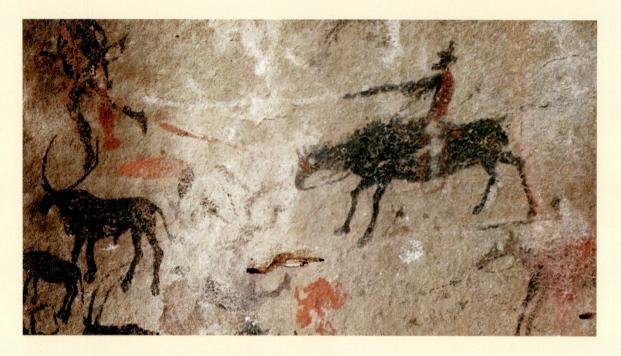

14-4 • SECTION OF SAN ROCK-WALL PAINTING San peoples, uncertain dates. Drakensberg Mountains, South Africa. Pigment and eland blood on rock.

IGBO-UKWU

A number of significant sites excavated in Nigeria in the mid twentieth century increase our understanding of the development of art and culture in west Africa. This includes the archaeological site of Igbo-Ukwu in eastern Nigeria where Igbo peoples reside, numerically one of Nigeria's largest populations. The earliest-known evidence for copper alloy or bronze casting in sub-Saharan Africa is found at Igbo-Ukwu. This evidence dates to the ninth and tenth centuries CE. Igbo-Ukwu is also the earliest-known site containing an elite burial and shrine complex yet found in sub-Saharan Africa. Three distinct archaeological sites have been excavated at Igbo-Ukwu—one containing a burial chamber, another resembling a shrine or storehouse containing ceremonial objects, and the third an ancient pit containing ceremonial and prestige objects.

The **BURIAL CHAMBER** (**FIG. 14–5**) contained an individual dressed in elaborate regalia, placed in a seated position, and surrounded by emblems of his power and authority. These included

three ivory tusks, thousands of imported beads that originally formed part of an elaborate necklace, other adornments, and a castbronze representation of a leopard skull. Elephants and leopards remain symbols of temporal and spiritual leadership in Africa today. Ethnographic research among the Nri, an Igbo-related people currently residing in the region, suggests that the burial site is that of an important Nri king or ritual leader (*eze*).

The second excavation uncovered a shrine or storehouse complex containing ceremonial and prestige objects. These copperalloy castings were made by the lost-wax technique (see "Lost-Wax Casting," page 418) in the form of elaborately decorated small bowls, fly-whisk handles, altar stands, staff finials (decorative tops), and ornaments. Igbo-Ukwu's unique style consists of the representation in bronze of natural objects such as gourd bowls and snail shells whose entire outer surface is covered with elaborate raised and banded decorations—including linear, spiral, circular, and granular designs, sometimes with the addition of small animals

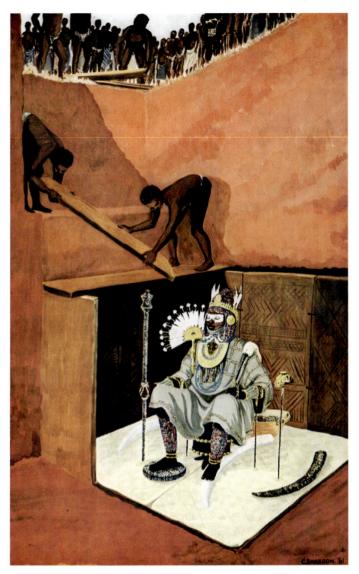

14-5 • **BURIAL CHAMBER** Igbo-Ukwu, Nigeria. Reconstruction showing the placement of the ruler and artifacts in the chamber in the 10th century. Painting by Caroline Sassoon.

or insects such as snakes, frogs, crickets, or flies applied to the decorated surface. Some castings are further enlivened with the addition of brightly colored beads.

A cast fly-whisk handle is topped with the representation of an equestrian figure whose face, like that of a pendant head also found during excavation, is scarified with patterning similar to that found on some of the terra-cotta and bronze heads of rulers at Ife. These markings resemble those called *ichi*, which are still used by Igbo men as a symbol of high achievement. Among the most technically sophisticated bronze castings found at Igbo–Ukwu is a roped vessel (see "A Closer Look," page 416) resembling a form of water-pot drum still used in this region of Nigeria. The vessel is filled with water and a flat mallet is struck across the surface of the water at the rim to create a percussive sound.

IFE

The sculpture created by the artists of the city of Ife are among the most remarkable works in the history of art. Ancient Ife, which arose in the southwestern, forested part of Nigeria about 800 CE, was essentially circular in plan, with the *oni*'s palace at the center. Ringed by protective stone walls and moats, it was connected to other Yoruba cities by roads that radiated from the center, passing through the city walls at fortified gateways and decorated with mosaics created from stones and pottery shards. From these elaborately patterned pavement mosaics, which covered much of Ife's open spaces, comes the name for Ife's most artistically cohesive historical period (c. 1000–1400), the Pavement period.

Just as the *oni*'s palace was located in a large courtyard in the center of Ife, so too were ritual spaces elsewhere in Ife located in paved courtyards with altars. In the center of such a sacred courtyard, outlined by rings of pavement mosaic, archaeologists excavated an exceptional terra-cotta vessel (**FIG. 14–6**). The jar's bottom had been ritually broken before it was buried, so that liquid offerings (libations) poured into the neck opening would flow into the

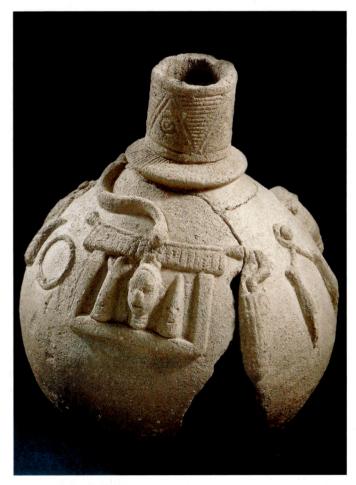

14-6 • **RITUAL VESSEL** From Ife, Nigeria. Yoruba, 13th–14th century cE. Terra cotta, height 9¹³/₁₆" (24.9 cm). University Art Museum, Obafemi, Awolowo University, Ife, Nigeria.

A CLOSER LOOK | Roped Pot on a Stand

From Igbo-Ukwu. 9th-10th century ce. Leaded bronze, height 12¹¹/₁₆" (32.3 cm). National Museum, Lagos.

Like a number of other objects excavated at Igbo-Ukwu, this vessel is a skeuomorph—an object created in a different material from the original but made to resemble the original in form, shape, and texture.

The knotted rope cage appears to be made from one continuous piece of "rope." Even the individual strands of the "rope" are replicated in leaded bronze.

Pot stands are used to support containers placed on sacred altars so that the water contained in the vessels will never touch the ground before its use in ritual ceremony.

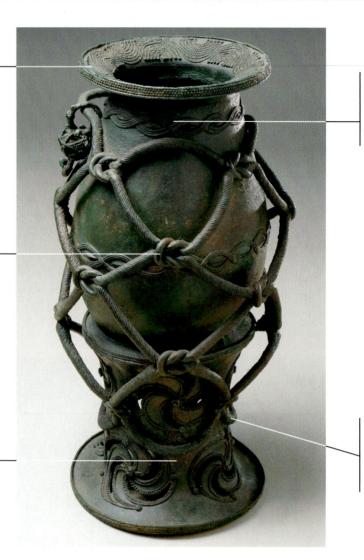

The flaring neck of the vessel just below the rim and the lower half of the pot stand were both cast separately. Molten metal was then applied to the edges of the separate castings to join them together.

The rope cage surrounding the pot and stand was cast separately and then positioned around the pot and upper part of the stand. The lower part of the knotted rope was then bent inward to grip the pot stand.

View the Closer Look for the roped pot on a stand on myartslab.com

earth. The objects depicted in relief on the surface of the vessel include what looks like an altar platform with three heads under it, the outer two quite abstract and the middle one in the naturalistic tradition of free-standing Yoruba portrait heads. The abstraction of the two outside heads may have been a way of honoring or blessing the central portrait, a practice that survives among Yoruba royalty today.

BENIN

Ife was probably the artistic parent of the great city-state of Benin, which arose 150 miles to the southeast. According to oral histories, the earliest kings of Benin belonged to the Ogiso, or Skyking, dynasty. After a long period of misrule, however, the people of Benin asked the *oni* of Ife for a new ruler, and the *oni* sent Prince Oranmiyan, who founded a new dynasty in 1170. Some two centuries later, the fourth king, or *oba*, of Benin sent to Ife for a master metalcaster named Iguegha to start a tradition of memorial sculpture like that of Ife, and this tradition of casting memorial heads for the shrines of royal ancestors endures among the successors of Oranmiyan to this day (**FIG. 14-7**).

Benin established cordial relations with Portugal in 1485 and carried on an active trade, at first in ivory and forest products, but eventually in slaves. Benin flourished until 1897, when, in reprisal for the massacre of a party of trade negotiators, British troops sacked and burned the royal palace, sending the *oba* into an exile from which he did not return until 1914 (see Chapter 29).

14-7 • MEMORIAL HEAD OF AN OBA

From Benin, Nigeria. Early Period, c. 16th century cE. Brass, height 9" (23 cm). The Nelson-Atkins Museum of Art, Kansas City, Missouri. Purchase: Nelson Trust through the generosity of Donald J. and Adele C. Hall, Mr. and Mrs. Herman Robert Sutherland, an anonymous donor, and the exchange of Nelson Gallery Foundation properties (87-7)

This belongs to a small group of rare Early Period sculptures called "rolled-collar" heads that are distinguished by the rolled collar that serves as a firm base for the exquisitely rendered head.

The palace was later rebuilt, and the present-day *oba* continues the dynasty started by Oranmiyan.

The British invaders discovered shrines to deceased *obas* covered with brass heads, bells, and figures. They also found wooden rattles and enormous ivory tusks carved with images of kings, court attendants, and sixteenth-century Portuguese soldiers. The British appropriated the treasure as war booty, making no effort to note which head came from which shrine, thus destroying evidence that would have helped establish the relative age of the heads and determine a chronology for the evolution of Benin style. Nevertheless, it has been possible to piece together a chronology from other evidence.

The Benin heads, together with other objects, were originally placed on a semicircular platform or **ALTAR** and surmounted by large elephant tusks, another symbol of power (**FIG. 14-8**). Benin brass heads range from small, thinly cast, and lifelike to large, thickly cast, and highly stylized. Many scholars have concluded

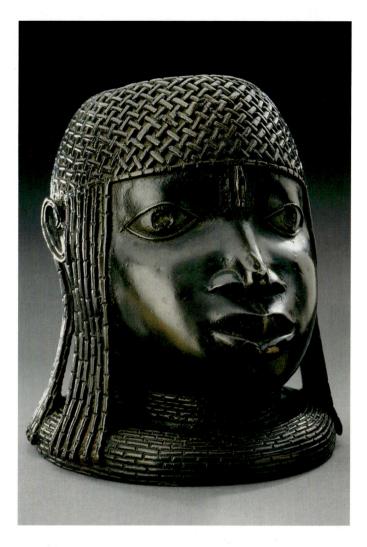

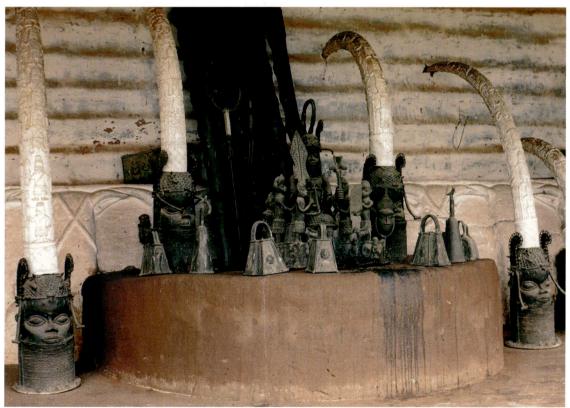

14-8 • PHOTOGRAPH OF AN ALTAR

Edo culture, Nigeria. c. 1959. The National Museum of African Art, Smithsonian Institution, Washington, DC. Eliot Elisofon Photographic Archives (7584)

TECHNIQUE | Lost-Wax Casting

In the lost-wax casting process a metal copy is produced from an original image made of wax. The usual metals for this casting process are bronze, an alloy of copper and tin, and brass, an alloy of copper and zinc. First, the sculptor models a wax original. Then the wax is invested in a heat-resistant mold, usually of clay. Next, the wax is melted, leaving an empty cavity into which molten metal is poured. After the metal cools and solidifies, the mold is broken away and the metal copy is chased and polished.

The progression of drawings here shows the steps used by the Benin sculptors of Africa. A heat-resistant "core" of clay (A) approximating the shape of the sculpture-to-be (and eventually becoming the hollow inside the sculpture) was covered by a layer of wax that had the thickness of

the final sculpture. The sculptor carved or modeled (B) the details in the wax. Rods and a pouring cup made of wax were attached (C) to the model. A thin layer of fine, damp sand was pressed very firmly into the surface of the wax model, and then model, rods, and cup were encased (D) in thick layers of clay. When the clay was completely dry, the mold was heated (E) to melt out the wax. The mold was then placed upside down in the ground to receive (F) the molten metal. When the metal was completely cool, the outside clay cast and the inside core were broken up and removed (G), leaving the cast-brass sculpture. Details were polished to finish the piece, which could not be duplicated because the mold had been destroyed.

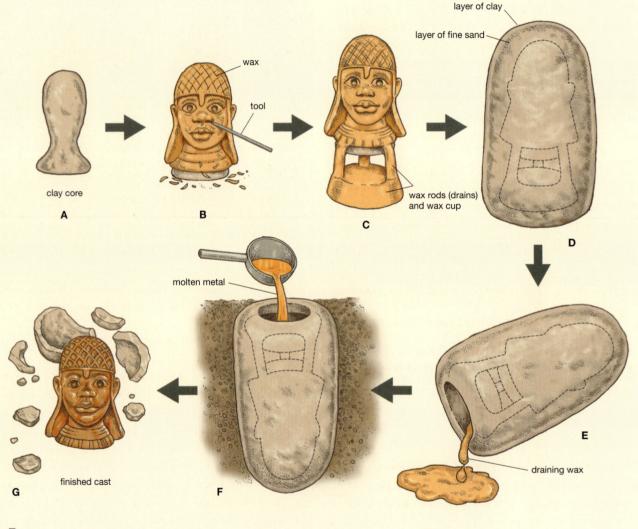

• Watch a video about the process of lost-wax casting on myartslab.com

that the smallest, most naturalistic heads with only a few strands of beads around the neck were created during a so-called Early Period (1400–1550), when Benin artists were still heavily influenced by Ife. Heads grew heavier and increasingly stylized, and the strands of beads increased in number until they concealed the chin during the Middle Period (1550–1700). Heads from the ensuing Late Period (1700–1897) are very large and heavy, with angular, stylized features, elaborate beaded crowns, and numerous neck-laces forming a tall, cylindrical mass. In addition, broad, horizontal flanges, or projecting edges, bearing small images cast in low relief

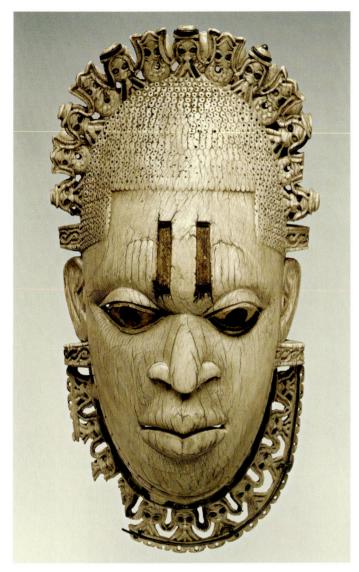

14-9 • HIP PENDANT REPRESENTING AN IYOBA ("QUEEN MOTHER")

From Benin City, Nigeria. Middle Period, c. 1550 CE. Ivory, iron, and copper, height 9%" (23.4 cm). Metropolitan Museum of Art, New York. The Michael C. Rockefeller Memorial Collection, Gift of Nelson A. Rockefeller (1978.412.323)

ring the base of the Late Period heads. The increase in size and weight of Benin memorial heads over time may reflect the growing power and wealth flowing to the *oba* from Benin's expanding trade with Europe.

At Benin, as in many other African cultures, the head is the symbolic center of a person's intelligence, wisdom, and ability to succeed in this world or to communicate with spiritual forces in the ancestral world. One of the honorifics used for the king is "Great Head": The head leads the body as the king leads the people. All memorial heads include representations of coral-beaded caps and necklaces and royal costume. Coral, enclosing the head and displayed on the body, is still the ultimate symbol of the *oba*'s power and authority.

The art of Benin is a royal art; only the oba could commission works in brass (see "A Warrior Chief Pledging Loyalty," page 420). Artisans who served the court were organized into guilds and lived in a separate quarter of the city. Obas also commissioned important works in ivory. One example is a beautiful ornamental pendant (FIG. 14-9) representing an iyoba (queen mother-the oba's mother), the senior female member of the royal court. The pendant was carved as a belt ornament and was worn at the oba's hip. Its pupils were originally inlaid with iron, as were the scarification patterns on the forehead. This particular belt ornament may represent Idia, who was the mother of Esigie, a powerful oba who ruled from 1504 to 1550. Idia is particularly remembered for raising an army and using magical powers to help her son defeat his enemies. Like Idia, the Portuguese helped Esigie expand his kingdom. The necklace represents heads of Portuguese soldiers with beards and flowing hair. In the crown, more Portuguese heads alternate with figures of mudfish, which symbolize Olokun, the Lord of the Great Waters. Mudfish live near river banks, mediating between water and land, just as the oba, who is viewed as semidivine, mediates between the human world and the supernatural world of Olokun.

OTHER URBAN CENTERS

Ife and Benin were only two of the many cities that arose in ancient Africa. The first European visitors to the west African coast at the end of the fifteenth century were impressed not only by Benin, but also by the city of Mbanza Kongo, south of the mouth of the Congo River. Along the east African coastline, Europeans also happened upon cosmopolitan cities that had been busily carrying on long-distance trade across the Indian Ocean and as far away as China and Indonesia for hundreds of years.

Important centers also existed in the interior, especially across the central and western Sudan. There, cities and the states that developed around them grew wealthy from the trans-Saharan trade that had linked west Africa to the Mediterranean since at least the first millennium BCE. Indeed, the routes across the desert were probably as old as the desert itself. Among the most significant goods exchanged in this trade were salt from the north and gold from west Africa. Such fabled cities as Mopti, Timbuktu, and Jenné arose in the vast area of grasslands along the Niger River in the region known as the Niger Bend (present-day Mali), a trading crossroads as early as the first century BCE. They were great centers of commerce, where merchants from all over west Africa met caravans arriving from the Mediterranean. Eventually the trading networks extended across Africa from the Sudan in the east to the Atlantic coast in the west. In the twelfth century CE a Mandespeaking people formed the kingdom of Mali (Manden). The rulers adopted Islam, and by the fourteenth century they controlled the oases on which the traders' caravans depended. Mali prospered, and wealthy cities like Timbuktu and Jenné became famed as centers of Islamic learning.

A BROADER LOOK | A Warrior Chief Pledging Loyalty

Produced during the sixteenth and seventeenth centuries, approximately 900 brass plaques, each averaging about 16 to 18 inches in height, once decorated the walls and pillars of the royal palace of the kingdom of Benin. Like the brass memorial heads and figure sculpture, the plaques were made using the lost-wax casting process. They illustrate a variety of subjects including ceremonial scenes at court, showing the *oba*, other court functionaries, and (at times) Portuguese soldiers. Modeled in relief, the plaques depict one or more figures, with precise details of costume and regalia. Some figures are modeled in such high relief that they appear almost free-standing as they emerge from a textured surface background that often includes foliate patterning.

This **PLAQUE** (**FIG. 14–10**) features a warrior chief in ceremonial attire. His rank is indicated by a necklace of leopard's teeth and a coral-decorated cap and collar. He also wears an elaborate skirt with a leopard mask

on his hip and holds a spear in one hand and an *eben* sword raised above his head in the other hand. The *eben* sword, with its distinctive leaf-shaped blade made of iron with openwork surface decoration is a principal symbol of high rank in Benin City even today (**FIGS.**

14-11, 14-12).

The plaque is organized in a hierarchal order with the warrior chief larger in size and in the center of the composition. The chief is flanked by two warriors holding shields and

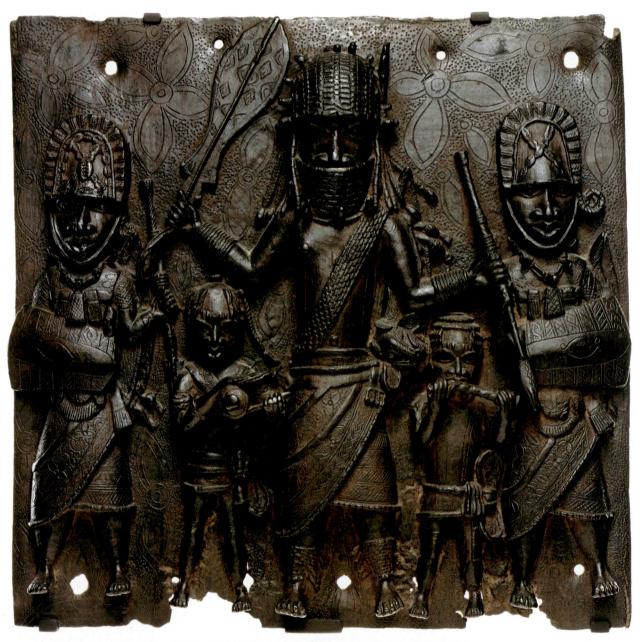

14–10 • PLAQUE: WARRIOR CHIEF FLANKED BY WARRIORS AND ATTENDANTS From Benin City, Nigeria. Middle Period, c. 1550–1650 cE. Brass, height $14\frac{3}{4}'' \times 15\frac{1}{2}''$ (37.5 × 39.4 cm). The Nelson-Atkins Museum of Art, Kansas City, Missouri. Purchase: William Rockhill Nelson Trust (58–3)

14-11 • SENIOR TOWN CHIEF Supported by two attendants, one of them carrying his *eben* sword.

spears, and two smaller figures representing court attendants. One attendant plays a sideblown horn that announces the warrior chief's presence, while the other attendant carries a ceremonial box for conveying gifts to the *oba*. The scene is a ceremony of obeisance to the *oba*, and the warrior chief's gesture of raising the *eben* sword is still performed at annual ceremonies in which chiefs declare their allegiance and loyalty to the *oba* by raising the sword and spinning it in the air to add drama, conviction, and authority to the ceremony.

14–12 • **OBA EREDIAUWA** Wearing coral-beaded regalia and seated on a dais.

At a site near Jenné known as Jenné-Jeno or Old Jenné, excavations (by both archaeologists and looters) have uncovered hundreds of terra-cotta figures dating from the thirteenth to the sixteenth centuries. The figures were polished, covered with a red clay slip, and fired at a low temperature. A HORSEMAN, armed with quiver, arrows, and a dagger, is a good example of the technique (FIG. 14-13). Man and horse are formed of rolls of clay on which details of the face, clothing, and harness are carved, engraved, and painted. The rider has a long oval head and jutting chin, pointed oval eyes set in multiple framing lids, and a long straight nose. He wears short pants and a helmet with a chin strap, and his horse has an ornate bridle. Such elaborate trappings suggest that the horseman could be a guardian figure, hero, or even a deified ancestor. Similar figures have been found in sanctuaries. But, as urban life declined, so did the arts. The long tradition of ceramic sculpture came to an end in the fifteenth and sixteenth centuries, when rivals began to raid the Manden cities.

JENNÉ

In 1655, the Islamic writer al-Sadi wrote this description of Jenné:

This city is large, flourishing, and prosperous; it is rich, blessed, and favoured by the Almighty.... Jenne [Jenné] is one of the great markets of the Muslim world. There one meets the salt merchants from the mines of Teghaza and merchants carrying gold from the mines of Bitou.... Because of this blessed city, caravans flock to Timbuktu from all points of the horizon.... The area around Jenne is fertile and well populated; with numerous markets held there on all the days of the week. It is certain that it contains 7,077 villages very near to one another.

(Translated by Graham Connah in *African Civilizations*, page 108)

By the time al-Sadi wrote his account, Jenné already had a long history. Archaeologists have determined that the city was established by the third century CE, and that by the middle of the ninth century it had become a major urban center. Also by the ninth century, Islam was becoming an economic and religious force in west and north Africa, and the northern terminals of the trans-Saharan trade routes had already been incorporated into the Islamic realm.

When Koi Konboro, the 26th king of Jenné, converted to Islam in the thirteenth century, he transformed his palace into the first of three successive mosques in the city. Like the two that followed, the first mosque was built of adobe brick, a sun-dried mixture of clay and straw. With its great surrounding wall and tall towers, it was said to have been more beautiful and more lavishly decorated than the Kaaba, the central shrine of Islam, at Mecca. The mosque eventually attracted the attention of austere Muslim rulers who objected to its sumptuous furnishings. Among these was the early nineteenth-century ruler Sekou Amadou, who had it razed and a far more humble structure erected on a new site. This

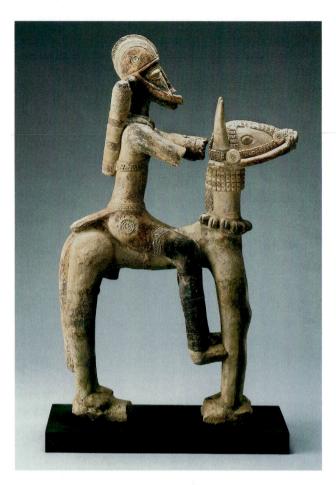

14-13 • HORSEMAN

From Old Jenné, Mali. 13th–15th century cE. Terra cotta, height 27³/₄" (70.5 cm). National Museum of African Art, Smithsonian Institution, Washington, DC. Museum Purchase (86-12-2)

second mosque was in turn replaced by the current grand mosque, constructed between 1906 and 1907 on the ancient site in the style of the original. The reconstruction was supervised by the architect Ismaila Traoré, the head of the Jenné guild of masons.

The mosque's eastern, or "marketplace," façade boasts three tall towers, the center one containing the *mihrab* (**FIG. 14-14**). The finials, or crowning ornaments, at the top of each tower bear ostrich eggs, symbols of fertility and purity. The façade and sides of the mosque are distinguished by tall, narrow, engaged columns, which act as buttresses. These columns are characteristic of west African mosque architecture, and their cumulative rhythmic effect is one of great verticality and grandeur. The most unusual features of west African mosques are the **torons**, wooden beams projecting from the walls. Torons provide permanent supports for the scaffolding erected each year so that the exterior can be replastered.

Traditional houses resemble the mosque on a small scale. Adobe walls, reinforced by buttresses, rise above the roofline in conical turrets, emphasizing the entrance. Rooms open inward onto a courtyard. Extended upper walls mask a flat roof terrace that gives more private space for work and living.

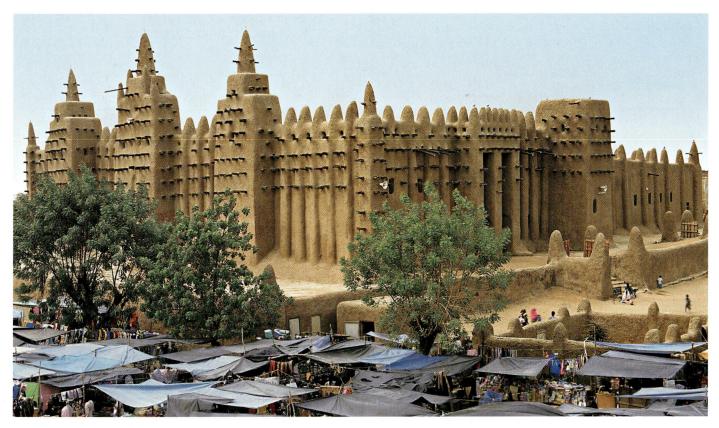

14-14 • GREAT FRIDAY MOSQUE

Jenné, Mali. Showing the eastern and northern façades. Rebuilding of 1907, in the style of 13th-century original.

The plan of the mosque is not quite rectangular. Inside, nine rows of heavy adobe columns, 33' (10 m) tall and linked by pointed arches, support a flat ceiling of palm logs. An open courtyard on the west side (not seen here) is enclosed by a great double wall only slightly lower than the walls of the mosque itself. The main entrances to the prayer hall are in the north wall (to the right in the photograph).

• Watch an architectural simulation explaining adobe-brick construction on myartslab.com

GREAT ZIMBABWE

Thousands of miles from Jenné, in southeastern Africa, an extensive trade network developed along the Zambezi, Limpopo, and Sabi rivers. Its purpose was to funnel gold, ivory, and exotic skins to the coastal trading towns that had been built by Arabs and Swahilispeaking Africans. There, the gold and ivory were exchanged for prestige goods, including porcelain, beads, and other manufactured items. Between 1000 and 1500 CE, this trade was largely controlled from a site that was called Great Zimbabwe, home of the Shona people.

The word *zimbabwe* derives from the Shona term *dzimba dza mabwe* ("venerated houses" or "houses of stone"). The stone buildings at Great Zimbabwe were constructed by the ancestors of the present-day people of this region. The earliest construction at the site took advantage of the enormous boulders abundant in the vicinity. Masons incorporated the boulders and used the uniform granite blocks that split naturally from them to build a series of tall enclosing walls high on a hilltop. Each enclosure defined a family's living space and housed dwellings made of adobe with conical, thatched roofs.

The largest building complex at Great Zimbabwe is located in a broad valley below the hilltop enclosures. Known as Imba Huru (the Great Enclosure), the complex is ringed by a masonry wall more than 800 feet long, up to 32 feet tall, and 17 feet thick at the base. Inside the great outer wall are numerous smaller stone enclosures and adobe platforms (FIG. 14-15). The buildings at Great Zimbabwe were built without mortar; for stability the walls are battered, or built so that they slope inward toward the top. Although some of the enclosures at Great Zimbabwe were built on hilltops, there is no evidence that they were constructed as fortresses. There are neither openings for weapons to be thrust through, nor battlements for warriors to stand on. Instead, the walls and structures seem intended to reflect the wealth and power of the city's rulers. The Imba Huru was probably a royal residence, or palace complex, and other structures housed members of the ruler's family and court. The complex formed the nucleus of a city that radiated for almost a mile in all directions. Over the centuries, the builders grew more skillful, and the later additions are distinguished by dressed, or smoothly finished, stones, laid in fine, even, level courses. One of these later additions is a structure known

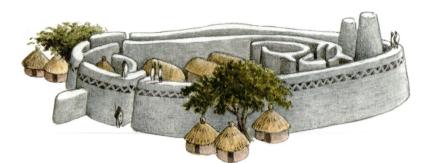

14-15 • DRAWING OF GREAT ENCLOSURE, GREAT ZIMBABWE

14-16 • CONICAL TOWER, GREAT ENCLOSURE

Great Zimbabwe Shona, Zimbabwe. c. 1350–1450 cE. Stone, height of tower 30' (9.1 m).

simply as the **CONICAL TOWER** (**FIG. 14–16**), 18 feet in diameter, 30 feet tall, and originally capped with three courses of ornamental stonework. Constructed between the two walls and resembling a granary, it may have represented the good harvest and prosperity believed to result from allegiance to the ruler of Great Zimbabwe.

It is estimated that at the height of its power, in the fourteenth century, Great Zimbabwe and its surrounding city housed a population of more than 10,000 people. A large cache of goods

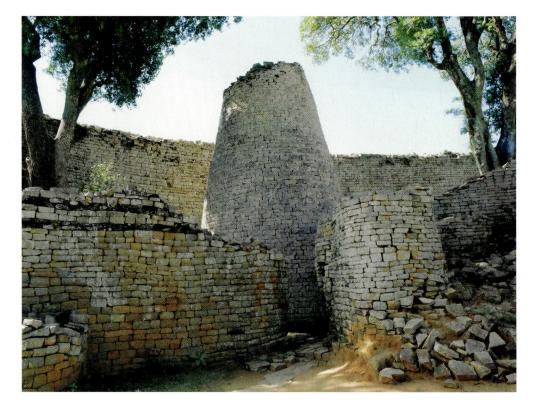

containing items of such far-flung origin as Portuguese medallions, Persian pottery, and Chinese porcelain testify to the extent of its trade. Yet beginning in the mid fifteenth century Great Zimbabwe was gradually abandoned as control of the lucrative southeast African trade network passed to the Mwene Mutapa and Khami empires a short distance away.

AKSUM AND LALIBELA

In the second century BCE Aksumite civilization increased in importance in the Ethiopian highlands through the control of trade routes from the African interior to the Red Sea port of Adulis. Its exports included ivory, gold, slaves, frankincense, myrrh, and salt. In the mid fourth century CE the Aksumite king Ezana converted to Christianity, and soon gold and silver coinage minted at Aksum bore the Christian cross.

The archaeological remains at Aksum and Gondar speak of the splendor of the ancient kingdom. By the third century CE a series of stone palaces were built at Aksum. The elites also erected a number of monolithic granite stelai which date from the third and fourth centuries, the largest over 95 feet in height. Their outer surfaces were decorated with such carved architectural details as false doors, inset windows, and timber beams. The stelai served as commemorative markers among the tombs and burial sites of the elite.

The power and influence of the Aksumite state were diminished by the displacement of the Red Sea trade routes after the Persian conquest of south Arabia, and Aksum was conquered by the Zagwe from Ethiopia's western highlands. After Aksum's demise and abandonment, a new capital arose, the influence and prestige of which lasted until near the end of the thirteenth century.

The Zagwe king Lalibela, wishing to create a "new" Jerusalem (the holy city revered by Christians, Jews, and Muslims) in Ethiopia, founded a holy site named after himself in the highlands south of Aksum. The cultural embrace of Christianity by the populace during the thirteenth century is evidenced by the numerous rockhewn sanctuaries that were created in Lalibela at this time. Rather than being built from the ground up, the churches and other structures were hewn from the living rock. A wide trench was first cut around the four sides of a block of volcanic tuff that would become the church. Stonemasons then carved out the exterior and

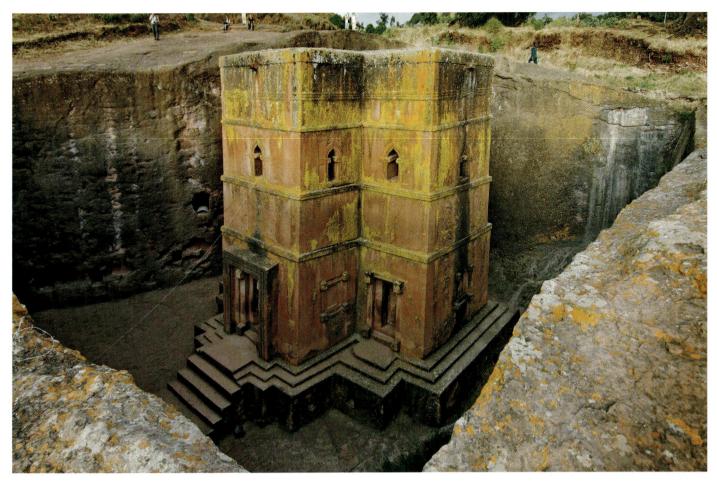

14-17 • BET GIORGIS (CHURCH OF ST. GEORGE), LALIBELA Ethiopia. 13th century. Volcanic rock.

Explore the architectural panoramas of Bet Giorgis on myartslab.com

interior of the sanctuaries with hammers and chisels. Each aspect of the structure had to be planned with precision before work could begin. The interior of the church was created with a hemispherical domed ceiling in the style of the Byzantine churches that Ethiopian priests would have seen during pilgrimages to Jerusalem.

The largest of the 11 churches is **BET GIORGIS (CHURCH OF ST. GEORGE)** which was cut 40 feet down within the rock in the form of a modified cross (**FIG. 14-17**). Most rock-cut sanctuaries have architectural details that appear to have been modeled in part from earlier Aksum palaces. However, Bet Giorgis has window details that are similar to the organic tendril forms found in later Ethiopian painted manuscripts. The origins of the rock-cut church are unknown. The churches at Lalibela may have been modeled on earlier Aksumite cave sanctuaries, but it has also been suggested that they have their origins in central and southern India where Buddhist and Hindu temples, shrines, and monasteries have been excavated from the living rock for over 2,000 years.

KONGO KINGDOM

As in other parts of sub-Saharan Africa, art-making traditions in the Kongo cultural region developed over thousands of years. However, as elsewhere on the African continent, the climate here is often not conducive to the survival of objects made from wood. Among the earliest-known wooden artworks from central Africa is a wood carving unearthed in Angola in 1928 (**FIG. 14–18**). This zoomorphic head may have been created for use as a headdress or mask. Its elongated snout, pointed ears, and geometric surface patterning resemble some masking traditions and sculptural practices that survived in the region well into the twentieth century.

The Portuguese first encountered Kongo culture in 1482 at approximately the same time that contact was made with the royal court of Benin in present-day western Nigeria. They visited the capital of Mbanza Kongo (present-day M'banza Congo) and met the *manikongo* ("king"), who ruled over a kingdom that was remarkable in terms of its complex political organization and artistic sophistication. The kingdom, divided into six provinces, encompassed over 100,000 square miles of present-day northwestern Angola and the western part of the Democratic Republic of the Congo. In 1491, King Nzinga aNkuwa converted to Christianity, as did his son and successor Afonso I, who established Christianity as the state religion. The conversions helped to solidify trade relations with the Portuguese, and trade in copper, salt, ivory, cloth,

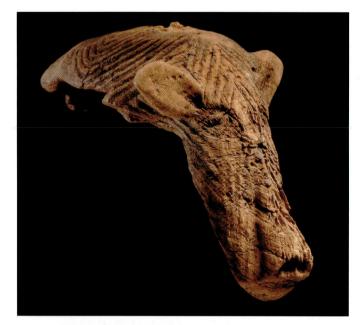

14-18 • ZOOMORPHIC HEAD Angola. c. 750 ce. Wood, 19% × 6% (50.5 × 15.5 cm). Royal Museum of Central Africa, Tervuren, Belgium.

14–19 • DECORATED TEXTILE Kongo. Before 1400 cE. Raffia, $9\frac{1}{2}$ " × $18\frac{1}{2}$ " (24 × 47 cm). Pitt Rivers Museum, University of Oxford, England. (1886.1.254.1)

14–20 • CRUCIFIX Kongo. Early 17th century ce. Bronze, height 10¹/₂" (26.7 cm). Metropolitan Museum of Art, New York. Collection of Ernst Anspach. (1999.295.7)

and, later, slaves brought increased prosperity to the kingdom. Kongo's influence expanded until the mid seventeenth century when its trading routes were taken over by neighboring peoples, including the Lunda and Chokwe.

The increase in wealth brought a corresponding increase in the production of specialty textiles, baskets, and regalia for the nobility. Textiles in central Africa, as elsewhere in Africa, are highly valued and were used as forms of currency before European contact. They figure prominently in funerary rituals even to the present day. Kongo **DECORATED TEXTILES** were lauded by the Portuguese from first contact and were accepted as gifts or collected, eventually finding their way into European museum collections (**Fig. 14–19**).

Following Portuguese contact in the fifteenth century and Nzinga aNkuwa's conversion, Kongolese art increasingly absorbed Western influences. Catholic missionaries brought with them various religious objects, including monstrances (highly decorated vessels used to display the consecrated Eucharistic host) and figures of the Virgin Mary and various saints. The **CRUCIFIX** became especially popular as a potent symbol of both conversion and political authority. Cast in brass and copper alloy, locally produced examples (**FIG. 14-20**) mirror their European prototypes, but are often restated in African terms. The features of the crucified Christ, as well as his hands and feet and those of the supporting figures, are stylized in ways that suggest local African art, as does the placement of supporting figures above and below the central figure. Although the supporting figures appear to be praying, they are actually clapping their hands-a common central African gesture of respect for another person.

EXPORTING TO THE WEST

Shortly after initial contact with European explorers, merchants, and traders, African artists not only continued to fashion objects for their own consumption but also began to produce them for export to Europe. For example, by the late fifteenth century, carvers residing in present-day Sierra Leone (called Sapi by the Portuguese) and Nigeria (Bini) began to produce ivory objects such as saltcellars, powder flasks, spoons, and forks, as well as exquisitely carved oliphants, or horns (FIG. 14-21) for European patrons.

The form of this Sapi-Portuguese oliphant and virtually all its decorative motifs are European-inspired. The mouthpiece is at the narrow end rather than on the side as is typical for African horns. The carvings, including the coat of arms of Portugal and Spain, the motto of Spain's Ferdinand V, and heraldic emblems and hunting scenes, were derived from illustrations found in European prayer books and other publications that were given to the artists as source material. However, not all of the designs found on some export ivories are derived from European sources. For example, some saltcellars depicting human subjects were carved in a style that resembles local stone figures that pre-date Portuguese contact with the west African coast. As we will see in Chapter 29, the synthesis of African traditions and Western influences continued to affect African art in both subtle and overt ways in the modern period.

14-21 • SAPI-PORTUGUESE STYLE HUNTING HORN

Sierra Leone, Late 15th century CE. Ivory, length 25" (63.5 cm). National Museum of African Art, Smithsonian Institution, Washington, DC. Gift of Walt Disney World Co., a subsidiary of the Walt Disney Company (2005-6-9)

THINK ABOUT IT

- 14.1 Analyze the formal characteristics of the human heads in FIGURES 14-7 and 14-9. What is the relationship between style and medium, as well as style and function?
- 14.2 What is the spiritual role of the oba in Benin? What is his relationship to the spirit world, and how is that relationship represented in one work discussed in the chapter?
- 14.3 Explain the original purpose of the Benin royal plaque (see "A Warrior Chief Pledging Loyalty," page 420). How do the identity and presentation of the individuals on the plaque relate to hierarchy at the royal court and the glorification of Benin kingship?
- 14.4 Evaluate the effect of Portuguese influence on African art by discussing the works in FIGURES 14-20 and 14-21. Which aspects of these works derive from local traditions and which are the result of European contact?

CROSSCURRENTS

FIG. 6-12

represent important people with heightened descriptive detail that suggests they may portray specific individuals. Discuss the similarities and differences in technique, style, and use. How does each work represent the culture that produced it?

Both of these works in bronze

Study and review on myartslab.com

15-1 • CHI RHO IOTA PAGE FROM THE BOOK OF KELLS Probably made at Iona, Scotland. Late 8th or early 9th century. Oxgall inks and pigments on vellum, $12^{3}/4'' \times 9^{1}/2''$ (32.5 × 24 cm). The Board of Trinity College, Dublin. MS. 58, fol. 34r

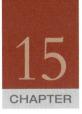

Early Medieval Art in Europe

The explosion of ornament surrounding-almost suffocating-the words on this page from an early medieval manuscript clearly indicates the importance of what is being expressed (FIG. 15-1). The large Greek letters chi rho iota (XPI) abbreviate the word Christi that starts the Latin phrase Christi autem generatio. The last word is written out fully and legibly at bottom right, clear of the decorative expanse. These words begin Matthew 1:18: "Now the birth of Jesus the Messiah took place in this way." So what is signaled here-not with a picture of the event but with an ornamental celebration of its initial mention in the text-is Christ's first appearance within this Gospel book. The book itself not only contains the four biblical accounts of Christ's life; it would also evoke Christ's presence on the altar of the monastery church where this lavish volume was once housed. It is precisely the sort of ceremonial book that we have already seen carried in the hands of a deacon in Justinian's procession into San Vitale in Ravenna to begin the liturgy (see FIG. 8-8).

There is nothing explicitly Christian about the ornamental motifs celebrating the first mention of the birth of Christ in this manuscript, known as the Book of Kells and produced in Ireland or Scotland sometime around the year 800. The swirling spirals and interlaced tangles of stylized animal forms have their roots in jewelry created by the migrating, socalled barbarian tribes that formed the "other" of the Greco-Roman world. But by this time, this ornamental repertory had been subsumed into the flourishing art of Irish monasteries. Irish monks became as famous for writing and copying books as for their intense spirituality and missionary fervor.

Wealthy, isolated, and undefended, Irish monasteries were easy victims to Viking attacks. In 806, fleeing Viking raids on the island of Iona (off the coast of modern Scotland), its monks established a refuge at Kells on the Irish mainland. They probably brought the Book of Kells with them. It was precious. Producing this illustrated version of the Gospels entailed lavish expenditure: Four scribes and three major painters worked on it (modern scribes take about a month to complete such a page), 185 calves were slaughtered to make the vellum, and colors for some of its paintings came from as far away as Afghanistan.

Throughout the Middle Ages and across Europe, monasteries were principal centers of art and learning. While prayer and acts of mercy represented their primary vocation, some talented monks and nuns also worked as painters, jewelers, carvers, weavers, and embroiderers. Few, however, could claim a work of art as spectacular as this one.

LEARN ABOUT IT

- **15.1** Identify and investigate the rich variety of early medieval artistic and architectural styles across Europe, as well as the religious and secular contexts in which they were developed.
- **15.2** Appreciate and understand the themes and subjects used to illustrate early medieval sacred books.
- **15.3** Assess the Carolingian and Ottonian revival of Roman artistic traditions in relation to the political position of the rulers as emperors sanctioned by the pope.
- **15.4** Recognize and evaluate the "barbarian" and Islamic sources that were adopted and transformed by Christian artists during the early Middle Ages.

((• Listen to the chapter audio on myartslab.com

THE EARLY MIDDLE AGES

As Roman authority crumbled at the dissolution of the Western Empire in the fifth century, it was replaced by rule of people from outside of the Roman Empire and cultural orbit of the Romans, people whom the Romans—like the Greeks before them—called "barbarians," since they could only "barble" the Greek or Latin language (MAP 15-1). Thus far we have seen these "barbarians" as adversaries viewed through Greek and Roman eyes—the defeated Gauls at Pergamon (see FIG. 5-60), the captives on the Gemma Augustea (see FIG. 6-23), or the enemy beyond the Danube River on Trajan's Column (see FIG. 6-48). But by the fourth century many Germanic tribes were allies of Rome. In fact, most of Constantine's troops in the decisive battle with Maxentius at the Milvian Bridge were Germanic "barbarians."

A century later the situation was entirely different. The adventures of the Roman princess Galla Placidia, whom we have already

met as a patron of the arts (see "The Oratory of Galla Placidia in Ravenna," page 228), bring the situation to life. She had the misfortune to be in Rome when Alaric and the Visigoths sacked the city in 410 (the emperor and pope were living safely in Ravenna). Carried off as a prize of war by the Goths, Galla Placidia had to join their migrations through France and Spain and eventually married the Gothic king, who was soon murdered. Back in Italy, married and widowed yet again, Galla Placidia ruled the Western Empire as regent for her son from 425 to 437/38. She died in 450, thus escaping yet another sack of Rome, this time by the Vandals, in 455. The fall of Rome shocked the Christian world, although the wounds were more psychological than physical. Bishop Augustine of Hippo (St. Augustine, d. 430) was inspired to write The City of God, a cornerstone of Christian philosophy, as an answer to people who claimed that the Goths represented the vengeance of the pagan gods on people who had abandoned them for Christianity.

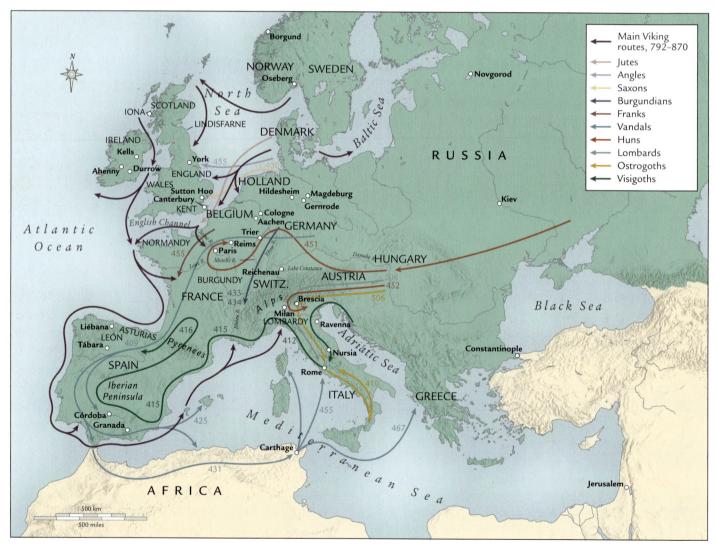

MAP 15-1 • EUROPE OF THE EARLY MIDDLE AGES

This map shows the routes taken by the groups of people who migrated into and through the western Roman world at the dawn of the Middle Ages. Modern country names have been used here for convenience, but at this time, these countries, as we know them, did not yet exist.

ART AND ITS CONTEXTS | Defining the Middle Ages

The roughly 1,000 years of European history between the dissolution of the Western Roman Empire during the fifth century and the Florentine Renaissance in the fifteenth century are generally referred to as the Middle Ages, or the medieval period. These terms reflect the view of Renaissance humanists who regarded the period that preceded theirs as a "dark age" of ignorance, decline, and barbarism, standing in the middle and separating their own "golden age" from the golden ages of ancient Greece and Rome. Although scholars now acknowledge the ridiculousness of this self-serving formulation and recognize the millennium of the "Middle Ages" as a period of great richness, complexity, creativity, and innovation, the term has endured.

Art historians commonly divide the Middle Ages into three periods: early medieval (ending c. 1000), Romanesque (eleventh and twelfth centuries), and Gothic (beginning in the mid twelfth and extending into the fifteenth century). In this chapter we can look at only a few of the many cultures that flourished during the early medieval period. For convenience, we will use modern geographic names as familiar points of reference (see MAP 15–1), but, in fact, European nations as we know them today did not yet exist.

Who were these people living outside of the Mediterranean orbit? Their wooden architecture is lost to fire and decay, but their metalwork and its animal and geometric ornament has survived. They were hunters and fishermen, shepherds and farmers living in villages with a social organization based on extended families and tribal loyalties. They engaged in pottery, weaving, and woodwork, and they fashioned metals into weapons, tools, and jewelry.

The Celts controlled most of western Europe (see "The Celts," page 150), and the Germanic people—Goths and others lived around the Baltic Sea. Increasing population evidently forced the Goths to begin to move south, into better lands and climate around the Mediterranean and Black Sea, but the Romans had extended the borders of their empire across the Rhine and Danube rivers. Seeking the relative security and higher standard of living they saw in the Roman Empire, the Germanic people crossed the borders and settled within the Roman world.

The tempo of migration speeded up in the fifth century when the Huns from Central Asia swept down on western Europe; the Ostrogoths (Eastern Goths) moved into Italy and deposed the last Western Roman emperor in 476; the Visigoths (Western Goths) ended their wanderings in Spain; the Burgundians settled in Switzerland and eastern France; the Franks in Germany, France, and Belgium; and the Vandals crossed over into Africa, making Carthage their headquarters before circling back to Italy, sacking Rome in 455.

As these "barbarian" groups gradually converted to Christianity, the Church served to unify Europe's heterogeneous population. As early as 345, the Goths adopted Arian Christianity, beliefs considered heretical by the Church in Rome. (Arian Christians did not believe that Christ was divine or co-equal with God the Father.) Not until 589 did they accept Roman Christianity. But the Franks under Clovis (r. 481–511), influenced by his Burgundian wife Clotilda, converted to Roman Christianity in 496, beginning a fruitful alliance between French rulers and the popes. Kings and nobles defended the claims of the Roman Church, and the pope, in turn, validated their authority. As its wealth and influence increased throughout Europe, the Church emerged as the principal patron of the arts, commissioning buildings and liturgical equipment, including altars, altar vessels, crosses, candlesticks, containers for the remains of saints (reliquaries), vestments (ritual garments), images of Christian symbols and stories, and copies of sacred texts such as the Gospels. (See "Defining the Middle Ages," above.)

THE ART OF THE "BARBARIANS" IN EUROPE

Weaving a rich fabric of themes and styles originating from inside and out of the empire, from pagan and Christian beliefs, from urban and rural settlements, brilliant new artistic styles were born across Europe as people migrated from the east to settle within the former Western Roman Empire. Many of the "barbarian" groups were superb metalworkers and created magnificent colorful jewelry, both with precious metals and with inlays of gems. Most of the motifs were geometric or highly abstract natural forms.

THE MEROVINGIANS

Among the "barbarian" people who moved into the Western Roman world during the fifth century were the Franks, migrating westward from what is now Belgium and settling in the northern part of Roman Gaul (modern France). There they were soon ruled by a succession of leaders from a dynasty named "Merovingian" after its legendary founder, Merovech. The Merovingians established a powerful kingdom during the reigns of Childeric I (c. 457–481) and his son Clovis I (481–511), whose conversion to Christianity in 496 connected the Franks to the larger European world through an ecclesiastical network of communication and affiliation.

Some early **illuminated** books (books that include not only text but pictures and decoration in color and gold) have been associated with the dynasty, but our knowledge of Merovingian art is based primarily on the jewelry that has been uncovered in the graves of kings, queens, and aristocrats, indicating that both men and women expressed their wealth (in death, as presumably in life) by wearing earrings, necklaces, finger rings, bracelets, and weighty

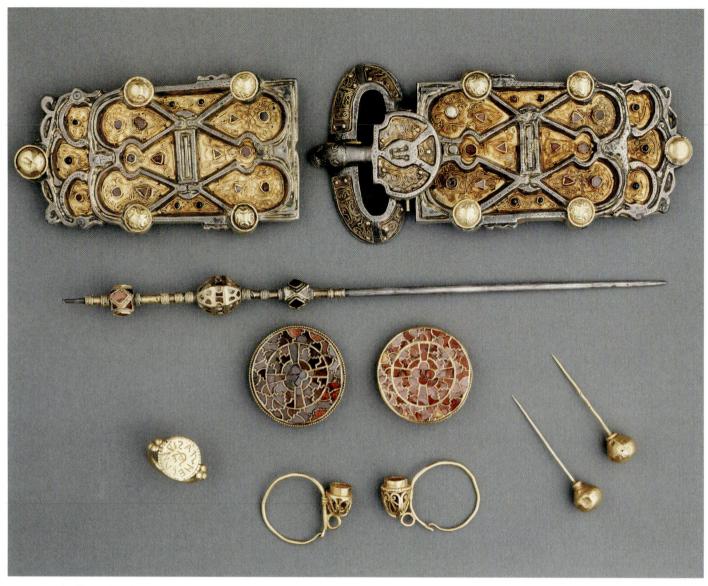

15-2 • JEWELRY OF QUEEN ARNEGUNDE

Discovered in her tomb, excavated at the Abbey of Saint-Denis, Paris. Burial c. 580–590. Gold, silver, garnets, and glass beads; length of pin 10³/₈" (26.4 cm). Musée des Antiquités Nationales, Saint-Germain-en-Laye, France.

leather belts, from which they suspended even more ornamental metalwork. One of the most spectacular royal tombs was that of Queen Arnegunde, unearthed during excavations in 1959 at the Abbey of Saint-Denis, near Paris, which was a significant center of Merovingian patronage.

Arnegunde was discovered within a stone sarcophagus undisturbed since her burial in c. 580–590. From her bodily remains, archaeologists determined that she was slight and blond, 5 feet tall, and about 70 years old at the time of her death. The inscription of her name on a gold ring on her left thumb provided the first clue to her identity, and her royal pedigree was confirmed by the sumptuousness of her clothing. She was outfitted in a short purple silk tunic, cinched at the waist by a substantial leather belt from which hung ornamental metalwork. The stockings that covered her legs were supported by leather garters with silver strap tongues and dangling ornaments. Over this ensemble was a dark red gown embroidered in gold thread. This overgarment was open at the front, but clasped at neck and waist by round brooches and a massive buckle (**FIG. 15-2**). These impressive objects were made by casting their general shape in two-piece molds, refining and **chasing** them with tools, and inlaying within reserved and framed areas carefully cut garnets to provide color and sparkle. Not long after Arnegunde's interment, Merovingian royalty ceased the practice of burying such precious items with the dead—encouraged by the Church to donate them instead to religious institutions in honor of the saints—but we are fortunate to have a few early examples that presumably document the way these royal figures presented themselves on state occasions.

THE NORSE

In Scandinavia (present-day Denmark, Norway, and Sweden), which was never part of the Roman Empire, people spoke variants of the Norse language and shared a rich mythology with other Germanic peoples. Scandinavian artists had exhibited a fondness for abstract patterning from early prehistoric times. During the first millennium BCE, trade, warfare, and migration had brought a variety of jewelry, coins, textiles, and other portable objects into northern Europe, where artists incorporated the solar disks and stylized animals on these objects into their already rich artistic vocabulary.

By the fifth century CE, the so-called **animal style** dominated the arts, displaying an impressive array of serpents, fourlegged beasts, and squat human figures. The **GUMMERSMARK BROOCH** (**FIG. 15–3**), for example, is a large silver-gilt pin dating from the sixth century in Denmark. Its elegant ornament consists of a large, rectangular panel and a medallionlike plate covering the safety pin's catch, connected by an arched bow. The surface of the pin seethes with human, animal, and geometric forms. An eyeand-beak motif frames the rectangular panel, a man is compressed between dragons just below the bow, and a pair of monster heads and crouching dogs with spiraling tongues frame the covering of the catch.

Certain underlying principles govern works with animal-style design: The compositions are generally symmetrical, and artists depict animals in their entirety either in profile or from above. Ribs and spinal columns are exposed as if they had been x-rayed; hip and shoulder joints are pear-shape; tongues and jaws extend and curl; and legs end in large claws.

The northern jewelers carefully crafted their molds to produce a glittering surface on the cast metal, turning a process intended to speed production into an art form of great refinement.

THE CELTS AND ANGLO-SAXONS IN BRITAIN

After the Romans departed Britain at the beginning of the fifth century, Angles and Saxons from Germany and the Low Countries (present-day Belgium and Holland), and Jutes from Denmark, crossed the sea to occupy southeastern Britain. Gradually they extended their control northwest across the island. Over the next 200 years, the arts experienced a spectacular efflorescence. A fusion of Celtic, Roman, Germanic, and Norse cultures generated a new style of art, sometimes known as Hiberno-Saxon (from the Roman name for Ireland, Hibernia). Anglo-Saxon literature is filled with references to sumptuous jewelry and weapons made of or decorated with gold and silver. Fortunately, some of these objects have survived.

The Anglo-Saxon epic *Beowulf*, composed perhaps as early as the seventh century, describes its hero's burial with a hoard of treasure in a grave mound near the sea. Such a burial site was discovered near the North Sea coast in Suffolk at a site called Sutton Hoo (*hoo* means "hill"). The grave's occupant had been buried in a ship—90 feet long and designed for rowing, not sailing—whose

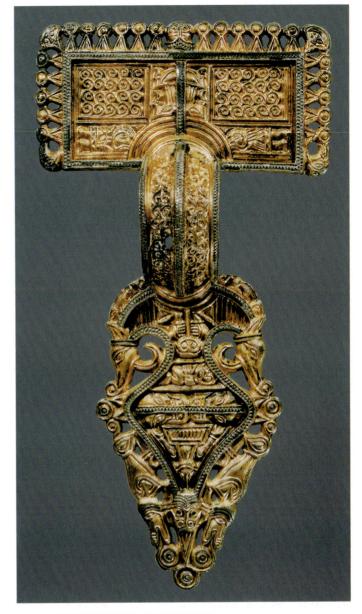

15-3 • GUMMERSMARK BROOCH Denmark. 6th century. Silver gilt, height 5³/₄" (14.6 cm). Nationalmuseet, Copenhagen.

traces in the earth were recovered by careful excavators. The wood—and the hero's body—had disintegrated, and no inscriptions record his name. He has sometimes been identified with the ruler Raedwald, who died about 625. Whoever he was, the treasures buried with him prove that he was a wealthy and powerful man. They include weapons, armor, other equipment to provide for the ruler's afterlife, and many luxury items. The objects from Sutton Hoo represent the broad multicultural heritage characterizing the British Isles at this time: Celtic, Scandinavian, and classical Roman, as well as Anglo-Saxon. There was even a Byzantine silver bowl at Sutton Hoo.

One of the most exquisite finds was a clasp of pure gold that once secured over his shoulder the leather body armor of

RECOVERING THE PAST | Sutton Hoo

The story of the excavation of Sutton Hoo-unquestionably one of the most important archaeological discoveries in Britain-begins with Edith May Pretty, who decided late in her life to explore the burial mounds that were located on her estate in southeast Suffolk, securing the services of a local amateur archaeologist, Basil Brown. Excavations began in 1938 as a collaborative effort between the two of them, and in the following year they encountered the famous ship burial. As rumors spread of the importance of the find, its excavation was gradually taken over by renowned experts and archaeologists who moved from the remains of the ship to the treasures of the burial chamber for which Sutton Hoo is most famous. Police officers were posted to guard the site, and the treasures were sent for safekeeping to the British Museum in London. although, since Sutton Hoo was determined not to be "Treasure Trove" (buried objects meant to be retrieved by their original owners and now considered property of the Crown-see "The Mildenhall Treasure," page 212), it was Pretty's legal property. She, however, decided to donate the entire contents of the burial mound to the British Museum.

Excavation of Sutton Hoo was interrupted by World War II, but in 1945 Rupert Bruce-Mitford of the British Museum began a scholarly study of its treasures that would become his life work. He not only subjected each piece to detailed scrutiny; he proposed reconstructions of objects that were only partially preserved, such as the harp, helmet, and drinking horns. Using the evidence that had been gathered in a famous murder case, he proposed that Sutton Hoo was actually a burial, even though no evidence of human remains were ever found, since they could have disappeared completely in the notably acidic soil of the mound. Other scholars used radiocarbon dating of timber fragments and close analysis of coins to focus the dating of the burial to c. 625, which happened to coincide with the death date of King Raedwald of East Anglia, the most popular candidate for the identity of the person buried at Sutton Hoo.

After heated discussions and considerable controversy, new excavations were carried out in the area of Sutton Hoo during the 1980s and 1990s. These revealed a series of other discoveries in what emerged as an important early medieval burial ground and proved that the area had been inhabited since the Neolithic period, but they uncovered nothing to rival the collection of treasures that were preserved at Sutton Hoo.

View the Closer Look for the pursue cover from the Sutton Hoo burial ship on myartslab.com

its distinguished owner (**FIG. 15–4**). The two sides of the clasp essentially identical in design—were connected when a long gold pin, attached to one half by a delicate but strong gold chain, was inserted through a series of aligned channels on the back side of the inner edge of each. The superb decoration of this work is created by thin pieces of garnet and blue-checkered glass (known as **millefiori**, from the Italian for "a thousand flowers") cut into precisely stepped geometric shapes or to follow the sinuous contours of stylized animal forms. The cut shapes were then inserted into channels and supplemented by granulation (the use of minute granules of gold fused to the surface; see also "Aegean Metalwork," page 90). Under the stepped geometric pieces that form a rectangular patterned field on each side, jewelers placed gold foil stamped with incised motifs that reflect light back up through the transparent garnet to spectacular effect. Around these carpetlike rectangles are borders of interlacing snakes, and in the curving compartments to the outside stand pairs of semitransparent, overlapping boars stylized in ways that reflect the traditions of Scandinavian jewelry. Their curly pig's tails overlap their strong rumps at the outer edges on each side of the clasp, and following the visible vertebrae along

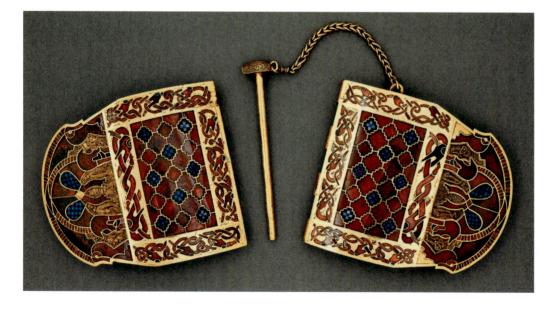

15-4 • HINGED CLASP, FROM THE SUTTON HOO BURIAL SHIP

Suffolk, England. First half of 7th century. Gold plaques with granulation and inlays of garnet and checked millefiori glass, length 5" (12.7 cm). British Museum, London. the arched forms of their backs, we arrive at their heads, with floppy ears and extended tusks. Boars represented strength and bravery, important virtues in warlike Anglo-Saxon society.

THE EARLY CHRISTIAN ART OF THE BRITISH ISLES

Although the Anglo-Saxons who settled in Britain had their own gods and myths, Christianity survived. Monasteries flourished in the Celtic north and west, and Christians from Ireland founded influential missions in Scotland and northern England. Cut off from Rome, these Celtic Christians developed their own liturgical practices, calendar, and distinctive artistic traditions. Then, in 597, Pope Gregory the Great (pontificate 590-604) dispatched missionaries from Rome to the Anglo-Saxon king Ethelbert of Kent, whose Christian wife, Bertha, was sympathetic to their cause. The head of this successful mission, the monk Augustine (St. Augustine of Canterbury, d. 604), became the first archbishop of Canterbury in 601. The Roman Christian authorities and the Irish monasteries, although allied in the effort to Christianize Britain, came into conflict over their divergent practices. The Roman Church eventually triumphed and brought British Christians under its authority. Local traditions, however, continued to influence their art.

ILLUSTRATED BOOKS

Among the richest surviving artworks of the period are lavishly decorated Gospel books, not only essential for spiritual and liturgical life within established monasteries, but also critical for the missionary activities of the Church, since a Gospel book was required in each new foundation. Often bound in gold and jeweled covers, they were placed on the altars of churches, carried in processions, and even thought to protect parishioners from enemies, predators, diseases, and all kinds of misfortune. Such sumptuous books were produced by monks in local monastic workshops called scriptoria (see "The Medieval Scriptorium," page 438).

THE BOOK OF DURROW One of the earliest surviving decorated Gospels of the period is the **BOOK OF DURROW**, dating to the second half of the seventh century (**FIG. 15-5**). The book's format reflects Roman Christian models, but its paintings are an encyclopedia of Hiberno-Saxon design. Each of the four Gospels is introduced by a three-part decorative sequence: a page with the symbol of its evangelist author, followed by a page of pure ornament, and finally elaborate decoration highlighting the initial words of the text (the *incipit*).

The Gospel of Matthew is preceded by his symbol, the man, but what a difference there is from the way humans were represented in the Greco-Roman tradition. The armless body is formed by a colorful checkered pattern recalling the rectangular panels of the Sutton Hoo clasp (see FIG. 15–4). Set on the body's rounded shoulders, a schematic, symmetrical, frontal face stares directly out at the viewer, and the tiny feet that emerge at its other end are

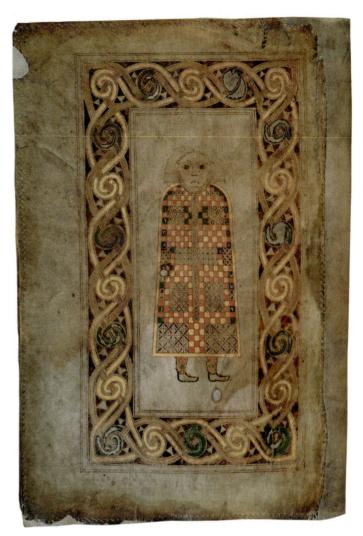

15-5 • SYMBOL OF THE EVANGELIST MATTHEW, GOSPEL BOOK OF DURROW

Page from the Gospel of Matthew. Probably made at Iona, Scotland, or in northern England. Second half of 7th century. Ink and tempera on parchment, $95\%' \times 61\%''$ (24.4 \times 15.5 cm). The Board of Trinity College, Dublin. MS. 57, fol. 21v

seen from a contrasting profile view, as if to deny any hint of lifelike form or earth-based spatial placement. Equally prominent is the bold band of complicated but coherent interlacing ornament that borders the figure's field.

THE BOOK OF KELLS The monastic scribes and artists of England, Scotland, and Ireland developed and expanded this artistic tradition in works of breathtaking virtuosity like the Lindisfarne Gospels (see "The Lindisfarne Gospels," page 436) and the Book of Kells. This chapter began with a close look at the most celebrated page in the Book of Kells—the page introducing Matthew's account of Jesus' birth (see FIG. 15–1). At first this appears to be a dense thicket of spiral and interlace patterns derived from metalworking traditions embellishing—in fact practically overwhelming—the Chi Rho monogram of Christ. The illuminators

The LINDISFARNE GOSPEL BOOK is one of the most extraordinary manuscripts ever created, admired for the astonishing beauty of its words and pictures (FIGS. 15-6, 15-7; see also "A Closer Look," page xxx, FIG. A), but also notable for the wealth of information we have about its history. Two and a half centuries after it was made, a priest named Aldred added a colophon to the book, outlining with rare precision its history, as he knew it-that it was written by Eadfrith, bishop of Lindisfarne (698-721), and bound by Ethelwald, his successor. Producing this stupendous work of art was an expensive and laborious proposition-requiring 300 calfskins to make the vellum and using pigments imported from as far away as the Himalayas for the decoration. Preliminary outlines were made for each of the pictures, using compasses, dividers, and straight edges to produce precise under-drawings with a sharp point of silver or lead, forerunner to our pencils.

The full pages of ornament set within cross-shape frameworks (see example in the Introduction) are breathtakingly complex, like visual puzzles that require patient and extended viewing. Hybrid animal forms tangle in acrobatic interlacing, disciplined by strict symmetry and sharp framing. Some have speculated that members of the religious community at Lindisfarne might have deciphered the patterns as a spiritual exercise. But principally the book was carried in processions and displayed on the altar, not shelved in the library to be consulted as a part of intellectual life. The text is heavily ornamented and abbreviated, difficult to read. The words that begin the Gospel of Matthew (see FIG. 15-6)-Liber generationis ihu xpi filii david filii abraham ("The book of the generation of Jesus Christ, son of David, son of Abraham")-are jammed together, even stacked on top of each other. They are

also framed, subsumed, and surrounded by a proliferation of the decorative forms, ultimately deriving from barbarian visual traditions, that we have already seen moving from jewelry into books in the Durrow Gospels (see FIG. 15–5) and the Book of Kells (see FIG. 15–1).

But the paintings in the Lindisfarne Gospels document more than the developing sophistication of an abstract artistic tradition. Roman influence is evident here as well. Instead of beginning each Gospel with a symbol of its author, the designer of this book introduced portraits of the evangelists writing their texts, drawing on a Roman tradition (see FIG. 15–7). The monastic library at Wearmouth-Jarrow, not far from Lindisfarne, is known to have had a collection of Roman books, and an author portrait in one of them seems to have provided the model for an artist there, who portrayed **EZRA RESTORING THE SACRED SCRIPTURES** within a huge Bible (**FIG. 15–8**). This painter worked to emulate the illusionistic traditions of the Greco-Roman world. Ezra is a modeled, three-dimensional form, sitting on a

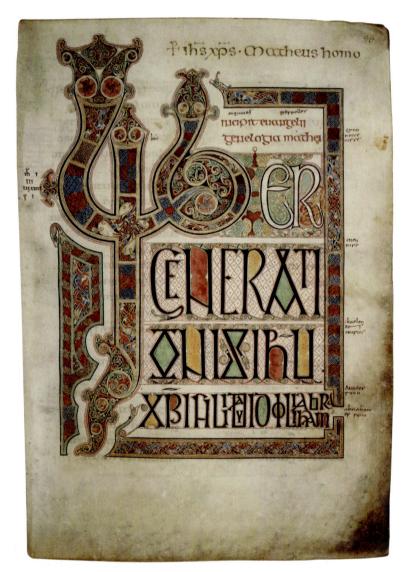

15-6 • PAGE WITH THE BEGINNING OF THE TEXT OF MATTHEW'S GOSPEL, LINDISFARNE GOSPEL BOOK

Lindisfarne. c. 715–720. Ink and tempera on vellum, $13\%''\times97_{16}''$ (34 \times 24 cm). The British Library, London. Cotton MS. Nero D.IV, fol. 27r

The words written in the right margin, just beside the frame, are an Old English gloss translating the Latin text, added here in the middle of the tenth century by the same Aldred who added the colophon. They represent the earliest surviving English text of the Gospels.

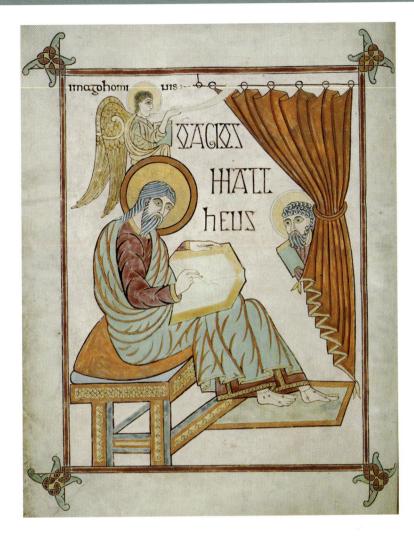

foreshortened bench and stool, both drawn in perspective to make them appear to recede into the distance. In the background, the obliquely placed books on the shelves of a cabinet seem to occupy the depth of its interior space.

Interestingly, the artist of the Matthew portrait in the Lindisfarne Gospels worked with the same Roman prototype, judging from the number of details these two portraits share, especially the figures' poses. But instead of striving to capture the lifelike features of his Roman model, the Lindisfarne artist sought to undermine them. Matthew appears against a blank background. All indications of modeling have been stripped from his clothing to foreground the decorative pattern and contrasting color created by the drapery "folds." By carefully arranging the ornament on the legs of Matthew's bench, the threedimensional shading and perspective evident in the portrait of Ezra have been successfully suppressed. The footstool has been liberated from its support to float freely on the surface, while still resting under the evangelist's silhouetted feet. Playing freely with an acknowledged and clearly understood alien tradition, the painter situates an enigmatic figure in the "background" at upper right behind a gathered drape-suspended from a curtain rod hanging from a screw eye sunk into the upper frame-that is not long enough to conceal the rest of his figure. Clearly there were important cultural reasons for such divergent reactions to a Mediterranean model-Wearmouth-Jarrow seeking to emphasize its Roman connections and Lindisfarne its indigenous roots. We are extremely fortunate to have two surviving works of art that embody the contrast so clearly.

15-7 • MATTHEW WRITING HIS GOSPEL, LINDISFARNE GOSPEL BOOK

Lindisfarne. c. 715–720. Ink and tempera on vellum, $13\%'' \times 9^{7}_{16''}$ (34 × 24 cm). The British Library, London. Cotton MS. Nero D.IV. fol. 25v

The identity of the haloed figure peeking from behind the curtain is still a topic of debate. Some see him as Christ confronting us directly around the veil that separated the holy of holies from worshipers in the Jewish Temple; others think he is Moses, holding the closed book of the law that was meant to be seen in contrast to the open book into which Matthew writes his Gospel. Also curious here is the Greek form of "saint" in Matthew's title ("O Agios" or "the holy"), written, however, with letters from the Latin alphabet.

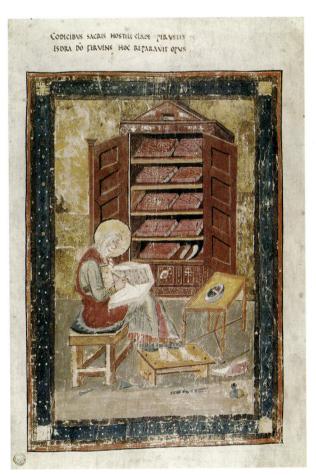

15-8 • EZRA RESTORING THE SACRED SCRIPTURES, IN THE BIBLE KNOWN AS THE CODEX AMIATINUS

Wearmouth-Jarrow. c. 700–715. Ink and tempera on vellum, $20''\times131\!\!/\!\!2''$ (50.5 \times 34.3 cm). Biblioteca Medicea Laurenziana, Florence. Cod. Amiat. I, fol. 5r

This huge manuscript (at over 2,000 pages, it weighs more than 75 pounds) is the earliest surviving complete text of the Bible in the Latin Vulgate translation of St. Jerome.

ART AND ITS CONTEXTS | The Medieval Scriptorium

Today books are made with the aid of computer software that can lay out pages, set type, and insert and prepare illustrations. Modern presses can produce hundreds of thousands of identical copies in full color. In medieval Europe, however, before the invention of printing from movable type in the mid 1400s, books were made by hand, one at a time, with parchment or vellum, pen and brush, ink and paint. Each one was a time-consuming and expensive undertaking. No two were exactly the same.

At first, medieval books were usually made by monks and nuns in a workshop called a scriptorium (plural, scriptoria) within the monastery. As the demand for books increased, rulers set up palace workshops employing both religious and lay scribes and artists, supervised by scholars. Books were written on carefully prepared animal skin—either vellum, which was fine and soft, or parchment, which was heavier and shinier. Ink and water-based paints also required time and experience to prepare, and many pigments—particularly blues and greens—were derived from costly semiprecious stones. In very rich books, artists also used gold leaf or gold paint.

Work on a book was often divided between scribes, who copied the text, and artists, who painted or drew illustrations, large initials, and other decorations. Occasionally, scribes and artists signed and dated their work on the last page, in what was called the **colophon**. One scribe even took the opportunity to warn: "O reader, turn the leaves gently, and keep your fingers away from the letters, for, as the hailstorm ruins the harvest of the land, so does the injurious reader destroy the book and the writing" (cited in Dodwell, p. 247).

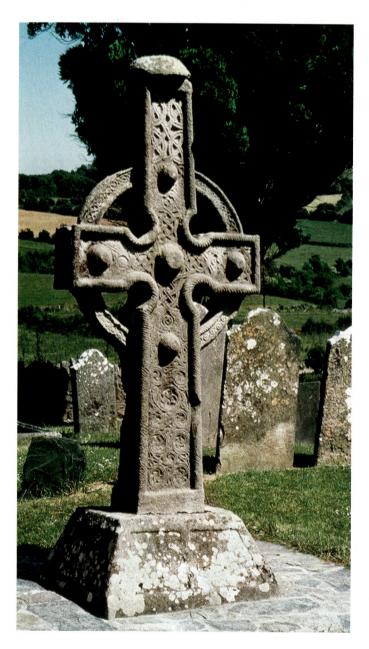

outlined each letter in the Chi Rho monogram, and then they subdivided the letters into panels filled with interlaced animals and snakes, as well as extraordinary spiral and knot motifs. The spaces between the letters form a whirling ornamental field, dominated by spirals.

In the midst of these abstractions, the painters inserted numerous pictorial and symbolic references to Christ—a fish (the Greek word for "fish," *ichthus*, comprises in its spelling the first letters of Jesus Christ, Son of God, Savior), moths (symbols of rebirth), the cross-inscribed wafer of the Eucharist, and numerous chalices and goblets. In a particularly intriguing image at bottom left, two cats pounce on a pair of mice nibbling the Eucharistic wafer, and two more mice torment the vigilant cats. Is this a metaphor for the struggle between good (cats) and evil (mice), or an acknowledgment of the perennial problem of keeping the sacred Host safe from rodents? Perhaps it is both.

IRISH HIGH CROSSES Metalworking traditions influenced not only manuscript decoration, but also the monumental stone crosses erected in Ireland during the eighth century. The **SOUTH CROSS** of Ahenny, in County Tipperary, is an especially wellpreserved example (**FIG. 15–9**). It seems to have been modeled on metal ceremonial or reliquary crosses, that is, cross-shape containers for holy relics. It is outlined with ropelike, convex moldings and covered with spirals and interlace. The large bosses (broochlike projections), which form a cross within this cross, resemble the jewels that were similarly placed on metal crosses. The circle enclosing the arms of such Irish high crosses—so called because of their size—has been interpreted as a ring of heavenly light or as a purely practical means of supporting the projecting arms.

15-9 • SOUTH CROSS, AHENNY County Tipperary, Ireland. 8th century. Sandstone.

MOZARABIC ART IN SPAIN

In 711, Islamic invaders conquered Spain, ending Visigothic rule. Bypassing the small Christian kingdom of Asturias on the north coast, they crossed the Pyrenees Mountains into France, but in 732 Charles Martel and the Frankish army stopped them before they reached Paris. Islamic rulers remained in the Iberian peninsula (Spain and Portugal) for nearly 800 years, until the fall of Granada to the Christians in 1492.

With some exceptions, Christians and Jews who acknowledged the authority of the Islamic rulers and paid higher taxes because they were non-Muslims were left free to follow their own religious practices. The Iberian peninsula became a melting pot of cultures in which Muslims, Christians, and Jews lived and worked together, all the while officially and firmly separated. Christians in the Muslim territories were called Mozarabs (from the Arabic *mustarib*, meaning "would-be Arab"). In a rich exchange of artistic influences, Christian artists incorporated some features of Islamic art into a colorful new style known as **Mozarabic**. When the Mozarabic communities migrated to northern Spain, which returned to Christian rule not long after the initial Islamic invasion, they took this Mozarabic style with them.

BEATUS MANUSCRIPTS

One of the most influential books of the early Middle Ages was a Commentary on the Apocalypse, compiled during the eighth century by Beatus, abbot of the monastery of San Martín at Liébana in the northern kingdom of Asturias. Beatus described the end of the world and the Last Judgment of the Apocalypse, rooted in the Revelation to John at the end of the New Testament, which vividly describes Christ's final, fiery triumph.

A lavishly illustrated copy of Beatus' Commentary called the Morgan Beatus was produced c. 940–945, probably at the monastery of San Salvador at Tábara, by an artist named Maius (d. 968), who both wrote the text and painted the illustrations. His gripping portrayal of the **WOMAN CLOTHED WITH THE SUN**, based on the biblical text of Apocalypse (Revelation) 12:1–18, extends over two pages to cover an entire opening of the book (**FIG. 15-10**). Maius has stayed close to the text in composing his tableau, which is dominated

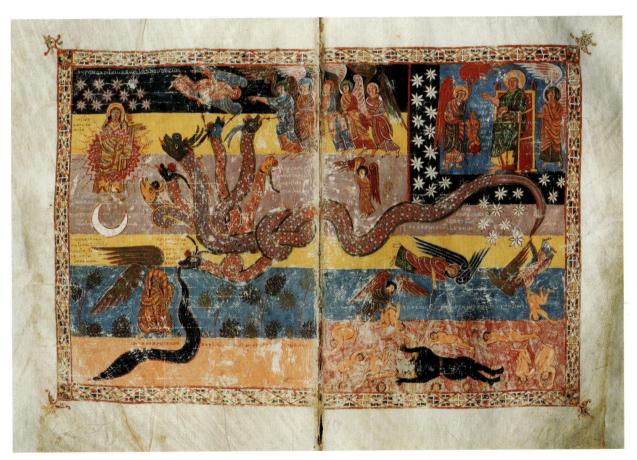

15–10 • Maius **WOMAN CLOTHED WITH THE SUN, THE MORGAN BEATUS** Monastery of San Salvador at Tábara, León, Spain. 940–945. Tempera on vellum, 15¹/₈" × 22¹/₆" (38.5 × 56 cm). The Morgan Library and Museum, New York. MS. M644, fols. 152v–153r

When the modern abstract French painter Fernand Léger (1881–1955; see FIG. 32–21) was visiting the great art historian Meyer Schapiro (1904–1996) in New York during World War II, the artist asked the scholar to suggest the single work of art that was most important for him to see while there. Schapiro took him to the Morgan Library to leaf through this manuscript, and the strong impact it had on Léger can be clearly seen in the boldness of his later paintings.

by the long, seven-headed, red dragon that slithers across practically the entire width of the picture to threaten at top left the "woman clothed with the sun, with the moon under her feet, and on her head a crown of twelve stars" (12:1). With his tail, at upper right, he sweeps a third of heaven's stars toward Earth while the woman's male child appears before the throne of God. Maius presents this complex allegory of the triumph of the Church over its enemies with a forceful, abstract, ornamental style that accentuates the dramatic, nightmarish qualities of the events outlined in the text. The background has been distilled into horizontal strips of color; the figures become striped bundles of drapery capped with faces dominated by staring eyes and silhouetted, framing haloes. Momentous apocalyptic events have been transformed by Maius into exotic abstractions that still maintain their power to captivate our attention.

Another copy of Beatus' Commentary was produced about 30 years later for Abbot Dominicus of San Salvador at Tábara. A colophon identifies Senior as the scribe for this project. Emeterius and a woman named Ende (or simply En), who signed herself "painter and servant of God," shared the task of illustration. For the first time in the West, a woman artist is identified by name with a specific surviving work of art. In an allegory of the triumph of Christ over Satan (**FIG. 15-11**), the painters show a peacock grasping a red-and-orange snake in its beak. The text explains that a bird with a powerful beak and beautiful plumage (Christ) covers itself with mud to trick the snake (Satan). Just when the snake decides the bird is harmless, the bird swiftly attacks and kills it. "So Christ in his Incarnation clothed himself in the impurity of our [human] flesh that through a pious trick he might fool the evil deceiver....

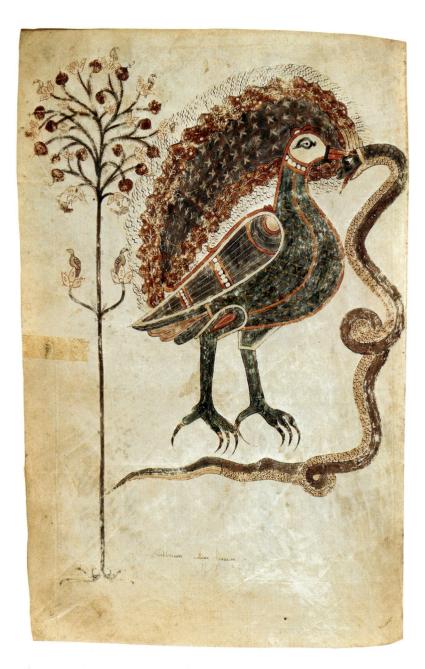

15-11 • Emeterius and Ende, with the scribe Senior BATTLE OF THE BIRD AND THE SERPENT, COMMENTARY ON THE APOCALYPSE BY BEATUS AND COMMENTARY ON DANIEL BY JEROME Made for Abbot Dominicus, probably at the monastery of San Salvador at Tábara, León, Spain. Completed July 6, 975. Tempera on parchment, $153/4'' \times 101/4'''$ (40 × 26 cm). Cathedral Library, Gerona, Spain. MS. 7[11], fol. 18v [W]ith the word of his mouth [he] slew the venomous killer, the devil" (cited in Williams, page 95).

THE VIKING ERA

During the eighth century, seafaring bands of Norsemen known as Vikings (*viken*, "people from the coves") descended on the rest of Europe. Setting off in flotillas of as many as 350 ships, they explored, plundered, traded with, and colonized a vast area during the ninth and tenth centuries. The earliest recorded Viking incursions were two devastating attacks on wealthy isolated Christian monasteries: one in 793, on the religious community on Lindisfarne, an island off the northeast coast of England; and another in 795, at Iona, off Scotland's west coast.

Norwegian and Danish Vikings raided a vast territory stretching from Iceland and Greenland—where they settled in 870 and 985, respectively—to Ireland, England, Scotland, and France. The Viking Leif Eriksson reached North America in 1000. In good weather a Viking ship could sail 200 miles in a day. In the early tenth century, the rulers of France bought off Scandinavian raiders (the Normans, or "northmen") with a large grant of land that became the duchy of Normandy. Swedish Vikings turned eastward and traveled down the Russian rivers to the Black Sea and Constantinople, where the Byzantine emperor recruited them to form an elite personal guard. Others, known as Rus, established settlements around Novgorod, one of the earliest cities in what would become Russia. They settled in Kiev in the tenth century and by 988 had become became Orthodox Christians (see Chapter 8).

THE OSEBERG SHIP

Since prehistoric times northerners had represented their ships as sleek sea serpents, and, as we saw at Sutton Hoo, they used them for burials as well as sea journeys. The ship of a dead warrior symbolized his passage to Valhalla (a legendary great hall that welcomed fallen warriors), and Viking chiefs were sometimes cremated in a ship in the belief that this hastened their journey. Women as well as men were honored by ship burials. A 75-footlong ship, discovered in Oseberg, Norway, and dated c. 815-820, served as the vessel for two women on their journey to eternity in 834, a queen and her companion or servant. Although the burial chamber was long ago looted of jewelry and precious objects, the ship itself and its equipment attest to the wealth and prominence of the ship's owner. A cart and four sleds, all made of wood with beautifully carved decorations, were stored on board. At least 12 horses, several dogs, and an ox had been sacrificed to accompany these women on their last journey.

The Oseberg ship itself, propelled by both sail and oars, was designed for travel in the relatively calm waters of fjords (narrow coastal inlets), not for voyages in the open sea. The rising prow spirals into a serpent's head, and bands of interlaced animals carved

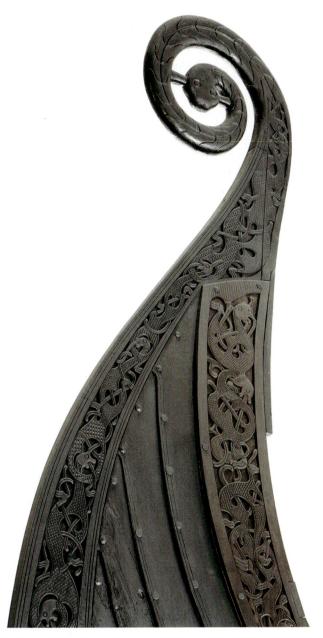

15–12 • GRIPPING BEASTS, DETAIL OF OSEBERG SHIP c. 815–820. Wood. Vikingskiphuset, Universitets Oldsaksamling, Oslo, Norway.

in low relief run along the edges (**FIG. 15-12**). Viking beasts are grotesque, broad-bodied creatures with bulging eyes, short muzzles, snarling mouths, and large teeth which clutch each other with sharp claws. Images of such gripping beasts adorned all sorts of Viking belongings—jewelry, houses, tent poles, beds, wagons, and sleds. Traces of color—black, white, red, brown, and yellow—indicate that the carved wood of this ship was originally painted.

All women, including the most elite, worked in the fiber arts. The Oseberg queen took her spindles, a frame for sprang (braiding), and tablets for tablet-weaving, as well as two upright looms, with her to the grave. Her cabin walls had been hung with tapestries, fragments of which survive. Women not only produced clothing and embroidered garments and wall hangings, but also

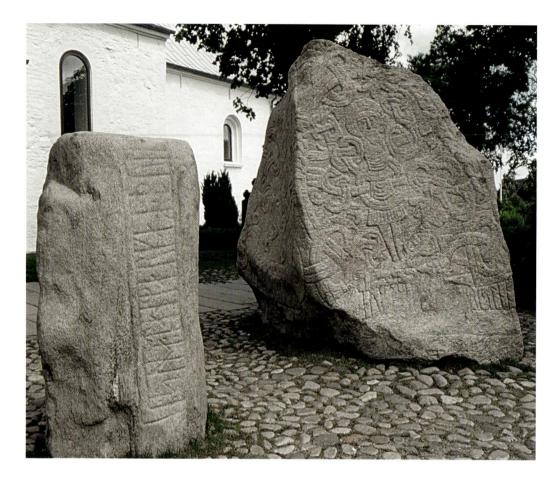

15-13 • ROYAL RUNE STONES, RIGHT-HAND STONE ORDERED BY KING HARALD BLUETOOTH Jelling, Denmark. 983–985. Granite, 3-sided, height about 8' (2.44 m).

wove the huge sails of waterproof unwashed wool that gave the ships a long-distance capability. The entire community—men and women—worked to create these ships, which represent the Vikings' most important surviving contribution to world architecture.

PICTURE STONES AT JELLING

Both at home and abroad, the Vikings erected large memorial stones. Those covered mostly with inscriptions are called **rune stones** (runes are twiglike letters of an early Germanic alphabet). Those with figural decoration are called picture stones. Traces of pigments suggest that the memorial stones were originally painted in bright colors.

About 980, the Danish king Harald Bluetooth (c. 940–987) ordered a picture stone to be placed near an old, smaller rune stone and the family burial mounds at Jelling (**FIG. 15–13**). Carved in runes on a boulder 8 feet high is the inscription "King Harald had this memorial made for Gorm his father and Thyra his mother: that Harald who won for himself all Denmark and Norway and made the Danes Christians." Harald and the Danes had accepted Christianity in c. 960, but Norway did not become Christian until 1015.

During the tenth century, a new style emerged in Scandinavia and the British Isles, one that combined interlacing foliage and ribbons with animals that are more recognizable than the gripping beasts of the Oseberg ship. On one face of the larger Jelling stone the sculptor carved the image of Christ robed in the Byzantine manner, with arms outstretched as if crucified. He is entangled in a double-ribbon interlace instead of nailed to a cross. A second side holds runic inscriptions, and a third, a striding creature resembling a lion fighting a snake. The loosely twisting double-ribbon interlace covering the surface of the stone could have been inspired by Hiberno-Saxon art.

TIMBER ARCHITECTURE

The vast forests of Scandinavia provided the materials for timber buildings of many kinds. Two forms of timber construction evolved: one that stacked horizontal logs, notched at the ends, to form a rectangular building (the still-popular log cabin); and the other that stood the wood on end to form a palisade or vertical plank wall, with timbers set directly in the ground or into a sill (a horizontal beam). More modest buildings consisted of wooden frames filled with wattle-and-daub (see "Early Construction Methods," page 19). Typical buildings had a turf or thatched roof supported on interior posts. The same basic structure was used for almost all building types-feasting and assembly halls, family homes (which were usually shared with domestic animals), workshops, barns, and sheds. The great hall had a central open hearth (smoke escaped through a louver in the roof) and an off-center door designed to reduce drafts. People secured their residences and trading centers by building massive circular earthworks topped with wooden palisades.

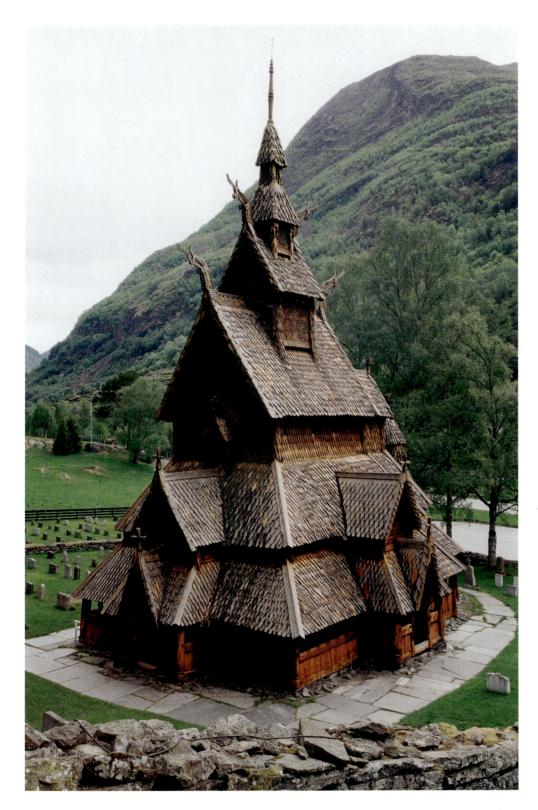

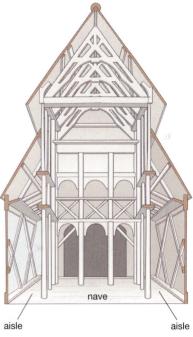

15-14 • EXTERIOR (A) AND CUTAWAY DRAWING (B) OF STAVE CHURCH, BORGUND, NORWAY c. 1125-1150.

 Watch an architectural simulation about stave church construction on myartslab.com

THE BORGUND STAVE CHURCH Subject to decay and fire, early timber buildings have largely disappeared, leaving only postholes and other traces in the soil. In rural Norway, however, a few later **stave churches** survive—named for the four huge timbers (staves) that form their structural core. Borgund church, from about 1125–1150 (**FIG. 15–14**), has four corner staves

supporting the central roof, with additional interior posts that create the effect of a nave and side aisles, narthex, and choir. A rounded apse covered with a timber tower is attached to the choir. Steeply pitched roofs covered with wooden shingles protect the walls—planks slotted into the sills—from the rain and snow. Openwork timber stages set on the roof ridge create a tower and give the church a steep pyramidal shape. On all the gables either crosses or dragon heads protect the church and its congregation from trolls and demons.

The Vikings were not always victorious. Their colonies in Iceland and the Faeroe Islands survived, but in North America their trading posts eventually had to be abandoned. In Europe, south of the Baltic Sea, a new German dynasty challenged and then defeated the Vikings. By the end of the eleventh century the Viking era had come to an end.

THE CAROLINGIAN EMPIRE

During the second half of the eighth century, a new force emerged on the Continent. Charlemagne (the French form of Carolus Magnus, Latin for "Charles the Great") established a dynasty and an empire known today as the Carolingian. He descended from a family that had succeeded the Merovingians in the late seventh century as rulers of the Franks in northern Gaul (parts of presentday France and Germany). Under Charlemagne (r. 768-814), the Carolingian realm reached its greatest extent, encompassing western Germany, France, the Lombard kingdom in Italy, and the Low Countries. Charlemagne imposed Christianity throughout this territory, and in 800, Pope Leo III (pontificate 795-816) crowned Charlemagne emperor in a ceremony in St. Peter's Basilica in Rome, declaring him the rightful successor to Constantine, the first Christian emperor. This endorsement reinforced Charlemagne's authority and strengthened the bonds between the papacy and secular government in the West.

The Carolingian rulers' ascent to the Roman imperium, and the political pretensions it implied, are clearly signaled in a small bronze equestrian statue—once thought to be a portrait of Charlemagne himself but now usually identified with his grandson **CHARLES THE BALD** (FIG. 15-15). The idea of representing an emperor as a proud equestrian figure recalls the much larger image of Marcus Aurelius (see FIG. 6-57) that was believed during the Middle Ages to portray Constantine, the first Christian emperor and an ideal prototype for the ruler of the Franks, newly legitimized by the pope. But unlike the bearded Roman, this Carolingian king sports a mustache, a Frankish sign of nobility that had also been common among the Celts (see FIG. 5-60). Works of art such as this are not the result of a slavish mimicking of Roman prototypes, but of a creative appropriation of Roman imperial typology to glorify manifestly Carolingian rulers.

Charlemagne sought to restore the Western Empire as a Christian state and to revive the arts and learning. As inscribed on his official seal, Charlemagne's ambition was "the Renewal of the Roman Empire." To lead this revival, Charlemagne turned to Benedictine monks and nuns. By the early Middle Ages, monastic communities had spread across Europe. In the early sixth century, Benedict of Nursia (c. 480–547) wrote his *Rule for Monasteries*, and this set of guidelines for a secluded life of monastic work and prayer became the model for Benedictine monasticism, soon the

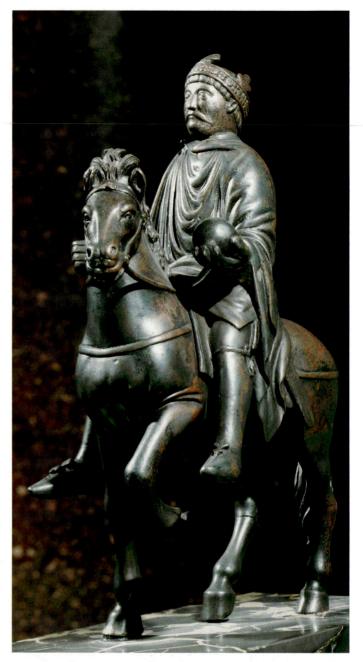

15-15 • EQUESTRIAN PORTRAIT OF CHARLES THE BALD (?)

9th century. Bronze, height 91/2" (24.4 cm). Musée du Louvre, Paris.

dominant form throughout Europe. The Benedictines became Charlemagne's "cultural army," and the imperial court at Aachen, Germany, one of the leading intellectual centers of western Europe.

CAROLINGIAN ARCHITECTURE

To proclaim the glory of the new empire in monumental form, Charlemagne's architects turned to two former Western imperial capitals, Rome and Ravenna, for inspiration. Charlemagne's biographer Einhard reported that the ruler, "beyond all sacred and venerable places... loved the church of the holy apostle Peter in Rome." Not surprisingly, Constantine's basilica of St. Peter, with

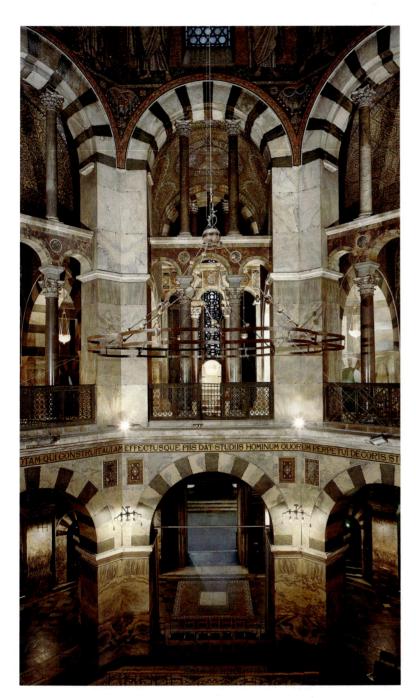

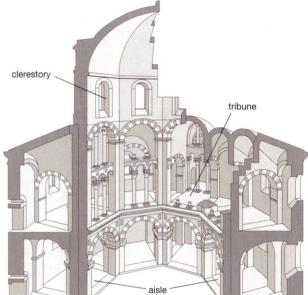

15-16 • INTERIOR VIEW (A) AND SECTION DRAWING (B), PALACE CHAPEL OF CHARLEMAGNE

Aachen (Aix-la-Chapelle), Germany. 792-805.

Extensive renovations took place here in the nineteenth century, when the chapel was reconsecrated as the cathedral of Aachen, and in the twentieth century, after it was damaged in World War II.

• Watch a video about the palace chapel of Charlemagne on myartslab.com

its long nave and side aisles ending in a transept and projecting apse (see page 653, left-hand plan), served as a model for many important churches in Charlemagne's empire. The basilican plan, which had fallen out of favor since the Early Christian period, emerged again as the principal arrangement of large congregational churches and would remain so throughout the Middle Ages and beyond.

CHARLEMAGNE'S PALACE AT AACHEN Charlemagne's palace complex provides an example of the Carolingian synthesis of Roman, Early Christian, and northern styles. Charlemagne, who enjoyed hunting and swimming, built a headquarters and palace complex amid the forests and natural hot springs of Aachen in the northern part of his empire and installed his court there in

about 794. The palace complex included a large masonry audience hall and chapel facing each other across a large square (reminiscent of a Roman forum), and a monumental gateway supporting a hall of judgment. Other administrative buildings, a palace school, homes for his circle of advisors and his large family, and workshops supplying all the needs of Church and state, were mostly constructed using the wooden building traditions indigenous to this part of Europe.

The **PALACE CHAPEL** (**FIG. 15-16**) functioned as Charlemagne's private place of worship, the church of his imperial court, a place for precious relics, and, after the emperor's death, the imperial mausoleum. The central, octagonal plan recalls the church of San Vitale in Ravenna (see FIG. 8–5), but the Carolingian architects added a monumental western entrance block. Known as a **westwork**, this structure combined a ground-floor narthex (vestibule) and an upper-story throne room which opened onto the chapel interior, allowing the emperor an unobstructed view of the liturgy at the high altar, and at the same time assuring his privacy and safety. The room also opened outside into a large walled forecourt where the emperor could make public appearances and speak to the assembled crowd. The soaring core of the chapel is an octagon, surrounded at the ground level by an ambulatory (curving aisle passageway) and on the second floor by a gallery (upper-story passageway overlooking the main space), and rising to a clerestory above the gallery level and under the octagonal dome. Two tiers of paired Corinthian columns and railings at the gallery level form a screen that re-emphasizes the flat, pierced walls of the octagon and enhances the clarity and planar geometry of its design. The effect is quite

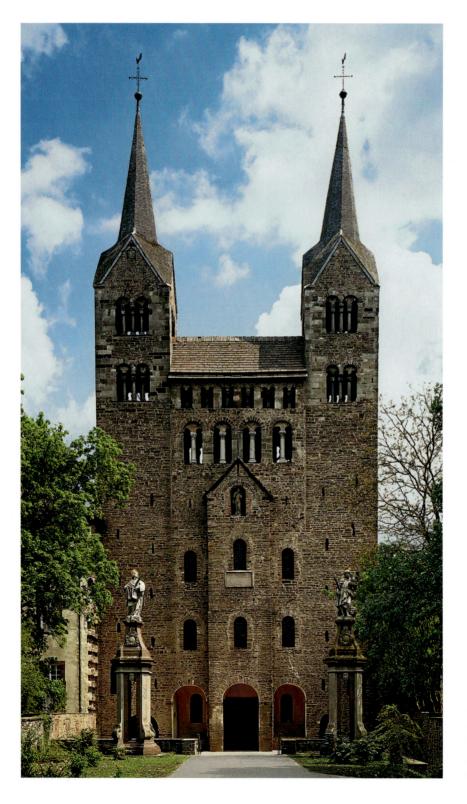

15-17 • WESTWORK, ABBEY CHURCH OF CORVEY Westphalia, Germany. Late 9th century (upper stories mid 12th century). different from the dynamic spatial play and undulating exedrae of San Vitale, but the veneer of richly patterned and multicolored stone—some imported from Italy—on the walls and the mosaics covering the dome at Aachen were clearly inspired by Byzantine architecture.

THE WESTWORK AT CORVEY Originally designed to answer practical requirements of protection and display in buildings such as Charlemagne's palace chapel, the soaring multi-towered westwork came to function symbolically as the outward and very visible sign of an important building and is one of the hallmarks of Carolingian architecture. A particularly well-preserved example is the late ninth-century westwork at the **ABBEY CHURCH OF CORVEY** (**FIG. 15-17**). Even discounting the pierced upper story and towers that were added in the middle of the twelfth century, this is a broad and imposing block of masonry construction. The strong, austere exterior is a symmetrical arrangement of towers flanking a central core punched with a regular pattern of windows and doors, free of elaborate carving or decoration. In addition to providing private spaces for local or visiting dignitaries, the interiors of westworks may have been used for choirs—medieval musical graffiti have been discovered in the interior of this westwork—and they were the starting point for important liturgical processions.

THE SAINT GALL PLAN Monastic life centered on prayer and work, and since it also demanded seclusion, it required a special type of architectural planning. While contemplating how best to house a monastic community, Abbot Haito of Reichenau developed, at the request of his colleague Abbot Gozbert of Saint Gall, a conceptual plan for the layout of monasteries. This extraordinary ninth-century drawing survives in the library of the Abbey of Saint Gall in modern Switzerland and is known as the SAINT GALL PLAN (FIG. 15-18). This is not a "blueprint" in the modern sense, prepared to guide the construction of an actual monastery, but an intellectual record of Carolingian meditations on the nature of monastic life. It does, however, reflect the basic design used in the layout of medieval monasteries, an efficient and functional arrangement that continues to be used by Benedictine monasteries to this day.

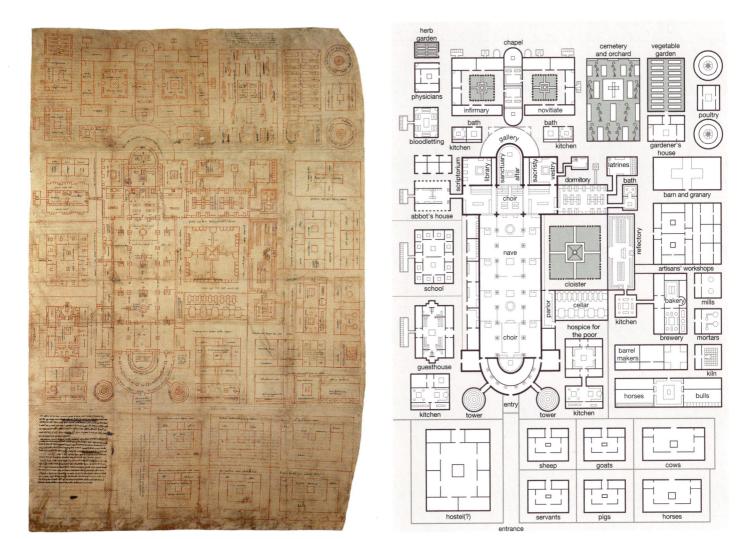

15-18 • SAINT GALL PLAN (ORIGINAL AND REDRAWN WITH CAPTIONS) c. 817. Original in red ink on parchment, 28" × 441/₈" (71.1 × 112.1 cm). Stiftsbibliothek, Saint Gall, Switzerland. Cod. Sang. 1092

At the center of the Saint Gall plan is the **cloister**, an enclosed courtyard around which open all the buildings that are central to the lives of monks. Most prominent is a large basilican church north of the cloister, with towers and multiple altars in nave and aisles as well as in the sanctuary at the east end, where monks would gather for communal prayer throughout the day and night. On the north side of the church were public buildings such as the abbot's house, the school, and the guesthouse. The monks' living quarters lie off the southern and eastern sides of the cloister, with dormitory, refectory (dining room), and work rooms. For night services the monks could enter the church directly from their dormitory. The kitchen, brewery, and bakery were attached to the refectory, and a huge cellar (indicated on the plan by giant barrels) was on the west side. Along the east edge of the plan are the cemetery, hospital, and an educational center for novices (monks in training).

The Saint Gall plan indicates beds for 77 monks in the dor-

mitory. Practical considerations for group living include latrines attached to every unit-dormitory, guesthouse, and abbot's house. Six beds and places in the refectory were reserved for visiting monks. In the surrounding buildings were special spaces for scribes and painters, who spent much of their day in the scriptorium studying and copying books, and teachers who staffed the monastery's schools and library. St. Benedict had directed that monks extend hospitality to all visitors, and the plan includes a hospice for the poor. South and west of the central core were the workshops, farm buildings, and housing for the lay support staff.

15-19 • PAGE WITH ST. MATTHEW THE EVANGELIST, CORONATION GOSPELS

Gospel of Matthew. Early 9th century. 12%'' \times 97/s" (36.3 \times 25 cm). Kunsthistorische Museum, Vienna.

Tradition holds that this Gospel book was buried with Charlemagne in 814, and that in the year 1000 Emperor Otto III removed it from his tomb. Its title derives from its use in the coronation ceremonies of later German emperors.

ILLUSTRATED BOOKS

Books played a central role in the efforts of Carolingian rulers to promote learning, propagate Christianity, and standardize church law and practice. Imperial workshops produced authoritative copies of key religious texts, weeding out the errors that had inevitably crept into books over centuries of copying them by hand. The scrupulously edited versions of ancient and biblical texts that emerged are among the lasting achievements of the Carolingian period. For example, the Anglo-Saxon scholar Alcuin of York, whom Charlemagne called to his court, spent the last eight years of his life producing a corrected copy of the Latin Vulgate Bible. His revision served as the standard text of the Bible for the remainder of the medieval period and is still in use.

Carolingian scribes also worked on standardizing script. Capitals (majuscules) based on ancient Roman inscriptions continued to be used for very formal writing, titles and headings, and luxury

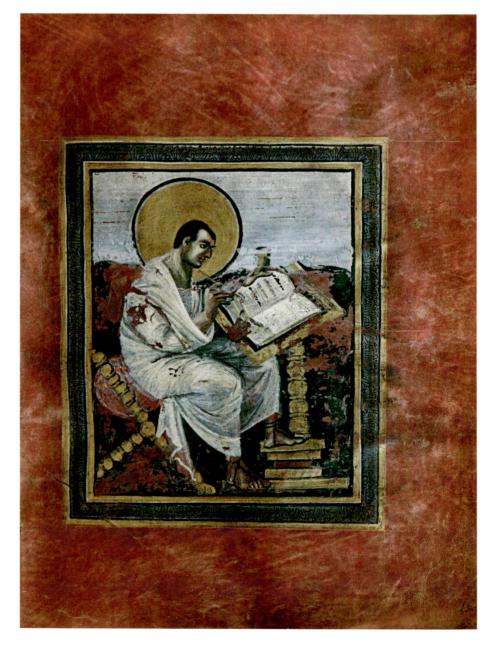

manuscripts. But they also developed a new, clear script called Carolingian minuscule, based on Roman forms but with a uniform lowercase alphabet that increased legibility and streamlined production. So like those who transformed revived Roman types—such as basilicas, central-plan churches, or equestrian Roman portraits—into creative new works, scribes and illuminators revived, reformed, and revitalized established traditions of book production. Notably, they returned the representation of lifelike human figures to a central position. For example, portraits of the evangelists (the authors of the Gospels)—as opposed to the symbols used to represent them in the Book of Durrow (see FIG. 15–5)—began to look like pictures of Roman authors.

THE CORONATION GOSPELS The portrait of Matthew (**FIG. 15-19**) in the early ninth-century Coronation Gospels of Charlemagne conforms to principles of idealized, lifelike representation quite consistent with the Greco-Roman Classical tradition. The full-bodied, white-robed figure is modeled in brilliant white and subtle shading and seated on the cushion of a folding chair set within a freely painted landscape. The way his foot lifts up to rest on the solid base of his writing desk emphasizes his threedimensional placement within an outdoor setting, and the frame enhances the Classical effect of a view seen through a window. Conventions for creating the illusion of solid figures in space may have been learned from Byzantine manuscripts in a monastic library, or from artists fleeing Byzantium as a result of the iconoclastic controversy (see "Iconoclasm," page 247).

THE EBBO GOSPELS The incorporation of the Roman tradition in manuscript painting was not an exercise in slavish copying. It became the basis for a series of creative Carolingian variations. One of the most innovative and engaging is a Gospel book made for Archbishop Ebbo of Reims (archbishop 816–835, 840–841) at the nearby Abbey of Hautvillers (**FIG. 15–20**). The calm, carefully painted grandeur characterizing Matthew's portrait in the Coronation Gospels (see **FIG. 15–19**) has given way here to spontaneous, calligraphic painting suffused with energetic abandon. The passion may be most immediately apparent in the intensity of Matthew's gaze, but the whole composition is charged with energy, from the evangelist's wiry hairdo and rippling drapery, to the rapidly sketched landscape, and even extending into the windblown acanthus leaves of the frame. These forms are related

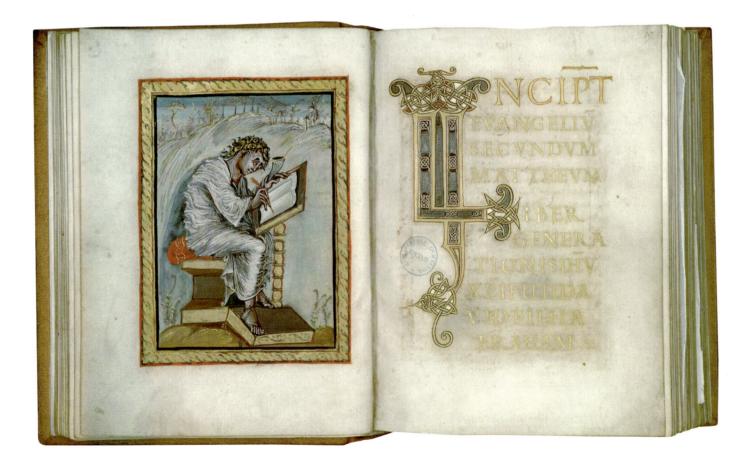

15-20 • PAGE WITH ST. MATTHEW THE EVANGELIST, EBBO GOSPELS Gospel of Matthew. Second quarter of 9th century. Ink, gold, and colors on vellum, $10^{1}/4'' \times 8^{3}/4''$ (26 × 22.2 cm). Médiathèque d'Épernay, France. MS. 1, fol. 18v A CLOSER LOOK | Psalm 23 in the Utrecht Psalter

c. 816–835. Ink on parchment, $13'' \times 9\%''$ (33 \times 25 cm). Utrecht University Library. MS. 32, fol. 13r

AME FICUMCLAMARE REMINISCENTURITCON OMSPINCUISTERRAF. ADEUMEXAUDIUITME. UERTENTURADDNM. INCONSPECTUEIUSCA **CUDTELAUSMEAINEC** UNIVERSIFINESTERRAF DENTOMSQUIDESCEN CLESIAMAGNA UOTA GIADORABUNTIN DUNTINTERRAM MIARIDDAMINCONS CONSPECTUEIUS . **GTANIMAMEAILLIUI** The basilica curtains are UNIVERSALEAMILIAE UET ETSEMENMEUM An angel supports the PECTUTIMENTIUEUM; drawn back to reveal an psalmist with a "rod and DENTRAUPERESETSA GENTIUM SERVIETICSI altar and hanging votive TURABUNTUR ITLAU **QUONIAMDNIESTREG** ADNUNCIABITURDNOCF staff" while anointing his crown: "I will dwell in NERATIOUENTURA H ADNUNCIABUNTIUMI DABUNTONMQUIRE NUM . HIPSEDOMINA head with oil (verses 4 the house of the Lord UIRUNTIUM UI BITURGENTIUM and 5). forever" (verse 6). UINICORDAIORUM MANDUCAUIRUNTIT TIÁTIUS TOPULOOUINAS INSAECULUSAECULI ADORAUIRUNT CITURQUILICITONS The artist has situated the psalmist in a pasture "Thou preparest a table filled with sheep, goats, before me in the presence and cattle, "beside the still of mine enemies" (verse 5). water" (verse 2) of a gently flowing stream. Enemies gather and shoot XXII PSALMUS arrows, but the psalmist The text of Psalm 23 (22 in USRECITORECTVIBIL INMEDIOUMBRAEMOR MEUSINIBRIANSQUAM ignores them to focus on the the Latin Vulgate) begins MIHIDEERIT INLOCOPAS PRATCLARUSIST TIS NONTIMEBOMALA table and the house of the here with the words Dominus CUEIBIMECOLLOCABIT QMTUMECUMES **ETMISERICORDIATUA** Lord, holding a conspicuous regit me ("The Lord ruleth UPERAQUAREFECTIO. **UIRCATUAFIBACULUSTU** SUBSEQUETURME. cup in his hand, presumably me"). This is the Latin NISEDUCAUITME ANI US. IPSAMICONSOLATAST: OMNIBUSDIEBUSUI overflowing (verses 5 and 6). translator's rewording of the MAMEAMCONVERTIT PARASTIINCONSPECTU LAIMIAE Hebrew text of the opening, OEDUXITMESUFERSEMI MEOMENSA ADUERSU **GTUTINHABITIMINDO** TASIUSTITIAE PROPTIR EOSQUITRIBULANTME which is more familiar to MODNI INIONGI NOMENSUUM Christians today as: "The I NEINGUASTIINOLIO TUDINEDLIKUM AMETSIABULAUERO Lord is my shepherd." CAPUTMEUM ETCALIX

Wiew the Closer Look for Psalm 23 in the Utrecht Psalter on myartslab.com

to content since the marked expressionism evokes the evangelist's spiritual excitement as he hastens to transcribe the Word of God delivered by the angel (also serving as Matthew's symbol), who is almost lost in the upper right corner. As if swept up in the saint's turbulent emotions, the footstool tilts precariously, and the top of the desk seems about to detach itself from the pedestal.

THE UTRECHT PSALTER One of the most famous Carolingian manuscripts, the Utrecht Psalter, is illustrated with ink drawings that match the nervous linear vitality encountered in Ebbo's Gospel book. Psalms do not tell straightforward stories but use metaphor and allegory in poems of prayer; they are exceptionally difficult to illustrate. Some psalters bypass this situation by illustrating scenes from the life of the presumed author (see FIG. 8–27), but the artists of the Utrecht Psalter decided to interpret the words and images of individual psalms literally (see "A Closer Look," above). Sometimes the words are acted out, as in a game of charades.

CAROLINGIAN METALWORK

The sumptuously illustrated manuscripts of the medieval period represented an enormous investment of time, talent, and materials, so it is not surprising that they were often protected with equally sumptuous covers. But because these covers were themselves made of valuable materials—ivory, enamelwork, precious metals, and jewels—they were frequently recycled or stolen. The elaborate book cover of gold and jewels, now on the Carolingian manuscript known as the **LINDAU GOSPELS** (FIG. 15-21), was probably made between 870 and 880 at one of the monastic workshops of Charlemagne's grandson, Charles the Bald (r. 840–877), but not for this book. Sometime before the sixteenth century it was reused on a late ninth-century manuscript from the monastery of Saint Gall.

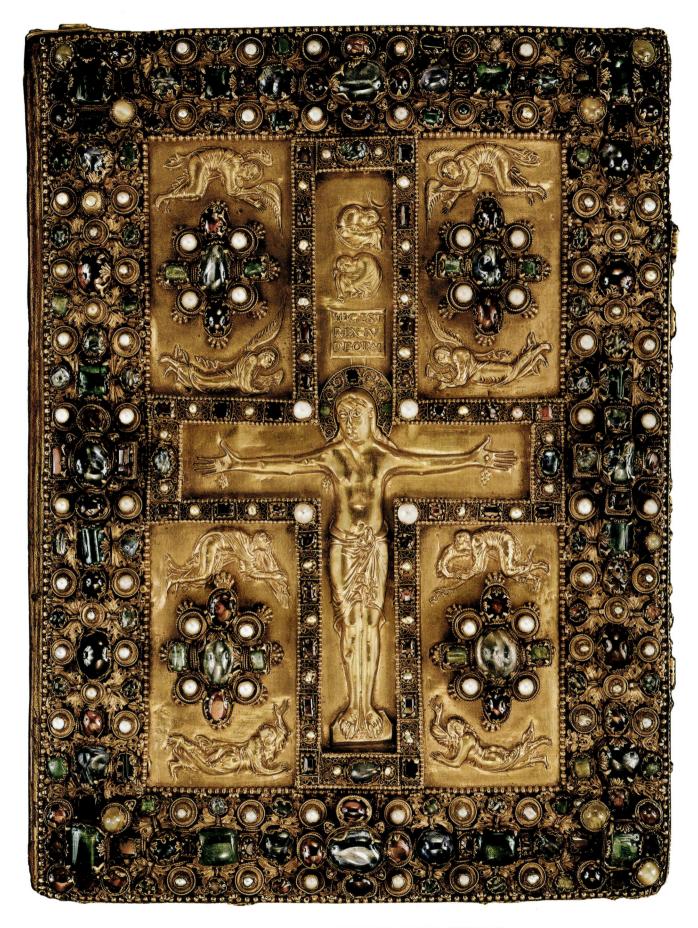

15-21 • CRUCIFIXION WITH ANGELS AND MOURNING FIGURES, LINDAU GOSPELS Outer cover. c. 870–880. Gold, pearls, sapphires, garnets, and emeralds, 13% × 10% (36.9 × 26.7 cm). The Morgan Library and Museum, New York. MS. 1

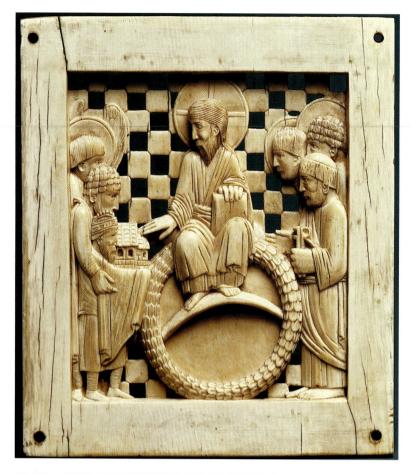

15-22 • OTTO I PRESENTING MAGDEBURG CATHEDRAL TO CHRIST

One of a series of 17 ivory plaques known as the Magdeburg Ivories, possibly carved in Milan. c. 962–968. Ivory, $5'' \times 4\frac{1}{2}''$ (12.7 \times 11.4 cm). Metropolitan Museum of Art, New York. Gift of George Blumenthal, 1941 (41.100.157)

The cross and the Crucifixion were common themes for medieval book covers. This one is crafted in pure gold with figures in repoussé (low relief produced by pushing or hammering up from the back of a panel of metal to produce raised forms on the front) surrounded by heavily jeweled frames. The jewels are raised on miniature arcades to allow reflected light to pass through them from beneath, imparting a lustrous glow, and also to allow light traveling in the other direction to reflect from the shiny surface of the gold.

Grieving angels hover above the arms of the cross, and earthbound mourners twist in agony below. Over Jesus' head personifications of the sun and the moon hide their faces in anguish. The gracefully animated poses of these figures, who seem to float around the jeweled bosses in the compartments framed by the arms of the cross, extend the expressive style of the Utrecht Psalter illustrations into another medium and a later moment. Jesus, on the other hand, has been modeled in a more rounded and calmer Classical style. He seems almost to be standing in front of the cross straight, wide-eyed, with outstretched arms, as if to prefigure his ultimate triumph over death. The flourishes of blood that emerge from his wounds are almost decorative. There is little, if any, sense of his suffering.

OTTONIAN EUROPE

In 843, the Carolingian Empire was divided into three parts, ruled by three grandsons of Charlemagne. One of them was Charles the Bald, whom we have already encountered (see FIG. 15-15). Another, Louis the German, took the eastern portion, and when his family died out at the beginning of the tenth century, a new Saxon dynasty came to power in lands corresponding roughly to presentday Germany and Austria. We call this dynasty Ottonian after its three principal rulers-Otto I (r. 936-973), Otto II (r. 973-983), and Otto III (r. 983-1002; queens Adelaide and Theophanu ruled as regents for him, 983-994). After the Ottonian armies defeated the Vikings in the north and the Magyars (Hungarians) on the eastern frontiers, the resulting peace permitted increased trade and the growth of towns, making the tenth century a period of economic recovery. Then, in 951, Otto I added northern Italy to his domain by marrying the widowed Lombard queen, Adelaide. He also re-established Charlemagne's Christian Roman Empire when he was crowned emperor by the pope in 962. The Ottonians and their successors so dominated the papacy and appointments to other high offices of the Church that in the twelfth century this union of Germany and Italy under a German ruler came to be known as the Holy Roman Empire. The empire survived in modified form as the Habsburg empire into the early twentieth century.

The Ottonian ideology, rooted in unity of Church and state, takes visual form on an ivory plaque, one of several that may once have been part of the decoration of an altar or pulpit presented to Magdeburg Cathedral at the time of its dedication in 968 (**FIG. 15-22**). Otto I presents a model of the cathedral to Christ and St. Peter. Hierarchic scale demands that the mighty emperor be represented as the smallest figure, and that the saints and angels, in turn, be taller than Otto but smaller than Christ. Otto is embraced by the patron saint of this church, St. Maurice, who was a third-century military commander martyred for refusing to worship pagan gods. The cathedral Otto holds is a basilica with prominent clerestory windows and a rounded apse that, like the character of the Carolingian basilicas before it, was intended to recall the Early Christian churches of Rome.

OTTONIAN ARCHITECTURE

As we have just seen, Ottonian rulers, in keeping with their imperial status, sought to replicate the splendors both of the Christian architecture of Rome and of the Christian empire of their Carolingian predecessors. German officials knew Roman basilicas well, since the German court in Rome was located near the Early Christian church of Santa Sabina (see FIGS. 7-10, 7-11). The buildings of Byzantium were another important influence, especially after Otto II married a Byzantine princess, cementing a tie with the East. But large timber-roofed basilicas were terribly vulnerable to fire. Magdeburg Cathedral burned down in 1008, only 40 years after its dedication; it was rebuilt in 1049, burned down again in 1207, and was rebuilt yet again. In 1009, the Cathedral of Mainz burned down on the day of its consecration. The church of St. Michael at Hildesheim was destroyed in World War II. Luckily the convent church of St. Cyriakus at Gernrode, Germany, still survives.

THE CONVENT CHURCH OF ST. CYRIAKUS IN GERN-RODE During the Ottonian Empire, aristocratic women often held positions of authority, especially as leaders of religious communities. When, in 961, the provincial military governor Gero founded the convent and **CHURCH OF ST. CYRIAKUS**, he installed his widowed daughter-in-law as the convent's first abbess. The church was designed as a basilica with a westwork flanked by circular towers (**FIG. 15-23**). At the eastern end, a transept with chapels led to a choir with an apse built over a crypt.

Like an Early Christian or Carolingian basilica, the interior of St. Cyriakus (see FIG. 15–23B) has a nave flanked by side aisles. But the design of the three-level wall elevation—nave arcade, gallery, and clerestory—creates a rhythmic effect distinct from the uniformity that had characterized earlier basilicas. Rectangular piers alternate with round columns in the two levels of arcades, and at gallery level, pairs of openings are framed by larger arches and then grouped in threes. The central rectangular piers, aligned on the two

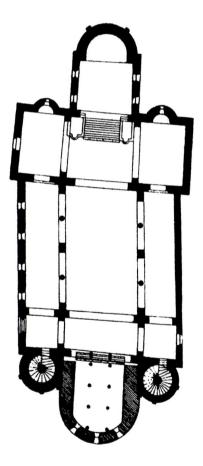

15-23 • PLAN (A) AND INTERIOR (B), CHURCH OF ST. CYRIAKUS, GERNRODE

Harz, Saxony-Anhalt, Germany. Begun 961; consecrated 973.

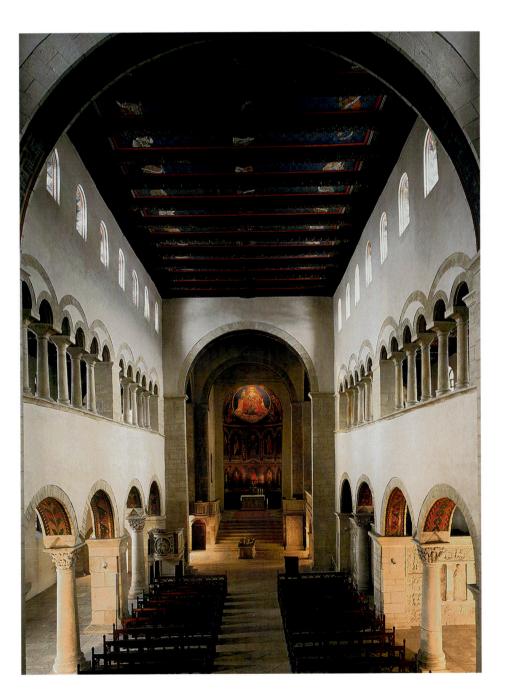

levels, bisect the walls vertically into two units, each composed of two broad arches of the nave arcade surmounted by three pairs of arches at the gallery level. This seemingly simple design, with its rhythmic alternation of heavy and light supports, its balance of rectangular and rounded forms, and its combination of horizontal and vertical movements, seems to prefigure the aesthetic exploration of wall design that will characterize the Romanesque architecture of the next two centuries.

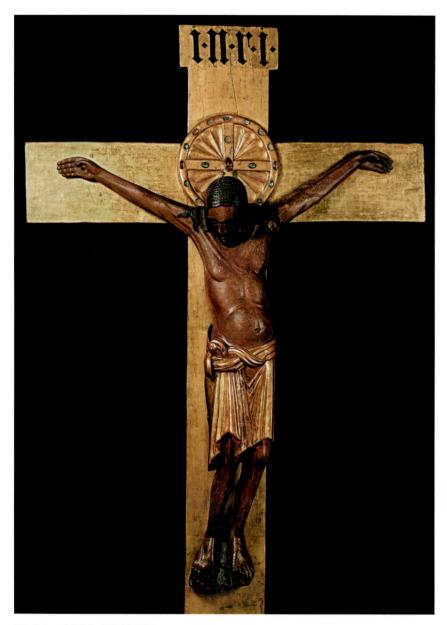

15-24 • GERO CRUCIFIX

Cologne Cathedral, Germany. c. 970. Painted and gilded wood, height of figure 6'2" (1.88 m).

This life-size sculpture is both a crucifix to be suspended over an altar and a special kind of reliquary. A cavity in the back of the head was made to hold a piece of the Host, or Communion bread, already consecrated by the priest. Consequently, the figure not only represents the body of the dying Jesus but also contains a "relic" of the Eucharistic body of Christ. In fact, the Ottonian chronicle of Thietmar of Meresburg (written 1012–1018) claims that Gero himself placed a consecrated Host, as well as a fragment of the true cross, in a crack that formed within the head of this crucifix and prayed that it be closed, which it was.

OTTONIAN SCULPTURE

Ottonian sculptors worked in ivory, bronze, wood, and other materials rather than stone. Like their Early Christian and Byzantine predecessors, they and their patrons focused on church furnishings and portable art rather than architectural sculpture. Drawing on Roman, Early Christian, Byzantine, and Carolingian models, they created large works in wood and bronze that would have a significant influence on later medieval art.

> THE GERO CRUCIFIX The GERO CRUCIFIX is one of the few large works of carved wood to survive from the early Middle Ages (FIG. 15-24). Archbishop Gero of Cologne (archbishop 969-976) commissioned the sculpture for his cathedral about 970. The life-size figure of Christ is made of painted and gilded oak. The focus here is on Jesus' human suffering. He is shown as a tortured martyr, not as the triumphant hero of the Lindau Gospels cover (see FIG. 15-21). His broken body sags on the cross and his head falls forward, eyes closed. The straight, linear fall of his golden drapery heightens the impact of his drawn face, emaciated arms and legs, sagging torso, and limp, bloodied hands. This is a poignant image of distilled anguish, meant to inspire pity and awe in the empathetic responses of its viewers.

> THE HILDESHEIM DOORS Under the last of the Ottonian rulers, Henry II and Queen Kunigunde (r. 1002-1024), Bishop Bernward of Hildesheim emerged as an important patron. His biographer, the monk Thangmar, described Bernward as a skillful goldsmith who closely supervised the artists working for him. Bronze doors made under his direction for the abbey church of St. Michael in Hildesheim-and installed by him, according to the inscription on them, in 1015-represented the most ambitious and complex bronze-casting project undertaken since antiquity (FIG. 15-25). Each door, including the impressive lion heads holding the ring handle, was cast as a single piece in the lost-wax process (see page 418) and later detailed and reworked with chisels and fine tools. Rounded and animated figures populate spacious backgrounds. Architectural elements and features of the landscape are depicted in lower relief, so that the figures stand out prominently, with their heads fully modeled in three dimensions. The result is lively, visually stimulating, and remarkably spontaneous for so monumental an undertaking.

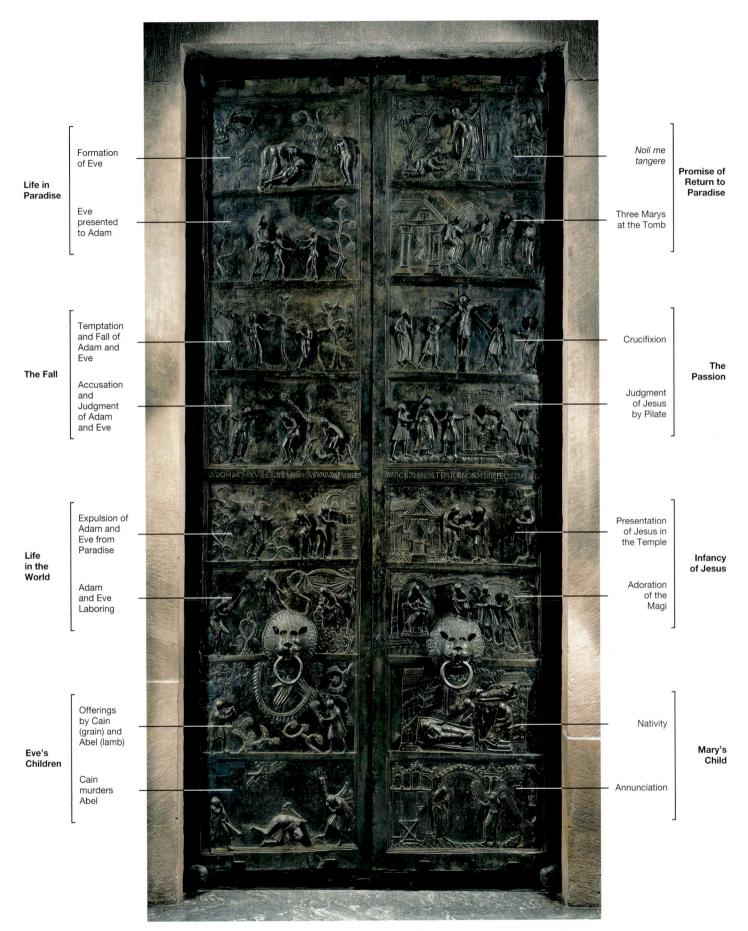

^{15-25 •} DOORS OF BISHOP BERNWARD Made for the abbey church of St. Michael, Hildesheim, Germany. 1015. Bronze, height 16'6" (5 m).

The doors, standing more than 16 feet tall, portray events from the Hebrew Bible on the left (reading down from the creation of Eve at the top to Cain's murder of Abel at the bottom) and from the New Testament on the right (reading upward from the Annunciation at the bottom to the *Noli me tangere* at the top). In each pair of scenes across from each other, the Hebrew Bible event is meant to present a prefiguration of or complement to the adjacent New Testament event. For instance, the third panel down on the left shows Adam and Eve picking the forbidden fruit in the Garden of Eden, believed by Christians to be the source of human sin, suffering, and death. The paired scene on the right shows the Crucifixion of Jesus, whose sacrifice was believed to have atoned for Adam and Eve's original sin, bringing the promise of eternal life. At the center of the doors, six panels down—between the

door pulls—Eve (left) and Mary (right) sit side by side, holding their sons. Cain (who murdered his brother) and Jesus (who was unjustly executed) signify the opposition of evil and good, damnation and salvation. Other telling pairs are the murder of Abel (the first sin) with the Annunciation (the advent of salvation) at the bottom, and, fourth from the top, the passing of blame from Adam and Eve to the serpent paired with Pilate washing his hands of any responsibility in the execution of Jesus.

ILLUSTRATED BOOKS

Like their Carolingian predecessors, Ottonian monks and nuns created richly illuminated manuscripts, often funded by secular rulers. Styles varied from place to place, depending on the traditions of the particular scriptorium, the models available in its library, and the creativity of its artists.

THE HITDA GOSPELS The presentation page of a Gospel book made in the early eleventh century for Abbess Hitda (d. 1041) of Meschede, near Cologne (**Fig. 15-26**) represents one of the most distinctive local styles. The abbess herself appears here, offering the book to St. Walpurga,

15-26 • PRESENTATION PAGE WITH ABBESS HITDA AND ST. WALPURGA, HITDA GOSPELS

Early 11th century. Ink and colors on vellum, $11^{3}\!\!/'_{a''} \times 5^{5}\!\!/'_{a''}$ (29 \times 14.2 cm). Universitäts- und Landesbibliothek, Darmstadt.

her convent's patron saint. The artist has angled the buildings of the sprawling convent in the background to frame the figures and draw attention to their interaction. The size of the architectural complex underscores the abbess's position of authority. The foreground setting—a rocky, undulating strip of landscape—is meant to be understood as holy ground, separated from the rest of the world by golden trees and the huge arch-shape aura that silhouettes St. Walpurga. The energetic spontaneity of the painting style suffuses the scene with a sense of religious fervor appropriate to the visionary saintly encounter.

THE GOSPELS OF OTTO III This Gospel book, made in a German monastery near Reichenau about 1000, shows another Ottonian painting style, in this case inspired by Byzantine art

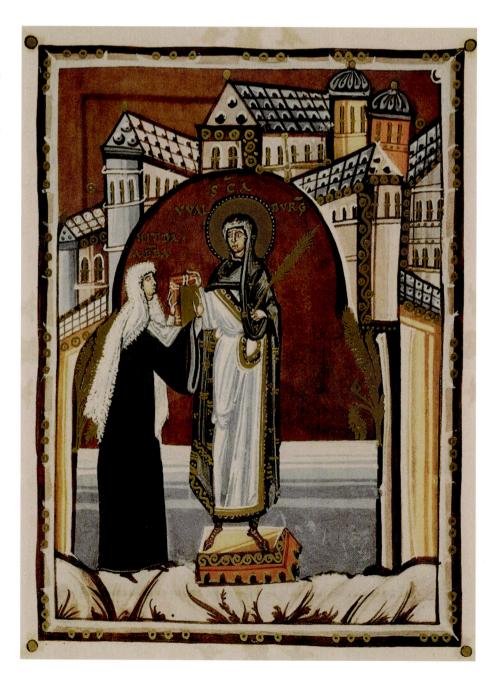

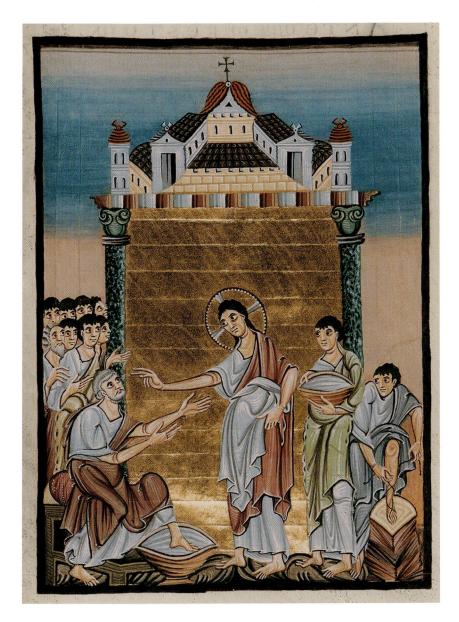

15-27 • PAGE WITH CHRIST WASHING THE FEET OF HIS DISCIPLES, GOSPELS OF OTTO III

c. 1000. Ink, gold, and colors on vellum, approx. $8'' \times 6''$ (20.5 \times 14.5 cm). Bayerische Staatsbibliothek, Munich. Clm 4453, fol. 237r

in the use of sharply outlined drawing and lavish fields of gold (FIG. 15-27). Backed by a more controlled and balanced architectural canopy than that sheltering Hitda and St. Walpurga, these tall, slender men gesture dramatically with long, thin fingers. The scene captures the moment when Jesus washes the feet of his disciples during their final meal together (John 13:1-17). Peter, who had tried to stop his Savior from performing this ancient ritual of hospitality, appears at left, one leg reluctantly poised over the basin, while a centrally silhouetted and hierarchically scaled Jesus gestures emphatically to underscore the necessity and significance of the act. Another disciple, at far right, enthusiastically raises his leg to untie his sandals so he can be next in line. Selective stylization has allowed the artist of this picture to transform the received Classical tradition into a style of stunning expressiveness and narrative power, features that will also characterize the figural styles associated with Romanesque art.

THINK ABOUT IT

- 15.1 Characterize the styles of painting that developed in Spain for the illustration of commentaries on the Apocalypse and in the Ottonian world for visualizing sacred narrative. Focus your answer on specific examples discussed in this chapter.
- **15.2** Discuss the themes and subjects used for the paintings in early medieval Gospel books by comparing two specific examples from different parts of Europe.
- **15.3** Explain the references to early Christian Roman traditions in Carolingian architecture. How did Carolingian builders transform their models?
- 15.4 Compare the renderings of the crucified Christ on the cover of the Lindau Gospels (FIG. 15-21) and the Gero Crucifix (FIG. 15-24). Consider the differences in media and expressive effect, as well as in style and scale.

CROSSCURRENTS

FIG. 6-57

The equestrian portrait on the right consciously emulates the Roman tradition represented by the work on the left. For the early Middle Ages, this sort of creative appropriation was common artistic practice. Discuss what it tells us about the Carolingians, grounding your answer in a discussion of these two works.

Study and review on myartslab.com

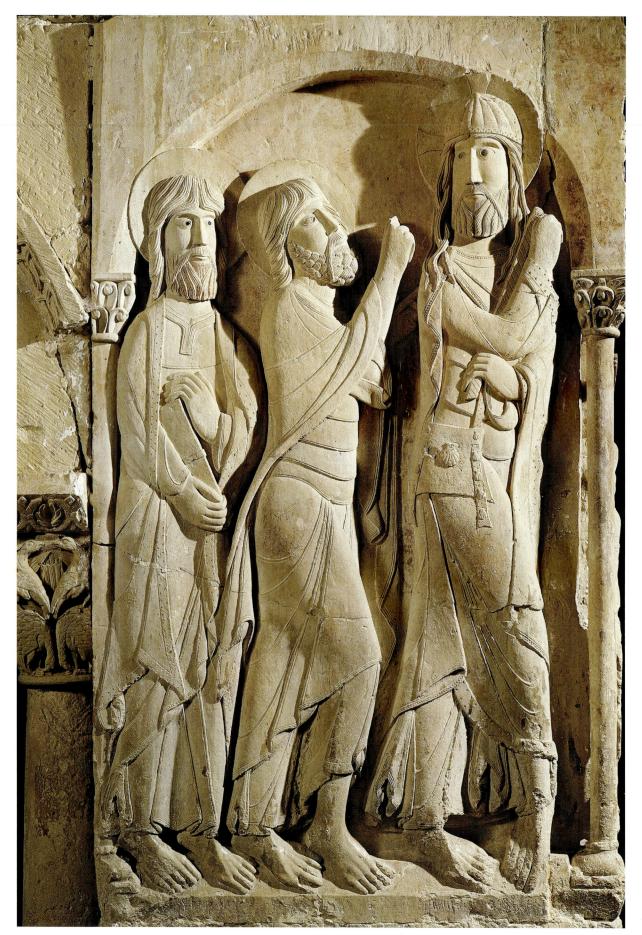

16-1 • CHRIST AND DISCIPLES ON THE ROAD TO EMMAUS Cloister of the abbey of Santo Domingo, Silos, Castile, Spain. c. 1100. Pier relief, figures nearly life-size.

The three men seem to glide forward on tiptoe as their leader turns back, reversing their forward movement (**FIG. 16-1**). Their bodies are sleek; legs cross in gentle angles rather than vigorous strides; their shoulders, elbows, and finger joints melt into languid curves; draperies delicately delineate shallow contours; bearded faces stare out with large, wide eyes under strong, arched brows. The figures interrelate and interlock, pushing against the limits of the architectural frame.

Medieval viewers would have quickly identified the leader as Christ, not only by his commanding size, but specifically by his cruciform halo. The sanctity of his companions is signified by their own haloes. The scene recalls to faithful Christians the story of the resurrected Christ and two of his disciples on the road from Jerusalem to Emmaus (Luke 24:13-35). Christ has the distinctive attributes of a medieval pilgrim-a hat, a satchel, and a walking stick. Even the scallop shell on his satchel is the badge worn by pilgrims to a specific site: the shrine of St. James at Santiago de Compostela. Early pilgrims reaching this destination in the far northwestern corner of the Iberian peninsula continued to the coast to pick up a shell as evidence of their journey. Soon shells were gathered (or fabricated from metal as brooches) and sold to the pilgrims-a lucrative business for both the sellers and the church. On the return journey home, the shell became the pilgrims' passport, a badge attesting to their piety

Romanesque Art

and accomplishment. Other distinctive badges were adopted at other pilgrimage sites.

This relief was carved on a corner pier in the cloister of the monastery of Santo Domingo in Silos, a major eleventh- and twelfth-century center of religious and artistic life south of the pilgrimage road across Spain (see "The Pilgrim's Journey to Santiago," page 464). It engaged an audience of monks-who were well versed in the meaning of Christian images—through a sculptural style that we call Romanesque. Not since the art of ancient Rome half a millennium earlier had sculptors carved monumental figures in stone within an architectural fabric. During the early Middle Ages, sculpture was small-scale, independent, and created from precious materials-a highlighted object within a sacred space rather than a part of its architectural envelope. But during the Romanesque period, narrative and iconic figural imagery in deeply carved ornamental frameworks would collect around the entrances to churches, focusing attention on their compelling portal complexes. These public displays of Christian doctrine and moral teaching would have been part of the cultural landscape surveyed by pilgrims journeying along the road to Santiago. Travel as a pilgrim opened the mind to a world beyond the familiar towns and agricultural villages of home, signaling a new era in the social, economic, and artistic life of Europe.

LEARN ABOUT IT

- **16.1** Explore the emergence of Romanesque architecture—with its emphasis on the aesthetic qualities of a sculptural wall—out of early masonry construction techniques.
- **16.2** Investigate the integration of painting and sculpture within the Romanesque building, and consider the themes and subjects that were emphasized.
- **16.3** Assess the cultural and social impact of monasticism and pilgrimage on the design and embellishment of church architecture.
- **16.4** Explore the eleventh- and twelfth-century interest in telling stories of human frailty and sanctity in sculpture, textiles, and manuscript painting—stories that were meant to appeal to the feelings as well as to the minds of viewers.

((•• Listen to the chapter audio on myartslab.com

EUROPE IN THE ROMANESQUE PERIOD

At the beginning of the eleventh century, Europe was still divided into many small political and economic units ruled by powerful families, such as the Ottonians in Germany (MAP 16-1). The nations we know today did not exist, although for convenience we shall use present-day names of countries. The king of France ruled only a small area around Paris known as the Île-de-France. The southern part of modern France had close linguistic and cultural ties to northern Spain; in the north the duke of Normandy (heir of the Vikings) and in the east the duke of Burgundy paid the French king only token homage.

When in 1066 Duke William II of Normandy (r. 1035–1087) invaded England and, as William the Conqueror, became that country's new king, Norman nobles replaced the Anglo-Saxon nobility there, and England became politically and culturally allied with Normandy. As astute and skillful administrators, the Normans formed a close alliance with the Church, supporting it with grants of land and gaining in return the allegiance of abbots and bishops. Normandy became one of Europe's most powerful domains. During this period, the Holy Roman Empire, re-established by the Ottonians, encompassed much of Germany and northern Italy, while the Iberian peninsula remained divided between Muslim rulers in the south and Christian rulers in the north. By 1085, Alfonso VI of Castile and León (r. 1065-1109) had conquered the Muslim stronghold of Toledo, a center of Islamic and Jewish culture in the kingdom of Castile. Catalunya (Catalonia) emerged as a power along the Mediterranean coast.

By the end of the twelfth century, however, a few exceptionally intelligent and aggressive rulers had begun to create national states. The Capetians in France and the Plantagenets in England were especially successful. In Germany and northern Italy, the power of local rulers and towns prevailed, and Germany and Italy remained politically fragmented until the nineteenth century.

POLITICAL, ECONOMIC, AND SOCIAL LIFE

Although towns and cities with artisans and merchants grew in importance, Europe remained an agricultural society, and developing agricultural practices in this period led to expanded food supplies and population growth. Land was the primary source of wealth and power for a hereditary aristocracy. Allegiances, obligations, and social relations among members of the upper echelons of society, as well as between them and the peasants who lived and worked on their land, were not static, but were subject to long- and short-term changes in power and wealth. Patterns of political and social dependencies, expectations, and obligations varied extensively from place to place, and from community to community. Life was often difficult, and people from all levels of society were vulnerable to the violence of warfare—both local and general—as well as recurrent famine and disease.

THE CHURCH

In the early Middle Ages, Church and state had forged some fruitful alliances. Christian rulers helped ensure the spread of Christianity throughout Europe and supported monastic communities with grants of land. Bishops and abbots were often royal relatives, younger brothers and cousins, who supplied crucial social and spiritual support and a cadre of educated administrators. As a result, secular and religious authority became tightly intertwined, and this continued through the Romanesque period. Monasteries continued to sit at the center of European culture, but there were two new cultural forces fostered by the Church: pilgrimages and crusades.

MONASTICISM Although the first universities were established in the eleventh and twelfth centuries in the growing cities of Bologna, Paris, Oxford, and Cambridge, monastic communities continued to play a major role in intellectual life. As in the early Middle Ages, monks and nuns also provided valuable social services, including caring for the sick and destitute, housing travelers, and educating the elite. Because monasteries were major landholders, abbots and priors were part of the political power structure. The children of aristocratic families continued to join religious orders, strengthening links between monastic communities and the ruling elite.

As life in Benedictine communities grew increasingly comfortable and intertwined with the secular world, reform movements sought a return to earlier monastic austerity and spirituality. The most important groups of reformers for the arts were the Burgundian congregation of Cluny, established in the tenth century, and later the Cistercians, who sought reform of what they saw as Cluniac decadence and corruption of monastic values.

PILGRIMAGES Pilgrimages to three of the holiest places of Christendom—Jerusalem, Rome, and Santiago de Compostela increased (see "The Pilgrim's Journey to Santiago," page 464), although the majority of pilgrimages were probably more local. Rewards awaited courageous travelers along the routes, both long and short. Pilgrims on long journeys could venerate the relics of local saints along the route, and artists and architects were commissioned to create spectacular and enticing new buildings and works of art to capture their attention.

CRUSADES In the eleventh and twelfth centuries, Christian Europe, previously on the defensive against the expanding forces of Islam, became the aggressor. In Spain, Christian armies of the north were increasingly successful against Islamic kingdoms in the south. At the same time, the Byzantine emperor asked the pope for help in his war with the Muslims surrounding his domain. The Western Church responded in 1095 by launching a series of holy wars, military offensives against Islamic powers known collectively as the crusades (from the Latin *crux*, referring to the cross crusaders wore).

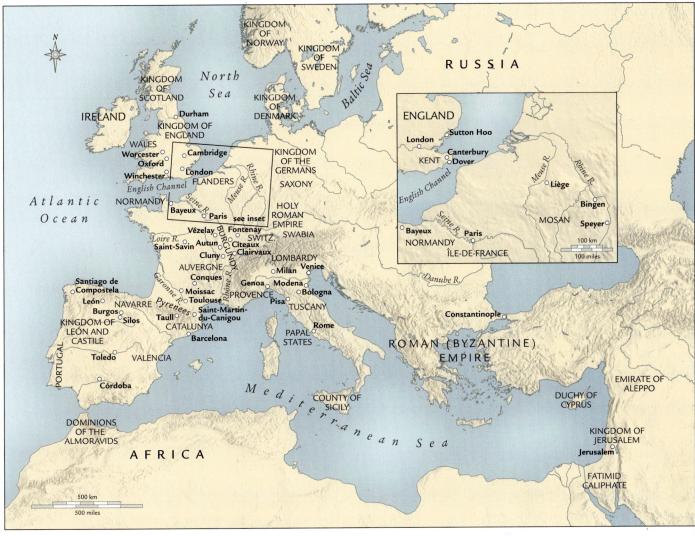

MAP 16-1 • EUROPE IN THE ROMANESQUE PERIOD

Although a few large political entities began to emerge in places like England and Normandy, Burgundy, and León/Castile, Europe remained a land of small economic entities. Pilgrimages, monasticism, and crusades acted as unifying international forces.

This First Crusade was preached by Pope Urban II (pontificate 1088-1099) and fought by the lesser nobility of France, who had economic and political as well as spiritual objectives. The crusaders captured Jerusalem in 1099 and established a short-lived kingdom. The Second Crusade in 1147, preached by St. Bernard and led by France and Germany, accomplished nothing. The Muslim leader Saladin united the Muslim forces and captured Jerusalem in 1187, inspiring the Third Crusade, led by German, French, and English kings. The Europeans recaptured some territory, but not Jerusalem, and in 1192 they concluded a truce with the Muslims, permitting the Christians access to the shrines in Jerusalem. Although the crusades were brutal military failures, the movement had far-reaching cultural and economic consequences, providing western Europeans with direct encounters with the more sophisticated material culture of the Islamic world and the Byzantine Empire. This in turn helped stimulate trade, and with trade came the development of an increasingly urban society during the eleventh and twelfth centuries.

ROMANESQUE ART

The word "Romanesque," meaning "in the Roman manner," was coined in the early nineteenth century to describe early medieval European church architecture, which often displayed the solid masonry walls and rounded arches and vaults characteristic of imperial Roman buildings. Soon the term was applied to all the arts of the period from roughly the mid-eleventh century to the second half of the twelfth century, even though that art derives from a variety of sources and reflects a multitude of influences, not just Roman.

This was a period of great building activity in Europe. New castles, manor houses, churches, and monasteries arose everywhere. One eleventh-century monk claimed that the Christian faithful were so relieved to have passed through the apocalyptic anxiety that had gripped their world at the millennial change around the year 1000, that, in gratitude, "Each people of Christendom rivaled with the other, to see which should worship in the finest buildings.

The world shook herself, clothed everywhere in a white garment of churches" (Radulphus Glaber, cited in Holt, vol. I, p. 18) (see FIG. 16–2). The desire to glorify the house of the Lord and his saints (whose earthly remains in the form of relics kept their presence alive in the minds of the people) increased throughout Christendom. There was a veritable building boom.

ARCHITECTURE

Romanesque architecture and art is a trans-European phenomenon, but it was inflected regionally, and the style varied in character from place to place. Although timber remained common in construction, Romanesque builders used stone masonry extensively. Masonry vaults were stronger and more durable, and they enhanced the acoustical effect of Gregorian chant (plainsong, named after Pope Gregory the Great, pontificate 590–604). Stone

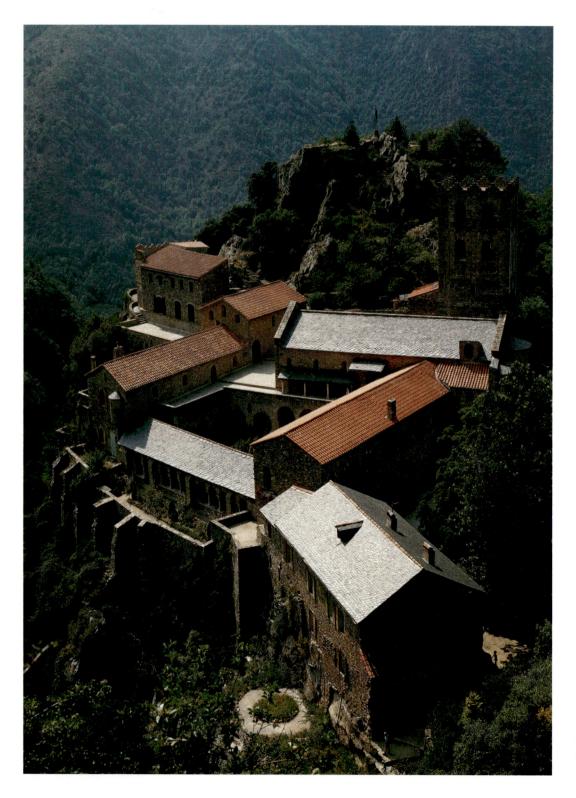

16-2 • SAINT-MARTIN-DU-CANIGOU French Pyrenees. 1001–1026. towers sometimes marked the church as the most important building in the community. Portals were often encrusted with sculpture that broadcast the moral and theological messages of the Church to a wide public.

"FIRST ROMANESQUE"

Soon after the year 1000, patrons and builders in Catalunya (northeast Spain), southern France, and northern Italy were already constructing all-masonry churches, employing the methods of late Roman builders. The picturesque Benedictine monastery of **SAINT-MARTIN-DU-CANIGOU**, nestled into the Pyrenees on a building platform stabilized by strongly buttressed retaining walls, is a typical example (**FIG. 16-2**). Patronized by the local Count Guifred, who took refuge in the monastery and died here in 1049, the complex is capped by a massive stone tower sitting next to the sanctuary of the two-story church. Art historians call such early stone-vaulted buildings "First Romanesque," employing the term that Catalan architect and theorist Josep Puig I Cadafalch first associated with them in 1928.

THE CHURCH OF SANT VINCENC, CARDONA Another fine example of "First Romanesque" is the CHURCH OF SANT VINCENC (St. Vincent) in the Catalan castle of Cardona (Fig. 16-3). Begun in the 1020s, it was consecrated in 1040. Castle residents entered the church through a two-story narthex into a nave with low narrow side aisles that permitted clerestory windows in the nave wall. The sanctuary was raised dramatically over an aisled crypt. The Catalan masons used local materials—small split stones, bricks, even river pebbles, and very strong mortar—to raise plain walls and round barrel or groin vaults. Today we can admire their skillful stonework both inside and out, but the builders originally covered their masonry with a facing of stucco.

To strengthen the exterior walls, and to enrich their sculptural presence, the masons added vertical bands of projecting masonry (called strip buttresses) joined by arches and additional courses of masonry to counter the weight and outward thrust of the vault. On the interior these masonry strips project from the piers and continue up and over the vault, creating a series of **transverse arches**. Additional projecting bands line the underside of the arches of the nave arcade. The result is a compound, sculptural pier that works in concert with the transverse arches to divide the nave into a series of bays. This system of bay division became standard in Romanesque architecture. It is a marked contrast to the flat-wall continuity and undivided space within a pre-Romanesque church like Gernrode (see FIG. 15–23).

PILGRIMAGE CHURCHES

The growth of a cult of relics and the desire to visit holy shrines such as St. Peter's in Rome or St. James's in Spain, as well as the shrines of local saints, increasingly inspired Christians in western Europe to travel on pilgrimages (see "The Pilgrim's Journey to Santiago," page 464). To accommodate the faithful and

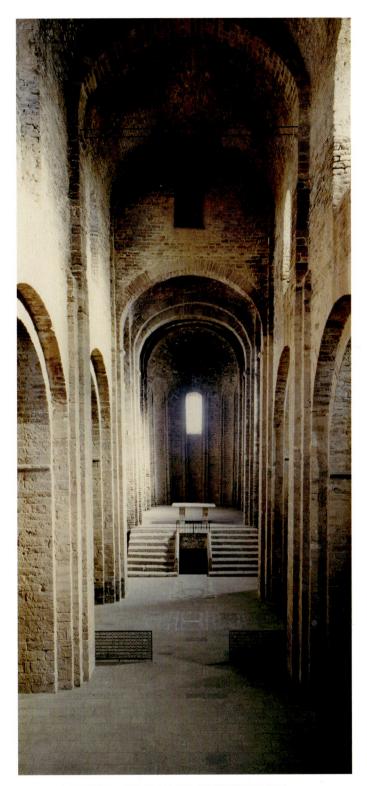

16-3 • INTERIOR, CHURCH OF SANT VINCENC, CARDONA 1020s-1030s.

proclaim Church doctrine, many monasteries—including those on the major pilgrimage routes—built large new churches, filled them with sumptuous altars and reliquaries, and encrusted them with elaborate stone sculpture on the exterior, especially around entrances.

ART AND ITS CONTEXTS | The Pilgrim's Journey to Santiago

Western Europe in the eleventh and twelfth centuries saw the growing popularity of religious pilgrimage—much of it local, but some of it international. The rough roads that led to the holiest destinations—the tomb of St. Peter and other martyrs in Rome, the church of the Holy Sepulcher in Jerusalem, and the cathedral of St. James in Santiago de Compostela in the northwest corner of Spain—were often crowded with pilgrims. Their journeys could last a year or more; church officials going to Compostela were given 16 weeks' leave of absence. Along the way the pilgrims had to contend with bad food and poisoned water, as well as bandits and dishonest innkeepers and merchants.

In the twelfth century, the priest Aymery Picaud wrote a guidebook for pilgrims on their way to Santiago through what is now France. Like travel guides today, Picaud's book provided advice on local customs, comments on food and the safety of drinking water, and a list of useful words in the Basque language. In Picaud's time, four main pilgrimage routes to Santiago crossed France, merging into a single road in Spain at Puente la Reina and leading on from there through Burgos and León to Compostela (MAP 16-2). Conveniently spaced monasteries and churches offered food and lodging, as well as relics to venerate. Roads and bridges were maintained by a guild of bridge builders and guarded by the Knights of Santiago.

Picaud described the best-traveled routes and most important shrines to visit along the way. Chartres, for example, housed the tunic that the Virgin was said to have worn when she gave birth to Jesus. The monks of Vézelay had the bones of St. Mary Magdalen, and at Conques,

THE CATHEDRAL OF ST. JAMES IN SANTIAGO DE COM-**POSTELA** One major goal of pilgrimage was the **CATHEDRAL** OF ST. JAMES in Santiago de Compostela (FIG. 16-4), which held the body of St. James, the apostle to the Iberian peninsula. Builders of this and several other major churches along the roads leading through France to the shrine developed a distinctive plan designed to accommodate the crowds of pilgrims and allow them to move easily from chapel to chapel in their desire to venerate relics (see "Relics and Reliquaries," page 467). This "pilgrimage plan" is a model of functional planning and traffic control. To the aisled nave the builders added aisled transepts with eastern chapels leading to an ambulatory (curving walkway) with additional radiating chapels around the apse. This expansion of the basilican plan allowed worshipers to circulate freely around the church's perimeter, visiting chapels and venerating relics without disrupting services within the main space.

At Santiago, pilgrims entered the church through the large double doors at the ends of the transepts rather than through the western portal, which served ceremonial processions. Pilgrims from France entered the north transept portal; the approach from the town was through the south portal. All found themselves in a transept in which the design exactly mirrored the nave in height and structure (**FIG. 16–5**). Both nave and transept have two stories—an arcade and a gallery. Compound piers with attached halfcolumns the skull of Sainte Foy was to be found. Churches associated with miraculous cures—Autun, for example, which claimed to house the relics of Lazarus, raised by Jesus from the dead—were filled with the sick and injured praying to be healed.

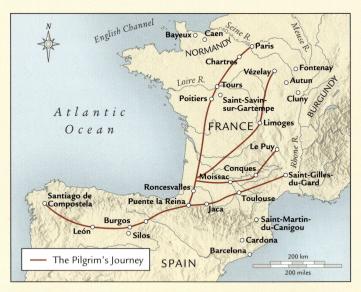

MAP 16-2 • THE PILGRIMAGE ROUTES TO SANTIAGO DE COMPOSTELA

on all four sides support the immense barrel vault and are projected over it vertically through a rhythmic series of transverse arches. They give sculptural form to the interior walls and also mark off individual vaulted bays in which the sequence is as clear and regular as the ambulatory chapels of the choir. Three different kinds of vaults are used here: barrel vaults with transverse arches cover the nave, groin vaults span the side aisles, and halfbarrel or quadrant vaults cover the galleries and strengthen the building by countering the outward thrust of the high nave vaults and transferring it to the outer walls and buttresses. Without a clerestory, light enters the nave and transept only indirectly, through windows in the outer walls of the aisles and upper-level galleries. Light from the choir clerestory and the large windows of an octagonal lantern tower (a structure built above the height of the main ceiling with windows that illuminate the space below) over the crossing would therefore spotlight the glittering gold and jeweled shrine of the principal relic at the high altar.

In its own time, Santiago was admired for the excellence of its construction—"not a single crack is to be found," according to the twelfth-century pilgrims' guide—"admirable and beautiful in execution...large, spacious, well-lighted, of fitting size, harmonious in width, length, and height...." Pilgrims arrived at Santiago de Compostela weary after weeks or months of difficult travel through dense woods and mountains. Grateful to St. James for his

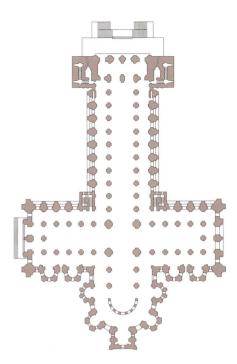

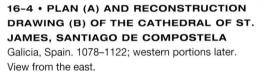

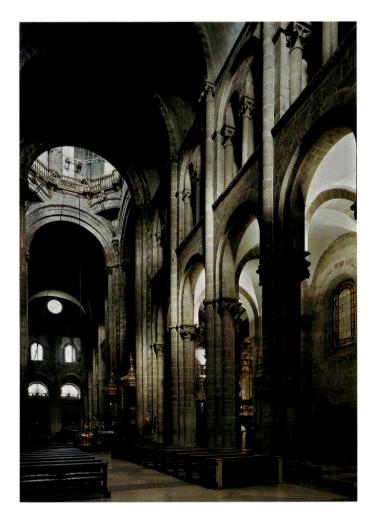

protection along the way, they entered a church that welcomed them with open portals, encrusted with the dynamic moralizing sculpture that characterized Romanesque churches. The cathedral had no doors to close—it was open day and night.

CLUNY

In 909, the duke of Burgundy gave land for a monastery to Benedictine monks intent on strict adherence to the original rules of St. Benedict. They established the reformed congregation of Cluny. From its foundation, Cluny had an independent status; its abbot answered directly to the pope in Rome rather than to the local bishop or lord. This freedom, jealously safeguarded by a series of long-lived and astute abbots, enabled Cluny to keep the profits from extensive gifts of land and treasure. Independent, wealthy, and a center of culture and learning, Cluny and its affiliates became important patrons of architecture and art.

16-5 • TRANSEPT INTERIOR, CATHEDRAL OF ST. JAMES, SANTIAGO DE COMPOSTELA

1078–1122. View toward the crossing.

Read the documents related to the cathedral of St. James, Santiago de Compostela on myartslab.com

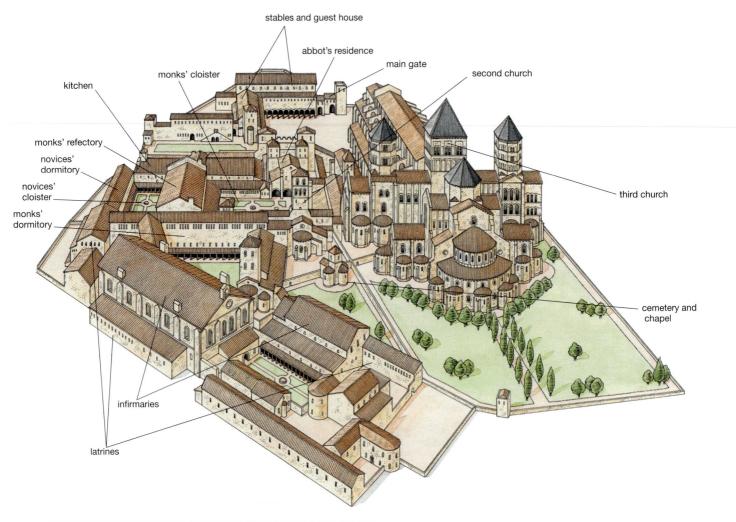

16-6 • **RECONSTRUCTION DRAWING OF THE ABBEY OF CLUNY** Burgundy, France. 1088–1130. View from the east.

Read the document related to the abbey at Cluny on myartslab.com

The monastery of Cluny was a city unto itself. By the second half of the eleventh century, there were some 200 monks in residence, supplemented by many laymen on whom they depended for material support. Just as in the Saint Gall plan of the Carolingian period (see FIG. 15-18), the cloister lay at the center of this monastic community, joining the church with domestic buildings and workshops (FIG. 16-6). In wealthy monasteries such as Cluny, the arcaded galleries of the cloister had elaborate carved capitals as well as relief sculpture on piers (see FIG. 16-1). The capitals may have served as memory devices or visualized theology to direct and inspire the monks' thoughts and prayers.

Cluniac monks observed the traditional eight Benedictine Hours of the Divine Office (including prayers, scripture readings, psalms, and hymns) spread over the course of each day and night. Mass was celebrated after the third hour (terce), and the Cluniac liturgy was especially elaborate. During the height of its power, plainsong, or Gregorian chant, filled the church with music 24 hours a day. And the elegant and extravagant design of the church at Cluny—as well as many of the churches of its host of dependent monasteries—was conceived largely as an elaborate setting for the performance of this liturgy. Cluniac churches were notable for their fine stone masonry with rich sculptured and painted decoration. In Burgundy, the churches were distinguished by their use of classicizing elements drawn from Roman art, such as fluted pilasters and Corinthian capitals. Cluniac monasteries elsewhere, however, were free—perhaps even encouraged—to follow regional traditions and styles.

THE THIRD CHURCH AT CLUNY The original church at Cluny, a small barnlike building, was soon replaced by a basilica with two towers and narthex at the west and a choir with tower and chapels at the east. Hugh de Semur, abbot of Cluny for 60 years (1049–1109), began rebuilding the abbey church for the third time in 1088 (**FIG. 16–8**). Money paid in tribute by Muslims to victorious Christians in Spain financed the building. When King Alfonso VI of León and Castile captured Toledo in 1085, he sent 10,000 pieces of gold to Cluny; German rulers were also generous donors. The church (known to art historians as Cluny

ART AND ITS CONTEXTS | Relics and Reliquaries

Christians turned to the heroes of the Church, especially martyrs who had died for their faith, to answer their prayers and to intercede with Christ on their behalf, and prayers offered to saints while in close proximity to their relics were considered especially effective. Bodies of saints, parts of bodies, and things associated with the Holy Family or the saints were kept in richly decorated containers called reliquaries. Reliquaries could be simple boxes, but they might also be created in more elaborate shapes, sometimes in the form of body parts such as arms, ribs, or heads. By the eleventh century, many different arrangements of crypts, chapels, and passageways gave people access to the relics kept in churches. When the Church decided that every altar required a relic, the saints' bodies and possessions were subdivided. In this way relics were multiplied; for example, hundreds of churches held relics of the true cross.

Owning and displaying these relics so enhanced the prestige and wealth of a community that people went to great lengths to acquire them, not only by purchase but also by theft. In the ninth century, for example, the monks of Conques stole the relics of the child martyr Sainte Foy (St. Faith) from her shrine at Agen. Such a theft was called "holy robbery," for the new owners insisted that it had been sanctioned by the saint who had communicated to them her desire to move. In the late ninth or tenth century, the monks of Conques encased their new relic—the skull of Sainte Foy—in a gold and jeweled statue whose unusually large head was made from a reused late Roman work. During the eleventh century, they added the crown and more jeweled banding, and, over subsequent centuries, jewels, cameos, and other gifts added by pilgrims continued to enhance the statue's splendor (**FIG. 16–7**).

This type of religuary-taking the form of a statue of the saint-was quite popular in the region around Conques, but not everyone was comfortable with the way these works functioned as cult images. Early in the eleventh century, the learned Bernard of Angers prefaces his tendentious account of miracles associated with the cult of Sainte Foy by confessing his initial misgivings about such reliquaries, specifically the way simple folks adored them. Bernard thought it smacked of idolatry: "To learned people this may seem to be full of superstition, if not unlawful, for it seems as if the rites of the gods of ancient cultures, or that the rites of demons, are being observed" (The Book of Sainte Foy, p. 77). But when he witnessed firsthand the interaction of the reliquary statue with the faithful, he altered his position: "For the holy image is consulted not as an idol that requires sacrifices, but because it commemorates a martyr. Since reverence to her honors God on high, it was despicable of me to compare her statue to statues of Venus or Diana. Afterwards I was very sorry that I had acted so foolishly toward God's saint." (ibid., p. 78)

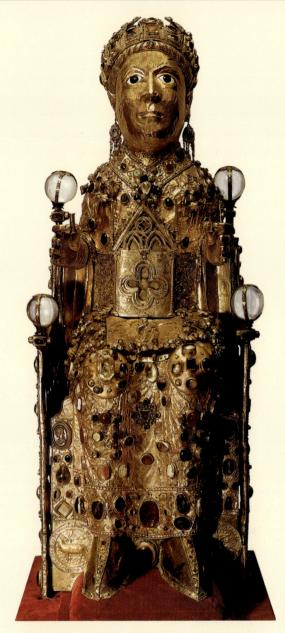

16-7 • RELIQUARY STATUE OF SAINTE FOY (ST. FAITH)

Abbey church, Conques, France. Late 9th or 10th century with later additions. Silver gilt over a wood core, with gems and cameos of various dates. Height 33" (85 cm). Church Treasury, Conques.

III because it was the third building at the site) was the largest in Europe when it was completed in 1130: 550 feet long, with five aisles like Old St. Peter's in Rome. Built with superbly cut masonry, and richly carved, painted, and furnished, Cluny III was a worthy home for the relics of St. Peter and St. Paul, which the monks had acquired from the church of St. Paul's Outside the Walls in Rome. It was also a fitting headquarters for a monastic order that eventually became so powerful within Europe that popes were chosen from its ranks.

In simple terms, the church was a basilica with five aisles, double transepts with chapels, and an ambulatory and radiating chapels around the high altar. The large number of chapels was necessary so that each monk-priest had an altar at which to perform daily Mass. Octagonal towers over the two crossings and additional towers over the transept arms created a dramatic pyramidal design at the east end. The nave had a three-part elevation. A nave arcade with tall compound piers, faced by pilasters to the inside and engaged columns at the sides, supported pointed arches lined by Classical ornament. At the next level a blind arcade and pilasters created a continuous sculptural strip that could have been modeled on an imperial Roman triumphal monument. Finally, triple clerestory windows in each bay let sunlight directly into the church around its perimeter. The pointed barrel vault with transverse arches rose to a daring height of 98 feet with a span of about 40 feet, made possible by giving the vaults a steep profile, rather than the weaker rounded profile used at Santiago de Compostela.

Cluny III was consecrated in 1130, but it no longer exists. The monastery was suppressed during the French Revolution, and this grandest of French Romanesque churches was sold stone by stone, transformed into a quarry for building materials. Today the

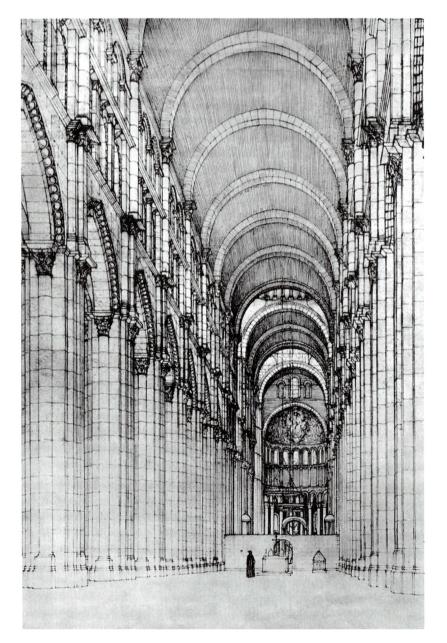

site is an archaeological park, with only one transept arm from the original church still standing.

THE CISTERCIANS

New religious orders devoted to an austere spirituality arose in the late eleventh and early twelfth centuries. Among these were the Cistercians, who spurned Cluny's elaborate liturgical practices and aspects of their arts, especially figural sculpture in cloisters (see "St. Bernard and Theophilus: The Monastic Controversy over the Visual Arts," page 470). The Cistercian reform began in 1098 with the founding of the abbey of Cîteaux (Cistercium in Latin, hence the order's name). Led in the twelfth century by the commanding figure of Abbot (later St.) Bernard of Clairvaux, the Cistercians advocated strict mental and physical discipline and a life devoted to prayer and intellectual pursuits combined with shared manual labor. Like the Cluniacs, however, Cistercians depended on the

> work of laypeople. To seclude themselves as much as possible from the outside world, they settled in reclaimed swamps and wild forests, where they then farmed and raised sheep. In time, their monasteries extended from Russia to Ireland.

> **FONTENAY** Cistercian architecture embodies the ideals of the order—simplicity, austerity, and purity. Always practical, the Cistercians made a significant change to the already very efficient monastery plan. They placed key buildings such as the refectory at right angles to the cloister walk so they could easily be extended should the community grow. The cloister fountain was relocated from the center to the side, conveniently in front of the refectory, where the monks could wash when coming from their work in the fields for communal meals. For easy access to the sanctuary during their prayers at night, monks entered the church directly from the cloister into the south transept or from the dormitory by way of the "night stairs."

The **ABBEY OF FONTENAY** in Burgundy is among the best-preserved early Cistercian monasteries. The abbey church, begun in 1139, has a regular geometric plan (**FIG. 16-9**) with a long bay-divided nave, rectangular chapels off the square-ended transept arms, and a shallow choir with a straight east wall. One of its characteristic features is the use of

16-8 • RECONSTRUCTION DRAWING OF THE INTERIOR LOOKING EAST, THIRD ABBEY CHURCH AT CLUNY 1088-1130.

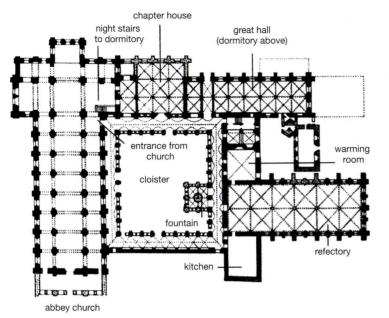

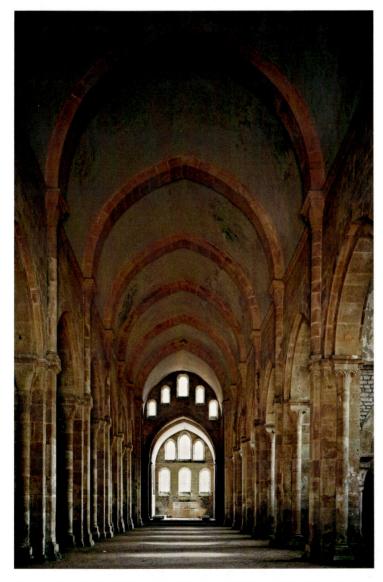

16-9 • PLAN (A) AND CHURCH INTERIOR (B) OF THE ABBEY OF NOTRE-DAME, FONTENAY Burgundy, France. 1139–1147.

pointed barrel vaults over the nave and pointed arches in the nave arcade and side-aisle bays. Although pointed arches are usually associated with Gothic architecture, they are actually common in the Romanesque buildings of some regions, including Burgundy—we have already seen them at Cluny. Pointed arches are structurally more stable than round ones, directing more weight down into the floor instead of outward against the walls. Consequently, they can span greater distances at greater heights without collapsing.

Although Fontenay and other early Cistercian monasteries fully reflect the architectural developments of their time in masonry construction, vaulting, and planning, the Cistercians concentrated on harmonious proportions, superbly refined stonework, and elegantly carved foliate and ornamental decoration, to achieve beauty in their architecture. The figural scenes and monstrous animals found on many Romanesque churches are avoided here. The large windows in the end wall, rather than a clerestory, provided light, concentrated here as at Santiago, on the sanctuary. The sets of triple windows may have reminded the monks of the Trinity. Some scholars have suggested that the numerical and proportional systems guiding the design of such seemingly simple buildings are saturated with the sacred numerical systems outlined by such eminent early theologians as St. Augustine of Hippo. The streamlined but sophisticated architecture favored by the Cistercians spread from their homeland in Burgundy to become an international style. From Scotland and Poland to Spain and Italy, Cistercian designs and building techniques varied only slightly in relation to local building traditions. Cistercian experiments with masonry vaulting and harmonious proportions influenced the development of the French Gothic style in the middle of the twelfth century.

REGIONAL STYLES IN ROMANESQUE ARCHITECTURE

The cathedral of Santiago de Compostela and the abbey church at Cluny reflect the cultural exchanges and international connections fostered by powerful monastic orders, and to a certain extent by travel along the pilgrimage roads, but Europe remained a land divided by competing kingdoms, regions, and factions. Romanesque architecture reflects this regionalism in the wide variety of its styles, traditions, and building techniques. Only a few examples can be examined here.

THE CATHEDRAL OF ST. MARY OF THE ASSUMP-TION IN PISA Throughout Italy artists looked to the stillstanding remains of imperial Rome and early Christianity. The influence remained especially strong in Pisa, on the west coast of Tuscany. Pisa became a maritime power, competing with Barcelona and Genoa as well as the Muslims for control of trade in the western Mediterranean. In 1063, after a decisive victory over the Muslims, the jubilant Pisans began

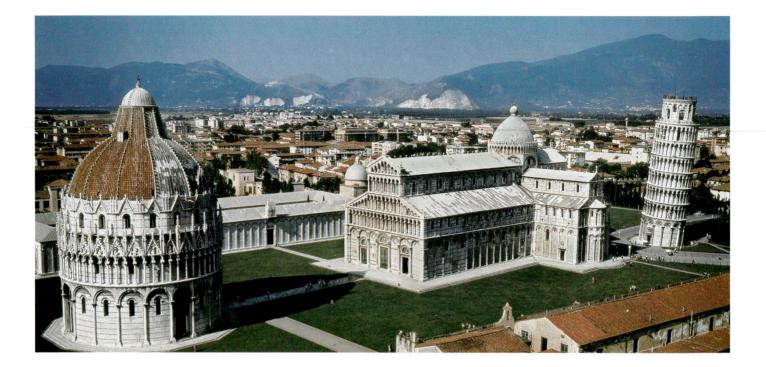

ART AND ITS CONTEXTS | St. Bernard and Theophilus: The Monastic Controversy over the Visual Arts

The twelfth century saw a heated controversy over the place and appropriateness of lavish art in monasteries. In a letter to William of Saint-Thierry, Bernard of Clairvaux wrote:

... in the cloisters, before the eyes of the brothers while they readwhat is that ridiculous monstrosity doing, an amazing kind of deformed beauty and yet a beautiful deformity? What are the filthy apes doing there? The fierce lions? The monstrous centaurs? The creatures part man and part beast? The striped tigers? The fighting soldiers? The hunters blowing horns? You may see many bodies under one head, and conversely many heads on one body. On one side the tail of a serpent is seen on a quadruped, on the other side the head of a guadruped is on the body of a fish. Over there an animal has a horse for the front half and a goat for the back; here a creature which is horned in front is equine behind. In short, everywhere so plentiful and astonishing a variety of contradictory forms is seen that one would rather read in the marble than in books, and spend the whole day wondering at every single one of them than in meditating on the law of God. Good God! If one is not ashamed of the absurdity, why is one not at least troubled at the expense? (Rudolph, Things of Greater Importance, pp. 11-12)

"Theophilus" is the pseudonym used by a monk who wrote a book during the first half of the twelfth century on the practice of artistic craft, voiced as a defense of the place of the visual arts within the monastic traditions of work and prayer. The book gives detailed instructions for panel painting, stained glass (colored glass assembled into ornamental or pictorial windows), and goldsmithing. In contrast to the stern warnings of Bernard, perhaps even in response to them, "Theophilus" assured artists that "God delights in embellishments" and that artists worked "under the direction and authority of the Holy Spirit."

He wrote:

Therefore, most beloved son, you should not doubt but should believe in full faith that the Spirit of God has filled your heart when you have embellished His house with such great beauty and variety of workmanship ...

... do not hide away the talent given to you by God, but, working and teaching openly and with humility, you faithfully reveal it to those who desire to learn.

... if a faithful soul should see a representation of the Lord's crucifixion expressed in the strokes of an artist, it is itself pierced; if it sees how great are the tortures that the saints have endured in their bodies and how great the rewards of eternal life that they have received, it grasps at the observance of a better life; if it contemplates how great are the joys in heaven and how great are the torments in the flames of hell, it is inspired with hope because of its good deeds and shaken with fear on considering its sins.

(Theophilus, On Divers Arts, pp. 78-79)

As we will see in the next chapter, Abbot Suger of Saint-Denis shared the position of Theophilus, rather than that of Bernard, and from this standpoint would sponsor a reconstruction of his abbey church that gave birth to the Gothic style.

16-10 • CATHEDRAL COMPLEX, PISA

Tuscany, Italy. Cathedral, begun 1063; baptistery, begun 1153; campanile, begun 1174; Campo Santo, 13th century.

When finished in 1350, the Leaning Tower of Pisa stood 179 feet high. The campanile had begun to tilt while still under construction, and today it leans about 13 feet off the perpendicular. In the latest effort to keep it from toppling, engineers filled the base with tons of lead.

16-11 • INTERIOR, CHURCH OF SAN CLEMENTE, ROME Consecrated 1128.

San Clemente contains one of the finest surviving collections of early church furniture: choir stalls, pulpit, lectern, candlestick, and also the twelfth-century inlaid pavement. Ninth-century choirscreen panels were reused from the earlier church on the site. The upper wall and ceiling decoration date from the eighteenth century.

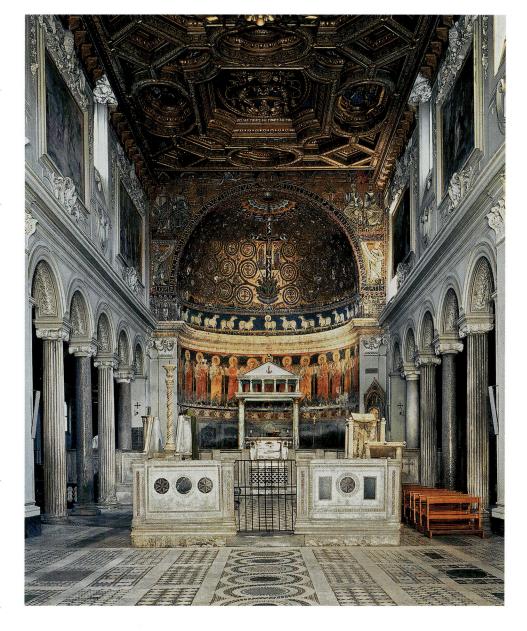

an imposing new cathedral dedicated to the Virgin Mary (**FIG. 16-10**). The cathedral was designed as a cruciform basilica by the master builder Busketos. A long nave with double side aisles (usually an homage to Old St. Peter's) is crossed by projecting transepts, designed like basilicas with their own aisles and apses. The builders added galleries above the side aisles, and a dome covers the crossing. Unlike Early Christian basilicas, the exteriors of Tuscan churches were richly decorated with marble—either panels of green and white marble or arcades. At Pisa, pilasters, applied arcades, and narrow galleries in white marble adorn the five-story façade.

In addition to the cathedral itself, the complex eventually included a baptistery, a campanile, and the later Gothic Campo Santo, a walled burial ground. The baptistery, begun in 1153, has arcading and galleries on the lower levels of its exterior that match those on the cathedral (the baptistery's present exterior dome and ornate upper levels were built later). The campanile (a free-standing bell tower—now known for obvious reasons as "the Leaning Tower of Pisa") was begun in 1174 by master builder Bonanno Pisano. Built on inadequate foundations, it began to lean almost immediately. The cylindrical tower is encased in tier upon tier of marble columns. This creative reuse of the Classical theme of the colonnade, turning it into a decorative arcade, is characteristic of Tuscan Romanesque art.

THE BENEDICTINE CHURCH OF SAN CLEMENTE IN ROME The Benedictine church of San Clemente in Rome was rebuilt beginning in the eleventh century (it was consecrated in 1128) on top of the previous church (which had itself been built over a Roman sanctuary of Mithras). The architecture and decoration reflect a conscious effort to reclaim the artistic and spiritual legacy of the early church (**FIG. 16-11**). As with the columns of Santa Sabina (see FIG. 7-10), the columns in San Clemente are **spolia**: that is, they were reused from ancient Roman buildings. The

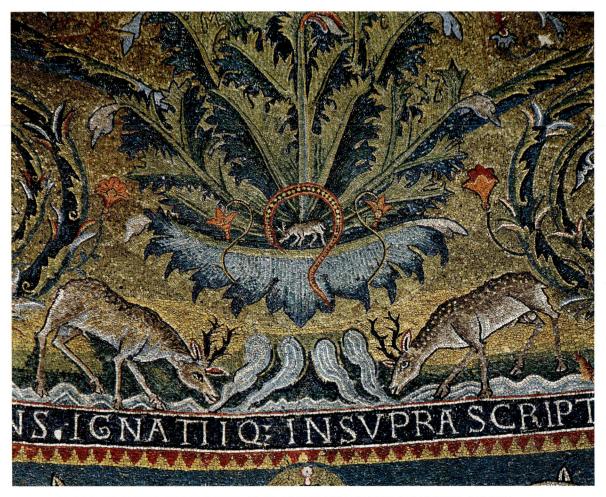

16-12 • **STAGS DRINKING FROM STREAMS FLOWING UNDER THE CRUCIFIED CHRIST** Detail of mosaics in the apse of the church of San Clemente, Rome. Consecrated 1128.

church originally had a timber roof (now disguised by an ornate eighteenth-century ceiling). Even given the Romanesque emphasis on stone vaulting, the construction of timber-roofed buildings continued throughout the Middle Ages.

At San Clemente, the nave ends in a semicircular apse opening directly off the rectangular hall without a sanctuary extension or transept crossing. To accommodate the increased number of participants in the twelfth-century liturgy, the liturgical choir for the monks was extended into the nave itself, defined by a low barrier made up of ninth-century relief panels reused from the earlier church. In Early Christian basilicas, the area in front of the altar had been similarly enclosed by a low stone parapet (see FIG. 7-10), and the Romanesque builders may have wanted to revive what they considered a glorious Early Christian tradition. A **baldachin** (a canopy suspended over a sacred space, also called a ciborium), symbolizing the Holy Sepulcher, covers the main altar in the apse.

The apse of San Clemente is richly decorated with marble revetment on the curving walls and mosaic in the semidome, in a system familiar from the Early Christian and Byzantine world (see FIGS. 7-19, 8-6). The mosaics recapture this past glory, portraying the trees and rivers of paradise, a lavish vine scroll inhabited

by figures, in the midst of which emerges the crucified Christ flanked by Mary and St. John. Twelve doves on the cross and the 12 sheep that march in single file below represent the apostles. Stags drink from streams flowing from the base of the cross, an evocation of the tree of life in paradise (**FIG. 16–12**). An inscription running along the base of the apse explains, "We liken the Church of Christ to this vine that the law causes to wither and the Cross causes to bloom," a statement that recalls Jesus' reference to himself as the true vine and his followers as the branches (John 15:1–11). The learned monks of San Clemente would have been prepared to derive these and other meanings from the evocative symbols within this elaborate, glowing composition.

Although the subject of the mosaic recalls Early Christian art, the style and technique are clearly Romanesque. The artists have suppressed the sense of lifelike illusionism that characterized earlier mosaics in favor of ornamental patterns and schemas typical of the twelfth century. The doves silhouetted on the dark blue cross, the symmetrical repetition of circular vine scrolls, even the animals, birds, and humans among their leaves conform to an overriding formal design. By an irregular setting of mosaic tesserae in visibly rough plaster, the artists are able to heighten color and increase the glitter of the pervasive gold field, allowing the mosaic to sparkle.

ART AND ITS CONTEXTS | The Paintings of San Climent in Taull: Mozarabic Meets Byzantine

As we see at San Clemente in Rome and at Saint-Savin-sur-Gartempe (see FIGS. 16-14, 16-15), Romanesque church interiors were not bare expanses of stone, but were often covered with images that glowed in flickering candlelight amid clouds of incense. Outside Rome during the Romanesque period, murals largely replaced mosaics on the walls of churches. Wall painting was subject to the same influences as the other visual arts: that is, the mural painters could be inspired by illuminated manuscripts, or ivories, or enamels in their treasuries or libraries. Some artists must have seen examples of Byzantine art; others had Carolingian or even Early Christian models.

Artists in Catalunya brilliantly combined the Byzantine style with their own Mozarabic and Classical heritage in the apse paintings of the church of San Climent in the mountain village of Taull (Tahull), consecrated in 1123, just a few years before the church of San Clemente in Rome. The curve of the semidome of the apse contains a magnificently expressive CHRIST IN MAJESTY (FIG. 16-13) holding an open book inscribed Ego sum lux mundi ("I am the light of the world," John 8:12)-recalling in his commanding presence the imposing Byzantine depictions of Christ Pantokrator, ruler and judge of the world, in Middle Byzantine churches (see FIG. 8-21). The San Climent artist was one of the finest painters of the Romanesque period, but where he came from and where he learned his art is unknown. His use of elongated oval faces, large staring eyes, and long noses, as well as the placement of figures against flat bands of color and his use of heavy outlines, reflect the Mozarabic past (see FIG. 15-10). At the same time his work betrays the influence of Byzantine art in his painting technique of modeling from light to dark through repeated colored lines of varying width in three shades-dark, medium, and light. Instead of blending the colors, he delights in the striped effect, as well as in the potential for pattern in details of faces, hair, hands, and muscles.

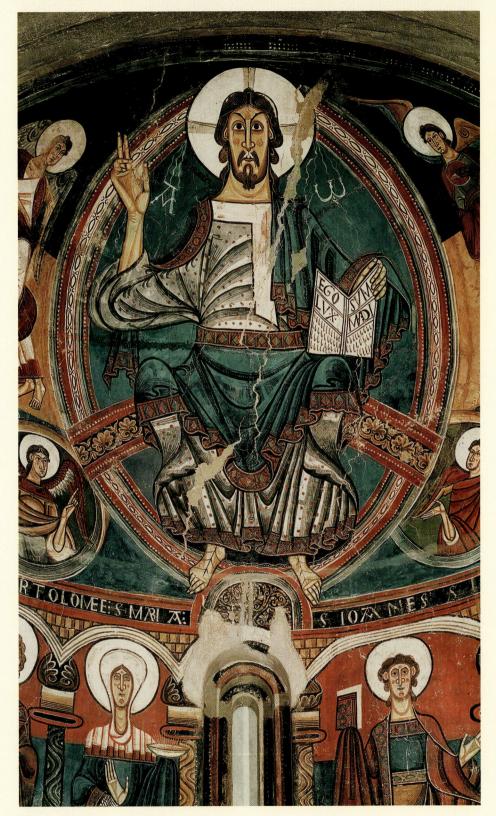

16-13 • CHRIST IN MAJESTY Detail of apse fresco, church of San Climent, Taull, Catalunya, Spain. Consecrated 1123. © MNAC—Museu Nacional d'Art de Catalunya, Barcelona.

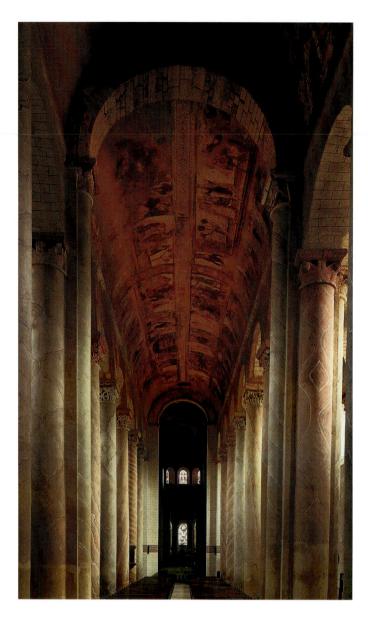

16-14 • ABBEY CHURCH OF SAINT-SAVIN-SUR-GARTEMPE Poitou, France. Choir c. 1060–1075; nave c. 1095–1115.

THE ABBEY CHURCH OF SAINT-SAVIN-SUR-GARTEMPE

At the Benedictine abbey church of Saint-Savin-sur-Gartempe in western France, a tunnel-like barrel vault runs the length of the nave and choir (**FIG. 16-14**). Without galleries or clerestory windows, the nave at Saint-Savin approaches the form of a "hall church," where the nave and aisles rise to an equal height. And unlike other churches we have seen (for example, **FIG. 16-5**), at Saint-Savin the barrel vault is unbroken by projecting transverse arches, making it ideally suited for paintings.

The paintings on the high vaults of Saint-Savin survive almost intact, presenting scenes from the Hebrew Bible and New Testament. The nave was built c. 1095–1115, and the painters seem to have followed the masons immediately, probably using the same scaffolding. Perhaps their intimate involvement with the building process accounts for the vividness with which they portrayed the biblical story of the **TOWER OF BABEL** (FIG. 16-15).

According to the account in Genesis (11:1–9), God (represented here by a striding figure of Christ on the left) punished the prideful people who had tried to reach heaven by means of their own architectural ingenuity by scattering them and making their languages mutually unintelligible. The tower in the painting is Romanesque in style, reflecting the medieval practice of visualizing all stories in contemporary settings, thereby underlining their relevance for the contemporary audience. Workers haul heavy stone blocks toward the tower, presumably intending to lift them to masons on the top with the same hoist that has been used to haul up a bucket of mortar. The giant Nimrod, on the far right,

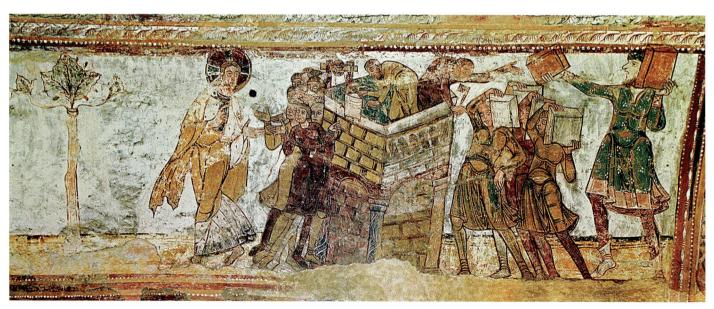

16-15 • TOWER OF BABEL Detail of painting in nave vault, abbey church of Saint-Savin-sur-Gartempe, Poitou, France. c. 1115.

simply hands over the blocks. These paintings embody the energy and narrative vigor that characterizes Romanesque art. A dynamic figure of God confronts the wayward people, stepping away from them even as he turns back, presumably to scold them. The dramatic movement, monumental figures, bold outlines, broad areas of color, and patterned drapery all promote the legibility of these pictures to viewers looking up in the dim light from far below. The team of painters working here did not use the *buon fresco* technique favored in Italy for its durability, but they did moisten the walls before painting, which allowed some absorption of pigments into the plaster, making them more permanent than paint applied to a dry surface.

THE CATHEDRAL OF THE VIRGIN AND ST. STEPHEN AT SPEYER The imperial cathedral at Speyer in the Rhine River Valley was a colossal structure. An Ottonian, woodenroofed church built between 1030 and 1060 was given a masonry vault c. 1080–1106 (**FIG. 16-16**). Massive compound piers mark each nave bay and support the transverse ribs of a groin vault that

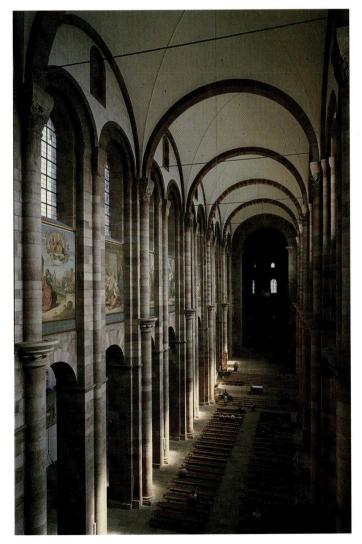

16-16 • INTERIOR, SPEYER CATHEDRAL Rhineland-Palatinate, Germany. As remodeled c. 1080–1106.

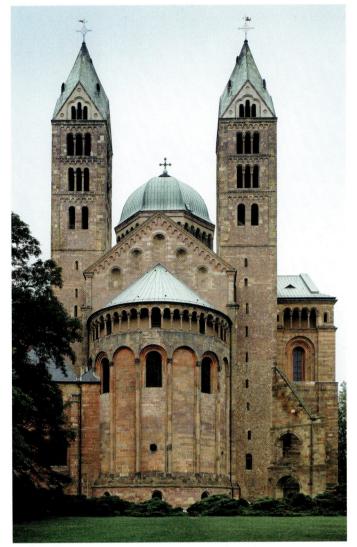

16-17 • EXTERIOR, SPEYER CATHEDRAL c. 1080–1106 and second half of the 12th century.

rises to a height of over 100 feet. These compound piers alternate with smaller piers supporting the vaults of the aisle bays. This rhythmic, alternating pattern of heavy and light elements, first suggested in Ottonian wooden-roofed architecture (see FIG. 15–23), became an important design element in Speyer. Since groin vaults concentrate the weight and thrust of the vault on the four corners of the bay, they relieve the stress on the side walls of the building. Large windows can be safely inserted in each bay to flood the building with light.

The exterior of Speyer Cathedral emphasizes its Ottonian and Carolingian background. Soaring towers and wide transepts mark both ends of the building, although a narthex, not an apse, stands at the west. A large apse housing the high altar abuts the flat wall of the choir; transept arms project at each side; a large octagonal tower rises over the crossing; and a pair of tall slender towers flanks the choir (**FIG. 16–17**). A horizontal arcade forms an exterior gallery at the top of the apse and transept wall, recalling the Italian practice we saw at Pisa (see FIG. 16–10).

DURHAM CATHEDRAL In Durham, an English military outpost near the Scottish border, a prince-bishop held both secular and religious authority. For his headquarters he chose a defensive site where the bend in the River Wear formed a natural moat. Durham grew into a powerful fortified complex including a castle, a monastery, and a cathedral. The great tower of the castle defended against attack from the land, and an open space between buildings served as the courtyard of the castle and the cathedral green.

DURHAM CATHEDRAL, begun in 1087 and vaulted starting in 1093, is an impressive example of Norman Romanesque, but like most buildings that have been in continuous use, it has been altered several times (**FIG. 16–18**). The nave retains its Norman character, but the huge circular window lighting the choir is a later Gothic addition. The cathedral's size and décor are ambitious. Enormous compound piers and robust columnar piers form the nave arcade and establish a rhythmic alternation. The columnar piers are carved with chevrons, spiral fluting, and diamond patterns, and some have scalloped, cushion-shape capitals. The richly carved arches that sit on them have multiple round moldings and chevron ornaments. All this carved ornamentation was originally painted.

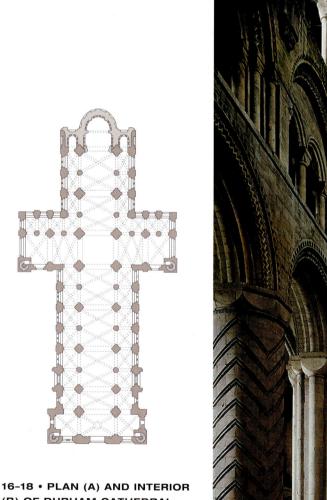

(B) OF DURHAM CATHEDRAL Northern England. 1087–1133. Original east end replaced by a Gothic choir, 1242–c. 1280. Vault height about 73' (22.2 m).

Explore the architectural panoramas of Durham Cathedral on myartslab.com

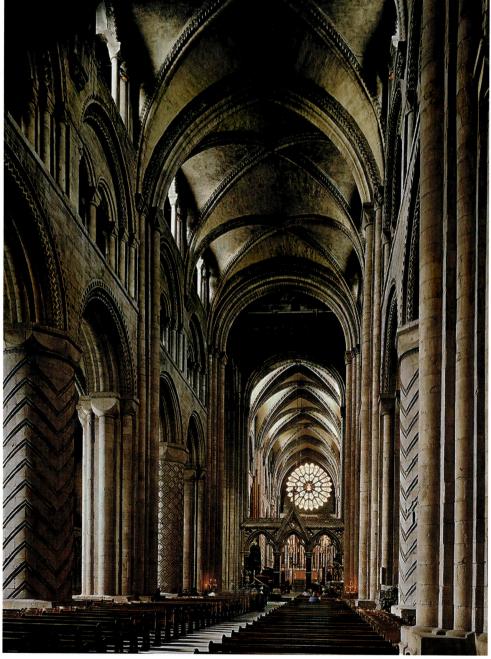

Above the cathedral's massive piers and walls rises a new system of ribbed groin vaults. Romanesque masons in Santiago de Compostela, Cluny, Fontenay, Speyer, and Durham were all experimenting with stone vaulting—and adopted different solutions. The Durham builders divided each bay with two pairs of diagonal crisscrossing rounded ribs and so kept the crowns of the vaults close in height to the keystones of the pointed transverse arches. Although this allows the eye to run smoothly down the length of the vault, and from vault to vault down the expanse of the nave, the richly carved zigzagging moldings on the ribs themselves invite us to linger over each bay, acknowledging traditional Romanesque bay division. This new system of ribbed groin vaulting will become a hallmark of Gothic architecture, though there it will create a very different aesthetic effect.

SECULAR ARCHITECTURE: DOVER CASTLE, ENGLAND

The need to provide for personal security in a time of periodic local warfare and political upheaval, as well as the desire to glorify the house of Christ and his saints, meant that communities used much of their resources to build castles and churches. Fully garrisoned, castles were sometimes as large as cities. In the twelfth century, **DOVER CASTLE**, safeguarding the southeastern coast of England from invasion, was a bold manifestation of military power (**FIG. 16–19**). It illustrates the way in which a key defensive position developed over the centuries.

The Romans had built a lighthouse on the point where the English Channel separating England and France narrows. The Anglo–Saxons added a church (both lighthouse and church can be seen in FIGURE 16–19 behind the tower, surrounded by the remains of earthen walls). In the early Middle Ages, earthworks topped by wooden walls provided a measure of security, and a wooden tower signified an important administrative building and residence. The advantage of fire-resistant walls was obvious, and in the twelfth and thirteenth centuries, military engineers replaced the timber tower and palisades with stone walls. They added the massive stone towers we see today.

The Great Tower, as it was called in the Middle Ages (but later known as a **keep** in England, and donjon in France), stood in a courtyard (called the bailey) surrounded by additional walls. Ditches outside the walls added to their height. In some castles, ditches were filled with water to form moats. A gatehouse—perhaps

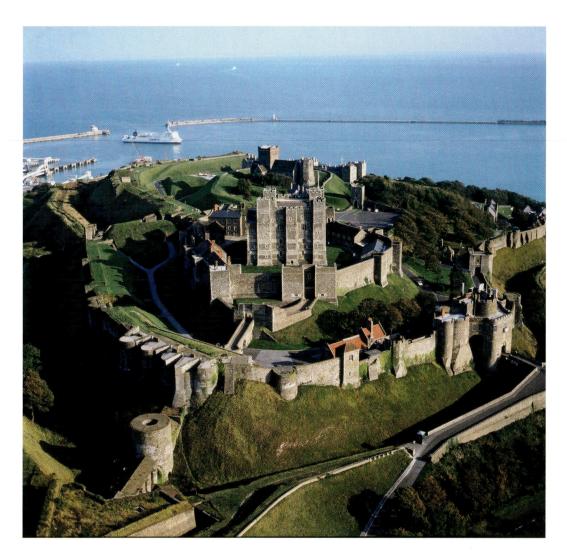

16–19 • DOVER CASTLE Southern England.

Aerial view overlooking the harbor and the English Channel. Center distance: Roman lighthouse tower, rebuilt Anglo-Saxon church, earthworks. Center: Norman Great Tower, surrounding earthworks and wall, twelfth century. Outer walls, thirteenth century. Modern buildings have red tiled roofs. The castle was used in World War II and is now a museum.

ELEMENTS OF ARCHITECTURE | The Romanesque Church Portal

The most important imagery on a Romanesque portal appears on the semicircular **tympanum** directly over the door—often a hierarchically scaled image of abstract grandeur such as Christ in Majesty or Christ presiding over the Last Judgment—as well as on the lintel beneath it. **Archivolts**—curved moldings composed of the wedge-shaped stone voussoirs of the arch—frame the tympanum. On both sides of the doors, the **jambs** (vertical elements) and occasionally a central pier (called the **trumeau**), support the lintel and archivolts, providing further fields for figures, columns, or narrative friezes. The jambs can extend forward to form a porch.

Watch an architectural simulation about the Romanesque church portal on myartslab.com

with a drawbridge—controlled the entrance. In all castles, the bailey was filled with buildings, the most important of which was the lord's hall; it was used to hold court and for feasts and ceremonial occasions. Timber buildings housed troops, servants, and animals. Barns and workshops, ovens and wells were also needed—the castle had to be self-sufficient.

If enemies broke through the outer walls, the castle's defenders retreated to the Great Tower. In the thirteenth century, the builders at Dover doubled the walls and strengthened them with towers, even though the castle's position on cliffs overlooking the sea made scaling the walls nearly impossible. The garrison could be forced to surrender only by starving its occupants.

During Dover Castle's heyday, improvements in farming and growing prosperity provided the resources for increased building activity across Europe. Churches, castles, halls, houses, barns, and monasteries proliferated. The buildings that still stand—despite the ravages of weather, vandalism, neglect, and war—testify to the technical skills and creative ingenuity of the builders and the power, local pride, and faith of the patrons.

ARCHITECTURAL SCULPTURE

Architecture dominated the arts in the Romanesque period—not only because it required the material and human resources of entire communities, but because it provided the physical context for a revival of the art of monumental stone sculpture, an art that had been almost dormant in Europe for 500 years. The "mute" façades used in early medieval buildings (see FIG. 15–17) were transformed by Romanesque sculptors into "speaking" façades with richly carved portals projecting bold symbolic and didactic programs to the outside world (see FIG. 16–21). Christ Enthroned in Majesty might be carved over the entrance, and increasing importance is accorded to the Virgin Mary. The prophets, kings, and queens of the Hebrew Bible were seen by medieval Christians as precursors of people and events in the New Testament, so these were depicted, and we can also find representations of contemporary bishops, abbots, other noble patrons, and even ordinary folk. A profusion of monsters, animals, plants, geometric ornament, allegorical figures such as Lust and Greed, and depictions of real and imagined buildings surround the sculpture within its architectural setting. The elect rejoice in heaven with the angels; the damned suffer in hell, tormented by demons; biblical and historical tales come alive. All these events seem to take place in a contemporary medieval setting, and they are juxtaposed with scenes drawn from the viewer's everyday life.

These innovative portals are among the greatest artistic achievements of Romanesque art, taking the central messages of the Christian Church out of the sanctuary (see FIGS. 8–6, 8–11) and into the public spaces of medieval towns. And figural sculpture appeared not only at entrances, but on the capitals of interior as well as exterior piers and columns, and occasionally spread all over the building in friezes, on corbels, even peeking around cornices or from behind moldings. There was plenty of work for stone sculptors on Romanesque building sites.

WILIGELMO AT THE CATHEDRAL OF MODENA

The spirit of ancient Rome pervades the sculpture of Romanesque Italy, and the sculptor Wiligelmo may have been inspired by Roman sarcophagi still visible in cemeteries when he carved horizontal reliefs across the west façade of Modena Cathedral,

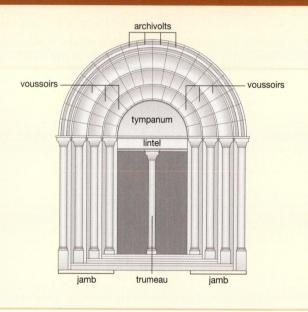

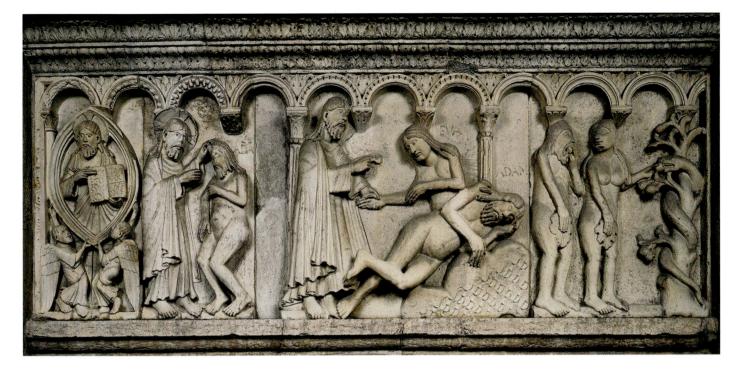

16-20 • Wiligelmo **CREATION AND FALL OF ADAM AND EVE, WEST FAÇADE, MODENA CATHEDRAL** Emilia, Italy. Building begun 1099; sculpture c. 1099. Height approx. 3' (92 cm).

c. 1099. Wiligelmo took his subjects here from Genesis, focusing on events from the **CREATION AND FALL OF ADAM AND EVE** (**FIG. 16-20**). On the far left, God, in a **mandorla** (body halo) supported by angels, appears in two persons as both Creator and Christ, identified by a cruciform halo. Following this iconic image, the narrative of creation unfolds in three scenes, from left to right: God brings Adam to life, then brings forth Eve from Adam's side, and finally Adam and Eve cover their genitals in shame as they greedily eat fruit from the forbidden tree, around which the wily serpent twists.

Wiligelmo's deft carving gives these figures a strong threedimensionality. The framing arcade establishes a stagelike setting, with the rocks on which Adam lies and the tempting tree of paradise serving as stage props. Wiligelmo's figures exude life and personality. They convey an emotional connection with the narrative they enact, and bright paint, now almost all lost, must have increased their lifelike impact still further. An inscription at Modena proclaims, "Among sculptors, your work shines forth, Wiligelmo." This self-confidence turned out to be justified. Wiligelmo's influence can be traced throughout Italy and as far away as Lincoln Cathedral in England.

THE PRIORY CHURCH OF SAINT-PIERRE AT MOISSAC

The Cluniac priory of Saint-Pierre at Moissac was a major stop on the pilgrimage route to Santiago de Compostela. The shrine at the site dates back to the Carolingian period, and after affiliating with Cluny in 1047, the monastery prospered from the donations of pilgrims and local nobility, as well as from its control of shipping on the nearby Garonne River. During the twelfth century, Moissac's monks launched an ambitious building campaign, and much of the sculpture from the cloister (c. 1100, under Abbot Ansquetil) and the church portal and porch (1100–1130, under Abbot Roger) has survived. The quantity and quality of the carving here are outstanding.

A flattened figure of CHRIST IN MAJESTY dominates the huge tympanum (FIG. 16-21), visualizing a description of the Second Coming in Chapters 4 and 5 of Revelation. This gigantic Christ is an imposing, iconic image of enduring grandeur. He is enclosed by a mandorla; a cruciform halo rings his head. Although Christ is stable, even static, in this apocalyptic appearance, the four winged creatures symbolizing the evangelists-Matthew the man (upper left), Mark the lion (lower left), Luke the ox (lower right), and John the eagle (upper right)-who frame him on either side move with dynamic force, as if activated by the power of his unchanging majesty. Rippling bands extending across the tympanum at Christ's sides and under him-perhaps representing waves in the "sea of glass like crystal" (Revelation 4:6)-delineate three registers in which 24 elders with "gold crowns on their heads" and either a harp or a gold bowl of incense (Revelation 4:4 and 5:8) twist nervously to catch a glimpse of Christ's majestic arrival. Each of them takes an individually conceived pose and gesture, as if the sculptors were demonstrating their ability to represent threedimensional human figures turning in space in a variety of postures, some quite challengingly contorted. Foliate and geometric ornament covers every surface surrounding this tableau. Monstrous

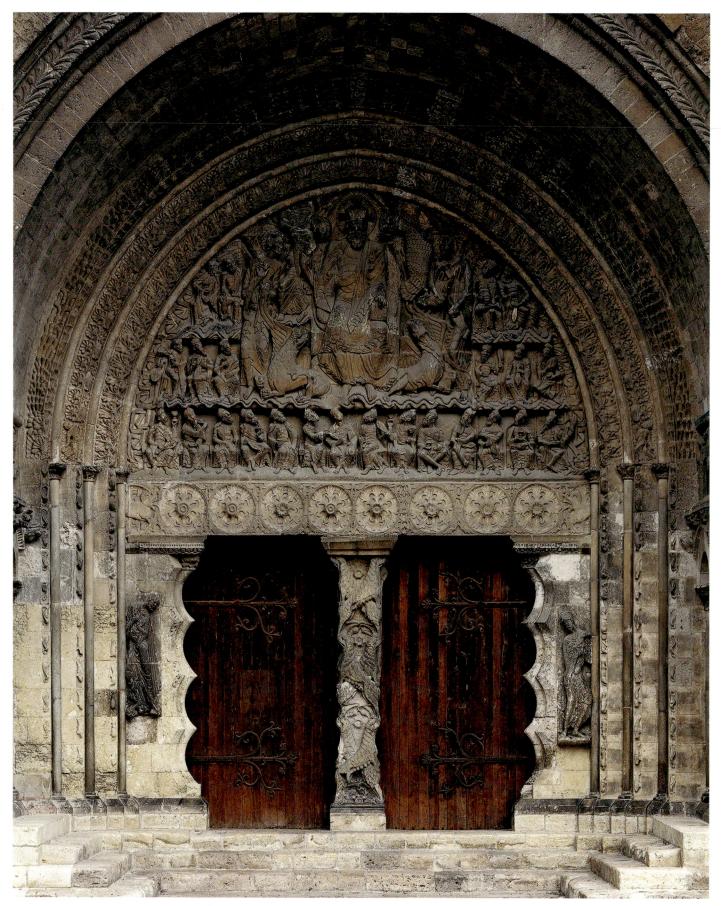

16-21 • SOUTH PORTAL, TYMPANUM SHOWING CHRIST IN MAJESTY, PRIORY CHURCH OF SAINT-PIERRE, MOISSAC Tarn-et-Garonne, France. c. 1115. heads in the lower corners of the tympanum spew ribbon scrolls, and other creatures appear at each end of the lintel, their tongues growing into ropes encircling acanthus rosettes.

Two side jambs and a trumeau (central portal pier) support the weight of the lintel and tympanum. These elements have scalloped profiles that playfully undermine the ability of the colonettes on the door jambs to perform their architectural function and give a sense of instability to the lower part of the portal, as if to underline the ability of the stable figure of Christ in Majesty to provide his own means of support. St. Peter and the prophet Isaiah flank the doorway on the jambs. Peter, a tall, thin saint, steps away from the door but twists back to look through it.

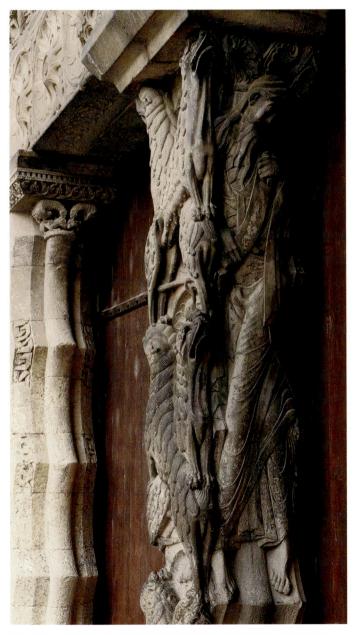

16-22 • TRUMEAU, SOUTH PORTAL, PRIORY CHURCH OF SAINT-PIERRE, MOISSAC c. 1115.

The **TRUMEAU** (**FIG. 16-22**) is faced by a crisscrossing pair of lions. On the side visible here, a prophet, usually identified as Jeremiah, twists toward the viewer, with legs crossed in a pose that would challenge his ability to stand, much less move. The sculptors placed him in skillful conformity with the constraints of the scalloped trumeau; his head, pelvis, knees, and feet moving into the pointed cusps. This decorative scalloping, as well as the trumeau lions and lintel rosettes, may reveal influence from Islamic art. Moissac was under construction shortly after the First Crusade, when many Europeans first encountered the Islamic art and architecture of the Holy Land. People from the region around Moissac participated in the crusade; perhaps they brought Islamic objects and ideas home with them.

A porch covering the area in front of the portal at Moissac provided a sheltered space for pilgrims to congregate and view the sculpture. The side walls of this porch are filled with yet more figural sculptures (**FIG. 16-23**), but the style of presentation changes here with the nature of the subject matter and the response that was sought from the audience. Instead of the stylized and agitated figures on the tympanum and its supports, here sculptors have substituted more lifelike and approachable human beings. Rather than embodying unchanging theological notions or awe-inspiring apocalyptic appearances, these figures convey human frailties and torments in order to persuade viewers to follow the Church's moral teachings.

Behind the double arcade framework of the lower part of the wall are hair-raising portrayals of the torments of those who fall prey to the two sins that particularly preoccupied twelfth-century moralists: avarice (greed and the hoarding of money) and lust (sexual misconduct). At bottom left, a greedy man is attacked by demons while the money bags around his neck weigh him down, strangling him. On the other side of the column, his counterpart, the female personification of lust (luxuria), is confronted by a potbellied devil while snakes bite at her breasts and another predator attacks her pubic area. In the scene that extends behind the column and across the wall above them, luxuria reappears, kneeling beside the deathbed of the miser, as devils make off with his money and conspire to make his final moments miserable. These scenes are made as graphic as possible so that medieval viewers could identify with these situations, perhaps even feel the pain in their own bodies as a warning to avoid the behaviors that lead to such gruesome consequences.

In the strip of relief running across the top of the wall, the mood is calmer, but the moral message remains strong and clear, at least for those who know the story. The sculpture recounts the tale of Lazarus and Dives (Luke 16:19–31), the most popular parable of Jesus in Romanesque art. The broad scene to the right shows the greedy, rich Dives, relishing the feast that is being laid before him by his servants and refusing even to give his table scraps to the leprous beggar Lazarus, spread out at lower left. Under the table, dogs—unsatisfied by leftovers from Dives' feast—turn to lick the pus from Lazarus' sores as the poor man draws his last breath. The

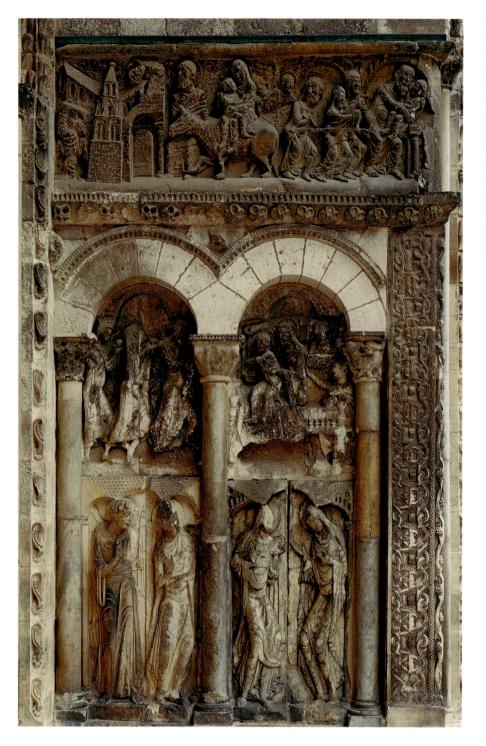

16-23 • RELIEFS ON THE LEFT (WEST) WALL OF THE SOUTH PORCH, PRIORY CHURCH OF SAINT-PIERRE, MOISSAC c. 1115.

The parable of Lazarus and Dives that runs across the top of this wall retains its moral power to our own day. This was the text of Martin Luther King's last Sunday sermon, preached only a few days before his assassination in Memphis, where he was supporting a strike by sanitation workers. Perhaps he saw the parable's image of the table scraps of the rich and greedy as particularly appropriate to his context. Just as in this portal, in Dr. King's sermon the story is juxtaposed with other stories and ideas to craft its interpretive message in a way that is clear and compelling for the audience addressed.

angel above Lazarus, however, transfers his soul (represented as a naked baby, now missing) to the lap of Abraham (a common image of paradise), where he is cuddled by the patriarch, the eternal reward for a pious life. The fate of Dives is not portrayed here, but it is certainly evoked on the lower section of this very wall in the torments of the greedy man, whom we can now identify with Dives himself. Clearly some knowledge is necessary to recognize the characters and story of this sculpture, and a "guide" may have been present to aid those viewers who did not readily understand, as is the case with many modern tourists. Nonetheless, the moral of sin and its consequences can be read easily and directly from the narrative presentation. This is not scripture for an ignorant illiterate population. It is a sermon sculpted in stone.

THE CHURCH OF SAINT-LAZARE AT AUTUN

A different sculptural style and another subject appear at Autun on the portal of the church of Saint-Lazare (see "A Closer Look," opposite), which was built in the first half of the twelfth century as part of the cathedral complex at Autun to house the relics of St. Lazarus, becoming the cathedral of Autun itself only in 1195. The

A CLOSER LOOK | The Last Judgment Tympanum at Autun

by Gislebertus (?), west portal, cathedral of Saint-Lazare. Autun, Burgundy, France. c. 1120-1130 or 1130-1145.

In one of the most endearing vignettes, an angel pushes one of the saved up through an open archway and into the glorious architectural vision of heaven. Another figure at the angel's side reaches up, impatient for his turn to be hoisted up into paradise.

Christ's mother, Mary, is enthroned as queen of heaven. Below, St. Peter-identified by the large keys slung over his shoulder-performs his duties as heavenly gatekeeper, clasping the hands of someone waiting to gain entrance.

This inscription proclaims "I alone dispose of all things and crown the just. Those who follow crime I judge and punish." Clearly, some of the viewers could read Latin.

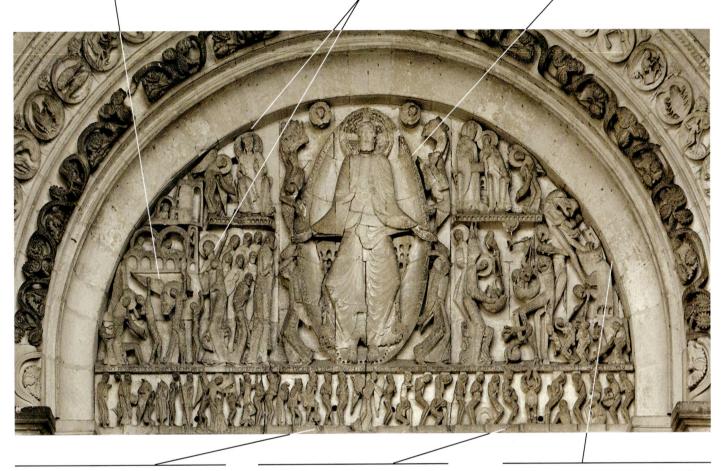

The cross (a badge of Jerusalem) and scallop shell (a badge of Santiago de Compostela) identify these two figures as former pilgrims. The clear message is that participation in pilgrimage will be a factor in their favor at the Last Judgment.

The incised ornament on these sarcophagi is guite similar to that on ancient Roman sarcophagi, one of many indications that the Autun sculptors and masons knew the ancient art created when Autun was a Roman city.

Interestingly, hell is represented here as a basilica, with a devil emerging from the toothy maw that serves as a side entrance, capturing sinners for eternal torment. The devil uses a sharp hook to grab luxuria, the female personification of lust.

View the Closer Look for the Last Judgment tympanum at Autun on myartslab.com

tympanum portrays the Last Judgment, in which Christ-enclosed in a mandorla held by two svelte angels-has returned at the end of time to judge the cowering, naked humans whose bodies rise from their sarcophagi along the lintel at his feet. The damned writhe in torment at Christ's left (our right), while on the opposite side the saved savor serene bliss. The inscribed message on the side of the damned reads: "Here let fear strike those whom earthly error binds, for their fate is shown by the horror of these figures," and under the blessed: "Thus shall rise again everyone who does not

lead an impious life, and endless light of day shall shine for him" (translations from Grivot and Zarnecki).

Another text, right under the feet of Christ, ascribes the Autun tympanum to a man named Gislebertus-Gislebertus hoc fecit ("Gislebertus made this"). Traditionally, art historians have interpreted this inscription as a rare instance of a twelfth-century artist's signature, assigning this façade and related sculpture to an individual named Gislebertus, who was at the head of a large workshop of sculptors. Recently, however, art historian Linda Seidel has challenged this reading, arguing that Gislebertus was actually a late Carolingian count who had made significant donations to local churches. Like the names inscribed on many academic buildings of American universities, this legendary donor's name would have been evoked here as a reminder of the long and rich history of secular financial support in Autun, and perhaps also as a challenge to those currently in power to respect and continue that venerable tradition of patronage themselves.

Thinner and taller than their counterparts at Moissac, stretched out and bent at sharp angles, the stylized figures at Autun are powerfully expressive and hauntingly beautiful. As at Moissac, a huge, hieratic figure of Christ dominates the composition at the center of the tympanum, but the surrounding figures are not arranged here in regular compartmentalized tiers. Their posture and placement conform to their involvement in the story they enact. Since that story is filled with human interest and anecdotal narrative detail, viewers can easily project themselves into what is going on. On the lintel, angels physically assist the resurrected bodies rising from their tombs, guiding them to line up and await their turn at being judged. Ominously, a pair of giant, pincerlike hands descends aggressively to snatch one of the damned on the right side of the lintel (as we look at it). Above these hands, the archangel Michael competes with devils over the fate of someone whose judgment is being weighed on the scales of good and evil. The man himself perches on the top of the scale, hands cupped to his mouth to project his pleas for help toward the Savior. Another man hides nervously in the folds of Michael's robe, perhaps hoping to escape judgment or cowering from the prospect of possible damnation.

By far the most riveting players in this drama are the frenzied, grotesque, screaming demons who grab and torment the damned and even try, in vain, to cheat by yanking the scales to favor damnation. The fear they inspire, as well as the poignant portrayal of the psychological state of those whom they torment, would have been moving reminders to medieval viewers to examine the way they were leading their own lives, or perhaps to seek the benefits of entering the doors in front of them to participate in the community of the Church.

The creation of lively narrative scenes within the geometric confines of capitals (called **historiated capitals**) was an important Romanesque innovation in architectural sculpture. The same sculptors who worked on the Autun tympanum carved historiated capitals for pier pilasters inside the church. Two capitals (**FIG. 16-24**) depict scenes from the childhood of Jesus drawn from Matthew 2:1–18. In one capital, the Magi—who have previously adored and offered gifts to the child Jesus—are interrupted in their sleep by an angel who warns them not to inform King Herod of the location of the newborn king of the Jews. In an ingenious compositional device, the sculptor has shown the reclining Magi and the head of their bed as if viewed from above, whereas the angel and the foot of the bed are viewed from the side. This allows us to see clearly the angel—who is appearing to them in a dream—as he touches the hand of the upper Magus, whose eyes have suddenly popped open. As on the façade, the sculptor has conceived this scene in ways that emphasize the human qualities of its story, not its deep theological significance. With its charming, doll-like figures, the other capital shows an event that occurred just

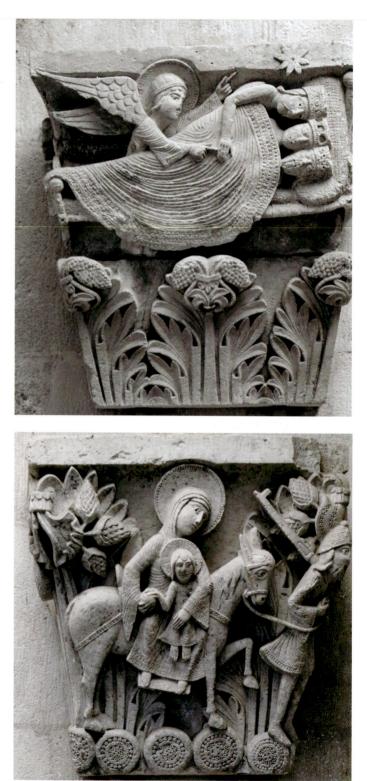

16-24 • THE MAGI ASLEEP (A) AND THE FLIGHT INTO EGYPT (B)

Capitals from the choir pier pilasters, Cathedral of Saint-Lazare, Autun, Burgundy, France. c. 1125.

after the Magi's dream: Joseph, Mary, and Jesus are journeying toward Egypt to escape King Herod's order to murder all young boys so as to eliminate the newborn royal rival the Magi had journeyed to venerate.

SCULPTURE IN WOOD AND BRONZE

Painted wood was commonly used when abbey and parish churches of limited means commissioned statues. Wood was not only cheap; it was lightweight, a significant consideration since these devotional images were frequently carried in processions. Whereas wood seems to have been a sculptural medium that spread across Europe, three geographic areas-the Rhineland, the Meuse River Valley, and German Saxony-were the principal metalworking centers. Bronze sculpture was produced only for wealthy aristocratic and ecclesiastical patrons. It drew on a variety of stylistic sources, including the work of contemporary Byzantine and Italian artists, as well as Classical precedents as reinterpreted by the sculptors' Carolingian and Ottonian forebears.

CHRIST ON THE CROSS (MAJESTAT BATLLÓ)

This mid-twelfth-century painted wooden crucifix from Catalunya, known as the **MAJESTAT BATLLÓ** (**FIG. 16-25**), presents a clothed, triumphant Christ, rather than the seminude figure we have seen at Byzantine Daphni (see FIG. 8–22) or on the Ottonian Gero Crucifix (see FIG. 15–24). This Christ's royal robes emphasize his kingship, although his bowed head, downturned

mouth, and heavy-lidded eyes convey a quiet sense of sadness or introspection. The hem of his long, medallion-patterned tunic has pseudo-kufic inscriptions—designs meant to resemble Arabic script—a reminder that silks from Islamic Spain were highly prized in Europe at this time.

MARY AS THE THRONE OF WISDOM

Any Romanesque image of Mary seated on a throne and holding the Christ Child on her lap is known as "The Throne of Wisdom." In a well-preserved example in painted wood dating from the second half of the twelfth century (**FIG. 16-26**), Mother and Child are frontal and regal. Mary's thronelike bench symbolized the lion-throne of Solomon, the Hebrew Bible king who represented earthly wisdom in the Middle Ages. Mary, as Mother and

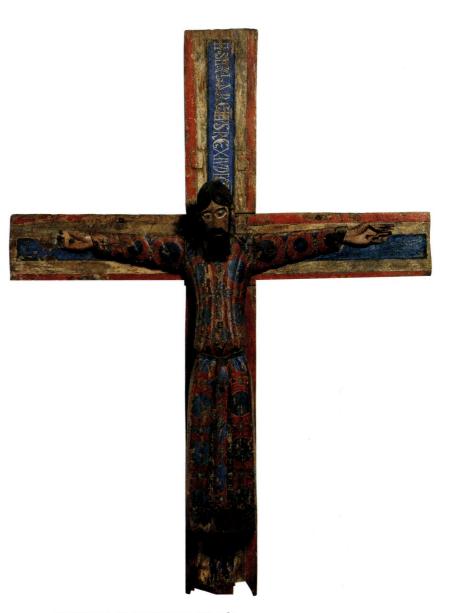

16-25 • CRUCIFIX (MAJESTAT BATLLÓ)

Catalunya, Spain. Mid-12th century. Polychromed wood, height approx. 3734'' (96 cm). © MNAC—Museu Nacional d'Art de Catalunya, Barcelona.

> "God-bearer" (the Byzantine *Theotokos*), gave Jesus his human nature. She forms a throne on which he sits in majesty, but she also represents the Church. Although the Child's hands are missing, we can assume that the young Jesus held a book—the Word of God—in his left hand and raised his right hand in blessing.

> Such statues of the Virgin and Child served as cult objects on the altars of many churches during the twelfth century. They also sometimes took part in the liturgical dramas becoming popular in church services at this time. At the feast of the Epiphany, celebrating the arrival of the Magi to pay homage to the young Jesus, townspeople representing the Magi acted out their journey by searching through the church for the newborn king. The roles of Mary and Jesus were "acted" by such sculptures, which the "Magi" discovered on the altar. On one of the capitals from Autun

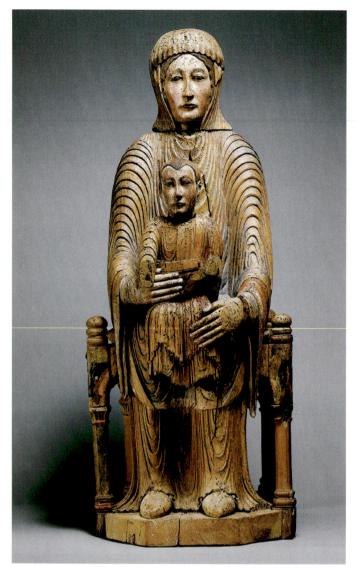

16-26 • VIRGIN AND CHILD

Auvergne region, France. Late 12th century. Oak with polychromy, height 31" (78.7 cm). Metropolitan Museum of Art, New York. Gift of J. Pierpont Morgan, 1916 (16.32.194)

in FIGURE 16–24, the Virgin and Child who sit on the donkey in the Flight into Egypt may record the theatrical use of a wooden statue, strapped to the back of a wooden donkey, that would have been rolled into the church on wheels, possibly referenced by the round forms at the base of the capital.

TOMB OF RUDOLF OF SWABIA

The oldest-known bronze tomb effigy (recumbent portraits of the deceased) is that of **KING RUDOLF OF SWABIA** (FIG. 16-27), who died in battle in 1080. The spurs on his oversized feet identify him as a heroic warrior, and he holds a scepter and cross-surmounted orb, emblems of Christian kingship. Although the tomb is in the cathedral of Merseburg, in Saxony, the effigy has been attributed to an artist originally from the Rhine Valley. Nearly life-size, it was cast in one piece and gilt, though few traces of the

gilding survive. The inscription around the frame was incised after casting, and glass paste or semiprecious stones may have originally been set into the eyes and crown. We know that during the battle that ultimately led to Rudolph's death he lost a hand—which was mummified separately and kept in a leather case—but the sculptor of his effigy presents him idealized and whole.

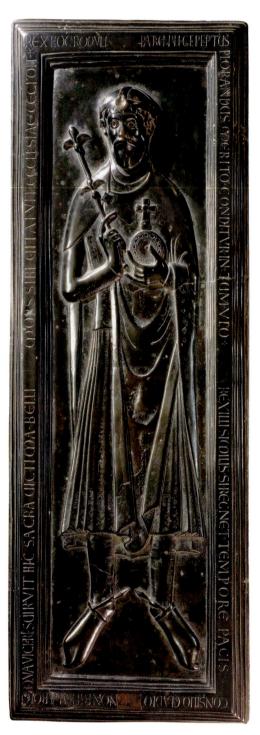

16-27 • TOMB COVER WITH EFFIGY OF KING RUDOLF OF SWABIA

Saxony, Germany. c. 1080. Bronze with niello, approx. $6'5\frac{1}{2}'' \times 2'2\frac{1}{2}''$ (1.97 \times 0.68 m). Cathedral of Merseburg, Germany.

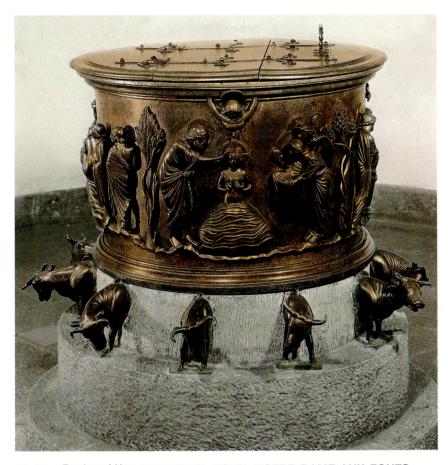

16–28 • Renier of Huy **BAPTISMAL FONT, NOTRE-DAME-AUX-FONTS** Liège, France. 1107–1118. Bronze, height 23⁵/₈" (60 cm); diameter 31¹/₄" (79 cm). Now in the church of Saint-Barthélémy, Liège.

RENIER OF HUY

Bronze sculptor Renier of Huy (Huy is near Liège in present-day Belgium) worked in the Mosan region under the profound influence of classicizing early medieval works of art, as well as the humanistic learning of Church scholars. Hellinus of Notre-Dameaux-Fonts in Liège (abbot 1107-1118) commissioned a bronze BAPTISMAL FONT from Renier (FIG. 16-28) that was inspired by the basin carried by 12 oxen in Solomon's Temple in Jerusalem (I Kings 7:23-24). Christian commentators identified the 12 oxen as the 12 apostles and the basin as the baptismal font, and this interpretation is given visual form in Renier's work. On the sides of the font are images of St. John the Baptist preaching and baptizing Christ, St. Peter baptizing the Roman soldier Cornelius, and St. John the Evangelist baptizing the philosopher Crato. Renier models sturdy but idealized bodies-nude or with clinging drapery-that move and gesture with lifelike conviction, infused with dignity, simplicity, and harmony. His understanding of human anatomy and movement must derive from his close observation of the people around him. He placed these figures within defined landscape settings, standing on an undulating ground line, and separated into scenes by miniature trees. Water rises in a mound of rippling waves (in Byzantine fashion) to cover nude figures discreetly.

TEXTILES AND BOOKS

Among the most admired arts during the Middle Ages are those that later critics patronized as the "minor" or "decorative" arts. Although small in scale, these works are often produced with technical virtuosity from very precious materials, and they were vital to the Christian mission and devotion of the institutions that housed them.

Artists in the eleventh and twelfth centuries were still often monks and nuns. They labored within monasteries as calligraphers and painters in the scriptorium to produce books and as metalworkers to craft the enamel- and jewelencrusted works used in liturgical services. They also embroidered the vestments, altar coverings, and wall hangings that clothed both celebrants and settings in the Mass. Increasingly, however, secular urban workshops supplied the aristocratic and royal courts with textiles, tableware, books, and weapons, for their own use or as donations to religious institutions.

CHRONICLING HISTORY

Romanesque artists were commissioned not only to illustrate engaging stories and embody important theological ideas within the context of sacred buildings and sacred books. They also created visual accounts of secular history, where moralizing was one of the principal objectives of pictorial narrative.

THE BAYEUX EMBROIDERY Elaborate textiles, including embroideries and tapestries, enhanced a noble's status and were thus necessary features in castles and palaces. The Bayeux Embroidery (see page 488) is one of the earliest examples to have survived. This extended narrative strip chronicles the events leading to Duke William of Normandy's conquest of England in 1066. The images depicted on the long embroidered band of linen may have been drawn by a Norman designer since there is a clear Norman bias in the telling of the story, but style suggests that it may have been Anglo-Saxons who did the actual needlework. This represents the kind of secular art that must once have been part of most royal courts. It could be rolled up and transported from residence to residence as the noble Norman owner traveled throughout his domain, and some have speculated that it may have been the backdrop at banquets for stories sung by professional performers who could have received their cues from the identifying descriptions that accompany most scenes. Eventually the embroidery was given to Bayeux Cathedral, perhaps by Bishop Odo, William's half-brother; we know it was displayed around the walls of the cathedral on the feast of the relics.

A BROADER LOOK | The Bayeux Embroidery

Rarely has art spoken more vividly than in the Bayeux Embroidery, a strip of embroidered linen that recounts the history of the Norman Conquest of England. Its designer was a skillful storyteller who used a staggering number of images to chronicle this history. In the 50 surviving scenes there are more than 600 human figures, 700 horses, dogs, and other creatures, and 2,000 inch-high letters.

On October 14, 1066, William, Duke of Normandy, after a hard day of fighting, became William the Conqueror, king of England. The story told in embroidery seeks to justify his action, with the intensity of an eyewitness account: The Anglo-Saxon nobleman Harold initially swears his allegiance to William, but later betrays his vows, accepting the crown of England for himself. Unworthy to be king, he dies in battle at the hands of William and the Normans.

Harold is a heroic figure at the beginning of the story, but then events overtake him. After his coronation, cheering crowds celebrate until Halley's Comet crosses the sky (**FIGS. 16–29, 16–30, 16–31**). The Anglo-Saxons, seeing the comet as a portent of disaster, cringe and point at this brilliant ball of fire with a flaming tail, and a man rushes to inform the new king. Harold slumps on his throne in the Palace of Westminster. He foresees what is to come: Below his feet is his vision of a ghostly

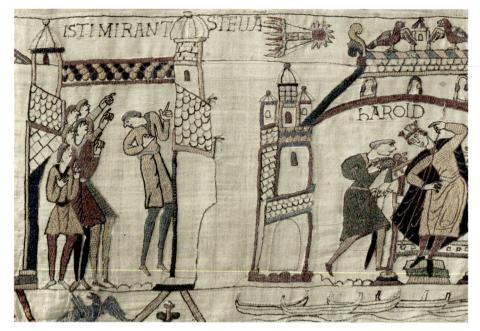

16-29 • MESSENGERS SIGNAL THE APPEARANCE OF HALLEY'S COMET, THE BAYEUX EMBROIDERY

Norman–Anglo-Saxon, perhaps from Canterbury, Kent, England. c. 1066–1082. Linen with wool embroidery, height 20" (50.8 cm). Centre Guillaume le Conquérant, Bayeux, France.

fleet of Norman ships already riding the waves. Duke William has assembled the last great Viking flotilla on the Normandy coast.

The tragedy of this drama has spoken movingly to audiences over the centuries.

It is the story of a good man who, like Shakespeare's Macbeth, is overcome by his lust for power and so betrays his lord. The images of this Norman invasion also spoke to people during the darkest days of World War II.

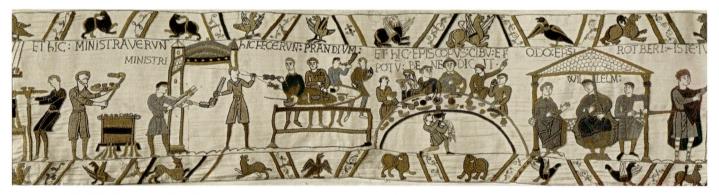

16-30 • BISHOP ODO BLESSING THE FEAST, THE BAYEUX EMBROIDERY

Norman–Anglo-Saxon, perhaps from Canterbury, Kent, England. c. 1066–1082. Linen with wool embroidery, height 20" (50.8 cm). Centre Guillaume le Conquérant, Bayeux, France.

Odo and William are feasting before the battle. Attendants bring in roasted birds on skewers, placing them on a makeshift table made of the knights' shields set on trestles. The diners, summoned by the blowing of a horn, gather at a curved table laden with food and drink. Bishop Odo—seated at the center, head and shoulders above William to his right—blesses the meal while others eat. The kneeling servant in the middle proffers a basin and towel so that the diners may wash their hands. The man on Odo's left points impatiently to the next event, a council of war between William (now the central and tallest figure), Odo, and a third man labeled "Rotbert," probably Robert of Mortain, another of William's halfbrothers. Translation of text: "and here the servants (*ministra*) perform their duty. / Here they prepare the meal (*prandium*) / and here the bishop blesses the food and drink (*cibu et potu*). Bishop Odo. William. Robert."

When the Allies invaded Nazi-occupied Europe in June 1944, they took the same route in reverse from England to beaches on the coast of Normandy. The Bayeux Embroidery still speaks to us of the folly of human greed and ambition and of two battles that changed the course of history.

Although traditionally referred to as the "Bayeux Tapestry," this work is really an embroidery. In tapestry, the colored threads that create images or patterns are woven together during the process of production, completely covering the canvas ground that serves as their support; in embroidery, stitches are applied on top of a tightly woven fabric that serves as their support, as well as the ground behind the patterns they create. The embroiderers, probably Anglo-Saxon women, worked in tightly twisted wool that was dyed in eight colors. They used only two stitches: the quick, overlapping stem stitch that produced a slightly jagged line or outline, and the time-consuming laid-and-couched work used to form blocks of color. For the latter, the embroiderer first "laid" a series of long, parallel covering threads; then anchored them with a second layer of regularly spaced crosswise stitches; and finally tacked all the strands down with tiny "couching" stitches. Some of the laid-and-couched work was done in contrasting colors to achieve particular effects. The creative coloring is often fanciful: for example, some horses have legs in four different colors. Skin and other light-toned areas are represented by the bare linen cloth that formed the ground of the work.

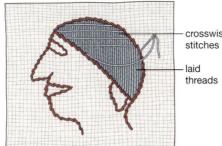

crosswise

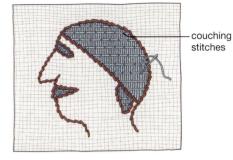

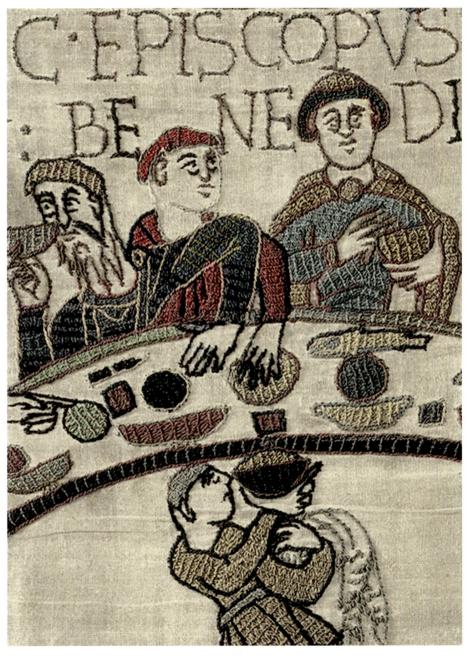

16-31 • DETAIL OF BISHOP ODO BLESSING THE FEAST (FIG. 16-30)

View the Closer Look for the Bayeux Embroidery on myartslab.com

THE WORCESTER CHRONICLE Another Romanesque chronicle is the earliest-known illustrated history book: the WORCESTER CHRONICLE (FIG. 16-32), written in the twelfth century by a monk named John. The pages shown here concern Henry I (r. 1100-1135), the second of William the Conqueror's sons to sit on the English throne. The text relates a series of nightmares the king had in 1130, in which his subjects demanded tax relief. The artist depicts the dreams with energetic directness. On the first night, angry farmers confront the sleeping king; on the second, armed knights surround his bed; and on the third, monks, abbots, and bishops present their case. In the fourth illustration, the king travels in a storm-tossed ship and saves himself by promising God that he will rescind the tax increase for seven years. The author of the Worcester Chronicle assured his readers that this story came from a reliable source, the royal physician Grimbald, who appears in the margins next to three of the scenes. The angry farmers capture our attention today because we seldom see working men with their equipment and simple clothing depicted in painting from this time.

SACRED BOOKS

Monastic scriptoria continued to be the centers of illustrated book production, which increased dramatically during the twelfth century. But the scriptoria sometimes employed lay scribes and artists who traveled from place to place. In addition to the books needed for the church services, scribes produced copies of sacred texts, scholarly commentaries, visionary devotional works, lives of saints, and collections of letters and sermons.

THE CODEX COLBERTINUS The portrait of **ST. MAT-THEW** from the Codex Colbertinus (**FIG. 16-33**) is an entirely Romanesque conception, quite different from Hiberno-Saxon and Carolingian author portraits. Like the sculptured pier figures of Silos (see FIG. 16-1), the evangelist stands within an architectural frame that completely surrounds him. He blesses and holds his book—rather than writing it—within the compact silhouette of his body. His dangling feet bear no weight, and his body has little sense of three-dimensionality, with solid blocks of color filling its strong outlines.

16-32 • John of Worcester THOSE WHO WORK; THOSE WHO FIGHT; THOSE WHO PRAY—THE DREAM OF HENRY I, WORCESTER CHRONICLE

Worcester, England. c. 1140. Ink and tempera on vellum, each page 12³/₄" × 9³/₆" (32.5 × 23.7 cm). Corpus Christi College, Oxford. CCC MS. 157, pp. 382–383

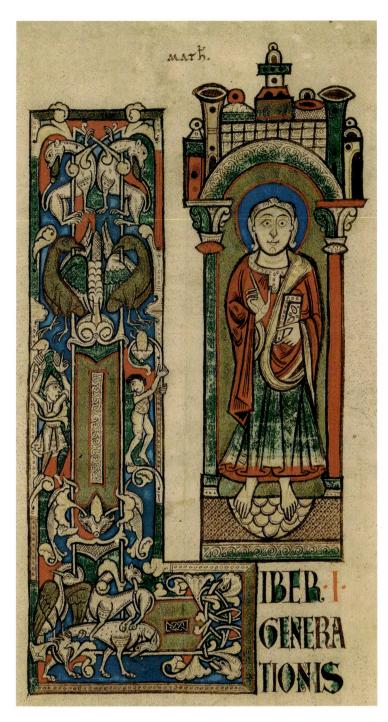

16-33 • ST. MATTHEW FROM THE CODEX COLBERTINUS c. 1100. Tempera on vellum, 7¹/₂" × 4" (19 × 10.16 cm). Bibliothèque Nationale, Paris. MS lat. 254, fol. 10r

The text of Matthew's Gospel begins with a complementary block of ornament to the left of Matthew's portrait. The "L" of *Liber generationis* ("The book of the generation") is a framed picture formed of plants and animals—what art historians call a historiated initial. Dogs or catlike creatures and long-necked birds twist, claw, and bite each other and themselves while, in the center, two humans—one dressed and one nude—clamber up the letter. This manuscript was made in the region of Moissac at about the same time that sculptors were working on the abbey church, and the stacking of intertwined animals here recalls the outer face of the Moissac trumeau (see FIGS. 16–21, 16–22).

THE GERMAN NUN GUDA In another historiated initial, this one from Westphalia in Germany, the nun Guda has a more modest presentation. In a **BOOK OF HOMI-LIES** (sermons), she inserted her self-portrait into the letter *D* and signed it as scribe and painter, "Guda, the sinful woman, wrote and illuminated this book" (**FIG. 16-34**). This is a simple colored drawing with darker blocks of color in the background, but Guda and her monastic sisters played an important role in the production of books in the twelfth century, and not all of them remain anonymous. Guda's image is the earliest signed self-portrait by a woman in western Europe. Throughout the Middle Ages, women were involved in the production of books as authors, scribes, painters, and patrons (see "Hildegard of Bingen," page 492).

16-34 • The Nun Guda **BOOK OF HOMILIES** Westphalia, Germany. Early 12th century. Ink on parchment. Universitätsbibliothek Johann Christian Senckenberg, Frankfurt am Main, Germany. MS. Barth. 42, fol. 110v

ART AND ITS CONTEXTS | Hildegard of Bingen

We might expect women to have a subordinate position in the hierarchical and militaristic society of the twelfth century. On the contrary, aristocratic women took responsibility for managing estates during their male relatives' frequent absences in wars or while serving at court. And women also achieved positions of authority and influence as the heads of religious communities. Notable among them was Hildegard of Bingen (1098–1179).

Born into an aristocratic German family, Hildegard transcended the barriers that limited most medieval women. She began serving as leader of her convent in 1136, and about 1147 she founded a new convent near Bingen. Hildegard also wrote important treatises on medicine and natural science, invented an alternate alphabet, and was one of the most gifted and innovative composers of her age, writing not only motets and liturgical settings, but also a musical drama that

is considered by many to be the first opera. Clearly a major, multitalented figure in the intellectual and artistic life of her time —comparison with the later Leonardo da Vinci comes to mind she also corresponded with emperors, popes, and the powerful abbots Bernard of Clairvaux and Suger of Saint-Denis.

Following a command she claimed to have received from God in 1141, and with the assistance of her nuns and the monk Volmar, Hildegard began to record the mystical visions she had been experiencing since she was 5 years old. The resulting book, called the Scivias (from the Latin scite vias lucis, "know the ways of the light"), is filled not only with words but with striking images of the strange and wonderful visions themselves (FIG. 16-35). The opening page (FIG. 16-36) shows Hildegard receiving a flash of divine insight, represented by the tongues of flame encircling her head-she said, "a fiery light, flashing intensely, came from the open vault of heaven and poured through my whole brain"-while her scribe Volmar writes to her dictation. But was she also responsible for the arresting pictures that accompany the text in this book? Art historian Madeline Caviness thinks so, both because of their unconventional nature and because they conform in several ways to the "visionary" effects experienced by many people during migraines, which plagued Hildegard throughout her life but especially during her forties while she was composing the Scivias. She said of her visions, "My outward eyes are open. So I have never fallen prey to ecstacy in the visions, but I see them wide awake, day and night. And I am constantly fettered by sickness, and often in the grip of pain so intense that it threatens to kill me." (Translated in Newman, p. 16.)

Perhaps in this miniature Hildegard is using the large stylus to sketch on the wax tablets in her lap the pictures of her visions that were meant to accompany the verbal descriptions she dictates to Volmar, who sits at the right with a book in his hand, ready to write them down.

16-35 • Hildegard of Bingen THE UNIVERSE

1927–1933 facsimile of Part I, Vision 3 of the *Liber Scivias* of Hildegard of Bingen. Original, 1150–1175.

Hildegard begins her description of this vision with these words: "After this I saw a vast instrument, round and shadowed, in the shape of an egg, small at the top, large in the middle, and narrowed at the bottom; outside it, surrounding its circumference, there was a bright fire with, as it were, a shadowy zone under it. And in that fire there was a globe of sparkling flame so great that the whole instrument was illuminated by it."

16-36 • HILDEGARD AND VOLMAR

1927–1933 facsimile of the frontispiece of the *Liber Scivias* of Hildegard of Bingen. Original, 1150–1175.

This author portrait was once part of a manuscript of Hildegard's *Scivias* that many believe was made in her own lifetime, but it was lost in World War II. Today we can study its images only from prewar black-and-white photographs or from a full-color facsimile that was lovingly hand-painted by the nuns of the abbey of St. Hildegard in Eigingen under the direction of Joesepha Krips between 1927 and 1933, the source of both pictures reproduced here.

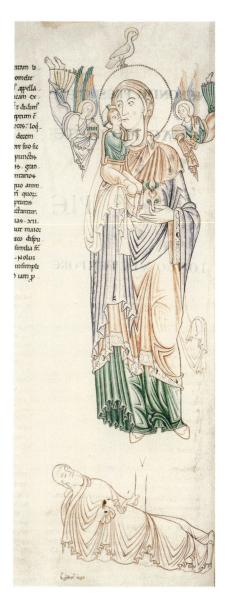

16-37 • PAGE WITH THE TREE OF JESSE, EXPLANATIO IN ISAIAM (ST. JEROME'S COMMENTARY ON ISAIAH)

Abbey of Cîteaux, Burgundy, France. c. 1125. Ink and tempera on vellum, $15'' \times 4^3\!\!4''$ (38 \times 12 cm). Bibliothèque Municipale, Dijon, France. MS. 129, fol. 4v

A CISTERCIAN TREE OF JESSE The Cistercians were particularly devoted to the Virgin Mary and are also credited with popularizing themes such as the Tree of Jesse as a device for showing her position as the last link in the genealogy connecting Jesus to King David. (Jesse, the father of King David, was an ancestor of Mary and, through her, of Jesus.) A manuscript of St. Jerome's Commentary on Isaiah, made in the scriptorium of the Cistercian mother house of Cîteaux in Burgundy about 1125, contains an image of an abbreviated TREE OF JESSE (FIG. 16–37).

A monumental Mary, with the Christ Child sitting on her veiled arm, stands over the forking branches of the tree, dwarfing the sleeping patriarch, Jesse, from whose body a small tree trunk grows. The long, vertical folds of Mary's voluminous drapery—especially the flourish at lower right, where a piece of her garment billows up, as if caught in an updraft—recall the treatment of drapery in the portal at Autun (see "A Closer Look," page 483), also from Burgundy. The artist has drawn, rather than painted, with soft colors, using subtle tints that seem somehow in keeping with Cistercian restraint. Christ embraces his mother's neck, pressing his cheek against hers in a display of tender affection that recalls Byzantine icons of the period, like the Virgin of Vladimir (see FIG. 8-28). The foliate form Mary holds in her hands could be a flowering sprig from the Jesse Tree, or it could be a lily symbolizing her purity.

The building held by the angel on the left equates Mary with the Church, and the crown held by the angel on the right is hers as queen of heaven. The dove above her halo represents the Holy Spirit; Jesse Trees often have doves sitting in the uppermost branches. In the early decades of the twelfth century, Church doctrine came increasingly to stress the role of the Virgin Mary and the saints as intercessors who could plead for mercy on behalf of repentant sinners, and devotional images of Mary became increasingly popular during the later Romanesque period. As we will see, this popularity would continue into the Gothic period, not only in books but on the sculpted portals and within the stained-glass windows of cathedrals.

THINK ABOUT IT

- **16.1** Discuss what is meant by the term "Romanesque" and distinguish some of the key stylistic features associated with architecture in this style.
- **16.2** Discuss the sculpture that was integrated into the exteriors of Romanesque churches. Why was it there? Whom did it address? What were the prominent messages? Make reference to at least one church discussed in this chapter.
- 16.3 What is a pilgrimage site? How did pilgrimage sites function for medieval Christians? Ground your answer in a discussion of Santiago de Compostela, focusing on specific features that were geared toward pilgrims.
- 16.4 Analyze one example of a Romanesque work of art in this chapter that tells a story of human frailty. Who was the intended audience? How does its style relate to the intended moral message?

CROSSCURRENTS

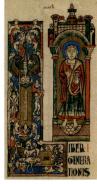

FIG. 16-33

These two pages served as the beginning of the Gospel of Matthew in two medieval manuscripts, one Hiberno-Saxon and the other Romanesque. Compare the designs of these two pages and the relationship that is established between words and images. How does the work of these two artists relate to work in other media during the period in which each was made?

Study and review on myartslab.com

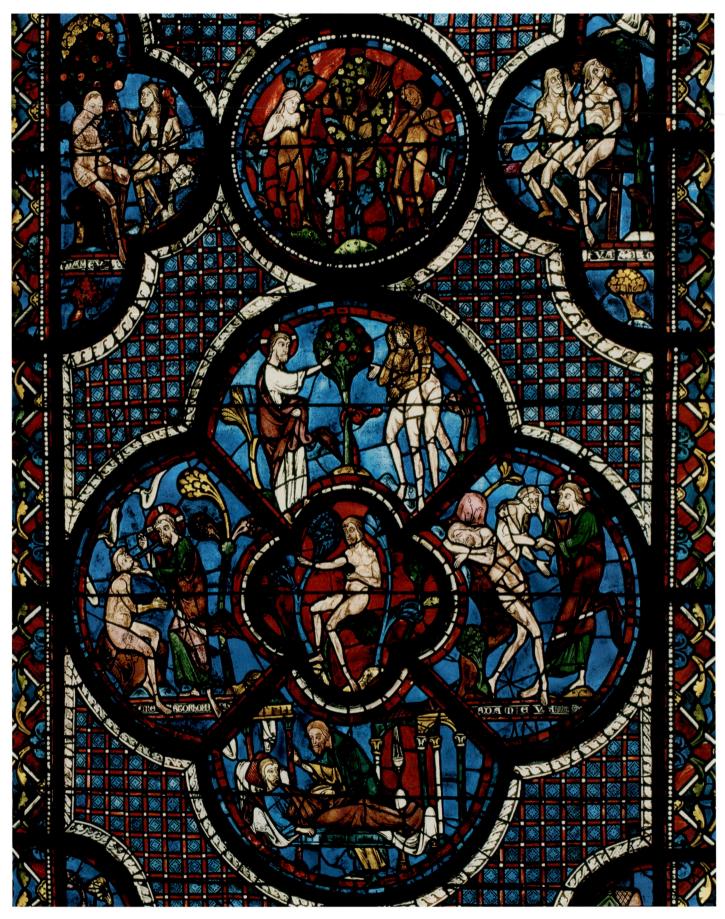

17-1 • SCENES FROM GENESIS

Detail of the Good Samaritan Window, south aisle of nave, Cathedral of Notre-Dame, Chartres, France. c. 1200–1210. Stained and painted glass.

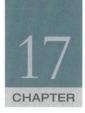

Gothic Art of the Twelfth and Thirteenth Centuries

The Gothic style—originating in the powerful monasteries of the Paris region—dominated much of European art and architecture for 400 years. By the mid twelfth century, advances in building technology, increasing financial resources, and new intellectual and spiritual aspirations led to the development of a new art and architecture that expressed the religious and political values of monastic communities. Soon bishops and rulers, as well as abbots, vied to build the largest and most elaborate churches. Just as residents of twentieth-century American cities raced to erect higher and higher skyscrapers, so too the patrons of western Europe competed during the Middle Ages in the building of cathedrals and churches with ever-taller naves and towers, diaphanous walls of glowing glass, and breathtakingly airy interiors that seemed to open in all directions.

The light captured in stained-glass windows created luminous pictures that must have captivated a faithful population whose everyday existence included little color, outside the glories of the natural world. And the light that passed through these windows transformed interior spaces into a many-colored haze. Truly, Gothic churches became the glorious jeweled houses of God, evocations of the heavenly Jerusalem. They were also glowing manifestations of Christian doctrine, and invitations to faithful living, encouraging worshipers to follow in the footsteps of the saints whose lives were frequently featured in the windows of Gothic churches. Stained glass soon became the major medium of monumental painting.

This detail from the Good Samaritan Window at Chartres Cathedral (FIG. 17-1), created in the early years of the thirteenth century, well into the development of French Gothic architecture, includes scenes from Genesis, the first book of the Bible. The window portrays God's creation of Adam and Eve, and continues with their subsequent temptation, fall into sin, and expulsion from the paradise of the Garden of Eden to lead a life of work and woe. Adam and Eve's story is used here to interpret the meaning of the parable of the Good Samaritan for medieval viewers, reminding them that Christ saves them from the original sin of Adam and Eve just as the Good Samaritan saves the injured and abused traveler (see FIG. 17-10). The stained-glass windows of Gothic cathedrals were more than glowing walls activated by color and light; they were also luminous sermons, preached with pictures rather than with words. These radiant pictures were directed at a diverse audience of worshipers, drawn from a broad spectrum of medieval society, who derived multiple meanings from gloriously complicated works of art.

LEARN ABOUT IT

- **17.1** Investigate the ideas, events, and technical innovations that led to the development of Gothic architecture in France.
- **17.2** Understand how artists communicated complex theological ideas, moralizing stories, and socio-political concerns, in stained glass, sculpture, and illustrated books.
- **17.3** Analyze the relationship between the Franciscan ideals of empathy and the emotional appeals of sacred narrative painting and sculpture in Italy.
- **17.4** Explore and characterize English and German Gothic art and architecture in relation to French prototypes.

((•- Listen to the chapter audio on myartslab.com

THE EMERGENCE OF THE GOTHIC STYLE

In the middle of the twelfth century, a distinctive new architecture known today as Gothic emerged in the Île-de-France, the French royal domain around Paris (MAP 17-1). The appearance there of a new style and technique of building coincided with the emergence of the monarchy as a powerful centralizing force. Within 100 years, an estimated 2,700 Gothic churches, shimmering with stained glass and encrusted with sculpture, were built in the Île-de-France region alone.

Advances in building technology allowed progressively larger windows and ever loftier vaults supported by more and more streamlined skeletal exterior buttressing. Soon, the Gothic style spread throughout western Europe, gradually displacing Romanesque forms while taking on regional characteristics inspired by them. Gothic prevailed until about 1400, lingering even longer in some regions. It was adapted to all types of structures, including town halls and residences, as well as Christian churches and synagogues.

The term "Gothic" was popularized by the sixteenth-century Italian artist and historian Giorgio Vasari, who disparagingly attributed the by-then-old-fashioned style to the Goths, Germanic invaders who had "destroyed" the Classical civilization of the Roman Empire that Vasari preferred. In its own day the Gothic style was simply called "modern art" or the "French style."

THE RISE OF URBAN AND INTELLECTUAL LIFE

The Gothic period was an era of both communal achievement and social change. Although Europe remained rural, towns gained increasing prominence. They became important centers of artistic patronage, fostering strong communal identity by public projects and ceremonies. Intellectual life was also stimulated by the interaction of so many people living side by side. Universities in Bologna, Padua, Paris, Cambridge, and Oxford supplanted monastic

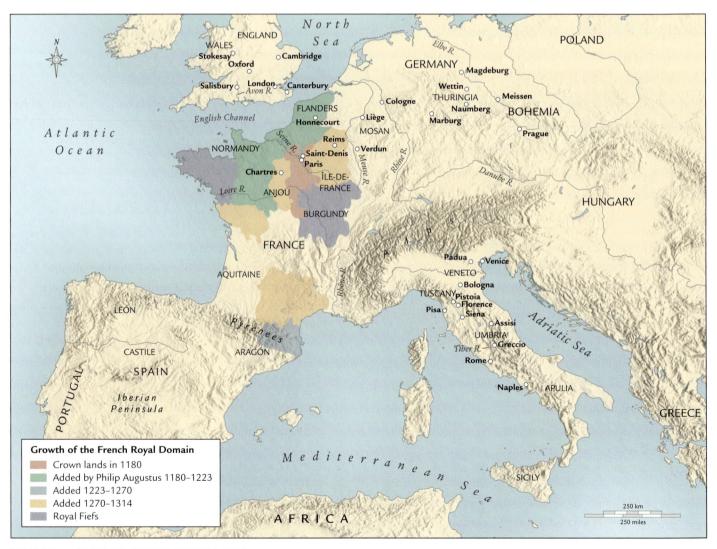

MAP 17-1 • EUROPE IN THE GOTHIC ERA

The color changes on this map chart the gradual expansion of territory ruled by the king of France during the period when Gothic was developing as a modern French style.

ART AND ITS CONTEXTS | Abbot Suger on the Value of Art in Monasteries

Suger, who masterminded the reconstruction of the abbey church at Saint-Denis while he was its abbot (1122–1151), weighed in on the twelfth-century monastic debate concerning the appropriateness of elaborate art in monasteries (see "St. Bernard and Theophilus," page 470) both through the magnificence of the new church he built and by the way he described and discussed the project in the account he wrote of his administration of the abbey.

These are his comments on the bronze doors (destroyed in 1794):

Bronze casters having been summoned and sculptors chosen, we set up the main doors on which are represented the Passion of the Saviour and His Resurrection, or rather Ascension, with great cost and much expenditure for their gilding as was fitting for the noble porch...

The verses on the door are these:

Whoever thou art, if thou seekest to extol the glory of these doors, Marvel not at the gold and the expense but at the craftsmanship of the work.

Bright is the noble work; but being nobly bright, the work Should lighten the minds, so that they may travel, through the true lights.

To the True Light where Christ is the true door,

In what manner it be inherent in this world the golden door defines:

The dull mind rises to truth through that which is material And, in seeing this light, is resurrected from its former subversion.

On the lintel, just under the large figure of Christ at the Last Judgment on the tympanum, Suger had inscribed:

Receive, O stern Judge, the prayers of Thy Suger; grant that I be mercifully numbered among Thy own sheep.

(Translations from Panofsky, pp. 47, 49)

Read the documents related to Abbot Suger on myartslab.com

and cathedral schools as centers of learning. Brilliant teachers like Peter Abelard (1079–1142) drew crowds of students, and in the thirteenth century an Italian theologian, Thomas Aquinas (1225– 1274), made Paris the intellectual center of Europe.

A system of reasoned analysis known as scholasticism emerged from these universities, intent on reconciling Christian theology with Classical philosophy. Scholastic thinkers used a question-andanswer method of argument and arranged their ideas into logical outlines. Thomas Aquinas, the foremost Scholastic, applied Aristotelian logic to comprehend religion's supernatural aspects, setting up the foundation on which Catholic thought rests to this day. Some have seen a relationship between the development of these new ways of thinking and the geometrical order that permeates the design of Gothic cathedrals, as well as with the new interest in describing the appearance of the natural world in sculpture and painting.

THE AGE OF CATHEDRALS

Urban cathedrals, the seats of the ruling bishops, superseded rural monasteries as centers of religious culture and patronage. So many cathedrals were rebuilt between 1150 and 1400—often to replace earlier churches destroyed in the fires that were an unfortunate byproduct of population growth and housing density within cities—that some have dubbed the period the "Age of Cathedrals." Cathedral precincts functioned almost as towns within towns—containing a palace for the bishop, housing for the clergy, and workshops for the multitude of artists and laborers necessary to support building campaigns. These gigantic churches certainly dominated their urban surroundings. But even if their grandeur inspired admiration, their enormous expense and some bishops' intrusive displays of power inspired resentment, even urban rioting.

GOTHIC ART IN FRANCE

The development and initial flowering of the Gothic style in France took place against the backdrop of the growing power of the Capetian monarchy. Louis VII (r. 1137–1180) and Philip Augustus (r. 1180–1223) consolidated royal authority in the Îlede-France and began to exert more control over powerful nobles in other regions. Louis VII's queen, Eleanor of Aquitaine, brought southwestern France into the royal domain, but when their marriage was annulled, Eleanor reclaimed her lands and married Henry Plantagenet—count of Anjou, duke of Normandy—who became King Henry II of England. The resulting tangle of conflicting claims kept France and England at odds for centuries.

As French kings continued to consolidate royal authority and to increase their domains and privileges, they also sparked a building boom with the growing centralization of their government in Paris, which developed from a small provincial town into a thriving urban center beginning in the middle of the twelfth century. Concentrated architectural activity in the capital may have provided the impetus—or perhaps simply the opportunity—for the developments in architectural technology and the new ways of planning and thinking about buildings that ultimately led to the birth of a new style.

THE BIRTH OF GOTHIC AT THE ABBEY CHURCH OF SAINT-DENIS

Many consider the church of the Benedictine abbey of Saint-Denis, just north of Paris, to be the first Gothic building. This monastery had been founded in the fifth century over the tomb of St. Denis, the Early Christian martyr who had been sent from Rome to convert the local pagan population, becoming the first bishop of Paris. Early on, the abbey developed special royal significance. It housed tombs of the kings of France, the regalia of the French crown, and the relics of St. Denis, patron saint of France.

Construction began in the 1130s of a new church that was

to replace the early medieval church at the abbey, under the supervision of Abbot Suger (abbot 1122-1151). In a written account of his administration of the abbey, Suger discusses the building of the church, a rare firsthand chronicle and justification of a medieval building program. Suger prized magnificence, precious materials, and especially fine workmanship (see "Abbot Suger on the Value of Art in Monasteries," page 497). He invited an international team of masons, sculptors, metalworkers, and glass painters, making this building site a major center of artistic exchange. Such a massive undertaking was extraordinarily expensive. The abbey received substantial annual revenues from the town's inhabitants, and Suger was not above forging documents to increase the abbey's landholdings, which constituted its principal source of income.

Suger began building c. 1135, with a new west façade and narthex attached to the old church, but it was in the new choir—completed in three years and three months between July 14, 1140 and its consecration on June 11, 1144—where the fully formed Gothic architectural style may first have appeared. In his account of the reconstruction, Suger argues that the older building was inadequate to accommodate the crowds of pilgrims who arrived on feast days to venerate the body of St. Denis, and too modest to express the importance of the saint himself. In working with builders to conceive a radically new church design, he turned for inspiration to texts that were attributed erroneously to a follower of St. Paul named Dionysius (the Greek form of Denis), who considered radiant light a physical manifestation of God. Since through the centuries, this Pseudo-Dionysius also became

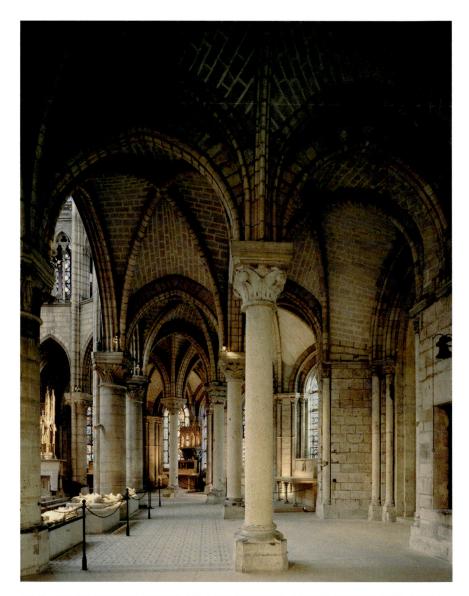

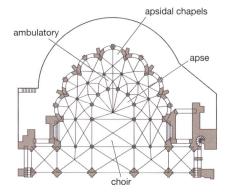

Contractory of

17-2 • PLAN OF THE CHOIR (A) AND VIEW OF AMBULATORY AND APSE CHAPELS (B) OF THE ABBEY CHURCH OF SAINT-DENIS France. 1140–1144.

Envisioning the completion of the abbey church with a transept, and presumably also a nave, Abbot Suger had the following inscription placed in the church to commemorate the 1144 dedication of the choir: "Once the new rear part is joined to the part in front, the church shines with its middle part brightened. For bright is that which is brightly coupled with the bright, and bright is the noble edifice which is pervaded by the new light." (Panofsky, p. 51).

ELEMENTS OF ARCHITECTURE | Rib Vaulting

An important innovation of Romanesque and Gothic builders was **rib vaulting**. Rib vaults are a form of groin vault (see "Roman Vaulting," page 187), in which the diagonal ridges (groins) rest on and are covered by curved moldings called ribs. After the walls and piers of the building reached the desired height, timber scaffolding to support these masonry ribs was constructed. When the mortar of the ribs was set, the web of the vault was then laid on forms built on the ribs themselves. After all the temporary forms were removed, the ribs may have provided strength at the intersections of the webbing to channel the vaults' thrust outward and downward to the foundations; they certainly add decorative interest. In short, ribs formed the "skeleton" of the vault; the webbing, a lighter masonry "skin." In Late Gothic buildings, additional decorative ribs give vaults a lacelike appearance.

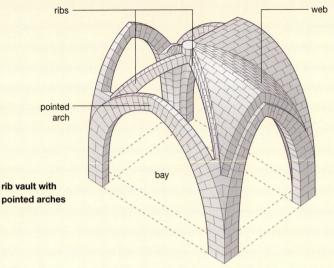

Watch an architectural simulation about rib vaulting on myartslab.com

identified with the martyred Denis whose body was venerated at the abbey, Suger was adapting what he believed was the patron saint's concept of divine luminosity in designing the new abbey church with walls composed essentially of stained-glass windows. In inscriptions he composed for the bronze doors (now lost), he was specific about the motivations for the church's new architectural style: "being nobly bright, the work should lighten the minds, so that they may travel, through the true lights, to the True Light where Christ is the true door" (Panofsky, p. 49).

The PLAN OF THE CHOIR (FIG. 17-2A) retains key features of the Romanesque pilgrimage plan (see FIG. 16-4A), with a semicircular apse surrounded by an ambulatory, around which radiate seven chapels of uniform size. And the structural elements of the choir had already appeared in Romanesque buildings, including pointed arches, ribbed groin vaults, and external buttressing to relieve stress on the walls. The dramatic achievement of Suger's builders was the coordinated use of these features to create an architectural whole that emphasized open, flowing space, enclosed by nonload-bearing walls of glowing stained glass (FIG. 17-2B). In Suger's words, the church becomes "a circular string of chapels by virtue of which the whole would shine with the wonderful and uninterrupted light of most luminous windows, pervading the interior beauty" (Panofsky, p. 101). And since Suger saw the contemplation of light as a means of illuminating the soul and uniting it with God, he was providing his monks with an environment especially conducive to their primary vocation of prayer and meditation.

The revolutionary stained-glass windows of Suger's Saint-Denis were almost lost in the wake of the French Revolution, when this royal abbey represented everything the new leaders were intent on suppressing. Thanks to an enterprising antiquarian named Alexandre Lenoir, however, the twelfth-century windows, though removed from their architectural setting, were saved from destruction. During the nineteenth century, some stained glass returned to the abbey, but many panels are now in museums. One of the bestpreserved—from a window that narrated Jesus' childhood—portrays **THE FLIGHT INTO EGYPT** (**FIG. 17-3**). The crisp elegance of the delineation of faces, foliage, and drapery—painted with vitreous enamel on the vibrantly colored pieces of glass that make up the panel (see "Stained-Glass Windows," page 501)—is almost as clear today as it was when the windows were new. One unusual detail—the Virgin reaching to pick a date from a palm tree that has bent down at the infant Jesus' command to accommodate her hungry grasp—is based on an apocryphal Gospel that was not included in the canonical Christian scriptures but remained a popular source for twelfth-century artists.

Louis VII and Eleanor of Aquitaine attended the consecration of the new choir in June 1144, along with a constellation of secular and sacred dignitaries. Since the bishops and archbishops of France were assembled at the consecration—celebrating Mass simultaneously at altars throughout the choir and crypt—they had the opportunity to experience firsthand this new Gothic style of building. The history of French architecture over the next few centuries indicates that they were quite impressed.

GOTHIC CATHEDRALS

The abbey church of Saint-Denis became the prototype for a new architecture of space and light based on a highly adaptable skeletal framework that supported rib vaulting on the points of slender piers—rather than along massive Romanesque walls—reinforced by external buttress systems. It initiated a period of competitive experimentation in France that resulted in ever-larger churches—principally cathedrals—enclosing increasingly taller interior spaces, walled with ever-greater expanses of stained glass.

17-3 • THE FLIGHT INTO EGYPT

Detail of the Incarnation (Infancy of Christ) Window, axial choir chapel, abbey church of Saint-Denis. c. 1140– 1144. The Glencairn Museum, Bryn Athyn, Pennsylvania.

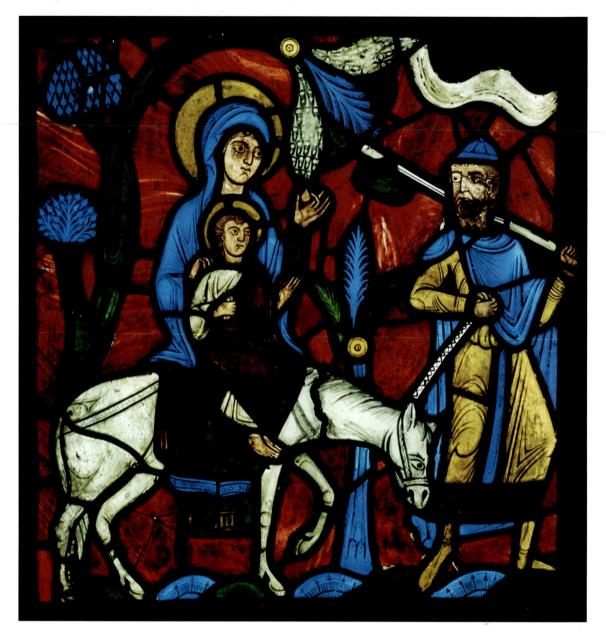

THE CATHEDRAL OF NOTRE-DAME AT CHARTRES

The new Gothic conceptions of space and wall, and the structural techniques that made them possible, were developed further at Chartres. The great cathedral dominates this town southwest of Paris and, for many people, is a near-perfect embodiment of the Gothic style in stone and glass. Constructed in several stages beginning in the mid twelfth century and extending into the mid thirteenth, with additions such as the north spire as late as the sixteenth century, Chartres Cathedral reflects the transition from an experimental twelfth-century architecture to a mature thirteenthcentury style.

Chartres was the site of a pre-Christian virgin-goddess cult, and later, dedicated to the Virgin Mary, it became one of the oldest and most important Christian shrines in France. Its main treasure was a piece of linen believed to have been worn by the Virgin Mary when she gave birth to Jesus. This relic was a gift from the Byzantine empress Irene to Charlemagne, whose grandson Charles the Bald donated it to Chartres in 876. It was kept below the high altar in a huge basement crypt. The healing powers attributed to the cloth made Chartres a major pilgrimage destination, especially as the cult of the Virgin grew in popularity in the twelfth and thirteenth centuries. Its association with important market fairs especially cloth markets—held at Chartres on the feast days of the Virgin put the textile relic at the intersection of local prestige and the local economy, increasing the income of the cathedral not only through pilgrimage but also through tax revenue it received from the markets.

The **WEST FAÇADE** of Chartres (**FIG. 17-4**) preserves an early sculptural program created within a decade of the reconstruction of Saint-Denis. Surrounding these three doors—the so-called Royal Portal, used not by the general public but only for important ceremonial entrances of the bishop and his retinue—sculpted

TECHNIQUE | Stained-Glass Windows

The "wonderful and uninterrupted light" that Suger sought in the reconstruction of the choir of Saint-Denis in the 1140s was provided by stained-glass artists that—as he tells us—he called in from many nations to create glowing walls for the radiating chapels, perhaps the clerestory as well. As a result of their exquisite work, this influential building program not only constituted a new architectural style; it catapulted what had been a minor curiosity among pictorial techniques into the major medium of monumental European painting. For several centuries, stained glass would be integral to architectural design, not decoration added subsequently to a completed building. Windows were produced at the same time as masons were building walls and carving capitals and moldings.

Our knowledge about the medieval art of stained glass is based on a precious twelfth-century text—*De Diversis Artibus (On Divers Arts)* written by a German monk who called himself Theophilus Presbyter (see "St. Bernard and Theophilus," page 470). In fact, the basic procedures of producing a stained-glass window have changed little since the Middle Ages. It is not a lost art, but it is a complex and costly process. The glass itself was made by bringing sand and ash to the molten state under intense heat, and "staining" it with color through the addition of metallic oxides. This molten material was then blown and flattened into sheets. Using a **cartoon** (full-scale drawing) painted on a whitewashed board as a guide, the glass painter would cut from these sheets the individual shapes of color that would make up a figural scene or ornamental passage. This was done with a hot iron that would crack the glass into a rough approximation that could be refined by chipping away at the edges carefully with an iron tool—a process called **grozing**—to achieve the precise shape needed in the composition.

The artists used a vitreous paint (made, Theophilus tells us, of iron filings and ground glass suspended in wine or urine) at full strength to block light and delineate features such as facial expressions or drapery folds. It could also be diluted to create modeling washes. Once painted, the pieces of glass would be fired in a kiln to fuse the painting with the glass surface. Only then did the artists assemble these shapes of color—like pieces of a complex compositional puzzle—with strips of lead (called **cames**), and subsequently mount a series of these individual panels on an iron framework within the architectural opening to form an ensemble we call a stained-glass window. Lead was used in the assembly process because it was strong enough to hold the glass pieces together but flexible enough to bend around their complex shapes and—perhaps more critically—to absorb the impact from gusts of wind and prevent the glass itself from cracking under pressure.

figures calmly and comfortably fill their architectural settings. On the central tympanum, Christ is enthroned in majesty, returning at the end of time surrounded by the four evangelists (**FIG. 17-5**). Although imposing, he seems more serene and more human than in the hieratic and stylized portrayal of the same subject at Moissac (see FIG. 16–21). The apostles, organized into four groups of three fill the lintel, and the 24 elders of the Apocalypse line the archivolts.

The right portal is dedicated to the Incarnation (God's first earthly appearance), highlighting the role of Mary in the early life of Christ, from the Annunciation to the Presentation in the Temple. On the left portal is the Ascension (the Incarnate God's return from earth to heaven). Jesus floats heavenward in a cloud, supported by angels. Running across all three portals, historiated capitals, on the top of the jambs just underneath the level of the lintels, depict Jesus' life on Earth in a series of small, lively narrative scenes.

17-4 • WEST FAÇADE, CHARTRES CATHEDRAL (CATHEDRAL OF NOTRE-DAME)

France. West façade begun c. 1134; cathedral rebuilt after a fire in 1194; building continued to 1260; north spire 1507–1513.

Explore the architectural panoramas of Chartres Cathedral on myartslab.com

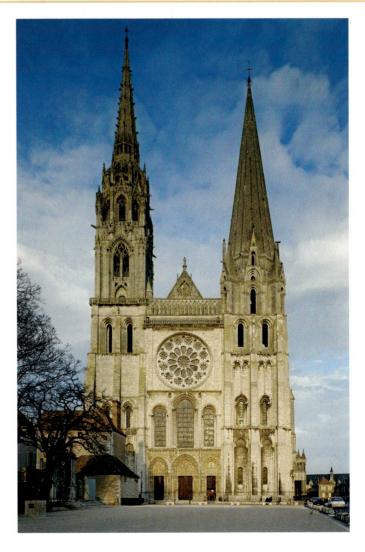

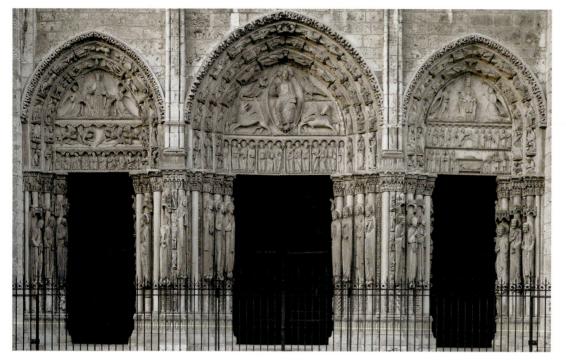

17-5 • ROYAL PORTAL, WEST FAÇADE, CHARTRES CATHEDRAL c. 1145–1155.

Read the document related to the building of Chartres Cathedral on myartslab.com

Flanking all three openings on the jambs are serenely calm column statues (FIG. 17-6)—kings, queens, and prophets from the Hebrew Bible, evocations of Christ's royal and spiritual ancestry, as well as a reminder of the close ties between the Church and the French royal house. The prominence of kings and queens here is what has given the Royal Portal its name. The elegantly elongated proportions and linear, but lifelike, drapery of these column statues echo the cylindrical shafts behind them. Their meticulously carved, idealized heads radiate a sense of beatified calm. In fact, tranquility and order prevail in the overall design as well as in the individual components of this portal, a striking contrast to the dynamic configurations and energized figures on the portals of Romanesque churches.

17-6 • **ROYAL PORTAL, WEST FAÇADE, CHARTRES CATHEDRAL** Detail of prophets and ancestors of Christ (kings and queens of Judea), right side, central portal. c. 1145–1155.

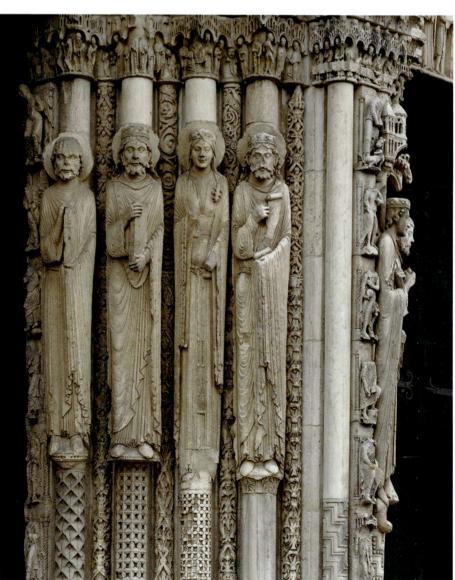

ELEMENTS OF ARCHITECTURE | The Gothic Church

Most large Gothic churches in western Europe were built on the Latin cross plan, with a projecting transept marking the transition from nave to choir, an arrangement that derives ultimately from the fourth-century Constantinian basilica of Old St. Peter's (see FIG. 7–13). The main entrance portal was generally on the west, with the choir and its apse on the east. A western narthex could precede the entrance to the nave and side aisles. An ambulatory with radiating chapels circled the apse and facilitated the movement of worshipers through the church. Many Gothic churches have a three-story elevation, with a triforium sandwiched between the nave arcade and a glazed clerestory. Rib vaulting usually covered all spaces. **Flying buttresses** helped support the soaring nave vaults by transferring their outward thrust over the aisles to massive, free-standing, upright external buttresses. Church walls were decorated inside and out with arcades of round or pointed arches, engaged columns and colonnettes, an applied filigree of **tracery**, and horizontal moldings called **stringcourses**. The pitched roofs above the vaults— necessary to evacuate rainwater from the building—were supported by wooden frameworks. A spire or crossing tower above the junction of the transept and nave was usually planned, though often never finished. Portal façades were also customarily marked by high, flanking towers or gabled porches ornamented with **pinnacles** and finials. Architectural sculpture proliferated on each portal's tympanum, archivolts, and jambs (**FIG. 17–7**), and in France a magnificent rose window typically formed the centerpiece of the flat portal façades.

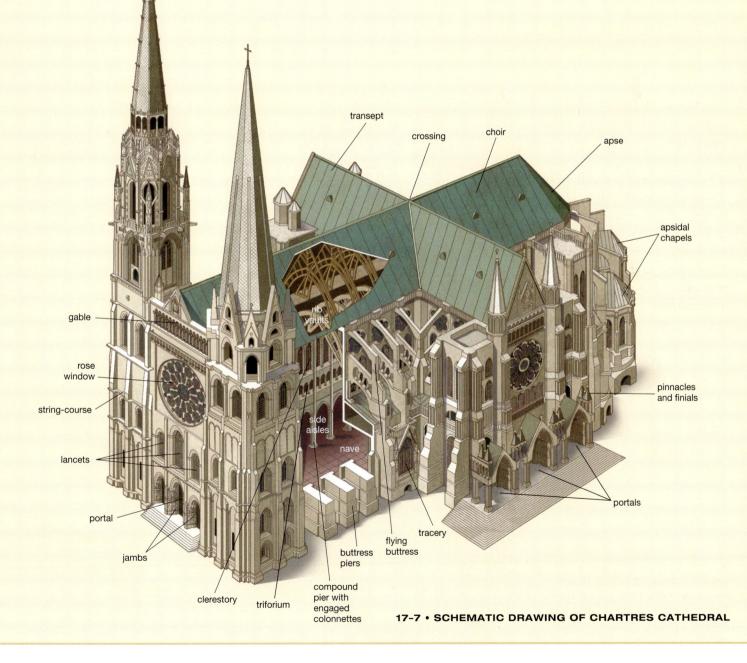

ART AND ITS CONTEXTS | Master Masons

Master masons oversaw all aspects of church construction in the Middle Ages, from design and structural engineering to construction and decoration. The master mason at Chartres coordinated the work of roughly 400 people scattered, with their equipment and supplies, across many locations, from distant stone quarries to high scaffolding. It has been estimated that this workforce set in place some 200 blocks of stone each day.

Funding shortages and technical delays, such as the need to let mortar harden for three to six months, made construction sporadic, so master masons and their crews moved constantly from job to job, with several masters and many teams of masons often contributing to the construction of a single building. Fewer than 100 master builders are estimated to have been responsible for all the major architectural projects around Paris during the century-long building boom there, some of them working on parts of as many as 40 churches. This was dangerous work. Masons were always at risk of injury, which could cut short a career in its prime. King Louis IX of France actually provided sick pay to a mason injured in the construction of Royaumont Abbey in 1234, but not all workers were this lucky. Master mason William of Sens, who supervised construction at Canterbury Cathedral, fell from a scaffold. His grave injuries forced him to return to France in 1178 because of his inability to work. Evidence suggests that some medieval contracts had pension arrangements or provisions that took potential injury or illness into account, but some did not.

Today, the names of more than 3,000 master masons are known to us, and the close study of differences in construction techniques often discloses the participation of specific masters. Master masons gained in prestige during the thirteenth century as they increasingly differentiated themselves from the laborers they supervised. In some cases their names were prominently inscribed in the labyrinths on cathedral floors. From the thirteenth century on, in what was then an exceptional honor, masters were buried, along with patrons and bishops, in the cathedrals they built.

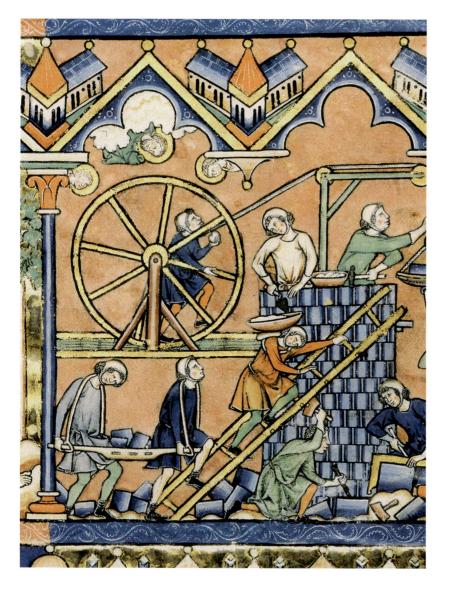

The bulk of Chartres Cathedral was constructed after a fire in 1194 destroyed an earlier Romanesque church but spared the Royal Portal, the windows above it, and the crypt with its precious relics. A papal representative convinced reluctant local church officials to rebuild. He argued that the Virgin had permitted the fire because she wanted a new and more beautiful church to be built in her honor. Between 1194 and about 1260 that new cathedral was built (see "The Gothic Church," page 503).

Such a project required vast resources money, raw materials, and skilled labor (see "Master Masons," above). A contemporary painting shows a building site with the **MASONS AT WORK** (FIG. **17-8**). Carpenters have built scaffolds, platforms, and a lifting machine. Master stonecutters measure and cut the stones; workers carry and hoist the blocks by hand or with a lifting wheel. Thousands of stones had to be cut accurately and placed carefully. Here a laborer carries mortar up a ladder to men working on the top of the wall, where the lifting wheel delivers cut stones. To fund this work,

17-8 • **MASONS AT WORK** Detail of a miniature from a Picture Bible made in Paris. 1240s. The Morgan Library and Museum, New York. MS. M638, fol. 3r

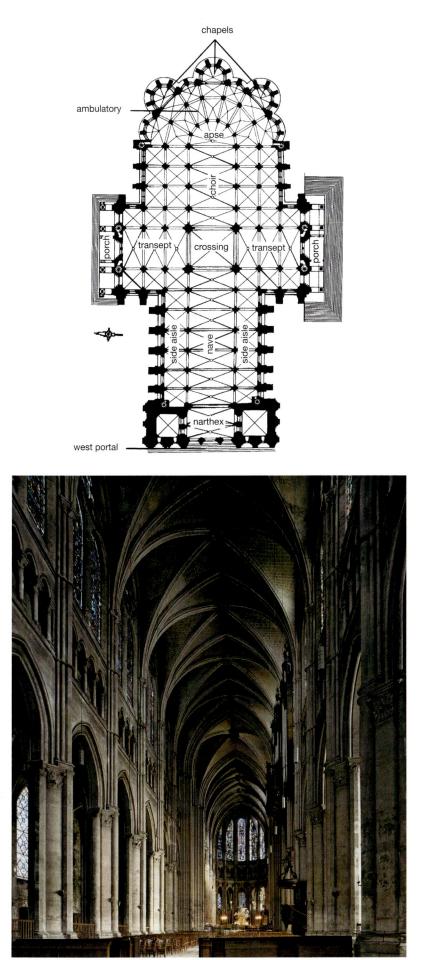

bishops and cathedral officials usually pledged all or part of their incomes for three to five, even ten years. Royal and aristocratic patrons joined in the effort. In an ingenious scheme that seems very modern, the churchmen at Chartres solicited contributions by sending the cathedral relics, including the Virgin's tunic, on tour as far away as England.

As the new structure rose higher during the 1220s, the work grew more costly and funds dwindled. But when the bishop and the cathedral clergy tried to make up the deficit by raising taxes, the townspeople drove them into exile for four years. This action in Chartres was not unique; people often opposed the building of cathedrals because of the burden of new taxes. The economic privileges claimed by the Church for the cathedral sparked intermittent uprisings by townspeople and the local nobility throughout the thirteenth century.

Building on the principles pioneered at Saint-Denis-a glass-filled masonry skeleton enclosing a large open space-the masons at Chartres erected a church over 45 feet wide with vaults that soar approximately 120 feet above the floor. As at Saint-Denis, the plan is rooted in the Romanesque pilgrimage plan, but with a significantly enlarged sanctuary occupying a full third of the building (FIG. 17-9A). The Chartres builders codified what were to become the typical Gothic structural devices: pointed arches and ribbed groin vaults rising from compound piers over rectangular bays. The vaults were supported externally by the recently developed flying buttress system (see FIG. 17-7) in which gracefully arched exterior supports countered the lateral thrust of the nave vault and transferred its weight outward, over the side aisles, where it is resolved into and supported by a buttressing pier, rising from the ground. Flying buttresses permitted larger and more luminous clerestory windows, nearly equal in height to the nave arcade (FIG. 17-9B). Paired lancets (tall openings with pointed tops), surmounted by small circular rose windows, are created in a technique known as plate tracery-holes are cut into the stone wall and nearly half the wall surface is filled with stained glass. The band between the clerestory and nave arcade was now occupied by a triforium (arcaded wall passageway) rather than a tall gallery.

17-9 • PLAN (A) AND INTERIOR LOOKING EAST (B), CHARTRES CATHEDRAL 1194-c. 1220.

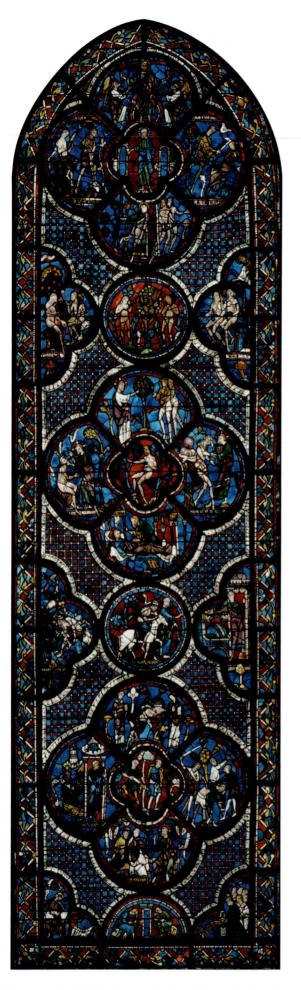

Chartres is distinctive among French Gothic buildings in that most of its stained-glass windows have survived. Stained glass is an enormously expensive and complicated medium of painting, but its effect on the senses and emotions made the effort worthwhile for medieval patrons and builders. By 1260, glass painters had installed about 22,000 square feet of stained glass in 176 windows (see "Stained-Glass Windows," page 501). Most of the glass dates from between about 1200 and 1250, but a few earlier windows, from the 1150s—comparable in style to the windows of Suger's Saint-Denis—survived the fire of 1194 and remain in the west wall above the Royal Portal.

In the aisles and chapels, where the windows were low enough to be easily seen, there were elaborate multi-scene narratives, with small figures composed into individual episodes within the irregularly shaped compartments of windows designed as stacked medallions set against dense, multicolored fields of ornament. Art historians refer to these as cluster medallion windows. The **GOOD SAMARITAN WINDOW** of c. 1200–1210 in the south aisle of the nave is a typical example of the design (**FIG. 17-10**). Its learned allegory on sin and salvation also typifies the complexity of Gothic narrative art.

The principal subject is a parable Jesus told his followers to teach a moral truth (Luke 10:25-37). The protagonist is a traveling Samaritan who cares for a stranger, beaten, robbed, and left for dead by thieves on the side of a road. Jesus' parable is an allegory for his imminent redemption of humanity's sins, and within this window a story from Genesis is juxtaposed with the parable to underscore that association (see FIG. 17-1). Adam and Eve's fall introduced sin into the world, but Christ (the Good Samaritan) rescues humanity (the traveler) from sin (the thieves) and ministers to them within the Church, just as the Good Samaritan takes the wounded traveler for refuge and healing to an inn (bottom scene, FIG. 17-1). Stylistically, these willowy, expressive figures avoid the classicizing stockiness in Wiligelmo's folksy Romanesque rendering of the Genesis narrative at Modena (see FIG. 16-20). Instead they take the dancelike postures that will come to characterize Gothic figures as the style spreads across Europe in ensuing centuries.

In the clerestory windows, the Chartres glass-painters mainly used not multi-scene narratives, but large-scale single figures that could be seen at a distance because of their size, bold drawing, and strong colors. Iconic ensembles were easier to "read" in lofty openings more removed from viewers, such as the huge north transept **ROSE WINDOW** (over 42 feet in diameter) surmounting five lancets (**FIG. 17-11**), an ensemble which proclaims the royal and priestly heritage of Mary and Jesus, and through them of the Church itself. In the central lancet, St. Anne holds her

17-10 • GOOD SAMARITAN WINDOW South aisle of nave, Chartres Cathedral. c. 1200–1210. Stained and painted glass.

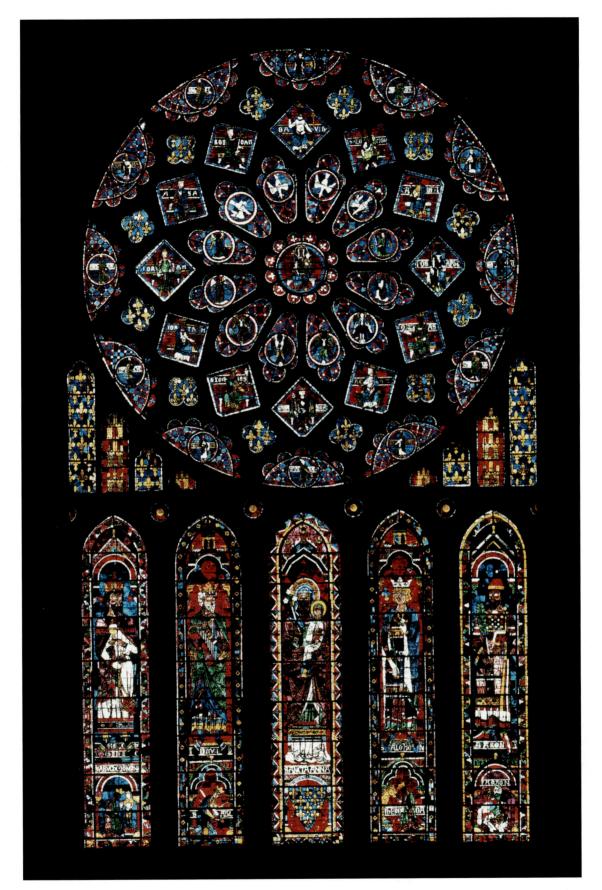

17-11 • ROSE WINDOW AND LANCETS, NORTH TRANSEPT, CHARTRES CATHEDRAL c. 1230–1235. Stained and painted glass.

View the Closer Look for the rose window and lancets in the north transept of Chartres Cathedral on myartslab.com

infant daughter Mary, flanked left to right by statuesque figures of Hebrew Bible leaders Melchizedek, David, Solomon, and Aaron. Above, in the very center of the rose window itself, Mary and Jesus are enthroned, surrounded by a radiating array of doves, angels, and Hebrew Bible kings and prophets.

This vast wall of glass was a gift from the young King Louis IX (r. 1226–1270), perhaps arranged by his powerful mother, Queen Blanche of Castile (1188–1252), who ruled as regent (1226–1234) during Louis's minority. Royal heraldic emblems secure the window's association with the king. The arms of France—golden *fleurs-de-lis* on a blue ground—fill a prominent shield under St. Anne at the bottom of the central lancet. *Fleurs-de-lis* also appear in the graduated lancets bracketing the base of the rose window and in a series of **quatrefoils** (four-lobed designs) within the rose itself. But also prominent is the Castilian device of golden castles on a red ground, a reference to the royal lineage of Louis's powerful mother. Light radiating from the deep blues and reds creates a hazy purple atmosphere in the soft light of the north side of the building. On a sunny day the masonry may seem to dissolve in color, but the bold theological and political messages of the rose window remain clear.

THE CATHEDRAL OF NOTRE-DAME IN REIMS Reims Cathedral, northeast of Paris in the region of Champagne, was the coronation church of the kings of France and, like Saint-Denis, had been a cultural and educational center since Carolin-

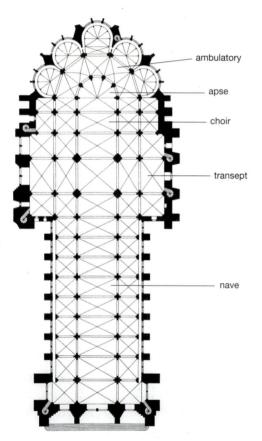

17-12 • PLAN OF CATHEDRAL OF NOTRE-DAME, REIMS France. Begun in 1211.

Explore the architectural panoramas of Reims Cathedral on myartslab.com

17-13 • WEST FAÇADE, CATHEDRAL OF NOTRE-DAME, REIMS

Rebuilding begun 1211; façade begun c. 1225; to the height of rose window by 1260; finished for the coronation of Philip the Fair in 1286; towers left unfinished 1311; additional work 1406–1428.

2002

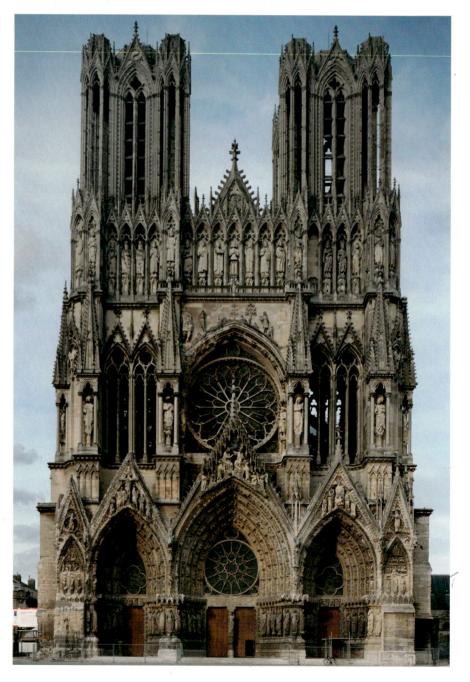

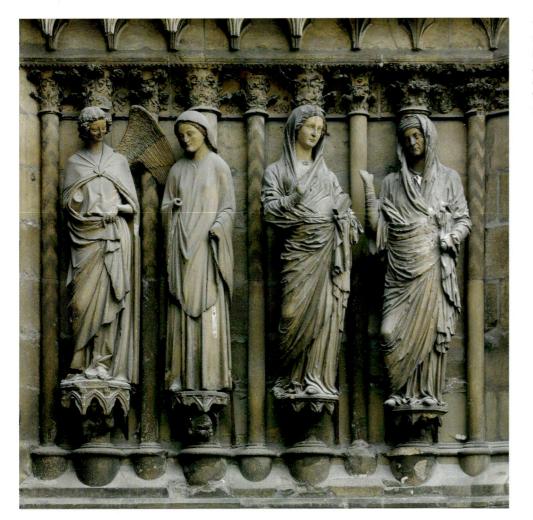

17-14 • CENTRAL PORTAL, RIGHT SIDE, WEST FAÇADE, REIMS CATHEDRAL

Annunciation (left pair: Mary [right] c. 1240, angel [left] c. 1250) and Visitation (right pair: Mary [left] and Elizabeth [right] c. 1230).

gian times. When, in 1210, fire destroyed this historic building, the community at Reims began to erect a new Gothic structure, planned as a large basilica (FIG. 17-12) similar to the model set earlier at Chartres (see FIG. 17-9A), only at Reims priority is given to an extended nave rather than an expanded choir, perhaps a reference to the processional emphasis of the coronation ceremony. The cornerstone of the cathedral was laid in 1211, and work continued throughout the century. The expense of the project sparked such local opposition that twice in the 1230s revolts drove the archbishop and canons into exile. At Reims, five master masons directed the work on the cathedral over the course of a century—Jean d'Orbais, Jean le Loup, Gaucher de Reims, Bernard de Soissons, and Robert de Coucy.

The west front of the Cathedral of Reims is a magnificent ensemble, in which almost every square inch of stone surface seems encrusted with sculptural decoration (**FIG. 17-13**). Its tall gabled portals form a broad horizontal base and project forward to display an expanse of sculpture, while the tympana they enclose are filled with stained-glass windows rather than stone carvings. Their soaring peaks—the middle one reaching to the center of the dominating rose window—unify the façade vertically. In a departure from tradition, Mary rather than Christ is featured in the central portal, a reflection of the growing popularity of her cult. Christ crowns her as queen of heaven in the central gable. The towers were later additions, as was the row of carved figures that runs from the base of one tower to the other above the rose window. This "gallery of kings" is the only strictly horizontal element of the façade.

hall

The sheer quantity of sculpture envisioned for this elaborate cathedral front required the skills of many sculptors, working in an impressive variety of styles over several decades. Four figures from the right jamb of the CENTRAL PORTAL illustrate the rich stylistic diversity (FIG. 17-14). The pair on the right portrays the Visitation, in which Mary (left), pregnant with Jesus, visits her older cousin, Elizabeth (right), pregnant with St. John the Baptist. The sculptor of these figures, active in Reims about 1230-1235, drew heavily on ancient sources. Reims had been a major Roman city, and there were remaining Roman works at the disposal of medieval sculptors. The bulky bodies show the same solidity seen in Roman sculpture (see FIG. 6-14), and the women's full faces, wavy hair, and heavy mantles recall imperial portrait statuary, even in their use of the two imperial facial ideals of unblemished youth (Mary) and aged accomplishment (Elizabeth) (compare FIGS. 6-40, 6-41). The figures shift their weight to one leg in contrapposto as they turn toward each other in conversation.

The pair to the left of the Visitation enacts the Annunciation in which the archangel Gabriel announces to Mary that she will

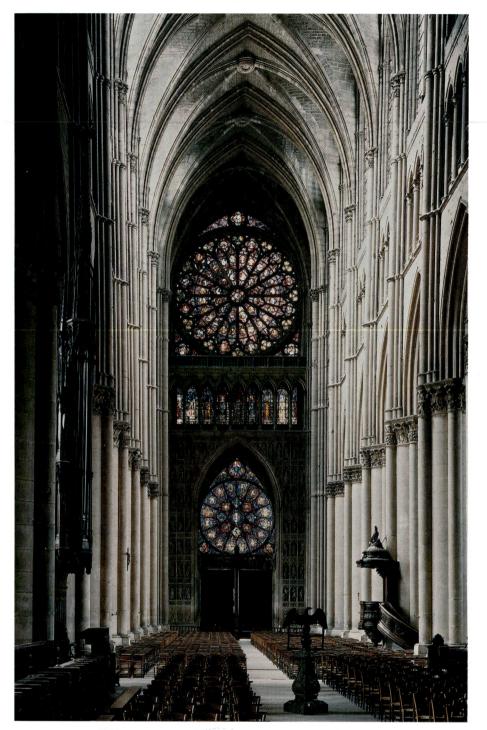

17-15 • INTERIOR LOOKING WEST, REIMS CATHEDRAL Begun 1211; nave c. 1220.

basis for what is called the International Gothic Style, fashionable across Europe well into the fifteenth century.

Inside the church (FIG. 17-15), the wall is designed, as at Chartres, as a three-story elevation with nave arcade and clerestory of equal height divided by the continuous arcade of a narrow triforium passageway. The designer at Reims gives a subtle emphasis to the center of each bay in the wall elevation, coordinating the central division of the clerestory into two lancets with a slightly enlarged colonnette at the middle of the triforium. This design feature was certainly noticed by one contemporary viewer, since it is (over)emphasized in the drawings Villard de Honnecourt made during a visit to Reims Cathedral c. 1230 (see FIG. 17-17). Villard also highlighted one of the principal innovations at Reims: the development of bar tracery, in which thin stone bars, called mullions, are inserted into an expansive opening in the wall to form a lacy framework for the stained glass (see rose window in FIG. 17-15). Bar tracery replaced the older plate tracery-still used at Chartres (see FIG. 17-11)—and made possible even larger areas of stained glass in relation to wall surface.

bear Jesus. This Mary's slight body, broad planes of simple drapery, restrained gesture, inward focus, and delicate features contrast markedly with the bold tangibility of the Mary in the Visitation next to her. She is clearly the work of a second sculptor. The archangel Gabriel (at the far left) represents a third artist, active at the middle of the century. This sculptor created tall, gracefully swaying figures with small, fine-featured heads, whose precious expressions, carefully crafted hairdos, and mannered poses of aristocratic refinement grew increasingly to characterize the figural arts in later Gothic sculpture and painting. These characteristics became the A remarkable ensemble of sculpture and stained glass fills the interior west wall at Reims. A great rose window fills the clerestory level; a row of lancets illuminates the triforium; and a smaller rose window replaces the stone of the portal tympanum. The lower level is anchored visually by an expanse of sculpture covering the inner wall of the façade. Here ranks of carved prophets and royal ancestors represent moral guides for the newly crowned monarchs who faced them while processing down the elongated nave and out of the cathedral following the coronation ceremony as they began the job of ruling France.

ART AND ITS CONTEXTS | Villard de Honnecourt

One of the most fascinating and enigmatic works surviving from Gothic France is a set of 33 sheets of parchment covered with about 250 drawings in leadpoint and ink, signed by a man named Villard from the Picardy town of Honnecourt, and now bound into a book housed in the French National Library. Villard seems to have made these drawings in the 1220s and 1230s judging from the identifiable buildings that he recorded, during what seem to have been extensive travels, made for unknown reasons, mainly in France—where he recorded plans or individual details of the cathedrals of Cambrai, Chartres, Laon, and especially Reims—but also in Switzerland and Poland.

Villard seems simply to have drawn those things that interested him—animals, insects, human beings, church furnishings, buildings, and construction devices (**FIGS. 17–16, 17–17**). Although the majority of his drawings have nothing to do with architecture, his renderings of aspects of Gothic buildings have received the most attention since the book was rediscovered in the mid nineteenth century, and led to a widespread belief that he was an architect or master mason. There is no evidence for this. In fact, the evidence we have argues against it, since the architectural drawings actually suggest the work of someone passionately interested in, but without a great deal of knowledge of, the structural systems and design priorities of Gothic builders. This in no way diminishes the value of this amazing document, which allows us rare access into the mind of a curious, well-traveled thirteenth-century amateur, who drew the things that caught his fancy in the extraordinary world around him.

17-16 • Villard de Honnecourt SHEET OF DRAWINGS WITH GEOMETRIC FIGURES

c. 1230. Ink ón vellum, $9\frac{1}{4}$ " \times 6" (23.5 \times 15.2 cm). Bibliothèque Nationale, Paris. MS. fr. 19093

This page, labeled "help in drawing figures according to the lessons taught by the art of geometry," demonstrates how geometric configurations underlie the shapes of natural forms and the designs of architectural features. They seem to give insight into the design process of Gothic artists, but could they also represent the fertile doodlings of a passionate amateur?

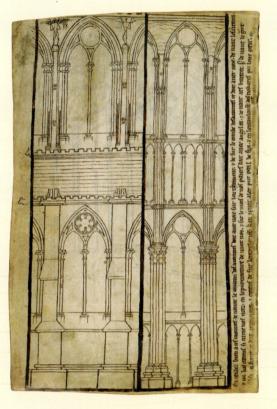

17-17 • Villard de Honnecourt DRAWINGS OF THE INTERIOR AND EXTERIOR ELEVATION OF THE NAVE OF REIMS CATHEDRAL

c. 1230. Ink on vellum, $91\!\!\!/4'' \times 6''$ (23.5 \times 15.2 cm). Bibliothèque Nationale, Paris. MS, fr. 19093

Scholars still debate whether Villard's drawings of Reims Cathedral—the church he documented most extensively, with five leaves showing views and two containing details —were made from observing the building itself, during construction, or copied from construction drawings that had been prepared to guide the work of the masons. But in either case, what Villard documents here are those aspects of Reims that distinguish it from other works of Gothic architecture, such as the use of bar tracery, the enlarged central colonnettes of the triforium, the broad bands of foliate carving on the pier capitals, or the statues of angels that perch on exterior buttresses. He seems to have grasped what it was that separated this building from the other cathedrals rising across France at this time.

Read the document related to Villard de Honnecourt on myartslab.com

In 1237, Baldwin II, Latin ruler of Constantinople-descendant of the crusaders who had snatched the Byzantine capital from Emperor Alexius III Angelus in 1204-was in Paris, offering to sell the relic of Christ's Crown of Thorns to his cousin, King Louis IX of France. The relic was at that time hocked in Venice, securing a loan to the cash-poor Baldwin, who had decided, rather than redeeming it, to sell it to the highest bidder. Louis purchased the relic in 1239, and on August 18, when the newly acquired treasure arrived at the edge of Paris, the humble king, barefoot, carried it through the streets of his capital to the royal palace. Soon after its arrival, plans were under way to construct a glorious new palace building to house it-the Sainte-Chapelle, completed for its ceremonial consecration on April 26, 1248. In the 1244 charter establishing services in the Sainte-Chapelle, Pope Innocent IV claimed that Christ had crowned Louis with his own crown, strong confirmation for Louis's own sense of the sacred underpinnings of his kingship.

The Sainte-Chapelle is an extraordinary manifestation of the Gothic style. The two-story building (FIG. 17-18)-there is both a lower and an upper liturgical space-is large for a chapel, and though it is now swallowed up into modern Paris, when it was built it was one of the tallest and most elaborately decorated buildings in the capital. The upper chapel is a completely open interior space surrounded by walls composed almost entirely of stained glass (FIG. 17-19), presenting viewers with a glittering, multicolored expanse. Not only the king and his court experienced this chapel; members of the public came to venerate and celebrate the relic, as well as to receive the indulgences offered to pious visitors. The Sainte-Chapelle resembles a reliquary made of painted stone and glass instead of gold and gems, turned inside out so that we experience it from within.

17-18 • SCHEMATIC DRAWING OF THE SAINTE-CHAPELLE Paris. 1239–1248.

But this arresting visual impression is only part of the story.

The stained-glass windows present extensive narrative cycles related to the special function of this chapel. Since they are painted in a bold, energetic style, the stories are easily legible, in spite of their breadth and complexity. Around the sanctuary's hemicycle (apse or semicircular interior space) are standard themes relating to the celebration of the Mass. But along the straight side walls are broader, four-lancet windows whose narrative expanse is dominated by the exploits of the sacred kings and queens of the Hebrew Bible, heroes Louis claimed as his own royal ancestors. Above the recessed niche where Louis himself sat at Mass was a window filled with biblical kings, whereas in the corresponding

niche on the other side of the chapel, his mother, Queen Blanche of Castile, and his wife, Queen Marguerite of Provence, sat under windows devoted to the lives of Judith and Esther, alternatively appropriate role models for medieval queens. Everywhere we look we see

kings being crowned, leading soldiers into holy warfare, or performing royal duties, all framed with heraldic references to Louis and the French royal house. There is even a window that includes scenes from the life of Louis IX himself.

After the French Revolution, the Sainte-Chapelle was transformed into an archive, and some stained glass was removed to allow more light into the building. Deleted panels made their way onto the art market, and, in 1803, wealthy Philadelphia

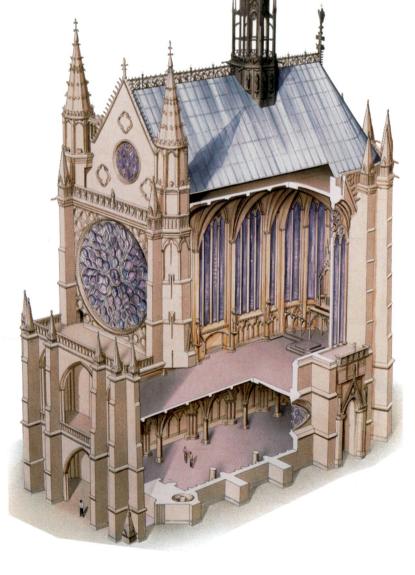

merchant William Powell bought three medallions from the Judith Window during a European tour, returning home to add them to his collection, the first in America to concentrate on medieval art. One portrays the armies of Holofernes crossing the Euphrates River (FIG. 17-20). A compact crowd of equestrian warriors to the right conforms to a traditional system of representing crowds as a measured, overlapping mass of essentially identical figures, but the warrior at the rear of the battalion breaks the pattern, turning to acknowledge a knight behind him. The foreshortened rump of this soldier's horse projects out into our space, as if he were marching from our real world into the fictive world of the window-an avant-garde touch from a major artist working in the progressive climate of the mid-thirteenth-century Parisian art world.

> 17-19 • UPPER CHAPEL INTERIOR, THE SAINTE-CHAPELLE Paris. 1239–1248.

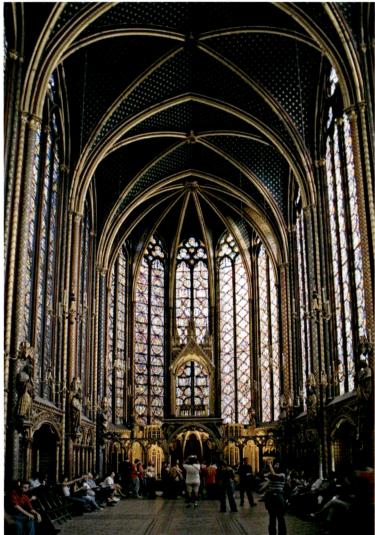

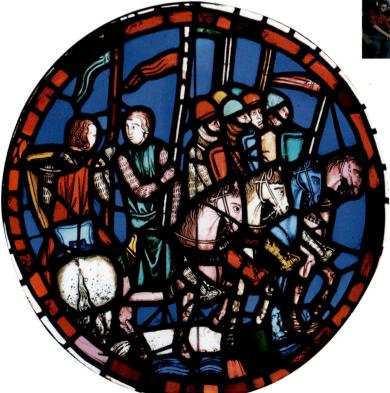

17-20 • HOLOFERNES' ARMY CROSSING THE EUPHRATES RIVER

Detail of the Judith Window, the Sainte-Chapelle, Paris. c. 1245. Stained, painted, and leaded glass, diameter $23^{5/16''}$ (59.2 cm). Philadelphia Museum of Art.

Explore the architectural panoramas of Sainte-Chapelle on myartslab.com

ART IN THE AGE OF ST. LOUIS

During the time of Louis IX (r. 1226-1270; canonized as St. Louis in 1297), Paris became the artistic center of Europe. Artists from all over France were lured to the capital, responding to the growing local demand for new and remodeled buildings, as well as to the international demand for the extraordinary works of art that were the specialty of Parisian commercial workshops. Especially valued were small-scale objects in precious materials and richly illuminated manuscripts. The Parisian style of this period is often called the "Court Style," since its association with the court of St. Louis was one reason it spread beyond the capital to the courts of other European rulers. Parisian works became trans-European benchmarks of artistic quality and sophistication.

THE SAINTE-CHAPELLE IN PARIS The masterpiece of mid-thirteenth-century Parisian style is the Sainte-Chapelle (Holy Chapel) of the royal palace, commissioned by Louis IX to house his collection of relics of Christ's Passion, especially the Crown of Thorns (see "The Sainte-Chapelle in Paris," page 512). In many ways this huge chapel can be seen as the culmination of the Gothic style that emerged from Suger's pioneering choir at Saint-Denis. The interior walls have been reduced to a series of slender piers and mullions that act as skeletal support for a vast skin of stained glass. The structure itself is stabilized by external buttressing that projects from the piers around the exterior of the building. Interlocking iron bars between the piers and concealed within the windows themselves run around the entire building, adding further stabilization. The viewer inside is unaware of these systems of support, being focused instead

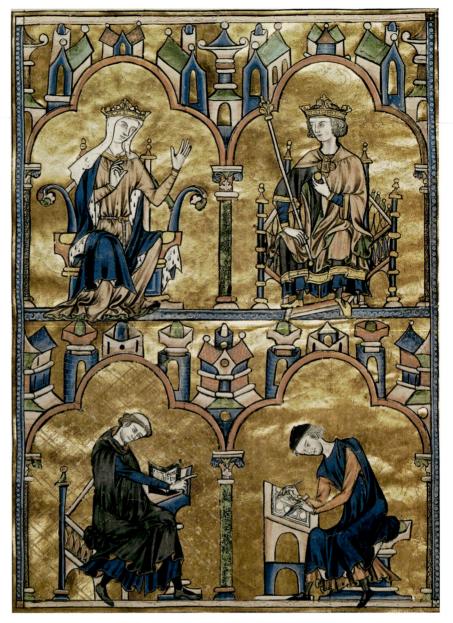

17-21 • QUEEN BLANCHE OF CASTILE AND KING LOUIS IX From a Moralized Bible made in Paris. 1226–1234. Ink, tempera, and gold leaf on vellum, each page $15'' \times 10^{1}/_{2}''$ (38 × 26.6 cm). The Morgan Library and Museum, New York. MS. M. 240, fol. 8r

on the kaleidoscopic nature of this jewelbox reliquary and the themes of sacred kingship that dominate the program of stainedglass windows.

ILLUMINATED MANUSCRIPTS Paris gained renown in the thirteenth century not only for its new architecture and sculp-ture but also for the production of books. Manuscript painters flocked to Paris from other regions to join workshops supervised by university officials who controlled the production and distribution of books. These works ranged from small Bibles used as textbooks by university students to extravagant devotional and theological works filled with exquisite miniatures for wealthy patrons.

A particularly sumptuous Parisian book from the time of St. Louis is a three-volume Moralized Bible from c. 1230, in which selected scriptural passages are paired with allegorical or moralized interpretations, using pictures as well as words to convey the message. The dedication page (FIG. 17-21) shows the teenage King Louis IX and his mother, Queen Blanche of Castile, who served as regent of France (1226–1234) until he came of age. The royal pair—emphasized by their elaborate thrones and slightly oversized heads—appear against a solid gold background under a multicolored architectural framework. Below them, a clerical scholar (left) dictates to a scribe, who seems to be working on a page from this very manuscript, with a column of roundels already outlined for paintings.

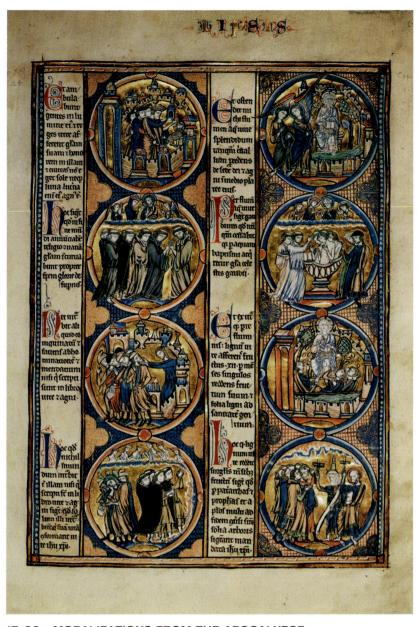

17-22 • **MORALIZATIONS FROM THE APOCALYPSE** From a Moralized Bible made in Paris. 1226–1234. Ink, tempera, and gold leaf on vellum, each page $15'' \times 10^{1}/_{2}''$ (38 × 26.6 cm). The Morgan Library and Museum, New York. MS. M. 240, fol. 6r

This design of stacked medallions—forming the layout for most of this monumental manuscript (**FIG. 17-22**)—clearly derives from stained-glass lancets with their columns of superimposed images (see FIG. 17-10). In the book, however, the schema combines pictures with words. Each page has two vertical strips of painted scenes set against a mosaiclike field and filled out by half-quatrefoils in the interstices—the standard format of mid-thirteenth-century windows. Adjacent to each medallion is an excerpt of text, either a summary of a scriptural passage or a terse contemporary interpretation or allegory. Both painted miniatures and texts alternate between scriptural summaries and their moralizing explications, outlined in words and visualized with pictures. This adds up to a very learned and complicated compilation, perhaps devised by clerical scholars at the University of Paris, but certainly painted by some of the most important professional artists in the cosmopolitan French capital.

GOTHIC ART IN ENGLAND

Plantagenet kings ruled England from the time of Henry II and Eleanor of Aquitaine until 1485. Many were great patrons of the arts. During this period, London grew into a large city, but most people continued to live in rural villages and bustling market towns. Textile production dominated manufacture and trade, and fine embroidery continued to be an English specialty. The French Gothic style influenced English architecture and manuscript illumination, but these influences were tempered by local materials and methods, traditions and tastes.

MANUSCRIPT ILLUMINATION

The universities of Oxford and Cambridge dominated intellectual life, but monasteries continued to house active scriptoria, in contrast to France, where book production became centralized in the professional workshops of Paris. By the end of the thirteenth century, secular workshops became increasingly active in England, meeting demands for books from students as well as from royal and noble patrons.

MATTHEW PARIS The monastic tradition of history writing that we saw in the Romanesque Worcester Chronicle (see FIG. 16-32) flourished into the Gothic period at the Benedictine monastery of St. Albans, where monk Matthew Paris (d. 1259) compiled a series of historical works. Paris wrote the texts of his chronicles, and he also added hundreds of marginal pictures that were integral to his history writing. The tinted drawings have a freshness that reveals the artist as someone working outside the

rigid strictures of compositional conventions—or at least pushing against them. In one of his books, Paris included an almost fullpage, framed image of the Virgin and Child in a tender embrace (**FIG. 17-23**). Under this picture, outside the sacred space of Mary and Jesus, Paris drew a picture of himself—identified not by likeness but by a label with his name, strung out in alternating red and blue capital letters behind him. He looks not at the holy couple, but at the words in front of him. These offer his commentary on the image, pointing to the affection shown in the playful Christ Child's movement toward his earthly mother, but emphasizing the authority he has as the divine incarnation of his father. Matthew Paris seems almost to hold his words in his hands, pushing them upward toward the object of his devotion.

A CLOSER LOOK | Psalm 1 in the Windmill Psalter

The opening of the Windmill Psalter.

Made in England, probably London. Late 13th century. Ink, pigments, and gold on vellum, each page $12^{3}4'' \times 8^{3}4''$ (32.3 \times 22.2 cm). The Morgan Library and Museum, New York. MS. 102, fols. Iv–2r

Although this page initially seems to have been trimmed at left, the flattened outside edge of the roundels marks the original end of the page. What might have started as an independent Jesse Tree may later have been expanded into the initial B, widening the pictorial composition farther than originally planned.

The four evangelists appear in the corner roundels as personified symbols writing at desks.

The windmill that has given this psalter its name seems to be a religious symbol based on the fourth verse of this Psalm: "Not so the wicked, not so: but like the dust, which the wind driveth from the face of the earth."

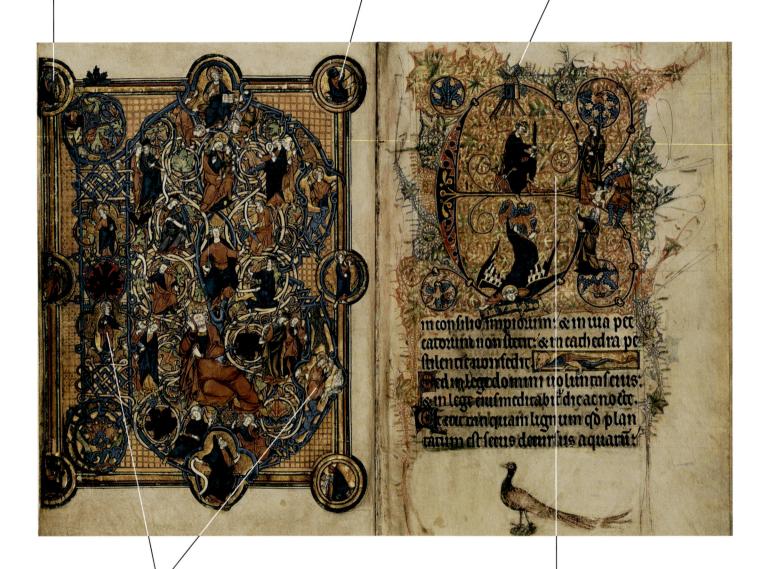

Tucked within the surrounds of the letter B are scenes from God's creation of the world, culminating in the forming of Adam and Eve. Medieval viewers would meditate on how the new Adam (Christ) and Eve (Mary)—featured in the Jesse Tree—had redeemed humankind from the sin of the first man and woman. Similarly, Solomon's choice of the true mother would recall Christ's choice of the true Church. Medieval manuscripts are full of cross-references and multiple meanings, intended to stimulate extended reflection and meditation, not embody a single truth or tell a single story.

Participants in this scene of the Judgment of Solomon have been creatively distributed within the unusual narrative setting of the letter *E*. Solomon sits on the crossbar; the two mothers are stacked one above the other; and the knight balancing the baby has to hook his toe under the curling extension of the crossbar to maintain his balance.

-View the Closer Look for Psalm 1 in the Windmill Psalter on myartslab.com

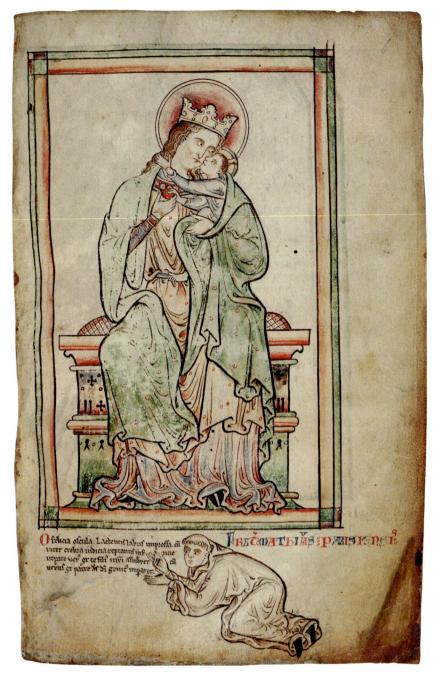

17-23 • Matthew Paris SELF-PORTRAIT KNEELING BEFORE THE VIRGIN AND CHILD

From the *Historia Anglorum*, made in St. Albans, England. 1250–1259. Ink and color on parchment, $14'' \times 9^{3}4''$ (35.8 \times 25 cm). The British Library, London. Royal MS. 14.c.vii, fol. 6r

THE WINDMILL PSALTER The dazzling artistry and delight in ambiguity and contradiction that had marked early medieval manuscripts in the British Isles (see FIG. 15–1) also survived into the Gothic period in the Windmill Psalter of c. 1270–1280 (see "A Closer Look," opposite). The letter *B*—the first letter of Psalm 1, which begins with the words *Beatus vir qui non abit in consilio impiorum* ("Happy are those who do not follow the advice of the wicked")—fills an entire left-hand page and outlines a densely interlaced thicket of tendrils and figures. This is a Tree of Jesse, a genealogical diagram of Jesus' royal and spiritual ancestors in the Hebrew Bible based on a prophesy in Isaiah 11:1–3. An oversized, semi-reclining figure of Jesse, father of King David, appears sheathed in a red mantle, with the blue trunk of a vinelike tree emerging from his side. Above him is his majestically enthroned royal son, who, as an ancestor of Mary (shown just above him), is also an ancestor of Jesus, who appears at the top of the sequence. In the circling foliage flanking this sacred royal family tree are a series of prophets, representing Jesus' spiritual heritage.

E, the second letter of the psalm's first word, appears at the top of the right-hand page and is formed from large tendrils emerging from delicate background vegetation to support characters in the story of the Judgment of Solomon portrayed within it (I Kings 3:16–27). Two women (one above the other at the right) claiming the same baby appear before King Solomon (enthroned on the crossbar) to settle their dispute. The king orders a guard to slice the baby in half with his sword and give each woman her share.

This trick exposed the real mother, who hastened to give up her claim in order to save the baby's life. It has been suggested that the positioning of this story within the letter E may have made a subtle association between Solomon and the reigning King Edward I. The rest of the psalm's five opening words appear on a banner carried by an angel who swoops down at the bottom of the E.

ARCHITECTURE

The Gothic style in architecture appeared early in England, introduced by Cistercian and Norman builders and by traveling master masons. But in England there was less emphasis on height than in France. English churches have long, broad naves and screenlike façades. **SALISBURY CATHEDRAL** The thirteenth-century cathedral in Salisbury is an excellent example of English Gothic. It has unusual origins. The first cathedral in this diocese had been built within the castle complex of the local lord. In 1217, Bishop Richard Poore petitioned the pope to relocate the church, claiming the wind on the hilltop howled so loudly that the clergy could not hear themselves sing the Mass. A more pressing concern was probably his desire to escape the lord's control. As soon as he moved, the bishop established a new town, called Salisbury. Material from the old church was carted down the hill and used in the new cathedral, along with dark, fossil-filled Purbeck stone from quarries in southern England and limestone imported from Caen. Building began in 1220, and most of the cathedral was finished by 1258,

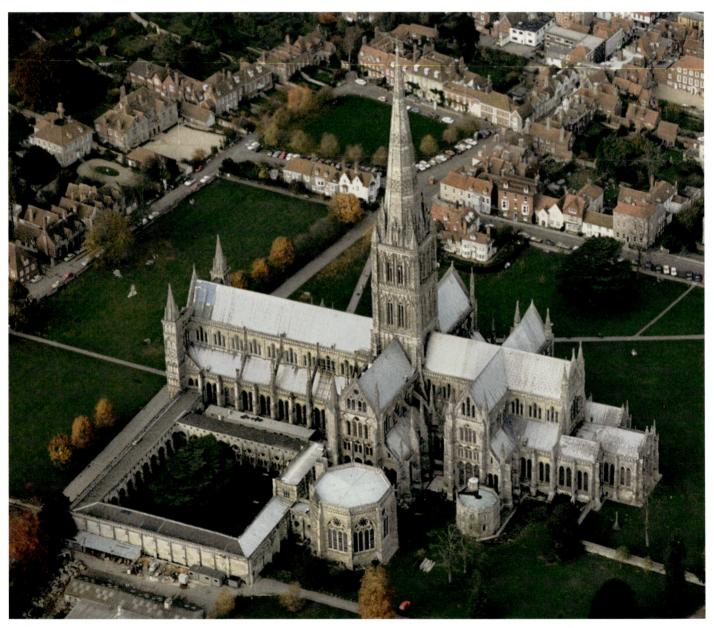

17-24 • SALISBURY CATHEDRAL England. Church building 1220–1258; west façade finished 1265; spire c. 1320–1330; cloister and chapter house 1263–1284.

Explore the architectural panoramas of Salisbury Cathedral on myartslab.com

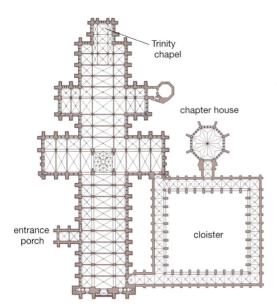

17-25 • PLAN OF SALISBURY CATHEDRAL

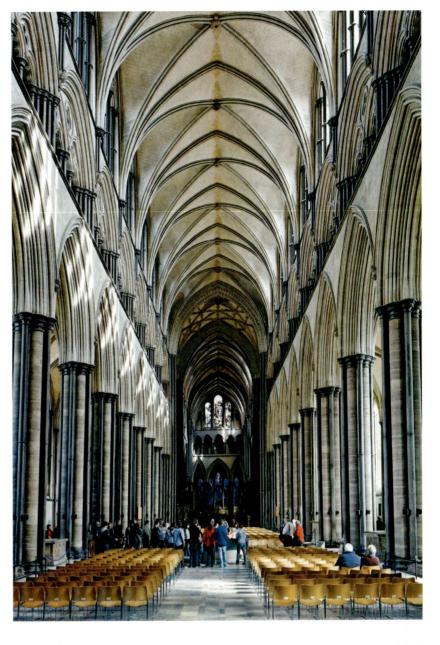

17-26 • INTERIOR LOOKING EAST, SALISBURY CATHEDRAL

In the eighteenth century, the English architect James Wyatt subjected the building to radical renovations, during which the remaining stained glass and figure sculpture were removed or rearranged. Similar campaigns to refurbish medieval churches were common at the time. The motives of the restorers were complex and their results far from our own notions of historical authenticity.

an unusually short period for such an undertaking (FIG. 17-24).

The west façade, however, was not completed until 1265. The small flanking towers project beyond the side walls and buttresses, giving the façade an increased width. A mighty crossing tower (the French preferred a slender spire) became the focal point of the building. (The huge crossing tower and its 400-foot spire are a fourteenth-century addition at Salisbury, as are the flying buttresses, which were added to stabilize the tower.) The slightly later cloister and chapter house provided for the cathedral's clergy.

Salisbury has a distinctive plan (FIG. 17-25), with wide projecting double transepts, a square east end with a single chapel, and a spacious sanctuary—more like a monastic church. The nave interior reflects the Norman building tradition of heavy walls and a tall nave arcade surmounted by a gallery and a clerestory with simple lancet windows (FIG. 17-26). The walls alone are substantial enough to buttress the four-part ribbed vault. The emphasis on the horizontal movement of the arcades, unbroken by continuous vertical colonnettes extending from the compound piers, directs worshipers' attention forward toward the altar behind the choir screen. The use of color in the stonework is reminiscent of the decorative effects in Romanesque interiors. The shafts supporting the fourpart rib vaults are made of dark Purbeck stone that contrasts with the lighter limestone of the rest of the interior. The original painting and gilding of the stonework would have enhanced the effect.

MILITARY AND DOMESTIC ARCHITECTURE Cathedrals were not the only Gothic buildings. Western European knights who traveled east during the crusades were impressed by the architectural forms they saw in Muslim castles and Byzantine fortifications. When they returned home, they had their own versions of these fortifications built. Castle gateways became more complex, nearly independent fortifications, often guarded by twin towers

17-27 • EXTERIOR OF THE GREAT HALL, STOKESAY CASTLE England. Late 13th century.

rather than just one. New rounded towers eliminated the corners that had made earlier square towers vulnerable to battering rams, and crenellations (notches) were added to tower tops to provide stone shields for more effective defense. The outer, enclosing walls were likewise strengthened. The open, interior space was enlarged and filled with more comfortable living quarters for the lord and wooden buildings to house the garrison and the support staff. Barns and stables for animals, including the extremely valuable war horses, were also erected within the enclosure.

STOKESAY CASTLE Military structures were not the only secular buildings outfitted for defense. In uncertain times, the manor (a landed estate), which continued to be an important economic unit in the thirteenth century, also had to fortify its buildings. And country houses equipped with a tower and crenellated roof-lines became a status symbol as well as a necessity. **STOKESAY CASTLE**, a remarkable fortified manor house, survives in England near the Welsh border. In 1291, a wool merchant, Lawrence of Ludlow, acquired the property of Stokesay and secured permission from King Edward I to fortify his dwelling—officially known as a "license to crenellate" (**FIG. 17-27**). Two towers—including a massive crenellated south tower—and a great hall still survive.

Life in the Middle Ages revolved around the hall. Windows on each side of Stokesay's hall open both toward the courtyard and out across a moat toward the countryside. By the thirteenth century, people began to expect some privacy as well as security; therefore at both ends of the hall are two-story additions that provided retiring rooms for the family and workrooms where women could spin and weave. Rooms on the north end could be reached from the hall, but the upper chamber at the south was accessible only by means of an exterior stairway. A tiny window a peephole—let women and members of the household observe the often rowdy activities in the hall below. In layout, there was essentially no difference between this manor far from the London court and the mansions built by the nobility in the city. Palaces followed the same pattern of hall and retiring rooms; they were simply larger.

GOTHIC ART IN GERMANY AND THE HOLY ROMAN EMPIRE

The Holy Roman Empire, weakened by internal strife and a prolonged struggle with the papacy, ceased to be a significant power in the thirteenth century. England and France were becoming strong nation-states, and the empire's hold on southern Italy and Sicily ended at mid century with the death of Emperor Frederick II. Subsequent emperors—who were elected—had only nominal authority over a loose conglomeration of independent principalities, bishoprics, and free cities. As in England, the French Gothic style, avidly embraced in the western Germanic territories, shows regional adaptations and innovations.

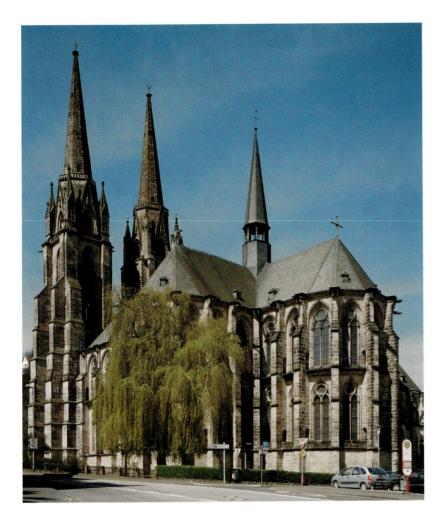

17-28 • EXTERIOR, CHURCH OF ST. ELIZABETH OF HUNGARY, MARBURG Germany. 1235–1283.

and she was canonized in 1235. Between 1235 and 1283, the knights of the Teutonic Order (who had moved to Germany from Jerusalem) built a church to serve as her mausoleum and pilgrimage center.

The plan of the church is an early German form, with choir and transepts of equal size, each ending in apses. The elevation of the building, however, is new, with nave and aisles of equal height. On the exterior wall, tall buttresses emphasize its verticality, and the two rows of windows suggest a two-story building, which is not the case. Inside, the closely spaced piers of the nave support the ribbed vault and, as with the buttresses, give the building a vertical, linear quality (**FIG. 17-29**). Light from the two stories of windows fills the interior, unimpeded by walls or galleries. The hall-church design was adopted widely for civic and residential buildings in Germanic lands and also for Jewish architecture.

ARCHITECTURE

In the thirteenth century, the increasing importance of the sermon in church services led architects in Germany to develop the **hall church**, a type of open, light-filled interior space that appeared in Europe in the early Middle Ages, characterized by a nave and side aisles of equal height. The spacious and well-lit design of the hall church provided accommodation for the large crowds drawn by charismatic preachers.

CHURCH OF ST. ELIZABETH OF HUNGARY IN MAR-BURG Perhaps the first true Gothic hall church, and one of the earliest Gothic buildings in Germany, was the CHURCH OF ST. ELIZABETH OF HUNGARY in Marburg (FIG. 17-28). The Hungarian princess Elizabeth (1207–1231) had been sent to Germany at age 4 to marry the ruler of Thuringia. He soon died of the plague, and she devoted herself to caring for people with incurable diseases. It was said that she died at age 24 from exhaustion,

17-29 • INTERIOR, CHURCH OF ST. ELIZABETH OF HUNGARY Marburg, Germany. 1235–1283.

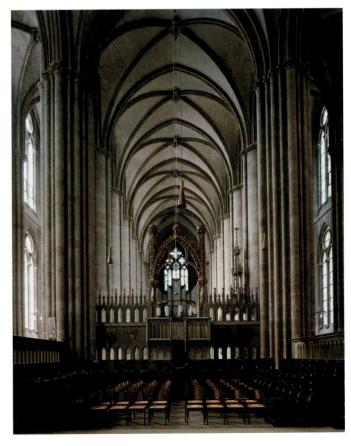

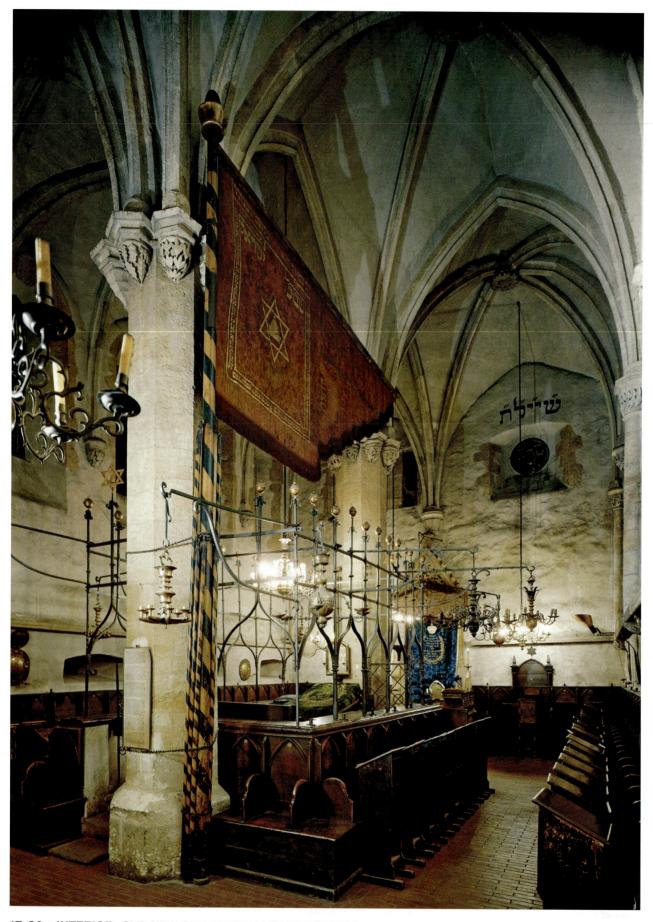

17-30 • **INTERIOR, OLD-NEW SYNAGOGUE (ALTNEUSCHUL)** Prague, Bohemia (Czech Republic). c. late 13th century; *bimah* after 1483.

THE OLD-NEW SYNAGOGUE Built in the third quarter of the thirteenth century using the hall-church design, Prague's **OLD-NEW SYNAGOGUE** (Altneuschul) is the oldest functioning synagogue in Europe and one of two principal synagogues serving the Jews of Prague (**FIG. 17-30**). Like a hall church, the vaults of the synagogue are all the same height. Unlike a basilican church, however, with its division into nave and side aisles, the Old-New Synagogue has only two aisles, each with three bays supported by the walls and two octagonal piers. Each bay has Gothic four-part ribbed vaulting to which a nonfunctional fifth rib has been added. Some say that this fifth rib was added to undermine the cross form made by the intersecting diagonal ribs.

Medieval synagogues were both places of prayer and communal centers of learning and inspiration where men gathered to read and discuss the Torah. The synagogue had two focal points, a shrine for the Torah scrolls (the *aron*), and a raised platform for reading from them (the *bimah*). The congregation faced the Torah shrine, which was located on the east wall, in the direction of Jerusalem, while the reading platform stood in the center of the hall, straddling the two center bays. In Prague it was surrounded by an ironwork open screen. The single entrance was placed off-center in a corner bay at the west end. Men worshiped and studied in the main space; women had to worship in annexes on the north and west sides.

SCULPTURE

Since the eleventh century, among the most creative centers of European sculpture were the Rhine River Valley and the region known as the Mosan (from the Meuse River, in present-day Belgium), with centers in Liège and Verdun. Ancient Romans had built camps and cities in this area, and Classical influence lingered through the Middle Ages, when Nicholas of Verdun and his fellow goldsmiths initiated a new classicizing style in the arts.

SHRINE OF THE THREE KINGS For the archbishop of Cologne, Nicholas created the magnificent SHRINE OF THE THREE KINGS (c. 1190–c. 1205/10), a reliquary for what were believed to be relics of the three Magi. Shaped in the form of a basilican church (FIG. 17-31), it is made of gilded bronze and silver, set with gemstones and dark blue enamel plaques that accentuate its architectural details. Like his fellow Mosan artists, Nicholas was inspired by ancient Roman art still found in the region, as well as by classicizing Byzantine works. The figures are lifelike, fully modeled, and swathed in voluminous but revealing drapery. The three Magi and the Virgin fill the front gable end, and prophets and apostles sit in the niches in the two levels of arcading on the sides. The work combines robust, expressively mobile sculptural forms with a jeweler's exquisitely ornamental detailing to create an opulent, monumental setting for its precious contents.

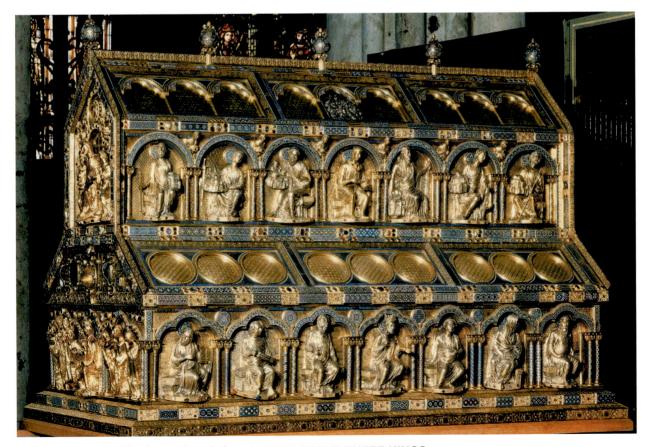

17–31 • Nicholas of Verdun and workshop SHRINE OF THE THREE KINGS Cologne (Köln) Cathedral, Germany. c. 1190–c. 1205/10. Silver and gilded bronze with enamel and gemstones, $5'8'' \times 6' \times 3'8''$ (1.73 × 1.83 × 1.12 m).

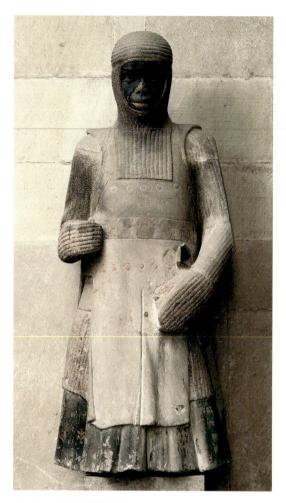

17-32 • ST. MAURICE Magdeburg Cathedral, Magdeburg, Germany. c. 1240– 1250. Dark sandstone with traces of polychromy.

ST. MAURICE A powerful current of realism runs through German Gothic sculpture. Some works seem to be carved after a living model. Among them is an arresting mid-thirteenth-century statue of **ST. MAURICE** in Magdeburg Cathedral (**FIG. 17-32**), the location of his relics since 968. The Egyptian Maurice, a commander in the Roman army, was martyred in 286 together with his Christian battalion while they were stationed in Germany. As patron saint of Magdeburg, he was revered by Ottonian emperors, who were anointed in St. Peter's in Rome at the altar of St. Maurice. He remained a favorite saint of military aristocrats. This is the first surviving representation of Maurice as a black African, an acknowledgment of his Egyptian origins and an aspect of the growing German interest in realism, which extends here to the detailed rendering of his costume of chain mail and riveted leather.

EKKEHARD AND UTA Equally portraitlike is the depiction of this couple, commissioned about 1245 by Dietrich II, bishop of Wettin, for the family funeral chapel, built at the west end of Naumburg Cathedral. Bishop Dietrich ordered life-size statues of

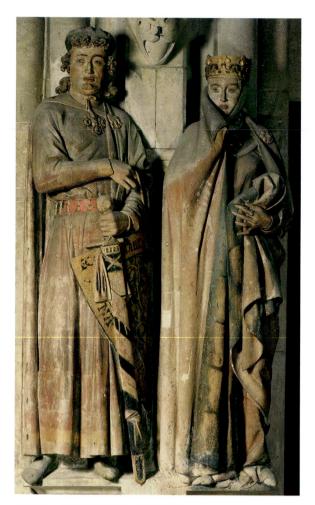

17-33 • EKKEHARD AND UTA West chapel, Naumburg Cathedral, Germany. c. 1245–1260. Stone with polychromy, height approx. 6'2" (1.88 m).

12 of his ancestors, who had been patrons of the church, to be placed on pedestals mounted at window level around the chapel.

In the representations of Margrave Ekkehard of Meissen (a margrave—count of the march or border—was a territorial governor who defended the frontier) and his Polish-born wife, Uta (FIG. 17-33), the sculptor created highly individualized figures and faces. Since these are eleventh-century people, sculpted in the thirteenth century, we are not looking at their portrait likenesses, but it is still possible that live models were used to heighten the sense of a living presence in their portraits. But more than their faces contribute to this liveliness. The margrave nervously fingers the strap of the shield that is looped over his arm, and the coolly elegant Uta pulls her cloak around her neck as if to protect herself from the cold. while the extraordinary spread of her left hand is necessary to control the cloak's voluminous, thick cloth. The survival of original polychromy (multicolored painting on the surface of sculpture or architecture) indicates that color added to the impact of the figures. The impetus toward descriptive realism and psychological presence, initiated in the thirteenth century, will expand in the art of northern Europe into the fifteenth century and beyond.

GOTHIC ART IN ITALY

The thirteenth century was a period of political division and economic expansion for the Italian peninsula. Part of southern Italy and Sicily was controlled by Frederick II von Hohenstaufen (1194–1250), Holy Roman emperor from 1220. Frederick was a politically unsettling force. He fought with a league of north Italian cities and briefly controlled the Papal States. On his death, however, Germany and the Holy Roman Empire ceased to be an important factor in Italian politics and culture.

In northern Italy, in particular, organizations of successful merchants created communal governments in their prosperous and independent city-states and struggled against powerful families for

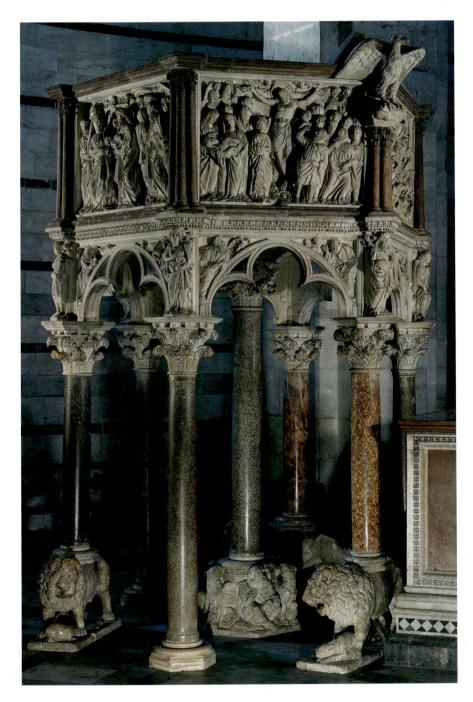

political control. Artists began to emerge as independent agents, working directly with wealthy clients and with civic and religious institutions.

It was during this time that new religious orders known as the mendicants (begging monks) arose to meet the needs of the growing urban population. They espoused an ideal of poverty, charity, and love, and they dedicated themselves to teaching and preaching, while living among the urban poor. Most notable in the beginning were the Franciscans, founded by St. Francis of Assisi (1182–1226; canonized in 1228). This son of a wealthy merchant gave away his possessions and devoted his life to God and the poor. As others began to join him, he wrote a simple rule for his followers, who were called brothers, or friars (from the Latin *frater*, mean-

ing "brother"), and the pope approved the new order in 1209–1210.

SCULPTURE: THE PISANO FAMILY

During the first half of the thirteenth century, the culturally enlightened Frederick II fostered a Classical revival at his southern Italian court. In the Romanesque period, artists in southern Italy had already turned to ancient sculpture for inspiration, but Frederick, mindful of his imperial status as Holy Roman emperor, encouraged this tendency to help communicate a message of power. He also encouraged artists to emulate the natural world around them. Nicola Pisano (active in Tuscany c. 1258–1278), who moved from the southern region of Apulia to Tuscany at mid century, became the leading exponent of this classicizing and naturalistic style.

NICOLA PISANO'S PULPIT AT PISA In

an inscription on a free-standing marble pulpit in the Pisa Baptistery (FIG. 17-34), Nicola identifies himself as a supremely self-confident sculptor: "In the year 1260 Nicola Pisano carved this noble work. May so gifted a hand be praised as it deserves." Columns topped with leafy Corinthian capitals support standing figures and Gothic trefoil arches, which in turn provide a platform for the six-sided pulpit. The columns rest on high bases carved with crouching figures, domestic animals, and shaggy-maned lions. Panels forming the

17-34 • Nicola Pisano **PULPIT** Baptistery, Pisa, Italy. 1260. Marble, height approx. 15' (4.6 m).

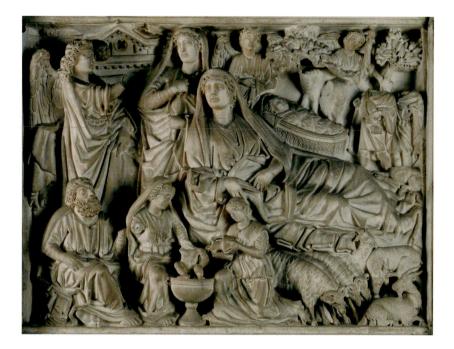

17-35 • Nicola Pisano ANNUNCIATION, NATIVITY, AND ADORATION OF THE SHEPHERDS

Detail of pulpit, Baptistery, Pisa, Italy. 1260. Marble, $33^{1}\!/_{2}'' \times 44^{1}\!/_{2}''$ (85 \times 113 cm).

pulpit enclosure illustrate New Testament subjects, each framed as an independent composition.

Each panel illustrates several scenes in a continuous narrative; FIGURE 17-35 depicts the ANNUNCIATION, NATIVITY, AND ADORATION OF THE SHEPHERDS. The Virgin reclines in the middle of the composition after having given birth to Jesus, who below receives his first bath from midwives. The upper left corner holds the Annunciation—the moment of Christ's conception, as announced by the archangel Gabriel. The scene in the upper right combines the Annunciation to the Shepherds with their Adoration of the Child. The viewer's attention moves from group to group within the shallow space, always returning to the regally detached Mother of God. The format, style, and technique of Roman sarcophagus reliefs—readily accessible in the burial ground near the baptistery—may have provided Nicola's models for this carving. The sculptural treatment of the deeply cut, full-bodied forms is certainly Classical in inspiration, as are the heavy, placid faces.

GIOVANNI PISANO'S PULPIT AT PISTOIA Nicola's son Giovanni (active c. 1265–1314) assisted his father while learning

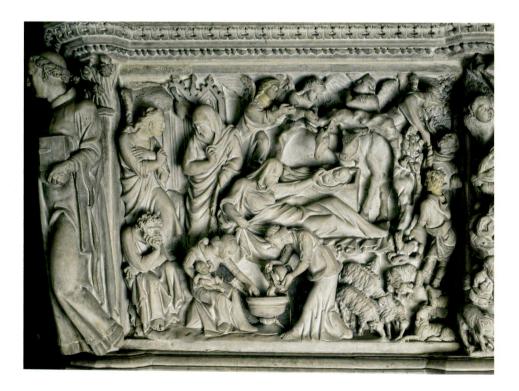

17-36 • Giovanni Pisano ANNUNCIATION, NATIVITY, AND ADORATION OF THE SHEPHERDS Detail of pulpit, Sant'Andrea, Pistoia, Italy. 1298–1301. Marble, $33'' \times 40'_{8}''$ (83×102 cm).

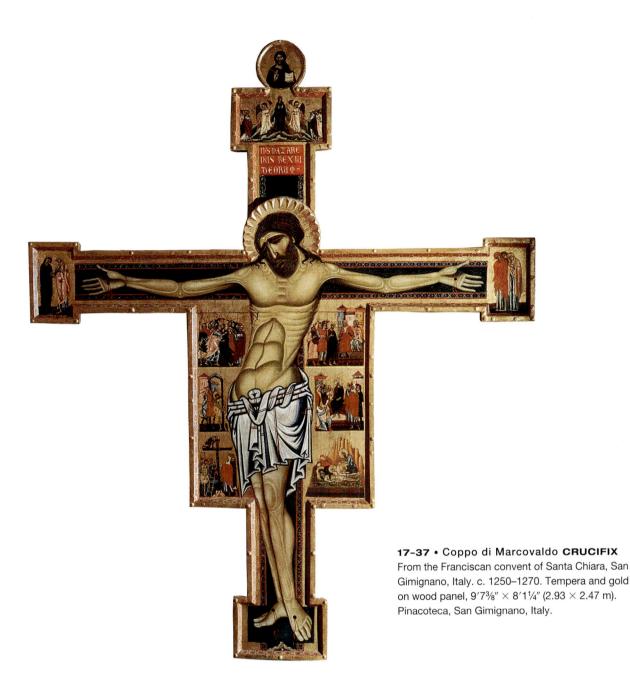

from him, and he may also have worked or studied in France. By the end of the thirteenth century, he had emerged as a versatile artist in his own right. Between 1298 and 1301, he and his workshop carved a pulpit for Sant'Andrea in Pistoia that is similar to his father's in conception but significantly different in style and execution. In his more dramatic rendering of the **ANNUNCIA-TION, NATIVITY, AND ADORATION OF THE SHEPHERDS**, Giovanni places graceful but energetic figures in an uptilted, deeply carved setting (FIG. 17-36). He replaces Nicola's imperious, stately Roman matron with a lithe, younger Mary, who recoils from Gabriel's advance at left, and at center, exhausted from giving birth, pulls at her bed-sheets for support while reaching toward her newborn baby. Sheep, shepherds, and angels spiral up through the trees at the right. Giovanni's sculpture is as dynamic as Nicola's is static.

PAINTING

The capture of Constantinople by crusaders in 1204 brought an influx of Byzantine art and artists to Italy. The imported style of painting, the *maniera greca* ("the Greek manner"), influenced thirteenth- and fourteenth-century Italian painting in style and technique and introduced a new emphasis on pathos and emotion.

PAINTED CRUCIFIXES One example, a large wooden crucifix attributed to the thirteenth-century Florentine painter Coppo di Marcovaldo (**FIG. 17-37**), represents an image of a suffering Christ on the cross, a Byzantine type with closed eyes and bleeding, sagging body that encourages viewers to respond emotionally and empathetically to the image (as in **FIGS. 8-22, 15-24**). This is a "historiated crucifix," meaning that narrative scenes flank Christ's body, in this case episodes from the story of his Passion.

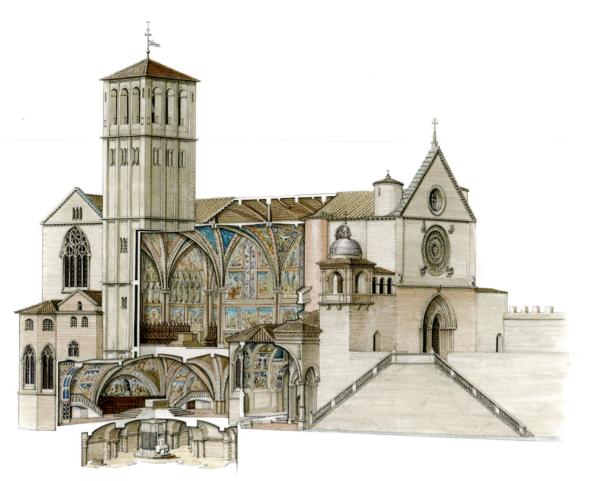

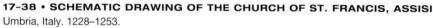

Explore the architectural panoramas of the church of St. Francis on myartslab.com

Such monumental crosses—this one is almost 10 feet high—were mounted on the choir screens that separated the clergy in the sanctuary from the lay people in the nave, especially in the churches of the Italian mendicants. One such cross can be seen from behind with its wooden bracing in FIGURE 17-39, tilted out to lean toward the worshiper's line of vision and increase the emotional impact.

THE CHURCH OF ST. FRANCIS AT ASSISI Two years after St. Francis's death in 1226, the church in his birthplace, Assisi, was begun. It was nearly finished in 1239 but was not dedicated until 1253. This building was unusually elaborate in its design, with upper and lower churches on two stories and a crypt at the choir end underneath both (**FIG. 17-38**). Both upper and lower churches have a single nave of four square vaulted bays, and both end in a transept and a single apse. The lower church has massive walls and a narrow nave flanked by side chapels. The upper church is a spacious, well-lit hall with excellent visibility and acoustics, designed to accommodate the crowds of pilgrims who came to see and hear the friars preach as well as to participate in church rituals and venerate the tomb of the saint. The church walls presented expanses of uninterrupted wall surface where sacred stories could unfold in murals. In the wall paintings of the upper church, the focus was on the story of Francis himself, presented as a model Christian life to which pilgrims, as well as resident friars, might aspire.

Scholars differ over whether the murals of the upper church were painted as early as 1290, but they agree on their striking narrative effectiveness. Like most Franciscan paintings, these scenes were designed to engage with viewers by appealing to their memories of their own life experiences, evoked by the inclusion of recognizable anecdotal details and emotionally expressive figures. A good example is **THE MIRACLE OF THE CRIB AT GREC-CIO** (**FIG. 17-39**), portraying St. Francis making the first Christmas manger scene in the church at Greccio.

The scene—like all Gothic visual narratives, set in the present, even though the event portrayed took place in the past—unfolds within a Gothic church that would have looked very familiar to late thirteenth-century viewers. A large wooden crucifix, similar to the one by Coppo di Marcovaldo (see FIG. 17–37), has been suspended from a stand on top of a screen separating the sanctuary from the nave. The cross has been reinforced on the back and tilted forward to hover over people in the nave, whom we see crowding behind an open door in the choir screen. A pulpit, with stairs leading up to its entrance and candlesticks at its corners, rises above the screen

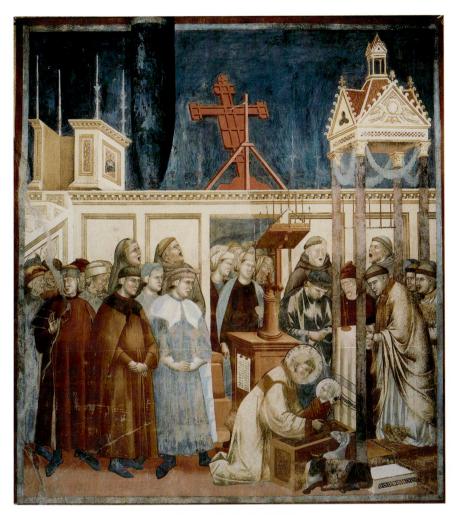

17-39 • THE MIRACLE OF THE CRIB AT GRECCIO From a cycle of the Life of St. Francis, church of St. Francis, Assisi. Late 13th or early 14th century. Fresco.

at the left. An elaborate carved baldacchino (canopy) surmounts the altar at the right, and an adjustable wooden lectern stands in front of the altar. Other small but telling touches include a seasonal liturgical calendar posted on the lectern, foliage swags decorating the baldacchino, and an embroidered altar cloth. And sound as well as sight is referenced here in the figures of the friars who throw their heads back, mouths wide open, to provide the liturgical soundtrack to this cinematic tableau.

The focus on the sacred narrative is confined to a small area at lower right, where St. Francis reverently holds the Holy Infant above a plain, boxlike crib next to miniature representations of various animals that might have been present at the Nativity, capturing the miraculous moment when, it was said, the Christ Child himself appeared in the manger. But even if the story is about a miracle, it takes place in a setting rich in worldly references that allowed contemporary viewers to imagine themselves as part of the scene, either as worshipers kneeling in front of the altar or as spectators pushing toward the doorway to get a better view. This narrative aspiration to engage directly with viewers through references to their own lives and their own time, initiated during the Middle Ages, will continue into the Renaissance.

THINK ABOUT IT

- 17.1 Characterize the most important technological innovations and sociocultural formations that made the "Age of the Cathedrals" possible?
- 17.2 Explain how manuscript illumination was used to convey complex theological ideas during the Gothic period. Analyze the iconography of one manuscript discussed in this chapter.
- 17.3 How was St. Francis's message of empathy conveyed in the frescos of the church of St. Francis in Assisi?
- 17.4 Analyze Salisbury Cathedral in England and the German church of St. Elizabeth of Hungary in Marburg. How does each reflect characteristics of French Gothic style, and how does each depart from that style and express architectural features characteristic of its own region?

CROSSCURRENTS

FIG. 16–20

These two works of art, one Romanesque and one Gothic, portray events from the same Bible story in a public context where they would have been seen by a diverse cross section of viewers. Compare the style of presentation. What features do these visual narratives have in common? How are they different? Is there a relationship between style, meaning, and medium?

Study and review on myartslab.com

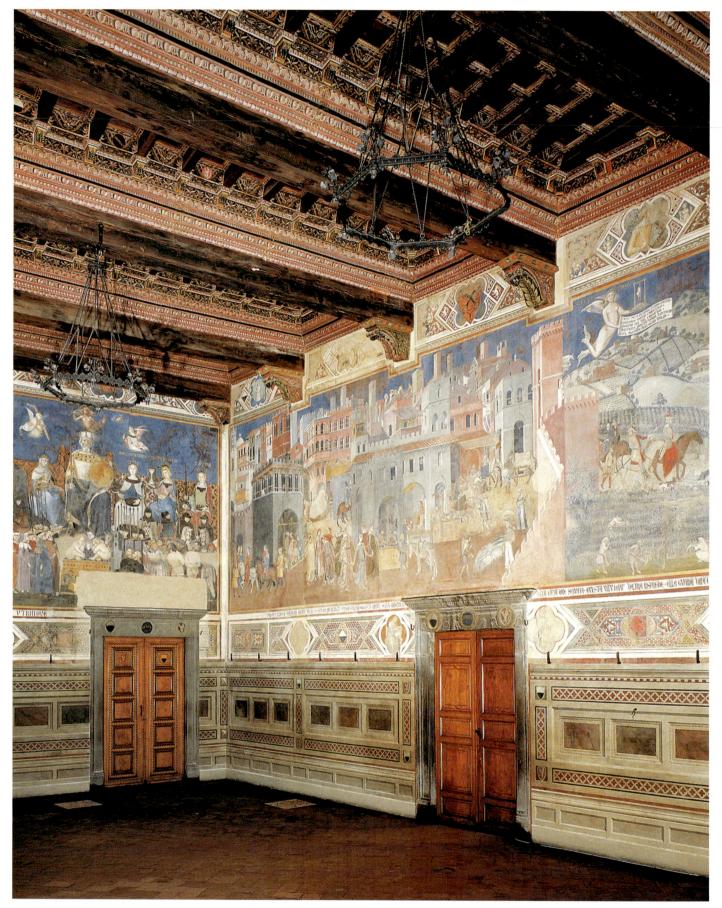

18-1 • Ambrogio Lorenzetti **FRESCOS OF THE SALA DEI NOVE (OR SALA DELLA PACE)** Palazzo Pubblico, Siena, Italy. 1338–1339. Length of long wall about 46' (14 m).

Read the document related to the frescos in the Palazzo Pubblico on myartslab.com

Fourteenth-Century Art in Europe

In 1338, the Nine—a council of merchants and bankers that governed Siena as an oligarchy—commissioned frescos from renowned Sienese painter Ambrogio Lorenzetti (c. 1295– c. 1348) for three walls in the chamber within the Palazzo Pubblico where they met to conduct city business. This commission came at the moment of greatest prosperity and security since the establishment of their government in 1287.

Lorenzetti's frescos combine allegory with panoramic landscapes and cityscapes to visualize and justify the beneficial effects of the Sienese form of government. The moral foundation of the rule of the Nine is outlined in a complicated allegory in which seated personifications (far left in FIG. 18-1) of Concord, Justice, Peace, Strength, Prudence, Temperance, and Magnanimity, not only diagram good governance but actually reference the Last Judgment in a bold assertion of the relationship between secular rule and divine authority. This tableau contrasts with a similar presentation of bad government, where Tyranny is flanked by the personified forces that keep tyrants in power-Cruelty, Treason, Fraud, Fury, Division, and War. A group of scholars would have devised this complex program of symbols and meanings; it is unlikely that Lorenzetti would have known the philosophical works that underlie them. Lorenzetti's fame, however, and the wall paintings' secure position among the most remarkable

surviving mural programs of the period, rests on the other part of this ensemble—the effects of good and bad government in city and country life (see FIG. 18–15).

Unlike the tableau showing the perils of life under tyrannical rule, the panoramic view of life under good government—which in this work of propaganda means life under the rule of the Nine—is well preserved. A vista of fourteenth-century Siena—identifiable by the cathedral dome and tower peeking over the rooftops in the background—showcases carefree life within shops, schools, taverns, and worksites, as the city streets bustle with human activity. Outside, an expansive landscape highlights agricultural productivity.

Unfortunately, within a decade of the frescos' completion, life in Siena was no longer as stable and carefree. The devastating bubonic plague visited in 1348—Ambrogio Lorenzetti himself was probably one of the victims—and the rule of the Nine collapsed in 1355. But this glorious vision of joyful prosperity preserves the dreams and aspirations of a stable government, using some of the most progressive and creative ideas in fourteenth-century Italian art, ideas we will see developed at the very beginning of the century, and whose history we will trace over the next two centuries through the Renaissance.

LEARN ABOUT IT

- 18.1 Compare and contrast the Florentine and Sienese styles of narrative painting as exemplified by Giotto and Duccio.
- **18.2** Investigate the Bible stories that were the subject of fourteenth-century sacred art, as well as the personal and political themes highlighted in secular art.
- **18.3** Assess the close connections between works of art and their patrons in fourteenth-century Europe.
- **18.4** Explore the production of small-scale works, often made of precious materials and highlighting extraordinary technical virtuosity, that continues from the earlier Gothic period.

((•- Listen to the chapter audio on myartslab.com

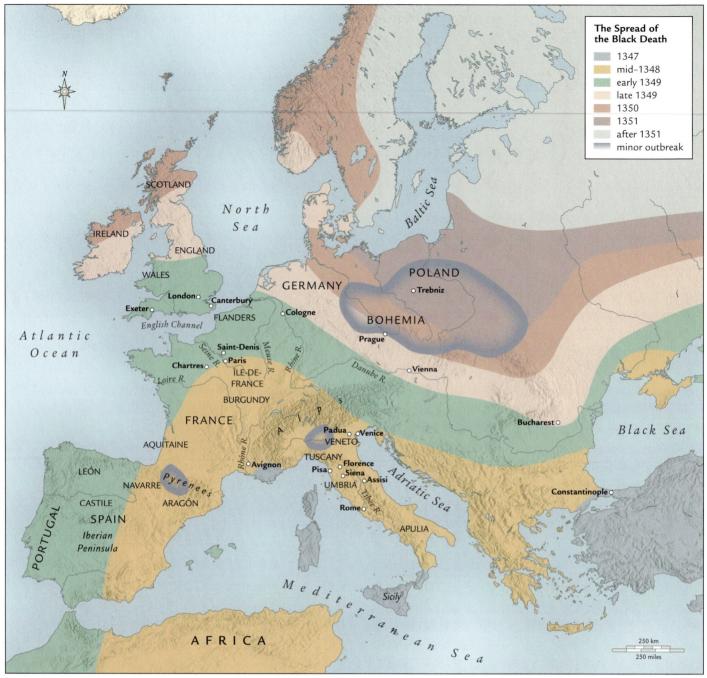

MAP 18-1 • EUROPE IN THE FOURTEENTH CENTURY

Following its outbreak in the Mediterranean in 1347, the Black Death swept across the European mainland over the next four years.

FOURTEENTH-CENTURY EUROPE

Literary luminaries Dante, Petrarch, Boccaccio, Chaucer, and Christine de Pizan (see "A New Spirit in Fourteenth-Century Literature," opposite) and the visionary painters Giotto, Duccio, Jean Pucelle, and Master Theodoric participated in a cultural explosion that swept through fourteenth-century Europe, and especially Italy. The poet Petrarch (1304–1374) was a towering figure in this change, writing his love lyrics in Italian, the language of everyday life, rather than Latin, the language of ceremony and high art. Similarly, the deeply moving murals of Florentine painter Giotto di Bondone (c. 1277–1337) were rooted in his observation of the people around him, giving the participants in sacred narratives both great dignity and striking humanity, thus making them familiar, yet new, to the audiences that originally experienced them. Even in Paris—still the artistic center of Europe as far as refined taste and technical sophistication were concerned—the painter Jean Pucelle began to show an interest in experimenting with established conventions. For Petrarch and his contemporaries, the essential qualifications for a writer were an appreciation of Greek and Roman authors and an ability to observe the people living around them. Although fluent in Latin, they chose to write in the language of their own time and place—Italian, English, French. Leading the way was Dante Alighieri (1265–1321), who wrote *The Divine Comedy*, his great summation of human virtue and vice, and ultimately human destiny, in Italian, establishing his daily vernacular as worthy to express great literary themes.

Francesco Petrarca, called simply Petrarch (1304–1374), raised the status of secular literature with his sonnets to his unattainable beloved, Laura, his histories and biographies, and his writings on the joys of country life in the Roman manner. Petrarch's imaginative updating of Classical themes in a work called *The Triumphs*—which examines the themes of Chastity triumphant over Love, Death over Chastity, Fame over Death, Time over Fame, and Eternity over Time—provided later Renaissance poets and painters with a wealth of allegorical subject matter.

More earthy, Giovanni Boccaccio (1313–1375) perfected the art of the short story in *The Decameron*, a collection of amusing and moralizing

tales told by a group of young Florentines who moved to the countryside to escape the Black Death. With wit and sympathy, Boccaccio presents the full spectrum of daily life in Italy. Such secular literature, written in Italian as it was then spoken in Tuscany, provided a foundation for fifteenth-century Renaissance writers.

In England, Geoffrey Chaucer (c. 1342–1400) was inspired by Boccaccio to write his own series of stories, *The Canterbury Tales*, told by pilgrims traveling to the shrine of St. Thomas à Becket (1118?–1170) in Canterbury. Observant and witty, Chaucer depicted the pretensions and foibles, as well as the virtues, of humanity.

Christine de Pizan (1364–c. 1431), born in Venice but living and writing at the French court, became an author out of necessity when she was left a widow with three young children and an aged mother to support. Among her many works are a poem in praise of Joan of Arc and a history of famous women—including artists—from antiquity to her own time. In *The Book of the City of Ladies*, she defended women's abilities and argued for women's rights and status.

These writers, as surely as Giotto, Duccio, Peter Parler, and Master Theodoric, led the way into a new era.

Changes in the way that society was organized were also under way, and an expanding class of wealthy merchants supported the arts as patrons. Artisan guilds-organized by occupationexerted quality control among members and supervised education through an apprenticeship system. Admission to the guild came after examination and the creation of a "masterpiece"-literally, a piece fine enough to achieve master status. The major guilds included cloth finishers, wool merchants, and silk manufacturers, as well as pharmacists and doctors. Painters belonged to the pharmacy guild, perhaps because they used mortars and pestles to grind their colors. Their patron saint, Luke, who was believed to have painted the first image of the Virgin Mary, was also a physicianor so they thought. Sculptors who worked in wood and stone had their own guild, while those who worked in metals belonged to another. Guilds provided social services for their members, including care of the sick and funerals for the deceased. Each guild had its patron saint, maintained a chapel, and participated in religious and civic festivals.

Despite the cultural flourishing and economic growth of the early decades, by the middle of the fourteenth century much of Europe was in crisis. Prosperity had fostered population growth, which began to exceed food production. A series of bad harvests compounded this problem with famine. To make matters worse, a prolonged conflict known as the Hundred Years' War (1337–1453) erupted between France and England. Then, in mid century, a lethal plague known as the Black Death swept across Europe (MAP 18-1), wiping out as much as 40 percent of the population. In spite of these catastrophic events, however, the strong

current of cultural change still managed to persist through to the end of the century and beyond.

ITALY

As great wealth promoted patronage of art in fourteenth-century Italy, artists began to emerge as individuals, in the modern sense, both in their own eyes and in the eyes of patrons. Although their methods and working conditions remained largely unchanged from the Middle Ages, artists in Italy contracted freely with wealthy townspeople and nobles as well as with civic and religious bodies. Perhaps it was their economic and social freedom that encouraged ambition and self-confidence, individuality and innovation.

FLORENTINE ARCHITECTURE AND METALWORK

The typical medieval Italian city was a walled citadel on a hilltop. Houses clustered around the church and an open city square. Powerful families added towers to their houses, both for defense and as expressions of family pride. In Florence, by contrast, the ancient Roman city—with its axial rectangular plan and open city squares—formed the basis for civic layout. The cathedral stood northeast of the ancient forum and a street following the Roman plan connected it with the Piazza della Signoria, the seat of the government.

THE PALAZZO DELLA SIGNORIA The Signoria (ruling body, from *signore*, meaning "Lord") that governed Florence met

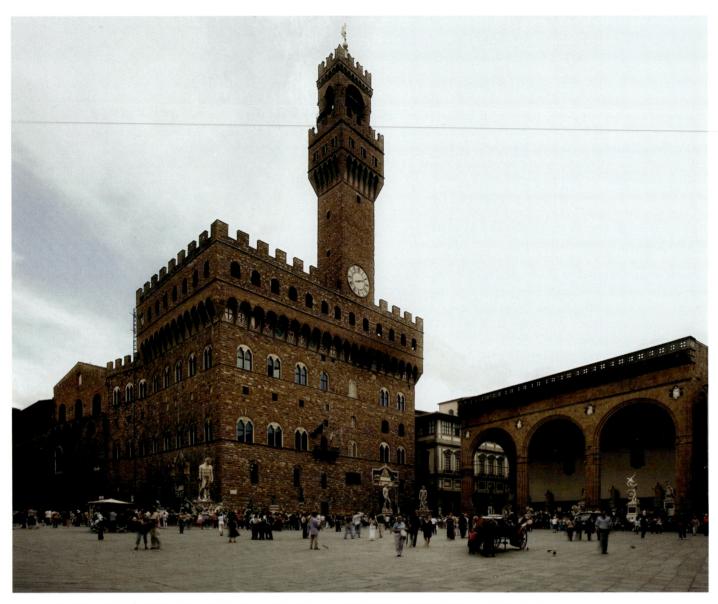

18-2 • PIAZZA DELLA SIGNORIA WITH PALAZZO DELLA SIGNORIA (TOWN HALL) 1299-1310, AND LOGGIA DEI LANZI (LOGGIA OF THE LANCERS), 1376-1382 Florence.

in the **PALAZZO DELLA SIGNORIA**, a massive fortified building with a bell tower 300 feet tall (**FIG. 18-2**). The building faces a large square, or piazza, which became the true center of Florence. The town houses around the piazza often had benches along their walls to provide convenient public seating. Between 1376 and 1382, master builders Benci di Cione and Simone Talenti constructed a huge **loggia** or covered open-air corridor at one side—now known as the Loggia dei Lanzi (Loggia of the Lancers)—to provide a sheltered locale for ceremonies and speeches.

THE BAPTISTERY DOORS In 1330, Andrea Pisano (c. 1290– 1348) was awarded the prestigious commission for a pair of gilded bronze doors for Florence's Baptistery of San Giovanni, situated directly in front of the cathedral. (Andrea's "last" name means "from Pisa," and he was not related to Nicola and Giovanni Pisano.) The doors were completed within six years and display 20 scenes from the **LIFE OF ST. JOHN THE BAPTIST** (the San Giovanni to whom the baptistery is dedicated) set above eight personifications of the Virtues (**FIG. 18–3**). The overall effect is two-dimensional and decorative: a grid of 28 rectangles with repeated quatrefoils filled by the graceful, patterned poses of delicate human figures. Within the quatrefoil frames, however, the figural compositions create the illusion of three-dimensional forms moving within the described spaces of natural and architectural worlds.

The scene of John baptizing a multitude (**FIG. 18-4**) takes place on a shelflike stage created by a forward extension of the rocky natural setting, which also expands back behind the figures into a corner of the quatrefoil frame. Composed as a rectangular group, the gilded figures present an independent mass of modeled forms. The illusion of three-dimensionality is enhanced by the

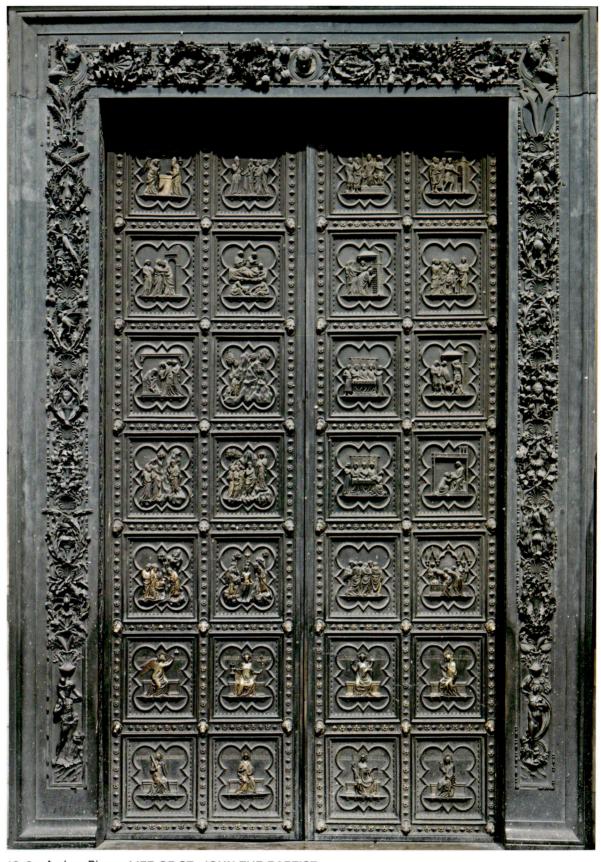

18-3 • Andrea Pisano LIFE OF ST. JOHN THE BAPTIST South doors, baptistery of San Giovanni, Florence. 1330–1336. Gilded bronze, each panel $191/4'' \times 17''$ (48 × 43 cm). Frame, Ghiberti workshop, mid 15th century.

The bronze vine scrolls filled with flowers, fruits, and birds on the lintel and jambs framing the door were added in the mid fifteenth century.

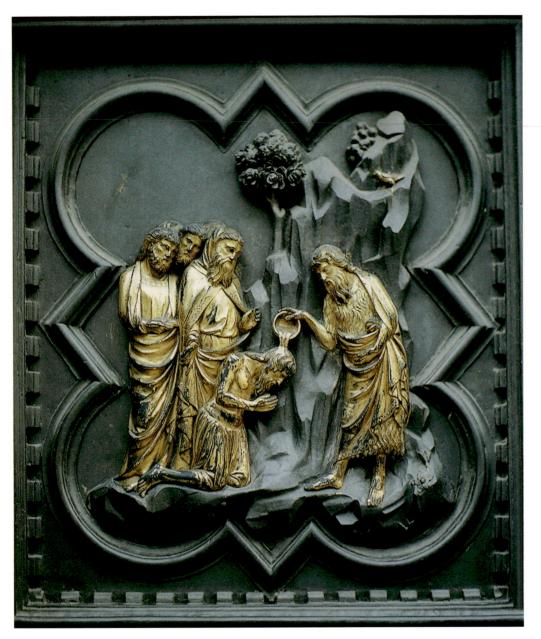

18-4 • Andrea Pisano THE BAPTISM OF THE MULTITUDE

Detail of the south doors, baptistery of San Giovanni, Florence. 1330–1336. Gilded bronze, $19^{1}/4^{\prime\prime} \times 17^{\prime\prime}$ (48 × 43 cm).

way the curving folds of their clothing wrap around their bodies. At the same time, their graceful gestures and the elegant fall of their drapery reflect the soft curves and courtly postures of French Gothic art.

FLORENTINE PAINTING

Florence and Siena, rivals in so many ways, each supported a flourishing school of painting in the fourteenth century. Both grew out of local thirteenth-century painting traditions and engendered individual artists who became famous in their own time. The Byzantine influence—the *maniera greca* ("Greek style")—continued to provide models of dramatic pathos and narrative iconography, as well as stylized features including the use of gold for drapery folds and striking contrasts of highlights and shadows in the modeling of individual forms. By the end of the fourteenth century, the painter and commentator Cennino Cennini (see "Cennino Cennini on Panel Painting," page 546) would be struck by the accessibility and modernity of Giotto's art, which, though it retained traces of the *maniera greca*, was moving toward the depiction of a lifelike, contemporary world anchored in solid, three-dimensional forms.

CIMABUE In Florence, this stylistic transformation began a little earlier than in Siena. About 1280, a painter named Cenni di Pepi (active c. 1272–1302), better known by his nickname "Cimabue," painted a panel portraying the **VIRGIN AND CHILD ENTHRONED** (**FIG. 18-5**), perhaps for the main altar of the church of Santa Trinità in Florence. At over 12 feet tall, this enormous painting set a new precedent for monumental altarpieces. Cimabue surrounds the Virgin and Child with angels and places a row of Hebrew Bible prophets beneath them. The hierarchically scaled figure of Mary holds the infant Jesus in her lap. Looking out at the viewer while gesturing toward her son as the path to salvation, she adopts a formula popular in Byzantine iconography since at least the sixth century (see FIG. 8–14).

Mary's huge throne, painted to resemble gilded bronze with inset enamels and gems, provides an architectural framework for the figures. Cimabue creates highlights on the drapery of Mary, Jesus, and the angels with thin lines of gold, as if to capture their divine radiance. The viewer seems suspended in space in front of the image, simultaneously looking down on the projecting elements of the throne and Mary's lap, while looking straight ahead at the prophets at the base of the throne and the angels at each side. These spatial ambiguities, the subtle asymmetries within the centralized composition, the Virgin's engaging gaze, and the individually conceived faces of the old men give the picture a sense of life and the figures a sense of presence. Cimabue's ambitious attention to spatial volumes, his use of delicate modeling in light and shade to simulate three-dimensional form, and his efforts to give naturalistic warmth to human figures had an impact on the future development of Florentine painting.

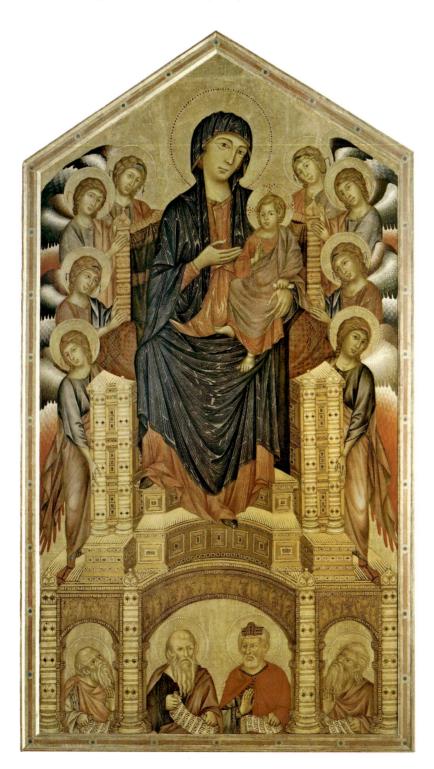

18-5 • Cimabue VIRGIN AND CHILD ENTHRONED

Most likely painted for the high altar of the church of Santa Trinità, Florence. c. 1280. Tempera and gold on wood panel, $12'7'' \times 7'4''$ (3.53 × 2.2 m). Galleria degli Uffizi, Florence.

• Watch a video about the egg tempera process on myartslab.com

GIOTTO DI BONDONE According to the sixteenth-century chronicler Giorgio Vasari, Cimabue discovered a talented shepherd boy, Giotto di Bondone (active c. 1300–1337), and taught him to paint; "not only did the young boy equal the style of his master, but he became such an excellent imitator of nature that he completely banished that crude Greek [i.e., Byzantine] style and revived the modern and excellent art of painting, introducing good drawing from live natural models, something which had not been done for more than two hundred years" (Vasari, translated by Bondanella and Bondanella, p. 16). After his training, Giotto

may have collaborated on murals at the prestigious church of St. Francis in Assisi. We know he worked for the Franciscans in Florence and absorbed facets of their teaching. St. Francis's message of simple, humble devotion, direct experience of God, and love for all creatures was gaining followers throughout western Europe, and it had a powerful impact on thirteenth- and fourteenthcentury Italian literature and art.

Compared to Cimabue's *Virgin and Child Enthroned*, Giotto's altarpiece of the same subject (**FIG. 18-6**), painted about 30 years later for the church of the Ognissanti (All Saints) in Florence,

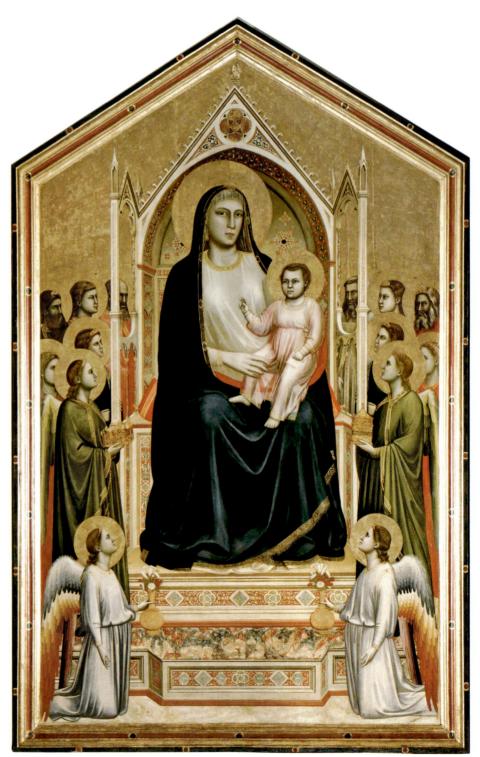

18-6 • Giotto di Bondone VIRGIN AND CHILD ENTHRONED

Most likely painted for the high altar of the church of the Ognissanti (All Saints), Florence. 1305–1310. Tempera and gold on wood panel, $10'8'' \times 6'8^{1}4''$ (3.53 \times 2.05 m). Galleria degli Uffizi, Florence.

TECHNIQUE | Buon Fresco

The two techniques used in mural painting are *buon* ("true") *fresco* ("fresh"), in which water-based paint is applied on wet plaster, and *fresco secco* ("dry"), in which paint is applied to a dry plastered wall. The two methods can be used on the same wall painting.

The advantage of *buon fresco* is its durability. A chemical reaction occurs as the painted plaster dries, which bonds the pigments into the wall surface. In *fresco* secco, by contrast, the color does not become part of the wall and tends to flake off over time. The chief disadvantage of *buon fresco* is that it must be done quickly without mistakes. The painter plasters and paints only as much as can be completed in a day, which explains the Italian term for each of these sections: **giornata**, or a day's work. The size of a *giornata* varies according to the complexity of the painting within it. A face, for instance, might take an entire day, whereas large areas of sky can be painted quite rapidly. In Giotto's Scrovegni Chapel, scholars have identified 852 separate *giornate*, some worked on concurrently within a single day by assistants in Giotto's workshop.

In medieval and Renaissance Italy, a wall to be frescoed was first prepared with a rough, thick undercoat of plaster known as the *arriccio*. When this was dry, assistants copied the master painter's composition onto it with reddish-brown pigment or charcoal. The artist made any necessary adjustments. These underdrawings, known as **sinopia**, have an immediacy and freshness that are lost in the finished painting. Work proceeded in irregularly shaped *giornate* conforming to the contours of major figures and objects. Assistants covered one section at a time with a fresh, thin coat of very fine plaster—the *intonaco*—over

exhibits greater spatial consistency and sculptural solidity while retaining some of Cimabue's conventions. The position of the figures within a symmetrical composition reflects Cimabue's influence. Gone, however, are Mary's modestly inclined head and the delicate gold folds in her drapery. Instead, light and shadow play gently across her stocky form, and her action-holding her child's leg instead of pointing him out to us-seems less contrived. This colossal Mary overwhelms her slender Gothic tabernacle of a throne, where figures peer through openings and haloes overlap faces. In spite of the hierarchic scale and the formal, enthroned image and flat, gold background, Giotto has created the sense that these are fully three-dimensional beings, whose plainly draped, bulky bodies inhabit real space. The Virgin's solid torso is revealed by her thin tunic, and Giotto's angels are substantial solids whose foreshortened postures project from the foreground toward us, unlike those of Cimabue, which stay on the surface along lateral strips composed of overlapping screens of color.

Although he was trained in the Florentine tradition, many of Giotto's principal works were produced elsewhere. After a sojourn in Rome during the last years of the thirteenth century, he was called to Padua in northern Italy soon after 1300 to paint frescos (see "*Buon Fresco*," above) for a new chapel being constructed at the site of an ancient Roman arena—explaining why it is usually

the *sinopia*, and when this was "set" but not dry, the artist worked with pigments mixed with water, painting from the top down so that drips fell on unfinished portions. Some areas requiring pigments such as ultramarine blue (which was unstable in *buon fresco*), as well as areas requiring gilding, would be added after the wall was dry using the *fresco secco* technique.

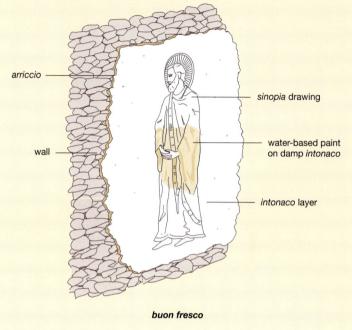

referred to as the Arena Chapel. The chapel was commissioned by Enrico Scrovegni, whose family fortune was made through the practice of usury—which at this time meant charging interest when loaning money, a sin so grave that it resulted in exclusion from the Christian sacraments. Enrico's father, Regibaldo, was a particularly egregious case (he appears in Dante's *Inferno* as the prototypical usurer), but evidence suggests that Enrico followed in his father's footsteps, and the building of the Arena Chapel next to his new palatial residence seems to have been conceived at least in part as a penitential act, part of Enrico's campaign not only to atone for his father's sins, but also to seek absolution for his own. He was pardoned by Pope Benedict XI (pontificate 1303–1304).

That Scrovegni called two of the most famous artists of the time—Giotto and Giovanni Pisano (see FIG. 17-36)—to decorate his chapel indicates that his goals were to express his power, sophistication, and prestige, as well as to atone for his sins. The building itself has little architectural distinction. It is a simple, barrel-vaulted room that provides broad walls, a boxlike space to showcase Giotto's paintings (FIG. 18-7). Giotto covered the entrance wall with the *Last Judgment* (not visible here), and the sanctuary wall with three highlighted scenes from the life of Christ. The Annunciation spreads over the two painted architectural frameworks on either side of the high arched opening into the sanctuary itself.

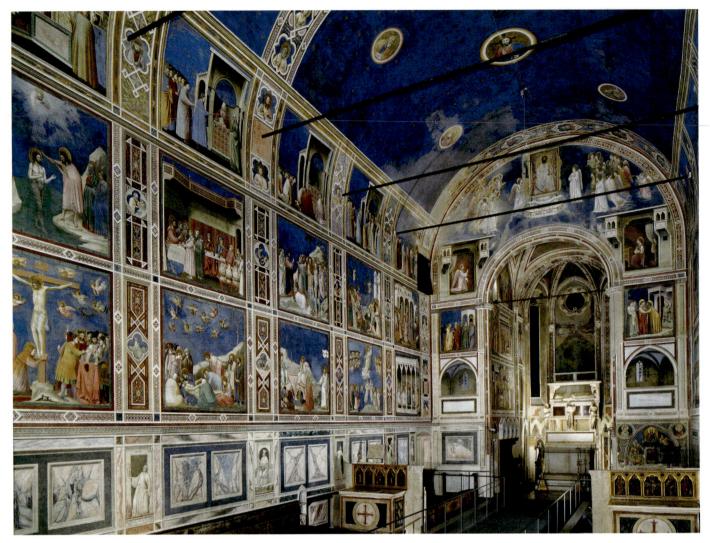

18-7 • Giotto di Bondone SCROVEGNI (ARENA) CHAPEL, VIEW TOWARD EAST WALL Padua. 1305–1306. Frescos.

View the Closer Look for the Scrovegni Chapel on myartslab.com

Below this are, to the left, the scene of Judas receiving payment for betraying Jesus, and, to the right, the scene of the Visitation, where the Virgin, pregnant with God incarnate, embraces her cousin Elizabeth, pregnant with John the Baptist. The compositions and color arrangement of these two scenes create a symmetrical pairing that encourages viewers to relate them, comparing the ill-gotten financial gains of Judas (a rather clear reference to Scrovegni usury) to the miraculous pregnancy that brought the promise of salvation.

Giotto subdivided the side walls of the chapel into framed pictures. A dado of faux-marble and allegorical **grisaille** (monochrome paintings in shades of gray) paintings of the Virtues and Vices support vertical bands painted to resemble marble inlay into which are inserted painted imitations of carved medallions. The central band of medallions spans the vault, crossing a brilliant, lapisblue, star-spangled sky in which large portrait disks float like glowing moons. Set into this framework are three horizontal bands of rectangular narrative scenes from the life of the Virgin and her parents at the top, and Jesus along the middle and lower registers, constituting together the primary religious program of the chapel.

Both the individual scenes and the overall program display Giotto's genius for distilling complex stories into a series of compelling moments. He concentrates on the human dimensions of the unfolding drama-from touches of anecdotal humor to expressions of profound anguish-rather than on its symbolic or theological weight. His prodigious narrative skills are apparent in a set of scenes from Christ's life on the north wall (FIG. 18-8). At top left Jesus performs his first miracle, changing water into wine at the wedding feast at Cana. The wine steward-looking very much like the jars of new wine himself-sips the results. To the right is the Raising of Lazarus, where boldly modeled and individualized figures twist in space. Through their postures and gestures they react to the human drama by pleading for Jesus' help, or by expressing either astonishment at the miracle or revulsion at the smell of death. Jesus is separated from the crowd. His transforming gesture is highlighted against the dark blue of the background, his profile face locked in communication with the similarly isolated

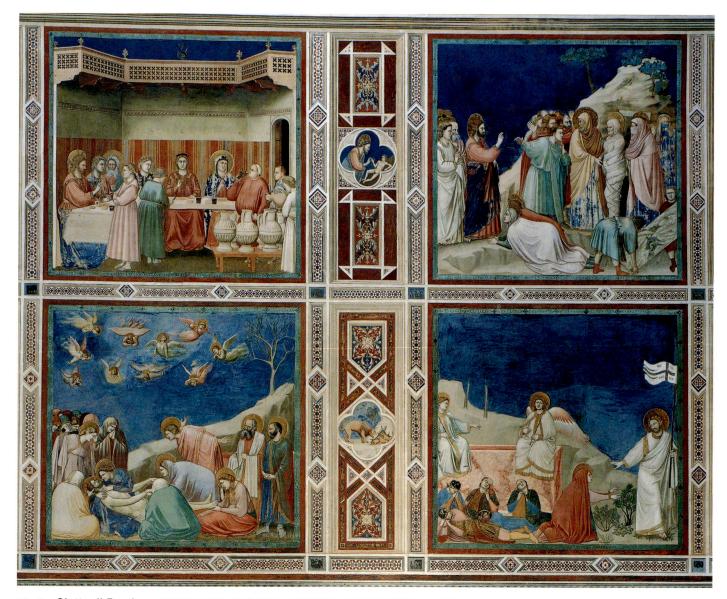

18-8 • Giotto di Bondone MARRIAGE AT CANA, RAISING OF LAZARUS, LAMENTATION, AND RESURRECTION/NOLI ME TANGERE North wall of Scrovegni (Arena) Chapel, Padua. 1305–1306. Fresco, each scene approx. 6'5" × 6' (2 × 1.85 m).

Lazarus, whose eyes—still fixed in death—let us know that the miracle is just about to happen.

On the lower register, where Jesus' grief-stricken followers lament over his dead body, Giotto conveys palpable human suffering, drawing viewers into a circle of personal grief. The stricken Virgin pulls close to her dead son, communing with mute intensity, while John the Evangelist flings his arms back in convulsive despair and others hunch over the corpse. Giotto has linked this somber scene—much as he linked the scene of Judas' pact and the Visitation across the sanctuary arch—to the mourning of Lazarus on the register above through the seemingly continuous diagonal implied by the sharply angled hillside behind both scenes and by the rhyming repetition of mourners in each scene—facing in opposite directions—who throw back their arms to express their emotional state. Viewers would know that the mourning in both scenes is resolved by resurrection, portrayed in the last picture in this set.

Following traditional medieval practice, the fresco program is full of scenes and symbols like these that are intended to be contemplated as coordinated or contrasting juxtapositions. What is new here is the way Giotto draws us into the experience of these events. This direct emotional appeal not only allows viewers to imagine these scenes in relation to their own life experiences; it also embodies the new Franciscan emphasis on personal devotion rooted in empathetic responses to sacred stories.

One of the most gripping paintings in the chapel is Giotto's portrayal of the **KISS OF JUDAS**, the moment of betrayal that represents the first step on Jesus' road to the Crucifixion (**FIG. 18-9**). Savior and traitor are slightly off-center in the near foreground. The expansive sweep of Judas' strident yellow cloak—the same outfit he

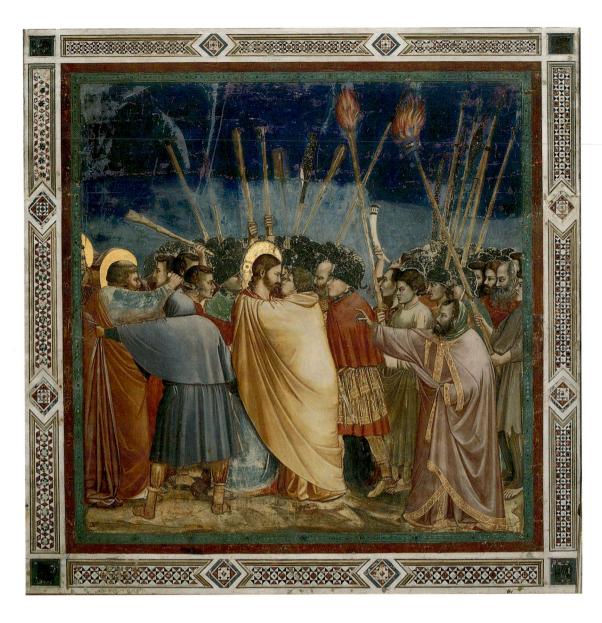

18-9 • Giotto di Bondone KISS OF JUDAS

South wall of Scrovegni (Arena) Chapel, Padua. 1305–1306. Fresco, $6'6^{3}\!\!\!/'' \times 6'^{7}\!\!\!/''' (2 \times$ 1.85 m).

wore at the scene of his payment for the betrayal on the strip of wall to the left of the sanctuary arch-almost completely swallows Christ's body. Surrounding them, faces glare from all directions. A bristling array of weapons radiating from the confrontation draws attention to the encounter between Christ and Judas and documents the militarism of the arresting battalion. Jesus stands solid, a model of calm resolve that recalls his visual characterization in the Resurrection of Lazarus, and forms a striking foil to the noisy and chaotic aggression that engulfs him. Judas, in simian profile, purses his lips for the treacherous kiss that will betray Jesus to his captors, setting up a mythic confrontation of good and evil. In a subplot to the left, Peter lunges forward to sever the ear of a member of the arresting retinue. They are behind another broad sweep of fabric, this one extended by an ominous figure seen from behind and completely concealed except for the clenched hand that pulls at Peter's mantle. Indeed, a broad expanse of cloth and lateral gestures creates a barrier along the picture plane-as if to protect viewers from the compressed chaos of the scene itself. Rarely has this poignant event been visualized with such riveting power.

SIENESE PAINTING

Like their Florentine rivals, Sienese painters were rooted in thirteenth-century pictorial traditions, especially those of Byzantine art. Sienese painting emphasized the decorative potential of narrative painting, with brilliant, jewel-like colors and elegantly posed figures. For this reason, some art historians consider Sienese art more conservative than Florentine art, but we will see that it has its own charm, and its own narrative strategies.

DUCCIO DI BUONINSEGNA Siena's foremost painter was Duccio di Buoninsegna (active 1278–1318), whose creative synthesis of Byzantine and French Gothic sources transformed the tradition in which he worked. Between 1308 and 1311, Duccio and his workshop painted a huge altarpiece commissioned for Siena Cathedral and known as the **MAESTÀ** ("Majesty") (**FIG. 18-10**). Creating this altarpiece—assembled from many wood panels bonded together before painting—was an arduous undertaking. The work was not only large—the central panel alone was 7 by 13 feet—but it had to be painted on both sides since it could

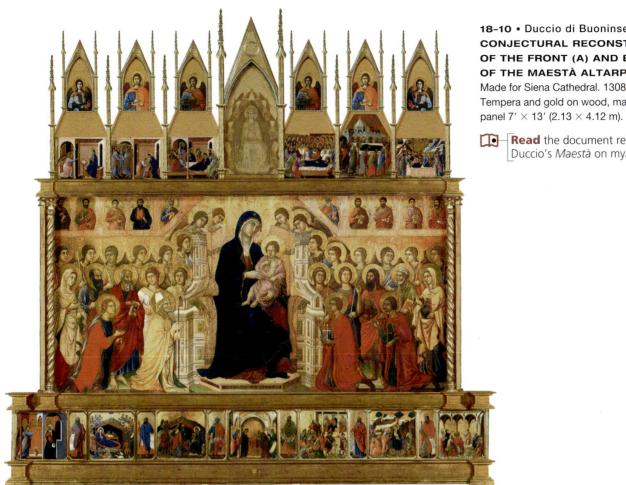

18-10 • Duccio di Buoninsegna CONJECTURAL RECONSTRUCTION OF THE FRONT (A) AND BACK (B) OF THE MAESTÀ ALTARPIECE Made for Siena Cathedral. 1308–1311. Tempera and gold on wood, main front

Read the document related to Duccio's Maestà on myartslab.com

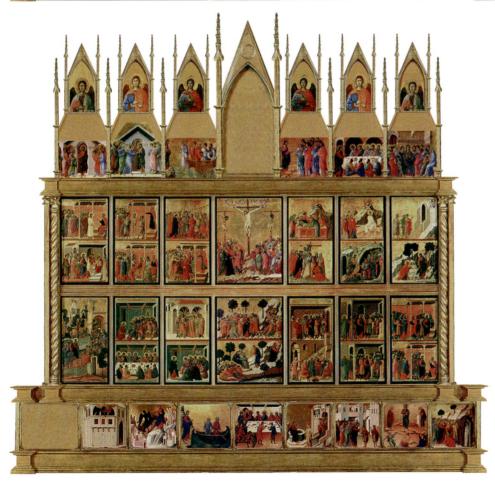

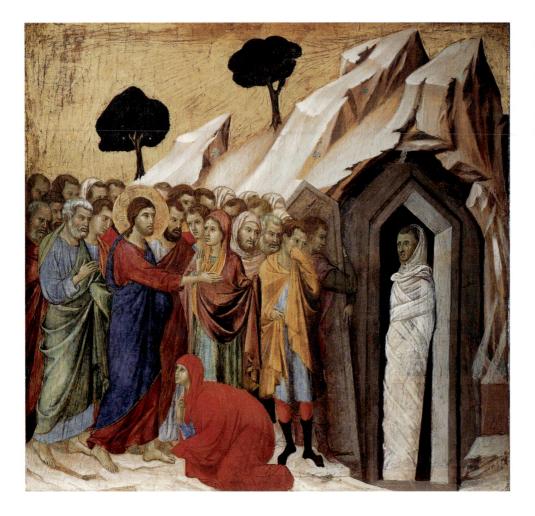

18-11 • Duccio di Buoninsegna RAISING OF LAZARUS

From the predella of the back of the *Maestà* altarpiece (lower right corner of FIG. 18–10B), made for Siena Cathedral. 1308–1311. Tempera and gold on wood, $171_{6}^{"} \times 181_{4}^{"}$ (43.5 × 46.4 cm). Kimbell Art Museum, Fort Worth, Texas.

be seen from all directions when installed on the main altar at the center of the sanctuary.

Because the Maestà was dismantled in 1771, its power and beauty can only be imagined from scattered parts, some still in Siena but others elsewhere. FIGURE 18-10A is a reconstruction of how the front of the original altarpiece might have looked. It is dominated by a large representation of the Virgin and Child in Majesty (thus its title of Maesta), flanked by 20 angels and ten saints, including the four patron saints of Siena kneeling in the foreground. Above and below this lateral tableau were small narrative scenes from the last days of the life of the Virgin (above) and the infancy of Christ (spread across the predella). An inscription running around the base of Mary's majestic throne places the artist's signature within an optimistic framework: "Holy Mother of God, be thou the cause of peace for Siena and life to Duccio because he painted thee thus." This was not Duccio's first work for the cathedral. In 1288, he had designed a stunning stained-glass window portraying the Death, Assumption, and Coronation of the Virgin for the huge circular opening in the east wall of the sanctuary. It would have hovered over the installed *Maestà* when it was placed on the altar in 1311.

On the back of the *Maestà* (FIG. 18–10B) were episodes from the life of Christ, focusing on his Passion. Sacred narrative unfolds in elegant episodes enacted by graceful figures who seem to dance their way through these stories while still conveying emotional

content. Characteristic of Duccio's narrative style is the scene of the RAISING OF LAZARUS (FIG. 18-11). Lyrical figures enact the event with graceful decorum, but their highly charged glances and expressive gestures-especially the bold reach of Christ-convey a strong sense of dramatic urgency that contrasts with the tense stillness that we saw in Giotto's rendering of this same moment of confrontation (see FIG. 18-8). Duccio's shading of drapery, like his modeling of faces, faithfully describes the figures' threedimensionality, but the crisp outlines of the jewel-colored shapes created by their clothing, as well as the sinuous continuity of folds and gestures, generate rhythmic patterns crisscrossing the surface. Experimentation with the portrayal of space extends from the receding rocks of the mountainous landscape to carefully studied interiors, here the tomb of Lazarus whose heavy door was removed by the straining hug of a bystander to reveal the shrouded figure of Jesus' resurrected friend, propped up against the door jamb.

Duccio's rendering of the **BETRAYAL OF JESUS (FIG. 18–12**) is more expansive, both pictorially and temporally, occupying one of the broadest panels in the altarpiece (see FIG. 18–10B, lower center) and encompassing within this one composition several moments in the sequential narrative of its subject matter. The tableau is centered and stabilized by the frontal figure of Jesus, whose dark mantle with its sinuous gold trim stands out from the densely packed, colorful crowd of figures surrounding him. Judas

approaches from the left to identify Jesus; although the heads of betrayer and betrayed touch in this moment, Duccio avoids the psychological power of Giotto's face-to-face confrontation in the Scrovegni chapel (see FIG. 18-9). Flanking Duccio's stable, packed central scene of betrayal, are two subsequent moments in the story, each pulling our attention away from the center and toward the sides. To the left, with a forceful stride and dynamic gesture, the apostle Peter lunges to sever the ear of a member of the arresting party, while on the other side of the composition a group of fearful apostles rushes gracefully but with united resolve to escape the central scene, abandoning Jesus to his fate. Within the complexity of this broad, multi-figure, continuous narrative, Duccio manages to express-through the postures and facial expressions of his figures-the emotional charge of these pivotal moments in the narrative of Christ's Passion. At the same time, he creates a dazzling picture, as rich in color and linear elegance as it is faithful to the human dimensions of the situations it portrays.

The enthusiasm with which citizens greeted a great painting or altarpiece like the *Maestà* demonstrates the power of images as well as the association of such magnificent works with the glory of the city itself. According to a contemporary account, on December 20, 1311, the day that Duccio's altarpiece was carried from his workshop to the cathedral, all the shops were shut, and everyone in the city participated in the procession, with "bells ringing joyously, out of reverence for so noble a picture as is this" (Holt, p. 69).

SIMONE MARTINI The generation of painters who followed Duccio continued to paint in the elegant style he established, combining the evocation of three-dimensional form with a grace-ful continuity of linear pattern. One of Duccio's most success-ful and innovative followers was Simone Martini (c. 1284–1344), whose paintings were in high demand throughout Italy, including in Assisi where he covered the walls of the St. Martin Chapel with frescos between 1312 and 1319. His most famous work, however, was commissioned in 1333 for the cathedral of his native Siena, an altarpiece of the **ANNUNCIATION** flanked by two saints (**FIG. 18-13**) that he painted in collaboration with his brother-in-law, Lippo Memmi.

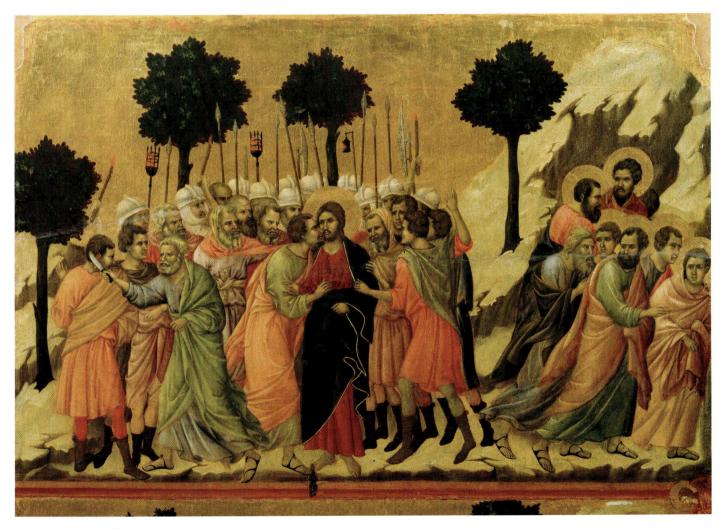

18-12 • Duccio di Buoninsegna **BETRAYAL OF JESUS** From the back of the *Maestà* altarpiece (lower center of FIG. 18–10B), made for Siena Cathedral. 1308–1311. Tempera and gold on wood, $22\frac{1}{2}" \times 40"$ (57.2 × 101.6 cm). Museo dell'Opera del Duomo, Siena.

TECHNIQUE | Cennino Cennini on Panel Painting

Il Libro dell' Arte (The Book of Art) of Cennino Cennini (c. 1370–1440) is a compendium of Florentine painting techniques from about 1400 that includes step-by-step instructions for making panel paintings, a process also used in Sienese paintings of the same period.

The wood for the panels, he explains, should be fine-grained, free of blemishes, and thoroughly seasoned by slow drying. The first step in preparing such a panel for painting was to cover its surface with clean white linen strips soaked in a **gesso** made from gypsum, a task, he tells us, best done on a dry, windy day. Gesso provided a ground, or surface, on which to paint, and Cennini specified that at least nine layers should be applied. The gessoed surface should then be burnished until it resembles ivory. Only then could the artist sketch the composition of the work with charcoal made from burned willow twigs. At this point, advised Cennini, "When you have finished drawing your figure, especially if it is in a very valuable [altarpiece], so that you are counting on profit and reputation from it, leave it alone for a few days, going back to it now and then to look it over and improve it wherever it still needs something. When it seems to you about right (and bear in mind that you may copy and examine things done by other good masters; that it is no shame to you) when the figure is satisfactory, take the feather and rub it over the drawing very lightly, until the drawing is practically effaced" (Cennini, trans. Thompson, p. 75). At this point, the final design would be inked in with a fine squirrel-hair brush. Gold leaf, he advises, should be affixed on a humid day, the tissue-thin sheets carefully glued down with a mixture of fine powdered clay and egg white on the reddish clay ground called bole. Then the gold is burnished with a gemstone or the tooth of a carnivorous animal. Punched and incised patterning should be added to the gold leaf later.

Fourteenth- and fifteenth-century Italian painters worked principally in tempera paint, powdered pigments mixed with egg yolk, a little water, and an occasional touch of glue. Apprentices were kept busy grinding pigments and mixing paints, setting them out for more senior painters in wooden bowls or shell dishes.

Cennini outlined a detailed and highly formulaic painting process. Faces, for example, were always to be done last, with flesh tones applied over two coats of a light greenish pigment and highlighted with touches of red and white. The finished painting was to be given a layer of varnish to protect it and intensify its colors.

Read the document related to Cennino Cennini on myartslab.com

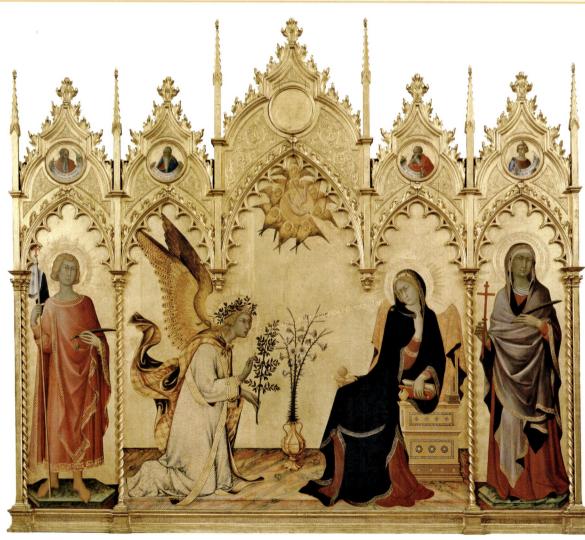

18-13 • Simone Martini and

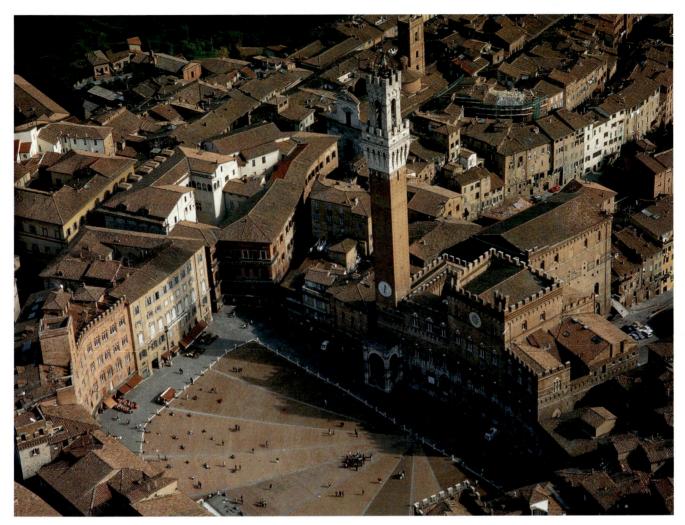

18-14 • AERIAL VIEW OF THE CAMPO IN SIENA WITH THE PALAZZO PUBBLICO (CITY HALL INCLUDING ITS TOWER) FACING ITS STRAIGHT SIDE Siena. Palazzo Pubblico 1297–c. 1315; tower 1320s–1340s.

The smartly dressed figure of Gabriel—the extended flourish of his drapery behind him suggesting he has just arrived, and with some speed—raises his hand to address the Virgin. The words of his message are actually incised into the gold–leafed gesso of the background, running from his opened mouth toward the Virgin's ear: *Ave gratia plena dominus tecum* (Luke 1:28: "Hail, full of grace, the Lord is with thee"). Seemingly frightened—at the very least startled—by this forceful and unexpected celestial messenger, Mary recoils into her lavish throne, her thumb inserted into the book she had been reading to safeguard her place, while her other hand pulls at her clothing in an elegant gesture of nobility ultimately deriving from the courtly art of thirteenth–century Paris (see Solomon, second lancet from the right in FIGURE 17–11).

AMBROGIO LORENZETTI The most important civic structure in Siena was the PALAZZO PUBBLICO (FIG. 18-14), the town hall which served as the seat of government, just as the Palazzo della Signoria did in rival Florence (see FIG. 18-2). There are similarities between these two buildings. Both are designed as strong, fortified structures sitting on the edge of a public piazza; both have a tall tower, making them visible signs of the city from a considerable distance. The Palazzo Pubblico was constructed from 1297 to c. 1315, but the tower was not completed until 1348, when the bronze bell, which rang to signal meetings of the ruling council, was installed.

The interior of the Palazzo Pubblico was the site of important commissions by some of Siena's most famous artists. In c. 1315, Simone Martini painted a large mural of the Virgin in Majesty surrounded by saints—clearly based on Duccio's recently installed *Maestà*. Then, in 1338, the Siena city council commissioned Ambrogio Lorenzetti to paint frescos for the council room of the Palazzo known as the Sala dei Nove (Chamber of the Nine) or Sala della Pace (Chamber of Peace) on the theme of the contrast between good and bad government (see FIG. 18–1).

Ambrogio painted the results of both good and bad government on the two long walls. For the expansive scene of **THE EFFECTS OF GOOD GOVERNMENT IN THE CITY AND IN THE COUNTRY**, and in tribute to his patrons, Ambrogio created an idealized but recognizable portrait of the city of Siena and its immediate environs (**FIG. 18–15**). The cathedral dome and the distinctive striped campanile are visible in the upper left-hand corner; the streets are filled with the bustling activity of productive citizens who also have time for leisurely diversions. Ambrogio shows the city from shifting viewpoints so we can see as much as possible, and renders its inhabitants larger in scale than the buildings around them so as to highlight their activity. Featured in the foreground is a circle of dancers—probably a professional troupe of male entertainers masquerading as women as part of a spring festival—and above them, at the top of the painting, a band of masons stand on exterior scaffolding constructing the wall of a new building.

The Porta Romana, Siena's gateway leading to Rome, divides the thriving city from its surrounding countryside. In this panoramic landscape painting, Ambrogio describes a natural world marked by agricultural productivity, showing activities of all seasons simultaneously—sowing, hoeing, and harvesting. Hovering above the gate that separates city life and country life is a woman clad in a wisp of transparent drapery, a scroll in one hand and a miniature gallows complete with a hanged man in the other. She represents Security, and her scroll bids those coming to the city to enter without fear because she has taken away the power of the guilty who would harm them.

The world of the Italian city-states—which had seemed so full of promise in Ambrogio Lorenzetti's *Good Government* fresco—was transformed as the middle of the century approached into uncertainty and desolation by a series of natural and societal disasters. In 1333, a flood devastated Florence, followed by banking failures in the 1340s, famine in 1346–1347, and epidemics of the bubonic plague, especially virulent in the summer of 1348, just a few years after Ambrogio's frescos were completed. Some art historians have traced the influence of these calamities on the visual arts at the middle of the fourteenth century (see "The Black Death," page 550). Yet as dark as those days must have seemed to the men and women living through them, the strong currents of cultural and artistic change initiated earlier in the century would persist. In a relatively short span of time, the European Middle Ages gave way in Florence to a new movement that would blossom in the Italian Renaissance.

FRANCE

At the beginning of the fourteenth century, the royal court in Paris was still the arbiter of taste in western Europe, as it had been in the days of King Louis IX (St. Louis). During the Hundred Years' War, however, the French countryside was ravaged by armed struggles and civil strife. The power of the nobility, weakened significantly by warfare, was challenged by townsmen, who took advantage of new economic opportunities that opened up in the wake of the conflict. As centers of art and architecture, the duchy of Burgundy, England, and, for a brief golden moment, the court of Prague began to rival Paris.

French sculptors found lucrative new outlets for their work not only in stone, but in wood, ivory, and precious metals, often decorated with enamel and gemstones—in the growing demand among wealthy patrons for religious art intended for homes as well as churches. Manuscript painters likewise created lavishly illustrated books for the personal devotions of the wealthy and powerful. And

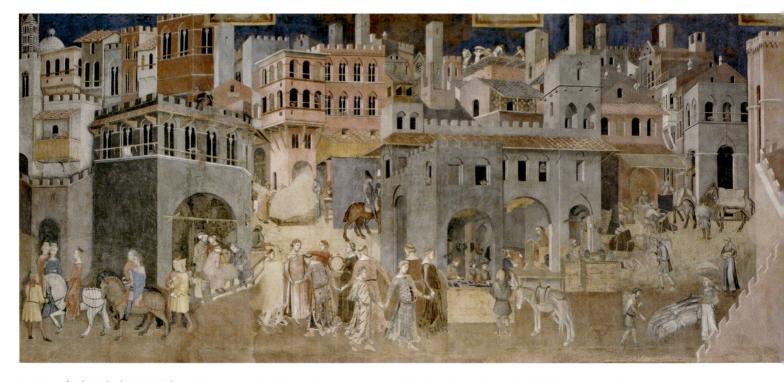

18-15 • Ambrogio Lorenzetti **THE EFFECTS OF GOOD GOVERNMENT IN THE CITY AND IN THE COUNTRY** Sala dei Nove (also known as Sala della Pace), Palazzo Pubblico, Siena, Italy. 1338–1339. Fresco, total length about 46' (14 m).

architectural commissions focused on exquisitely detailed chapels or small churches, often under private patronage, rather than on the building of grand cathedrals funded by Church institutions.

MANUSCRIPT ILLUMINATION

By the late thirteenth century, private prayer books became popular among wealthy patrons. Because they contained special prayers to be recited at the eight canonical devotional "hours" between morning and night, an individual copy of one of these books came to be called a **Book of Hours**. Such a book included everything the lay person needed for pious practice—psalms, prayers and offices of the Virgin and other saints (such as the owners' patron or the patron of their home church), a calendar of feast days, and sometimes prayers for the dead. During the fourteenth century, a richly decorated Book of Hours was worn or carried like jewelry, counting among a noble person's most important portable possessions.

THE BOOK OF HOURS OF JEANNE D'ÉVREUX Perhaps at their marriage in 1324, King Charles IV gave his 14-year-old queen, Jeanne d'Évreux, a tiny Book of Hours—it fits easily when open within one hand—illuminated by Parisian painter Jean Pucelle (see "A Closer Look," page 551). This book was so precious to the queen that she mentioned it and its illuminator specifically in her will, leaving this royal treasure to King Charles V. Pucelle painted the book's pictures in *grisaille*—monochromatic painting in shades of gray with only delicate touches of color. His style clearly derives from the courtly mode established in Paris at the time of St. Louis, with its softly modeled, voluminous draperies gathered loosely and falling in projecting diagonal folds around tall, elegantly posed figures with carefully coiffed curly hair, broad foreheads, and delicate features. But his conception of space, with figures placed within coherent, discrete architectural settings, suggests a firsthand knowledge of contemporary Sienese art.

Jeanne appears in the initial *D* below the Annunciation, kneeling in prayer before a lectern, perhaps using this Book of Hours to guide her meditations, beginning with the words written on this page: *Domine labia mea aperies* (Psalm 51:15: "O Lord, open thou my lips"). The juxtaposition of the praying Jeanne's portrait with a scene from the life of the Virgin Mary suggests that the sacred scene is actually a vision inspired by Jeanne's meditations. The young queen might have identified with and sought to feel within herself Mary's joy at Gabriel's message. Given what we know of Jeanne's own life story and her royal husband's predicament, it might also have directed the queen's prayers toward the fulfillment of his wish for a male heir.

In the Annunciation, Mary is shown receiving the archangel Gabriel in a Gothic building that seems to project outward from the page toward the viewer, while rejoicing angels look on from windows under the eaves. The group of romping youths at the bottom of the page at first glance seems to echo the angelic jubilation. Folklorists have suggested, however, that the children are playing "froggy in the middle" or "hot cockles," games in which one child was tagged by the others. To the medieval viewer, if the game symbolized the mocking of Christ or the betrayal of Judas, who "tags" his friend, it would have evoked a darker mood by referring to the picture on the other page of this opening, foreshadowing Jesus' imminent death even as his life is beginning.

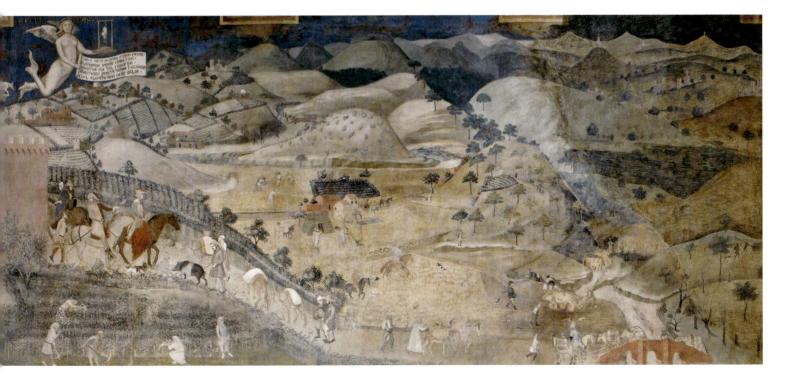

Read the document related to The Effects of Good Government in the City and in the Country on myartslab.com

ART AND ITS CONTEXTS | The Black Death

A deadly outbreak of the bubonic plague, known as the Black Death after the dark sores that developed on the bodies of its victims, spread to Europe from Asia, both by land and by sea, in the middle of the fourteenth century. At least half the urban population of Florence and Siena-some estimate 80 percent-died during the summer of 1348, probably including the artists Andrea Pisano and Ambrogio Lorenzetti. Death was so quick and widespread that basic social structures crumbled in the resulting chaos; people did not know where the disease came from, what caused it, or how long the pandemic would last.

Mid-twentieth-century art historian Millard Meiss proposed that the Black Death had a significant impact on the development of Italian art in the middle of the fourteenth century. Pointing to what he saw as a reactionary return to hieratic linearity in religious art, Meiss theorized that artists had retreated from the rounded forms that had characterized the work of Giotto to old-fashioned styles, and that this artistic change reflected a growing reliance on traditional religious values in the wake of a disaster that some interpreted as God's punishment of a world in moral decline.

An altarpiece painted in 1354–1357 by Andrea di Cione, nicknamed Orcagna ("Archangel"), under the patronage of Tommaso Strozzi-the so-called Strozzi Altarpiece (FIG. 18-16)-is an example of the sort of paintings that led Meiss to his interpretation. This painting's otherworldly vision is dominated by a central figure of Christ, presumably enthroned, but without any hint of an actual seat, evoking the image of the judge at the Last Judgment, outside time and space. The silhouetted outlines of the standing and kneeling saints emphasize surface over depth; the gold expanse of floor beneath them does not offer any reassuring sense of spatial recession to contain them and their activity. Throughout, line and color are more prominent than form.

Recent art historians have stepped back from Meiss's contextual explanation of stylistic change. Some have pointed out logical relationships between style and subject in the works Meiss cites; others have seen in them a mannered outgrowth of current style rather than a reversion to an earlier style; still others have discounted the underlying notion that stylistic change is connected with social situations. But there is a clear relationship of works such as the Strozzi Altarpiece with death and judgment, sanctity and the promise of salvation-themes also suggested in the narrative scenes on the predella (the lower zone of the altarpiece): Thomas Aquinas's ecstasy during Mass, Christ's miraculous walk on water to rescue Peter, and the salvation of Emperor Henry II because of a pious donation. While these are not uncommon scenes in sacred art, it is easy to see a relationship between their choice as subject matter here and the specter cast by the Black Death over a world that had just imagined its prosperity in pathbreaking works of visual art firmly rooted in references to everyday life (see FIG. 18-15).

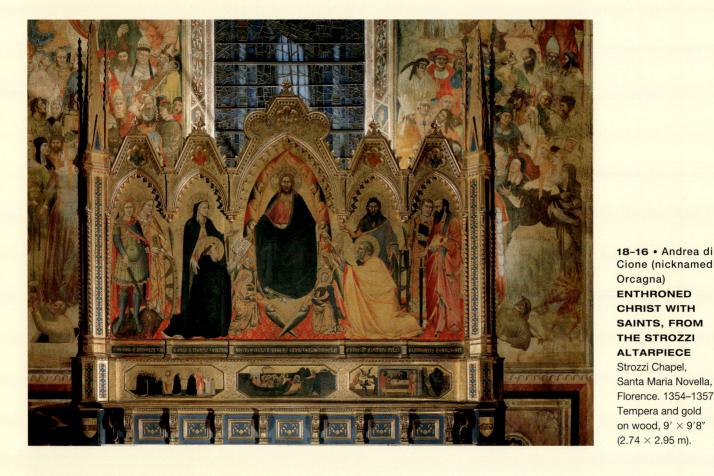

Cione (nicknamed Orcagna) ENTHRONED CHRIST WITH SAINTS, FROM THE STROZZI ALTARPIECE Strozzi Chapel, Santa Maria Novella. Florence. 1354-1357. Tempera and gold on wood, 9' × 9'8"

Read the document related to the Black Death on myartslab.com

A CLOSER LOOK | The Hours of Jeanne d'Évreux

by Jean Pucelle, Two-Page Opening with the Kiss of Judas and the Annunciation. Paris. c. 1324–1328. *Grisaille* and color on vellum, each page $35/6'' \times 27/16''$ (9.2 × 6.2 cm). Metropolitan Museum of Art, New York. The Cloisters Collection (54.1.2), fols. 15v–16r

In this opening Pucelle juxtaposes complementary scenes drawn from the Infancy and Passion of Christ, placed on opposing pages, in a scheme known as the Joys and Sorrows of the Virgin. The "joy" of the Annunciation on the right is paired with the "sorrow" of the betrayal and arrest of Christ on the left.

Christ sways back gracefully as Judas betrays him with a kiss. The S-curve of his body mirrors the Virgin's pose on the opposite page, as both accept their fate with courtly decorum.

The prominent lamp held aloft by a member of the arresting battalion informs the viewer that this scene takes place at night, in the dark. The angel who holds up the boxlike enclosure where the Annunciation takes place is an allusion to the legend of the miraculous transportation of this building from Nazareth to Loreto in 1294.

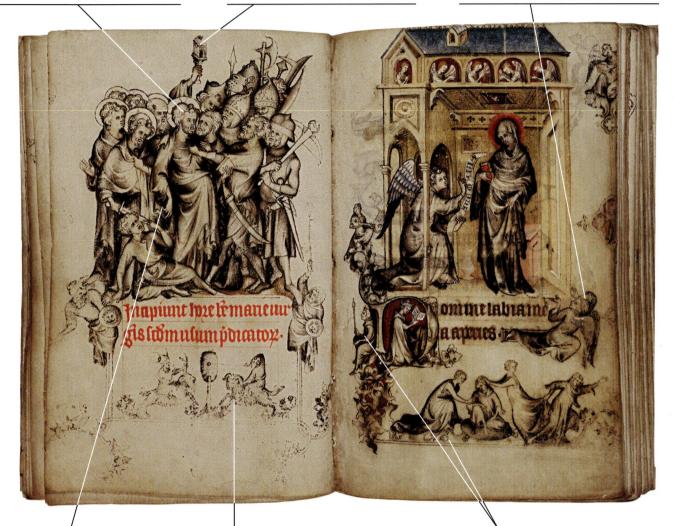

Christ reaches casually down to heal Malchus, the assistant of the high priest whose ear Peter had just cut off in angry retaliation for his participation in the arrest of Jesus. Scenes of secular amusements from everyday life, visual puns, and off-color jokes appear at the bottom of many pages of this book. Sometimes they relate to the themes of the sacred scenes above them. These comic knights riding goats may be a commentary on the lack of valor shown by the soldiers assaulting Jesus, especially if this wine barrel conjured up for Jeanne an association with the Eucharist.

The candle held by the cleric who guards the "door" to Jeanne's devotional retreat, as well as the rabbit emerging from its burrow in the marginal scene, are sexually charged symbols of fertility that seem directly related to the focused prayers of a child bride required to produce a male heir.

-View the Closer Look for the Hours of Jeanne d'Évreux on myartslab.com

Fourteenth-century Paris was renowned for more than its goldsmiths (see Fig. 18–20). Among the most sumptuous and sought-after Parisian luxury products were small chests assembled from carved ivory plaques that were used by wealthy women to store jewelry or other personal treasures. The entirely secular subject matter of these chests explored romantic love. Indeed, they seem to have been courtship gifts from smitten men to desired women, or wedding presents offered by grooms to their brides.

A chest from around 1330–1350, now in the Walters Museum (**FIGS. 18–17, 18–18, 18–19**), is one of seven that have survived intact; there are fragments of a dozen more. It is a delightful and typical example. Figural relief covers five exterior sides of the box: around the perimeter and on the hinged top. The assembled panels were joined by metal hardware—strips, brackets, hinges, handles, and locks—originally

wrought in silver. Although some chests tell a single romantic story in sequential episodes, most, like this one, anthologize scenes drawn from a group of stories, combining courtly romance, secular allegory, and ancient fables.

On the lid of the Walters casket (see FIG. 18-18), jousting is the theme. Spread over the central two panels, a single scene catches two charging knights in the heat of a tournament, while trumpeting heralds call the attention of spectators, lined up above in a gallery to observe this public display of virility. The panel at right mocks the very ritual showcased in the middle panels by pitting a woman against a knight, battling not with lances but with a longstemmed rose (symbolizing sexual surrender) and an oak bough (symbolizing fertility). Instead of observing these silly goings-on, however, the spectators tucked into the upper architecture pursue their own amorous flirtations. Finally, in the scene on the left,

knights use crossbows and a catapult to hurl roses at the Castle of Love, while Cupid returns fire with his seductive arrows.

On the front of the chest (see FIG. 18-17), generalized romantic allegory gives way to vignettes from a specific story. At left, the longbearded Aristotle teaches the young Alexander the Great, using exaggerated gestures and an authoritative text to emphasize his point. Today's lesson is a stern warning not to allow the seductive power of women to distract the young prince from his studies. The subsequent scene, however, pokes fun at his eminent teacher, who has become so smitten by the wiles of a young beauty named Phyllis that he lets her ride him around like a horse, while his student observes this farce, peering out of the castle in the background. The two scenes at right relate to an eastern legend of the fountain of youth, popular in medieval Europe. A line of bearded elders approaches the fountain

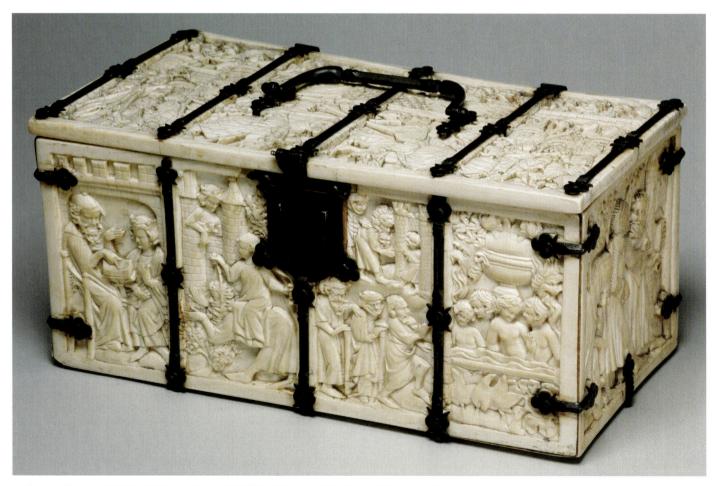

18-17 • SMALL IVORY CHEST WITH SCENES FROM COURTLY ROMANCES Made in Paris. c. 1330–1350. Elephant ivory with modern iron mounts, height 4¹/₂" (11.5 cm), width 9¹¹/₁₆" (24.6 cm), depth 4⁷/₈" (12.4 cm). The Walters Art Museum, Baltimore.

from the left, steadied by their canes. But after having partaken of its transforming effects, two newly rejuvenated couples, now nude, bathe and flirt within the fountain's basin. The man first in line for treatment, stepping up to climb into the fountain, looks suspiciously like the figure of the aging Aristotle, forming a link between the two stories on the casket front.

Unlike royal marriages of the time, which were essentially business contracts based on

political or financial exigencies, the romantic love of the aristocratic wealthy involved passionate devotion. Images of gallant knights and their coy paramours, who could bring intoxicating bliss or cruelly withhold their love on a whim, captured the popular Gothic imagination. They formed the principal subject matter on personal luxury objects, not only chests like this, but mirror backs, combs, writing tablets, even ceremonial saddles. And these stories evoke themes that still captivate us since they reflect notions of desire and betrayal, cruel rejection and blissful folly, at play in our own romantic conquests and relationships to this day. In this way they allow us some access to the lives of the people who commissioned and owned these precious objects, even if we ourselves are unable to afford them.

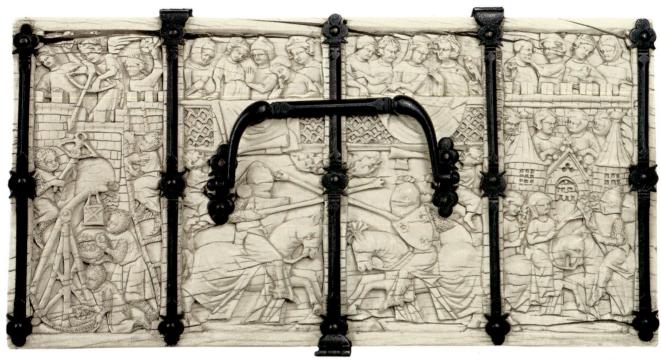

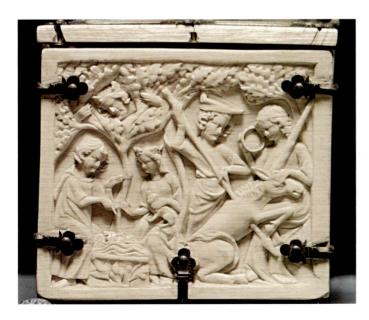

18-18 • ATTACK ON THE CASTLE OF LOVE Top of the chest in FIG. 18–17.

18-19 • TRISTAN AND ISEULT AT THE FOUNTAIN; CAPTURE OF THE UNICORN

Left short side of the chest in FIG. 18-17.

Two other well-known medieval themes are juxtaposed on this plaque from the short side of the ivory chest. At left, Tristan and Iseult have met secretly for an illicit romantic tryst, while Iseult's husband, King Mark, tipped off by an informant, observes them from a tree. But when they see his reflection in a fountain between them, they alter their behavior accordingly, and the king believes them innocent of the adultery he had (rightly) suspected. The medieval bestiary ("book of beasts") claimed that only a virgin could capture the mythical unicorn, which at right lays his head, with its aggressively phallic horn, into the lap of just such a pure maiden so that the hunter can take advantage of her alluring powers over the animal to kill it with his phallic counterpart of its horn, a large spear.

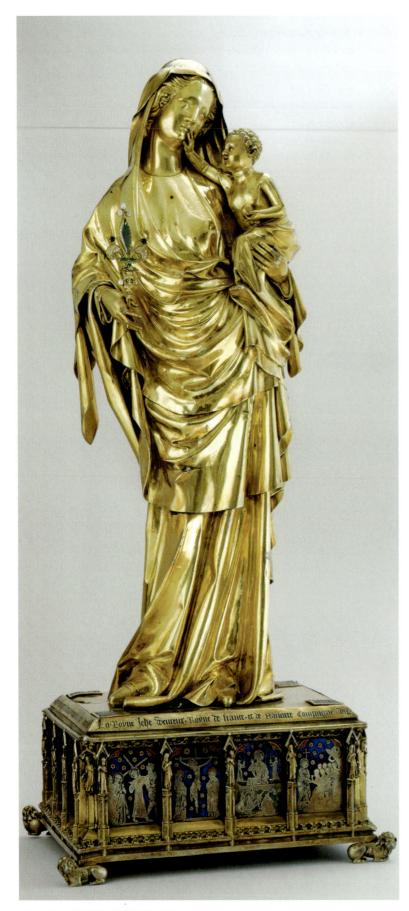

18-20 • VIRGIN AND CHILD
c. 1324–1339. Silver gilt and enamel, height 27¹/₈" (69 cm).
Musée du Louvre, Paris.

METALWORK AND IVORY

Fourteenth-century French sculpture is intimate in character. Religious subjects became more emotionally expressive; objects became smaller and demanded closer scrutiny from the viewer. In the secular realm, tales of love and valor were carved on luxury items to delight the rich (see "An Ivory Chest with Scenes of Romance," page 552). Precious materials—gold, silver, and ivory—were preferred.

THE VIRGIN AND CHILD FROM SAINT-DENIS A silver-gilt image of a standing **VIRGIN AND CHILD**

(FIG. 18-20) is a rare survivor that verifies the acclaim that was accorded fourteenth-century Parisian goldsmiths. An inscription on the base documents the statue's donation to the abbey church of Saint-Denis in 1339 and the donor's name, the same Queen Jeanne d'Évreux whose Book of Hours we have just examined. In a style that recalls the work of artist Jean Pucelle in that Book of Hours, the Virgin holds Jesus in her left arm with her weight on her left leg, standing in a graceful, characteristically Gothic S-curve pose. Mary originally wore a crown, and she still holds a large enameled and jeweled fleur-de-lis-the heraldic symbol of royal France-which served as a reliquary container for strands of Mary's hair. The Christ Child, reaching out tenderly to caress his mother's face, is babylike in both form and posture. On the base, minuscule statues of prophets stand on projecting piers to separate 14 enameled scenes from Christ's Infancy and Passion, reminding us of the suffering to come. The apple in the baby's hand carries the theme further with its reference to Christ's role as the new Adam, whose sacrifice on the cross-medieval Christians believed-redeemed humanity from the first couple's fall into sin when Eve bit into the forbidden fruit.

ENGLAND

Fourteenth-century England prospered in spite of the ravages of the Black Death and the Hundred Years' War with France. English life at this time is described in the brilliant social commentary of Geoffrey Chaucer in the *Canterbury Tales* (see "A New Spirit in Fourteenth-Century Literature," page 533). The royal family, especially Edward I (r. 1272–1307)—the castle builder—and many of the nobles and bishops were generous patrons of the arts.

EMBROIDERY: OPUS ANGLICANUM

Since the thirteenth century, the English had been renowned for pictorial needlework, using colored silk and gold threads to create images as detailed as contemporary painters produced in manuscripts. Popular throughout Europe, the art came to be called *opus anglicanum* ("English work"). The popes had more than 100 pieces in the Vatican treasury. The names of several prominent embroiderers are known, but in the thirteenth century no one surpassed Mabel of Bury St. Edmunds, who created both religious and secular articles for King Henry III (r. 1216–1272).

THE CHICHESTER-CONSTABLE CHASUBLE This opus anglicanum liturgical vestment worn by a priest during Mass (**FIG. 18-21**) was embroidered c. 1330–1350 with images formed by subtle gradations of colored silk. Where gold threads were laid and couched (tacked down with colored silk), the effect resembles the burnished gold-leaf backgrounds of manuscript illuminations.

The Annunciation, the Adoration of the Magi, and the Coronation of the Virgin are set in cusped, crocketed ogee (S-shape) arches, supported on animal-head corbels and twisting branches sprouting oak leaves with seed-pearl acorns. Because the star and crescent moon in the Coronation of the Virgin scene are heraldic emblems of Edward III (r. 1327–1377), perhaps he or a family member commissioned this luxurious vestment.

During the celebration of the Mass, especially as the priest moved, *opus anglicanum* would have glinted in the candlelight amid treasures on the altar. Court dress was just as rich and colorful, and at court such embroidered garments proclaimed the rank and status of the wearer. So heavy did such gold and bejeweled garments become that their wearers often needed help to move.

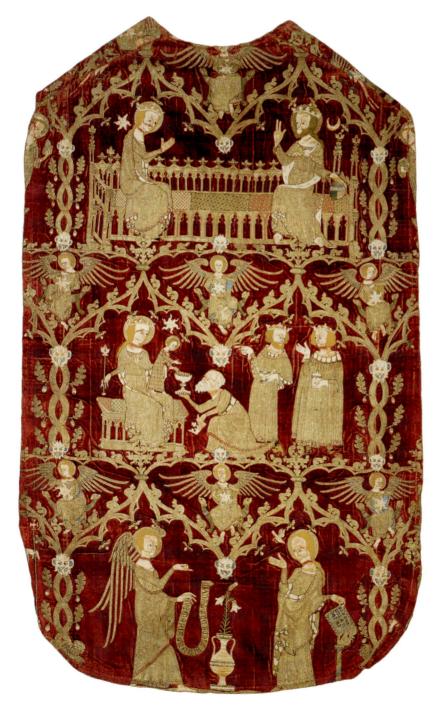

anglicanum from southern England. c. 1330–1350. Red velvet with silk and metallic thread and seed pearls, length 4'3" (129.5 cm), width 30" (76 cm). Metropolitan Museum of Art, New York. Fletcher Fund, 1927 (27 162.1)

ARCHITECTURE

In the later years of the thirteenth century and early years of the fourteenth, a distinctive and influential Gothic architectural style, popularly known as the "Decorated style," developed in England. This change in taste has been credited to Henry III's ambition to surpass St. Louis, who was his brother-in-law, as a royal patron of the arts.

THE DECORATED STYLE AT EXETER One of the most complete Decorated-style buildings is **EXETER CATHEDRAL**. Thomas of Witney began construction in 1313 and remained

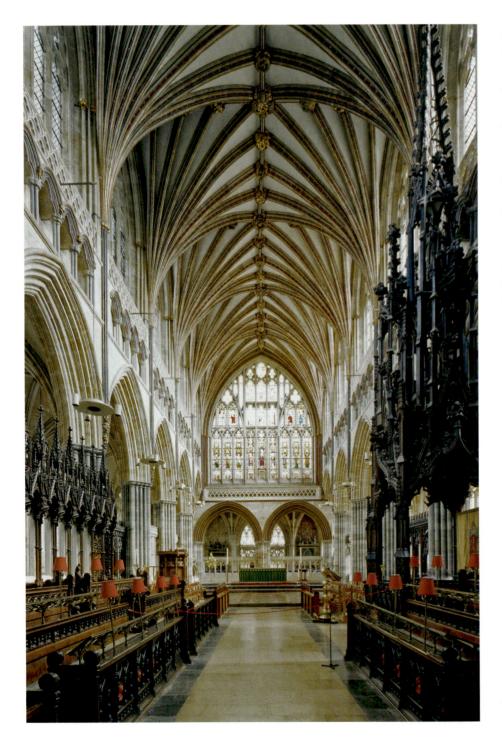

master mason from 1316 to 1342. He supervised construction of the nave and redesigned upper parts of the choir. He left the towers of the original Norman cathedral but turned the interior into a dazzling stone forest of colonnettes, moldings, and vault ribs (**FIG. 18-22**). From piers formed by a cluster of colonnettes rise multiple moldings that make the arcade seem to ripple. Bundled colonnettes spring from sculptured foliate corbels (brackets that project from a wall) between the arches and rise up the wall to support conical clusters of 13 ribs that meet at the summit of the vault, a modest 69 feet above the floor. The basic structure here is the four-part vault with intersecting cross-ribs, but the designer

> added additional ribs, called tiercerons, to create a richer linear pattern. Elaborately carved **bosses** (decorative knoblike elements) signal the point where ribs meet along the ridge of the vault. Large bartracery clerestory windows illuminate the 300-foot-long nave. Unpolished gray marble shafts, yellow sandstone arches, and a white French stone, shipped from Caen, add subtle gradations of color to the upper wall.

> Detailed records survive for the building of Exeter Cathedral, documenting work over the period from 1279 to 1514, with only two short breaks. They record where masons and carpenters were housed (in a hostel near the cathedral) and how they were paid (some by the day with extra for drinks, some by the week, some for each finished piece); how materials were acquired and transported (payments for horseshoes and fodder for the horses); and, of course, payments for the building materials (not only stone and wood but rope for measuring and parchment on which to draw forms for the masons). The bishops contributed generously to the building funds. This was not a labor only of love.

Thomas of Witney also designed the intricate, 57-foot-high bishop's throne (at right in FIGURE 18–22), constructed by Richard de Galmeton and Walter of Memburg, who led a team of a dozen carpenters. The

18-22 • INTERIOR, EXETER CATHEDRAL

Devon, England. Thomas of Witney, choir, 14th century and bishop's throne, 1313–1317; Robert Lesyngham, east window, 1389–1390. canopy resembles embroidery translated into wood, with its maze of pinnacles, bursting with leafy crockets and tiny carved animals and heads. To finish the throne in splendor, Master Nicolas painted and gilded the wood. When the bishop was seated on his throne wearing embroidered vestments like the Chichester-Constable Chasuble (see FIG. 18-21), he must have resembled a golden image in a shrine—more a symbol of the power and authority of the Church than a specific human being.

THE PERPENDICULAR STYLE AT EXETER During years following the Black Death, work at Exeter Cathedral came to a standstill. The nave had been roofed but not vaulted, and the windows had no glass. When work could be resumed, tastes had changed. The exuberance of the Decorated style gave way to an austere style in which rectilinear patterns and sharp angular shapes replaced intricate curves, and luxuriant foliage gave way to simple stripped-down patterns. This phase is known as the Perpendicular style.

In 1389–1390, well-paid master mason Robert Lesyngham rebuilt the great east window (see FIG. 18–22, far wall), designing its tracery in the new Perpendicular style. The window fills the east wall of the choir like a glowing altarpiece. A single figure in each light stands under a tall painted canopy that flows into and blends with the stone tracery. The Virgin with the Christ Child stands in the center over the high altar, with four female saints at the left and four male saints on the right, including St. Peter, to whom the church is dedicated. At a distance, the colorful figures silhouetted against the silver *grisaille* glass become a band of color, conforming to and thus reinforcing the rectangular pattern of the mullions and transoms. The combination of *grisaille*, silver-oxide stain (staining clear glass with shades of yellow or gold), and colored glass produces a glowing wall and casts a cool, silvery light over the nearby stonework.

Perpendicular architecture heralds the Renaissance style in its regularity, its balanced horizontal and vertical lines, and its plain wall or window surfaces. When Tudor monarchs introduced Renaissance art into the British Isles, builders were not forced to rethink the form and structure of their buildings; they simply changed the ornament from the pointed cusps and crocketed arches of the Gothic style to the round arches and columns and capitals of Roman Classicism. The Perpendicular style itself became an English architectural vernacular. It has even been popular in the United States, especially for churches and college buildings.

THE HOLY ROMAN EMPIRE

By the fourteenth century, the Holy Roman Empire existed more as an ideal fiction than a fact. The Italian territories had established their independence, and in contrast to England and France, Germany had become further divided into multiple states with powerful regional associations and princes. The Holy Roman emperors, now elected by Germans, concentrated on securing the fortunes of their families. They continued to be patrons of the arts, promoting local styles.

MYSTICISM AND SUFFERING

The by-now-familiar ordeals of the fourteenth century—famines, wars, and plagues—helped inspire a mystical religiosity in Germany that emphasized both ecstatic joy and extreme suffering. Devotional images, known as *Andachtsbilder* in German, inspired worshipers to contemplate Jesus' first and last hours, especially during evening prayers, or vespers, giving rise to the term *Vesperbild* for the image of Mary mourning her son. Through such religious exercises, worshipers hoped to achieve understanding of the divine and union with God.

VESPERBILD In this well-known example (**FIG. 18-23**), blood gushes from the hideous rosettes that form the wounds of an emaciated and lifeless Jesus who teeters improbably on the lap of his

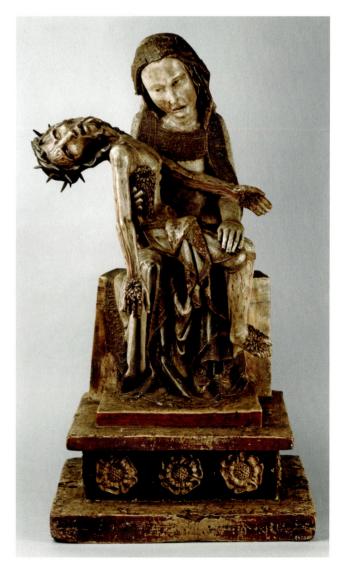

18-23 • VESPERBILD (PIETÀ) From the Middle Rhine region, Germany. c. 1330. Wood and polychromy, height $34\frac{1}{2}$ " (88.4 cm). Landesmuseum, Bonn.

a

hunched-over mother. The Virgin's face conveys the intensity of her ordeal, mingling horror, shock, pity, and grief. Such images took on greater poignancy since they would have been compared, in the worshiper's mind, to the familiar, almost ubiquitous images of the young Virgin mother holding her innocent and loving baby Jesus.

THE HEDWIG CODEX The extreme physicality and emotionalism of the *Vesperbild* finds parallels in the actual lives of some medieval saints in northern Europe. St. Hedwig (1174–1243), married at age 12 to Duke Henry I of Silesia and mother of his seven children, entered the Cistercian convent of Trebniz (in modern Poland) on her husband's death in 1238. She devoted the rest of her life to caring for the poor and seeking to emulate the suffering of Christ by walking barefoot in the snow. As described in her *vita* (biography), she had a particular affection for a small ivory statue of the Virgin and Child, which she carried with her at all times, and which "she often took up in her hands to envelop it in love, so that out of passion she could see it more often and through the seeing could prove herself more devout, inciting her to even greater love of the glorious Virgin. When she once blessed the sick with this image they were cured immediately" (translation from Schleif, p. 22). Hedwig was buried clutching the statue, and when her tomb was opened after her canonization in 1267, it was said that although most of her body had deteriorated, the fingers that still gripped the beloved object had miraculously not decayed.

A picture of Hedwig serves as the frontispiece (**FIG. 18-24**) of a manuscript of her *vita* known as the Hedwig Codex, commissioned

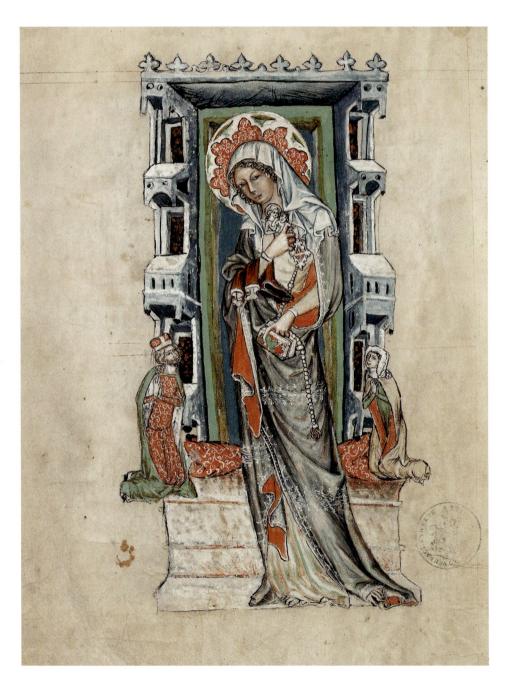

Dedication page of the Hedwig Codex. 1353. Ink and paint on parchment, $13^7\!/_{16}"\times 9^3\!/_1"$ (34 \times 25 cm). The J. Paul Getty Museum, Los Angeles. MS. Ludwig XI 7, fol. 12v

in 1353 by one her descendants, Ludwig I of Liegnitz–Brieg. Duke Ludwig and his wife, Agnes, are shown here kneeling on either side of St. Hedwig, dwarfed by the saint's architectural throne and her own imposing scale. With her prominent, spidery hands, she clutches the famous ivory statue, as well as a rosary and a prayer book, inserting her fingers within it to maintain her place as if our arrival had interrupted her devotions. She has draped her leather boots over her right wrist in a reference to her practice of removing them to walk in the snow. Hedwig's highly volumetric figure stands in a swaying pose of courtly elegance derived from French Gothic, but the fierce intensity of her gaze and posture are far removed from the mannered graciousness of the smiling angel of Reims (see statue at far left in FIG. 17–14), whose similar gesture and extended finger are employed simply to grasp his drapery and assure its elegant display.

THE SUPREMACY OF PRAGUE

Charles IV of Bohemia (r. 1346–1378) was raised in France, and his admiration for the French king Charles IV was such that he changed his own name from Wenceslas to Charles. He was officially crowned king of Bohemia in 1347 and Holy Roman Emperor in 1355. He established his capital in Prague, which, in the view of his contemporaries, replaced Constantinople as the "New Rome." Prague had a great university, a castle, and a cathedral overlooking a town that spread on both sides of a river joined by a stone bridge, a remarkable structure itself.

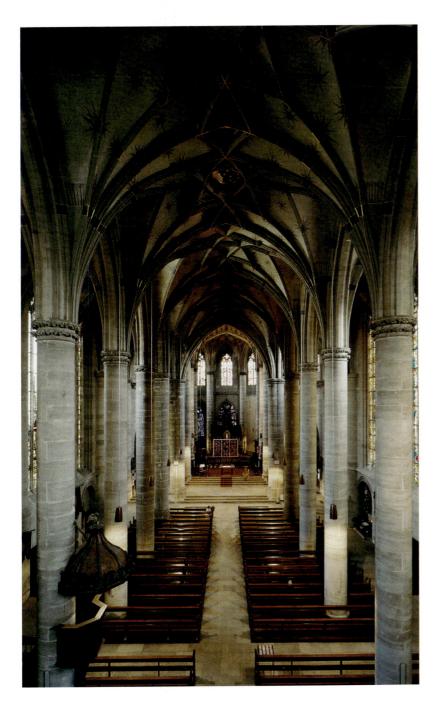

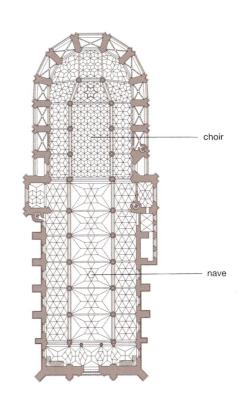

18-25 • Heinrich and Peter Parler PLAN AND INTERIOR OF THE CHURCH OF THE HOLY CROSS, SCHWÄBISCH GMÜND Germany. Begun in 1317 by Heinrich Parler; choir by Peter Parler begun in 1351; vaulting completed 16th century.

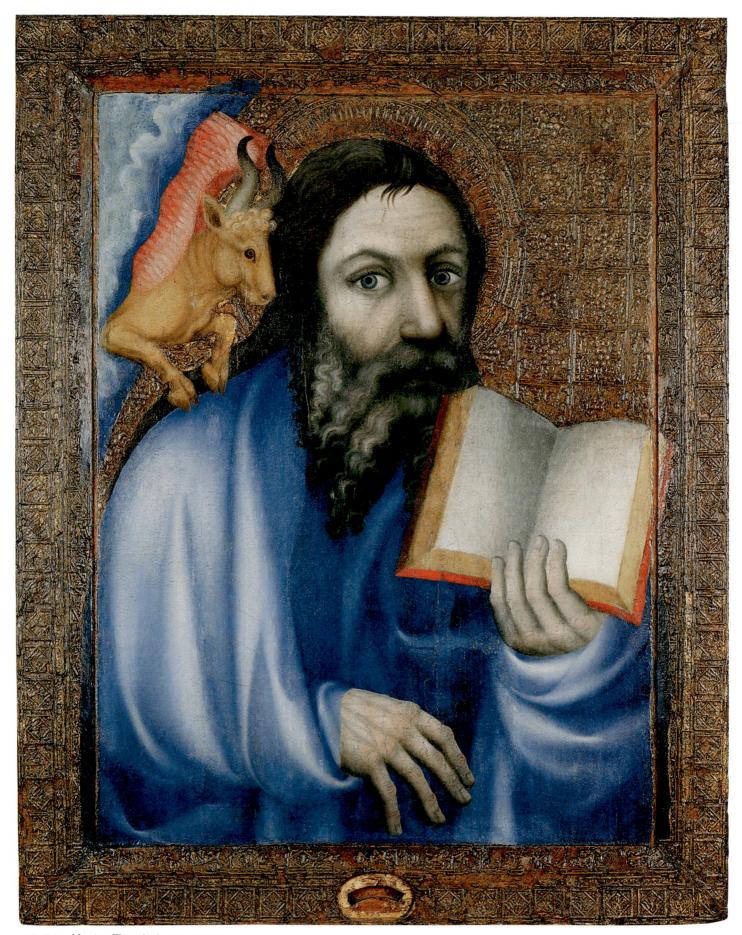

18-26 • Master Theodoric ST. LUKE
Holy Cross Chapel, Karlstejn Castle, near Prague. 1360–1364. Paint and gold on panel, 45¼" × 37" (115 × 94 cm).

and setter

When Pope Clement VI made Prague an archbishopric in 1344, construction began on a new cathedral in the Gothic style to be named for St. Vitus. It would also serve as the coronation church and royal pantheon. But the choir was not finished for Charles's first coronation, so he brought Peter Parler from Swabia to complete it.

THE PARLER FAMILY In 1317, Heinrich Parler, a former master of works on Cologne Cathedral, designed and began building the church of the Holy Cross in Schwäbisch Gmünd, in southwest Germany. In 1351, his son Peter (c. 1330–1399), the most brilliant architect of this talented family, joined the workshop. Peter designed the choir (**FIG. 18–25**) in the manner of a hall church whose triple-aisled form was enlarged by a ring of deep chapels between the buttresses. The contrast between Heinrich's nave and Peter's choir (seen clearly in the plan of **FIGURE 18–25**) illustrates the increasing complexity of rib patterns covering the vaults, which emphasizes the unity of interior space rather than its division into bays.

Called by Charles IV to Prague in 1353, Peter turned the unfinished St. Vitus Cathedral into a "glass house," adding a vast clerestory and glazed triforium supported by double flying buttresses, all covered by net vaults that created a continuous canopy over the space. Because of the success of projects such as this, Peter and his family became the most successful architects in the Holy Roman Empire. Their concept of space, luxurious decoration, and intricate vaulting dominated central European architecture for three generations. MASTER THEODORIC At Karlstein Castle, a day's ride from Prague, Charles IV built another chapel, covering the walls with gold and precious stones as well as with paintings. There were 130 paintings of the saints serving as reliquaries, with relics inserted into their frames. Master Theodoric, the court painter, provided drawings on the wood panels, and he painted about 30 images himself. Figures are crowded into-even extend over-their frames, emphasizing their size and power. Master Theodoric was head of the Brotherhood of St. Luke, and the way that his painting of ST. LUKE (FIG. 18-26), patron saint of painters, looks out at the viewer has suggested to scholars that this may be a selfportrait. His personal style combined a preference for substantial bodies, oversized heads and hands, dour and haunted faces, and soft, deeply modeled drapery, with a touch of grace derived from the French Gothic style. The chapel, consecrated in 1365, so pleased the emperor that in 1367 he gave the artist a farm in appreciation of his work.

Prague and the Holy Roman Empire under Charles IV had become a multicultural empire where people of different religions (Christians and Jews) and ethnic heritages (German and Slav) lived side by side. Charles died in 1378, and without his strong central government, political and religious dissent overtook the empire. Jan Hus, dean of the philosophy faculty at Prague University and a powerful reforming preacher, denounced the immorality he saw in the Church. He was burned at the stake, becoming a martyr and Czech national hero. The Hussite Revolution in the fifteenth century ended Prague's—and Bohemia's—leadership in the arts.

THINK ABOUT IT

- 18.1 Compare and contrast Giotto's and Duccio's renderings of the biblical story of Christ's Raising of Lazarus (FIGS. 18–8, 18–11).
- 18.2 Discuss Ambrogio Lorenzetti's engagement with secular subject matter in his frescos for Siena's Palazzo Pubblico (FIG. 18–15). How did these paintings relate to their sociopolitical context?
- **18.3** Discuss the circumstances surrounding the construction and decoration of the Scrovegni (Arena) Chapel, with special attention to its relationship to the life and aspirations of its patron.
- 18.4 Choose one small work of art in this chapter that is crafted from precious materials with exceptional technical skill. Explain how it was made and how it was used. How does the work of art relate to its cultural and social context?

CROSSCURRENTS

FIG. 18-20

Depictions of the Virgin Mary holding the infant Jesus represent a continuing theme in the history of European Christian art, developed early on, and continuing to this day. Describe the relationship between the mother and child in these two examples. Characterize the difference in artistic style. How does the choice of medium contribute to the distinction between them? How were they used?

Study and review on myartslab.com

Glossary

abacus (p. 108) The flat slab at the top of a **capital**, directly under the **entablature**.

abbey church (p. 239) An abbey is a monastic religious community headed by an abbot or abbess. An abbey church often has an especially large **choir** to provide space for the monks or nuns.

absolute dating (p. 12) A method, especially in archaeology, of assigning a precise historical date at which, or span of years during which, an object was made. Based on known and recorded events in the region, as well as technically extracted physical evidence (such as carbon-14 disintegration). See also radiometric dating, relative dating.

abstract (p. 7) Of art that does not attempt to describe the appearance of visible forms but rather to transform them into stylized patterns or to alter them in conformity to ideals.

academy (p. 926) An institution established for the training of artists. Academies date from the Renaissance and after; they were particularly powerful, staterun institutions in the seventeenth and eighteenth centuries. In general, academies replaced guilds as the venues where students learned the craft of art and were educated in art theory. Academies helped the recognition of artists as trained specialists, rather than craftsmakers, and promoted their social status. An academician is an academy-trained artist.

acanthus (p. 110) A Mediterranean plant whose leaves are reproduced in Classical architectural ornament used on moldings, friezes, and capitals.

acroterion (pl. acroteria) (p. 110) An ornament at the corner or peak of a roof.

Action painting (p. 1074) Using broad gestures to drip or pour paint onto a pictorial surface. Associated with mid-twentieth-century American Abstract Expressionists, such as Jackson Pollock.

adobe (p. 399) Sun-baked blocks made of clay mixed with straw. Also: buildings made with this material.

aedicula (p. 609) A decorative architectural frame, usually found around a niche, door, or window. An aedicula is made up of a **pediment** and **entablature** supported by **columns** or **pilasters**.

aerial perspective (p. 626) See under perspective. agora (p. 137) An open space in a Greek town used as a central gathering place or market. Compare forum.

aisle (p. 225) Passage or open corridor of a church, hall, or other building that parallels the main space, usually on both sides, and is delineated by a row, or **arcade**, of **columns** or **piers**. Called side aisles when they flank the **nave** of a church.

akropolis (p. 128) The citadel of an ancient Greek city, located at its highest point and housing temples, a treasury, and sometimes a royal palace. The most famous is the Akropolis in Athens.

album (p. 796) A book consisting of a series of paintings or prints (album leaves) mounted into book form.

allegory (p. 627) In a work of art, an image (or images) that symbolizes an idea, concept, or principle, often moral or religious.

alloy (p. 23) A mixture of metals; different metals melted together.

altarpiece (p. xl) A painted or carved panel or ensemble of panels placed at the back of or behind and above an altar. Contains religious imagery (often specific to the place of worship for which it was made) that viewers can look at during liturgical ceremonies (especially the **Eucharist**) or personal devotions.

amalaka (p. 302) In Hindu architecture, the circular or square-shaped element on top of a spire (*shikhara*), often crowned with a **finial**, symbolizing the cosmos. **ambulatory** (p. 224) The passage (walkway) around the **apse** in a church, especially a **basilica**, or around the central space in a **central-plan building**.

amphora (*pl.* **amphorae**) (**p.** 101) An ancient Greek or Roman jar for storing oil or wine, with an egg-shaped body and two curved handles.

animal style or interlace (p. 433) Decoration made of interwoven animals or serpents, often found in early medieval Northern European art.

ankh (p. 51) A looped cross signifying life, used by ancient Egyptians.

appropriation (p. xxviii) The practice of some Postmodern artists of adopting images in their entirety from other works of art or from visual culture for use in their own art. The act of recontextualizing the appropriated image allows the artist to critique both it and the time and place in which it was created.

apse (p. 192) A large semicircular or polygonal (and usually **vaulted**) recess on an end wall of a building. In a Christian church, it often contains the altar. "Apsidal" is the adjective describing the condition of having such a space.

arabesque (p. 267) European term for a type of linear surface decoration based on foliage and calligraphic forms, thought by Europeans to be typical of Islamic art and usually characterized by flowing lines and swirling shapes.

arcade (p. 170) A series of **arches**, carried by **columns** or **piers** and supporting a common wall or **lintel**. In a **blind arcade**, the arches and supports are **engaged** and have a purely decorative function.

arch (p. 95) In architecture, a curved structural element that spans an open space. Built from wedgeshaped stone blocks called **voussoir**s placed together and held at the top by a trapezoidal keystone. It forms an effective space-spanning and weight-bearing unit, but requires buttresses at each side to contain the outward thrust caused by the weight of the structure. Corbeled arch: an arch or vault formed by courses of stones, each of which projects beyond the lower course until the space is enclosed; usually finished with a capstone. Horseshoe arch: an arch of more than a half-circle; typical of western Islamic architecture. Round arch: an arch that displaces most of its weight, or downward thrust along its curving sides, transmitting that weight to adjacent supporting uprights (door or window jambs, columns, or piers). Ogival arch: a sharply pointed arch created by S-curves. Relieving arch: an arch built into a heavy wall just above a post-andlintel structure (such as a gate, door, or window) to help support the wall above by transferring the load to the side walls. Transverse arch: an arch that connects the wall piers on both sides of an interior space, up and over a stone vault.

Archaic smile (p. 114) The curved lips of an ancient Greek statues in the period c. 600–480 BCE, usually interpreted as a way of animating facial features. architrave (p. 107) The bottom element in an entablature, beneath the frieze and the cornice. archivolt (p. 478) A band of molding framing an arch, or a series of stone blocks that form an arch resting directly on flanking columns or piers.

ashlar (p. 99) A highly finished, precisely cut block of stone. When laid in even **courses**, ashlar masonry creates a uniform face with fine joints. Often used as a facing on the visible exterior of a building, especially as a veneer for the **façade**. Also called **dressed stone**.

assemblage (p. 1026) Artwork created by gathering and manipulating two- and/or three-dimensional found objects.

astragal (p. 110) A thin convex decorative **molding**, often found on a Classical **entablature**, and usually decorated with a continuous row of beadlike circles.

atelier (p. 946) The studio or workshop of a master artist or craftsmaker, often including junior associates and apprentices.

atmospheric perspective (p. 183) See under perspective.

atrial cross (p. 943) A cross placed in the **atrium** of a church. In Colonial America, used to mark a gathering and teaching place.

atrium (p. 158) An unroofed interior courtyard or room in a Roman house, sometimes having a pool or garden, sometimes surrounded by **columns**. Also: the open courtyard in front of a Christian church; or an entrance area in modern architecture.

automatism (p. 1057) A technique in which artists abandon the usual intellectual control over their brushes or pencils to allow the subconscious to create the artwork without rational interference.

avant-garde (p. 972) Term derived from the French military word meaning "before the group," or "vanguard." Avant-garde denotes those artists or concepts of a strikingly new, experimental, or radical nature for their time.

axis (p. xxxii) In pictures, an implied line around which elements are composed or arranged. In buildings, a dominant line around which parts of the structure are organized and along which human movement or attention is concentrated.

axis mundi (p. 300) A concept of an "axis of the world," which marks sacred sites and denotes a link ^{*} between the human and celestial realms. For example, in Buddhist art, the axis mundi can be marked by monumental free-standing decorative pillars.

baldachin (p. 472) A canopy (whether suspended from the ceiling, projecting from a wall, or supported by columns) placed over an honorific or sacred space such as a throne or church altar.

bar tracery (p. 510) See under tracery.

barbarian (p. 149) A term used by the ancient Greeks and Romans to label all foreigners outside their cultural orbit (e.g., Celts, Goths, Vikings). The word derives from an imitation of what the "barblings" of their language sounded like to those who could not understand it.

barrel vault (p. 187) See under vault.

bas-relief (p. 325) Another term for low relief ("bas" is the French word for "low"). See under **relief sculpture**.

basilica (p. 191) A large rectangular building. Often built with a **clerestory**, side **aisles** separated from the center **nave** by **colonnades**, and an **apse** at one or both ends. Originally Roman centers for administration, later adapted to Christian church use.

bay (p. 170) A unit of space defined by architectural elements such as **columns**, **piers**, and walls.

beehive tomb (p. 98) A **corbel-vaulted** tomb, conical in shape like a beehive, and covered by an earthen mound.

Benday dots (p. 1095) In modern printing and typesetting, the individual dots that, together with many others, make up lettering and images. Often machineor computer-generated, the dots are very small and closely spaced to give the effect of density and richness of tone.

bilum (p. 865) Netted bags made mainly by women throughout the central highlands of New Guinea. The bags can be used for everyday purposes or even to carry the bones of the recently deceased as a sign of mourning.

biomorphic (p. 1058) Denoting the biologically or organically inspired shapes and forms that were routinely included in abstracted Modern art in the early twentieth century.

black-figure (p. 105) A technique of ancient Greek **ceramic** decoration in which black figures are painted on a red clay ground. Compare **red-figure**.

blackware (p. 855) A **ceramic** technique that produces pottery with a primarily black surface with **matte** and glossy patterns on the surface.

blind arcade (p. 780) See under arcade.

bodhisattva (p. 311) In Buddhism, a being who has attained enlightenment but chooses to remain in this world in order to help others advance spiritually. Also defined as a potential Buddha.

Book of Hours (p. 549) A prayer book for private use, containing a calendar, services for the canonical hours, and sometimes special prayers.

boss (p. 556) A decorative knoblike element that can be found in many places, e.g. at the intersection of a Gothic **rib vault** or as a buttonlike projection on metalwork.

bracket, bracketing (p. 341) An architectural element that projects from a wall to support a horizontal part of a building, such as beams or the eaves of a roof.

buon fresco (p. 87) See under fresco.

burin (p. 592) A metal instrument used in **engraving** to cut lines into the metal plate. The sharp end of the burin is trimmed to give a diamond-shaped cutting point, while the other end is finished with a wooden handle that fits into the engraver's palm.

buttress, buttressing (p. 170) A projecting support built against an external wall, usually to counteract the lateral **thrust** of a **vault** or **arch** within. In Gothic church architecture, a **flying buttress** is an arched bridge above the **aisle** roof that extends from the upper **nave** wall, where the lateral thrust of the main vault is greatest, down to a solid **pier**.

cairn (p. 17) A pile of stones or earth and stones that served both as a prehistoric burial site and as a marker for underground tombs.

calligraphy (p. 275) Handwriting as an art form.

calyx krater (p. 119) See under krater.

calotype (p. 969) The first photographic process utilizing negatives and paper positives; invented by William Henry Fox Talbot in the late 1830s. **came** (*pl.* **cames**) (p. 501) A lead strip used in the making of leaded or **stained-glass** windows. Cames have an indented groove on the sides into which individual pieces of glass are fitted to make the overall design.

cameo (p. 172) Gemstone, clay, glass, or shell having layers of color, carved in low relief (see under **relief sculpture**) to create an image and ground of different colors.

camera obscura (p. 750) An early cameralike device used in the Renaissance and later for recording images from the real world. It consists of a dark box (or room) with a hole in one side (sometimes fitted with a lens). The camera obscura operates when bright light shines through the hole, casting an upside-down image of an object outside onto the inside wall of the box.

canon of proportions (p. 64) A set of ideal mathematical ratios in art based on measurements, as in the proportional relationships between the basic elements of the human body.

canopic jar (p. 53) In ancient Egyptian culture, a special jar used to store the major organs of a body before embalming.

capital (p. 110) The sculpted block that tops a **column**. According to the **conventions** of the orders, capitals include different decorative elements (see **order**). A *historiated capital* is one displaying a figural composition and/or narrative scenes.

capriccio (*pl.* **capricci**) (p. 915) A painting or print of a fantastic, imaginary landscape, usually with architecture.

capstone (p. 17) The final, topmost stone in a **corbeled arch** or **vault**, which joins the sides and completes the structure.

cartoon (p. 501) A full-scale drawing of a design that will be executed in another **medium**, such as wall painting, **tapestry**, or **stained glass**.

cartouche (p. 187) A frame for a **hieroglyphic** inscription formed by a rope design surrounding an oval space. Used to signify a sacred or honored name. Also: in architecture, a decorative device or plaque, usually with a plain center used for inscriptions or epitaphs.

caryatid (p. 107) A sculpture of a draped female figure acting as a column supporting an **entablature**. *cassone (pl. cassoni*) (p. 616) An Italian dowry chest often highly decorated with carvings, paintings, inlaid designs, and gilt embellishments.

catacomb (p. 215) An underground cemetery consisting of tunnels on different levels, having niches for urns and **sarcophagi** and often incorporating rooms (**cubicula**).

cathedral (p. 220) The principal Christian church in a diocese, the bishop's administrative center and housing his throne (*cathedra*).

celadon (p. 358) A high-fired, transparent **glaze** of pale bluish-green hue whose principal coloring agent is an oxide of iron. In China and Korea, such glazes were typically applied over a pale gray **stoneware** body, though Chinese potters sometimes applied them over **porcelain** bodies during the Ming (1368–1644) and Qing (1644–1911) dynasties. Chinese potters invented celadon glazes and initiated the continuous production of celadon-glazed wares as early as the third century CE.

cella (p. 108) The principal interior room at the center of a Greek or Roman temple within which the cult statue was usually housed. Also called the **naos**.

celt (p. 383) A smooth, oblong stone or metal object, shaped like an axe-head.

cenotaph (p. 771) A funerary monument commemorating an individual or group buried elsewhere.

centering (p. 170) A temporary structure that supports a masonry **arch**, **vault**, or **dome** during construction until the mortar is fully dried and the masonry is self-sustaining. **central-plan building (p. 225)** Any structure designed with a primary central space surrounded by symmetrical areas on each side, e.g., a **rotunda**.

ceramics (p. 20) A general term covering all types of wares made from fired clay.

chacmool (p. 396) In Maya sculpture, a half-reclining figure probably representing an offering bearer.

chaitya (p. 305) A type of Buddhist temple found in-India. Built in the form of a hall or **basilica**, a *chaitya* hall is highly decorated with sculpture and usually is carved from a cave or natural rock location. It houses a sacred shrine or **stupa** for worship.

chamfer (p. 780) The slanted surface produced when an angle is trimmed or beveled, common in building and metalwork.

chasing (p. 432) Ornamentation made on metal by incising or hammering the surface.

château (*pl.* **châteaux**) (p. 693) A French country house or residential castle. A *château fort* is a military castle incorporating defensive works such as towers and battlements.

chattri (p. 780) In Indian architecture, a decorative pavilion with an umbrella-shaped **dome**.

chevron (p. 357) A decorative or heraldic motif of repeated Vs; a zigzag pattern.

chiaroscuro (p. 636) An Italian word designating the contrast of dark and light in a painting, drawing, or print. *Chiaroscuro* creates spatial depth and volumetric forms through gradations in the intensity of light and shadow.

choir (p. 225) The part of a church reserved for the clergy, monks, or nuns, either between the **transept** crossing and the **apse** or extending farther into the **nave**; separated from the rest of the church by screens or walls and fitted with stalls (seats).

cista (*pl.* **cistae**) (**p.** 157) Cylindrical containers used in antiquity by wealthy women as a case for toiletry articles such as a mirror.

clerestory (p. 57) In a **basilica**, the topmost zone of a wall with windows, extending above the **aisle** roofs. Provides direct light into the **nave**.

cloisonné (p. 257) An **ename**ling technique in which artists affix wires or strips to a metal surface to delineate designs and create compartments (*cloisons*) that they subsequently fill with enamel.

cloister (p. 448) An enclosed space, open to the sky, especially within a monastery, surrounded by an **arcade**d walkway, often having a fountain and garden. Since the most important monastic buildings (e.g., dormitory, refectory, church) open off the cloister, it represents the center of the monastic world.

codex (*pl.* **codices**) (p. 245) A book, or a group of **manuscript** pages (folios), held together by stitching or other binding along one edge.

coffer (p. 197) A recessed decorative panel used to decorate ceilings or **vault**s. The use of coffers is called coffering.

coiling (p. 848) A technique in basketry. In coiled baskets a spiraling coil, braid, or rope of material is held in place by stitching or interweaving to create a permanent shape.

collage (p. 1025) A composition made of cut and pasted scraps of materials, sometimes with lines or forms added by the artist.

colonnade (p. 69) A row of **columns**, supporting a straight **lintel** (as in a **porch** or **portico**) or a series of **arches** (an **arcade**).

colophon (p. 438) The data placed at the end of a book listing the book's author, publisher, illuminator, and other information related to its production. In East Asian **handscrolls**, the inscriptions which follow the painting are also called colophons.

combine (p. 1087) Combination of painting and sculpture using nontraditional art materials.

complementary color (p. 995) The primary and secondary colors across from each other on the color wheel (red and green, blue and orange, yellow and purple). When juxtaposed, the intensity of both colors increases. When mixed together, they negate each other to make a neutral gray-brown.

Composite order (p. 161) See under order. composite pose or image (p. 10) Combining different viewpoints within a single representation. composition (p. xxix) The overall arrangement, organizing design, or structure of a work of art. conch (p. 236) A halfdome.

connoisseur (p. 289) A French word meaning "an expert," and signifying the study and evaluation of art based primarily on formal, visual, and stylistic analysis. A connoisseur studies the style and technique of an object to assess its relative quality and identify its maker through visual comparison with other works of secure authorship. See also Formalism.

continuous narrative (p. 245) See under narrative image.

contrapposto (p. 120) Italian term meaning "set against," used to describe the Classical convention of representing human figures with opposing alternations of tension and relaxation on either side of a central axis to imbue figures with a sense of the potential for movement.

convention (p. 31) A traditional way of representing forms.

corbel, corbeling (p. 19) An early roofing and arching technique in which each course of stone projects slightly beyond the previous layer (a corbel) until the uppermost corbels meet; see also under arch. Also: brackets that project from a wall.

corbeled vault (p. 99) See under vault.

Corinthian order (p. 108) See under order.

cornice (p. 110) The uppermost section of a Classical entablature. More generally, a horizontally projecting element found at the top of a building wall or pedestal. A raking cornice is formed by the junction of two slanted cornices, most often found in pediments.

course (p. 99) A horizontal layer of stone used in building.

crenellation, crenellated (p. 44) Alternating high and low sections of a wall, giving a notched appearance and creating permanent defensive shields on top of fortified buildings.

crocket (p. 587) A stylized leaf used as decoration along the outer angle of spires, pinnacles, gables, and around capitals in Gothic architecture.

cruciform (p. 228) Of anything that is cross-shaped, as in the cruciform plan of a church.

cubiculum (pl. cubicula) (p. 220) A small private room for burials in a catacomb.

cuneiform (p. 28) An early form of writing with wedge-shaped marks impressed into wet clay with a stylus, primarily used by ancient Mesopotamians. curtain wall (p. 1045) A wall in a building that does not support any of the weight of the structure. cyclopean (p. 93) A method of construction using huge blocks of rough-hewn stone. Any largescale, monumental building project that impresses by sheer size. Named after the Cyclopes (sing. Cyclops), one-eyed giants of legendary strength

in Greek myths.

cylinder seal (p. 35) A small cylindrical stone decorated with incised patterns. When rolled across soft clay or wax, the resulting raised pattern or design served in Mesopotamian and Indus Valley cultures as an identifying signature.

dado (pl. dadoes) (p. 161) The lower part of a wall, differentiated in some way (by a molding or different coloring or paneling) from the upper section.

daguerreotype (p. 969) An early photographic process that makes a positive print on a light-sensitized copperplate; invented and marketed in 1839 by Louis-Jacques-Mandé Daguerre.

dendrochronology (p. xxxvi) The dating of wood based on the patterns of the tree's growth rings.

dentils (p. 110) A row of projecting rectangular blocks forming a molding or running beneath a cornice in Classical architecture.

desert varnish (p. 406) A naturally occurring coating that turns rock faces into dark surfaces. Artists would draw images by scraping through the dark surface and revealing the color of the underlying rock. Extensively used in southwest North America.

diptych (p. 212) Two panels of equal size (usually decorated with paintings or reliefs) hinged together.

dogu (p. 362) Small human figurines made in Japan during the Jomon period. Shaped from clay, the figures have exaggerated expressions and are in contorted poses. They were probably used in religious rituals.

dolmen (p. 17) A prehistoric structure made up of two or more large upright stones supporting a large, flat, horizontal slab or slabs.

dome (p. 187) A rounded vault, usually over a circular space. Consists of curved masonry and can vary in shape from hemispherical to bulbous to ovoidal. May use a supporting vertical wall (drum), from which the vault springs, and may be crowned by an open space (oculus) and/or an exterior lantern. When a dome is built over a square space, an intermediate element is required to make the transition to a circular drum. There are two systems. A dome on pendentives incorporates arched, sloping intermediate sections of wall that carry the weight and **thrust** of the dome to heavily **buttress**ed supporting **pier**s. A dome on squinches uses an arch built into the wall (squinch) in the upper corners of the space to carry the weight of the dome across the corners of the square space below. A halfdome or conch may cover a semicircular space.

domino construction (p. 1045) System of building construction introduced by the architect Le Corbusier in which reinforced concrete floor slabs are floated on six free-standing posts placed as if at the positions of the six dots on a domino playing piece.

Doric order (p. 108) See order.

dressed stone (p. 84) Another term for ashlar.

drillwork (p. 188) The technique of using a drill for the creation of certain effects in sculpture.

drum (p. 110) The circular wall that supports a dome. Also: a segment of the circular shaft of a column.

drypoint (p. 748) An intaglio printmaking process by which a metal (usually copper) plate is directly inscribed with a pointed instrument (stylus). The resulting design of scratched lines is inked, wiped, and printed. Also: the print made by this process.

earthenware (p. 20) A low-fired, opaque ceramic ware, employing humble clays that are naturally heat-resistant and remain porous after firing unless glazed. Earthenware occurs in a range of earth-toned colors, from white and tan to gray and black, with tan predominating.

earthwork (p. 1102) Usually very large-scale, outdoor artwork that is produced by altering the natural environment.

echinus (p. 110) A cushionlike circular element found below the abacus of a Doric capital. Also: a similarly shaped molding (usually with egg-and-dart motifs) underneath the volutes of an Ionic capital.

electronic spin resonance (p. 12) Method that uses magnetic field and microwave irradiation to date material such as tooth enamel and its surrounding soil.

elevation (p. 108) The arrangement, proportions, and details of any vertical side or face of a building. Also: an architectural drawing showing an exterior or interior wall of a building.

embroidery (p. 397) Stitches applied in a decorative pattern on top of an already-woven fabric ground.

en plein air (p. 987) French term (meaning "in the open air") describing the Impressionist practice of painting outdoors so artists could have direct access to the fleeting effects of light and atmosphere while working.

enamel (p. 255) Powdered, then molten, glass applied to a metal surface, and used by artists to create designs. After firing, the glass forms an opaque or transparent substance that fuses to the metal background. Also: an object created by the enameling technique. See also cloisonné.

encaustic (p. 246) A painting medium using pigments mixed with hot wax.

engaged (p. 171) Of an architectural feature, usually a column, attached to a wall.

engraving (p. 592) An intaglio printmaking process of inscribing an image, design, or letters onto a metal or wood surface from which a print is made. An engraving is usually drawn with a sharp implement (burin) directly onto the surface of the plate. Also: the print made from this process.

entablature (p. 107) In the Classical orders, the horizontal elements above the columns and capitals. The entablature consists of, from bottom to top, an architrave, a frieze, and a cornice.

entasis (p. 108) A slight swelling of the shaft of a Greek column. The optical illusion of entasis makes the column appear from afar to be straight.

esquisse (p. 946) French for "sketch." A quickly executed drawing or painting conveying the overall idea for a finished painting.

etching (p. 748) An intaglio printmaking process in which a metal plate is coated with acid-resistant resin and then inscribed with a stylus in a design, revealing the plate below. The plate is then immersed in acid, and the exposed metal of the design is eaten away by the acid. The resin is removed, leaving the design etched permanently into the metal and the plate ready to be inked, wiped, and printed.

Eucharist (p. 220) The central rite of the Christian Church, from the Greek word for "thanksgiving." Also known as the Mass or Holy Communion, it reenacts Christ's sacrifice on the cross and commemorates the Last Supper. According to traditional Catholic Christian belief, consecrated bread and wine become the body and blood of Christ; in Protestant belief, bread and wine symbolize the body and blood.

exedra (pl. exedrae) (p. 197) In architecture, a semicircular niche. On a small scale, often used as decoration, whereas larger exedrae can form interior spaces (such as an apse).

expressionism (p. 149) Artistic styles in which aspects of works of art are exaggerated to evoke subjective emotions rather than to portray objective reality or elicit a rational response.

façade (p. 52) The face or front wall of a building.

faience (p. 88) Type of ceramic covered with colorful, opaque glazes that form a smooth, impermeable surface. First developed in ancient Egypt. fang ding (p. 334) A square or rectangular bronze vessel with four legs. The *fang ding* was used for ritual offerings in ancient China during the Shang dynasty.

fête galante (p. 910) A subject in painting depicting well-dressed people at leisure in a park or country setting. It is most often associated with eighteenth-century French Rococo painting.

filigree (p. 90) Delicate, lacelike ornamental work.

fillet (p. 110) The flat ridge between the carved-out flutes of a column shaft.

finial (p. 780) A knoblike architectural decoration usually found at the top point of a spire, pinnacle, canopy, or gable. Also found on furniture. Also the ornamental top of a staff.

flutes (p. 110) In architecture, evenly spaced, rounded parallel vertical grooves incised on **shafts** of **columns** or on columnar elements such as **pilaster**s.

flying buttress (p. 503) See under buttress

flying gallop (p. 88) A non-naturalistic pose in which animals are depicted hovering above the ground with legs fully extended backwards and forwards to signify that they are running.

foreshortening (p. xxxi) The illusion created on a flat surface by which figures and objects appear to recede or project sharply into space. Accomplished according to the rules of **perspective**.

formal analysis (p. xxix) An exploration of the visual character that artists bring to their works through the expressive use of elements such as line, form, color, and light, and through its overall structure or composition.

Formalism (p. 1073) An approach to the understanding, appreciation, and valuation of art based almost solely on considerations of form. The Formalist's approach tends to regard an artwork as independent of its time and place of making.

forum (p. 176) A Roman town center; site of temples and administrative buildings and used as a market or gathering area for the citizens.

fresco (p. 81) A painting technique in which waterbased pigments are applied to a plaster surface. If the plaster is painted when wet, the color is absorbed by the plaster, becoming a permanent part of the wall (*buon fresco*). *Fresco secco* is created by painting on dried plaster, and the color may eventually flake off. Murals made by both these techniques are called frescos.

frieze (p. 107) The middle element of an entablature, between the architrave and the cornice. Usually decorated with sculpture, painting, or moldings. Also: any continuous flat band with relief sculpture or painted decoration.

frottage (p. 1057) A design produced by laying a piece of paper over a textured surface and rubbing with charcoal or other soft **medium**.

fusuma (p. 820) Sliding doors covered with paper, used in traditional Japanese construction. *Fusuma* are often highly decorated with paintings and colored backgrounds.

gallery (p. 236) A roofed passageway with one or both of its long sides open to the air. In church architecture, the story found above the side **aisles** of a church or across the width at the end of the **nave** or **transept**s, usually open to and overlooking the area below. Also: a building or hall in which art is displayed or sold.

garbhagriha (p. 302) From the Sanskrit word meaning "womb chamber," a small room or shrine in a Hindu temple containing a holy image.

genre painting (p. 714) A term used to loosely categorize paintings depicting scenes of everyday life, including (among others) domestic interiors, parties, inn scenes, and street scenes.

geoglyph (p. 399) Earthen design on a colossal scale, often created in a landscape as if to be seen from an aerial viewpoint.

gesso (p. 546) A ground made from glue, gypsum, and/or chalk, used as the ground of a wood panel or the priming layer of a canvas. Provides a smooth surface for painting.

gilding (p. 90) The application of paper-thin gold leaf or gold pigment to an object made from another **medium** (for example, a sculpture or painting). Usually used as a decorative finishing detail.

giornata (pl. giornate) (p. 539) Adopted from the Italian term meaning "a day's work," a *giomata* is the section of a **fresco** plastered and painted in a single day.

glazing (p. 600) In **ceramics**, an outermost layer of vitreous liquid (**glaze**) that, upon firing, renders the ware waterproof and forms a decorative surface. In painting, a technique used with oil **media** in which a transparent layer of paint (glaze) is laid over another, usually lighter, painted or glazed area. In architecture, the process of filing openings in a building with windows of clear or **stained glass**.

gold leaf (p. 47) Paper-thin sheets of hammered gold that are used in gilding. In some cases (such as Byzantine icons), also used as a ground for paintings. *gopura* (p. 775) The towering gateway to an Indian Hindu temple complex.

Grand Manner (p. 923) An elevated style of painting popular in the eighteenth century in which the artist looked to the ancients and to the Renaissance for inspiration; for portraits as well as history painting, the artist would adopt the poses, compositions, and attitudes of Renaissance and antique models.

Grand Tour (p. 913) Popular during the eighteenth and nineteenth centuries, an extended tour of cultural sites in France and Italy intended to finish the education of a young upper-class person primarily from Britain or North America.

 $\ensuremath{\text{granulation}}$ (p. 90) A technique of decoration in which metal granules, or tiny metal balls, are fused onto a metal surface.

graphic arts (p. 698) A term referring to those arts that are drawn or printed and that utilize paper as the primary support.

grattage (p. 1057) A pattern created by scraping off layers of paint from a canvas laid over a textured surface. Compare frottage.

grid (p. 65) A system of regularly spaced horizontally and vertically crossed lines that gives regularity to an architectural plan or in the composition of a work of art. Also: in painting, a grid is used to allow designs to be enlarged or transferred easily.

grisaille (p. 540) A style of monochromatic painting in shades of gray. Also: a painting made in this style. groin vault (p. 187) See under vault.

grozing (p. 501) Chipping away at the edges of a piece of glass to achieve the precise shape needed for inclusion in the composition of a **stained-glass** window.

guild (p. 419) An association of artists or craftsmakers. Medieval and Renaissance guilds had great economic power, as they controlled the marketing of their members' products and provided economic protection, political solidarity, and training in the craft to its members. The painters' guild was usually dedicated to St. Luke, their patron saint.

hall church (p. 521) A church with nave and aisles of the same height, giving the impression of a large, open hall.

halo (p. 215) A circle of light that surrounds and frames the heads of emperors and holy figures to signify their power and/or sanctity. Also known as a nimbus.

handscroll (p. 343) A long, narrow, horizontal painting or text (or combination thereof) common in Chinese and Japanese art and of a size intended for individual use. A handscroll is stored wrapped tightly around a wooden pin and is unrolled for viewing or reading. hanging scroll (p. 796) In Chinese and Japanese art, a vertical painting or text mounted within sections of silk. At the top is a semicircular rod; at the bottom is a round dowel. Hanging scrolls are kept rolled and tied except for special occasions, when they are hung for display, contemplation, or commemoration.

haniwa (p. 362) Pottery forms, including cylinders, buildings, and human figures, that were placed on top of Japanese tombs or burial mounds during the Kofun period (300–552 cE).

Happening (p. 1087) An art form developed by Allan Kaprow in the 1960s, incorporating performance, theater, and visual images. A Happening was organized without a specific narrative or intent; with audience participation, the event proceeded according to chance and individual improvisation.

hemicycle (p. 512) A semicircular interior space or structure.

henge (p. 17) A circular area enclosed by stones or wood posts set up by Neolithic peoples. It is usually bounded by a ditch and raised embankment.

hierarchic scale (p. 27) The use of differences in size to indicate relative importance. For example, with human figures, the larger the figure, the greater her or his importance.

hieratic (p. 484) Highly stylized, severe, and detached, often in relation to a strict religious tradition. hieroglyph (p. 52) Picture writing; words and ideas rendered in the form of pictorial symbols.

high relief (p. 307) See under relief sculpture.

historiated capital (p. 484) See under capital.

historicism (p. 965) The strong consciousness of and attention to the institutions, themes, styles, and forms of the past, made accessible by historical research, textual study, and archaeology.

history paintings (p. 926) Paintings based on historical, mythological, or biblical narratives. Once considered the noblest form of art, history paintings generally convey a high moral or intellectual idea and are often painted in a grand pictorial style.

horizon line (p. 569) A horizontal "line" formed by the implied meeting point of earth and sky. In **linear perspective**, the **vanishing point** or points are located on this "line."

horseshoe arch (p. 272) See under arch.

hue (p. 77) Pure color. The saturation or intensity of the hue depends on the purity of the color. Its value depends on its lightness or darkness.

hydria (p. 139) A large ancient Greek or Roman jar with three handles (horizontal ones at both sides and one vertical at the back), used for storing water.

hypostyle hall (p. 66) A large interior room characterized by many closely spaced **columns** that support its roof.

icon (p. 246) An image representing a sacred figure or event in the Byzantine (later the Orthodox) Church. Icons are venerated by the faithful, who believe their prayers are transmitted through them to God.

iconic image (p. 215) A picture that expresses or embodies an intangible concept or idea.

iconoclasm (p. 248) The banning and/or destruction of images, especially **icons** and religious art. Iconoclasm in eighth- and ninth-century Byzantium and sixteenthand seventeenth-century Protestant territories arose from differing beliefs about the power, meaning, function, and purpose of imagery in religion.

iconography (p. xxxiii) Identifying and studying the subject matter and **conventional** symbols in works of art.

iconology (p. xxxv) Interpreting works of art as embodiments of cultural situation by placing them within broad social, political, religious, and intellectual contexts. **iconophile** (p. 247) From the Greek for "lover of images." In periods of **iconoclasm**, iconophiles advocate the continued use of sacred images.

idealization (p. 134) A process in art through which artists strive to make their forms and figures attain perfection, based on pervading cultural values and/or their own personal ideals.

illumination (p. 431) A painting on paper or parchment used as an illustration and/or decoration in a **manuscript** or **album**. Usually richly colored, often supplemented by gold and other precious materials. The artists are referred to as illuminators. Also: the technique of decorating manuscripts with such paintings.

impasto (p. 749) Thick applications of pigment that give a painting a palpable surface texture.

impluvium (p. 178) A pool under a roof opening that collected rainwater in the **atrium** of a Roman house.

impost block (p. 170) A block of masonry imposed between the top of a **pier** or above the **capital** of a **column** in order to provide extra support at the springing of an **arch**.

incising (p. 118) A technique in which a design or inscription is cut into a hard surface with a sharp instrument. Such a surface is said to be incised.

ink painting (p. 812) A monochromatic style of painting developed in China, using black ink with gray washes.

inlay (p. 30) To set pieces of a material or materials into a surface to form a design. Also: material used in or decoration formed by this technique.

installation, installation art (p. 1051)

Contemporary art created for a specific site, especially a gallery or outdoor area, that creates a complete and controlled environment.

intaglio (p. 592) A technique in which the design is carved out of the surface of an object, such as an engraved seal stone. In the graphic arts, intaglio includes engraving, etching, and drypoint—all processes in which ink transfers to paper from incised, ink-filled lines cut into a metal plate.

intarsia (p. 618) Technique of inlay decoration using variously colored woods.

intuitive perspective (p. 182) See under perspective. lonic order (p. 107) See under order.

iwan (p. 277) In Islamic architecture, a large, vaulted chamber with a monumental arched opening on one side.

jamb (p. 478) In architecture, the vertical element found on both sides of an opening in a wall, and supporting an **arch** or **lintel**.

Japonisme (p. 996) A style in French and American nineteenth-century art that was highly influenced by Japanese art, especially prints.

jasperware (p. 919) A fine-grained, unglazed, white **ceramic** developed in the eighteenth century by Josiah Wedgwood, often with raised designs remaining white above a background surface colored by metallic oxides. *Jataka* tales (p. 303) In Buddhism, stories associated

with the previous lives of Shakyamuni, the historical Buddha.

joggled voussoirs (p. 268) Interlocking **voussoirs** in an **arch** or **lintel**, often of contrasting materials for colorful effect.

joined-block sculpture (p. 373) Large-scale wooden sculpture constructed by a method developed in Japan. The entire work is made from smaller hollow blocks, each individually carved, and assembled when complete. The joined-block technique allowed production of larger sculpture, as the multiple joints alleviate the problems of drying and cracking found with sculpture carved from a single block.

kantharos (p. 117) A type of ancient Greek goblet with two large handles and a wide mouth.

keep (p. 477) The innermost and strongest structure or central tower of a medieval castle, sometimes used as living quarters, as well as for defense. Also called a donjon.

kente (p. 892) A woven cloth made by the Ashanti peoples of West Africa. *Kente* cloth is woven in long, narrow pieces featuring complex and colorful patterns, which are then sewn together.

key block (p. 828) The master block in the production of a colored **woodblock print**, which requires different blocks for each color. The key block is a flat piece of wood upon which the outlines for the entire design of the print were first drawn on its surface and then all but these outlines were carved away with a knife. These outlines serve as a guide for the accurate **registration** or alignment of the other blocks needed to add colors to specific parts of a print.

keystone (p. 170) The topmost **voussoir** at the center of an **arch**, and the last block to be placed. The pressure of this block holds the arch together. Often of a larger size and/or decorated.

kiln (p. 20) An oven designed to produce enough heat for the baking, or firing, of clay, for the melting of the glass used in **enamel** work, and for the fixing of vitreous paint on **stained glass**.

kiva (p. 405) A subterranean, circular room used as a ceremonial center in some Native American cultures.

kondo (p. 366) The main hall inside a Japanese Buddhist temple where the images of Buddha are housed.

korambo (p. 865) A ceremonial or spirit house in Pacific cultures, reserved for the men of a village and used as a meeting place as well as to hide religious artifacts from the uninitiated.

kore (pl. kourai) (p. 114) An Archaic Greek statue of a young woman.

koru (p. 872) A design depicting a curling stalk with a bulb at the end that resembles a young tree fern; often found in Maori art.

kouros (*pl.* **kouroi**) (**p.** 114) An Archaic Greek statue of a young man or boy.

kowhaiwhai (p. 872) Painted curvilinear patterns often found in Maori art.

krater (p. 99) An ancient Greek vessel for mixing wine and water, with many subtypes that each have a distinctive shape. *Calyx krater*: a bell-shaped vessel with handles near the base that resembles a flower calyx. *Volute krater*: a krater with handles shaped like scrolls.

Kufic (p. 275) An ornamental, angular Arabic script. kylix (p. 120) A shallow ancient Greek cup, used for drinking, with a wide mouth and small handles near the rim.

lacquer (p. 824) A type of hard, glossy surface varnish, originally developed for use on objects in East Asian cultures, made from the sap of the Asian sumac or from shellac, a resinous secretion from the lac insect. Lacquer can be layered and manipulated or combined with pigments and other materials for various decorative effects.

lakshana (p. 306) The 32 marks of the historical Buddha. The *lakshana* include, among others, the Buddha's golden body, his long arms, the wheel impressed on his palms and the soles of his feet, and his elongated earlobes.

lamassu (p. 42) Supernatural guardian-protector of ancient Near Eastern palaces and throne rooms, often represented sculpturally as a combination of the bearded head of a man, powerful body of a lion or bull, wings of an eagle, and the horned headdress of a god, usually possessing five legs.

lancet (p. 505) A tall, narrow window crowned by a sharply pointed arch, typically found in Gothic architecture.

lantern (p. 464) A turretlike structure situated on a roof, vault, or dome, with windows that allow light into the space below.

lekythos (*pl.* **lekythoi**) (**p.** 141) A slim ancient Greek oil vase with one handle and a narrow mouth.

linear perspective (p. 595) See under perspective.

linga shrine (p. 315) A place of worship centered on an object or representation in the form of a phallus (the lingam), which symbolizes the power of the Hindu god Shiva.

lintel (p. 18) A horizontal element of any material carried by two or more vertical supports to form an opening.

literati painting (p. 793) A style of painting that reflects the taste of the educated class of East Asian intellectuals and scholars. Characteristics include an appreciation for the antique, small scale, and an intimate connection between maker and audience.

lithography (p. 953) Process of making a print (lithograph) from a design drawn on a flat stone block with greasy crayon. Ink is applied to the wet stone and adheres only to the greasy areas of the design.

loggia (p. 534) Italian term for a **gallery**. Often used as a corridor between buildings or around a courtyard, a loggia usually features an **arcade** or **colonnade**.

longitudinal-plan building (p. 225) Any structure designed with a rectangular shape and a longitudinal axis. In a cross-shaped building, the main arm of the building would be longer than any arms that cross it. For example, a **basilica**.

lost-wax casting (p. 36) A method of casting metal, such as bronze. A wax mold is covered with clay and plaster, then fired, thus melting the wax and leaving a hollow form. Molten metal is then poured into the hollow space and slowly cooled. When the hardened clay and plaster exterior shell is removed, a solid metal form remains to be smoothed and polished.

low relief (p. 40) See under relief sculpture.

lunette (p. 221) A semicircular wall area, framed by an **arch** over a door or window. Can be either plain or decorated.

lusterware (p. 277) Pottery decorated with metallic glazes.

madrasa (p. 277) An Islamic institution of higher learning, where teaching is focused on theology and law.

maenad (p. 104) In ancient Greece, a female devotee of the wine god Dionysos who participated in orgiastic rituals. Often depicted with swirling drapery to indicate wild movement or dance. Also called a Bacchante, after Bacchus, the Roman equivalent of Dionysos.

majolica (p. 573) Pottery painted with a tin **glaze** that, when fired, gives a lustrous and colorful surface.

mandala (p. 302) An image of the cosmos represented by an arrangement of circles or concentric geometric shapes containing diagrams or images. Used for meditation and contemplation by Buddhists.

mandapa (p. 302) In a Hindu temple, an open hall dedicated to ritual worship.

mandorla (p. 479) Light encircling, or emanating from, the entire figure of a sacred person.

manuscript (p. 244) A hand-written book or document.

maqsura (p. 272) An enclosure in a Muslimmosque, near the *mihrab*, designated for dignitaries.martyrium (*pl.* martyria) (p. 238) A church, chapel,

or shrine built over the grave of a Christian martyr. **mastaba** (p. 53) A flat-topped, one-story structure with slanted walls built over an ancient Egyptian underground tomb.

matte (p. 573) Of a smooth surface that is without shine or luster.

mausoleum (p. 175) A monumental building used as a tomb. Named after the tomb of King Mausolos erected at Halikarnassos around 350 BCE.

medallion (p. 222) Any round ornament or decoration. Also: a large medal.

medium (pl. media) (p. xxix) The material from which a work of art is made.

megalith (*adj.* megalithic) (p. 16) A large stone used in some prehistoric architecture.

megaron (p. 93) The main hall of a Mycenaean palace or grand house.

memento mori (p. 909) From Latin for "remember that you must die." An object, such as a skull or extinguished candle, typically found in a *vanitas* image, symbolizing the transience of life.

menorah (p. 186) A Jewish lampstand with seven or nine branches; the nine-branched menorah is used during the celebration of Hanukkah. Representations of the seven-branched menorah, once used in the Temple of Jerusalem, became a symbol of Judaism.

metope (p. 110) The carved or painted rectangular panel between the **triglyph**s of a Doric **frieze**.

mihrab (p. 265) A recess or niche that distinguishes the wall oriented toward Mecca (*qibla*) in a mosque.

millefiori (p. 434) A glassmaking technique in which rods of differently colored glass are fused in a long bundle that is subsequently sliced to produce disks or beads with small-scale, multicolor patterns. The term derives from the Italian for "a thousand flowers."

minaret (p. 274) A tower on or near a **mosque** from which Muslims are called to prayer five times a day.

minbar (p. 265) A high platform or pulpit in a **mosque**.

miniature (p. 245) Anything small. In painting, miniatures may be illustrations within **albums** or **manuscripts** or intimate portraits.

mirador (p. 280) In Spanish and Islamic palace architecture, a very large window or room with windows, and sometimes balconies, providing views to interior courtyards or the exterior landscape.

mithuna (p. 305) The amorous male and female couples in Buddhist sculpture, usually found at the entrance to a sacred building. The *mithuna* symbolizes the harmony and fertility of life.

moai (p. 875) Statues found in Polynesia, carved from tufa, a yellowish brown volcanic stone, and depicting the human form. Nearly 1,000 of these statues have been found on the island of Rapa Nui but their significance has been a matter of speculation.

modeling (p. xxix) In painting, the process of creating the illusion of three-dimensionality on a two-dimensional surface by use of light and shade. In sculpture, the process of molding a three-dimensional form out of a malleable substance.

module (p. 346) A segment or portion of a repeated design. Also: a basic building block.

molding (p. 319) A shaped or sculpted strip with varying contours and patterns. Used as decoration on architecture, furniture, frames, and other objects.

mortise-and-tenon (p. 18) A method of joining two elements. A projecting pin (tenon) on one element fits snugly into a hole designed for it (mortise) on the other.

mosaic (p. 145) Image formed by arranging small colored stone or glass pieces (**tesserae**) and affixing them to a hard, stable surface.

mosque (p. 265) A building used for communal Islamic worship.

Mozarabic (p. 439) Of an eclectic style practiced in Christian medieval Spain when much of the Iberian peninsula was ruled by Islamic dynasties. *mudra* (p. 307) A symbolic hand gesture in Buddhist art that denotes certain behaviors, actions, or feelings.

mullion (p. 510) A slender straight or curving bar that divides a window into subsidiary sections to create **tracery**.

muqarna (p. 280) In Islamic architecture, one of the nichelike components, often stacked in tiers to mark the transition between flat and rounded surfaces and often found on the **vault** of a **dome**.

naos (p. 236) The principal room in a temple or church. In ancient architecture, the **cella**. In a Byzantine church, the **nave** and **sanctuary**.

narrative image (p. 215) A picture that recounts an event drawn from a story, either factual (e.g. biographical) or fictional. In **continuous narrative**, multiple scenes from the same story appear within a single compositional frame.

narthex (p. 220) The vestibule or entrance porch of a church.

nave (p. 191) The central space of a church, two or three stories high and usually flanked by **aisle**s.

necropolis (p. 53) A large cemetery or burial area; literally a "city of the dead."

nemes headdress (p. 51) The royal headdress of ancient Egypt.

niello (**p**. 90) A metal technique in which a black sulfur **alloy** is rubbed into fine lines engraved into metal (usually gold or silver). When heated, the alloy becomes fused with the surrounding metal and provides contrasting detail.

oculus (*pl.* **oculi**) (**p.** 187) In architecture, a circular opening. Usually found either as windows or at the apex of a **dome**. When at the top of a dome, an oculus is either open to the sky or covered by a decorative exterior **lantern**.

odalisque (p. 952) Turkish word for "harem slave girl" or "concubine."

oil painting (p. 575) Any painting executed with pigments suspended in a **medium** of oil. Oil paint has particular properties that allow for greater ease of working: among others, a slow drying time (which allows for corrections), and a great range of relative opaqueness of paint layers (which permits a high degree of detail and luminescence).

oinochoe (p. 126) An ancient Greek jug used for wine.

olpe (p. 105) Any ancient Greek vessel without a spout.

one-point perspective (p. 259) See under perspective.

orant (p. 220) Of a standing figure represented praying with outstretched and upraised arms.

oratory (p. 228) A small chapel.

order (p. 110) A system of proportions in Classical architecture that includes every aspect of the building's plan, elevation, and decorative system. Composite: a combination of the Ionic and the Corinthian orders. The capital combines acanthus leaves with volute scrolls. Corinthian: the most ornate of the orders, the Corinthian includes a base, a fluted column shaft with a capital elaborately decorated with acanthus leaf carvings. Its entablature consists of an architrave decorated with moldings, a frieze often containing relief sculpture, and a cornice with dentils. Doric: the column shaft of the Doric order can be fluted or smooth-surfaced and has no base. The Doric capital consists of an undecorated echinus and abacus. The Doric entablature has a plain architrave, a frieze with metopes and triglyphs, and a simple cornice. Ionic: the column of the Ionic order has a base, a fluted shaft, and a capital decorated with volutes. The Ionic entablature consists of an architrave of three panels and moldings,

a frieze usually containing sculpted relief ornament, and a cornice with dentils. *Tuscan*: a variation of Doric characterized by a smooth-surfaced column shaft with a base, a plain architrave, and an undecorated frieze. *Colossal* or *giant*: any of the above built on a large scale, rising through two or more stories in height and often raised from the ground on a **pedestal**.

Orientalism (p. 968) A fascination with Middle Eastern cultures that inspired eclectic nineteenthcentury European fantasies of exotic life that often formed the subject of paintings.

orthogonal (p. 138) Any line running back into the represented space of a picture perpendicular to the imagined picture plane. In linear perspective, all orthogonals converge at a single vanishing point in the picture and are the basis for a grid that maps out the internal space of the image. An orthogonal plan is any plan for a building or city that is based exclusively on right angles, such as the grid plan of many major cities.

pagoda (p. 347) An East Asian **reliquary** tower built with successively smaller, repeated stories. Each story is usually marked by an elaborate projecting roof.

painterly (p. 253) A style of painting which emphasizes the techniques and surface effects of brushwork (also color, light, and shade).

palace complex (p. 41) A group of buildings used for living and governing by a ruler and his or her supporters, usually fortified.

palazzo (p. 602) Italian term for palace, used for any large urban dwelling.

palette (p. 183) A hand-held support used by artists for arranging colors and mixing paint during the process of painting. Also: the choice of a range of colors used by an artist in a particular work, as typical of his or her style. In ancient Egypt, a flat stone used to grind and prepare makeup.

panel painting (p. xli) Any painting executed on a wood support, usually planed to provide a smooth surface. A panel can consist of several boards joined together.

parchment (p. 245) A writing surface made from treated skins of animals. Very fine parchment is known as **vellum**.

parterre (p. 761) An ornamental, highly regimented flowerbed; especially as an element of the ornate gardens of a seventeenth-century palace or **château**. **passage grave** (p. 17) A prehistoric tomb under

a **cairn**, reached by a long, narrow, slab-lined access passageway or passageways.

pastel (p. 914) Dry pigment, chalk, and gum in stick or crayon form. Also: a work of art made with pastels.

pedestal (p. 107) A platform or base supporting a sculpture or other monument. Also: the block found below the base of a Classical **column** (or **colonnade**), serving to raise the entire element off the ground.

pediment (p. 107) A triangular gable found over major architectural elements such as Classical Greek **porticos**, windows, or doors. Formed by an **entablature** and the ends of a sloping roof or a raking **cornice**. A similar architectural element is often used decoratively above a door or window, sometimes with a curved upper **molding**. A *broken pediment* is a variation on the traditional pediment, with an open space at the center of the topmost angle and/or the horizontal cornice.

pendant (also **pendent**) (**p. 640**) One of a pair of artworks meant to be seen in relation to each other as a set.

pendentive (p. 236) The concave triangular section of a **vault** that forms the transition between a square or polygonal space and the circular base of a **dome**.

Performance art (p. 1087) A contemporary artwork based on a live, sometimes theatrical performance by the artist.

peristyle (p. 66) In Greek architecture, a surrounding **colonnade**. A peristyle building is surrounded on the exterior by a colonnade. Also: a peristyle court is an open colonnaded courtyard, often having a pool and garden.

perspective (p. xxvii) A system for representing three-dimensional space on a two-dimensional surface. Atmospheric or aerial perspective: a method of rendering the effect of spatial distance by subtle variations in color and clarity of representation. Intuitive perspective: a method of giving the impression of recession by visual instinct, not by the use of an overall system or program. Oblique perspective: an intuitive spatial system in which a building or room is placed with one corner in the picture plane, and the other parts of the structure recede to an imaginary vanishing point on its other side. Oblique perspective is not a comprehensive, mathematical system. One-point and multiple-point perspective (also called linear, scientific, or mathematical perspective): a method of creating the illusion of threedimensional space on a two-dimensional surface by delineating a horizon line and multiple orthogonal lines. These recede to meet at one or more points on the horizon (vanishing point), giving the appearance of spatial depth. Called scientific or mathematical because its use requires some knowledge of geometry and mathematics, as well as optics. Reverse perspective: a Byzantine perspective theory in which the orthogonals or rays of sight do not converge on a vanishing point in the picture, but are thought to originate in the viewer's eye in front of the picture. Thus, in reverse perspective the image is constructed with orthogonals that diverge, giving a slightly tipped aspect to objects.

photomontage (p. 1039) A photographic work created from many smaller photographs arranged (and often overlapping) in a composition, which is then rephotographed.

pictograph (p. 337) A highly stylized depiction serving as a symbol for a person or object. Also: a type of writing utilizing such symbols.

picture plane (p. 575) The theoretical plane corresponding with the actual surface of a painting, separating the spatial world evoked in the painting from the spatial world occupied by the viewer.

picturesque (p. 919) Of the taste for the familiar, the pleasant, and the agreeable, popular in the eighteenth and nineteenth centuries in Europe. Originally used to describe the "picturelike" qualities of some landscape scenes. When contrasted with the **sublime**, the picturesque stood for the interesting but ordinary domestic landscape.

piece-mold casting (p. 334) A casting technique in which the mold consists of several sections that are connected during the pouring of molten metal, usually bronze. After the cast form has hardened, the pieces of the mold are disassembled, leaving the completed object.

pier (p. 270) A masonry support made up of many stones, or rubble and concrete (in contrast to a column **shaft** which is formed from a single stone or a series of **drums**), often square or rectangular in plan, and capable of carrying very heavy architectural loads.

pietà (p. 230) A devotional subject in Christian religious art. After the Crucifixion the body of Jesus was laid across the lap of his grieving mother, Mary. When other mourners are present, the subject is called the Lamentation.

pietra serena (p. 602) A gray Tuscan sandstone used in Florentine architecture.

pilaster (p. 158) An **engaged** columnlike element that is rectangular in format and used for decoration in architecture.

pilgrimage church (p. 239) A church that attracts visitors wishing to venerate **relic**s as well as attend religious services.

pinnacle (p. 503) In Gothic architecture, a steep pyramid decorating the top of another element such as a **buttress**. Also: the highest point.

plate tracery (p. 505) See under tracery. plein air (p. 989) See under en plein air.

plinth (p. 161) The slablike base or **pedestal** of a

column, statue, wall, building, or piece of furniture. **pluralism** (**p. 1107**) A social structure or goal that allows members of diverse ethnic, racial, or other groups to exist peacefully within the society while continuing to practice the customs of their own divergent cultures. Also: an adjective describing the state of having a variety of valid contemporary styles available at the same time to artists.

podium (p. 138) A raised platform that acts as the foundation for a building, or as a platform for a speaker.

poesia (*pl.* **poesie**) (**p.** 656) Italian Renaissance paintings based on Classical themes, often with erotic overtones, notably in the mid-sixteenth-century works of the Venetian painter Titian.

polychromy (p. 524) Multicolored decoration applied to any part of a building, sculpture, or piece of furniture. This can be accomplished with paint or by the use of multicolored materials.

polyptych (p. 566) An **altarpiece** constructed from multiple panels, sometimes with hinges to allow for movable wings.

porcelain (p. 20) A type of extremely hard and fine white **ceramic** first made by Chinese potters in the eighth century CE. Made from a mixture of kaolin and petuntse, porcelain is fired at a very high temperature, and the final product has a translucent surface.

porch (p. 108) The covered entrance on the exterior of a building. With a row of **columns** or **colonnade**, also called a **portico**.

portal (p. 40) A grand entrance, door, or gate, usually to an important public building, and often decorated with sculpture.

portico (p. 63) In architecture, a projecting roof or porch supported by **columns**, often marking an entrance. See also **porch**.

post-and-lintel (p. 19) An architectural system of construction with two or more vertical elements (posts) supporting a horizontal element (**lintel**).

potassium-argon dating (p. 12) Archaeological method of **radiometric dating** that measures the decay of a radioactive potassium isotope into a stable isotope of argon, and inert gas.

potsherd (p. 20) A broken piece of ceramic ware. *poupou* (p. 873) In Pacific cultures, a house panel, often carved with designs.

Prairie Style (p. 1046) Style developed by a group of Midwestern architects who worked together using the aesthetic of the prairie and indigenous prairie plants for landscape design to create mostly domestic homes and small public buildings.

predella (p. 550) The base of an **altarpiece**, often decorated with small scenes that are related in subject to that of the main panel or panels.

primitivism (p. 1022) The borrowing of subjects or forms, usually from non-European or prehistoric sources by Western artists, in an attempt to infuse their work with the expressive qualities they attributed to other cultures, especially colonized cultures.

pronaos (p. 108) The enclosed vestibule of a Greek or Roman temple, found in front of the **cella** and marked by a row of **columns** at the entrance.

proscenium (p. 148) The stage of an ancient Greek or Roman theater. In a modern theater, the area of the stage in front of the curtain. Also: the framing **arch** that separates a stage from the audience.

psalter (p. 256) In Jewish and Christian scripture, a book of the Psalms (songs) attributed to King David.

psykter (p. 126) An ancient Greek vessel with an extended base to allow it to float in a larger **krater**; used to chill wine.

putto (*pl.* **putti**) (p. 224) A plump, naked little boy, often winged. In Classical art, called a cupid; in Christian art, a cherub.

pylon (p. 66) A massive gateway formed by a pair of tapering walls of oblong shape. Erected by ancient Egyptians to mark the entrance to a temple complex.

qibla (p. 274) The mosque wall oriented toward Mecca; indicated by the *mihrab*.

quatrefoil (p. 508) A four-lobed decorative pattern common in Gothic art and architecture.

quillwork (p. 847) A Native American technique in which the quills of porcupines and bird feathers are dyed and attached to materials in patterns.

radiometric dating (p. 12) Archaeological method of **absolute dating** by measuring the degree to which radioactive materials have degenerated over time. For dating organic (plant or animal) materials, one radiometric method measures a carbon isotope called radiocarbon, or carbon-14.

raigo (p. 378) A painted image that depicts the Amida Buddha and other Buddhist deities welcoming the soul of a dying believer to paradise.

raku (p. 823) A type of ceramic made by hand, coated with a thick, dark glaze, and fired at a low heat. The resulting vessels are irregularly shaped and glazed and are highly prized for use in the Japanese tea ceremony.

readymade (p. 1038) An object from popular or material culture presented without further manipulation as an artwork by the artist.

red-figure (p. 119) A technique of ancient Greek **ceramic** decoration characterized by red clay-colored figures on a black background. The figures are reserved against a painted ground and details are drawn, not engraved; compare **black-figure**.

register (p. 30) A device used in systems of spatial definition. In painting, a register indicates the use of differing groundlines to differentiate layers of space within an image. In **relief sculpture**, the placement of self-contained bands of reliefs in a vertical arrangement.

registration marks (p. 828) In Japanese woodblock prints, two marks carved on the blocks to indicate proper alignment of the paper during the printing process. In multicolor printing, which used a separate block for each color, these marks were essential for achieving the proper position or registration of the colors.

relative dating (p. 12) Archaeological process of determining relative chronological relationships among excavated objects. Compare **absolute dating**.

relic (p. 239) Venerated object or body part associated with a holy figure, such as a saint, and usually housed in a **reliquary**.

relief sculpture (p. 5) A three-dimensional image or design whose flat background surface is carved away to a certain depth, setting off the figure. Called **high** or **low** (**bas-**) **relief** depending upon the extent of projection of the image from the background. Called **sunken relief** when the image is carved below the original surface of the background, which is not cut away.

reliquary (p. 366) A container, often elaborate and made of precious materials, used as a repository for sacred relics.

repoussé (p. 90) A technique of pushing or hammering metal from the back to create a protruding image. Elaborate reliefs are created by pressing or hammering metal sheets against carved wooden forms.

rhyton (p. 88) A vessel in the shape of a figure or an animal, used for drinking or pouring liquids on special occasions.

rib vault (p. 499) See under vault.

ridgepole (p. 16) A longitudinal timber at the apex of a roof that supports the upper ends of the rafters.

roof comb (p. 392) In a Maya building, a masonry wall along the apex of a roof that is built above the level of the roof proper. Roof combs support the highly decorated false **façades** that rise above the height of the building at the front.

rose window (p. 505) A round window, often filled with stained glass set into tracery patterns in the form of wheel spokes, found in the **façades** of the **naves** and **transepts** of large Gothic churches.

rosette (p. 105) A round or oval ornament resembling a rose.

rotunda (p. 195) Any building (or part thereof) constructed in a circular (or sometimes polygonal) shape, usually producing a large open space crowned by a **dome**.

round arch (p. 170) See under arch.

roundel (p. 158) Any ornamental element with a circular format, often placed as a decoration on the exterior of a building.

rune stone (p. 442) In early medieval northern Europe, a stone used as a commemorative monument and carved or inscribed with runes, a writing system used by early Germanic peoples.

rustication (p. 602) In architecture, the rough, irregular, and unfinished effect deliberately given to the exterior facing of a stone edifice. Rusticated stones are often large and used for decorative emphasis around doors or windows, or across the entire lower floors of a building.

sacra conversazione (p. 630) Italian for "holy conversation." Refers to a type of religious painting developed in fifteenth-century Florence in which a central image of the Virgin and Child is flanked by standing saints of comparable size who stand within the same spatial setting and often acknowledge each other's presence.

salon (p. 907) A large room for entertaining guests or a periodic social or intellectual gathering, often of prominent people, held in such a room. Also: a hall or **gallery** for exhibiting works of art.

sanctuary (p. 102) A sacred or holy enclosure used for worship. In ancient Greece and Rome, consisted of one or more temples and an altar. In Christian architecture, the space around the altar in a church called the chancel or presbytery.

sarcophagus (pl. sarcophagi) (p. 49) A stone coffin. Often rectangular and decorated with **relief** sculpture.

scarab (p. 51) In ancient Egypt, a stylized dung beetle associated with the sun and the god Amun.

scarification (p. 409) Ornamental decoration applied to the surface of the body by cutting the skin for cultural and/or aesthetic reasons.

school of artists or painting (p. 285) An arthistorical term describing a group of artists, usually working at the same time and sharing similar styles, influences, and ideals. The artists in a particular school may not necessarily be directly associated with one another, unlike those in a workshop or **atelier**.

scriptorium (pl. scriptoria) (p. 244) A room in a monastery for writing or copying manuscripts.

scroll painting (p. 347) A painting executed on a flexible support with rollers at each end. The rollers permit the horizontal scroll to be unrolled as it is studied or the vertical scroll to be hung for contemplation or decoration.

sculpture in the round (p. 5) Three-dimensional sculpture that is carved free of any background or block. Compare **relief sculpture**.

serdab (p. 53) In ancient Egyptian tombs, the small room in which the *ka* statue was placed.

sfumato (p. 636) Italian term meaning "smoky," soft, and mellow. In painting, the effect of haze in an image. Resembling the color of the atmosphere at dusk, *sfumato* gives a smoky effect.

sgraffito (p. 604) Decoration made by incising or cutting away a surface layer of material to reveal a different color beneath.

shaft (p. 110) The main vertical section of a **column** between the **capital** and the base, usually circular in cross section.

shaft grave (p. 97) A deep pit used for burial.

shikhara (p. 302) In the architecture of northern India, a conical (or pyramidal) spire found atop a Hindu temple and often crowned with an *amalaka*.

shoin (p. 821) A term used to describe the various features found in the most formal room of upper-class Japanese residential architecture.

shoji (p. 821) A standing Japanese screen covered in translucent rice paper and used in interiors.

siapo (p. 876) A type of **tapa** cloth found in Samoa and still used as an important gift for ceremonial occasions.

silkscreen printing (p. 1092) A technique of printing in which paint or ink is pressed through a stencil and specially prepared cloth to reproduce a design in multiple copies.

sinopia (*pl. sinopie*) (p. 539) Italian word taken from Sinope, the ancient city in Asia Minor that was famous for its red-brick pigment. In **fresco** paintings, a fullsized, preliminary sketch done in this color on the first rough coat of plaster or *arriccio*.

site-specific (p. 1102) Of a work commissioned and/or designed for a particular location.

slip (p. 118) A mixture of clay and water applied to a **ceramic** object as a final decorative coat. Also: a solution that binds different parts of a vessel together, such as the handle and the main body.

spandrel (p. 170) The area of wall adjoining the exterior curve of an **arch** between its **springing** and the **keystone**, or the area between two arches, as in an **arcade**.

spolia (p. 471) Fragments of older architecture or sculpture reused in a secondary context. Latin for "hide stripped from an animal."

springing (p. 170) The point at which the curve of an **arch** or **vault** meets with and rises from its support.

squinch (p. 238) An arch or lintel built across the upper corners of a square space, allowing a circular or polygonal **dome** to be securely set above the walls.

stained glass (p. 287) Glass stained with color while molten, using metallic oxides. Stained glass is most often used in windows, for which small pieces of different colors are precisely cut and assembled into a design, held together by lead **cames**. Additional details may be added with vitreous paint.

stave church (p. 443) A Scandinavian wooden structure with four huge timbers (staves) at its core.

stele (*pl.* **stelai**), also **stela** (*pl.* **stelae**) (**p.** 27) A stone slab placed vertically and decorated with inscriptions or reliefs. Used as a grave marker or commemorative monument.

stereobate (p. 110) In Classical architecture, the foundation upon which a temple stands.

still life (*pl.* **still lifes**) (**p**. **xxxv**) A type of painting that has as its subject inanimate objects (such as food and dishes) or fruit and flowers taken out of their natural contexts.

stoa (p. 107) In Greek architecture, a long roofed walkway, usually having **columns** on one long side and a wall on the other.

stoneware (p. 20) A high-fired, vitrified, but opaque **ceramic** ware that is fired in the range of 1,100 to 1,200 degrees Celsius. At that temperature, particles of silica in the clay bodies fuse together so that the finished vessels are impervious to liquids, even without glaze. Stoneware pieces are glazed to enhance their aesthetic appeal and to aid in keeping them clean. Stoneware occurs in a range of earth-toned colors, from white and tan to gray and black, with light gray predominating. Chinese potters were the first in the world to produce stoneware, which they were able to make as early as the Shang dynasty.

stringcourse (p. 503) A continuous horizontal band, such as a **molding**, decorating the face of a wall.

stucco (p. 72) A mixture of lime, sand, and other ingredients made into a material that can easily be molded or modeled. When dry, it produces a durable surface used for covering walls or for architectural sculpture and decoration.

stupa (p. 302) In Buddhist architecture, a bell-shaped or pyramidal religious monument, made of piled earth or stone, and containing sacred **relic**s.

style (p. xxxvi) A particular manner, form, or character of representation, construction, or expression that is typical of an individual artist or of a certain place or period.

stylobate (p. 110) In Classical architecture, the stone foundation on which a temple **colonnade** stands.

stylus (p. 28) An instrument with a pointed end (used for writing and printmaking), which makes a delicate line or scratch. Also: a special writing tool for **cuneiform** writing with one pointed end and one triangular.

sublime (p. 955) Of a concept, thing, or state of greatness or vastness with high spiritual, moral, intellectual, or emotional value; or something aweinspiring. The sublime was a goal to which many nineteenth-century artists aspired in their artworks.

sunken relief (p. 71) See under relief sculpture.

symposium (p. 119) An elite gathering of wealthy and powerful men in ancient Greece that focused principally on wine, music, poetry, conversation, games, and love making.

syncretism (p. 220) A process whereby artists assimilate and combine images and ideas from different cultural traditions, beliefs, and practices, giving them new meanings.

taotie (p. 334) A mask with a dragon or animal-like face common as a decorative motif in Chinese art.

tapa (p. 876) A type of cloth used for various purposes in Pacific cultures, made from tree bark stripped and beaten, and often bearing subtle designs from the mallets used to work the bark.

tapestry (p. 292) Multicolored decorative weaving to be hung on a wall or placed on furniture. Pictorial or decorative motifs are woven directly into the supporting fabric, completely concealing it.

tatami (p. 821) Mats of woven straw used in Japanese houses as a floor covering.

temenos (p. 108) An enclosed sacred area reserved for worship in ancient Greece.

tempera (p. 141) A painting **medium** made by blending egg yolks with water, pigments, and occasionally other materials, such as glue.

tenebrism (p. 723) The use of strong *chiaroscuro* and artificially illuminated areas to create a dramatic contrast of light and dark in a painting.

terra cotta (p. 114) A **medium** made from clay fired over a low heat and sometimes left unglazed. Also: the orange-brown color typical of this medium.

tessera (*pl.* **tesserae**) (**p.** 145) A small piece of stone, glass, or other object that is pieced together with many others to create a **mosaic**.

thatch (p. 16) Plant material such as reeds or straw tied over a framework of poles to make a roof, shelter, or small building.

thermo-luminescence dating (p. 12) A method of **radiometric dating** that measures the irradiation of the crystal structure of material such as flint or pottery and the soil in which it is found, determined by luminescence produced when a sample is heated.

tholos (p. 98) A small, round building. Sometimes built underground, e.g. as a Mycenaean tomb.

thrust (p. 170) The outward pressure caused by the weight of a **vault** and supported by **buttressing**. See also under **arch**.

tondo (*pl.* tondi) (p. 126) A painting or relief sculpture of circular shape.

torana (p. 302) In Indian architecture, an ornamented gateway arch in a temple, usually leading to the **stupa**.

torc (p. 149) A circular neck ring worn by Celtic warriors.

toron (p. 422) In West African **mosque** architecture, the wooden beams that project from the walls. Torons are used as support for the scaffolding erected annually for the replastering of the building.

tracery (p. 503) Stonework or woodwork forming a pattern in the open space of windows or applied to wall surfaces. In *plate tracery*, a series of openings are cut through the wall. In *bar tracery*, mullions divide the space into segments to form decorative patterns.

transept (p. 225) The arm of a cruciform church perpendicular to the nave. The point where the nave and transept intersect is called the crossing. Beyond the crossing lies the sanctuary, whether apse, choir, or chevet.

transverse arch (p. 463) See under arch.

trefoil (p. 298) An ornamental design made up of three rounded lobes placed adjacent to one another.

triforium (p. 505) The element of the interior elevation of a church found directly below the **clerestory** and consisting of a series of arched openings in front of a passageway within the thickness of the wall.

triglyph (p. 110) Rectangular block between the **metope**s of a Doric **frieze**. Identified by the three carved vertical grooves, which approximate the appearance of the end of wooden beams.

triptych (p. 566) An artwork made up of three panels. The panels may be hinged together in such a way that the side segments (wings) fold over the central area.

trompe l'oeil (p. 618) A manner of representation in which artists faithfully describe the appearance of natural space and forms with the express intention of fooling the eye of the viewer, who may be convinced momentarily that the subject actually exists as threedimensional reality.

trumeau (p. 478) A column, pier, or post found at the center of a large **portal** or doorway, supporting the **lintel**.

tugra (p. 288) A calligraphic imperial monogram used in Ottoman courts.

tukutuku (p. 872) Lattice panels created by women from the Maori culture and used in architecture.

Tuscan order (p. 158) See under order.

twining (p. 848) A basketry technique in which short rods are sewn together vertically. The panels are then joined together to form a container or other object.

tympanum (p. 478) In medieval and later architecture, the area over a door enclosed by an **arch** and a **lintel**, often decorated with sculpture or mosaic.

ukiyo-e (p. 828) A Japanese term for a type of popular art that was favored from the sixteenth century, particularly in the form of color **woodblock prints**. *Ukiyo-e* prints often depicted the world of the common people in Japan, such as courtesans and actors, as well as landscapes and myths.

undercutting (p. 212) A technique in sculpture by which the material is cut back under the edges so that the remaining form projects strongly forward, casting deep shadows.

underglaze (p. 800) Color or decoration applied to a **ceramic** piece before glazing.

upeti (p. 876) In Pacific cultures, a carved wooden design tablet, used to create patterns in cloth by dragging the fabric across it.

uranium-thorium dating (p. 12) Technique used to date prehistoric cave paintings by measuring the decay of uranium into thorium in the deposits of calcium carbinate that cover the surfaces of cave walls, to determine the minimum age of the paintings under the crust.

urna (p. 306) In Buddhist art, the curl of hair on the forehead that is a characteristic mark of a buddha. The *uma* is a symbol of divine wisdom.

ushnisha (p. 306) In Asian art, a round turban or tiara symbolizing royalty and, when worn by a buddha, enlightenment.

vanishing point (p. 610) In a perspective system, the point on the horizon line at which orthogonals meet. A complex system can have multiple vanishing points.

vanitas (p. xxxvi) An image, especially popular in Europe during the seventeenth century, in which all the objects symbolize the transience of life. *Vanitas* paintings are usually of **still lifes** or genre subjects.

vault (p. 17) An arched masonry structure that spans an interior space. *Barrel* or *tunnel vault*: an elongated or continuous semicircular vault, shaped like a halfcylinder. *Corbeled vault*: a vault made by projecting *courses* of stone; see also under *corbel*. *Groin* or *cross vault*: a vault created by the intersection of two barrel vaults of equal size which creates four side compartments of identical size and shape. *Quadrant vault*: a half-barrel vault. *Rib vault*: a groin vault with ribs (extra masonry) demarcating the junctions. Ribs may function to reinforce the groins or may be purely decorative.

veduta (pl. vedute) (p. 915) Italian for "vista" or "view." Paintings, drawings, or prints, often of expansive city scenes or of harbors.

vellum (p. 245) A fine animal skin prepared for writing and painting. See also **parchment**.

verism (p. 168) Style in which artists concern themselves with describing the exterior likeness of an object or person, usually by rendering its visible details in a finely executed, meticulous manner.

vihara (p. 305) From the Sanskrit term meaning "for wanderers." A vihara is, in general, a Buddhist monastery in India. It also signifies monks' cells and gathering places in such a monastery.

volute (p. 110) A spiral scroll, as seen on an Ionic capital.

votive figure (p. 31) An image created as a devotional offering to a deity.

voussoir (p. 170) Wedge-shaped stone block used to build an arch. The topmost voussoir is called a keystone. See also joggled voussoirs.

warp (p. 292) The vertical threads in a weaver's loom. Warp threads make up a fixed framework that provides the structure for the entire piece of cloth, and are thus often thicker than weft threads.

wattle and daub (p. 16) A wall construction method combining upright branches, woven with twigs (wattles) and plastered or filled with clay or mud (daub).

weft (p. 292) The horizontal threads in a woven piece of cloth. Weft threads are woven at right angles to and through the **warp** threads to make up the bulk of the decorative pattern. In carpets, the weft is often completely covered or formed by the rows of trimmed knots that form the carpet's soft surface.

westwork (p. 446) The monumental, west-facing entrance section of a Carolingian, Ottonian, or Romanesque church. The exterior consists of multiple stories between two towers; the interior includes an entrance vestibule, a chapel, and a series of **galleries** overlooking the **nave**.

white-ground (p. 141) A type of ancient Greek pottery in which the background color of the object was painted with a **slip** that turns white in the firing process. Figures and details were added by painting on or incising into this slip. White-ground wares were popular in the Classical period as funerary objects.

woodblock print (p. 591) A print made from one or more carved wooden blocks. In Japan, woodblock prints were made using multiple blocks carved in relief, usually with a block for each color in the finished print. See also woodcut.

woodcut (p. 592) A type of print made by carving a design into a wooden block. The ink is applied to the block with a roller. As the ink touches only on the surface areas and lines remaining between the carvedaway parts of the block, it is these areas that make the print when paper is pressed against the inked block, leaving the carved-away parts of the design to appear blank. Also: the process by which the woodcut is made.

yaksha, yakshi (p. 301) The male (yaksha) and female (yakshi) nature spirits that act as agents of the Hindu gods. Their sculpted images are often found on Hindu temples and other sacred places, particularly at the entrances.

yamato-e (p. 374) A native style of Japanese painting developed during the twelfth and thirteenth centuries, distinguished from Japanese painting styles that emulate Chinese traditions.

ziggurat (p. 28) In ancient Mesopotamia, a tall stepped tower of earthen materials, often supporting a shrine.

Bibliography

Susan V. Craig, updated by Carrie L. McDade

This bibliography is composed of books in English that are suggested "further reading" titles. Most are available in good libraries, whether college, university, or public. Recently published works have been emphasized so that the research information would be current. There are three classifications of listings: general surveys and art history reference tools, including journals and Internet directories; surveys of large periods that encompass multiple chapters (ancient art in the Western tradition, European medieval art, European Renaissance through eighteenth-century art, modern art in the West, Asian art, and African and Oceanic art, and art of the Americas); and books for individual Chapters 1 through 33.

General Art History Surveys and Reference Tools

- Adams, Laurie Schneider. Art Across Time. 4th ed. New York: McGraw-Hill, 2011.
- Barnet, Sylvan. A Short Guide to Writing about Art. 10th ed. Upper Saddle River, NJ: Pearson/Prentice Hall, 2010.
- Bony, Anne. Design: History, Main Trends, Main Figures. Edinburgh: Chambers, 2005.
- Boström, Antonia. *Encyclopedia of Sculpture*. 3 vols. New York: Fitzroy Dearborn, 2004.
- Broude, Norma, and Mary D. Garrard, eds. Feminism and Art History: Questioning the Litany. Icon Editions. New York: Harper & Row, 1982.
- Chadwick, Whitney. Women, Art, and Society. 4th ed. New York: Thames & Hudson, 2007.
- Chilvers, Ian, ed. *The Oxford Dictionary of Art.* 4th ed. New York: Oxford Univ. Press, 2009.
- Curl, James Stevens. A Dictionary of Architecture and Landscape Architecture. 2nd ed. Oxford: Oxford Univ. Press. 2006.
- Davies, Penelope J.E., et al. Janson's History of Art: The Western Tradition. 8th ed. Upper Saddle River, NJ: Prentice Hall, 2010.
- The Dictionary of Art. Ed. Jane Turner. 34 vols. New York: Grove's Dictionaries, 1996.
- Frank, Patrick, Duane Preble, and Sarah Preble. Prebles' Artforms. 10th ed. Upper Saddle River, NJ: Pearson/ Prentice Hall, 2011.
- Gaze, Delia, ed. Dictionary of Women Artists. 2 vols. London: Fitzroy Dearborn, 1997.
- Griffiths, Antony. Prints and Printmaking: An Introduction to the History and Techniques. 2nd ed. London: British Museum Press, 1996.
- Hadden, Peggy. The Quotable Artist. New York: Allworth Press, 2002.
- Hall, James. Dictionary of Subjects and Symbols in Art. 2nd ed. Boulder, CO: Westview Press, 2008.
- Holt, Elizabeth Gilmore, ed. A Documentary History of Art. 3 vols. New Haven: Yale Univ. Press, 1986.
- Honour, Hugh, and John Fleming. The Visual Arts: A History. 7th ed. rev. Upper Saddle River, NJ: Pearson/ Prentice Hall, 2010.
- Johnson, Paul. Art: A New History. New York: HarperCollins, 2003.
- Kemp, Martin, ed. The Oxford History of Western Art. Oxford: Oxford Univ. Press, 2000.
- Kleiner, Fred S. Gardner's Art through the Ages. Enhanced 13th ed. Belmont, CA: Thomson/Wadsworth, 2011.
- Kostof, Spiro. A History of Architecture: Settings and Rituals. 2nd ed. Revised Greg Castillo. New York: Oxford Univ. Press, 1995.
- Mackenzie, Lynn. Non-Western Art: A Brief Guide. 2nd ed. Upper Saddle River, NJ: Pearson/Prentice Hall, 2001.
- Marmor, Max, and Alex Ross, eds. Guide to the Literature of Art History 2. Chicago: American Library Association, 2005.
- Onians, John, ed. Atlas of World Art. New York: Oxford Univ. Press, 2004.

Sayre, Henry M. Writing about Art. 6th ed. Upper Saddle River, NJ: Pearson/Prentice Hall, 2009.

- Sed-Rajna, Gabrielle. Jewish Art. Trans. Sara Friedman and Mira Reich. New York: Abrams, 1997.
- Slatkin, Wendy. Women Artists in History: From Antiquity to the Present. 4th ed. Upper Saddle River, NJ: Pearson/ Prentice Hall, 2001.
- Sutton, Ian. Western Architecture: From Ancient Greece to the Present. World of Art. New York: Thames & Hudson, 1999.
- Trachtenberg, Marvin, and Isabelle Hyman. Architecture, from Prehistory to Postmodernity. 2nd ed. Upper Saddle River, NJ: Pearson/Prentice Hall, 2002.
- Watkin, David. A History of Western Architecture. 4th ed. New York: Watson-Guptill, 2005.

Art History Journals: A Select List of Current Titles

- African Arts. Quarterly. Los Angeles: Univ. of California at Los Angeles, James S. Coleman African Studies Center, 1967–.
- American Art: The Journal of the Smithsonian American Art Museum. 3/year. Chicago: Univ. of Chicago Press, 1987–.
- American Indian Art Magazine. Quarterly. Scottsdale, AZ: American Indian Art Inc., 1975–.
- American Journal of Archaeology. Quarterly. Boston: Archaeological Institute of America, 1885-.

Antiquity: A Periodical of Archaeology. Quarterly. Cambridge: Antiquity Publications Ltd., 1927–.

- Apollo: The International Magazine of the Arts. Monthly. London: Apollo Magazine Ltd., 1925-.
- Architectural History. Annually. Farnham, UK: Society of Architectural Historians of Great Britain, 1958-.
- Archives of American Art Journal. Quarterly. Washington, DC: Archives of American Art, Smithsonian Institution, 1960–.
- Archives of Asian Art. Annually. New York: Asia Society, 1945-.
- Ars Orientalis: The Arts of Asia, Southeast Asia, and Islam. Annually. Ann Arbor: Univ. of Michigan Dept. of Art History, 1954–.
- Art Bulletin. Quarterly. New York: College Art Association, 1913-.
- Art History: Journal of the Association of Art Historians. 5/year. Oxford: Blackwell Publishing Ltd., 1978-.
- Art in America. Monthly. New York: Brant Publications Inc., 1913–.
- Art Journal. Quarterly. New York: College Art Association, 1960–.
- Art Nexus. Quarterly. Bogota, Colombia: Arte en Colombia Ltda, 1976–.
- Art Papers Magazine. Bimonthly. Atlanta: Atlanta Art Papers Inc., 1976–.
- Artforum International. 10/year. New York: Artforum International Magazine Inc., 1962–.
- Artnews. 11/year. New York: Artnews LLC, 1902-.
- Bulletin of the Metropolitan Museum of Art. Quarterly. New York: Metropolitan Museum of Art, 1905–.
- Burlington Magazine. Monthly. London: Burlington Magazine Publications Ltd., 1903–.
- Dumbarton Oaks Papers. Annually. Locust Valley, NY: J.J. Augustin Inc., 1940–.
- Flash Art International. Bimonthly. Trevi, Italy: Giancarlo Politi Editore, 1980-.
- Gesta. Semiannually. New York: International Center of Medieval Art, 1963–.
- History of Photography. Quarterly. Abingdon, UK: Taylor & Francis Ltd., 1976-.
- International Review of African American Art. Quarterly. Hampton, VA: International Review of African American Art, 1976–.
- Journal of Design History. Quarterly. Oxford: Oxford Univ. Press, 1988-.

- Journal of Egyptian Archaeology. Annually. London: Egypt Exploration Society, 1914–.
- Journal of Hellenic Studies. Annually. London: Society for the Promotion of Hellenic Studies, 1880–.
- Journal of Roman Archaeology. Annually. Portsmouth, RI: Journal of Roman Archaeology LLC, 1988–.
- Journal of the Society of Architectural Historians. Quarterly. Chicago: Society of Architectural Historians, 1940–. Journal of the Warburg and Courtauld Institutes. Annually.
- London: Warburg Institute, 1937–.
- Leonardo: Art, Science, and Technology. 6/year. Cambridge, MA: MIT Press, 1968-.
- Marg. Quarterly. Mumbai, India: Scientific Publishers, 1946–.
- Master Drawings. Quarterly. New York: Master Drawings Association, 1963-.
- October. Cambridge, MA: MIT Press, 1976-.
- Oxford Art Journal. 3/year. Oxford: Oxford Univ. Press, 1978-.
- Parkett. 3/year. Zürich, Switzerland: Parkett Verlag AG, 1984-.
- Print Quarterly. Quarterly. London: Print Quarterly Publications, 1984–.
- Simiolus: Netherlands Quarterly for the History of Art. Quarterly. Apeldoorn, Netherlands: Stichting voor Nederlandse Kunsthistorische Publicaties. 1966–
- Woman's Art Journal. Semiannually. Philadelphia: Old City Publishing Inc., 1980–.

Internet Directories for Art History Information: A Selected List

ARCHITECTURE AND BUILDING,

http://www.library.unlv.edu/arch/rsrce/webresources/ A directory of architecture websites collected by Jeanne Brown at the Univ. of Nevada at Las Vegas. Topical lists include architecture, building and construction, design, history, housing, planning, preservation, and landscape architecture. Most entries include a brief annotation and the last date the link was accessed by the compiler.

ART HISTORY RESOURCES ON THE WEB,

http://witcombe.sbc.edu/ARTHLinks.html Authored by Professor Christopher L.C.E. Witcombe of Sweet Briar College in Virginia, since 1995, the site includes an impressive number of links for various art-historical eras as well as links to research resources, museums, and galleries. The content is frequently updated.

ART IN FLUX: A DIRECTORY OF RESOURCES FOR RESEARCH IN CONTEMPORARY ART, http://www.boisestate.edu/art/artinflux/intro.html

Cheryl K. Shurtleff of Boise State Univ. in Idaho has authored this directory, which includes sites selected according to their relevance to the study of national or international contemporary art and artists. The subsections include artists, museums, theory, reference, and links.

ARTCYCLOPEDIA: THE GUIDE TO GREAT ART ON THE INTERNET,

http://www.artcyclopedia.com

With more than 2,100 art sites and 75,000 links, this is one of the most comprehensive Web directories for artists and art topics. The primary search is by artist's name but access is also available by title of artwork, artistic movement, museums and galleries, nationality, period, and medium.

MOTHER OF ALL ART AND ART HISTORY LINKS PAGES,

http://umich.edu/~motherha

Maintained by the Dept. of the History of Art at the Univ. of Michigan, this directory covers art history departments, art museums, fine arts schools and departments, as well as links to research resources. Each entry includes annotations.

VOICE OF THE SHUTTLE,

http://vos.ucsb.edu

Sponsored by Univ. of California, Santa Barbara, this directory includes more than 70 pages of links to humanities and humanities-related resources on the Internet. The structured guide includes specific subsections on architecture, on art (modern and contemporary), and on art history. Links usually include a one-sentence explanation and the resource is frequently updated with new information.

ARTBABBLE,

http://www.artbabble.org/

An online community created by staff at the Indianapolis Museum of Art to showcase art-based video content, including interviews with artists and curators, original documentaries, and art installation videos. Partners and contributors to the project include Art21, Los Angeles County Museum of Art, The Museum of Modern Art, The New York Public Library, San Francisco Museum of Modern Art, and Smithsonian American Art Museum.

YAHOO! ARTS>ART HISTORY,

http://dir.yahoo.com/Arts/Art_History/

Another extensive directory of art links organized into subdivisions with one of the most extensive being "Periods and Movements." Links include the name of the site as well as a few words of explanation.

Ancient Art in the Western Tradition, General

- Amiet, Pierre. Art in the Ancient World: A Handbook of Styles and Forms. New York: Rizzoli, 1981.
- Beard, Mary, and John Henderson. Classical Art: From Greece to Rome. Oxford History of Art. Oxford: Oxford Univ. Press, 2001.
- Boardman, John. Oxford History of Classical Art. New York: Oxford Univ. Press, 2001.
- Chitham, Robert. *The Classical Orders of Architecture*. 2nd ed. Boston: Elsevier/Architectural Press, 2005.
- Ehrich, Robert W., ed. Chronologies in Old World Archaeology. 3rd ed. 2 vols. Chicago: Univ. of Chicago Press, 1992.
- Gerster, Georg. The Past from Above: Aerial Photographs of Archaeological Sites. Ed. Charlotte Trümpler. Trans. Stewart Spencer. Los Angeles: J. Paul Getty Museum, 2005.
- Groenewegen-Frankfort, H.A., and Bernard Ashmole. Art of the Ancient World: Painting, Pottery, Sculpture, Architecture from Egypt, Mesopotamia, Crete, Greece, and Rome. Library of Art History. Upper Saddle River, NJ: Prentice Hall, 1972.
- Haywood, John. The Penguin Historical Atlas of Ancient Civilizations. New York: Penguin, 2005.
- Milleker, Elizabeth J., ed. The Year One: Art of the Ancient World East and West. New York: Metropolitan Museum of Art, 2000.
- Nagle, D. Brendan. The Ancient World: A Social and Cultural History. 7th ed. Upper Saddle River, NJ: Pearson/ Prentice Hall, 2010.
- Saggs, H.W.F. Civilization before Greece and Rome. New Haven: Yale Univ. Press, 1989.
- Smith, William Stevenson. Interconnections in the Ancient Near East: A Study of the Relationships between the Arts of Egypt, the Acgean, and Western Asia. New Haven: Yale Univ. Press, 1965.
- Tadgell, Christopher. Imperial Form: From Achaemenid Iran to Augustan Rome. New York: Whitney Library of Design, 1998.
- Trigger, Bruce G. Understanding Early Civilizations: A Comparative Study. New York: Cambridge Univ. Press, 2003.
- Woodford, Susan. The Art of Greece and Rome. 2nd ed. New York: Cambridge Univ. Press, 2004.

European Medieval Art, General

- Backman, Clifford R. *The Worlds of Medieval Europe*. 2nd ed. New York: Oxford Univ. Press, 2009.
- Bennett, Adelaide Louise, et al. Medieval Mastery: Book Illumination from Charlemagne to Charles the Bold: 800– 1475. Trans. Lee Preedy and Greta Arblaster-Holmer. Turnhout: Brepols, 2002.
- Benton, Janetta R. Art of the Middle Ages. World of Art. New York: Thames & Hudson, 2002.
- Binski, Paul. Painters. Medieval Craftsmen. London: British Museum Press, 1991.
- Brown, Sarah, and David O'Connor. *Glass-painters*. Medieval Craftsmen. London: British Museum Press, 1991.

- Calkins, Robert G. Medieval Architecture in Western Europe: From A.D. 300 to 1500. New York: Oxford Univ. Press, 1998.
- Cherry, John F. Goldsmiths. Medieval Craftsmen. London: British Museum Press, 1992.
- Clark, William W. The Medieval Cathedrals. Westport, CT: Greenwood Press, 2006.
- Coldstream, Nicola. *Masons and Sculptors*. Medieval Craftsmen. London: British Museum Press, 1991. ———. *Medieval Architecture*. Oxford History of Art. Oxford: Oxford Univ. Press, 2002.
- De Hamel, Christopher. Scribes and Illuminators. Medieval Craftsmen. London: British Museum Press, 1992.
- Duby, Georges. Art and Society in the Middle Ages. Trans. Jean Birrell. Malden, MA: Blackwell, 2000.
- Fossier, Robert, ed. The Cambridge Illustrated History of the Middle Ages. Trans. Janet Sondheimer and Sarah Hanbury Tenison. 3 vols. Cambridge: Cambridge Univ. Press, 1986–97.
- Hürlimann, Martin, and Jean Bony. French Cathedrals. Rev. & enlarged ed. London: Thames & Hudson, 1967.
- Jotischky, Andrew, and Caroline Susan Hull. The Penguin Historical Atlas of the Medieval World. New York: Penguin, 2005.
- Kenyon, John. *Medieval Fortifications*. Leicester: Leicester Univ. Press, 1990.
- Pfaffenbichler, Matthias. Armourers. Medieval Craftsmen. London: British Museum Press, 1992.
- Rebold Benton, Janetta. Art of the Middle Ages. World of Art. New York: Thames & Hudson, 2002.
- Rudolph, Conrad, ed. A Companion to Medieval Art. Blackwell Companions to Art History. Oxford: Blackwell, 2006.
- Sekules, Veronica. *Medieval Art*. Oxford History of Art. New York: Oxford Univ. Press, 2001.
- Snyder, James, Henry Luttikhuizen, and Dorothy Verkerk. Art of the Middle Ages. 2nd ed. Upper Saddle River, NJ: Pearson/Prentice Hall, 2006.
- Staniland, Kay. *Embroiderers*. Medieval Craftsmen. London: British Museum Press, 1991.

Stokstad, Marilyn. Medieval Art. 2nd ed. Boulder, CO: Westview Press, 2004.

———. Medieval Castles. Greenwood Guides to Historic Events of the Medieval World. Westport, CT: Greenwood Press, 2005.

European Renaissance through Eighteenth-Century Art, General

- Black, C.F., et al. *Cultural Atlas of the Renaissance*. New York: Prentice Hall, 1993.
- Blunt, Anthony. Art and Architecture in France, 1500–1700. 5th ed. Revised Richard Beresford. Pelican History of Art. New Haven: Yale Univ. Press, 1999.
- Brown, Jonathan. Painting in Spain: 1500–1700. Pelican History of Art. New Haven: Yale Univ. Press, 1998.
- Cole, Bruce. Studies in the History of Italian Art, 1250–1550. London: Pindar Press, 1996.
- Graham-Dixon, Andrew. *Renaissance*. Berkeley: Univ. of California Press, 1999.
- Harbison, Craig. The Mirror of the Artist: Northern Renaissance Art in Its Historical Context. Perspectives. New York: Abrams, 1995.
- Harris, Ann Sutherland. Seventeenth-Century Art & Architecture. 2nd ed. Upper Saddle River, NJ: Pearson/ Prentice Hall, 2008.
- Harrison, Charles, Paul Wood, and Jason Gaiger. Art in Theory 1648–1815: An Anthology of Changing Ideas. Oxford: Blackwell, 2000.
- Hartt, Frederick, and David G. Wilkins. History of Italian Renaissance Art: Painting, Sculpture, Architecture. 7th ed. Upper Saddle River, NJ: Pearson/Prentice Hall, 2011.
- Jestaz, Bertrand. *The Art of the Renaissance*. Trans. I. Mark Paris. New York: Abrams, 1994.
- Minor, Vernon Hyde. Baroque & Rococo: Art & Culture. New York: Abrams, 1999.
- Paoletti, John T., and Gary M. Radke. Art in Renaissance Italy. 3rd ed. Upper Saddle River, NJ: Pearson/Prentice Hall, 2005.
- Smith, Jeffrey Chipps. *The Northern Renaissance*. Art & Ideas. London and New York: Phaidon Press, 2004.
- Stechow, Wolfgang. Northern Renaissance, 1400–1600: Sources and Documents. Upper Saddle River, NJ: Pearson/ Prentice Hall, 1966.
- Summerson, John. Architecture in Britain, 1530–1830. 9th ed. Pelican History of Art. New Haven: Yale Univ. Press, 1993.

- Waterhouse, Ellis K. Painting in Britain, 1530–1790. 5th ed. Pelican History of Art. New Haven: Yale Univ. Press, 1994.
- Whinney, Margaret Dickens. Sculpture in Britain: 1530– 1830. 2nd ed. Revised John Physick. Pelican History of Art. London: Penguin, 1988.

Modern Art in the West, General

- Arnason, H.H., and Elizabeth C. Mansfield. History of Modern Art: Painting, Sculpture, Architecture, Photography. 6th ed. Upper Saddle River, NJ: Pearson/Prentice Hall, 2009.
- Ballantyne, Andrew, ed. Architectures: Modernism and After. New Interventions in Art History, 3. Malden, MA: Blackwell, 2004.
- Barnitz, Jacqueline. Twentieth-Century Art of Latin America. Austin: Univ. of Texas Press, 2001.
- Bjelajac, David. American Art: A Cultural History. Rev. and expanded ed. Upper Saddle River, NJ: Pearson/Prentice Hall, 2005.
- Bowness, Alan. Modern European Art. World of Art. New York: Thames & Hudson, 1995.
- Brettell, Richard R. Modern Art, 1851–1929: Capitalism and Representation. Oxford History of Art. Oxford: Oxford Univ. Press, 1999.
- Chipp, Herschel B. Theories of Modern Art: A Source Book by Artists and Critics. California Studies in the History of Art, 11. Berkeley: Univ. of California Press, 1984.
- Clarke, Graham. *The Photograph*. Oxford History of Art. Oxford: Oxford Univ. Press, 1997.
- Craven, David. Art and Revolution in Latin America, 1910–1990. New Haven: Yale Univ. Press, 2002.
- Craven, Wayne. American Art: History and Culture. 2nd ed. Boston: McGraw-Hill, 2003.
- Doordan, Dennis P. Twentieth-Century Architecture. New York: Abrams, 2002.
- Doss, Erika. Twentieth-Century American Art. Oxford History of Art. Oxford: Oxford Univ. Press, 2002.
- Edwards, Steve, and Paul Wood, eds. Art of the Avant-Gardes. Art of the 20th Century. New Haven: Yale
- Univ. Press, 2004.
- Foster, Hal, et al. Art Since 1900: Modernism, Antimodernism, Postmodernism. New York: Thames & Hudson, 2004.
- Gaiger, Jason, ed. Frameworks for Modern Art. Art of the 20th Century. New Haven: Yale Univ. Press, 2003.
- ——, and Paul Wood, eds. Art of the Twentieth Century: A Reader. New Haven: Yale Univ. Press, 2003.
- Hamilton, George Heard. Painting and Sculpture in Europe, 1880–1940. 6th ed. Pelican History of Art. New Haven: Yale Univ. Press, 1993.
- Hammacher, A.M. Modern Sculpture: Tradition and Innovation. Enl. ed. New York: Abrams, 1988.
- Harris, Ann Sutherland, and Linda Nochlin. Women Artists: 1550–1950. Los Angeles: Los Angeles County Museum of Art, 1976.
- Harrison, Charles, and Paul Wood, eds. Art in Theory: 1900–2000: An Anthology of Changing Ideas. 2nd ed. Malden, MA: Blackwell, 2003.
- Hunter, Sam, John Jacobus, and Daniel Wheeler. Modern Art: Painting, Sculpture, Architecture, Photography. 3rd rev. & exp. ed. Upper Saddle River, NJ: Pearson/Prentice Hall, 2004.
- Krauss, Rosalind E. Passages in Modern Sculpture. Cambridge, MA: MIT Press, 1977.
- Mancini, JoAnne Marie. Pre-Modernism: Art-World Change and American Culture from the Civil War to the Armory Show. Princeton, NJ: Princeton Univ. Press, 2005.
- Marien, Mary Warner. Photography: A Cultural History. 3rd ed. Upper Saddle River, NJ: Pearson/Prentice Hall, 2011.
- Meecham, Pam, and Julie Sheldon. *Modern Art: A Critical Introduction*. 2nd ed. New York: Routledge, 2005.
- Newlands, Anne. Canadian Art: From Its Beginnings to 2000. Willowdale, Ont.: Firefly Books, 2000.
- Phaidon Atlas of Contemporary World Architecture. London: Phaidon Press, 2004.
- Powell, Richard J. Black Art: A Cultural History. World of Art. 2nd ed. New York: Thames & Hudson, 2003.
- Rosenblum, Naomi. A World History of Photography. 4th ed. New York: Abbeville Press, 2007.

Scully, Vincent Joseph. Modern Architecture and Other Essays.

Ruhrberg, Karl. Art of the 20th Century. Ed. Ingo F. Walther. 2 vols. New York: Taschen, 1998.

Princeton, NJ: Princeton Univ. Press, 2003.

Univ. of California Press, 1996.

Stiles, Kristine, and Peter Selz. Theories and Documents

of Contemporary Art: A Sourcebook of Artists' Writings.

California Studies in the History of Art, 35. Berkeley:

BIBLIOGRAPHY

573

- Tafuri, Manfredo. Modem Architecture. History of World Architecture. 2 vols. New York: Electa/Rizzoli, 1986.
- Upton, Dell. Architecture in the United States. Oxford History of Art. Oxford: Oxford Univ. Press, 1998.
- Wood, Paul, ed. Varieties of Modernism. Art of the 20th Century. New Haven: Yale Univ. Press, 2004.
- Woodham, Jonathan M. Twentieth-Century Design. Oxford History of Art. Oxford: Oxford Univ. Press, 1997.

Asian Art, General

- Addiss, Stephen, Gerald Groemer, and J. Thomas Rimer, eds. Traditional Japanese Arts and Culture: An Illustrated Sourcebook. Honolulu: Univ. of Hawai'i Press, 2006.
- Barnhart, Richard M. Three Thousand Years of Chinese Painting. New Haven: Yale Univ. Press, 1997. Blunden, Caroline, and Mark Elvin. Cultural Atlas of China.
- 2nd ed. New York: Checkmark Books, 1998. Brown. Kerry, ed. Sikh Art and Literature. New York:
- Routledge in collaboration with the Sikh Foundation, 1999.
- Chang, Léon Long-Yien, and Peter Miller. Four Thousand Years of Chinese Calligraphy. Chicago: Univ. of Chicago Press, 1990.
- Chang, Yang-mo. Arts of Korea. Ed. Judith G. Smith. New York: Metropolitan Museum of Art, 1998.
- Clark, John. Modern Asian Art. Honolulu: Univ. of Hawai'i Press, 1998.
- Clunas, Craig. Art in China. 2nd ed. Oxford History of Art. Oxford: Oxford Univ. Press, 2009.
- Coaldrake, William H. Architecture and Authority in Japan. London: Routledge, 1996.
- Collcutt, Martin, Marius Jansen, and Isao Kumakura. Cultural Atlas of Japan. New York: Facts on File, 1988.
- Craven, Roy C. Indian Art: A Concise History. Rev. ed. World of Art. New York: Thames & Hudson, 1997.
- Dehejia, Vidya. Indian Art. Art & Ideas. London: Phaidon Press, 1997.
- Fisher, Robert E. Buddhist Art and Architecture. World of Art. New York: Thames & Hudson, 1993.
- Fu, Xinian. Chinese Architecture. Ed. & exp., Nancy S. Steinhardt. New Haven: Yale Univ. Press, 2002.
- Hearn, Maxwell K., and Judith G. Smith, eds. Arts of the Sung and Yian: Papers Prepared for an International Symposium. New York: Dept. of Asian Art, Metropolitan Museum of Art, 1996.
- Heibonsha Survey of Japanese Art. 31 vols. New York: Weatherhill, 1972–80.
- Hertz, Betti-Sue. Past in Reverse: Contemporary Art of East Asia. San Diego: San Diego Museum of Art, 2004.
- Japanese Arts Library. 15 vols. New York: Kodansha International, 1977–87.
- Kerlogue, Fiona. Arts of Southeast Asia. World of Art. New York: Thames & Hudson, 2004.
- Khanna, Balraj, and George Michell. Human and Divine: 2000 Years of Indian Sculpture. London: Hayward Gallery, 2000.
- Lee, Sherman E. A History of Far Eastern Art. 5th ed. Ed.
 Naomi Noble Richards. New York: Abrams, 1994.
 China, 5000 Years: Innovation and Transformation in the Arts. New York: Solomon R. Guggenheim Museum, 1998
- Liu, Cary Y., and Dora C.Y. Ching, eds. Arts of the Sung and Yüan: Ritual, Ethnicity, and Style in Painting. Princeton, NJ: Art Museum, Princeton Univ., 1999.
- McArthur, Meher. The Arts of Asia: Materials, Techniques, Styles. New York: Thames & Hudson, 2005.
- Mason, Penelope. *History of Japanese Art.* 2nd ed. Upper Saddle River, NJ: Pearson/Prentice Hall, 2005.
- Michell, George. Hindu Art and Architecture. World of Art. London: Thames & Hudson, 2000.
- -------. The Penguin Guide to the Monuments of India. 2 vols. New York: Viking, 1989.
- Mitter, Partha. Indian Art. Oxford History of Art. Oxford: Oxford Univ. Press, 2001.
- Murase, Miyeko. Bridge of Dreams: The Mary Griggs Burke Collection of Japanese Art. New York: Metropolitan Museum of Art, 2000.
- Nickel, Lukas, ed. Return of the Buddha: The Qingzhou Discoveries. London: Royal Academy of Arts, 2002.
- Pak, Youngsook, and Roderick Whitfield. Buddhist Sculpture. Handbook of Korean Art. London: Laurence King Publishing, 2003.
- Sullivan, Michael. *The Arts of China*. 5th ed., rev. & exp. Berkeley: Univ. of California Press, 2008.

BIBLIOGRAPHY

574

- Thorp, Robert L., and Richard Ellis Vinograd. Chinese Art & Culture. New York: Abrams, 2001.
- Topsfield, Andrew, ed. In the Realm of Gods and Kings: Arts of India. London: Philip Wilson, 2004.
- Tucker, Jonathan. The Silk Road: Art and History. Chicago: Art Media Resources, 2003.
- Tregear, Mary. *Chinese Art.* Rev. ed. World of Art. New York: Thames & Hudson, 1997.
- Vainker, S.J. Chinese Pottery and Porcelain: From Prehistory to the Present. New York: Braziller, 1991.

African and Oceanic Art and Art of the Americas, General

- Anderson, Richard L., and Karen L. Field, eds. Art in Small-Scale Societies: Contemporary Readings. Upper Saddle River, NJ: Pearson/Prentice Hall, 1993.
- Bacquart, Jean-Baptiste. The Tribal Arts of Africa. New York: Thames & Hudson, 1998.
- Bassani, Ezio, ed. Arts of Africa: 7000 Years of African Art. Milan: Skira, 2005.
- Benson, Elizabeth P. Retratos: 2,000 Years of Latin American Portraits. San Antonio, TX: San Antonio Museum of Art, 2004.
- Berlo, Janet Catherine, and Lee Anne Wilson. Arts of Africa, Oceania, and the Americas: Selected Readings. Upper Saddle River, NJ: Prentice Hall, 1993.
- Calloway, Colin G. First Peoples: A Documentary Survey of American Indian History. 3rd ed. Boston: Bedford/St. Martin's, 2008.
- Coote, Jeremy, and Anthony Shelton, eds. Anthropology, Art, and Aesthetics. New York: Oxford Univ. Press, 1992.
- Drewal, Henry, and John Pemberton III. Yoruba: Nine Centuries of African Art and Thought. New York: Center for African Art, 1989.
- Evans, Susan Toby. Ancient Mexico & Central America: Archaeology and Culture History. 2nd ed. New York: Thames & Hudson, 2008.
- ——, and David L. Webster, eds. Archaeology of Ancient Mexico and Central America: An Encyclopedia. New York: Garland, 2001.
- —, and Joanne Pillsbury, eds. Palaces of the Ancient New World: A Symposium at Dumbarton Oaks, 10th and 11th October, 1998. Washington, DC: Dumbarton Oaks Research Library and Collection, 2004.
- Geoffroy-Schneiter, Bérénice. *Tribal Arts*. New York: Vendome Press, 2000.
- Hiller, Susan, ed. & compiled. The Myth of Primitivism: Perspectives on Art. London: Routledge, 1991.
- Mack, John, ed. Africa, Arts and Cultures. London: British Museum Press, 2000.
- Mexico: Splendors of Thirty Centuries. New York: Metropolitan Museum of Art, 1990.
- Nunley, John W., and Cara McCarty. Masks: Faces of Culture. New York: Abrams in assoc. with the Saint Louis Art Museum, 1999.
- Perani, Judith, and Fred T. Smith. *The Visual Arts of Africa: Gender, Power, and Life Cycle Rituals.* Upper Saddle River, NJ: Pearson/Prentice Hall, 1998.
- Phillips, Tom, ed. Africa: The Art of a Continent. New York: Prestel, 1995.
- Price, Sally. *Primitive Art in Civilized Places.* 2nd ed. Chicago: Univ. of Chicago Press, 2001.
- Rabineau, Phyllis. Feather Arts: Beauty, Wealth, and Spirit from Five Continents. Chicago: Field Museum of Natural History, 1979.
- Schuster, Carl, and Edmund Carpenter. Patterns that Connect: Social Symbolism in Ancient & Tribal Art. New York: Abrams, 1996.
- Scott, John F. Latin American Art: Ancient to Modern. Gainesville: Univ. Press of Florida, 1999.
- Stepan, Peter. Africa. Trans. John Gabriel and Elizabeth Schwaiger. London: Prestel, 2001.
- Visonà, Monica Blackmun, et al. A History of Art in Africa. 2nd ed. Upper Saddle River, NJ: Pearson/Prentice Hall, 2008.

Introduction

- Acton, Mary. Learning to Look at Paintings. 2nd ed. New York: Routledge, 2009.
- Arnold, Dana. Art History: A Very Short Introduction. Oxford and New York: Oxford Univ. Press, 2004.
- Baxandall, Michael. Patterns of Intention: On the Historical Explanation of Pictures. New Haven: Yale Univ. Press, 1985.
- Clearwater, Bonnie. *The Rothko Book*. London: Tate Publishing, 2006.

- Decoteau, Pamela Hibbs. Clara Peeters, 1594–ca.1640 and the Development of Still-Life Painting in Northern Europe. Lingen: Luca Verlag, 1992.
- Geertz, Clifford. "Art as a Cultural System." Modern Language Notes 91 (1976): 1473–1499.
- Hochstrasser, Julie Berger. Still Life and Trade in the Dutch Golden Age. New Haven: Yale Univ. Press, 2007.
- Holstein, Jonathan. The Pieced Quilt: An American Design Tradition. New York: Galahad Books, 1973.
- Jolly, Penny Howell. "Rogier van der Weyden's Escorial and Philadelphia Crucifixions and Their Relation to Fra Angelico at San Marco." Oud Holland 95 (1981): 113–126.
- Mainardi, Patricia. "Quilts: The Great American Art." The Feminist Art Journal 2/1 (1973): 1, 18–23.
- Miller, Angela L., et al. American Encounters: Art, History, and Cultural Identity. Upper Saddle River, NJ: Pearson/ Prentice Hall, 2008.
- Minor, Vernon Hyde. Art History's History. Upper Saddle River, NJ: Pearson/Prentice Hall, 2001.
- Nelson, Robert S., and Richard Shiff, eds. Critical Terms for Art History. 2nd ed. Chicago: Univ. of Chicago Press, 2003.
- Panofsky, Erwin. Studies in Iconology: Humanistic Themes in the Art of the Renaissance. New York: Oxford Univ. Press, 1939.
- _____. Meaning in the Visual Arts. Phoenix ed. Chicago: Univ. of Chicago Press, 1982.
- Preziosi, Donald, ed. The Art of Art History: A Critical Anthology. 2nd ed. Oxford and New York: Oxford Univ. Press, 2009.
- Rothko, Mark. Writings on Art. Ed. Miguel López-Remiro. New Haven: Yale Univ. Press, 2006.
- _____. The Artist's Reality: Philosophies of Art. Ed. Christopher Rothko. New Haven: Yale Univ. Press, 2004.
- Schapiro, Meyer. "The Apples of Cézanne: An Essay on the Meaning of Still Life." Art News Annual 34 (1968): 34–53. Reprinted in Modern Art 19th & 20th Centuries: Selected Papers 2, London: Chatto & Windus, 1978.
- Sovers, Robert. Rethinking the Forms of Visual Expression. Berkelev: Univ. of California Press, 1990.
- Taylor, Joshua. Learning to Look: A Handbook for the Visual Arts. 2nd ed. Chicago: Chicago Univ. Press, 1981.
- Tucker, Mark. "Rogier van der Weyden's 'Philadelphia Crucifixion."" Burlington Magazine 139 (1997): 676–683.
- Wang, Fangyu, et al., eds. Master of the Lotus Garden: The Life and Art of Bada Shanren (1626–1705). New Haven: Yale Univ. Press, 1990.

Chapter 1 Prehistoric Art

2001.

1987.

- Aujoulat, Norbert. Lascaux: Movement, Space, and Time. New York: Abrams, 2005.
- Bahn, Paul G. The Cambridge Illustrated History of Prehistoric Art. Cambridge Illustrated History. Cambridge: Cambridge Univ. Press, 1998.
- Bataille, Georges. The Cradle of Humanity: Prehistoric Art and Culture. Ed. Stuart Kendall. Trans. Michelle Kendall and Stuart Kendall. New York: Zone Books, 2005. Berghaus, Gunter. New Perspectives on Prehistoric Art.
- Westport, CT: Praeger, 2004.
- Chippindale, Christopher. Stonehenge Complete. 3rd ed. New York: Thames & Hudson, 2004.
- Clottes, Jean. Chauvet Cave: The Art of Earliest Times. Salt Lake City: Univ. of Utah Press, 2003.
- , and J. David Lewis-Williams. The Shamans of Prehistory: Trance and Magic in the Painted Caves. Trans. Sophie Hawkes. New York: Abrams, 1998. Connah, Graham. African Civilizations: An Archaeological

Perspective. 2nd ed. Cambridge: Cambridge Univ. Press,

Coulson, David, and Alec Campbell. African Rock Art: Painting

Prehistoric Europe. New York: Oxford Univ. Press, 2001.

Early Art. Chicago: Institute for Prehistoric Investigation,

Forte, Maurizio, and Alberto Siliotti. Virtual Archaeology: Re-

Creating Ancient Worlds. New York: Abrams, 1997.

Garlake, Peter S. The Hunter's Vision: The Prehistoric Art of

Zimbabwe. Seattle: Univ. of Washington Press, 1995.

Gowlett, John A.J. Ascent to Civilization: The Archaeology of

Guthrie, R. Dale. The Nature of Paleolithic Art. Chicago:

Univ. of Chicago Press, 2005.

Early Humans. 2nd ed. New York: McGraw-Hill, 1993.

Freeman, Leslie G. Altamira Revisited and Other Essays on

and Engravings on Stone. New York: Abrams, 2001.

Cunliffe, Barry W., ed. The Oxford Illustrated History of

- Jope, E.M. Early Celtic Art in the British Isles. 2 vols. New York: Oxford Univ. Press, 2000.
- Kenrick, Douglas M. Jomon of Japan: The World's Oldest Pottery. New York: Kegan Paul, 1995.
- Leakey, Richard E., and Roger Lewin. Origins Reconsidered: In Search of What Makes Us Human. New York: Doubleday, 1992.
- Le Quellec, Jean-Loïc. Rock Art in Africa: Mythology and Legend. Trans. Paul Bahn. Paris: Flammarion, 2004. Leroi-Gourhan, André. The Dawn of European Art: An
- Introduction to Paleolithic Cave Painting. Trans. Sara Champion. Cambridge: Cambridge Univ. Press, 1982.
- Lewis-Williams, J. David. The Mind in the Cave: Consciousness and the Origins of Art. New York: Thames & Hudson, 2002.
- O'Kelly, Michael J. Newgrange: Archaeology, Art, and Legend. New Aspects of Antiquity. London: Thames & Hudson, 1982.
- Price, T. Douglas. Images of the Past. 5th ed. Boston: McGraw-Hill, 2008.
- Renfrew, Colin, ed. The Megalithic Monuments of Western Europe. London: Thames & Hudson, 1983.
- Sandars, N.K. Prehistoric Art in Europe. 2nd ed. Pelican History of Art. New Haven: Yale Univ. Press, 1992. Sura Ramos, Pedro A. The Cave of Altamira. Gen. Ed.
- Antonio Beltran. New York: Abrams, 1999. Sieveking, Ann. *The Cave Artists*. Ancient People and
- Places, vol. 93. London: Thames & Hudson, 1979. White, Randall. Prehistoric Art: The Symbolic Journey of
- Mankind. New York: Abrams, 2003.

Chapter 2 Art of the Ancient Near East

- Akurgal, Ekrem. Ancient Civilizations and Ruins of Turkey: From Prehistoric Times until the End of the Roman Empire. 5th ed. London: Kegan Paul, 2002.
- Aruz, Joan, et al., eds. Beyond Babylon: Art, Trade, and Diplomacy in the Second Millennium B.C. New Haven: Yale Univ. Press, and Metropolitan Museum of Art, 2008. ——, ed. Art of the First Cities: The Third Millennium B.C. from the Mediterranean to the Indus. New York:
- Metropolitan Museum of Art, 2003. Bahrani, Zainab. The Graven Image: Representation in Babylonia and Assyria. Archaeology, Culture, and Society Series. Philadelphia: Univ. of Pennsylvania Press, 2003.
- Boardman, John. Persia and the West: An Archaeological Investigation of the Genesis of Achaemenid Art. New York: Thames & Hudson, 2000.
- Bottero, Jean. Everyday Life in Ancient Mesopotamia. Trans. Antonia Nevill. Baltimore, MD: Johns Hopkins Univ. Press, 2001.
- Charvat, Petr. *Mesopotamia before History*. Rev. & updated ed. New York: Routledge, 2002.
- Crawford, Harriet. Sumer and the Sumerians. 2nd ed. New York: Cambridge Univ. Press, 2004.
- Curtis, John, and Nigel Tallis, eds. Forgotten Empire: The World of Ancient Persia. Berkeley: Univ. of California Press, 2005.
- Ferrier, R.W., ed. *The Arts of Persia*. New Haven: Yale Univ. Press, 1989.
- Frankfort, Henri. The Art and Architecture of the Ancient Orient. 5th ed. Pelican History of Art. New Haven: Yale Univ. Press, 1996.
- Haywood, John. Ancient Civilizations of the Near East and Mediterranean. London: Cassell, 1997.
- Meyers, Eric M., ed. The Oxford Encyclopedia of Archaeology in the Near East. 5 vols. New York: Oxford Univ. Press, 1997.
- Moorey, P.R.S. Idols of the People: Miniature Images of Clay in the Ancient Near East. The Schweich Lectures of the British Academy, 2001. New York: Oxford Univ. Press, 2003.
- Polk, Milbry, and Angela M.H. Schuster. *The Looting of the Iraq Museum, Baghdad: The Lost Legacy of Ancient Mesopotamia.* New York: Abrams, 2005.
- Reade, Julian. Assyrian Sculpture. Cambridge, MA: Harvard Univ. Press, 1999.
- Roaf, Michael. Cultural Atlas of Mesopotamia and the Ancient Near East. New York: Facts on File, 1990.
- Roux, Georges. Ancient Iraq. 3rd ed. London: Penguin, 1992. Winter, Irene. "Sex, Rhetoric, and the Public Monument: The Alluring Body of the Male Ruler." In Sexuality in Ancient Art, eds Natalie Kampen and Bettina A.
- Bergmann. Cambridge: Cambridge Univ. Press, 1996: 11–26. Zettler, Richard L., and Lee Horne, ed. *Treasures from the*
- Royal Tombs of Ur. Philadelphia: Univ. of Pennsylvania, Museum of Archaeology and Anthropology, 1998.

Chapter 3 Art of Ancient Egypt

- Arnold, Dieter. Temples of the Last Pharaohs. New York: Oxford Univ. Press, 1999.
- Baines, John, and Jaromír Málek. Cultural Atlas of Ancient Egypt. Rev. ed. New York: Facts on File, 2000.
- Brier, Bob. Egyptian Mummies: Unraveling the Secrets of an Ancient Art. New York: Morrow, 1994.
- *Egyptian Art in the Age of the Pyramids.* New York: Metropolitan Museum of Art, 1999.
- The Egyptian Book of the Dead: The Book of Going Forth by Day: Being the Papyrus of Ani (Royal Scribe of the Divine Offerings). 2nd rev. ed. Trans. Raymond O. Faulkner. San Francisco: Chronicle, 2008.
- Freed, Rita E., Sue D'Auria, and Yvonne J. Markowitz. *Pharaohs of the Sun: Akhenaten, Nefertiti, Tutankhamen.* Boston: Museum of Fine Arts in assoc. with Bulfinch Press/Little, Brown, 1999.
- Hawass, Zahi A. Tutankhamun and the Golden Age of the Pharaohs. Washington, DC: National Geographic, 2005.
- Johnson, Paul. The Civilization of Ancient Egypt. Updated ed. New York: HarperCollins, 1999.
- Kozloff, Arielle P. Egypt's Dazzling Sun: Amenhotep III and His World. Cleveland: Cleveland Museum of Art, 1992. Lehner, Mark. The Complete Pyramids. New York: Thames
- & Hudson, 2008. Love Songs of the New Kingdom. Trans. John L. Foster. New
- York: Scribner, 1974; Austin: Univ. of Texas Press, 1992. Málek, Jaromir. Egypt: 4,000 Years of Art. London: Phaidon
- Press, 2003. Pemberton, Delia. Ancient Egypt. Architectural Guides for
- Travelers. San Francisco: Chronicle, 1992. Robins, Gay. *The Art of Ancient Egypt*. Rev. ed. Cambridge, MA: Harvard Univ. Press, 2008.
- Roehrig, Catharine H., Renee Dreyfus, and Cathleen A. Keller. *Hatshepsut, from Queen to Pharaoh*. New York: Metropolitan Museum of Art, 2005.
- Russmann, Edna R. Egyptian Sculpture: Cairo and Luxor. Austin: Univ. of Texas Press, 1989.
- Smith, Craig B. *How the Great Pyramid Was Built.* Washington, DC: Smithsonian Books, 2004.
- Smith, William Stevenson. The Art and Architecture of Ancient Egypt. 3rd ed. Revised William Kelly Simpson. Pelican History of Art. New Haven: Yale Univ. Press, 1998.
- Strouhal, Eugen. Life of the Ancient Egyptians. Trans. Deryck Viney. Norman: Univ. of Oklahoma Press, 1992.
- Strudwick, Nigel, and Helen Strudwick. Thebes in Egypt: A Guide to the Tombs and Temples of Ancient Luxor. Ithaca, NY: Cornell Univ. Press, 1999.
- Thomas, Thelma K. Late Antique Egyptian Funerary Sculpture: Images for this World and for the Next. Princeton, NJ: Princeton Univ. Press, 2000.
- Tiradritti, Francesco. Ancient Egypt: Art, Architecture and History. Trans. Phil Goddard. London: British Museum Press, 2002.
- The Treasures of Ancient Egypt: From the Egyptian Museum in Cairo. New York: Rizzoli, 2003.

Ancient Egyptian Painting and Sculpture. London: Thames & Hudson, 1992. Winstone, H.V.F. Howard Carter and the Discovery of the Tomb

- of Tutankhamen. Rev. ed. Manchester: Barzan, 2006.
- Ziegler, Cristiane, ed. The Pharaohs. New York: Rizzoli, 2002.
- Zivie-Coche, Christiane. Sphinx: History of a Monument. Trans. David Lorton. Ithaca, NY: Cornell Univ. Press, 2002.

Chapter 4 Art of the Ancient Aegean

- Demargne, Pierre. The Birth of Greek Art. Trans. Stuart Gilbert and James Emmons. Arts of Mankind, vol. 6. New York: Golden, 1964.
- Doumas, Christos. The Wall-Paintings of Thera. 2nd ed. Trans. Alex Doumas. Athens: Kapon Editions, 1999.
- Fitton, J. Lesley. *Cycladic Art.* 2nd ed. London: British Museum Press, 1999.
- Getz-Gentle, Pat. Personal Styles in Early Cycladic Sculpture. Madison: Univ. of Wisconsin Press, 2001.
- Hamilakis, Yannis. ed. Labyrinth Revisited: Rethinking "Minoan" Archaeology. Oxford: Oxbow, 2002.
- Hendrix, Elizabeth. "Painted Ladies of the Early Bronze Age," *The Metropolitan Museum of Art Bulletin* New Series, 55/3 (Winter 1997–1998): 4–15.

- Higgins, Reynold A. Minoan and Mycenean Art. New. ed. World of Art. New York: Thames & Hudson, 1997.
- Hitchcock, Louise. Minoan Architecture: A Contextual Analysis. Studies in Mediterranean Archaeology and Literature, Pocket-Book, 155. Jonsered: P. Åströms Förlag, 2000.
- Hoffman, Gail L. "Painted Ladies: Early Cycladic II Mourning Figures?" American Journal of Archaeology 106/4 (October 2002): 525–550.
- Immerwahr, Sara Anderson. Aegean Painting in the Bronze Age. University Park: Pennsylvania State Univ. Press, 1990.
- Preziosi, Donald, and Louise Hitchcock. *Aegean Art and Architecture*. Oxford History of Art. Oxford: Oxford Univ. Press, 1999.
- Shelmerdine, Cynthia W., ed. The Cambridge Companion to the Aegean Bronze Age. New York: Cambridge Univ. Press, 2008.
- Strasser, Thomas F. "Location and Perspective in the Theran Flotilla Fresco," Journal of Mediterranean Archaeology 23/1 (2010): 3-26.

Chapter 5 Art of Ancient Greece

- Barletta, Barbara A. The Origins of the Greek Architectural Orders. New York: Cambridge Univ. Press, 2001.
- Beard, Mary. *The Parthenon*. Cambridge, MA: Harvard Univ. Press, 2003.
- Belozerskaya, Marina, and Kenneth D.S. Lapatin. Ancient Greece: Art, Architecture, and History. Los Angeles: J. Paul Getty Museum, 2004.
- Boardman, John. Early Greek Vase Painting: 11th–6th Centuries B.C.: A Handbook. World of Art. London: Thames & Hudson, 1998.
- ———. Greek Sculpture: The Archaic Period: A Handbook. World of Art. London: Thames & Hudson, 1991. ———. Greek Sculpture: The Classical Period: A Handbook.
- London: Thames & Hudson, 1985.
- ——. Greek Sculpture: The Late Classical Period and Sculpture in Colonies and Overseas. World of Art. New York: Thames & Hudson, 1995.
- ———. The History of Greek Vases: Potters, Painters, and Pictures. New York: Thames & Hudson, 2001. Burn, Lucilla. Hellenistic Art: From Alexander the Great to
- Augustus. Los Angeles: J. Paul Getty Museum, 2004.
- Clark, Andrew J., Maya Elston, and Mary Louise Hart. Understanding Greek Vases: A Guide to Terms, Styles, and Techniques. Los Angeles: J. Paul Getty Museum, 2002.
- De Grummond, Nancy T. and Brunilde S. Ridgway. From Pergamon to Sperlonga: Sculpture in Context. Berkeley: Univ. of California Press, 2000.
- Donohue, A.A. Greek Sculpture and the Problem of Description. New York: Cambridge Univ. Press, 2005.
- Fullerton, Mark D. Greek Art. Cambridge: Cambridge Univ. Press, 2000.
- Hard, Robin. The Routledge Handbook of Greek Mythology: Based on H.J. Rose's "Handbook of Greek Mythology." 7th ed. London: Routledge, 2008.
- Hurwit, Jeffrey M. The Acropolis in the Age of Pericles. New York: Cambridge Univ. Press, 2004.
- Karakasi, Katerina. Archaic Korai. Los Angeles: J. Paul Getty Museum, 2003.
- Lawrence, A.W. Greek Architecture. 5th ed. Revised R.A. Tomlinson. Pelican History of Art. New Haven: Yale Univ. Press, 1996.
- Martin, Roland. Greek Architecture: Architecture of Crete, Greece, and the Greek World. History of World Architecture. New York: Electa/Rizzoli, 1988.
- Neils, Jenifer. The British Museum Concise Introduction to Ancient Greece. Ann Arbor: Univ. of Michigan, 2008.
- Osborne, Robin. Archaic and Classical Greek Art. Oxford History of Art. Oxford: Oxford Univ. Press, 1998.
- Palagia, Olga, ed. Greek Sculpture: Function, Materials, and Techniques in the Archaic and Classical Periods. New York: Cambridge Univ. Press, 2006.
- —, and J.J. Pollitt, eds. Personal Styles in Greek Sculpture. Yale Classical Studies, vol. 30. Cambridge: Cambridge Univ. Press, 1996.
- Pedley, John Griffiths. Greek Art and Archaeology. 5th ed. Upper Saddle River, NJ: Pearson/Prentice Hall, 2012. Pollitt, J.J. Art and Experience in Classical Greece. Cambridge:

. The Art of Ancient Greece: Sources and Documents.

Fifth Century Styles in Greek Sculpture. Princeton,

BIBLIOGRAPHY

575

Cambridge Univ. Press, 1972; reprinted 1999.

2001

2nd ed. rev. Cambridge: Cambridge Univ. Press,

Ridgway, Brunilde Sismondo. The Archaic Style in Greek

Sculpture. 2nd ed. Chicago: Ares, 1993.

NJ: Princeton Univ. Press, 1981.

——. Fourth Century Styles in Greek Sculpture. Wisconsin Studies in Classics. Madison: Univ. of Wisconsin Press, 1997.

——. Hellenistic Sculpture 1: The Styles of ca. 331–200 B.C. Wisconsin Studies in Classics. Madison: Univ. of Wisconsin Press, 1990.

- Stafford, Emma J. Life, Myth, and Art in Ancient Greece. Los Angeles: J. Paul Getty Museum, 2004.
- Stewart, Andrew F. Greek Sculpture: An Exploration. 2 vols. New Haven: Yale Univ. Press, 1990.
- Whitley, James. *The Archaeology of Ancient Greece*. New York: Cambridge Univ. Press, 2001.

Chapter 6 Etruscan and Roman Art

- Bianchi Bandinelli, Ranuccio. Rome: The Centre of Power: Roman Art to A.D. 200. Trans. Peter Green. Arts of Mankind, 15. London: Thames & Hudson, 1971.
- Borrelli, Federica. The Etruscans: Art, Architecture, and History. Ed. Stefano Peccatori and Stefano Zuffi. Trans. Thomas Michael Hartmann. Los Angeles: J. Paul Getty Museum, 2004.
- Brendel, Otto J. Prolegomena to the Study of Roman Art. New Haven: Yale Univ. Press, 1979.
 ——. Etruscan Art. 2nd ed. Pelican History of Art. New
- Haven: Yale Univ. Press, 1995. Conlin, Diane Atnally. *The Artists of the Ara Pacis: The*
- Comin, Diare Anany. The Anisis of the And Parts. The Process of Hellenization in Roman Relief Sculpture. Studies in the History of Greece & Rome. Chapel Hill: Univ. of North Carolina Press, 1997.
- Cornell, Tim, and John Matthews. Atlas of the Roman World. New York: Facts on File, 1982.
- D'Ambra, Eve. Roman Art. Cambridge: Cambridge Univ. Press, 1998.
- Elsner, Jas. Imperial Rome and Christian Triumph: The Art of the Roman Empire A.D. 100–450. Oxford History of Art. Oxford: Oxford Univ. Press, 1998.
- Gabucci, Ada. Ancient Rome: Art, Architecture, and History. Eds. Stefano Peccatori and Stephano Zuffi. Trans. T.M. Hartman. Los Angeles: J. Paul Getty Museum, 2002.
- Haynes, Sybille. Etruscan Civilization: A Cultural History. Los Angeles: J. Paul Getty Museum, 2000.
- Holloway, R. Ross. Constantine & Rome. New Haven: Yale Univ. Press, 2004.
- Kleiner, Fred. S. A History of Roman Art. Belmont, CA: Thomson/Wadsworth, 2007.
- MacDonald, William L. The Architecture of the Roman Empire: An Introductory Study. Rev. ed. 2 vols. Yale Publications in the History of Art, 17, 35. New Haven: Yale Univ. Press, 1982.
- ———. The Pantheon: Design, Meaning, and Progeny. New foreword by John Pinto. Cambridge, MA: Harvard Univ. Press, 2002.
- Mattusch, Carol C. Pompeii and the Roman Villa: Art and Culture around the Bay of Naples. Washington, DC: National Gallery of Art, 2008.
- Mazzoleni, Donatella. Domus: Wall Painting in the Roman House. Los Angeles: J. Paul Getty Museum, 2004.
- Packer, James E. The Forum of Trajan in Rome: A Study of the Monuments in Brief. Berkeley: Univ. of California Press, 2001.
- Pollitt, J.J. The Art of Rome, c. 753 B.C.-337 A.D.: Sources and Documents. Upper Saddle River, NJ: Pearson/ Prentice Hall, 1966.
- Polybius. The Histories. Trans. W.R. Paton. 6 vols. Loeb Classical Library. Cambridge, MA: Harvard Univ. Press, 2000.
- Ramage, Nancy H., and Andrew Ramage. Roman Art: Romulus to Constantine. 5th ed. Upper Saddle River, NJ: Pearson/Prentice Hall, 2009.
- Spivey, Nigel. *Etruscan Art.* World of Art. New York: Thames & Hudson, 1997.
- Stamper, John W. The Architecture of Roman Temples: The Republic to the Middle Empire. New York: Cambridge Univ. Press, 2005.
- Stewart, Peter. Statues in Roman Society: Representation and Response. Oxford Studies in Ancient Culture and Representation. New York: Oxford Univ. Press, 2003.
- Strong, Donald. Roman Art. 2nd ed. rev. & annotated. Ed. Roger Ling. Pelican History of Art. New Haven: Yale Univ. Press, 1995.
- Ward-Perkins, J.B. Roman Architecture. History of World Architecture. New York: Electa/Rizzoli, 1988. ———. Roman Imperial Architecture. Pelican History of Art.
- New Haven: Yale Univ. Press, 1981.

BIBLIOGRAPHY

576

Wilson Jones, Mark. Principles of Roman Architecture. New Haven: Yale Univ. Press, 2000.

Chapter 7 Jewish and Early Christian Art

- Age of Spirituality: Late Antique and Early Christian Art, Third to Seventh Century. New York: Metropolitan Museum of Art, 1979.
- Beckwith, John. Early Christian and Byzantine Art. 2nd ed. Pelican History of Art. New Haven: Yale Univ. Press, 1986.
- Bleiberg, Edward, ed. Tree of Paradise: Jewish Mosaics from the Roman Empire. Brooklyn: Brooklyn Museum, 2005.
- Cioffarelli, Ada. Guide to the Catacombs of Rome and Its Surroundings. Rome: Bonsignori, 2000.
- Fine, Steven. Art and Judaism in the Greco-Roman World: Toward a New Jewish Archaeology. New York: Cambridge Univ. Press, 2005.
- Hachlili, Rachel. Ancient Mosaic Pavements: Themes, Issues, and Trends. Leiden: Brill, 2009.
- Jensen, Robin Margaret. Understanding Early Christian Art. New York: Routledge, 2000.
- Krautheimer, Richard, and Slobodan Curcic. Early Christian and Byzantine Architecture. 4th ed. Pelican History of Art. New Haven: Yale Univ. Press, 1992.
- Levine, Lee I., and Zeev Weiss, eds. From Dura to Sepphoris: Studies in Jewish Art and Society in Late Antiquity. Journal of Roman Archaeology: Supplementary Series, no. 40. Portsmouth, RI: Journal of Roman Archaeology, 2000. Lowden, John. Early Christian and Byzantine Art. Art &
- Ideas. London: Phaidon Press, 1997.
- Mathews, Thomas F. The Clash of Gods: A Reinterpretation of Early Christian Art. Rev. ed. Princeton, NJ: Princeton Univ. Press, 1999.
- Olin, Margaret. The Nation without Art: Examining Modern Discourses on Jewish Art. Lincoln: Univ. of Nebraska Press, 2001.
- Olsson, Birger, and Magnus Zetterholm, eds. The Ancient Synagogue from Its Origins until 200 C.E.: Papers Presented at an International Conference at Lund University, October 14–17, 2001. Coniectanea Biblica: New Testament Series, 39. Stockholm: Almqvist & Wiksell International, 2003.
- Rutgers, Leonard V. Subterranean Rome: In Search of the Roots of Christianity in the Catacombs of the Eternal City. Leuven: Peeters, 2000.
- Sed-Rajna, Gabrielle. *Jewish Art.* Trans. Sara Friedman and Mira Reich. New York: Abrams, 1997.
- Spier, Jeffrey, ed. Picturing the Bible: The Earliest Christian Art. New Haven: Yale Univ. Press, 2007.
- Tadgell, Christopher. Imperial Space: Rome, Constantinople and the Early Church. New York: Whitney Library of Design, 1998.
- Webb, Matilda. The Churches and Catacombs of Early Christian Rome: A Comprehensive Guide. Brighton, UK: Sussex Academic Press, 2001.
- Weitzmann, Kurt. Late Antique and Early Christian Book Illumination. New York: Braziller, 1977.
- Wharton, Annabel Jane. Refiguring the Post-Classical City: Dura Europos, Jerash, Jerusalem and Ravenna. Cambridge: Cambridge Univ. Press, 1995.
- White, L. Michael. The Social Origins of Christian Architecture. 2 vols. Baltimore, MD: Johns Hopkins Univ. Press, 1990.

Chapter 8 Byzantine Art

- Beckwith, John. *Early Christian and Byzantine Art.* 2nd ed. Pelican History of Art. New Haven: Yale Univ. Press, 1986.
- Cormack, Robin. Byzantine Art. Oxford: Oxford Univ. Press, 2000.
- —, and Maria Vassilaki, eds. Byzantium, 330–1453. London: Royal Academy of Arts, 2008.
- Cutler, Anthony. The Hand of the Master: Craftsmanship, Ivory, and Society in Byzantium 9th-11th Centuries. Princeton, NJ: Princeton Univ. Press, 1994.
- Durand, Jannic. Byzantine Art. Paris: Terrail, 1999
- Eastmond, Antony, and Liz James, eds. Icon and Word: The Power of Images in Byzantium: Studies Presented to Robin Cormack. Burlington, VT: Ashgate, 2003.
- Evans, Helen C., ed. Byzantium: Faith and Power (1261– 1557). New York: Metropolitan Museum of Art, 2004.
 —, and William D. Wixom, eds. The Glory of Byzantium: Art and Culture of the Middle Byzantine era, A.D. 843–1261. New York: Abrams, 1997.
- Freely, John. Byzantine Monuments of Istanbul. Cambridge & New York: Cambridge Univ. Press, 2004.
- Gerstel, Sharon, and Robert Nelson. Approaching the Holy Mountain: Art and Liturgy at St. Catherine's Monastery in the Sinai. Turnhout: Brepols, 2010.

- Grabar, André. Byzantine Painting: Historical and Critical
- Study. Trans. Stuart Gilbert. New York: Rizzoli, 1979. Kitzinger, Ernst. The Art of Byzantium and the Medieval
- West: Selected Studies. Ed. W. Eugene Kleinbauer. Bloomington: Indiana Univ. Press, 1976.
- ——. Byzantine Art in the Making: Main Lines of Stylistic Development in Mediterranean Art, 3rd–7th Century. Cambridge, MA: Harvard Univ. Press, 1977.
- Kleinbauer, W. Eugene. Hagia Sophia. London: Scala, 2004. Krautheimer, Richard, and Slobodan Curcic. Early Christian and Byzantine Architecture. 4th ed. Pelican History of Art. New Haven: Yale Univ. Press 1992
- Lowden, John. Early Christian and Byzantine Art. Art & Ideas. London: Phaidon Press, 1997.
- Maguire, Henry. The Icons of Their Bodies: Saints and Their Images in Byzantium. Princeton, NJ: Princeton Univ. Press, 1996.
- Mainstone, Rowland J. Hagia Sophia: Architecture, Structure and Liturgy of Justinian's Great Church. 2nd ed. New York: Thames & Hudson, 2001.
- Mango, Cyril. Art of the Byzantine Empire, 312–1453: Sources and Documents. Upper Saddle River, NJ: Pearson/ Prentice Hall, 1972.
- Mathews, Thomas F. Byzantium: From Antiquity to the Renaissance. Perspectives. New York: Abrams, 1998. Ousterhout, Robert. Master Builders of Byzantium.
- Princeton, NJ: Princeton Univ. Press, 1999. Pentcheva, Bissera. The Sensual Icon: Space, Ritual, and the
- Senses in Byzantium. University Park: Pennsylvania State Univ. Press, 2010.
- Procopius, with an English translation by H.B. Dewing. 7 vols. Loeb Classical Library. Cambridge, MA: Harvard Univ. Press, 1940.
- Rodley, Lyn. Byzantine Art and Architecture: An Introduction. Cambridge: Cambridge Univ. Press, 1994.
- Weitzmann, Kurt. Place of Book Illumination in Byzantine Art. Princeton, NJ: Art Museum, Princeton Univ., 1975.

Chapter 9 Islamic Art

- Al-Faruqi, Isma'il R., and Lois Ibsen Al-Faruqi. Cultural Atlas of Islam. New York: Macmillan, 1986.
- Atil, Esin. The Age of Sultan Suleyman the Magnificent. Washington, DC: National Gallery of Art, 1987.
- Baker, Patricia L. Islam and the Religious Arts. London: Continuum, 2004.
- Barry, Michael A. Figurative Art in Medieval Islam and the Riddle of Bihzåd of Heråt (1465–1535). Paris: Flammarion, 2004.
- Blair, Sheila S., and Jonathan Bloom. The Art and Architecture of Islam 1250–1800. Pelican History of Art. New Haven: Yale Univ. Press, 1995.
- Dodds, Jerrilynn D., ed. *Al-Andalus: The Art of Islamic Spain.* New York: Metropolitan Museum of Art, 1992.
- Ecker, Heather. Caliphs and Kings: The Art and Influence of Islamic Spain. Washington, DC: Arthur M. Sackler Gallery, 2004.
- Ettinghausen, Richard, Oleg Grabar, and Marilyn Jenkins-Madina. Islamic Art and Architecture, 650–1250. 2nd ed. Pelican History of Art. New Haven: Yale Univ. Press, 2001.
- Frishman, Martin, and Hasan-Uddin Khan. The Mosque: History, Architectural Development and Regional Diversity. London: Thames & Hudson, 1994.
- Grabar, Oleg. *The Formation of Islamic Art.* Rev. and enl. New Haven: Yale Univ. Press, 1987.

- ——, Monammad Al-Asad, Abeer Auden, and Said Nuseibeh. The Shape of the Holy: Early Islamic Jerusalem. Princeton, NJ: Princeton Univ. Press, 1996.
- Hillenbrand, Robert. Islamic Art and Architecture. World of Art. London: Thames & Hudson, 1999.
- Irwin, Robert. The Alhambra. Cambridge, MA: Harvard Univ. Press, 2004.
- Khalili, Nasser D. Visions of Splendour in Islamic Art and Culture. London: Worth Press, 2008.
- Komaroff, Linda, and Stefano Carboni, eds. The Legacy of Genghis Khan: Courtly Art and Culture in Western Asia, 1256–1353. New York: Metropolitan Museum of Art, 2002.
 Lentz, Thomas W., and Glenn D. Lowry. Timur and the

Princely Vision: Persian Art and Culture in the Fifteenth Century.

Los Angeles: Los Angeles County Museum of Art, 1989.

- Necipolu, Gülru. The Age of Sinan: Architectural Culture in the Ottoman Empire. Princeton, NJ: Princeton Univ. Press, 2005.
- Petruccioli, Attilio, and Khalil K. Pirani, eds. Understanding Islamic Architecture. New York: Routledge Curzon, 2002.
- Roxburgh, David J., ed. Turks: A Journey of a Thousand Years, 600–1600. London: Royal Academy of Arts, 2005.
- Sims, Eleanor, B.I. Marshak, and Ernst J. Grube. *Peerless Images: Persian Painting and Its Sources*. New Haven: Yale Univ. Press, 2002.
- Stanley, Tim, Mariam Rosser-Owen, and Stephen Vernoit. Palace and Mosque: Islamic Art from the Middle East. London: V&A Publications, 2004.
- Stierlin, Henri. Islamic Art and Architecture. New York: Thames & Hudson, 2002.
- Tadgell, Christopher. Four Caliphates: The Formation and Development of the Islamic Tradition. London: Ellipsis, 1998.
- Ward, R.M. Islamic Metalwork. New York: Thames & Hudson, 1993.
- Watson, Oliver. Ceramics from Islamic Lands. New York: Thames & Hudson in assoc. with the al-Sabah Collection, Dar al-Athar al-Islamiyyah, Kuwait National Museum, 2004.

Chapter 10 Art of South and Southeast Asia before 1200

- Atherton, Cynthia Packert. The Sculpture of Early Medieval Rajasthan. Studies in Asian Art and Archaeology, vol. 21. New York: Brill, 1997.
- Behl, Benoy K. The Ajanta Caves: Artistic Wonder of Ancient Buddhist India. New York: Abrams, 1998.
- Behrendt, Kurt A. The Buddhist Architecture of Gandhara. Handbook of Oriental Studies: Section Two: India, vol. 17. Boston: Brill, 2004.
- Chakrabarti, Dilip K. India, an Archaeological History: Palaeolithic Beginnings to Early Historic Foundations. 2nd ed. New York: Oxford Univ. Press, 2009.
- Craven, Roy C. Indian Art: A Concise History. Rev. ed. World of Art. New York: Thames & Hudson, 1997. Czuma, Stanisław J. Kushan Sculpture: Images from Early India.
- Cleveland: Cleveland Museum of Art, 1985.
- Dehejia, Vidya. Art of the Imperial Cholas. New York: Columbia Univ. Press, 1990.
- ———. The Sensuous and the Sacred: Chola Bronzes from South India. New York: American Federation of Arts, 2002.
- Dessai, Vishakha N., and Darielle Mason, eds. Gods, Guardians, and Lovers: Temple Sculptures from North India, A.D. 700–1200. New York: Asia Society Galleries, 1993.
- Dhavalikar, Madhukar Keshav. *Ellora*. New York: Oxford Univ. Press, 2003.
- Girard-Geslan, Maud. Art of Southeast Asia. Trans. J.A. Underwood. New York: Abrams, Inc., 1998.
- Heller, Amy. *Early Himalayan Art*. Oxford: Ashmolean Museum, 2008.
- Huntington, Susan L. The Art of Ancient India: Buddhist, Hindu, Jain. New York: Weatherhill, 1985.
- Leaves from the Bodhi Tree: The Art of Pala India (8th–12th Centuries) and Its International Legacy. Dayton, OH: Dayton Art Institute, 1990.
- Hutt, Michael. Nepal: A Guide to the Art and Architecture of the Kathmandu Valley. Boston: Shambhala, 1995.
- Knox, Robert. Amaravati: Buddhist Sculpture from the Great Stupa. London: British Museum Press, 1992.
- Khanna, Sucharita. Dancing Divinities in Indian Art: 8th-12th Century A.D. Delhi: Sharada Pub. House, 1999. Kramrisch, Stella. The Art of Nepal. New York: Abrams,
- Press, 1981. Meister, Michael, ed. Encyclopedia of Indian Temple Architecture. 2 vols. in 7. Philadelphia: Univ. of Pennsylvania Press, 1983.
- Michell, George. *Elephanta*. Bombay: India Book House, 2002.
- Mitter, Partha. Indian Art. Oxford History of Art. Oxford: Oxford Univ. Press, 2001.
- Neumayer, Erwin. Lines on Stone: The Prehistoric Rock Art of India. New Delhi: Manohar, 1993.
- Pal, Pratapaditya, ed. The Ideal Image: The Gupta Sculptural Tradition and Its Influence. New York: Asia Society, 1978.
- Poster, Amy G. From Indian Earth: 4,000 Years of Terracotta Art. Brooklyn, NY: Brooklyn Museum, 1986.

- Skelton, Robert, and Mark Francis. Arts of Bengal: The Heritage of Bangladesh and Eastern India. London: Whitechapel Art Gallery, 1979.
- Stierlin, Henri. Hindu India: From Khajuraho to the Temple City of Madurai. Taschen's World Architecture. New York: Taschen, 1998.
- Tadgell, Christopher. India and South-East Asia: The Buddhist and Hindu Tradition. New York: Whitney Library of Design, 1998.
- Williams, Joanna G. Art of Gupta India, Empire and Province. Princeton, NJ: Princeton Univ. Press, 1982.

Chapter 11 Chinese and Korean Art before 1279

- Ciarla, Roberto, ed. The Eternal Army: The Terracotta Soldiers of the First Chinese Emperor. Vercelli: White Star, 2005.
- Fong, Wen, ed. Beyond Representation: Chinese Painting and Calligraphy, 8th–14th Century. Princeton Monographs in Art and Archaeology, 48. New York: Metropolitan Museum of Art, 1992.
- Fraser, Sarah Elizabeth. Performing the Visual: The Practice of Buddhist Wall Painting in China and Central Asia, 618–960. Stanford, CA: Stanford Univ. Press, 2004.
- James, Jean M. A Guide to the Tomb and Shrine Art of the Han Dynasty 206 B.C.-A.D. 220. Chinese Studies, 2. Lewiston, NY: Mellen Press, 1996.
- Karetzky, Patricia Eichenbaum. Court Art of the Tang. Lanham, MD: Univ. Press of America, 1996.
- Kim, Kumja Paik. Goryeo Dynasty: Korea's Age of Enlightenment, 918–1392. San Francisco: Asian Art Museum—Chong-Moon Lee Center for Asian Art and Culture in cooperation with the National Museum of Korea and the Nara National Museum, 2003.
- Li, Jian, ed. The Glory of the Silk Road: Art from Ancient China. Dayton, OH: Dayton Art Institute, 2003.
- Little, Stephen, and Shawn Eichman. Taoism and the Arts of China. Chicago: Art Institute of Chicago, 2000.
- Liu, Cary Y., Dora C.Y. Ching, and Judith G. Smith, eds. Character & Context in Chinese Calligraphy. Princeton, NJ: Art Museum, Princeton Univ., 1999.
- Luo, Zhewen. Ancient Pagodas in China. Beijing, China: Foreign Languages Press, 1994.
- Ma, Chengyuan. Ancient Chinese Bronzes. Ed. Hsio-Yen Shih. Hong Kong: Oxford Univ. Press, 1986.
- Murck, Alfreda. Poetry and Painting in Song China: The Subile Art of Dissent. Harvard-Yenching Institute Monograph Series. Cambridge, MA: Harvard Univ. Asia Center for the Harvard-Yenching Institute, 2000.
- Ortiz, Valérie Malenfer. Dreaming the Southern Song Landscape: The Power of Illusion in Chinese Painting. Studies in Asian Art and Archaeology, vol. 22. Boston: Brill, 1999.
- Paludan, Ann. Chinese Tomb Figurines. Hong Kong: Oxford Univ. Press, 1994.
- Portal, Jane. Korea: Art and Archaeology. New York: Thames & Hudson, 2000.
- Rawson, Jessica. Mysteries of Ancient China: New Discoveries from the Early Dynasties. London: British Museum Press, 1996.
- Rhie, Marylin M. Early Buddhist Art of China and Central Asia. 2 vols in 3. Handbuch der Orientalistik. Vierte Abteilung; China, 12. Leiden: Brill, 1999.

Scarpari, Maurizio. Splendours of Ancient China. London: Thames & Hudson, 2000.

So, Jenny F. ed. Noble Riders from Pines and Deserts: The Artistic Legacy of the Qidan. Hong Kong: Art Museum, Chinese Univ. of Hong Kong, 2004.

Sturman, Peter Charles. Mi Fu: Style and the Art of Calligraphy in Northern Song. New Haven: Yale Univ. Press, 1997.

Wang, Eugene Y. Shaping the Lotus Sutra: Buddhist Visual Culture in Medieval China. Seattle: Univ. of Washington Press, 2005.

 Watson, William. The Arts of China to A.D. 900. Pelican History of Art. New Haven: Yale Univ. Press, 1995.
 — The Arts of China 900–1620. Pelican History of Art. Reissue ed. 2003. New Haven: Yale Univ. Press, 2000.

- Watt, James C.Y. China: Dawn of a Golden Age, 200–750 A.D. New York: Metropolitan Museum of Art, 2004.
- Whitfield, Susan, and Ursula Sims–Williams, eds. The Silk Road: Trade, Travel, War and Faith. Chicago: Serindia Publications, 2004.
- Wu Hung. Monumentality in Early Chinese Art and Architecture. Stanford, CA: Stanford Univ. Press, 1995.
- Yang, Xiaoneng, ed. The Golden Age of Chinese Archaeology: Celebrated Discoveries from the People's Republic of China. Washington, DC: National Gallery of Art, 1999.

Chapter 12 Japanese Art before 1333

- Cunningham, Michael R. Buddhist Treasures from Nara. Cleveland: Cleveland Museum of Art, 1998.
- Harris, Victor, ed. Shinto: The Sacred Art of Ancient Japan. London: British Museum Press, 2001.
- Izutsu, Shinryu, and Shoryu Omori. Sacred Treasures of Mount Koya: The Art of Japanese Shingon Buddhism. Honolulu: Koyasan Reihokan Museum, 2002.
- Kurata, Bunsaku. Horyu-ji, Temple of the Exalted Law: Early Buddhist Art from Japan. New York: Japan Society, 1981.
- Levine, Gregory P.A., and Yukio Lippit. Awakenings: Zen Figure Painting in Medieval Japan. New York: Japan Society, 2007.
- McCallum, Donald F. The Four Great Temples: Buddhist Archaeology, Architecture, and Icons of Seventh-Century Japan. Honolulu: Univ. of Hawai'i Press, 2009.
- J. J. Mino, Yutaka. The Great Eastern Temple: Treasures of Japanese Buddhist Art from Todai-ji. Chicago: Art Institute of Chicago, 1986.
- Mizoguchi, Koji. An Archaeological History of Japan: 30,000 B.C. to A.D. 700. Philadelphia: Univ. of Pennsylvania Press, 2002.
- Murase, Miyeko. The Tale of Genji: Legends and Paintings. New York: Braziller, 2001.
- Nishiwara, Kyotaro, and Emily J. Sano. The Great Age of Japanese Buddhist Sculpture, A.D. 60–1300. Fort Worth, TX: Kimbell Art Museum, 1982.
- Pearson, Richard J. Ancient Japan. Washington, DC: Arthur M. Sackler Gallery, 1992.
- Ten Grotenhuis, Elizabeth. Japanese Mandalas: Representations of Sacred Geography. Honolulu: Univ. of Hawai'i Press, 1999.
- Washizuka, Hiromitsu, Park Youngbok, and Kang Woobang. Transmitting the Forms of Divinity: Early Buddhist Art from Korea and Japan. Ed. Naomi Noble Richard. New York: Japan Society, 2003.
- Wong, Dorothy C., and Eric M. Field, eds. Horyuji Reconsidered. Newcastle: Cambridge Scholars, 2008.

Chapter 13 Art of the Americas before 1300

- Benson, Elizabeth P., and Beatriz de la Fuente. Olmec Art of Ancient Mexico. Washington, DC: National Gallery of Art, 1996.
- Berrin, Kathleen, ed. Feathered Serpents and Flowering Trees: Reconstructing the Murals of Teotihuacan. San Francisco: Fine Arts Museums of San Francisco, 1988.
- Brody, J.J. Anasazi and Pueblo Painting. Albuquerque: Univ. of New Mexico Press, 1991.
- Burger, Richard L. Chavin and the Origins of Andean Civilization. New York: Thames & Hudson, 1992.
- Clark, John E., and Mary E. Pye, eds. Olmec Art and Archaeology in Mesoamerica. Studies in the History of Art, 58: Symposium Papers, 35. Washington, DC: National Gallery of Art, 2000.
- Clayton, Lawrence A., Vernon J. Knight, and Edward Moore, eds. The De Soto Chronicles: The Expedition of Hernando de Soto to North America, 1539–1543. 2 vols. Tuscaloosa: Univ. of Alabama Press, 1993.
- Coe, Michael D. and Rex Koontz. Mexico: From the Olmecs to the Aztecs. 5th ed. New York: Thames & Hudson, 2005.

———. Breaking the Maya Code. Rev. ed. New York: Thames & Hudson, 1999.

- Donnan, Christopher. Moche Portraits from Ancient Peru. Austin: Univ. of Texas Press, 2003.
- Fagan, Brian M. Chaco Canyon: Archaeologists Explore the Lives of an Ancient Society. New York: Oxford Univ. Press, 2005.
- Hall, Robert L. An Archaeology of the Soul: North American Indian Belief and Ritual. Urbana: Univ. of Illinois Press, 1997.
- Heyden, Doris, and Paul Gendrop. Pre-Columbian Architecture of Mesoamerica. Trans. Judith Stanton. History of World Architecture. New York: Electa/Rizzoli, 1988.
- Korp, Maureen. The Sacred Geography of the American Mound Builders. Native American Studies. Lewiston, NY: Mellen Press, 1990.
- Kubler, George. The Art and Architecture of Ancient America: The Mexican, Maya, and Andean Peoples. 3rd ed. with updated bib. Pelican History of Art. New Haven: Yale Univ. Press, 1993.
- Labbé, Armand J. Shamans, Gods, and Mythic Beasts: Colombian Gold and Ceramics in Antiquity. New York: American Federation of Arts, 1998.
- LeBlanc, Steven A. Painted by a Distant Hand: Mimbres Pottery from the American Southwest. Cambridge, MA: Peabody Museum Press, 2004.

- Loendorf, Lawrence L., Christopher Chippindale, and David S. Whitley, eds. Discovering North American Rock Art. Tucson: Univ. of Arizona Press, 2005.
- Martin, Simon, and Nikolai Grube. Chronicle of the Maya Kings and Queens: Deciphering the Dynasties of the Ancient Maya. 2nd ed. New York: Thames & Hudson, 2008.
- Miller, Mary Ellen. The Art of Mesoamerica: From Olmec to Aztec. 4th ed. World of Art. London: Thames & Hudson, 2006.
- ——. Maya Art and Architecture. World of Art. London: Thames & Hudson, 1999.
- —, and Simon Martin. Courly Art of the Ancient Maya. San Francisco: Fine Arts Museums of San Francisco, 2004.
- ——, and Karl Taube. The Gods and Symbols of Ancient Mexico and the Maya: An Illustrated Dictionary of Mesoamerican Religion. London: Thames & Hudson, 1993.
- Milner, George R. The Moundbuilders: Ancient Peoples of Eastern North America. Ancient Peoples and Places, 110. London: Thames & Hudson, 2004.
- Noble, David Grant. In Search of Chaco: New Approaches to an Archaeological Enigma. Santa Fe, NM: School of American Research Press, 2004.
- O'Connor, Mallory McCane. Lost Cities of the Ancient Southeast. Gainesville: Univ. Press of Florida, 1995.
- Pasztory, Esther. Teotihuacan: An Experiment in Living. Norman: Univ. of Oklahoma Press, 1997.
- Pillsbury, Joanne, ed. Moche Art and Archaeology in Ancient Penu. Studies in the History of Art: Center for Advanced Study in the Visual Arts, 63: Symposium Papers, 40. Washington, DC: National Gallery of Art, 2001.
- Power, Susan C. Early Art of the Southeastern Indians: Feathered Serpents & Winged Beings. Athens: Univ. of Georgia Press, 2004.
- Rohn, Arthur H., and William M. Ferguson. Puebloan Ruins of the Southwest. Albuquerque: Univ. of New Mexico Press, 2006.
- Sharer, Robert J., and Loa P. Traxler. *The Ancient Maya*. 6th ed. Stanford, CA: Stanford Univ. Press, 2006.
- Stierlin, Henri. The Maya: Palaces and Pyramids of the Rainforest. Cologne: Taschen, 2001.
- Stone-Miller, Rebecca. Art of the Andes: From Chavin to Inca. 2nd ed. World of Art. New York: Thames & Hudson, 2002.
- ———. To Weave for the Sun: Ancient Andean Textiles. New York: Thames & Hudson 1994.
- Townsend, Richard F., and Robert V. Sharp, eds. Hero, Hawk, and Open Hand: American Indian Art of the Ancient Midwest and South. Chicago: Art Institute of Chicago, 2004.
- Von Hagen, Adriana, and Craig Morris. *The Cities of the Ancient Andes*. New York: Thames & Hudson, 1998.

Chapter 14 Early African Art

- Ben-Amos, Paula. *The Art of Benin*. Rev. ed. Washington, DC: Smithsonian Institution Press, 1995.
- Berzock, Kathleen Bickford. Benin: Royal Arts of a West African Kingdom. Chicago: Art Institute of Chicago, 2008. Blier, Suzanne Preston. The Royal Arts of Africa: The Majesty
- of Form. Perspectives. New York: Abrams, 1998. Cole, Herbert M. Igbo Arts: Community and Cosmos. Los
- Angeles: Fowler Museum of Cultural History, Univ. of California, 1984.
- Connah, Graham. African Civilizations: An Archaeological Perspective, 2nd ed. New York: Cambridge Univ. Press, 2001.
- ———. Forgotten Africa: An Introduction to Its Archaeology. New York: Routledge, 2004.
- Darish, Patricia J. "Memorial Head of an Oba: Ancestral Time in Benin Culture." In *Tempus Fugit, Time Flies*. Ed. Jan Schall. Kansas City, MO: Nelson-Atkins Museum of Art, 2000: 290–297.
- Eyo, Ekpo, and Frank Willett. Treasures of Ancient Nigeria. Ed. Rollyn O. Kirchbaum. New York: Knopf, 1980.
- Garlake, Peter S. Early Art and Architecture of Africa. Oxford History of Art. Oxford: Oxford Univ. Press, 2002.
- Grunne, Bernard de. The Birth of Art in Africa: Nok Statuary in Nigeria. Paris: A. Biro, 1998.
- Huffman, Thomas N. Symbols in Stone: Unravelling the Mystery of Great Zimbabwe. Johannesburg: Witwatersrand Univ. Press, 1987.
- LaViolette, Adria Jean. Ethno-Achaeology in Jenné, Mali: Craft and Status among Smiths, Potters, and Masons. Oxford: Archaeopress, 2000.
- M'Bow, Babacar, and Osemwegie Ebohon. Benin, a Kingdom in Bronze: The Royal Court Art. Ft. Lauderdale, FL: African American Research Library and Cultural Center, Broward County Library, 2005.

- Phillipson, D.W. African Archaeology. 3rd ed. Cambridge World Archaeology. New York: Cambridge Univ. Press, 2005.
- Schädler, Karl-Ferdinand. Earth and Ore: 2500 Years of African Art in Terra-Cotta and Metal. Trans. Geoffrey P. Burwell. Munich: Panterra, 1997.

Chapter 15 Early Medieval Art in Europe

- Alexander, J.J.G. Medieval Illuminators and Their Methods of Work. New ed. New Haven: Yale Univ. Press, 1994. The Art of Medieval Spain, A.D. 500–1200. New York:
- Metropolitan Museum of Art, 1993.
- Backhouse, Janet, D.H. Turner, and Leslie Webster, eds. The Golden Age of Anglo-Saxon An, 966–1066. Bloomington: Indiana Univ. Press, 1984.
- Bandmann, Günter. Early Medieval Architecture as Bearer of Meaning. New York: Columbia Univ. Press, 2005.
- Brown, Michelle P. The Lindisfame Gospels: Society, Spirituality and the Scribe. Toronto: Univ. of Toronto Press, 2003.
- Calkins, Robert G. Illuminated Books of the Middle Ages. Ithaca, NY: Cornell Univ. Press, 1983.
- Carver, Martin. Sutton Hoo: A Seventh-Century Princely Burial Ground and Its Context. London: British Museum Press, 2005.
- Davis-Weyer, Caecilia. Early Medieval Art, 300–1150: Sources and Documents. Upper Saddle River, NJ: Pearson/ Prentice Hall, 1971.
- Diebold, William J. Word and Image: An Introduction to Early Medieval Art. Boulder, CO: Westview Press, 2000.
- Dodwell, C.R. Pictorial Arts of the West, 800–1200. Pelican History of Art. New Haven: Yale Univ. Press, 1993.
- Farr, Carol. The Book of Kells: Its Function and Audience. London: British Library, 1997.
- Fitzhugh, William W., and Elisabeth I. Ward, eds. Vikings: The North Atlantic Saga. Washington, DC: Smithsonian Institution Press, 2000.
- Harbison, Peter. The Golden Age of Irish Art: The Medieval Achievement, 600–1200. London: Thames & Hudson, 1999.
- Henderson, George. From Durrow to Kells: The Insular Gospel-Books, 650–800. London: Thames & Hudson, 1987.
- Horn, Walter W., and Ernest Born. Plan of Saint Gall: A Study of the Architecture and Economy of and Life in a Paradigmatic Carolingian Monastery. California Studies in the History of Art, 19. 3 vols. Berkeley: Univ. of California Press, 1979.
- Lasko, Peter. Ars Sacra, 800-1200. 2nd ed. Pelican History of Art. New Haven: Yale Univ. Press, 1994.
- McClendon, Charles B. The Origins of Medieval Architecture: Building in Europe, A.D. 600–900. New Haven: Yale Univ. Press, 2005.
- Mayr-Harting, Henry. Ottonian Book Illumination: An Historical Study. 2nd rev. ed. 2 vols. London: Harvey Miller, 1999.
- Mentré, Mireille. Illuminated Manuscripts of Medieval Spain. New York: Thames & Hudson, 1996.
- Nees, Lawrence. Early Medieval Art. Oxford History of Art. Oxford: Oxford Univ. Press, 2002.
- Richardson, Hilary, and John Scarry. An Introduction to Irish High Crosses, Dublin: Mercier, 1990.

Schapiro, Meyer. Language of Forms: Lectures on Insular Manuscript Art. Ed. Jane Rosenthal. New York: Pierpont Morgan Library, 2006.

- Stalley, R.A. Early Medieval Architecture. Oxford History of Art. Oxford: Oxford Univ. Press, 1999.
- Wickham, Chris. Framing the Early Middle Ages: Europe and the Mediterranean 400–800. New York: Oxford Univ. Press, 2005.
- Williams, John. Early Spanish Manuscript Illumination. New York: Braziller, 1977.
- Wilson, David M. Anglo-Saxon Art: From the Seventh Century to the Norman Conquest. London: Tharnes & Hudson, 1984. , and Ole Klindt-Jensen. Viking Art. 2nd ed. Minneapolis: Univ. of Minnesota Press, 1980.

Chapter 16 Romanesque Art

- Barral i Altet, Xavier. The Romanesque: Towns, Cathedrals and Monasteries. Taschen's World Architecture. New York: Taschen, 1998.
- The Book of Sainte Foy. Ed. and trans. Pamela Sheingorn. Philadelphia: Univ. of Pennsylvania Press, 1995.
- Cahn, Walter. Romanesque Manuscripts: The Twelfth Century. 2nd ed. 2 vols. A Survey of Manuscripts Illuminated in France. London: Harvey Miller, 1996.
- Caviness, Madeline H. "Hildegard as Designer of the Illustrations to her Works." In *Hildegard of Bingen: The*

Context of her Thought and Art. Ed. Charles Burnett and Peter Dronke. London: Warburg Institute, 1998: 29–63.

- Davis-Weyer, Caecilia. Early Medieval Art, 300–1150. Sources and Documents. Upper Saddle River, NJ: Pearson/ Prentice Hall, 1971.
- Dimier, Anselme. Stones Laid before the Lord: A History of Monastic Architecture. Trans. Gilchrist Lavigne. Cistercian Studies Series, no. 152. Kalamazoo, MI: Cistercian Publications, 1999.
- Fergusson, Peter. Architecture of Solitude: Cistercian Abbeys in Twelfth-Century England. Princeton, NJ: Princeton Univ. Press, 1984.
- Forsyth, Ilene H. The Throne of Wisdom: Wood Sculptures of the Madonna in Romanesque France. Princeton, NJ: Princeton Univ. Press, 1972.
- Gaud, Henri, and Jean-François Leroux-Dhuys. Cistercian Abbeys: History and Architecture. Cologne: Könemann, 1998.
- Gerson, Paula, ed. *The Pilgrim's Guide to Santiago de Compostela: A Critical Edition.* 2 vols. London: Harvey Miller, 1998.
- Grivot, Denis, and George Zarnecki. Gislebertus: Sculptor of Autun. New York: Orion Press, 1961.
- Hearn, M. F. Romanesque Sculpture: The Revival of Monumental Stone Sculptures in the Eleventh and Twelfth Centuries. Ithaca, NY: Cornell Univ. Press, 1981.
- Hicks, Carola. The Bayeux Tapestry: The Life Story of a Masterpiece. London: Chatto & Windus, 2006.
 Holt, Elizabeth Gilmore, ed. A Documentary History of Art. 2
- vols. Princeton, NJ: Princeton Univ. Press, 1982-86. Hourihane, Colum, ed. Romanesque Art and Thought in the Twelfth Century: Essays in Honor of Walter Cahn. The
- Index of Christian Art Occasional Papers 10. University Park, PA: Penn State Press, 2008. Kubach, Hans E. *Romanesque Architecture*. History of World
- Kubach, Hans E. Romanesque Architecture. History of World Architecture. New York: Electa/Rizzoli, 1988. Minne-Sève, Viviane, and Hervé Kergall. Romanesque
- and Gothic France: Architecture and Sculpture. Trans. Jack Hawkes and Lory Frankel. New York: Abrams, 2000.
- Newman, Barbara. Sister of Wisdom: St. Hildegard's Theology of the Feminine. 2nd ed. Berkeley: Univ. of California Press, 1997.
- Rudolph, Conrad. The "Things of Greater Importance": Bernard of Clairvaux's Apologia and the Medieval Attitude Toward Art. Philadelphia: Univ. of Pennsylvania Press, 1990.
- Schapiro, Meyer. Romanesque Art: Selected Papers. New York: George Braziller, 1977.
- _____. The Romanesque Sculpture of Moissac. New York: Braziller, 1985.
- _____. Romanesque Architectural Sculpture: The Charles Eliot Norton Lectures. Ed. Linda Seidel. Chicago: Univ. of Chicago Press, 2006.
- Seidel, Linda. Legends in Limestone: Lazarus, Gislebertus, and the Cathedral of Autun. Chicago: Univ. of Chicago Press, 1999.
- Sundell, Michael G. *Mosaics in the Eternal City.* Tempe: Arizona Center for Medieval and Renaissance Studies, 2007.
- Swanson, R.N. The Twelfth-Century Renaissance. Manchester: Manchester Univ. Press, 1999.
- Theophilus. On Divers Arts: The Foremost Medieval Treatise on Painting, Glassmaking, and Metalwork. Trans. John G. Hawthorne and Cyril Stanley Smith. New York: Dover, 1979.
- Toman, Rolf, ed. Romanesque: Architecture, Sculpture, Painting. Trans. Fiona Hulse and Ian Macmillan. Cologne: Könemann, 1997.
- Wilson, David M. The Bayeux Tapestry: The Complete Tapestry in Color. London: Thames & Hudson and New York: Knopf, 2004.
- Zarnecki, George, Janet Holt, and Tristram Holland, eds. English Romanesque Art, 1066-1200. London: Weidenfeld and Nicolson, 1984.

Chapter 17 Gothic Art of the Twelfth and Thirteenth Centuries

- Barnes, Carl F. The Portfolio of Villard de Honnecourt: A New Critical Edition and Color Facsimile. Burlington, VT: Ashgate, 2009.
- Binding, Günther. High Gothic: The Age of the Great Cathedrals. Taschen's World Architecture. London: Taschen, 1999.
- Binski, Paul. Becket's Crown: Art and Imagination in Gothic England, 1170–1300. New Haven: Yale Univ. Press, 2004.
- Bony, Jean. French Gothic Architecture of the 12th and 13th Centuries. California Studies in the History of Art, 20. Berkeley: Univ. of California Press, 1983.

- Camille, Michael. Gothic Art: Glorious Visions. Perspectives. New York: Abrams, 1996.
- Coldstream, Nicola. Masons and Sculptors. Toronto & Buffalo, NY: Univ. of Toronto Press, 1991.
- Crosby, Sumner M. The Royal Abbey of Saint-Denis from Its Beginnings to the Death of Suger, 475–1151. Yale Publications in the History of Art, 37. New Haven: Yale Univ. Press, 1987.
- Erlande-Brandenburg, Alain. Gothic Art. Trans. I. Mark Paris. New York: Abrams, 1989.
- Frankl, Paul. Gothic Architecture. Revised Paul Crossley. Pelican History of Art. New Haven: Yale Univ. Press, 2000.
- Frisch, Teresa G. Gothic Art, 1140–c.1450: Sources and Documents. Upper Saddle River, NJ: Pearson/Prentice Hall, 1971.
- Grodecki, Louis, and Catherine Brisac. Gothic Stained Glass, 1200–1300. Ithaca, NY: Cornell Univ. Press, 1985.
- Jordan, Alyce A. Visualizing Kingship in the Windows of the Sainte-Chapelle. Turnhout: Brepols, 2002. Moskowitz, Anita Fiderer, Nicola & Giovanni Pisano: The
- Pulpits: Pious Devotion, Pious Diversion. London: Harvey Miller, 2005.
- Trans. Scott Kleager. New Haven: Yale Univ. Press, 2000.
- Panofsky, Erwin. Abbot Suger on the Abbey Church of St.-Denis and Its Art Treasures. 2nd ed. Ed. Gerda Panofsky-Soergel. Princeton, NJ: Princeton Univ. Press, 1979.
- Parry, Stan. Great Gothic Cathedrals of France. New York: Viking Studio, 2001.
- Sauerländer, Willibald. Gothic Sculpture in France, 1140–1270. Trans. Janet Sandheimer. London: Thames & Hudson, 1972.
- Scott, Robert A. The Gothic Enterprise: A Guide to Understanding the Medieval Cathedral. Berkeley: Univ. of California Press, 2003.
- Simsom, Otto Georg von. The Gothic Cathedral: Origins of Gothic Architecture and the Medieval Concept of Order. 3rd ed. exp. Bollingen Series. Princeton, NJ: Princeton Univ. Press, 1988.
- Suckale, Robert, and Matthias Weniger. Painting of the Gothic Era. Ed. Ingo F. Walther. New York: Taschen, 1999.
- Williamson, Paul. Gothic Sculpture, 1140–1300. Pelican History of Art. New Haven: Yale Univ. Press, 1995.

Chapter 18 Fourteenth-Century Art in Europe

- Alexander, Jonathan, and Paul Binski, eds. Age of Chivalry: Art in Plantagenet England, 1200–1400. London: Royal Academy of Arts, 1987.
- Backhouse, Janet. Illumination from Books of Hours. London: British Library, 2004.
- Boehm, Barbara Drake, and Jirí Fajt, eds. Prague: The Crown of Bohemia, 1347–1437. New York: Metropolitan Museum of Art, 2005.
- Bony, Jean. The English Decorated Style: Gothic Architecture Transformed, 1250–1350. The Wrightsman Lecture, 10. Oxford: Phaidon Press, 1979.
- Cennini, Cennino. The Craftsman's Handbook "Il libro dell'arte." Trans. D.V. Thompson, Jr. New York: Dover, 1960.
- Derbes, Anne, and Mark Sandona, eds. *The Cambridge Companion to Giotto.* Cambridge and New York: Cambridge Univ. Press, 2003.
- Fajt, Jirí, ed. Magister Theodoricus, Court Painter to Emperor Charles IV: The Pictorial Decoration of the Shrines at Karlstejn Castle. Prague: National Gallery, 1998.
- Holt, Elizabeth Gilmore, ed. A Documentary History of Art. 2 vols. Princeton, NJ, Princeton Univ. Press, 1982–86.
- Ladis, Andrew. ed, *The Arena Chapel and the Genius of Giotto: Padua.* Giotto and the World of Early Italian Art, 2. New York: Garland, 1998.
- Meiss, Millard. Painting in Florence and Siena after the Black Death: The Arts, Religion, and Society in the Mid-Fourteenth Century. 2nd ed. Princeton, NJ: Princeton Univ. Press, 1978.
- Moskowitz, Anita Fiderer. Italian Gothic Sculpture: c. 1250c. 1400. New York: Cambridge Univ. Press, 2001.
- Norman, Diana, ed. Siena, Florence, and Padua: Art, Society, and Religion 1280–1400. 2 vols. New Haven: Yale Univ. Press, 1995.
- Poeschke, Joachim. Italian Frescoes, the Age of Giotto, 1280–1400. New York: Abbeville Press, 2005.
- Schleif, Corine. "St. Hedwig's Personal Ivory Madonna: Women's Agency and the Powers of Possessing Portable Figures." In The Four Modes of Seeing: Approaches to Medieval Imagery in Honor of Madeline Harrison Caviness. Eds. Evelyn Staudinger Lane, Elizabeth Carson Paston,

and Ellen M. Shortell. Farnham, Surrey: Ashgate, 2009: 282–403.

- Vasari, Giorgio. The Lives of the Artists. Trans. Julia Conaway Bondanella and Peter Bondanella. Oxford World's Classics. New York: Oxford Univ. Press, 2008.
- Welch, Evelyn S. Art in Renaissance Italy, 1350–1500. New ed. Oxford History of Art. Oxford: Oxford Univ. Press, 2000.
- White, John. Art and Architecture in Italy, 1250 to 1400. 3rd ed. Pelican History of Art. Harmondsworth, UK: Penguin, 1993.
- Wieck, Roger S. Time Sanctified: The Book of Hours in Medieval Art and Life. 2nd ed. New York: Braziller, 2001.

Chapter 19 Fifteenth-Century Art in Northern Europe

- Art from the Court of Burgundy: The Patronage of Philip the Bold and John the Fearless 1364–1419. Dijon: Musée des Beaux-Arts and Cleveland: Cleveland Museum of Art, 2004.
- Baxandall, Michael. The Limewood Sculptors of Renaissance Germany. New Haven: Yale Univ. Press, 1980.
- Blum, Shirley. Early Netherlandish Triptychs: A Study in Patronage. California Studies in the History of Art, 13. Berkeley: Univ. of California Press, 1969.
- Borchert, Till-Holger. Age of Van Eyck: The Mediterranean World and Early Netherlandish Painting, 1430–1530. New York: Thames & Hudson, 2002.
- Campbell, Lorne. *The Fifteenth-Century Netherlandish* Schools (National Gallery Catalogues). London: National Gallery, 1998.
- Cavallo, Adolph S. The Unicorn Tapestries at the Metropolitan Museum of Art. New York: Metropolitan Museum of Art, 1998.
- Chastel, Andrè. French Art: The Renaissance, 1430–1620. Paris: Flammarion, 1995.
- Dhanens, Elisabeth. Van Eyck: The Ghent Altarpiece. New York: Viking Press, 1973.
- Füssel, Stephan. Gutenberg and the Impact of Printing. Trans. Douglas Martin. Burlington, VT: Ashgate, 2005.
- Koster, Margaret L. "The Arnolfini Double Portrait: A Simple Solution." Apollo 157 (September 2003): 3–14.
- Lane, Barbara G. The Altar and the Altarpiece: Sacramental Themes in Early Netherlandish Painting. New York: Harper & Row, 1984.
- Marks, Richard, and Paul Williamson, eds. Gothic: Art for England 1400-1547. London: V&A Publications, 2003.
- Meiss, Millard. French Painting in the Time of Jean de Berry: The Limbourgs and their Contemporaries. 2 vols. New York: Braziller, 1974.
- Müller, Theodor. Sculpture in the Netherlands, Germany, France, and Spain: 1400–1500. Trans. Elaine and William Robson Scott. Pelican History of Art. Harmondsworth, UK: Penguin, 1966.
- Pächt, Otto. Early Netherlandish Painting: From Rogier van der Weyden to Gerard David. Ed. Monika Rosenauer. Trans. David Britt. London: Harvey Miller, 1997. _____. Van Eyck and the Founders of Early Netherlandish Painting. London: Miller, 1994.
- Panofsky, Erwin. Early Netherlandish Painting, Its Origins and Character. 2 vols. Cambridge, MA: Harvard Univ. Press, 1966.
- Parshall, Peter W., and Rainer Schoch. Origins of European Printmaking: Fifteenth-Century Woodcuts and their Public. Washington, DC: National Gallery of Art, 2005.
- Plummer, John. The Last Flowering: French Painting in Manuscripts, 1420–1530, from American Collections. New York: Pierpont Morgan Library, 1982.
- Seidel, Linda. Jan van Eyck's Arnolfini Portrait: Stories of an Icon. New York: Cambridge Univ. Press, 1993.
- Smith, Jeffrey Chipps. *The Northern Renaissance*. London and New York: Phaidon Press, 2004.
- Snyder, James. Northern Renaissance Art: Painting, Sculpture, the Graphic Arts from 1350 to 1575. 2nd ed. rev. Larry Silver and Henry Luttikhuizen. Upper Saddle River, NJ: Prentice Hall, 2005.
- Vos, Dirk de. The Flemish Primitives: The Masterpieces. Princeton, NJ: Princeton Univ. Press, 2002.
- Zuffi, Stefano. European Art of the Fifteenth Century. Trans. Brian D. Phillips. Art through the Centuries. Los Angeles: J. Paul Getty Museum, 2005.

Chapter 20 Renaissance Art in Fifteenth-Century Italy

- Adams, Laurie Schneider. Italian Renaissance Art. Boulder, CO: Westview Press, 2001.
- Ahl, Diane Cole, ed. *The Cambridge Companion to Masaccio*. New York: Cambridge Univ. Press, 2002.

- Ames-Lewis, Francis. Drawing in Early Renaissance Italy. 2nd ed. New Haven: Yale Univ. Press, 2000.
- Baxandall, Michael. Painting and Experience in Fifteenth-Century Italy: A Primer in the Social History of Pictorial Style. 2nd ed. Oxford: Oxford Univ. Press, 1988.
- Boskovits, Miklós. Italian Paintings of the Fifteenth Century. The Collections of the National Gallery of Art. Washington, DC: National Gallery of Art, 2003.
- Botticelli and Filippino: Passion and Grace in Fifteenth-Century Florentine Painting. Milan: Skira, 2004.
- Brown, Patricia Fortini. Art and Life in Renaissance Venice. Perspectives. New York: Abrams, 1997. Reissue ed. Upper Saddle River, NJ: Pearson/Prentice Hall, 2006.
- Brucker, Gene. Florence: The Golden Age, 1138–1737. Berkeley: Univ. of California Press, 1998.
- Christiansen, Keith, Laurence B. Kanter, and Carl Brandon Strehlke. *Painting in Renaissance Siena*, 1420–1500. New York: Metropolitan Museum of Art, 1988.
- Gilbert, Creighton, ed. Italian Art, 1400–1500: Sources and Documents. Evanston, IL: Northwestern Univ. Press, 1992.
- Heydenreich, Ludwig Heinrich. Architecture in Italy, 1400–1500. Revised Paul Davies. Pelican History of Art. New Haven: Yale Univ. Press, 1996.
- Hind, Arthur M. An Introduction to a History of Woodcut. New York: Dover, 1963.
- Hyman, Timothy. Sienese Painting: The Art of a City-Republic (1278–1477). World of Art. New York: Thames & Hudson, 2003.
- King, Ross. Brunelleschi's Dome: How a Renaissance Genius Reinvented Architecture. New York: Walker, 2000.
- Lavin, Marilyn Aronberg, ed. Piero della Francesca and his Legacy. Studies in the History of Art, 48: Symposium Papers, 28. Washington, DC: National Gallery of Art, 1995.
- Pächt, Otto. Venetian Painting in the 15th Century: Jacopo, Gentile and Giovanni Bellini and Andrea Mantegna. Ed. Margareta Vyoral-Tschapka and Michael Pächt. Trans. Fiona Elliott. London: Harvey Miller, 2003.
- Paoletti, John T., and Gary M. Radke. Art in Renaissance Italy. 4th ed. Upper Saddle River, NJ: Pearson/Prentice Hall, 2012.
- Partridge, Loren W. The Art of Renaissance Rome, 1400–1600. 2nd ed. Upper Saddle River, NJ: Pearson/ Prentice Hall, 2006.
- . Art of Renaissance Florence, 1400–1600. Berkeley: Univ. of California Press, 2009.
- de Pisan, Christine. The Book of the City of Ladies. Trans. Rosalind Brown-Grant. London: Penguin Books, 1999.
- Poeschke, Joachim. Donatello and His World: Sculpture of the Italian Renaissance. Trans. Russell Stockman. New York: Abrams, 1993.
- Pope-Hennessy, John. Italian Renaissance Sculpture. 4th ed. London: Phaidon Press, 1996.
- Radke, Gary M., ed. The Gates of Paradise: Lorenzo Ghiberti's Masterpiece. New Haven: Yale Univ. Press, 2007.
- Randolph, Adrian W.B., Engaging Symbols: Gender, Politics, and Public Art in Fifteenth-Century Florence. New Haven: Yale Univ. Press, 2002.
- Troncelliti, Latifah. The Two Parallel Realities of Alberti and Cennini: The Power of Writing and the Visual Arts in the Italian Quattrocento. Studies in Italian Literature, vol. 14. Lewiston, NY: Mellen Press, 2004.
- Turner, Richard. Renaissance Florence: The Invention of a New Art. Perspectives. New York: Abrams, 1997. Reissue ed. Upper Saddle River, NJ: Pearson/Prentice Hall, 2006.
- Vasari, Giorgio. The Lives of the Artists. Trans. Julia Conaway Bondanella and Peter Bondanella. Oxford
- World's Classics. New York: Oxford Univ. Press, 2008. Verdon, Timothy, and John Henderson, eds. Christianity and the Renaissance: Image and Religious Imagination in the Quattrocento. Syracuse, NY: Syracuse Univ. Press, 1990.
- Walker, Paul Robert. The Feud that Sparked the Renaissance: How Brunelleschi and Ghiberti Changed the Art World. New York: William Morrow, 2002.
- Welch, Evelyn S. Art and Society in Italy, 1350–1500. Oxford History of Art. Oxford: Oxford Univ. Press, 1997.

Chapter 21 Sixteenth-Century Art in Italy

- Acidini Luchinat, Cristina, et al. The Medici, Michelangelo, & the Art of Late Renaissance Florence. New Haven: Yale Univ. Press, 2002.
- Bambach, Carmen. Drawing and Painting in the Italian Renaissance Workshop: Theory and Practice, 1330–1600. Cambridge: Cambridge Univ. Press, 1999.

- Barriault, Anne B., ed. *Reading Vasari*. London: Philip Wilson in assoc. with the Georgia Museum of Art, 2005.
- Brambilla Barcilon, Pinin. Leonardo: The Last Supper. Chicago: Univ. of Chicago Press, 2001.
- Brown, Patricia Fortini. Art and Life in Renaissance Venice. Perspectives. New York: Abrams, 1997.
- Cellini, Benvenuto. Autobiography. Rev. ed. Trans. George Bull. Penguin Classics. New York: Penguin, 1998.
- Chelazzi Dini, Giulietta, Alessandro Angelini, and Bernardina Sani. Sienese Painting: From Duccio to the Birth of the Baroque. New York: Abrams, 1998.
- Cole, Alison. Virtue and Magnificence: Art of the Italian Renaissance Courts. Perspectives. New York: Abrams, 1995. Reissue ed. as Art of the Italian Courts. Upper Saddle River, NJ: Pearson/Prentice Hall, 2006.
- Franklin, David, ed. Leonardo da Vinci, Michelangelo, and the Renaissance in Florence. Ottawa: National Gallery of Canada in assoc. with Yale Univ. Press, 2005.
- Freedberg, S.J. Painting in Italy, 1500 to 1600. 3rd ed. Pelican History of Art. New Haven: Yale Univ. Press, 1993.
- Goffen, Rona. Renaissance Rivals: Michelangelo, Leonardo, Raphael, Titian. New Haven: Yale Univ. Press, 2002. Titian's Venus of Urbino. Masterpieces of Western
- Painting. Cambridge: Cambridge Univ. Press, 1997. . Titian's Women. New Haven: Yale Univ. Press, 1997
- Hall, Marcia B. After Raphael: Painting in Central Italy in the Sixteenth Century. New York: Cambridge Univ. Press, 1999.
- -------, ed. The Cambridge Companion to Raphael. New York: Cambridge Univ. Press, 2005.
- Hollingsworth, Mary. Patronage in Sixteenth Century Italy. London: John Murray, 1996.
- Hopkins, Andrew. Italian Architecture: From Michelangelo to Borromini. World of Art. New York: Thames & Hudson, 2002.
- Hughes, Anthony. *Michelangelo*. Art & Ideas. London: Phaidon Press, 1997.
- Huse, Norbert, and Wolfgang Wolters. Art of Renaissance Venice: Architecture, Sculpture, and Painting, 1460–1590. Trans. Edmund Jephcott. Chicago: Univ. of Chicago Press, 1990.
- Joannides, Paul. Titian to 1518: The Assumption of Genius. New Haven: Yale Univ. Press, 2001.
- Klein, Robert, and Henri Zerner. Italian Art, 1500–1600: Sources and Documents. Upper Saddle River, NJ: Pearson/ Prentice Hall, 1966.
- Kliemann, Julian-Matthias, and Michael Rohlmann. Italian Frescoes: High Renaissance and Mannerism, 1510–1600. Trans. Steven Lindberg. New York: Abbeville Press, 2004.
- Landau, David, and Peter Parshall. *The Renaissance Print:* 1470–1550. New Haven: Yale Univ. Press, 1994.
- Lieberman, Ralph. Renaissance Architecture in Venice, 1450–1540. New York: Abbeville Press, 1982.
- Lotz, Wolfgang, Architecture in Italy, 1500–1600. Revised Deborah Howard. Pelican History of Art. New Haven: Yale Univ. Press, 1995.
- Meilman, Patricia, ed. The Cambridge Companion to Titian. New York: Cambridge Univ. Press, 2004.
- Mitrovic, Branko. Learning from Palladio. New York: Norton, 2004.
- Murray, Linda. The High Renaissance and Mannerism: Italy, the North and Spain, 1500–1600. World of Art. London: Thames & Hudson, 1995.
- Partridge, Loren W. The Art of Renaissance Rome, 1400–1600. 2nd ed. Upper Saddle River, NJ: Pearson/ Prentice Hall, 2006.
- . Art of Renaissance Florence, 1400–1600. Berkeley: Univ. of California Press, 2009.
- _____. Michelangelo, the Last Judgment: A Glorious Restoration. New York: Abrams, 1997.
- Pilliod, Elizabeth. Pontormo, Bronzino, Allori: A Genealogy of
- Florentine Art. New Haven: Yale Univ. Press, 2001. Pope-Hennessy, John. Italian High Renaissance and Baroque
- Sculpture. 4th ed. London: Phaidon Press, 1996. Rosand, David. Painting in Cinquecento Venice: Titian,
- Veronese, Tintoretto. Rev. ed. Cambridge: Cambridge Univ. Press, 1997.
- Rowe, Colin, and Leon Satkowski. Italian Architecture of the 16th Century. New York: Princeton Architectural Press, 2002.
- Rowland, Ingrid D. The Culture of the High Renaissance. Ancients and Moderns in Sixteenth Century Rome. Cambridge: Cambridge Univ. Press, 1998.

BIBLIOGRAPHY

580

Shearman, John. Mannerism. Harmondsworth, UK: Penguin, 1967. Reissue ed. New York: Penguin, 1990.

- Vasari, Giorgio. The Lives of the Artists. Trans. Julia Conaway Bondanella and Peter Bondanella. Oxford World's Classics. New York: Oxford Univ. Press, 2008.
- Verheyen, Egon. The Paintings in the Studiolo of Isabella d'Este at Mantua. Monographs on Archaeology and Fine Arts, 23. New York: New York Univ. Press, 1971.
- Williams, Robert. Art, Theory, and Culture in Sixteenth-Century Italy: From Techne to Metateche. Cambridge:

Cambridge Univ. Press, 1997. Chapter 22 Sixteenth-Century Art in Northern Europe and the Iberian Peninsula

- Bartrum, Giulia. Albrecht Dürer and his Legacy: The Graphic Work of a Renaissance Artist. London: British Museum Press, 2002.
- _____. German Renaissance Prints 1490–1550. London: British Museum Press, 1995.
- Brown, Jonathan. Painting in Spain, 1500–1700. Pelican History of Art. New Haven: Yale Univ. Press, 1998.
- Buck, Stephanie, and Jochen Sander. Hans Holbein the Younger: Painter at the Court of Henry VIII. Trans. Rachel Esner and Beverley Jackson. New York: Thames & Hudson, 2004.
- Chapuis, Julien. Tilman Riemenschneider: Master Sculptor of the Late Middle Ages. Washington, DC: National Gallery of Art, 1999.
- Davies, David, and John H. Elliott. *El Greco*. London: National Gallery, 2003.
- Dixon, Laurinda. Bosch. Art & Ideas. New York: Phaidon Press, 2003.
- Foister, Susan. *Holbein and England*. New Haven: Published for Paul Mellon Centre for Studies in British Art by Yale Univ. Press, 2004.
- Hayum, Andrée. The Isenheim Altarpiece: God's Medicine and the Painter's Vision. Princeton Essays on the Arts, 18. Princeton, NJ: Princeton Univ. Press, 1989.
- Hearn, Karen, ed. Dynasties: Painting in Tudor and Jacobean England, 1530-1630. New York: Rizzoli, 1996.
- Koerner, Joseph Leo. The Reformation of the Image. Chicago: Univ. of Chicago Press, 2004.
- Kubler, George. Building the Escorial. Princeton, NJ: Princeton Univ. Press, 1982.
- Nash, Susie. Northern Renaissance Art. Oxford History of Art. New York: Oxford Univ. Press, 2008.
- Price, David Hotchkiss. Albrecht Dürer's Renaissance: Humanism, Reformation, and the Art of Faith. Studies in Medieval and Early Modern Civilization. Ann Arbor: Univ. of Michigan Press, 2003.
- Roberts-Jones, Philippe, and Françoise Roberts-Jones. Pieter Bruegel. New York: Abrams, 2002.
- Smith, Jeffrey Chipps. Nuremberg, a Renaissance City, 1500–1618. Austin: Huntington Art Gallery, Univ. of Texas, 1983.
- _____. The Northern Renaissance. London and New York: Phaidon Press, 2004.
- Snyder, James. Northern Renaissance Art: Painting, Sculpture, the Graphic Arts from 1350 to 1575. 2nd ed. rev. Larry Silver and Henry Luttikhuizen. Upper Saddle River, NJ: Pearson/Prentice Hall, 2005.
- Strong, Roy C. Artists of the Tudor Court: The Portrait Miniature Rediscovered, 1520–1620. London: V&A Publications, 1983.
- Zerner, Henri. Renaissance Art in France: The Invention of Classicism. Paris: Flammarion, 2003.
- Zorach, Rebecca. Blood, Milk, Ink, Gold: Abundance and Excess in the French Renaissance. Chicago: Univ. of Chicago Press, 2005.

Chapter 23 Seventeenth-Century Art in Europe

- Adams, Laurie Schneider. Key Monuments of the Baroque. Boulder, CO: Westview Press, 2000.
- Allen, Christopher. French Painting in the Golden Age. World of Art. New York: Thames & Hudson, 2003.
- Alpers, Svetlana. The Art of Describing: Dutch Art in the Seventeenth Century. Chicago: Chicago Univ. Press, 1983.
- _____. The Making of Rubens. New Haven: Yale Univ. Press, 1995.
- Blankert, Albert. *Rembrandt: A Genius and His Impact.* Melbourne: National Gallery of Victoria, 1997.
- Boucher, Bruce. Italian Baroque Sculpture. World of Art. New York: Thames & Hudson, 1998.
- Brown, Beverly Louise, ed. *The Genius of Rome, 1592–1623*. London: Royal Academy of Arts, 2001.

- Brown, Jonathan. Painting in Spain, 1500–1700. Pelican History of Art. New Haven: Yale Univ. Press, 1998.
- ——, and Carmen Garrido. Velásquez: The Technique of Genius. New Haven: Yale Univ. Press, 2003. Careri, Giovanni. Baroques. Tran. Alexandra Bonfante-
- Warren. Princeton: Princeton Univ. Press, 2003. Chapman, H. Perry. Rembrandt's Self-Portraits: A Study in
- 17th-Century Identity. Princeton: Princeton Univ. Press, 1990.
- Chong, Alan, and Wouter Kloek. Still-Life Paintings from the Netherlands, 1550–1720. Zwolle: Waanders, 1999.
- Enggass, Robert, and Jonathan Brown. *Italian and Spanish Art*, 1600–1750: *Sources and Documents*. 2nd ed. Evanston, IL: Northwestern Univ. Press, 1992.
- Franklin, David, and Sebastian Schütze. Caravaggio and his Followers in Rome. New Haven: Yale Univ. Press, 2011.
- Frantis, Wayne E., ed. The Cambridge Companion to Vermeer. Cambridge: Cambridge Univ. Press, 2001. ———. Dutch Seventeenth-Century Genre Painting: Its Stylistic
- and Thematic Evolution. New Haven: Yale Univ. Press, 2004.
- Harbison, Robert. *Reflections on Baroque*. Chicago: Univ. of Chicago Press, 2000.
- Keazor, Henry. Nicolas Poussin, 1594–1665. Cologne & London: Taschen, 2007.
- Kiers, Judikje, and Fieke Tissink. Golden Age of Dutch Art: Painting, Sculpture, Decorative Art. London: Thames & Hudson, 2000.
- Lagerlöf, Margaretha Rossholm. Ideal Landscape: Annibale Carracci, Nicolas Poussin, and Claude Lorrain. New Haven: Yale Univ. Press, 1990.
- McPhee, Sarah. Bernini and the Bell Towers: Architecture and Politics at the Vatican. New Haven: Yale Univ. Press, 2002.
- Millon, Henry A., ed. The Triumph of the Baroque: Architecture in Europe, 1600–1750. 2nd ed. rev. New York: Rizzoli, 1999.
- Morrissey, Jake. The Genius in the Design: Bernini, Borromini, and the Rivalry that Transformed Rome. New York: William Morrow, 2005.
- Puttfarken, Thomas. Roger de Piles' Theory of Art. New Haven: Yale Univ. Press, 1985.
- Rand, Richard. Claude Lorrain, the Painter as Draftsman: Drawings from the British Museum. New Haven: Yale Univ. Press; Williamstown, MA: Clark Art Institute, 2006.
- Slive, Seymour. *Dutch Painting 1600–1800.* Pelican History of Art. New Haven: Yale Univ. Press, 1995.
- Summerson, John. Inigo Jones. New Haven: Published for the Paul Mellon Centre for Studies in British Art by Yale Univ. Press, 2000.
- Tomlinson, Janis. From El Greco to Goya: Painting in Spain, 1561–1828. Perspectives. New York: Abrams, 1997.
- Vlieghe, Hans. Flemish Art and Architecture, 1585–1700. Pelican History of Art. Reissue ed. 2004. New Haven: Yale Univ. Press, 1998.
- Walker, Stefanie, and Frederick Hammond, eds. Life and the Arts in the Baroque Palaces of Rome: Ambiente Barocco. New Haven: Yale Univ. Press; for the Bard Graduate Center for Studies in the Decorative Arts, New York, 1999.
- Wheelock Jr., Arthur K. Flemish Paintings of the Seventeenth Century. Washington, DC: National Gallery of Art, 2005.
- Wittkower, Rudolf. Art and Architecture in Italy, 1600–1750. 3 vols. 6th ed. Revised Joseph Connors and Jennifer Montague. Pelican History of Art. New Haven: Yale Univ. Press, 1999.
- Zega, Andrew, and Bernd H. Dams. Palaces of the Sun King: Versailles, Trianon, Marly: The Châteaux of Louis XIV. New York: Rizzoli, 2002.

Chapter 24 Art of South and Southeast Asia after 1200

- Asher, Catherine B. Architecture of Mughal India. New York: Cambridge Univ. Press, 1992.
- Beach, Milo Cleveland. Mughal and Rajput Painting. New York: Cambridge Univ. Press, 1992.
- Guy, John, and Deborah Swallow, eds. Arts of India, 1550–1900. London: V&A Publications, 1990.
- Khanna, Balraj, and Aziz Kurtha. Art of Modern India. London: Thames & Hudson, 1998.Koch, Ebba. Mughal Art and Imperial Ideology: Collected Essays. New Delhi: Oxford Univ. Press, 2001.

Love Song of the Dark Lord: Jayadeva's Gitagovinda. Trans.

1977.

Barbara Stoler Miller. New York: Columbia Univ. Press,

- Michell, George. *Hindu Art and Architecture*. World of Art. London: Thames & Hudson, 2000.
- Moynihan, Elizabeth B., ed. The Moonlight Garden: New Discoveries at the Taj Mahal. Asian Art & Culture. Washington, DC: Arthur M. Sackler Gallery, 2000.
- Nou, Jean-Louis. *Taj Mahal.* Text by Amina Okada and M.C. Joshi. New York: Abbeville Press, 1993.
- Pal, Pratapaditya. Court Paintings of India, 16th–19th Centuries. New York: Navin Kumar, 1983.
 ——. The Peaceful Liberators: Jain Art from India. New York: Thames & Hudson, 1994.
- Rossi, Barbara. From the Ocean of Painting: India's Popular Paintings, 1589 to the Present. New York: Oxford Univ. Press, 1998.
- Schimmel, Annemarie. The Empire of the Great Mughals: History, Art and Culture. Ed. Burzine K. Waghmar. Trans. Corinne Attwood. London: Reaktion Books, 2004.
- Stronge, Susan. Painting for the Mughal Emperor: The Art of the Book, 1560–1660. London: V&A Publications, 2002.
- Controversy, and Change since 1850. New Haven: Yale Univ. Press, 1989. Verma, Som Prakash. Painting the Mughal Experience. New
- York: Oxford Univ. Press, 2005. Welch, Stuart Cary. The Emperors' Album: Images of Mughal

Chapter 25 Chinese and Korean Art after 1279

- Andrews, Julia Frances, and Kuiyi Shen. A Century in Crisis: Modernity and Tradition in the Art of Twentieth-Century China. New York: Solomon R. Guggenheim Museum, 1998.
- Barnhart, Richard M. Painters of the Great Ming: The Imperial Court and the Zhe School. Dallas: Dallas Museum of Art, 1993.
- Barrass, Gordon S. The Art of Calligraphy in Modern China. London: British Museum Press, 2002.
- Berger, Patricia Ann. Empire of Emptiness: Buddhist Art and Political Authority in Qing China. Honolulu: Univ. of Hawai'i Press, 2003.
- Bickford, Maggie. Ink Plum: The Making of a Chinese Scholar-Painting. New York: Cambridge Univ. Press, 1996.
- Billeter, Jean François. The Chinese Art of Writing. New York: Skira/Rizzoli, 1990.
- Bush, Susan, and Hsio-yen Shih, eds. Early Chinese Texts on Painting. Cambridge, MA: Harvard Univ. Press, 1985.
- Cahill, James. The Distant Mountains: Chinese Painting in the Late Ming Dynasty, 1580–1644. New York: Weatherhill, 1982.
- Hills Beyond a River: Chinese Painting of the Y'uan Dynasty, 1279–1368. New York: Weatherhill, 1976.
 Parting at the Shore: Chinese Painting of the Early
- and Middle Ming Dynasty 1368–1580. New York: Weatherhill, 1978. Chaves, Jonathan (trans.). The Chinese Painter as Poet. New
- York: Art Media Resources, 2000.
- Chung, Anita. Drawing Boundaries: Architectural Images in Qing China. Honolulu: Univ. of Hawai'i Press, 2004.
- Clunas, Craig. Pictures and Visuality in Early Modern China. Princeton, NJ: Princeton Univ. Press, 1997.
- Fang, Jing Pei. Treasures of the Chinese Scholar: Form, Function, and Symbolism. Ed. J. May Lee Barrett. New York: Weatherbill, 1997.
- Fong, Wen C. Between Two Cultures: Late-Nineteenth- and Twentieth-Century Chinese Paintings from the Robert H. Ellsworth Collection in the Metropolitan Museum of Art. New York: Metropolitan Museum of Art, 2001.
- Hearn, Maxwell K., and Judith G. Smith, eds. Chinese Art: Modern Expressions. New York: Dept. of Asian Art, Metropolitan Museum of Art, 2001.
- Ho, Chuimei, and Bennet Bronson. Splendors of China's Forbidden City: The Glorious Reign of Emperor Qianlong. Chicago: Field Museum, 2004.
- Ho, Wai-kam, ed. The Century of Tung Ch'i-Ch'ang, 1555–1636. 2 vols. Kansas City, MO: Nelson-Atkins Museum of Art, 1992.
- Kim, Hongnam. The Life of a Patron: Zhou Lianggong (1612– 1672) and the Painters of Seventeenth-Century China. New York: China Institute in America, 1996.
- Knapp, Ronald G. China's Vernacular Architecture: House Form and Culture. Honolulu: Univ. of Hawai'i Press, 1989.

- Lee, Sherman, and Wai-Kam Ho. Chinese Art Under the Mongols: The Y'uan Dynasty, 1279–1368. Cleveland: Cleveland Museum of Art, 1968.
- Lim, Lucy, ed. Wu Guanzhong: A Contemporary Chinese Artist. San Francisco: Chinese Culture Foundation, 1989.
- Moss, Paul. Escape from the Dusty World: Chinese Paintings and Literati Works of Art. London: Sydney L. Moss, 1999.
- Ng, So Kam. Brushstrokes: Styles and Techniques of Chinese Painting. San Francisco: Asian Art Museum of San Francisco, 1993.
- The Poetry [of] Ink: The Korean Literati Tradition, 1392–1910. Paris: Réunion des Musées Nationaux: Musée National des Arts Asiatiques Guimet, 2005.
- Smith, Karen. Nine Lives: The Birth of Avant-Garde Art in New China. Zürich: Scalo, 2006.
- Till, Barry. The Manchu Era (1644–1912), Arts of China's Last Imperial Dynasty. Victoria, BC: Art Gallery of Greater Victoria, 2004.
- Vainker, S.J. Chinese Pottery and Porcelain: From Prehistory to the Present. London: British Museum Press, 1991.
- Watson, William. The Arts of China 900–1620. Pelican History of Art. New Haven: Yale Univ. Press, 2000.
- Weidner, Marsha Smith. Views from Jade Terrace: Chinese Women Artists, 1300–1912. Indianapolis, IN: Indianapolis Museum of Art, 1988.
- Xinian, Fu, et al. *Chinese Architecture*. Ed. Nancy S. Steinhardt. New Haven: Yale Univ. Press, 2002.

Chapter 26 Japanese Art after 1333

- Addiss, Stephen. The Art of Zen: Painting and Calligraphy by Japanese Monks, 1600-1925. New York: Abrams, 1989.
- Berthier, François. Reading Zen in the Rocks: The Japanese Dry Landscape Garden. Trans. & essay Graham Parkes. Chicago: Univ. of Chicago Press, 2000.
- Calza, Gian Carlo. Ukiyo-e. New York: Phaidon Press, 2005.
- Graham, Patricia J. Faith and Power in Japanese Buddhist Art, 1600–2005. Honolulu: Univ. of Hawai'i Press, 2007.
 —. Tea of the Sages: The Art of Sencha. Honolulu: Univ. of Hawai'i Press, 1998.
- Guth, Christine. Art of Edo Japan: The Artist and the City 1615–1868. Perspectives. New York: Abrams, 1996.
- Hickman, Money L. Japan's Golden Age: Momoyama. New Haven: Yale Univ. Press, 1996.
- Kobayashi, Tadashi, and Lisa Rotondo-McCord. An Enduring Vision: 17th to 20th Century Japanese Painting from the Gitter-Yelen Collection. New Orleans: New Orleans Museum of Art, 2003.
- Lillehoji, Elizabeth, ed. Critical Perspectives on Classicism in Japanese Painting, 1600–1700. Honolulu: Univ. of Hawai'i Press, 2004.
- McKelway, Matthew P. Traditions Unbound: Groundbreaking Painters of Eighteenth-Century Kyoto. San Francisco: Asian Art Museum–Chong-Moon Lee Center, 2005.
- Meech, Julia, and Jane Oliver. Designed for Pleasure: The World of Edo Japan in Prints and Paintings, 1680–1860. Seattle: Univ. of Washington Press in association with the Asia Society and Japanese Art Society of America, New York, 2008.
- Miyajima, Shin'ichi and Sato Yasuhiro. Japanese Ink Painting. Ed. George Kuwayama. Los Angeles: Los Angeles County Museum of Art, 1985.

Munroe, Alexandra. Japanese Art after 1945: Scream Against the Sky. New York: Abrams, 1994.

Murase, Miyeko, ed. Turning Point: Oribe and the Arts of Sixteenth-Century Japan. New York: Metropolitan Museum of Art, 2003.

- Newland, Amy Reigle, ed. The Hotei Encyclopedia of Japanese Woodblock Prints. 2 vols. Amsterdam: Hotei Publishing, 2005.
- Ohki, Sadako. Tea Culture of Japan. New Haven: Yale Univ. Press, 2009.
- Rousmaniere, Nicole, ed. Crafting Beauty in Modern Japan: Celebrating Fifty Years of the Japan Traditional Art Crafts Exhibition. Seattle: Univ. of Washington Press, 2007.
- Screech, Timon. The Lens Within the Heart: The Western Scientific Gaze and Popular Imagery in Later Edo Japan. 2nd ed. Honolulu: Univ. of Hawai'i Press, 2002.

Singer, Robert T., and John T. Carpenter. Edo, Art in Japan 1615–1868. Washington, DC: National Gallery of Art, 1998.

Chapter 27 Art of the Americas after 1300

Bauer, Brian S. Ancient Cuzco: Hearland of the Inca. Joe R. and Teresa Lozano Long Series in Latin American and Latino Art and Culture. Austin: Univ. of Texas Press, 2004.

- Berlo, Janet Catherine, and Ruth B. Phillips. Native North American Art. Oxford History of Art. Oxford: Oxford Univ. Press, 1998.
- Bringhurst, Robert. The Black Canoe: Bill Reid and the Spirit of Haida Gwaii. Seattle: Univ. of Washington Press, 1991.
- Burger, Richard L., and Lucy C. Salazar, eds. Machu Picchu: Unveiling the Mystery of the Incas. New Haven: Yale Univ. Press, 2004.
- Coe, Michael D. and Rex Koontz. Mexico: From the Olmecs to the Aztecs. 5th ed. New York: Thames & Hudson, 2005
- Fields, Virginia M., and Victor Zamudio-Taylor. *The Road to Aztlan: Art from a Mythic Homeland*. Los Angeles: Los Angeles County Museum of Art, 2001.
- Griffin-Pierce, Trudy. Earth is my Mother, Sky is my Father: Space, Time, and Astronomy in Navajo Sandpainting. Albuquerque: Univ. of New Mexico Press, 1992.
- Jonaitis, Aldona. Art of the Northwest Coast. Seattle: Univ. of Washington Press, 2006.
- Kaufman, Alice, and Christopher Selser. The Navajo Weaving Tradition: 1650 to the Present. New York: Dutton, 1985.
- Macnair, Peter L., Robert Joseph, and Bruce Grenville. Down from the Shimmering Sky: Masks of the Northwest Coast. Vancouver: Douglas & McIntyre, 1998.
- Matos Moctezuma, Eduardo, and Felipe R. Solís Olguín. Aztecs. London: Royal Academy of Arts, 2002.
- Matthews, Washington. "The Night Chant: A Navaho Ceremony." In Memoirs of the American Museum of Natural History, vol. 6. New York, 1902.
- Moseley, Michael E. The Incas and Their Ancestors: The Archaeology of Peru. Rev. ed. London: Thames & Hudson, 2001.
- Nabokov, Peter, and Robert Easton. Native American
- Architecture. New York: Oxford Univ. Press, 1989. Pasztory, Esther. Aztec Art. Norman: Univ. of Oklahoma Press, 2000.
- Rushing III, W. Jackson, ed. Native American Art in the Twentieth Century: Makers, Meanings, Histories. New York: Routledge, 1999.
- Shaw, George Everett. Art of the Ancestors: Antique North American Indian Art. Aspen, CO: Aspen Art Museum, 2004.
- Taylor, Colin F. Buckskin & Buffalo: The Artistry of the Plains Indians. New York: Rizzoli, 1998.
- Townsend, Richard F., ed. *The Aztecs*. 2nd rev. ed. Ancient Peoples and Places. London: Thames & Hudson, 2000.
- Trimble, Stephen. Talking with the Clay: The Art of Pueblo Pottery in the 21st Century. 20th anniversary rev ed. Santa Fe, NM: School for Advanced Research Press, 2007.
- Wood, Nancy C. Taos Pueblo. New York: Knopf, 1989.

Chapter 28 Art of Pacific Cultures

- Caruana, Wally. *Aboriginal Art.* 2nd ed. World of Art. New York: Thames & Hudson, 2003.
- Craig, Barry, Bernie Kernot, and Christopher Anderson, eds. Art and Performance in Oceania. Honolulu: Univ. of Hawai'i Press, 1999.
- D'Alleva, Anne. Arts of the Pacific Islands. Perspectives. New York: Abrams, 1998.
- Herle, Anita, et al. Pacific Art: Persistence, Change, and Meaning. Honolulu: Univ. of Hawai'i Press, 2002.
- Kaeppler, Adrienne Lois, Christian Kaufmann, and Douglas Newton. Oceanic Art. Trans. Nora Scott and Sabine Bouladon. New York: Abrams, 1997.
- Kirch, Patrick Vinton. The Lapita Peoples: Ancestors of the Oceanic World. The Peoples of South-East Asia and the Pacific. Cambridge, MA: Blackwell, 1997.
- Kjellgren, Eric. Splendid Isolation: Art of Easter Island. New York: Metropolitan Museum of Art, 2001.
- ——, and Carol Ivory. Adoming the World: Art of the Marquesas Islands. New Haven: Yale Univ. Press in assoc. with the Metropolitan Museum of Art, 2005.
- Küchler, Susanne, and Graeme Were. Pacific Pattern. London: Thames & Hudson, 2005.
- Lilley, Ian, ed. Archaeology of Oceania: Australia and the Pacific Islands. Malden, MA: Blackwell, 2006.
- McCulloch, Susan. Contemporary Aboriginal Art: A Guide to the Rebirth of an Ancient Culture. Rev. ed. Crows Nest, NSW. Australia: Allen & Unwin, 2001.
- Moore, Albert C. Arts in the Religions of the Pacific: Symbols of Life. Religion and the Arts Series. New York: Pinter, 1995.
- Morphy, Howard. Aboriginal Art. London: Phaidon Press, 1998.
- Morwood, M.J. Visions from the Past: The Archaeology of Australian Aboriginal Art. Washington, DC: Smithsonian Institution Press, 2002.

- Neich, Roger, and Mick Pendergrast. Traditional Tapa Textiles of the Pacific, London: Thames & Hudson, 1997
- Newton, Douglas, ed. Arts of the South Seas: Island Southeast Asia, Melanesia, Polynesia, Micronesia; The Collections of the Musée Babier-Mueller. Trans. David Radzinowicz Howell. New York: Prestel, 1999.
- Rainbird, Paul. The Archaeology of Micronesia. Cambridge World Archaeology. New York: Cambridge Univ. Press, 2004.
- Smidt, Dirk, ed. Asmat Art: Woodcarvings of Southwest New Guinea. New York: George Braziller in assoc. with Rijksmuseum voor Volkenkunde, Leiden, 1993.
- Starzecka, D. C., ed. Maori Art and Culture. London: British Museum Press, 1996.
- Taylor, Luke. Seeing the Inside: Bark Painting in Western Amhem Land. Oxford Studies in Social and Cultural Anthropology. New York: Oxford Univ. Press, 1996.
- Thomas, Nicholas. Oceanic Art. World of Art. New York: Thames & Hudson, 1995.
- —, Anna Cole, and Bronwen Douglas, eds. Tattoo: Bodies, Art, and Exchange in the Pacific and the West. Durham, NC: Duke Univ. Press, 2005.

Chapter 29 Art of Africa in the Modern Era

- Anatsui, El. *El Anatsui Gauu*. Llandudno, Wales, UK: Oriel Mostyn Gallery, 2003.
- Astonishment and Power. Washington, DC: National Museum of African Art, Smithsonian Institution Press, 1993.
- Beckwith, Carol, and Angela Fisher. African Ceremonies. 2 vols. New York: Abrams, 1999.
- Binkley, David A. "Avatar of Power: Southern Kuba Masquerade Figures in a Funerary Context." Africa– Journal of the International African Institute 57/1 (1987): 75–97.
- Cameron, Elisabeth L. Art of the Lega. Los Angeles: UCLA Fowler Museum of Cultural History, 2001.
- Cole, Herbert M., ed. I Am Not Myself: The Art of African Masquerade. Los Angeles: Fowler Museum of Cultural History, Univ. of California, 1985.
- . Icons: Ideals and Power in the Art of Africa. Washington, DC: National Museum of African Art, Smithsonian Institution Press, 1989.
- A Fiction of Authenticity: Contemporary Africa Abroad. St. Louis, MO: Contemporary Art Museum St. Louis, 2003.
- Fogle, Douglas, and Olukemi Ilesanmi. Julie Mehretu: Drawing into Painting. Minneapolis, MN: Walker Art Center, 2003.
- Gillow, John. African Textiles. San Francisco: Chronicle Books, 2003.
- Graham, Gilbert. Dogon Sculpture: Symbols of a Mythical Universe. Brookville, NY: Hillwood Art Museum, Long Island Univ., C. W. Post Campus, 1997.
- Hess, Janet Berry. Art and Architecture in Postcolonial Africa. Jefferson, NC: McFarland, 2006.
- Jordán, Manuel, ed. Chokwe! Art and Initiation Among the Chokwe and Related Peoples. Munich: Prestel, 1998.
- Kasfir, Sidney Littlefield. Contemporary African Art. World of Art. London: Thames & Hudson, 2000.
- Morris, James, and Suzanne Preston Blier. Butabu: Adobe Architecture of West Africa. New York: Princeton Architectural Press, 2004.
- Oguibe, Olu, and Okwui Enwezor. Reading the Contemporary: African Art from Theory to the Marketplace. Cambridge, MA: MIT Press, 1999.
- Pemberton III, John, ed. Insight and Artistry in African Divination. Washington, DC: Smithsonian Institution Press, 2000.
- Perrois, Louis, and Marta Sierra Delage. The Art of Equatorial Guinea: The Fang Tribes. New York: Rizzoli, 1990.
- Picton, John, et al. *El Anatsui: A Sculpted History of Africa*. London: Saffron Books in conjunction with the October Gallery, 1998.
- Roberts, Mary Nooter, and Allen F. Roberts, eds. Memory: Luba Art and the Making of History. New York: Museum for African Art, 1996.
- Roy, Christopher D. Art of the Upper Volta Rivers. Meudon, France: Chaffin, 1987.
- Stepan, Peter. Spirits Speak: A Celebration of African Masks. Munich: Prestel, 2005.
- Van Damme, Annemieke. Spectacular Display: The Art of Nkanı Initiation Rituals. Washington, DC: National Museum of African Art, Smithsonian Institution Press, 2001.
- Vogel, Susan Mullin. Baule: African Art, Western Eyes. New Haven: Yale Univ. Press, 1997.

Chapter 30 Eighteenth- and Early Nineteenth-Century Art in Europe and North America

- Bailey, Colin B., Philip Conisbee, and Thomas W. Gaehtgens. The Age of Watteau, Chardin, and Fragonard: Masterpieces of French Genre Painting. New Haven: Yale Univ. Press in assoc. with the National Gallery of Canada, Ottawa, 2003.
- Boime, Albert. Art in an Age of Bonapartism, 1800–1815. Chicago: Univ. of Chicago Press, 1990.
- . Art in an Age of Counterrevolution, 1815–1848. Chicago: Univ. of Chicago Press, 2004.

———. Art in an Age of Revolution, 1750–1800. Chicago: Univ. of Chicago Press, 1987.

- Bowron, Edgar Peters, and Joseph J. Rishel, eds. Art in Rome in the Eighteenth Century. London: Merrell in association with Philadelphia Museum of Art, 2000.
- Brown, David Blayney. *Romanticism*. London: Phaidon Press, 2001.
- Chinn, Celestine, and Kieran McCarty. Bac: Where the Waters Gather. Univ. of Arizona: Mission San Xavier Del Bac, 1977.
- Craske, Matthew. Art in Europe, 1700–1830: A History of the Visual Arts in an Era of Unprecedented Urban Economic Growth. Oxford History of Art. Oxford: Oxford Univ. Press, 1997.
- Denis, Rafael Cardoso, and Colin Trodd, eds. Art and the Academy in the Nineteenth Century. New Brunswick, NJ: Rutgers Univ. Press, 2000.
- Goodman, Elise, ed. Art and Culture in the Eighteenth Century: New Dimensions and Multiple Perspectives. Studies in Eighteenth-Century Art and Culture. Newark: Univ. of Delaware Press, 2001.
- Hofmann, Werner. Goya: To Every Story There Belongs Another. New York: Thames & Hudson, 2003.
- Irwin, David G. Neoclassicism. Art & Ideas. London: Phaidon Press, 1997.
- Jarrassé, Dominique. 18th-Century French Painting. Trans. Murray Wyllie. Paris: Terrail, 1999.
- Kalnein, Wend von. Architecture in France in the Eighteenth Century. Trans. David Britt. Pelican History of Art. New Haven: Yale Univ. Press, 1995.
- Levey, Michael. Painting in Eighteenth-Century Venice. 3rd ed. New Haven: Yale Univ. Press, 1994.
- Lewis, Michael J. *The Gothic Revival*. World of Art. New York: Thames & Hudson, 2002.
- Lovell, Margaretta M. Art in a Season of Revolution: Painters, Artisans, and Patrons in Early America. Early American Studies. Philadelphia: Univ. of Pennsylvania Press, 2005.
- Monneret, Sophie. David and Neo-Classicism. Trans. Chris Miller and Peter Snowdon. Paris: Terrail, 1999.
- Natter, Tobias, ed. Angelica Kauffman: A Woman of Immense Talent. Ostfildern: Hatje Cantz, 2007.
- Porterfield, Todd, and Susan L. Siegfried. Staging Empire: Napoleon, Ingres, and David. University Park: Pennsylvania State Univ. Press, 2006.
- Poulet, Anne L. Jean-Antoine Houdon: Sculptor of the Enlightenment. Washington, DC: National Gallery of Art, 2003.
- Summerson, John. Architecture of the Eighteenth Century. World of Art. New York: Thames & Hudson, 1986.
- Wilton, Andrew, and Ilaria Bignamini, eds. Grand Tour: The Lure of Italy in the Eighteenth Century. London: Tate Gallery, 1996.
- Chapter 31 Mid- to Late Nineteenth-Century Art in Europe and the United States
- Adams, Steven. The Barbizon School and the Origins of Impressionism. London: Phaidon Press, 1994.
- Bajac, Quentin. The Invention of Photography. Discoveries. New York: Abrams, 2002.
- Barger, M. Susan, and William B. White. The Daguereotype: Nineteenth-Century Technology and Modern Science. Washington, DC: Smithsonian Institution Press, 1991.
- Benjamin, Roger. Orientalist Aesthetics: Art, Colonialism, and French North Africa, 1880–1930. Berkeley: Univ. of California Press, 2003.
- Bergdoll, Barry. European Architecture, 1750–1890. Oxford History of Art. New York: Oxford Univ. Press, 2000.
- Blühm, Andreas, and Louise Lippincott. Light!: The Industrial Age 1750–1900: Art & Science, Technology & Society. New York: Thames & Hudson, 2001.
- Boime, Albert, The Academy and French Painting in the Nineteenth Century. 2nd ed. New Haven: Yale Univ. Press, 1986.
- Butler, Ruth, and Suzanne G. Lindsay. European Sculpture of the Nineteenth Century. Washington, DC: National Gallery of Art, 2000.

- Callen, Anthea. The Art of Impressionism: Painting Technique & the Making of Modernity. New Haven: Yale Univ. Press, 2000.
- Chu, Petra ten-Doesschate. Nineteenth Century European Art. 3rd. ed. Upper Saddle River, NJ: Pearson/Prentice Hall, 2012.
- Clark, T. J. The Painting of Modern Life: Paris in the Art of Manet and His Followers. Rev. ed. London: Thames & Hudson, 1999.
- Conrads, Margaret C. Winslow Homer and the Critiss: Forging a National Art in the 1870s. Princeton, NJ: Princeton Univ. Press in assoc. with the Nelson-Atkins Museum of Art. 2001.
- Denis, Rafael Cardoso, and Colin Trodd. Art and the Academy in the Nineteenth Century. New Brunswick, NJ: Rutgers Univ. Press, 2000.
- Eisenman, Stephen F. Nineteenth Century Art: A Critical History. 3rd ed. New York: Thames & Hudson, 2007.
- Eitner, Lorenz. Nineteenth Century European Painting: David to Cezanne. Rev. ed. Boulder, CO: Westview Press, 2002.
- Frazier, Nancy. Louis Sullivan and the Chicago School. New York: Knickerbocker Press, 1998.
- Fried, Michael. Manet's Modernism, or, The Face of Painting in the 1860s. Chicago: Univ. of Chicago Press, 1996.
- Gerdts, William H. American Impressionism. 2nd ed. New York: Abbeville Press, 2001. Greenhalgh, Paul, ed. Art Nouveau, 1890–1914. London:
- V&A Publications, 2000.
- Grigsby, Darcy Grimaldo. Extremities: Painting Empire in Post-Revolutionary France. New Haven: Yale Univ. Press, 2002.
- Groseclose, Barbara. Nineteenth-Century American Art. Oxford History of Art. Oxford: Oxford Univ. Press, 2000.
- Harrison, Charles, Paul Wood, and Jason Gaiger. Art in Theory 1815–1900: An Anthology of Changing Ideas. Oxford: Blackwell, 1998.
- Herrmann, Luke. Nineteenth Century British Painting. London: Giles de la Mare, 2000.
- Hirsh, Sharon L. Symbolism and Modern Urban Society. New York: Cambridge Univ. Press, 2004.
- Kaplan, Wendy. The Arts & Crafts Movement in Europe & America: Design for the Modern World. New York: Thames & Hudson in assoc. with the Los Angeles County Museum of Art, 2004.
- Kendall, Richard. Degas: Beyond Impressionism. London: National Gallery, 1996.
- Lambourne, Lionel. Japonisme: Cultural Crossings between Japan and the West. New York: Phaidon Press, 2005.
- Lemoine, Bertrand. Architecture in France, 1800–1900. Trans. Alexandra Bonfante-Warren. New York: Abrams, 1998.
- Lewis, Mary Tompkins, ed.. Critical Readings in Impressionism and Post-Impressionism: An Anthology. Berkeley: Univ. of California Press, 2007.
- Lochnan, Katharine Jordan. *Turner Whistler Monet*. London: Tate Publishing in assoc. with the Art Gallery of Ontario, 2004.
- Miller, Angela L., et al. American Encounters: Art, History, and Cultural Identity. Upper Saddle River, NJ: Pearson/ Prentice Hall, 2008.
- Noon, Patrick J. Crossing the Channel: British and French Painting in the Age of Romanticism. London: Tate Publishing, 2003.
- Pissarro, Joachim. Pioneering Modern Painting: Cézanne & Pissarro 1865–1885. New York: Museum of Modern Art, 2005.
- Rodner, William S. J.M.W. Turner: Romantic Painter of the Industrial Revolution. Berkeley: Univ. of California Press, 1997.
- Rosenblum, Robert, and H.W. Janson. 19th Century Art. Rev. & updated ed. Upper Saddle River, NJ: Pearson/ Prentice Hall, 2005.
- Rubin, James H. Impressionism. Art & Ideas. London: Phaidon Press, 1999.
- Rybczynski, Witold. A Clearing in the Distance: Frederick Law Olmsted and America in the Nineteenth Century. New York: Scribner, 1999.
- Smith, Paul. Seurat and the Avant-Garde. New Haven: Yale Univ. Press, 1997.
- Thomson, Belinda. Impressionism: Origins, Practice, Reception. World of Art. New York: Thames & Hudson, 2000.
- Twyman, Michael. Breaking the Mould: The First Hundred Years of Lithography. The Panizzi Lectures, 2000. London: British Library, 2001.
- Vaughan, William, and Francoise Cachin. Arts of the 19th Century. 2 vols. New York: Abrams, 1998.

- Werner, Marcia. Pre-Raphaelite Painting and Nineteenth-Century Realism. New York: Cambridge Univ. Press, 2005.
- Zemel, Carol M. Van Gogh's Progress: Utopia, Modernity, and Late-Nineteenth-Century Art. California Studies in the History of Art, 36. Berkeley: Univ. of California Press, 1997.

Chapter 32 Modern Art in Europe and the Americas, 1900–1950

- Ades, Dawn, comp. Art and Power: Europe under the Dictators, 1930–45. Stuttgart, Germany: Oktagon in assoc. with Hayward Gallery, 1995.
- Antliff, Mark, and Patricia Leighten. Cubism and Culture. World of Art. London: Thames & Hudson, 2001. Bailey, David A. Rhapsodies in Black: Art of the Harlem
- Renaissance. London: Hayward Gallery, 1997. Balken, Debra Bricker. Debating American Modernism:
- Stieglitz, Duchamp, and the New York Avant-Garde. New York: American Federation of Arts, 2003.
- Barron, Stephanie, ed. Degenerate Art: The Fate of the Avant-Garde in Nazi Germany. Los Angeles: Los Angeles County Museum of Art, 1991.
- —, and Wolf-Dieter Dube, eds. German Expressionism: Art and Society. New York: Rizzoli, 1997. Bochner, Jay. An American Lens: Scenes from Alfred Stieglitz's
- New York Secession. Cambridge, MA: MIT Press, 2005. Bohn, Willard. The Rise of Surrealism: Cubism, Dada, and
- the Pursuit of the Marvelous. Albany: State Univ. of New York Press, 2002. Bowlt, John E., and Evgeniia Petrova, eds. *Painting*
- Revolution: Kandinsky, Malevich and the Russian Avant-Garde. Bethesda, MD: Foundation for International Arts and Education, 2000.
- Bown, Matthew Cullerne. Socialist Realist Painting. New Haven: Yale Univ. Press, 1998.
- Brown, Milton W. Story of the Armory Show. 2nd ed. New York: Abbeville Press, 1988.
- Chassey, Eric de, ed. American Art: 1908–1947, from Winslow Homer to Jackson Pollock. Trans. Jane McDonald. Paris: Réunion des Musées Nationaux, 2001.
- Corn, Wanda M. The Great American Thing: Modern Art and National Identity, 1915–1935. Berkeley: Univ. of California Press, 1999.
- Curtis, Penelope. Sculpture 1900–1945: After Rodin. Oxford History of Art. Oxford: Oxford Univ. Press, 1999.
- Dachy, Marc. Dada: The Revolt of Art. Trans. Liz Nash. New York: Abrams, 2006.
- Elger, Dietmar. Expressionism: A Revolution in German Art. Ed. Ingo F. Walther. Trans. Hugh Beyer. New York: Taschen, 1998.
- Fer, Briony. On Abstract Art. New Haven: Yale Univ. Press, 1997.
- Fletcher, Valerie J. Crosscurrents of Modernism: Four Latin American Pioneers: Diego Rivera, Joaquín Torres-García, Wifredo Lam, Matta. Washington, DC: Hirshhorn Museum and Sculpture Garden in assoc. with the Smithsonian Institution Press, 1992.
- Folgarait, Leonard. Mural Painting and Social Revolution in Mexico, 1920–1940: Art of the New Order. New York: Cambridge Univ. Press, 1998.
- Forgács, Eva. The Bauhaus Idea and Bauhaus Politics. Trans. John Bátki. New York: Central European Univ. Press, 1995.
- Frampton, Kenneth. Modern Architecture: A Critical History. 4th ed. World of Art. London: Thames & Hudson, 2007.
- Gooding, Mel. Abstract Art. Movements in Modern Art. Cambridge: Cambridge Univ. Press, 2001.
- Grant, Kim. Surrealism and the Visual Arts: Theory and Reception. New York: Cambridge Univ. Press, 2005. Green, Christopher. Art in France: 1900–1940. Pelican
- History of Art. New Haven: Yale Univ. Press, 2000. Harris, Jonathan. Federal Art and National Culture: The Politics
- of Identity in New Deal America. Cambridge Studies in American Visual Culture. New York: Cambridge Univ. Press, 1995.
- Harrison, Charles, Francis Frascina, and Gill Perry. Primitivism, Cubism, Abstraction: The Early Twentieth Century. New Haven: Yale Univ. Press, 1993.
- Haskell, Barbara. The American Century: Art & Culture, 1900–1950. New York: Whitney Museum of American Art, 1999.
- Herskovic, Marika, ed. American Abstract Expressionism of the 1950s: An Illustrated Survey: With Artists' Statements, Artwork and Biographies. New York: New York School Press, 2003.

- Hill, Charles C. The Group of Seven: Art for a Nation. Ottawa: National Gallery of Canada, 1995.
- James-Chakraborty, Kathleen, ed. Bauhaus Culture: From Weimar to the Cold War. Minneapolis: Univ. of Minnesota Press, 2006.
- Karmel, Pepe. *Picasso and the Invention of Cubism*. New Haven: Yale Univ. Press, 2003.
- Lista, Giovanni. Futurism. Trans. Susan Wise. Paris: Terrail, 2001.
- Lucie-Smith, Edward. Latin American Art of the 20th Century. 2nd ed. World of Art. London: Thames & Hudson, 2005.
- McCarter, Robert, ed. On and by Frank Lloyd Wright: A Primer of Architectural Principles. New York: Phaidon Press, 2005.
- Moudry, Roberta, ed. The American Skyscraper: Cultural Histories. New York: Cambridge Univ. Press, 2005.
- Rickey, George. Constructivism: Origins and Evolution. Rev. ed. New York: Braziller, 1995. Taylor, Brandon. Collage: The Making of Modern Art.
- London: Thames & Hudson, 2004. Weston, Richard. *Modernism.* London: Phaidon Press, 1996.
- Weston, Richard. Modernism. Eondon. Fination Fress, 1990 White, Michael. De Stijl and Dutch Modernism. Critical Perspectives in Art History. New York: Manchester Univ. Press, 2003.
- Whitfield, Sarah. *Fauvism*. World of Art. New York: Thames & Hudson, 1996.
- Whitford, Frank. The Bauhaus: Masters and Students by Themselves. Woodstock, NY: Overlook Press, 1993.

Zurier, Rebecca, Robert W. Snyder, and Virginia M. Mecklenburg. *Metropolitan Lives: The Ashcan Artists and Their New York*. Washington, DC: National Museum of American Art, 1995.

Chapter 33 The International Scene since 1950

- Alberro, Alexander, and Blake Stimson, eds. Conceptual Art: A Critical Anthology. Cambridge, MA: MIT Press, 1999. Archer, Michael. Art Since 1960. 2nd ed. World of Art.
- New York: Thames & Hudson, 2002.
- Atkins. Robert. Artspeak: A Guide to Contemporary Ideas, Movements, and Buzzwords. 2nd ed. New York: Abbeville Press, 1997.
- Ault, Julie. Art Matters: How the Culture Wars Changed America. Ed, Brian Wallis, Marianne Weems, and Philip Yenawine. New York: New York Univ. Press, 1999. Battcock, Gregory. Minimal Art: A Critical Anthology.
- Berkeley: Univ. of California Press, 1995.
- Beardsley, John. Earthworks and Beyond: Contemporary Art in the Landscape. 4th ed. ebook. New York: Abbeville Press, 2006.
- Bird, Jon, and Michael Newman, eds. *Rewriting Conceptual Art.* Critical Views. London: Reaktion Books, 1999.
- Bishop, Claire. Installation Art: A Critical History. New York: Routledge, 2005.
- Blais, Joline, and Jon Ippolito. At the Edge of Art. London: Thames & Hudson, 2006.
- Buchloh, Benjamin H.D. Neo-Avantgarde and Culture Industry: Essays on European and American Art from 1955 to 1975. Cambridge, MA: MIT Press, 2000.

Carlebach, Michael L. American Photojournalism Comes of Age. Washington, DC: Smithsonian Institution Press, 1997. Causey, Andrew. Sculpture Since 1945. Oxford History of

Art. Oxford: Oxford Univ. Press, 1998. Corris, Michael, ed. Conceptual Art: Theory, Myth, and

Practice. New York: Cambridge Univ. Press, 2004. De Oliveira, Nicolas, Nicola Oxley, and Michael Petry.

Installation Art in the New Millennium: The Empire of the Senses. New York: Thames & Hudson, 2003.

- De Salvo, Donna, ed. Open Systems: Rethinking Art c.1970. London: Tate Gallery, 2005.
- Fabozzi, Paul F. Artists, Critics, Context: Readings In and Around American Art Since 1945. Upper Saddle River, NJ: Pearson/Prentice Hall, 2002.
- Fineberg, Jonathan. Art Since 1940: Strategies of Being. 3rd ed. Upper Saddle River, NJ: Pearson/Prentice Hall, 2011. Flood, Richard, and Frances Morris. Zero to Infinity: Arte
- Plood, Richard, and Frances Morris. Zero to infinity: Ane Povera, 1962–1972. Minneapolis, MN: Walker Art Center, 2001.
- Fried, Michael. "Art and Objecthood." Artforum 5 (June 1967): 12–23.
- Goldberg, RoseLee. Performance Art: From Futurism to the Present. Rev. and exp. ed. World of Art. London: Thames & Hudson, 2001.
- Goldstein, Ann. A Minimal Future? Art as Object 1958–1968. Los Angeles: Museum of Contemporary Art, 2004.
- Grande, John K. Art Nature Dialogues: Interviews with Environmental Artists. Albany: State Univ. of New York Press, 2004.

- Grosenick, Uta, ed. Women Artists in the 20th and 21st Century. New York: Taschen, 2001.
- _____, and Burkhard Riemschneider, eds. Art at the Turn of the Millennium. New York: Taschen, 1999.
- Grunenberg, Christoph, ed. Summer of Love: Art of the Psychedelic Era. London: Tate Gallery, 2005.
- Hitchcock, Henry Russell, and Philip Johnson. The International Style. New York: Norton, 1995.
- Hopkins, David. After Modern Art: 1945–2000. Oxford History of Art. Oxford: Oxford Univ. Press, 2000.
- Jencks, Charles. The New Paradigm in Architecture: The Language of Post-Modernism. New Haven: Yale Univ. Press, 2002.
- Jodidio, Philip. New Forms: Architecture in the 1990s. Taschen's World Architecture. New York: Taschen, 2001.
- Johnson, Deborah, and Wendy Oliver, eds. Women Making Art: Women in the Visual, Literary, and Performing Arts Since 1960. Eruptions, vol. 7. New York: Peter Lang, 2001.
- Jones, Caroline A. Machine in the Studio: Constructing the Postwar American Artist. Chicago: Univ. of Chicago Press, 1996.
- Joselit, David. American Art Since 1945. World of Art. London: Thames & Hudson, 2003.
- Legault, Réjean, and Sarah Williams Goldhagen, eds. Anxious Modernisms: Experimentation in Postwar Architectural Culture. Montréal: Canadian Centre for Architecture, 2000.
- Lucie-Smith, Edward. *Movements in Art Since 1945*. New ed. World of Art. London: Thames & Hudson, 2001.
- Madoff, Steven Henry, ed. Pop Art: A Critical History. The Documents of Twentieth-Century Art. Berkeley: Univ. of California Press, 1997.
- Moos, David, ed. The Shape of Colour: Excursions in Colour Field Art, 1950–2005. Toronto: Art Gallery of Ontario, 2005.
- Nochlin, Linda. "Why Have There Been No Great Women Artists?" Art News 69 (January 1972): 22–39.
- Owens, Craig. "The Discourse of Others: Feminists and Postmodernism." In *The Anti-Aesthetic: Essays on Postmodern Culture*, ed. Hal Foster. Seattle: Bay Press, 1983: 57–82.
- Paul, Christiane. Digital Art. 2nd ed. World of Art. London: Thames & Hudson, 2008.
- Phillips, Lisa. The American Century: Art and Culture, 1950–2000. New York: Whitney Museum of American Art, 1999.
- Pop Art: Contemporary Perspectives. Princeton, NJ: Princeton Univ. Art Museum, 2007.
- Ratcliff, Carter. The Fate of a Gesture: Jackson Pollock and Postwar American Art. New York: Farrar, Straus, Giroux, 1996.
- Reckitt, Helena, ed. Art and Feminism. Themes and Movements. London: Phaidon Press, 2001.
- Robertson, Jean, and Craig McDaniel. Themes of Contemporary Art: Visual Art after 1980. 2nd ed. New York: Oxford Univ. Press, 2009.
- Robinson, Hilary, ed. Feminism-Art-Theory: An Anthology, 1968–2000. Malden, MA: Blackwell, 2001.
- Rorimer, Anne. New Art in the 60s and 70s: Redefining Reality. New York: Thames & Hudson, 2001.
- Rush, Michael. New Media in Late 20th-Century Art. 2nd ed. World of Art. London: Thames & Hudson, 2005.
- Sandler, Irving. Art of the Postmodern Era: From the Late 1960s to the Early 1990s. New York: Icon Editions, 1996.
- Shohat, Ella. Talking Visions: Multicultural Feminism in a Transnational Age. Documentary Sources in Contemporary Art, vol. 5. New York: New Museum of Contemporary Art, 1998.
- Smith, Terry. Contemporary Art: World Currents. Upper Saddle River, NJ: Pearson/Prentice Hall, 2011.
- Stiles, Kristine, and Peter Selz. Theories and Documents of Contemporary Art: A Sourcebook of Artists' Writings. California Studies in the History of Art, 35. Berkeley: Univ. of California, 1996.
- Sylvester, David. About Modern Art. 2nd ed. New Haven: Yale Univ. Press, 2001.
- Varnedoe, Kirk, Paola Antonelli, and Joshua Siegel, eds. Modem Contemporary: Art Since 1980 at MoMA. Rev. ed. New York: Museum of Modern Art, 2004.
- Waldman, Diane. Collage, Assemblage, and the Found Object. New York: Abrams, 1992.
 Weintraub, Linda, Arthur Danto, and Thomas McEvilley.

Art on the Edge and Over: Searching for Art's Meaning in

Insights, 1996.

Contemporary Society, 1970s-1990s. Litchfield, CT: Art

BIBLIOGRAPHY

583

Introduction

Intro-1 © 2010 Digital Image, The Museum of Modern Art, New York/Scala, Florence © 2005 Kate Rothko Prizel & Christopher Rothko/Artists Rights Society (ARS), New York; Intro-2 object no 1997.007.0697; Intro-3 C Achim Bednorz, Cologne: page xxx A British Library Board/Robana; page xxx A detail British Library Board/Robana; page xxx C © Studio Fotografico Quattrone, Florence; page xxx D Robana Picture Library/The British Library Board; page xxx D detail British Library Board/Robana; Intro-4 Suconcessione del Ministero per il Beni e le Attività Culturali, photo INDEX/Tosi; Intro-5 © 2007 Image copyright The Metropolitan Museum of Art/Art Resource, NY/Scala, Florence; Intro-5 A Closer Look a Ashmolean Museum, Oxford, England, U.K; Intro-5 A Closer look b Princeton University Art Museum. Museum Purchase in memory of Ellen B. Elliott. Fowler McCormick, Class of 1922, Fund 2008-345. Photo: © UAM/Bruce M. White, 2008; Intro-6 © 2004. Photo The Philadelphia Museum of Art/Scala, Florence; Intro-7 Kunsthistorisches Museum, Vienna; Intro-8 © Studio Fotografico Quattrone, Florence; Intro-9 © 2009 Photo Scala, Florence courtesy of the Ministero Beni e. Att. Culturali; Intro-10 © 2004. Photo The Philadelphia Museum of Art/Scala, Florence.

Chapter 1

1.1 Scala, Florence/BPK, Bildagentur fuer Kunst, Kultur und Geschichte, Berlin; 1.2 © Tom Till; 1.3 © 2009 Photo Werner Forman Archive/Scala, Florence; 1.4 Image courtesy of Christopher Henshilwood; 1.5 Jack Unruh/National Geographic Stock; 1.6 K.H. Augustin, Esslingen/Ulmer Museum; 1.7 akg-images/Erich Lessing; 1.8 The Art Archive/Moravian Museum Brno/Alfredo Dagli Orti; 1.9 Sisse Brimberg/National Geographic Image Collection; 1.10 French Ministry of Culture and Communication, Regional Direction for Cultural Affairs-Rhône-Alpes region-Regional department of archaeology Slide no 10; 1.11 akg-images; 1.12 Yvonne Vertut; 1.13 Sisse Brimberg/National Geographic Stock; 1.14 Yvonne Vertut; 1.15 John Swogger; 1.16 akg-images/Erich Lessing; 1.17 The Art Archive/ Museum of Anatolian Civilizations Ankara/Gianni Dagli Orti; page 15 Reconstruction by John Gordon Swogger, originally published as figure 5.8 in Ian Hodder's The Leopard's Tale, Thames & Hudson; 1.18 Souvatzi, S. 2009. A Social Archaeology of Households in Neolithia Greece: An Anthropological Approach, fig. 4.8b. Cambridge University Press. After Theocharis 1973 (Theocharis, D.R. Neolithic Greece National Bank of Greece, 1973); 1.19 © National Monuments Service. Dept of Arts, Heritage, and the Gaeltacht, Ireland; 1.20 Aerofilms/English Heritage Photo Library; 1.21 Peter Adams The Image Bank/Getty; 1.22 Courtesy Antiquity magazine; 1.23 English Heritage Photo Library; 1.24 © Sakamoto Photo Research Laboratory/Corbis; 1.25 Catherine Perlès; 1.26a & 1.26b akg-Erich Lessing; 1.27 The Department of Antiquities of Jordan(DoA); 1.28 & 1.29 akg-images/Erich Lessing; 1.30 Giraudon/The Bridgeman Art Library.

Chapter 2

2.1 Photo Josse, Paris; 2.2 World Tourism Organization: Iraq; 2.3 & 2.4a © 2008. Photo Scala, Florence/BPK, Bildagentur fuer Kunst Kultur und Geschichte, Berlin; 2.4b Photo Scala, Florence; 2.5 Courtesy of the Oriental Institute of the University of Chicago; 2.9 BaghdadMuseum.org; 2.6 Courtesy of the Penn Museum, imag #191209; 2.7 Courtesy of the Penn Museum, image # 160104; 2.8 Courtesy of the Penn Museum, image #150888; 2.10a Courtesy of the Penn Museum, image #10872; 2.10b Courtesy of the Penn Museum, image #10872; 2.11 Courtesy of the Penn Museum, image #150424; 2.12 © 1990 Photo Scala, Florence; 2.13 Michael S. Yamashita/CORBIS; 2.14 D. Arnaudet/Louvre, Paris, France/ Réunion des Musées Nationaux; 2.15 RMN/Hervé Lewandowski; 2.16 Art Archive/Dagli Orti; 2.17 © The Trustees of the British Museum. All rights reserved; 2.18 Courtesy of the Oriental Institute of the University of Chicago; page 42 © The Trustees of the British Museum. All rights reserved; 2.19 World Tourism Organization: Iraq; 2.20 © The Trustees of the British Museum. All rights reserved; 2.21 Courtesy of the Oriental Institute of the University of Chicago; 2.22 © 2012 Photo Scala, Florence/BPK, Bildagentur fuer Kunst, Kultur und Geschichte, Berlin; 2.23 Kurt and Rosalia Scholz/ SuperStock; 2.24 Gérard Degeorge/CORBIS; 2.29b Courtesy of the Penn Museum, image #10872.

Chapter 3

3.1 Photo: Jürgen Liepe; page 52, both akg-images/Erich Lessing; 3.3 Iberfoto/Alinari Archives; 3.4 National Geographic/SuperStock; 3.5 Maltings © Dorling Kindersley; 3.6 © Roger Wood/Corbis; 3.7 Werner Forman Archive; 3.8 Araldo de Luca/The Egyptian Museum, Cairo; 3.9 Photograph © 2013 Museum of Fine Arts, Boston; 3.10 RMN-Grand Palais (Musée du Louvre)/Franck Raux; 3.11 Courtesy of the Oriental Institute of the University of Chica 3.12 & 3.14 Yvonne Vertut; 3.15 © 2009 White Image/Scala, Florence; 3.16 © The Trustees of the British Museum. All rights reserved; 3.17 Photo: Jürgen Liepe; page 64 C The Trustees of the British Museum. All rights reserved; 3.20 Yvonne Vertut; 3.21 The Metropolitan Museum of Art/Scala, Florence/Art Resource NY; 3.22 Kurt and Rosalia Scholz/SuperStock; 3.23 Dorling Kindersley; 3.24 Photo Scala, Florence; 3.25 Araldo de Luca/IKONA; 3.26 & 3.27 Photo Scala, Florence/BPK, Bildagentur fuer Kunst, Kultur und Geschichte, Berlin: 3.28 © 2012 Photo Scala, Florence/BPK Bildagentur fuer Kunst, Kultur und Geschichte, Berlin; 3.29 Araldo de Luca Studio; 3.30 The Art Archive/Gianni Dagli Orti; 3.32 Terrence Spencer/Time & Life Pictures/Getty Images; 3.33 © The Trustees of the British Museum. All rights reserved; 3.34 The Getty Conservation Institute. © The J. Paul Getty Trust 2010. All rights reserved. Photo by Guillermo Aldana; 3.35 © The Trustees of the British Museum. All rights reserved; 3.36 RMN/Hervé Lewandowski; 3.37 & 3.38a © The Trustees of the British Museum. All rights reserved.

Chapter 4

4.1 Ch. Doumas, *The Wall Paintings of Thera*, Idryma Theras—Petros M. Nomikos, Athens 1992; 4.2a © 2009 Image copyright The Metropolitan Museum of Art/Art Resource/Scala, Florence; 4.3 © Copenhagen National Museum #4697; 4.4 © Craig & Marie Mauzy, Athens; 4.5 McRae Books Srl; 4.6 Roger Wood/Corbis; 4.7 © Craig & Marie Mauzy, Athens; 4.8 British School at Athens by permiss of the Management Committee (courtesy of the Department of Classics, University of Columbia, USA, photo © L.H. Sackett); 4.9a & 4.9b Craig & Marie Mauzy, Athens; 4.10 akg-images/Nimatallah; 4.11 © Craig & Marie Mauzy, Athens; 4.12 Studio Kontos, Photostock; 4.13 © Craig & Marie Mauzy, Athens; 4.14 Studio Kontos Photostock; page 92-93 akg-images/Nimatallah; 4.15 Studio Kontos Photostock; 4.17 Deutsches Archaologisches Institut, Athens; 4.19 University of Cincinnati, Department of Classics (courtesy Professor C.W.Blegen); 4.20 © Craig & Marie Mauzy, Athens; 4.21 The Art Archive/National Archaeological Museum Athens/Gianni Dagli Orti; 4.23 & 4.24 © Craig & Marie Mauzy, Athens; 4.25 © Craig & Marie Mauzy, Athens.

Chapter 5

5.1 Photo: Vatican Museums; 5.2 & 5.3 © 2012 Image copyright The Metropolitan Museum of Art/Art Resource/Scala, Florence; 5.4 The J. Paul Getty Museum, Villa Collection, Malibu, California 5.5 The Art Archive/Gianni Dagli Orti; 5.6 Dorling Kindersley; 5.8 Craig & Marie Mauzy, Athens; 5.9b Fotografica Foglia, Naples; 5.10 Craig & Marie Mauzy, Athens; 5.11 Courtesy of Laurence King Publishing, John Griffiths Pedley, Greek Art and Archaeology 4th edition © 2007; 5.13 Staatliche Antikensammlungen, Munich; 5.14, 5.15, 5.16, & 5.17 Staatliche Antikensammlungen, Munich/ Studio Koppermann; 5.18 Image © The Metropolitan Museum of Art/Art Resource/Scala, Florence; 5.19 Photo Scala, Florence/ BPK, Bildagentur fuer Kunst, Kultur und Geschichte, Berlin: 5.20 © Craig & Marie Mauzy, Athens; 5.21 © Craig & Marie Mauzy, Athens/Acropolis Museum, Athens, Greece; 5.23 Bibliothèque Nationale de France; 5.24 & 5.25 Photograph © 2013 Museum of Fine Arts, Boston; page 119 © 2012 Photo Scala, Florenceof the Ministero Beni e Att. Culturali; 5.26a © Craig & Marie Mauzy, Athens; 5.26b Studio Kontos Photostock; 5.27 Photo Scala, Florence/BPK, Bildagentur fuer Kunst, Kultur und Geschichte, Berlin; 5.28 C Craig & Marie Mauzy, Athens/Archaeological Museum, Delphi; 5.29a & 5.29b akg-images/Nimatallah; 5.30 © Aaron M. Levin, Baltimore; 5.31 Photo Scala, Florence-courtesy of the Ministero Beni e Att. Culturali; 5.32 Photo Scala, Florence, Fotografica Foglia-courtesy of the Ministero Beni e Att. Culturali; 5.33 © The Trustees of the British Museum, All rights reserved: 5.34 Courtesy Ministero per i Beni e le Attivita Culturali; 5.36a © Craig & Marie Mauzy, Athens; 5.37a, 5.37b, 5.37c, 5.38, & 5.39 © The Trustees of the British Museum. All rights reserved; 5.40 Giraudon/ The Bridgeman Art Library; 5.41 With permission of the Royal Ontario Museum © ROM; 5.42 akg-images/Nimatallah; 5.43 & 5.44 Studio Kontos Photostock; 5.45 Borisb17 / Shutterstock; 5.46 © Craig & Marie Mauzy, Athens/Akropolis Museum, Athens; 5.48 Photograph © 2013 Museum of Fine Arts, Boston; 5.49 © 2007 Image copyright The Metropolitan Museum of Art/Scala, Florence; 5.50 Photo Scala, Florence; 5.51 Photograph © 2013 Museum of Fine Arts, Boston; 5.52 Craig & Marie Mauzy, Athens/ Archaeological Museum, Olympia; 5.53 akg-images/Nimatallah; 5.54 Photo: Vatican Museums; 5.55 Image © The Metropolitan Museum of Art/Art Resource/Scala, Florence; 5.56 © 2011 Photo

Scala, Florence—courtesy of the Ministero Beni e Att. Culturali; 5.57 & 5.58 Studio Kontos Photostock; 5.59a © Craig & Marie Mauzy, Athens; 5.60 © Araldo de Luca/CORBIS; 5.61 © RMN/Jean-Gilles Berizzi; 5.62 Photo Scala, Florence/PK, Bildagentur fuer Kunst, Kultur und Geschichte, Berlin; 5.63 © 2011 Photo Scala, Florence/ BPK, Bildagentur fuer Kunst, Kultur und Geschichte, Berlin; 5.64 Photo Scala, Florence; 5.65 RMN/Gérard Blot/Christian Jean; 5.66 Image copyright The Metropolitan Museum of Art/Art Resource/ Scala, Florence; 5.67 RMN/Hervé Lewandowski.

Chapter 6

6.1 © Vincenzo Pirozzi, Rome; 6.2 Maurizio Bellu/IKONA; 6.3a Courtesy of Penelope Davies: 6.4 © Vincenzo Pirozzi, Rome: 6.5 The Art Archive/Gianni Dagli Orti; 6.6 © 1990 Photo Scala, Florence. Courtesy of the Ministero Beni e Att. Culturali; 6.7 akgimages/De Agostini Picture Library; 6.8 Photo Scala, Floren courtesy of the Ministero Beni e Att, Culturali; 6.9 Araldo de Luca/CORBIS; 6.10 Photograph © 2013 Museum of Fine Arts, Boston; 6.11 © 2012 Photo Scala, Florence; 6.12 © Araldo de Luca/CORBIS; 6.13 Canali Photobank; 6.14 Araldo de Luca; 6.15 Canali Photobank, Milan, Italy; 6.16 American Numismatic Society of New York; 6.17 C Jon Arnold Images/DanitaDelimont.com 6.18a © Vincenzo Pirozzi, Rome; 6.19 Araldo de Luca/CORBIS; 6.20 Andrea Jemolo/IKONA; 6.21 Andrea Jemolo/IKONA; 6.23 Kunsthistorisches Museum, Vienna, Austria; 6.24 George Gerster/Photo Researchers; 6.25 Dorling Kindersley; 6.26 Canali Photobank; 6.27 Alberti/Index Ricerca Iconografica; 6.29 Canali Photobank; 6.30 Photo Scala, Florence/Luciano Roman of the Ministero Beni e Att. Culturali; 6.31 Image copyright The Metropolitan Museum of Art/Art Resource/Scala, Florence: 6.32 © Vincenzo Pirozzi, Rome; 6.33 © 2003. Photo Scala, Florence/ Fotografica Foglia. Courtesy of the Minstero Beni e Att. Culturali; 6.34 akg-images/Erich Lessing; 6.35 © 2012 Photo Scala, Florence/ Fotografica Foglia-courtesy of the Ministero Beni e Att. Culturali; 6.36 A. Vasari/Index Ricerca Iconografica; 6.37 © Achim Bednorz, Cologne; 6.39 Canali Photobank; 6.40a&b Araldo de Luca/Index Ricerca Iconografica; 6.41a&b Musei Vaticani/IKONA; 6.42 Index/ Vasari; 6.44 Dr. James E. Packer; 6.45 akg-images/Peter Connolly 6.46 Scala, Florence-courtesy of the Ministero Beni e Att. Culturali; 6.47 © Vincenzo Pirozzi, Rome; 6.48 Photo Scala, Florencecourtesy of the Ministero Beni e Att. Culturali; 6.49 © Vincenzo Pirozzi, Rome; 6.51 After William L. MacDonald, The Architecture of the Roman Empire I: An Introductory Study. New Haven and London: Yale University Press. 1965, fig. 9; 6.52 ALIMDI.NET/Birgit Koch; 6.54 © Vincenzo Pirozzi, Rome; 6.55 Photo Scala, Florence/BPK, Bildagentur fuer Kunst, Kultur und Geschichte, Berlin; 6.56 Photo Vatican Museums; 6.57 Canali Photobank/Museo Capitolino; 6.58 © Araldo de Luca/CORBIS; page 202 Photo © The Walters Art Museum, Baltimore; 6.59 The Metropolitan Museum of Art/ Art Resource/Scala, Florence; 6.60a © Alinari Archives/CORBIS; 6.61 Araldo de Luca; 6.63 © Achim Bednorz, Cologne; 6.62 © Cameraphoto Arte, Venice; 6.64 C Achim Bednorz, Cologne; 6.65 Araldo de Luca/Index Ricerca Iconografica; 6.66 Vasari, Roma/ IKONA; 6.67a ALIMDI.NET/Raimund Kutter; 6.68 C Vincenzo Pirozzi, Rome; 6.69 C The Trustees of the British Museum, All rights reserved; 6.70 V&A Images.

Chapter 7

7.1 Index Ricerca Iconografica; 7.2 Soprintendenza Archeologica di Roma/IKONA; 7.3 Princeton University Press/Art Resource, NY; 7.4 Yale University Art Gallery, Dura-Europos Collection; page 219 Zev Radovan/Bibleland Pictures; 7.6 Yale University Art Gallery, Dura-Europos Collection; 7.7 Canali Photobank; 7.10 Nimatallah/ Index Ricerca Iconografica; 7.11 © Vincenzo Pirozzi, Rome; 7.12 & 7.15 Photo Scala, Florence; 7.16 Photo: Vatican Museums; 7.17 Vasari/Index Ricerca Iconografica; 7.18 © Gina Berto Vanni/Vanni Archive/CORBIS; 7.19 Canali Photobank; 7.20 © Cameraphoto Arte, Venice; 7.21 Hirmer Fotoarchiv.

Chapter 8

8.1 © 2007 Image copyright The Metropolitan Museum of Art/ Art Resource, NY/Scala, Florence; 8.2 & 8.4 Photo: Ayhan Altun; 8.6 © 1990, Photo Scala, Florence; 8.7 akg-images/Cameraphoto; 8.8 & 8.9 © Cameraphoto Arte, Venice; 8.10 Prisma Bildagentur AG/Alamy; 8.12 © The Trustees of the British Museum. All rights reserved; 8.13 Bildarchiv der Osterreichische Nationalbibliothek; 8.14 Studio Kontos Photostock; 8.16 Photo: Ayhan Altun; 8.18 The Art Archive/Gianni Dagli Orti; 8.19 & 8.20 Bruce White Photography; 8.21 akg-images/Erich Lessing; 8.22 Studio Kontos Photostock; 8.23 The Art Archive/Gianni Dagli Orti; 8.24 © Cameraphoto Arte, Venice; 8.25a&b RMN (Musée du Louvre)/Daniel Arnaudet; 8.26 & 8.27 Bibliothèque Nationale de France; page 257 © Cameraphoto Arte, Venice; 8.28 Photo Scala, Florence; 8.30, 8.31, 8.32, & 8.33 Photo: Ayhan Altun; 8.34 The Art Archive/Icon Gallery, Ohrid, Macedonia/Gianni Dagli Orti; 8.35 Photo Scala, Florence.

Chapter 9

9.1 Bibliothèque Nationale de France; 9.2 Kazuyoshi Nomachi/ Corbis; 9.3a Zoonar GmbH/Alamy; 9.3b Dorling Kindersley; 9.4 The Art Archive/Gianni Dagli Orti; 9.5 Roger Wood/Corbis; 9.6 & 9.8 Raffaello Bencini Fotografo; 9.9 akg-images/Erich Lessing; 9.10 © 2012 The Metropolitan Museum of Art/Scala, Florence; 9.11 RMN/Thierry Ollivier; 9.13b After Robert Hillenbrand, Islamia Architecture, 1994, p.195; 9.14 Bernard O'Kane/Alamy; page 279 © 2012 Image The Metropolitan Museum of Art/Art Resource Scala, Florence; 9.15 © Achim Bednorz, Cologne; 9.16 Peter Sanders Photography; 9.17 © 2012 The Metropolitan Museum of Art/Art Resource/Scala, Florence; 9,18 Digital Image Museum Associates/ LACMA/Art Resource NY/Scala, Florence; 9.19 © 2012 Image The Metropolitan Museum of Art/Art Resource/Scala, Florence; 9.20 RMN (Musée du Louvre)/Franck Raux; 9.21 Courtesy of Alexandria Press; 9.22 akg-images/Gerard Degeorge; 9.23a Drawn by Christopher Woodward. From A History of Ottoman Architecture by Godfrey Goodwin, Thames & Hudson, London and New York; 9.23b Sonia Halliday Photographs; 9.24 & 9.25 Photo: Ayhan Altun; 9.26 © 2012 The Metropolitan Museum of Art/Art Resource/Scala, Florence; 9.28a Drawing by Keith Turner after Henri Stierlin © Aga Khan Visual Archive, MIT; 9.28b photo: Abbas Aminmansour Magnum Photos; 9.29 © Culture and Sport Glasgow. CIC Glasgow Museums Collection; 9.31 Courtesy of the architect/Aga Khan Trust for Culture

Chapter 10

10.1 Rick Asher; 10.2ab Giraudon/The Bridgeman Art Library; 10.2c, 10.2d, 10.2e, & 10.2f National Museum of Karachi, Karachi, Pakistan/The Bridgeman Art Library; 10.3 & 10.4 Copyright J.M. Kenoyer/Harappa.com, Courtesy Dept. of Archaeology and Museums, Govt. of Pakistan; 10.5 National Museum of New Delhi; 10.6 Borromeo/Art Resource, NY; 10.7 Rick Asher; 10.8 © Adam Woolfitt/Robert Harding World Imagery/Corbis; page 304 Dinodia Photo; 10.9 © Richard Ashworth/Robert Harding; 10.10 age fotostock/Dinodia Photo; 10.11 T. Paramjit/Ancient Art & Architecture Collection Ltd; 10.12 Richard Todd/National Museum of New Delhi: 10.13 & 10.14 Rick Asher: 10.15 akg-images; 10.16 Luca Tettoni/Robert Harding; 10.17 Asian Art Archives, University of Michigan (AAAUM); 10.18 Borromeo/Art Resource, NY; 10.19 Photo: Dominc Sansoni; 10.20 Kevin Schafer/Alamy; 10.21 & 10.22 Asian Art Archives, University of Michigan (AAAUM); 10.23 © Robert Gill; Papilio/CORBIS All Rights Reserved; 10.24 Rick Asher; 10.25 Photograph by John C. Huntington Courtesy of The Huntington Photographic Archive at The Ohio State University; 10.26 Photo: Srinivas Padma; 10.27 © David Cumming; Eye Ubiquitous/CORBIS All Rights Reserved; 10.28 © Richard Ashworth/Robert Harding World Imagery/Corbis; 10.30 Dinodia Photo; 10.29 Robert Harding World Imagery/Mrs. Holdsworth; 10.33 RMN-Grand Palais (Musée Guimet, Paris)/Thierry Ollivier; 10.34 © Luca Tettoni/Corbis; 10.35 akg-images/Gerard Degeorge; 10.36 Irvna Rasko / Shutterstock; 10.37 © 1983 Visual Resources Collections, Department of History of Art, Regents of the University of Michigan; 10.38 © Christophe Boisvieux/Corbis; 10.39 Pho John Listopad; 10.40 Tim Hall/Robert Harding; 10.41 © Kevin R. Morris/Corbis

Chapter 11

11.1 National Geographic Image Collection; 11.3 Line drawing illustrated in Michael Sullivan, *The Arts of China*, Berkeley: University of California Press, 2008, fig. 1-14, after Wenwu, no. 1 (1988), fig. 20; 11.5 Photo: Imaging Department © President and Fellows of Harvard College; 11.7 Asian Art & Archaeology, Inc./ CORBIS; 11.8 Cultural Relics Publishing House; page 340 Courtesy of Fleming & Honour; 11.10 © The Trustees of the British Museum. All rights reserved; 11.11 National Palace Museum, Taipei, Taiwan, Republic of China; 11.12 © Nastya Tepikina – Fotolia; 11.13 Photograph © 2013 Museum of Fine Arts, Boston; 11.14 dbimages/ Alamy; 11.15 Photograph by John C. Huntington Courtesy of The Huntington Photographic Archive at The Ohio State University; 11.16 James Caldwell/Alamy; 11.17 Photograph © 2013 Museum of Fine Arts, Boston; 11.18 Photo: Imaging Department © President and Fellows of Harvard College; 11.9 Cultural Relics Publishing House; 11.21 National Palace Museum, Taipei, Taiwan, Republic of China; 11.23 Photo Courtesy of the Palace Museum, Beijing; 11.25 © The Trustees of the British Museum. All rights reserved; 11.26 National Museum of Korea, Seoul, Republic of Korea; 11.27 Photo: Imaging Department © President and Fellows of Harvard College; 11.28 National Museum of Korea; 11.30 Tokyo National Museum/ TNM Image Archives/DNP; 11.31 Photo: Imaging Department © President and Fellows of Harvard College.

Chapter 12

12.1 Photo: Bruce Schwarz; 12.2 Collection of the Tokyo National Museum/TNM Image Archives/DNP; 12.3 Watanabe Yoshio/ Pacific Press Service; 12.4 Getty/DAJ; 12.5 & 12.6 Photo: ASKAEN CO., LTD; 12.7 Shosoin, Todaiji, Nara; 12.8 Photo: Patricia J. Graham; 12.9 Z. Legacy. Images Resource Centers; 12.11 akgimages/Nimatallah; 12.12 Sakamoto Photo Research Laboratory/ CORBIS; page 374 The Tokugawa Reimeikai Foundation/ DNP Image Archives; 12.14 TNM Image Archives/DNP; 12.15 Photograph © 2013 Museum of Fine Arts, Boston; 12.16 Asanuma Photo Studios, Kyoto, Japan; 12.17 Photo Courtesy of Kyoto National Museum; 12.18 TNM Image Archives/DNP; 12.19 Kenchoji, Kamakura.

Chapter 13

13.1 The Art Archive/National Anthropological Museum Mexico/ Gianni Dagli Orti; 13.2 Scala, Florence/Art Resource, NY/The Metropolitan Museum of Art, NY; 13.3 Werner Forman Archive; 13.4 C Yann Arthus-Bertrand/CORBIS; 13.6 The Art Archive/ Gianni Dagli Orti; 13.8 © M.L. Sinibaldi/Corbis; 13.9 George Steinmetz/Corbis; 13.10 The Art Archive/National Anthropological Museum Mexico/Gianni Dagli Orti; 13.11 © 2012 Photo Scala, Florence; page 394 Rollout photograph © Justin Kerr, K2887; 13.12 The Art Archive/Gianni Dagli Orti; 13.13 Rollout photograph © Justin Kerr, K2803; 13.14 akg-images/Hedda Eid; 13.16 akgimages/Bildarchiv Steffens; 13.15 John Bigelow Taylor; 13.18 George Steinmetz/Corbis; 13.19 © 2005 Photo Scala, Florence. BPK, Bildagentur fuer Kunst, Kultur und Gechsichte, Berlin; 13.20 Photo: Dr. Chris Donnan; 13.21 © Gilcrease Museum, Tulsa; 13.22 Tony Linck/SuperStock; 13.23 William Iseminger, "Reconstruction of Central Cahokia Mounds." c. 1150 CE. Courtesy of Cahokia Mounds State Historic Site; 13.24 Courtesy of the Penn Museum, image #160303; 13.25 Peabody ID #24-15-10/94585; 13.26 Saint Louis Art Museum; 13.27 © Richard A. Cooke/Corbis; 13.28 Whit Richardson/Aurora Open/SuperStock; 13.29 Fred Hirschmann Photography; 13.30 National Archives photo no.10055.

Chapter 14

14.1 © 1980 Dirk Bakker; 14.2 © Kazuyoshi Nomachi/Corbis; 14.3 Werner Forman Archive/National Museum, Lagos, Nigeria. Location: 02; 14.4 Neil Lee/Ringing Rocks Digitizing Laboratory/ www.SARADA.co.za/San Heritage Centre/Rock Art Research Centre/University of the Witwatersrand, Johannesburg; 14.5 From Thurstan Shaw, Igbo-Ukuu: An Account of Archaeological Discoveries in Eastern Nigeria. 2 vols. Evanston: Northwestern University Press, 1970; 14.6 Jerry L. Thompson/Art Resource, NY; page 416 © 1980 Dirk Bakker; 14.8 Photograph by Eliot Elisofon 1959; 14.9 © 2012 The Metropolitan Museum of Art/Art Resource/Scala, Florence; 14.11 & 14.12 Photograph by Joseph Nevadomsky, Benin, Nigeria, c. 1997. Joseph Nevadomsky Collection Eliot Elisofon Photographic Archives. National Museum of African Art Smithsonian Institutio 14.13 National Museum of African Art/Smithsonian Institution. Photo by Franko Khoury 14.14 Peter Adams/Getty; 14.15 Dorling Kindersley; 14.16 I. Vanderharst/Robert Harding World Imagery; 14.18 Heini Schneebeli/The Bridgeman Art Library; 14.19 The Pitt Rivers Museum/University of Oxford. Photo by Heini Schneebeli; 14.20 © 2008 Image copyright The Metropolitan Museum of Art/ Art Resource/Scala, Florence; 14.21 Photograph by Frank Khoury.

Chapter 15

15.2 © RMN/Jean-Gilles Berizzi; 15.3 Kit Weiss/National Museum of Denmark, Copenhagen; 15.4 © The Trustees of the British Museum. All rights reserved; 15.6 & 15.7 British Library Board/ Robana; 15.8 Photo Scala, Florence—courtesy of the Ministero Beni e Att. Culturali; 15.9 South Cross, Ahenny, County Tipperary, Ireland, eighth century. Stone. Courtesy of Marilyn Stokstad, Private Collection; 15.10 © 2012 Photo The Morgan Library & Museum Art Resource/Scala, Florence; 15.11 Archivo Fotographico Oronoz, Madrid; 15.12 © Museum of Cultural History, University of Oslo, Norway/Eirik Irgens Johnsen; 15.13 © Carmen Redondo/CORBIS; 15.14a akg/Bildarchiv Monheim; 15.15 akg-images/Erich Lessing; 15.16a & 15.17 © Achim Bednorz, Cologne; 15.18a Stiftsbibliotjek, St. Gallen; 15.19 Kongan Library & Museum/Art Resource/Scala, Florence; 15.20 2012 Photo The Morgan Library Kensource/Scala, Florence; 15.20 2012 The Metropolitan Museum of Art/

Art Resource/Scala, Florence; 15.23b © Achim Bednorz, Cologne; 15.24 Rheinisches Bildarchiv, Museen Der Stadt Cologne; 15.25 Dom-Museum Hildesheim. Photo by Frank Tomio.

Chapter 16

16.1 The Art Archive/Monastery of Santo Domingo de Silos Spain/ Gianni Dagli Orti; 16.2 Giraudon/The Bridgeman Art Library; 16.3 Archivo Fotographico Oronoz, Madrid; 16.5 © Achim Bednorz, Cologne; 16.6 Dorling Kindersley Media Library, Stephen Conlin © Dorling Kindersley; 16.7 © 2012 Swiss Foundation of Photography/ Artists Rights Society (ARS), New York; 16.8 From Kenneth John Covant, Carolingian and Romanesque Architecture 800-1200. The Pelican History of Art (Penguin Middlesex, 1959; Yale, Plate 60. Penguin Books Ltd. UK; 16.9a C Achim Bednorz, Cologne; 16.10 Studio Folco Quilici Produzioni Edizioni Srl; 16.11 A. Vasari/ Index Ricerca Iconografica; 16.12 Archivi Alinari, Florence; 16.13 Photographers: Calveras/Mérida/Sagristà; 16.14 © Achim Bednorz, Cologne; 16.15 Giraudon/The Bridgeman Art Library; 16.16 © Achim Bednorz, Cologne; 16.17 akg-images/Erich Lessing; 16.18a akg-images/A.F.Kersting; 16.19 English Heritage Photo Library; 16.20 Ghigo Roli/Index Ricerca Iconografica; 16.21, 16.22, 16.23, & page 483 © Achim Bednorz, Cologne; 16.24a & 16.24b Cathedral Museum of St. Lazare, Autun, Burgundy, France/The Bridgeman Art Library; 16.25 Photographers: Calveras/Mérida/Sagristà; 16.26 Image © 2012 The Metropolitan Museum of Art/Art Resource/ Scala, Florence; 16.27 Constantin Beyer; 16.28 C Achim Bednorz, Cologne; 16.29 Musée de la Tapisserie, Bayeux, France. With special authorization of the city of Bayeux/The Bridgeman Art Library; 16.30 Musée de la Tapisserie, Bayeux, France/The Bridgeman Art Library; 16.31 Musée de la Tapisserie, Bayeux, France. With special authorization of the city of Bayeux/Giraudon/The Bridgeman Art Library; 16.32 By Permission of the President and Fellows of Corpus Christi Gollege, Oxford (CCC Ms 157); 16.33 Bibliothèque Nationale de France; 16.34 Universitätsbibliothek Johann Christian Senckenberg Frankfurt am Main; 16.35 & 16.36 akg-images/Erich Lessing

Chapter 17

17.1 Sonia Halliday Photographs; 17.2b © Achim Bednorz, Cologne; 17.3 © 2008 Glencairn Museum; 17.4 Pascal Lemaître © Centre des Monuments Nationaux; 17.5 & 17.6 C Achim Bednorz, Cologne; 17.8 Photo The Morgan Library & Museum/Art Resource/Scala, Florence; 17.9b © Achim Bednorz, Cologne; 17.10 Sonia Halliday Photographs: 17.11 Angelo Hornak Photo Library; 17.13 C Achim Bednorz, Cologne; 17.14 Angelo Hornak Photo Library; 17.15 J.Paul Getty Trust. Wim Swaan Photograph Collection. The Getty Research Institute, Los Angeles 96.P.21; 17.16 & 17.17 Bibliothèque Nationale de France; 17.18 Dorling Kindersley; 17.19 F1 ONLINE/ SuperStock; 17.20 The Philadelphia Museum of Art/Art Resource NY/Scala, Florence; 17.21 & 17.22 The Morgan Library & Museum New York/Art Resource, NY/Scala, Florence; 17.23 British Library Board/Robana; 17.20 The Morgan Library & Museum New York/ Art Resource, NY/Scala, Florence; 17.24 © Skyscan/Corbis; 17.26 Robert Preston Photography/Alamy; 17.27 Nigel Corrie/English Heritage Photo Library; 17.28 & 17.29 © Achim Bednorz, Cologne; 17.30 akg-images/Erich Lessing; 17.31 Hirmer Fotoarchiv, Munich, Germany; 17.32 Constantin Beyer; 17.33 © Achim Bednorz, Cologne; 17.34 Canali Photobank; 17.35 & 17.36 Photo Scala, Florence; 17.37 Canali Photobank; 17.38 Dorling Kindersley; 17.39 Photo Scala, Florence

Chapter 18

18.1 akg-images/Electa; 18.2 © Achim Bednorz, Cologne; 18.3 © Studio Fotografico Quattrone, Florence; 18.4 Photo: David G. Wilkins; 18.5 & 18.6 © Studio Fotografico Quattrone, Florence; 18.7 Assessorato ai Musei Politiche Culturali e Spettacolo del Commune di Padova; 18.8 © Studio Fotografico Quattrone, Florence; 18.9 © Studio Deganello, Padua; 18.10a Lew Minter; 18.10b Photo Scala, Florence; 18.11 © Kimbell Art Museum, Fort Worth, Texas/Art Resource/Scala, Florence: 18.12 Photo Opera Metropolitana Siena/ Scala, Florence; 18.13 © Studio Fotografico Quattrone, Florence; 18.14 Archivi Alinari, Florence; 18.15 & 18.16 © Studio Fotografico Quattrone, Florence; page 551 © 2012 The Metropolitan Museum of Art/Art Resource/Scala, Florence; 18.17, 18.18, & 18.19 Photo © The Walters Art Museum, Baltimore; 18.20 Jacqueline Guillot/akgimages; 18.21 © 2007 Image copyright The Metropolitan Museum of Art/Art Resource/Scala, Florence; 18.22 akg/Bildarchiv Monheim; 18.23 Landschaftsverband Rheinland/Rheinisches Landesmuseum Bonn; 18.25a © Achim Bednorz, Cologne; 18.26 Photo: Radovan Boček

Figures in *italics* refer to illustrations and captions

Α

Aachen, Germany 444 Palace Chapel of Charlemagne 445, 445-7 abacus 108, 110 Abbas I, Shah 290, 291 Abbasids 268-9, 275 pottery 277 abbey churches 239 Cluny, France 460, 465-8, 466, 468, 469 Corvey, Germany 446, 446-7 Saint-Denis, France 432, 497, 498, 498 Saint-Savin-sur-Gartempe, France 474, 474-5 Abduction of Sita (relief) 326, 326 Abelard, Peter 497 Abhaya mudra 308, 308 ablaq masonry 268, 279 Abraham 32, 216, 226, 262, 266, 271 abstract art/abstraction xxiv, xxvii, 7 Abu Simbel, Egypt: Temples of Ramses II 74, 74, 75, 76, 77 Acacus Mountains, Libya: rock art 411-12 acanthus leaves (Corinthian order) 110, 110 Achaemenid Persians 295 Achaemenids 44, 47 Achilles 98, 100, 101, 118 Achilles Painter (style of): Woman and Maid 141, 141 acroteria 110, 110 Actium, Battle of (31 BCE) 147, 167 Acts of the Apostles 220 Adam and Eve 221, 221, 252, 269, 479, 479 Adelaide, Queen (Ottonian) 452 Adena culture, North America 401, 402 Admonitions of the Imperial Instructress to Court Ladies (attrib. Gu Kaizhi) 342, 343 adobe construction 399, 422 Adoration of the Magi, the 230 adyton 109 Aegean cultures 23, 81, 82 Cycladic 82-4 map 83 Minoan 84-92 Mycenaean (Helladic) 92-9 Aegina, island of 102 Temple of Aphaia 108, 109, 111, 111, 112, 113, 113-14 Aeschylus 148 Aesop 105 Afghanistan 281, 296, 306 Bamiyan Buddhas 312, 312 Herat School of painting 285, 289 Africa 410 Islamic culture 410, 419, 422, 423 map 411 rock art 410-12 sculpture 410 see also specific countries

Agamemnon 85, 93, 97, 98 "Mask of Agamemnon" 97, 97 Agora, Athenian 137-8, 138 Agrippa, Marcus 175, 195 Ahenny, County Tipperary, Ireland: South Cross 438. 438 'Ain Ghazal, Jordan: human figures 21, 23, 23 Aix-la-Chapelle see Aachen, Germany Ajanta Caves, India 311 wall paintings 311, 311-12 Ajax and Achilles Playing a Game (Exekias) 100, 101 Akhenaten (Amenhotep IV) 69, 70, 70, 71, 73 Akhenaten and His Family (relief) 71,71-2 Akhetaten (Egypt) 69, 70-71, 73 Akkad/Akkadians 27, 28, 35, 37 Disk of Enheduanna 35, 35–6 Head of a Man (Akkadian Ruler) 36, 36 Stele of Naram-Sin 26, 27, 34, 36 Akropolis, The (Athens) 128, 128-9 Athena Parthenos (Pheidias) 133, 133 Athena Promachos (Pheidias) 129 Erechtheion 129, 135-6, 136 Parthenon (Kallikrates and Iktinos) 129, 129-30; sculptures 34, 130, 130-33, 131, 132 Porch of the Maidens 136, 136 The Propylaia 129, 135, 135 Temple of Athena Nike 129, 135, 137, 137 Akrotiri (Thera) 81 "Flotilla Fresco" 92, 92-3 Girl Gathering Saffron Crocus Flowers (fresco) 80, 81,91 Landscape ("Spring Fresco") 91, 91-2 Aksum/Aksumites, Ethiopia 424, 425 Alaric, Visigoth ruler 430 Alaska 384 Alcuin of York 448 Aldred 436 Alexander the Great 47, 79, 141-2, 142, 145, 147, 306 Alexander the Great Confronts Darius III at the Battle of Issos (?Philoxenos of Eretria or Helen of Egypt) 145, 146 Alexandria, Egypt 147 Alexius III Angelus, Emperor 512 Alfonso VI, of Castile and León 460, 466 Algeria: Tassili-n-Ajjer mountains rock art 411-12, 413 Alhambra, the (Granada, Spain) 280 Court of the Lions 280, 280 Court of the Myrtles 268 muqarnas ornamentation, Palace of the Lions 268, 280, 281 'Ali ibn Muhammad al-Barmaki: oil lamp 279 Ali, Caliph 267 Altamira, Spain: cave paintings 8-9, 11, 11 Altar of Augustan Peace see Ara Pacis Augustae amalakas 302, 319 Amarna period 70-71 Akhenaten and His Family (relief) 71,71-2 colossal figure of Akhenaten 70, 71

fish-shaped perfume bottle 73, 76, 76 head of Nefertiti 72, 72-3 portrait of Queen Tiy 72, 72 Amasis Painter: Dionysos with Maenads 117, 117-18 Amaterasu-o-mi-kami (goddess) 363 Amazons 131 ambulatories 224, 224 Amenemhat, stele of 65, 65 Amenhotep III, of Egypt 66, 69, 72 Amenhotep IV see Akhenaten Americas, the 384 map 385 see Mesoamerica; North America; South America Amida Buddha 369, 371 Amida Buddha (Jocho) 372, 373, 373 in raigo paintings 378-9, 379, 381 Amitabha Buddha 345 bronze altar to (Sui dynasty) 345, 345 Amorites 28 amphitheaters, Roman 177, 186-8, 187, 188 amphoras 117 Ajax and Achilles Playing a Game (Exekias) 100, 101 Dionysos with Maenads (Amasis Painter) 117, 117 - 18Herakles Driving a Bull to Sacrifice (Andokides Painter) 118, 118 Herakles Driving a Bull to Sacrifice (Lysippides Painter) 118, 118 Amun (god) 51, 66, 69, 73, 74 Amykos, King 157 Ananda Temple, Bagan, Myanmar 327, 327-8 statue of King Kyanzittha 327, 328 Anasazi, the see Ancestral Puebloan culture Anastasis 230 Anastasis (Byzantine fresco) 260, 260 Anatolia 37, 277, 286, see also Turkey Anavysos Kouros 115, 116, 160 Ancestral Puebloan culture 404 seed jar 404, 404 "The White House" 405, 407, 407 Andachtsbilder 557 Andean peoples 397-8 Chavin de Huantar, Peru 398 textiles 397 Andokides Painter: Herakles Driving a Bull to Sacrifice 118, 118 Andronicus II Palaeologus, Emperor 260 Angelico, Fra Annunciation xl Mocking of Christ with the Virgin Mary and St. Dominic xl, xlAngkor Wat, Cambodia 328, 328-9 relief sculpture 329, 329 Angles 430, 433 Anglo-Saxons 435, 448 Bayeux Embroidery 487, 488, 488-9, 489 Beowulf 433 jewelry 433-5, 434

Angola 425 zoomorphic head 425, 426 animal style 433, 433 ankh 51 Annunciation (Martini and Memmi) 545, 546, 547 Annunciation to the Virgin (icon) 262, 262 Annunciation, the 230 Ansquetil, Abbot of Moissac 479 Anthemius of Tralles: Hagia Sophia, Istanbul 235, 235-6, 236, 237 Antigonids 147 Antoninus Pius, Emperor 190 Anu (god) 28 Anubis (god) 51, 69, 77 Anyang, China: royal tombs 335 Apadana (audience hall), Persepolis 45, 46 Aphrodite (goddess) 104, 130 Aphrodite of Knidos (Praxiteles) 143, 144 Aphrodite of Melos (Alexandros) 154, 155 Apocalypse, the 220, 439, 515 Apollo (?Vulca) 160, 160 Apollo (god) 104, 107 Apollodorus of Damascus Trajan's Forum, Rome 191, 191 see also Pantheon, Rome Apoxyomenos (Lysippos) see Man Scraping Himself appropriation xxviii aqueducts, Roman 170, 170, 179 Aquinas, Thomas 497, 550 Ara Pacis Augustae 172, 174, 174-5, 175 arabesques, Islamic 267 Arcadius, Emperor 228 Arch of Constantine, Rome 207-9, 208, 209 Arch of Titus, Rome 185, 185-6, 217 archaeology 81 Archaic period 105-20, 139; see Greece, ancient architectural relief sculpture 107-8, 108 architecture 106, 107, 107, 108, 109, 111, 11 sculpture 112, 113, 113-15, 114-16 vases 117, 117-20, 118, 119 "Archaic smile" 114, 160 Archangel Michael (ivory) 244, 244-5 arches horseshoe 272, 274 keel 274 muqarnas 280 pointed 274 semicircular 274 transverse 463 arches, Roman structural 170, 170 triumphal 185, 185-6, 207-9, 208, 209 architectural orders Composite order (Roman) 161, 161, 185 Corinthian 108, 110, 110, 147 Doric 108, 110, 110 Ionic 107, 107, 110, 110, 135-6, 171 Tuscan (Etruscan) 158, 161, 161 architectural plans xxv, xxv architecture xxiv, xxv, xxviii Assyrian 38, 41, 41-3 Babylonian 44, 44, 45 Buddhist chaitya halls 305, 305 Buddhist stupas 302, 302-4, 303, 304 Buddhist temples 345-7, 346, 347 (Tang Chinese), 364-6, 366, 367, 372, 373 (Japanese) Byzantine 235, 235-6, 236, 237, 238, 238-9, 240, 242, 243, 248, 249, 249–51, 250, 251, 254, 254, 258, 259, 260, 261

Carolingian 444-8, 445, 446 Chavin de Huantar, Peru 398 Chinese 341, 341 (Han), 345-7, 346, 347 (Tang) Decorated style (England) 556, 556-7 early Christian 223, 223-4, 224, 225, 225, 228, 228 Egyptian: funerary 53-5, 54, 55, 68, 68-9, 69; temples 50, 51, 57, 58, 65-7, 66, 67, 68, 68-9, 69, 74, 74, 75, 76, 102 English 476, 476-8, 477 (Romanesque), 518, 518-19, 519 (Gothic), 519-20, 520 (castles and domestic), 556, 556-7 (Decorated style), 557 (Perpendicular style) Etruscan 158, 158, 159, 160, 161 French 462, 463, 465-9, 466, 468, 469 (Romanesque), 469, 470, 497, 498, 498-500, 501, 503, 503, 504-5, 505, 508, 508-9, 510, 510, 511, 512, 512, 514 (Gothic) German 445, 445-7 (Carolingian), 452-4, 453 (Ottonian), 474, 474 (Romanesque), 520-21, 521 (Gothic), 559, 561 (14th century) Gothic 477; in Czech Republic 522, 523; in England 518, 518-19, 519; in France 469, 470, 497, 498, 498-500, 501, 503, 503, 504-5, 505, 508, 508-9, 510, 510, 511, 512, 512, 514; in Germany 520-21, 521; in Italy 528, 528 Greek 106, 107, 107, 108, 109, 110, 111, 111 (Archaic), 128, 128-30, 129, 135, 135-6, 136, 137-8 (Classical) Hellenistic 147, 147, 149 Hindu temples 302, 302; 309, 309-10 (Gupta dynasty), 314, 314-16, 315, 317, 317-18 (rock-cut), 318, 318-19 (Chandella dynasty), 320-21, 321 (Chola dynasty) Hittite 38, 40 Islamic 269, 269-70, 270, 277; see also mosques Italian 469, 470, 470, 471, 471-2 (Romanesque), 528, 528 (Gothic), 533-4, 534 (14th century) Jain 302 Japanese 363-4, 364, 367 (Shinto), 364-6, 366, 367, 372, 373 (Buddhist) Maya 392, 392-3, 393, 395, 396 megalithic 16-20, 18 Minoan 84, 85-7, 86, 87 Neolithic 13, 13-20, 15, 16, 18, 20 Norman Romanesque 476, 476-7 Ottoman 286-7, 287 Ottonian 452-4, 453, 475 Paleolithic 4-5, 5 Perpendicular style (England) 557 Persian 45, 46 Roman 161, 161, 186-8, 187, 188, 190-92, 192, 203, 204, and see below Roman basilicas 191, 191-2, 206, 206-7, 207, 209, 210, 211 Roman houses and villas 178, 178-9, 179, 181, 197, 197, 198, 199-200 Roman temples 171, 171, 194, 195, 195, 196, 197 Romanesque 454, 461-3; in England 476, 476-8, 477; in France 462, 463, 465-9, 466, 468, 469, 474, 474-5; in Germany 475, 475; in Italy 469, 470, 470, 471, 471-2; Safavid 290, 290 Scandinavian (timber) 442-4, 443 in Spain 463, 463-5, 465

Spanish 272, 272-3, 273, 280, 280, 281 (Islamic), 463, 463-5, 465 (Romanesque) Sumerian ziggurats 28, 29, 37, 37 Timurid 281-3, 282, 290 see also building methods and techniques; tombs architraves 107, 110 Arena Chapel frescos, Padua (Giotto) 539-42, 540-42 Ares (god) 104, 131 Argonauts, the 157 Arian Christianity 431 Aristotle 141 Ark of the Covenant 217, 217 arms and armor, samurai 377, 377 Arnegunde, Queen 432 jewelry 432, 432 Arnhem Land, Australia: Rainbow Serpent rock 2,2 art abstract xxiv, xxvii, 7 basic properties xxii-xxiii characteristics and definitions xxvi-xxix conventions 31, 51 art history xxix-xxxvi case study xxxvi-xli Artemis (goddess) 104, 216 Arvans 299 Ascension, the 230 asceticism 299, 301 ashlar masonry 99 Ashoka, Mauryan king 295, 299 Ashokan pillars 294, 295, 299-300 Lion capital 300, 300-1 Assisi, Italy church of St. Francis 528, 528; frescos 528-9, 529, 538, 545 St. Martin Chapel frescos (Martini) 545 Assurbanipal, King of the Assyrians 42-3, 43 Assurnasirpal II, of Assyria 38, 40, 41 Assyria/Assyrians 38, 44 architecture 38, 41, 41-3 lamassus 42, 43 relief sculpture 40, 41, 42, 43, 43 astragal 110, 110 Asuka period, Japan 364 architecture 364-7, 366 Aswan High Dam, Egypt 50, 74 Aten (god) 70, 71, 73 Athena (goddess) 104, 135 Athena Attacking the Giants (Pergamon frieze) 150, 151 Athena Parthenos (Pheidias) 133, 133 Athena Promachos (Pheidias) 129 Athens 102, 107, 117, 120, 127-8, 130, 138, 141 Agora and stoas 137-8, 138, 140 Panathenaic festival 132, 135 Temple of Olympian Zeus 147, 147, 149 see also Akropolis, The atmospheric perspective xxiii Atreus 85 'Treasury of Atreus," Mycenae 98, 98-9 Attalus I, of Pergamon 149 Augustine, St., Archbishop of Canterbury 435 Augustine, St., Bishop of Hippo 430, 469 The City of God 430 Augustus, Emperor (Octavian) 167, 168, 171-2, 174, 175, 190, 203 Augustus of Primaporta 172, 173 Aulus Metellus (Roman bronze) 169, 169

Aurelius, Emperor Marcus 190, 202 equestrian statue 200, 200–1 Australia: Rainbow Serpent Rock, Arnhem Land 2, 2 Austria: Woman from Willendorf 6, 6–7 Autun Cathedral, France 464, 482 relics of Lazarus 464 sculpture 483, 483–5, 484 axis mundi 300 Aztec civilization 388

в

Babur, Mughal emperor 286 Babylon 28, 37, 44, 44 Ishtar Gate 44, 45 palace of Nebuchadnezzar II 44 Babylonians 217 religion/gods 28, 39 Stele of Hammurabi 37, 39, 39 Bacchus (god) 104, 181 see also Dionysos/Dionysus Bada Shanren see Zhu Da Baekje, Korea 356, 357 Bagan, Myanmar (Burma) Ananda Temple 327, 327-8 statue of King Kyanzittha 327, 328 Baghdad, Iraq 269, 277 National Museum 34 Bahram Gur (Bahram V), Sasanian king 283, 283-4 Baizhuang, Henan Province, China: tomb model of house and tower 341. 341 baldachins 472 Baldwin II, of Constantinople 512 ballgames/ballcourts, Mesoamerican 384, 385 Maya 390, 392, 395, 395 Bamiyan Buddhas, Afghanistan 312, 312 Ban Chiang, Thailand 321 Bangladesh 296 banner, Han 338, 339, 343 Banpo, Shaanxi, China: Neolithic bowl 332, 332 baptisteries 220, 221, 227 Baptistery of St. Louis (Ibn al-Zain) 284, 284 "barbarians" 149, 430-31 Barberini Togatus (Roman sculpture) 168, 168 Basil I, Emperor 249 Basil the Great, of Cappadocia 246 basilica synagogues 218, 220 basilican churches, Christian 223-4, 444-5 basilicas 191 Basilica at Trier 206, 206-7 Basilica Nova/Basilica of Maxentius and Constantine, Rome 209, 210, 211 Basilica Ulpia, Rome 191, 191-2 Bastet (goddess) 51 Baths of Caracalla, Rome 203, 204 Battle between the Gods and the Giants (frieze) 107-8, 108 Battle of Centaurs and Wild Beasts (Roman mosaic) 198, 199-200 Battle of Issos, The (?Philoxenos of Eretria or Helen of Egypt) 145, 146 Battle of the Bird and the Serpent (Emeterius, Ende, and Senior) 440, 440-41 Bayeux Embroidery 487, 488, 488-9, 489 Baygara, Sultan Husavn 285 Beatus Commentaries 439, 439-41, 440 beaver effigy platform pipe (Hopewell culture)

401–2, *402*

Becket, St. Thomas à 533 Bee Pendant (Minoan) 90, 90 beehive tombs see tholos tombs Beijing 355 Confucian temples 342 Belarus 250 Belize 384 bell krater 117 Bellini, Gentile 254 Benci di Cione: Loggia dei Lanzi, Florence 534, 534 Benedict, St., of Nursia: Rule for Monasteries 444, 448 Benedictine order 444, 460, 463, 465, 466, 471 Beni Hasan, Egypt: rock-cut tombs 62, 62-3, 63 Benin 410, 416-17 altar 417, 417 brass plaques 420, 420 memorial heads 417, 417-19 obas 416, 419, 420, 420, 421 Beowulf 433 Berber Marinids 277 Berlin Kore 115, 115 Bernard of Angers 467 Bernard of Clairvaux, St. 461, 468, 470, 492 Bernward, Bishop of Hildesheim 454 Bertha, Queen of Kent 435 Beth Alpha Synagogue, Israel 220 mosaic floor 219 Betrayal of Jesus (Duccio) 544-5, 545 bhakti movements 319-20 Bhumisparsha mudra 308, 308 Bhutan 296 Bibles Codex Amiatinus 436-7, 437 Hebrew 216, 217, 222, 226 Moralized Bible 514, 514-15, 515 New Testament 220, 226, 227 Vulgate 223, 448 see also Gospel Books Bihar, India Ashokan pillar 294, 295 Female figure holding a fly-whisk (yakshi) 300, 301 Bihzad, Kamal al-Din 285, 289 Bustan of Sa'di 285, 285-6 Black Death 531, 532, 533, 550, 554 black-figure vases, Greek 100, 101, 105, 105, 117, 117-19, 118, 119, 139, 139 Blanche of Castile, Queen 508, 512, 514 Blombos Cave, South Africa engraved ocher 4, 4 ocher decoration 410 Bloodletting Ritual (Teotihuacan fresco) 389, 389-90 Boat and sea battle (prehistoric rock carving) 24-5, 25 Boccaccio, Giovanni 532 The Decameron 533 Bodhidharma see Daruma bodhisattvas 301, 311, 325 Bodhisattva (Ajanta Cave painting) 311, 311-2 Seated Guanyin Bodhisattva (Liao dynasty) 350, 350 Seated Willow-branch Gwanse'eum Bosal (Korean scroll) 359, 359 Bohuslän, Sweden: Bronze Age rock carvings 24-5.25 Bologna, Italy: University 460, 496 Boniface IV, Pope 197

Book of Durrow 435, 435 Book of Kells 428, 429, 435, 438 Book of the City of Ladies, The (Christian de Pizan) 533 books Carolingian 448, 448-50, 449, 451, 452 Islamic 284-6, 284, 285 Merovingian 431 see also literature; manuscripts; Qur'an, the Books of Hours 549 The Book of Hours of Jeanne d'Evreux (Pucelle) 549.551 Books of the Dead, Egyptian 77, 77 Borgund, Norway: stave church 443, 443-4 Borobudur, Java, Indonesia 323-4, 324 relief sculpture 324-5, 325 Boscoreale, Italy: House of Publius Fannius Synistor 181, 181-2 bosses 556 bracketing system, Chinese 341 Bradley, Richard 24 Brahma 309, 310, 325 Brahman 315 Brahmins 299, 308 Breuil, Abbé Henri 8 Brihadeshvara see Rajarajeshvara Temple of Shiva Brinkmann, Vinzenz and Koch-Brinkmann, Ulrike: reconstruction of Greek sculpture 113, 113 Britain see England British Museum 434 Bronze Age 23-4 Aegean cultures 81-4, 92 bronzes 23, 24 Akkadian head of a ruler 36, 36 Egyptian statue 78, 78 Etruscan 156, 157, 164, 165, 165, 166 Greek 104, 105 (Geometric), 120-22, 122, 123, 126 (Classical) Hellenistic 149 Mycenaean dagger blade 97, 97-8 Roman 169, 169, 200, 200-1 bronzework Carolingian 444, 444 Chola dynasty (India) Shiva Nataraja 322, 322 Florence Baptistery doors (A. Pisano) 534, 535, 536, 536 Han dynasty (China) incense burner 339, 339 Hildesheim doors 454, 455, 456 Igbo-Ukwu roped pot 416 Japanese 362, 367, 367, 370, 370 Romanesque 486, 486, 487, 487 Shang dynasty (China) 334-5, 335, 336 Sui dynasty (China) altar 345, 345 Thai 321, 323, 323 Yoruba head of a ruler 408, 409 Zhou dynasty (China) bells 336, 337 Bruce-Mitford, Rupert 434 Brunei 296 "Brutus"/Head of a Man 164, 166 Buddha, the 299, 301 Amitabha Buddha 345 Buddha Birushana (Vairochana) 367, 370 Dainichi (Japan) 371 depictions 306, see Buddhist sculpture Maitreya Buddha 301 mudras 307, 308, 308 Parinirvana of the Buddha, GalVihara, Sri Lanka 320, 320 sermon 300-1

Shakyamuni 299, 301, 325 see also Amida Buddha Buddhism 296, 299, 301, 302, 308, 331 in China 341, 344, see Buddhist architecture Esoteric 369, 371, 378 Four Noble Truths of 301 in India 299, see Buddhist architecture in Japan 301, 361, 364, 369, see Buddhist architecture in Korea 301, 357, 359 Mahayana 301, 345 symbols 306, 368, 368 Tantric 369, 371 Theravada 301, 320 "Three Jewels" 303 Wheel of Life 368 Wheel of the Law 300-1, 368 see also Pure Land Buddhism; Zen Buddhism Buddhist architecture Borobudur, Java, Indonesia 323-4, 324 Chinese 345, 346, 346-7, 347, 351 Indian 304-5, 305 (chaitya halls), 302, 302-4, 303, 304, 305, 306, 351, 351 (stupas), see also Ashokan pillars Japanese 364-7, 366, 370, 370, 372, 373 Buddhist sculpture Altar to Amitabha Buddha (Chinese) 345, 345 Bamiyan Buddhas (Afghanistan) 312, 312 Buddha and Attendants (Indian) 307, 307-8 Buddha Preaching His First Sermon (Indian) 310-11, 310 Buddha Shaka and Attendant Bodhisattvas (Japanese) 367, 367 Seated Buddha (Chinese) 344, 344 Seated Shakyamuni Buddha (Korean) 357-8, 358 Standing Buddha (Gandharan) 306, 307 Standing Dvaravati Buddha (Thai) 323, 323 see also bodhisattvas building methods and techniques ashlar masonry 99 barrel vaults 187, 187 bosses 556 cames 501 concrete (Roman) 194 corbeled vaults 17, 17, 19, 98, 99 cyclopean masonry 93 domes 228, 236, 236, 238, 238, 249, 272-3, 273, 281 dressed stone 84 drywall masonry 93 flying buttresses 503, 505 glazed bricks 44 Gothic 499, 499, 503, 503 grozing 501 mortise-and-tenon 18 post-and-lintel 17, 18, 19, 158 ridgepoles 16 Romanesque 462, 463 stringcourses 503 thatch 16 tiercerons 556 timber construction 442-4, 443 voussoirs 170,170 wattle and daub 16, 442 window tracery 503, 505, 510 wood-post framing 19, 20, 20 wooden strapwork 268 see also arches; construction methods and techniques; vaulting Bull Leaping fresco (Knossos) 87, 87-8

Bull's-head Rhyton (Minoan) 89, 89 buon fresco 87, 539, 539 Burgundians 430, 431 Burgundy, duchy of 548 Burma see Myanmar Busketos: Pisa Cathedral 469, 470, 471 Bustan of Sa'di (Bihzad) 285, 285-6 Butcher (Egyptian) 60, 60-61 Byzantine Empire 234, 286, 461 architecture 235, 235-6, 236, 237, 238, 238-9, 240, 242, 243, 248, 249, 249-51, 250, 251, 254, 254, 258-9, 259, 260, 261 frescos 253, 253-4, 260, 260 icons and iconoclasm 246, 246-8, 247, 257, 257-8, 258, 262, 262-3, 263 ivories 244, 244-5, 255, 255-6, 256 manuscripts 244, 245, 245, 247, 256, 256-7 map 234 mosaics 239, 240, 241, 242, 243, 244, 248, 248-9, 250, 251, 251-4, 252, 253, 254, 254, 258-9, 259, 262 silverwork 232, 233, 246, 433 Byzantium 234, see Constantinople

С

Cadafalch, Josep Puig I 463 Caesar, Julius 171, 172, 190 denarius 169, 169 Cahokia, Illinois 403, 403 cairns, Neolithic 17 Cairo, Egypt 279 Madrasa-Mausoleum-Mosque of Sultan Hasan 268, 278, 279 calendars, Mesoamerican 384, 390 caliphs 267 calligraphy Chinese 343, 343 Islamic 275, 275-6, 276, 279, 282, 282, 283; see also Kufic script Japanese 375, 375-6 calyx kraters 117 The Death of Sarpedon (Euphronios and Euxitheos) 119, 119-20, 130 Cambodia 296, 323 Angkor Wat 328, 328-9, 329 Harihara 323, 324 Cambridge University, England 460, 496, 515 cames 501 Canaan 217 Canada 384 "Canon" of Polykleitos 134, 142 canopic jars, Egyptian 53 Canterbury Cathedral, England 504 shrine of St. Thomas à Becket 533 Canterbury Tales, The (Chaucer) 533, 554 Capetians 460, 497 capitals, historiated 484, 484-5, 501 Capitoline She-Wolf (?Etruscan bronze) 165, 165 capstones 17 Caracalla, Emperor 203 Baths of Caracalla 203, 204 portraits 203, 203 caravanserais 277 Cardona, Spain: Church of Sant Vincenc 463, 463 Carnarvon, George Herbert, 5th Earl of 49 Carolingian Empire 444 architecture 444-8, 445, 446 Gospel Books 448, 449, 449-50, 451, 452 metalwork 450, 451, 452

scripts (majuscule and minuscule) 448-9 Utrecht Psalter 450, 450 carpets, Safavid 291, 291, 292, 292 Carrey, Jacques 130 Carruba, Anna Maria 165 Carter, Howard 49 Carthage 167, 431 Carthusians xl-xli cartoons xxiv caryatids 107, 136, 136 catacomb paintings 214, 215, 217, 217, 220, 222, 222 Çatalhöyük, Turkey 13 houses 13-15, 15 wall painting 14, 15 cathedrals 220, 239, 497 Autun, France 464, 482 Canterbury, England 504, 533 Durham, England 476, 476-7 Exeter, England 556, 556-7 Magdeburg, Germany 452, 453, 524, 524 Mainz, Germany 453 Pisa, Italy 469, 470, 471 Reims, France 508, 508-10, 509, 511 St. James, Santiago 463, 464-5, 465, 469 St. Mark's, Venice 254, 254 Salisbury, England 518, 518-19, 519 Speyer, Germany 475, 475 see also Chartres Cathedral, France cave art. Paleolithic paintings xlii, 1, 8-11, 9, 10, 11 sculptures 1, 11-12, 12 cave-temples, Indian 314, 314-15 Caviness, Madeline 492 celadon-glazed ceramics, Korean 358, 358-9 cella 108, 109 Celts 19, 150, 431, 433, 444 goldwork 150, 150 see also Hiberno-Saxon art Cennini, Cennino: Il Libro dell'Arte (The Book of Art) 536, 546 ceramics/pottery xxiv, 20 Ancestral Puebloan culture 404, 404 Chinese 332, 332 (Neolithic), 348, 348, 349, 349 (Tang), 355, 355 (Southern Song) Cycladic 82 Egyptian 20, 50 Greek vases 100, 101, 102-4, 103, 105, 105, 117, 117-20, 118, 119, 139, 139 (Archaic), 126, 126-7, 127, 141, 141 (Classical) Han tomb model of house and tower 341, 341 Ife terra-cotta ritual vessel 415, 415-16 Indus Valley terra-cotta figurines 298 Islamic 276, 276-7, 277, 283, 283-4 Japanese 362 (Jomon), 362-3, 363 (Kofun) Jenné terra-cotta figures 422, 422 Jomon (Japan) pottery 21, 21 Korean 356, 356-7 (Silla kingdom), 358, 358-9 (Goryeo dynasty) Maya 395, 395 Mimbres 404, 404 Minoan 85, 85, 88, 89, 89-90 Moche 400, 400 Mycenaean 99, 99 Neolithic 20-21, 21, 22, 22 Olmec 387 Ottoman 288 Paleolithic figurine 7, 7 Qin terra-cotta army 330, 331, 336-7 Sasanian 283, 283-4 see also terra cottas

Ceres (goddess) 104 Cernavodă, Romania: figurines 21, 22, 22 Cerveteri, Italy Etruscan tombs 160, 162, 163 Sarcophagus 163, 163-4 chacmools, Maya 396, 396 Chaco Canyon, New Mexico 404-5, 405, 407 Chad, Lake 410, 412 chahar bagh 280 chaitva halls 305, 305 chakra (Buddhist symbol) 368, 368 Champollion, Jean-François 79 Chan Buddhism see Zen Buddhism Chang'an (Xian), China 345 Great Wild Goose Pagoda 347, 347 Changsha, China: painted banner 338, 339 Chanhu-Daro 296 Charioteer, The (Greek bronze) 122, 122 Charlemagne 444, 445, 448, 500 Charles IV, of Bohemia 559, 561 Charles IV, of France 549, 559 Charles Martel 439 Charles the Bald 450 equestrian statue 444, 444 Charpentier, Marguérite-Louise xxxv Mme. Charpentier and Her Children (Renoir) xxxii, xxxiii, xxxiii, xxxv Chartres Cathedral, France 500, 503, 504-5, 505 sculptures 500-2, 502 stained glass 494, 495, 506, 506, 507, 508 Virgin's tunic 464 Chaucer, Geoffrey 532 The Canterbury Tales 533, 554 Chauvet Cave paintings, Vallon-Pont-d'Arc, France 9,9-10 Chi Rho 428, 429, 435, 438 Chichen Itza, Yucatan, Mexico 394, 396 ballcourt 395 chacmools 396, 396 pyramid ("El Castillo") 396, 396 Chichester-Constable Chasuble, The 555, 555 Childeric I, Merovingian king 431 Chile 384 China 331, 332, 341 architecture 332 (Neolithic), 341, 341 (Han), 345, 346, 346-7, 347 (Tang) Bronze Age 334-6 bronzework 334-5, 335, 336 (Shang), 336, 337 (Zhou), 339, 339 (Han), 345, 345 (Sui) Buddhism/Buddhist art and architecture 301, 341, 344, 344, 346, 346-7, 347, 351, 351 calligraphy 343, 343 ceramics 332, 332 (Neolithic), 348, 348, 349, 349 (Tang), 355, 355 (Southern Song) Confucius/Confucianism 338, 340, 341, 342, 343 Daoism 338, 339, 341, 342 Great Wall 338 incense burner (han) 339, 339 jade congs (Neolithic) 332, 333, 334, 334 legalism 338, 340 lute 369, 369 map 333 Neolithic cultures 332, 334 Northern Wei dynasty 344 oracle bones 334 painted banner (Han) 338, 339, 343 paintings see scroll paintings (below) potter's wheel 20 rock-cut caves 344

scroll paintings 341-3, 342 (Six Dynasties), 347, 347-8, 352, 352-4, 353, 354 (Northern Song), 354-5, 354-5 (Southern Song) temples (Tang) 345, 346, 346-7, 347 terra-cotta army (Qin) 330, 331, 336-7 wall paintings 345, 346, 347 (Tang) Warring States period 336 writing 334, 337, 337, 365 see also Han, Northern Song, Qin, Shang, Six Dynasties, Song, Southern Song, Sui, Tang, Yuan and Zhou dynasties chini khana (niches) 268, 287 Chludov Psalter 247 Chokwe, the 426 Chola dynasty (India): Shiva Nataraja (Shiva as Lord of the Dance) (bronze) 322, 322 Christ see Jesus of Nazareth Christ Crowning Emperor Romanos II and Empress Eudokia (Byzantine ivory) 255-6, 256 Christ Enthroned, flanked by Angels, St. Vitalis, and Bishop Ecclesius (mosaic) 239, 241 Christ in Majesty (Romanesque fresco) 473, 473 Christ in Majesty (tympanum sculpture) 479, 480, 481 Christ Pantocrator 250, 251, 252, 252 Christ Washing the Feet of His Disciples (Gospels of Otto III) 456-7, 457 Christianity 39, 166, 207, 211, 212, 213 Christians, early 216, 220, 267, 431, 435 catacomb paintings 214, 215, 220, 222, 222 house-churches 220, 221, 221, see also churches mosaics 224, 224, 226, 227, 228, 229, 231, 231 sculpture 222, 222 see also Gospel books Christine de Pizan 532, 533 The Book of the City of Ladies 533 Chryssolakkos, Crete: bee pendant 90, 90 churches early Christian 220, 21, 221, 223, 223-4, 224, 225, 225, 228, 228 German hall churches 521, 521 naming of 239 Norwegian stave churches 443, 443-4 see also abbey churches Cimabue (Cenni di Pepi) 536 Virgin and Child Enthroned 536-7, 537, 539 cistae, Etruscan 156, 157, 164 Cistercian order 460, 468-9, 493, 518, 558 Cîteaux, France: abbey 468 city-states Greek 102, 120 Mesopotamian 28, 37 "classic"/"classical" 120 Classical period (Greece) 120-27 (early), 127-41 (high), 141-7 (late) Clement VI, Pope 561 Cleopatra VII, of Egypt 67, 79, 147, 167 clerestories 57 cloisters 448 Clotilda 431 Clovis I, king of the Franks 431 Cluny, Abbey churches of/Cluniac order 460, 465-8, 466, 468, 469 see also Moissac, France: priory church of Saint-Pierre Code of Hammurabi 39, 39 codices 245 Codex Amiatinus (from Wearmouth-Jarrow) 436-7, 437

Codex Colbertinus 490-91, 491 Hedwig Codex 558, 558-9 Cologne Cathedral, Germany Gero Crucifix 454, 454 Shrine of the Three Kings (Nicholas of Verdun) 523, 523 Colombia: lost-wax casting 396 color xxix, xxxi attributes of xxii Colossal heads, San Lorenzo (Olmec) 385-6, 386 Colosseum, Rome 186-8, 187, 188 columns Greek 108, 110, 110 Minoan 84 Commodus, Emperor 190, 202 Commodus as Hercules 201, 201, 205 Composite order 161, 161, 185 composite poses 10, 53 composition xxiii, xxix, xxxii-xxxiii concrete, Roman 194, 199 Confucianism 338, 340, 341, 342, 343, 352 see also Neo-Confucianism Confucius 338, 342, 347 congs, jade (Liangzhu) 332, 333, 334, 334 Connelly, Joan 132 Conques abbey church, France: reliquary statue of Sainte Foy 464, 467, 467 Constantia 224, 226 Constantine IV, Emperor 247 Constantine V 247 Constantine VII Porphyrogenitos, Emperor 255, 256 Constantine, Emperor ("the Great") 200, 207, 211, 223, 227, 234, 430, 444 Head 211, 211 Constantinople 207, 227, 231, 246, 248, 250-51, 254, 258, 273, 286, 441, 527 Hagia Sophia xxv Nika Revolt (532) 235 see also Istanbul Constantius Chlorus, Tetrarch 206 construction methods and techniques adobe 399, 422 bracketing system (Chinese) 341 domes 272-3, 273 joined-block (wood) 372, 372, 373 mugarnas 268, 280, 281 wooden strapwork (Islamic) 268 see also arches content xxiv contrapposto 120, 122 conventions, artistic 31, 51 Copan, Honduras: ballcourt 395, 395 copper artifacts, Neolithic 23 Coppo di Marcovaldo: Crucifix 527, 527-8 corbeled vaults 17, 17, 19, 98, 99 Cordoba, Spain 272 Great Mosque 272, 272-3, 273, 275 Corinth, Greece 102, 167 olpe 105, 105 Corinthian order 108, 110, 110, 147 Coronation Gospels 448, 449 Corvey, Germany: Abbey church 446, 447 Cossutius: Temple of Olympian Zeus 147, 147, 149 Costa Rica: Diquis culture 396-7, 397 "Court of Gayumars, The" (Sultan Muhammed) 289, 289 Creation and Fall of Adam and Eve (Wiligelmo) 478-9, 479, 506

crenellations 44 Crete 81, 82, 85 see Knossos; Minoan civilization Crossing of the Red Sea, The (wall painting) 217-18, 218 crucifix, Kongo 426, 426-7 Crucifixion Triptych with Donors and Saints (van der Weyden) xxxviii-xxxix, xxxix Crucifixion with the Virgin and St. John the Evangelist (van der Weyden) xxxvi-xxxviii, xxxvii, xl, xli, xli Crucifixion, the 230 Crucifixion (Byzantine mosaic) 252-3, 253, 258 Crucifixion with Angels and Mourning Figures (Lindau Gospels) 451, 452 Gero Crucifix 454, 454 Majestat Batlló (crucifix) 485, 485 painted (Coppo di Marcovaldo) 527, 527-8 crusades/crusaders 234, 248, 258, 460-61, 512, 519, 527 cultural context xxxv-xxxvi cuneiform writing 28, 30, 33 Cupid (god) 104 Cybele (Great Mother) 166 Cycladic islands 81, 82 sculpture 82, 82-4, 84 cyclopean masonry 93 cylinder seals, Sumerian 34-5, 35 Cyrus II ("the Great"), of Persia 44 Cyrus the Great, of Persia 217 Czech Republic Gothic architecture 522, 523 see also Prague

D

dagger blade, Mycenaean 97, 97–8 Damascus, Syria 268, 269 Dancers in Ceremonial Attire (Algerian rock-wall painting) 411-12, 413 Dante Alighieri 532 The Divine Comedy 533, 539 Dao, the 338 Daodejing 338 Daoism 338, 339, 341, 342 Daphni, Greece: Church of the Dormition (mosaics) 252, 252-3, 253, 258 Darius and Xerxes Receiving Tribute (relief) 45, 47, 47 Darius I, of Persia 44-5, 47, 47 Darius II, of Persia 47 darshan 309 Daruma 380 Zen portrait 380, 380 dating methods 12 dendrochronology xxxvi, 82 electron spin resonance 12 potassium-argon 12 radiometric 12 thermo-luminescence 12 uranium-thorium 1, 12 Datong, Shanxi, China: Seated Buddha 344, 344 David Composing the Psalms (from Paris Psalter) 256, 256-7 "David Plates" 232, 233, 246 de Jong, Piet: Pylos Palace 96 Death of Sarpedon, The (Euphronios and Euxitheos) 119, 119-20, 133 Decameron, The (Boccaccio) 533 Deccan, India 304 Decorated style 556, 556-7

Deir el-Bahri, Egypt 67 funerary temple of Hatshepsut 68, 68-9, 69 Deir el-Medina, Egypt 65 deities Babylonian 39 Egyptian 50-51, 65, 66, 70 Greek 104 Roman 104 Sumerian 28, 36 Delphi, Greece Sanctuary of Apollo 106, 107, 122 Treasury of the Siphnians 107, 107-8, 108 Demeter (goddess) 104 denarius (of Julius Caesar) 169, 169 dendrochronology xxxvi, 82 Denis, St. 498 Denmark 441 Gummersmark Brooch 433, 433 Jelling rune stones 442, 442 Deogarh, India: Vishnu Temple 309, 309-10, 310 Descent from the Cross, the 230 Descent into Limbo, the 230 Descent of the Ganges (rock-cut relief) 316, 316-17 Devi 309 dharma 295, 299-300, 320 Dharmachakra mudra 308, 308 Dharmaraja Ratha 315, 315-16 Dhyana mudra 308, 308 Diana (goddess) 104 Didarganj, Bihar, India: Female figure holding a fly-whisk 300, 301 Dietrich II, Bishop of Wettin 524 dioceses 220 Diocletian, Emperor 205, 227 Dionysius/Pseudo-Dionysius 498-9 498 Dionysos with Maenads (Amasis Painter) 117, 117-18 Dionysos/Dionysus (god) 104, 117, 130, 142, 143, 148, 155, 201, 202 Dionysus see Dionysos diptych, Roman 212-13, 213 Dipylon Krater 103, 103-4 Diquis culture 396 gold pendant 396-7, 397 Disk of Enheduanna 35, 35-6 Divine Comedy, The (Dante) 533, 539 Djoser's Complex, Saqqara, Egypt 53-5, 54, 55 dogu 362 dolmens 17 Dolní Věstonice, Czech Republic 7, 7 kilns 20 dome construction 187, 187, 195, 197, 228, 236, 236, 238, 238, 249, 272-3, 273, 281 Dome of the Rock, Jerusalem 217, 268, 269, 269-71,270 Domitian, Emperor 185, 195 Dongson, Vietnam 321 Doni Tondo (Michelangelo) xxxi Doric order 108, 110, 110 Doryphoros (Polykleitos) see Spear Bearer Douris 126 Frolicking Satyrs 126, 126 A Youth Pouring Wine into the Kylix of a Companion 126-7, 127 Dover Castle, England 477, 477-8 Drakensberg Mountains, South Africa: San rockwall painting 414, 414 drawing(s) xxiv Duccio di Buoninsegna 259, 532, 542 Betrayal of Jesus 544-5, 545

Maestà 542, 543, 544 Raising of Lazarus 544, 544 Duccio di Buoninsegna 259 Dunhuang Caves, China: wall paintings 345, 346, 347 Dur Sharrukin (Khorsabad, Iraq) 41 lamassus 42, 43 palace of Sargon II 41, 41-2 Dura-Europos, Syria baptistery 221, 221 The Crossing of the Red Sea (wall painting) 217-18, 218 The Good Shepherd with Adam and Eve After the Fall (marble figure) 221, 221 house-synagogue 216, 217, 218, 220, 221 Durga 317 Durham Cathedral, England 476, 476-7 Durrington Walls, England 20, 20 Dust Muhammed 289 Dvaravati kingdom 323 Standing Dvaravati Buddha 323, 323 Dying Gallic Trumpeter (?Epigonos) 149, 149 Dying Warrior (from Temple of Aphaia) 111, 112, 113

Е

Eadrich, Bishop of Lindisfarne 436 earthenware 20 East Timor 296 Eastern Orthodox Church see Orthodox Christianity Ebbo Gospels 449, 449-50 Ebbo, Archbishop of Reims 449 Ecclesius, bishop of Ravenna 238, 239, 241, 242 echinus 110, 110 Edict of Milan (313) 207, 223 Edirne, Turkey: Mosque of Sultan Selim (Sinan) 286, 287 Edo culture, Nigeria: altar 417, 417 Education of the Virgin, The (La Tour) xxx Edward I, of England 518 Edward III, of England 555 Effects of Good Government in the City and in the Country, The (Lorenzetti) 530, 531, 547-8, 548-9 Egypt 267, 269, 279 glassmaking and ceramics 276, 277, 279 Madrasa-Mausoleum-Mosque of Sultan Hasan, Cairo 268, 278, 279 New Gourna, Luxor (Fathy) 292, 293 see also Mamluks Egypt, ancient 38, 50, 50, 78, 79, 82, 141, 147, 167 artistic conventions 51, 65 Books of the Dead 77, 77 canopic jars 53 dynasties and kingdoms 56, 62, 65, 77 funerary stelai 63, 63-5, 64, 65, 105 glassmaking 73, 76, 76 god-kings 50-51 goldwork 48, 49, 72, 73, 73 Great Sphinx, Giza 57, 58, 62 hieroglyphs 51, 52, 79, 79 mastabas 53, 55, 55, 61 Middle Kingdom 62-5 mummification 53 necropolises 53, 62 New Kingdom 65-77 Old Kingdom 56-61 pharaohs 65

pictorial relief sculpture 63, 63-4, 64, 71, 71-2 poetry 70 pottery 20, 50 pyramids 55, 56, 56-7, 57 rock-cut tombs 62, 62-3 sculpture 57-61, 59, 60, 70, 67-8, 68, 70, 71, 74, 74, 78, 78-9; portraits 62, 62, 72, 72-3 symbols 51 temples 50, 51, 57, 58, 65-7, 66, 67, 68, 68-9, 69, 74, 74, 75, 76, 102 Third Intermediate Period 77-8 tomb paintings 62-3, 63 76, 77 tomb reliefs 61, 61, 69-70, 70 tombs 50, 53-5, 54, 69, see also mastabas; pyramids; rock-cut tombs (above) town planning 65 Einhard 444 Ekkehard and Uta (sculpture) 524, 524 Elamites 34, 36 Eleanor of Aquitaine 497, 499, 515 electron spin resonance dating method 12 Elephanta, India Cave-temple of Shiva 314, 314-15 Eternal Shiva (rock-cut relief) 314, 315 "Elgin Marbles" 34, 133 Ellora, Maharashtra, India: Kailasha Temple 317, 317-18 embroidery Andean 397 Bayeux Embroidery 487, 488, 488-9, 489 opus anglicanum 554-5, 555 Paracas 399, 399 Emeterius and Ende: Battle of the Bird and the Serpent 440, 440-41 encaustic painting 246 England 520, 533 architecture 476, 476-8, 477 (Romanesque), 518, 518-19, 519 (Gothic), 519-20, 520 (castles and domestic), 556, 556-7 (Decorated style), 557 (Perpendicular style) Durrington Walls, Wiltshire 20, 20 illuminated manuscripts (Gothic) 515, 516, 516, 517, 517-18 "Mildenhall Treasure" 211-12, 212 literature 533 Norman invasion 460 opus anglicanum (embroidery) 554-5, 555 Stonehenge, Wiltshire 15, 17-20, 18, 19 universities 460, 496, 515 see also Anglo-Saxons Enheduanna 35–6 Disk of Enheduanna 35, 35-6 Enkidu 28 entablature 107, 110, 110 entasis 108 Enthroned Christ with Saints (Strozzi Altarpiece) (Orcagna) 550, 550 ephemeral arts xxv Ephesus, Turkey: Library of Celsus (facade) 161 Epic of Gilgamesh 28, 32 Epidauros, Greece: theater 148, 148 Epigonos (?): Dying Gallic Trumpeter 149, 149 Epistles, the 220 Erechtheion, Akropolis, Athens 129, 135-6, 136 Eriksson, Leif 441 Eros (god) 104 Eshnunna (Tell Asmar, Iraq): votive figures 31, 31, 34 Esigie, oba of Benin 419 Eternal Shiva (rock-cut relief) 314, 315

Ethelbert, King of Kent 435 Ethelwald, Bishop of Lindisfarne 436 Etruscans 124, 158, 166, 167 architecture 158, 158, 159, 160 bronzes 156, 157, 164, 165, 165, 166 sarcophagi 163, 163-4, 164 sculpture 160, 160 tombs 133, 160, 161, 162, 163 Eucharist, the 220, 224, 253 Eudokia, Empress 255, 256, 256 Euphrates, River 28, 29, 40, 44 Euphronios and Euxitheos: The Death of Sarpedon 119, 119-20, 133 Euripides 148 evangelists, the 220 Evans, Sir Arthur 84, 85, 96 Évreux, Queen Jeanne d' 549, 554 The Book of Hours of Jeanne d'Évreux (Pucelle) 549, 551 Exekias 118 Ajax and Achilles Playing a Game 100, 101, 118 - 19Exeter Cathedral, England 556, 556, 557 bishop's throne 556-7 expressionism xxiv, 149 Ezana, Aksumite king 424 Ezra Restoring the Sacred Scriptures (Codex Amiatinus) 436-7, 437

F

Faeroe Islands 444 Fan Kuan: Travelers Among Mountains and Streams 352, 352 fang ding 334-5, 335 Fathy, Hasan 293 New Gourna, Luxor, Egypt 292, 293 Fatima 269 Fatimid Shi'ites 269 Faunus (god) 104 Feminist Art Journal, The xxix Feng Ju album (Weng Xizhi) 343, 343 Fertile Crescent 28, 29 Ficoroni Cista, The (Novios Plautios) 156, 157, 164 filigree 90 Firdawsi 289 firmans 288 Fishing in a Mountain Stream (Xu Daoning) 353, 353 fish-shaped perfume bottle, Egyptian 73, 76, 76 Flavians 184, 186, 188, 189 Flight into Egypt, the 230 Flight into Egypt, The (capital) 484, 484, 485 Flight into Egypt, The (stained glass) 499, 500 Florence, Italy 533, 536 Baptistery doors (A. Pisano) 534, 535, 536, 536 Loggia dei Lanzi (Benci di Cione and Talenti) 534, 534 Monastery of San Marco frescos (Fra Angelico) xl, xlPalazzo della Signoria 533-4, 534 Strozzi Chapel altarpiece, Santa Maria Novella (Orcagna) 550, 550 Florida Glades culture, North America 403, 403-4 "Flotilla Fresco" (Minoan) 92, 92-3 flying buttresses 503, 505 Fontenay, France: Abbey of Notre-Dame 468-9, 469

foreshortening xxxi form (in art) xxii and space xxiii and texture xxiii formal analysis xxix-xxxiii Foundry Painter: A Bronze Foundry 120-21, 121 France 431, 460, 520, 533, 548 architectural sculpture 479, 480, 481-5, 481-4 (Romanesque), 500-2, 502, 509, 509-10 (Gothic) architecture 462, 463, 465-9, 466, 468, 469 (Romanesque), 469, 470, 501, 503, 503, 504-5, 505, 508, 508-9, 510, 510, 511, 512, 512, 514 (Gothic) ivory chest (14th century) 552, 552-3, 553 manuscript illumination 548-9, 551 painting 532 Paleolithic cave paintings xlii, 1, 8, 9-11, 9, 10, 11 Paleolithic sculpture 7, 7, 11-12, 12 pilgrimage routes 464, 464 sculpture (14th century) 554, 554, see also architectural sculpture (above) see also Franks; Gaul/Gauls; Merovingians; Paris Franchthi Cave, Greece: pottery 21, 21 Francis, St., of Assisi 525, 528, 529 Franciscan order 525 Franks, the 430, 431, 439, 444 Frederick II von Hohenstaufen, Emperor 520, 525 Freeman, Leslie G. 8 frescos xxiv, xl, xl, 87, 539, 539 French (Romanesque) 474, 474-5 Greek 124, 124, 125 Italian 528-9, 529, 530, 531, 539-42, 540-42, 545, 545, 547-8, 547-8 (13th-14th century) Minoan 87, 87-8, 91, 91-2, 92-3 Roman 179-84, 180-84 Spanish (Romanesque) 473, 473 see also wall paintings friezes 107, 110, 110 Athena Attacking the Giants (Pergamon) 150, 151 Battle Between the Gods and the Giants (Siphnian Treasury) 107-8, 108 Parthenon 131, 131-3, 132 Frobenius, Leo 409 Frolicking Animals (attrib. Toba Sojo) 376, 376, 377 Frolicking Satyrs (Douris) 126, 126 Fujiwara, the 361

G

Gal Vihara, Sri Lanka 320 Parinirvana of the Buddha 320, 320 Galerius, Emperor 227 Galla Placidia 228, 430 Gamble, Clive 6-7 Gandhara style 306-7, 310 Standing Buddha 306, 307 Ganesha 309 Ganymede 127, 145 garbhagrihas 302, 309, 310, 315, 318 garden carpet 291, 291 Gaul/Gauls 149, 150, 167 Gemma Augustea (Roman cameo) 172, 176, 176 Genghiz Khan 277, 281 geoglyphs, Nazca 399, 400 Geometric period (Greece) 102-5 Germanic tribes 430, 431

Germany 431, 460, 525, 557 architecture 445, 445-7 (Carolingian), 452-4, 453 (Ottonian), 474, 474 (Romanesque), 520-21, 521 (Gothic), 559, 561 (14th century) Gospel books (Ottonian) 456, 456-7, 457 ivory plaques (Ottonian) 452, 452 relief sculpture 454, 455, 456 (Ottonian), 523, 523 (Gothic) sculpture 454, 454 (Ottonian), 557, 557-8 (14th century) Gernrode, Harz, Germany: St. Cyriakus 453, 453-4.463 Gero Crucifix (Cologne Cathedral) 454, 454 Geshtinanna (goddess) 37 gesso 546 Ghana 410 Gigliotti, Vittorio: Islamic Mosque and Cultural Center, Rome 293, 293 gilding 90 Gilgamesh 28, 32 giornata (pl. giornate) 539 Giotto di Bondone 254, 259, 532, 536, 538, 539, 550 Scrovegni (Arena) Chapel (Padua) frescos 539-42, 540-42, 545 Kiss of Judas 541-2. 542 Lamentation 541, 541 Marriage at Cana 540, 541 Raising of Lazarus 540-41, 541 Resurrection/Noli Me Tangere 541, 541 Virgin and Child Enthroned 538, 538-9 Girl Gathering Saffron Crocus Flowers (fresco) 80, 81,91 Girsu (Telloh, Iraq) 37 votive statues 37, 38 Gislebertus: The Last Judgment (tympanum) 483, 483-4 Giza, Egypt Great Sphinx 57, 58 pyramids 55, 56, 56-7, 57 glassmaking, Egyptian 73, 76, 76 glassware: Mamluk oil lamp 279 Glykera 145-6 Gnosis: Stag Hunt 146, 146-7 Goguryeo, Korea 356, 357 goldwork Anglo-Saxon 433-5, 434 Carolingian 450, 451, 452 Celtic 150, 150 Diquis 396-7, 397 Egyptian 48, 49, 72, 73, 73 Greek 145, 145 Korean 356, 356 Merovingian 432, 432 Minoan 88, 89, 90, 90-91, 91 Moche 401, 401 Mycenaean 97, 97 Neolithic 23, 24 Persian 47 Gondar, Ethiopia 424 Good Samaritan Window, Chartres Cathedral 494, 495, 506, 506 Good Shepherd, The (mosaic) 228, 229 Good Shepherd, The (sculpture) 222, 222 Good Shepherd with Adam and Eve After the Fall, The (fresco) 221, 221 Goryeo dynasty (Korea) 358 celadon-glazed ceramics 358, 358-9 hanging scroll 359, 359

Gospel, the 220, 429 Book of Durrow 435, 435, 449 Book of Kells 428, 429, 435, 438 Coronation Gospels 448, 449 Ebbo Gospels 449, 449-50 Gospels of Otto III 456-7, 457 Hitda Gospels 456, 456 Lindau Gospels 450, 451, 452 Lindisfarne Gospel Book 436, 436-7, 437 Gothic period/style 431, 495, 496-7 architectural sculpture 500-2, 502, 509, 509-10 (France) architecture 477; in Czech Republic 522, 523; in England 518, 518-20, 519; in France 469, 470, 497, 498, 498-500, 501, 503, 503, 504-5, 505, 508, 508-9, 510, 510, 511, 512, 512, 514; in Germany 520-21, 521; in Italy 528, 528 illuminated manuscripts 514, 514-15, 515 (French), 515, 516, 516, 517, 517-18 (English) map 496 sculpture 523, 523-4 (German), 525, 525-7, 526 (Italian), see also architectural sculpture (above) stained glass 476, 476, 494, 495, 499, 500, 501, 503, 506, 506, 507, 508, 510, 510, 512-13, 513 Goths 430, 431 Gournia, Crete 85 Gozbert of Saint Gall, Abbot 447 Granada, Spain: The Alhambra 280 Court of the Lions 280, 280 Court of the Myrtles 268, 280 muqarnas ornamentation, Palace of the Lions 268, 280, 281 granulation 90 graphic arts xxiv-xxv Great Altar, Pergamon 150, 151, 152 Great Pyramid, La Venta, Mexico 385, 386 Great Serpent Mound, Ohio 402, 402 Great Sphinx, Giza, Egypt 57, 58, 62 Great Temple of Amun, Karnak, Egypt 66, 66-7, 67 Great Wild Goose Pagoda, Chang'an, China 347, 347 Great Zimbabwe 423-4, 424 Greece, ancient 102 Archaic period 105-20 architecture 106, 107, 107, 108, 109, 110, 111, 111 (Archaic), 128, 128-30, 129, 135, 135-6, 136, 137-8 (Classical), see also architectural orders bronzes 104, 105 Classical period 105, 120-47 deities 102, 104 Geometric period 102-5, 117 goldwork 145, 145 grave stelai 139-40, 140 map 103 Neolithic pottery 21, 21 Neolithic stone-foundation house 16, 16 Neolithic wattle-and-daub walls 19 Orientalizing period 105 painting 124, 125, 140, 145-6, see also vases (below) philosophers 120 relief sculpture 107-8, 108 (Archaic), 131, 131-3, 132, 137, 137, 139-40, 140 (Classical) sanctuaries 102, 106, 107

sculpture 104, 104, 105, 111, 112, 113, 113-15, 114, 115, 116, 117 (Archaic), 120-22, 121, 122, 123, 126, 130, 130-31, 133, 133, 134, 134, 142-3, 143, 144, 145 (Classical) symposia 124, 125, 127 theater 148, 148 urban planning 138-9 vases 100, 101, 102-4, 103, 105, 105, 117, 117-20, 118, 119, 139, 139 (Archaic), 126, 126-7, 127, 141, 141 (Classical) see also Hellenistic period greenstone figures, Olmec 382, 383, 387 Gregorian chant 462, 466 Gregory I, Pope ("the Great") 435, 462 grisaille 540, 549, 551 grozing 501 Gu Kaizhi (after): Admonitions of the Imperial Instructress to Court Ladies 342, 343 Guan ware (Southern Song) 355, 355 guang (ritual pouring vessel) 335, 336 Guanyin Bodhisattva (Liao dynasty) 350, 350 Guatemala 383, 384 jade 386-7 Maya civilization 391–2 Guda: Book of Homilies 491, 491 Gudea, ruler of Lagash 37, 38 guilds, artisan 533 Gummersmark Brooch 433, 433 Gupta period (India) 308-12, 309, 311 Guti, the 37

н

Habsburg empire 452 Hades 104 Hadrian, Emperor 147, 190, 191, 195 Hadrian's Villa, Tivoli 197, 197, 198, 199-200 Hagesandros, Polydoros, and Athenodoros of Rhodes: Laocoön and His Sons 152, 153 Hagia Sophia, Istanbul xxv, 286 Hagia Sophia, Istanbul (Anthemius of Tralles and Isidorus of Miletus) 235, 235-6, 236, 237 Virgin and Child (mosaic) 248, 248-9 Haito of Reichenau, Abbot 447 hajj 266, 271 al-Hakam II, Caliph 272 hall churches, German 521, 521 Hall of Bulls, Lascaux Caves, France 10, 10-11 Halley's Comet 402 haloes 215 Hammurabi, King 28, 37 Code/Stele of Hammurabi 34, 37, 39 Han dynasty (China) 306, 338, 339, 340, 341, 349 architecture 341, 341 incense burner 339, 339 painted banner 338, 339, 343 palaces 341 relief sculpture 340, 340-41 hand-axes, Paleolithic 3, 4 handscrolls see scroll paintings handscrolls xxiv Hanging Gardens of Babylon 44 hanging scrolls xxiv, see scroll paintings Hangzhou, China 348, 355 haniwa, Japanese 362-3, 363 Harald Bluetooth 442 Harappan civilization 296 Male torso 298, 299 Harbaville Triptych (Byzantine ivory) 255, 255 Harihara (Khmer sculpture) 323, 324

Al-Hariri: Magamat 264, 265 Harkhuf (Egyptian envoy) 410 Harold, King 488 Harvester Rhyton (Minoan) 88, 88-9, 99 Harvesting of Grapes (mosaic) 224, 224, 226 Hasan, Mamluk Sultan 279 Hathor (god) 69, 77 Hatshepsut 67-8 Funerary Temple of Hatshepsut, Deir el-Bahri 68,68-9,69 Hatshepsut Kneeling 67-8, 68 Hattusha (Turkey) 37 Lion Gate 38, 40 Hawes, Harriet Boyd 85 Head of a Man (Akkadian Ruler) 36, 36 Head of a Man ("Brutus") 164, 166 Head of Constantine 211, 211 Heavenly Maidens (Sri Lankan wall painting) 312, 313 Hedwig Codex 558, 558-9 Hedwig, St. 558 Heian period, Japan 361, 369-76, 381 architecture 372, 373 poetry 375, 375-6 wood sculpture 372, 372, 373, 373 Helen of Egypt (?): Alexander the Great Confronts Darius III at the Battle of Issos 145, 146 Helena, St. 207 Helladic culture 92; see Mycenaean culture Hellenistic period 147 architecture 147, 147, 148 map 142 mosaics 145-7, 146 sculpture 143, 143, 149, 149-50, 152, 153, 153, 154, 155 Hellinus, Abbot of Notre-Dame-aux-Fonts, Liège 487 henges 17, see Stonehenge Henry I, of England 490, 490 Henry II, of England 497 Henry II, Ottonian king 454 Hephaistos (god) 104 Hera (goddess) 102, 104, 108, 180 Heraclius, Emperor 233 Herakleitos: The Unswept Floor 199, 199 Herakles Driving a Bull to Sacrifice (Andokides Painter), 118, 118 Herakles Driving a Bull to Sacrifice (Lysippides Painter) 118, 118 Herakles/Hercules 201 Commodus as Hercules 201, 201 Herat School of painting, Afghanistan 285, 285-6, 289 Herculaneum: still life 183, 184 Hercules see Herakles Hermes (god) 104, 119 Hermes and the Infant Dionysos (Praxiteles) 142-3, 143 Herod the Great 217 Herodotus 50, 53 Hestia (goddess) 104, 130 Hiberno-Saxon art 433 Gospel books 428, 429, 435, 435, 436, 436-7, 437 Hierakonpolis, Egypt Narmer Palette 51-3, 52 tomb paintings 50 hierarchic scale 27, 52 hieroglyphics, Maya 390, 390 hieroglyphs, Egyptian 51, 52, 79, 79

hijira 266 Hildegard of Bingen 492, 492 Liber Scivias 492, 492 Hildesheim, Germany Doors of Bishop Bernward 454, 455, 456 St. Michael 453 Hindu architecture Elephanta cave-temples 314, 314-15 temples 302, 302; 309, 309-10 (Gupta dynasty), 314, 314-16, 315, 317, 317-18 (rock-cut), 318, 318-19 (Chandella dynasty), 320-21, 321 (Chola dynasty) Hindu art relief sculpture 310, 310, 319, 319-20, 325-6, 326, 329, 329 rock-cut reliefs 314, 315, 316, 316-17 sculpture 322, 322 Hinduism 296, 299, 308, 309 deities 309 Hippodamus of Miletos 139 hiragana 365, 365 Hissarlik, Turkey 85 historiated capitals 484, 484-5, 501 historiated initials 491 Hitda Gospels (Ottonian) 456, 456 Hittites 37-8, 76 Hoffman, Gail 84 Hohlenstein-Stadel, Germany: Lion-Human 5, 5-6 Hohokam culture, Arizona 404 Holstein, Jonathan xxviii Holy Family, The (Michelangelo) xxxi Holy Roman Empire 452, 460, 520, 525, 557, 561 Homer Iliad 85, 93, 97-8, 119 Odyssey 85 Homo sapiens sapiens 2, 3-4, 8 Honduras 383, 384 ballcourt, Copan 395, 395 Honorius, Emperor 227, 228 Hopewell culture 401 pipes 401-2, 402 Horace: Epistulae 167 horseshoe arches 272, 274 Horseshoe Canyon, Utah 406, 406 Horus (god) 51, 51, 53, 77 Horyuji (temple), Nara, Japan 344, 365-6, 366 Shaka Triad (Buddha Shaka and Attendant Bodhisattvas) 367, 367 Tamamushi Shrine 366, 366-7 Hosios Loukas Monastery Churches, Greece 249, 249-50, 250, 251 Hospitality of Abraham, The (Rublyov) 262-3, 263 house-church, early Christian 220, 221, 221 hues xxii Hugh de Semur, abbot of Cluny 466 Huizong, Emperor 353 (attrib.) Ladies Preparing Newly Woven Silk 347, 347-8 humanism 120 humanists, Renaissance 431 Humay and Humayun (Junayd) xxxi Hummingbird geoglyph (Nazca), Peru 399, 400 Hundred Years' War (1337-1453) 533, 548, 554 Hunefer 77, 77 Hungry Tigress Jataka (Tamamushi Shrine panel) 366, 367 Huns 430, 431 Hurrem (wife of Suleyman) 288

Hus, Jan 561 Husayn Bayqara, Sultan 285 Hussite Revolution 561 *huyuk 29* hydria 117 *Woman at a Fountain House* (Priam Painter) 139, 139 Hyksos, the 65 hypostyle halls 66, 66, 67, 67 mosques 268, 271, 272

L

Ibn al-Wasiti, Yahya: The Magamat of Al-Hariri 264, 265 Ibn al-Zain, Muhammad: Baptistery of St. Louis (brass basin) 284, 284 Ibn Marzug 275 Ibn Muqla 275 Iceland 444 iconoclasm/iconoclasts 247, 247, 248 iconography xxxiii, xxxiv, xxxv iconology xxxv icons, Byzantine 246, 246-8, 257, 257-8, 258, 262, 262-3.263 'Id al-Adha 271 'Id al-Fitr 271 idealism 120, 169 idealization xxiv, 134 Ife, Nigera 409, 415 Crowned Head of a Yoruba Ruler 408, 409 pavement mosaics 415 terra-cotta ritual vessel 415, 415-16 Igbo-Ukwu, Nigeria burial chamber 414, 414 fly-whisk handle 415 roped pot on a stand 415, 416 Iguegha (metalcaster) 416 Iktinos 120 Parthenon, Athens 129, 129-30 Iliad (Homer) 85, 93, 97-8, 119 illumination, manuscript xxiv, xxx illusionism xxiv, 145-6 Imhotep: Djoser's Complex, Saqqara, Egypt 53-5, 54,55 Inanna (goddess) 28, 30, 36 Incarnation, the 230 incense burner, Han 339, 339 India 267, 286, 296, 299, 301, 419 Ajanta Caves 311, 311-12 Ashokan pillars 294, 295, 299-301, 300 Buddhism 299, 301, 308 Buddhist architecture (stupas) 302, 302-4, 303, 304, 305, 306, 351, 351 Chola dynasty 320-21, 321 Elephanta cave-temples 314, 314-15 Gupta period 308-12, 309, 311 Hindu rock-cut temples 302, 302, 304-5, 314, 314-16, 315, 317, 317-18 Hindu temples 302, 302; 309, 309-10 (Gupta dynasty), 318, 318-19 (Chandella dynasty), 320-21, 321 (Chola dynasty) Kushan period 306-8, 307, 310 Mathura period 306, 307-8, 310-11 Mughals 286 Pallava period 315, 315-17, 316 relief sculpture 310, 310 rock-cut reliefs 314, 315, 316, 316-17 Satavahana dynasty 301

1995

sculpture 306, 306 (Kushan), 306-7, 307 (Gandhara) 307, 307-8 (Mathura) Shunga dynasty 301 Vedas, the 299, 309, 320 Vedic gods 304 Vedic period 299 see also Mauryan period Indian Triumph of Dionysus (Roman sarcophagus) 201, 202 Indonesia 296, see Java Indus Valley civilization 296 seals 296, 296, 298 terra-cotta figurines 298 see also Mohenjo-Daro Infant Virgin Mary Caressed by Her Parents Joachim and Anna, The (Byzantine mosaic) 259, 262 Innocent IV, Pope 512 insulae 176 International Gothic Style 510 Iona, Scotland: monastery 441 see also Book of Durrow; Book of Kells Ionic order 107, 107, 110, 110, 135-6, 171 Iran 277, 286 carpets 292, 292 ceramics 276, 276 see also Isfahan Iraq 269, 277, 286 Ireland high crosses 438, 438 Knowth passage grave 17 Newgrange passage grave 17, 17 see also Hiberno-Saxon art Irene, Empress 247, 500 Ise, Japan: Grand Shrine 363-4, 364 Isfahan, Iran 290 Ali Qapu Pavilion 268 Chahar Bagh 290 Madrasa Imami 282, 282 Masjid-i Shah 290, 290 Ishmael 266 Ishtar (goddess) 28 Ishtar Gate, Babylon 44, 45 Isidorus of Miletus: Hagia Sophia, Istanbul 235, 235-6, 236, 237 Isimila Korongo, Tanzania: Paleolithic hand-axe 4.4 Isis 76, 166 Islam 266-8, 296, 410, 419 Five Pillars 271, 282 map 267 Islamic architecture 269, 269-71, 270, 277, 278, 279, 280, 280, 281, 282, 282-3 ornamentation 267, 268, 270, 270-71, 280, 281, 281-2, 282 see also mosques Islamic art 266-7 books and manuscripts 284-6, 285, see also Qur'an, the calligraphy and script 275, 275-6, 276, 279, 282, 282, 283 ceramics 276, 276-7, 277, 283, 283-4 metalwork 284, 284 mosaics 268, 270, 270-71, 282, 282 Islamic Mosque and Cultural Center, Rome (Portoghesi, Gigliotti, and Mousawi) 293, 293 Isma'il, Shah 289 isometric drawings xxv, xxv Istanbul Church of Christ in Chora (Kariye Müzesi) 258-9, 260, 260, 261, 262

Hagia Sophia xxv, 286 Hagia Sophia (Anthemius of Tralles and Isidorus of Miletus) 235, 235-6, 236, 237, 248, 248-9 Topkapi Palace 286-7, 287; Baghdad Kiosk 287, 288 see also Constantinople Italy 460, 533 architecture 469, 470, 470, 471, 471-2 (Romanesque), 528, 528 (Gothic), 533-4, 534, 547, 547 (14th century) frescos 528-9, 529, 530, 531, 539-42, 540-42, 547-8, 547-8 (13th-14th century) literature 532, 533, 539 mosaics (Romanesque) 472, 472 painted crucifix 527, 527-8 relief sculpture 478-9, 479 (Romanesque), 525, 525-7, 526 (Gothic), 534, 535, 536, 536 (14th century) tempera painting 536-7, 537, 538, 538-9, 542, 543, 544, 544-5, 545, 546, 547 ivories Benin hip pendant 419, 419 Byzantine 244, 244-5, 255, 255-6, 256 chest with scenes of romance (French) 552, 552-3.553 Magdeburg Ivories (Ottonian) 452, 452 Minoan statuette 88, 88 Paleolithic figures 5, 5-6, 7, 7 Priestess of Bacchus (Roman diptych) 212-13, 213 Sierra Leone 427, 427 iwans 277, 290, 290 Ixion 180 iyoba pendant, Benin 419, 419

J

jade Liangzhu (China) cong 332, 333, 334, 334 Olmec 382, 384, 385, 386-7 Jainism/Jains 299 rock-cut temples 302, 304-5, 317 Japan 331 architecture 363-4, 364 (Shinto), 364-7, 366, 370, 370, 372, 373 (Buddhist) Asuka period 364-7 bronzes 362, 367, 367, 370, 370 Buddhism 301, 361, 364, 369 Buddhist architecture 364-7, 366, 370, 370, 372, 373 Buddhist art 360, 361, 366, 366-7, 367, 369; see also Esoteric Buddhism; Pure Land Buddhism; Zen Buddhism (below) calligraphy 375, 375-6 ceramics 362 (Jomon), 362-3, 363 (Kofun) Esoteric Buddhism/Buddhist art 369, 371, 371 haniwa 362-3, 363 Heian period 361, 369-76, 381 Jomon period 362 Kamakura period 376-81 kami 361, 363, 365 Korun period 362-4 mandalas 360, 361, 371, 371 map 362 Nara period 367-9 Neolithic (Jomon) pottery 21, 21 pagodas 351, 351, 366, 366 poetry 365, 375, 375-6 Pure Land Buddhism/Buddhist art 345, 371, 372, 373, 373, 377-9, 378, 379, 381

samurai/samurai arms and armor 376, 377, 377 script 365, 365, 373, 375 scroll paintings 371, 371, 374, 374-5, 376, 376, (Heian period), 360, 361, 377, 378, 378-9, 379, 380, 380 (Kamakura) sculpture 367, 367 (Asuka period), 372, 373, 373 (Heian period), 377-8, 378 (Kamakura period) Shinto/Shinto shrines 361, 362, 363-4, 364, 367 shoguns 376-7, 380 tombs 362 Yayoi period 362 Zen Buddhism/Buddhist art 380, 380, 381 Jasaw Chan K'awiil (Maya ruler) 391, 392 tomb 391, 391 Jashemski, Wilhelmina 179 Jataka tales 303, 366, 367 Java, Indonesia Borobudur 323-5, 324, 325 Loro Jonggrang, Prambanan 325–6, 326 relief, Chandi Shiva, Prambanan 326, 326 Jayavarman II, Khmer king 328 Jelling, Denmark: rune stones 442, 442 Jenné, Mali 419, 422 Great Friday Mosque 422, 423 terra-cotta figures 422, 422 Jerome, St. 220 Commentary on Isaiah 493, 493 Vulgate 223, 437 Jerusalem 252, 288, 460, 461 Dome of the Rock 217, 268, 269, 269-71, 270 Holy Sepulcher 464 looting of the Temple 167, 185, 185-6 Temples 217, 236 Jesse Trees 493, 493 Jesus of Nazareth/Jesus Christ/Christ 216, 220, 271 early depictions 215, 220, 221, 221, 222, 222, 226, 228, 229 life 230 jewelry Celtic torc 150, 150 Danish 433, 433 Diquis pendant 396-7, 397 Greek earrings 145, 145 Korean headdress 356, 356 Merovingian 431-2, 432 Minoan pendant 90, 90 Moche earspools 401, 401 Neolithic 23 Jews/Jewish art 44, 167, 185, 216-17, 221, 267 catacomb art 217, 217 mosaics 219, 220 wall paintings 217-18, 218 Jiangzhai, China: Neolithic dwellings 332 Jiaxiang, Shandong, China: Wu family shrine reliefs 340, 340-41 Jinas 304 Jocho: Amida Buddha 372, 373, 373 John of Damascus 246 John, St. (evangelist) 220 Johnson, John G.: Collection xxxviii Jolly, Penny Howell xl, xli Jomon period, Japan 362 Jomon pottery (Japan) 21, 21 Jonah 222, 222 Josephus, Flavius: Jewish Wars 167 Judaism 166, 216, 246 see also Torah

Judgment of Hunefer before Osiris (Book of the Dead) 77, 77 Judith Window, Sainte-Chapelle, Paris 512–13, 513 Julio-Claudians 172, 184 Junayd: Humay and Humayun xxxi Juno (goddess) 104 junzi 342 Jupiter (god) 104 Jurchen tribes 348 Justinian and His Attendants (mosaic) 239, 241, 242 Justinian I, Emperor 234, 235, 236, 238–9, 242, 429 Jutes 430, 433

κ

ka 53, 61

Kaaba, Mecca 266, 266, 271 Kaifeng, China 348 Kailasha Temple, Ellora, India 317, 317-18 Kairouan, Tunisia: Great Mosque 271, 271, 274, 277 Kalhu (Nimrud, Iraq) 38 palace of Assurnasirpal II 40, 41, 42 Kallikrates Parthenon 129, 129-30 Temple of Athena Nike 129, 135, 137, 137 Kamakura period, Japan 376-81 raigo paintings 378-9, 379, 381 scroll paintings 360, 361, 377, 378, 378-9, 379, 380, 380, 381 Kamares ware 85, 85, 90 kami (Japanese deities) 361, 363, 365 kana script 365, 373, 375 Kandariya Mahadeva Temple, Khajuraho, India 318, 318-19 erotic sculptures 319, 319 Kanishka, King: statue 306, 306 kanji 365, 365 kantharos 117, 117 Karle, India: Chaitya hall 305, 305 Karlstejn Castle, near Prague Holy Cross Chapel 560, 561 St. Luke (Master Theodoric) 560, 561 Karnak, Egypt 71, 76 Great Temple of Amun 66, 66-7, 67 Karomama (Egyptian bronze) 78, 78 Karttikeya 309 Kashan 291 Kassapa, King 312 Kasuga Shrine Mandala (Japanese hanging scroll) 360, 361, 381 Kasuga Shrine, Nara, Japan 367 katakana 365, 365 Kavousi, Crete 85 keel arches 274 Kenchoji, Kamakura: Zen temple 380 Key Marco, Florida 403 keystones 170, 170 Khafre, Egyptian king funerary complex 57 Great Sphinx 57, 58, 62 Pyramid (Giza) 55, 56, 56, 57 statue 57-8, 59 Valley Temple of Khafre 19, 57, 58, 58 Khajuraho, India: Kandariya Mahadeva Temple 318, 318-19 erotic sculptures 319, 319

Khmer, the architecture (Angkor Wat) 328, 328-9 relief sculpture 329, 329 sculpture 323, 324 Khons (god) 65, 66 Khorsabad, Iraq see Dur Sharrukin Khufu, Pyramid of (Giza) 56, 56, 57 Khurasan, Iran 277 ceramics 276, 276 Ki no Tsurayuki: poetry 375, 376 Kiev, Ukraine 250-51, 252, 258, 441 Santa Sophia 251-2, 252 kilim weaving 292, 292 Kilwa 410 kirikane (gold-leaf technique) 379, 379 Kiss of Judas (Giotto) 541-2, 542 kivas 405 Knossos, Crete 84, 85, 90 Bull Leaping fresco 87, 87-8 Labyrinth 84,86 Palace complex 85-6, 86, 87, 87 Knowles, Martha xxvii My Sweet Sister Emma (quilt) xxvii, xxvii-xxviii, xxix Knowth, Ireland: passage grave 17 Kofun period, Japan 362-4 Koi Konboro, king of Jenné 422 Komnenos, Alexios 253 Komyo, Empress 368, 369 kondo 366 Kongo kingdom 425-6 bronze crucifix 426, 426-7 textiles 426, 426 kore (pl. korai) 114 Berlin Kore 115, 115 "Peplos" Kore 115, 116, 117 Korea 331, 356, 362 Buddhism/Buddhist art 301, 357, 357-8, 358, 359, 359 ceramics 356, 356-7 (Silla kingdom), 358, 358-9 (Goryeo dynasty) goldwork 356, 356 map 333 scroll painting (Buddhist) 359, 359 Three Kingdoms period 356-7 Kosho: Kuya Preaching 377-8, 378 kouros (pl. kouroi) 114, 120 Anavysos Kouros 115, 116, 160 Metropolitan Kouros 114, 114 kraters 117 Dipylon Krater 103, 103-4 Warrior Krater 99, 99 see also calyx kraters Krishna I, Rashtrakuta king 317 Kritias 141 Kritios Boy 113, 120, 121 Kublai Khan, Mongol leader 355 Kufic script 275, 275-6, 276, 279, 282, 282, 283 Kunigunde, Ottonian queen 454 Kush, kingdom of 74, 78 Kushan period (India) 306, 306-8, 307, 310 Kuya (monk) 377, 381 Kuya Preaching (Kosho) 377-8, 378 Kyanzittha, King 327 statue 327, 328 Kydias 157 kylixes 117 A Bronze Foundry 120-21, 121

Khamerernebty II, Queen 59, 59

A Youth Pouring Wine into the Kylix of a Companion (Douris) 126–7, 127 Kyoto, Japan 369, 376–7

L

La Tour, Georges de: The Education of the Virgin xxx La Venta, Mexico 385 basalt monuments 386 Colossal heads 386 Great Pyramid 385, 386 Olmec figurines 382, 383 Labyrinth at Knossos, the 84, 86 Ladies Preparing Newly Woven Silk (attrib. Emperor Huizong) 347, 347-8 Lady Xok (Maya queen) 394, 394 Lagash (Iraq) 28, 37 lakshanas (Buddhist symbols) 306, 368, 368 Lalibela, Ethiopia 424-5 Bet Giorgis (Church of St. George) 425, 425 Lalibela, Zagwe king 424 lamassus 42, 43 Lamentation (Giotto) 541, 541 Lamentation, the 230 Lamentation with Standing Monastic Saints Below (fresco) 253, 253-4 Laming-Emperaire, Annette 8 lancets 505, 506, 507, 510, 515 Landscape ("Spring Fresco") (Minoan) 91, 91-2 lantern towers 464 Lanxi Daolong, Chan master 380 portrait 380, 380 Lanzón, Chavin de Huantar, Peru 398, 398 Laocoön and His Sons (Hagesandros et al.) 152, 153 Laos 296 Laozi 338 lapis lazuli 30, 33, 34, 35, 35 Lapith Fighting a Centaur (Parthenon relief) 131, 131.133 Lascaux Cave paintings, Dordogne, France 10, 10-11, 11 Last Judgment, The (Gislebertus) 483, 483-4 Last Supper, the 220, 230 Lauriya Nandangarh, Bihar, India: Ashokan pillar 294.295 law code: Code of Hammurabi 37, 39, 39 Lazarus 230 relics 464, 482 see also Raising of Lazarus Le Corbusier (Charles-Édouard Jeanneret): Nôtre-Dame-du-Haut, Ronchamp, France xxviii, xxviii legalism, Chinese 338, 340 Léger, Fernand 439 lekythoi 117 Woman and Maid (style of Achilles Painter) 141, 141 Lenoir, Alexandre 499 Leo III, Emperor 247 Leo III, Pope 444 Leo IV, Emperor 247 Leo V, Emperor 247 Lepenski Vir, Serbia: Neolithic houses/shrines 13, 13, 14, 15 Leroi-Gourhan, André 8 Lesyngham, Robert: east window, Exeter Cathedral 556, 557 Levi, Calling of 230 Lewis-Williams, David 9 li 342, 351

Li Bai xxxiv Liang Wu Di, Emperor 344 Liangzhu culture 332, 334 jade congs 332, 333, 334, 334 Liao dynasty (China) 350 Seated Guanyin Bodhisattva 350, 350 Liber Scivias (Hildegard of Bingen) 492, 492 Libya: Acacus Mountains rock art 411-12 Liège, Belgium: Saint-Barthélémy baptismal font (Renier of Huy) 487, 487 light/lighting xxix, xxx, xxxi Lindau Gospels 450, 451, 452, 454 Lindisfarne, England: monastery 441 Lindisfarne Gospels 436, 436-7, 437 Carpet Page xxx line xxii implied xxxii linear perspective xxiii linear styles xxiv linga shrine 314, 315 lintels 18 post-and-lintel construction 17, 18, 19, 158 Lion capital (Ashokan pillar) 300, 300-1 "Lion Gate," Mycenae 93, 95, 95 Lion-Human (Paleolithic sculpture) 5, 5-6 literature Anglo-Saxon 533 14th century 532, 533, 539, 554 Italian 532, 533, 539 Liu Sheng, Prince: tomb 339 Livia 171, 172, 175, 176 Villa of Livia, Primaporta 182, 183 Lombards 444 London 515 Lorblanchet, Michel 8 "Lord of the Dance" 309, 322, 322 Lorenzetti, Ambrogio 531, 550 The Effects of Good Government in the City and in the Country 530, 531, 547-8, 548-9 Loro Jonggrang, Prambanan, Java 325–6, 326 lost-wax casting 36, 396, 418, 418 lotus flower (Buddhist symbol) 368, 368, 370, 370 Louis IX, of France (St. Louis) 504, 508, 512, 514, 548 Louis VII, of France 497, 499 Ludwig I, of Bavaria 111 Ludwig I, of Liegnitz-Brieg 559 Luke, St. 220, 258, 533 St. Luke (Master Theodoric) 560, 561 Lullubi people 27, 36 Lunda, the 426 lunettes 221, 221, 228, 229 lusterware, Islamic 276-7, 277 lute, Chinese 369, 369 Luxor, Egypt 67, 76 New Gourna Village (Fathy) 292, 293 lyres, Sumerian 32-3, 33, 34 Lysippides Painter: Herakles Driving a Bull to Sacrifice 118, 118 Lysippos 145, 155 Man Scraping Himself (Apoxyomenos) 144, 145

Μ

Ma'at (goddess) 51, 77 Macedonian Renaissance 256 Madame Charpentier and Her Children (Renoir) xxxii, xxxiii, xxxv Madonna of the Goldfinch (Madonna del Cardellino) (Raphael) xxxii, xxxii–xxxiii, xxxv madrasas 277 maenads 104 Magdeburg Cathedral 452, 453 St. Maurice 524, 524 Maestà (Duccio) 542, 543, 544 Magdeburg Ivories 452, 452 Magenta, Black, Green, on Orange (No. 3/No. 13) (Rothko) xxvi, xxvii, xxix Magi, the 230 Magi Asleep, The (capital) 484, 484 Magyars 452 Mahabharata 299 Mahavira 299 Mahayana Buddhism 301, 345 Mahendravarman I, King 315 Mainardi, Patricia xxix Mainz, Germany: Cathedral 453 Maitreya Buddha 301 Maius: Woman Clothed with the Sun 439, 439-40 Majestat Batlló (crucifix) 485, 485 Malaysia 296 Mali 410, 419, 422 Great Friday Mosque, Jenné 422, 423 terra-cotta figures 422, 422 Mamallapuram, India 315 Descent of the Ganges (rock-cut relief) 316, 316-17 Dharmaraja Ratha 315, 315-16 Mamluks 277, 279, 288 architecture 278, 279 Baptistery of St. Louis (basin) 284, 284 glass oil lamp 279 manuscript illustration 284, 285 metalwork 284, 284 Qur'ans 284, 285 mammoth ivory sculpture 5, 5-6 mammoth-bone houses, prehistoric 4-5, 5 Man and Centaur (Greek bronze) 104, 105 Man Scraping Himself (Apoxyomenos) (Lysippos) 144.145 mandalas 302, 309, 310, 315, 368, 371 Kasuga Shrine Mandala 360, 361, 381 Womb World Mandala 371, 371 mandapas 302, 318-19 Manden 419, 422 maniera greca 527 manuscript illumination xxiv, xxx manuscripts Byzantine 244, 245, 245, 247, 256, 256-7 Gothic 514, 514-15, 515 (French), 515, 516, 516, 517, 517-18 (English) Islamic 264, 265, 289, 289-90 Mamluk 284, 285 Mozarabic (Beatus manuscripts) 439, 439-41, 440 see also books; books of hours; Gospel Books; Qur'an, the Mappo 371 maps Americas (pre-1300) 385 ancient Aegean world 83 Ancient Africa 411 ancient Egypt 50 ancient Greece 103 ancient Near East 29 Byzantine Empire 234 China and Korea 333 Europe in the early Middle Ages 430 Europe in the 14th century 532 Europe in the Gothic era 496

Europe in the Romanesque period 461 Hellenistic Greece 142 Islamic World 267 Japan 362 prehistoric Europe 3 Roman Empire 159, 216 South and Southeast Asia 297 Maqamat of Al-Hariri (Ibn al-Wasiti) 264, 265 maqsura 272 marble 82, 114 Marburg, Germany: Church of St. Elizabeth of Hungary 521, 521 Marduk (god) 44 Marduk Ziggurat, Babylon 44 Mark, St. 220 Marrakesh, Morocco: Kutubiya Mosque minbar 268, 274, 274-5 Marriage at Cana (Giotto) 540, 541 Marriage at Cana 230 Mars (god) 104 Martini, Simone 545 Annunciation (with Memmi) 545, 546, 547 martyria 238 masjid 267 Masjid-i Shah, Isfahan, Iran 290, 290 mask motifs, Chinese 332, 333, 334 "Mask of Agamemnon" 97, 97 Mask of Tutankhamun, Funerary 48, 49 Masons at Work 504, 504 masons, medieval 504 Mass 220 mass xxiii Massacre of the Innocents, the 230 mastabas 53, 54, 55, 55, 61 Mathura style (India) 306, 310-11 Buddha and Attendants 307, 307-8 Matthew, St. (Levi) 230 The Calling of Matthew 230 Gospel of 220, 429, 436, 436 St. Matthew (Codex Colbertinus) 490-91, 491 St. Matthew the Evangelist (Coronation Gospels of Charlemagne) 448, 449 St. Matthew the Evangelist (Ebbo Gospels) 449, 449-50 St. Matthew Writing His Gospel (Lindisfarne Gospel Book) 437, 437 symbol of (Gospel Book of Durrow) 435, 435 Mau, August 182 Maurice, St. 524 sculpture 524, 524 Maurya period (India) 295, 299 Ashokan pillars 294, 295, 299-301, 300 sculpture 300, 301 Mausoleum of Constantina, Rome 224, 226 sarcophagus 226, 226 Maxentius 206, 207, 209, 211, 430 Maximian, Emperor 205 Maximianus, Archbishop 239 Maya civilization 384, 390-91 architecture 392, 392-3, 393, 395, 396 ballgames/ballcourts 390, 392, 395, 395 carved lintels 384, 384 ceramics 395, 395 chacmools 396, 396 hieroglyphs 390, 392 sarcophagus 393, 393 sculpture 393, 393 writing 390, 390 Mayapan, Yucatan Peninsula, Mexico 396 maydan 290

Mbanza Kongo 419, 426 Mecca 265, 266, 266, 271, 286 Kaaba 266, 266, 271 Medes, the 44 Media 44, 45 Medina 266, 286 Mosque of the Prophet 266, 267-8 medium/media xxiv, xxix megalithic architecture 16-20, 18 megarons, Mycenaean 93, 96, 96 Mehmed II, Ottoman sultan 263 Meier, Richard 175 Meiss, Millard 550 Memmi, Lippo: Annunciation (with Martini) 545, 546, 547 Memphis, Egypt 78, 79 mendicants 525 Menkaure, King 56 Menkaure and a Queen 59, 59 Pyramid of Menkaure (Giza) 56, 56, 57 menorahs 217, 217 Mercury (god) 104 Merovingians 431 jewelry 431-2, 432 Merseburg, Germany: tomb effigy 486, 486 Mesoamerica 383, 384-96 Maya civilization 390-96 Olmecs 384-7 Teotihuacan 387-390 Mesopotamia 28 metalwork Bronze Age 23-4 Islamic 284, 284 Moche 400 Neolithic 23, 24 see also bronzes; bronzework; goldwork; silverwork, Roman Metochites, Theodore 258, 260 funerary chapel of 258, 260, 260 metopes 110, 110 reliefs 131, 131, 133 Metropolitan Kouros 114, 114 Mexico 383 Maya civilization 390-96, 392-6 Mexico City 384 Mezhirich, Ukraine: Paleolithic dwellings 5 Michael III, Emperor 249 Michelangelo Buonarroti: The Holy Family (Doni Todo) xxxi Middle Ages: definition 431 Middle-aged Flavian Woman (Roman sculpture) 188, 189 mihrabs 265, 274, 278, 282, 282 Milan, Italy 206 Edict of Milan (313) 207 "Mildenhall Treasure," England 211–12, 212 Milvian Bridge, Battle of (312) 207 Mimbres culture, New Mexico 404 bowls 404, 404 mina'i ware 283, 283-4 Minamoto, the 376, 377, 378, 380 minarets 274, 286, 287 minbars 265, 268, 274, 274-5, 278 Minerva (goddess) 104 miniatures, Byzantine 245, 256, 256-7 Minoan civilization 82, 83, 84, 90 architecture 84, 85-7, 86, 87 ceramics 85, 85, 88, 89, 89-90 goldwork 88, 89, 90, 90-91, 91 ivory figure 88, 88

stone rhytons 88, 88-9, 89 Minos, King 84, 85 Minotaur, the 84 Miracle of the Crib at Greccio, The (fresco) 528-9, 529 miradors 280 Mississippian period, North America 402 Cahokia 403, 403 Great Serpent Mound 402, 402 Mithen, Steve 8–9 Mithras 166, 207, 216, 471 mithuna couples 305 Moche culture, Peru 399-400 earspools 401, 401 portrait vessels 400, 400 Tomb of the Warrior Priest 401 Mocking of Christ with the Virgin Mary and St. Dominic (Fra Angelico) xl, xl modeling xxix, xxxi, xxxii Modena Cathedral, Italy: reliefs (Wiligelmo) 478-9, 479, 506 Mogadishu 410 Mohenjo-Daro 296, 298 "Priest-king" (sculpture) 298, 298 water tank 296, 297 Moissac, France: priory church of Saint-Pierre (sculpture) 479, 480, 481, 481-2, 482 Mombasa 410 Mon kingdom of Dvaravati 323 Standing Dvaravati Buddha 323, 323 monasticism/monasteries 435, 444, 460, 490 Byzantine 242, 243, 244, 248, 249, 249-50, 250, 251, 253, 253-4 Cluny, France 465-8, 466, 468 Hosios Loukas, Greece, 249, 249-50, 250, 251 Iona, Scotland 428, 429, 435, 441 Lindisfarne, England 436-7, 441 St. Albans, England 515 St. Catherine's, Sinai 242, 243, 244; icon 246, 246-8 Saint Gall, Switzerland 447, 447-8, 450 Saint-Martin-du-Canigou, France 462, 463 St. Panteleimon (frescos) 253, 253-4 scriptoria in 244, 438, 487, 490, 493 Wearmouth/Jarrow, England 436 Mongols 277, 281, 286, 355 Mopti, Mali 419 Moralized Bible 514, 514-15, 515 Moretti, Giuseppe 175 Morgan Beatus 439, 439-40 Morgan, Jacques de 34 Morocco 277 Kutubiya Mosque, Marrakesh: minbar 268, 274, 274 - 5mortise-and-tenon joints 18 mosaics xxiv, 199 Battle of Centaurs and Wild Beasts (Hadrian's Villa) 198, 199-200 The Battle of Issos (?Philoxenos of Eretria or Helen of Egypt) 145, 146 Byzantine 239, 240, 241, 242, 243, 244, 248, 248-9, 250, 251, 251-4, 252, 253, 254, 254, 258-9, 259, 262 early Christian 224, 224, 226, 227, 228, 229, 231, 231 Islamic 268, 270, 270-71, 282, 282 Jewish 219, 220 Romanesque 472 Stag Hunt (Gnosis) 146, 146-7

The Unswept Floor (Herakleitos) 199, 199

Moses 39, 217, 218, 242, 244, 271 mosques 264, 265, 267 Great Friday Mosque, Jenné, Mali 422, 423 Great Mosque of Cordoba 272, 272-3, 273, 275 Great Mosque of Kairouan, Tunisia 271, 271, 274,27 hypostyle 268, 271, 272 iwan 277, 278, 279, 290, 290 Kutubiya Mosque, Marrakesh: minbar 268, 274, 274 - 5Mosque of the Prophet, Medina 267-8 Mosque of Sultan Selim, Edirne, Turkey (Sinan) 286, 287 Sultan Hasan Madrasa-Mausoleum-Mosque complex, Cairo 268, 278, 279 Mousawi, Sami: Islamic Mosque and Cultural Center, Rome 293, 293 Mozarabic art 439, 439-41, 440 Muawiya, Caliph 267 mudras 307, 308, 308, 323, 323, 325 Mughals 281, 286 Muhammad V, Sultan 280 Muhammad, Prophet 216, 266, 267, 268, 271, 283 Muhammad, Sultan al-Nasir 279 mullions 510 mummification 53 Muqaiyir, Iraq see Ur mugarnas 268, 280, 281 Muqi xxxvi Murasaki, Lady: The Tale of Genji 369, 373-5, 374 Museum of Modern Art, New York xxvii Muslims see Islam/Islamic art Mussolini, Benito 175 Mut (goddess) 65, 66 Myanmar (Burma) 296, 323 Ananda Temple 327, 327-8 Mycenae 85, 93, 94 "Lion Gate" 93, 95, 95 Mycenaean culture 90, 92 bronze dagger blades 97, 97-8 ceramics 99, 99 citadels/palaces 92-3, 94, 96, 96 "Mask of Agamemnon" 97, 97 megarons 93, 96, 96 shaft graves 97 tholos (beehive) tombs 98 "Treasury of Atreus" 98, 98-9

Ν

see also Mycenae

Nabonidus, Neo-Babylonian ruler 44 Namibia: animal figures 410 Nanchan Temple, Shanxi, China 345, 346, 346-7 Nanna (god) 36, 37 ziggurat (Ur) 37, 37 Napoleon Bonaparte 49,79 Nara, Japan 367, 368, 369 Horyuji 344, 365-7, 366, 367 Kasuga Shrine 360, 361, 367 Todaiji 367-9, 370, 370 Naram-Sin, Stele of 26, 27, 34, 36 Narasimhavarman I, King (Mamalla) 315, 316 Narmer, Palette of 51-3, 52 Nasrids 277, 280 see also Alhambra, the Native Americans 34 Nativity, the 230 naturalism xxiv

Naumburg Cathedral, Germany: Ekkehard and Uta 524, 524 Naxos, island of: marble 82, 114 Neanderthals 1, 3 Nebuchadnezzar II, King of Babylonia 44, 217 necropolises, Egyptian 53, 62 Nefertari, Queen 74, 76 Queen Nefertari Making an Offering to Isis (tomb painting) 76,77 Nefertiti, Queen 71, 71, 72, 82 portrait bust 72, 72-3 Nekhbet (goddess) 51,73 nemes headdress 51, 73 Neo-Babylonians 44 Neo-Confucianism 350-51, 352 Neolithic cultures (China) 332 jade cong 332, 333, 334, 334 pottery 332, 332 Neolithic period 2, 12-13, 23, 50 architecture 13, 13-16, 15, 16 ceramics 20-21, 21, 22, 22 copper artifacts 23 Cycladic sculpture 82, 82-4, 84 goldwork 23, 24 jewelry 23 plaster figures 21, 23, 23 sculpture 13, 14, 21, 22, 22 tombs 14, 17, 17 wall painting 14, 15 Neoplatonism 205 Nepal 296 Tantric Buddhism 369 Neptune (god) 104 Nerezi, Macedonia: Monastery Church of St. Panteleimon (frescos) 253, 253-4 Nero, Emperor 172, 184, 186 Nerva, Emperor 190 Netherlands: painting (flowers) xxxiv, xxxvi New Gourna Village, Egypt (Fathy) 292, 293 Newgrange, Ireland: passage grave 17, 17 Nicaragua 384 Nicea, Council of (787) 247 Nicholas of Verdun: Shrine of the Three Kings 523, 523 Nicomachus Flavianus, Virius: diptych 212-13, 213 niello decoration 90 Niger River 410, 412, 419 Nigeria Benin culture 416-19, 417, 419 Edo altar 417, 417 Ife culture 408, 409, 415, 415-16 Igbo-Ukwu culture 414-15, 415, 416 Nok culture 412-13, 413 Night Attack on the Sanjo Palace (Japanese handscroll) 377, 378, 381 Nikaya Buddhism 301 Nike (goddess) 104, 133 Nike (Victory) Adjusting Her Sandal (relief) 137, 137, 143 Nike (Victory) of Samothrace 153, 153, 155 Nile, River/Nile Valley 50, 50, 56, 65, 74 Nîmes, France: Pont du Gard 170, 170 Nimrud, Iraq see Kalhu Nine Mile Canyon, Utah: Hunter's Mural 406, 406 Nineveh (Ninua, Iraq) 42, 44 Head of a Man (Akkadian Ruler) 36, 36 palace of Sargon II 42-3, 43 nirvana 301 Nishapur, Iran: pottery 276

Nok culture, Nigeria 412-13 heads 413, 413 Noli Me Tangere 230 Noli Me Tangere (Giotto) 541, 541 nonrepresentational/nonobjective art xxiv Normans 441, 460, 518 architecture 476, 476-7, 519 Norse cultures 433 North America 384, 401-7 Ancestral Puebloan (Anasazi) people 404, 404-5, 405, 407 Florida Glades culture 403, 403-4 Hohokam culture 404 Mimbres culture 404, 404 Mississippian period 402, 402-3, 403 Woodland period 401-2, 402 Northern Song dynasty (China) 348 painting 351-4, 352, 353, 354 Northern Wei dynasty, China: Buddha 344, 344 Norway 441, 442 stave churches 443, 443-4 Nôtre-Dame-du-Haut, Ronchamp, France (Le Corbusier) xxviii, xxviii Novgorod, Russia 441 Novios Plautios: The Ficoroni Cista 156, 157 Nri people 414 Nubia/Nubians 50, 58, 62, 65, 74, 78, 410 Sphinx of Taharqo 78, 78-9 Nzinga aNkuwa, king of Kongo 425, 426

0

obas, Benin 416, 419, 420, 420, 421 memorial head 417, 417 Octopus Flask (Minoan) 89, 89-90 Odo, Bishop 487 Bishop Odo Blessing the Feast 488, 489 Odyssey (Homer) 85 oil lamp ('Ali ibn Muhammad al-Barmaki) 279 oinochoe 117 Old Woman (Hellenistic sculpture) 154, 155 Olduvai Gorge, Tanzania 2 Olga, Princess 251 Olmec civilization 383, 384-5, 387, 389 ceramics 387 Colossal heads, San Lorenzo 385-6, 386 Great Pyramid, La Venta 385, 386 greenstone and jade figurines 382, 383, 387 Olokuin (god) 419 Olorgesailie, Kenya 3 olpe 105, 105, 117 Olympian Games 102 oni 409, 416 opithodomos 129 opus anglicanum (embroidery) 554-5, 555 opus reticulatum 194 oracle bones, Chinese 334 Oranmiyan, Prince of Benin 416 orant figures 220, 222, 231, 251 Orator, The (Roman bronze) 169, 169 oratories 227 Oratory of Galla Placidia, Ravenna, Italy 228, 228, 229 Orcagna (Andrea di Cione): Enthroned Christ with Saints (Strozzi Altarpiece) 550, 550 orders, architectural see architectural orders Orthodox Christianity 250, 251, 441 orthogonal plans (city planning) 138 orthogonals xxiii Oseberg Ship 441, 441-2

Osiris (god) 51, 73, 74, 75, 77, 166 Ostrogoths 227, 238, 430, 431 O'Sullivan, Timothy: Ancient Ruins in the Canyon de Chelley 407 Otto I 452 Otto I Presenting Magdeburg Cathedral to Christ (ivory) 452, 452 Otto II 452, 453 Otto III 452 Gospels of Otto III 456-7, 457 Ottoman Empire 286 architecture 286-7, 287 tugras 288, 288 Ottoman Turks 234, 248, 263 architecture 475 Ottonian Empire 452, 460 architecture 452-4, 453 Gospel books 456, 456-7, 457 ivory plaques 452, 452 sculpture 454, 454, 455, 456 Oxford University, England 460, 496, 515

Р

Padua, Italy Scrovegni (Arena) Chapel) frescos (Giotto) 539-42, 540-42 University 496 Paestum see Poseidonia pagodas Chinese 347, 347, 351, 351 Japanese 351, 351, 366, 366 Painted Pottery cultures (China) 332 Painter at Work, A (Roman fresco) 183, 183 painterly xxiv painting(s) xxiv, 292 cave xlii, 1, 8-11, 9, 10, 11 Dutch (flowers) xxxiv, xxxvi Egyptian (tomb) 62-3, 63 76, 77 Etruscan 160, 161, 162, 163 Greek 124, 125, 140, 145-6, see also vases, Greek Herat School, Afghanistan 285, 285-6 Minoan 87, 87-8, 91, 91-2, 92-3 Neolithic (wall) 14, 15 Roman 179-84, 180-84 Safavid 289, 289 Saharan rock-wall 411-12, 413 South African (San) rock-wall 414, 414 see also scroll paintings; tugras; wall paintings Pakal the Great, of Palenque 392 Sarcophagus 393, 393 stucco portrait 393, 393 Pakistan 286, 296, 306 Palaikastro, Crete 88 Octopus Flask 89, 89-90 statuette of male figure 88, 88 Palenque, Mexico 392 Portrait of Pakal the Great 393, 393 Sarcophagus of Pakal the Great 393, 393 Temple of the Inscriptions 392, 392-3 Paleolithic period 2 cave paintings xlii, 1, 8-11, 9, 10, 11 decorated ocher 4, 4 hand-axes 3, 4 Homo sapiens sapiens 2, 3-4 ivory figures 5, 5-6, 7, 7 map 3 Neanderthals 1, 3 relief sculpture 5, 11-12, 12 rock art 2, 2

sculpture 5-7, 5-7, 7, 7 tools 1, 2-3, 4 Palestine 267, 286 Palette of Narmer 51-3, 52 Pallava period 315 rock-cut reliefs 316, 316-17 rock-cut temples 315, 315-16 Pan (god) 104 panel painting xxiv Panofsky, Erwin xxxiii, xxxv Pantheon, Rome 194, 195, 195, 196, 197 paper 276 Paracas culture, Peru 399 textiles 399, 399 parchment 245, 275-6 Parinirvana of the Buddha, Gal Vihara, Sri Lanka 320, 320 Paris 495, 497, 504, 532, 552 Sainte-Chapelle 512, 512-13, 513, 514 Saint-Denis 432, 497, 498, 498-9, 500, 505 University 460, 496 Paris Psalter 256. 256-7 Paris, Matthew 515 Self-Portrait Kneeling Before the Virgin and Child 515, 517 Parler, Heinrich and Peter: Church of the Holy Cross, Schwäbish Gmünd, Germany 559, 561 Parnassos, Mount 107 Paros, island of grave stele of little girl 139, 139 marble 82, 114 Parthenon see Akropolis Parthians 172, 221 Parvati 309, 314 passage graves, Neolithic (Ireland) 17, 17 patricians, Roman: portraits 167, 167, 169 Patrician Carrying Portrait Busts of Two Ancestors 168, 168 pattern xxix, xxx Paul, St. 220, 226-7, 253, 467, 498 Pausanias 130, 142, 167 Pausias 146 pavement period, Ife 415 Pavlov, Czech Republic 7 Pax Romana 172 Pearson, Mike Parker 19 Pech-Merle Cave, Dordogne, France: Spotted horses and human hands xlii, 1, 8 pediments 107, 110 Peeters, Clara: Still Life with Fruit and Flowers xxxiv, xxxvi Pelican figurehead, Florida Glades 403, 403-4 Pella, Macedonia: floor mosaic 146, 146-7 Peloponnesian War 127-8 pendentives 228, 236, 238, 238, 251 "Peplos" Kore 115, 116, 117 Pergamon, Turkey 149 Great Altar 150, 151, 152 Perikles 128, 129 period style xxiv peristyle 109 courts 66 gardens 178, 178-9 Perpendicular style 557 Persephone (goddess) 104 Persepolis (Iran) 45, 46, 47, 142 Persian Empire 44-5, 47, 120 Persian Wars 120, 128, 130, 141 perspective xxiii, xxvii, 259 atmospheric xxiii, 183

divergent xxiii intuitive xxiii, 182 linear xxiii vertical xxiii Peru Chavin de Huantar 398 Lanzón, Chavin de Huantar 398, 398 Moche culture 399-400, 400 Nazca culture 399, 400 Paracas culture 399 textiles 397, 399, 399 Perugia, Italy: Porta Augusta 158, 158 Peter, Bishop of Illyria 223 Peter, St. 223, 226-7, 467 Petrarch (Francesco Petrarca) 532, 533 The Triumphs 533 petroglyphs, Native American 406 Phaistos 85 Pheidias 142 Athena Parthenos 133, 133 Athena Promachos 129 Parthenon 129-30 Philadelphia, Pennsylvania Philadelphia Museum of Art xxxvi, xxxviii Vanna Venturi House xxv Philip Augustus, of France 497 Philip II, of Macedon 141, 142 Philip the Fair 508 Philippines, the 296 Philoxenos of Eretria (?): Alexander the Great Confronts Darius III at the Battle of Issos 145, 146 Phoebus (god) 104 Phoenix Hall, Byodoin, Uji, Japan 372, 373 Amida Buddha (Jocho) 372, 373, 373 phonograms 30 Photios (patriarch) 249 photography xxiv, xxv Picaud, Aymery 464 Picking Figs (tomb painting) 63, 63 pictographs 30, 337, 337, 406 pictorial depth xxiii picture plane xxiii picture space xxiii pietà 230 see also Vesperbilder pilgrimages/pilgrimage churches/pilgrimage roads 459, 460, 463, 464, 464-5, 469, 500 Pisa, Italy 469 Baptistery pulpit (N. Pisano) 525, 525-6, 526 Cathedral complex 469, 470, 471 Pisano, Andrea 550 Florence Baptistery doors 534, 535, 536, 536 Pisano, Bonanno: "Leaning Tower of Pisa" 470, 471 Pisano, Giovanni 526-7, 539 pulpit, Sant'Andrea, Pistoia 526, 526-7 Pisano, Nicola 525 Pisa Baptistery pulpit 525, 525-6, 526 pishtaa 290 Pistoia, Italy: Sant'Andrea pulpit (G. Pisano) 526, 527 Plantagenets 460, 515 Plato 141 Pliny the Elder: Natural History 145, 153, 167, 199 Pliny the Younger 167 Plotinus 205 Plutarch 53, 145 Pluto (god) 104

Polybius 168 Polygnotos of Thasos 140 Polykleitos of Argos 120, 139 "Canon" 134, 142 Spear Bearer (Doryphoros) 134, 134 Pompeii 167, 176-7, 177, 178 four styles of painting 182 House of G. Polybius 179 House of the Silver Wedding 178 House of the Surgeon (fresco) 183, 183 House of the Vettii 178, 178, 179, 179-80 Portrait of a Married Couple 183-4, 184 Villa of the Mysteries 180, 181 Pont du Gard, Nîmes, France 170, 170 Pontius Pilate 226, 230 Poore, Bishop Richard 518 porcelain 20 Porta, Giacomo della: fountain, Rome 194 Portoghesi, Paolo: Islamic Mosque and Cultural Center, Rome 293, 293 Portrait of a Married Couple (wall painting) 183-4, 184 portraiture, Roman 167, 167, 168, 168, 169, 169, 204, 205, 205-6, 211, 211 Portugal 269 Poseidon (god) 104, 135 Poseidonia (Paestum), Italy Temple of Hera I 108, 109 Tomb of the Diver 124, 124, 125 post-and-lintel construction 17, 18, 19, 158 potassium-argon dating method 12 potsherds 20 pottery 20, see ceramics Poverty Point, Louisiana 401 pozzolana 194 Prague 548, 559, 561 Old-New Synagogue (Altneuschul) 522, 523 Prakrit (language) 295 Prambanan, Java, Indonesia Loro Jonggrang 325-6, 326 reliefs (Abduction of Sita) 325-6, 326 Praxiteles 142, 155 Aphrodite of Knidos 143, 144 Hermes and the Infant Dionysos 142-3, 143 prayer rugs 291 prehistory 1, see Neolithic period; Paleolithic period Prědmosti, Czech Republic 7 Pretty, Edith May 434 Priam Painter: Women at a Fountain House 139, 139 Priestess of Bacchus (Roman ivory) 212-13, 213 "Priest-king" (from Mohenjo-Daro) 298, 298 Primaporta, Italy: Livia's villa 182, 183 Princep, James 295 prints xxiv–xxv Procopius of Caesarea 235-6 pronaos 108, 109 Prophet, the see Muhammad, Prophet Propylaia, Akropolis, Athens 129, 135, 135 propylons 111, 111 Proserpina (goddess) 104 psalters Chludov Psalter 247 Paris Psalter 256, 256-7 Utrecht Psalter 450, 450 Windmill Psalter 516, 517-18 psykters 117 Frolicking Satyrs (Douris) 126, 126 Ptah (god) 51, 74

Ptolemy V, of Egypt 79 Ptolemy, king of Egypt 79, 147 Pucelle, Jean 532 The Book of Hours of Jeanne d'Évreux 549, 551 Pueblo Bonito, Chaco Canyon, New Mexico 404-5.405 puja 309 Pure Land Buddhism 345, 371, 377 Amida Buddha (Jocho) 373, 373 Byodoin Temple 372, 373 portrait sculpture 377-8, 378 raigo paintings 378-9, 379, 381 putti 224, 226 Pylos, Greece 96 Palace 96, 96 pyramids 55, 57 Borobudur, Java, Indonesia 324, 324-5 Chavin de Huantar, Peru 398 Djoser's step pyramid (Saqqara) 54, 54-5 Huaca de la Luna, Moche Valley, Peru 399-400 Huaca del Sol, Moche Valley, Peru 399 La Venta, Mexico 385, 386 Maya 391, 391, 392, 392-3, 396, 396 Pyramid of Khafre (Giza) 55, 56, 56, 57 Pyramid of Khufu (Giza) 56, 56, 57 Pyramid of Menkaure (Giza) 56, 56, 57 Teotihuacan, Mexico 387, 388-9 Pythian Games 107, 122

Q

Qawsun, Sayf al-Din 279 qi 342 qibla wall 274, 278 Qin dynasty 331, 332, 336, 338 legalism 338, 340 Terra-cotta army of Shihuangdi 330, 331, 336–7 quilts xxvii, xxvii–xxix Quince (Mugua) (Zhu Da) xxxiv, xxxv, xxxvi Qur'an, the 267, 270, 275, 275–6, 279, 282, 283, 284, 284, 285 Qutham bin Abbas 283

R

Ra (god) 51 radiometric dating method 12 Raedwald, King of East Anglia 433, 434 al-Rahman I, Abd, Umayyad caliph 272 al-Rahman III, Abd, Umayyad caliph 272 Ra-Horakhty (god) 69,74 raigo paintings (Japan) 378-9, 379, 381 Rainbow Serpent rock, Arnhem Land, Australia 2, 2 Raising of Lazarus (Duccio) 544, 544 Raising of Lazarus (Giotto) 540-41, 541 Raising of Lazarus 230 Rajaraja I, Chola ruler 320 Rajarajeshvara Temple of Shiva, Thanjavur, India 320-21.321 Ramadan 271 Ramayana 299, 326, 326 Ramose, tomb of (Thebes) 69-70, 70 Ramses II, Pharaoh 66, 67, 73, 76, 77 Temples, Abu Simbel 74, 74, 75, 76, 77 Raphael (Raffaello Sanzio): Madonna of the Goldfinch (Madonna del Cardellino) xxxii, xxxii-xxxiii, xxxv rationalism 120 Ravenna, Italy 227, 235, 238-9 Oratory of Galla Placidia 228, 228, 229

San Vitale xxv, 238, 238-9; mosaics 239, 240, 241,242 Razatis, Persian general 233 Realism xxiv realism xxiv, 169, 183 Rebecca at the Well (codex page) 245, 245 red-figure vases, Greek 118, 118, 119, 126, 126-7, 127 regional styles xxiv registers 30 Reims Cathedral, France 508, 508-9, 510, 511 sculptures 509, 509-10 Reinach, Salomon 8 relics and reliquaries 464, 467, 500, 505, 512, 514 Reliquary statue of Sainte Foy, Conques, France 467.467 relief sculpture xxv Akkadian 26, 27, 35, 35-6 Assyrian 40, 41, 42, 43, 43 Babylonian 34, 37, 39, 39, 40 Benin plaques 420, 420 Buddhist 303-4, 304, 307, 307-8 (Indian), 324-5, 325 (Indonesian) Byzantine 244, 244-5, 255, 255-6, 256 Chinese (Han) 340, 340-41 early Christian 226-7, 227 Egyptian 51-3, 52, 61, 61, 71, 71-2; stelai 63, 63-4, 64; tomb 61, 61, 69-70, 70 Etruscan 161, 162, 163 French 479, 480, 481-5, 481-4 (Romanesque), 500-2, 502 (Gothic), 552, 552-3, 553 (14th century) German 454, 455, 456 (Ottonian), 523, 523 (Gothic) Gothic 500-2, 502 (French), 523, 523-4 (German), 525, 525-6, 526 (Italian) Greek 107-8, 108 (Archaic), 131, 131-3, 132, 137, 137, 139-40, 140 (Classical) Hellenistic 150, 151, 152 Hindu 310, 310, 314, 315, 316, 316-17, 319, 319-20, 325-6, 326, 329, 329 Indonesian 324-5, 325 (Buddhist), 326, 326 (Hindu) Italian 478-9, 479 (Romanesque), 525, 525-7, 526 (Gothic), 534, 535, 536, 536 (14th century) Mathura style 307, 307-8 Maya 393, 393, 394, 394 Ottonian 454, 455, 456 Paleolithic 5, 11-12, 12 Persian 45, 47, 47 rock-cut (Hindu) 314, 315, 316, 316-17 Roman 174, 174-5, 175, 186, 186, 192-3, 193, 201, 202, 208, 208-9, 209 Romanesque architectural 458, 459, 478, 478-9, 479, 480, 481-5, 481-4 Romanesque bronzework 486, 486, 487, 487 Sumerian 30-31, 31, 34-5, 35 religions Akkadian 36 Christianity 166, 207, 211, 212, 213 Egyptian 50-51 Greek 102, 104 Mesopotamian 28 Roman 104, 166, 207 Sumerian 28, 30, 31 ren 342 Renier of Huy 487 baptismal font 487, 487 Renoir, Auguste

Mme. Charpentier and Her Children xxxii, xxxiii, xxxiii, xxxv repoussé work 90, 91 representational styles xxiv Resurrection, the 230 Resurrection/Noli Me Tangere (Giotto) 541, 541 Revelation, Book of 220 rhytons, Minoan 88, 88-9, 89 Riace Warriors, The (Greek bronzes) 122, 123, 126, 127 Richard de Galmeton: bishop's throne, Exeter Cathedral 556-7 rock art African 410-11 American Southwest 406, 406 Bronze Age carvings 24-5, 25 Paleolithic 2, 2 Saharan 411-12, 413 San (South African) 414, 414 see also cave art rock-cut reliefs, Indian 314, 315, 316, 316-17 rock-cut temples, Indian 302, 302, 304-5, 314, 314-16, 315, 317, 317-18 rock-cut tombs, Egyptian 62, 62-3 Roger, Abbot of Moissac 479 Rollefson, Gary 21 Roman Catholic Church 431, 460 Roman Empire 171, 205, 212, 430, 431, 435 map 216 religions 216, 220, 223 see also Romans; Rome Roman Republic 164, 166-7, 171 Romanesque period 431, 460-61 architectural sculpture 458, 459, 478, 478-9, 479, 480, 481-5, 481-4 architecture 454, 461-3, 519; in England 476, 476-8, 477; in France 462, 463, 465-9, 466, 468, 469, 474, 474-5; in Germany 475, 475; in Italy 469, 470, 470, 471, 471-2; in Spain 463, 463-5, 465 Bayeux Embroidery 487, 488, 488-9, 489 books 490, 490-91, 492, 492, 493, 493 map 461 mosaics 472 sculpture 485, 485-7, 486, 487 wall paintings 473, 473, 474, 474-5 Romanos II, Emperor 255, 256, 256 Romans 157, 166 amphitheaters 177, 186-8, 187, 188 aqueducts 170, 170, 179 arches: structural 170, 170; triumphal 185, 185-6, 207-9, 208, 209 architectural orders 161, 161 bronzes 169, 169, 200, 200-1 cities 176-7 concrete 194 deities 104 fora 176, 177, 190 houses and villas 178, 178-9, 179, 181, 197, 197, 198, 199-200 ivory diptych 212-13, 213 map 159 mosaics 198, 199, 199-200 painting 183-4, 184, see also wall paintings (below) peristyle gardens 178, 178-9 portrait sculpture 167, 167, 168, 168, 169, 169, 178, 188, 189, 204, 205, 205-6 relief sculpture 174, 174-5, 175, 186, 186, 192-3, 193, 201, 202, 208, 208-9, 209

religions 104, 166, 207, 212 sculpture 172, 173, 211, 211; copies of Greek statues 143, 143, 144, 145; see also portrait sculpture (above) silver 169, 169, 211-12, 212 temples 171, 171, 194, 195, 195, 196, 197 theater 177, see amphitheaters (above) vaulting 187, 187 wall paintings 179-83, 180-84 see also Roman Republic; Rome Rome 167, 171, 190, 190-91, 202, 205, 234, 235, 430, 431, 460 Ara Pacis Augustae 172, 174, 174-5, 175 Arch of Constantine 207-9, 208, 209 Arch of Titus 185, 185-6, 217 Basilica Nova/Basilica of Maxentius and Constantine 209, 210, 211 Basilica Ulpia 191, 191-2 Baths of Caracalla 203, 204 Catacomb of Commodilla 214, 215, 220 Catacomb of SS. Peter and Marcellinus 220, 222, 222 Colosseum 186-8, 187, 188 Islamic Mosque and Cultural Center (Portoghesi, Gigliotti, and Mousawi) 293, 293 Old St. Peter's 223, 223, 224, 225, 225 Pantheon 194, 195, 195, 196, 197 San Clemente 471, 471-2, 472 Santa Costanza xxv, 224, 224, 225, 225, 226 Santa Sabina 223, 223-4, 224, 452-3 Temple of ?Portunus, Forum Boarium 171, 171 Trajan's Column 192-3, 193 Trajan's Forum 191, 191 Trajan's Market 191, 192, 192 Villa Torlonia (catacomb wall painting) 217, 217 see also St. Peter's Rome Ronchamp, France: Nôtre-Dame-du-Haut (Le Corbusier) xxviii, xxviii rose windows 505, 506, 507, 508 Rosen, David xxxviii Rosetta Stone 34, 79, 79 Rothko, Mark xxvii, xxviii Magenta, Black, Green, on Orange (No. 3/No. 13) xxvi, xxvii, xxix Rublyov, Andrey: The Hospitality of Abraham 262-3, 263 Rudolf of Swabia (tomb effigy) 486, 486 rugs, prayer 291 rune stones, Viking 442, 442 Rus 250, 441 Russia 44, 250 Byzantine art 234, 262-3, 263 Paleolithic settlements 4-5

S

al-Sadi 422 Safavids 281, 285, 286, 289 architecture 290, *290* book production 289 carpets 291, *291* painting 289, *289* Saharan rock art 411–12 St. Albans, monastery of 515 St. Catherine's Monastery, Sinai 242, *243*, 244 *Virgin and Child with Saints and Angels* (icon) *246*, 246–8 Saint-Denis, Abbey church of (near Paris) 432, 497, *498*, 498–9, *500*, 505 Saint Gall, Switzerland *447*, 447–8, 450 St. Mark's Cathedral, Venice 254, 254 Saint-Martin-du-Canigou, monastery of (France) 462, 463 St. Michael the Archangel (icon) 257, 258 St. Peter's, Rome 444, 463, 464 Sarcophagus of Junius Bassus 226-7, 227 St. Peter's, Rome (Old) 223, 223, 224, 225, 225 Saint-Savin-sur-Gartempe, France: abbey church 474, 474-5 Sainte-Chapelle, Paris 512, 512-13, 513, 514 Saints Onesiphoros and Porphyrios Standing before an Architectural Backdrop (mosaic) 227, 231, 231 Saladin, Sultan 461 Salisbury Cathedral, England 518, 518-19, 519 Saljuqs 277, 288 Samarkand, Uzbekistan 281 ceramics 276 Sha-i Zinda funerary complex 268, 282, 282-3 samsara 299, 301, 309 samurai/samurai arms and armor 376, 377, 377 San Lorenzo, Mexico 385 Colossal heads (Olmec) 385-6, 386 San peoples, South Africa: rock paintings 414, 414 San Vitale, Ravenna, Italy 238, 238-9 mosaics 239, 240, 241, 242 Sanchi, India: Great Stupa 302-4, 303, 304, 305, 306 Sanskrit (language) 295, 299 Santiago de Compostela, Spain 460 Cathedral of St. James 463, 464-5, 465, 469 Sapi-Portuguese oliphant (hunting horn) 427, 427 Sappho 105 Saqqara, Egypt Djoser's Complex 53-5, 54, 55 Tomb of Ti 61, 61 sarcophagi Etruscan 163, 163-4, 164 Roman 201, 202 Sarcophagus of Junius Bassus, Rome 226-7, 227 Sarcophagus of Pakal the Great, Palenque, Mexico 393, 393 Sargon I, Akkadian king 35, 36 Sargon II, of Assyria 41 palace complex, Dur Sharrukin 41, 41-2, 43 Sarnath, India Buddha Preaching His First Sermon 310-11, 311 Lion capital 300, 300-1 Sasanian Persians 233, 267, 283 ceramics 283, 283-4 Satavahana dynasty, India 301 saturation, color xxii Saxons 430, 433 Scandinavia architecture 442-4, 443 see also Denmark; Vikings scarabs 51, 66, 82 Scarification, Yoruba 408, 409 Schaden, Otto 49 Schapiro, Meyer 439 Schliemann, Heinrich 85, 95, 95, 97 scholasticism 497 Schwäbisch Gmünd, Germany: Church of the Holy Cross (H. and P. Parler) 559, 561 Scraper, The see Man Scraping Himself scriptoria 244, 438, 487, 490, 493 scripts see writing/scripts scroll painting(s) xxiv Chinese 341-3, 342 (Six Dynasties), 347, 347-8 (Tang), 352, 352-4, 353, 354 (Northern Song), 354-5, 354-5 (Southern Song)

Japanese 374, 374-5, 376, 376 (Heian yamato-e), 360, 361, 377, 378, 378-9, 379, 380, 380, 381 (Kamakura) Korean 359, 359 scrolls, papyrus 245 Scrovegni (Arena) Chapel frescos, Padua (Giotto) 539-42, 540-42, 545 sculpture xxiv, xxv African 410, see also specific countries Akkadian 36, 36, 37 Angolan 425, 426 Benin heads 417, 417-19 Buddhist 304, 305, 306, 307 (Indian), 344, 345, 345 (Chinese) Chavin de Huantar 398, 398 Chinese 344, 344 (Buddhist), 350, 350 (Liao) Cucladic 82, 82-4, 84 early Christian 222, 222 Egyptian 57-61, 59, 60, 62, 62, 70, 67-8, 68, 70, 71, 72, 72-3, 74, 74, 78, 78-9 Etruscan 160, 160 Florida Glades culture 403, 403-4 French 467, 467 (Romanesque), 509, 509-10 (Gothic), 552, 552-3, 553, 548, 554, 554 (14th century) German 454, 454 (Ottonian), 524, 524 (Gothic), 557, 557-8 (14th century) Gothic 509, 509-10 (French), 524, 524 (German) Greek 104, 104, 105, 111, 112, 113, 113-15, 114, 115, 116, 117 (Archaic), 120-22, 121, 122, 123, 126, 130, 130-31, 133, 133, 134, 134, 142-3, 143, 144, 145 (Classical) Hellenistic 149, 149-50, 152, 153, 153, 154, 155 Hindu 322, 322 Hopewell culture 401-2, 402 Indian 294, 295, 299-301, 300 (Mauryan), 304, 305 (Sanchi), 306-8, 306, 307 (Kushan/ Gandhara/Mathura) Indus Valley 298, 298, 299 Japanese 367, 367 (Asuka period), 372, 373, 373 (Heian period), 377-8, 378 (Kamakura period) Khmer 323, 324 Korean (Buddhist) 357, 357-8, 358 Maya 393, 393 Minoan 88, 88-9, 89 Myanmar 327, 328 Neolithic 13, 14, 21, 22, 22, 23, 23 Nok 413, 413 Olmec 382, 383, 385-7, 386 Ottonian 454, 454 Paleolithic 1, 5-7, 5-7, 11-12, 12 Roman 172, 173, 211, 211; portraiture 167, 167, 168, 168, 169, 169, 204, 205, 205-6 Romanesque 467, 467 (French), 485, 485 (Spanish) Spanish 485, 485 (Romanesque) Sumerian 30, 30, 31, 31, 34, 34, 37, 38 Teotihuacan culture 388, 388-9 see also relief sculpture Scythians 44 seals Chinese 343 cylinder (Sumerian) 34-5, 35 Indus Valley 296, 296, 298 Seated Scribe (Egyptian) 60, 60 Seidel, Linda 483-4 Sekou Amadou, ruler of Jenné 422

Seleucids 147.149 Selim II. Sultan 286 Semele 202 Senegal River 412 Senusret II, of Egypt 65 Senusret III, of Egypt: portrait head 62, 62 Seokguram, Korea 357 Seated Shakyamuni Buddha 357-8, 358 serdab 53 Sesklo, Greece: stone-foundation houses 16, 16 Sety I, Pharaoh 67 Severan emperors 203, 205 Severus, Emperor Septimius 203 shading xxix, xxxi shaft graves, Mycenaean 97 Shah-i Zinda funerary complex, Samarkand 268, 282, 282-3 Shahmana of Shah Tahmasp 289, 289 shamanism 9 Shamash (god) 39 Shang dynasty (China) 334, 335 bronzes 334-5, 335, 336 burials/tombs 334 fang ding 334-5, 335 guang (ritual pouring vessel) 335, 336 jade congs 334 oracle bones 334 Seated Buddha 344, 344 shape xxii Shi'ites 267, 269, 271, 286 Shield Jaguar (Maya ruler) 394, 394 Shihuangdi, Emperor 331, 36 Terra-cotta army 330, 331, 336-7 shikhara 302, 309, 318, 319 Shingon Buddhism 369 Shinto 361, 362, 363 pictures 379, 381 shrines 361, 363-4, 364, 367 ship burials Oseberg Ship 441, 441-2 Sutton Hoo 433-5, 434 shipwrecks 82, 122, 127 Shiva (god) 309, 314, 316, 317, 318, 320, 325 Eternal Shiva (rock-cut relief) 314, 315 Shiva Nataraja (Shiva as Lord of the Dance) (Chola bronze) 322, 322 Shomu, Emperor 367, 368, 369 Shotoku, Prince of Japan 365-6 shramana traditions 299 Shrine of the Three Kings (Nicholas of Verdun) 523. 523 Shunga dynasty, India 301 Siddhartha Gautama, Prince 301, 304; see Buddha Shakyamuni Siena, Italy 531, 536, 542 Palazzo Pubblico 547, 547; frescos (Lorenzetti) 530, 531, 547-8, 548-9 Sierra Leone: ivory hunting horn 427, 427 Sigiriya, Sri Lanka 312, 313 Heavenly Maidens (wall painting) 312, 313 Silk Road 338, 344, 345, 349, 369 rock-cut caves 344 Silla kingdom, Korea 356, 357 Bodhisattva Seated in Meditation 357, 357 Ceremonial stand 356, 356-7 Silos, Spain: pier figures, Abbey of Santo Domingo 458, 459, 490 silverwork Byzantine 232, 233, 246, 433 French (14th century) 554, 554

silverwork. Roman denarius of Julius Caesar 169, 169 platter 211-12, 212 Sinai, Mount 217 St. Catherine's Monastery 242, 243, 244; Virgin and Child with Saints and Angels (icon) 246, 246 - 7Sinan 286 Mosque of Sultan Selim, Edirne, Turkey 286, 287 Singapore 296 sinopia drawing 539, 539 Six Dynasties (China) 341 Buddhist art and architecture 344 calligraphy 341, 343, 343 painting/handscroll 341-3, 342 Socrates 139 Solomon, King 217, 269, 485, 516, 517-18 Song dynasty (China) 348 Neo-Confucianism 350-51 see also Northern Song; Southern Song Songhay 410 Sophocles 148 Sosos of Pergamon: The Unswept Floor 199, 199 South Africa: rock paintings 414, 414 South America 384 see Andean peoples; Peru Southern Song dynasty (China) 348 ceramics 355, 355 painting 354-5, 354-5 space xxiii Spain 431 architecture 268, 272, 272-3, 273, 280, 280, 281 (Islamic), 463, 463-5, 465 (Romanesque) cave paintings 1, 8-9, 11, 11 Great Mosque of Cordoba 272, 272-3, 273, 275 Islam/Muslims 267, 269, 277, 280, 460 Mozarabic art 439, 439-41, 440 Nasrids 280, see Alhambra, the pilgrimage routes 459, 464, 464 Romanesque crucifix 485, 485 Romanesque fresco 473, 473 spandrels 170, 170 Sparta/Spartans 102, 120, 127-8, 141 spatial recession xxiii, xxiii Spear Bearer (Doryphoros) (Polykleitos) 134, 134, 142 - 3, 145Speyer Cathedral, Germany 475, 475 Sphinx of Taharqo (from Nubia) 78, 78-9 Sphinx, the (Giza) 57, 58 spolia 272, 471 Spotted horses and human hands (cave painting) xlii, 1.8 Spring Festival on the River (Zhang Zeduan) 353, 354 "Spring Fresco" (Minoan) 91, 91-2 squinches 238, 238, 249, 252 Sri Lanka 296 Buddhism 301 Sigiriya 312, 313 Stag Hunt (Gnosis) 146, 146-7 Stags Drinking from Streams Flowing under the Crucified Christ (mosaic) 472, 472 stained glass windows xxiv, 501 Gothic 476, 476, 494, 495, 499, 500, 501, 503, 506, 506, 507, 508, 510, 510, 512-13, 513 Perpendicular style 556, 557 stave churches, Norwegian 443, 443-4

stelai grave stele of Ktesilaos and Theano 139-40, 140 grave stele of little girl (from Paros) 139, 140 Stele of Amenemhat 65, 65 Stele of Hammurabi 34, 37, 39, 39 Stele of Naram-Sin 26, 27, 34, 36 Stele of the Sculptor Userwer 63, 63-4, 64 step pyramids, Egyptian 53, 54, 54-5, 55 stereobates 109, 110, 110, 129 Stevanović, Mira 16 Stewart, Andrew 113-14 Still Life (House of the Stags, Herculaneum) 183, 184 Still Life with Fruit and Flowers (Peeters) xxxiv, xxxvi still life xxxvi stoas 137-8, 140 Stokesay Castle, England 520, 520 Stone Age see Neolithic period; Paleolithic period Stonehenge, England 15, 17-20, 18, 19 stoneware 20 Minoan rhytons 88, 88-9, 89 Strasser, Thomas 92 stringcourses 503 Strozzi Altarpiece, Santa Maria Novella, Florence (Orcagna) 550, 550 stupas 302, 302, 351, 351 Great Stupa at Sanchi 302-4, 303, 304, 305, 306 styles xxiv stylobates 109, 110, 110, 128 stylus 28, 30 subject matter identifying xxxiii, xxxv natural xxxv Sudan 410, 412, 419 Suger, Abbot of Saint-Denis 470, 492, 497, 498-9 Sui dynasty (China) 345 bronze altar to Amitabha Buddha 345, 345 Suleyman "the Magnificent," Sultan 286, 288 tugras 288, 288 Sultan Muhammad: The "Court of Gayumars" 289, 289 Sumer/Sumerians 28, 37 alabaster vessel 30-31, 31 cylinder seals 34-5, 35 Epic of Gilgamesh 28, 32 inventions 28 lvres 32-3, 33, 34 metalworking 34 religion 28, 30, 31, 37 royal burials 32-3 sculpture 30, 30, 31, 31, 34, 34 votive figures 31, 31, 34, 37, 38 writing 28, 30 ziggurats 28, 29, 37, 37 Sunni Muslims 267 Suryavarman II, Khmer king 328-9 Susa (Iran) 34 Sutton Hoo burial ship 433, 434 hinged gold clasp 433-5, 434 Symmachus, Quintus Aurelius: diptych 212-13, 213 symposia 124, 125, 127 synagogues 217 Beth Alpha, Israel 219, 220 Dura-Europos, Syria 217-18, 218 Old-New Synagogue (Altneuschul), Prague 522, 523

syncretism 220 Syria 267, 268, 279, 286 glassmaking and ceramics 276, 277, 279

т

Tabriz, Iran 285, 289 Tahmasp, Shah 289 Shahnama 289, 289 Taira, the 376, 377, 378 Tale of Genji, The (Lady Murasaki) 369, 373-4 illustrated handscrolls 374, 374-5, 377 Talenti, Simone: Loggia dei Lanzi, Florence 534, 534 Tamerlane 281 Tang dynasty (China) 345, 348, 349 Buddhist architecture 345-7, 346, 347 earthenware figures 348, 348, 349, 349 five-stringed lute 369, 369 scroll paintings 347, 347-8 tantra/tantrism 319-20 Tantric Buddhism 369, 371 Taoism see Daoism taotie motif 334, 335, 336 Tarquinia, Italy: Etruscan tombs 160, 161, 162, 163 Tassili-n-Ajjer mountains, Algeria: rock art 411-12, 413 Taull, Spain: San Climent apse fresco 473, 473 technique xxiv Tell Asmar, Iraq: votive figures 31, 31, 34 Tell el-Amarna, Egypt see Amarna period Telloh, Iraq see Girsu tells 29 temenos 108, 111 tempera paintings 546 Byzantine 245, 245, 247, 247, 257-8, 258, 262-3, 263 Italian 536-7, 537, 538, 538-9, 542, 543, 544, 544-5, 545, 546, 547 temples Chinese (Tang dynasty) 345, 346, 346-7, 347 Egyptian 50, 51, 57, 58, 65-7, 66, 67, 68, 68-9, 69, 74, 74, 75, 76, 102 Etruscan 158, 159, 160 Greek 106, 107, 108, 109, 111, 111, 113-14, 171 (Archaic), 128, 129, 129-33, 135, 137, 137 Indian (Buddhist) see stupas Indian (Hindu) 302, 302; 309, 309-10 (Gupta dynasty), 314, 314-16, 315, 317, 317-18 (rock-cut), 318, 318-19 (Chandella dynasty), 320-21, 321 (Chola dynasty) Indonesian 325-6, 326 (Hindu), 327, 327-8 (Buddhist) Japanese 365-6, 366, 370, 370, 372, 373 (Buddhist) Khmer 328, 328-9 Roman 171, 171, 194, 195, 195, 196, 197 Ten Commandments, the 39, 217 Tendai Buddhism 369 Teotihuacan, Mexico 387, 387-8, 389, 390, 391 Avenue of the Dead 387, 388 Bloodletting Ritual fresco 389, 389-90 The Ciudadela 388 Pyramid of the Feathered Serpent 388, 388-9 Pyramid of the Moon 387, 388 Pyramid of the Sun 387, 388 tepe 29 terra cottas

Etruscan 160, 160, 163, 163-4 Greek 114 Ife ritual vessel 415, 415-16 Indus Valley figurines 298 Jenné (Mali) figures 422, 422 Qin (China) army 330, 331, 336-7 Tetrarchs 205 portraits 204, 205, 205-6 textiles Andean 397 Bayeux Embroidery 487, 488, 488-9, 489 English 515; opus anglicanum 554-5, 555 Han (China) 338, 339 Kongo 426, 426 Ottoman 288 Paracas 399, 399 Peruvian 397 Romanesque 487, 488, 488-9, 489 see also carpets; embroidery; tapestries Thailand 296 bronzework 321, 323, 323 Thangmar (monk) 454 Thanjavur, India: Rajarajeshvara Temple of Shiva 320-21, 321 theater Greek 148, 148 Roman 177, see amphitheaters, Roman Thebes, Egypt 51, 65, 66, 78 Tomb of Ramose 69-70, 70 Theodora, Empress 234, 235, 239, 242 Theodora and Her Attendants (mosaic) 239, 241, 242 Theodora, Empress (9th century) 247 Theodore Metochites see Metochites, Theodore Theodoric, Master 532, 561 St. Luke 560, 561 Theodosius I, Emperor 227, 228 Theophanu, Queen (Ottonian) 452 Theophilus, Emperor 247 Theophilus Presbyter: On Divers Arts 470, 501 Thera, island of 81, 82, 91, 92 see also Akrotiri Theravada Buddhism 301, 320 thermo-luminescence dating method 12 Theseus 84 Thessaloniki, Greece 227 St. George mosaics 227, 231, 231 Thietmar of Meresburg: chronicle 454 Thirty-Six Immortal Poets (anthology) 375, 375-6 tholos tombs, Mycenaean 98, 98-9 Thomas of Witney: Exeter Cathedral, England 556, 556-7 Thomas, Henrietta xxvii My Sweet Sister Emma (quilt) xxvii, xxvii-xxviii, xxix Thoth (god) 51 Thutmose (sculptor) 72 Thutmose I, Pharaoh 66, 67 Thutmose II, Pharaoh 67 Thutmose III, Pharaoh 65, 66, 67 Tiberius, Emperor 172, 175, 176 Tibet: Buddhism 301, 369, 371 tiercerons 556 Tigris, River 28, 29 Tikal, Guatemala 391, 391-2 Timbuktu, Mali 419 Timur 281 Timurids 281, 285, 286, 289 architecture 281-3, 282, 290 tirthankara 299

Titus, Emperor 167, 185-6, 217 Tivoli, Italy: Hadrian's Villa 197, 197, 198, 199-200 Tiy, Queen: portrait 72, 72 Toba Sojo (attrib.): Frolicking Animals 376, 376, 377 Todaiji, Nara, Japan 367 Great Buddha Hall 367-8, 370, 370 Shosoin Imperial Repository 368-9, 369 Toledo, Spain 460, 466 tomb paintings and reliefs Egyptian 61, 61, 62-3, 63, 69-70, 70, 76, 77 Etruscan 160, 161, 162, 163 Greek 124, 125 tombs Egyptian 49, 50, 53-5, 54, 62, 62, see also mastabas; pyramids Etruscan 153, 160, 161, 162, 163 Mycenaean 93, 97-9, 98 Neolithic 14, 17, 17 see also tomb paintings and reliefs tools, prehistoric 1, 2-3, 4 Topkapi Palace, Istanbul 286-7 Baghdad Kiosk 287, 288 Torah, the 216-17, 218, 220, 523 toranas 302, 303, 304, 304 torcs, Celtic/Gallic 149, 150, 150 Tori Busshi 367 Buddha Shaka and Attendant Bodhisattvas 367, 367 torons 422 Tower of Babel (Romanesque wall painting) 474, 474-5 town planning Egyptian 65 Greek 138-9 Roman 176, 177 tracery 503 bar 510 plate 505, 510 Trajan, Emperor 190, 191, 192, 193 Trajan's Column, Rome 192-3, 193 Trajan's Forum, Rome 191, 191 Trajan's Market, Rome 191, 192, 192 Transfiguration, the 230 Transfiguration of Christ, The (mosaic) 242, 243 Travelers Among Mountains and Streams (Fan Kuan) 352, 352 "Treasury of Atreus" (Mycenaean tomb) 98, 98-9 Treasury of the Siphnians, Delphi 107, 107-8, 108 Tree of Jesse (Cistercian drawing) 493, 493 trefoil motif 298 Trier, Germany: Basilica 206, 206-7, 207 triglyphs 110, 110 trilithons 18 Tringham, Ruth 16 Triumphs, The (Petrarch) 533 Troy/Trojan War 85, 93, 100, 101, 111, 119 trumeaux, Romanesque 478, 481, 481 Tuc d'Audoubert, Le, France: cave sculpture 11-12, 12 Tucker, Mark xxxvi, xxxviii, xli tugras 288, 288 Tulum 396 Tunisia 269 Great Mosque of Kairouan 271, 271, 274, 277 Turkey Hagia Sophia, Istanbul xxv Library of Celsus (facade), Ephesus 161 see also Çatalhöyük; Pergamon; Troy/Trojan War

Tuscan order 158, 161, 161

(UNIT OF

Tutankhamun 73 funerary mask 48, 49 inner coffin from sarcophagus 73, 73 tomb 49 *Twelve Views of Landscape* (Xia Gui) 354–5, 354–5 tympana, Romanesque 478, 479, 480, 481, 483, 483–4

U

Ukraine 44, 234, 248, 250 mammoth-bone house 4-5, 5 see also Kiev Ulu Burun, Turkey: shipwreck 82 Umayyads 267, 268-9, 272 under-drawings xxxvi universities 460, 496-7, 515 Unswept Floor, The (Herakleitos/Sosos of Pergamon) 199, 199 Upanishads, the 299 Ur (Muqaiyir, Iraq) 28, 32 bull's head lyre 32-3, 33 burials 32, 32 cylinder seals 35, 35 Nanna ziggurat 37, 37 uranium-thorium dating method 1, 12 Urban II, Pope 461 urna (Buddhist symbol) 306, 368, 368 Urnammu, King of Ur 37 Uruk (Warka, Iraq) 28, 30 alabaster vessel 30-31, 31 Anu ziggurat 28, 29 Face of a woman 30, 30, 34, 34 White Temple 28, 29, 30 Userwer, Stele of 63, 63-4, 64 Disk of Enheduanna 35, 35-6 ushnisha (Buddhist symbol) 306, 344, 368, 368 Utah Horseshoe Canyon rock art 406, 406 Nine Mile Canyon mural 406, 406 Uthman, Caliph 267 Utrecht Psalter 450, 450 Uzbekistan 281, 306 see also Samarkand

V

Vakataka dynasty 311 cave painting 311, 311-12 Valentinian III, Emperor 228 Valley of the Kings 49, 50, 67, 73, 77 Valley of the Queens 50, 67 values, color xxii van der Hoof, Gail xxviii Vandals 430, 430, 431 vanishing point xxiii vanitas paintings xxxvi Vapheio Cup (Minoan) 90-91, 91, 99 Varada mudra 308, 308 Varna, Bulgaria: gold and copper artifacts 23, 24 Vasari, Giorgio 496, 538 vases, Greek 100, 101, 102-4, 103, 105, 105, 117, 117-20, 118, 119, 139, 139 (Archaic), 126, 126-7, 127, 141, 141 (Classical) vaults/vaulting barrel 187, 187, 228, 229 corbeled 17, 17, 19, 98, 99 rib 499, 499 ribbed groin 477 tierceron 556

Vedas, the 299, 309, 320 Vedic gods 304 Vedic period 299 Veii, Italy 160 vellum 245, 276, 436, 490, 491 Venice, Italy 248, 254 St. Mark's Cathedral 254, 254 "Venus" figures 6 Venus (goddess) 104 Venus de Milo (Alexandros) 154, 155 verism 168 Vespasian, Emperor 184 Vesperbilder 557, 557-8 Vesta (goddess) 104 Vesuvius, Mount 167, 176-7 Vézelay, France: relics of St. Mary Magdalen 464 Victory (goddess) 104, see Nike Victory of Samothrace 153, 153, 155 Vienna Genesis 245, 245 Vietnam 296 vihara 305 Vikings 250-51, 429, 430, 441, 444, 452, 460, 488 Oseberg Ship 441, 441-2 rune stones 442, 442 Villanovans 158 Villard de Honnecourt: drawings 511, 511 Virgin and Child (mosaic) 248, 248-9 Virgin and Child (silver gilt) 554, 554 Virgin and Child (wooden statue) 485-6, 486 Virgin and Child Enthroned (Cimabue) 536-7, 537, 539 Virgin and Child Enthroned (Giotto) 538, 538-9 Virgin and Child with Saints and Angels (icon) 246, 246 - 8Virgin of Vladimir (icon) 257-8, 258 Vishnu (god) 309, 317, 325 Vishnu Churning the Ocean of Milk (relief) 329, 329 Vishnu Lying on the Cosmic Waters (relief) 310, 310 Visigoths 272, 430, 430, 431, 439 Visitation, the 230 Vitarka mudra 308, 308, 323 Vitelli, Karen 21 Vitruvius 158, 167 Vladimir, Grand Prince 251 Volmar (monk) 492, 492 volume xxiii volutes 110, 110 votive figures, Sumerian 31, 31, 34, 37, 38 voussoirs 170, 170 joggled 268, 279 Vulca (?): Apollo 160, 160 Vulcan (god) 104 Vulgate, the 223, 437, 448

W

waaf (endowment) 277 Wadjet (goddess) *51*, 73 Wagner Carpet, the 291, *291 waka* (Japanese poetry) 375 wall paintings xxiv Byzantine *253*, 253–4, 260, *260* catacomb *214*, 215, 217, *217*, 220, 222, *222* Chinese (Tang) 345, *346* Etruscan 160, *161*, *162*, 163 Greek 124, *124*, *125* Indian *311*, 311–12 Minoan *87*, 87–8, *91*, 91–2, *92–3* Neolithic *14*, 15 Roman 179–84, *180–84*

Sri Lankan 312, 313 see also cave paintings, prehistoric; frescos; tomb paintings and reliefs Walter of Memburg: bishop's throne, Exeter Cathedral 556-7 Wang Xizhi: Feng Ju album 343, 343 "Warka Head" 30, 30, 34, 34 Warka see Uruk Warring States period (China) 336 Warrior Krater (Mycenaean) 99, 99 Watson Brake, Louisiana 401 wattle and daub 16, 19 weapons, bronze 24 Wearmouth-Jarrow, England 436, 437 Western Paradise of Amitabha Buddha (wall painting) 345, 346 westworks 446, 446, 447 Weyden, Rogier van der xxxvi, xl-xli Crucifixion Triptych with Donors and Saints xxxviii–xxxix, xxxix Crucifixion with the Virgin and St. John the Evangelist xxxvi-xxxviii, xxxvii, xl, xli, xli Whitney Museum, New York xxviii "Abstract Design in American Quilts" xxviii Wiligelmo: Modena Cathedral reliefs 478-9, 479, 506 Willendorf, Austria: Woman from Willendorf 6, 6-7 William I ("the Conqueror") 460, 487, 488 William of Sens 504 Windmill Psalter 516, 517-18 Winter, Irene 27 Woman and Maid (style of Achilles Painter) 141, 141 Woman at a Fountain House (Priam Painter) 139, 139 Woman Clothed with the Sun (Maius) 439, 439-40 Woman from Brassempouy 7, 7 Woman from Dolní Věstonice 7, 7 Woman from Willendorf 6, 6-7 Wonderwerk Cave, South Africa 414 wood sculpture, Japanese joined-block construction 372, 372, 373, 373 portrait sculpture 377-8, 378 Woodland period, North America 401-2 wood-post framing 19, 20, 20 Woolley, Katherine 32 Woolley, Sir Leonard 32, 32, 35 Worcester Chronicle 490, 490 Worth, Charles Frederick xxxv writing/scripts Carolingian (majuscule and minuscule) 448-9 Chinese 334, 337, 337, 365 cuneiform 28, 30 Egyptian hieroglyphs 51, 52, 79, 79 Japanese 365, 365, 373, 375 Kufic 275, 275-6, 276, 279, 282, 282, 283 Maya 390, 390 Wudi, Han emperor 340

Х

Xerxes I, of Persia 47, 47 Xi River, China 332 Xi'an, China see Chang'an, China Xia dynasty (China) 334 Xia Gui: *Twelve Views of Landscape* 354–5, 354–5 Xie He 342 Xu Daoning: *Fishing in a Mountain Stream* 353, 353 Xuanzang (monk) 347

Υ

yakshas 304, 307 yakshis 300, 301 bracket figure 304, 305 yamato-e handscrolls Frolicking Animals 376, 376, 377 The Tale of Genji 374, 374-5, 377 Yangshao culture 332 bowl 332, 332 Yangzi River, China 332 Yaroslav, Grand Prince 251, 252 Yaxchilan, Mexico: Maya carved lintels 394, 394 Yayoi period, Japan 362 Yellow River/Valley, China 332, 334 Yi, Marquis of Zeng: tomb 336, 337 Yishan Yining 380 inscription 380, 380 Yoritomo, shogun 376-7 Yoruba, the 409

Crowned Head of a Yoruba Ruler (bronze) 408, 409 see also Ife Young Flavian Woman (Roman sculpture) 188, 189 Young, Thomas 79 Youth Pouring Wine into the Kylix of a Companion, A (Douris) 126–7, 127 Yuan dynasty (China) 355 Yucatan Peninsula, Mexico 384, 391 Chichen Itza 394, 396, 396 Mayapan 396 Yungang, Shanxi Province, China caves 312, 344 Seated Buddha 344, 344

z

Zagwe, the 424 *zakah* 271 Zen Buddhism 380, 381

painting 380, 380 Zeus (god) 102, 104, 107, 127, 130, 145, 180, 216 Zhang Xuan 347-8 Zhang Zeduan 353 Spring Festival on the River 353, 354 Zhou dynasty (China) 334, 335-6, 338, 340, 348 bronze bells 336, 337 seals 343 Zhu Da (Bada Shanren) xxxv-xxxvi Quince (Mugua) xxxiv Zhuangzi 338 ziggurats Babylonian 44 Sumerian 28, 29, 347, 347 Zimbabwe Great Zimbabwe 423-4, 424 painted stone flakes 414 Zoroaster 216